ART

THROUGH THE AGES

I

Ancient,
Medieval,
and
Non-European
Art

NINTH EDITION

GARDNER'S
ART
THROUGH
THE
AGES

NINTH EDITION

I

Ancient, Medieval,
and Non-European Art

HORST DE LA CROIX

RICHARD G. TANSEY

DIANE KIRKPATRICK
University of Michigan, Ann Arbor

HBJ

HARCOURT BRACE JOVANOVICH, PUBLISHERS

San Diego New York Chicago Austin Washington, D.C.
London Sydney Tokyo Toronto

COVER ART: Palace of Darius and Xerxes, Persepolis, Persia, *c.* 500 B.C.
Fred J. Maroon/Photo Researchers.

PREFACE

Since publication of the first edition in 1926, Helen Gardner's *Art through the Ages* has been a favorite with generations of students and general readers who have found it an exciting and informative survey of world art. Helen Gardner's enthusiasm, knowledge, and humanity have made it possible for the beginner to learn how to see and thereby to penetrate the seeming mysteries of even the most complex artistic achievements. In this volume, we have made every effort to preserve her freshness of style and, above all, her sympathetic approach to individual works of art and the styles of which they are a part.

Helen Gardner completed the third edition shortly before her death in 1946. The fourth edition was prepared in 1959 by Professor Sumner Crosby and his colleagues at Yale University. Professors Horst de la Croix and Richard Tansey assumed editorial responsibility for the project with the fifth edition in 1970, and prepared the sixth edition in 1975, the seventh in 1980, and the eighth in 1986. For this, the ninth edition, Professor Diane Kirkpatrick joins as a third coauthor. She is responsible for the revision of the final four chapters, which deal with the art of the modern world. The authors were led to prepare this edition not only by the steady appearance of new works of art and new interpretations and re-interpretations but also by suggestions received from readers. We hope that the ninth edition of *Art through the Ages* will continue its long tradition as a standard and popular survey of the history of world art.

In this edition, in addition to emendations made throughout the book, the text and the number of pictures have been expanded to include works of art recently discovered, restudied, or considered by the authors to be particularly characteristic of their periods and illustrative of developmental trends. Fuller treatment has been given to periods and monuments when warranted. Many new pictures are in color, and a large number of pictures that were black and white in previous editions have been converted to color in this one. Every effort has been made to accommodate the results of recent research in as comprehensive and detailed a survey of the material as the physical limits of a textbook of this scope permit.

In presenting a balanced historical introduction to the art of the whole world, the hardest task is selection—in effect, limitation—of the monuments to be discussed and illustrated. Though a corpus of monuments essential to the art history survey course has long been forming, and though considerable agreement exists as to its makeup, differences of choice, deriving from differences of emphasis, will naturally occur. A radical departure from the corpus might well obliterate the outlines of the study. To avoid the random, systemless distribution of material that might result, we have generally adhered to the corpus and have only occasionally introduced movements less well known, newly discovered, or not customarily treated in a survey. The latter classifications are especially applicable to the works selected for the modern period, which have yet to be subjected to the judgment of history. In the modern section of the book, more than in any other, the selection of monuments is designed to attempt to present significant representatives of the major approaches. Our aim throughout has been to present and interpret works as reflections of an intelligible development rather than merely as items of a catalogue. We have tried to give coherence to the assortment of materials by stressing the ways in which art, in many historical variations, has expressed and participated in the crucial transformations of human beings' views of themselves and of their world.

In recent years, in what has been called a "crisis of art history," new art-historical methods have been changing the perspectives and concerns of many scholars. Theories of interpretation, built upon anthropological, sociological, psychological, semiotic, and feminist conceptual foundations, have been transforming—sometimes

in competition, sometimes in concert—the writing of art history as well as the way it looks at its objects. In the process, the role of the traditional method of stylistic analysis and periodicity is being minimized; there is the wish in some quarters to modify the customary apparatus of categories—style-period, master, school, influence, development, and the like. We feel that our method of presentation, rooted as it is in the recognition, differentiation, and classification of styles in art and architecture, and the firm binding of them to the times and places of their origin, is best for introducing art history. Confronted with any new domain of knowledge, beginners want to know first how to discriminate among its multitude of data. For the history of art, this means learning how to distinguish one work of art from another by style, culture, and time. The classification and chronological mapping of the world of art as an intelligible continuum is the business of the survey, and the survey has long proved its pedagogical value.

Various teaching aids accompany the ninth edition of Gardner's *Art through the Ages*. For the first time, a pronunciation guide to artists' names, compiled by Cara-lin Getty of the University of South Carolina at Sumter and Mikle Ledgerwood of Rhodes College is included at the end of the book. The *Study Guide* by Kathleen Cohen contains chapter-by-chapter drills on the identification of geographical locations, time periods, styles, terms, iconography, major art movements, and specific philosophical, religious, and historical movements as they relate to particular works of art examined in the textbook. Self-quizzes and discussion questions enable students to evaluate their grasp of the material. Kathleen Cohen is also the author of the *Instructor's Manual*, which includes sample lecture topics for each chapter, a testbank of questions in formats ranging from matching to essay, studio projects, and lists of resources. A computerized testbank consisting of questions from the *Instructor's Manual* has been put on disk for textbook users. A manual for new teachers and teaching assistants, *Opening the Doors: A Practical Guide for Teachers of Art History Survey* by Mary Sweeney Ellett of Randolph-Macon Woman's College, is also available.

A work as extensive as a history of world art could not be undertaken or completed without the counsel and active participation of experts in fields other than our own. In some cases, this took the form of preparation of portions of chapters; in others, of reviews of work in progress or already prepared. For such contributions to this edition and to previous ones, we offer our sincere thanks to James Ackerman, Harvard University; Majorie P. Balge, Mount Holyoke College; Colleen Bercsi, California State University, Northridge; Barbara W. Blackmun, San Diego Mesa College; Jacques Bordaz, University of Pennsylvania; Louise Alpers Bordaz, Columbia University; James Cahill, University of California, Berkeley; Miles L. Chappell, College of William and Mary; Herbert M. Cole, University of California, Santa Barbara; George Corbin, Lehman College, City University of New York; Gerald Eknoian, DeAnza College; Mary S. Ellett, Randolph-Macon Woman's College; Roger K. Elliott, Central Virginia Community College; Mary F. Francey, University of Utah; Ian Fraser, Herron School of Art, Indiana University; Stockton Garver, Wichita State University; Judith Paetow George, Miami University; Oleg Grabar, Harvard University; Sandra C. Haynes, Pasadena City College; Hamilton Hazelhurst, Vanderbilt University; M. F. Hearn, University of Pittsburgh; Howard Hibbard, late of Columbia University; Philancy N. Holder, Austin Peay State University; John Howett, Emory University; Joseph M. Hutchinson, Texas A & M University; Joel Isaacson, University of Michigan; R. Steven Janke, State University of New York at Buffalo; M. Barry Katz, Virginia Commonwealth University; Herbert L. Kessler, Johns Hopkins University; Fred S. Kleiner, Boston University; Robert A. Koch, Princeton University; Avra Liakos, Northern Illinois University; Elizabeth Lipsmeyer, Old Dominion University; William L. MacDonald, formerly of Smith College; A. Dean McKenzie, University of Oregon; Mary Jo McNamara, Wayne State University; Kathleen Maxwell, Santa Clara University; Milan Mihal, Vanderbilt University; Diane Degasis Moran, Sweet Briar College; Harry Murutes, University of Akron; Kristi Nelson, University of Cincinnati; Jane S. Peters, University of Kentucky;

Edith Porada, Columbia University; Bruce Radde, San Jose State University; Gervais Reed, University of Washington; Raphael X. Reichert, California State University at Fresno; Richard Rubenfeld, Eastern Michigan University; Grace Seiberling, University of Rochester; Peter Selz, University of California, Berkeley; David Simon, Colby College; Pamela H. Simpson, Washington and Lee University; David M. Sokol, University of Illinois at Chicago; Lilla Sweatt, San Diego State University; Marcia E. Vetrocq, University of New Orleans; Richard Vinograd, University of Southern California; Joanna Williams, University of California, Berkeley; and the Art History Department, Herron School of Art, Indiana University–Purdue University at Indianapolis.

We would also like to thank the following instructors, who sent helpful reactions and suggestions for the ninth edition of *Art through the Ages:* James Allen-Toth, Skyline College; Eric C. Apfelstadt, Santa Clara University; Peter G. Arnovick, Menlo College; Vicki Artimovich, Bellevue Community College; Helen C. Austin, John C. Calhoun State Community College; Larry Bakke, Syracuse University; C. Roy Blackwood, Southeastern Louisiana University; Art Bond, John C. Calhoun State Community College; George A. Civey III, Eastern Kentucky University; Patricia Coronel, Colorado State University; Kenneth M. Davis, Ball State University; George F. Deremo, Cerritos College; William R. Derrevere, Tulsa Junior College; Ruth Deshaies, Tallahassee Community College; Richard P. Dewitt, Merced College; Suzette J. Doyon-Bernard, University of West Florida; Peter W. Guenther, University of Houston; Janet Higgins, Middle Tennessee State University; Donald R. Johnson, Emporia State University; Klaus Kallenberger, Middle Tennessee State University; W. Eugene Kleinbauer, Middle Tennessee State University; Carolyn Kolb, University of New Orleans; Kristine Koozin, University of North Dakota; Harry D. Korn, Ventura College; Lynne Lokensgard, Lamar University; Richard A. Luehrman, Central Missouri State University; Jane C. Maller, San Francisco State University; Nina A. Mallory, State University of New York at Stony Brook; Peggy Pulliam McDowell, University of New Orleans; Robert O. Mellown, University of Alabama; Bob Owens, North Georgia College; Angelika Pagel, Weber State College; Stephen Polcari; Kenneth J. Proctor, University of Montevallo; Marceil V. Pultorak, Carroll College; Wayne L. Roosa, Bethel College; Margaret Rothman, William Patterson College; Patricia Sanders, San Jose State University; Gregory P. Senn, Eastern New Mexico University; Anthony Stansfeld, Mercer University; Thomas Sternal, Morehead State University; Duncan Stewart, University of West Florida; Grant Throp, East Central University; Mary Jane Timmerman, Murray State University; Jeanne L. Trabold, California State University at Northridge; Patricia Trutty-Coohill, Western Kentucky University; Richard J. Tuttle, Tulane University; Elizabeth M. Walter, University of North Alabama; Marilyn Wyman, San Jose State University; Jay J. Zumeta, Art Academy of Cincinnati. We owe a special debt of gratitude to Joel G. Tansey, who compiled the bibliography for the first nineteen chapters of the text and made valuable suggestions on its content, and to Cara-lin Getty and Mikle Ledgerwood, who compiled the pronunciation guide.

Among those at Harcourt Brace Jovanovich who have contributed their efforts to the management of an enormously detailed manuscript are our acquisitions editor, Julia Berrisford; our manuscript editor, Helen Triller; our production editors, Joan Harlan and Mary Allen, and their assistant Michael Ferreira; our art editor, Susan Holtz, and her assistants on this project, Cindy Robinson and Louise Sandy-Karkoutli; our designer, Cathy Reynolds; and our production manager, Lynne Bush. We would like to thank all those, named and unnamed, who have helped immeasurably in the production of this book, and hope that, as with the previous editions, it will prove a pleasurable first guide through the immense landscape of its subject, art through the ages.

Horst de la Croix
Richard G. Tansey
Diane Kirkpatrick

A NOTE ON THE PAPERBOUND VERSION

This volume is one of two that constitute the paperbound version of Gardner's *Art through the Ages*, ninth edition. The two volumes exactly reproduce the text of the one-volume version, including its pagination. The first of these volumes contains Part I, The Ancient World; Part II, The Middle Ages; and Part III, The Non-European World. The second volume contains Part IV, The Renaissance and the Baroque and Rococo; and Part V, The Modern World. The Introduction, pronunciation guide, glossary, bibliography, and index appear in both volumes. The two-volume printing is intended for those who have occasion to use only half of *Art through the Ages*. The differences between the one-volume and the two-volume versions of the book are differences in form only.

CONTENTS

7 EARLY CHRISTIAN, BYZANTINE, AND ISLAMIC ART 252

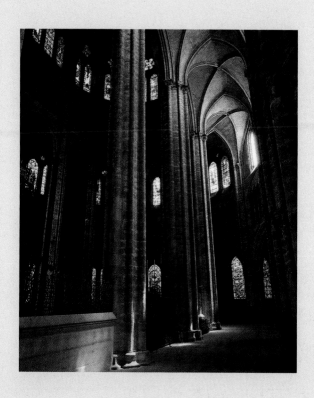

II THE MIDDLE AGES 314

8 EARLY MEDIEVAL ART 318

9 ROMANESQUE ART 346

10 GOTHIC ART 378

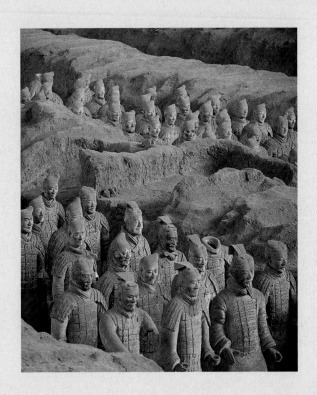

III THE NON-EUROPEAN WORLD 420

11 THE ART OF INDIA 424

ART

THROUGH THE AGES

NINTH EDITION

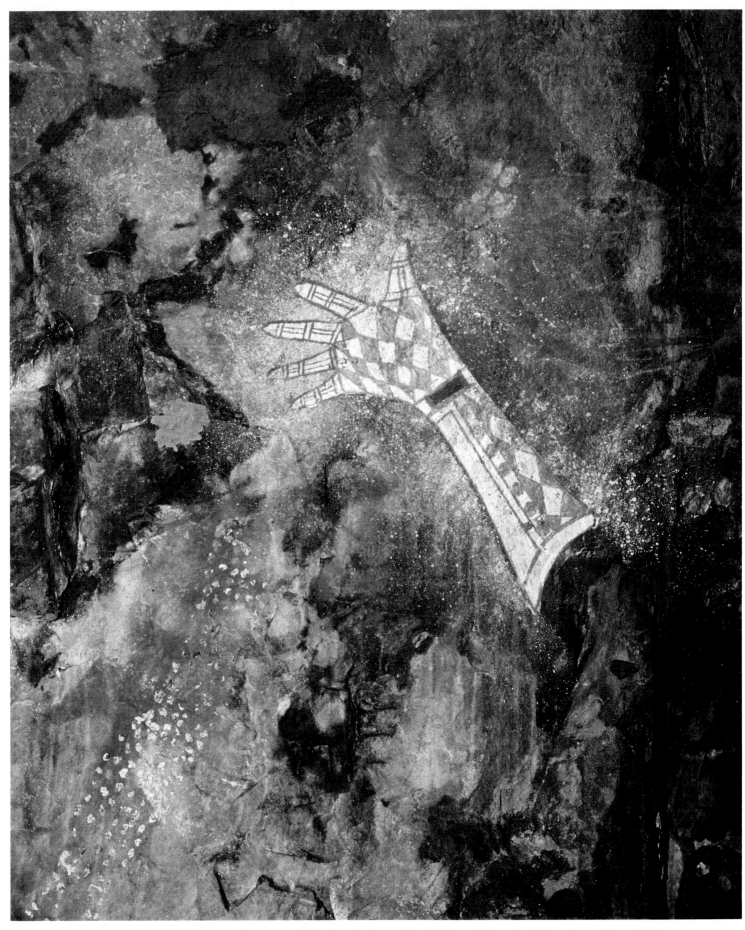

Nineteenth-century native Australians painted this hand at Inagurdurwil, West Arnhem Land. Similar motifs are found as far away in time and place as Upper Paleolithic Europe.

INTRODUCTION

The goal of art history is the discerning appreciation and enjoyment of art, from whatever time and place it may have come, by whatever hands it may have been made. Outside the academic world, the terms *art* and *history* are not often juxtaposed. People tend to think of history as the record and interpretation of past human actions, particularly social and political actions. Most think of art—quite correctly—as something *present* to the eye and touch, which, of course, the vanished human events that make up history are not. The fact is that a visible and tangible work of art is a kind of *persisting event*. It was made at a particular time and place by particular persons, even if we do not always know just when, where, and by whom. Although it is the creation of the past, art continues to exist in the present, long surviving its times; Charlemagne has been dead for a thousand years, but his chapel still stands at Aachen.

THE BASES OF ART HISTORY

Style

The time in which a work of art was made has everything to do with the way it looks—with, in one key term, its *style*. In other words, the style of a work of art is a function of its historical *period*. The historiography of art proceeds by sorting works of architecture, sculpture, and painting into stylistic classes on the bases of their similarities and the times or periods in which they were produced. It is a fundamental hypothesis of art history that works of art produced at the same time and in the same place will generally have common stylistic traits. Of course, all historiography assumes that events derive their character from the time in which they happen (and perhaps from their "great men," also products of their time). Thus, we can speak of the Periclean Age, the Age of Reason, or even the Age of Roosevelt. We also must know the time of a work if we are to know its meaning—to know it for what it is. Yet if the work of art still stands before us, persisting from the past, is not this sufficient? By virtue of its survival, is not the work in a sense *independent* of time? May not a work of art speak to people of all times as long as it survives? The key to this last question is the word *speak*. Indeed, it may speak, but what is its language? What does it say to us? Art

may be more than a form of communication, but it is certainly that, and it is the business of art history to learn the "languages" of the art of many different periods as they are embodied in the monuments from their respective times. We can assume that artists in every age express in their works some sort of meaning that is intelligible both to themselves and to others. We can discover that meaning only by comparing a particular work to other works like it that were made about the same time. By grouping works in this way, we can infer a community of meaning as well as of *form; a style will then be outlined*. In a chronological series of works having common stylistic features, we may find also stylistic *differences between the later and the earlier works*. The art historian tends to think of this phenomenon as reflecting an evolution, a *development*.

It is important to stress, however, that "development" does not mean an orderly progression of styles toward some ideal type or formal perfection, such as, for example, absolute truth to natural appearances. Although at times in the development of Western art the "imitation of nature" has been an expressed goal of the artist, photographic realism—the mechanical reporting of what the eye supposedly perceives in the visual field—has been rarely either the purpose or the result of that development. Moreover, stylistic development does not lead to ever increasing esthetic value; later phases cannot be appraised as "better" than earlier ones simply because they are presumed closer to some imagined goal of competence and achievement. Instead, we should understand stylistic development as an irregular series of steps of varying duration, in which the possibilities of a given style are worked out by artists, both independently and in collaboration with others, until those possibilities are fully realized, and new stylistic traits and tendencies appear and are distinguishable as such. Thus, when we talk of stylistic development in art, we do not mean artistic *progress*—certainly not in the sense of scientific or technological progress, whereby our knowledge appears to increase in a sequence of necessary and interdependent steps toward ever greater scope and certainty.

Chronology

It is obvious that before stylistic development can be inferred, it is necessary to be sure that each monument is correctly dated; without this certainty, art-historical order and intelligibility are impossible. Thus, an indispensable tool of the historian is *chronology, the measuring scale of historical time*. Without chronology, there could be no history of style—only a confusion of unclassifiable monuments, impossible to describe in any sequence of change.

The table of contents of this book reflects what is essentially a series of periods and subperiods arranged in chronological order—the historical sequence that embraces the sequence of art styles. Until the later eighteenth century, the history of art was really a disconnected account of the lives and the works of individual artists. We now regard art history as a record of the dynamic change of styles in time, and the art of individual masters as substyles of the overall period styles. Although one speaks of "change" in the history of art, the objects themselves obviously do not change; as we have said, they persist, although each naturally suffers some material wear and tear with time. But the fact that works of art from one period look different from those of other periods leads us to infer that *something* changes. This something can only be the points of view of the artists with respect to the meaning of life and of art. Modern historiography is heavily influenced by modern philosophies of change and evolution, and, from the terms and data of

biological science, our modern history of art was bound to borrow a sense of continuous process to help explain art-historical change.

In art history, as in the sciences and in other historical disciplines, we have made considerable progress in knowing a thing once we have classified it. Art historians, having done this, resemble experienced travelers who learn to discriminate the different "styles" peculiar to different places. Such travelers know that one must not expect the same style of life in the Maine woods as on the Riviera, and when they have seen a great many places and peoples, they are not only at ease with them, but can be said to know and appreciate them for what they are. As their experience broadens, so does their discrimination or perception of distinctive differences. As world travelers come to see that the location contributes to the unique quality and charm of a town, so students of art, viewing it in the historical dimension, become convinced that a work's peculiar significance, quality, and charm are a function of the time of its making.

Purpose

Is the historical "placing" of a work of art, then, irrelevant to the *appreciation* of it? Is art-historical knowledge *about* a work of art in some way different from the direct experience of it? The answers lie in the fact that uninstructed appreciators, no matter how well intentioned, still approach a work of art with the esthetic presuppositions of their own time, rather than of the time of the work itself. Their presuppositions can be tantamount to prejudices, so that their appreciation, even if genuine, may well be for the wrong reasons. It will, in fact, be undiscerning and indiscriminate, so that they may view dozens of works of art in the same way, without savoring the individual significance and quality of each. Thus, as a work of art is intended for a particular audience at a particular time and place, its *purpose* also may be quite particular, and its purpose necessarily enters into its meaning. For example, the famous *Vladimir Madonna* (FIG. 7-59, p. 296) is a Byzantine-Russian icon, a species of art produced not as a work of "fine art" but as a sacred object endowed with religio-magical power. It was considered, moreover, the especially holy picture of Russia that miraculously saved the city of Vladimir from the hosts of Tamerlane, the city of Kazan from the later Tartar invasions, and all of Russia from the Poles in the seventeenth century. We may admire it for its innate beauty of line, shape, and color, its expressiveness, and its craftsmanship, but unless we are aware of its special historical function as a wonder-working image, we miss the point. We can admire many works of art for their form, content, and quality, but we need a further characterizing experience; otherwise, we are admiring very different works without discriminating their decisive differences. We will be confused, and our judgment will be faulty.

Place of Origin

Although our most fundamental way of classifying works of art is by the time of their making, classification by *place of origin* is also crucial. In many periods, a general style (Gothic, for example) will have a great many regional variations: French Gothic architecture is strikingly different from both English and Italian Gothic. Differences of climate helped to make French Gothic an architecture with no bearing walls and with great spaces for stained-glass windows and Italian Gothic an architecture with large expanses of wall wonderfully suited to mural painting. Art history, then, is also concerned

with the spread of a style from its place of origin. Supplementing time of origin with place of origin therefore adds another dimension to our understanding of the overall stylistic development of art monuments.

The Artist

The *artist* provides still another dimension in the history of art. As we have noted, early "histories" of art, written before the advent of modern concepts of style and stylistic development, were simply biographies of artists. Biography as one dimension is still important, for through it we can trace stylistic development within the career of the artist. We can learn much from contemporaneous historical accounts, from documents such as commission contracts, and from the artist's own theoretical writings and literary remains. All of this is useful in "explaining" an artist's works, although no complete "explanation" exhausts the meaning of them. Relationships to predecessors, contemporaries, and followers can be described in terms of the concepts *influence* and *school*. It is likely that artists are influenced by their masters and then influence or are influenced by fellow artists working somewhat in the same style at the same time and place. We designate a group of such artists as a *school*. By this, we do not mean an academy, but a classification of time, place, and style. We speak of the Dutch school of the seventeenth century and, within it, of subschools such as those of Haarlem, Utrecht, and Leyden.

The art-historical record often has tended to exclude the contributions of women to art. Evidence from many times and places (some of it collected quite recently), however, indicates that women clearly have produced art and craftwork of extremely high quality. Women artists were known in classical antiquity and have been recognized in China, Japan, India, and many other cultures. In the Western Middle Ages, women were renowned as skilled illuminators of manuscripts and workers of textiles. With the Renaissance, women painters began to come into prominence, along with women printmakers and sculptors. Artistic talent, skill, competence, inventiveness, and refinement clearly are not functions of gender.

Iconography

The categories of time and place, the record of the artist, influences, and schools are all used in the composition of the picture of stylistic development. Another kind of classification, another key to works of art, is *iconography*—the study of the subject matter and symbolism of works of art. Iconography groups paintings and sculptures in terms of their themes rather than their styles, and the development of subject matter becomes a major focus of critical study. Iconographic studies have an ancillary function in stylistic analysis; they often are valuable in tracing influences and in assigning dates and places of origin.

Recently, a new method of analysis has been used to supplement the information acquired as a result of iconographic studies. *Semiotics* is not the study of images per se, but of images "read" as *signs* by which human beings communicate. In semiotics, pictorial images are taken to signify the conscious or unconscious attitudes, inclinations, wishes, intentions, convictions, and values of peoples in different cultures and periods. Born of the science of linguistics (the study of the common structure of all languages), semiotic analysis draws art into relation with literature, psychology, sociology, and anthropology, finding structures and meanings common to the data in all of

these fields. In the semiotic analysis of art, the intentions of the artist are reconstructed from an examination of the images made, within the context of the conventional meanings they have for a particular society. Often the analysis attempts to recover the artist's own psychological set to explain the image choices.

Historical Context

Another very broad source of knowledge about a work of art lies outside the realm of artistic concerns, yet encloses them and interacts with them. This is the *general historical context*—the political, social, economic, scientific, technological, and intellectual background that accompanies and influences specifically art-historical events. The fall of Rome, the coming of Christianity, and the barbarian invasions all had much to do with stylistic changes in architecture, sculpture, and painting in the early centuries of our era. The triumph of science and technology had everything to do with the great transformation of the Renaissance tradition that took place in what we call "modern art"—the art of our own time. The work of art, the persisting event, is, after all, a historical document.

THE WORK OF ART

This book is concerned primarily with the plastic arts, which differ from the temporal arts in several very basic ways. The temporal arts—music, dance, and poetry, for example—require time for their performance or presentation. They are transitory or ephemeral in the sense that, once performed, they cease to exist to the observer, except in memory. On the other hand, the plastic arts—painting, sculpture, and architecture, for instance—have physical bulk and a tangible, enduring existence in space. To describe and analyze a plastic work of art, we use categories and vocabularies that have become standard and that are indispensable to an understanding of this book.

General Concepts

Form, for the purposes of art history, refers to the shape of the "object" of art; in the made object, form is the shape that the expression of content takes. To create forms, to make a work of art, artists must shape materials with tools. Each of the many materials, tools, and processes available has its own potentialities and limitations; it is part of all artists' creative activity to select the tools most suitable to their purpose. The technical processes that the artists employ, as well as the distinctive, personal ways in which they handle them, we call their *technique*. If the material that artists use is the substance of their art, then their technique is their individual manner of giving that substance form. Form, technique, and material are interrelated, as we can readily see in a comparison of the marble statue of *Apollo* from Olympia (FIG. 5-40, p. 152) with the bronze *Charioteer of Delphi* (FIG. 5-37, p. 150). The Apollo is firmly modeled in broad, generalized planes, reflecting the ways of shaping stone that are more or less dictated by the character of that material and by the tool used—the chisel. On the other hand, the Charioteer's fineness of detail, seen in the crisp, sharp folds of the drapery, reflects the qualities inherent in cast metal. However, a given medium can lend itself to more than

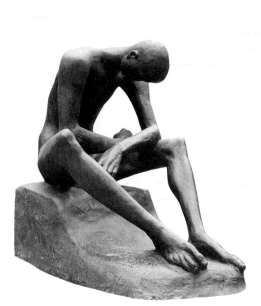 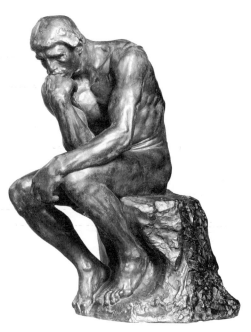

1 WILHELM LEHMBRUCK, *Seated Youth*, 1918. Bronze. Wilhelm-Lehmbruck-Museum, Duisburg.

2 AUGUSTE RODIN, *The Thinker*, 1880. Bronze. Metropolitan Museum of Art, New York (gift of Thomas F. Ryan, 1910).

one kind of manipulation. The technique of Lehmbruck's bronze *Seated Youth* (FIG. **1**), for example, contrasts strikingly with Rodin's *The Thinker* (FIG. **2**), also in bronze. The surfaces of Lehmbruck's figure are smooth, flowing, quiet; those of Rodin's figure are rough, broken, and tortuous. Here, it is not so much the bronze that determines the form as it is the sculptor's difference of purpose and of personal technique.

Space, in our commonsense experience, is the bounded or boundless "container" of collections of objects. For the analysis of works of art, we regard space as bounded by and susceptible to esthetic and expressive organization. Architecture provides us with our most common experience of the actual manipulation of space; the art of painting frequently projects an image (or illusion) of our three-dimensional spatial world onto a two-dimensional surface.

Area and *plane* describe a limited, two-dimensional space and generally refer to surface. A plane is flat and two-dimensional—like this page and like elements dealt with in plane geometry (a circle, square, or triangle). An area, which also can be described in terms of plane geometry, is often a plane or a flat surface that is enclosed or bounded. Bernini created an oval area when he defined the essentially plane surface in front of St. Peter's by means of his curving colonnades (FIG. 19-3, p. 753).

Mass and *volume*, in contradistinction to plane and area, describe three-dimensional space. In both architecture and sculpture, mass is the bulk, density, and weight of matter in space. Yet the mass need not be solid; it can be the exterior form of enclosed space. For example, "mass" can apply to a pyramid (FIG. 3-10, p. 81), which is essentially solid, or to the exterior of Hagia Sophia (FIG. 7-40, p. 284), which is essentially a shell enclosing vast spaces. Volume is the space that is organized, divided, or enclosed by mass. It may be the spaces of the interior of a building, the intervals between the masses of a building, or the amount of space occupied by three-dimensional objects like sculpture, ceramics, or furniture. Volume and mass describe the exterior as

well as the interior forms of a work of art—the forms of the matter of which it is composed *and* the forms of the spaces that exist immediately around that matter and interact with it. For example, in the Lehmbruck statue (FIG. 1), the expressive volumes enclosed by the attenuated masses of the torso and legs play an important part in the open design of the piece. The absence of enclosed volumes in the Rodin figure (FIG. 2) is equally expressive, closing the design, making it compact, heavy, and confined. Yet both works convey the same mood—one of brooding introversion. These closed and open forms, manifest throughout the history of art, demonstrate the intimate connection between mass and the space that surrounds and penetrates it.

Line is one of the most important, but most difficult, terms to comprehend fully. In both science and art, line can be understood as the path of a point moving in space, the track of a motion. Because the directions of motions can be almost infinite, the quality of line can be incredibly various and subtle. It is well known that psychological responses are attached to the direction of a line: a vertical line is active; a horizontal line, passive; a diagonal line, suggestive of movement, energy, or unbalance; and so on. Hogarth regarded the serpentine or S-curve line as the "line of beauty." Our psychological response to line is also bound up with our esthetic sense of its quality. A line may be very thin, wirelike, and delicate, conveying a sense of fragility, as in Klee's *Twittering Machine* (FIG. 22-42, p. 989). Or it may alternate quickly from thick to thin, the strokes jagged, the outline broken, as in a 600-year-old Chinese painting (FIG. 12-19, p. 465) in which the effect is of vigorous action and angry agitation. A gentle, undulating, but firm line, like that in Picasso's *Bathers* (FIG. 3), defines a *contour* that is restful and quietly sensuous. A contour continuously and subtly contains and suggests mass and volume. In the Picasso drawing, the line is distinct, dark against the white of the paper. But line can be felt as a controlling presence in a hard edge, profile, or boundary created by a contrasting area, even when its tone differs only

3 PABLO PICASSO, detail of *Bathers*, 1918. Pencil drawing. Fogg Art Museum, Harvard University, Cambridge, Massachusetts (bequest of Paul J. Sachs).

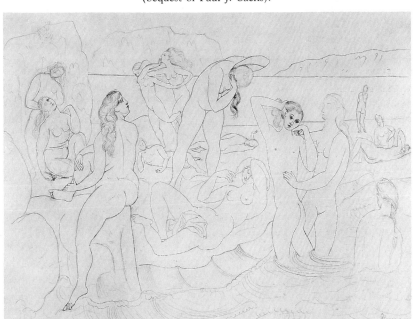

slightly from the tone of the area it bounds. A good example of this can be seen in the central figure of the goddess in Botticelli's *The Birth of Venus* (FIG. 16-60, p. 624).

An *axis* is a line along which forms are organized. The axis line itself may not be evident; several axis lines may converge (usually with one dominant), as in the layout of a city. Although we are most familiar with directional axes in urban complexes, they occur in all the arts. A fine example of the use of axis in large-scale architecture is the plan of the Palace of Versailles and its magnificent gardens (FIG. 19-66, p. 807). Axis, whether vertical, horizontal, or diagonal, is also an important compositional element in painting.

Perspective, like axis, is a method of organizing forms in space, but perspective is used primarily to create an illusion of depth or space on a two-dimensional surface. Because we are conditioned by exposure to Western, single-point perspective, an invention of the Italian Renaissance (see pages 634–67), we tend to see perspective as a systematic ordering of pictorial space in terms of a single point—a point at which lines converge to mark the diminishing size of forms as they recede into the distance (FIG. 17-16, p. 647). Renaissance and Baroque artists created masterpieces of perspective illusionism. In Leonardo's *The Last Supper* (FIG. 4), for example, the lines of perspective (dashed lines) converge on Christ and, in the foreground, project the picture space into the room on the wall of which the painting appears, creating the illusion that the space of the picture and the space of the room are continuous. Yet we must remember that Renaissance perspective is only one of several systems for depicting depth. Other systems were used in ancient Greece and Rome and still others in the East. Some of these other systems, as well as the Italian Renaissance perspective, continue to be used. There is no final or absolutely correct projection of what we "in fact" see.

Proportion deals with the relationships (in terms of size) of the parts of a work. The experience of proportion is common to all of us. We seem to recognize at once when the features of the human face or body are "out of proportion." If the nose or ears are too large for the face or the legs are too short for the body, an instinctive or conventional sense of proportion leads us to regard the disproportionate elements as ludicrous or ugly. Formalized

4 LEONARDO DA VINCI, *The Last Supper*, c. 1495–1498. Fresco. Santa Maria delle Grazie, Milan. (Perspective lines are dashed; lines indicating proportions are solid white or black.)

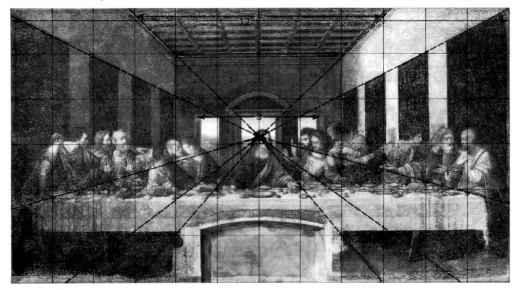

proportion is the mathematical relationship in size of one part of a work of art to the other parts within the work, as well as to the totality of the parts; it implies the use of a denominator that is common to the various parts. One researcher has shown that the major elements of Leonardo's *Last Supper* exhibit proportions found in harmonic ratios in music—12:6:4:3 (FIG. 4). These figures (with the greatest width of a ceiling panel taken as one unit) are the horizontal widths, respectively, of the painting, the ceiling (at the front), the rear wall, and the three windows (taken together and including interstices); they apply to the vertical organization of the painting as well. Leonardo found proportion everywhere: "not only in numbers and measures, but also in sounds, weights, intervals of time, and in every active force in existence."* The ancient Greeks, who considered beauty to be "correct" proportion, sought a canon (rule) of proportion, not only in music, but also for the human figure. The famous Canon of Polykleitos (page 163), expressed in his statue of the *Doryphoros* (FIG. 5-58, p. 163), long served as an exemplar of correct proportion. But it should be noted that canons of proportion differ from time to time and culture to culture and that, occasionally, artists have used disproportion deliberately. Part of the task facing students of art history is to perceive and adjust to these differences in an effort to understand the wide universe of art forms. Proportional relationships are often based on a *module*, a dimension of which the various parts of a building or other work are fractions or multiples. A module might be the diameter of a column, the height of the human body, or an abstract unit of measurement. For example, the famous "ideal" plan of the ninth-century monastery of St. Gall (FIG. 8-22, p. 337) has a modular base of 2½ feet, so that all parts of the structure are multiples or fractions of this dimension.

Scale also refers to the dimensional relationships of the parts of a work to its totality (or of a work to its setting), usually in terms of appropriateness to use or function. We do not think that a private home should be as high as an office building or that an elephant's house at the zoo should be the size of a hen coop, or vice versa. This sense of scale is necessary to the construction of form in all the arts. Most often, but not necessarily, it is the human figure that gives the scale to form.

Light in the world of nature is so pervasive that we often take its function for granted. Few of us realize the extraordinary variations wrought by light, either natural or artificial, on our most familiar surroundings. Daylight, for example, changes with the hour or season. Few of us realize the full extent to which light affects and reveals form. One who did—the French artist Monet (pages 923–24)—painted the reflections in a water-lily pond according to their seasonal variations and, in a series of more than forty canvases of the façade of Rouen Cathedral, revealed its changing appearance from dawn until twilight in different seasons (FIG. **5**). Light is as important for the perception of form as is the matter of which form is made.

Value is one function of light. In painting, and in the graphic arts generally, value refers to lightness, or the amount of light that is (or appears to be) reflected from a surface. Value is a subjective experience, as FIG. **6** shows. In absolute terms (if measured, for example, by a photoelectric device), the center bar in this diagram is uniform in value. Yet where the bar is adjacent to a dark area, it *looks* lighter, and where the bar is adjacent to a lighter area, it *looks* darker. Value is the basis of the quality called, in Italian, *chiaroscuro* (*chiaro*, or light; *scuro*, or dark), which refers to the gradations between light

*Thomas Brachert, "A Musical Canon of Proportion in Leonardo da Vinci's *Last Supper*," *Art Bulletin*, Vol. 53, No. 4 (December 1971), pp. 461–66.

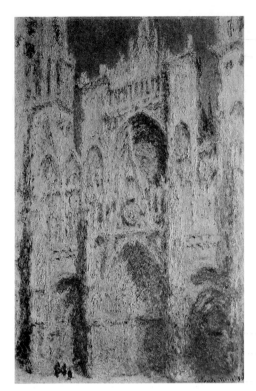 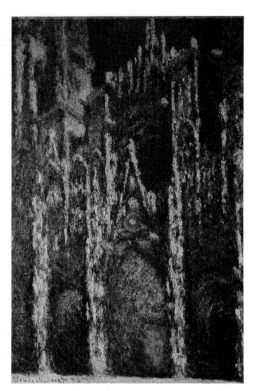

5 CLAUDE MONET, façade of Rouen Cathedral, early 1890s. (*Right*) Museum of Fine Arts, Boston (bequest of Hanna Marcy Edwards); (*left*) National Gallery of Art, Washington, D.C. (Chester Dale Collection).

and dark that produce the effect of *modeling*, or of light reflected from three-dimensional surfaces, as exemplified in Leonardo's superb rendering of *The Virgin and Child with St. Anne and the Infant St. John* (FIG. 17-2, p. 636).

In the analysis of light, an important distinction must be made for the realm of art. Natural light, or sunlight, is whole or additive light, whereas the painter's light in art—the light reflected from pigments and objects—is subtractive light. Natural light is the sum of all the wavelengths composing the visible spectrum, which may be disassembled or fragmented into the individual colors of the spectral band. (Recent experiments with lasers—*l*ight *a*mplification by *s*timulated *e*mission of *r*adiation—have produced color of incredible brilliance and intensity, opening possibilities of color composition that, until now, were unsuspected. The range and strength of color produced in this way approach, although at considerable distance, those of the sun.) Although the esthetics of color is largely the province of the artist and can usually be genuinely experienced and understood only through intense practice and experimentation, some aspects can be analyzed and systematized. Paint pigments produce their individual colors by reflecting a segment of the spectrum while absorbing all the rest. "Green" pigment, for example, subtracts or absorbs all the light in the spectrum except that seen by us as green, which it reflects to the eye. (In the case of transmitted, rather than reflected, light, the coloring matter blocks or screens out all wavelengths of the spectrum except those of the color we see.) Thus, theoretically, a mixture of pigments that embraced all the colors of the spectrum would subtract all light—that is, it would be black; actually, such a mixture of pigments never produces more than a dark gray.

Hue is the property that gives a color its name—red, blue, yellow. Although the colors of the spectrum merge into each other, artists usually conceive of

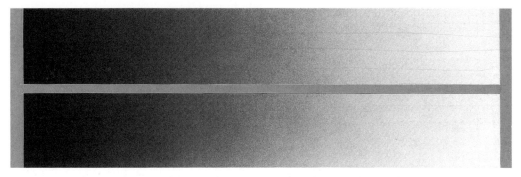

6 Effect of adjacent value on apparent value. Actual value of center bar is constant.

their hues as distinct from each other, giving rise to many different devices for representing color relationships. There are basically two variables in color—the apparent amount of light reflected and the apparent purity; a change in one must produce a change in the other. Some terms for these variables are *value* and *tonality* (for lightness) and *chroma, saturation,* and *intensity* (for purity).

One of the more noteworthy diagrams of the relationships of colors is the triangle (FIG. 7), once attributed to Goethe, in which red, yellow, and blue (the *primary colors*) are the vertexes of the triangle and orange, green, and purple (the *secondary colors,* which result from mixing pairs of primaries) lie between them. Colors that lie opposite each other, such as red and green, are called *complementary* colors, because they complement, or complete, one another, each absorbing those colors that the other reflects. The result is a neutral tone or gray (theoretically, black), which is produced when complementaries are mixed in the right proportions. The inner triangles in FIG. 7 are the products of such mixing.

7 Color triangle. Developed by Josef Albers and Sewell Sillman, Yale University, New Haven, Connecticut.

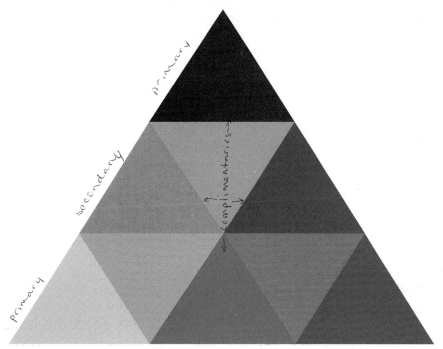

Color also has a psychological dimension: red and yellow, quite naturally, connote warmth; blue and green, coolness. Generally, *warm* colors seem to *advance* and *cool* colors seem to *recede*.

Texture is the quality of a surface (rough, smooth, hard, soft, shiny, dull) as revealed by light. The many painting media and techniques permit the creation of a variety of textures. The artist may simulate the texture of the materials represented, as in Kalf's *Still Life* (FIG. 19-55, p. 797), or create arbitrary surface differences, even using materials other than canvas, as in Picasso's *Still Life with Chair-Caning* (FIG. 22-9, p. 926).

Specialized Concepts

The terms we have been discussing have connotations for all the visual arts. Certain observations, however, are relevant to only one category of artistic endeavor—either to architecture, or to sculpture, or to painting.

IN ARCHITECTURE

Works of architecture are so much a part of our environment that we accept them as fixed and scarcely notice them until our attention is summoned. People have long known how to enclose space for the many purposes of life. The spatial aspect of the arts is most obvious in architecture. The architect makes groupings of enclosed spaces and enclosing masses, always keeping in mind the function of the structure, its construction and materials, and, of course, its design—the correlative of the other two. We experience architecture both visually and by moving through and around it, so that we perceive architectural space and mass together. The articulation of space and mass in building is expressed graphically in several ways; the principal ones include plans, sections, and elevations.

A *plan* is essentially a map of a floor, showing the placement of the masses of a structure and, therefore, the spaces they bound and enclose (FIG. 7-42, p. 286). A *section*, like a vertical plan, shows placement of the masses as if the building were cut through along a plane, often along a plane that is a major axis of the building (FIG. 3-11, p. 82). An *elevation* is a head-on view of an external or internal wall, showing its features and often other elements that would be visible beyond or before the wall (FIG. 5-54, p. 161).

Our response to a building can range from simple contentment to astonishment and awe. Such reactions are products of our experience of a building's function, construction, and design; we react differently to a church, a gymnasium, and an office building. The very movements we must make to experience one building will differ widely and profoundly from the movements required to experience another. These movements will be controlled by the continuity (or discontinuity) of the plan or by the placement of its axes. For example, in a central plan—one that radiates from a central point, as in the Pantheon in Rome (FIG. 6-58, p. 228)—we perceive the whole spatial entity at once. In the long axial plan of a Christian basilica (FIG. 7-26, p. 273) or a Gothic cathedral (FIG. 10-18, p. 392), however, our attention tends to focus on a given point—the altar at the eastern end of the nave. Mass and space can be interrelated to produce effects of great complexity, as, for example, in the Byzantine Church of the Katholikon (FIG. 7-46, p. 288) or in Le Corbusier's church at Ronchamp (FIG. 23-9, p. 1038). Thus, our experience of architecture will be the consequence of a great number of material and formal factors, including training, knowledge, and our perceptual and psychological makeup, which function in our experience of any work of art.

The architect must have the sensibilities of a sculptor and of a painter and, in establishing the plan of a building, must be able to use the instruments of a

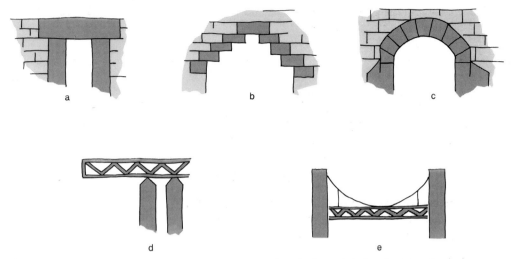

8 Basic structural devices: (a) post and lintel; (b) corbeled arch; (c) arch; (d) cantilever; (e) suspension.

mathematician. As architects resolve structural problems, they act as (or with) engineers who are cognizant of the structural principles underlying all architecture (FIG. 8). Their major responsibilities, however, lie in the manner in which they interpret the *program* of the building. We are not talking in architectural terms when we describe a structure simply as a church, a hospital, an airport concourse, or a house. Any proposed building presents an architect with problems peculiar to it alone—problems related to the site and its surroundings, the requirements of the client, and the materials available, as well as the function of the building. A program, then, deals with more than function; it addresses all of the problems embodied in a specific building.

IN SCULPTURE

Like architecture, sculpture exists in the three-dimensional space of our physical world. But sculpture as image is closer to painting than is architecture. Until recently, sculpture has been concerned primarily with the representation of human and natural forms in tangible materials, which exist in the same space as the forms they represent. However, sculpture also may embody visions and ideals and consistently has presented images of deities and people in their most heroic as well as their most human aspects (FIGS. 17-19, p. 652, and 5-76, p. 174). Today, sculpture often dispenses with the figure as image, and even with the image itself, producing new forms in new materials and with new techniques (FIGS. 23-6, p. 1036; 23-39, p. 1060; 23-44, p. 1064; 23-79, p. 1092).

Sculpture may be associated intimately with architecture, often to such a degree that it is impossible to disassociate the two (FIG. 10-15, p. 390). Sculpture is called *relief* sculpture when it is attached to a back slab or back plate (FIG. 3-44, p. 102); *high relief*, if the figures or design project boldly (FIG. 5-78, p. 175); and *low relief*, or *bas-relief*, if the figures or design project slightly (FIG. 3-44, p. 102).

Sculpture that exists in its own right, independent of any particular architectural frame or setting (FIG. 17-46, p. 673), is usually referred to as *freestanding* sculpture, or "sculpture in the round," although, in the art of Greece and of the Renaissance, freestanding sculpture has been allied closely to architecture on many occasions. Indeed, sculpture is such a powerful agent in creating a spatial as well as an intellectual environment that its presence in

9 DONATELLO, *St. John the Evangelist,* 1412–1415. Marble. Museo del Duomo, Florence. (*Left*) as seen in museum; (*right*) as intended to be seen on façade of Florence Cathedral.

city squares or in parks and gardens is usually the controlling factor in creating their "atmosphere" or general effect (FIG. 19-73, p. 812).

Some statues are meant to be seen as a whole—to be walked around (FIG. 17-46, p. 673). Others have been created to be viewed only from a restricted angle. How a sculpture is meant to be seen must be taken into account by the sculptor and by those who exhibit the work. The effect of ignoring this is illustrated in FIG. **9**. The left photograph is taken directly from the front, as the piece is now seen in the museum; the right photograph is taken from below, at approximately the same angle from which the statue was originally meant to be seen in its niche on the façade of the cathedral of Florence.

In sculpture, perhaps more than in any other medium, textures, or tactile values, are important. One's first impulse is almost always to handle a piece of sculpture, to run one's finger over its surfaces. The sculptor plans for this, using surfaces that vary in texture from rugged coarseness to polished smoothness (FIGS. 10-56, p. 414, and 16-50, p. 615). Textures, of course, are often intrinsic to a material, and this influences the type of stone, wood, plastic, clay, or metal that the sculptor selects. There are two basic categories of sculptural technique: *subtractive* and *additive.* Carving, for instance, is a subtractive technique; the final form is a reduction of the original mass (FIG. **10**). Additive sculpture is built up, usually in clay around a framework, or armature; the piece is fired and used to make a mold in which the final work is cast in a material such as bronze (FIG. 16-52, p. 617). Casting is a popular technique today. Another common additive technique is the direct construction of forms accomplished by welding shaped metals together (FIG. 23-6, p. 1036).

Within the sculptural family, we must include ceramics and metalwork, and numerous smaller, related arts, all of which employ highly specialized

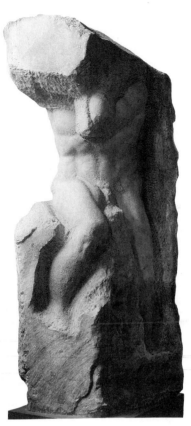

10 MICHELANGELO, *Unfinished Bound Slave*, 1519. Marble. Accademia, Florence.

techniques described in distinct vocabularies. These will be considered as they arise in the text.

IN THE PICTORIAL ARTS

The forms of architecture and sculpture exist in actual, three-dimensional space. The forms of painting (and of its relatives, drawing, engraving, and the like) exist almost wholly on a two-dimensional surface on which the artist creates an illusion, something that replicates what we see around us or something that is unique to the artist's imagination and corresponds only vaguely or slightly to anything we can see in the optical world. Human discovery of the power to project illusions of the three-dimensional world onto two-dimensional surfaces goes back thousands of years and marks an enormous step in the control and manipulation of the things we perceive. To achieve this illusion, the artist configures images or representations drawn from the world of common visual experience. Throughout the history of art, this world has been interpreted in an almost infinite variety of ways. Undoubtedly, there is much that all people *see* in common and can agree on: the moon at night, a flying bird, an obstacle in one's path. Many people may differ, though, in their *interpretation* of the seen. Seeing and then representing what is seen are very different matters. The difference between *seeing* and *representing* determines the variability of artistic styles, both cultural and personal. What we *actually* see (the optical "fact") is not necessarily reported in what we represent. In other words, in art, there is and need be little agreement between the *likeness* of a thing and the *representation* of it. This lack of agreement makes for a persisting problem in the history of art. How are we to interpret or "read" images or replicas of the seen? Is there a "correct" vision of the "real" world?

THE PROBLEM OF REPRESENTATION

The conundrum of seeing something and making a representation of it is artfully illustrated in FIG. **11**, a cartoon of a life-drawing class in ancient Egypt that Gombrich uses to introduce his invaluable *Art and Illusion*. The cartoon and the actual representation of an Egyptian queen (FIG. **12**) raise many questions: Did Egyptian artists copy models exactly as they saw them? (Did Egyptians actually *see* each other in this way?) Or did they translate what they saw according to some formula dictated by conventions of representation peculiar to their culture? Would we have to say—if what was seen and what was recorded were optically the same—that this is the way Egyptians must have looked? or wished to look? Beginning students usually have questions somewhat like these in mind when they perceive deviations in historical styles from the recent Western realism to which they are conditioned. They ask whether the Egyptians, or other artists, were simply unskilled at matching eye and hand, so to speak, and could not draw from what they saw. But such a question presupposes that the objective of the artist has always been to match appearances with cameralike exactitude. This is not the case, nor is it the case that artists of one period "see" more "correctly" and render more "skillfully" than those of another. Rather, it seems that artists represent what they *conceive* to be real, not what they *perceive*. They bring to the making of images conceptions that have been instilled in them by their cultures. They understand the visible world in certain unconscious, culturally agreed on ways and thus bring to the artistic process ideas and meanings out of a common stock. They record not so much what they *see* as what they *know* or

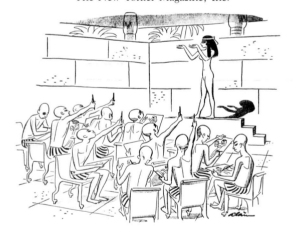

11 ALAIN. Drawing. Copyright © 1955, 1983, The New Yorker Magazine, Inc.

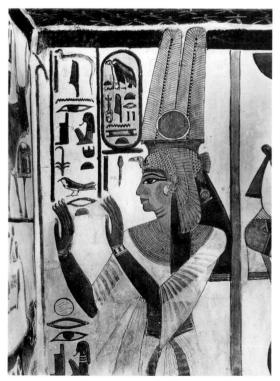

12 *Queen Nofretari,* from her tomb at Thebes, c. 1250 B.C. Detail of a painted bas-relief.

mean. Even in the period of dominant realism in recent western European art, great deviations from camera realism have set in. Moreover, in our everyday life there are images familiar to all of us that distort optical "reality" quite radically; consider, for example, the images of the ubiquitous comic strip.

Solutions to the problem of representation constitute the history of artistic style. It is useful to examine some specimens of sharp divergence in representational approach. Compare, for example, the lion drawn by the Medieval artist Villard de Honnecourt (FIG. **13**) with those done by the Renaissance artist Albrecht Dürer (FIG. **14**). In the de Honnecourt lion—which, it is important to notice, the artist asserts was drawn from life—the figure is entirely adequate for identification but preconceived and constructed according to the formulas of its time. Dürer's lions, drawn some three centuries later, obviously are a much different report of what the artist saw. So are the Assyrian lions of the hunting reliefs (FIG. 2-33, p. 63), the *Lion from the Processional Way* of the Ishtar Gate (FIG. 2-35, p. 64), the lion in Henri Rousseau's *The Sleeping Gypsy* (FIG. 21-90, p. 943), or (in slight shift of species) Barye's sculpture of a jaguar in his *Jaguar Devouring a Hare* (FIG. 21-7, p. 870). In each case, *personal vision* joins with the *artistic conventions* of time and place to decide the manner and effect of the representation. Yet, even at the same time and place (for example, nineteenth-century Paris), we can find sharp differences in representation when the opposing personal styles of Ingres and Delacroix record the same subject (FIGS. 21-16 and 21-17, pp. 876–77).

A final example will underscore the relativity of vision and representation that differences in human cultures produce. We recognize, moreover, that close matching of appearances has mattered only in a few times and places.

13 VILLARD DE HONNECOURT, *Lion Portrayed from Life*, c. 1230–1235. Drawing. Cabinet des Manuscripts, Bibliothèque Nationale, Paris.

14 ALBRECHT DÜRER, *Two Lions*, c. 1521. Drawing. Staatliche Museen Preussischer Kulturbesitz, Kupferstichkabinet, Berlin.

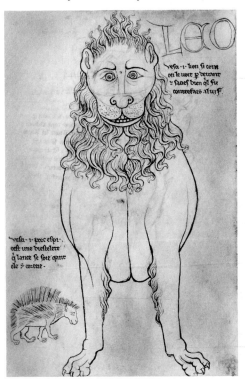

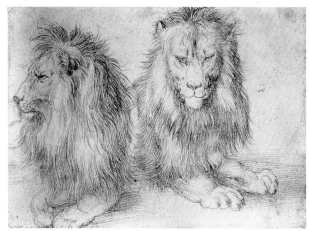

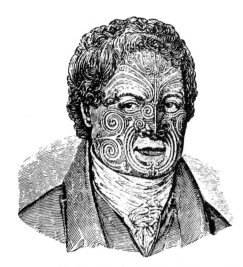 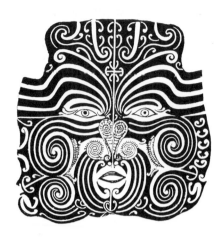

15 *The Maori Chief Tupai Kupa, c.* 1800. (*Left*) after a drawing by John Sylvester;
(*right*) a self-portrait. From *The Childhood of Man* by Leo Frobenius, 1909.
Reproduced by permission of J. B. Lippincott Company.

Although both portraits of a Maori chieftain from New Zealand (FIG. **15**)—one
by a European, the other by the chieftain himself—reproduce his facial
tatooing, the first portrait is a simple, commonplace likeness that underplays
the tatooing. The self-portrait is a statement by the chieftain of the supreme
importance of the design that symbolizes his rank among his people. It is the
splendidly composed insignia that is his image of himself, the European
likeness being superficial and irrelevant to him.

Students of the history of art, then, learn to distinguish works by
scrutinizing them closely within the context of their time and place of origin.
But this is only the beginning. The causes of stylistic change over time are
mysterious and innumerable, and it is only through the continuing process of
art-historical research that we can hope to make the picture even
fragmentarily recognizable. Incomplete though the picture is and will remain,
the panorama of art, changing in time, lies before students, and as their
art-historical perspective gains depth and focus, they will come to perceive
the continuity of the art of the past with that of the present. It will become
clear that one cannot be understood without the other and that our un-
derstanding of the one will constantly change with changes in our under-
standing of the other. The great American poet and critic T. S. Eliot has
cogently expressed this truth for all art in a passage that suggests the
philosophy and method of this book:

> What happens when a new work of art is created is something that happens simulta-
> neously to all the works of art which preceded it. The existing monuments form an ideal
> order among themselves, which is modified by the introduction of the new (the really
> new) work of art among them. . . . Whoever has approved this idea of order . . . will not
> find it preposterous that the past should be altered by the present as much as the present
> is directed by the past.*

As new works of art continue to be created, old ones, buried by time, are
recovered and others, known to have existed, disappear. Many come to light
by chance, and many are destroyed by catastrophe or neglect. Restoration and
reconstruction either damage or rescue them. The whole domain of art

*T. S. Eliot, "Tradition and the Individual Talent," in *Selected Essays 1917–1932* (New York: Harcourt, Brace,
1932), p. 5.

constantly shifts in outline and population, as does our knowledge of it. Identification of a work of art may be accepted at one time, rejected at another. Attribution of certain works to certain artists may be challenged; the chronology of stylistic change may be readjusted; and the dating of particular works may be debated and revised. Critics may disagree as to the number of works to be ascribed to a single artist. (Some credit Rembrandt with as many as 600 paintings; others credit him with as few as 350.) Reinterpretation of the meanings and functions of works of art is an ongoing process, as is the reassessment of their artistic value and stylistic importance. Our knowledge of art history is as much in flux as artistic creation itself; what seems to be certain at one time proves to be inconclusive or erroneous at another. Evidence for our conclusions is never all in; more of it is always turning up, and much of it cannot be found.

Students are therefore cautioned not to expect this book to contain an outlay of facts that are incontestable beyond all alteration. The facts are the works of art themselves, as made palpable to our senses; our descriptions of these works—our dating, attributions, classifications, interpretations—are forever provisional and open to doubt. What is not open to doubt is the presence in our world of a small universe of objects of art that expresses, in myriad, arresting forms, the highest values and ideals of the human race. It is essential to the quality of our own experience to encounter, comprehend, appreciate, and preserve these precious works.

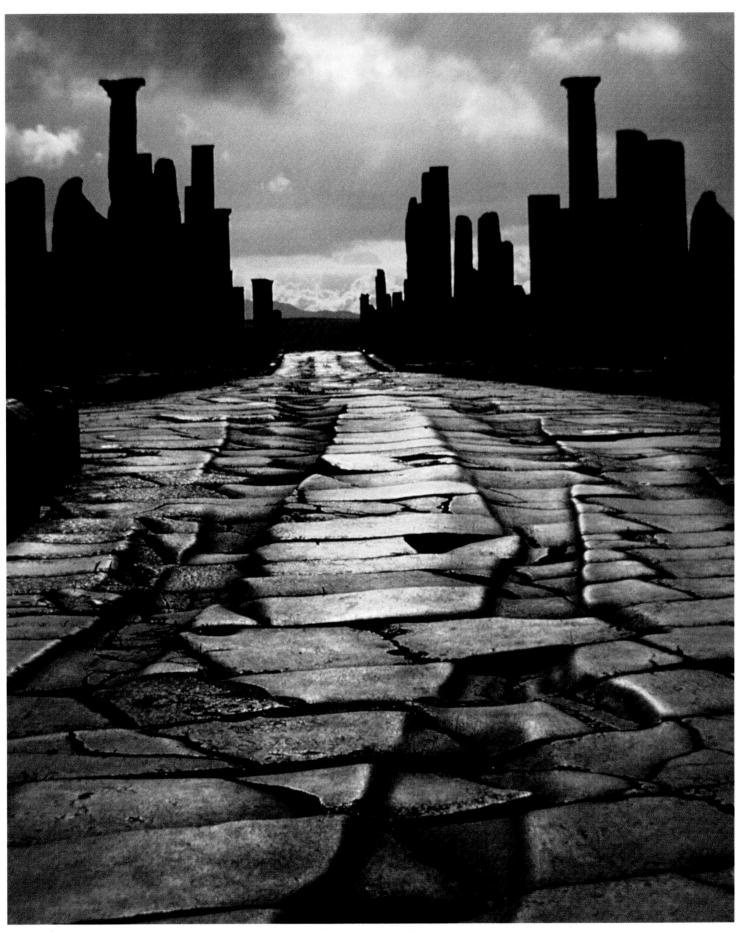

The Roman road to Timgad in North Africa stands as a legacy
of the greatest empire of the ancient world.

I

THE ANCIENT WORLD

The Christian civilizations of the Western world early distinguished an ancient past from a new age—the times, respectively, before (B.C.) and after (A.D.) Christ. For them the ancient world, the world of the Old Testament, had the character of a preparation; it was related to the new era as promise is related to fulfillment. This slightly condescending view toward antiquity changed during the Renaissance, when scholars and artists deeply admired the Greek and Roman past and often debated the question of which was superior, the "ancient" or the "modern." Interest in Greco-Roman antiquity was later broadened to encompass the great civilizations that preceded it: the pre-Greek Mediterranean, the Egyptian, the Near Eastern, and the very remote, prehistoric cave cultures of western Europe.

From the end of the eighteenth century to the present, archeologists and art historians, utilizing ever-improving methods of investigation, have recovered great tracts of forgotten history to fill out our picture of the distant past with increasing accuracy. Within the past few decades, evidence of the existence of civilizations that flourished as early as 7500 B.C. has been uncovered.

Historical perspective is likely to produce a distortion of view similar to that of the early Christian depreciation of the pre-Christian world. Until we have become familiar with the ancient world, it seems to us to be simply *that* (ancient, exceedingly old), and we imagine it in terms and images of faded inscriptions, dusty ruins, fallen idols, and long-outdated institutions. More properly, we should see *ourselves* as ancient—as living in the later eras of a great epoch at the beginning of which, thousands of years ago, some of our most fundamental beliefs, institutions, folkways, and art and science had their inception.

Following the development of agriculture and the widespread domestication of animals, the precarious, furtive life of the cave-dwelling hunter and the later nomadic herdsman was succeeded by the more sedentary, predictable, and ordered life of the village farmer. Aside from the technological revolutions of our times, this leap from food gathering to food production brought perhaps the most significant transformation of the human condition and made possible all that has followed. In Mesopotamia, Asia Minor, and Egypt, more complex forms of human community were created—

cities, city-states, and kingdoms. Formal religion and codes of law were developed to regulate the relationships among human beings and between gods and human beings. Writing was invented, as well as numbers and the art of calculation. The courses of the stars were plotted in order to predict the seasons and the times for planting and harvesting. Architecture, sculpture, and painting flourished in the service of kingly magnificence. The sacred books of Judaism and Christianity were produced in the shadow of mighty and hostile empires, and the legacy of Israel, which has contributed so much to the formation of the Western spirit, was preserved through all the vicissitudes of a remarkably tenacious people.

With the Greeks, there emerged what might be called the specifically "Western intelligence," with its respect for reason, scientific inquiry, the physical concept of nature, and the humanistic view of humankind. The city-states of Greece were more than seats of commerce and government; the loyalties of the citizens of each city-state had social, educative, and local religious bases as well. It was in some of these city-states—Athens in particular—that democracy first evolved in a limited form. About twenty-five hundred years ago, the government of Athens was largely run by a council of citizens, who were chosen by lot, and a kind of legislative assembly made up of all citizens—although citizenship did not extend to women or to the slaves who made up nearly half the population. With the repulsion of the Persian invaders in the fifth century B.C., the Greeks inaugurated the first authentic phase of European culture, the content and spirit of which, commingled with Hebraism, are still largely with us in our patterns of life and thought today.

Rome, although never matching Greek achievements in intellectual and artistic culture, produced the greatest empire of the ancient world. During a period of about eight hundred years, Rome progressed from its beginnings as a trading center under Etruscan kings to the zenith of its empire, which extended from what are now the borders of Scotland to Jordan and to the far

British archeologist Howard Carter spent six years searching for the tomb of the Eighteenth Dynasty pharaoh, Tutankhamen, and another eight years removing, cataloguing, and restoring the more than two thousand objects found in the tomb. Examining one of the three coffins of the young pharaoh, Carter brushes dust off the gilt wood.

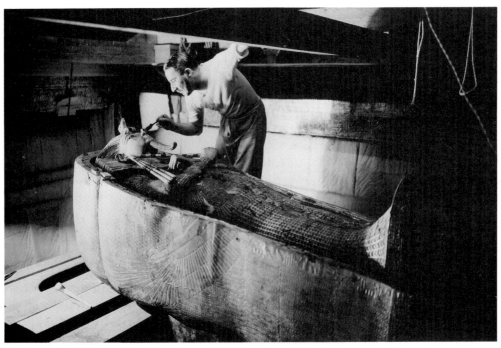

shores of the Black Sea, asserting its dominance over a multitude of peoples and lands. The dynamic and aggressive Roman spirit was reflected in and supported by an astonishing military machine and technology, although Roman control over diverse peoples was exercised as much by the encouragement of their participation in the empire as by the naked assertion of Roman power. The Romanization of western Europe—through the Roman genius for government and the ''Roman Peace''—still has much to do with the character of Europe, and the Roman ideal of a single, peaceful community of all humankind is very much in our view today as at least an ideal and a hope.

NOTE: Most of the time spans shown on the chronologies involving early dates have been determined by the method of *radiocarbon dating* invented in 1955. This is such an effective dating method that archeologists have called it ''the radiocarbon revolution.'' Radiocarbon dating is based on the fact that living organisms constantly absorb carbon isotopes, including the radioactive carbon-14, which continually disintegrates into nonradioactive nitrogen-14. On the death of the organism, absorption ceases but disintegration continues. Because the rate of disintegration is known, the age of organic matter—such as charcoal or carbonized bone—can be calculated on the basis of the amount of carbon-14 remaining in it.

In recent years, the chemical ''clock'' provided by the disintegration of carbon-14 has sometimes been out of phase with known dates before about 1000 B.C., making them later than they should be; it may be that other energy phenomena interfere with the regularity of this chemical ''clock.'' Radiocarbon dating has therefore been supplemented and corrected by another dating technique called *dendrochronology*, which determines the age of timber. By counting the annual rings of trees, visible in the cross sections of their trunks (notably, the very ancient bristlecone pines of California), accurate dates as far back as about the year 4000 B.C. can be obtained.

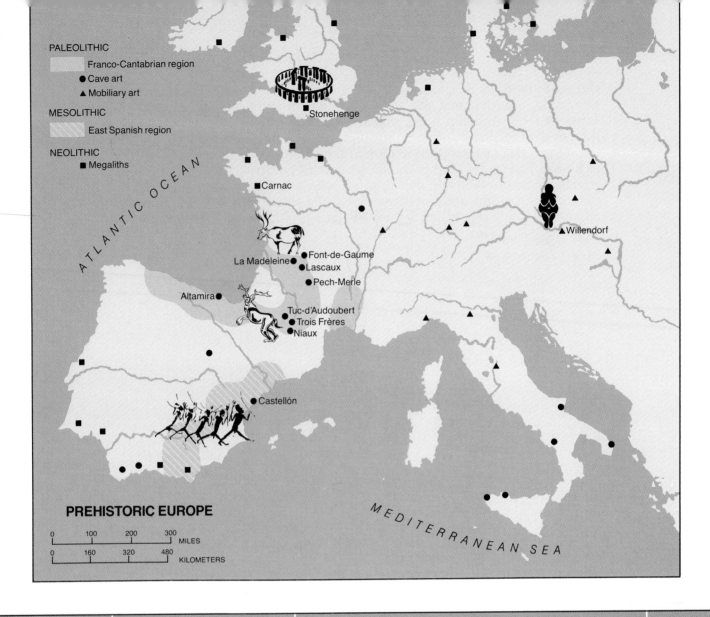

PALEOLITHIC
- [shaded] Franco-Cantabrian region
- ● Cave art
- ▲ Mobiliary art

MESOLITHIC
- [hatched] East Spanish region

NEOLITHIC
- ■ Megaliths

ATLANTIC OCEAN

Stonehenge

Carnac

● Font-de-Gaume
La Madeleine ● Lascaux
● Pech-Merle

Altamira ●

Tuc-d'Audoubert
● Trois Frères
● Niaux

● Castellón

Willendorf ▲

MEDITERRANEAN SEA

PREHISTORIC EUROPE

| 0 | 100 | 200 | 300 | MILES |
| 0 | 160 | 320 | 480 | KILOMETERS |

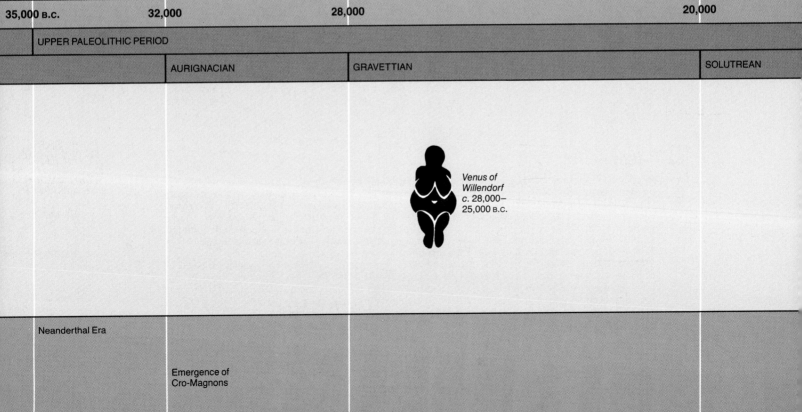

35,000 B.C.	32,000	28,000	20,000
UPPER PALEOLITHIC PERIOD			
	AURIGNACIAN	GRAVETTIAN	SOLUTREAN

Venus of Willendorf c. 28,000–25,000 B.C.

Neanderthal Era

Emergence of Cro-Magnons

1
THE BIRTH OF ART

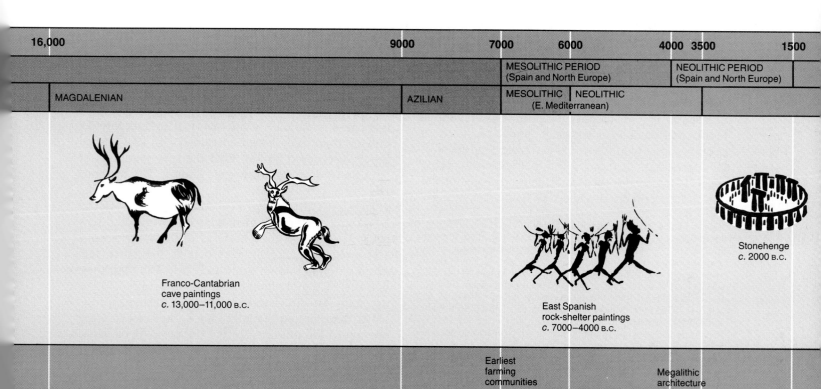

16,000		9000	7000	6000	4000	3500	1500
			MESOLITHIC PERIOD (Spain and North Europe)		NEOLITHIC PERIOD (Spain and North Europe)		
MAGDALENIAN		AZILIAN	MESOLITHIC \| NEOLITHIC (E. Mediterranean)				

Franco-Cantabrian
cave paintings
c. 13,000–11,000 B.C.

East Spanish
rock-shelter paintings
c. 7000–4000 B.C.

Stonehenge
c. 2000 B.C.

Earliest
farming
communities

Megalithic
architecture

Domestication
of cattle

Final recession
of ice and
onset of
temperate climate

WHAT GENESIS is to the biblical account of the fall and redemption of humankind, early cave art is to the history of human intelligence, imagination, and creative power. In the caves of southern France and of northern Spain, which were discovered only about a century ago and are still being explored (as well as in central Europe, North Africa, and Asia), we may witness the birth of that characteristically human capability that has made us masters of our environment—the making of images and symbols. By this original and tremendous feat of abstraction, Upper Paleolithic cave dwellers were able to fix in place the world of their experience, rendering the continuous processes of life in discrete and unmoving shapes that had the identity and meaning of the living animals that were their prey. Like Adam, Paleolithic peoples gathered and named the animals, and the faculty of imagination came into being along with the concepts of identity and meaning.

In that remote time during the last advance and retreat of the great glaciers, Stone Age people made the critical breakthrough and became wholly human. Our intellectual and imaginative processes function through the recognition and construction of images and symbols. We see and understand the world around us much as we are taught to, according to representations of that world that are familiar to our particular time and place. The immense achievement of Stone Age people, the invention of *representation*, cannot be exaggerated.

THE LATER OLD STONE AGE (UPPER PALEOLITHIC)*

The physical environment of the cave peoples over thousands of years would not appear to be favorable to the creation of an art of quality and sophistication; survival alone would seem to have required most of their energies. Although the Aurignacian period began between the early and main advances of the last glaciers and for a while was temperate, it grew

*The prehistoric periods Paleolithic, Mesolithic, and Neolithic refer to the stone (Greek: *lithos*) technology that prevailed through thousands of years of early human life; the prefixes *paleo-*, *meso-*, and *neo-* mean early, middle, and late, respectively. These terms were coined in the nineteenth century and no longer fit the facts precisely as modern archeology now classifies them, but they are used habitually and are difficult to replace. For convenience, we will use them here. Subdivisions within these three prehistoric periods (Perigordian, Aurignacian, Solutrean, Magdalenian) are named for the sites (mostly in France) at which characteristic artifacts, such as tools and weapons, have been found. The terms *lower* and *upper*, placed before these names, signify the earlier and later phases of a period.

cold toward its end. The great ice sheet advanced south from Scandinavia over the plains of north central Europe, and glaciers spread down from the Alps and other mountain ranges to produce a tundra and forest-tundra climate. With the end of the Magdalenian period about 9000 B.C., the final recession of the ice and the onset of temperate weather began. In the cold periods, human hunters and food gatherers took refuge in caves. It was here that Cro-Magnon peoples, who first appeared during the Aurignacian period, replacing Neanderthals, took the remarkable steps that made them not simply fabricators of stone tools, but artists.

Cave Painting

The first example of cave painting was discovered accidentally by amateurs in 1879 near Santander in northern Spain. Marcelino de Sautuola, a local resident interested in the antiquity of the human race, was exploring the Altamira caves on his estate, in which he had already found specimens of flint and carved bone. His little daughter was with him. Because the ceiling of the debris-filled cavern was only a few inches above the father's head, it was the child who was first able to discern, from her lower vantage point, the shadowy forms of painted beasts on the cave roof. De Sautuola was the first modern man to explore this cave, and he was certain that these paintings dated back to prehistoric times. Archeologists, however, were highly dubious of the authenticity of these works, and at the Lisbon Congress on Prehistoric Archeology in 1880, the Altamira paintings were officially dismissed as forgeries. But in 1896, at Pair-non-Pair in the Gironde district of France, paintings were discovered partially covered by calcareous deposits that would have taken thousands of years to accumulate. These paintings were the first to be recognized by experts as authentic. The conviction grew that these remarkable works were of an antiquity far greater than ever before dreamed. In 1901, Abbé Breuil discovered and verified the cave paintings of Font-de-Gaume in Dordogne, France. The skeptics were finally convinced.

The caves at Lascaux, near Montignac, also in the Dordogne region of France, were discovered accidentally in 1940, and the paintings in those caves (FIG. 1-1) are now generally regarded as the most outstanding of all known prehistoric art. Although they had survived more than fifteen thousand years in the dry subterranean chambers, many of these paintings have deteriorated rapidly since the caves were opened to the public in recent decades. At Lascaux, for example, it was found that moisture and carbon dioxide exhaled by hordes of visitors settled on the

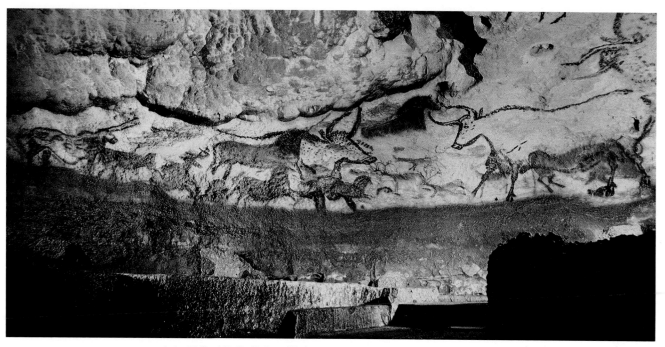

1-1 *Hall of Bulls* (left wall), Lascaux, *c.* 13,000 B.C. Dordogne, France.

walls and encouraged the growth of fungi destructive to the paintings. For this reason, and to prevent further damage, the caves have been closed to the general public since 1963.

The Lascaux caverns (FIG. **1-2**), like the others, had served as subterranean water channels, a few hundred to some 4,000 feet long. They are often choked, sometimes almost impassably, by faults or by deposits, such as stalactites and stalagmites. Far inside these caverns, well removed from the cave mouths that they often chose for habitation, the hunter-artists engraved and painted on the walls pictures of animals—mammoth, bison, reindeer, horse, boar, wolf. For light, they used tiny stone lamps filled with marrow or fat, with a wick, perhaps, of moss. For drawing, they used chunks of red and yellow ocher; for painting, they ground these same ochers into powders that they blew onto the walls or mixed with some medium, such as animal fat, before applying. A large flat bone served as a palette; they could make brushes from reeds or bristles; they could use a blowpipe of reeds to trace outlines of figures and to put pigments on out-of-reach surfaces; and they had stone scrapers for smoothing the wall and sharp flint points for engraving. Along with the more famous paintings, more than a thousand engravings (FIG. **1-3**) have recently been found on the walls and ceilings at Lascaux, indicating that engraving was as much a practiced technique as painting—and quite as important for our appreciation of the art of the caves.

During the years that the caves of Lascaux have been closed to tourism, archeologists, such as the late

1-2 Diagram of the caves of Lascaux. Dordogne, France. (After Arlette Leroi-Gourhan.)

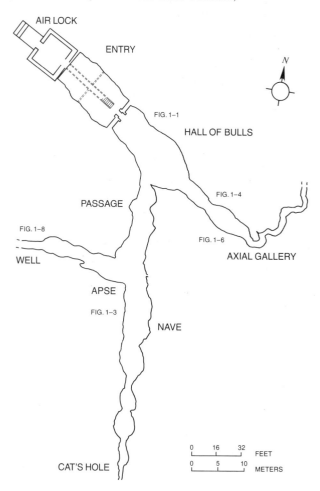

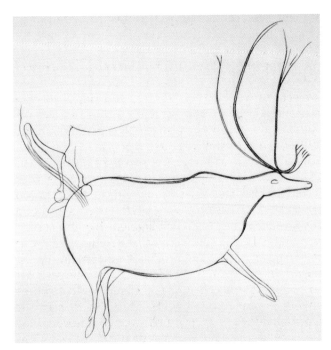

1-3 Engraved reindeer, Lascaux, *c.* 13,000 B.C.
Engraving on rock, 28″ long. Dordogne, France.
(Simplified copy of a tracing by Abbé André Glory.)

Abbé André Glory, who made careful tracings of all the engravings, have worked indefatigably, recovering artifacts that provide firm evidence of the Magdalenian artists' methods and materials. Some 130 stone lamps have been found, and from the remains of their burnt tallow and wicks, it has been shown that their light must have been as strong and steady as candlelight and must have lasted for an hour at a time. Numerous flat stones have been found that served as palettes for mixing colors. The colors themselves have been found, lumps of pigment have been chemically analyzed, and the different mineral powders that composed them have been ascertained. Recesses cut into the rock wall some seven feet or more above the floor must have held joists for a scaffolding that could support a platform made of saplings lashed together. This permitted the painters access to the upper surfaces of the caves, where they could occupy themselves for hours if necessary; remains of meals indicate that they could take them without having to descend. Carbon-14 analysis of the charcoal in the lamps and of bone artifacts associated with the various strata of the paintings confirms a date for the art of Lascaux of around 13,000 B.C. Researchers think it likely that the period of artistic activity may have extended over a relatively short span of time, coinciding with only several centuries of human occupation of the caves.

The artist's approach to the figures, as seen at Lascaux and at other sites, is "naturalistic"; each artist attempts to represent as convincing a pose and action as possible. Each painting reflects the keen observation and extraordinary memory of the hunter-artist, whose accuracy in capturing fleeting poses (FIGS. 1-1 and 1-6) is hardly surpassed by today's camera. Yet this observation was selective; the artist saw and recorded only those aspects that were essential to interpret the appearance and the character of the animal—its grace or awkwardness, its cunning, dignity, or ferocity. It is almost as if the artist were constructing a pictorial definition of the animal, capturing its very essence.

PURPOSE AND FUNCTION

Any modern interpretation of this cave art must, of course, remain speculative. Properties common to all these paintings, however, provide some fairly definite clues as to what they may have meant to their creators. For instance, the fact that the paintings are never found in those parts of the caves that were inhabited or near daylight rules out any purely decorative purpose. The first paintings at Font-de-Gaume were encountered about 70 yards behind the cave mouth, and the painted animals in the "Salon Noir" in the cave at Niaux were found some 850 tortuous yards from the entrance. The remoteness and difficulty of access of many of these sites and the fact that they appear to have been used for centuries suggest that the prehistoric hunter attributed magical properties to them. Therefore, the paintings themselves could have had magical meaning for their creators. As Abbé Breuil has suggested, "by confining the animal within the limits of a painting, one subjected it to one's power in the hunting grounds." Within this context, the artist's aim to be realistic may be explained by the probable conviction that the painting's magical power was directly related to its lifelike characteristics.

The naturalistic pictures of animals in the caves are often accompanied by geometric signs, some of which seem to represent man-made structures, or *tectiforms* (FIG. **1-4**); others consist of checkers, dots, squares, or other arrangements of lines. Several observers have seen a primitive form of writing in these representations of nonliving things, but they, too, may have had magical significance. The ones that look like traps or snares, for example, may have been drawn to ensure success in hunting with these devices. In many places, representations of human hands, most of them "negative," appear where the artist placed one hand against the wall and then painted or blew pigment around it (FIG. **1-5**). Occasionally, the artist would dip a hand in paint and then press it against the wall, leaving a "positive" imprint. These handprints, too, may have had magical signifi-

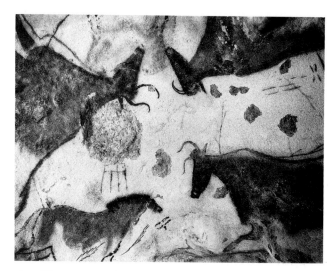

1-4 *Three Cows and One Horse*, ceiling of the Axial Gallery, Lascaux, c. 13,000 B.C. Approx. life size. Dordogne, France.

cance or may simply have been the "signatures" left by whole generations of visitors to these sacred places, much as modern tourists leave some memento of their presence.

The figures are in themselves striking approximations of optical fact, but their arrangement on the cave walls shows little concern for any consistency of placement in relationship to each other or to the wall space, although this has been claimed. Certainly, we find no compositional adjustment to suggest the perspective effect and no notion of separation and enframement. Figures, far from being proportionally related, are often superimposed at random and are of quite different sizes (FIGS. 1-1 and 1-3). Generations of artists, working in the same sanctuaries, covered and recovered the crowded walls, although pains often seem to have been taken not to break through the

outlines of an earlier figure. It seems that attention to a single figure—the rendering of a single image—in itself fulfilled the purpose of the artist.

The hunter-artists made frequent and skillful use of the naturally irregular surfaces of the walls, utilizing projections, recessions, fissures, and ridges to help give the illusion of real presence to their forms. An outward swelling of the wall could be used within the outline of a charging bison to suggest the bulging volume of the beast's body. The spotted horse at Pech-Merle (FIG. 1-5) may have been inspired by a rock formation that resembles a horse's head and neck (on the right of the figure), although the artist's eventual version of the head is much smaller than the formation and is highly abstract. Natural forms, like those of foliage or clouds, the profile of a mountain, or the shapes of eroded earth and rock, can represent for any of us—sometimes quite startlingly—the features of people, animals, or objects. Thus, the first artistic representations may have followed some primal experience of resemblance between the chance configuration of a cave wall and the animal the artist had just been hunting. This resemblance might have had for the artist the effect of an awesome apparition of the very animal—a miraculous and magical reappearance of its vanished life. With the impulse to give the apparition even more presence, the artist could have "finished" the form by cutting an outline around the relief and continuing it until a more or less complete and familiar silhouette emerged. The addition of color would enhance the reality of the image.

Researchers have evidence that the hunters in the caves, perhaps in a frenzy stimulated by magical rites and dances, treated the painted animals as if they were alive. Not only was the quarry often painted as pierced by arrows (FIG. 1-6), but hunters actually may

1-5 *Spotted Horses and Negative Hand Imprints*, Pech-Merle, c. 13,000 B.C. 11' 2" long. Lot, France.

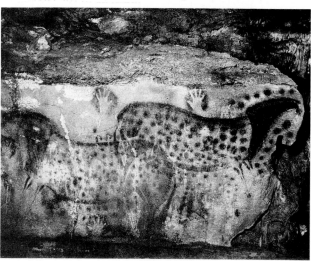

1-6 *Chinese Horse* (detail of FIG. 1-4), Axial Gallery, Lascaux, c. 13,000 B.C. Approx. 56" long. Dordogne, France.

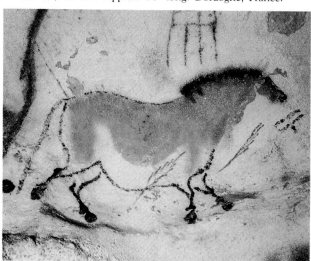

have thrown spears at the images, as sharp gouges in the side of the bison at Niaux (FIG. **1-7**) suggest. This practice, intended to predestinate and magically command the death of the animals, would be analogous to the kind of magic, still cultivated in parts of the world today, that is based on the belief that harm can be done to an enemy by abusing an image of that person.

This art produced in caverns deep in the earth must have had some profound magical functions. Familiar in religious architecture, which had its beginning thousands of years after the era of the caves, are the cavelike spaces of the sanctuary where the most sacred and hidden mysteries are kept and where the god dwells in silence. The sacred often has meant the mysterious—a place of darkness, lit only by fitful light, where at the culmination of rituals, absolute silence reigns. These features of the sacred environment were already present in the "architecture" of the caves, and the central theme has never been lost despite its myriad variations.*

It is significant that the miracle of abstraction—the creation of image and symbol—should take place in such secret and magical caverns. Abstraction is representation, a human device of fundamental power, by which not only art but ultimately science comes into existence. Both art and science are methods for the control of human experience and the mastery of the environment. And that was also the end purpose of the hunter-magicians—to control the world of the beasts they hunted. The making of the image was, by itself, a form of magic. By painting an animal, the hunter fixed and controlled its soul within the prison of an outline; from this initial magic, all the rest would follow. Rites before the paintings may have served to improve the hunter's luck. At the same time, prehistoric peoples must have been anxious to preserve their food supply, and the representations of pregnant animals (FIG. 1-6) suggest that these cavalcades of painted beasts may also have served magically to assure the survival of the actual herds.

But magic must not be considered the sole function of cave art; other functions also have been suggested. The processions and groupings of the animals are not

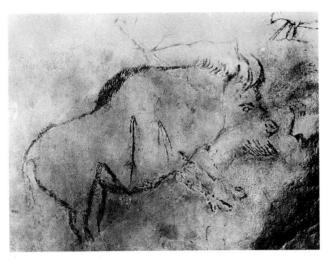

1-7 *Bison with Superposed Arrows*, Niaux, c. 13,000 B.C. 50" long. Ariège, France.

entirely haphazard and seem to express an order in terms of the preferences and concerns of the hunter. Cattle and horses, for example, regularly appear together. The *palimpsest effect* of superimposing images one on top of another may be a spatial representation of time (one hunting season taking the place of another—a sort of mark-off calendar). The animals may be a kind of heraldic-totemistic image, representative of their blood relationship to different tribes, or they may be objects of worship, as was the buffalo for the peoples of the North American plains.

Abbé Breuil's "hunting-magic" theory had wide currency during the first half of this century. It is appealingly simple and has parallels in modern hunter-gatherer societies. In the late 1960s, Abbé Breuil's views were challenged and partly superseded by other, more complex interpretations. Two French anthropologists, André Leroi-Gourhan and Annette Laming-Emperaire, recognized a certain order in the arrangement of cave paintings, which formerly had been felt to be chaotically arranged. Leroi-Gourhan and Laming-Emperaire found that animals that represent maleness predominate in the peripheral areas of caves, while those that represent femaleness are concentrated in central areas. From such a seeming division between male and female, they extrapolated a social organization that was much more complex than any that formerly had been attributed to a foraging society.

Leroi-Gourhan's interpretation of cave painting, which does not explain the great diversity in image production, nor the effects that these images may have produced on their prehistoric viewers, is today dismissed as "monolithic" by a majority of scholars. In a partial return to Abbé Breuil's theory, Henri Delporte, of the Musée des Antiquités Nationales near

*In the later Paleolithic, magic may have been developing into religious ritual and communal belief. At the El Juyo cave site near Santander in northern Spain (the neighborhood of the Altamira caves), a sanctuary was uncovered containing an altarlike stone slab that weighs nearly a ton and is supported by other vertical slabs of stone. It appears to be the shrine of the sanctuary, the focus of a group religion. The shrine area, covering 118 square feet, contains clay-faced mounds that cover trenches in the floor. The trenches hold a variety of deliberately arranged objects that may have been used as sacred accessories in ceremonies of some sort. Structured cave, sanctuary, shrine, and repositories—the rudimentary elements of religious architecture—are already here in primitive form. The site dates from about 12,000 B.C.

Paris, says: "I think it is possible that sometimes images were made for hunting magic in the way that Abbé Henri Breuil imagined. But I think there were probably many different reasons why people produced art of different kinds, and we should not just think of single explanations." Today the emphasis is on "context and a diversity of explanations." Anthropologists are searching for the social context of Paleolithic art and for those elements inherent in it that made it meaningful to the people who produced it. But so far, no one has found a completely satisfactory answer to the enigma of the caves.

THE REPRESENTATION OF THE HUMAN FIGURE

Human figures almost never appear among the vivid troops of animals portrayed in the cave paintings. At least two notable exceptions, however, are known to exist. A very puzzling picture at Lascaux (FIG. **1-8**) shows a stick-figure man, falling or fallen, before a huge bison that has been disemboweled, probably by the rhinoceros at the left, which slouches away from the scene. The two animals are rendered with all the skilled attention to animal detail we are accustomed to in cave art: the rhinoceros heavy and lumbering; the buffalo tense and bristling with rage,

its bowels hanging from it in a heavy coil. But the bird-faced (masked?) man is rendered with the crude and clumsy touch of the unskilled at any time or place. His position is ambiguous. Is he dead or in an ecstatic trance? The meaning of the bird on the staff and of the spear and throw stick is no more obvious. We will not add to the already abundant speculation as to the meaning of this picture. A more important question deals with why the human and the animal figures are treated differently. Did early peoples distinguish themselves so much from the beasts that they could find no images suitable to self-depiction? Or were they afraid to cast a spell on themselves, as they cast it on the animals, by rendering their images visible?

Another (equally problematical) representation is found at Trois Frères in the Pyrenees. This depiction of a very strange humanoid creature—the so-called *Sorcerer*—is masked and wears the antlers of a reindeer (FIG. **1-9**). Is this the memory sketch of a shaman or witch doctor? The chamber in which the figure appears is crowded with beasts, and Abbé Breuil has suggested that the figure may be their god, who has descended into the witch doctor and filled him with his bestial power. It has also been suggested that this

1-8 *Well Scene*, Lascaux, c. 13,000 B.C. Bison 55″ high. Dordogne, France.

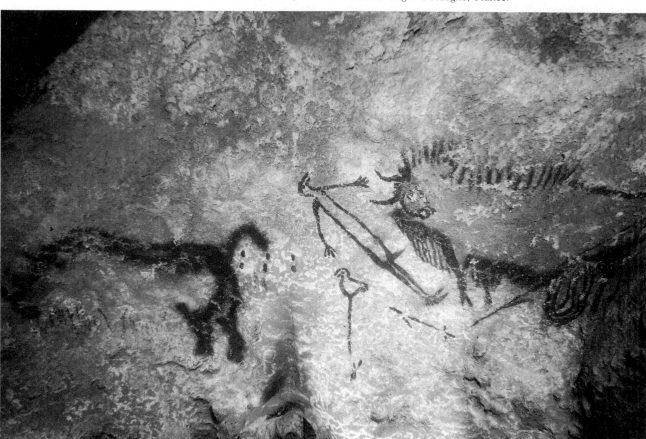

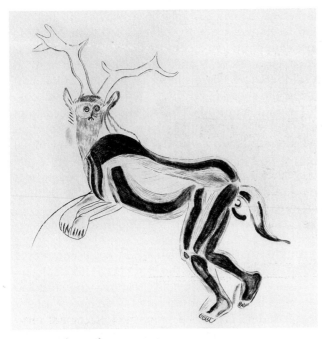

1-9 *Sorcerer*, Trois Frères, *c.* 13,000–11,000 B.C. 24″ high. Ariège, France.

1-10 *Reindeer*, Font-de-Gaume, *c.* 13,000–11,000 B.C. Dordogne, France. (After a copy by Abbé Breuil.)

is only a hunter camouflaged to stalk deer, but again it would appear that, for Paleolithic peoples, human beings simply were not to be counted among the animals. At least their figures must be so disguised—perhaps to avoid magical self-involvement—as to be unrecognizable as human beings.

QUALITY

In trying to explain the great accomplishment of Stone Age peoples, we must not forget that their art is *art*. It is not simply that they made images, but that they made them skillfully and beautifully. Ancient and modern art have produced, along with masterpieces, images that are dull, prosaic, and of indifferent quality. The art of the caves is of extraordinary caliber. The splendid horse in the Axial Gallery at Lascaux (FIG. 1-6) has been called the *Chinese Horse* because its style strangely resembles Chinese painting of the highest quality. Not only do the outlines have the elastic strength and fluency that we find in Chinese calligraphy and brushwork, but the tone is so managed as to suggest both the turning under of the belly of the pregnant animal and the change in the color of the coat. At Font-de-Gaume, a painted reindeer (FIG. **1-10**) was executed with deft elegance in the contours and remarkable subtlety in the modeling tones. The grace of the antlers is effortlessly translated into an upward-sweeping line that renders the natural shapes with both strength and delicacy. Abbé Breuil, while copying the originals, discerned some highly sophisticated pictorial devices that one expects to find only in the art of far later times; for example, note the darkening of the forward contour of the left hind leg, which serves to bring it nearer to the observer than the right leg.

The pictures of cattle at Lascaux and elsewhere (FIG. 1-4) show a convention of representation of the horns that has been called *twisted perspective,* because we see the heads in profile but the horns from a different angle. Thus, the approach of the artist is not strictly or consistently *optical* (organized from the perspective of a fixed viewpoint). Rather, the approach is *descriptive* of the fact that cattle have two horns. Two horns would be part of the concepts "cow" and "bull." In strict optical-perspective profile, only one horn would be visible, but to paint the animal in that way would, as it were, amount to an incomplete definition of it. Twisted perspective was not used universally, however, and there is a style, thought to be a later development, that dispenses with it in favor of a very convincing illusionism.

Sculpture

The principal bequests of the hunter-artists are their paintings and engravings; we have seen that both abound at Lascaux. They also have left us sculpture in stone, ivory, bone, and antler. In the *Bison with Turned Head* (FIG. **1-11**), we are impressed by the striking vitality and simplicity with which the formal beauty is expressed. This piece, executed on reindeer horn, exhibits a simplicity and economy of means that distinguishes the great paintings. The head is turned so that it is entirely framed by the massive bulk of the body. The artist has achieved a vivid play of curve and countercurve and a surface contrast obtained by the use of decorative hatching to indicate

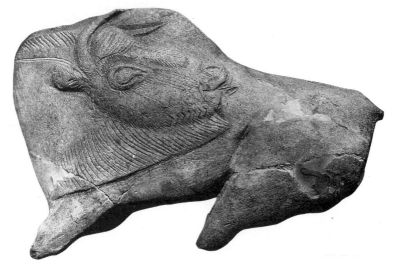

1-11 *Bison with Turned Head,* La Madeleine, *c.* 11,000–9,000 B.C. Reindeer horn, 4⅛″ high. From Dordogne, France. Musée des Antiquités Nationales, St. Germain-en-Laye.

the mane. The artist would have been perfectly familiar with incising techniques; incising the outlines of a figure before the tones were introduced was the usual procedure for painting. But the artists of the caves went beyond incision and produced sculpture in *deep relief* and in the *full round.* An especially fine example of deep relief has been found in a rotundalike space that terminates a succession of chambers in the caves at Tuc d'Audoubert. Independent of the rock wall against which they are propped, a pair of lifelike bison has been modeled in clay (FIG. **1-12**). The distinguishing features are delineated as carefully as those

of the reindeer-horn bison, and their placement produces sharp shadows that create an illusion of three-dimensionality, an effect doubtless intended by the sculptor. These Tuc d'Audoubert bison are related stylistically to painted examples (FIG. 1-7) and provide striking evidence of an already mature sense of three-dimensional form.

The Magdalenian culture and the cultures that went before were not uniquely French-Spanish. A distinct culture, Gravettian (28,000–20,000 B.C.), produced artifacts that are found from the Rhine to Russia, most abundantly in central Europe. Best known

1-12 *Bison,* Tuc d'Audoubert, *c.* 13,000–8000 B.C. Unbaked clay, each about 2′ long. Ariège, France.

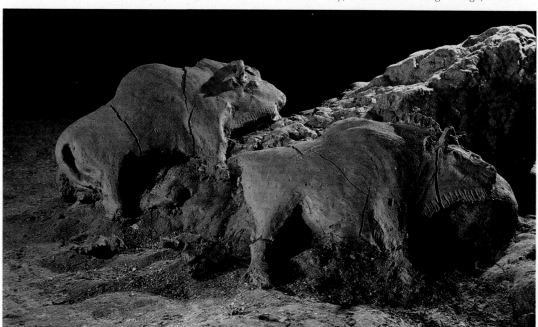

among these are small sculptures (formerly called "Venus figures" by archeologists), which represent the female figure executed in the full round. These figures constitute an exception to the rule of exclusion of the human figure from the cave artist's inventory of forms. Perhaps the most famous of them is the *Venus of Willendorf* (FIG. **1-13**), a figurine of a woman that is composed of a cluster of almost ball-like shapes. The anatomical exaggeration suggests that this and similar statuettes served as fertility fetishes; the needs for game and human offspring were one in the dangerous life of the hunter. But again the artistic approach to the human figure differs from the way these early artists represented animals. They obviously do not aim for that heightened realism so characteristic of their animal representations; facial features, for instance, are seldom indicated in these statuettes, and not even the heads are shown in some specimens. Evidently, the aim was not to show the female of the species, but rather the idea of female fecundity; the artist depicted not woman, but fertility.

1-13 *Venus of Willendorf, c.* 28,000–25,000 B.C. Limestone, 4⅜″ high. Naturhistorisches Museum, Vienna. (Cast of original.)

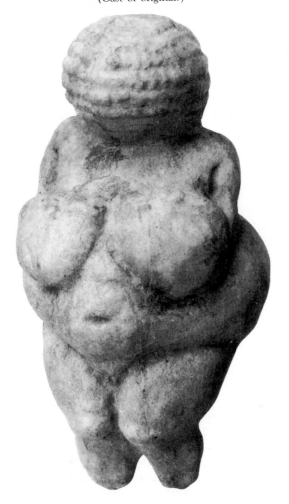

THE MIDDLE STONE AGE (MESOLITHIC)

Rock-shelter Paintings

Around 7000 B.C., the ice of the Paleolithic period melted as the climate grew warmer. The reindeer migrated north, the woolly mammoth and rhinoceros disappeared, and the hunters left their caves. The Ice Age gave way to a transitional period, the Mesolithic, during which Europe became climatically, geographically, and biologically much as it is today. In this period, a culture flourished and produced art that complements—and, indeed, may have partially originated from—cave art. Since 1903, diminutive, extraordinarily lively paintings of animals and men in scenes of the hunt, battle, ritual dance, and harvest have been discovered on the stone walls of shallow rock shelters among the barren hills along the east coast of Spain (the Spanish Levant). The artists show the same masterful skill in depicting animal figures as that demonstrated by their predecessors in the caves, and it may be that we have here specimens of a lingering tradition or long-persisting habit of vision and representation of animals. But what is strikingly new is the appearance of the human figure—not only singly, but in large, coherent groups with a wide variety of poses, subjects, and settings. We have seen that the human figure almost never appears in cave art; the falling or fallen man of the *Well Scene* (FIG. 1-8) at Lascaux is quite exceptional. In the rock-shelter paintings, the new sentiment for human themes and concerns, and the emphasis on action in which humans dominate animals are central. The new inventory of forms may have migrated across the Mediterranean from North Africa, where many paintings similar to those in the Spanish Levant have been found. Scholars have debated the dating of Spanish rock-shelter art and some now agree that its beginnings were around 7000 B.C. and that the style may have lasted (with many variations) until about 4000 B.C.

Some characteristic features of the rock paintings appear in an energetic group of five warriors found in the Gasulla gorge (FIG. **1-14**). The group, only about nine inches in width, shows a customary tense exaggeration of movement, a rhythmic repetition of basic shape, and a general sacrifice of naturalistic appearance to narrative and to unity of action. Even so, we can distinguish details that are economically descriptive—bows, arrows, and the feathered headdress of the leader. The widely splayed legs communicate a leaping stride, perhaps a march to battle or a ritual dance.

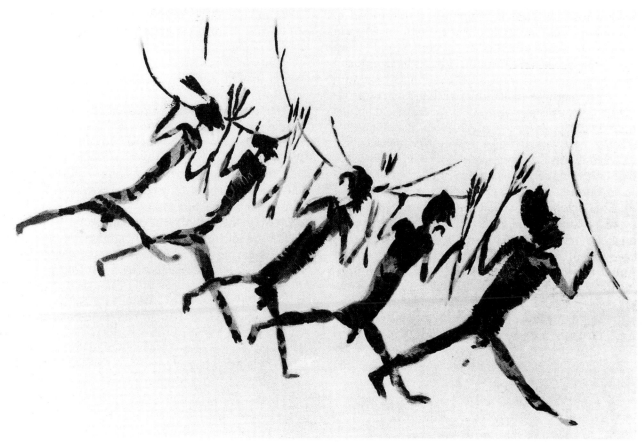

1-14 *Marching Warriors* (ritual dance?), Gasulla gorge, *c.* 7000–4000 B.C. Approx. 9″ wide. Castellón, Spain.

Other such paintings show an even greater uniformity of basic shape and a nervous, sharp angularity, which suggest the *pictograph* or even the *phonetic hieroglyph*. And over the millennia, rock-painting styles did become more abstract and schematic, more symbol than picture; it is likely that they recorded a step in the evolution of the *symbolic* from the *pictorial*— an evolution that in the Near East culminated in the invention of writing. Later on, the liveliness and spontaneity of the rock paintings were lost in the rigid uniformities of almost letterlike shapes repeated as if from a limited stock of signs.

Like the cave paintings, the rock paintings are probably of magical-religious significance, although some observers believe them to be no more than pictorial records of memorable events. The rock paintings are concentrated at particular sites that were used for long periods; nearby places, better suited for painting, were not used. This fact suggests that the sites were held sacred, not only by the Mesolithic painters, but also by artists working well into the historical period. Iberian and Latin inscriptions indicate that supernatural powers were ascribed to some of these holy places as late as the Roman era.

THE NEW STONE AGE (NEOLITHIC)

In a supreme feat of intellection, Paleolithic peoples learned to abstract their world by making a picture of it. They sought to control the world by capturing and holding its image. In the Neolithic period, human beings took a giant stride toward the actual, concrete control of their environment by settling in fixed abodes and domesticating plants and animals. Their food supply assured, they changed from hunters to herdsmen, to farmers, and, perhaps as early as 7000 B.C. in the Near East, to townsmen. The wandering hunter settled down to organized community living in villages surrounded by cultivated fields. Then began the long evolution toward the incredible technological command of the physical environment that exists today.

Recent research seems to indicate that local Neolithic populations in several areas of western Europe developed a monumental architecture consisting of graves and of rows or circles of massive, rough-hewn stones. These constructions have been dated to as

early as 4000 B.C. The very dimensions of the stones, some as high as 17 feet tall and at a weight of as many as fifty tons, have prompted the historian to call them *megaliths* (great stones) and the culture that produced them *megalithic*.

Several types of megalithic structures have been classified. The *dolmen* consists of several great stones set on end, with a large covering slab. Dolmens may be the remains of passage graves from which a covering earth mound has been washed away. The *passage grave*, the dominant megalithic tomb type (with literally thousands having been found in France and England), has a corridor lined with large stone slabs leading to a circular chamber in which each of numerous rings of stones projects inward beyond the underlying course, until the rings close at the top (a *corbeled vault* construction). These graves were frequently built into a hill slope or covered by mounds of earth. At Carnac in Brittany, great single stones, called *menhirs*, set on end, were arranged in parallel rows, some of which run for several miles and consist of thousands of stones. Their purpose was evidently religious and may have had to do with a cult of the dead or the worship of the sun. Sometimes these huge stones were arranged in a circle known as a *cromlech*. Among the most imposing cromlechs are those at Avebury and at Stonehenge in England (FIGS. **1-15** and **1-16**). The structure at Avebury is surrounded by a stone bank about four-fifths of a mile in diameter. The remains at Stonehenge are of a complex of rough-cut sarsen (a form of sandstone) stones and smaller "bluestones" (various igneous rocks). Outermost is a ring of large monoliths of sarsen stones capped by lintels. Next is a ring of bluestones, which,

1-15 Stonehenge, c. 2000 B.C. 97' in diameter. Salisbury Plain, Wiltshire, England.

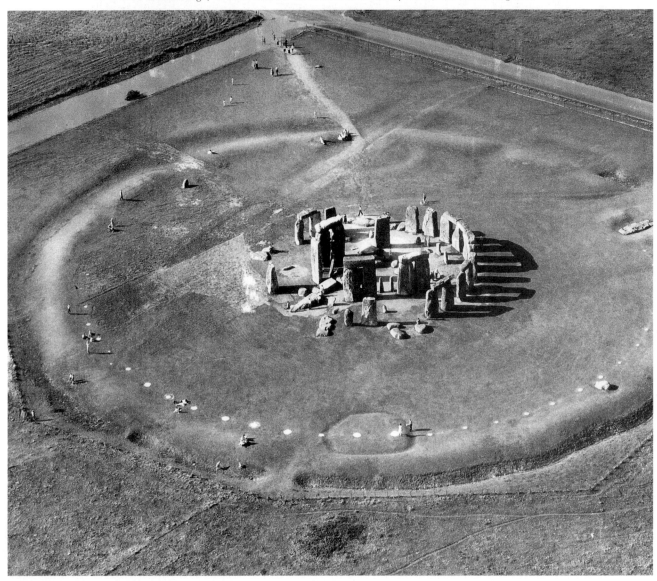

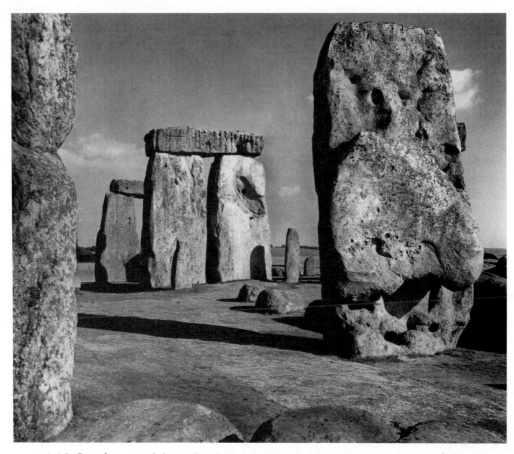

1-16 Stonehenge, trilithons (lintel-topped pairs of stones at center). Approx. 24′ high (including lintel). Salisbury Plain, Wiltshire, England.

in turn, encircled a horseshoe (open end facing east) of *trilithons*—five lintel-topped pairs of the largest sarsens, each weighing forty-five to fifty tons. Standing apart and to the east is the "heel-stone," which, for a person looking outward from the center of the complex, would have marked the point at which the sun rose at the midsummer solstice.

Stonehenge seems to have been built in several phases around 2000 B.C., according to recently corrected radiocarbon dates. Computer-based calculations have raised something of a controversy, not so much over the date as over the purpose of Stonehenge, which seems to have been a kind of astronomical observatory. These mysterious structures, believed in the Middle Ages to have been the work of the magician Merlin, who spirited them from Ireland, or the work of a race of giants, have come in our own time to be thought of as a remarkably accurate calendar—a testimony to the rapidly developing intellectual powers of humans. Even in their ruined condition, the monoliths of Stonehenge, created by heroic physical and intellectual human effort, possess a solemn majesty. At Avebury, as at Stonehenge, the series of concentric circles with connecting curvilinear pathways or avenues conveys a feeling for order, symmetry, and rhythm that is evidence not only of well-developed and systematized ceremonial rituals, but perhaps also of a maturing geometrical sense born of the observation of the apparent movements of the sun and moon.

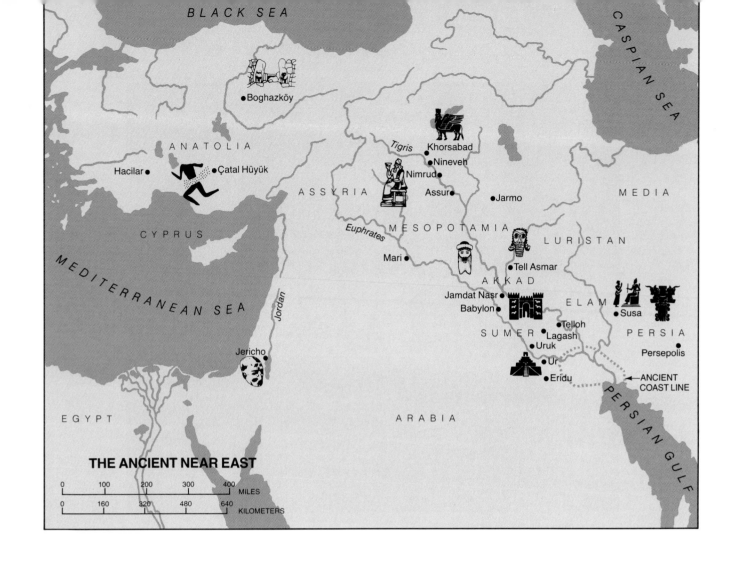

THE ANCIENT NEAR EAST

MILES				
0	100	200	300	400

KILOMETERS				
0	160	320	480	640

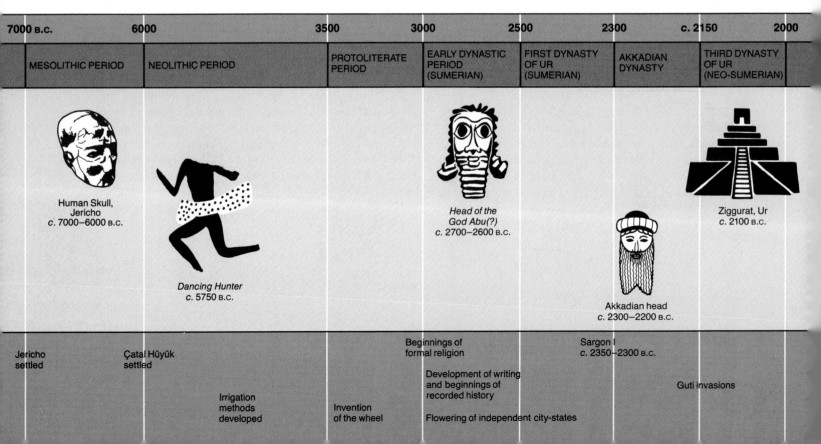

7000 B.C.	6000	3500	3000	2500	2300	c. 2150	2000
MESOLITHIC PERIOD	NEOLITHIC PERIOD	PROTOLITERATE PERIOD	EARLY DYNASTIC PERIOD (SUMERIAN)	FIRST DYNASTY OF UR (SUMERIAN)	AKKADIAN DYNASTY	THIRD DYNASTY OF UR (NEO-SUMERIAN)	

Human Skull, Jericho
c. 7000–6000 B.C.

Dancing Hunter
c. 5750 B.C.

Head of the God Abu(?)
c. 2700–2600 B.C.

Akkadian head
c. 2300–2200 B.C.

Ziggurat, Ur
c. 2100 B.C.

Jericho settled

Çatal Hüyük settled

Irrigation methods developed

Invention of the wheel

Beginnings of formal religion

Development of writing and beginnings of recorded history

Flowering of independent city-states

Sargon I
c. 2350–2300 B.C.

Guti invasions

2
THE ANCIENT NEAR EAST

1900		1600		1150		c. 900		625	612		538		330

FIRST DYNASTY OF BABYLON | KASSITES AND MITANNI

ASSYRIAN EMPIRE

NEO-BABYLONIAN KINGDOM

PERSIAN EMPIRE (ACHAEMENID DYNASTY)

Stele of Hammurabi
c. 1780 B.C.

Lion Gate, Boghazköy
c. 1400 B.C.

Ashurnasirpal II
Drinking
c. 875 B.C.

Winged Bull,
Khorsabad
c. 720 B.C.

Ishtar Gate
c. 575 B.C.

Bull Capitol,
Susa
c. 375 B.C.

Hammurabi
c. 1790–1750 B.C.

Sack of Babylon
by Hittites
c. 1595 B.C.

Rise of
Assyrian
power

Nebuchadnezzar II
605–562 B.C.

Darius I
520–486 B.C.

Xerxes
485–465 B.C.

Battle
of Issus
331 B.C.

JUST HOW AND WHY the state of human society that we call civilization began, we are not certain; we are more certain where and when it began. Since World War II, archeologists have been uncovering sites in the Near East that give clear evidence of a definite transformation beginning as early as 8000 B.C. The onset of civilized life is marked off from all that went before by the development of agriculture. The conventional division of prehistory into the Paleolithic, Mesolithic, and Neolithic periods is based on the development of stone implements. That distinction, however, is not as basic and decisive as the simpler distinction between an age of food gathering and an age of food production. In this scheme, the Paleolithic period corresponds roughly to the age of food gathering, and the Mesolithic period, the last phase of that age, is marked by intensified food gathering and the domestication of the dog. The proto-Neolithic period of incipient food production and greater domestication of animals precedes the Neolithic period, when agriculture and stock-raising became man's major food sources.

At one time, researchers proposed that the area we know today as the Near East (Egypt, Israel, Syria, Iraq, Iran, Lebanon, Jordan, and Turkey) dried out into desert and semidesert after the last retreat of the glaciers, compelling the inhabitants to move to the fertile alluvial valleys of the Nile in Egypt and the Tigris and Euphrates in Mesopotamia (parts of modern Syria and Iraq). This view is no longer tenable in light of archeological and paleoenvironmental findings. The oldest settled communities are found not in the river valleys but in the grassy uplands bordering them. These regions provided the necessary preconditions for the development of agriculture. Species of native plants, such as wild wheat and barley, were plentiful, as were herds of animals (goats, sheep, and pigs) that could be domesticated; sufficient rain also was available for the raising of crops. It was only after village farming life was well developed that settlers, attracted by the greater fertility of the soil, moved into the river valleys and deltas. There, in addition to systematic agriculture, civilized societies originated government, law, and formal religion, and such instrumentalities and techniques as writing, measurement and calculation, weaving, metalcraft, and pottery.

For a long time, it was thought that these developments occurred concurrently in Egypt and Mesopotamia. But again, archeology has forced a revision of our views. It is now clear that Mesopotamia and its neighbors were far ahead of Egypt temporally. Village farming communities like Jarmo in Iraq and Çatal Hüyük in southern Anatolia (Turkey) date back to the mid-seventh millennium B.C., and the remarkable fortified town of Jericho, before whose walls Joshua appeared thousands of years later, is even older. The oldest villages in Egypt, in the Faiyûm district near the Nile Delta, do not seem to have been founded before 4500 B.C., and an urban society like that of Mesopotamia seems never to have developed there. The invention of writing in Mesopotamia preceded writing in Egypt by several hundred years, and it may be that the whole development of Egyptian civilization was the result of Mesopotamian influence.

THE BEGINNINGS

Jericho

By 7000 B.C., agriculture was well established in at least three Near Eastern regions: Jordan, Iran, and Anatolia (Turkey). Although no remains of domestic cereal grains have been found that can be dated before 7000 B.C., the advanced state of agriculture at that time presupposes a long development; indeed, the very existence of a town like Jericho gives strong support to this assumption. The site of Jericho—a plateau in the Jordan River valley with an unfailing spring—was occupied by a small village as early as the ninth millennium B.C. This proto-Neolithic village underwent spectacular development around 8000 B.C., when a new town was built with houses of mud brick on round or oval stone foundations. As the town's wealth grew and powerful neighbors established themselves, the need for protection resulted in the first known permanent stone fortifications. By approximately 7500 B.C., the town, estimated to have had a population of over two thousand people, was surrounded by a wide, rock-cut ditch and a five-foot-thick wall. Into this wall, which has been preserved to a height of 12 feet, was built a great circular stone tower, 30 feet in height and diameter (FIG. 2-1). Not enough of the site has been excavated to determine whether this tower was solitary, like the keeps in medieval castles, or one of several similar towers that formed a complete defense system. In either case, a structure like this, built with the aid of only the most primitive kinds of stone tools, was certainly a tremendous technical achievement.

Around 7000 B.C., the Jericho site was abandoned by its original inhabitants, but new settlers arrived in the early seventh millennium. They built rectangular mud-brick houses on stone foundations and carefully plastered and painted their floors and walls. Several of the excavated buildings seem to have served as shrines, the plan of one of them being remarkably similar to that of the later Greek *megaron* (see FIG.

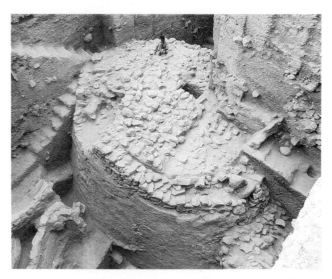

2-1 Great stone tower built into the settlement wall, Jericho, *c.* 8000–7000 B.C.

5-20a). These settlers fashioned statuettes of a mother goddess and of animals associated with a fertility cult. Most striking is a group of human skulls on which the features have been "reconstructed" in plaster (FIG. **2-2**). Subtly modeled, with inlaid seashells for eyes and painted hair (including a painted mustache that has been preserved on one specimen), their appearance is strikingly lifelike. Because the skulls were detached from the bodies before burial

2-2 Human skull, Jericho, *c.* 7000–6000 B.C. Features molded in plaster, painted and inlaid with shell.

and displayed above ground, they may have been regarded as "spirit traps," implying a well-developed belief in survival after the death of the body.

Çatal Hüyük

Perhaps even more remarkable than the Jericho finds are discoveries in Anatolia. Excavations at Hacilar and Çatal Hüyük have shown not only that the central Anatolian plateau was the site of a flourishing Neolithic culture between 7000 and 5000 B.C., but also that it may well have been culturally the most advanced region of its time. Twelve successive building levels excavated at Çatal Hüyük between 1961 and 1965 have been dated between 6500 and 5700 B.C. On a single 32-acre site (of which only one acre has been explored), it is possible to retrace, in an unbroken sequence, the evolution of a Neolithic culture over a period of eight hundred years.

Along with Jericho, Çatal Hüyük has been called "one of man's first essays in the development of town life." The regularity of the town plan suggests that it was built according to some a priori scheme. A peculiarity of the town is its complete lack of streets; the houses adjoin each other, and access is provided over their roofs (FIG. **2-3**). Impractical as such an arrangement may appear today (although it survives in parts of central Turkey and western Iran), it did offer some advantages. The buildings, being attached, were more stable than freestanding structures and, at the limits of the town site, formed a perimeter wall well suited to defense against human or natural forces. Thus, if an enemy managed to breach the exterior wall, he would find himself not inside the town, but inside a single room with the defenders waiting for him on the roof—a dismal prospect at best.

2-3 Schematic reconstruction of a section of Level VI, Çatal Hüyük, *c.* 6000–5900 B.C. (After J. Mellaart.)

Here and there, the dense building mass at Çatal Hüyük is interrupted by an open court, which served as a garbage dump. Liberal amounts of ashes mixed in with the refuse acted as sterilizers, although probably not as deodorants. The houses, constructed of mud brick strengthened by sturdy timber frames, varied in size but were of a standard plan. Walls and floors were plastered and painted, and platforms along walls served for sleep, work, and eating. A great number of shrines have been found intermingled with standard houses. Varying with the different levels, the average ratio is about one shrine to every four houses. This figure may not hold true for the entire town; only about one-thirtieth of the settlement area has been excavated.

The shrines (FIG. **2-4**) are distinguished from the house structures by the greater richness of their interior decoration, which consisted of wall paintings, plaster reliefs, animal heads, bucrania (bovine skulls), and cult statuettes. Bulls' horns, which adorn most shrines, sometimes in considerable numbers, were set into stylized, remodeled heads of bulls or into benches and pillars and may have been thought to protect the inhabitants and ward off evil. Nothing, however, suggests that the bull, or any other animal, was regarded as a deity. Cult statuettes found at Çatal Hüyük indicate that the people believed their gods to have human form, either male or female. When represented in association with animals (the female deity usually with leopards; the male, with a bull), the animals are always shown as subservient.

The statuettes are of stone or baked clay. Most are quite small (2–8 inches high); only a few reach 12 inches. All the female figures, which predominate, seem to represent a mother goddess, but in a great variety of aspects: young, old, in ritual marriage, in pregnancy, giving birth, and as ruler of wild animals. These figures are described explicitly, and although the bulbous forms of the headless *Seated Goddess* (FIG. **2-5**) may remind us of the *Venus of Willendorf* (FIG.

2-4 Reconstruction of a shrine, Level VI, Çatal Hüyük, c. 5900 B.C. (After J. Mellaart.)

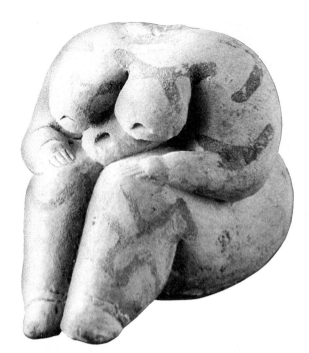

2-5 *Seated Goddess*, Çatal Hüyük, c. 5900 B.C. Fired clay, approx. 2″ high.

1-13), the artist's approach to the subject is quite realistic. Unlike the Paleolithic artist, who tried to represent the abstract concept of fertility, the Neolithic sculptor converts an abstract being (a goddess) into a human figure. The breasts are sensitively modeled, the small hands carefully rendered, and, judging from other examples, it may be safely assumed that the lost head had fairly well described facial features. The figure is painted with crosslike floral patterns that are known also from wall paintings and may endow the goddess with the specific function of an agrarian deity.

Fertility and agricultural symbolism dominate the art of the upper (later) levels of Çatal Hüyük, but hunting also played an important part in the early Neolithic economy; Paleolithic hunting rituals survived far into the Neolithic period. Numerous crude animal figurines, broken and damaged, have been found at Çatal Hüyük. They may have served as animal surrogates during hunting rites and then have been buried in pits. The importance of hunting as a food source (until about 5700 B.C.) is reflected also in wall paintings, in which, in the older shrines, hunting scenes predominate. In style and concept, the *Deer Hunt* (FIG. **2-6**) recalls the rock-shelter paintings of the Spanish Levant, but the figures at Çatal Hüyük are more full-bodied and are rendered with greater realism. The artist used a full range of pigments, primarily derived from minerals, which were applied with a brush to the white background of dry plaster.

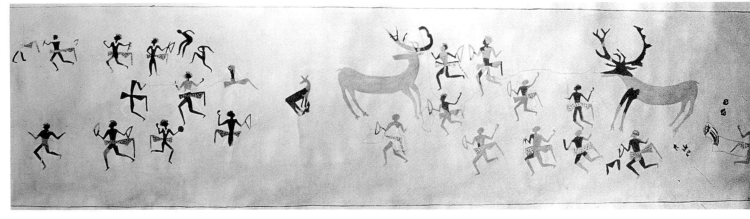

2-6 *Deer Hunt,* detail of a copy of a wall painting from Level III, Çatal Hüyük, *c.* 5750 B.C.

A fragment from the *Deer Hunt* (FIG. **2-7**) shows a dancing hunter, dressed in a white loincloth and a leopard skin, holding a bow in one hand. The speed of his movement is emphasized by the manner in which the leopard skin whirls around his waist. Once the apparently ritual function of these paintings had been fulfilled, they were covered with a layer of white plaster and later replaced with a new painting of a similar or a different subject.

In one of the older shrines at Çatal Hüyük, a painting was uncovered that has been interpreted as a

2-7 *Dancing Hunter,* fragment of a wall painting, a part of which is shown in copy in FIG. 2-6.

pure landscape (FIG. **2-8**). As such, it would be unique for thousands of years into the future. According to carbon-14 dating, the painting was executed soon after 6200 B.C. In the foreground is what may be a town, with rectangular houses neatly laid out side by side, perhaps representing Çatal Hüyük itself. Behind the town, on a smaller scale, as though far away, appears a mountain with two peaks; dots and lines issuing from the higher of the two cones may represent a volcanic eruption. The mountain has been tentatively identified as the 10,600-foot Hasan Dag, which was located within view of Çatal Hüyük and was the only twin-peaked volcano in central Anatolia. Because the painting appears on the walls of a shrine, the conjectured volcanic eruption would have had some religious meaning. Although the artist may have linked the event with the underworld and witnessed it with fearful awe, this dread may have been mingled with gratitude to a bountiful Mother Earth; it is believed that Çatal Hüyük derived much of its wealth from trade in obsidian, a vitreous volcanic stone easily chipped into fine cutting edges and highly valued by Neolithic tool- and weapon-makers.

The rich finds at Çatal Hüyük give the impression of a prosperous and well-ordered society that practiced a great variety of arts and crafts. In addition to painting and sculpture, weaving and pottery were well established, and even the art of smelting copper and lead in small quantities was known before 6000 B.C. The society seems to have been conservative in its long retention of Paleolithic traditions and practices, but it also was progressive in its slow but relentless achievement of a complex, fully food-producing economy. In the arts, this development is perhaps mirrored in a de-emphasis of realism in favor of a more abstract symbolism, in a gradual decline in the production of statuettes representing male deities,

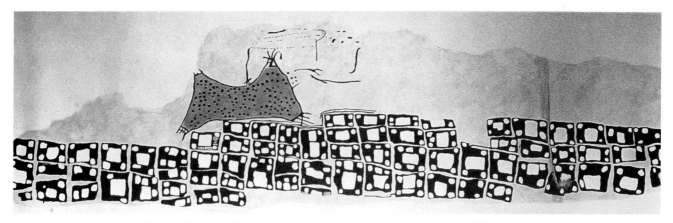

2-8 *Landscape with Volcanic Eruption* (?), detail of a copy of a wall painting from Level VII, Çatal Hüyük, c. 6150 B.C.

and in the disappearance of hunting scenes. At the same time, representations of the mother goddess increased in number, perhaps reflecting a corresponding change in the importance, if not the social position, of women. As agriculture took precedence over hunting, female occupations, like the milling of grain, baking, weaving, and the care and feeding of domestic animals, became ever more important. At Çatal Hüyük, the conversion to a fully agrarian economy appears to have been completed by about 5700 B.C. Less than a century later, the site was abandoned. A probably related culture at Hacilar, two hundred miles to the west, provided an afterglow, but by about 5000 B.C., the limelight shifted eastward to Mesopotamia and Iran, and southward to Syria.

SUMER

Some time in the early fourth millennium B.C., a critical event—the settlement of the great river valleys—took place in Mesopotamia. Writing, art, monumental architecture, and new political forms were introduced in Mesopotamia and Egypt shortly thereafter, but with striking differences in function. As Henri Frankfort describes it:

> The earliest written documents of Mesopotamia . . . facilitated the administration of large economic units, the temple communities. The earliest Egyptian inscriptions were legends on royal monuments or seal engravings identifying the king's officials. The earliest representations in Mesopotamian art are preponderantly religious; in Egyptian art, they celebrate royal achievements and consist of historical subjects. Monumental architecture consists, in Mesopotamia, of temples; in Egypt, of royal tombs. The earliest civilized society of Mesopotamia crystallized, in separate nuclei, a number of distinct, autonomous cities—clear-cut, self-assertive polities—with the surrounding lands to sustain each one. Egyptian society as-

sumed the form of the single, united, but rural domain of an absolute monarch.*

Thus, not one, but *two* civilizations emerged, each with its own special character. From this time forward, world history was to be the record of the birth, development, and disappearance of civilizations and the rise and decline within them of peoples, states, and nations. It is with these two mighty, contrasting civilizations bordering the eastern Mediterranean region that the drama of Western man truly begins. One must not think, however, that these two distinct societies were geographically or culturally isolated from one another. Ancient Palestine (land of the Phoenicians) and Syria connected them on the west. On the east, Mesopotamia adjoined the vast territory of Iran and the north Indian civilization of the Indus River valley, with its important city of Mohenjo-Daro. Thus, a continuous range of more or less contemporaneous city civilizations existed from Egypt to India, linked by trade, cultural diffusion, and conquest, and ringed about by nomadic peoples or sedentary farmer villages in Arabia, North Africa, and northern Eurasia.

In the fertile lower valley of the Tigris and Euphrates, humans may have found the equivalent of the Garden of Eden, which was celebrated in Genesis and was long a part of Mesopotamian tradition. Once the art of irrigation and, to a degree, the control of floods had been learned, human beings saw the possibility of creating a great oasis. The turbulence of its history strongly suggests that this land, with its promise of a hitherto unknown life of abundance, was enormously attractive.

At the dawn of recorded history, southern Mesopotamia was occupied by the Sumerians, a group whose origin is still one of the great puzzles of an-

*Henri Frankfort, *The Art and Architecture of the Ancient Orient* (Baltimore: Penguin, 1971).

cient history. Researchers have suggested that the Sumerians came from the east in the Preliterate period, from the area bordering the Persian Gulf that is now western Iran. Their migration to southern Mesopotamia was preceded by that of a people whose culture is given the name Jamdat Nasr, after its cultural type site in Iraq.

A handsome *minotaur* (man-bull) figure in soldered silver (FIG. **2-9**) is assigned to the Jamdat Nasr period. Seated and making an offering of a vessel, which it holds between the hooves of its extended forelegs, the statuette is an early example of a universal theme in Ancient Near Eastern art: the man-animal monster. We shall see it often, in both miniature and monumental form (consider the Egyptian Sphinx). In the Jamdat Nasr figure, the sculptor shows a grasp of the essential form of the bodies of beast and man, the natural sweep of planes and contours. With an aston-

2-9 *Kneeling Man-Bull,* from Jamdat Nasr, *c.* 3000 B.C. Silver, 6½" high. Metropolitan Museum of Art, New York (Joseph Pulitzer Bequest).

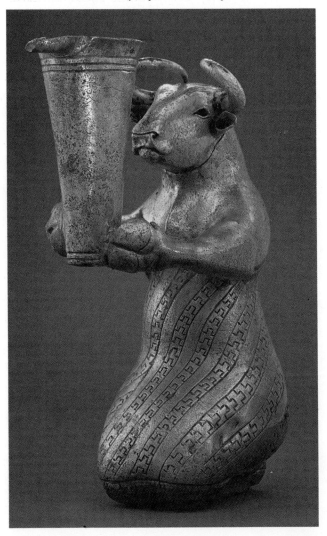

ishing sureness of touch, a gesture is portrayed that is both solemn and graceful. Such mastery could only be the result of a long tradition of observation of natural form and of the craft of metalwork. The religious import of this figure (it is performing a ritual act of some sort) must also express a long tradition of religious art that goes back millennia. Through its long development, this tradition came to align the figures of the great beasts with the figure of man. It is a tradition received and shared by the Sumerians and their successors in Mesopotamia.

The Sumerians were an agricultural people who learned to control floods and built strong-walled towns, such as Warka (the biblical Erech and the ancient Uruk) and Al-Hiba (the ancient Lagash). Sumerian influence extended widely from its base in southern Mesopotamia, eastward to Susa in Iran, northward to Assur, and westward to Syria, where recently discovered archives, consisting of thousands of clay tablets in the Sumerian language, testify to the far-flung network of contacts Sumer made throughout the ancient Near East as it engaged in a kind of cultural colonialism. After several centuries, Semitic nomad shepherds came from the western desert; they adopted agriculture, absorbed much from Sumerian culture, and built their own cities—Kish, Akkad, Mari, and Babylon—farther north. Over the centuries, dominion oscillated between the two peoples, but the Semites produced two of the mightiest kings, Sargon and Hammurabi.

From as early a time as the Paleolithic caves, we have evidence of people's efforts to control their environment by picture magic. With the appearance of the Sumerians and the beginning of recorded history, the older magic was replaced by a religion of gods, benevolent or malevolent, who personified the forces of nature that often contended destructively with human hopes and designs. In the fertile valleys of the Tigris and Euphrates, the fiery heat of summer and the catastrophic floods, droughts, blights, and locusts might easily have persuaded people that powers above and beyond their control must somehow be placated and won over. Formal religion, a kind of system of transactions between gods and human beings, may have begun with the Sumerians; no matter how it has been systematized and diversified since then, religion has retained its original propitiatory devices—prayer, sacrifice, and ritual—as well as a view of humans as imperfect by nature and dependent on and obligated to some higher being. The religion of the Sumerians and of those who followed them centered about nature gods: Anu, god of the sky; En-lil (Bel), a creator and ruler of earth and "lord of the storm"; Ea (or Enki), lord of the waters (a healing, benevolent god); Nannar (Sin), the moon god;

Utu (Shamash), the sun god; and Inanna (associated with the planet Venus), goddess of love and fertility, who, as Ishtar, is later also endowed with the functions of battle goddess.*

Architecture

Religion, which dominated life and invested it with meaning, determined the form of society as well as architectural and artistic expression. The Mesopotamian city-state was under the protection of the god of the city; the king was his representative on earth and the steward of his earthly treasure. The relationship of the king to the gods and to his subjects may be read in the prayer of an early Sumerian king to the god En-lil of the city of Nippur:

> O En-lil, the king of the lands, may Anu to his beloved father speak my prayer; to my life may he add life, and cause the lands to dwell in security; may he give me warriors as many as the grass; the herds of heaven may he watch over; the land with prosperity endow; the good fortune which the gods have given me, may he not change; and may I ever remain the shepherd, who standeth at the head.

The plan of the city reflected the central role of the god in city life, his temple being the city's monumental nucleus. The temple was the focus not only of local religious practice but also served as an administrative and economic center. It was indeed the domain of the god, who was regarded as a great and rich holder of lands and herds as well as the protector of the city. The whole function of the city was to serve the god as a master, as the function of all people in

*Bel and Shamash are Akkadian names; Sin is Babylonian.

general was to serve the gods. The vast temple complex, a kind of city within a city, had multiple functions. A temple staff of priests and scribes carried on city business, looking after the possessions of the god and of the king. It must have been in such a setting that writing developed into an instrument of precision; the very earliest examples have to do with the keeping of accounts and the description of simple transactions, stores, and supplies.

Two types of temples can be distinguished, both dating from the fourth millennium B.C. One type stands at ground level, the other on a raised platform. They have been classified as "low" and "high" temples, and it has been surmised that the latter form eventually evolved into a chapel that stood on top of a stepped pyramid, or *ziggurat*. With rare exceptions, only the bases of early Mesopotamian temples can still be recognized; their mud-brick superstructures usually have eroded. The typical low temple, its corners oriented to the cardinal points, centered around a rectangular or T-shaped inner courtyard that contained an offering table and the statue of a god, housed in a niche. This core was surrounded by rooms that served as storage areas, offices, and lodgings for the priests. The basic components of the high temple were the same, albeit with a somewhat changed interior arrangement.

An early example of a high temple is the White Temple of Warka (FIG. **2-10**), which dates from about 3200 to 3000 B.C. Its preservation is exceptional. Enough of the structure remains to permit a fairly reliable reconstruction (FIG. **2-11**). The temple stands on a platform 40 feet above street level in the center of the city. Like most of the older platforms, this one is composed of the ruins of earlier temples filled in with

2-10 White Temple, Warka (ancient Uruk), 3200–3000 B.C.

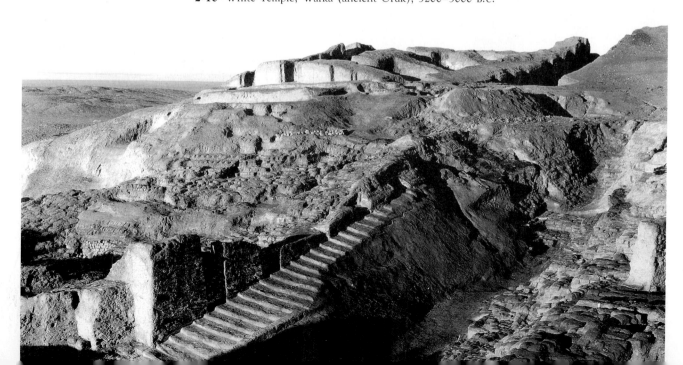

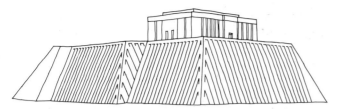

2-11 Reconstruction of the White Temple, Warka. (After E. S. Piggott.)

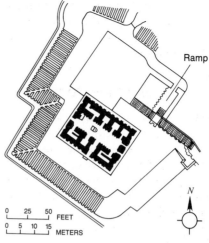

2-12 Plan of the White Temple, Warka. (After Frankfort.)

brickwork, a fact that hints at the possible origin of the custom of raising temples above the level of their surroundings. This feature, of course, is not only pregnant with symbolism but also most practical in a flood-prone river valley; gradually the practical form must have taken on religious meaning and was sanctified.

The platform of the White Temple has sloping sides of paneled brickwork, and the walls of the temple show traces of the whitewash that gave it its name. Unusual, and unlike the layout of the low temples, is the fact that worshipers entered the sanctuary from one of its sides (FIG. **2-12**), despite the presence of imposing gateways at either end, one of which displaced the altar from its axial position. This arrangement has been explained by identifying the high temple as a portal through which the god could pass on his visits to earth. In the low temples, his presence was symbolized by a cult statue.

While its evolution from the platform supporting high temples remains uncertain, the ziggurat is undoubtedly the most characteristic structure found in Mesopotamia. Its function as a stairway by which the gods of the country mounted to heaven every night likewise remains speculative. No shrines have been preserved, although researchers believe that such

structures must have stood on the top of the ziggurats and that they were the setting in which the priests prayed to the "gods of the night" (the planets and constellations), prepared meals for the gods, or sacrificed lambs for an omen. An old Babylonian text (c. 1900–1600 B.C.) reads

> The gods and goddesses of the country—
> Shamash, Sin, Adad, and Ishtar—
> have gone home to heaven to sleep.
> They will not give decisions or verdicts [tonight].

Most of the ruined cities of Sumer—Ur, Warka, Nippur, Larsa, Eridu—are still dominated by their eroded ziggurats. The ziggurat at Ur dates from the period called Neo-Sumerian (2100–2000 B.C.), when builders were attempting to attain the greatest heights possible. The base structure is a solid mass of mud brick 50 feet high (FIG. **2-13**), which is truncated

2-13 Ziggurat (northeastern façade with restored stairs), Ur, c. 2100 B.C.

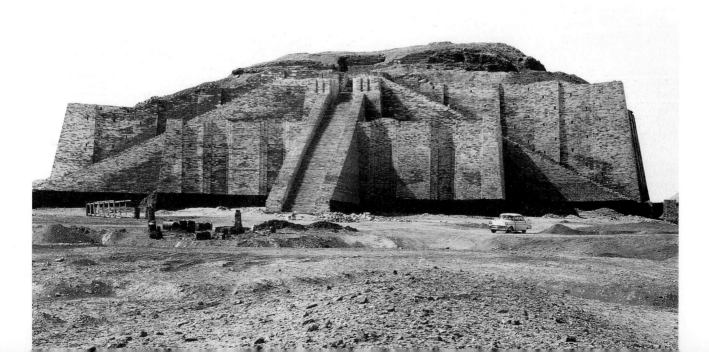

and edge-worn by time, weather, and depredation. In a conjectural reconstruction (FIG. **2-14**), two successively smaller stages are evident. The base and the stage above it were faced with baked brick laid in bitumen. The uppermost stage presumably served as a pedestal for the shrine. Three ramplike stairways of a hundred steps each converge on a tower-flanked gateway from which another flight of steps probably led to the shrine. Only officiating priests were permitted access to the shrine level. The structure's facing has withstood floods and weathering so well that the ziggurat at Ur is the best preserved in southern Mesopotamia. The loftiness of the great ziggurats—especially of the one at Babylon, which was about 270 feet high and intended by its pious builders to reach into Heaven—made a profound impression on the ancient Hebrews, who memorialized the Babylon ziggurat as the Tower of Babel, a monument to the insolent pride of man.

The three great inventions of the Sumerians—a system of gods and god-man relationships, the city-state itself, and the art of writing—provided the basis for a new order of human society. In the city-state, consecrated by the presence of the civic deity, human beings experienced new interrelationships with their god and with each other, and formalized and gave permanence to these interrelationships by recording them in writing. Life became regularized, and the community assumed functions, such as defense against others and the caprices of nature, that formerly had been left to the individual. This integration and the division of labor (specialization), which is encouraged where large numbers of people are concentrated in a coherent community, emancipated the inhabitants from the consuming necessities of daily life, so that they could develop and apply skills and talents unthinkable in fluid and unintegrated societies. The relatively fixed character of the city-state also conferred on the community a permanent identity as a city ruled by a king and a god who were known and present. This sense of identity extended to the individual inhabitant as well, who received a personal identity from membership in the community, discovering self in interrelationships with the city, god, king, and other citizens. The new written language may also have contributed to this growing identification through which individuals came to perceive themselves as names among the names for other things and actions. Thus, from the Sumerian creation of stable life patterns begins that sense of identity—that self-awareness—that will mature and reach its highest development in the civilization of Greece.

Sculpture

In the animal paintings of the caves, human figures almost never appear; humans have not yet entered the area of self-awareness. Although the rock paintings of the Spanish Levant do indeed represent the human figure, they do so only schematically and almost in the form of picture-writing. Thus, we are not prepared for the beautiful female head from Warka (FIG. **2-15**). Its ancestry is unknown. Dating from the so-called Protoliterate period, when writing first appeared, it is not a complete head but a marble face meant to be attached to a wood backing and wigged, perhaps, in gold. The deep recesses for the eyebrows were filled with colored shell or stone, as were the

2-15 *Female Head*, from Warka, c. 3500–3000 B.C. Alabaster, approx. 8″ high. The Iraq Museum, Baghdad.

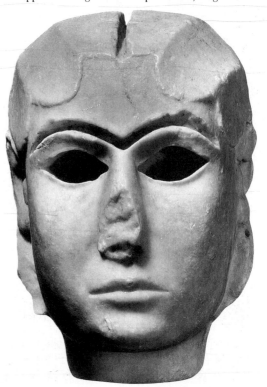

2-14 Reconstruction of the ziggurat at Ur. (Adapted from a drawing at the British Museum, London.)

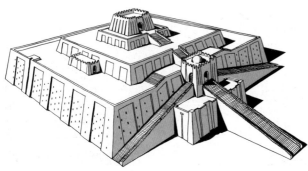

large eyes. The subject is unknown (goddess, priestess, queen?), but our ignorance of her and of the history of the head does not diminish our appreciation of its exquisite refinement of feature and expression, despite the mutilations of time and accident. The soft modeling of the cheeks, the sensitivity of the mouth, and the hesitancy of the expression between sweet and somber not only present us with a person in herself beguiling and mysterious but also suggest a sophistication in the artist beyond our expectation of the time in which the work was produced.

One notices at once in the Warka head the disproportionately large eyes. This trait is characteristic of a whole group of figures from Tell Asmar (FIGS. 2-16 and 2-17). The reason for this convention, which is not only Sumerian but appears throughout ancient art, can only be guessed. Long before Aristotle asserted that people are distinguished from the animals by being rational and that sight is the most "rational"

of all of the senses, humans must have perceived and feared the power of the eye to hold, charm, and hypnotize for ends good or ill. The "evil eye" was feared in the ancient world, as it is feared still. It is a popular belief and a part of folklore that one can learn much about another's intentions and character by "looking him straight in the eye," and the modern affectation of dark glasses (curiously Sumerian when oversized!) may be both a defense and a badge of attractive mystery. To the ancient artist, the eyes, the "windows of the soul," could have had several associations. Large eyes fixed in unflagging gaze see all, and frontal, binocular vision, distinguishing human from mere animal sight, represents the all-seeing vigilance and omniscience of the gods and the guarantee of justice. In the conventionalization of the human image, vision understandably becomes a peculiarly human trait—in its lesser physical sense as well as in its greater intellectual, spiritual, and theistic sense.

2-16 Statuettes from the Abu Temple, Tell Asmar, *c.* 2700–2600 B.C. Marble with shell and black limestone inlay, tallest figure approx. 30″ high. The Iraq Museum, Baghdad, and The Oriental Institute, University of Chicago.

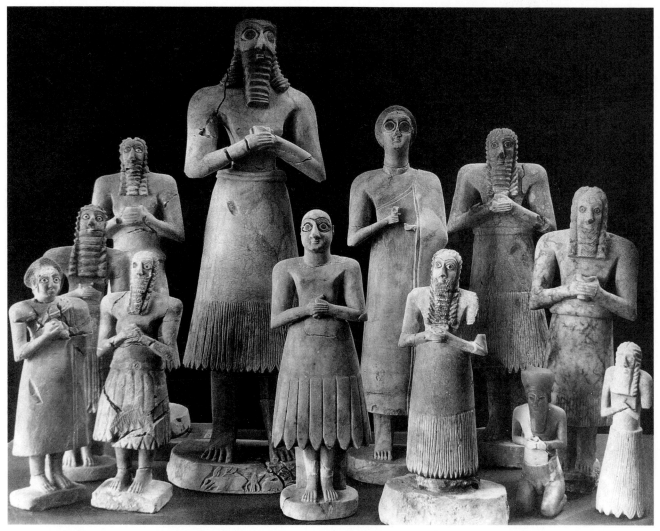

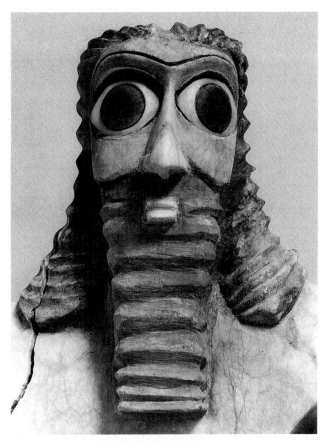

2-17 Head formerly believed to be of the god Abu (detail of FIG. 2-16), Tell Asmar, c. 2700–2600 B.C. Marble with shell and black limestone inlay. The Iraq Museum, Baghdad.

Godlike vision as the foundation of law and justice is evident in the stories of the great lawgivers of the ancient world, including Hammurabi of Babylon, Moses, Lycurgus of Sparta, and Solon of Athens.

Although it may be that none of our speculations entered the mind of the artist of the Tell Asmar figures, some association of vision with supernatural powers seems to be indicated by the fact that the two largest figures, formerly identified as deities, also have the largest eyes in relationship to their heads (FIG. 2-17). The other statuettes represent worshipers (the larger ones, priests; the smaller ones, laymen). With their hands tightly clasped across their chests in the attitude of prayer, their large eyes seem to express reverent awe in the presence of their gods. The purpose of these votive figures was to offer constant prayers to the gods on behalf of their donors; thus, their open-eyed stares may symbolize the eternal wakefulness necessary to fulfill their duty.

CONVENTIONALIZATION

Just as the Sumerians created a new kind of human experience through formal religion and civic life, they found a new way to represent that experience through writing and figurative art. Writing had been invented by simplifying pictures into signs, or wedge-shaped (*cuneiform*) strokes in numerous combinations, pressed by a stylus into wet clay tablets. An analogous simplification in figurative art employed a few telling traits to present the human figure and human action. This process of simplification is variously named schematization, stylization, conventionalization, generalization, or formalization. *Conventional* simplifications of the human figure are universal and are not characteristic only of ancient art. Indeed, all artistic styles are conventional in that, in the societies in which they prevail, they are tacitly accepted as a comprehensible means of representation. The conventions may be broad or narrow, slow to change or under continual revision, as in our times. In any case, such criteria as fidelity to optical "fact" should not be used in evaluating a style. Although the main trends in modern art since the 1800s have been away from optical fact, and today's artists often deliberately disregard photographic "truth," the images they make, such as those seen in comic strips and in commercial art and advertising, are perfectly recognizable to us.

The Sumerians, working out patterns and conventions that regulated the new life that they had in effect devised, also established conventions for the construction of the human image. The large eyes of the Warka and Tell Asmar figures are not the only conventionalized details. In the small figures of a shell-inlaid box, the so-called *Standard of Ur* (FIG. 2-18), several devices of representation simplify the narrative, explain the action, and even convey the impression of motion. The panel shown here depicts a Sumerian military victory—the advance of the foot soldiers, the charge of the chariots. A second panel (not shown) represents the aftermath of the victorious battle, with lines of prisoners and servants bringing in booty and the king relaxing, drinking with his nobles, listening to harp and song. The figures are all carefully arranged in superimposed strips, each strikingly suggestive of a film or comic strip; doubtless, the purpose is the same—to achieve a continuous narrative effect. Each individual figure is carefully spaced, with little overlapping. (Compare this regularized, formal presentation with the casual, haphazard placement of the figures in Paleolithic and Mesolithic art.) Poses are repeated, as in the line of foot soldiers, to suggest large numbers. The horses of the war chariots (with the lines of the legs repeated to suggest the other horses of the team and their alignment in space) change from a walk to a gallop as they attack. The figures are essentially in profile, but it is an almost universal convention in the ancient Near East that the eyes—again, very large—are in front

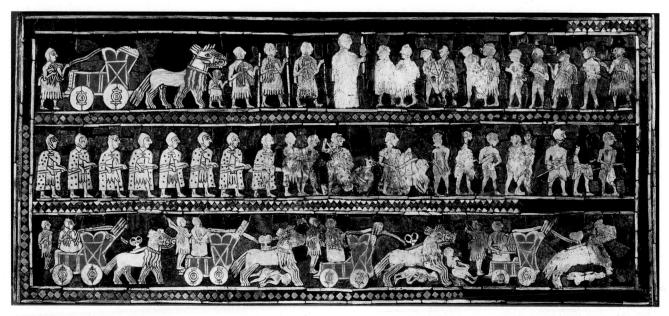

2-18 *Scenes of War*, panel from the *Standard of Ur*, c. 2700 B.C. Panel inlaid with shell, lapis lazuli, and red limestone, approx. 8″ × 19″. British Museum, London.

view, as are the torsos. The artist indicates the parts of the human body that enter into our concept of what the human form looks like and avoids positions, attitudes, or views that would conceal or obscure the characterizing parts. For example, if the figures were in strict profile, an arm and perhaps a leg would be concealed; the body would appear to have only half its breadth; and the eye would not "read" as an eye at all, because it would not have its distinctive flat oval shape and the pupil, so important in the Tell Asmar figures, would not appear.

We could call this approach "conceptual" rather than "optical," because the artist records not the immediate, fleeting aspect of things but rather a concept of the distinguishing and abiding properties of the human body. It is the fundamental forms of things and the artist's knowledge of them, not their accidental appearance, that direct the artist's hand. But this approach is simply a reflection of the general *formalism* that was imposed at the beginning of the historical period in an effort to create an enduring order. This formalism continued to rule human conduct throughout history in thousands of customs, conventions, and ceremonies regarded as sacred and above change. In Greece, many centuries later, Plato conceived the famous philosophy of forms, claiming that the world of pure form, in which the ultimate and unchanging truths of mathematical figures and relationships exist, is the real world, whereas the world we see, the world of mere appearance, is the realm of the unreal, of illusion, of change, and of death.

THE UNION OF THE FORMAL AND THE NATURAL

On the inlaid sound box of a lyre from Ur (FIG. 2-19), figures in the top register represent a Sumerian hero wrestling with two man-headed bulls. In the lower registers, real and fantastic animals prepare a banquet. The topmost register of the panel presents the figures in heraldic symmetry, and, except that the heads are in front view, they exhibit the conventional formalized pose of the *Standard of Ur*. On the other hand, the animal figures in the other registers exhibit a markedly relaxed formalism. The dog wearing a dagger and carrying a laden table, the lion bringing in the wine service, the ass playing the lyre, the jackal playing the zither, the bear steadying the lyre (or perhaps dancing), and the gazelle offering goblets of wine to the scorpion-man are all seen in more or less true profile. Torsos naturally cut off the view of the far arms, and the near legs obstruct the far legs. Shoulders are properly placed, and features are carefully noted and designated. The heroic human figures have the formality we find in the stylized animals on a coat of arms, but the banquet animals are at ease and seem almost to be burlesquing a stately parade of servants and musicians. Long before the human figure appeared in art, naturalistic animal figures were painted in the Paleolithic caves. Then for a long time, as if by rule, humans were represented with rigid formality, but animal figures looked and moved much as they would appear to the eye. The sound-box panel shows a delightful Aesop-like scene (the comedy of which may not have been intended)

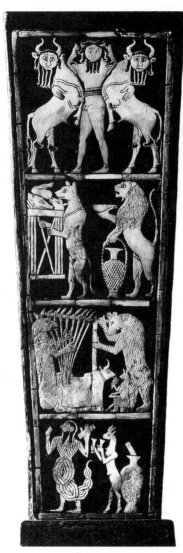

2-19 Sound box of a royal lyre from the tomb of Queen Puabi, Ur, c. 2600 B.C. Wood with inlaid gold, lapis lazuli, and shell, approx. 12″ high. University Museum, Philadelphia.

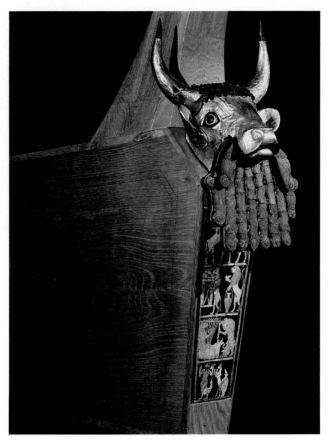

2-20 Bull's head from the lyre sound box shown in FIG. 2-19. Gold leaf and lapis lazuli with inlaid eyes over a wooden core, approx. 18″ high. University Museum, Philadelphia.

in what is probably a representation of ancient myths. Surely it is a very early specimen of the theme in both literature and art in which animals act as people; thus, we pass from the artist of this panel to Aesop's fables, to the medieval bestiaries, and to the zoological creations of Walt Disney.

Archaic artists share with their prehistoric predecessors the genius for rendering with sharp perception the features, almost the personality, of animals. The bull was revered throughout the ancient Near East and the Mediterranean. A splendid bull's head (FIG. **2-20**), finished in gold leaf with beard and details in lapis lazuli, is part of the Ur lyre. (Note where the head is attached to the lyre, as it is shown on the third register from the top in FIG. 2-19.) The bull, an exemplification of fertility and strength, naturally would have been worshiped by early herdsmen, who might

have invoked its power against the natural enemies of cattle—drought and predatory beasts. In this example, the beard may represent some supernatural amplification of the bull's power. The beard and such humanizing features as the man-heads added to the bulls in the top register of the sound-box panel foreshadow the man-headed bulls and lions that appeared much later in Assyria.

The contest between natural and supernatural forces in the Mesopotamian world is expressed as a struggle between animals and monsters. Such a struggle is represented in miniature with exquisite refinement on a cylinder seal only 1½ inches high (FIG. **2-21**), dating perhaps from the Akkadian period. A seal consisted of a cylindrical piece of stone, usually about an inch or so in height, pierced for the attachment of a cord. Made of various colored stones, both hard and soft, such as rock crystal, agate, carnelian and jasper, lapis lazuli, marble, and alabaster, seals were decorated with a design in *intaglio* (incised), so that a raised pattern was left when the seal was rolled over soft clay. With this device, the Sumerians sealed, signed, and identified their letters and documents, which were written on clay tablets. Our illus-

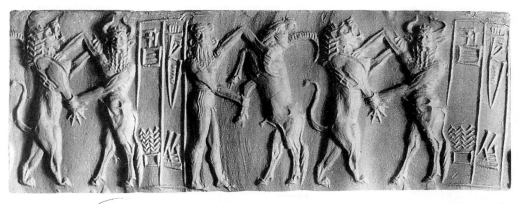

2-21 Cylinder seal (detail) and its impression, from Ur, *c.* 2300 B.C. Stone, approx. 1½" high. The Oriental Institute, University of Chicago.

tration shows both a detail of the seal and the more complete relief design made from it. A hero fights a bull, and a being that is half-man and half-bull fights a lion. The heraldic attitudes and groupings reflect the formal method of representation, but even in the small area of the seal, the skillful artist shows such mastery of animal form that we can almost hear the roaring and bellowing of the struggle.

AKKAD

At about 2300 B.C., the loose group of cities known as Sumer, where the tremendous change from pre-history to civilization had begun, came under the domination of a great ruler, Sargon of Akkad. The Akkadians, although they were Semitic in origin and spoke a language entirely different from that of Sumer, had assimilated Sumerian culture. Under Sargon and his followers, they introduced a new concept of royal power; its basis was unswerving loyalty to the king rather than to the city-state. During the rule of Sargon's grandson, Naram-Sin, governors of cities were called "slaves" of the king, who, in turn, called himself "King of the Four Quarters"—in effect, ruler of the earth.

A magnificent bronze head of a king from Nineveh (FIG. **2-22**), perhaps a portrait of Naram-Sin, embodies this new concept of absolute monarchy. The elaborate coiffure, Sumerian in style, attests to the persistence of the tradition of Sumer and serves as crown to the remarkable face with its expression of majestic serenity. The sensitive mouth, the large eyes, made even larger by the absence of the precious stones once embedded in the sockets, and the emphatic ridgelike brows seem to echo a long tradition that extends back even to the Warka head (FIG. 2-15). This Akkadian bronze shows to particular advantage the union of the formal and the natural that is so com-

mon in Mesopotamian art. The symmetry of the head and the stylized motifs of the curly locks of hair manage to be consistent with the projection of personality—a strong-minded and commanding one, but in a pensive and composed mood, with perhaps just a trace of irony. The age of metals has come, and the piece demonstrates the craftsman's sophisticated skill in casting and in the engraving of details.

Roughly contemporary with the Akkadian portrait is the copper-cast head of a ruler whose name we do not know (FIG. **2-23**); the provenance and date are also uncertain. This head rivals that of the Akkadian king in its masterful blending of formal simplicity and firmness, with carefully observed particularity of detail. The features are those of a specific individual—

2-22 *Head of an Akkadian Ruler,* from Nineveh, *c.* 2200 B.C. Bronze, approx. 12" high. The Iraq Museum, Baghdad.

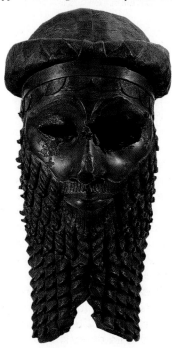

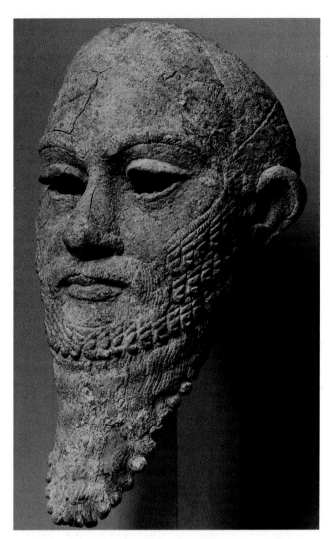

2-23 *Portrait Head of a Ruler*, from ancient Iran (Elam?), c. 2100–2000 B.C. Copper, 13½" high. Metropolitan Museum of Art, New York (Rogers Fund).

large eyes, prominent nose, the compressed lips of a wide mouth, a beard that adds strength to the jaw—the speaking likeness of a grave, thoughtful, and wise man. The sculptor sets the features within spare, firm contours, composing a mask of dignity and authority. A sensitive reading of personality is thus disciplined by a convention that imposes a certain immobility of expression; this treatment is characteristic of the formality of portraiture in the ancient Near East, especially of persons of high rank. We will presently see it in the portraits of Egyptian pharaohs.

The godlike sovereignty claimed by the kings of Akkad is also evident in another masterpiece of Akkadian art, the *Victory Stele of Naram-Sin* (FIG. **2-24**). On the stele, the warlike grandson of Sargon is represented leading his victorious armies up the slopes of a wooded mountain and through the routed enemy, who are crushed underfoot, fall, flee, die, or beg for

mercy. The king stands alone, far taller than his men, treading on the bodies of two of the fallen enemy. He wears the horned helmet that signifies his deification, and two auspicious astral bodies, representing Shamash and Ishtar, shine on his triumph. The artist shows an almost startling originality, not only in his ingenious management of the theme but also in the variety of poses and in the setting. The king's troops, a whole army suggested by eight figures marching in two orderly files, carry spears and flying banners as they encounter the shattered enemy (seven figures), one of whom falls headlong down the mountainside. In comparison with the stele figures, those of the *Standard of Ur* seem rather static and formal. The *Naram-Sin* artist is a daring inventor, and although he adheres to older conventions, especially in portraying the king and his soldiers in simultaneous profile and front view, he nevertheless relies on his own perception to create the first landscape in Near Eastern art since Çatal Hüyük (FIG. 2-8).

2-24 *Victory Stele of Naram-Sin*, from Susa, c. 2300–2200 B.C. Pink sandstone, approx. 6' 6" high. Louvre, Paris.

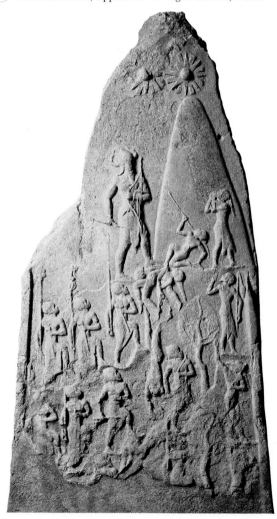

The achievements of Akkad were brought to an end by an incursion of barbarous mountaineers, the Guti, who dominated life in central and lower Mesopotamia for sixty years, until the cities of Sumer, responding to the alien presence, reasserted themselves and established a Neo-Sumerian polity under the kings of Ur. During this age, the most conspicuous contribution came from the city of Lagash, under its ruler, Gudea. There are about twenty statues of Gudea, showing him seated or standing, hands tightly clasped, and sometimes wearing a woolen cap; the statue illustrated here (FIG. **2-25**) is typical. Gudea attributed his good fortune and that of his city to the favor of the gods, and he was a zealous overseer of the performance of rites in their honor. His statues were numerous so that he could take his symbolic place in the temples and there render perpetual service to the benevolent deities. Like the others, the standing Gudea shown here is of dolerite, an extremely hard stone that the sculptor worked with

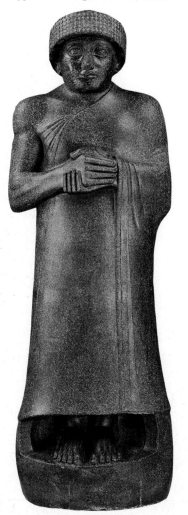

2-25 *Gudea Worshiping,* from Telloh, *c.* 2100 B.C. Dolerite, approx. 42″ high. Louvre, Paris.

consummate skill. The difficulty of working such hard stone was compounded by the fact that stone, almost nonexistent in southern Mesopotamia, was rare and costly, and had to be imported. Blocks and boulders of irregular size and shape were usually not large enough to permit the sculptor to execute the whole length of the standing figure without sacrificing its natural proportions; hence, a certain stumpiness often resulted. The sculptor emphasized the portrait head at the expense of the rest of the body, often preferring the seated to the standing figure. The capped figure of Gudea stands in the formal frontal pose that descends from the age of Tell Asmar; the great eyes and eyebrow ridges are in the Mesopotamian tradition. One shoulder and arm are bare; the drapery pulls about the torso and under the arm and falls almost vertically from the other arm. The overall contour is simple in the extreme, with no irregular or complex relief. The singular unity and compactness of the figure arise from the artist's conception of it as a cylindrical or conical form that resides in the mass of the finely textured stone. The smooth sweep of its contours, the elegance of the profile, and the richness of the polished dolerite all complement each other.

BABYLONIA

Lagash, which had retained its independence during the Guti invasion, became a dependency of Ur during that city's brief resurgence late in the third millennium B.C. For a little over a century, the Third Dynasty of Ur ruled a once-more united realm. Its last king fell before the attacks of foreign invaders, and the following two centuries witnessed the reemergence of the traditional Mesopotamian political pattern in which several independent city-states existed side by side. Until its most powerful king, Hammurabi, was able to reestablish a centralized government that ruled the whole country, Babylon was one of these city-states. Perhaps the most renowned king in Mesopotamian history, Hammurabi was famous for his codification of the confused, conflicting, and often unwritten laws of the Mesopotamian towns. Although not the first to try to bring order out of the chaos, Hammurabi was the first to succeed; echoes of his code are found in the Law of Moses.

The code, beautifully inscribed on a tall, irregularly surfaced black basalt stele, is capped by a relief sculpture of Hammurabi receiving the inspiration for the laws from the flame-shouldered sun god, Shamash (FIG. **2-26**). The god is seated on a mountain, indicated by a scale pattern beneath his feet. He holds the symbols of divine power, ring and staff, in a hand stretched toward Hammurabi, who is represented in

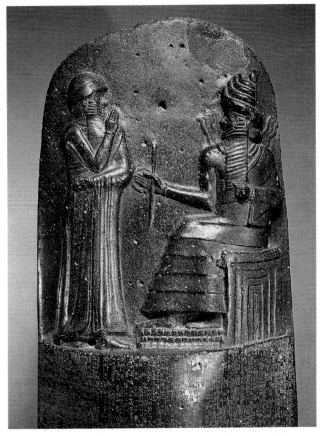

2-26 *Stele of Hammurabi* (upper part), from Susa, *c.* 1780 B.C. Basalt, entire stele approx. 7′ 4″ high. Louvre, Paris.

a gesture of reverent attention, his hand raised in prayer. The Mesopotamian artist's instinct for cylindrical volume is again evident. Shamash is represented in the familiar convention of combined front and side views, which gives his figure great breadth; Hammurabi, his servant, is shown in a position closer to profile, so that he occupies far less space. This confrontation between god and man expresses the increasing humanization of natural and supernatural forces, as man, increasingly self-aware, began (in Babylon) to attribute human form to the gods.

Hammurabi's Babylonian empire was brought down by the Hittites, who, after sacking Babylon around 1595 B.C., retired to Anatolia, the seat of Hittite power. Babylonia was left in the hands of marauding mountaineers, the Kassites. The Hittites, who spoke an Indo-European tongue, developed an art of great power and originality. Their strongly fortified capital, near the modern Turkish village of Boghazköy, was fronted with massive stone gates set between towers (FIG. 2-27). Projecting from the Cyclopean stones, a building material very different from the brick of Mesopotamian architecture, are rugged figures of lions, blunt and brutal in aspect. Whatever the source for this concept of guardian beasts, be it Mesopotamia, Syria, or Egypt, the Hittite realization of it is original, the figures being strongly bound to and dominated by the architecture, rather than freestanding and in the round.

2-27 Lion Gate, Boghazköy, Anatolia (Turkey), *c.* 1400 B.C. Lions approx. 7′ high.

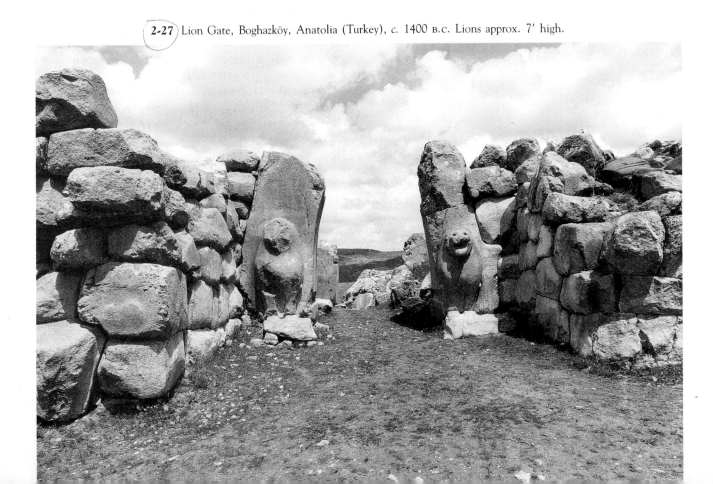

ASSYRIA

While Sumer, Akkad, and Babylon flourished in southern Mesopotamia, what was happening in the northern sector of the great river valleys? For a long time, archeologists thought of it as a kind of empty region—a staging area for nomadic migrations southward or an unstable territory without significant settlement. In the last few years, however, archeological exploration has uncovered evidence for the existence of powerful northern communities that rival the centers of southern Mesopotamia (until now the focus of archeological investigation) in historic importance and influence. We now know that many centuries before the later Assyrian empire extended its sway over all of the ancient Near East, a king named Shamshi Adad, a contemporary of Hammurabi, dominated the north and built his palaces at a site in northeastern Syria near the later Assur, which gives Assyria its name. Shamshi Adad called his city Shubat Enlil (Shagar Bazar) and built it on the ruins of a great city more ancient than his own by two millennia. The immense walls of that city, which measure 50 feet high and about 60 feet thick, have been uncovered beneath the two palaces of Shamshi Adad. The walls form a two-mile perimeter around what must have been the capital of a northern empire as powerful and perhaps older than Sumer. Its origins are still a mystery; its language was neither Semitic nor Sumerian, and it has been suggested that its people may have been Indo-Aryans from the east. Below this level are still earlier remains of human habitation that date to the sixth millennium B.C.

The later Assyrians, familiar to us from the Old Testament and from their inscriptions and monuments, were frustrated in their impulse to power by the kingdoms of the south—Sumer, Akkad, and Babylon—and, on the northwest, by the Mitanni, to whom they were subject for a while. Their opportunity came when their Mitannian overlords were broken by the Hittites and when the weak Kassite kingdom that had succeeded the Babylonian dynasty proved incapable of effective resistance. By about 900 B.C., Assyrian destiny was already becoming an actuality, and for the next three centuries, Assyria was the dominant power in the Near East. Assyrian kings became military commanders, and Assyria itself, with its center successively at Nimrud (ancient Calah), Khorsabad (ancient Dur Sharrukin), and Nineveh, became a garrison state with an imperial structure that extended from the Tigris to the Nile and from the Persian Gulf to Asia Minor. Centuries of unremitting warfare against their neighbors and often rebellious subjects hardened the Assyrians into a cruel and merciless people whose atrocities in warfare were bitterly decried throughout the ancient world. Although they held the restless Babylonian south in thrall, the Assyrians respected the religion and the culture of Sumer-Babylon and were, in fact, dependent on its advanced civilization.

Architecture

The unfinished royal citadel of Sargon II of Assyria, built at Khorsabad reveals in its ambitious layout (FIG. **2-28**) the confidence of the "great kings" in their all-conquering might. The palace covered some 25 acres and had over two hundred courtyards and rooms. The city itself, above which the citadel-palace stood on a mound 50 feet high, measures about a square mile in area. The palace may have been elevated solely to raise it above flood level, but its elevation also served to put the king's residence above those of his subjects and midway between his subjects and the gods. Although the builders probably aimed at symmetry, the plan is rambling, embracing an aggregation of rectangular rooms and halls grouped around square and rectangular courts (FIG. 2-29). The shape of the long, narrow rooms and the massiveness of the side walls suggest that the rooms were covered by brick *barrel vaults* (see FIG. 6-53), the most practical roofing method in a region that lacks both timber and good building stone. Behind the main courtyard, each side of which measures 300 feet in length, were the residential quarters of the king, who received foreign emissaries in the long, high, brilliantly painted throne room. All visitors entered from another large courtyard, passing through the central entrance between huge guardian demons, over 13 feet tall. The walls of the court were lined with giant figures of the king and his courtiers.

Sargon II regarded his city and palace as an expression of his grandeur, which he viewed as founded on

2-28 Reconstruction drawing of the citadel of Sargon II, Khorsabad, *c.* 720 B.C. (After Charles Altman.)

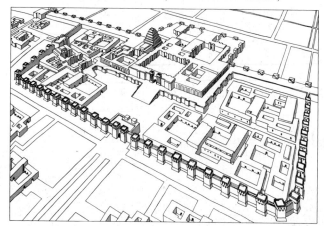

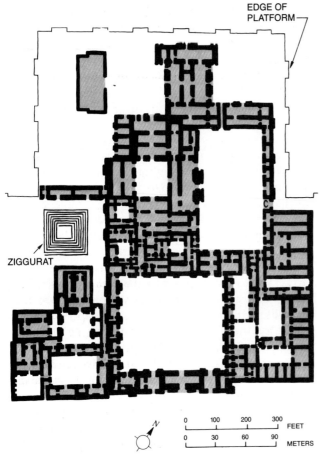

EDGE OF
PLATFORM

ZIGGURAT

```
        0    100   200   300
                              FEET
        0    30    60    90
                              METERS
```

2-29 Plan of the inner precincts of the citadel of Sargon II, Khorsabad.

royal Assyrian plan to overwhelm the visitor. The doorway was guarded by colossal winged bulls called *lamassu* (FIG. 2-30). These man-headed bulls, derived from age-old composite creatures of Mesopotamian art, served to ward off enemies, visible and invisible, and to guard the kings whose features their faces probably reflect. Carved partly in the round and partly in high relief, these figures combine the front view at rest with the side view in motion, contriving this combination by the addition of a fifth leg. The gigantic size, the bold, vigorous carving, the fine sweep of the wings, and the patterning of the surface by the conventional treatment of details together produce a splendor and strength that are awesome even today. We may think of the lamassu in all their majesty not so much as guardians of the king but as augmentations of his regality. They wear the horned crowns of the god-kings of Akkad and the large-eyed, bearded masks familiar ever since Sumer. The bull and lion bodies and eagle wings of the Khorsabad gate figures suggest the superhuman strength and fierceness of the king and his swiftness to bring justice or vengeance. The virtues of Assyrian kingship are written large in these hybrid beasts. Ancient art repeatedly testifies to people's persisting fear and

2-30 *Winged Human-Headed Bull (lamassu),* from Khorsabad, c. 720 B.C. Limestone, approx. 13' 10" high. Louvre, Paris.

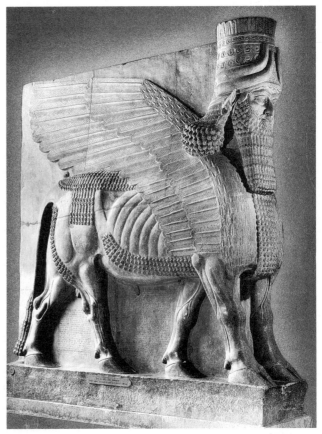

the submission and enslavement of his enemies. He writes in an inscription: "I built a city with [the labors of] the peoples subdued by my hand, whom Assur, Nabu, and Marduk had caused to lay themselves at my feet and bear my yoke at the foot of Mount Musri, above Nineveh." And in another text, he proclaims: "Sargon, King of the World, has built a city. Dur Sharrukin he has named it. A peerless palace he has built within it."

In addition to the complex of courtyards, throne room, state chambers, harem, service quarters, and guard rooms that made up the palace, the royal citadel included the essential temple and ziggurat. The ziggurat at Khorsabad may have had as many as seven stages, of which four have been preserved, each 18 feet high and each painted a different color. The ascent was made by a continuous ramp that spiraled around the building from its base to its summit.

The palace façade consisted of a massive crenelated wall broken by huge rectangular towers flanking an arched doorway. Around the arch and on the towers were friezes of brilliantly colored glazed tiles. Dazzling brilliance also seems to have been part of the

admiration of the great beasts that serve as their metaphors for the powers of nature and for the gods themselves.

Relief Sculpture

Although the kings of Assyria had their power depicted in nonhuman forms, they considered themselves very much a part of the world and expected their greatness to be recorded in unmistakably exact and concrete terms. In conformity with his position between his subjects and his gods, every action of the king had importance. His conquests in battle had the significance of auspicious events, and the same appears to have been true of his successes in hunting. These two royal activities were recorded in the throne rooms of the earlier palaces; later, they also were carved on the walls of what may have been less official rooms. The style of the reliefs, different in the reign of each king who left them, reflects the Assyrian desire for factual reporting, which also is found in the accounts of the campaigns given in bands of inscriptions that accompany the reliefs.

The history of Assyrian art is mainly the history of relief carving; very little sculpture in the round survives. Even the great winged beasts are thought of as relief sculpture and are locked into their stone slabs, presenting three relief surfaces. To narrate the royal feats pictorially, Assyrian carvers used flat, continuous surfaces on which numerous campaigns, sieges, conquests, slaughters, hunts, and scenes of ritual significance could be repeated. For the narrative scenes, the artists devised a vocabulary of forms that, although conventional, was sharply descriptive. At

first, continuity was broken by the edges of the fitted block; in their most developed stage, the reliefs extended over the entire wall or walls of a room or corridor.

The astonishing multiplicity of a relief of Ashurnasirpal II at war (FIG. **2-31**) compels careful study of the composition in order to discriminate its details. The king stands in his chariot drawing his bow. He is accompanied by officers, and, in the sky above him, the winged god of Assyria, Ashur, leads him on. The king's team, the reins tight, is passing an enemy chariot that is already breaking up; its driver has been thrown down and one horse has fallen. Assyrian foot soldiers cut the throats of the wounded enemies. At the upper center, an Assyrian soldier slays a foe while another enemy warrior tries to save his comrade. Behind them a soldier is lying dead; in the upper right, enemy bowmen desperately defend the towers of their city. The ease with which we read these incidents is quite remarkable, especially since they are not depicted in perspective or in logical sequence. The artist uses the space of the limestone block as a field to be divided as narrative convenience and a sense of both the factual and the dramatic dictate. The liveliness of individual poses and movements is exceptionally fine and convincing, and despite the formality that exists in Mesopotamian art side by side with naturalistic details, sophisticated spatial devices appear throughout. One is the overlapping of figures to suggest greater or lesser distance from the observer; the king overlapping his officers is a good example.

The formality of Assyrian art at its most rigid can be seen in another relief of Ashurnasirpal II (FIG. **2-32**),

2-31 *Ashurnasirpal II at War*, from Nimrud, c. 875 B.C. Limestone, approx. 39" high. British Museum, London.

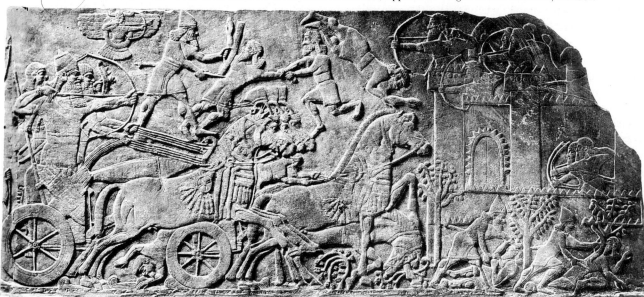

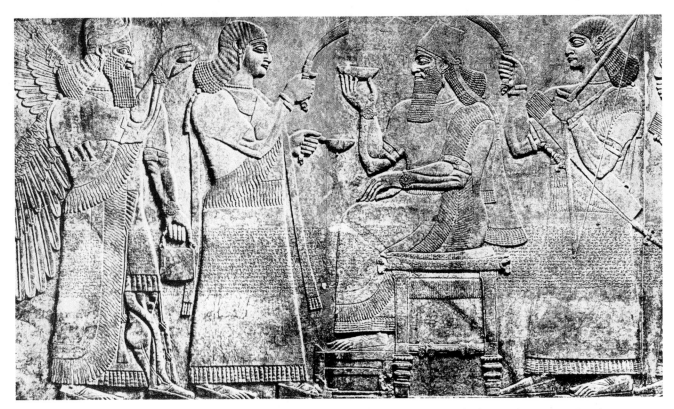

2-32 *Ashurnasirpal II Drinking,* from Nimrud, *c.* 875 B.C. Limestone, approx. 7' 8" high. British Museum, London.

in which the king, seated right of center, solemnly raises a ceremonial cup, while the presence of an august personage at the far left, a winged genius who sprinkles holy water, makes it clear that the king's act is part of a sacred ritual. The slow gestures and stately mien are what we would expect of some grave liturgy; we recognize these characteristics in religious services today. The cuneiform inscriptions on the flat, thin slabs of relief continue across the shallow recesses between the slabs, accentuating the neutrality of the planes and suggesting that the carving is meant to be not so much a three-dimensional form as a report of an event in pictures and in writing. An interesting Assyrian convention nevertheless makes itself felt: the human body is represented as thickset and weighty and the limbs are portrayed bulging with muscle. This second characteristic is especially evident in the advanced left leg of the genius and the arms of the king. The calf and forearm muscles are exaggerated, and the veins are like cables—an example of realistic observation converted to a kind of symbol of brute human strength. Also noteworthy is the way in which the profile view of the arms comprises, with the front-view torso, a kind of three-quarter view. The artist, although subject to the conventions of the time, is experimenting here with the problems of representing what the eyes see.

Two centuries later, in a relief from Nineveh showing Ashurbanipal hunting lions (FIG. **2-33**), the conventions of the time of Ashurnasirpal II persist, although more realistic elements are introduced. In this relief, lions released from cages in a large, enclosed arena charge the king, who, in his chariot and with his servants protecting his blind sides, shoots down the enraged animals. The king, menaced by the savage spring of a lion at his back, is saved by the quick action of two of his spearmen. Behind his chariot lies a pathetic trail of dead and dying animals, pierced by what would appear to be far more arrows than are needed to kill them. A wounded lioness (FIG. **2-34**) drags her hindquarters, paralyzed by arrows that pierce her spine. Blood streams from her wounds, a detail that recurs often in Assyrian art and reveals the savage character of its patrons. The artist gives a ruthless reading of the straining muscles, the swelling veins, the corrugations of the muzzle, and the flattened ears—hard realism under the control of the formality of a silhouette in low relief. Modern sympathies make this scene of carnage a kind of heroic tragedy, with the lions as protagonists, but it is unlikely that the artists of the king had any intention other than to aggrandize his image by piling up his kills, by showing the king of men pitting himself against the king of beasts and conquering him.

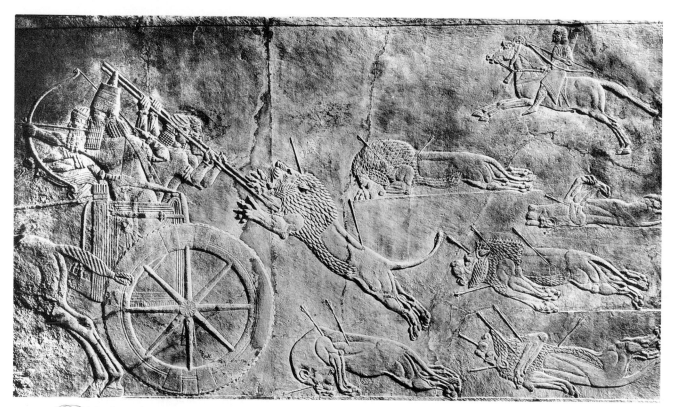

2-33 *Ashurbanipal Hunting Lions,* from Nineveh, *c.* 650 B.C. Alabaster, approx. 60" high. British Museum, London.

2-34 *Dying Lioness,* from Nineveh, *c.* 650 B.C. Limestone, figure approx. 15¾" high. British Museum, London.

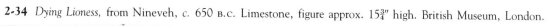

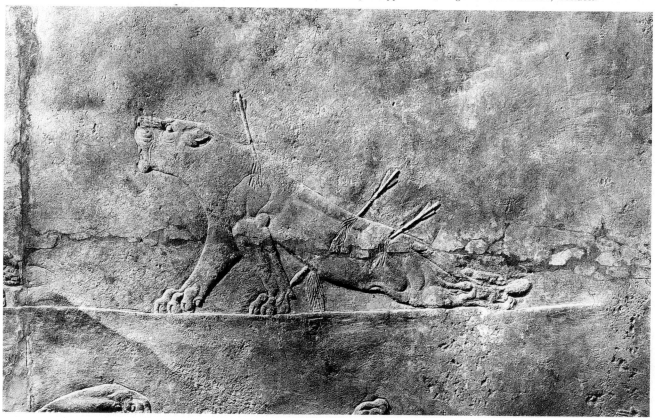

NEO-BABYLONIA

The Assyrian empire was never very secure, and most of its kings had to fight revolts in large sections of the Near East. Opposition to Assyrian rule increased steadily throughout the seventh century B.C., and during the last years of Ashurbanipal's reign, the empire began to disintegrate. Under his son and successor, it collapsed before the simultaneous onslaught of the Medes from the east and the resurgent Babylonians from the south. Babylon rose once again, and in a brief renewal (612–538 B.C.), the old southern Mesopotamian culture flourished. King Nebuchadnezzar, whose exploits we read of in the Book of Daniel, made Babylon a fabulous city once again and its famous "hanging gardens" one of the seven wonders of the ancient world. Only a little of the great ziggurat of Babylon's temple to Bel (the Hebrews' Tower of Babel) remains, but Herodotus, the ancient Greek traveler and "father of history," has left us the following description in a brief account of his visit to the temple complex during the fifth century B.C.:

> In the one [division of the city] stood the palace of the kings, surrounded by a wall of great strength and size; in the other was the sacred precinct of Zeus-Bel, an enclosure a quarter of a mile square, with gates of solid brass, which was also remaining in my time. In the middle of the precinct, there was a tower of solid masonry, a furlong in length and breadth, on which was raised a second tower, and on that a third, and so on up to eight. The ascent to the top is on the outside, by a path which winds round all the towers. When one is about halfway up, one finds a resting place and seats, where persons are wont to sit some time on their way to the summit. On the top-most tower, there is a spacious temple, and inside the temple, stands a couch of unusual size, richly adorned, with a golden table by its side . . . They also declare that the god comes down in person into this chamber, and sleeps on the couch, but I do not believe it.

A grand approach to the temple complex led down a walled processional way lined with sixty stately figures of lions molded in relief on brightly colored glazed bricks (FIG. 2-35). These remarkable beasts, sacred to the goddess Ishtar, are glazed in yellow-brown and red against a ground of turquoise or dark blue. The Babylonian glazes are opaque and hard; possibly, each brick was molded and enameled separately. It may be that, as a result of this technique, these animals, whose vigor is suggested by snarling muzzles, long, nervous tails, and carefully depicted muscles, are more stylized than those of the Assyrian hunting reliefs.

The processional way passed through the monumental, brilliantly glazed Ishtar Gate (FIG. 2-36), the design of which, with its flanking crenelated towers, conforms to the type of gate found in earlier Babylonian and Assyrian architecture. Glazed tiles had been used much earlier, but the surface of the bricks, even of those on which figures appeared, was flat. On the surfaces of the Ishtar Gate, laboriously reassembled, are superposed tiers of the alternating profile figures of the dragon of Marduk and the bull of Adad. This gate is characteristic Mesopotamian formality at its best. The figures compose a stately heraldry proclaiming the gods of the temples toward which the Sacred Way leads. The lessons of architectural sculp-

2-35 *Lion from the Processional Way,* Ishtar Gate, from Babylon, *c.* 575 B.C. Glazed brick, approx. 38¼″ high. Metropolitan Museum of Art, New York (Fletcher Fund).

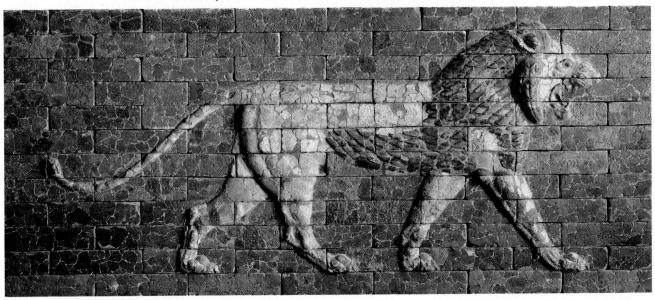

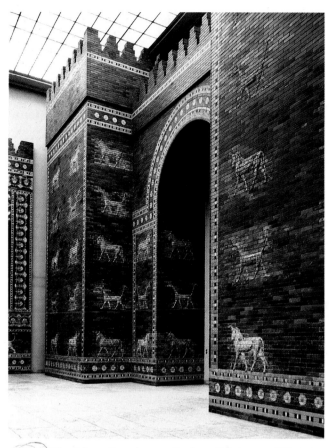

2-36 The Ishtar Gate (restored), from Babylon, *c.* 575 B.C. Glazed brick. Pergamon Museum, East Berlin.

ture from Boghazköy and Khorsabad have been well learned, and the perfect adjustment of figure to wall found in the Ishtar animals rarely has been surpassed; certainly, in the history of architecture, few more colorful and durable surface ornaments are known.

ANCIENT IRAN: ELAM AND ACHAEMENID PERSIA

The later Persian Empire that came into conflict with the Greeks was preceded at a considerable distance in time by a civilization contemporary with the civilizations of Akkad and Old Babylon and regularly in cultural and political transaction with them. Situated in western Iran, this civilization was known by the biblical name Elam.* The empire of Elam corresponded roughly to the Iranian province of Khuzistan. Although most often dominated by Mesopotamia, Elam was strong enough on one occasion to

*Some critics have suggested that the fine portrait head of a ruler seen earlier in this chapter (FIG. 2-23) may have originated in Elam at the time when Sumer was at its peak of influence.

plunder Babylon and to carry off the stele of Naram-Sin and the stele of Hammurabi (FIGS. 2-24 and 2-26). The empire of Elam was destroyed by the Assyrian king, Ashurbanipal, who, in 641 B.C., sacked its capital, Susa (a city that would rise again to great importance under the Achaemenid Persian Empire).

During a relatively brief flowering of Elamite culture in about 1300 B.C., a sculptor cast a freestanding bronze portrait statue of Niparasu, a queen of Elam (FIG. 2-37). Although sadly mutilated, enough remains of the work to show how obedient the sculptor was to the conventions of Mesopotamian art: the tight silhouette, strict frontality, firmly clasped hands held close to the body—characteristics we have seen in the Tell Asmar and Gudea figures. Yet within these rigid conventions of form and pose, the artist manages to create refinements that could only be the result of close observation: the feminine softness of arm and bust, the grace and elegance of the long-fingered hands, the supple and quiet bend of the wrist, the ring and bracelets, the brocaded gown and the wave pattern of its hem. The figure presents the ideal in queenly deportment, with just a touch of demureness to mitigate the severity of the conventional pose. As

2-37 *Statue of Queen Niparasu*, from Susa, Elam (ancient Iran), *c.* 1300 B.C. Bronze, solid cast, 56″ high. Louvre, Paris.

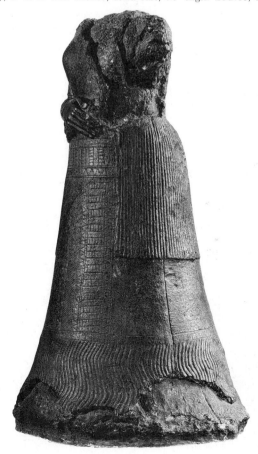

we have seen in Assyrian sculpture, it is possible to wed convention with observed details, as the Elamite artist does so successfully here.

The Assyrians succumbed to the Babylonians, who were to fall, in their turn, once and for all. The later Babylonian King Nebuchadnezzar, Daniel's "King of Kings," boasted: "I caused a mighty wall to circumscribe Babylon . . . so that the enemy who would do evil would not threaten . . . [and] of the city of Babylon [I] made a fortress." Nevertheless, the handwriting on the wall appeared, and the city was taken in the sixth century by Cyrus of Persia (559–529 B.C.), founder of the Achaemenid dynasty, who traced his ancestry back to a mythical King Achaemenes and who may have been descended from an Elamite line. The impetus of the Persians' expansion carried them far beyond Babylon. Egypt fell to them in 525 B.C. By 480 B.C., the Persian Empire extended from the Indus to the Danube, and only the successful resistance of the Greeks in the fifth century prevented it from embracing southeastern Europe as well. The Achaemenid line came to an end with the death of Darius III in 330 B.C., after his defeat in the Battle of Issus and the fall of his empire to Alexander the Great.

Architecture

The most important source of our knowledge of Persian building is the palace at Persepolis (FIG. **2-38**), built between 520 and 460 B.C. by Darius I and Xerxes I, successors of Cyrus. Situated on the high plateau, the heavily fortified palace stood on a wide platform overlooking the plain. Although destroyed by Alexander the Great in a gesture symbolizing the destruction of Persian imperial power, the still impressive ruins of the palace complex permit a fairly complete reconstruction of its original appearance, ambitious scale, and spatial intricacy.

Unlike the Assyrian palace, with its tightly enclosed courts (FIG. 2-29), the Persepolis buildings, although axially aligned, were loosely grouped and separated from each other by streets and irregular open spaces (FIG. 2-39). The dominant structure was a vast columned hall, 60 feet high and over 200 feet square. Standing on its own rock-cut podium, which is about 10 feet high, this huge royal audience hall (*apadana*) has been called "one of the noblest structures of the ancient world." It contained thirty-six columns (each 40 feet high) with fluted shafts and

2-38 Royal audience hall and stairway, Palace of Darius in the background, Persepolis, Persia, *c.* 500 B.C.

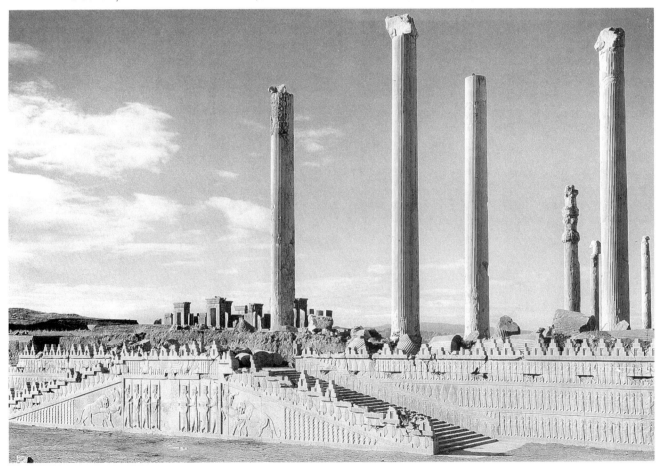

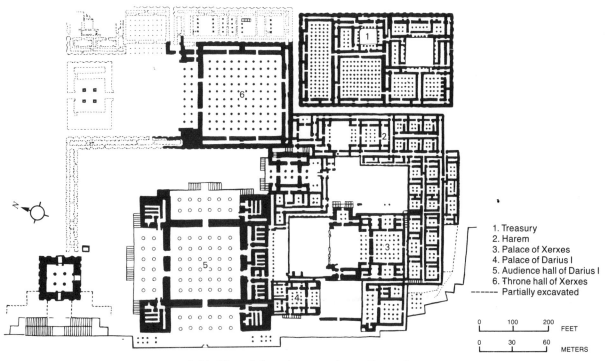

1. Treasury
2. Harem
3. Palace of Xerxes
4. Palace of Darius I
5. Audience hall of Darius I
6. Throne hall of Xerxes
------ Partially excavated

2-39 Plan of the palace complex at Persepolis.

capitals composed of the foreparts of bulls or lions, arranged to provide a firm cradle for the roof timbers. A well-preserved example from the somewhat later palace of Artaxerxes II at Susa is shown in FIG. **2-40**. These unique capitals are an impressive and decorative Persian invention with no known antecedents or descendants. The genesis of the square, many-columned hall so characteristic of the Persepolis palace is also unknown. It has been suggested that it may have been derived from Median architecture, which has remained a blank page in archeologists' books. The Medes were the northern allies and later subjects of the Persians and are believed to have been the intermediaries through whom Persian art received a variety of Iranian stylistic elements that became permanent constituents of it.

Stone, easily available at the site, was used liberally at Persepolis for platforms, gateways, stairs, and columns; brick was used for the walls, however, while the smaller columns and the roofs were made of wood. The ruins of the palace at Persepolis (FIG. **2-41**) show that stone also was used for door and window frames. The forms are derived from Egyptian architecture, which had impressed Darius, but here the frames are not composed structurally of posts, lintels, and sills but are cut in an arbitrary manner and used as sculptural ornaments. In fact, the entire complex of buildings, and particularly the apadana, seems to have been designed primarily for visual effect; it is a gigantic stage setting for magnificent ceremonials celebrating not only traditional festivals but also the

2-40 Bull capital from the royal audience hall of the palace of Artaxerxes II, from Susa, Persia, c. 375 B.C. Gray marble, 7′ 7″ high, 12′ 3″ wide. Louvre, Paris.

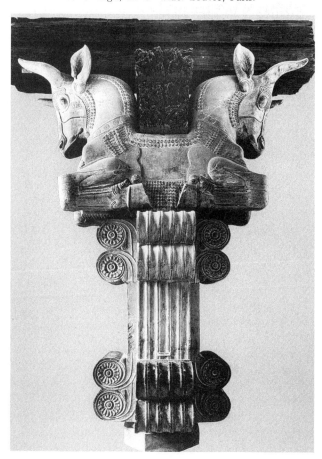

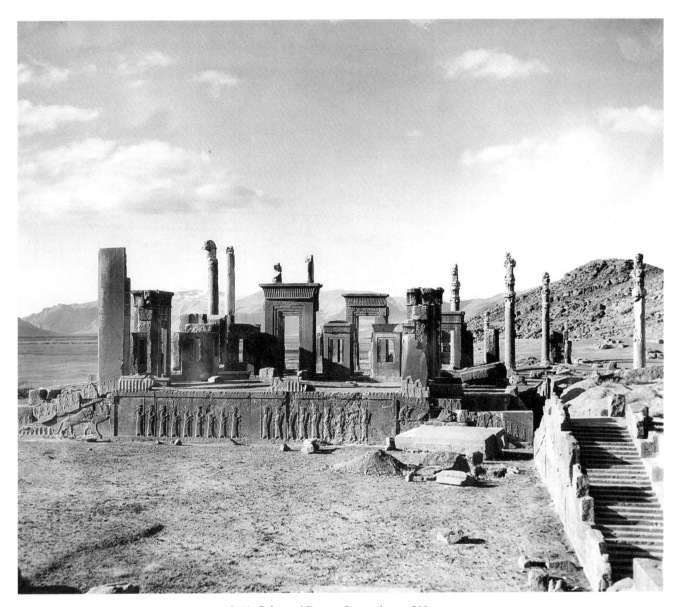

2-41 Palace of Darius, Persepolis, *c.* 500 B.C.

greatness of the Persian Empire, the power of its king, and the weight of his authority on his numerous tributaries.

Sculpture

The approach to the apadana leads through a monumental gateway flanked by colossal man-headed bulls and then turns at right angles toward the elevated great hall. Broad, ceremonial stairways provide access to the royal audience hall. The walls of the terrace and staircases are decorated with reliefs representing processions of royal guards, Persian and Median nobles and dignitaries, and representatives from the subjected nations bringing tribute and gifts

to the king (FIG. **2-42**). These reliefs are thought to represent, in a shorthand version, the actual ceremonies that took place at Persepolis during the great New Year festivals. Traces of color found on similar monuments at other Persian sites suggest that these reliefs were colored, at least in part. Their original effect must have been even greater than it is today, as the rows of figures sparkled in a blaze of colors rivaling that presented by the court during the festivals. On the other hand, the present denuded state of the reliefs makes it easier for us to appreciate their highly refined sculptural style. The cutting of the stone, both in the subtly modeled surfaces and the crisply chiseled details, is technically superb. Although they may have been inspired by Assyrian reliefs (FIGS. 2-31,

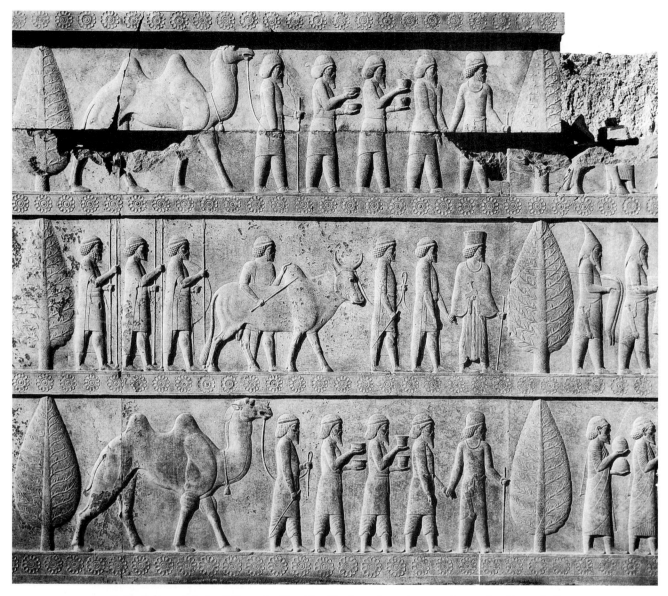

2-42 *Subjects Bringing Gifts to the King* (detail), from the stairway to the royal audience hall, Persepolis, Persia, *c.* 500 B.C. Limestone.

2-32, and 2-33), these Persian reliefs are strikingly different in style. The forms are more rounded, and they project more from the background; such details as straining sinews and bulging muscles are emphasized less; and, most important perhaps, the figures seem organically more unified, as the torsos are now shown in natural side view and are thus more convincingly related to heads and legs. The supposition that most of these modifications of traditional formal elements are the result of Greek (Ionian) influence becomes almost a certainty when we note how the garments worn by the figures have been stylized in accordance with Greek Archaic practice (see FIGS. 5-14, 5-18, 5-28). Despite the modifications, the Persepolis reliefs represent a triumph of Near Eastern

formality in art. Their purpose and function—to glorify the king in a manner both decorative and monumental—is fulfilled most successfully.

Craft Art

Love for well-ordered forms enabled Persian designers to create, on a vast scale, a rich and unified setting for official ceremonials. But the Persians also could work successfully on a much smaller scale. They were excellent goldsmiths and silversmiths; a jar handle in the form of a winged ibex (FIG. **2-43**) typifies their exquisite and enduring art. The ibex, of silver inlaid with gold, rears up on a palmette growing from the head of a satyr. The leaping, lithe body

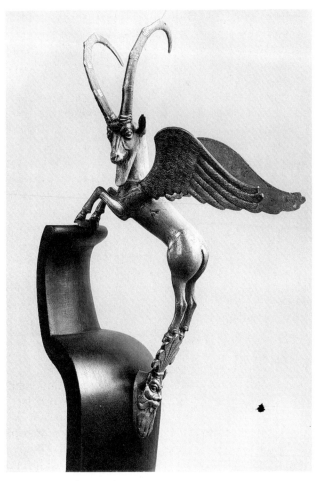

2-43 Jar handle in the form of a winged ibex, from Persia, 400–300 B.C. Silver inlaid with gold, approx. 10½″ high, Louvre, Paris.

rises into the higher curve of the horns, and the suave curves of the wings smooth the motion. All that is needed of truth to nature is here, and none of it intrudes on the effortless play of fancy.

As with most elements of Persian art, it is not difficult to trace the genesis of this winged ibex. Although the animal's body has regained its organic unity, probably through Mesopotamian influence, its original source of inspiration is to be found among the Luristan bronzes. Luristan, a mountainous region to the east of the Mesopotamian river valleys, inhabited at different times by Kassites, Medes, and other seminomadic tribes, was the home of a flourishing bronze industry that reached its peak during the eighth and seventh centuries B.C. Luristan craftsmen produced a variety of portable objects, such as cups, bowls, weapons, bridles, and articles of personal adornment that, collectively, are referred to as "nomad's gear." Although we do not know by and for whom these objects were made, they form a homogeneous group that is rooted in an old and widespread tradition

whose exponents delighted in working with animal forms. This so-called animal style may have originated in the Luristan region; at any rate, it spread over much of the ancient world, from the Asiatic steppes to central and western Europe. The Luristan bronzes are characterized by a high degree of abstraction that converts the representations of animals into purely decorative devices. In the handle of the ceremonial cauldron illustrated in FIG. 2-44, the two rearing ibexes make interlocking arcs that echo in linear

2-44 Ceremonial cauldron, from Luristan, eighth century B.C. Bronze, approx. 12″ high. Cincinnati Art Museum (The Mary Hanna Fund).

form the three-dimensional shape of the vessel to which they are attached. Although wingless, their pose, attitude, and purpose leave little room for doubt that they are the forerunners of the Persian ibex. The source of inspiration for the Persian animal's wings seems to appear in the embossed decoration of the bowl, where the Luristan artist has boldly copied Assyrian winged bulls and sacred emblems in Assyrian style and technique.

Eclecticism of Achaemenid Art

Thirty years ago, Achaemenid art was called eclectic—that is, derivative and lacking in originality. Today, as more knowledge has been accumulated about the earlier periods of art in Iran, much art that seemed to have been brought in from the outside also can be shown to have had roots in earlier Iranian periods and to have been accepted in a new form from that source. Thus, the platforms of the palaces at Persepolis are similar to those found in Mesopotamia, but the fact that Persepolis was built on the terrace of a mountain spur may reflect ancient Persian custom. The inhabitants of southwest Iran carved rock reliefs with lines of marching figures, the monotony of which has been compared with some of the reliefs adorning the stairway façades at Persepolis. On the other hand, the guardian figures are of Assyrian origin, the machinelike precision in the carving of details is reminiscent of Assyrian relief sculpture, the columned halls may have been influenced by Egyptian or Median models, and the fluting of columns is derived from Greek (Ionian) practice. Yet the manner in which these various elements have been combined produces an ensemble that is quite new and different from the art of those nations from which they may derive. A Persian column cannot be mistaken for an Egyptian or a Greek one, and nothing like the Persian apadana has been found in earlier architecture. Even with all their derivative elements, the architecture and sculpture of Persepolis produce a coherent and majestic impression.

Prior to the Persian conquest of the Near East, Persian art had consisted mainly of small-scale nomad's gear. Their monumental art was not created until they found themselves masters of the Near East and heirs to its rich culture. To glorify and eternalize their military and political achievements, the Persians not only adopted those features of foreign and conquered cultures that seemed to serve this purpose but also brought into the country the artisans who could best realize their ambitious projects. A building inscription at Susa names Ionians, Sardians, Medes, Egyptians, and Babylonians among the workmen who built and decorated the palace. Under the single-minded direction of its Persian masters, this mixed crowd, with a widely varied cultural and artistic background, created a new and coherent style that was perfectly suited to the expression of Persian imperial ambitions. A court style, like that of Louis XIV over two millennia later, the new style compelled its contributors into an artistic synthesis that was to remain remarkably uniform during the two-hundred-year reign of the Achaemenid dynasty.

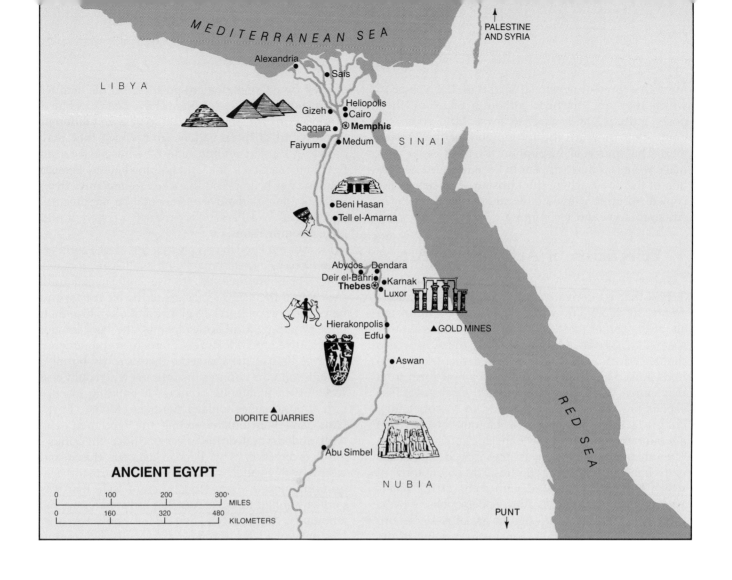

ANCIENT EGYPT

MEDITERRANEAN SEA

PALESTINE AND SYRIA

LIBYA

Alexandria
Sais
Heliopolis
Gizeh • Cairo
Saqqara • ⊗ **Memphis**
Faiyum • Medum

SINAI

Beni Hasan
Tell el-Amarna

Abydos • Dendara
Deir el-Bahri
Thebes ⊗ • Karnak
• Luxor

Hierakonpolis
Edfu
▲ GOLD MINES

Aswan

▲ DIORITE QUARRIES

RED SEA

Abu Simbel

NUBIA

PUNT

0	100	200	300	
MILES				
0	160	320	480	
KILOMETERS

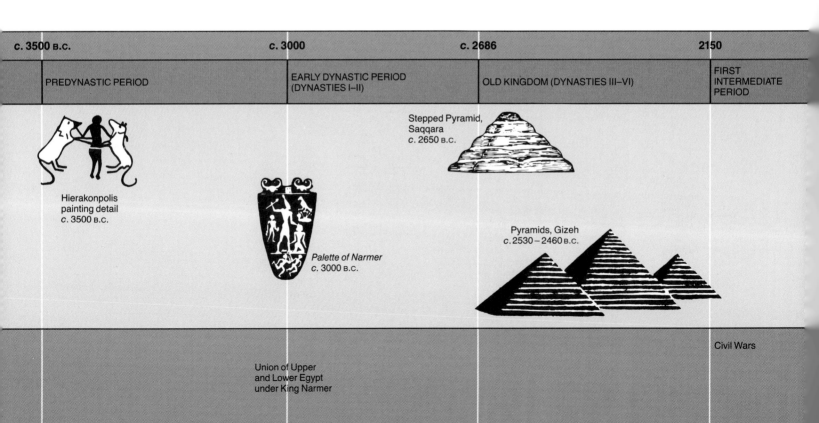

c. 3500 B.C.	c. 3000	c. 2686	2150
PREDYNASTIC PERIOD	EARLY DYNASTIC PERIOD (DYNASTIES I–II)	OLD KINGDOM (DYNASTIES III–VI)	FIRST INTERMEDIATE PERIOD

Hierakonpolis painting detail
c. 3500 B.C.

Palette of Narmer
c. 3000 B.C.

Stepped Pyramid, Saqqara
c. 2650 B.C.

Pyramids, Gizeh
c. 2530 – 2460 B.C.

Civil Wars

Union of Upper and Lower Egypt under King Narmer

3

THE ART OF EGYPT

2050	1750	1570		1070	716	332
MIDDLE KINGDOM	SECOND INTERMEDIATE PERIOD	NEW KINGDOM (EMPIRE PERIOD) (DYNASTIES XVIII–XX)		THIRD INTERMEDIATE PERIOD (DYNASTIES XXI–XXIV)	LATE PERIOD (DYNASTIES XXV–XXX)	

Temple of Amen-Re, Karnak c. 1280 B.C.

Rock-cut tombs, Beni Hasan
c. 2000 B.C.

Queen Nefertiti
c. 1360 B.C.

Abu Simbel
c. 1257 B.C.

Hyksos invasions

Reunification
of Egypt under
Mentuhotep II

Ahmose I
defeats
the Hyksos

Amarna Period
(Akhenaton)
1361–1352 B.C.

Tutankhamen
1361–1352 B.C.

Persia
conquers
Egypt
525 B.C.

Alexander
conquers
Persia and
Egypt
332 B.C.

OVER TWO THOUSAND years ago, Herodotus wrote: "Concerning Egypt itself I shall extend my remarks to a great length, because there is no country that possesses so many wonders, nor any that has such a number of works which defy description." A little later, he added: "They [the Egyptians] are religious to excess, far beyond any other race of men." People of discernment, aware of the profusion of monuments left to the world by the ancient Egyptians, have long been in agreement with these observations. Although the Egyptians built their dwellings of impermanent materials, they constructed their tombs (which they believed would preserve their bodies forever), their temples to the immortal gods, and the statues of their equally immortal god-king of imperishable stone. The stone cliffs of the Libyan and Arabian deserts, from which the building materials were hewn, and the Nile flowing between them could represent, respectively, the timelessness of the Egyptian world and the endless cycles of natural process. Religion and permanence are the elements that characterize the solemn and ageless art of Egypt and express the unchanging order that, for the ancient Egyptians, was divinely ordained.

Even more than the Tigris and the Euphrates, the Nile, by virtue of its presence, defined the cultures that developed along its banks. Originating deep in Africa, the world's longest river descended through many cataracts to sea level in Egypt, where, in annual flood, it deposited rich soil brought thousands of miles from the African hills. Hemmed in by the narrow valley, which reaches a width of only about twelve miles in its widest parts, the Nile flows through regions that may not have a single drop of rainfall in a decade. Yet, crops grew luxuriantly from the fertilizing silt. Game also abounded then, and the great river that made life possible entered the consciousness of the Egyptians as a god and as a symbol of life.

In Predynastic, or prehistoric, and Pharaonic times, the river held wider sway than it does today. Egypt was a land of marshes dotted with island ridges, and what is now arid desert valley was grassy parkland well suited for hunting and grazing cattle. Amphibious animals swarmed in the marshes and were hunted through tall forests of papyrus and rushes. The fertility of Egypt was proverbial, and, at the end of its dynastic history, when Egypt had become a province of the Roman Empire, it was the granary of the Mediterranean world.

Before settled communities could be built along the Nile's banks, however, it was necessary to control the annual floods. The Egyptians built dams to divert flood waters into fields instead of attempting to control the flow of the river; the communal effort put forth to construct these dams provided the basis for the growth of an Egyptian civilization, just as the irrigation projects in the Mesopotamian valley had furnished the civilizing impetus for that region a few centuries earlier.

In the Middle Ages, when the history of Egypt was thought of as part of the history of Islam, Egypt's reputation as an ancient land of wonders and mystery lived on in more or less fabulous report. Until the later eighteenth century, its undeciphered writing and exotic monuments were regarded as treasures of occult wisdom, locked away from any but those initiated in the mystic arts. Scholars knew something of the history of Egypt from references in the Old Testament, from the unreliable reports of ancient and modern travelers, and from a history of Egypt written in Greek by an Egyptian named Manetho in the second century B.C. Manetho described the succession of pharaohs, dividing them into the still-useful groups we call dynasties, but his chronology is inaccurate and his account untrustworthy.

Scientific history—or, at least, scientific archeology—had its start at the end of the eighteenth century, when modern Europe rediscovered Egypt. Egypt became the first subject of archeological exploration, followed by the uncovering of the ancient civilizations of the Tigris and the Euphrates. In 1799, Napoleon Bonaparte, on a military expedition to Egypt, took with him a small troop of scholars, linguists, antiquarians, and artists. The chance discovery of the famed Rosetta Stone, now in the British Museum, gave the eager scholars a key to deciphering Egyptian hieroglyphic writing. The stone bears an inscription in three sections: one in Greek, which was easily read; one in demotic (Late Egyptian); and one in formal hieroglyphic. It was at once suspected that the inscription was the same in all three sections and that, using Greek as the key, the other two sections could be deciphered. More than two decades later, after many false starts, a young linguist, Jean François Champollion, deduced that the hieroglyphs were not simply pictographs; he proposed that they were the signs of a once-spoken language, vestiges of which survived in Coptic, the later language of Christian Egypt. Champollion's feat made him a kind of Columbus of the new science of archeology, as well as of that special branch within it, Egyptology. Those who followed Champollion, individuals such as Auguste Mariette and Gaston Maspero, sought to build classified collections and to protect Egyptian art from unscrupulous plundering. Men like Flinders Petrie introduced new excavating techniques, laying the groundwork for the development of sounder methods for validating knowledge of Egyptian civilization.

Ideally, the foundation of archeological knowledge is a reliable chronology. Yet, as the body of archeological evidence grows and new scientific methods of dating are developed, the chronology must change to accommodate them. Sometimes, what was thought to be close to certain becomes problematical; sometimes, what was guesswork or speculation suddenly becomes probable. Because this is more often the case the further back we travel in time, the Predynastic beginnings of Egyptian civilization are chronologically vague, as are those of Mesopotamia. Some time around 3500 B.C., a people of native African stock may have been exposed to influences from Mesopotamia, or it is possible that, as in Sumer, the sudden cultural development may have been due to an actual incursion of a new people.

A wall painting from the Late Predynastic period (FIG. **3-1**), found in a shrine at Hierakonpolis in Upper Egypt, represents men, animals, and boats in a lively, helter-skelter fashion. The boats, symbolic of the journey down the river of life and death, are painted white and seem to carry a cargo of tombs mourned over by women. Other depictions include a heraldic grouping of two animals (perhaps lions) shown flanking a human figure, many figures of gazelles, and men fighting. The heraldic group, a composi-

tional type usually associated with Mesopotamian art, suggests that influences from Mesopotamia not only had reached Egypt by this time but had already made the thousand-mile journey upstream. The stick figures and their apparently random arrangement remind us of the Mesolithic rock paintings from the Spanish Levant and North Africa, the style of which flourished also in the central Sahara and may have been another impetus to the development of Egyptian art.

The Hierakonpolis mural is the earliest known representative of that millennia-long tradition of painting that reveals to us the *funerary customs* of Egypt, so much at the center of Egyptian life. Most paintings are found in tombs and provide the principal archeological evidence for the historical reconstruction of Egyptian civilization. Religion pervaded that civilization. In Herodotus' words, the Egyptians were "religious to excess," and their concern for immortality amounted to near obsession; the overall preoccupation in this life was to ensure safety and happiness in the next life. The majority of the monuments the Egyptians left behind them were dedicated to this preoccupation.

The sharp distinction between body and soul, long familiar to Christians and to adherents of other later

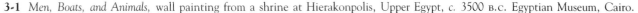

3-1 *Men, Boats, and Animals,* wall painting from a shrine at Hierakonpolis, Upper Egypt, *c.* 3500 B.C. Egyptian Museum, Cairo.

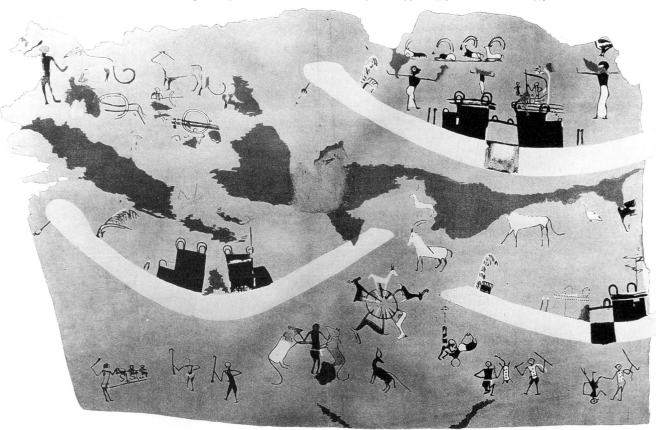

religions, was not made by the Egyptians. Rather, they believed that, from birth, one was accompanied by a kind of other self, the *ka*, which, on the death of the fleshly body, could inhabit the corpse and live on. For the ka to live securely, however, the dead body had to remain as nearly intact as possible. To ensure that it did, the Egyptians developed the technique of embalming to a high art; their success is evident in numerous well-preserved mummies of kings, princes and others of noble birth, as well as those of some common persons. *Mummification* was only the first requirement for immortality. Food and drink also had to be provided, as did clothing, utensils, and all the apparatus of living, so that nothing would be lacking that had been enjoyed on earth. Images of the deceased, sculptured in the round and placed in shallow recesses, guaranteed the permanence of one's identity by providing substitute dwelling places for the ka in case the mummy disintegrated. Wall paintings (for the use and delectation of the ka) recorded, with great animation and detail, the recurring round of human activities—a cycle of "works and days" that changed with the calendar and the seasons. The Egyptians hoped and expected that the images and inventory of life, collected and set up within the protective stone walls of the tomb, would ensure immortality, but almost from the beginning of the elaborate interments, the thorough plundering of tombs became a profitable occupation. Only one royal burial place escaped nearly intact. At the time of its discovery in 1924, the tomb of the Eighteenth Dynasty ruler Tutankhamen revealed to a fascinated world the full splendor of a pharaoh's funerary assemblage.

THE EARLY DYNASTIC PERIOD AND THE OLD KINGDOM

Egypt has been known as the "Kingdom of the Two Lands," a reference to its very early physical and political division into Upper Egypt and Lower Egypt. The upper land was dry, rocky, and culturally rustic; the lower land was opulent, urban, and populous. Even in Predynastic times, conflict must have erupted between the two, for the ancient Egyptians began the history of Egypt, as we do, with the forcible unification of the two lands by a ruler named Menes.

The *Palette of Narmer*

Menes is thought to be King Narmer, whose image and name appear on a slate slab, or *palette*, from Hierakonpolis (FIG. **3-2**). The *Palette of Narmer* is an elaborate, formalized version of a utilitarian object commonly used in the Predynastic period as a tablet

on which eye makeup was prepared to protect the eyes against irritation and the glare of the sun. It is important, not only as a historical document that records the unification of the two Egypts and the beginning of the Dynastic period, but also as a kind of early blueprint of the formula of figure representation that was to rule Egyptian art for three thousand years. On the back of the palette, the king, wearing the high, bowling-pin-shaped crown of Upper Egypt, is about to slay an enemy as a sacrifice. A hawk, symbol of the sky god, Horus, and protector of the king, faces Narmer and takes captive a man-headed hieroglyph for land from which papyrus grows (a symbol for Lower Egypt). Below the king are two fallen enemies. Two heads of Hathor, a goddess favorably disposed to Narmer, are depicted at the top. The front of the

3-2 *Palette of Narmer* (back and front), from Hierakonpolis, Upper Egypt, *c.* 3000 B.C. Slate, 25″ high. Egyptian Museum, Cairo.

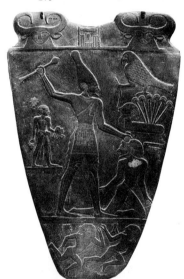

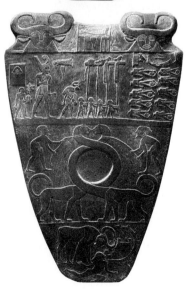

palette shows Narmer wearing the cobra crown of Lower Egypt and reviewing the beheaded bodies of the enemy. By virtue of his superior rank, the king in both cases performs his ritual task alone and towers over his own men and the enemy. The superhuman strength of the king is symbolized by a great bull knocking down a rebellious city, perhaps Hierakonpolis. Historical narrative, as we find it in Mesopotamian reliefs (see the *Victory Stele of Naram-Sin*, FIG. 2-24), is not of primary importance in this work. What is important is the concentration on the king as a deified figure, isolated from all ordinary men and solely responsible for his triumph. As early as the Narmer palette (about 3000 B.C.), we see evidence of the Egyptian convention of thought, of art, and of state policy that establishes the kingship as divine and proclaims that its prestige is one with the prestige of the gods.

If what belongs to the gods and to nature is unchanging and if the king is divine, then his attributes must be eternal. We have already seen in Mesopotamian art that natural shapes are formalized into simple poses, attitudes, and actions. The same thing happens in Egypt, even though the instinct for convention leads to a somewhat different style. In the figure of Narmer, we find the stereotype of kingly transcendence that, with several slight variations, will be repeated in subsequent representations of all Egyptian dynasts except the fourteenth-century pharaoh, Akhenaton (see FIG. 3-38). The king is seen in a perspective that combines the profile views of head, legs, and arms with the front views of eye and shoulders. Although the proportions of the figure would change, the method of its representation becomes a standard for all later Egyptian art. Like a set of primordial commandments, the *Palette of Narmer* sets forth the basic laws that would govern art along the Nile for thousands of years. In the Hierakonpolis painting (FIG. 3-1), figures are scattered across the wall more or less haphazardly; on the palette, the surface is subdivided into a number of bands, and the pictorial elements are inserted into their organized setting in a neat and orderly way. The horizontal lines that separate the bands also define the ground that supports the figures, a mode of representation that would persist in hundreds of acres of Egyptian wall paintings and reliefs.

In addition to recording an important historical event and to laying down ground rules for the pictorial arts, the *Palette of Narmer* also illustrates several stages in the development of Egyptian writing. The story of Narmer's victories is represented in the different registers, with varying degrees of symbolism. Straight pictorial narrative is used to show the king following his standard-bearers in triumphal procession and inspecting the bodies of his slain enemies. This simple picture writing becomes symbolic when, in a bottom register, the king is shown as a bull breaking down the walls of an enemy fortress. The symbolism becomes more abstract in the pile of decapitated foes; here, each body, its severed head neatly placed between its legs, is probably a numerical symbol representing a specific number of fallen enemies. Finally, in the signs appearing near the heads of the more important figures, pictographs take on phonetic values, as the names of the respective individuals, including that of the all-victorious king, have been written in true hieroglyphs, making this palette the earliest labeled work of historical art extant.

Nearly three centuries after the *Palette of Narmer*, we find the basic conventions of Egyptian figure representation that were set up in the palette refined and systematized on a carved wooden panel (FIG. 3-3) representing Hesire, a high official from the court of King Zoser. The figure's swelling forms have been modeled with greater subtlety, and its proportions

3-3 *Panel of Hesire*, from Saqqara, c. 2650 B.C. Wood, 45″ high. Egyptian Museum, Cairo.

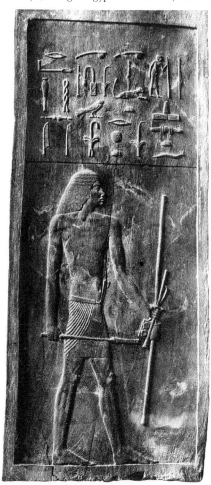

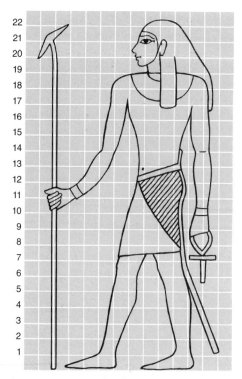

3-4 The *Later Canon* (rule of proportion) of Egyptian art. (After Panofsky.)

have been changed to a broad-shouldered, narrow-hipped ideal. The artist uses the conceptual approach (see page 53), rather than the optical, representing what is known to be true of the object, instead of some random view of it, and showing its most characteristic parts at right angles to the line of vision. This conceptual approach expresses a feeling for the constant and changeless aspect of things and lends itself to systematic methods of figure construction (FIG. **3-4**). Although perhaps not quite as simple as his description of it might imply, the system is explained by Erwin Panofsky as follows:

> With its more significant lines permanently fixed on specific points of the human body, the Egyptian network [of equal squares] immediately indicates to the painter or sculptor how to organize his figure: he will know from the outset that he must place the ankle on the first horizontal line, the knee on the sixth, . . . and so on. . . . It was, for instance, agreed that in a [lunging] figure, . . . the length of pace . . . should amount to $10\frac{1}{2}$ units, while this distance in a figure quietly standing was set at $4\frac{1}{2}$ or $5\frac{1}{2}$ units. Without too much exaggeration, one could maintain that, when an Egyptian artist familiar with this system of proportion was set the task of representing a standing, sitting, or striding figure, the result was a foregone conclusion once the figure's absolute size was determined.*

*Erwin Panofsky, *Meaning in the Visual Arts* (Garden City, NY: Doubleday, 1955), pp. 58–61.

Architecture

Similar principles of permanence and regularity appear in the design of the Egyptian tomb, the symbol of the timeless and the silent house of the dead. The standard tomb shape during the Old Kingdom was the *mastaba* (FIG. **3-5**). The mastaba (Arabic for "bench") was a rectangular brick or stone structure with battered (sloping) sides erected over a subterranean tomb chamber that was connected with the outside by a shaft, which provided the ka with access to the tomb. The form probably was developed from mounds of earth or stone that had covered earlier tombs. Although mastabas originally housed single burials, during the latter part of the Old Kingdom, they were used for multiple family burials and became increasingly complex. The central, underground chamber was surrounded by storage rooms and compartments, whose number and size increased with time, until the area covered far surpassed that of the tomb chamber proper. Built into the superstructure, or sometimes attached to the outside of its eastern face, was the funerary chapel, which contained a statue of the deceased in a small,

3-5 Mastabas (*bottom*), with plan (*middle*) and schematic section (*top*).

1. Chapel
2. False door
3. Shaft into burial chamber
4. Serdab (chamber for statue of deceased)
5. Burial chamber

concealed chamber called the *serdab*. The interior walls of the chapel and the ancillary rooms were decorated with colored relief carvings and with paintings of scenes from daily life intended magically to provide the deceased with food and entertainment.

About 2650 B.C., the Stepped Pyramid of King Zoser (or Djeser) of the Third Dynasty was raised at Saqqara, the ancient *necropolis* (city of the dead) of Memphis (FIG. 3-6). It is one of the oldest stone structures in Egypt and the first monumental royal tomb. Begun as a large mastaba, the structure was enlarged twice before taking on its final shape, which appears to be a sort of compromise between a mastaba and the later "true" pyramids at Gizeh. About 200 feet high, it seems to be composed of a series of mastabas of diminishing size, piled one on top of another to form a structure that resembles the great ziggurats of Mesopotamia. Unlike the ziggurats, however, Zoser's pyramid is a tomb, not a temple platform, and

its dual function was to protect the mummified king and his possessions and to symbolize, by its gigantic presence, his absolute and godlike power.

The pyramid stands near the center of a rectangular enclosure that measures about 1,800 feet by 900 feet and is surrounded by a monumental, 35-foot high, niched wall of white limestone (FIG. 3-7). Against the pyramid's northern face stands the funerary temple where daily rituals for the deceased were performed. Numerous buildings in the temple complex are arranged around several courts. With the exception of the funerary temple and a royal pavilion, all are dummy structures with stone walls enclosing fills of rubble, sand, or gravel. The buildings imitate in stone masonry various types of temporary structures made of plant stems and mats that were erected in Upper and Lower Egypt for the celebration of the Jubilee Festival, the rituals of which perpetually renewed the affirmation of the royal existence in the hereafter. The

3-6 IMHOTEP, Stepped Pyramid of King Zoser, Saqqara, *c.* 2650 B.C.

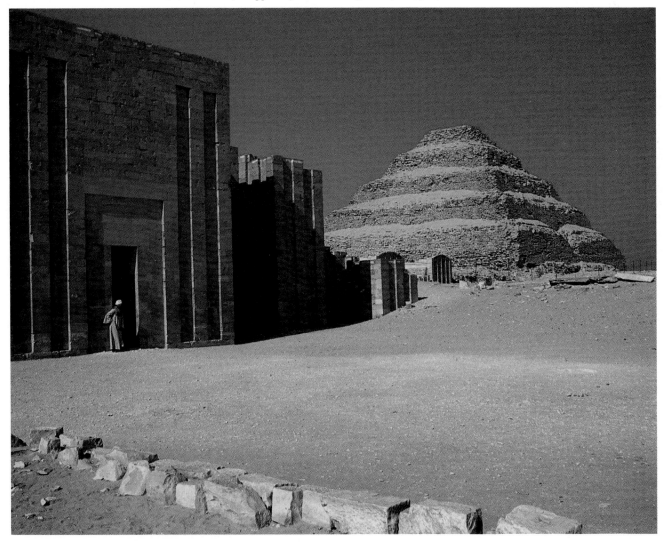

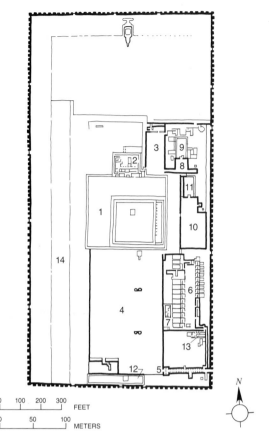

1. Stepped pyramid derived from
 square-plan mastaba
2. Funerary temple of Zoser
3. Court with serdab
4. Large court with altar and
 two B-shaped stones
5. Entrance portico
6. Heb-Sed court flanked by
 sham chapels
7. Small temple
8. Court before North Palace
9. North Palace
10. Court before South Palace
11. South Palace
12. South tomb
13. Royal Pavilion
14. Magazines

3-7 Plan of the mortuary precinct of King Zoser, Saqqara.
(After Lange and Hirmer.)

3-8 Reconstruction of an Upper Egyptian tent building,
mortuary precinct of King Zoser, Saqqara.
(After J. P. Lauer.)

3-9 Remains of an Upper Egyptian tent building.

reconstructed façade of one of these rubble-filled dummy buildings (FIG. **3-8**) imitates an Upper Egyptian tent building in which tall poles support a mat roof that billows in a desert breeze. A striking feature of the preserved lower parts of these supporting "poles" (FIG. **3-9**) is their fluting, which is of the type that was to become characteristic of Greek Doric columns many centuries later. Egyptian columns, if they did not imitate reed or papyrus bundles, generally were smooth-shafted or beveled to polygonal shapes. Here, the "proto-Doric" fluting is believed to be derived from the dressing of softwood trunks with the rounded cutting edge of the Egyptian adze. While these tall and slender shafts hardly qualify as columns, more "properly" proportioned stone columns appear in considerable numbers elsewhere in the compound. Their design is inspired by natural plant forms, and they imitate bundled reeds or papyrus

stalks whose blossoms serve as capitals. Not freestanding, they are attached to walls and wall projections, as though the builders had not realized yet the full structural potential of stone columns. Still, this is their first appearance in the history of architecture and thus epoch-making for its subsequent development in later periods.

The architect of Zoser's mortuary complex and the first known artist of recorded history was IMHOTEP, the king's grandvizier and a man of legendary powers. Priest, scribe, physician, and architect, Imhotep came to be known as the "father of medicine," and in Greek times was associated with Aesculapius, the patron god of physicians. As an architect, his greatest achievement was to translate the impermanent building types of both Upper and Lower Egypt into stone and combine them with two funerary traditions in a single compound, thereby consolidating and giving

visual permanence to the idea of a unified Egyptian kingdom.

At Gizeh, near modern Cairo but on the west side of the Nile (the dead were always buried on the side where the sun sets), stand the three pyramids (FIG. 3-10) of the Fourth Dynasty pharaohs Khufu (the Greek Cheops), Khafre (Chephren), and Menkure (Mycerinus). Built around 2500 B.C., the pyramids of Gizeh represent the culmination of an architectural evolution that began with the mastaba. The pyramid form did not evolve out of necessity; kings could have gone on indefinitely piling mastabas, one on top of another, to make their weighty tombs. Rather, it has been suggested that when the kings of the Third Dynasty moved their permanent residence to Memphis, they came under the influence of nearby Heliopolis. This city was the seat of the powerful cult of Re, the sun god, whose fetish was a pyramidal stone, the *ben-ben.* By the Fourth Dynasty, the pharaohs considered themselves the sons of Re and his incarnation on earth. It would have been only a small step for the pharaohs from the belief that the spirit and power of Re resided in the pyramidal ben-ben to the belief that their divine spirits and bodies would be similarly preserved within pyramidal tombs.

Is the pyramid form, then, an invention inspired by a religious demand, rather than the result of a formal evolution? We need not resolve this question here. Our concern is with the remarkable features of the Fourth Dynasty pyramid. Of the three pyramids at Gizeh, that of Khufu is the oldest and largest. Except for the galleries and burial chamber, it is an almost solid mass of limestone masonry—a stone mountain built on the same principle as the Stepped Pyramid of King Zoser, the interior spaces in plan and elevation being relatively tiny, as if crushed out of the scheme by the sheer weight of stone (FIG. 3-11). The limestone was quarried in the eastern Nile cliffs and floated across the river during the seasonal floods. After the masons finished cutting the stones, they marked them with red ink to indicate the place of each stone in the structure. Then great gangs of laborers dragged them up temporary ramps (the wheel was not yet known) and laid them course on course. Finally the pyramid was surfaced with a casing of pearly white limestone, cut so precisely that the eye

3-10 Great Pyramids of Gizeh. *From left:* Menkure, *c.* 2460 B.C.; Khafre, *c.* 2500 B.C.; Khufu, *c.* 2530 B.C.

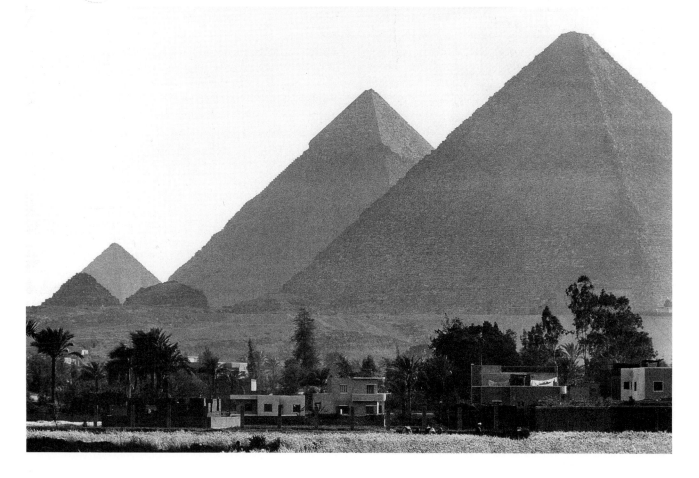

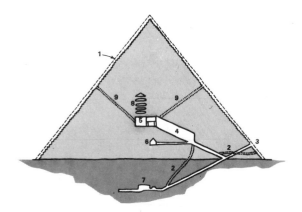

1. Silhouette with original facing stone
2. Thieves' tunnels
3. Entrance
4. Grand gallery
5. King's chamber
6. So-called queen's chamber
7. False tomb chamber
8. Relieving blocks
9. Airshafts?

3-11 Section of the Pyramid of Khufu, Gizeh. (After Hoelscher.)

could scarcely detect the joints. A few casing stones can still be seen in the cap that covers the Pyramid of Khafre, all that remain after many centuries during which the pyramids were stripped to supply limestone for the Islamic builders of Cairo. The immensity of the Pyramid of Khufu is indicated by some dimensions in round numbers: at the base, the length of one side is 775 feet and its area is some 13 acres; its present height is 450 feet (originally 480 feet). According to Flinders Petrie, the structure contains about 2.3 million blocks of stone, each weighing an average of $2\frac{1}{2}$ tons. Napoleon's scholars calculated that the blocks in the three pyramids were sufficient to build a wall 1 foot wide and 10 feet high around France. The art of this structure is inherent not only in its huge size and successful engineering but also in its formal design. The proportions and immense dignity are consistent with its funerary and religious functions and well adapted to its geographical setting. The four sides are oriented to the cardinal points of the compass, and the simple mass dominates the flat landscape to the horizon. The ironic outcome of this stupendous effort may be read from the cross section shown in FIG. 3-11. The dotted lines at the base of the structure (2) indicate the path cut into the pyramid by ancient grave robbers. Unable to locate the carefully sealed and hidden entrance, they started some 40 feet above the base and tunneled into the structure until they intercepted the ascending corridor. Many royal tombs were plundered almost as soon as the funeral ceremonies had ended; the very conspicuousness of the pyramid was an invitation to despoilment. The successors of the Old Kingdom pyramid-builders had learned this hard lesson; they built few pyramids, and those were relatively small and inconspicuous.

From the remains surrounding the pyramid of Khafre at Gizeh, we can reconstruct an entire pyramid complex (FIG. **3-12**) consisting of the pyramid itself, within or below which was the burial chamber; the chapel, adjoining the pyramid on the east side, where offerings were made, ceremonies were performed, and cloth, food, and ceremonial vessels were stored; the covered causeway leading down to the valley; and the valley temple, or vestibule, of the causeway. Beside the causeway and dominating the temple of Khafre rose the Great Sphinx (FIG. **3-13**), carved from a spur of rock to commemorate the pharaoh and to serve as a silent guardian of his tomb. The rock was cut so that the immense figure, adjacent to the temple's west front, gives visitors coming from the east the illusion that it rests on a great pedestal. The lion figure with a human head, possibly a portrait of Khafre, again shows us the conjunction of a powerful beast with the attributes of absolute kingship, as we have seen in the hawk and the bull of the *Palette of Narmer* (FIG. 3-2). For centuries, the huge head of the Great Sphinx stood up above the drifting tides of desert sand that covered the body, providing generations of ancient and modern travelers with an awe-inspiring and unforgettable image of mysterious power.

The valley temple of the Pyramid of Khafre (FIG. **3-14**) was built using the post-and-lintel system in which horizontal beams, or lintels, rest on upright supports, or posts. Both posts and lintels were huge, rectangular, red-granite monoliths, finely proportioned, skillfully cut and polished, and devoid of decoration. Alabaster slabs covered the floor, and seated statues, the only embellishment of the temple, were ranged along the wall. The interior was lighted by a few slanting rays filtering in from above. Although

3-12 Reconstruction of the pyramids of Khufu and Khafre, Gizeh. (After Hoelscher.)

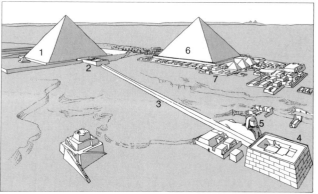

1. Pyramid of Khafre
2. Mortuary temple
3. Covered causeway
4. Valley temple
5. Great Sphinx
6. Pyramid of Khufu
7. Pyramids of the royal family and mastabas of nobles

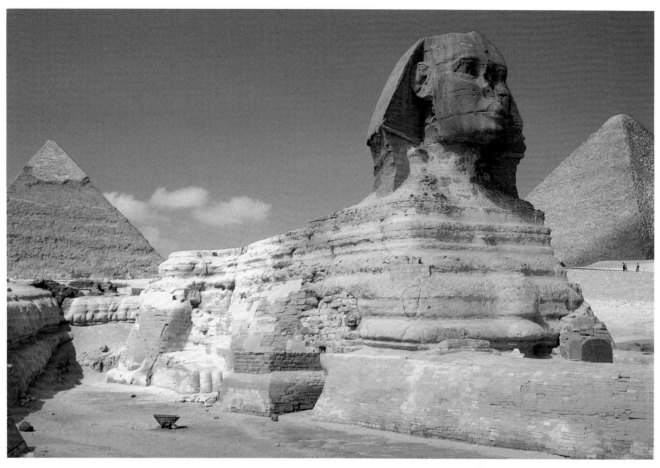

3-13 The Great Sphinx (with Pyramid of Khafre in left background), Gizeh, *c.* 2530 B.C. Sandstone, 65′ high, 240′ long.

3-14 Middle aisle of the hall of pillars, valley temple of the Pyramid of Khafre, Gizeh, *c.* 2500 B.C.

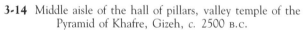

the Egyptians knew of the arch and the vault and had used them occasionally in Predynastic tombs, they rarely used them after about 3000 B.C., the beginning of the Dynastic period. Egyptian architects preferred the static forms of the post-and-lintel system, which, if cast into the heavy, massive shapes of the Khafre temple, expressed, perhaps better than any other architectural style, the changeless and the eternal.

Sculpture

In Egyptian tombs, we have already noted that sculpture in the round served the important function of creating an image of the deceased that could serve as an abode for the ka (the other self), should the mummy be destroyed. For this reason, an interest in portraiture developed early in Egypt. Thus, too, permanence of style and material were essential. Although wood, clay, and bronze were used, mostly for images of those not of the royal or noble classes, stone was the primary material. Limestone and sandstone were brought from the Nile cliffs, granite from the cataracts of the upper Nile, and diorite from the desert.

A seated statue of Khafre (FIG. **3-15**), who ruled from 2558–2533 B.C., was one of a series of similar statues carved for Khafre's valley temple near the Great Sphinx. These statues, the only organic forms in the geometric severity of the temple structure, with its flat-planed posts and lintels, help create a striking atmosphere of solemn majesty. Khafre is seated on a throne at the base of which is carved a symbol of the united Egypt, an intertwined lotus and papyrus. Sheltering his head are the protecting wings of the hawk, symbol of the sun, indicating Khafre's divine status as son of Re. He wears the simple kilt of the Old Kingdom and a linen headdress that covers his forehead and falls in pleated folds over his shoulders. The representation of the king is permeated with an imperturbable calm, reflecting the enduring power of the pharaoh and of kingship in general. This effect, common to royal statues of the ka, is achieved by devices of form and technique that we can still admire. The figure has great compactness and solidity, with few projecting, breakable parts; the form manifests the purpose—to last for eternity. The body is attached to a back slab, the arms are held close to the torso and thighs, the legs are close together and attached to the throne by stone webs. Like Mesopotamian statues, the pose is frontal, rigid, and bisymmetrical. This repeatable scheme arranges the parts of the body so that they are presented in a totally frontal projection or entirely in profile. As Erwin Panofsky observed:

> We can recognize from many unfinished pieces that even in sculpture the final form is always determined by an underlying geometrical plan originally sketched on the surfaces of the block. It is evident that the artist drew four separate designs on the vertical surfaces of the block . . . that he then evolved the figure by working away the surplus mass of stone, so that the form was bounded by a system of planes meeting at right angles and connected by slopes. . . . There is a sculptor's working drawing . . . that illustrates the mason-like method of these sculptors even more clearly: as if he were constructing a house, the sculptor drew up plans for his sphinx in frontal elevation, ground plan, and profile elevation . . . so that even today the figure could be executed according to plan.*

This *subtractive* method of "working away the surplus . . . stone" accounts for the blocklike look of the standard Egyptian statue, which differs strongly from the cylindrical or conical shape seen, for example, in the Mesopotamian statues of Gudea (FIG. 2-25). The hardest stone was used to ensure the permanence of the image, and Egypt (unlike Mesopotamia) was rich

*Erwin Panofsky, *Meaning in the Visual Arts* (Garden City, NY: Doubleday, 1955), pp. 58–59.

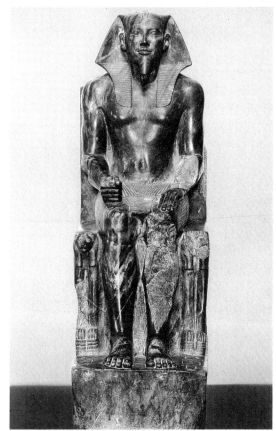

3-15 *Khafre* (side and front), from Gizeh, *c.* 2500 B.C. Diorite, 66" high. Egyptian Museum, Cairo.

in stone. Even so, the difficulty of working granite and diorite with bronze tools made production too expensive for all but the wealthiest. Much of the finishing had to be done by abrasion.

Since the figure was cut to plan, its proportions were determined beforehand. A canon of ideal proportions, designated as appropriate for the representation of imposing majesty, was accepted and applied quite independently of optical fact. The generalized anatomy persisted in Egyptian statuary even into the Ptolemaic period, when Greek influence might have been expected to shift it toward realism. The Egyptian sculptor seems to have been indifferent to realistic representation of the body, preferring to strive for fidelity to nature in the art of portraiture, at which the Egyptians excelled.

An example of their skill is a so-called reserve (duplicate, or spare) head of a prince of the family of Khufu (FIG. **3-16**). Attention is given only to the execution of the face, which shows the union of the formal and the realistic that gives distinction to so many portrait busts of its type. Reserve heads were placed outside the burial chamber, and their purpose is not understood. This head displays the extraordinary sensitivity of Old Kingdom portraiture. The personality, that of a sharply intelligent, vivacious, and alert individual, is read by the sculptor with a penetration and sympathy seldom achieved in sculptural representation.

In the history of art, especially portraiture, it is almost a rule that formality is relaxed and realism is increased when the subject is a person of lesser importance. The famous wood statue of Ka-Aper (Sheikh el Beled) is a case in point (FIG. **3-17**). The work is a lively representation of a man whose function was to serve the king in the spirit world as he had in life. The face is startlingly alive, an effect that is heightened by eyes of rock crystal. The figure stands erect in conventional frontal pose, left leg advanced. His paunchy physique lacks the idealized proportions found in representations of royalty and nobility; he was, after all, only a minor official. The wood medium permitted the artist to omit the back slab and try a freer pose. Actually, what we see is the wood core that was covered originally with painted plaster, a common procedure when soft or unattractive woods were used.

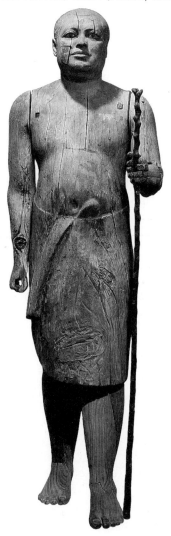

3-17 *Ka-Aper (Sheikh el Beled),* from his tomb at Saqqara,
c. 2400 B.C. Wood, approx. 43″ high.
Egyptian Museum, Cairo. (Partially restored.)

3-16 *"Reserve" Head of a Prince,* Gizeh, *c.* 2500 B.C.
Limestone, life size. Egyptian Museum, Cairo.

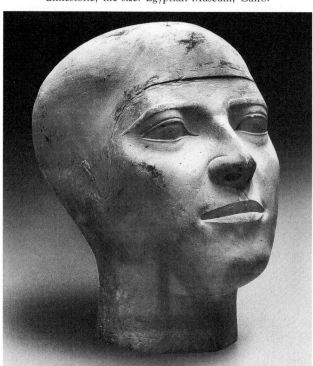

Painting and Relief

The scenes in painted limestone relief that decorate the walls of the tomb of an Old Kingdom official, Ti, typify the subjects favored by patrons adorning their tombs. Most often they are of agriculture and hunting (FIG. **3-18**), activities that represent the fundamental human concern with nature and that are associated with the provisioning of the ka in the hereafter. Ti, his men, and his boats move slowly through the marshes, hunting birds and hippopotamuses in a dense growth of towering papyrus. The slender, reedy stems of the plants are delineated with repeated fine grooves that fan out gracefully at the top into a commotion of frightened birds and stalking beasts. Beneath the boats, the water, signified by a pattern of wavy lines, is crowded with hippopotamuses and other aquatic fauna. Ti's men seem frantically busy with their spears, while Ti himself, who is portrayed twice their size, stands impassive and aloof in the formal stance seen earlier in the figure of Hesire (FIG. 3-3). The outsize and ideal proportions bespeak Ti's rank, as does the conventional pose, which contrasts with the realistically rendered activity of his diminutive servants and with the precisely observed figures of the birds and animals among the papyrus buds.

A rare and fine example of Old Kingdom painting is the frieze called the *Geese of Medum* (FIG. **3-19**). In the prehistoric art of the caves, the rock paintings, and the art of Mesopotamia, we have admired the peculiar sensitivity of early artists to the animal figure. They seem to have empathized with the non-human creature, to have possessed what Keats called ''negative capability''—the power almost to share the being of the animal and to feel as it feels.

The dry-fresco (*fresco secco*) technique used, in which the artist lets the plaster dry before painting on it, lends itself to slow and meticulous work, encouraging the trained professional to take pains in rendering the image and in expressing an exact knowledge

3-18 *Ti Watching a Hippopotamus Hunt,* tomb of Ti, Saqqara, *c.* 2400 B.C. Painted limestone relief, approx. 48″ high.

of the subject. The delicate, prehensile necks of the geese, the beaks, the suppleness of the bodies, and the animals' characteristic step and carriage are rendered with an exactitude and discernment that would elicit the admiration of an Audubon. The firm, strong execution of the figures is the work of an expert with a superbly trained eye and hand. It is probable, too, that religious motives mingled here with esthetic ones, for, after all, once a tomb was sealed, no mortal

3-19 *Geese of Medum* (detail of a fresco), *c.* 2530 B.C. Tempera on plaster, approx. 18″ × 68″. Egyptian Museum, Cairo.

eyes were ever expected to see the paintings again. It must have been thought that, in the darkness and silence, the pictures worked their own spell, creating a force that would serve the ka eternally; some of the magical intent of the Stone Age cave paintings seems to persist here.

The art of the Old Kingdom is the classic art of Egypt in that its conventions, definitively established, remained the basis of subsequent styles of Egyptian art through three millennia.

THE MIDDLE KINGDOM

About 2150 B.C., the power of the pharaohs was challenged by ambitious feudal lords; for about a century, the land was in a state of civil unrest and near anarchy. Eventually, a Theban ruler, Mentuhotep II, managed to unite Egypt again under the rule of a single king. In the Eleventh, Twelfth, and Thirteenth Dynasties (the Middle Kingdom) that followed, art was revived and a rich and varied literature appeared.

The Egyptians continued to build pyramids but on a much smaller scale than in the Old Kingdom. Since it had become apparent that size was no defense against tomb robbers, builders now attempted to thwart thieves with intricate and ingenious interior layouts. Entrances were not placed in the center of the north side, as was traditional, but were hidden and screened from the secret tomb chamber by various types of sliding portcullises and by a series of passages that turned and doubled back on themselves at various levels in labyrinthine fashion. Less massive than their Old Kingdom predecessors, Middle Kingdom pyramids were built either entirely of brick or as stone frameworks filled with brick or rubble. What the pyramids lost in size and mass during the Middle Kingdom, however, was partly recompensed by the increased size of the sarcophagi, which became extremely large and heavy. Designed like small tomb chambers and weighing up to 150 tons, these granite coffins were intended to foil potential robbers by their very bulk and mass.

Rock-cut Tombs

Among the most characteristic remains of the Middle Kingdom are the rock-cut tombs at Beni Hasan (FIG. 3-20), south of Memphis. One of the best preserved is the tomb of Khnumhotep, who boasted in an inscription of its elaborateness, saying that its doors were of cedar, seven cubits (about 20 feet) high. Expressing the characteristic Egyptian attitude toward the last resting place, he added:

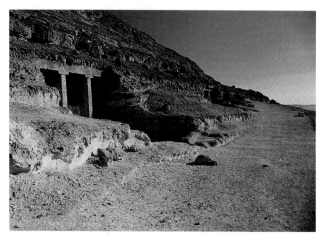

3-20 Rock-cut tombs, Beni Hasan, *c.* 2000 B.C.

My chief nobility was: I executed a cliff-tomb, for a man should imitate that which his father does. My father made for himself a house of the *ka* in the town of Menofret, of good stone of Ayan, in order to perpetuate his name forever and establish it eternally.

The rock-cut tombs of the Middle Kingdom largely replaced the Old Kingdom mastabas. Hollowed out of the living rock at remote sites, these tombs, fronted by a shallow, columned portico, contained the fundamental units of Egyptian architecture: a portico or vestibule, a columned hall, and a sacred chamber (FIG. 3-21). In the hall of the rock-cut tomb of

3-21 Plan (*bottom*) and section (*top*) of a rock-cut tomb. (After Sir Banister Fletcher.)

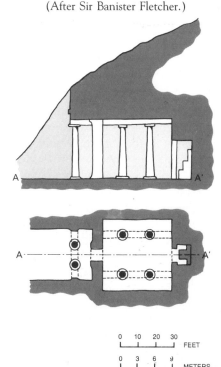

0	10	20	30	
				FEET

0	3	6	9	
				METERS

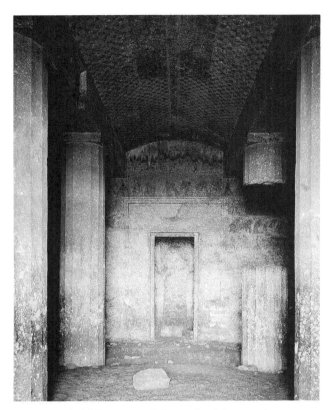

3-22 Hall interior of the tomb of Amenemhet,
Beni Hasan, *c.* 1930 B.C.

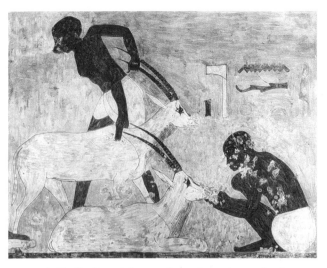

3-23 *Feeding of Oryxes,* fresco from the tomb of
Khnumhotep, Beni Hasan, *c.* 1900 B.C. Tempera facsimile.

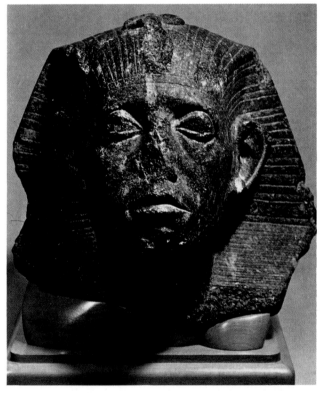

3-24 *Sesostris III* (ruled 1878–1843 B.C.),
from the Temple of Medamud. Granite, 11″ high.
Egyptian Museum, Cairo.

Amenemhet (FIG. **3-22**), the *reserve* columns serve no supporting function, being, like the portico columns, continuous parts of the rock fabric. (Note the broken column in the rear, suspended from the ceiling like a stalactite.) Tomb walls were decorated with paintings and painted reliefs, as in former times, and the subjects were much the same.

Painting and Sculpture

A painting from the tomb of Khnumhotep (FIG. **3-23**) shows servants feeding oryxes (antelopes), the domesticated pets of the Egyptian gentry. Here the artist has made a daring attempt to present the shoulders and backs of both human figures by foreshortening. However, working within the rigid framework of convention, the artist simply joined their front and side views in an unusual combination. As a result, the action reads convincingly enough, but the figures fall short of optical consistency.

A somewhat deepened perception of personality and mood can be noted in portrait sculpture of the Middle Kingdom, as shown in a partially damaged head (FIG. **3-24**) thought to be of Sesostris III. The head, detail of a sphinx, has a pessimistic expression that, interestingly, reflects the dominant mood of the literature of the Middle Kingdom. The strong mouth,

the drooping lines about the nose and eyes, and the shadowy brows show a determined ruler, who had also shared in the cares of the world, sunk in brooding meditation. The portrait is strangely different from the typically realistic and "public" Old Kingdom faces; it is personal, almost intimate, in its revelation of the mark of anxiety that a troubled age might leave on the soul of a king.

THE NEW KINGDOM

This anxiety may have reflected premonitions of disaster. Like the one that preceded it, the Middle Kingdom disintegrated, and power passed to a line of migrant Semitic Asiatics from the Syrian and Mesopotamian uplands. The Hyksos, or Shepherd Kings, brought with them a new and influential culture and that practical instrument, the horse. The invasion and domination of the Hyksos, traditionally thought to have been disastrous, were later reassessed and judged seminal influences that kept Egypt in the mainstream of Bronze Age culture in the eastern Mediterranean. In any event, the innovations introduced by the Hyksos, especially in weaponry and the techniques of war, contributed to their own overthrow by native Egyptian kings of the Seventeenth Dynasty. Ahmose I, final conqueror of the Hyksos and first king of the Eighteenth Dynasty, ushered in the New Kingdom (the Empire)—the most brilliant period in Egypt's long history. At this time, Egypt extended her borders by conquest from the Euphrates in the east deep into Nubia (the Sudan) to the south. Wider foreign contact was afforded by visiting embassies and by new and profitable trade with Asia and the Aegean islands. The booty taken in wars and the tribute exacted from subjected peoples made possible the development of a new capital, Thebes, which became a great and luxurious metropolis with magnificent palaces, tombs, and temples along both banks of the Nile. Thutmose III, who died in the fifty-first year of his reign in the second half of the fifteenth century B.C., was the greatest pharaoh of the New Kingdom, if not of all Egyptian history, and his successors continued the grand traditions he established. The optimistic mood of the new era is recorded in an inscription above the heads of revelers in a painting now in the British Museum:

The Earth-god has implanted his beauty in every body.
The Creator has done this with his two hands as balm to his heart.
The channels are filled with waters anew
And the land is flooded with his love.

Architecture

If the most impressive monuments of the Old Kingdom are its pyramids, those of the New Kingdom are its grandiose temples. Burial still demanded the elaborate care shown earlier, and, partly in keeping with the tradition of the Middle Kingdom, nobles and kings hollowed their burial chambers deep in the cliffs west of the Nile. In the Valley of the Kings, the rock-cut tombs are approached by long corridors that extend as far as 500 feet into the hillside. The entrances to these burial chambers were concealed carefully, and the mortuary temples were built along the banks of the Nile at some distance from the tombs. The temple, which provided the king with a place for worshiping his patron god and then served as a mortuary chapel after his death, became elaborate and sumptuous, befitting both the king and the god.

The most majestic of these royal mortuary temples, at Deir el-Bahri, was the Temple of Queen Hatshepsut (FIG. 3-25), who preceded the conquering

3-25 Temple of Queen Hatshepsut (with excavations of mortuary complex of Mentuhotep in foreground), Deir el-Bahri, c. 1450 B.C.

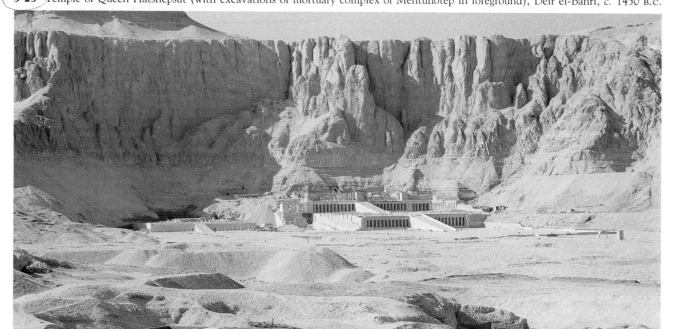

pharaoh Thutmose III. A princess who became queen when there were no legitimate male heirs old enough to rule, she boasted of having made the "Two Lands to labour with bowed back for her." Built about 1450 B.C. along the lines of the neighboring Middle Kingdom temple of Mentuhotep I, her mortuary temple rises from the valley floor in three colonnaded terraces connected by ramps. It is remarkable how visually well suited the structure is to its natural setting. The long horizontals and verticals of the colonnades and their rhythm of light and dark repeat, in manmade symmetry, the pattern of the rocky cliffs above. The pillars of the colonnades, which are either simply rectangular or *chamfered* (beveled, or flattened at the edges) into sixteen sides, are esthetically proportioned and spaced. Statues in the round, perhaps as many as two hundred, were intimately associated with the temple architecture. The brightly painted low relief (whose remnants may still be seen) that covered the walls also was carefully integrated into the structure's design. The relief represented Hatshepsut's birth, coronation, and great deeds. In her day, the terraces were not the barren places they are now

but gardens with frankincense trees and rare plants brought by the queen from an expedition to the faraway "land of Punt" on the Red Sea, an event that figures prominently in the temple's relief decorations.

The immense rock-cut temple of Ramses II, Egypt's last great warrior-pharaoh, who lived a little before the Exodus from Egypt under Moses, was built far up the Nile at Abu Simbel. (The whole monument was moved in 1968 to save it from submersion in the Aswân High Dam reservoir.) Ramses, proud of his many campaigns to restore the empire, augmented his greatness by placing four colossal images of himself in the temple façade (FIG. 3-26). In later times, the glories of kings and emperors in periods of conquest and imperial grandeur were also celebrated in huge monuments; gigantism seems characteristic of much of the art of empires that have reached their peaks. At Abu Simbel, Ramses' artists use the principle of augmentation both by size and by repetition. The massive statues lack the refinement of earlier periods, because much is sacrificed to overwhelming size. The grand scale is carried out in the interior also (FIG. 3-27), where giant figures of the king, formed as col-

3-26 Temple of Ramses II, Abu Simbel, Nubia (now relocated), 1257 B.C. Colossi approx. 60' high.

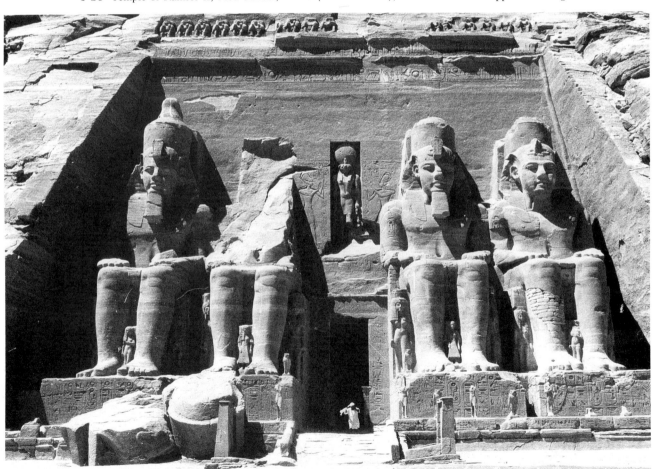

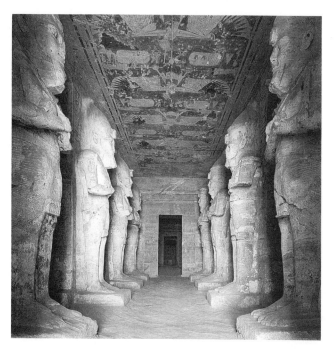

3-27 Interior of the Temple of Ramses II, Abu Simbel.

umns, face each other across the narrow corridor; their exaggerated mass appears to appropriate the architectural space. The columns are reserved (hewn from the living rock) and have no bearing function; in this respect, they resemble the columns in the tombs at Beni Hasan. The figure-as-column, the *atlantid* (male) or *caryatid* (female) form, will appear later in Greek architecture, and its presence at Abu Simbel may be its earliest use.

Distinct from the mortuary temples were the edifices built to honor one or more of the gods and often added to by successive kings until they reached gigantic size (as seen in the temples at Karnak and Luxor, FIGS. 3-32 and 3-33). These temples all had similar plans. A typical *pylon temple* plan (FIG. **3-28**) is bilaterally symmetrical along a single axis that runs from an approaching avenue through a colonnaded court and hall into a dimly lighted sanctuary. The dominating feature of the statuary-lined approach is the façade of the pylon, simple and massive, with sloping walls. The pylon shown in FIG. 3-29 is from the Temple of Horus at Edfu, which was constructed

3-28 Plan of a typical pylon temple.

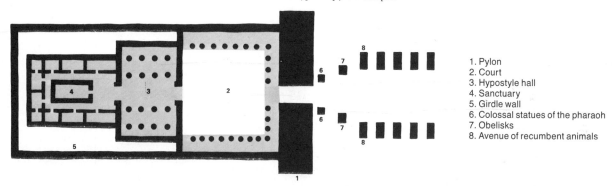

1. Pylon
2. Court
3. Hypostyle hall
4. Sanctuary
5. Girdle wall
6. Colossal statues of the pharaoh
7. Obelisks
8. Avenue of recumbent animals

3-29 Pylon Temple of Horus, Edfu, *c.* 237–212 B.C.

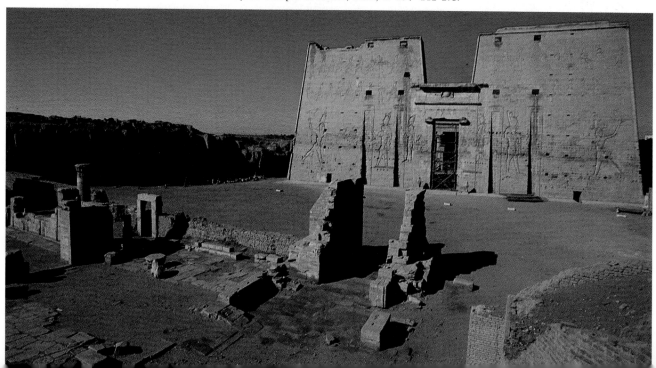

during the Ptolemaic period and is a striking monument to the persistence of Egyptian artistic traditions. Its broad surface is broken by the doorway with its overshadowing cornice, by deep channels to hold great flagstaffs, and by sunken reliefs. Moldings finish its top and sides. Inside is an open court colonnaded on three sides, followed by a hall between court and sanctuary, its long axis placed at right angles to that of the entire building complex. This "broad" or *hypostyle* hall (one having a roof supported by columns) is crowded with massive columns and roofed by stone slabs carried on lintels that rest on impost blocks supported by the great capitals. In the hypostyle hall of the Temple of Amen-Re (a variant reading is Imen-Re) at Karnak (FIGS. **3-30** and **3-31**), the columns are 66 feet high, and the capitals are 22 feet in diameter at the top, large enough to hold one hundred people. The Egyptians, who used no cement, depended on the weight of the huge stones to hold the columns in place. In many hypostyle halls, the central rows of columns were higher than those at the sides, raising the roof of the central section and creating a *clerestory*. Openings in the clerestory permitted light to filter into the interior. This method of construction appears in primitive form as early as the Old Kingdom in the valley temple of the Pyramid of Khafre. Evidently an Egyptian invention, it has remained an important architectural feature down to our times and was particularly important in the design of medieval cathedrals.

The Egyptian temple plan evolved from ritualistic requirements. Only the pharaoh and the priest could enter the sanctuary; a chosen few were admitted to the hypostyle hall; the mass of the people was allowed only as far as the open court, and a high mud-

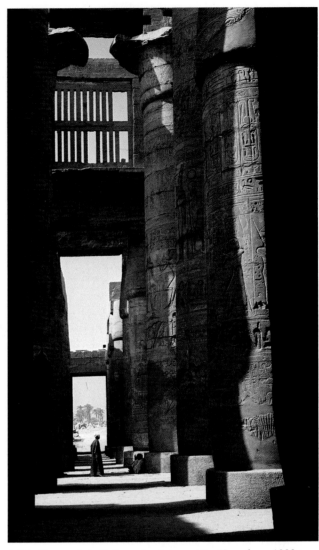

3-30 Hypostyle hall, Temple of Amen-Re, Karnak, *c.* 1280 B.C.

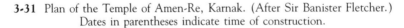

3-31 Plan of the Temple of Amen-Re, Karnak. (After Sir Banister Fletcher.)
Dates in parentheses indicate time of construction.

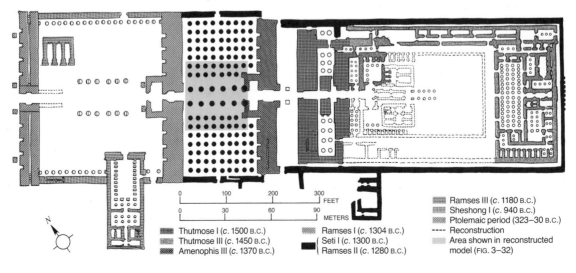

Thutmose I (*c.* 1500 B.C.)	Ramses I (*c.* 1304 B.C.)
Thutmose III (*c.* 1450 B.C.)	Seti I (*c.* 1300 B.C.) / Ramses II (*c.* 1280 B.C.)
Amenophis III (*c.* 1370 B.C.)	
Ramses III (*c.* 1180 B.C.)	Sheshong I (*c.* 940 B.C.)
Ptolemaic period (323–30 B.C.)	Reconstruction
Area shown in reconstructed model (FIG. 3-32)	

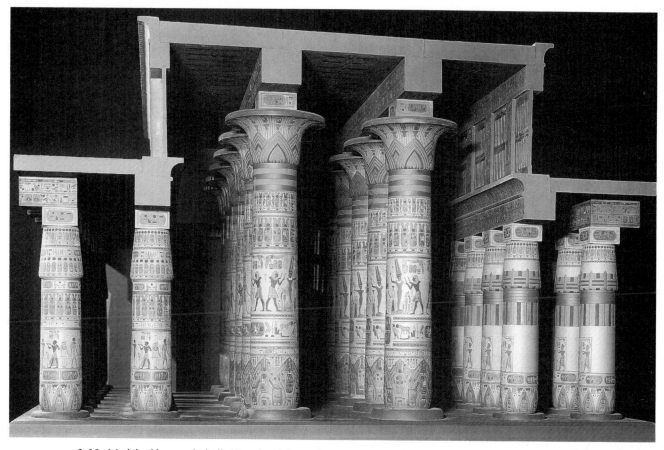

3-32 Model of hypostyle hall, Temple of Amen-Re, Karnak, c. 1280 B.C. Metropolitan Museum of Art, New York (bequest of Levi Hale Willard, 1890).

brick wall shut off the site from the outside world. The conservative Egyptians did not deviate from this basic plan for hundreds of years. The *corridor axis,* which dominates the plan, makes the temple not so much a building as, in Oswald Spengler's phrase, "a path enclosed by mighty masonry." Like the Nile, the corridor may have symbolized the Egyptian concept of life. Spengler suggests that the Egyptians saw themselves moving down a narrow, predestined life-path that ended before the judges of the dead. The whole of Egyptian culture can be regarded as illustrating this theme.

A model of the hypostyle hall at Karnak (FIG. **3-32**) shows the smooth-shafted (as opposed to fluted) Egyptian columns with the two basic types of capitals: bud shaped and bell shaped, or campaniform. Although the columns are structural members, unlike the reserve "columns" of the Middle Kingdom tombs at Beni Hasan and the figure-columns at Abu Simbel (see FIGS. 3-22 and 3-27), their function as carriers of vertical stress is almost hidden by horizontal bands of relief sculpture and painting, suggesting that the intention of the architects was not to emphasize the functional role of the columns so much as to utilize

them as surfaces for decoration. This contrasts sharply with later Greek practice, which emphasizes the vertical lines of the column and its structural function by freeing the surfaces of the shaft from all ornament.

The courts and colonnades of the Temple of Amen-Mut-Khonsu at Luxor (FIG. **3-33**) exhibit the columnar style especially well. The post-and-lintel structure of the temples appears to have had its origin in an early building technique that used firmly bound sheaves of reeds and swamp plants as roof supports in adobe structures. We have seen how Imhotep, some fourteen centuries earlier, first translated such early and relatively impermanent building methods into stone at Saqqara (see page 79). Evidence of their swamp-plant origin is still seen in these columns at Karnak and Luxor, which are carved to resemble lotus or papyrus, with bud-cluster or bell-shaped capitals. Painted decorations, traces of which still can be seen on the surfaces of the shafts and capitals, emphasized these natural details. In fact, the flora of the Nile valley supplied the basic decorative motifs in all Egyptian art. With respect to possible Mesopotamian influence, it is important to note that, until the time of

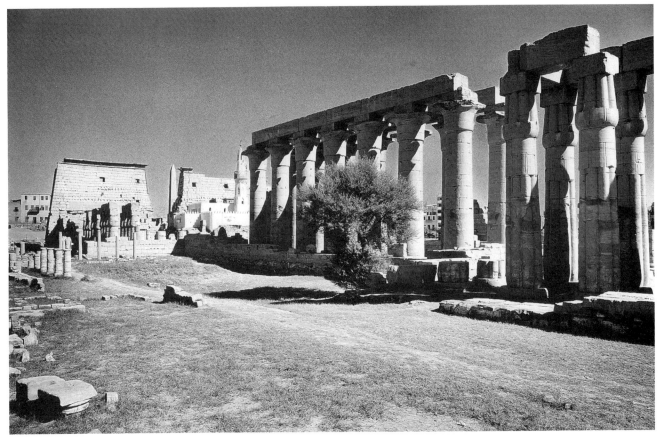

3-33 *Left:* court and pylon of Ramses II, *c.* 1280 B.C.; *right:* court and colonnade of Amenhotep III, *c.* 1370 B.C.
Temple of Amen-Mut-Khonsu, Luxor.

Persia, Mesopotamian architecture seldom employed the post-and-lintel system; the column was rarely seen. Moreover, the formalization of plant forms into the rigid profiles of architecture is precisely the same thing as the formalization of human bodies and action that the Egyptians achieved so skillfully in tomb painting and sculpture.

Sculpture and Painting

This radical simplification of form, which preserves in the ka figures the cubic essence of the block, can be seen to advantage in the statue showing Senmut (Queen Hatshepsut's chancellor and architect of her temple at Deir el-Bahri) with Princess Nefrua (FIG. **3-34**). This curious design, evidently popular in the New Kingdom, concentrates attention on the portrait head and leaves the "body" a cubic block, given over to inscriptions. With surfaces turning subtly about smoothly rounded corners, it seems another expression of the Egyptian fondness for volume enclosed by flat, unambiguous planes. The polished stone shape has its own simple beauty.

The persistence of the formulas for projection of an image onto a flat surface can be seen in wall paintings

3-34 *Senmut with Princess Nefrua*, from Thebes, *c.* 1450 B.C. Black stone, block statue approx. 40″ high. Staatliche Museen, Berlin.

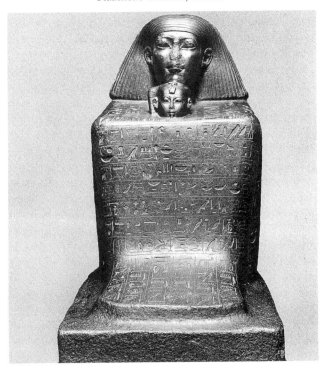

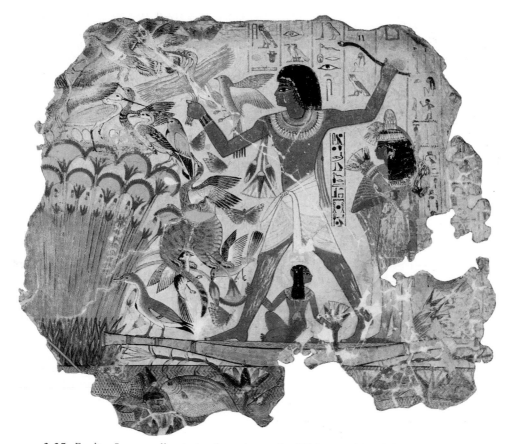

3-35 *Fowling Scene,* wall painting from the tomb of Nebamun (?), Thebes, *c.* 1400 B.C. Painting on dry plaster. British Museum, London.

in the tomb of Nebamun (?) at Thebes (FIG. **3-35**), which dates from the Eighteenth Dynasty. The deceased nobleman is standing in his boat, flushing the birds from a papyrus swamp. In contrast to the static pose of the hippopotamus-hunting Ti (FIG. 3-18), Nebamun is shown striding forward and swinging his throwstick vigorously. In his right hand, he holds three birds he has caught; a wild cat, on a papyrus stem just in front of him, has caught two more in her claws and is holding the wings of a third in her teeth. His two companions, perhaps his wife and daughter, their figures scaled down in proportion to their rank, are holding the lotuses they have gathered. Although the water and the figures are represented by the usual conventions, cat, fish, and birds show a naturalism based on visual perception similar to what we see in the *Geese of Medum* (FIG. 3-19).

The tomb chamber, as we see it in the well-preserved New Kingdom tomb of Nakht at Thebes (FIG. **3-36**), is similar to the tomb chambers of the Old Kingdom. In the mural, the system of registers still preserves the rigid separation of the zones of action, but some innovations of detail appear here, such as a new liveliness and a closer inspection of life. Another fresco fragment, probably from the tomb of Nebamun

3-36 Tomb of Nakht, Thebes, *c.* 1450 B.C. Fresco on rear wall 60″ × 55″.

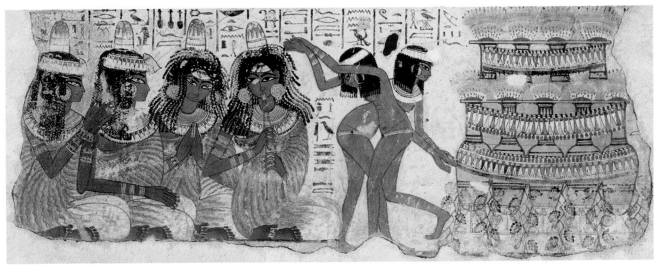

3-37 *Musicians and Dancers*, detail of a wall painting from the tomb of Nebamun (?), Thebes, c. 1400 B.C. Fragment 11¾″ × 27¼″. British Museum, London.

(FIG. **3-37**), shows four ladies watching and apparently participating in a musicale and dance in which two nimble little nude dancing girls perform. The overlapping of the girls' figures, facing in opposite directions, and the rather complicated gyrations of the dance are carefully and accurately observed and executed. Of the four ladies of the audience, two at the left are represented conventionally, but the other two face the observer in what is a most unusual and very rarely attempted frontal pose. They seem to beat time to the dance; one of them plays the reeds. The artist takes careful note of the soles of their feet as they sit cross-legged. This informality constitutes a relaxation not only of the stiff rules of representation but also of the set themes once thought appropriate for tomb painting. In addition, we may have here the reflection of a more luxurious mode of life in the New Kingdom; at this point, the ka may have required not only necessities and comforts in the hereafter but formal entertainment as well.

Akhenaton and the Amarna Period

These small variations on age-old formulas heralded a short but violent upheaval in Egyptian art, the only major break in the continuity of its long tradition. In the fourteenth century B.C., the emperor Amenophis IV (Amenhotep IV), later known as Akhenaton (or Ikhnaton), proclaimed the religion of Aton, the universal and only god of the sun. He thus contested and abolished the native cult of Amen, sacred to Thebes and professed by the mighty priests of such temples as Karnak and Luxor, as well as by the people of Egypt. He blotted out the name of Amen from all inscriptions, and even from his own name

and that of his father, Amenophis III. He emptied the great temples, embittered the priests and people, and moved his capital downriver from Thebes to a site now called Tell el-Amarna, where he built his own city and shrines to the religion of Aton.

These actions by Amenophis IV—now Akhenaton—although they might savor of the psychotic or of the fanaticism of sudden conversion, were portended by events in the formation and expansion of the power of the great Eighteenth Dynasty. Egyptian might had formed the first world empire. The conquering imperialist pharaohs—ruling over an empire that included Syria in the north and Nubia in the south—had gradually enlarged the powers of their old sun god, Amen, to make him not simply god of the Egyptians, but god of all men. Even before Egypt had become the main force in the Mediterranean world, Thutmose I, a founder of the fortunes of the dynasty, could say of the sun god that his kingdom extended as far as "the circuit of the sun." The military pharaoh, Thutmose III, said of this aggrandized god: "He seeth the whole earth hourly." Thus, Akhenaton was exploiting already-gathering forces when he raised the imperialized god of the sun to be the only god of all the earth and proscribed any rival as blasphemous. He appropriated to himself the new and universal god, making himself both the son and prophet, even the sole experient, of Aton. To him alone could the god make revelation. Akhenaton's hymn to Aton survives:

Thou art in my heart.
There is no other that knoweth thee
Save thy son Ikhnaton.
Thou hast made him wise
In thy designs and might.
The world is in thy hand,

Even as thou hast made them . . .
Thou didst establish the world,
And raise them up for thy son,
Who came forth from thy limbs,
The king of Upper and Lower Egypt,
Living in Truth, Lord of Two Lands . . .

Egypt has left us the ingredients, as it were, of the later monotheisms so influential in the world. Akhenaton's brief theocracy seems to have embodied the seeds of later concepts of one god, of an eternal son who is also a king, of a world created by that one god, and of the intimate revelation of that god's spirit to a chosen one.

One effect of the new religious philosophy seems to have been a temporary relaxation of the Egyptian preoccupation with death and the hereafter and a correspondingly greater concern with life on earth. In art, this change is reflected in a different attitude toward the representation of the human figure. Artists aimed for a new sense of life and movement, expressed in swelling, curvilinear forms; their long-fostered naturalistic tendencies, thus far confined largely to the representation of animals, were extended not only to the lowly human figure but, significantly, to royalty as well. A colossal statue of Akhenaton from Karnak (FIG. **3-38**) retains the standard frontal pose, but the strange, epicene body, with its

3-38 *Akhenaton,* from a pillar statue in the Temple of Amen-Re, Karnak, *c.* 1375 B.C. Sandstone, approx. 13' high. Egyptian Museum, Cairo.

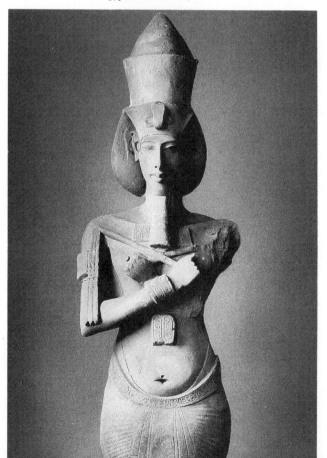

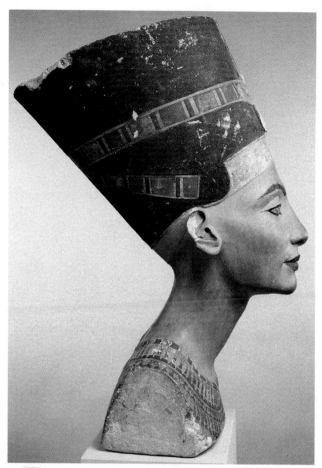

3-39 *Queen Nefertiti,* from Tell el-Amarna, *c.* 1360 B.C. Limestone, approx. 20" high. Ägyptisches Museum, Berlin.

curving contours, and the long, full-lipped face, heavy-lidded eyes, and dreaming expression, show that the artist has studied the subject with care and rendered him with all the physiognomical and physical irregularities that were part of the king's actual appearance. The predilection for curved lines stresses the softness of the slack, big-hipped body, a far cry indeed from the heroically proportioned figures of Akhenaton's predecessors. In a daring mixture of naturalism and stylization, the artist has given us an informal and uncompromising portrayal of the king, charged with both vitality and a psychological complexity that has been called expressionistic.

The famous painted limestone bust of Akhenaton's queen, Nefertiti (FIG. **3-39**), exhibits a similar expression of entranced musing and an almost mannered sensitivity and delicacy of curving contour. The sculptor may have been deliberately alluding to a heavy flower on its slender stalk by exaggerating the weight of the crowned head and the length of the almost serpentine neck. One thinks of those modern descendants of Queen Nefertiti—the models in the

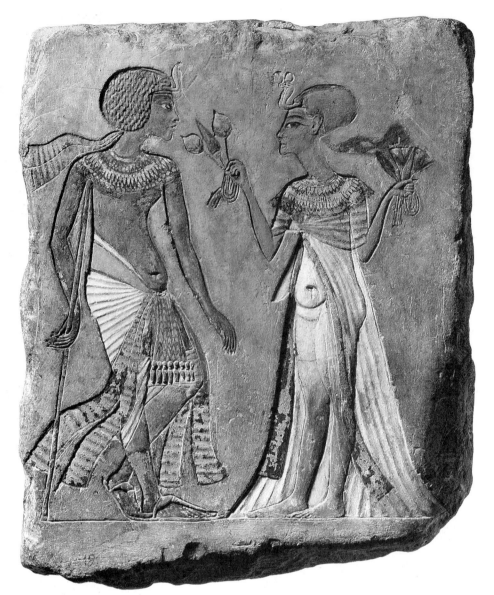

3-40 *King Smenkhkare and Meritaten (?)*, from Tell el-Amarna, *c.* 1360 B.C. Painted limestone relief, approx. 9½″ high. Staatliche Museen, Berlin.

fashion magazines, with their gaunt, swaying frames, masklike, pallid faces, and enormous, shadowed eyes. As the modern mannerism shapes the living model to its dictates, so the sculptors of Tell el-Amarna may have had some standard of spiritual beauty to which they adjusted the actual likenesses of their subjects. Even so, one is made very much aware of the reality of the queen through her contrived mask of beauty, a masterpiece of cosmetic art. The Nefertiti bust is one more example of that <u>elegant blending of the real and the formal</u> that we have noticed so often in the art of the ancient Near East.

During the last three years of his reign, Akhenaton's coregent was his half-brother, Smenkhkare. A relief from Tell el-Amarna may show Smenkh-

kare and his wife Meritaten (FIG. **3-40**) in an informal, even intimate, pose that contrasts strongly with the traditional formality in the representation of exalted persons. Once-rigid lines have become undulating curves, and the pose of Smenkhkare has no known precedent. The prince leans casually on his staff, one leg at ease, in an attitude that presumes knowledge on the sculptor's part of the flexible shift of body masses, a principle not really grasped until the Classical period in Greece. This quite realistic detail accompanies others that are the result of a freer expression of what is observed: details of costume and the departures from the traditional formality, such as the elongated and bulging head of Meritaten and the prominent bellies that characterize figures of

the Amarna school. Proportions of figures no longer depend on rank; the princess is depicted in the same scale as her husband on the basis of their natural proportions.

We have seen some slight loosening of the conventions of sculpture and painting even before Akhenaton, but the Amarna style (and a subsequent return to the earlier tradition) marks a break too abrupt and emphatic to permit us to conclude that the style was simply a local, native flowering. It is possible that there was some influence from the Mediterranean world. We know that Egypt dealt commercially with Crete, beginning in the Predynastic period, and the livelier, less convention-bound art of the Minoans could have proved suggestive and stimulating to the Amarna artists. Although the Cretan palace culture came to an end around 1400 B.C. (see Chapter 4), and Akhenaton did not ascend the Egyptian throne until 1378 B.C. (first as co-ruler with his father), the time lag does not seem too great to preclude such an influence. It may be that some Cretan artists, finding refuge in Egypt and a sympathetic artistic climate under Akhenaton's rule, fertilized the Amarna style.

The Tomb of Tutankhamen and the Late Period

The survival of the Amarna style is seen in the fabulously rich art and artifacts found in the unplundered tomb of the young pharaoh Tutankhamen (1361–1352 B.C.), who is known in modern folklore as "King Tut." The treasures of the tomb, which include sculpture, furniture, jewelry, and accessories of all sorts, were uncovered in 1922. The adventure of their discovery gained world renown. Installed in the Egyptian Museum in Cairo, a selection of these treasures was made available to a larger public in the late 1970s, when they were sent on a tour of museums throughout the world. It has been estimated that the collection attracted the greatest number of visitors recorded for any single tour of works of art. It reawakened public interest in the legend of "King Tut" and undoubtedly stimulated appreciation of ancient Egyptian art.

The principal monument in the collection is, of course, the tomb of the king himself. The royal mummy reposed in the innermost of three coffins, nested one within the other and shaped in the form of Osiris, god of death (FIG. **3-41**). The innermost coffin was the most sumptuously wrought of the three. Made of beaten gold (about a quarter ton of it) and inlaid with such semiprecious stones as lapis lazuli, turquoise, and carnelian, it is a supreme monument to the sculptor's and goldsmith's craft. The stylized

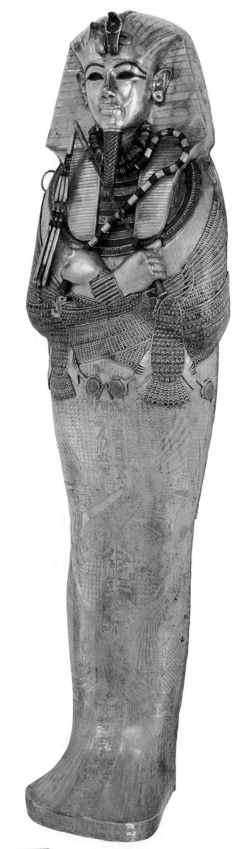

3-41 The innermost coffin of Tutankhamen (ruled 1361–1352 B.C.). Gold with inlay of enamel and semiprecious stones, 6' ⅞" long. Egyptian Museum, Cairo.

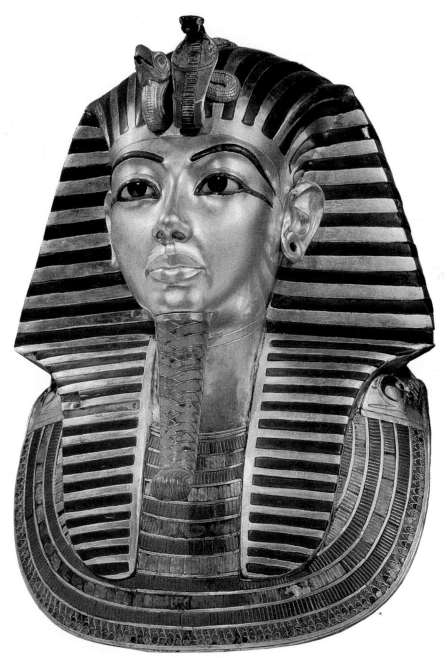

3-42 Death mask of Tutankhamen, found in innermost coffin. Gold with inlay of semiprecious stones. Egyptian Museum, Cairo.

portrait mask, which covered the king's face, shows his features relaxed in a kind of musing serenity that betokens his confidence in eternal life (FIG. **3-42**). Despite a lingering Amarnan sensitivity, softness of contour, and subtlety in the reading of personality, the general effect is one of grandeur and richness expressive of Egyptian power, pride, and affluence at the time of the onset of empire.

That the king must have defined his mission as imperial conqueror, and would have himself so represented, is shown in the panels of a painted chest from the treasures of the young pharaoh's tomb (FIG. **3-43**). The lid panel shows the king as a great hunter, pursuing droves of fleeing animals in the desert, and the side panel shows him as a great warrior. Together, the two panels are a double advertisement of royal power familiar in Assyrian art. From a war chariot drawn by spirited, plumed horses, Tutankhamen, shown larger than all other figures on the chest, draws his bow against a cluster of bearded, Asian enemies, who fall in confusion before him. He slays the enemy, like game, in great numbers. Above him,

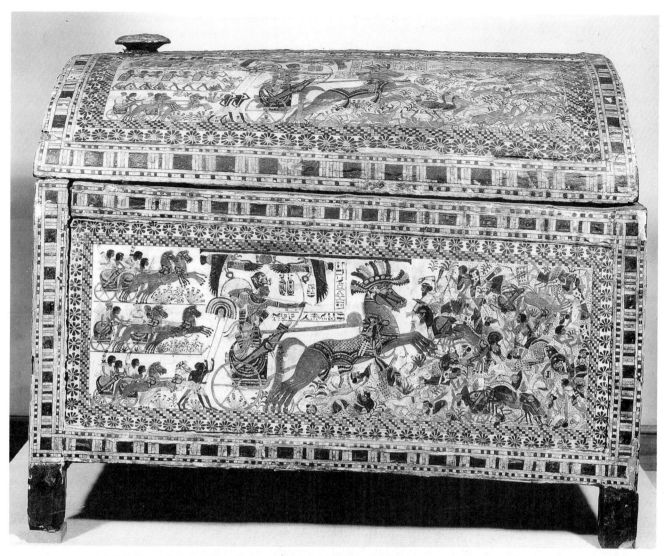

3-43 Painted chest, from the tomb of Tutankhamen, Thebes, c. 1350 B.C. Approx. 20″ long.
Egyptian Museum, Cairo.

the sun disc shines on his victory and the vulture goddess Nekh-bet, his special protectress, shelters him with her wings. Behind him are three tiers of war chariots in diminutive scale, which serve to magnify the figure of the king and to increase the count of his warriors. The themes are traditional, but the fluid, curvilinear forms, the dynamic compositions with their emphasis on movement and action, and the disposition of the hunted, overthrown animals and enemy—who, freed of conventional ground lines, race wildly across the panels—are features reminiscent not only of the Amarna style but, as we shall see, of the lively naturalism of Cretan art as well.

The pharaohs who followed Akhenaton reestablished the cult and priesthood of Amen, restored the temples and the inscriptions, and returned to the old manner in art. Akhenaton's monuments were wiped out, his heresy anathematized, and his city aban-

doned. The conservative reaction can be seen in a relief of the pharaoh Seti I (FIG. **3-44**). The rigid, flattened shapes repeat the formula of the *Palette of Narmer* (FIG. 3-2) and the static formality of Old Kingdom art.

Seti I and his successor, Ramses II, were builders both of the Egyptian Empire and the titanic colonnades of Karnak at Thebes, where their victories are celebrated in thousands of feet of relief sculpture and hieroglyphic inscription. Karnak was a monument to the Theban god Amen, restored to favor after the heresy of Akhenaton. Sixteen miles northwest of Karnak at Abydos, Seti I also constructed a great temple to the death god Osiris, whose religion he expanded from a local to a national one. The gods of Thebes were official, belonging to the state religion; their temples were in the care of an elite, privileged priesthood isolated from the people. But Osiris, god of the

3-44 *Seti I Offering*, from the Temple of Seti I, Abydos, c. 1300 B.C. Painted limestone. Louvre, Paris.

dead and king of the underworld as well as giver of eternal life, became the object of devotion for all Egyptians, including the humblest among them. According to the myth of Osiris, he is slain and dismembered but rises again and, by his resurrection, conquers death; thus, he becomes the source of immortality for all humanity.

The ritual of the cult of Osiris is recorded in collections of spells, prayers, formulas, and counsels that compose the so-called Book of the Dead. Illuminated papyrus scrolls, some as long as 70 feet, were the essential equipment of the tombs of well-to-do persons. The papyrus scroll of Hu-Nefer, found in his tomb in the Theban necropolis, represents the final judgment of the deceased (FIG. **3-45**). At the left, he is led into the hall of judgment by Anubis, the jackal-headed god of embalming. Anubis then adjusts the scales to weigh the heart of the dead man against the feather of the goddess Maat, protectress of truth and right. A hybrid monster, half hippopotamus and half lion, the devourer of souls awaits the decision of the scales; if it is unfavorable to the deceased, the monster will destroy his soul on the spot. The ibis-headed god Thoth records the proceedings. Above, the gods of the Egyptian pantheon are arranged as witnesses. Having been justified by the scales, Hu-Nefer is brought by Osiris' son, the falcon-headed Horus, into the presence of the green-faced Osiris, the goddess Isis (wife of Osiris and mother of Horus), and the

3-45 *Psychostasis* (soul-raising) *of Hu-Nefer*, from Thebes. Painted papyrus scroll, 2¾″ high. British Museum, London.

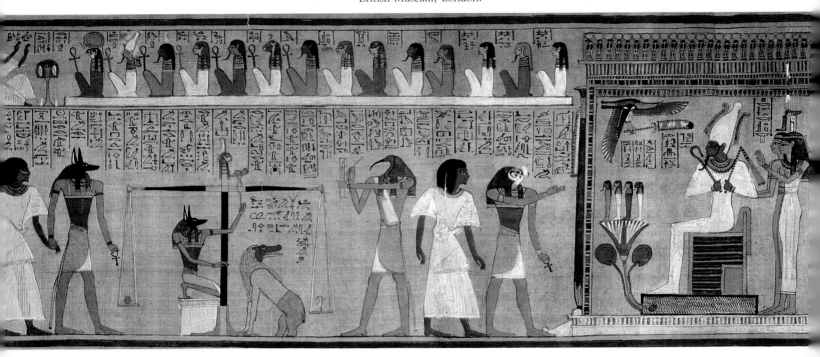

goddess Nephtys (the sister of Isis and Osiris) to receive the award of eternal life.

The figures have all the formality of stance, shape, and attitude—all the flat linearity—that we find in the art of the Old Kingdom. Abstract figures and hieroglyphs alike are aligned rigidly along the same planar surface. There is nothing here of the flexible, curvilinear style suggestive of movement that is evident in the art of Amarna and Tutankhamen. The conservatism is complete, as it is in the Seti I relief.

And so, in essence, it remained through the last centuries of Egyptian figural art. During this time, Egypt lost the commanding role it once had played in the Near East. The empire dwindled away, and the land was invaded, occupied, and ruled by foreign powers, Assyria and Persia, and peoples from the west (Libya) and south (Nubia-Ethiopia). From the period of the last-mentioned reign in Egypt, a portrait statue, *Mentemhet the Governor* (FIG. **3-46**), survives that easily could be mistaken for a Memphite work of the Old Kingdom (FIGS. 3-15 and 3-17). Yet this statue dates from the Twenty-fifth Dynasty in the seventh century B.C. The Old Kingdom formulas, conventions, and details of representation are all here in summary: the rigidity of stance, frontality, spareness of silhouette, arms at the side and one leg advanced, the kilt, the headdress, even the material (granite) and the carving technique recall the Old Kingdom. Only the realism of the head, with its rough, almost brutal, characterization, differentiates the work from that of the earlier age. The pharaohs of the late period deliberately referred back to the art of Egypt's classical phase to give authority to their royal image; religious and political motives only partly explain this deliberate archaism, however. As we noted at the beginning of this chapter, conservatism is a trait of the Egyptian character, perhaps the principal trait. The Egyptians' resistance to significant change over a period of almost three millennia may stem from a profound religiosity inspired by the steady sun, the eternal desert, the slow pulse of the Nilotic seasons, and the enduring conviction that life is not really interrupted by death.

3-46 *Mentemhet the Governor, c.* 650 B.C. Granite, 53" high. Egyptian Museum, Cairo.

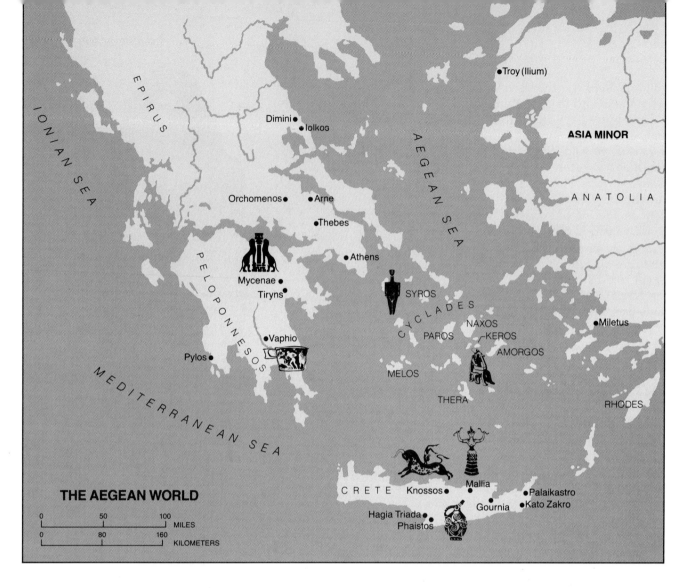

THE AEGEAN WORLD

				MILES
0	50	100		
0	80	160		KILOMETERS

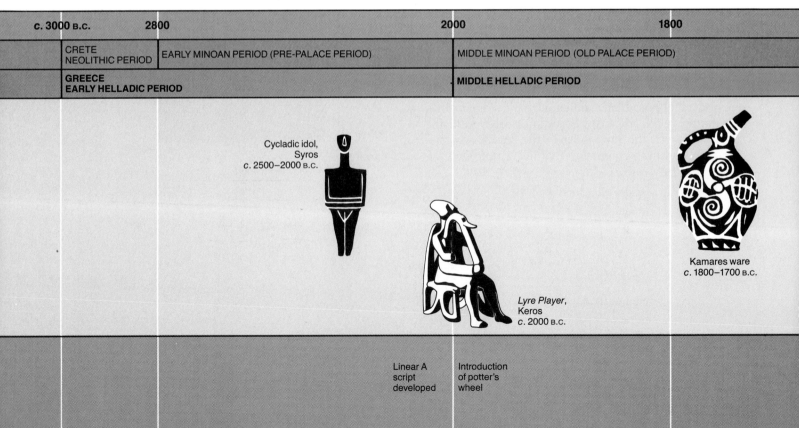

c. 3000 B.C.	2800		2000	1800
CRETE NEOLITHIC PERIOD	EARLY MINOAN PERIOD (PRE-PALACE PERIOD)		MIDDLE MINOAN PERIOD (OLD PALACE PERIOD)	
GREECE EARLY HELLADIC PERIOD			**MIDDLE HELLADIC PERIOD**	

Cycladic idol,
Syros
c. 2500–2000 B.C.

Lyre Player,
Keros
c. 2000 B.C.

Kamares ware
c. 1800–1700 B.C.

Linear A
script
developed

Introduction
of potter's
wheel

*Bold type indicates Helladic and Mycenaean chronology.

4

THE AEGEAN: CYCLADIC, MINOAN, AND MYCENAEAN ART

1700	1600	1500	1400	1200	1000

	LATE MINOAN PERIOD (NEW PALACE PERIOD)		SUB-MINOAN PERIOD

	LATE HELLADIC (MYCENAEAN) PERIOD		SUB-MYCENAEAN PERIOD

The Vaphio Cups
c. 1500 B.C.

Snake Goddess,
Knossos
c. 1600 B.C.

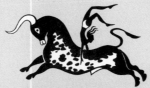

The Toreador Fresco,
Knossos c. 1500 B.C.

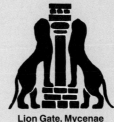

Lion Gate, Mycenae
c. 1300 B.C.

Destruction of
old palaces
c. 1700

Decline of
new palaces
c. 1400–1200

Dorian invasion
of Greece
c. 1200

HOMER, IN THE _ILIAD_, wrote of the might and splendor of the Achaean host deployed for war against Troy:

> So clan after clan poured out from the ships and huts onto the plain of Scamander, and . . . found their places in the flowery meadows by the river, innumerable as the leaves and blossoms in their season . . . the Locrians . . . the Athenians . . . the citizens of Argos and Tiryns of the Great Walls . . . troops from the great stronghold of Mycenae, from wealthy Corinth . . . from Lacedaemon . . . from Pylos . . . Knossos in Crete, Phaistos . . . and the other troops that had their homes in Crete of the Hundred Towns.

The list goes on and on, outlining the peoples and the geography of the Aegean world in intimate detail. Until about 1870, historians of ancient Greece, although they acknowledged Homer's superb art, discounted him as a historian, attributing the profusion of names and places in his writings to the rich abundance of his imagination. The prehistory of Classical Greece remained shadowy and lost, historians believed, in an impenetrable world of myth. That they had done less than justice to the truth of Homer's account, or for that matter, to ancient Greek literary sources in general, was proved by a German amateur archeologist. Between 1870 and his death twenty years later, Heinrich Schliemann uncovered some of the very cities of the Trojan and Achaean heroes Homer celebrates: Troy, Mycenae, Orchomenos, and Tiryns. In 1870, at Hissarlik in the northwest corner of Asia Minor, which Schliemann's knowledge of the _Iliad_ had led him to believe was the site of Homer's Troy, he dug into a vast _tell,_ or mound, and found there a number of fortified cities built on the remains of one another, together with the evidence of the destruction of one of them by fire. Schliemann continued his excavations at Mycenae on the Greek mainland, from which, he believed, Agamemnon and Achilles had sailed to avenge the capture of Helen, and here his finds were even more startling. Massive fortress-palaces, elaborate tombs, quantities of gold jewelry and ornaments, cups, and inlaid weapons revealed a magnificent pre-Classical civilization.

But further discoveries were to prove that Mycenae had not been the center of this fabulous civilization. Nor had the lesson of Schliemann's success in pursuing hunches based on the careful reading of ancient legends been lost on his successors. An important Greek legend told of Minos, king of Crete, who had exacted from Athens a tribute of youths and maidens to be fed to the Minotaur, a creature half bull and half man that was housed in a vast labyrinth. Might this legend too be based on historical fact? An English-

man, Arthur Evans, had long considered Crete a potentially fertile field for investigation, and Schliemann himself, shortly before his death, had wanted to explore the site of Knossos. In 1900, Evans began work on Crete, and a short time later he uncovered extensive palaces, built by the old sea-kings of Crete, which indeed did resemble labyrinths (FIG. 4-6). His findings, primarily at Knossos, were augmented by additional excavations there and at Phaistos, Hagia Triada, and other important sites along the southern coast of the island. In 1962, excavation of another palace was begun on the eastern tip of Crete at Kato Zakro; more recently, a queen's burial chamber judged to be thirty-four hundred years old was found near Knossos.

The civilization of the coasts and islands of the Aegean emerged about the same time as the river valley civilizations of Egypt and Mesopotamia. Although close contact existed at various times and an active exchange of influences took place, each civilization manifested an originality of its own. The Aegean civilization has a special significance as the forerunner of the first truly European civilization—that of Greece. The sea-dominated geography of the Aegean contrasts sharply with that of the Near East, as does its temperate climate. In ancient times, these conditions produced a busy, commercial, seafaring culture with decentralized authority and a vigorous, vivacious, and pleasure-loving way of life. This description is especially true of Crete, the ancient center of Aegean civilization and the source from which its creative forces radiated. As a commercial crossroads for the ancient world, Crete was placed strategically in the eastern Mediterranean, and her agricultural products and manufactured goods were exported widely. The sea provided a natural defense against the frequent and often disruptive invasions that checker the histories of land-bound civilizations like those of Mesopotamia, and the navies of the sea-kings maintained a prosperous maritime empire that served for the transmission of ideas and influences as well as goods. The controlled accessibility to Crete of impulses from abroad, especially from Egypt and Mesopotamia, may account for the emergence and influence of its culture, which was felt in all of the Aegean area. Modifications of it on the Greek mainland and in the islands of the Cyclades north of Crete have been identified. Thus, the art of the islands is called Cycladic; that of Crete, Minoan, after King Minos; and that of the mainland, Helladic. The culture associated with Mycenae on the mainland, the Mycenaean culture, is classed under Late Helladic (about 1550–1100 B.C.).

The archeological problems confronting investigators of Near Eastern civilizations were much less difficult than those that confronted archeologists working in the Aegean area. Very few documents survived in

Aegean sites with which to correlate the archeological findings and no "absolute" dates were agreed upon that could be expressed numerically. Chronicles and inscriptions such as those discovered for Egypt and Mesopotamia did not exist for the Aegean. Evans had to construct a "relative" dating system based on different ceramics and different decorative styles from various sites on Crete, in the Cyclades, and at Mycenae. His tripartite division of Minoan art into Early, Middle, and Late Minoan and the further division of each large period into three subperiods are a classic example of a relative chronology used by archeologist-historians who lack absolute dates. The Minoan chronology received some corroboration when points of contact with the chronology of Egyptian art were established. Imported objects of a certain style from one country were uncovered in datable contexts in the other, and in this way, for example, the Middle Minoan period was found to be roughly contemporary with the Middle Kingdom in Egypt.

The two earliest of several scripts found on Crete seem to have been inspired by Egyptian hieroglyphs. Of the later scripts, Linear A and Linear B, only the latter has been deciphered (as late as 1953); it is a pre-Homeric form of Greek, but the tablets inscribed with it almost exclusively represent inventories and tallies of objects and are of little aid in delineating the Minoan culture. For Minoan history, pottery remains have provided by far the greatest evidence, since figurative art is relatively scarce and often so fragmentary and diminutive as to preclude building a stylistic continuity on it. Potsherds are one of the mainstays of archeology when documentary and monumental evidence is sparse or missing. Broken kitchenware, for example, was often thrown on a garbage heap, where the perishable materials decayed over the years, leaving only the pottery sherds, which settled into firmly stratified mounds. The careful excavation of these mounds can produce relative chronologies. Although the sequence of Cretan pottery styles was well established by Evans, some archeologists now feel that his method of dating is inadequate in view of increased knowledge of the Minoan civilization. A new chronology has been suggested that is based on the construction of the great Cretan palaces. Its relationship to the traditional chronology is shown on page 104.

Overall, absolute dates for Minoan civilization are few, and our knowledge of Minoan history remains vague and provisional. Even the origin of the Cretans is problematical. Some believe that they may have come from Anatolia as early as 6000 B.C., bringing with them a well-developed Neolithic culture, complete with pottery. The Bronze Age then may have been ushered in by a new wave of immigrants (also possibly from Anatolia) around the year 2800 B.C.

THE EARLY MINOAN PERIOD

The Early Minoan (pre-Palace) period is known to us primarily through pottery and a few scattered pieces of minor sculpture. Mochlos stoneware, dated to this period, is named after the site at which it was found and apparently was copied from Egyptian pieces of the First to Fourth Dynasties. Other representative pieces include handmade clay pots decorated with incised geometric patterns.

The most striking and perhaps the most appealing Aegean products of the Early Bronze Age are the numerous marble statuettes from the Cyclades. Most of them are representations of nude females with their arms folded across their abdomens. Varying in height from a few inches to life size, these flat "plank idols" are highly schematized descendants of the Neolithic mother goddess (see FIG. 2-5). They differ in style as much as in size and range from figures of almost normal proportions to shapes that resemble violins rather than human figures. The example shown (FIG. 4-1) occupies a middle ground: the organic forms have been converted into geometric shapes (triangles, rectangles, ovals, and cylinders),

4-1 Cycladic idol, Syros, *c.* 2500–2000 B.C. Marble, 8½" high.

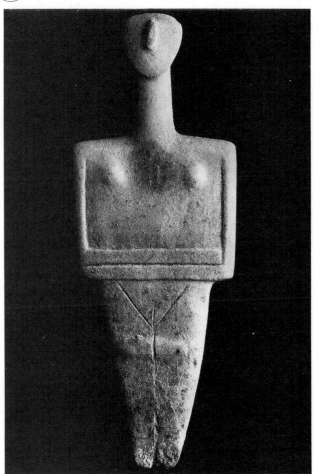

but the reference to the female figure remains clear, and the manner in which the various stylized parts have been combined has considerable esthetic appeal. Traces of paint found on some specimens show that at least parts of these figures were colored. The eyes were usually painted, and additional color touches were provided by painted necklaces and bracelets.

Male figures also occur occasionally in the Cycladic repertoire. They usually take the form of musicians, like the *Lyre Player* (FIG. 4-2), who, wedged between the echoing shapes of chair and lyre, performs a task that seems to have been a part of funerary rituals. In

4-2 *Lyre Player*, from Keros, *c.* 2000 B.C. Marble, 9″ high. National Archeological Museum, Athens.

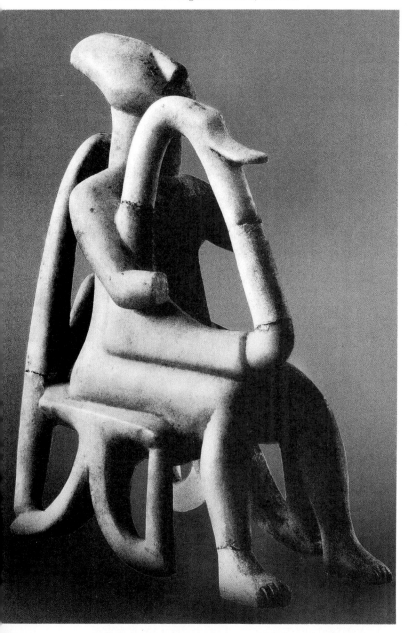

the rendering of the figure, the disk-shaped head and the long, tubular neck are in the same style as the plank figures, but the body has gained mass and volume, and the composition has a three-dimensional quality lacking in the plank idols. Although it has not been possible to establish a chronological sequence for these Cycladic figurines, most seem to date from the second half of the third millennium B.C.; the *Lyre Player* is believed to belong to the end of this period and may have been contemporary with the Cretan palaces.

THE MIDDLE MINOAN PERIOD

The Middle Minoan period is marked by the founding of the old palaces around the year 2000 B.C. Building in Crete did not emphasize tombs, temples, or fortresses. Palaces for the king and his retainers were the most permanent architectural form, and royal towns grew up around them. The absence of fortification on Crete is conspicuous in the Aegean world; fortified sites appear everywhere in the Helladic and Cycladic areas. This fact attests either to the power of the Cretan navies, or to a long-enduring insular peace, or to both. But after only about three centuries, around 1700 B.C., these old palaces were destroyed, probably by one of the frequent earthquakes that ravage this part of the Mediterranean region.

An important technological advance that took place at the beginning of the Old Palace period was the introduction of the potter's wheel, which permitted the throwing of vessels with thinner walls and subtler shapes and led to the development of a thriving industry. In this so-called eggshell ware, the Minoan potter's art reached a degree of excellence that deserves our highest admiration, if for the delicacy of the ceramic technique alone. But Cretan artists also developed a style of decoration that complemented the delicate fabric and sophisticated shapes of their pottery. Beginning with relatively simple, curvilinear patterns painted dark on light (FIG. 4-3), Cretan potters moved toward a fully polychrome style of decoration that found its culmination in the splendid pottery discovered in the cave at Kamares on the slope of Mount Ida (FIG. 4-4). On a surface swelling robustly with the peculiarly Minoan feel for the vigor and buoyancy of active life, we find a lustrous black ground on which a quasi-geometric pattern of creamy white is interspersed with yellow and red to form a colorful and harmonious decoration. As in Egypt, the motifs derive from natural forms; on the Kamares pitcher, they are simplified into a play of spirals, beautifully adjusted to and integrated with the shape of the vessel.

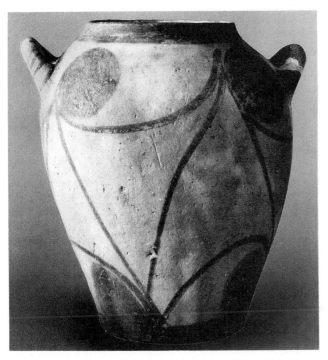

4-3 Small storage jar, from Psyra, *c.* 2000–1850 B.C. 11″ high.

4-4 Kamares pitcher, from Phaistos, *c.* 1800–1700 B.C. Approx. 10⅝″ high. Archeological Museum, Herakleion.

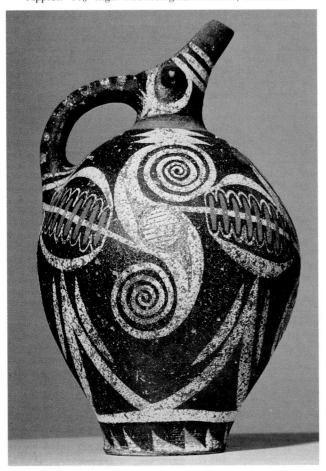

THE LATE MINOAN PERIOD

The New Palace period began somewhere between 1600 and 1500 B.C., when the destroyed palaces were rebuilt and the golden age of Crete produced the first great Western civilization. The bulk of the surviving archeological material—the evidence of an age of unsurpassed creative energy and precocious artistic achievement—dates from this era, which ended about 1400 B.C.

Architecture

The palaces rebuilt for the kings and their retainers were large, comfortable, and handsome, with ample staircases and courtyards for pageants, ceremonies, and games. Archeologists have recovered their ruins, along with rich treasures of art and artifacts that document the power and prosperity of Minoan civilization. The principal palace sites on Crete are at Knossos, Phaistos, Mallia, and Kato Zakro, situated at the eastern tip of the island. All of these are laid out along similar lines. The largest of the palaces, that at Knossos (FIGS. **4-5** and **4-6**), is a rambling structure built against the upper slopes and across the top of a low hill that rises from a fertile plain. The great rectangular court, around which the units of the palace are grouped, had been leveled in the time of the old palace; the manner of the grouping of buildings suggests that the palace was not preplanned but that several building nuclei grew together, with the court as the major organizing element. A secondary organization of the palace plan is provided by two long corridors. On the west side of the court, a north–south corridor separates official and ceremonial rooms from the magazines, where wine, grain, oil, and honey were stored in large jars (*pithoi*). On the east side of the court, an east–west corridor separates the king's and queen's quarters and reception rooms (to the south) from the workmen's and servant's quarters (on the north). At the northwest corner of the entire building complex is the "arena," a theaterlike area with steps on two sides that may have served as seats. This form is a possible forerunner of the later Greek theater. Its purpose is unknown, but it is a feature that, like the central court, appears in other Cretan palaces. For the Greeks, the complexity of the palace's plan came to be associated with the cult of the double axe (*labrys*), perhaps giving rise to the Greek myth of the Cretan *labyrinth*. Certainly, the palace's layout was the product of wealth and luxurious tastes and of a love for the convenient. Beneath the palace is a remarkably efficient drainage system of terra-cotta pipes that must have made Knossos one of the most sanitary cities in the world before the twentieth century.

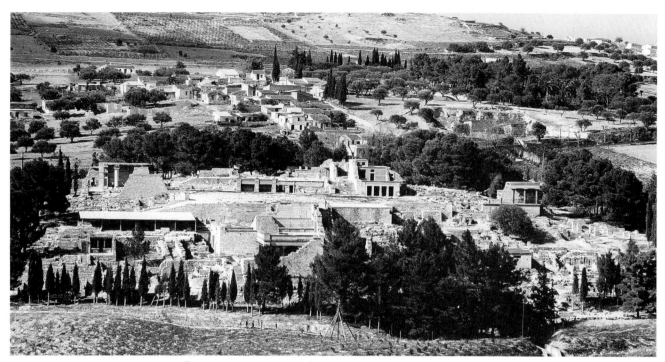

4-5 Palace at Knossos, c. 1600–1400 B.C. (view from the east).

4-6 Plan of the palace at Knossos. (After J. D. S. Pendlebury.)

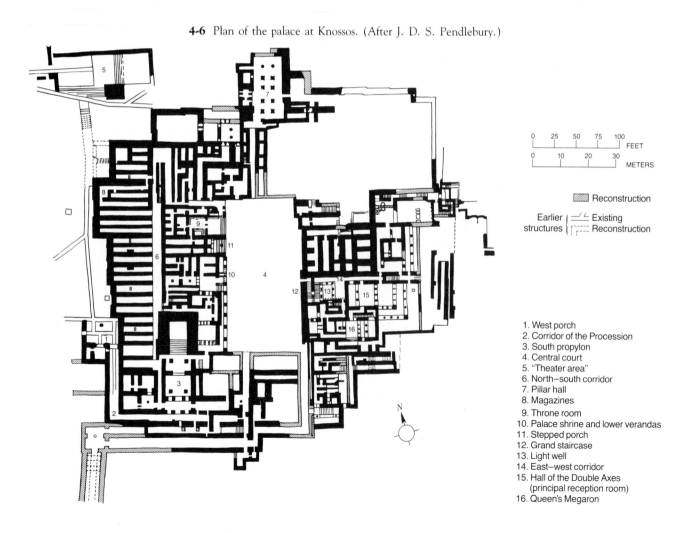

0 25 50 75 100
FEET
0 10 20 30
METERS

Reconstruction

Earlier { Existing
structures { Reconstruction

1. West porch
2. Corridor of the Procession
3. South propylon
4. Central court
5. "Theater area"
6. North–south corridor
7. Pillar hall
8. Magazines
9. Throne room
10. Palace shrine and lower verandas
11. Stepped porch
12. Grand staircase
13. Light well
14. East–west corridor
15. Hall of the Double Axes
 (principal reception room)
16. Queen's Megaron

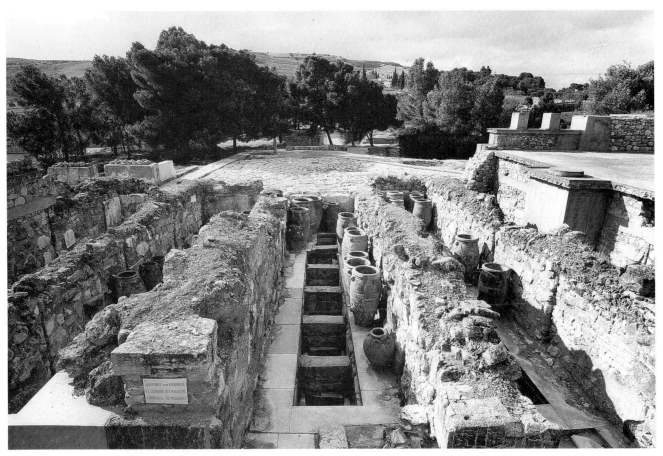

4-7 View of the magazine, west wing of the palace at Knossos, with large pithoi in situ.

4-8 Reconstruction of a stairwell, palace at Knossos.

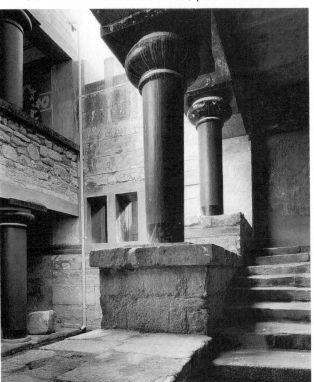

The practical storage system is exhibited in the magazines of the west wing (FIG. 4-7), where some of the pithoi are still in place. Some of the rooms had flat floors; others (like those shown here) had stone-lined pits. The walls were quite thick, as must have been the roofing over these magazines; the masonry may have been covered with earth to keep the interior cool. In most parts of the palace, the masonry walls were rough, consisting of unshaped field stones imbedded in mortar. Ashlar masonry, made of shaped blocks of stone, was used at building corners and around door and window openings.

The palace had as many as three stories, with interior staircases built around light and air wells (FIG. 4-8), which provided necessary illumination and ventilation. Distinguishing features of the Minoan columns, which were originally fashioned of wood but were restored in stone (with, it is now thought, mistakenly bulky proportions), are their bulbous, cushionlike capitals and the manner in which the column shafts taper toward the base. Strong evidence that the column had religious significance for the Cretans is found in the fact that the base of a column in one of the lower stories of the palace at Knossos is surrounded by a trough that was used for libations.

Painting

A view into the Queen's Megaron, with its pillared hall and light well (FIG. 4-9), shows the typically elaborate wall decoration of the more important rooms at Knossos. Here, plastered walls were painted with frescoes, which, together with the red- or blue-shafted columns, must have provided an extraordinarily rich effect. The frescoes depicted many aspects of Cretan life (bullfights, processions, and ceremonies) and of nature (birds, animals, flowers, and—as here—marine life, with dolphins frolicking among other fauna of the sea).*

One of the most memorable figures from the art of Crete is from a procession of cupbearers in a fresco in the south propylon at Knossos. *The Cupbearer*† (FIG.

*The Dolphin Fresco in the Queen's Megaron has recently been shown to be misrestored; it originally may have decorated the floor of another room in the palace.

†The scarred, patchy, and broken surface that makes the figure of *The Cupbearer* hard to discern is a good illustration of the fact that Minoan painting, like so much painting throughout the world, has survived only in fragments. To make sense of the fragments, the archeologist has had to reconstruct or restore the ruined painting to some semblance of its original appearance. Using exact, painstaking methods, experts have replaced fallen fragments in agreement with those remaining on the wall, and by careful deduction or even by conjecture and guesswork, they have achieved the complete picture. The task is like putting together an enormously complex jigsaw puzzle when many parts are missing and many completions are possible. A key to reading *The Cupbearer* and other fragmentary pictures will help: the smooth, lighter tonal areas show what is missing; the streaked and mottled, darker tonal areas are surviving fragments that have remained attached or that have been picked up and replaced.

4-10) is the only one preserved from a sequence, shown in two registers, that may have contained over five-hundred figures, if those from the Corridor of the Procession (FIG. 4-6) are included. The figure itself is unmistakably Minoan. The youth has long curly hair, wears an elaborately embroidered loincloth with a silver-mounted girdle, and has ornaments on his arms, neck, ankles, and wrist. Although the profile pose with the full-view eye was a familiar convention in Egypt and Mesopotamia, the elegance of the Cretan figure, with its pinched waist, proud, self-confident bearing, and free movement, distinguishes it from all other early figure styles. The angularity of the older styles is modified in the curving line that suggests the elasticity of the living and moving being. The ceremonial *rhyton* (vessel for pouring ritual libations) carried by the youth has a typically Minoan shape, found nowhere else except as a Minoan import.

Vivacity and spontaneity also characterize *The Toreador Fresco* (FIG. 4-11). Although only fragments of it have been recovered, they are extraordinary in their depiction of the vigorous movements of the girls and the young man who is shown in the air, having, perhaps, grasped the bull's horns and somersaulted over its back. We have seen how important the bull is in the Near East, especially in Mesopotamian art. The difference in the Minoan paintings is in the relationship of the bull to human beings. In this fresco, man and beast contest with each other in a dangerous game that takes place in the here and now, the human beings as conspicuous in the action as the

4-9 Reconstruction of the Queen's Megaron, palace at Knossos.

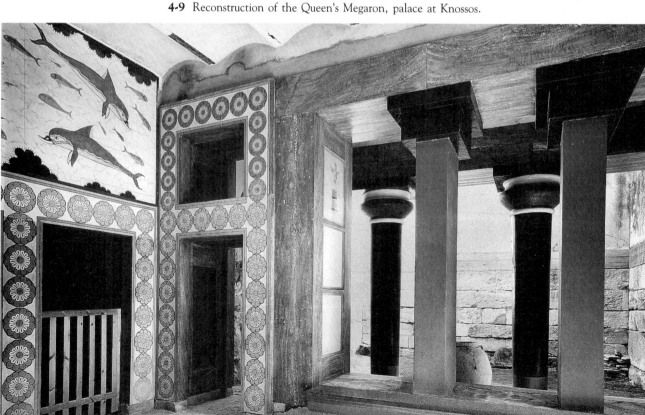

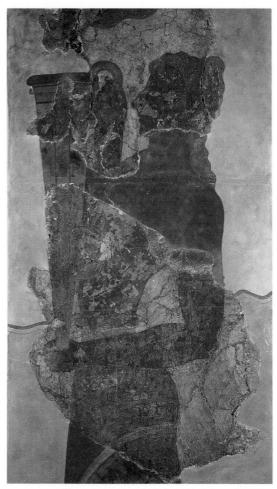

4-10 *The Cupbearer*, from the palace at Knossos, *c.* 1500 B.C. Fresco, approx. 60″ high. Archeological Museum, Herakleion.

bull. In a powerful characterization of the natures of both man and beast, the poise and agility of the toreadors play off against the exploding energy of the bull. (We are reminded of the charging bulls of the Paleolithic caves; see FIG. 1-1.) Everywhere within the frame are curving lines, the directional lines of action, and nowhere are they more conspicuous and vital than in the electric energy of the line that sweeps from the head of the bull to the whip of his tail.

Because of her cosmetic prettiness, which resembles that of a sophisticated, modern woman, a girl represented in a fragment of another fresco has been labeled *La Parisienne* (FIG. **4-12**). With her conventionally enlarged and front-view eye, her turned-up nose, full red lips, and elaborate coiffure, she is almost disturbingly of our own times, especially as we conventionalize her type in popular art. Surely, nothing quite like this sprightly charm, freshness, and joie de vivre appears in the art of the ancient Near East. The painting method used is appropriate to the lively spirit of the Minoans. Unlike the Egyptians, who painted in the dry-fresco *(fresco secco)* technique, the Minoans used a *true,* or *wet,* fresco method, which required rapid execution and a skill in achieving quick, almost impressionistic effects. If one is to catch an interesting but fugitive aspect of an object or a scene, one must work quickly, even spontaneously, allowing for happy accidents. Thus, because the wet-fresco technique compelled the artist to work rapidly, the spirit of *La Parisienne* is also a product of the resultant verve of the artist's hand, and the simple, light delicacy of the technique exactly matches the vivacity

4-11 *The Toreador Fresco*, from the palace at Knossos, *c.* 1500 B.C. Approx. 32″ high, including border. Archeological Museum, Herakleion.

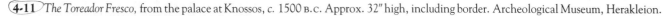

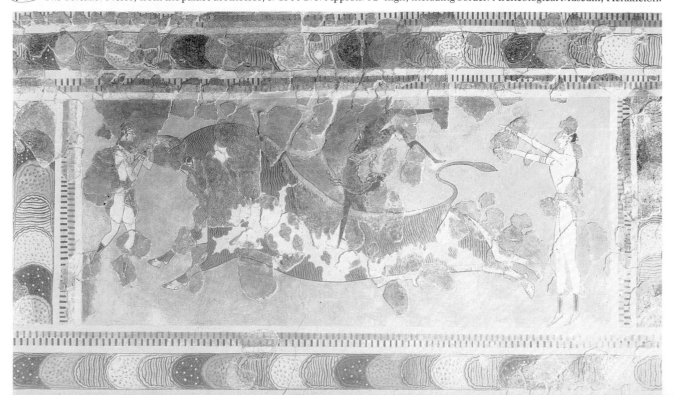

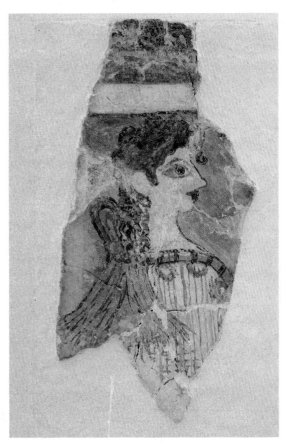

4-12 *La Parisienne*, from the palace at Knossos, c. 1500 B.C. Fragment of a fresco, approx. 10″ high. Archeological Museum, Herakleion.

of the subject. It is the Minoan sense of immediate life and the skill in catching it that strike us as novel in the ancient world and prophetic of great changes in people's outlook on nature.

This sense and skill are vividly present in wall paintings recently found in ruins on the volcanic island of Santorini (ancient Thera), sixty miles north of Crete. Thera was the site of an enormous seismic explosion that left a huge crater in the center of the island. Archeologists formerly dated the event at 1500 B.C. and speculated that it must have had disastrous effects on the palaces of Crete to the south of Thera. But recent radiocarbon investigation of the algae beds in the sea-filled crater have pushed the date of its marine life, and, hence that of the catastrophe, back as far as 1800 B.C.

Today, Santorini is regarded as a kind of early Pompeii, so well preserved are the remains of its streets, buildings, and especially its painted walls. We can feel the freshness and vitality of the Minoan vision of nature in the lovely mural *The Springtime Fresco* (FIG. 4-13). The undulating earth, the graceful lillies, and the darting swallows express vernal qualities—the vigor of growth, the delicacy of flowering, and the lightness of bird song and flight. In the lyrical language of curving line, the artist celebrates the breezy rhythms of spring. Landscape painting of this naturalistic sort is a Minoan innovation in the art of the ancient world, as far as we have yet discovered, and the forerunner of Greek and Roman landscape.

4-13 *The Springtime Fresco*, from Room Delta 2, Akrotiri, Santorini (ancient Thera), c. 1500 B.C. Approx. 7′ 6″ high. National Archeological Museum, Athens.

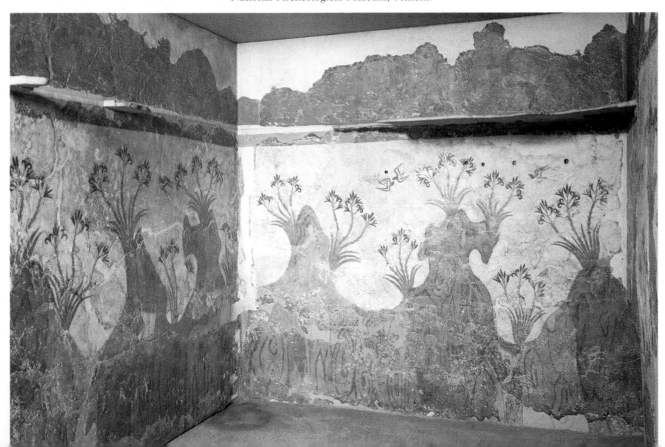

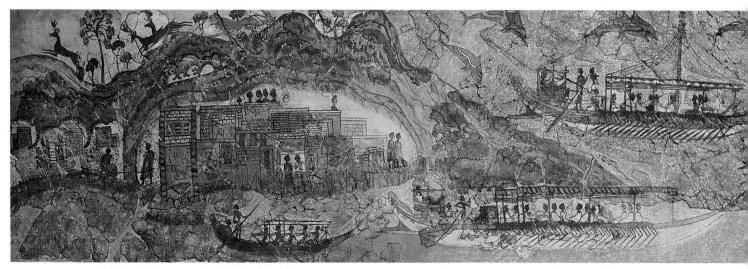

4-14 *The Flotilla Fresco,* from Room 5, West House, Akrotiri, Santorini, *c.* 1500 B.C. 17″ high.
National Archeological Museum, Athens.

Another painting of high quality from Santorini gives us a detailed picture of scenes from Minoan life. Seascape and landscape combined, *The Flotilla Fresco* (FIG. **4-14**) shows a fleet of ships plying between two ports. The details of ship design and of sailing are carefully observed, as if by one who knew ships well. Just as carefully observed are the placements and poses of steersmen, supercargoes, sailors, rowers, and passengers. Little of the conventional stereotyping and repetition that we find, for example, in much of Ancient Near Eastern art (FIG. 2-18) is evident here; instead, we find an almost casual arrangement of figures and variation of pose according to the role being played—steering, tending to the sail, rowing, or simply sitting and conversing. Dolphins resembling those in the Queen's Megaron at Knossos (FIG. 4-9) frolic about the ships, and on the shore (at the upper left), a lion pursues fleeing deer. The ports—the one at the left encircled by a river represented as arching above it—show quays, houses, and streets occupied by a variety of people attentive to the coming of the ships, waiting to unload them, or simply going about their business. The whole composition has the openness and lightness of the seagirt lands of Crete and the Greek islands, suggesting the freedom of movement of a people for whom seafaring is second nature, and nature—with all its flora and fauna—is, in itself, delightful and worthy of representation.

A painting of a young fisherman holding his abundant catch in both hands is yet another indication of the keen attention the Minoan artist paid to natural appearances (FIG. **4-15**). What at first appears to be the Egyptian convention of pose, frontal and profile views combined, can be read as an adjustment of the figure to allow both clusters of fish to be seen at the

4-15 *Young Fisherman Fresco,* from Room 5, West House, Akrotiri, Santorini, *c.* 1500 B.C. 53″ high.
National Archeological Museum, Athens.

same time, much as a modern sport fisherman, proud of his catch, might turn slowly to display it as his picture is being taken. The informality of the young fisherman might be compared with the strict formality of profile found in the cupbearer at Knossos (FIG. 4-10), the contrast reflecting differences of rank and occupation, with the lesser rank and humble occupation of the fisherman calling for, or permitting, a more realistic representation. We have found elsewhere in ancient art that persons of lower rank and scenes from common life are treated with less formality and greater realism than are kings and nobles, or scenes of royal and religious ritual.

Pottery and Sculpture

The Minoan feeling for the dynamics of nature, revealed in their figurative and landscape art, is no less visible in their pottery, which is among the finest in history. In the Kamares ware (FIG. 4-4), this interest in animate nature did not appear at once; the taste was for abstract spiral forms, scrolls, whorls, and the like. As time went on, however, the tendency toward naturalism in decoration increased. Motifs such as dolphins, seaweed, and octopuses were derived from sea life. The tentacles reaching out over the curving surfaces of *The Octopus Jar* (FIG. **4-16**) embrace the piece and emphasize its elastic volume. This is a mas-

4-17 Three-handled jar with papyrus decoration, from the palace at Knossos, c. 1425 B.C. Approx. 53″ high. Archeological Museum, Herakleion.

4-16 *The Octopus Jar*, from Palaikastro, c. 1500 B.C. Amphora approx. 11″ high. Archeological Museum, Herakleion.

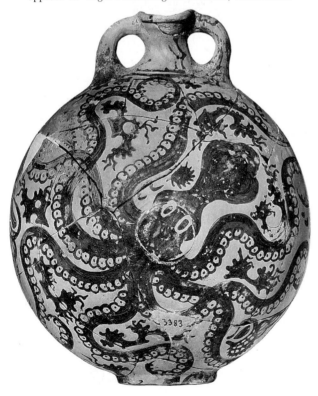

terful realization of the relationship between the decoration of the vessel and its shape, always a problem for the ceramist. From the Kamares silhouetting of light, abstract forms on a dark ground, we proceed, in *The Octopus Jar*, to a silhouetting of dark, naturalistic forms on a light ground. This manner of presentation lasted from about 1600 to 1500 B.C., when the fluid, open, and lively naturalistic style became increasingly stiff and abstract. This late style can be seen in a three-handled jar from Knossos (FIG. **4-17**), dated about 1425 B.C. The stalks of its papyrus decoration grow symmetrically, and the flowers turn into stylized scrolls and fans, symmetrically balanced. Wavy bands, simple concentric circles with crosses, and other rudimentary space-fillers occupy the surface rather than adjust to it and embrace it. Such devolution from naturalism to formalism and abstraction can be observed frequently in the history of world art.

An increasing self-awareness, which we have watched evolve slowly in ancient art, requires that humans represent themselves ever more as they are, in more conditions and situations, with fewer restric-

4-18 Detail of *The Harvester Vase* (FIG. 4-19). Archeological Museum, Herakleion.

tions imposed by tradition. *The Harvester Vase* (FIGS. **4-18** and **4-19**), made of <u>steatite (soapstone)</u>, gives a <u>sharp new glimpse of man as he is in his usual physical context</u>. This egg-shaped rhyton, its lower half missing, shows a riotous crowd of olive harvesters, singing and shouting. Their forward movement and lusty exuberance are vividly expressed. The pattern of pitchforks fills the upper part of the band; the figures below, in higher relief, create a variation in surface. The entire design, like the octopus of the Palaikastro jar (FIG. 4-16), hugs the shape so tightly that it seems to be an integral part of the wall of the vase. But the figures themselves are depicted with a gusto that matches their mood. They are led by a man who carries a *sistrum*, or rattle, and beats time, while his lungs are so inflated with air that his ribs show. The harvesters' facial expressions are rendered with astonishing exactitude; degrees of hilarity and vocal effort are clearly visible, all marked in the tension or relaxation of facial muscles. This reading of the human face as a vehicle of emotional states is without precedent in ancient art before the Minoans.

Minoan art includes <u>little sculpture in the round</u>, and what there is generally is small. Monumental sculpture of gods, kings, and monsters, such as we find in Mesopotamia and Egypt, has not been found. This absence of large-scale sculpture may reflect an absence of systematic and formal religion, although this assumption is entirely speculative due to our ignorance of Minoan religion. The small figures of

4-19 *The Harvester Vase*, from Hagia Triada, c. 1500 B.C. Steatite, approx. 5″ wide. Archeological Museum, Herakleion. (Lower part is lost.)

4-20 *Snake Goddess*, from the palace at Knossos, *c.* 1600 B.C. Faïence, approx. 13½" high. Archeological Museum, Herakleion.

"snake goddesses" like the one shown from Knossos (FIG. 4-20) are hardly more than of talisman or fetish size. They exhibit most of the rigid conventions, including the frontal pose, found in Egypt and Mesopotamia, but the arms have been released from the core of the block and are held forward or aloft. Thus, they are shown to be active and, somehow, appear more alive than their Near Eastern or Egyptian cousins. The Cretans seem to have worshiped a mother goddess sacred to many places and manifest in many forms. Whether these miniature figures brandishing snakes are images of her is not certain, but they are identified clearly as Minoan by their costume. We find the open bodice and flounced skirt worn by Minoan women depicted many times over. This touch of the real may be another example of human beings fashioning their gods in their own images.

The circumstances under which the Minoan civilization came to an end are still disputed, although it is now widely believed that Mycenaeans moved onto the island and established themselves at Knossos without meeting major resistance. From the repaired palace at Knossos, these intruders appear to have ruled the island for at least half a century, perhaps much longer. Parts of the palace continued to be occupied until its final destruction around 1200 B.C., this time by the Dorians, but its importance as a cultural center faded soon after 1400 B.C., as the focus of Aegean civilization shifted to the Greek mainland.

MYCENAEAN ART

The origins of the Mycenaean culture also are still being debated. The primitive Greeks may have moved onto the mainland about the time that the old palaces were being built in Crete—that is, about the beginning of the second millennium B.C. Doubtless these people were influenced by Crete even then, and some believe that the mainland was a Minoan colony for a long time, although the mainlanders developed and held to many cultural features of their own. At any rate, Mycenaean power developed on the mainland in the palmy days of the new palaces on Crete, and by 1500 B.C., a new and splendid culture was flourishing in Greece—a culture to which, some seven hundred years later, Homer was to give the epithet "rich in gold."

It is possible that the Mycenaeans made close contact in this new era not only with Crete but also with Egypt, with which they may have been allied against the Hittites during the early part of the New Kingdom. The Mycenaeans' taste for gold, as well as their actual treasure, may have been acquired in the mercenary service of Egypt, which was known in the ancient world for its lavish use of the metal. Thus, the awakening of the Mycenaean world may have been the consequence of a kind of three-way route of influence connecting the mainland, Crete, and Egypt. The destruction of the Cretan palaces left the Mycenaean (mainland) culture supreme, but new waves of migrating proto-Greek peoples, the so-called Peoples of the Sea, finally submerged the Mycenaean civilization. The steady infiltration of these peoples had already led to the development of a fortress architecture (unnecessary in Crete), and by about 1200 B.C., the fortified citadels of the mainland were overwhelmed by the invaders. The heroes and battles of these last centuries of Aegean civilization must have provided the tradition that, hundreds of years later, Homer would immortalize in the first great European epics, the *Iliad* and the *Odyssey*.

Although Mycenae appears to have been the cultural center of the mainland development, the remains of other large citadels have been found at Vaphio, Pylos, Orchomenos, Arne, and Iolkos. The best preserved and most impressive Mycenaean remains are those of the fortified palaces at Tiryns and Mycenae, both built at the beginning of the Late Mycenaean period, about 1400 B.C., and razed (along with the others) between 1250 and 1200 B.C.

The Citadel of Tiryns (FIG. **4-21**)—located only ten miles from Mycenae, so that at times they may have been under the same lord—was known by Homer as Tiryns of the Great Walls and by the ancient world as the birthplace of Herakles (Hercules). The ancient sightseer and guidebook writer, Pausanias, considered the walls of Tiryns to be as spectacular as the pyramids of Egypt. The heavy walls contrast sharply with the open Cretan palaces and clearly reveal their defensive character. The buildings within the 20-foot-thick walls are aligned axially and seem to have been laid out according to a predetermined plan. Unlike the rambling and often confusing layout of the Cretan palaces, the Mycenaean plan is an example of a clear and simple arrangement of the units. The *megaron, a* three-chambered structure at the heart of the design

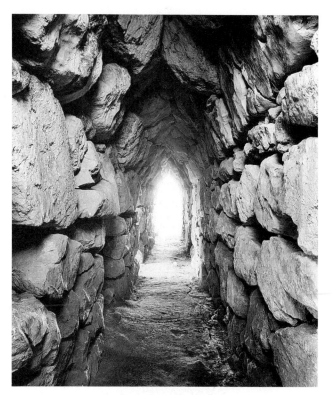

4-22 Corbeled gallery, Tiryns.

4-21 Plan of the Citadel of Tiryns, *c.* 1400–1200 B.C.

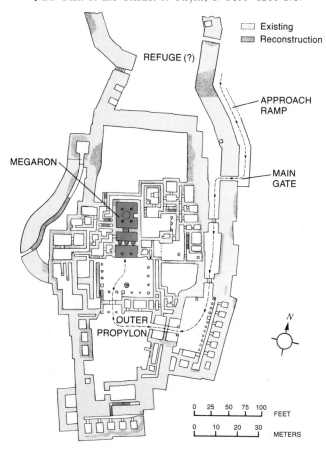

and the center of life in the citadel, embodies the germ of the Classical temples of Greece. This fundamental building type does not appear in the palaces of Crete, but does appear, surprisingly, at Troy as early as 2000 B.C. A hall of state, the megaron was rectangular, with a central hearth and four columns supporting the roof.

The massive fortification walls at Tiryns and other Mycenaean sites, built of unhewn or roughly dressed stone, were called Cyclopean by later Greeks, who imagined them to have been built by that mythical race of giants, the Cyclopes. Through the walls at intervals run corbeled galleries (FIG. **4-22**), which may have been part of the defensive structure or part of a complicated and dramatic ceremonial path leading, through a porch and vestibule, to the megaron. The corbeled gallery pictured makes use, as its name indicates, of the primitive corbeled arch. The rough appearance of these Cyclopean structures is most impressive in its crude monumentality; it possesses an earthy dynamism not found in other, more sophisticated, ancient architectural styles.

The technique of building in large, unhewn stones (*megaliths*) did not originate in Mycenaean Greece but has a long tradition going back within the Neolithic period to well before 3000 B.C. The huge megalithic construction at Stonehenge belongs to an extensive family of megalithic structures found throughout the Mediterranean world and many areas of Europe. The

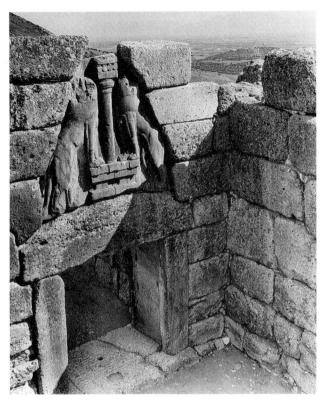

4-23 The Lion Gate, Mycenae, *c.* 1300 B.C.
Limestone, relief panel approx. $9\frac{1}{2}'$ high.

island of Malta has well-preserved megalithic monuments, "temples," and tombs, constructed of great stones, which were dressed and fitted. Perhaps the most ancient of masonry edifices in Europe, these enclose variously shaped spaces. The monumental fortress walls, palace gates, and vaulted tombs at Tiryns and Mycenae represent high points in the development of megalithic structural composition.

The sternness of these fortress-palaces was relieved by frescoes, by carvings, and, at Mycenae at least, by monumental architectural sculpture. The Lion Gate at Mycenae (FIG. 4-23) is the outer gateway of the stronghold. It is protected on the left by a wall and on the right by a projecting bastion and is formed of two great monoliths capped with a huge lintel. Above the lintel, the layers of stone form a corbeled arch, leaving a triangular opening that serves to lighten the weight to be carried by the lintel itself. The triangular space is filled with a slab on which two lions, carved in high relief, confront each other on either side of a column of the probably sacred Minoan type, resting their forepaws on its base. (This column of the Lion Gate supplies evidence of what the vanished wooden Minoan columns looked like.) Holes near the top of the animals indicate that the heads, now lost, were made of separate pieces of stone or metal. The lions are carved with breadth and vigor, and the whole

design admirably fills its triangular space, harmonizing in dignity, strength, and scale with the massive stones that form the walls and gate. We find similar groups in miniature on Cretan seals, and one senses that these lions are not too distant from Mesopotamian heraldic composition.

Within the gate and to the right lies the *grave circle*, an enclosure containing a number of simple shaft graves, covered and marked by a stele. These stone-lined pits served as tombs for kings and their families. Another similar grave circle was recently discovered outside the walls of Mycenae. Both grave circles date from about 1600–1500 B.C. But, at this time, shaft graves were gradually being replaced by the so-called beehive tombs, of which the best preserved is the remarkable "Treasury of Atreus" (FIGS. 4-24 and 4-25).

4-24 Plan and sections of the "Treasury of Atreus," Mycenae, *c.* 1400 B.C. (After A. W. Lawrence.)

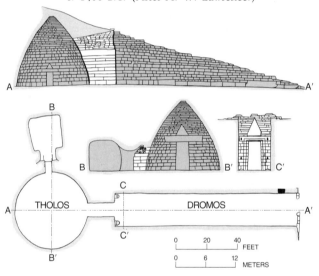

4-25 Interior of the tholos, "Treasury of Atreus," Mycenae. Vault approx. 40' high.

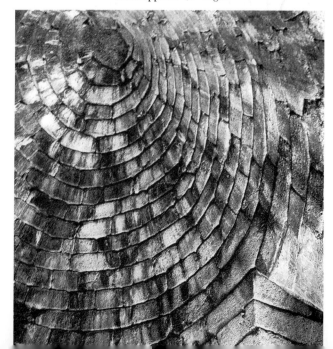

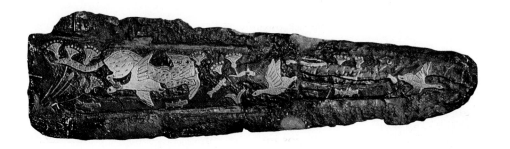

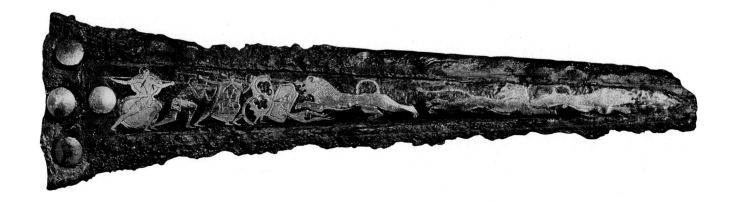

4-26 Inlaid dagger blades from the royal tombs at Mycenae, *c.* 1600–1500 B.C. Bronze inlaid with gold and electrum, longest blade approx. 9″ long. National Archeological Museum, Athens.

This structure was misnamed by Heinrich Schliemann, who thought it to be the storehouse for the treasure of Atreus, father of Agamemnon and Menelaus. Approached by a long passage, or *dromos*, the beehive shape of the round tomb chamber, or *tholos*, was achieved by use of corbeled courses of stone laid on a circular base, splendidly cut to the curve of the wall and ending in a lofty dome, which, after completion, was covered with earth. About 40 feet high, this vaulted structure, without interior supports, was the largest unified space in all antiquity until the Roman Pantheon was built fifteen hundred years later.

Most of the beehive tombs had been thoroughly looted long before their modern rediscovery, but rich finds were made in shaft graves at Mycenae. Inlaid with gold and electrum (an alloy of gold and silver), some bronze daggers found in these graves reveal the influence of the Minoan figure style (FIG. **4-26**). On the longest of the three blades illustrated, three hunters with spears, bows, and shields attack a lion that has struck down a fourth hunter, while two other lions flee. The subject is of Mesopotamian derivation, but the costumes are Cretan and the vigorous, spirited movements of the hunters, the lithe strength and spring of the lions, are Minoan.

Beaten gold *(repoussé)* masks were found in the shaft graves, attached to the faces of the mummified Mycenaean princes (FIG. **4-27**). Recording fairly closely the features of the deceased, they also testify to the influx of gold from Egypt. This and the elaboration of funeral practices lend strong support to the supposition that the impulse that started this high phase of Mycenaean civilization originated partly in Egypt and partly in Crete.

4-27 Funeral mask from the royal tombs of Mycenae, *c.* 1500 B.C. Beaten gold, approx. 12″ high. National Archeological Museum, Athens.

The golden culture of Mycenae produced such masterpieces as the famous cups from Vaphio (FIG. **4-28**). Found in a beehive tomb, these beautiful vessels are still the subject of much debate among experts who see them as originating in Crete and those who insist that, despite their undoubted resemblance to Minoan figure style, they are Mycenaean. The cups are a pair, each made of two plates of gold. One plate was worked in *repoussé* for the outside of the cup, the other left plain to make a smooth surface for the inside. The plates were fastened together, the handles riveted on, and some of the details then engraved. The subject seems to be Minoan (the men are costumed in the Minoan manner) and related to the bull-leaping ritual; bulls are being trapped and snared, with a cow used as a lure in one case. Continuing around each cup, the scenes together compose a complete narrative. On the cup at the right, a bull, charging furiously, impales a man, while another bull (on the side not visible) dashes madly from the fracas.

The scene visible on the cup on the left shows a bull moving slowly toward a decoy cow. The climax of the episode is shown on the opposite side of this cup; the bellowing bull is captured and hobbled. The scenes are pulled together compositionally by the trees and, on the cup on the right, by the figure of the falling man. The whole design is admirably composed to fit its space. In both cups, areas not filled by the animal and human figures contain landscape motifs of trees, rocks, and clouds similar to those in contemporary painting. The shallowness of the relief and the conventional treatment of the trees produce a rich play of light and shade and a variety of textures.

The Warrior Vase (FIG. **4-29**) represents a file of Mycenaean soldiers strikingly different in costume and physiognomy from the Cretan figure types we have seen in Minoan art. This fact would seem to strengthen the argument that the Mycenaeans were of different racial stock from the Minoans and the indigenous builders of their own civilization. It may

4-28 *The Vaphio Cups,* Laconia, *c.* 1500 B.C. Gold with *repoussé* decoration, approx. 3½″ high.
National Archeological Museum, Athens.

be, too, that we are looking here at the last Mycenaean warriors who marched forth to meet the invaders, or perhaps internal enemies, under whose onslaught the Mycenaean civilization collapsed after 1200 B.C. The victors carried iron weapons, superior to the softer bronze of the Mycenaeans, and their success illustrates the historical commonplace that a superior technology can overcome an otherwise more highly developed civilization.

The centuries-long period that followed the obliteration of Aegean culture, although little survives from it, cannot be considered merely a historical void. The proto-Greek language of Linear B must have evolved toward Archaic and Classical Greek; the rites of the gods of the Olympian cult were already celebrated and no doubt transmitted, as were common types and motifs in the craft arts, metalwork, pottery, gems, and ornaments in gold. Though much has disappeared that would make the continuity exactly and fully traceable, enough remains and continues to be uncovered that would suggest the direct descent of Classical Greek art from Mycenaean. Through the "dark age," new energies were gathering that would form one of the greatest civilizations the world has ever known—a civilization new, bold, self-confident, and modern.

4-29 *The Warrior Vase,* from Mycenae, *c.* 1200 B.C. Approx. 14″ high. National Archeological Museum, Athens.

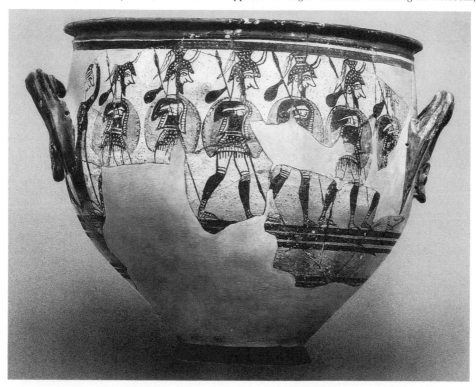

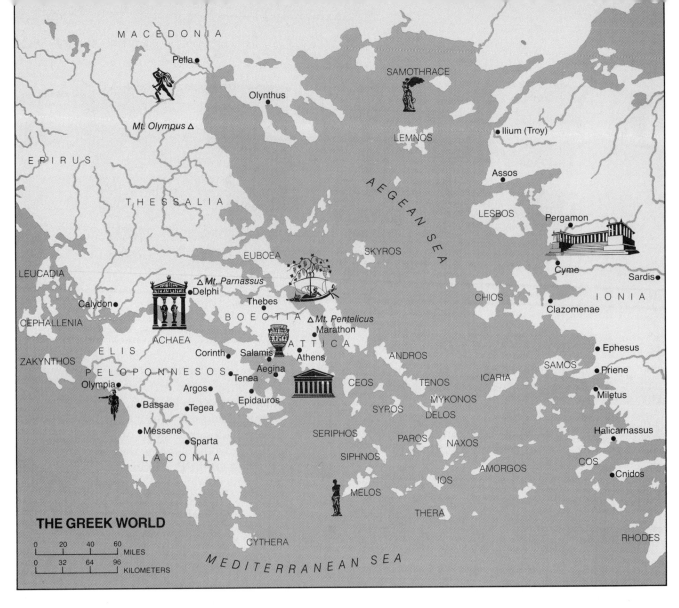

THE GREEK WORLD

0 20 40 60 MILES
0 32 64 96 KILOMETERS

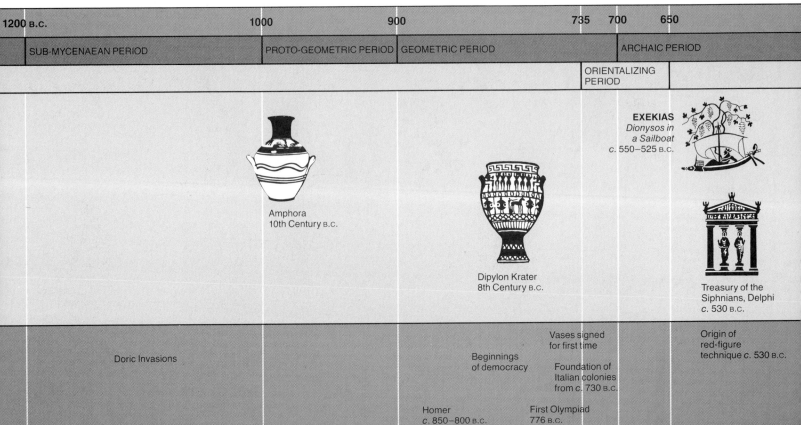

1200 B.C.		1000	900	735	700	650

SUB-MYCENAEAN PERIOD	PROTO-GEOMETRIC PERIOD	GEOMETRIC PERIOD		ARCHAIC PERIOD

ORIENTALIZING PERIOD

EXEKIAS
Dionysos in a Sailboat
c. 550–525 B.C.

Amphora
10th Century B.C.

Dipylon Krater
8th Century B.C.

Treasury of the
Siphnians, Delphi
c. 530 B.C.

Doric Invasions

Beginnings
of democracy

Vases signed
for first time

Foundation of
Italian colonies
from c. 730 B.C.

Origin of
red-figure
technique c. 530 B.C.

Homer
c. 850–800 B.C.

First Olympiad
776 B.C.

5
THE ART OF GREECE

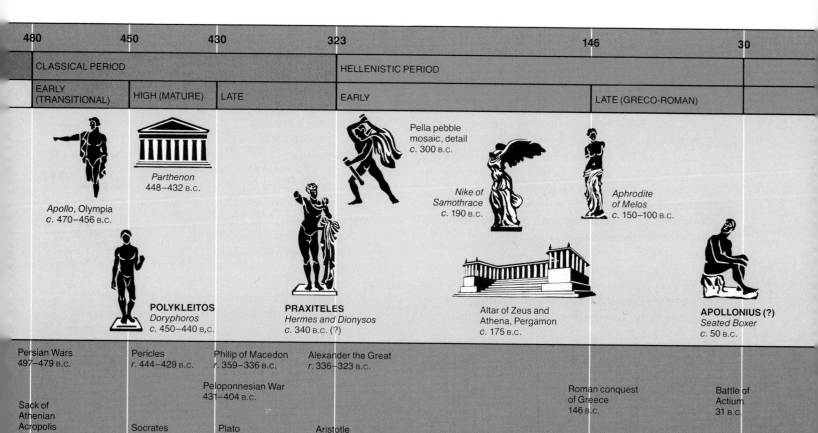

480	450	430	323	146	30
CLASSICAL PERIOD			HELLENISTIC PERIOD		
EARLY (TRANSITIONAL)	HIGH (MATURE)	LATE	EARLY	LATE (GRECO-ROMAN)	

Apollo, Olympia
c. 470–456 B.C.

Parthenon
448–432 B.C.

Pella pebble mosaic, detail
c. 300 B.C.

Nike of Samothrace
c. 190 B.C.

Aphrodite of Melos
c. 150–100 B.C.

POLYKLEITOS
Doryphoros
c. 450–440 B.C.

PRAXITELES
Hermes and Dionysos
c. 340 B.C. (?)

Altar of Zeus and
Athena, Pergamon
c. 175 B.C.

APOLLONIUS (?)
Seated Boxer
c. 50 B.C.

Persian Wars
497–479 B.C.

Pericles
r. 444–429 B.C.

Philip of Macedon
r. 359–336 B.C.

Alexander the Great
r. 336–323 B.C.

Peloponnesian War
431–404 B.C.

Roman conquest
of Greece
146 B.C.

Battle of
Actium
31 B.C.

Sack of
Athenian
Acropolis
480 B.C.

Socrates
469–399 B.C.

Plato
429–347 B.C.

Aristotle
384–322 B.C.

OR WE ARE LOVERS of the beautiful, yet with simplicity, and we cultivate the mind without loss of manliness. . . . We are the school of Greece." In the fifth century B.C., the golden age of Athens, Thucydides had Pericles make this assertion in praise of the Athenians, comparing their open, democratic society with the closed, barracks-state of their rivals, the Spartans. But Pericles might have been speaking in general of Greek culture, as we have received it, and of the ideal of humanistic education and life created by that culture. In the humanistic view, man is what matters, and he is, in the words of Protagoras, the "measure of all things."

For the Greeks, what set human beings apart was their intelligence, and human intelligence, trained in reasoning, was the highest function nature had created. Moreover, Aristotle assured us that "all men by nature desire to know." And what we know is the order of nature, which is one with the order of human reason.

The order of both nature and reason, said the Greeks, is beautiful and simple, and the beauty of things is one with our knowledge of them; thus, the good life, the achievement of the "beautiful soul," follows on compliance with that typically Greek command, "Know thyself!" One achieves the good life, then, through an intellectual process; one lives "according to nature," according to the natural laws of life discoverable by reason. The self now becomes of first importance, and as human beings come to full self-awareness, they necessarily become aware of nature as well.

Humanity is regarded as the highest creation of and value in nature, and it was the Greeks who created democracy as well as the natural human image in art. A late, great scholar of Classical Greece, Werner Jaeger, wrote of the Greeks' exaltation of humanity: "As against the Oriental exaltation of one God-king . . . and the . . . suppression of the great mass of the people . . . , the beginning of Greek history appears to be the beginning of a new conception of the individual. . . . the history of personality in Europe must start with [the Greeks]."* This honoring of the individual, and through the individual, the laws of human nature, is so completely part of our habit of mind that we are scarcely aware of it and of its origin in the minds of the Greeks.

From the Paleolithic period, we have been surveying human beings in a world dominated by the great beasts—threatened by them, fighting them, dependent on them (or their embodiment), worshiping

them, conceding their might and our own weakness. Now, in Greece, humans assert that their own peculiar power—the power of intelligence—puts them far above the beasts. But the Greek mind was not dryly or pallidly rationalistic; it knew well the forces of the irrational against which reason must struggle constantly. In fact, Greek art constitutes with Greek culture a compact synthesis of opposites, a harmony between profound passion and rational order. Its clarity and symmetry are not cold, but vital; its forms can be rigorous and mathematical, yet full of life.

In marked contrast to Egypt, with its long horizontals of alluvial plain between desert plateaus and seemingly invariable sunshine, Greece is a country of diversified geography and climate. The bays of its deeply indented, rugged coastline make the country half land and half sea; mountain ridges divide it into many small units. The climate is vigorous—cold in winter, dry and hot in summer. A breeze almost always blows from the sea. The unusually clear, almost crystalline atmosphere is often softened by a haze. Both sky and sea are brilliant in color. It is little wonder that the Greeks, attuned to nature, should people their mountains, woods, streams, sky, and sea with divinities—that they should picture Zeus, the king of this realm of gods, as reigning from their loftiest peak, Olympus; the Muses as dwelling in the deep, cool groves on the long slopes of Parnassus and Cithaeron; and Apollo as speaking from the awe-inspiring rocky clefts of Delphi.

Nature worship evolved into personification. The Greek gods assumed human forms whose grandeur and nobility were not free from human frailty; indeed, unlike the gods of Egypt and Mesopotamia, the Greek gods differed from human beings only in that they were immortal. It has been said that the Greeks made their gods into men and their men into gods. Man, becoming the measure of all things, in turn must represent, if all things in their perfection are beautiful, the unchanging standard of the best; to create the perfect individual became the Greek ideal.

The Greeks, or Hellenes, as they called themselves, appear to have been the product of an intermingling of Aegean peoples and Indo-European invaders. This intermingling may have been a vitalizing factor that should be considered, together with the climate and the strongly diversified mountain-valley terrain of the Greek peninsula, in hypothesizing the causes of the peculiarly high competitive and creative energy of the Greek peoples.

The first of the invaders began to drift into the area about 2000 B.C., and after 1600 B.C., as we have seen, they formed the Mycenaean civilization on the Greek peninsula. After about 1200 B.C., the Mycenaeans were apparently overwhelmed in turn by new invad-

*Werner Jaeger, *Paideia: The Ideals of Greek Culture* (New York: Oxford University Press, 1939), Vol. 1, p. xix.

ers from the north—the Dorians and perhaps the Ionians. The Dorians made the Peloponnesos the center of their power and may have forced the Ionians eastward across the Aegean to the coast of Asia Minor. The origin of the Ionians is still a matter of dispute. Some scholars feel that proto-Ionians lived at Athens during Mycenaean times and were displaced during the Doric invasions. Others hold that the Ionians developed on the coast of Asia Minor between the eleventh and eighth centuries B.C. out of a mixed stock of settlers. In either case, the Ionians seem to have been more individualistic than the tribally ordered Dorians, whose most characteristic city became conservative Sparta.

In Ionia, on the east coast of Asia Minor, epics of individual greatness had come to be celebrated by the eighth century B.C., and by the seventh century, the rational philosophers of Miletus had begun to interpret the world in terms of reason rather than religion, beginning the immense transformation of the worship of nature into the science of nature. Between Ionia and the Peloponnesos lay Attica, and there, in Athens, a conservative tribal order and individualistic striving combined to produce the most fruitful of all the *poleis,* or city-states, of Greece—the one that Thucydides could boast was the "school of Greece."

By the eighth century B.C., the separate Greek-speaking states had held their first ceremonial games in common, the Olympiad of 776 B.C., from which time the historical Greeks calculated their chronology. From then on, despite their chronic rivalries and wars, they regarded themselves as Hellenes, distinct from the surrounding "barbarians" who did not speak Greek. The enterprising Hellenes, greatly aided by their indented coasts and island stepping-stones, became a trading and colonizing people who enlarged the geographic and cultural boundaries of Hellas. Tribal organizations had evolved into city-states, with each an individual unit. Political development differed from state to state, but a pattern emerged in which rule was first by kings, then by nobles, and then by tyrants who seized personal power. At last, in Athens, appeared the dynamic balance called *democracy.*

Athens has in many ways become the symbol of Greek culture; many of the finest products of Greek civilization were created by Athenians or by others closely associated with Athens and its traditions. But Athens must not be considered the sole focus and center of Greek civilization, though it is convenient for us to use it as a distinctive type and standard. Increasingly, art-historical and archeological investigation find that the creative energy of Greek civilization was widely and fairly evenly distributed throughout the Mediterranean world, bound by

Phoenician territories to the west and the Persian Empire to the east. From the mother cities of Greece on the Ionian coast of Asia Minor—long under the sway of Persia—Greek influence extended westward through Cyprus and the opulent cities of southern Italy (Magna Graecia) and Sicily to the coasts of France and Spain; it reached from the shores of the Black Sea to the Libyan coast, where it met the culture of Egypt. The language, industry, art, and political institutions of the Greeks were diffused through this broad area by maritime commercial traffic and political expansion. Thus we can place Athens and her achievements within the context of an extensive Hellenic cultural empire, whose far-flung city-states could often rival her in power and magnificence, as well as in artistic invention and influence.

Athens, at the time of its brief flowering after the Persian Wars, was an active city of one hundred thousand people. Above its olive groves and rooftops towered the Acropolis, or higher city, formerly a Mycenaean fortress but, in this age, crowned with temples rising in bright colors against an intensely blue sky. Under the covered colonnades (*stoas*) that surrounded the city's central marketplace (*agora*), the citizens congregated to discuss the latest political development or philosophical idea. Among the Athenians, argument was both a public and a private exercise that went on wherever a few disputants could be assembled. This love of intellectual contest, the vigorous forerunner of science itself, was astonishingly popular; whether in the house of a rich man or in the marketplace, in the gymnasium, or on the street corner, such discussion was the key to the intense political and intellectual life that developed in the Greek city-state. Physical exercise also played a large part in education and daily life; the Athenian aim of achieving a balance of intellectual and physical discipline, an ideal of humanistic education, is expressed in the Latin, *mens sana in corpore sano* (a sound mind in a sound body).

The tragedies of Aeschylus and Sophocles, played before the eager citizens, presented the individual as having an obligation to the gods and the rise and fall of his fortunes as reflecting the contest between blind fate and the new-found power of reason.

The constants of Greek culture were humanity, nature, and reason, and the Greeks understood goodness to be the harmony of all three. On this elementary conviction, they built their grand achievements in art, poetry, mathematics, philosophy, logic, history, and science—the heritage on which the modern Western world in turn was constructed. In discovering man, the Greeks discovered and confronted the problem of persistence and change: individuals pass away, but humanity remains. And

although they aspired toward the timeless ideal, the Greeks realized the changes that produce growth and development.

To modern eyes, the realities of Greek life and society may seem to fall well short of what we would call "ideal," although the word has a different meaning in Greek philosophy than it does in modern usage. Slavery was regarded as natural, even beneficial, and was a universal institution among the Greeks. Aristotle declared at the beginning of his *Politics:* "It is clear that some are free by nature, and others are slaves." Women were secluded in their homes and played no part in public or political life. Aristotle may have been expressing the general view when he described woman as "more dispirited, more despondent, and more given to falsehood than the male. . . . she is more envious, more querulous, more slanderous, and more contentious." Womanly virtues were beauty, temperance, and industriousness. In the man's world of Greece, love between men was not considered illicit; in Plato's *Symposium*, Socrates is praised by the lascivious Alcibiades for his almost superhuman imperviousness to seduction. Although the Greeks invented and passed on to us the concept and practice of democracy, most Greek states, even those constituted as democracies, were ruled by the wellborn and affluent, in effect by aristocrats, and the most admired virtues were not wisdom and justice, but statecraft and military valor. Greek men were educated in the values of the heroes of Homer and the athletic exercises of the *palestrae*. War among the city-states was chronic and often atrocious. Fighting among themselves and incapable of unifying, the Greeks eventually fell prey to the autocracy of Macedon and the imperialism of Rome.

In our own time, the uncritical admiration of Greek art and culture that characterized the eighteenth and nineteenth centuries has undergone sharp revision; Greek art is no longer regarded as perfect and worthy of imitation. What we call "modern art" turns its back on the ancient Greek example (Gauguin called Greek art "a lie!"). Greek language and literature are rarely studied in schools, and Greek ideals and values, even the best of them, are clearly not to the modern taste. Yet insofar as the Greeks sought and revered ideal beauty, found it in the order of nature—above all, in the human body—and revealed it in their art, we may still enjoy the art of Greece if we approach it with a sympathetic comprehension of its contexts, intentions, and archetypal forms.

The remains of Greek civilization enable us to reconstruct the development of the Greek style in art. That the Greek style should in fact have *developed* is in itself significant. Development in the art of Egypt, for example, was minimal; the pattern of ritual and of form was not to be broken. Change in Egypt occurred, when it did, *despite* the pattern of the culture as a whole. Of course, we must remember that an important factor in the sudden historical eminence of Greece was the base from which Greek civilization rose—the civilizations of Egypt and the Near East. The Greeks quite honestly acknowledged borrowing ideas, motifs, conventions, and skills from these older civilizations. But from the beginning, the Greeks embraced experiment, even while adopting and holding to the older forms. Development and change were inherent in Greek culture (as conservatism was in Egyptian culture), and change has recognizable forms. Greek art displays much more readily discernible stages than the relatively unchanging art of the ancient Near East.

THE GEOMETRIC AND ARCHAIC PERIODS: 900–480 B.C.

Pottery serves, as no other artistic medium can, to link the very late Mycenaean (sub-Mycenaean) period with that of historical Greece. For one thing, it has survived. We can trace a continuity from the sub-Mycenaean period into the Classical fifth century B.C. entirely in terms of the figurative decoration of Greek ceramic ware, which shows the artist's confrontation with radically new ideas and problems and some equally radical interpretations and solutions. It is appropriate, then, given this continuity and the Greek concept of the development of forms, to begin the study of Greek art with vase paintings, for these illuminate changes that were profoundly influential in human history and that take place in a curiously logical order.

Already, we have seen numerous examples of how artists represent the human form, from the strange, falling stick figure in the *Well Scene* at Lascaux (FIG. 1-8) to the agile Minoans of *The Vaphio Cups* (FIG. 4-28). Now we can review changes in the representation of the human body that are the result not of accidental differences of convention but of carefully accumulated increments of knowledge. In Greece, these changes were firmed into a tradition of technical procedure that did not backslide, as was the case in the Egyptian return to old forms after the death of the innovative Akhenaton (see Chapter 3). In the Archaic Greek vases, the human figure became the subject of intense analytical study for the first time. As the Greek philosopher questioned human nature and purpose, the Greek artist began to inquire how human beings look to others of their kind in the

world of optical experience. The conceptual way of placing the figure and enumerating its features, which we have seen in the art of older civilizations, gradually was given up and replaced by a method of painstaking observation of the pose and motion of the body in life. This did not happen all at once; centuries were involved in the great transformation, and the dated sequence of vases reveals the ordered phases of the change. It is useful to describe these changes at the outset, for, from its earliest appearances on vases, the human figure remained the principal motif of Greek art, as the human being was central to its thought and interest.

Vase Painting

A proto-Geometric *amphora* (FIG. **5-1**), a two-handled jar for wine or oil, from the tenth century B.C. shows us the formative phase of what is called the *Geometric style*. Although it borrows the decorative devices of the earlier sub-Mycenaean style, its execution is neater and more painstaking. The artist now uses compasses to form careful, regular concentric circles, a new motif that contrasts sharply with the casual brush strokes used elsewhere on the shoulder of the vessel. As the Geometric style developed, the Minoan stock of curvilinear forms was gradually replaced by rectilinear shapes arranged in tight bands to cover more of the vessel's surface.

5-1 Proto-Geometric amphora, from the Dipylon cemetery, tenth century B.C. Approx. 16½" high. Keramikos Museum, Athens.

5-2 *Dipylon Vase* (Geometric amphora), from the Dipylon cemetery, eighth century B.C. Approx. 61" high. National Archeological Museum, Athens.

The human figure reappeared in the decorative scheme during the period of the culminating Geometric style, specifically in the so-called *Dipylon Vase* (FIG. **5-2**), from the eighth century B.C., named after the Dipylon cemetery in Athens, where it was found. The figures are hardly more than symbols, fashioned of diamond and wedge shapes that fit the severe, regular, geometric characteristics of the banded decoration. Carefully arranged on a panel that has been placed prominently on the shoulder of the vessel, the figures represent a funeral scene with mourners attending the deceased, who is laid out on a bier—an appropriate subject for this funerary vase, which was set up over a grave. This vase represents a key moment in the development of Greek art; it marks the reintroduction of the human figure and the figure's use as a vehicle for pictorial narrative. But its historical importance should not blind us to the vase's high artistic quality. In a subtle crescendo, the sophisticated design builds up from below to the climactic figured panel, decreasing again above it in a sequence that is repeated with variations on the tall neck of the vase. If a major problem of the painter is to adjust the design to the shape of the vase, then this geometric amphora surely must represent a high point in the history of vase painting. It is difficult to imagine a design that is more closely bound to its carrier than these encircling bands, which seemingly contain and compress the flexing volume of the vase's form.

Another type of Greek vase, the _krater_, had a larger body and wider mouth than the amphora. A krater from the Dipylon cemetery (FIG. **5-3**), possibly of the same date as the _Dipylon Vase_ (FIG. 5-2) or somewhat later, shows a certain loss of refinement as the geometric ornament becomes secondary. The figures represent a funeral procession, with horse-drawn chariots occupied by warriors carrying shields. In the old conceptual manner, both wheels of each chariot are represented, and the horses are carefully distinguished, each with the correct number of legs. The warriors are standing behind their shields, which are shown in front view. The number of figures represented is markedly greater than the number shown in FIG. 5-2, suggesting that the artist was intrigued with the rediscovery of the human figure, which had been absent from mainland pottery decoration for over four hundred years. Even if the fascination with figured representation overwhelms the abstract geometric pattern on this vase, however, a sense of order and restraint still dominates its design. The regimented figures as yet seem incapable of escaping from the two bands into which they have been placed. Soon they will no longer be constrained in this manner.

5-3 Geometric krater, from the Dipylon cemetery, eighth century B.C. Approx. 40½" high. Metropolitan Museum of Art, New York (Rogers Fund).

5-4 _The Blinding of Polyphemus_ and _Gorgons_ (proto-Attic amphora), from Eleusis, c. 675–650 B.C. Approx. 56" high. Archeological Museum, Eleusis.

The Geometric period was succeeded by the Orientalizing phase of the Archaic period, a time of marked commercial and colonial expansion that brought the Greeks into closer contact with ancient Near Eastern civilizations. A consequence of these new relationships was the frequent appearance of Oriental animals and composite monsters on Greek vases. Motifs familiar to us from Mesopotamian and Egyptian art include lions, sphinxes, griffins, and centaurs.

Stylistically, a vase from Eleusis (FIG. **5-4**), typical of the Orientalizing period, represents a complete and radical break with the orderly Geometric manner. The figurative decor occupies most of the vessel; the arrangement of the motifs is loose, almost casual, and the shapes are mostly curvilinear. It is as if the artist were intentionally throwing off the Geometric straitjacket as an awkward restraint on a new interest—the representation of narrative scenes, some from Homeric legend. On the amphora in FIG. 5-4, human figures, resembling those of the Geometric period, but much more filled out, rounded, and active, now occupy the largest areas of the vessel, and the ornament retreats to the smaller areas in the neck, shoulder, and base. In the Geometric period, the Homeric themes were collected in the great epics. The Orientalizing period marks their diffusion and their achievement of universal popularity in Greece. Two popular myths are represented on the Eleusis amphora: the main scene on the body of the vessel

shows the Gorgons pursuing Perseus after he had beheaded Medusa; on the neck of the vase, Ulysses is blinding the one-eyed giant, Polyphemus. The illustration of the epics was to occupy the surfaces of vases for centuries to come; it might almost seem that this first great reflection of human action, in Greek epic, launched the enterprise of representing it in art.

During the Geometric and Archaic periods, numerous pottery centers developed throughout the Aegean world. They have been divided into two main groups: those of the mainland and those of eastern Greece (the regions east of the mainland). On the mainland, the most important centers were Athens in Attica and Corinth in the Peloponnesos; after 550 B.C., Athens became the principal ceramic center and the largest exporter of vases in the Mediterranean basin. In this brief survey, we shall confine ourselves to Athenian wares.

The number of basic Attic (Athenian) vase shapes was limited to six or seven, each subject to four or five variations. The shapes developed out of specific usages and were entirely functional (FIG. 5-5).

The François Vase (FIG. 5-6), which was named after its discoverer and is perhaps the finest extant example of an Archaic krater, with its volute handles and extraordinarily vigorous shape, was found in an

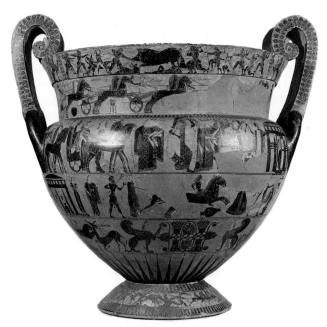

5-6 ERGOTIMOS and KLEITIAS, *The François Vase* (Attic black-figure krater), from Chiusi, *c.* 575 B.C. Approx. 26" high. Museo Archeologico, Florence.

Etruscan necropolis. (We are indebted to the Etruscans for their avid collecting of Greek vases; many of the best preserved have been found in Etruscan tombs.) It is especially important, not only for its high quality but also for the fact that it is signed by both ERGOTIMOS, the potter ("Ergotimos made it"), and KLEITIAS, the painter ("Kleitias drew it"). Signed vases appear for the first time in the early sixth century B.C. and suggest that their makers had pride in their profession and that their art was becoming increasingly popular and prestigious.

The François Vase is ornamented with over two hundred figures distributed in bands around the vessel. Representing almost the entire Greek pantheon, the figures provide one of our first pictorial glimpses of the forms and personages of Greek religion. The subject is the wedding of Peleus, with the gods in attendance; pictured in addition to the scene of the gods and Peleus, father of Achilles, are depictions of the Calydonian boar hunt, the ambush of Troilus, and the funeral games for Patroclus. Several more scenes are shown on the other side of the vase, and on its foot is an account of an animated battle between cranes and pygmies, above which rays felicitously augment the swelling surface of the krater. The lively scenes are rigidly organized in six bands of varying widths, the widest placed on the vessel's shoulders, a return to the discipline and formality of the Geometric style after the casual and permissive Orientalizing style of the vase from Eleusis (FIG. 5-4).

The François Vase is decorated in an early form of the so-called *black-figure* technique, which is shown fully

5-5 Greek vase shapes: (**a**) the *hydria* (from the Greek for "water"), a water jar with three handles, two for lifting and one for carrying; (**b**) the *lekythos*, an oil flask with a long, narrow neck adapted for pouring oil slowly, used chiefly in funeral rites; (**c**) the *krater* (from the Greek "to mix"), a bowl for mixing wine and water, the usual beverage of the Greeks; (**d**) the *amphora* (meaning "to carry on both sides," referring to the two handles), a vessel for storing provisions (wine, corn, oil, honey), with an opening large enough to admit a ladle and usually fitted with a cover; (**e**) the *kylix* (from the Greek "to roll," referring to the vase being turned on the potter's wheel), chief form of the drinking cup; (**f**) the *oenochoe* (from the Greek "to pour out wine"), a wine jug, the lip pinched into a trefoil shape to facilitate pouring.

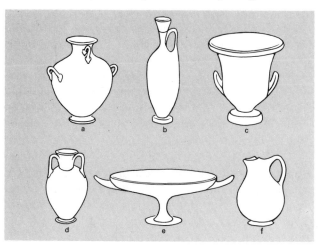

developed and at its best in a *kylix* (drinking cup) by the potter-painter EXEKIAS (FIG. 5-7). Dark figures are silhouetted against the light background of the natural reddish clay. Details are incised into the silhouettes with a sharp, pointed instrument to expose the red beneath; touches of white and purple, particularly on the earlier wares, add color to the dominantly monochrome decoration. Although the black areas are customarily referred to as "glazes," it should be pointed out that the black on these Greek pots is neither a pigment nor a glaze but *engobe,* a slip of finely sifted clay that originally is of the same color as the clay of the pot. In the three-phase firing process used by Greek potters, the first (oxidizing) phase turns both pot and slip red; during the second (reducing) phase, the oxygen supply into the kiln is shut off and both pot and slip turn black; in the final (reoxidizing) phase, the coarser material of the pot reabsorbs oxygen and becomes red again, while the smoother, silica-laden slip does not and remains black. After long experiment, Greek potters developed a velvety, jet-black "glaze" of this kind. The touches of white and purple were used more sparingly, with the result that the figures stood in even stronger contrast against their reddish backgrounds. This superb formal control provides the framework for a wealth of naturalistic detail, some of it strikingly novel.

On the inside of Exekias' cup, we see Dionysos, the god of wine and a popular subject for drinking cups such as this one, sailing over the sea carrying his gifts

5-7 EXEKIAS, *Dionysos in a Sailboat* (interior of an Attic black-figure kylix), from Vulci, *c.* 550–525 B.C. 12″ in diameter. Staatliche Antikensammlungen und Glyptothek, Munich.

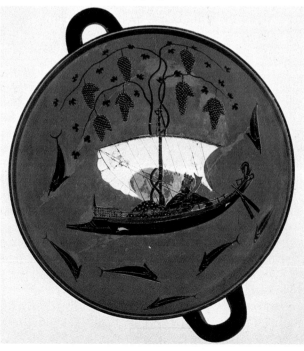

to mankind. He is accompanied by sporting dolphins, and his boat's mast is entwined by a grapevine. The representation introduces a spectacular innovation that heralds the beginning of a revolution in Western art. In his drawing, Exekias does not show a traditional and conventional symbol that "reads" as a sail; instead, he shows a sail as it would actually look, bellying out and filled with wind. It is an image of the action of wind itself, the wind made palpable as a force, and it must have come from a new awareness of the physical presence of nature. This awareness was abroad; it is in the Ionian speculations about the physical constitution of the world and in the reality-charged poetry of Homer: "But soon an offshore breeze blew to our liking—a canvas-bellying breeze. . . . The bows went plunging . . . sails cracked and lashed out."

Although in Homer the gods are still the manipulators of the elements, it is men who feel their effects, who hear the howl of the great winds, smell the brine, and feel the harsh ropes and drenching rain. Man's experience of the world, as well as the world itself, begins to be understood by him in physical terms. Such a profound change in man's awareness of his relationship to nature and, in consequence, of his own nature is one that is bound to make itself felt in art. From Exekias' sail on, Greek art manifests an increasing comprehension of physical nature as it is apprehended by vision.

Exekias' skill and subtlety also solve to perfection a difficult compositional problem: how to fix the ship within its circular frame. Part of his solution lies in the down-branching weight of the loaded vines; part lies in the reverse hooklike dolphins, which seem to stitch the composition to its frame.

Around 530 B.C., a new painting technique was invented that reversed the black-figure style by making the background black and leaving the figures reserved in red. Human and animal figures are no longer dark and earthy, massive against a light ground; now they are luminous, like light and air, shining forth from the black background. In this new *red-figure* technique, the major interior markings were rendered with relief lines applied with a syringelike instrument that squeezed out the black "glaze" matter evenly and smoothly. Secondary markings, such as those representing hair, muscles, and sometimes even shading, were painted in "dilute glaze" (engobe diluted with water), which could be applied with a fine brush. The style is freer and more facile than the earlier black-figure style, which it largely replaced within two decades. Artists felt no need to enlarge their limited color scheme; the polished coppery red against a velvety black created an effect that was rich and elegant. The artist usually credited with the invention of the red-figure technique is the ANDOKIDES

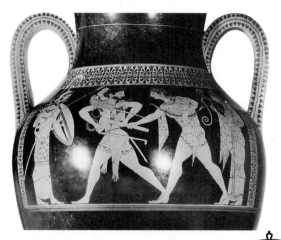

5-8 ANDOKIDES PAINTER, *Herakles and Apollo Struggling for the Tripod* (detail from amphora), c. 530 B.C. Outline drawing at right indicates relation to whole vessel. Portion shown approx. 11″ high, whole vessel approx. 23″ high. Staatliche Museen, Berlin.

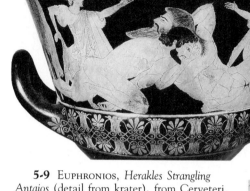

5-9 EUPHRONIOS, *Herakles Strangling Antaios* (detail from krater), from Cerveteri, c. 510–500 B.C. Outline drawing at right indicates relation to whole vessel. Portion shown approx. 12″ high, whole vessel approx. 19″ high. Louvre, Paris.

PAINTER, who is named for the potter Andokides, several of whose signed vases he decorated. Sometimes considered to be a student of Exekias, the Andokides Painter uses pictorial devices that are rooted in the style of the older master. On an amphora that depicts *Herakles and Apollo Struggling for the Tripod* (FIG. 5-8), he shows an interest in rich drapery ornaments and textural effects such as those found in the work of his presumed master. His work lacks some of the warmth and sympathy of Exekias', because he is more concerned with exploiting the possibilities of his newly discovered technique. And there he breaks new ground, experimenting with novel and varied effects of color (he liked to use both purple and white) and, in a technique that dispenses with the laborious process of incision, creating new decorative schemes of great elegance.

A krater painted by EUPHRONIOS, one of the most forceful red-figure painters working near the end of the sixth century B.C., shows *Herakles Strangling Antaios* (FIG. 5-9). Euphronios was among the first to devote himself seriously to the study of anatomy, and he was famous for this even in his own time. Here, he shows two male figures in a complicated wrestling pose. One figure is shown from the side, the other from the front. Euphronios attempts such radical experiments as the doubled-under leg of Antaios and the rendering of Antaios' face in white to suggest the pallor of impending death. He makes an effort to describe Herakles' and Antaios' straining, powerful bodies with painstaking attention to the musculature, and although he does not entirely succeed in producing a correct representation, his attempt to apply knowledge gained through observation of bodily action is significant.

EUTHYMIDES was a contemporary and competitor of Euphronios and, like him, an experimenter. As we can see from his picture of *Revelers*, done on an amphora (FIG. 5-10), Euthymides is less concerned with anatomical description than with the problems of foreshortening and of showing the figures from different viewpoints. The fairly tipsy dancers, mightily

5-10 EUTHYMIDES, *Revelers*, from Vulci, c. 510–500 B.C. Approx. 24″ high. Staatliche Antikensammlungen und Glyptothek, Munich.

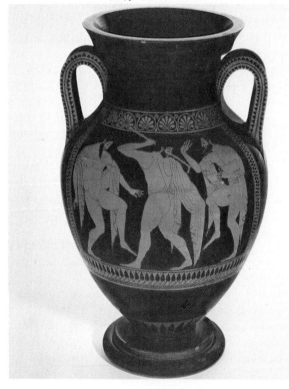

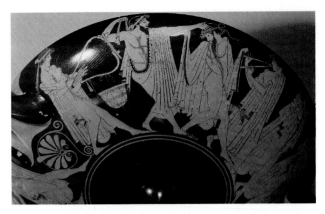

5-11 Brygos Painter, *Revelers* (detail from kylix), from Vulci, *c.* 490 B.C. Outline drawing at right indicates relation to whole vessel. Portion shown approx. 10″ wide, whole vessel approx. 13″ wide. Martin V. Wagner Museen der Universität, Würzburg.

enjoying themselves, are a rather popular subject on Late Archaic and Early Classical vases and celebrate the Hellenic sense of the comic that served as counterpoint to the Greek genius for tragic art in the drama. In this case, the drunken dancers theme gave Euthymides an opportunity to present the figures in informal motion and in fairly successful three-quarter back and front views. The turning and twisting of the figures indicate that the artist is beginning to conceive of them as three-dimensional volumes that have free mobility in a space deeper than the flat, two-dimensional surface of the picture plane—a significant departure from pre-Greek tradition. The maturing self-consciousness of the Greeks is shown not only in their concern for the human figure, but also, of course, in their consciousness of themselves as artists. They signed their names to their work and they were aware that they were doing new and revolutionary things as collaborators and rivals in a common professional enterprise. Euthymides, in an inscription on this amphora (FIG. 5-10), proclaimed with naïve pride: "Euphronios never did anything like it."

As revolutionary as Euphronios and Euthymides had been, the Brygos Painter (an anonymous artist who is named after the potter whose vases he decorated) took a significant step beyond them, around 490 B.C. Again the *Revelers* theme, with its gaily swinging movement, gave the experimenting artist his opportunity (FIG. **5-11**). For twenty-five hundred years, since the *Palette of Narmer* (FIG. 3-2), painted figures and figures in relief had advanced the *far* leg to show a stride—which, after all, is the best way if the torso is to be shown in front view with minimum distortion of the figure. Euthymides had broken this rule, advancing the *near* leg of a figure to show it in a

three-quarter rear view (FIG. 5-10). But the Brygos Painter, for the first time, presents a striding figure with the near leg advanced and its shoulder turned diagonally toward the observer (see the two central figures in FIG. 5-11). The result is the first true *contrapposto* stance that we have. The figure is now understood as an acting unit, not merely an assemblage of parts; the problem of its engineering has been solved to the extent that it can be represented in convincing movement. At first, this matter may seem unimportant, but this apparently superficial detail may be the manifestation of an epoch-making change in the concept of what human beings perceive.

Sculpture

Trends in the development of sculpture in Greece are just as evident as those we have traced in vase painting, although much less sculpture survives. The earliest pieces go back to the beginning of the ninth century B.C. and consist of small-scale representations of animals (horses, oxen, deer, birds) and of human figures in various materials: copper, bronze, lead, ivory, and terra-cotta. Some of these figures were ornaments on larger objects, like vases and bronze tripods; others, found near ancient sanctuaries, were separate votive offerings. At Olympia, these figures seem to have been manufactured on the spot for sale to visitors to the shrines.

A bronze warrior from the Acropolis of Athens, dated to the late eighth century B.C. (FIG. **5-12**), shows all the clear simplifications of the Geometric period. The figure, a favorite type in Geometric art, is solid cast. Given its diminutive size, this would be the reasonable casting method; hollow casting, which was understood at this time, would not have saved much bronze. The warrior originally held a spear in one raised arm and a shield in the other, although both shield and spear are missing in most surviving examples of such figures. The rather carefully rendered head and face, with the large eyes and broad grimace attest to the fact that this figure is a late specimen of a type whose earlier examples had heads and faces that were little more than shapeless lumps. Moreover, the later body forms have become smoother, losing some of their former angularity, as if the artist were trying to rid himself of centuries-old conventions of Geometric figure representation before trying the new visual approach. The inspiration for these warrior statuettes may have come from Syria, but an important difference in the evolution of Greek sculpture should be noted: the Greek figures are represented nude, while the Syrian prototypes wear loincloths. As early as the eighth century B.C., the Greek instinct for the natural beauty of the human figure, which

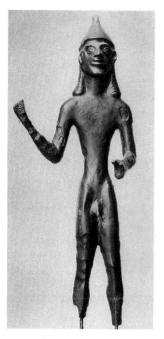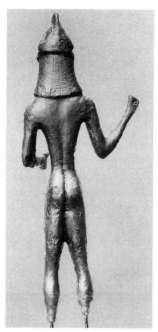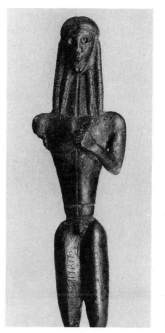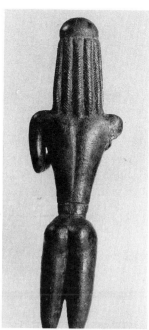

5-12 Geometric bronze warrior (front and back views), from the Acropolis, Athens, late eighth century B.C. Bronze, approx. 8″ high. National Archeological Museum, Athens.

5-13 *Mantiklos "Apollo"* (front and back views), from Thebes, *c.* 680 B.C. Bronze, approx. 8″ high. Museum of Fine Arts, Boston (Francis Bartlett Fund).

peculiarly and permanently distinguishes Greek art, is set in contrast with the traditional Near Eastern prejudice against the representation of the nude in sculpture in the round.

KOUROS AND KORE

A bronze figure of a youth from around 680 B.C. (FIG. **5-13**) can be dated to the beginning of the Archaic period; it is a small forerunner of the later *kouros* figures (see FIGS. 5-15 and 5-16). The silhouette remains essentially geometric, with a triangular torso, a narrow waist, and bulging thighs, but the forms have gained volume. The modeling of the pectoral muscles and the description of other anatomical details by means of incised lines show an incipient interest in the structure of the body.

Monumental, freestanding sculpture (life-size or larger) first appeared about 600 B.C., in the earlier stages of the Archaic period. Its rise was contemporary with the Orientalizing period in vase painting and was probably inspired by foreign sources, most likely Egypt and Mesopotamia, which were the only areas at that time that could show monumental sculpture in abundance. An early Greek example of this monumental, freestanding sculpture is the *Hera* from Samos (FIG. **5-14**), which is over six feet tall and has a cylindrical shape that could have been derived only from Mesopotamia (compare FIGS. 2-25 and 2-26). The goddess stands in a frontal pose, feet together, the right arm held tightly to the side, the left bent to the

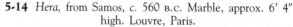

5-14 *Hera*, from Samos, *c.* 560 B.C. Marble, approx. 6′ 4″ high. Louvre, Paris.

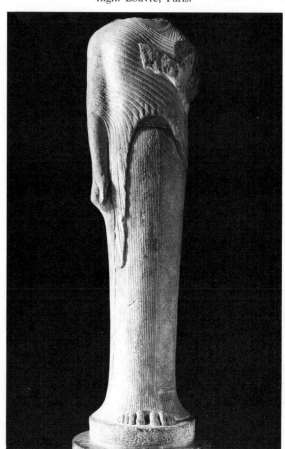

breast and probably originally holding some attribute, or symbol, of authority. Her form is that of a sheathed column as were those of the deities of Crete and Mycenae, but here the Greek artist displays an extraordinary sensitivity for surface ornamentation. The stability of the lower portions, where the striations of the *chiton* (or tunic) are placed against the plain surface of the *himation* (a kind of cape) contrasts with the movement in the upper portions, where the himation is drawn in gracefully curving folds around the delicate modeling of the swelling bosom.

The early kouros figures (FIGS. **5-15** and **5-16**) remind us of Egyptian statues. Some of these figures are of youths who are dedicated to a god and are apparently advancing into his presence; others are memorial statues that stand over the graves of noble-

men. Thus, they are figures of men, not gods (not, as once thought, "Apollos"), and this glorification of men in monumental statues that commemorate their triumph and give them a godlike scale and presence is significant. The kouroi recall Egyptian statues in the pose (the left foot advanced), in the broad, square shoulders, and in the rigidly frontal and symmetrical design. Egyptian and Mesopotamian artists thought of the sculptured human body as a smooth envelope of stone, but Greek sculptors were interested in the structural parts and how they fit together.

The kouros from Tenea (FIG. 5-15) shows us characteristic traits of the figure type, although the kouroi differ markedly from each other. Because the figures were freestanding, without the Egyptian stone slab for support, most kouroi have been found broken at

5-15 Kouros from Tenea, *c.* 570 B.C. Marble, approx. 60" high. Staatliche Antikensammlungen und Glyptothek, Munich.

5-16 *Kroisos* (kouros), from Anavysos, *c.* 540–515 B.C. Marble, approx. 6' 4" high. National Archeological Museum, Athens.

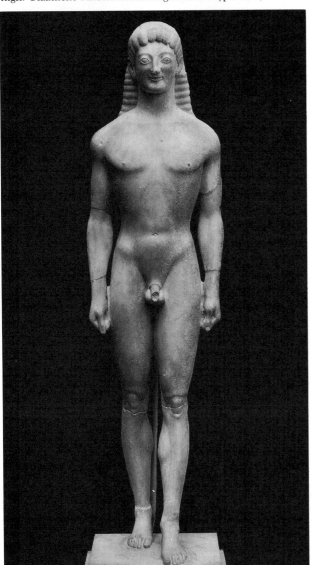

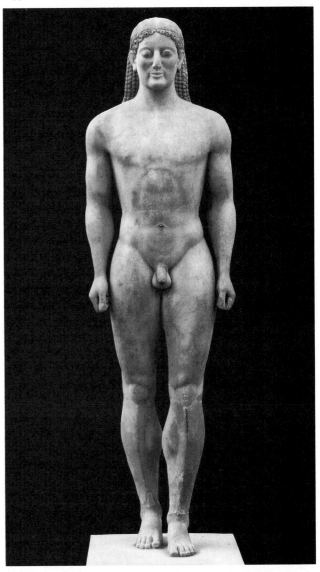

the ankles. Obviously, the Greek sculptor was not aiming for Egyptian permanence as much as for fidelity to appearance, and one of the first steps toward that goal was the liberation of the figure from the original block of stone. On the broad planes of the figure, anatomical details are carefully modeled, as we see in the chest and the knee joints. The head is geometrically simplified into flat planes: the eyes are large and protruding, and the nose, mouth, ears, and headdress are all highly stylized attributes of the almost cubic mass of the head. Although still almost provincial Egyptian, the Tenea kouros is quite un-Egyptian in its nudity and in its more dynamic, half-striding stance. Moreover, this figure is slender and elegant, with the alert, elastic physique of a sprinter. Description of the anatomy by incised line, typical of the earlier models, has been given up, and the torso, thighs, and calves are modeled in the full round with ever-closer approximation of anatomical truth.

With the *Kroisos* from Anavysos (FIG. 5-16), we come to the verge of a breakthrough similar to the one we have seen in vase painting. According to an inscription on its base, the statue is a funerary monument of a youth, Kroisos, who died a hero's death in battle. Where the anatomy of the Tenea figure is still somewhat generalized, here it becomes specific and accurate. The artist not only understands the structural parts of the figure and their natural relationship and how to represent their surfaces by modeling the stone, but he is able to give us what amounts to a *portrait* of the body, a likeness of a particular physique—in this case, that of a muscular wrestler, heavier and more massive than the taut, spare Tenea figure. It is noteworthy that the Greeks began their monumental sculpture with portraits not of the head but of the body. This "bodiliness" of Greek sculpture persisted for centuries until it became lost in a realism that compelled the sculptor to use illusional devices more appropriate to painting.

What we might think of as companion figures to the *kouroi* (youths) are the draped *korai* (maidens), contemporaneous with the former and manifesting in their own style similar features of concept and design. The *Peplos Kore* (FIG. **5-17**), contemporary with the *Kroisos*, is one of numerous figures found on the Acropolis of Athens, thrown down by the Persians during their sack of the city in 480 B.C. The purpose of the korai is obscure, but they may have been votive figures attending the deities in a kind of permanent and perpetual ritual. In contrast with earlier types, the face of this kore is more expressively modeled; the chin, cheeks, and corners of the mouth are subtly planed. The great eyes, originally with painted lids, may have been intended to have hypnotic power: we think back to the ancient head from Warka (FIG. 2-15).

5-17 *Peplos Kore*, from the Acropolis, Athens, c. 530 B.C. Marble, approx. 48" high. Acropolis Museum, Athens.

The missing left arm was extended, a break from the frontal compression of the arms at the sides in Egyptian statues. The body itself is modeled with a soft smoothness that takes account of the figure beneath the drapery, much like the earlier *Hera* from Samos (FIG. 5-14) but anatomically more realistic. Traces of paint may be seen on parts of the figure; all Greek stone statues were painted, the powder-white of Classical statues being an error of modern interpretation. But the Greeks did not smear their statues garishly with bright colors, indifferent to their place and effect; only the decisive parts, such as the eyes, lips, hair, edges of drapery, and other decorative details were painted to provide accents and contrast with the soft color of the marble itself, which was waxed and polished. The whole purpose of coloring was to make the statue more lifelike, more convincing as a kind of person confronting visitors to the shrines of the Acropolis. The painting was done in the very durable technique of *encaustic*, in which pigment is mixed with wax and applied to the surface while hot. This

5-18 Kore from Chios (?), c. 510 B.C. Marble, approx. 21½" high. Acropolis Museum, Athens.

method was widely used in ancient wall painting and on wooden panels, as well as in the embellishment of statues.

The preservation of the color of many of the kore statues is a result of the Athenians' use of fragments of broken statues and temples as rubble fill in rebuilding the temples and retaining walls of the Acropolis after the Persian destruction. In this fill, modern archeologists have found works such as the kore from Chios (?) (FIG. **5-18**), which had been buried there since 480 B.C. The luxurious gowns of the korai figures may be evidence that they were made in Ionia, where the wealthy Greek states cultivated the Oriental taste for rich ornamentation in both life and art. Ionian influence was strong in Athens during the Archaic period, and Ionian fashions, featuring the intricately folded, chic chiton, interested not only women but sculptors, who found in the representation of delicate texture and fold a peculiarly difficult challenge. For some time, sculptors seemed to delight in working out the complexities of the pleats and folds made by the thin, soft material and were content to let the matter remain one of decoration rather

than structure. At this point, although sculptors must have learned much about the movement of a surface independent of the body beneath it, the kore figures remained frontal and basically unchanged for a considerable period. Although there were slight changes, the scheme of this example was repeated over and over until the end of the Archaic period. The attractive problem of surface texture appears to have deflected the sculptors of the kore figures from larger issues.

The larger issues involve not the draped female figure but the nude kouros figure type that we have been describing; at least, the break with age-old sculptural traditions takes place in connection with the kouroi. The female nude does not appear in ancient sculpture, with some minor exceptions, until the fourth century B.C. We will see that its appearance in Greek art accompanies changes of a fundamental kind in Greek culture and morals. The Greek artist found early, as any student of the living model in art has found, that the male figure is much more revealing of human anatomical structure. Nude male models could be observed in exercises and at the games; we know that in the Dorian world, of which Sparta was the capital, the Greek artist would also have been able to observe female models, yet the male figure was given priority. By the time of Plato, nudity in the context of athletics was commonplace in the Greek world, and the prejudice against it could be regarded as barbarous—that is, merely a prejudice of the non-Hellenic Near East. In Plato's *Republic*, Socrates remarked:

> Not long ago . . . the Hellenes were of the opinion, which is still generally received among the barbarians, that the sight of a naked man was ridiculous and improper. . . . But experience showed that to let all things be uncovered was far better than to cover them up.

Certainly by about 520 B.C., the male nude must have been familiar enough for the artist to construct a convincingly real image from the observation of it. The establishment of this new convention, the propriety of the nude, implied the setting aside of the three-thousand-year-old convention of the pre-Greek world that inhibited the study of the structure of the human body as given to the eye, probably because nudity was the badge of slavery.

In the *Kroisos* figure (FIG. 5-16), the independent elements of the body are sufficiently described. The question now becomes one of how the elements work together. From the time of King Narmer, sculptors had attempted more or less successful approximations of the human figure with enumerated parts, the attitudes universally stiff and immobile. What can

put these parts into motion? The answer appears in a Late Archaic or Early Transitional figure found in the Acropolis rubble that dates from just before the Persian destruction. The statue, which must have been the consequence of a mind deliberating on what had already been done, is called the *Kritios Boy* (FIG. **5-19**), after its presumed sculptor. It is not in action, but stands at rest; that is to say, it *really* stands at rest, not merely in a stiff-legged pose or a pose bound to a block. The secret of this new and radical naturalness lies in the artist's knowledge of the principle of *weight shift*, the shifting of position of the main parts of the body around the vertical, but flexible, axis of the spine. The shifting of the human body in life never takes place in a rigid stiff-legged manner; indeed, we laugh at or are in terror of the science-fiction monster that moves in this ponderous, mechanical way. Rather, when we change place and move, the elastic musculoskeletal structure of our bodies dictates a harmonious, smooth motion of all the elements of the body. Greek artists were the first to grasp this fact, and the artist of the *Kritios Boy* was the first to represent it. The youth turns his head only very slightly away from the central axis. The slight dip to the

5-19 *Kritios Boy* (front and side views), from the Acropolis, Athens, *c.* 480 B.C. Marble, approx. 34″ high. Acropolis Museum, Athens.

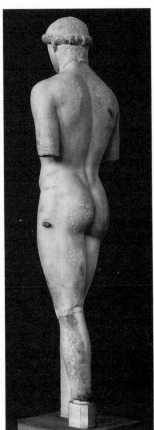

shoulders and the hips indicates the shifting of weight onto the left leg; the right leg is at ease. (One can easily assume this pose and the contrasting flat-footed poses of the earlier kouros statues.) Once the principle of weight shift has been realized, all motion of the human figure is possible in the world of representation—not simply in terms of the signs of motion evident in simple gesture, but also in terms of the motion of the whole body as we see *and* experience it. After the *Kritios Boy*, Greek sculpture rapidly passes through the possibilities of the figure understood as having its own physical principle of motion, a principle revealed to the eye in ordinary optical experience and confirmed by the observer's own physical sense of motion.

So far, we have been considering sculpture apart from architecture. But the decoration of buildings, especially temples, with sculpture, both in relief and in the round, offered the Greek sculptor a major opportunity. Because sculpture was applied only to very specific and limited areas of temples, it is necessary first to become acquainted with the basic structure of the various buildings that it adorned.

Architecture

Greek architecture and its Roman and Renaissance descendants and hybrids are almost as familiar to us as modern architecture. The so-called Greek revival instituted by European architects in the late eighteenth century brought about a wide diffusion of the Greek architectural style; official public buildings (court houses, banks, city halls, legislative chambers), designed for impressive formality, especially imitated the architecture of Classicism, which was fundamentally Greek in inspiration. The ancient Greeks were industrious builders, even though their homes were unpretentious places, they had no monarchs to house royally until Hellenistic times, and they performed state religious rites in the open. Their significant buildings began primarily as simple shrines to protect the statues of their gods. More and more attention was lavished on these structures over time. Eventually, the belief may have arisen that the qualities of the god were embodied in the buildings themselves. Figure sculpture played its part in this construction program, partly to embellish the protective building, partly to tell something about the deity symbolized within, and partly as a votive offering. But the building itself also was conceived as sculpture, abstract in form and possessing the power of sculpture to evoke human responses. The commanding importance of the sculptured temple, its inspiring function in public life, was emphasized in its elevated site, often on a hill above the city (the *acropolis*). As

Aristotle stipulated: "The site should be a spot seen far and wide, which gives due elevation to virtue and towers over the neighborhood." And the reverent awe that must have been attached to the temple and to the genius of its founders later was echoed by Plato: "Gods and temples are not easily instituted, and to establish them rightly is the work of a mighty intellect."

Although still a matter of ardent debate, one theory holds that the earliest temples were made of wood, and that these wooden forms were in time translated into the more permanent materials of limestone and sometimes marble. Marble was expensive, but mountains of it were available: bluish-white stone came from Hymettus, just east of Athens; glittering white stone, particularly adapted for carving, was brought from Pentelicus, northeast of the city; and from the islands of the Aegean, Paros in particular, marble of varying quantities and qualities was supplied.

In its plan, the Greek temple discloses a close affinity with the Mycenaean megaron and, even in its most elaborate form, it retains the latter structure's basic simplicity (FIG. 5-20): a single or double room (the *naos*) with no windows and one door (two for a double naos) and with (a) a portico with two columns between the extended walls (columns *in antis*), or (b) a colonnade across the front (*prostyle*), or (c) a colonnade across both front and back (*amphiprostyle*), or any of these plans surrounded by (d and e) a single (*peripteral*) or (f) a double (*dipteral*) colonnade. What strikes the eye first in the Greek scheme, after what has been seen of the architecture of the ancient Near East, is its remarkable order, compactness, and symmetry, in contrast, say, to the relative irregularity of the Egyptian temple. The difference lies in the Greeks' sense of proportion and in their effort to achieve ideal forms in terms of regular numerical relationships and the rules of geometry.

We can discern in the plans a kind of development from quite simple to more complex units, without, however, any fundamental change in the nature of the units or of their grouping. Classical Greek architecture, like classical music, has a simple core theme from which a series of complex, but always quite in-

5-20 Six representative plans of the Greek temple: (**a**) a temple *in antis*, in which the portico is formed by the projecting side walls of the naos with two columns set between their ends (*antae*); (**b**) Temple B at Selinus, Sicily, a *prostyle* temple, in which the columns stand in front of the naos and extend to its width; (**c**) Temple of Athena Nike on the Acropolis at Athens, an *amphiprostyle* temple, in which the prostyle plan has a porch added at the rear; (**d**) Temple of Hera at Olympia and (**e**) Temple of Aphaia at Aegina, *peripteral* temples, in which a single colonnade surrounds the naos; and (**f**) Temple of Apollo at Didyma, near Miletus, a *dipteral* temple, in which two colonnades surround the naos. (*Drawings are not to scale.*)

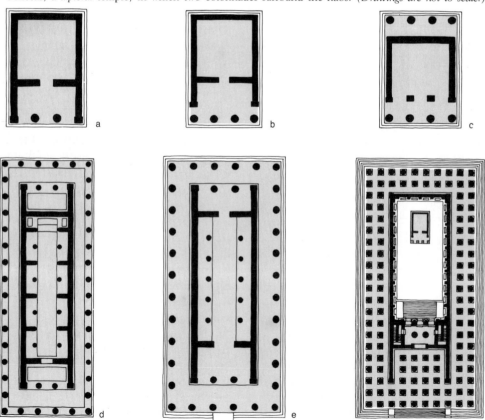

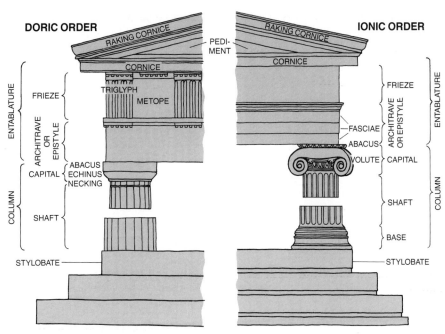

5-21 Doric and Ionic orders. (After I. H. Grinnell.)

telligible, variations is developed. And, to change the analogy, the development of the temple scheme is like that other great invention of the Greeks, geometry, in which theorems, propositions, and their corollaries are deduced from a simple original set of axioms. The Greeks' insistence on proportional order guided the experiments with the proportions of temple plans. The earlier, Archaic temples tended to be long and narrow (FIG. 5-20d), with the proportion of the ends to the sides roughly expressible as 1:3. Late Classical and Hellenistic plans approached but rarely had a proportion of exactly 1:2, with Classical temples tending to be a little longer than twice their width (FIG. 5-20e) and Hellenistic temples tending to be a little shorter (FIG. 5-20f). Proportion in architecture and sculpture, and harmony in music, were much the same to the Greek mind and reflected and embodied the cosmic order, just as did the rationally pursued "good life."

The elevation of a Greek building is described in terms of the platform, column, and *entablature* (FIG. 5-21); this combination and relationship of three units is called an *order*. The three orders developed by Greek builders are differentiated partly by details but chiefly by the relative proportions of the parts. Each order served different purposes and embodied different meanings. The earliest of the Greek architectural orders to be formulated were the *Doric*, of mainland Greece, and the *Ionic*, of Asia Minor and the Aegeans (FIG. 5-21). The *Corinthian* order followed much later.

The columns, which rest on a platform (*stylobate*), have two or three parts, depending on the order: the *shaft*, which is marked with vertical channels (*fluting*); the *capital*; and (in the Ionic and Corinthian orders) the *base*. As the shaft rises, its diameter decreases gradually, giving the profile a subtle curve (*entasis*); the top (in the Doric) is marked with one or several horizontal lines (*necking*) that furnish the transition to the capital. The capital has two elements, the lower of which (the *echinus*) varies with the order: in the Doric, it is convex and cushionlike; in the Ionic, it is small and supports a bolster ending in scroll-like spirals (the *volutes*); and in the Corinthian, it is shaped like an inverted bell and is decorated with a design of stylized acanthus leaves. The upper element, present in all orders, is a flat, square block (the *abacus*) that provides the immediate support for the entablature. The entablature has three parts: the *architrave* or *epistyle*, the main weight-bearing and weight-distributing element; the *frieze*; and the *cornice*, a molded horizontal projection. In some buildings, the third part, with two sloping (*raking*) cornices, forms a triangle that enframes the *pediment*. The architrave is usually subdivided into three horizontal bands (*fasciae*) in the Ionic and Corinthian orders. The frieze is subdivided into *triglyphs* and *metopes* in the Doric order and is left open in the Ionic to provide a continuous field for reliefs.

The Doric order is massive in appearance, its sturdy columns firmly planted on the stylobate. Compared with the weighty and severe Doric, the Ionic order seems light, airy, and much more decorative. Its columns are more slender and rise from molded bases. The Doric flutings meet in sharp

ridges (arrises), but the Ionic ridges are flat (fillets). The most obvious differences among the three orders are, of course, in the capitals: the Doric, severely plain; the Ionic and Corinthian, highly ornamental.

In ancient times, the Doric and Ionic orders were contrasted as masculine and feminine. The Corinthian order was not developed until the fifth century B.C., when it appeared inside the temple, like a natural form growing in the darkness of the interior. On the exteriors of buildings, however, it was not widely used until Roman times. Since the Renaissance and until about two generations ago, much of the architecture in the Western world was considered to be in essence the display of the refined beauty of these architectural orders.

According to one theory, many of the parts of the Doric order seem to be translations into stone of an earlier timber architecture. Pausanias, writing in the second century A.D., noted that in the even-then ancient Temple of Hera at Olympia (FIG. 5-20d), a wooden column was still in place; the others had been replaced by stone columns. It has been inferred, from the varying proportions of these columns, that the wooden columns were replaced at different times, probably as the wood of the original columns rotted. One feature of the Doric order, the organization of the frieze into triglyphs and metopes, can be explained best as a translation from the wooden original into stone. The triglyphs most likely derived from the ends of crossbeams that rested on the main horizontal support, the architrave. The metopes would then correspond to the voids between the beam ends in the original wooden structure.

Sculptural ornament, which played an important part in the design of the temple, was concentrated on the upper part of the building, in the frieze and pediments. The sculpture was gaily painted in red and blue, with touches of green, yellow, black, and perhaps a little gold, and was usually applied only to those parts of the building that had no structural function or that suggested a former structural function. This is true particularly of the Doric style, in which decorative sculpture was applied only to the "voids" of the metopes and of the pediment. Ionic builders, less severe in this respect, were willing to decorate the entire frieze and sometimes even the lower drums of columns. Occasionally, they replaced their columns with female figures (caryatids), something the Doric builder probably would not have done. Using color, the designer could bring out more clearly the relationships of the structural parts, soften the glitter of the stone at specific points, and provide a background to set off the figures.

Although color was used for emphasis and to mitigate what might have seemed too bare a simplicity (in Doric as well as in Ionic buildings), the primary dependence in Greek architecture, as in Greek mathematics, science, and philosophy, was on the setting of clear limits. This thesis had to begin with the axiom that the limits themselves must never be encroached on, must always define, and must never be vague. The three Greek architectural orders just described were embodiments of codified limits that appeared plainly to the eye as functioning realities. To the Greeks, it was unthinkable to use surfaces in the way that the Egyptians used their gigantic columns—as fields for complicated ornamentation. The very building itself, the Greek temple as given to the eye, must have the clarity of a Euclidean demonstration. This principle is borne out not only by its plan, elevation, and function-enhancing ornamentation, but also by its "dry-jointed" construction (construction without mortar), which provides evidence that Greek architects looked on their temples not as "buildings" but as monumental pieces of sculpture.

The placement of the building strengthened its sculptural aspect. Unlike Egyptian temples, Greek temples faced outward. Rites were performed at altars in front of the temple, and the building itself served to house the cult statue and perhaps trophies and treasure. Private cults were frowned on, and public ritual prevailed. Thus, it was on the exterior of the building and its surfaces that the architect generally concentrated all efforts at making the temple a suitable monument to the deity. The studied visual relationships of solids and voids, of light and shade in the colonnades, and the lighter accents of the entablature made a sculptural form out of the rectangular mass of the temple. The history of Greek architecture is the history of Greek artists' unflagging efforts to express the form of the temple in its most satisfactory (that is to say, what they believed to be perfect) proportions.

The experiment in proportions can be followed rather easily if we begin with the Archaic Doric architecture of the Greek colonies, especially in Sicily and southern Italy, for it is here that the best-preserved examples of Archaic temples are found. (In examining Greek architecture, it is useful to keep in mind the development of the human figure in Greek painting and in sculpture; the architectural events are not only contemporaneous, but reflect a similar concern with proportions.)

The "Basilica" at Paestum, south of Naples, dates from about 550 B.C., and is a typical example of Archaic Doric style (FIG. 5-22). Called the "Basilica" after a Roman building type that early investigators felt it resembled, we now know that this structure was dedicated to Hera. It is referred to as Hera I in current literature, to distinguish it from the later Temple of

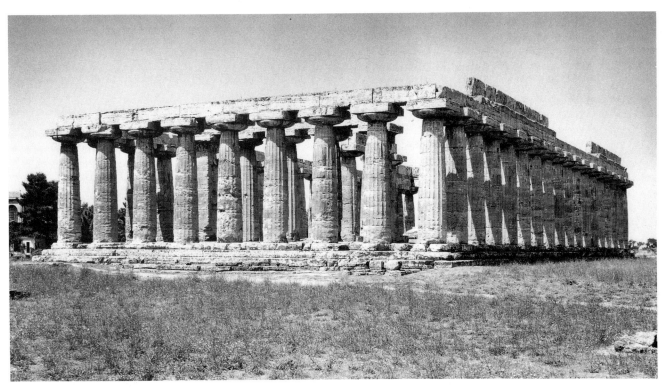

5-22 The "Basilica," Paestum, Italy, *c.* 550 B.C.

Hera II, which stands nearby. The misnomer is partly due to the building's plan (FIG. **5-23**), which differs from that of most other Greek temples. The unusual feature, which is found in only a few very early Archaic temples, but which here has survived well into the sixth century B.C., is the central row of columns that divides the naos into two aisles. Placing columns underneath the ridgepole might seem to be the logical way to provide interior support for the roof structure, but it resulted in several disadvantages. Among these was the fact that this interior arrangement allowed no place for a central cult statue. Also, the pe-

5-23 Plan of the "Basilica."

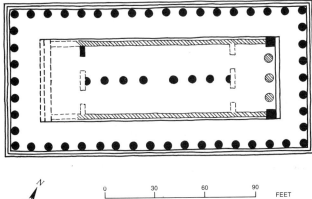

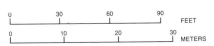

FEET

METERS

ripteral colonnade, in order to correspond with the interior, had to have an odd number of columns across the building's façade. This, in turn, ruled out a central doorway through which the cult statue could be viewed.

The elevation of the temple is characterized by heavy, closely spaced columns with pronounced entasis and large, bulky, pillowlike capitals. These columns carry a high and massive entablature that makes them seem proportionately squat. In later Doric structures, these parts of the order gradually will be adjusted until a lighter and taller combination is achieved. One structural reason, perhaps, for the heaviness of the design and the narrowness of the spans between the columns might be that the Archaic builders, uncertain of the strength of their materials, were trying to provide a broad margin of safety. A detail of the "Basilica" colonnade (FIG. **5-24**) shows the extreme spread of the cushion capitals and exaggeration of the supporting surface in relation to the spans bridged by the architrave. The columns are built up of separate, dry-jointed "drums," fitted with square metal plugs to prevent turning as well as shifting. The whole temple was of this typically Greek construction, the blocks of stone in a horizontal course being held together by metal cramps, while those of different courses, one above the other, were joined vertically by metal dowels. Through the "Basilica" colonnade can be seen the nearby Temple of

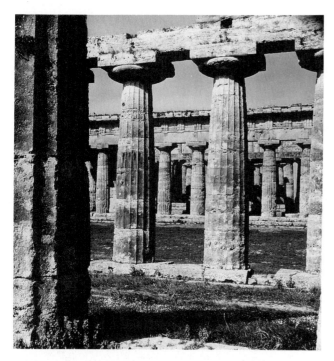

5-24 "Basilica" colonnade, with view of the Temple of Hera II beyond.

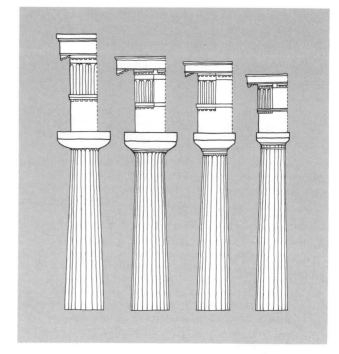

5-25 Evolution of Doric order proportions, Archaic to Classical. (*Examples are not drawn to same scale.*)

Hera II, which was built eighty to ninety years later with columns of strikingly different proportions from those of the "Basilica."

The diagram showing the evolution in the proportions of the Doric order from Archaic to Classical (FIG. **5-25**) emphasizes the thesis that Greek art evolved in conjunction with a certain logic, whether in its figurative or its architectural forms, that moved toward a conclusion that was as satisfactory as it was true. Plato, in speaking of the imitative arts, declared the degree of their truth or rightness to be determined by the proportionality of their elements. If they were to be judged at all, they must be judged by the "standard of truth, and by no other whatever." In this diagram, we see the architects working toward proportions that could be thought of as "true" and final. Some of the earliest columns (not shown) were extremely slender, under massive capitals. The shafts soon thickened to the shape of the "Basilica" type, as the builders searched for a better relationship between the shaft and the capital. From then on, the forms were constantly refined, the shafts becoming more slender, the entasis subtler, the capitals smaller, and the entablature lighter. The final Classical proportions were considered to be ideal ones, beyond which further refinement was impossible.

The Temple of Hera II at Paestum (FIG. **5-26**) dates from about 460 B.C. Although the forms have been refined, the columns are still massive and closely spaced. This temple was erected at a time when, on the Greek mainland, the Doric order had already achieved its Classical proportions (as early as 490 B.C.) in the Temple of Aphaia at Aegina. There was a considerable time lag between developments on the mainland and their adoption by the colonies in Italy and Sicily, so that the colonial architecture exhibits the usual provincial conservatism characteristic of styles distant from their source of inspiration in the cultural capital. The plan and section of the Temple of Hera II (FIG. **5-27**) show an improvement on the earlier Paestum temple. The even number of façade columns, the single central doorway and the open middle aisle of the now three-aisled naos combined to permit the placement of the cult statue on the central axis of the temple, where it could be seen from the outside. These changes in plan were made possible by a different interior roof-support system, which here consists of two rows of small Doric columns flanking the middle aisle. Each of the two double-tiered rows is made up of two sets of columns, a small one standing on a stone course supported by a larger set of columns below. This arrangement was standard where Doric columns were used to support the roof. The reason for this may have been that a single row of large columns, as in the "Basilica," would produce a distortion of scale and look oppressively out of

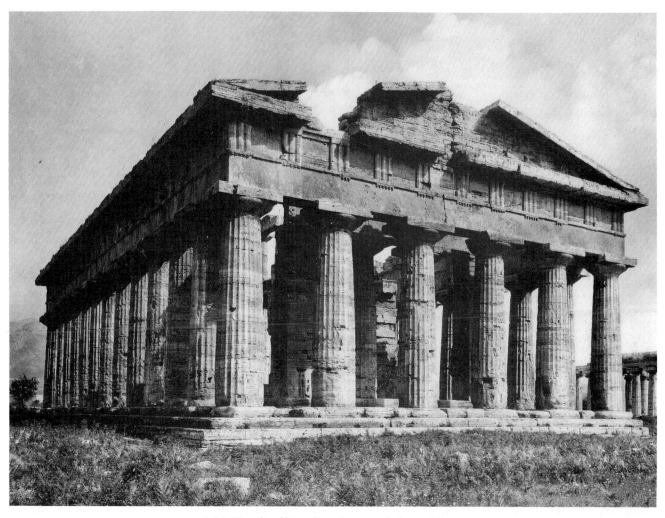

5-26 Temple of Hera II at Paestum, Italy, *c.* 460 B.C.

5-27 Plan (*left*) and section (*right*) of the Temple of Hera II at Paestum. (After Sir Banister Fletcher.)

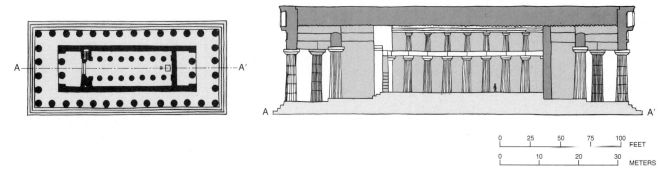

proportion inside the relatively small naos. Later, the support problem was solved by using Ionic or Corinthian columns in the interior; they were taller than the Doric ones in relation to their diameters.

One of the earliest Ionic buildings in Greece is the Treasury of the Siphnians at Delphi, constructed about 530 B.C. (FIG. **5-28**). Although it has no Ionic columns (the supporting function is assumed by luxuriously carved caryatids, whose style and drapery match those of the Ionian kore of the Athenian Acropolis shown in FIG. 5-18), the Treasury has the identifying Ionic feature—the continuous frieze—that appears here as part of a heavy Archaic entablature. The caryatids, with their elaborate costume and

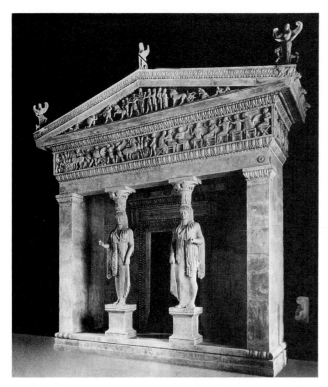

5-28 Treasury of the Siphnians from the Sanctuary of Apollo at Delphi, *c.* 530 B.C. Archeological Museum, Delphi. (Façade reconstructed.)

pediment. The caryatids are exceptional, but their use is fairly rare. Ordinarily, the weight-carrying columns and the weight-distributing architraves were not decorated, although war trophies may have been hung on the blank Doric architrave. In the Doric order, only the metopes bore relief sculpture. Some may argue that the fluting of columns is a form of decoration, but, in fact, the fluting simply explains and emphasizes the form and function of the column, stressing its verticality. It also exhibits the column's rotundity, for when the sunlight strikes sharply on the shaft (FIG. 5-24), the fluting throws numerous shadows of graduated width and darkness that lead the eye around the shaft in a series of graded steps, making the effect of roundness more evident. In the non-fluted column, the sunlight creates a single, indistinct line separating the light and dark sides.

The Greek architectural sculptor faced a problem similar to that of the Greek vase painter: how to adjust the image to the surface on which it is placed. This is not apparent in the frieze from the Treasury of the Siphnians (FIG. **5-29**), for here the sculptor has a continuous blank zone to manage and can arrange the figures in a simple file, their heads on the same level, each filling a unit of space of approximately the same dimension. This is a good example of the formalizing effect of architectural line on figurative composition, just as the surface of the ceramic vessel imposed its necessities on the vase painter, encouraging simplicity and elegance of style. In fact, a stylistic resemblance exists between the Siphnian figures and such contemporary painting as that of the Andokides Painter (FIG. 5-8). But an awkward space like that of the triangular pediment of the Archaic Temple of Artemis (early sixth century B.C.) on the island of Corfu

very irregular silhouettes, would never have fitted into a context of Doric architecture, with its severity of line and disdain of ornament.

ARCHITECTURAL SCULPTURE

We have noted already that decorative sculpture was applied only to those parts of a temple that had no evident structural function—the frieze and the

5-29 *Battle of the Gods and Giants,* from the north frieze of the Treasury of the Siphnians. Marble, approx. 26″ high. Archeological Museum, Delphi.

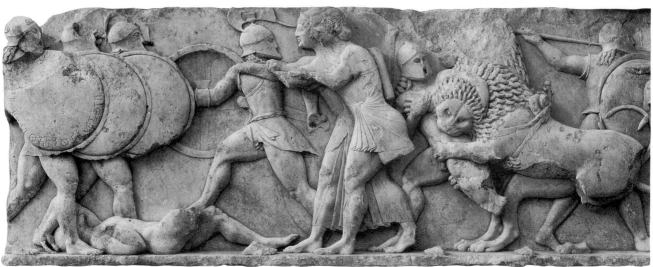

5-30 Reconstruction drawing superimposed on a photograph of the remaining fragments of the west pediment of the Temple of Artemis at Corfu, *c.* 600–580 B.C. Limestone fragments. Archeological Museum, Cairo.

5-31 Reconstruction drawing of the east pediment of the Temple of Aphaia at Aegina, *c.* 490 B.C.

(FIG. **5-30**) is more troublesome to manage. Here, the figures are arranged heraldically and bring to mind compositions that go back beyond the Lion Gate at Mycenae (FIG. 4-23) to the symmetrical man-beast compositions of Mesopotamia (FIG. 2-9). On the thin panel of stone that fills the space between the cornices of the pediment, the sculptor presents the Gorgon, Medusa, flanked by spotted panthers. The Gorgon, a guardian monster whose glance could turn men to stone, grimaces hideously, exposing her boar's teeth and fulfilling her function as a winged demon to repulse all enemies from the sanctuary of the goddess. To the left and right of the Medusa figure appear her children, Chrysaor and Pegasus, who, according to legend, sprang from the Gorgon's head when she was struck by the sword of Perseus. They are both represented on a smaller scale. Still smaller are two groups of figures beyond the panthers: Zeus slaying a giant (on the observer's right) and one of the climactic events of the Trojan War, Neoptolemus killing Priam. In the outer ends of the pediment, recumbent figures represent a fallen Trojan and a dead giant. As pieced together from the surviving fragments, the artist's narrative intention is clear enough, but the odd shape of the surface on which he worked compelled him to distribute his figures somewhat haphazardly around the central ones and to show them on different scales. As time progressed, the Greek artist attempted to fill the space more organically, with figures grouped so that they appeared to be of the same size, participating in a unified way in a single event.

Toward the end of the Archaic period, Greek sculptors were arriving at a solution to the problem of pedimental composition. In the pedimental sculptures of the Temple of Aphaia at Aegina (FIGS. **5-31** to **5-33**), we find that the figures, in different poses but of the same scale, have been fitted into the difficult triangular space. Only the goddess Athena is shown on a slightly larger scale than the human combatants around her. The figures, which were heavily cleaned and over-restored in the nineteenth century, but recently restored anew to their original condition, probably represent some episode of the Trojan War. The exact original arrangement is still a matter of dispute, and art historians have suggested various solutions. Athena, with aegis and spear, stands in the center, with fighting groups on either side. We notice most the freedom of movement and the variety of pose. The figures are modeled with great vigor and an understanding of the human physique that, as we have seen in the contemporary vase paintings, reflect a careful observation of nature. The figure of the *Fallen Warrior* from the left angle of the pediment (FIG. 5-32) exhibits the daring with which the sculptor tackles the challenging problem of a difficult twisted pose. The bold composition of the turning masses of the body manifests the artist's new confidence in having mastered the science of representation. The dynamics of muscular tension and relaxation are appreciated and are close to life in their rendering. Mistakes are still made, and the transition from chest to pelvis has not been fully solved in this complex pose (note the misplaced navel). However, these rather technical considerations should not blind us to the marvelously expressive power of this figure. The *Fallen Warrior* brings to mind the spare and monumental nobility of Homer's heroes and particularly the Homeric simile,

5-32 *Fallen Warrior,* from the east pediment of the Temple of Aphaia at Aegina. Marble, 6′ long. Staatliche Antikensammlungen und Glyptothek, Munich.

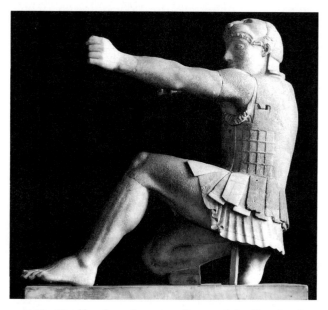

5-33 *Herakles,* from the east pediment of the Temple of Aphaia at Aegina. Marble, approx. 31″ high. Staatliche Antikensammlungen und Glyptothek, Munich.

''darkness came down upon his eyes, and he crashed in the battle like a falling tower.''

The figure of the archer *Herakles* (FIG. 5-33), from the same pediment, is another instance of the Greek sculptor's triumph over age-old taboos and difficulties of representation. It is thought that this nimble archer is executing a maneuver hard to perform without long practice but required in the Greek war games and in actual combat. Running forward, he has dropped suddenly almost to one knee, and, from this tense position, takes aim and rapidly fires a flight of

arrows. Soon he will spring to his feet to run forward again. The practiced strength and poise demanded by such a feat are beautifully caught in the elastic, though momentarily rigid, pose. One might read here the expression of a new spirit in Greek life and art—a spirit buoyant and optimistic as it meets the great challenge of the Persians at Marathon and looks to a future that the ancient Near Eastern world could never envision and never encompass.

THE EARLY CLASSICAL (TRANSITIONAL) PERIOD: 480–450 B.C.

The thirty or so years of the Early Classical period constitute the heroic age of the Athenians and of all the Hellenes who joined forces against the invasion of Greece by the Persians. Just as we look back to the age of the American Revolution and to the founding fathers of the republic for our models of heroism and civic wisdom and virtue, so the Greeks of the later fifth century revered the men of Marathon, Thermopylae, and Salamis—the battles that daunted and finally turned back the mighty hosts of Asia led by Xerxes. The new world of the Greeks, which they attributed to the Homeric feats of their heroes, turned away from Asia, barbarism, tyranny, and ignorance (it was all the same to the Greeks) to build a Hellenic civilization productive of a new species of mankind. Typical of the time were the views of the great dramatist Aeschylus, who celebrated, in his *Oresteia,* the triumph of reason and law over barbarous crime, blood

feud, and mad vengeance. Himself a veteran of Marathon, Aeschylus repudiated in majestic verse all the slavish and inhuman traits of nature that the Greeks at that time of crisis associated with the Persians.

The Severe Style

Shortly after Athens was occupied and sacked in 480 B.C., the Greeks won a great naval victory over the Persians at Salamis. This resilient toughness of the Athenians signified a new pride that was to mature into a sense of Hellenic identity so strong that thenceforth the history of European civilization would be distinct from the civilization of Asia, even though in interaction with it. The period of struggle with the Persians, calling repeatedly for courage and endurance, produced in the Hellenes a kind of austere grandeur that manifested itself in the art of that period in what usually is referred to as the *severe style*. Stern simplification of outline and surface, fixed pose, firm stance, and immobility of expression characterize the severe style as we find it in two superb, life-size bronze statues of warriors recovered from the sea in 1972 and restored to their original appearance, although without their original attributes, such as shields and weapons (FIGS. **5-34** to **5-36**). *The Riace Bronzes* take their name from Riace Marina, a shore resort in Reggio Calabria, the site of an ancient Greek colony at the toe of the Italian boot. These priceless additions to the history of world art were found by an underwater swimmer just offshore, buried in the sand some 25 feet beneath the surface of the sea. Painstakingly cleaned—the cleaning itself a masterpiece of the modern restorer's art—the statues are now generally regarded as original Greek bronzes of the Transitional period of the so-called severe style, which preceded the Classical period. Weight, cost, and the tendency of large masses of bronze to distort when cooling would have made life-size castings in solid bronze impractical, if not impossible. Larger sculptures in bronze were (and are) hollow-cast in the *cire perdue* (lost-wax) method (see Glossary). This art of bronze casting, used since Sumerian times and probably learned by the Greeks from the Egyptians in the sixth century B.C., is found here in all perfection, as is the craft of working the metal surfaces to produce the greatest subtlety of detail. The mastery of material and technique is matched by the sculptor's sure knowledge of the structure and dynamics of the human body. Although one leg of the *Warrior* is advanced (FIG. 5-34) in the tradition of the Archaic kouroi (FIGS. 5-15 and 5-16), the weight shift, which we noted in the *Kritios Boy* (FIG. 5-19), is more pronounced, and the articulation of the body masses is at once more defined and fluent (FIG. 5-35). The slight

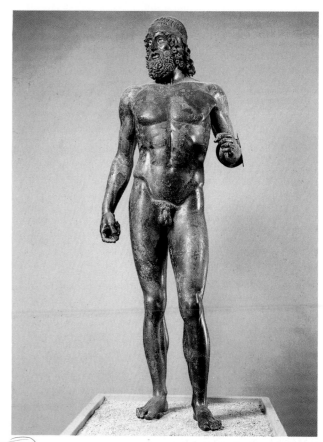

5-34 *The Riace Bronzes, Warrior Figure*, 460–450 B.C. Bronze, silver teeth and eyelashes, copper lips and nipples; each figure 6′ 1″ high. Archeological Museum, Reggio Calabria, Italy.

5-35 *Warrior*, rear view (restored).

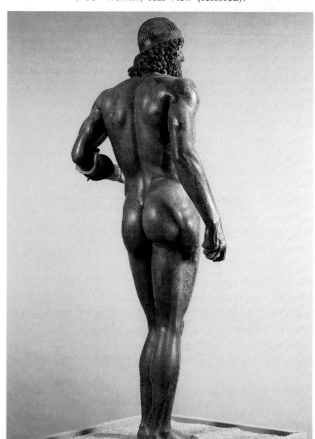

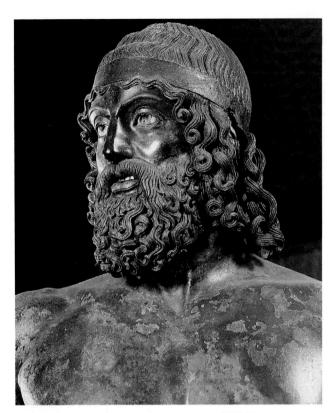

5-36 Detail of FIG. 5-34.

turning of the head and tilting of the shoulders, the
unlocking of the arms from the body, and the lifting
and crooking of the left arm (which perhaps held a
shield) are all features that break through the rigid
"slab" of space confining the Archaic kouros and
suggest the beginning of natural movement and the
shift of viewpoint from the strictly frontal aspect. The
massive physique and the alert, menacing stance
express extraordinary strength and a brutal ferocity.
The face (FIG. 5-36), its silver teeth bared in a snarl,
could be imagined as the very mask of merciless
"War," defined by Homer as "the bane of men."

The high quality of *The Riace Bronzes* can be found
again in another fine bronze, *The Charioteer of Delphi*
(FIG. **5-37**). This statue belonged to a grouping that
included chariot and horses, probably erected to com-
memorate the victory of King Polyzalos of Gela at
the races in 478 B.C. *The Charioteer of Delphi* represents
the king's driver, who stands firmly on both feet,
holding the reins in his outstretched hand. He is
dressed in the customary garment of a driver, girdled
high and held in at the shoulders and the back to
keep it from flapping. A band tied behind the head
confines the hair. The eyes are made of glass paste
and shaded by lashes of hairlike pieces of bronze. We
feel the sharp clarity of Archaic work in the figure,
especially in the lower part (where the folds of the
dress have almost the quality of a fluted column), in

5-37 *The Charioteer of Delphi,* from the Sanctuary
of Apollo at Delphi, *c.* 470 B.C. Bronze, approx. 5′ 11″ high.
Archeological Museum, Delphi.

the sharp lines of the brow, and in the conventional way in which the hair is worked. But we notice also the skillful modeling of the hand and the feet, and the slight twist of the torso, which gives the feeling of an organic structure beneath the drapery. These subtleties are not seen at first, and we might mistake the statue for another example of the Archaic formula of rigid frontality. But it is only the formality of the pose, not ignorance of the principle of weight distribution, that determines the tight composure of the figure; it is as "alive" as the pose of a soldier at parade rest. The statue may be a portrait, yet few individualized traits are shown. This lack of individualized traits typified most works of the Greek Classical period and distinguished Greek from Egyptian portrait statues, which had a religious function (the preservation of the deceased's likeness to preserve the ka). Although, with the Greeks, man comes to complete self-consciousness ("Know thyself!"), and although the *human figure* is idealized, no individual is regarded as being true or perfect or, consequently, an appropriate subject for representation. In the words of Bruno Snell:

> If we want to describe the statues of the fifth century in the words of their age, we should say that they represent beautiful or perfect men, or, to use a phrase employed in the early lyrics for purposes of eulogy, "godlike" men. Even for Plato, the norm of judgment still rests with the gods, and not with men.[*]

Thus, our observations at the beginning of this chapter must be modified. Although, according to the philosopher Protagoras, "man is the measure of all things," for art, the gods are the measure of man, and to achieve the ideal is to achieve the "godlike."

The rapid process of liberation from Archaic limits continues in the renowned *Discobolos* of the sculptor MYRON (FIG. **5-38**), which dates from about 450 B.C. Like most freestanding statues by the "Great Masters" of Greek sculpture, the *Discobolos* has survived only in Roman marble copies of the bronze original (see page 163). Myron's representation of an athlete engaged in the discus throw was revolutionary as a result of its vigorous and convincing movement. It has been widely reproduced in both the ancient and modern worlds. However, the motion of the *Discobolos* has clearly been restricted to one plane, which means that only two distinct views are possible. The figure is represented at the point between the backward swing and the forward thrust of the arm and by means of certain formal devices becomes an expression of concentrated force. The composition is in terms of two intersecting arcs, creating the impres-

*Bruno Snell, *The Discovery of the Mind: The Greek Origins of European Thought* (New York: Harper & Row, 1960), p. 247.

5-38 MYRON, *Discobolos*. Roman marble copy after a bronze original of *c.* 450 B.C., life size. Museo Nazionale Romano, Rome.

sion of a tightly stretched bow a moment before the string is released.

The severe early style of the Transitional period finds its clearest and most representative expression in the pedimental sculptures of the Temple of Zeus at Olympia (FIG. **5-39**). On the west pediment, the combat of centaurs and Lapiths at the wedding feast of Peirithous is represented. The centaurs (half man, half beast) had been invited to the celebration, but they became drunk and attempted to abduct the bride and her maidens. They were prevented from doing so by Peirithous and Theseus; Apollo, appearing above the combat, approves the heroes' chastisement of this breach of hospitality. The scene symbolizes three things: the Greek victories over the Persians; the sacred truce of Olympia (which outlawed strife

5-39 Reconstruction of the west pediment of the Temple of Zeus at Olympia, 468–460 B.C. Approx. 91′ wide.

within or on the approaches to the consecrated precincts of the temple); and the responsibility of men, who, unlike animals, acknowledge the rule of law.

The grouping of the figures in the Olympia pediments shows considerable improvement over the older Aegina grouping (FIG. 5-31) in the adjustment of the poses to fit the triangular pediment. In the center, Apollo thrusts out his arm amid the tumult (FIG. 5-40). The figure should be compared with the Archaic kouroi (FIGS. 5-15 and 5-16). From its formality and such lingering archaisms as the tight, decorative treatment of the hair, it seems the last of that great line, although the new understanding of bodily structure shows in the splendid and exact modeling of the athletic physique. The musculature is no longer schematic, but swelling with life and power. The transitions from one group of muscles to another are made

smoothly and subtly, and this soft flow of planes and contours belies the formal rigidity of the pose.

The face of the *Apollo*, like those of *The Charioteer of Delphi* and the *Discobolos*, is composed in the expressionless mask of regular beauty deemed appropriate to gods and godlike men, despite their action or potential for action. This ideal mask, expressing the conviction of Greek philosophy that reason must be above and in control of the passions, precludes the distortion of the face by any strain of emotion, even in scenes of the most violent action. In the twisted complication of the group of *Hippodameia and the Centaur* (FIG. 5-41), where the bride of Peirithous tries to wrench the centaur's clutching hand from her breast, the girl's face remains serenely neutral. Her predicament is dire, as the artful sculptor dramatically describes it; yet, and significantly, it is only the cen-

5-40 *Apollo*, from the west pediment of the Temple of Zeus at Olympia, *c.* 470–456 B.C. Marble, height of Apollo 10′ 2″. Archeological Museum, Olympia.

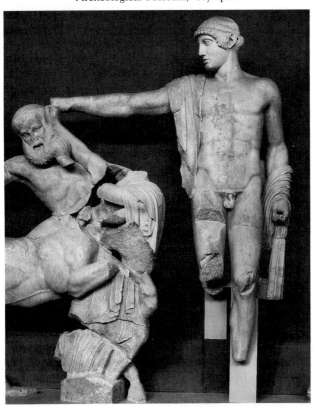

5-41 *Hippodameia and the Centaur*, from the west pediment of the Temple of Zeus at Olympia. Marble, slightly over life size. Archeological Museum, Olympia.

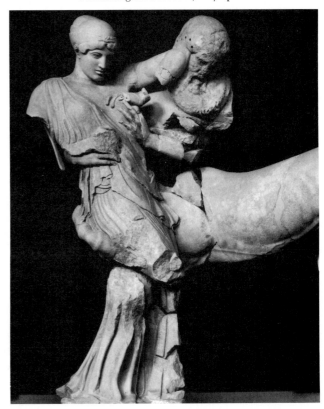

taur's face that is distorted, as befits such a low creature, surrendering to drunkenness and lust. This distinction between the calm of noble men and women and the frenzy of the creature abandoned to impulse prevailed for centuries in Greek art. The Greeks were convinced that overwhelming disaster awaited those who yielded to the spell cast by Dionysos, the dark god of intoxication and madness; this conviction is reflected in their drama and in their persistent appeal to reason and order, both in art and in life. Against Dionysos they attempted to raise the shining figure of Apollo, god of light, beauty, and wisdom. Thus, it was with the pediments of Olympia that the visual arts moved into the realm of philosophy and drama, and it was in the presence of these sculptures that the Greek athletes took their oath at the altar of Zeus before the Olympic Games.

THE HIGH (MATURE) CLASSICAL PERIOD: 450–430 B.C.

The prestige that the Athenians won by their leading role in the repulse of the Persians, and by virtue of the powerful fleet they built in the process, made them the dominant political force in the Greek world. They acquired a sea empire disguised as a religious

and more or less democratic alliance of city- and island-states throughout the Aegean. Members of the alliance, which was called the Delian League, had cause enough to complain bitterly that they were more the subjects of Athens than her allies and that she siphoned off a large part of the common treasury (raised as a fund for defense against Persia) for her own uses. Despite chronic warfare within the alliance (and between it and the rival league led by Sparta), Athens, under the leadership of its adroit statesman, Pericles, became an immensely prosperous and proud community. The brief period of Athenian glory under Pericles saw a concentration of human creative energy and a triumph of drama, philosophy, and art that has been known in no other place or time in all of Western history.

Architecture

Disdaining to reassemble the desecrated stones of the Athenian Acropolis after the sack of the city in 480 B.C., the Athenians, led by Pericles, signalized their new power and independence by completely rebuilding the Acropolis, undertaking one of the greatest building projects of antiquity before Roman times. Their success stands as a rare human achievement against the larger history of human failure. The beauty of the buildings, set on a towering platform of rock with difficult access (FIGS. **5-42** and **5-43**), was

5-42 Plan of the Acropolis of Athens, restored as of 400 B.C.

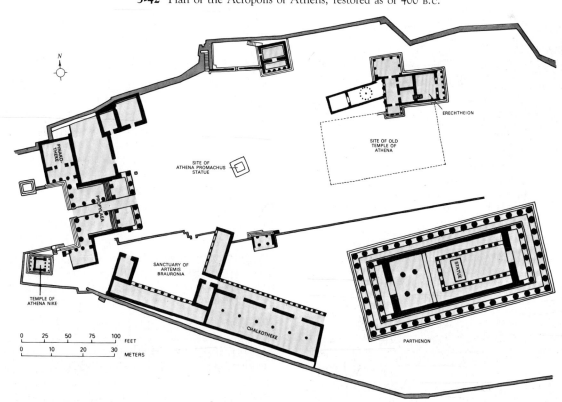

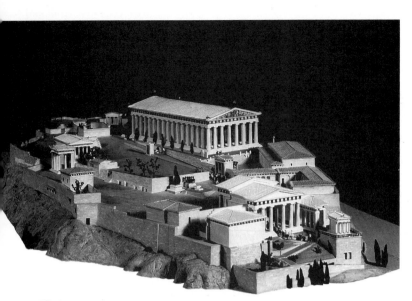

5-43 Restoration (model) of the Acropolis of Athens toward the end of the fifth century B.C.: the Parthenon (*upper center*), the Erechtheion (*left center*), and the Propylaia and the Temple of Athena Nike (*right foreground*). Royal Ontario Museum, Toronto.

recognized and celebrated in ancient times as it is today. Plutarch, writing some five hundred years after the rebuilding of the Acropolis, commented:

> Pericles' works are especially admired, as having been made quickly, to last long. For every particular piece of his work was immediately, even at that time when it was new, recognized as ancient, because of its beauty and elegance; and yet in its vigor and freshness it looks to this day as if it has just been done. There is a sort of bloom and newness upon those works of his, preserving them from the touch of time.

Architect Eric Mendelssohn (1887–1953) made almost the same observation when he first visited Athens. Expecting to be depressed by viewing the original source of that academic Classicism from which his generation was fighting to free itself, he found himself exclaiming that the Parthenon is "modern," meaning that good architecture is always good, and so, always "modern."

Time, vandalism, accident, and neglect had, by the nineteenth century, reduced the buildings of the Acropolis to a clutter of ruins. Modern archeologists have cleared away centuries of encumbering, later structures and accumulated rubble that obscured and defaced the original design and have restored the Periclean works to some broken semblance of their former splendor. Today, a uniquely modern blight threatens the buildings. The corrosive emissions of automobile exhaust are decomposing the ancient marbles; the smog-laden air of the modern traffic-clogged city is the solvent of ancient stone. Steps are now being taken to encase the buildings in materials that will resist further damage from corrosion. The

restoration and preservation of a priceless heritage has become a modern obligation and task.

THE PARTHENON

Of the Periclean buildings on the Acropolis, the Parthenon (the temple sacred to Athena Parthenos) was the first and the largest to be constructed (FIG. 5-44). Its architects were IKTINOS and KALLIKRATES, and its sculptures were produced under the direction of PHIDIAS, friend of Pericles and one of the great sculptors of all time. In plan (FIG. 5-42), the Parthenon is a peripteral temple, its short side slightly less than half the length of its long side. Its naos is subdivided into two parts: the larger contained the ivory and gold cult statue of Athena Parthenos, a figure some 40 feet in height, the work of Phidias; the smaller had been designed to serve as the treasury of the Delian League, but most of the revenues contributed by the Aegean members were expended on Pericles' ambitious building projects. The interiors of the two rooms are organized differently. The naos proper had two double rows of small columns for roof support; although long disputed, the purpose of the rows may have been to provide a second-story gallery from which visitors could view the statue, the foundation of which is still visible. The treasury had four single Ionic columns, one of several Ionic features in the otherwise Doric building, another being the continuous frieze of sculpture that runs around the top of the naos wall on the exterior. Except for these Ionic elements, the Parthenon epitomizes the Classical Doric temple, exhibiting that order at the peak of its refinement.

Seen today, the building is a partial restoration. Through the centuries, the Parthenon has undergone many transformations, having been both a Greek temple and a Christian church; after the Ottoman conquest of Greece, a Turkish mosque was built inside its naos. In 1687, the Turks used the naos as an ammunition dump while at war with the Venetians. A Venetian rocket scored a direct hit, and the resultant explosion blew out the center of the building. During the past century the colonnades have been reassembled, but the core of the structure remains a ruin.

Despite its dilapidated condition, the Parthenon is probably the most carefully surveyed and measured building in the world. This searching study has revealed that the builders aimed for unsurpassable excellence in every detail; the "refinements" of the structure have become almost a subtopic in the history of Greek architecture. If we are led to expect anything from the severe Doric order, it is that its lines must be rigidly and consistently straight and plumb; yet few straight structural lines are to be found in the Parthenon. The stylobate is convex, so subtly as to be

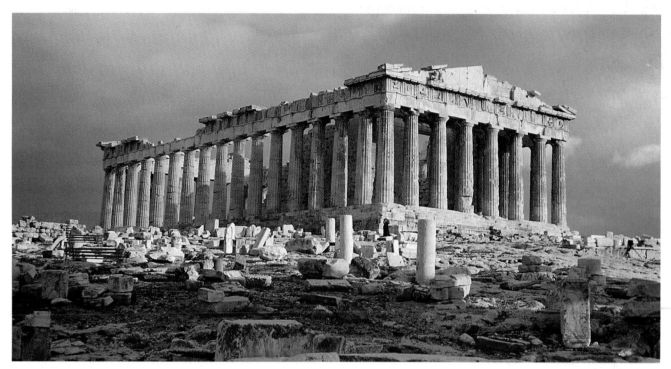

5-44 Iktinos and Kallikrates, the Parthenon, Acropolis, Athens, 448–432 B.C. (view from the northwest).

almost imperceptible as a curve; only if one sights along it from one end does the curvature, which is repeated in the entablature, become visible. The columns tilt slightly inward and are not uniformly spaced, standing closer to each other at the corners of the building. Moreover, not all the columns are of the same diameter; those at the corners have a somewhat greater girth than the rest. The entasis, which gives a kind of muscle-tense elasticity and buoyancy to the profile of the column, has the same subtlety seen in the curvature of the stylobate and the entablature.

These deviations from the mechanical, plumb-line, straight-edged norm are plainly intentional; most have been found in other temples. But interpretations of these refinements do not agree. Some feel that they are purely functional; the curvature of the stylobate, for example, may have been designed to facilitate drainage, or perhaps in anticipation of the settling of the central part of the building. Others believe that the deviations were intended to offset marginal distortions in the human visual field—optical illusions that might make columns with exactly vertical profiles look pinched and weak. Still other speculation is that the Greek instinct for completeness in the look of the building and for integrity with its surroundings required such refinements; the downward-tending curve of the stylobate would find its limit in the earth, for example, making a visually stable and strong base for the building's aspect. A reasonable conjecture would be that the builders intended the Parthenon to

be more than a product of engineering logic—that it was to be viewed and appreciated as a great work of sculpture, having the elasticity, resilience, and life of the human figure in statuary. Thus, the particulars would be designed to work in smooth relationship to each other and to the whole structure in an organic way in which, of course, the curved line predominates over the straight. The Parthenon columns especially display this principle in their entasis, appearing to respond to the burden they bear by the seeming swell of their compressed contours—expressing their function not mechanically, but organically.

Parts of the building were painted. This painting provided background against which sculpture could be seen clearly and, perhaps more important, delineated the upper parts of the building against the bright sky, so that the temple's basic proportions were shown crisply and could not be misread. Color also ensured that the visible parts of the building would be defined clearly and distinguished from one another.

The insistence on clarity in argument, which led the Greeks to invent *logic*, operates just as strongly in the "arguments" of their architectural design. Unfortunately, the *syllogism*, that early triumph of Greek thought, with its three propositions ending in a logically correct conclusion, cannot quite be matched in the Doric order. As examination of a corner of the Parthenon (FIG. **5-45**) will show, Greek architecture was not as "rational" as Greek logic. The Doric frieze

was organized according to three inflexible rules: (1) a triglyph must be exactly over the center of each column; (2) a triglyph must be over the center of each intercolumniation; and (3) triglyphs at the corners of the frieze must meet, so that no space is left over. But the architectural "syllogism" is faulty, for the conclusion cannot be harmonized with proposition (1): if the corner triglyphs must meet, then they cannot be placed over the center of the corner column. Although irremediable, this might seem to us a minor flaw, even in a building that aimed at perfection in all details. The Greeks wanted to be sure, and they worked out, in logic, a method for making series of statements conform to a rule for validity. But in Doric architecture, something was left over; something did not fit. To the Greeks, it must have appeared to be like one of the incommensurable "irrational" numbers (such as the square root of two)—a disturbing thing with no limit or definition. (According to a singular and significant Greek legend, the man who first revealed the mystery of the irrationals perished by shipwreck, "for the unspeakable and the formless must be left hidden forever!") In much the same manner as mathematicians and logicians faced with some disturbing contradiction in their results, the architects and artists who aimed at perfection must have found this problem of the corner triglyph a con-

5-45 Southeast corner of the Parthenon.

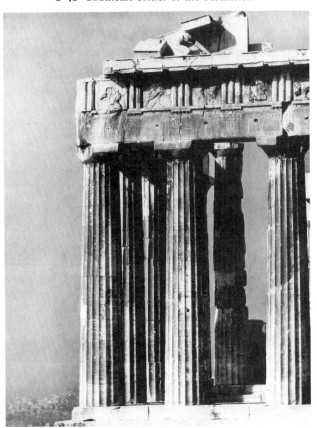

stant irritation and embarrassment. Indeed, it may have contributed to the eventual decline of the Doric order, which began in the fourth century B.C., and to the rise of the Ionic and Corinthian orders, the continuous friezes of which eliminate the problem.

As already noted, the main purpose of the Parthenon was to house the cult statue of Athena Parthenos. Because the image of Athena, for whom the city of Athens was named, was made of ivory and gold, it did not survive centuries of depredation, although it seems to have been in existence as late as the second century A.D. We know the look of it only from accounts by Pausanias and others and from a few small replicas that differ in detail. Plutarch, in his *Life of Pericles,* tells us that its artist, Phidias, probably the scapegoat in an anti-Pericles plot, was convicted of stealing some of the gold intended for the statue and died in prison (although we know from other sources and recent excavations that Phidias was working on a statue of Zeus at Olympia after he left Athens and that he died in exile).

Because work on the colossal cult statue for the naos of the Parthenon must have taken up most of Phidias' time, it is quite likely that he planned and designed the pedimental groups and friezes but left the carving of these architectural sculptures to his students and assistants. Nevertheless, they undoubtedly reflect his style, and they are among the most marvelous of all surviving Greek works of sculpture and among the supreme masterworks of all time. The sculptures of the pediments, the metopes, and the great frieze compose the most elaborate sculptural program in the history of Greek art. As in the cases of Aegina and Olympia, scholars still debate the arrangement of the pedimental statues. While they differ in their interpretations and reconstructions, they seem to agree that the east pedimental group depicted the birth of Athena, the tutelary goddess of Athens; the west group is conceded to depict her contest with Poseidon for possession of the city. The import is clear: the immortal glory of Athens is manifested in its divine genealogy and patronage.

Most of these sculptures are now in the British Museum in London, where they are known popularly as the "Elgin marbles." Between 1801 and 1803, while Greece was still under Turkish rule, Lord Elgin, the British ambassador to the Ottoman court at Constantinople, was permitted to dismantle some of the Parthenon sculptures and to ship the best-preserved ones to England. He eventually sold them to the British government at a great financial loss to himself. Although he was criticized severely for having "stolen" the treasures of Athens (the Greek government is attempting to retrieve them), Lord Elgin's quite civilized motives in saving the statues from almost certain ruin are no longer in doubt. During his

time, it was an unlikely prospect that the statues, surrounded by rubble and neglected for centuries, might one day be salvaged and protected against further damage and decay.

The figure of *Dionysos* (identified by some as *Herakles*) from the Parthenon (FIG. **5-46**) shows the final relaxation of all the limitations of Archaic figurative art. Phidias and his assistants are in full possession of the knowledge of the organic, coordinated human body and render it effortlessly and with entirely convincing consistency in all its parts. This fidelity to nature was a revelation, even in the nineteenth century, an age that was at the end of a long tradition of respect for nature in art. Artist Benjamin Robert Haydon, writing at that time, described his reaction to the reclining figure of *Dionysos (Herakles?)*, which he called Theseus:

> But when I turned to the Theseus, and saw that every form was altered by action or repose—when I saw that the two sides of his back varied, one side stretched from the shoulder blade being pulled forward, and the other being compressed from the shoulder blade being pushed close to the spine, as he rested on his elbow, with the belly flat because the bowels fell into the pelvis as he sat—when I saw in fact the most heroic style of art, combined with all the essential detail of actual life, the thing was done at once and forever. . . . Here were principles which the great Greeks in their finest time established.*

These principles seem indeed to be the monumental or heroic style "combined," as Haydon wrote, "with all the essential detail of actual life," the calm grandeur and simplicity of the one being in no way weakened by the precise, dynamic, anatomical logic of the other.

*In F. H. Taylor, *The Taste of Angels* (Boston: Little, Brown, 1948), p. 502.

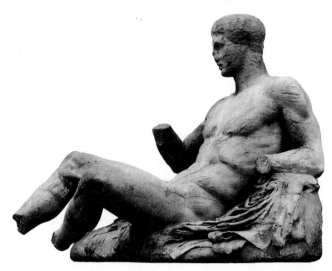

5-46 *Dionysos (Herakles?)*, from the east pediment of the Parthenon. Marble, over life size. British Museum, London.

The *Three Goddesses* from the east pediment of the Parthenon (FIG. **5-47**) shows even more than the *Dionysos (Herakles?)* the reinforcing and complementary actions of the principles of monumentality of scale and simplicity of pose with the "essential detail of actual life." The statues are typically Phidian in style, at once majestic and utterly "real" in the reading of the relaxed forms. In thin and heavy folds, the drapery alternately reveals and conceals the main and lesser masses of the bodies, at the same time swirling in a compositional tide that subtly unifies the group; the articulation and integration of the bodies produce a wonderful variation of surface and play of light and shade. Not only are the bodies fluidly related to each other, but they are related to the draperies as well, although the latter remain distinct from the bodies materially. The treatment of body and drapery as obviously different but in functional relationship to one another illustrates the thoroughly reasoned laws

5-47 *Three Goddesses*, from the east pediment of the Parthenon. Marble, over life size. British Museum, London.

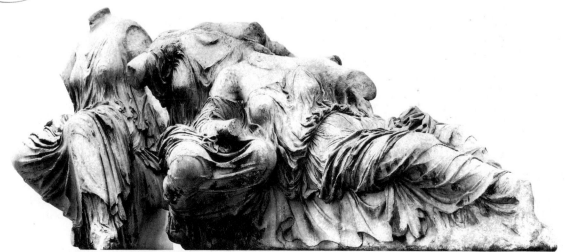

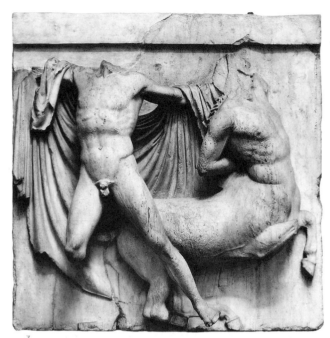

5-48 *Lapith and Centaur,* metope from the Parthenon. Marble, 56" high. British Museum, London.

of appearance that Phidias and his generation had come to know and respect.

In addition to the statuary of the pediments, sculptured metopes were set between the triglyphs in the outer face of the Doric colonnade (FIG. 5-45). Within the colonnade, at the top of the external naos wall, a continuous Ionic frieze ran around the four sides of the building, forming an unbroken band of bas-relief sculpture some 524 feet long. The metope sculptures provide an accent of movement, notably by the use of diagonal forms in successive compositions of pairs of struggling, interlocking figures in high relief—centaurs and Lapiths, gods and giants, Greeks and Amazons. The metope illustrated (FIG. 5-48) shows a battle between a Lapith and a centaur, the theme of the Apollo pediment at Olympia (FIG. 5-39). Although

5-49 *Horsemen,* from the west frieze of the Parthenon. Marble, approx. 43" high. British Museum, London.

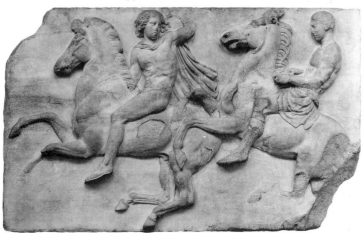

some of the metope designs are more successful than others, the figures generally are accommodated to the square spaces with great adroitness, and the whole series displays the ingenuity of the Phidian school in varying the poses and attitudes of the figures and avoiding the monotony that a regularly repeated space could impose. It is interesting also that the fortunes of the contestants are about equally balanced, the Greeks seeming to win or lose as often as their opponents.

The inner Ionic frieze of figures (FIGS. **5-49** and **5-50**) was seen from below in reflected light against a colored ground. It enriched the plain wall and directed attention toward the entrance to the temple. Though its subject is still a matter of scholarly dispute ("the riddle of the Parthenon frieze"), it probably represents the Panathenaic procession that took place every four years when the citizens of Athens gathered in the marketplace and carried the *peplos,* or robe, for the statue of Athena to the Parthenon. The robe was not for Phidias' ivory and gold statue, but for an older, Archaic one, kept, ultimately, in the Erechtheion of the Acropolis. This is the first known representation of a nonmythological subject in Greek temple reliefs.

The Panathenaic frieze is unique in the ancient world for its careful creation of the impression of the passage of time, albeit a brief fragment of time. The effect is achieved by the use of a sequence of figures posed to present a gradation of motion—a rudimentary picture of time as an acceleration or deceleration. In order to experience the illusion, the observer must also be in motion, following the frieze around the colonnade of the temple. In the part of the frieze that decorated the western side of the naos, the viewer can see the procession forming: youths are lacing their sandals and holding or mounting their horses; they are guided by marshals who stand at intervals, and particularly at the corners, to slow movement and guide the horsemen at the turn. In the friezes of the two long sides of the naos, the procession moves in parallel lines, a cavalcade of spirited youths, chariots, elders, jar carriers, and animals for sacrifice. Seen throughout the procession is that balance of the monumentally simple and the actual, of the tactile and the optical, of the "ideal" and the "real," of the permanent and the momentary that, again, is characteristically Greek and the perfect exemplification of the "inner concord of opposites" that Heraclitus, the philosopher, wrote of in the sixth century B.C. The eye follows the movement of light and shade in the drapery, pausing at any point by shifting focus to the broad areas of planes, with their sharply linear outlines. The movement of the procession becomes slower and more solemn as it nears the eastern side of the naos, when, after turning the corner, it ap-

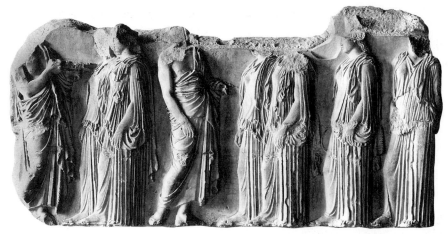

5-50 *Head of the Procession,* from the east frieze of the Parthenon. Marble, approx. 43″ high. Louvre, Paris.

proaches the seated divinities, who appear to be guests of Athena at her great festival. Standing figures—to note one device of the artists—face against the general movement at ever-closer intervals, slowing the forward motion of the procession (FIG. 5-50).

OTHER BUILDINGS OF THE ACROPOLIS

To reach the Parthenon, the Panathenaic procession would have wound its way from the lower level of the city of Athens, up the steep slope of the Acropolis, and through the gate called the Propylaia (FIGS. 5-42 and **5-51**), another structure of the Periclean project. Built by MNESIKLES between 437 and 432 B.C., the Propylaia was begun immediately following the completion of the Parthenon but was never finished, partly because of the financial drain of the Pelopon-

nesian War and partly, it is believed, because one of its wings would have trespassed on the sanctuary of Artemis Brauronia. The design is a monumental and subtle elaboration of a gate unit leading through a city wall, the gate hall itself being flanked by buildings containing a library and perhaps the first picture gallery (*pinakotheke*) in history. Here, members of the procession could rest in beautiful surroundings after the steep climb, before passing on to the sacred buildings on the summit. The Propylaia shows modifications of Doric regularity in the broadening of the space between the central columns to make the passageway wide enough for wheeled traffic, and (like the Parthenon) the gateway includes Ionic elements, such as the columns that line the corridor for the purpose of giving greater height where necessary to

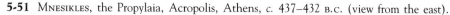

5-51 MNESIKLES, the Propylaia, Acropolis, Athens, c. 437–432 B.C. (view from the east).

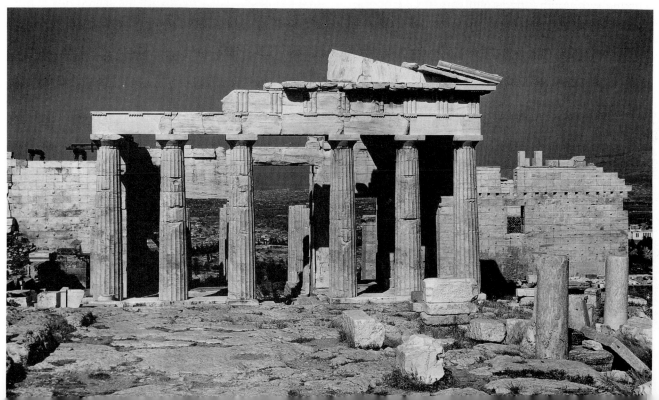

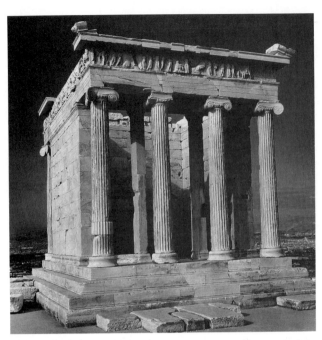

5-52 KALLIKRATES, the Temple of Athena Nike, Acropolis, Athens, 427–424 B.C. (view from the east).

support the central roof structure. Mnesikles innovated here in another respect. Greek buildings, whether religious or secular, ordinarily existed in isolation, self-sufficient and relatively independent of their surroundings. Here, for the first time, buildings of different types and functions (propylon and halls) were combined into an axially aligned grouping that looks ahead to later Hellenistic designs and the axial compositions of the Roman Imperial forums (FIG. 6-45).

The beautiful, little Ionic Temple of Athena Nike, built under the direction of Kallikrates between 427 and 424 B.C. (FIGS. 5-20c, 5-42, and **5-52**), is the earliest completely Ionic building extant on the Acropolis. Before this time, the Ionic order had been employed

in the construction of a whole building only in the cases of a few treasuries at Olympia and Delphi on the Greek mainland (for example, the Treasury of the Siphnians, FIG. 5-28), and these buildings had been constructed by Aegean islanders, not by Greeks of the mainland. It was through Athens' rule of the islands that the city became open to eastern Greek and Ionian influences. The little amphiprostyle Ionic temple stands on what used to be a Mycenaean bastion near the Propylaia. The slender, exquisite proportions of the temple offer a striking contrast to the Doric severity of the gate unit, heightening the effects of both.

Another Ionic building situated on the Acropolis is the Erechtheion (FIGS. 5-42, **5-53**, and **5-54**), the last of the Periclean program. Constructed between 421 and 405 B.C., the Erechtheion is most unusual in plan and quite unlike any other Greek temple. It was named after a mythical Athenian hero, Erechtheus, to whom, in part, it was dedicated. Its many unusual features are due partly to the irregularity of its site and partly to the number of shrines included within it. According to Pausanias, the Greek geographer and historian of the second century A.D., the Erechtheion stood on the traditional site of the contest between Poseidon and Athena for dominion over Athens, the theme of the sculpture group in the west pediment of the Parthenon. Also located at the site were a rock supposed to be positioned at the imprint of Poseidon's trident, the spring of saltwater that the stroke of the trident produced, Athena's olive tree, and the tomb of the legendary King Kekrops, who judged the Athena-Poseidon contest. The asymmetrical plan of the building resulted from the need to bring these traditionally revered sites together and from the fact that pious reluctance to disturb the sacred places precluded terracing of the uneven ground. Hence, this

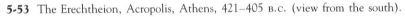

5-53 The Erechtheion, Acropolis, Athens, 421–405 B.C. (view from the south).

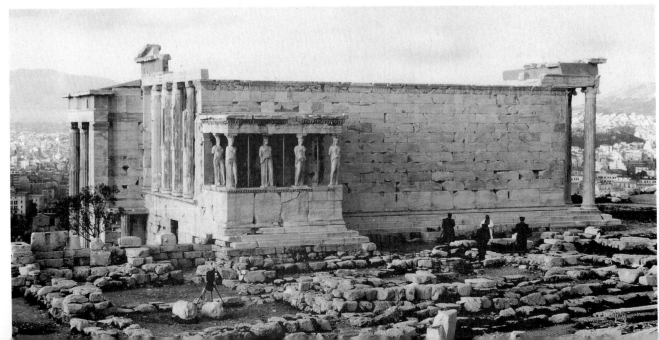

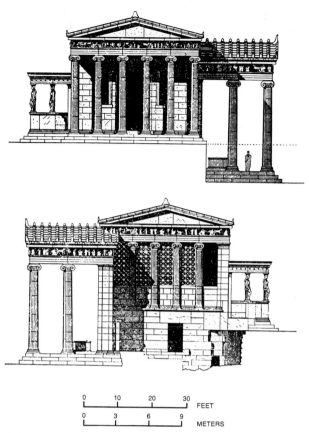

5-54 Reconstructed elevations of the east and west façades of the Erechtheion, Acropolis, Athens.

5-55 Porch of the Maidens, the Erechtheion.

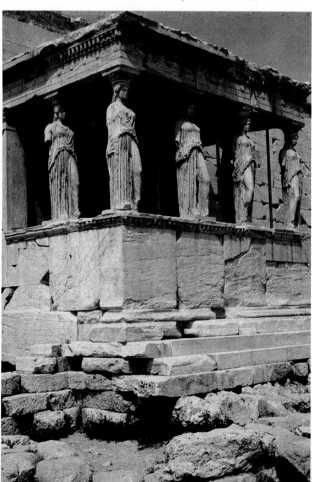

unique building stands on several levels, with different porches projecting from three sides and an unusual screen wall closing off the fourth. The irregularity of the structure, a feature so uncommon in Greek architecture, was formerly explained as the result of a kind of hurried, *ad hoc* completion necessitated by political and financial problems brought on by the duress of the Peloponnesian War; we now believe that the Erechtheion was finished according to plan and that the architect adjusted the design with great ingenuity to the difficult demands of ritual and site. In no way an esthetic failure, the asymmetrical form of the structure offers an effective counterpoint to the symmetrical unity of the nearby Parthenon; the graceful caryatids of the Porch of the Maidens (FIG. 5-55) strikingly complement the severity of the Parthenon's Doric columns, and the building's carved details are among the most refined and subtle in all of Greek art. The Erechtheion beautifully balances its larger neighbor, the Parthenon, setting Ionic complexity and elaboration against Doric simplicity and monumentality, repeating on a major scale the juxtaposition of the Propylaia and the Nike temple at the entrance of the *temenos* (sacred precinct).

Sculpture

The Porch of the Maidens, the south porch of the Erechtheion, takes its name from the caryatids that are its dominating feature (FIG. 5-55). It brings to mind that earlier Ionic caryatid design, the Treasury of the Siphnians (FIG. 5-28), and comparison of the two is useful. Unlike the Siphnian caryatids, those of the south porch of the Erechtheion do not carry a full entablature; they support instead one that consists of architrave and cornice only, the topmost *fascia* (flat, horizontal band) that makes up the architrave being decorated with medallions to simulate the missing frieze. This arrangement seems to be a deliberate, proportional adjustment undertaken by the sculptors of the Erechtheion figures to avoid the effect seen in the Siphnian caryatids, which look overloaded by the entablature; the sculptors must have been aware that figures graceful in attitude and dimension could scarcely harmonize with a massive architectural superstructure they would be presumed to be supporting. Technical and esthetic reasons may be given for the Erechtheion adjustment. Although the weight of a full entablature was borne by the Siphnian caryatids, in this case the load could have been too great for the necks of the figures, their weakest point; however, esthetic considerations were probably the more persuasive. Thus, again, we find the Classical architect-sculptor balancing the realities of structure with the necessities of ideal beauty. The figures have enough rigidity to suggest the structural column and

just the degree of flexibility necessary to suggest the living body. The compromise is superbly executed. The corner figures determine the stance by representing the weight as falling on the outer leg. The inner figures repeat this pose, so that the legs not carrying the weight, and bent at the knee, do not determine the architectural verticals or disturb their natural plumb-line straightness. These figures have all the monumental majesty of the Phidian figures on the Parthenon pediments; the pleats and folds of their draperies reveal the quiet power of their bodies, and the very obligation imposed on them by the architecture serves only to strengthen their noble poise.

The Phidian style dominated Athenian sculpture until the end of the fifth century B.C. Due to the Peloponnesian War, fewer large-scale sculptural enterprises were launched, although the style lingered on in smaller works, such as the popular grave stelae produced in considerable numbers for both local use and export. One of the most harmoniously designed of these is the *Grave Stele of Hegeso* (FIG. **5-56**), which was found in the Dipylon cemetery. As is often the case in grave reliefs of the Classical period, the figures are placed in an architectural framework. The

5-57 *Nike Fastening Her Sandal,* from the parapet of the Temple of Athena Nike, Acropolis, Athens, *c.* 410 B.C. Marble, approx. 42" high. Acropolis Museum, Athens.

deceased is seated on a chair with sweepingly curved back and legs that provide an effective transition from the frozen forms of the architecture to the organic forms of the figures. Hegeso is contemplating a necklace (originally rendered in paint) that she has taken from the box held by her girl servant. The quiet glances of mistress and servant are directed at Hegeso's right hand, which, placed exactly in the center of the panel, is the compositional focal point. Although the stele was carved toward the end of the fifth century B.C., it is devoid of the sentimentality found in many other works of its day; the solemn pathos of the scene links the stele with the grandiose conception of the Parthenon sculptures.

The relief of *Nike Fastening Her Sandal* (FIG. **5-57**), from a parapet constructed around the Temple of Athena Nike about 410 B.C., shows how sculptors, having achieved the Classical perfection of the human form, now exhibited their virtuosity. The function of the concentrically arranged draperies, heavy and clinging to the form as if drenched with water, is to reveal the supple beauty of the young body. The interplay of the intricately moving drapery and the smooth volumes of the body seen in the *Three Goddesses* of the Parthenon (FIG. 5-47) is here refined to make a deliberately transparent veil for the female

5-56 *Grave Stele of Hegeso,* from the Dipylon cemetery, *c.* 410–400 B.C. Marble, 59" high. National Archeological Museum, Athens.

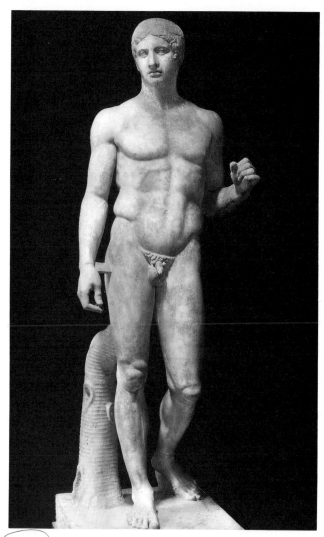

5-58 Polykleitos, *Doryphoros*. Roman marble copy after a bronze original of c. 450–440 B.C. 6' 6" high. Museo Nazionale, Naples.

Empire, marble statues were used to make lime for mortar. After the Romans conquered Greece in the second century B.C., they took Greek works of art to Rome to adorn the imperial palaces and the villas of the rich. Numerous copies were made of some statues, reflecting their popularity and fame. Many of the copyists took liberties with the originals; changes were made to conform with popular taste, and very few of the copies even approach the quality and refinement that the originals must have had. When the Romans were copying bronze in marble, they used awkward devices, such as a tree trunk placed next to a statue's leg or braces and struts attached to the arms (as can be seen in the *Doryphoros*), to strengthen weak points. Nevertheless, the copy of the *Doryphoros* does provide evidence of the appearance of the original, and we can compare its blocky solidity and strength with the subtle grace of the Phidian style. Although the unity and equilibrium that pervade the works of Phidias also are apparent in the Polykleitan statue, the origins differ; the artists at work on the Parthenon seem to have achieved their results with a deft, spontaneous translation of natural appearances, but Polykleitos worked according to a canon of proportions in which he formulated the principles that gave rise to unity. Although Polykleitos' own treatise enunciating his canon has been lost, a physician, Galen, who lived during the second century A.D., interpreted it as follows in his *Placita Hippocratis et Platonis*:

> [beauty consists] in the proportions, not of the elements, but of the parts, that is to say, of finger to finger, and of all the fingers to the palm and the wrist, and of these to the forearm, and of the forearm to the upper arm, and of all the other parts to each other, as they are set forth in the Canon of Polykleitos.

It has been said that in the *Doryphoros* Polykleitos had made not simply a statue but had manifested sculpture itself, and Aristotle used "sculptor" and "Polykleitos" interchangeably. The Greeks saw proportion as the central problem in architecture and in sculpture, and they viewed Polykleitos' canon as the embodiment of proportional rationality for sculpture.

Movement, which began to be expressed successfully in the early fifth century B.C., is disciplined in the *Doryphoros* through the use of an imposed system of proportions. The mighty body, with its broad shoulders, thick torso, and muscular limbs, strikes us as the embodiment of the Spartan ideal of the warrior physique, the human equivalent of the Doric order. And, like the Doric order, the figure appeals to the intellect and must be studied carefully for a long period before it reveals itself fully to the observer. The slow forward walk, the standard Polykleitan pose,

figure, which now emerges fully from the elaborate costume of the kore tradition.

In contrast with the Ionian sumptuousness of the Phidian style is a work of the Argive school of southern Greece, the *Doryphoros* (FIG. **5-58**) of Polykleitos, a sculptor whose fame rivaled that of Phidias in the ancient world. The work shown here, the original of which is dated 450–440 B.C., is a Roman copy made much later.

Almost all extant works of the so-called Great Masters of Greek sculpture are replicas, the originals having disappeared. Originals of Roman copies can be identified through descriptions by ancient authors, especially Pausanias and Pliny the Elder, and occasionally through representations on ancient coins. A number of factors account for the disappearance of the originals. In war, statues made of precious materials were often pillaged, and bronze statues were melted to make weapons or utensils; during the barbarian invasions, in the time of the fall of the Roman

stresses the principle of weight shift, the maneuver that must be made before we can move at all and with which the whole development of the representation of the moving human figure begins. What appears to be a casually natural pose is, in fact, the result of an extremely complex and subtle organization of the various parts of the figure. Note, for instance, how the function of the supporting leg is echoed by the straight-hanging arm to provide the right side of the figure with the columnar stability needed to anchor the dynamically flexed limbs of the left side. If read anatomically, on the other hand, the tensed and relaxed limbs may be seen to oppose each other diagonally (that is, the right arm and the left leg are relaxed, and the tensed supporting leg is opposed by the flexed left arm, which held a spear). Thus, all parts of the figure have been carefully composed to achieve the utmost variety within a compact and stable whole. A most circumspect and subtle artist has combined realism, monumentality, and diversity in a unified design that seems to be beyond the cavil of even the most discriminating critic.

Painting

Of Greek wall (mural) painting, little remains. Most of our knowledge of what it looked like must be drawn from vase painting and from the later Roman painting derived from it. We do have a specimen of Greek mural painting, however, that dates from the early fifth century B.C. On a wall of the so-called Tomb of the Diver at Paestum in southern Italy (the site of the well-preserved Doric temples examined earlier in FIGS. 5-22, 5-23, and 5-25), a banquet or sym-

posium (Greek: *sympósion,* a drinking party) is represented. This subject appears often on Greek vase painting. In the detail of the fresco shown here (FIG. **5-59**), reclining guests at the left play a game that originated in Sicily and was widely popular throughout Greece. One individual holds out his wine cup, while another attempts to flick the remainder of his wine into it. A third guest looks over with curious interest at the affectionate pair to the right. The figures are silhouetted as dark shapes against a flat, light ground. Modeling is not used; details of facial and bodily features are indicated by line. The composition is friezelike, as in sculpture, all of the heads at one level. Each figure is sharply delineated in profile, with only sparing detail. Enough information is given to present the amusing situation clearly, and though the actions of each of the figures are discerned easily by pose and gesture, they are all bound into a group by the rhythmically curving directional lines of the carefully planned design.

We know from ancient accounts that great painters lived and worked in all periods of Greek art. The mural painter POLYGNOTOS enjoyed almost as much fame in antiquity as his contemporaries, Phidias and Polykleitos. Unfortunately, none of his works survive. On the basis of ancient literary sources, it is believed that his compositional style is reflected in the vase decoration of the NIOBID PAINTER, whose *Argonaut Krater* (FIG. **5-60**) illustrates a radical break with the traditional decorative style. For over two centuries, figures had been arranged *isocephalically* (with all the heads at one level) in horizontal bands, not only in Greek vase decoration but also in monumental painting. Evidence to support an isocephalic arrange-

5-59 "Banquet scene," from the Tomb of the Diver, Paestum, Italy, 480–470 B.C. Fresco. Museo Archeologico Nazionale, Paestum.

5-60 Niobid Painter, *Argonaut Krater*, from Orvieto, *c.* 455–450 B.C. Outline drawing at right indicates relation to whole vessel. Portion shown approx. 15″ high, whole vessel approx. 21″ high. Louvre, Paris.

ment in Greek monumental painting seems to be provided by surviving Etruscan frescoes, which presumably reflect contemporary, or slightly earlier, Greek mural styles (see Chapter 6). On the *Argonaut Krater*, the figures have been placed on different levels, and the ground lines on which they stand or recline attempt to introduce into painting the illusion of depth, an effect that is thwarted here by the uniform size of the figures. Ancient reports state that Polygnotos modeled his figures in dark and light, aiming for three-dimensional and sculptural effects. This last feature was not adopted by the Niobid Painter, whose style remains linear and does not reveal what must have been an impressive statuesque quality of Polygnotan figures. The Niobid Painter's works are important as dim reflections of the monumental manner of Polygnotos, but they also represent the decline of vase painting; as the figurative decoration loses contact with the body of the vessel, the earlier cohesion of figure and surface becomes mere adhesion.

Although the work of the Niobid Painter may provide us with some idea of the general compositional schemes of Polygnotos, it tells nothing of his use of color. A pale reflection of his color usage may be found in the so-called *white-ground* vases of the fifth century B.C. Experiments with the white-ground technique date back to the Andokides Painter, but the method became popular only toward the middle of the fifth century B.C. The white-ground technique is essentially a variation of the red-figure technique; the pot was first covered with a slip of very fine white clay that, when burnished, provided a glossy or *matte*

white surface on which to draw in black glaze or dilute brown wash. The range of colors remained limited to purple, brown, and several kinds of red; few colors known to the Greeks could survive the heat of the kiln. Another shortcoming was the fact that the white slip, although highly effective as background for drawing and coloring, was not durable and tended to flake off. This impermanence was crucial for wares that saw daily use, such as cups and kraters, but was less important in vessels that had a more limited use, such as funerary *lekythoi* (oil flasks), which were not handled after they had been deposited in the tomb. After mid-century, the white-ground technique was reserved almost exclusively for funerary vases of this type, some of which were even painted in full polychrome *after* the vase had been fired (and at an even greater cost in durability).

The krater by the Phiale Painter, illustrated in fig. **5-61**, shows Hermes handing the infant Dionysos to Papposilenos ("granddad-satyr"). The other figures represent the nymphs in the shady glens of Nysa, where Zeus had sent Dionysos, one of his numerous natural sons, to be raised, safe from the possible wrath of his wife, Hera. The artist has used the conservative colors that could withstand firing— reds, brown, purple, and a special snowy white. The white was used for the flesh of the nymphs and for such details as the hair, beard, and shaggy body of Papposilenos. Despite this rather limited color scheme, the painting's effect is warm and rich; in

5-61 Phiale Painter, *Hermes Bringing the Infant Dionysos to Papposilenos* (krater), from Vulci, *c.* 440–435 B.C. Approx. 14″ high. Vatican Museums, Rome.

mbination with the compositional devices of the
obid Painter, it may provide a shadowy idea of the
appearance of the famed Polygnotan murals, which
so impressed ancient viewers.

The grandeur of the age of Phidias and Polykleitos,
when their styles briefly dominated Greek art, passed
with them. What followed, although exquisite and
virtuoso, constituted a descent from the heights, as
Greek art became more elegant, slight, naturalistic,
and less concerned with lofty themes and majestic
forms. The statues of "godlike" men became statues
of men of this world.

THE LATE CLASSICAL PERIOD: 430–323 B.C.

The Peloponnesian War, which began in 431 B.C.,
ended in 404 B.C. with the complete defeat of Athens
and left Greece drained of its strength. Sparta and
then Thebes took the leadership of Greece, both un-
successfully. In the latter half of the fourth century
B.C., the Greek states lost their liberty to Philip of
Macedon. Athens lost its precedence, and the whole
structure of life changed; the traditional balance be-
tween the city-state and the individual was lost. The
serene idealism of the fifth century, born of a simple,
robust concept of mind and matter, of man and the
state, gave way to chronic civil wars, social and politi-
cal unrest, skepticism, and cynicism.

The Apollonian command, "Know thyself," which
Socrates had taught the people as he spoke with them
in their daily gathering places, inevitably changed the
Greek point of view to a more individualistic one.
Euripides, too, seems to have regarded the individual
as paramount, and his dramas depict a whole spec-
trum of human passions and crises. Aristophanes,
however, ridiculed both Socrates and Euripides for
their apparent departures from the good old classical
ways and customs, and especially for their emphasis
on the role and value of the individual. During the
fourth century B.C., intellectual independence was
firmly established by Plato (however much he himself
regretted the passing of the old ways), whose doc-
trine of such eternal forms as "virtue," "justice," and
"courage" served as the rational model on which the
individual could construct his life. Aristotle, perhaps
the most versatile of all thinkers, formulated the op-
erations of reason in the science we call "logic," con-
verting reason into an instrument applicable to all
human discourse. Aristotle turned his attention sys-
tematically to just about everything that could be of
interest to the questing intellect, and among his fun-
damental contributions is the outline of the sciences
of nature.

Thus, gradually separating themselves from the
old assurances—the gods, their oracles, and time-
honored custom—as prime interpreters of the mean-
ing of life, the Greeks carried on their search to know
themselves and to achieve knowledge of the world
and life through observant experience. Their depend-
ence on the city-state lessened, until they boasted
with Diogenes of being citizens "of the world."
Knowing the real, for whatever purpose, became the
conspicuously Greek faculty and value. In the midst
of political disaster, Greece, in the fourth century,
enacted a daring drama of human discovery.

Sculpture

The humanizing tendency that had been gathering
force throughout the fifth century B.C. achieved char-
acteristic expression in the sculpture of the fourth
century B.C.; themes lost something of the earlier,
solemn grandeur and representations of the greater
gods gave way to those of lesser gods. At the same
time, the naturalistic view of the human figure be-
came fully focused.

Hermes and Dionysos (FIG. 5-62), once attributed to
PRAXITELES himself, is a work of such high quality that
it may be taken as a later superb example of that

5-62 Once attributed to PRAXITELES, *Hermes and Dionysos*,
from Olympia, *c.* 340 B.C. (?). Marble, approx. 7' high.
Archeological Museum, Olympia.

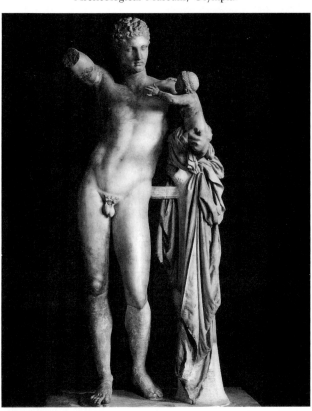

sculptor's style. (Some scholars would even date it as late as the second century B.C., long after Praxiteles' time.) The god is represented standing, <u>with a shift in weight from the left arm</u> (supporting the upper body) <u>to the right leg,</u> so that the double distribution of the weight gives the pose, with its fluid axis, the form of a sinuous, shallow <u>S-curve</u> that becomes a manner with Praxiteles. On his arm, <u>Hermes holds the infant Dionysos, who reaches for something</u> (probably a bunch of grapes) that Hermes held in his right hand. Hermes is looking off into space with a dreamy expression, half smiling. The whole figure, particularly the head, seems <u>in deep reverie</u>, the god withdrawn in self-admiration. The modeling is deliberately <u>smooth and subtle</u>, producing soft shadows that follow the planes as they flow almost imperceptibly one into another. <u>The delicacy of the features is enhanced</u> by the rough, impressionistic way in which the hair is indicated, and the deep folds of the realistic drapery are sharply contrasted with the flow and gloss of the languidly graceful figure. We need but a comparative glance at Polykleitos' *Doryphoros* (FIG. 5-58) to see how broad a change in artistic attitude and intent took place from the mid-fifth to the mid-fourth century. Majestic strength and rationalizing design are replaced by sensuous languor and <u>an order of beauty</u> that appeals <u>more to the eye than to the mind.</u>

<u>Praxiteles'</u> esthetic of the human nude, slenderer in its proportions, with its emphasis on the exquisitely smooth modeling that reproduces the tones of resilient flesh, naturally led him to <u>popularize the nude female statue.</u> His *Aphrodite of Cnidos* was regarded widely in antiquity as the <u>most beautiful of all statues</u> and was the <u>pride of Cnidos</u>, the city that owned it. Its presumed fidelity to natural appearance, a quality much prized by its ancient admirers, is reflected in an old story. The goddess Aphrodite herself, viewing the statue, cried out, "Oh! ye Gods! where could Praxiteles have seen me naked?" The charm of the work can be understood, not from the inferior Roman copy of it, but from a much later, Hellenistic work, the *Aphrodite of Cyrene* (FIG. **5-63**), which, two centuries removed, conveys a Praxitelean poetry of sensual beauty. For both the male and female nude, Praxiteles set a new, more personal and naturalistic ideal of physical beauty.

Although his style was greatly admired and his theme of the bathing Aphrodite was represented again and again long after his time, Praxiteles was not the only influential sculptor of the Late Classical period. A fellow Athenian, <u>SCOPAS</u>, is known for a <u>robust and vigorous style</u> more suited to the representation of action and perhaps derived from Polykleitos. A head fragment from Tegea in Greece (FIG. **5-64**) illustrates Scopas' style and shows a hitherto

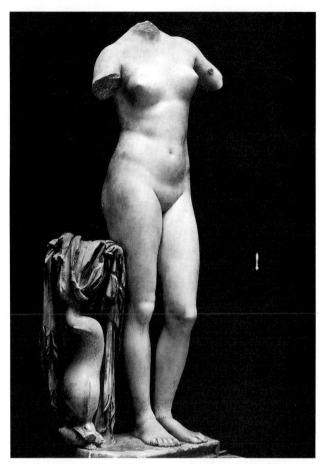

5-63 *Aphrodite of Cyrene*, from North Africa, *c.* 100 B.C. (). Marble, approx. 56" high. Museo Nazionale Romano, Rome.

5-64 Attributed to SCOPAS, *Warrior's Head*, from the Temple of Athena Alea at Tegea, Greece, *c.* 350 B.C. Marble, approx. 11¾" high. National Archeological Museum, Athens.

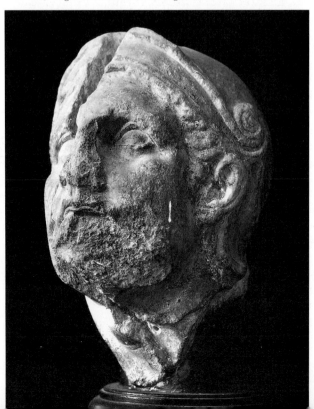

undepicted tension of facial expression. The features are broad and strong, the eyes large, round, and set deeply under knitted brows. As a reflection of inner states through varied facial expressions, this work breaks with the Classical tradition of benign, serene features and prefigures later Hellenistic art, when the depiction of emotion became more important to sculpture.

The monumental Tomb of Mausolus, another of the seven wonders of the ancient world, was built for King Mausolus and his queen, Artemisia. Mausolus was king of Caria, a non-Greek state in southwest Asia Minor, and was in the service of the king of Persia. The colossal portrait-statue of the king (FIG. 5-65) and another of his queen, which is not shown here, date from about 355 B.C. Presumably, they are intended to be likenesses; the sculptor, who is unknown, is particular about the hair and the dynamics of the drapery. He continues that study of the drapery masses begun in the previous century and is at pains to read them so closely and realistically that

folds and pleats are differentiated from the minute creases thin drapery would acquire in use. The colossal tomb monument and the large figures reflect an Eastern influence, and already we sense that mingling of East and West that is to compose the Hellenistic styles of the last centuries before Christ.

The most renowned sculptor of the second half of the fourth century B.C. was LYSIPPOS, court sculptor to Alexander the Great. Although Lysippos was very prolific, his work is extant in copies only, including, notably, the *Apoxyomenos* (FIG. 5-66), which represents a young athlete scraping oil and mud from his body before taking his bath. The figure embodies two important innovations of the time, which may be credited to Lysippos. One was a new canon of proportions, replacing the Polykleitan canon and reflecting a change in taste noticeable in all the arts. The new canon required a more slender, supple, and tall figure, a conception toward which we have already seen Praxiteles moving. This innovation may indeed have been influenced by the second (also foreshad-

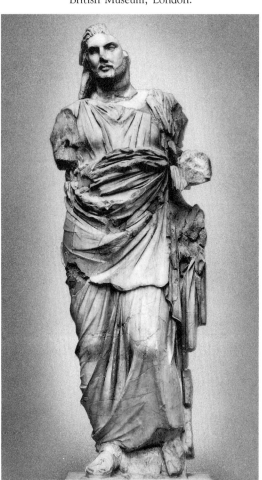

5-65 *Mausolus,* from the mausoleum at Halicarnassus (modern Bodrum, Turkey), *c.* 355 B.C. Marble, approx. 9′ 10″ high. British Museum, London.

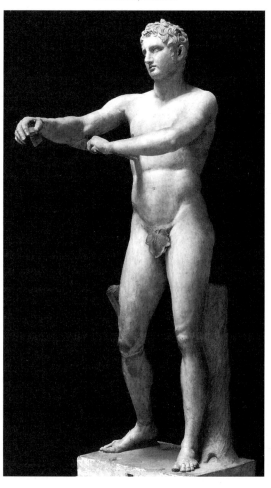

5-66 LYSIPPOS, *Apoxyomenos.* Roman marble copy after a bronze original of *c.* 330 B.C., approx. 6′ 9″ high. Vatican Museums, Rome.

owed in earlier works)—the full realization of the figure as if moving in space, not in the two dimensions of the figures hitherto examined (whether Phidian, Polykleitan, or Praxitelean), but in *three* dimensions. Thus, the figure now seems to move in a kind of free spiral through the space around it; it is made to be seen from a variety of angles and is related to things in its environment other than itself. The earliest Greek figures had been shown in a stiff frontal position, with the planes closely related to the stone block from which they had been carved; they were best seen from only one or two positions. Even when the figure was treated less rigidly, so that the torso as well as the arms and legs moved in a curve, it was still seen satisfactorily only from one or two points of view. In this respect, the Archaic kouros (FIG. 5-16) and the *Hermes and Dionysos* of Praxiteles (FIG. 5-62) are more nearly alike than are the *Hermes* and the *Apoxyomenos* of Lysippos. In the last, the arms curve forward, the figure enclosing space in its reach and twisting in it; the small head is thrown into stronger perspective by the large hand interposed between it and the viewer. Lysippos said that he wished to make men the way the eye sees them, allowing for accidents of perspective.

A bronze figure of a youth (FIG. **5-67**), recovered from the Adriatic Sea near Fano, so clearly expresses the Lysippic intention to show the human body in natural movement through space, that, given its recognizably Lysippic traits, some scholars believe it may be an original from that sculptor's own hand. The tall, slender, elegant young man, whose proportions are certainly Lysippic and whose individualized physique is more that of a runner than a wrestler, appears to be gliding past the observer. His gesture, it has been suggested, is that of an athlete at the games, placing on his head the wreath of victory. The facial features are like those we find in the Roman copies of the statues of Lysippos that record his style, and the naturalness of physique and pose in this masterful work clearly shows the artist's wish to render an image of nature given momentarily to the eye.

Although Lysippos' art tends toward the visually real, something of the older Polykleitan ideal persists in the sculpture of the fourth century, suppressing some features of the real in the interest of ideal form. Indeed, at this time, two stylistic tendencies, *idealizing* and *naturalizing*, prevailed—sometimes moving separately, sometimes merging. In the *Antikythera Youth* (FIG. **5-68**), we find them merging. The head is Polykleitan, as are the massive physique and the forward-walking stance; the unengaged left arm and hand resemble, in attitude and flexure, the right arm and hand of the *Doryphoros* (FIG. 5-58). But in the free

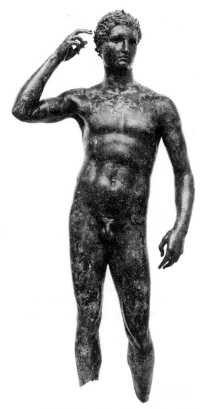

5-67 LYSIPPOS (?), *Athlete (The Getty Bronze)*, late fourth century B.C. Bronze, 6′ high. J. Paul Getty Museum, Malibu, California.

5-68 *Antikythera Youth*, late fourth century B.C., found in the sea off Antikythera, Greece. Bronze, 6′ 4½″ high. National Archeological Museum, Athens.

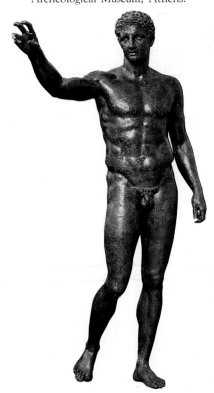

sweep of the far-extended right arm and in the slenderer proportions and flowing outline, we sense the influence of Lysippic style. The gesture the youth makes suggests a subject; he is not simply an athlete throwing a ball, but perhaps a Perseus holding up the severed head of Medusa, or a Herakles reaching for the golden apple he has sought in the Garden of the He perides. The meaning of the statue is uncertain, but its exquisite refinement of form and its technical perfection make this one of the finest examples of the Greek art of representing the human figure in bronze.

As Praxiteles prepared the way for developing optical realism in his subtle surface effects, so Scopas and Lysippos foreshadowed Hellenistic themes, demanding force, action, and dramatic emotion. Before the new drama could develop in sculpture, however, space had to be understood in a new way—not merely as the limit of the body, but as an environment in which the body could act freely, as in nature.

Architecture

It is noteworthy that, in its full development of the Corinthian order, the architecture of the fourth century also produced a "body" that offered a complete aspect from any angle. The first Corinthian capital (remember that the order differs from the Ionic only in its capital) appeared on the inside of the naos of the Temple of Apollo at Bassae, in the second half of the fifth century B.C. It crowned a column that, because it stood as a divider between two parts of the naos, could be seen from all sides. Presumably designed for this purpose, the Corinthian capital provided a much more satisfactory solution than the Ionic capital, which was designed to be seen effectively from two sides only. When Ionic colonnades were required to turn corners, as on peripteral structures, special "corner capitals" had to be designed that looked the same on the two sides that faced outward. The sharply projecting edge formed by the two meeting volutes never quite satisfied Classical architects, who also may have felt that this solution was achieved only at the expense of the structural logic of the Ionic capital and by a distortion of its functional parts. The problem was solved by the Corinthian capital, which can be seen to equal advantage from all sides.

The original design of the capital has been associated with the relief sculptor and metalworker Callimachos, who may have been at Bassae when the Temple of Apollo was built. The sentimental story was told of Callimachos in antiquity that he was inspired to design the capital when he saw acanthus leaves—which decorate the Corinthian capital—growing up around a slab-weighted votive basket on the grave of a maiden. Be that as it may, although the

5-69 Corinthian capital from the tholos at Epidauros, c. 350 B.C. Museum, Epidauros.

Corinthian order appeared in the fifth century B.C., it was used only on the inside of Greek temples for almost a century. Whether this interior use is to be attributed to religious conservatism, which would tend to preserve a feature that had taken on a certain sanctity from its function at the temple's center, or whether Ionic experiments were continuing and a Doric tradition persisting is uncertain. In any event, full emergence of the Corinthian order on a public exterior takes place about the same time as Lysippos' freeing of the sculptured figure from its two-aspect limits.

A mid-fourth century capital from Epidauros (FIG. **5-69**) illustrates a step along the elaborative route of the Corinthian order, which culminates in the characteristic Hellenistic and Roman luxuriance. Here, the bell of the capital is clothed with carved acanthus leaves and manifests that same increasing attention to the deep and detailed sculpturing of stone surfaces noted in sculptured figures.

The Monument of Lysikrates (FIG. **5-70**), constructed in Athens in 334 B.C., shows the first known use of the Corinthian order on the outside of a building. Significantly, the innovation appears not on a religious but on a commemorative monument. The graceful cylinder to which the Corinthian columns are engaged memorializes the victory of a choric group, patronized by Lysikrates, which had won the prized trophy of the tripod in the wild, dithyrambic

5-70 The Monument of Lysikrates, Athens, 334 B.C.

contest of song in honor of Dionysos. The little tholos serves as a base for the monumentalized tripod. Henceforth, the Corinthian order was used more and more on the exterior of public buildings, enjoying particular favor among Roman builders. In addition to having solved the vexing problems of the Doric and Ionic orders (the corner-triglyph and the corner-volute dilemmas), the Corinthian order, with its ornateness, was bound to suit the developing taste for sumptuous elaboration of form and realistic representation that guided artistic effort in the Hellenistic world.

The capital from Epidauros predates the Monument of Lysikrates by some fifteen years and, significantly, was designed for the interior colonnade of a Doric round temple, or *tholos*. The temple was part of an extensive building program that converted the town of Epidauros into one of the greatest spas of the ancient world. The influx of ever more visitors to the sanctuary of Asklepios, the god of healing, required the construction of ancillary buildings to provide not only for the spiritual and physical health of the numerous patients, but also for their accommodation and entertainment. One of the chief architects at the site was Polykleitos the Younger, who, in addition to the tholos, also designed a theater that Pausanias declared was the finest in Greece.

Almost all major Greek towns had a theater. The precursor of the formal Greek theater was a place

where ancient rites, songs, and dances were performed. This circular piece of earth with a hard and level surface later became the *orchestra* of the theater. The rituals were a spectacle and Greek architects provided a convenient place (a *theatron* or "place for seeing") from which nonparticipants could watch. The most practical location was a slope rising above the orchestra; such siting, both logical and efficient, persisted and almost all later Greek theaters were built against or into the natural slopes of hills. If a suitable place could be found at the base of the town's acropolis, as was the case in Athens, the commingling of practical and symbolic elements rendered the site ideal.

At Epidauros, the theater (FIGS. **5-71** and **5-72**) is sited some 500 yards southeast of the sanctuary of

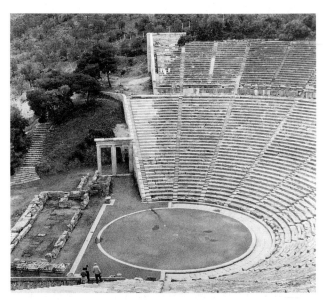

5-71 POLYKLEITOS THE YOUNGER, theater at Epidauros, Greece, *c.* 350 B.C.

5-72 Plan of the theater at Epidauros. (After F. Krischen.)

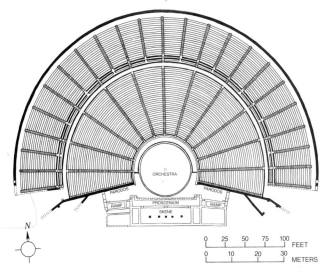

Asklepios. The slightly more than semicircular auditorium, with a diameter of 387 feet and a capacity of about fourteen thousand spectators, is built into the side of a hill. Staircase aisles, laid out on radii projecting from the center of the circular orchestra (where the chorus of Greek dramas performed), separate blocks of stone benches that are divided into two tiers by a broad corridor. The *proscenium* and the *skene* were arranged for maximum viewing convenience of the performance. The *parados*, a passageway between stage and seats, is wide enough to permit rapid exit. Unfortunately, the superstructure of the stage has not survived, but the acoustics are still excellent and the theater is used even today for summer productions of ancient Greek drama. When the acoustic excellence is added to the superb layout of the theater, the result is a harmonious structure that is admirably efficient and perfectly suited to its purpose. Such careful planning for the convenience of an audience represents a shift away from the ritualistic origins of the theater and marks, as did the New Comedy plays performed at the time the theater was built, increasing concern for individual views and responses.

THE HELLENISTIC PERIOD: 323–30 B.C.

Philip of Macedon brought the once-free Greek city-states into subjection. His son, Alexander the Great, educated in Hellenism, the culture of Greece, by none other than Aristotle, returned the visit the Persians had made to Greece a century and a half before, overthrew their empire, and conquered all the Near East, including Egypt. Greek conquest of this vast area produced a culture and period called Hellenistic—a curious mingling of Western and Eastern ideas, religions, and arts—and a long period of Greek cultural and partly political dominance that made her the cosmopolitan heir of Sumer, Babylon, Egypt, Assyria, and Persia. Greedy for the lands their young leader had conquered, his generals asked Alexander on his death bed, "To which one of us do you leave your empire?" In the skeptical manner of the age, but also with more than a tinge of an older irony, he supposedly answered, "To the strongest." Although probably apocryphal, this exchange points up the near inevitability of what followed—the division of Alexander's far-flung empire among his Greek generals and their subsequent naturalization among the Orientals whom they held subject.

In the late 1970s, excavations at Vergina in northern Greece, within the territory of ancient Macedonia, turned up what is now widely regarded to be the grave of Alexander's father, King Philip of Macedon.

Among the rich finds, which only a royal tomb might be thought to yield, were five tiny portrait heads in ivory, presumably representing Philip, Alexander, and other members of the family. The portrait thought to be that of King Philip (FIG. 5-73) shows in miniature those tendencies toward realism, already appearing in the earlier fourth century B.C., that ripened to maturity in the Hellenistic period. The king's features are highly personalized, vividly mobile, and expressive—broadly and surely modeled in the details. Undoubtedly, the sculptor was closely familiar with his king and patron's face, so confident is he in the representation of it. In the Hellenistic world, the relationship of royal patron and artist was to draw ever closer.

The centers of culture in the Hellenistic period were the court cities of Greek kings—Antioch in Syria, Alexandria in Egypt, Pergamon in Asia Minor, and others. An international culture united the Hellenistic world, and its language was Greek. Hellenistic princes became enormously rich on the spoils of the East, priding themselves on their libraries, art collections, scientific enterprises, and skills as critics and connoisseurs, as well as on the learned men they could assemble at their courts. The world of the small, austere, and heroic city-state passed away, as had the power and prestige of its center, Athens; a "world" civilization, much like today's, replaced it.

5-73 *Philip of Macedon* (?), from Vergina, c. 350 B.C. Ivory, 1¼" high. Archeological Museum, Salonika.

Sculpture

The tendencies traced thus far from the Archaic period were not interrupted by this complex change in political fortunes and cultural affiliations but simply proceeded to anticipated completions. The Hellenistic artists' technical command of the medium and virtuosity in manipulation of form mutually reinforce one another in a masterpiece of the second century B.C., the *Dherveni Krater* (FIG. **5-74**). Composed of hammered gilt-bronze with encrustations of silver, this sumptuous vessel is an incomparable specimen of the metalworker's craft, perfected by a long tradition that may reach back to Mycenaean times. The material, perfectly malleable in the artist's hands, embodies effortlessly wrought representations of the human figure, gracefully disposed upon and around the body of the piece. Hard metal is transfigured into a glowing vision of the erotic; ecstatic Maenads, almost nude, dance exuberantly in celebration of the rites of their god Dionysos. The god himself, tall, slender, and supple, reclines in sensual indolence, his right leg across the lap of Ariadne, who demurely removes her veil. Yet, despite the theme of voluptuous pleasure that dominates the vessel, the purpose of the krater is funerary; it was intended as part of the burial treasure of a doubtless

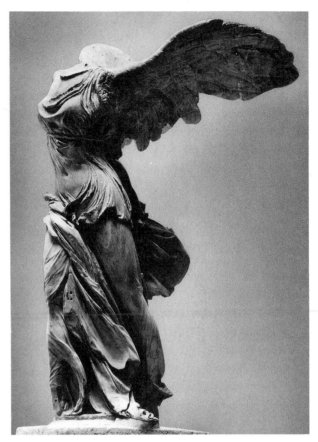

5-75 *Nike of Samothrace, c.* 190 B.C. Marble, approx. 8' high. Louvre, Paris.

5-74 *Dherveni Krater,* second century B.C. Bronze with silver incrustations, 27½" high. Archeological Museum, Salonika.

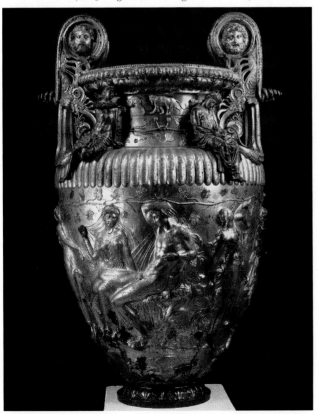

wealthy and sybaritic patron. The four solid-cast female figures around the neck of the krater may, by their pensive mien, provide the note of mourning we would think appropriate to the vessel's mortuary purpose; yet, as we have seen so often in ancient art, themes of life can be associated with those of death in tomb paintings and furnishings. In any event, the *Dherveni Krater* exemplifies the high degree of sophistication achieved by the cosmopolitan culture of the Hellenistic world, its artists' superb technical mastery, their expert rendering of the human figure in its natural aspects, and the scope and refinement of their knowledge of the great themes of Greek myth, lyric, and drama. Here, the themes of Eros (love) and Thanatos (death) meet in perfect harmony.

The "environment" that opened up around the *Apoxyomenos* of Lysippos (FIG. 5-66) opened up still more around the *Nike of Samothrace* (FIG. **5-75**). The goddess of victory is represented as alighting on the prow of a war galley, triumphant in some conflict among the successors of Alexander in the Greek world around 190 B.C. One of the masterpieces of the Hellenistic age, the *Nike of Samothrace,* windswept, her wings still beating, her missing right arm (a fragment of the hand survives) once raised high in an

imperious gesture of victory, brings strength, weight, and airy grace into an equipoise one would not expect to see achieved in the hard mass of sculptured marble. Here, the sculptors have worked their stone with a freedom emulative of painters, achieving shadows and gradations of shadows by variations of surface carving, almost as if they were using heavy instead of light brush strokes. The gauzelike stretch of material across the stomach and the waves of drapery around the striding thighs and legs amount not only to an exercise in virtuosity of stonecraft but a successful effort to make stone do what poetry and painting do—render at the same time the visual nuances of the moment and the ongoing essence of action. In the end, the sculptor wants us to sense, from the figure itself, an atmosphere of wind and sea.

The statue was found on the island of Samothrace in the ruins of a monumental fountain situated on a lofty rise overlooking the harbor and the sea. Reconstruction of the site shows that the Nike and the war galley were part of a larger composition. The group was set into a rock-walled grotto and dominated a great, two-tiered fountain, its reflection caught in the rippling pool of the lower basin. The effect was an illusion of the victorious galley in full sail, breasting the brisk sea breeze and the surge of the waves. The wind that whips the drapery about the body of the Nike and the moving waters that buoy the ship are thus replicated in a composition that binds together artificial and natural elements, integrating the sculptured group with its environment of shaped rock and flowing water. Much visited in ancient times, the Nike ship-fountain at Samothrace is perhaps the finest example of the victorious ship motif familiar on the coins and sculptural reliefs of the Greco-Roman world; the motif appears again in the Baroque period of later European art.

The extension of the spatial environment of the figure, so as to suggest a stage on which it may and does act, appears in sculptures associated with the Hellenistic kingdom of Pergamon and the island republic of Rhodes, in the third, second, and first centuries B.C. From a group dedicated by Attalus I of Pergamon (241–197 B.C.), a figure, in Roman copy, survives of a *Dying Gaul* (FIG. **5-76**). The figure is on stage, realistic, and also historical, representing a Gallic casualty in the wars Attalus had just fought with barbarian invaders. Comparison of the *Dying Gaul* and the *Fallen Warrior* from Aegina (FIG. 5-32) shows that, in a little more than two centuries, the principle of uniformity of movement had been learned well. The Gaul, dying from a chest wound that bleeds heavily, slowly loses strength, his weight falling rapidly on his last support, the trembling right arm; its collapse will be his own. The observer reads this at once from the lines and planes of the body—visually, with no need to interpret or expand the meaning. The statue is a triumph of realism. It also may mark the surrender of the interests of sculpture to the stage, where, we know, spectacles of human suffering painted with all realism of detail were sapping the great tradition of drama and diminishing human life in bloody scenes that could only present it as worthless. With the *Dying Gaul*, the sculpture of action degenerates into brutal stagecraft. Realism can go no further, even while it triumphs.

A later school of Pergamon exhibits a realism not quite so explicit, yet nonetheless related to the Hel-

5-76 *Dying Gaul.* Roman marble copy after a bronze original from Pergamon of *c.* 240 B.C., life size. Museo Capitolino, Rome.

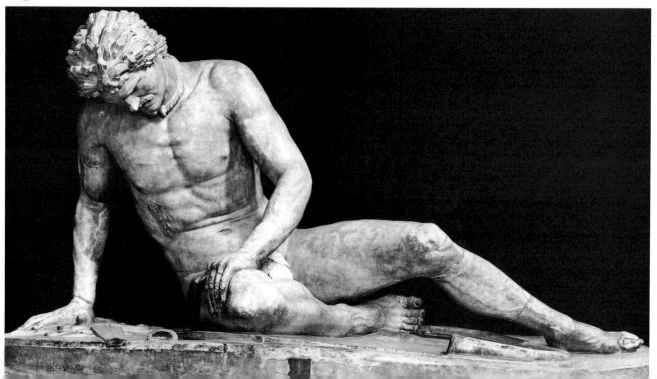

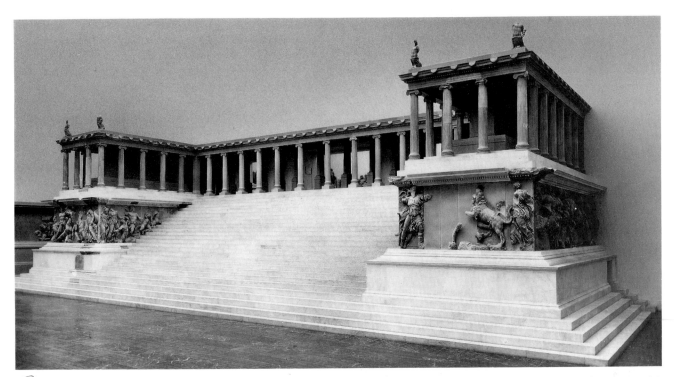

5-77 Altar of Zeus and Athena, Pergamon, *c.* 175 B.C. Staatliche Museen, Antiken-Sammlung, East Berlin. (West front restored.)

lenistic taste for tableaux of monumental suffering. A section of the great frieze of the *Battle of the Gods and Giants* from the Pergamon Altar of Zeus and Athena (FIGS. **5-77** and **5-78**) illustrates the highly dramatic kind of figurative sculpture that descended from Scopas and Lysippos. The altar was erected about 175 B.C. by the son and successor of Attalus I to glorify his father's victories. In a representation less factual than the group of dying Gauls, the artists here revert to the traditional Greek approach of presenting historical events in mythological disguise. The suffering and death, the writhing gesticulation, are somewhat formalized and we do not feel so much that we are in the presence of pain that ordinary men might feel. In the figure of Alcyoneos, the young giant whom Athena takes by the hair (FIG. **5-78**), the anguish of the face is based on Scopas and the twisting of the figure on the athleticism of both Scopas and Lysippos. The tragic content is read through the increasingly dramatic style of stonecraft. The Greek revision of the climactic instant is still seen against a neutral background. Now, however, shadows almost obscure the background, from which the figures project like bursts of light. All these devices are "baroque" and closely related to those developed in seventeenth-century Europe. The unity of the design is achieved by a fluid, yet binding organization of parts, not unlike that of the figures of the *Three Goddesses* of the Parthenon (FIG. **5-47**). Indeed, the two major figures of the frieze, Zeus and Athena, are inspired directly by the

figures of Poseidon and Athena from the Parthenon pediments; yet this dynamic integration of the whole composition is unlike the carefully studied relationships of *separate* parts seen in the Early Classical period. In such pictorial unity, produced by the movement of light and the contrast of shade, we again recognize the strong influence of painting.

5-78 *Athena Taking Young Alcyoneos by the Hair*, from the frieze of the Altar of Zeus and Athena, Pergamon. Marble, 7′ 6″ high. Staatliche Museen, Antiken-Sammlung, East Berlin.

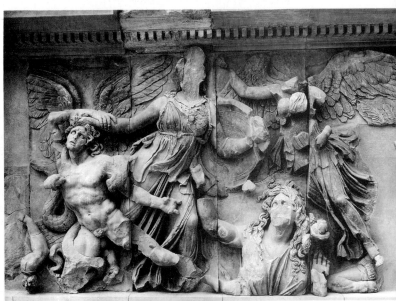

The theme of suffering is so pervasive in the Hellenistic world and its art that it could almost be understood as *the* interpretation of life by those who felt the hopelessness attendant on the decline of an older, more reasonable system. A late work of Hellenistic sculpture, the *Laocoön* group (now thought to date from the first century A.D.), was the product of a still quite active school at Rhodes (FIG. **5-79**). It shows the Trojan priest, Laocoön, and his sons being strangled by sea serpents, some say because of his defiance of Apollo, others, because he offended Poseidon (who sided with the Greeks) by warning his Trojan compatriots about the Trojan Horse. Whatever his offense, Vergil described his plight with unsparing realism:

> Laocoön . . . they [the sea serpents] seize and bind in mighty folds; and now, twice encircling his waist, twice winding their scaly backs around his throat, they tower above with head and lofty necks. He the while strains his hands to burst the knots, his fillets steeped in blood and black venom; the while he lifts to heaven hideous cries, like the bellowings of a wounded bull that has fled from the altar and shaken from its neck the ill-aimed axe. (*Aeneid*, II, 40–56, 199–231)

5-79 *Laocoön* group, first century B.C. to first century A.D. Marble, 8′ high. Vatican Museums, Rome. (Partially restored.)

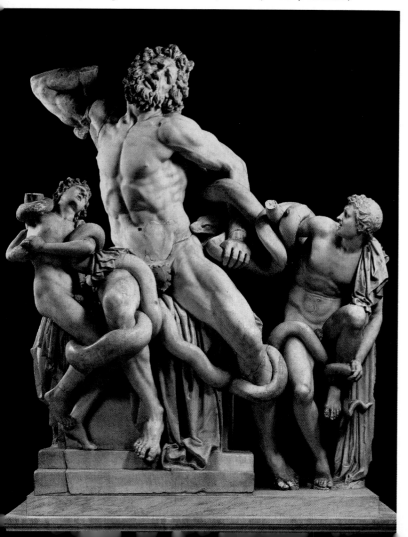

The spectacular torment of Laocoön and his sons is presented with all the devices of rhetorical realism available to artists as well as poets—the tortuous poses, straining muscles, and swelling veins. Yet, curiously, the figures exhibit lapses from consistent visual fact, as in the perhaps deliberate disproportion of the size of the sons in relationship to the size of the father, indicating them as *sons*, although they appear simply as small men.* The exceedingly popular group was reproduced frequently, sometimes on a colossal scale; in the eighteenth century, the analysis of it by Gotthold Lessing in his *Laocoön* led to his designation of art and poetry as opposed in function and to the foundation of the branch of philosophy called *esthetics*.

Pliny named three Rhodians as the sculptors of the *Laocoön* group: AGESANDER, ATHENODOROS, and POLYDOROS. The same three names are inscribed on the stern of a marble ship (FIG. **5-80**) that formed part of one of several sculptured groups, fragments of which have been found in a large grotto near the sea at Sperlonga, some eighty miles south of Rome. The cave, adjacent to a large imperial Roman villa built early in the first century A.D., had been used as a kind of dining room. Multifigured, sculptured groups appear to have been displayed in two niches and in a round central pool within the grotto. At least some of the sculptures must have been brought from Rhodes and were installed in the grotto around A.D. 29, when the cave was refashioned after a partial collapse.

A definitive interpretation of the scenes is difficult because the groups were found only in fragments, the figures evidently having been smashed to make lime or out of religious fanaticism. Three scenes from the *Odyssey* seem to have been represented: the blinding of Polyphemos (among the finds are the legs of a colossus that must have stood nearly 20 feet high), Scylla attacking Odysseus' ship, and a sinking ship. Our illustration shows the terrified helmsman falling from the stern of the sinking vessel (FIG. 5-80). The dramatic group may have been placed, quite strikingly, against the dark, stalactite-covered walls of the cave. Probably the finest of the fragments is the *Head of Odysseus* (FIG. **5-81**) from another group. Less convulsed and emotional than Laocoön's head, it nevertheless reflects strikingly the horrifying situation and the fear of impending death. The effect is produced not by the use of grimaces or the exaggerated eyes and anguished mouth of Laocoön but by the wind-tossed, whirling hair and beard that frame the face of the Homeric hero. The dating of the Sperlonga sculptures has been a matter of ardent debate

*The second son, on the viewer's right, may have been added by the sculptors when working from an earlier group that had only two figures. The greater compositional integration of the two left figures is obvious.

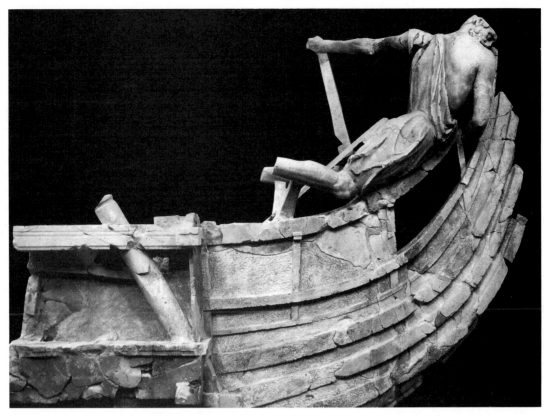

5-80 AGESANDER, ATHENODOROS, and POLYDOROS, *Odysseus' Helmsman Falling*, first century B.C. to first century A.D. Marble, approx. life size. Museo Archeologico Nazionale, Sperlonga, Italy.

5-81 AGESANDER, ATHENODOROS, and POLYDOROS, *Head of Odysseus*, first century B.C. to first century A.D. Marble, life size. Museo Archeologico Nazionale, Sperlonga, Italy.

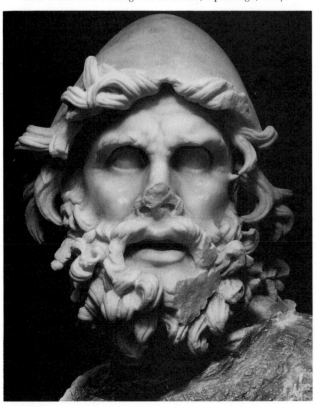

since their discovery in 1957. Dates from the second century B.C. to the first century A.D. have been advanced, shifting the *Laocoön* dates accordingly. If the same masters produced the two groups, scholars suggest that the Sperlonga figures must be earlier than the *Laocoön* group, because they show the expressive power of the Rhodian sculptors at its height, before it succumbed to the theatrical exhibitionism that marks the *Laocoön* sculpture.

Side by side with the drama of suffering, Hellenistic sculpture continued the tradition of ideal, Praxitelean beauty seen in the *Aphrodite of Cyrene* (FIG. 5-63). Another Hellenistic descendant of this Praxitelean line is the *Aphrodite of Melos* (FIG. **5-82**), the famed *Venus de Milo*. Here, again the ideal is taken out of the hypersensible world of reasoned proportions and made into an apparition of living flesh, like the coming alive of Pygmalion's statue of Galatea. The feeling for stone as stone has quite surrendered to the ambition of making stone look as though it were the soft, warm substance of the human body. Such effects as these can be obtained only by an artist with brilliant technical facility working in the conviction that the business of the artist is to produce from stone a vision of beauty, faithful to optical reality but modified to make the keenest appeal to the senses as a flawless manifestation of the human form. In some cases, faithfulness to optical fact also can lead the

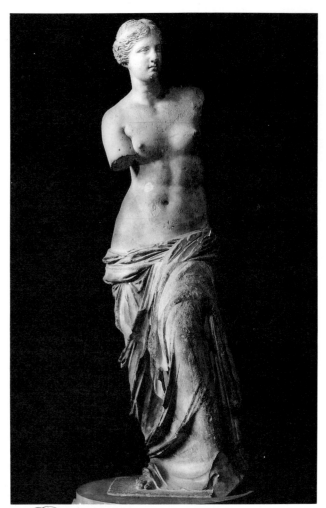

5-82 *Aphrodite of Melos, c.* 150–100 B.C. Marble, approx. 6′ 10″ high. Louvre, Paris.

sculptor to represent, with unflattering explicitness, the opposite of beauty, as seen in the *Old Market Woman* (FIG. 5-83). This bent, hobbling creature is offered to the viewer as an object of contempt, pity, or disgust, depending on one's temperament.

The disparity in subject of these two works reflects the wide scope of theme and the visual curiosity of Hellenistic sculptors. They aim to move the observer in terms of the themes of their work. They wish, moreover, for recognition by the observer of those traits in the statue that the observer knows in life, so that a large part of the response to the statue comes from the observer's familiarity with its model or type in the context of personal experience. Thus, while the Classical sculptor generally showed young adults at the height of their physical development, the Hellenistic artist expanded the subject matter to include not only the very old but also the very young. A group of two figures, *Eros and Psyche* (FIG. 5-84), who symbolize love and the human soul, represent ado-

lescents in fond embrace, oblivious to all but themselves. The story of Eros and Psyche was popular in the Hellenistic and Roman worlds and was often retold; the reader can find a late and beautiful retelling of it in Apuleius' *The Golden Ass.* The repertory of worldly and profane (that is, not religious in any formal sense) subjects was opened wide in Hellenistic art, and a principal theme, erotic art, was not overlooked. Plumply sensual, the nude and half-nude figures turn together in an artfully managed contrary motion, not unlike that of a slow, insinuating dance. The rhythmic flow of contour and plane enhances the softly amorous effect, although the artist's intent seems to be to convey prettiness and charm rather than blunt sexuality. In any event, Hellenistic sculptors are now in complete possession of the formal and technical means to render whatever subjects they might choose or might be chosen for them.

It seems unlikely that a fifth-century B.C. sculptor would have imagined that a *Boy Strangling a Goose*

5-83 *Old Market Woman,* second century B.C. Marble, 49½″ high. Metropolitan Museum of Art, New York (Rogers Fund).

5-84 *Eros and Psyche, c.* 150 B.C. Marble, 49″ high. Museo Capitolino, Rome.

5-85 BOETHOS, *Boy Strangling a Goose,* second century B.C. Marble, approx. 33″ high. Staatliche Antikensammlungen und Glyptothek, Munich.

5-86 Attributed to APOLLONIUS, *Seated Boxer, c.* 50 B.C. Bronze, approx. 50″ high. Museo Nazionale Romano, Rome.

(FIG. **5-85**) could be a subject worthy of representation. The sculpture may strike us as somewhat unpleasant, with its sadistic overtones, but doubtless it was intended to be "cute" and to elicit fond smiles as well as praise for the artist, BOETHOS, for his ingenuity in inventing a curious subject. And it must be admitted that Boethos has succeeded, from the formal point of view, in converting a trivial subject into a remarkably effective work of art. The swirling forms have been contained in a compact, pyramidal composition, at once complex and unified, in which the voids, like the solids, have been studied carefully and used as functioning parts of the whole.

Attributed to APOLLONIUS, the *Seated Boxer* (FIG. **5-86**), a very late Hellenistic work (perhaps more properly referred to as Greco–Roman, since it dates about a century after the absorption of Greece into the Roman Empire), shows a heavily battered veteran

of the arena resting. He has perhaps been beaten and is listening to the berating of his manager. The boxer is a man of huge physique, but his smashed face, broken nose, and deep scars tell the gist of his story. The sculptor appeals not to our intellect but to our emotions in striving to evoke compassion for the battered hulk of a once-mighty fighter. Story, realism, and human interest became the Hellenistic artist's focus at the end of the development of Greek sculpture, which ran, in a few centuries, a spectrum of possibilities and realizations ranging from the *Apollo* of Olympia (FIG. 5-40) to a brutish boxer past his prime. This should in no sense be construed as a decline of artistic quality or a failure of spiritual force. Hellenistic art is to be appreciated within the whole history of art for its thematic variety, its virtuosity of technique, and its power and passion in expressing the drama of human life. Its strength is felt throughout the development of Roman art, which, in many ways, is the extension of it.

Architecture

The greater variety, complexity, and sophistication of Hellenistic culture called for an architecture on an imperial scale and of wide diversity, something far beyond the requirements of the Classical city-state. Building activity shifted from the old centers on the Greek mainland to the opulent cities of the Hellenistic monarchs in Asia Minor—sites more central to the Hellenistic world. Great scale and ingenious development of interior space, the latter peculiarly a feature of Hellenistic architecture, are shown in the oracular Temple of Apollo at Didyma (the Didymaion) near Miletus, the old Ionian city on the west coast of Asia Minor (FIGS. 5-20f and **5-87**). This dipteral Ionic temple, begun in 313 B.C., is raised on a seven-stepped base some 13 feet above the level of the large naos, which was intentionally left open to the sky *(hypaethral)*. The temple is 167 feet by 358 feet, and the great columns are over 64 feet high. The deep and column-filled pronaos precedes an antechamber from which oracles may have been delivered. Entrance to the temple's interior was not through this room, which has a threshold some five feet high, but through two lateral, barrel-vaulted tunnels that sloped down toward the inner court, which was planted with bay trees in honor of Apollo. In the back of this court stood a small prostyle shrine that protected the cult statue, the foundations of which may be seen in the illustration. On the opposite end of the court, a stairway some 50 feet wide rose majestically toward three portals leading into the oracular room, which, approachable from both front and back, was the focal point of the entire design. This complex spatial planning of large interiors leads directly into later

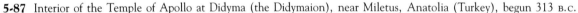

5-87 Interior of the Temple of Apollo at Didyma (the Didymaion), near Miletus, Anatolia (Turkey), begun 313 B.C.

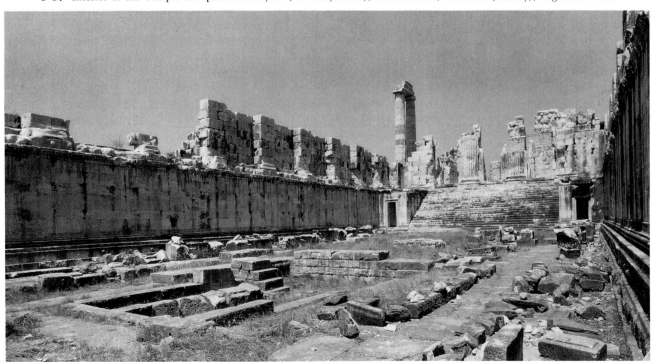

Roman practice and marks a sharp departure from Classical Greek architecture, which stressed the exterior of the building almost as a work of sculpture and left the interior relatively undeveloped.

The thoughtful adaptation of space to serve human uses, rather than, as in ancient times, to honor gods and to satisfy the whims of kings, is part of Greek humanism's contribution to history. The Hellenistic Greeks also broadened their conception of architectural design to take in whole cities. The regular street patterns of the gridiron type, which date from the Archaic period in Greece, were systematized during the fifth century B.C. by HIPPODAMOS, a Milesian architect, whose name has been linked with the rectangular plans of urban Hellenistic building foundations.* The *Hippodamian plan*, as illustrated by the city of Priene (FIG. 5-88), consists of a close-meshed network of streets that intersect at right angles, without any particular axial emphasis that might suggest dominant traffic patterns. At Priene, the plan has been superimposed on an irregular, sloping site, without regard to the nature of the terrain. Only the defensive walls on the city's perimeter closely follow

*Knowledge of ancient urbanism is rather scanty, since archeologists generally prefer to investigate limited sites, and it is rarely economically feasible for them to uncover and trace miles of city streets. The fragmentary evidence shows, however, that cities with regular, usually rectangular street plans existed in both ancient Egypt and Mesopotamia.

the topographical contours, with the result that walls and street plan are unrelated. On the other hand, the system is neat and orderly and, because it makes few distinctions of either a social or an economic nature, it is essentially democratic.

The major ordering principles of so-called Hippodamian plans were the rectangle and rectangular relationships. The *agora* was centrally located and easily accessible to all citizens. It was partially surrounded by long, roofed, colonnaded *stoas*, which housed shops and offices and were the architectural expression of the public life of the city. In these structures, the city's business and politics, its administration, and its gossip went on, and it is from the fact that they taught their rational, moral discipline in a stoa that the philosophy of the Stoics takes its name.

The *bouleuterion* (part of the agora) was as important as the stoa to the life of the civic organism. It served as a meeting place for the city council, a function that required a large, roofed, and enclosed space within which lines of sight were uninterrupted and acoustics were good. Efforts to fulfill these requirements came to fruition in the late third century B.C. in a new building type, an impressive example of which is the bouleuterion of Miletus (FIGS. 5-89 and 5-90). Here, the architectural problems were solved by incorporating a curved, theaterlike auditorium of steeply rising tiers of seats into a rectilinear masonry shell with a timber roof supported by four columns,

5-88 City of Priene, fourth century B.C. *Right:* Simplified ground plan. Shaded rectangle indicates area shown in detail at *left*.

1. Temple ruins
2. Wells
3. Fish and meat market
4. Sanctuary of Olympian Zeus
5. Gymnasium
6. Bouleuterion

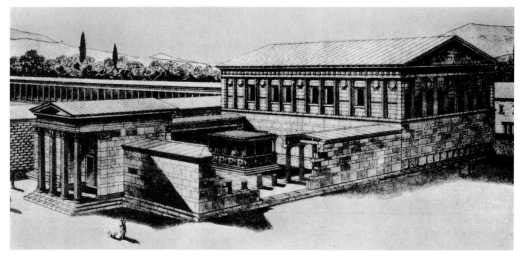

5-89 Bouleuterion at Miletus, late third century B.C.

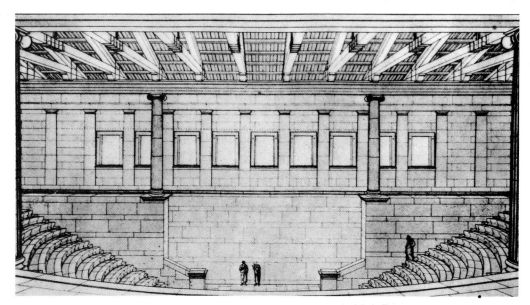

5-90 Reconstruction of council chamber, bouleuterion at Miletus.

ingeniously placed so as not to obstruct the audience's view of the rostrum.

It is at this point in the history of architecture that we can speak of domestic building and examine a human dwelling capable of being called a "house" (FIG. 5-91). Typically, the lot on which the Hellenistic house stood was enclosed by a wall to shut out the dirt and noise of the narrow street. A single door opened into an office, or service quarters, from which a covered passage led to the main unit through a courtyard, into which roofed chambers opened. Wealthier residents had, in addition to a forecourt (similar to the Roman *atrium*), a colonnaded garden, the *peristyle*.

The residential requirements of ordinary people without means were recognized and occasionally sat-isfied in Classical and Hellenistic Greece by planned housing projects. Such a development was built in a suburb of Olynthus in the late fifth century B.C. Here, groups of ten houses were arranged in rectangular blocks of about 300 feet × 120 feet, neatly fitted together in a Hippodamian grid pattern (FIG. 5-92). The individual houses varied in plan, but one feature, a spacious central courtyard with verandas, was common to all. Residential groupings of this sort predate the Roman *insula*, an even more integrated housing plan not unlike that of a modern apartment house. On a small scale, the Priene and Olynthus houses reflect a general interest in convenient, interior spaces, as well as a growing concern for utility and convenience in the daily life of the ordinary individual.

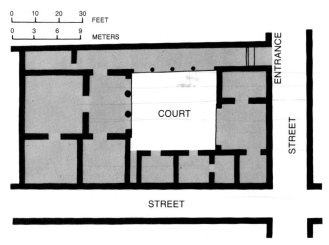

5-91 Plan of House XXXIII, Priene, fourth century B.C.

Priene was a provincial town, and its houses were relatively unpretentious. In the capitals of the Hellenistic kingdoms—at Alexandria in Egypt, Pergamon in Asia Minor, and Pella in Macedonia—life unfolded its richest and most sumptuous aspects. The kings and their retainers surrounded themselves with luxury that became proverbial, and their way of life set a standard that was to be surpassed only by the Roman emperors in later antiquity.

The great, urbanized citadel of the Attalid kings at Pergamon was a wonder of the ancient world and, even in its present, ruined state, still commands our admiration. Beautifully accommodated to its dra-

5-92 Plan of residential blocks, Olynthus, late fifth century B.C.

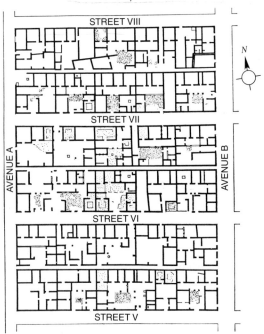

matic, mountainous site, the city proper was linked with the acropolis, some 800 feet above it, by an agora, a gymnasium, and the Sanctuary of Demeter, which were sited on intermediate levels. On the acropolis stood the fortress-palace of the rulers and, grouped around a theater, temples and sanctuaries like the Altar of Zeus and Athena (FIGS. 5-77 and 5-78). It was here on the acropolis that Pergamon achieved its greatest splendor in a sophisticated and dynamic grouping of architectural masses (FIGS. **5-93** and **5-94**). The deployment of the structures along flexible axes for maximum visibility is a free departure from the symmetric regularity of the Hippodamian plan and must have produced, at a distance, the faceted effect of a great gem, reflecting in its brilliance the wealth and power of the Pergamene dynasty. We have seen the sculptural celebration of Pergamon's

5-93 Plan of the acropolis, Pergamon, third to second century B.C.

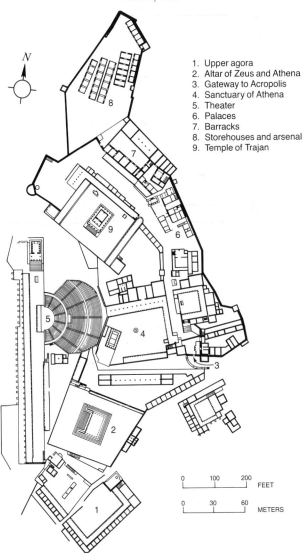

1. Upper agora
2. Altar of Zeus and Athena
3. Gateway to Acropolis
4. Sanctuary of Athena
5. Theater
6. Palaces
7. Barracks
8. Storehouses and arsenal
9. Temple of Trajan

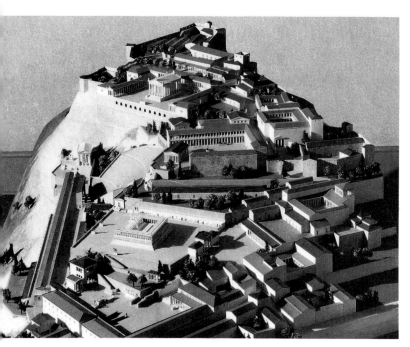

5-94 Model of the acropolis, Pergamon. Staatliche Museen, Antiken-Sammlung, East Berlin.

victories over the Gauls, and it is noteworthy that the Attalid kings were known in Hellenistic times as patrons of culture and art just as much as for their statecraft and their prowess in war.

Mosaics

Among the most lasting symbols of Hellenistic luxury were the floor mosaics with which the wealthy residents of the court cities embellished their houses. As an art form, mosaic had a rather prosaic and utilitarian beginning. (The Sumerian custom of covering walls with baked-clay cones and the technique of shell inlay, as found in the *Standard of Ur*, FIG. 2-18, were not long-lived.) In the Mediterranean region, the mosaic technique seems to have been invented primarily for the purpose of developing an inexpensive and durable flooring. Originally, small pebbles collected from beaches and riverbanks were set into a thick coat of cement. Artisans soon discovered, however, that the stones could be arranged in decorative patterns. At first, these patterns were quite simple and were confined to geometric shapes; examples of this type, dating back to the eighth century B.C., have been found at Gordium in Asia Minor. Eventually, the stones were arranged to form more complex pictorial designs, and, by the fourth century B.C., the technique had developed to the point that mythological subjects could be represented on a large scale with a rich variety of colors.

The most famous of these fourth-century pebble mosaics were found at Olynthus, which was destroyed by Philip of Macedon in 348 B.C., and at Pella, the Macedonian capital under King Archelaus around 400 B.C. Almost forgotten until the late 1950s (excavations there were begun in 1957), it was at Pella that Alexander was born, that Aristotle taught, and that Euripides died. Under Alexander, Pella became virtually the capital of the world, and he ruled his vast empire from there. Although little has been preserved of the buildings' superstructures, furniture, or other works of art from Pella, the uncovered floor mosaics provide ample evidence of the luxury and beauty of the city's houses. A detail from one of several well-preserved pebble mosaics (FIG. 5-95) shows an almost life-sized figure from a scene representing a lion hunt. The stones that have been arranged to form the picture are neither hewn nor shaped, but natural pebbles. A variety of colors has been used to produce a polychrome effect, but the chief pictorial impact is derived from a strong dark and light contrast. Some outlines and interior markings are defined with thin strips of terra cotta, a refinement that increases the clarity of the design but that was to enjoy no lasting favor.

Because they were cheap and durable, pebble mosaics remained popular through Roman times; in fact, they are still used for decorative pavements in Mediterranean countries. However, the desire for ever-greater pictorial realism led to the simple, but revolutionary, practice of cutting stones to desired shapes, so that they could be fitted together more closely. At first, these shaped stones, or *tesserae*, which permitted more precise description of detail, were used together with pebbles in limited areas that were felt to require greater definition. "True" mosaics, composed entirely of cut stones, may have originated in Hellenistic Sicily. They were being designed at Pergamon and Delos by the second century B.C., at which time the technique had been perfected to include colored glass (*smalto*) for strong colors, such as pure blue, red, and green, which are rarely found in natural materials. One of the most durable of the artistic media, mosaic was highly refined and popular in Roman times and became one of the chief vehicles for the pictorial expression of Early Christian and Byzantine artists.

While Alexander and his successors were Hellenizing the East, a power was rising in the western Mediterranean that, in its own way, would, like Greece, greatly determine the history of Europe and the Europeanized world. In one fateful year, 146 B.C., that power—Rome—sacked the Greek city of Corinth and destroyed an old enemy, Carthage, absorb-

ing the small Greek states into the Roman province of Achaea and constructing around the ruins of Carthage the province of Africa. Thus, in a double stroke, Rome took under its aegis the culture of Greece and brought to an end in the Mediterranean West the ancient Near Eastern civilization that had continued to flourish in the old Phoenician (eastern contemporary of the Minoan) sea-empire. Although this constituted another step in the westernizing of the ancient world, it did not mean a blocking of the channels of commercial and intellectual intercourse with the East. For what Rome adopted from Greece it passed on to the medieval and modern worlds in a form much transformed by the Oriental message of Christianity. If Greece was peculiarly the inventor of the European spirit, Rome was its propagator and amplifier.

5-95 *Hunter,* detail of the *Lion Hunt* mosaic, Pella, *c.* 300 B.C. Pebble mosaic, approx. 66″ high. Archeological Museum, Pella.

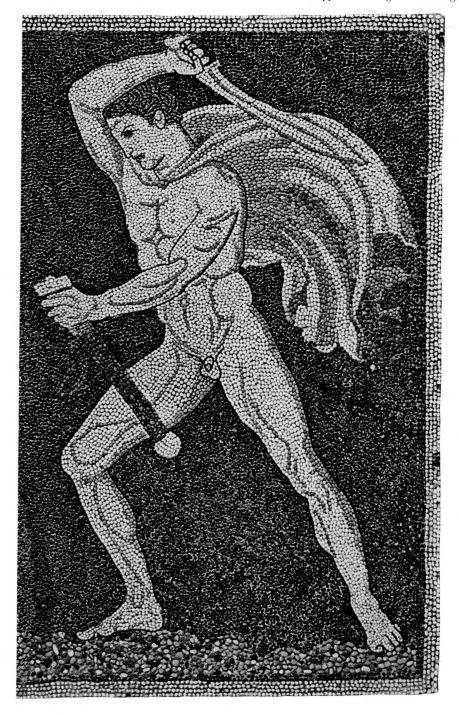

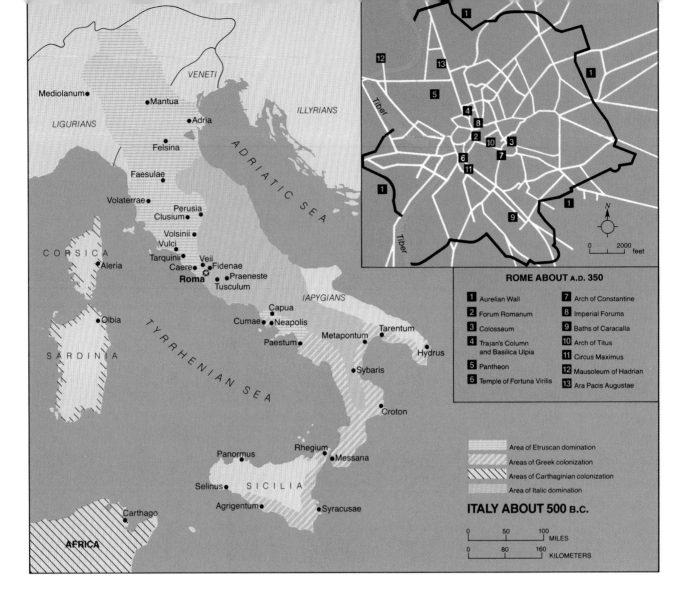

ROME ABOUT A.D. 350

1 Aurelian Wall
2 Forum Romanum
3 Colosseum
4 Trajan's Column and Basilica Ulpia
5 Pantheon
6 Temple of Fortuna Virilis
7 Arch of Constantine
8 Imperial Forums
9 Baths of Caracalla
10 Arch of Titus
11 Circus Maximus
12 Mausoleum of Hadrian
13 Ara Pacis Augustae

Area of Etruscan domination
Areas of Greek colonization
Areas of Carthaginian colonization
Area of Italic domination

ITALY ABOUT 500 B.C.

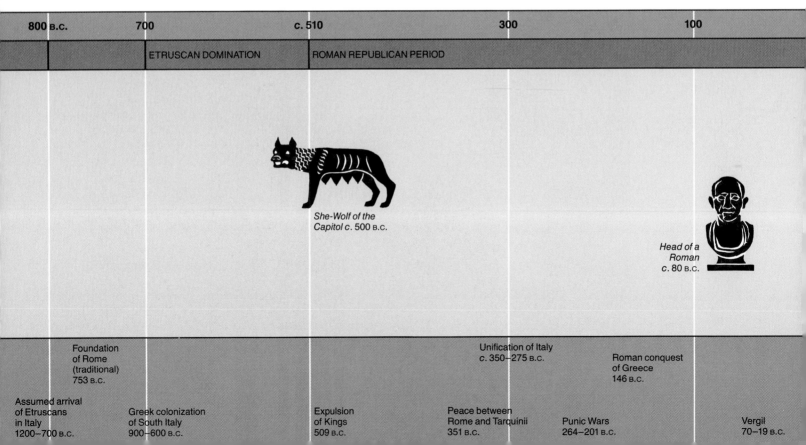

800 B.C. 700 c. 510 300 100

ETRUSCAN DOMINATION ROMAN REPUBLICAN PERIOD

She-Wolf of the Capitol c. 500 B.C.

Head of a Roman c. 80 B.C.

Foundation of Rome (traditional) 753 B.C.

Unification of Italy c. 350–275 B.C.

Roman conquest of Greece 146 B.C.

Assumed arrival of Etruscans in Italy 1200–700 B.C.

Greek colonization of South Italy 900–600 B.C.

Expulsion of Kings 509 B.C.

Peace between Rome and Tarquinii 351 B.C.

Punic Wars 264–201 B.C.

Vergil 70–19 B.C.

6
ETRUSCAN AND ROMAN ART

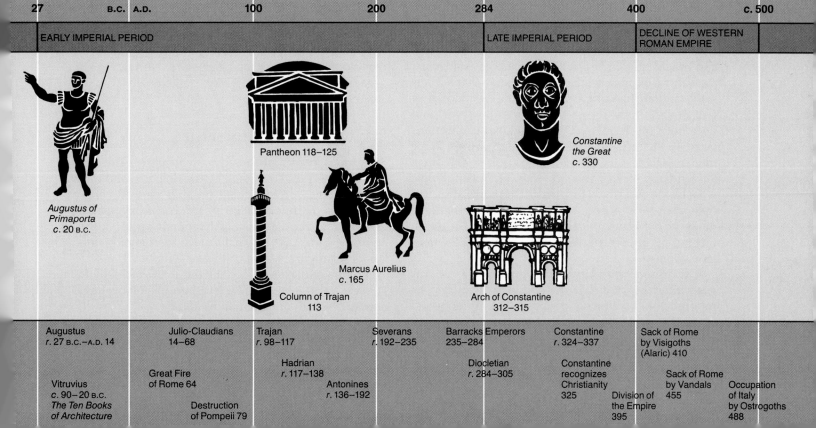

27	B.C.	A.D.	100	200	284	400	c. 500

| EARLY IMPERIAL PERIOD | | LATE IMPERIAL PERIOD | DECLINE OF WESTERN ROMAN EMPIRE | |

Augustus of Primaporta c. 20 B.C.

Pantheon 118–125

Marcus Aurelius c. 165

Column of Trajan 113

Constantine the Great c. 330

Arch of Constantine 312–315

Augustus
r. 27 B.C.–A.D. 14

Vitruvius
c. 90–20 B.C.
The Ten Books of Architecture

Julio-Claudians
14–68

Great Fire
of Rome 64

Destruction
of Pompeii 79

Trajan
r. 98–117

Hadrian
r. 117–138

Antonines
r. 136–192

Severans
r. 192–235

Barracks Emperors
235–284

Diocletian
r. 284–305

Constantine
r. 324–337

Constantine
recognizes
Christianity
325

Division of
the Empire
395

Sack of Rome
by Visigoths
(Alaric) 410

Sack of Rome
by Vandals
455

Occupation
of Italy
by Ostrogoths
488

THE PEOPLE of Italy, while touched at an early date by the radiance of Greece, had deep and tenacious qualities of their own. Both Etruscan (or Etrurian) and Roman art, like the art of any other culture or area, must be recognized as a synthesis of influences from outside sources and of elements indigenous to the country. Roman art, the immediate heir of all earlier Mediterranean cultures, was in many ways a synthesis of the arts of antiquity, as was Greek art, although in quite a different way. Rome was also deeply involved in bringing civilization to western Europe and to North Africa. The art of Rome was, therefore, in later times often regarded as the symbol of the art of antiquity.

In terms of political development, the early histories of Greece and Italy are roughly parallel, but the vigorous advances in Greece after the Persian Wars of the fifth century B.C., culminating in the Age of Pericles, found no counterpart in Italy, where culture was retarded by the bitter struggles among competing Italic peoples and between Italic groups and the Etruscans.

THE ETRUSCANS

The origin of the Etruscans, like that of the Mycenaeans, has long been one of the mysteries of the ancient world. Their language, although written in a Greek-derived script and extant in inscriptions that are still obscure, is unrelated to the Indo-European linguistic family. Ancient historians, as fascinated by the puzzle as modern scholars, generally felt that the Etruscans emigrated from Asia Minor; Herodotus, the "father of history," specifically declared that they came from Lydia. This tradition has persisted, and because the Etruscan culture emerges as distinct from those of other Italic peoples around 700 B.C., its arrival in Italy has long been put at the eighth century B.C. Such a view seems too simple, however, and does not explain adequately the evident connections between the Etruscan and earlier Italic cultures. Some modern scholars feel that the Etruscans are the direct descendants of very old pre–Indo-European people who had moved into Italy from the north. But this theory, in turn, cannot fully account for certain elements of the Etruscan culture, particularly the elaborate burial cult, which seems to be linked with Oriental customs.

A compromise theory points out that Herodotus gives no dates and that the migration to which he referred could well have occurred during the period of the great Mediterranean shifting of peoples around 1200 B.C. that caused the collapse of the Mycenaean civilization. At that time, immigrants from Asia Minor could have settled in Italy, mingled with the native population, and produced the culture of the so-called Villanovans, who, in turn, may have been the direct predecessors of the Etruscans. The changes that produced the Etruscan culture proper then would have to be explained in terms of increasing exposure to Oriental and then Greek influences, brought about by expanding commerce and trade. The Etruscans enjoyed high repute as skilled seafarers (or disrepute as pirates) in antiquity and emerged into the light of history during the so-called Orientalizing period.

Historians now generally concede that Etruscan art developed largely as a consequence of the Greek colonization of southern Italy during the eighth and seventh centuries B.C. Although they were responsible for halting further Greek expansion northward along the Tyrrhenian coast, and despite deep-rooted distrust and antagonism toward their southern neighbors, the Etruscans eagerly absorbed Greek influences, without relinquishing any of their native characteristics. Using the Greek colonial cities as a model, the Etruscans shifted from village life to an urban civilization and established themselves in strongly fortified hilltop cities. By the sixth century B.C., they controlled most of northern and central Italy from such strongholds as Tarquinia (ancient Tarquinii), Cerveteri (ancient Caere), Veii, Perugia (ancient Perusia), and Orvieto (ancient Volsinii). But these cities never united to form a state, and so it is improper to speak of an Etruscan "nation" or "kingdom." The cities coexisted, flourishing or fading independently, and any semblance of unity among them was based primarily on common linguistic ties and religious beliefs and practices. This lack of political cohesion eventually made the Etruscans relatively easy prey for the Roman aggressors. During the ten-year siege of Veii, for instance, no Etruscan city came to the aid of its beleaguered cousin.

Architecture

Little is known of Etruscan architecture. The cities were either razed or rebuilt by the Romans, and those that survived were located on sites so well chosen that they continue to be inhabited to this day, making excavation impossible. Scattered remnants suggest that the Etruscans, at least during their later history, made considerable use of the masonry arch, a structural device used occasionally but not favored by the Greeks, and one that was to become of profound importance in later Roman building.

We know about early Etruscan houses chiefly from clay models that served as cinerary urns and from

tomb chambers in which domestic interiors were emulated. To judge from the interior of the Tomb of the Reliefs (FIG. 6-3), an originally simple, rectangular structure with a sloping roof grew progressively more elaborate, reaching its climactic development in the *atrium* houses of Pompeii and Herculaneum. Inventiveness showed itself in the development of the atrium, a high, square or rectangular central hall that was lighted through a large opening in the roof and around which the other rooms were arranged symmetrically. The atrium was the focus of family life and the shrine for the *lares* and *penates,* the household gods. The ancient sacred hearth of Mediterranean family religion found an appropriate architectural expression in the noble atrium, which gave to Italic domestic architecture an importance and dignity beyond that developed by the Greeks.

Our knowledge of the Etruscan temple (FIG. **6-1**) is based on a few preserved foundations and on a description given by the ancient Roman authority on architecture, Vitruvius (see page 220). The temple form very possibly may have had its origins in Greece. Its plan, for example, closely resembles the Greek prostyle plan (FIG. 5-20b). Yet the Etruscan adaptation, in typical fashion, developed its own characteristics. Resting on a high base *(podium),* with steps at one end only, the temple was constructed mostly of wood and sun-dried brick in a post-and-lintel system and had a heavy wooden superstructure richly decorated with brightly painted terra-cotta reliefs. The Etruscan emphasis on a highly ornate façade, with relatively spare treatment of the sides and rear, concentrated attention on the entrance porch. The axial organization was quite different from that of the Greek temple. Behind the sunlit pavilion of the porch, the shrine, which was divided into three *cellae* of equal size, formed dark cavelike spaces. The temple was not meant to be seen as a sculptural mass from the outside and from all directions, as the Greek temple was, but was intended to function instead primarily as a confined interior space for the cult god. It was a place of shelter, protected by the wide overhang of its roof.

The Etruscans have revealed themselves to us with the greatest clarity, however, in the remains of their elaborate burial grounds. In the rich array of wall paintings and painted reliefs with which they decorated the interiors of their tombs, they recount their zestful lives, their banquets, and their dances (which, in their suppleness and verve, seem partly Ionian and partly barbarian). They tell us of both their athletic contests and of their wars. Their rise and fall from power is reflected in a gradual change from optimism to pessimism and in the choice of ever-more morbid and bloodthirsty subjects as their political fortunes declined. Although the Etruscans' reputation for cruel and unrestrained behavior is based largely on the testimony of the ancient Greeks and Romans, who were their enemies, elements in their tomb paintings indicate that many aspects of their society were in fact violent and extravagant. Indeed, these qualities may have played a decisive role in the formation of an energetic and creative culture that was to contribute to the rise to world rulership of their Roman successors.

The Etruscans built their cemeteries at some distance from their cities. Hundreds of tombs arranged in an orderly manner along a network of streets produce the effect of veritable cities of the dead. The tombs varied according to region and local custom. In the northern part of Etruria, they were usually constructed above ground; in the south, they were often excavated from the live rock, particularly in areas where tufa soil facilitated digging. Tufa, primarily strongly compressed volcanic ash, is excavated easily and hardens to a concretelike consistency on exposure to the atmosphere; it also can be cut into durable building blocks that require no firing. Tufa was used extensively by the Etruscans and Romans, and a minor tufa-brick industry still flourishes in Italy today.

A characteristic Etruscan tomb type is the *tumulus,* a round structure containing one or more subterranean tomb chambers and covered by a large mound of earth (FIG. **6-2**). This form was favored in Cerveteri (ancient Caere) and, in view of its domical shape, seems to carry on an ancient Mediterranean tradition. The majority of Etruscan tomb interiors, however, including those of the tumuli, are rectangular and imitate the rooms of domestic architecture. A striking example is the Tomb of the Reliefs (FIG. **6-3**), a large underground chamber in Cerveteri, in which massive piers with pseudo-Ionic (Aeolic) capitals support a

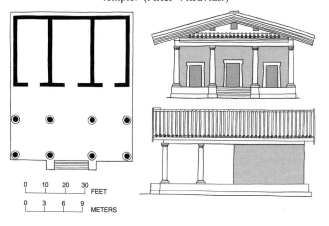

6-1 Plan *(left)* and elevations *(right)* of an Etruscan temple. (After Vitruvius.)

0 10 20 30 FEET

0 3 6 9 METERS

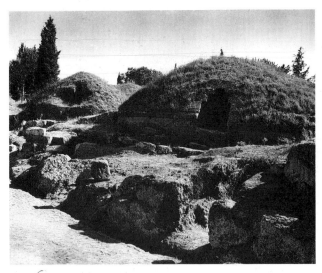

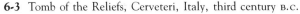**6-2** Necropolis at Cerveteri (ancient Caere), Italy, fifth to fourth century B.C.

slanting, beamed ceiling. The piers are *reserved*, having been formed by cutting away the live tufa until the remaining rock assumes the shape of a pier or column, as in the Egyptian rock-cut tombs at Beni Hasan (FIG. 3-20). The Tomb of the Reliefs, like most Etruscan tombs, was designed for multiple burials, the final resting place of an entire family and its servants. Sarcophagi, cinerary urns, and other tomb furnishings were placed in niches and on the benchlike projection at the base of the walls. Decoration in the Tomb of the Reliefs consists of painted plaster representations of weapons, tools, and kitchen utensils and displays a generous inventory of Etruscan objects of daily use. Occasionally, tombs at Cerveteri also were decorated with mural paintings.

Painting

The Tarquinians adorned the walls of most of their subterranean tomb chambers with colorful and lively murals. Although the subjects of tomb painting in Etruria are sometimes drawn from Greek legend, more often they are concerned with scenes of banquet and revel, as in the Tomb of the Leopards of Tarquinia (FIG. 6-4). This small chamber tomb is decorated in the manner favored in Tarquinia during the fifth century B.C.; a banquet scene appears on the wall opposite the entrance, and groups of dancers and musicians enliven the side walls. In contrast to the all-male festivities shown in the Greek tomb at Paestum (FIG. 5-59), women share in this banquet. Their light skin color distinguishes them from their dark-skinned male partners, a pictorial convention in ancient art that goes back to early Egyptian times. The men are bare chested, while the ladies wear chi-

6-3 Tomb of the Reliefs, Cerveteri, Italy, third century B.C.

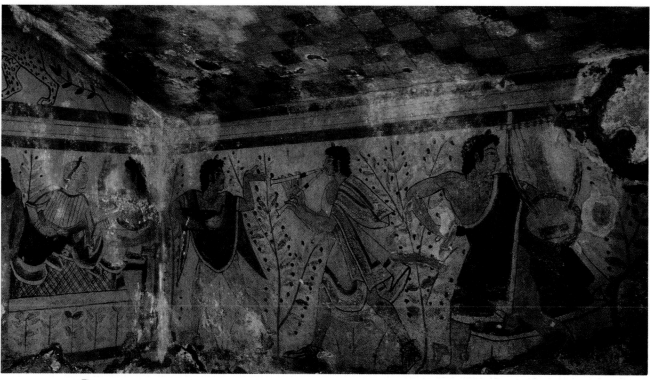

6-4 *Revelers*, detail of a wall painting from the Tomb of the Leopards, Tarquinia (ancient Tarquinii), c. 470 B.C.

tons. The ladies also share the men's interest in an egg, which the reclining celebrant second from left ritually holds up. This gesture identifies the event as a funeral banquet; the egg was the symbol of young life and regeneration and thus an object of reverent contemplation and consolation on this somber occasion.

The contemplative mood of the banqueting scene changes into life-affirming exuberance on the adjoining wall. Three young men, one clad only in a light scarf, the other two in the elegant *chlamys* (cloak), seem to be hurrying through a grove of graceful little laurel trees, the leader carrying a cup of wine and beckoning the others, who play the double flute and the seven-stringed lyre. They already seem to be dancing, facing rhythmically in opposite directions, as if performing some circling step. The gestures have a kind of choreographic exaggeration, especially those of the enlarged hands and fingers of the flutist, which hold and touch the instrument with such sureness and delicacy. Spirited movement rarely is portrayed so convincingly in the painting of the ancient world, and it would be difficult to find from that time a more fitting monument to the beauty of youth, springtime, music, and the dance. The picture is a kind of fresco painting on a thin slip applied to the living tufa wall or on a stucco paste made from tufa. The colors (blacks, blues, blue-greens, and ocherreds) still retain much of their original freshness and

harmonize easily and naturally with the creamy yellow ground.

The later Etruscans seem to have surrendered their native, joyous vigor for a quiet, classicizing formalism like that seen in the *Woman of the Velcha Family* (FIG. **6-5**), from a chamber in the Tomb of Orcus (Hades) in Tarquinia. The composed, even reflective, expression

6-5 Detail of the *Woman of the Velcha Family*, wall painting from the Tomb of Orcus (Hades), Tarquinia, fourth century B.C.

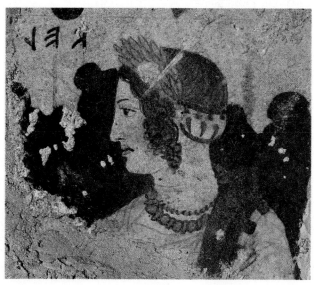

of this splendidly painted head (note the advanced draftsmanship of the foreshortened eye) suits the somber theme that is its context—the sufferings of the dead in Hades in the midst of the menacing demons of the underworld. The earlier Etruscan euphoria has disappeared, extinguished by the more cosmopolitan religions of the Hellenistic world, which stressed not the last happiness of the funeral revels, but the sadness of humanity's fate.

Sculpture

The Etruscan tombs yield a notable furniture of sculptured objects in both clay and bronze, materials that the Etruscans apparently preferred, although numerous stone sarcophagi also survive. The forms are modeled rather than carved, modeling being a technique congenial to the impetuous temperament and fluid style characteristic of the Etruscans. Funerary urns and sarcophagi with recumbent portrait figures present some of the best examples of Etruscan sculpture. A canopic (cinerary) urn (FIG. **6-6**) from Chiusi (ancient Clusium) has a terra-cotta head for a lid and is set in a bronze model of a chair; the head is obviously intended to be a portrait likeness of the deceased whose ashes the urn contained. The strongly rounded form of the urn has a crude vitality that is carried into the head, with its blunt, aggressive features and massive neck.

In the reclining effigies of a man and his wife on the lid of a sarcophagus from Cerveteri (FIG. **6-7**), we read

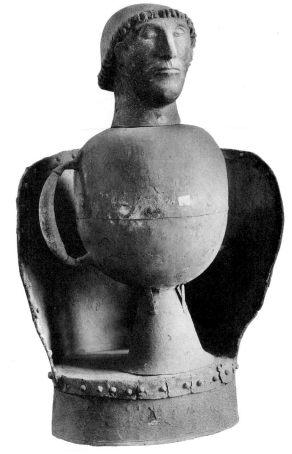

6-6 Canopic urn, from Chiusi (ancient Clusium), second half of the seventh century B.C. Hammered bronze with terra-cotta head, approx. 33″ high. Museo Etrusco, Chiusi.

6-7 Sarcophagus from Cerveteri, c. 520 B.C. Painted terra-cotta, approx. 6′7″ long. Museo Nazionale di Villa Giulia, Rome.

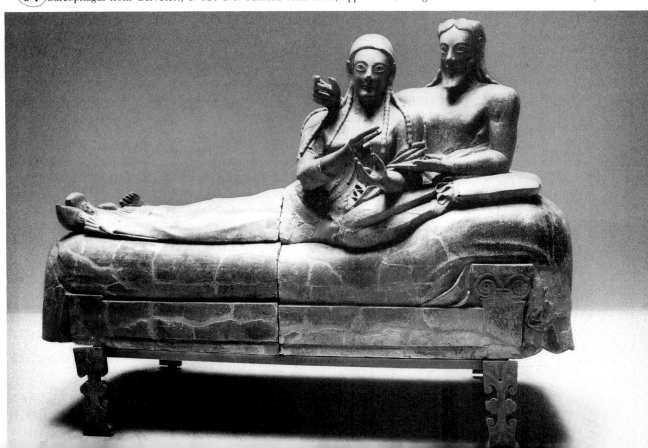

esty of the *Apollo* at Olympia (FIG. 5-40), this Apollo moves like a dangerous giant. His overpowering physical presence reflects small concern for the Greek preoccupation with harmonious proportions or idealized humanity. The Ionian elaboration of the drapery lines bespeaks the Eastern component in Etruscan art, but the animal force, the huge, swelling contours, and the plunging motion are certainly not Ionian and show little mainland Greek influence. The *Apollo* from Veii, given its architectural function, naturally differs from the painted Etruscan forms we have seen; yet it has in common with them the peculiarly Etruscan strength, energy, and excitement.

Greek influences on Etruscan art continued even when the Etruscans were at the height of their power—sending their own art commodities throughout the Mediterranean area, including Greece—and through the centuries of their decline. The so-called *Mars from Todi* (FIG. 6-9) exemplifies the Etruscan interpretation of the Greek Classical style in the beginning of the fourth century B.C. The figure, dressed in

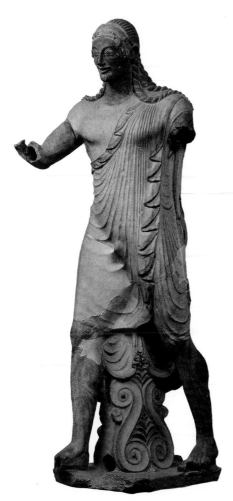

6-8 *Apollo*, from Veii, *c.* 510 B.C. Painted terra-cotta, approx. 70″ high. Museo Nazionale di Villa Giulia, Rome.

the traits of Archaism as we have found them in early Greek art. The work is a kind of three-dimensional formalization of the animated banquet scenes painted on Etruscan tomb walls to satisfy the demands of some cult ritual of the dead, the details of which are unknown. But there is nothing here of the solemn or the macabre, and the Etruscan instinct for the lifelike is preserved. The figures are relaxed and genial, much in contrast with the funerary formality of Egyptian statues, and the Archaic features of style, although present, produce neither stiffness nor awkwardness.

The *Apollo* from Veii (FIG. 6-8), an *acroterium* figure from the ridgepole of an Etruscan temple, is evidence that, like the Greeks, the Etruscans made use of architectural sculpture. But the Greek Archaic elements—the closed contour, the grimacing mask, the frontality—although immediately evident here, are superficial; the awkward, lurching vigor of the powerful figure is a forceful example of Etruscan clay-modeling techniques and the use to which the confident, quick-conceiving, and quick-executing sculptor could put them. In contrast with, say, the serene maj-

6-9 *Mars from Todi*, early fourth century B.C. Bronze, approx. 56″ high. Vatican Museums, Rome.

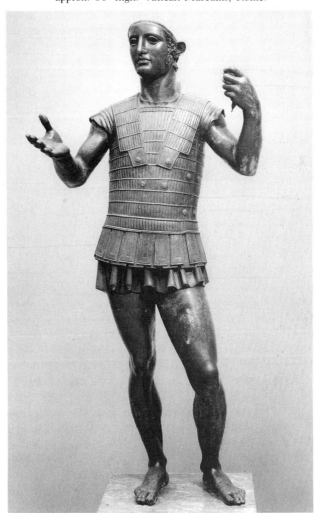

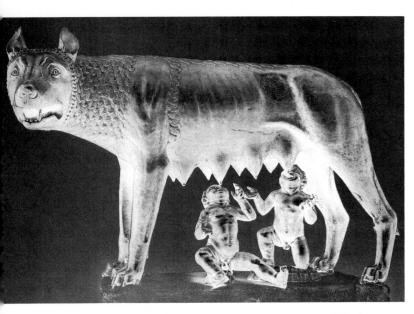

6-10 *She-Wolf of the Capitol*, c. 500 B.C. Bronze, approx. 33½″ high. Museo Capitolino, Rome.

more or less contemporary military garb, executes a peculiar movement of the whole body, involving sideways and contrary directions of head, torso, arms, and legs, without seeming to move from his position. The sculptor may have been exaggerating the Polykleitan weight-shift stance but renders it with a kind of agility quite unlike the Polykleitan balance of weight and poise. We find again, as in the much earlier *Apollo* from Veii, that an Etruscan interpretation of prevailing Greek style brings out the native quality of energy, whether in the blunt drive of the *Apollo* or in the almost sprightly stance of the *Mars*.

One of the most famous animals in the history of world art, the *She-Wolf of the Capitol* (FIG. **6-10**), owes her fame not simply to her antiquity and her magnificence as a work of art, but also to the fact that, for centuries, she has been the totem of the city of Rome. Ancient legend tells us that the founding heroes of Rome, Romulus and Remus, were abandoned as infants and suckled by a she-wolf. The cult of Romulus and Remus was as old as the fourth century B.C., and we know that a statue of a she-wolf was dedicated on the Capitoline Hill in Rome in 296 B.C. We do *not* know whether the present statue of the she-wolf on the Capitoline Hill is the original (the suckling infants were cast during the Renaissance); its dating has been hotly debated, but its Etruscan origin now is accepted widely. Here, the vitality we have noted in the human figure in Etruscan art is concentrated in the tense, watchful animal body, with its spare flanks, gaunt ribs, and taut, powerful legs. The lowering of the neck and head, alert ears, glaring eyes, and ferocious muzzle render the psychic vibrations of the

fierce and, at the same time, protective beast; the incised lines along the neck describe its rising hackles as it watches danger approach. Not even the great animal reliefs of Assyria can match, much less surpass, this profound reading of animal temper.

A somewhat later bronze figure is the splendid *Chimera* (FIG. **6-11**) from Arezzo (ancient Arretium), a monster with a rough-maned lion's head, a serpent's tail (restored in the Renaissance by Benvenuto Cellini), and a second head—that of a goat—whose right horn is seized by the serpent. Although the *Chimera* bears the wounds inflicted by the hero Bellerophon, who hunted and slew it, the figure does not merely illustrate that event but almost certainly has some further demonic significance. The Etruscans, much of whose art is associated with mortuary ritual, had a well-developed *demonology* (an aggregation of demonic types that plague the dead in the underworld). Unlike the Greeks, who preferred to humanize their demons, the Etruscans, perhaps as a result of their Asiatic origins, employed their customary expressive force in representing *their* demons as dreadful animal hybrids. The precedents for the monster types go back to the sphinxes of Egypt, the winged, man-headed bulls of Mesopotamia, the ornamental animal bronzes of Luristan, and the associated animal-heraldic style of much of the metalwork of central Asia. It may be that these traditions lingered in the Etruscan spirit, and the manifestation of them in such powerful form as the *Chimera*—a highly anti-Greek and forcefully Asiatic figure—attests most firmly to the Eastern component in Etruscan culture. By the time of the Middle Ages, a whole population of monsters swarmed through Western art.

6-11 *Chimera*, from Arezzo (ancient Arretium), fifth to fourth century B.C. Bronze, approx. 31½″ high. Museo Archeologico Nazionale, Florence.

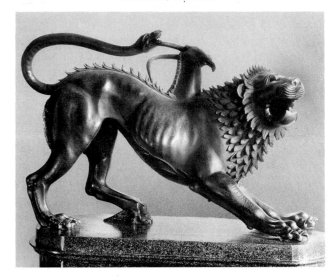

6-12 Engraved back of a mirror, *c.* 400 B.C. Bronze, approx. 6″ in diameter. Vatican Museums, Rome.

The Etruscans also assimilated the practice of *divination* from Eastern cultures and passed it on to the Romans. Diviners (priests) sought to predict the future, which was viewed as a product of arcane forces personified as gods or demons. On the assumption that all nature constituted a universe of affinities, prediction was based on the state of the viscera (especially the liver) of sacrificed animals, the flights of flocks of birds, and unseasonable and unusual events. The engraved back of an exquisitely wrought bronze mirror (FIG. **6-12**) displays all the refinement for which the Etruscan craft arts were celebrated. The engraving represents a winged figure labeled Calchas, a priest in Homer's *Iliad*, divining from a liver that he holds in his hand and on which he muses. The figure is a kind of miniature emblem for that world of benign and malign forces that surrounded human beings in antiquity and that they tried to approach or fend off by prophecy, sacrifice, oracle, omen, spell, and incantation. Greek rationalism made very little headway against the ancient world's overwhelming faith in the magical manipulation of nature.

Closely related to the delicately incised, Classical mirrors of the fourth century B.C., like the Calchas mirror, are the bronze cists of Palestrina (ancient Praeneste), which undoubtedly echo the styles of the great Greek masters of mural painting—Polygnotos,

Euphranor, and others. Etruscan bronze vessels and mirrors with incised mythological scenes were famous and highly prized objects in Greece. Perhaps the outstanding example of this type is the *Ficoroni Cist* (FIG. **6-13**). Most significantly, the artist, NOVIUS PLAUTIUS, is not Etruscan; he signed his work in Latin and made it in Rome. Here, Plautius has skillfully adapted a frieze of Greek figures, faithfully taking over the idealized naturalism of the Late Classical period. Many think that the composition may have been copied directly from a lost Greek panel painting. Naturalistic innovations include figures seen entirely from behind or in three-quarter rear view, complicated seated poses, figures on several levels rather than rigidly attached to a single ground line, details of landscape, and a kind of approximate perspective space. In his work, the artist represents the passing of the Etruscan genius and the acceptance of the irresistible influence of Greece. Yet something of the Etruscan sense for the real was to persist through the formal Classicism of Greece and, in turn, partly direct the course of the art of Rome; this earlier Etruscan sense would sharpen into the characteristic Roman taste for the factual in art, as in human affairs.

6-13 NOVIUS PLAUTIUS, *The Ficoroni Cist*, from Palestrina (ancient Praeneste), late fourth century B.C. Bronze, approx. 21″ high. Museo Nazionale di Villa Giulia, Rome.

THE ROMANS

The Roman power that succeeded and replaced the Etruscan and Greek colonial powers on the Apennine peninsula compelled the contesting peoples of Italy into a Roman state and, eventually, the peoples of western Europe, the Mediterranean shores, North Africa, and the Near East into the Roman Empire. The rise and triumph of Rome, and the awesome spectacles of its decline and fall, make, in the stately words of its great historian, Edward Gibbon, "a revolution which will ever be remembered, and is still felt, by the nations of the earth." A single government stretched from the Tigris and Euphrates to the borders of Scotland. Under its energetic and efficient—if sometimes ruthless and brutal—rule lived people of innumerable races, creeds, tongues, traditions, and cultures: Britons, Gauls, Spaniards, Germans, Greeks, Africans, Egyptians, Syrians, and Arabs, to name only a very few. If the Greek genius, as we review it, shone most brightly in art, science, philosophy, history, and, in general, creations of the intellect and imagination, the Roman genius shone in the realm of worldly action—in law and in government. Roman monuments of art and architecture are distributed throughout the world that the Romans governed and are the most conspicuous and numerous of all the remains of the ancient civilizations we have studied thus far. But Roman monuments of a kind also survive in our concepts of law and government; in our calendar; in our festivals, rituals, languages, and religions; in the nomenclature of many of the sciences; and, for our special interest here, in the concept of art as worthy of historical study and criticism.

The main energies of Rome were devoted to conquest and administration, with conquest opening the way for the spread of Roman civilization. Roman cities sprang up not only all around the Mediterranean basin but also as far north as the Danube, the Rhine, and the Thames. Each city was a center for the propagation of Roman government, language, and customs and was closely connected with the city of Rome itself by a well-planned system of roads and harbors. By about A.D. 200, Rome was the capital of the greatest empire the world had ever known, an empire efficiently organized with fifty thousand miles of sea routes and expertly engineered highways for travel and commerce. Rome itself was cosmopolitan and splendid. The size, power, and complexity of the empire called for an impressive capital. The practical demands arising from the administration of a great empire required engineering skills for the construction of bridges, roads, sewers, and aqueducts, but the imperial ideal also called for public buildings that would express the dignity and diversity of the state.

Roman art takes its character in large part from the imperial role the Roman state was required to play.

Roman art came to have its own quite distinctive characteristics, although both Etruscan and Greek influences played a role in its early development. The Romans, almost from the beginning of their rise to power, had been fully aware of Greek art, but it was only in the later Republican and Augustan ages that Hellenism became a conscious fashion. "Conquered Greece," wrote Horace, "led her proud conqueror captive." Shiploads of Greek marbles and bronzes were brought to Rome by generals and provincial governors to adorn their mansions, and when the supply was exhausted, copies were made or Greek artists were employed to create new works. Fashionable art for a time became, to a large extent, the mere copying of Greek works. Finally, a deeper assimilation took place, and the art of imperial Rome emerged, a product of its richly varied heritage and its own unique genius.

This art-historical view of Roman art is comparatively new. Until about 1900, scholars saw Roman art merely as decadent Greek art, unoriginal and inferior. It is true that, drawing as it necessarily does on what went before, Roman art does not have the degree of originality that distinguishes the great styles of Egypt, Mesopotamia, Greece, or even Etruria. Yet it is more than a mere "propagator and preserver of the classical heritage"; it is the "first comprehensive stage of western European art." Roman art makes use of Classical forms, but expresses non-Classical concepts. It combines an interest in individual personality with an interest in such abstract concepts as "law," "state," and "civilization." The vast body of the material of Roman art—found on three continents, with much still not evaluated and with much more still underground—almost suggests methods of mass production, in which anonymous artists (virtually no names survive, in contrast with Roman writers and poets) became the servants of their patrons: private or public, wealthy connoisseur or the Roman state. Nevertheless, in the collective as well as in the individual case, Roman art has survived as an imposing style that took its own course in the days of the late republic.

THE REPUBLICAN PERIOD

The Roman republic was founded after the last of the (possibly Etruscan) kings had been driven out of Italy. From the fifth century B.C. to the collapse of the republic and the assassination of Julius Caesar in 44 B.C., the external business of Rome was expansion abroad and the consolidation of imperial power in the

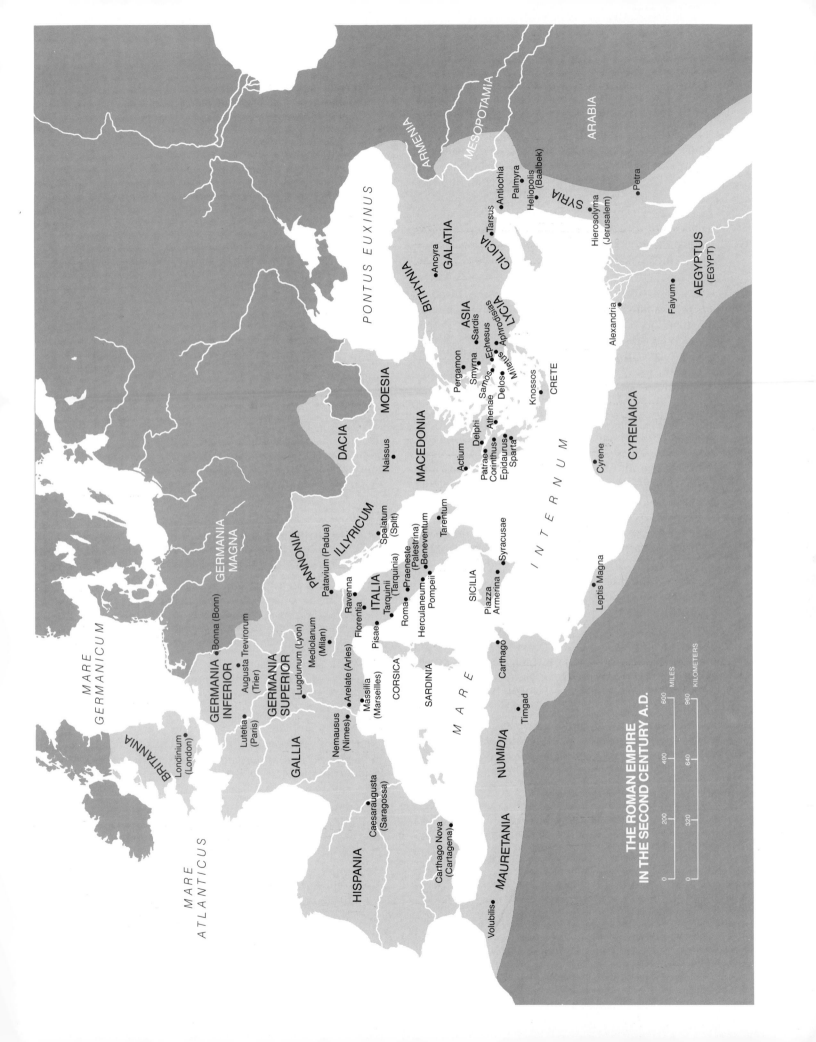

THE ROMAN EMPIRE
IN THE SECOND CENTURY A.D.

Western world. In a succession of wars, the most harrowing and dangerous of which were the wars with Carthage, the Romans developed their peculiar qualities of character: disciplined valor, tenacity, practicality, obedience to authority, and a pitiless realism in recognizing the facts of power. Yet the constitutional structure of the republic, adequate to a limited city-state, could not begin to meet the requirements of an empire. Internal quarrels between the *patrician* and the *plebeian* classes were inflamed by disputes over disposition of the enormous wealth won abroad. When successful armies led by popular generals intervened in the politics of the republic, civil war began. The war, which lasted almost a hundred years, exhausted the state and destroyed its constitution; dictators like Marius, Sulla, Caesar, and Pompey ruled. When the great-nephew of Julius Caesar, Octavian (who called himself Augustus), finally found himself alone at the head of the Roman polity, the republic was little more than a pious, ritualized memory.

It is in this period of the crisis of the republic, even while Greek influence became increasingly strong, that Roman art began to emerge as an entity distinguishable from the Late Hellenistic style. In 146 B.C., when Greece was absorbed into the Roman Empire as the province of Achaea, a sculptural style came into being that we call *Greco-Roman*. The coining of this term is an admission that the two styles cannot be readily separated. Much of the original sculpture of the period was produced by immigrant Greek artists, like the sculptor (perhaps Apollonius) of the *Seated Boxer* (FIG. 5-86). But the growing Roman fascination with individual traits of personality is apparent in portrait sculpture, a field in which the Romans made one of their most original contributions (the others being architecture and landscape painting) and one in which they achieved a quite typical, uncompromising, and often unflattering realism. However, the Hellenizing idealism that is found balancing this hard Roman realism in the last days of the republic bears witness to the peculiar dualism in the Roman attitude toward the defeated Greeks: admiration for their art and grace was mixed with contempt for their "unmanly" cleverness and for their lack of skill in managing their own affairs as a people. Cicero described this Roman ambiguity of sentiment and scored the Greeks on their un-Roman insincerity in terms a little like those of nineteenth-century American travelers commenting on the French:

> I grant them literature, I grant them a knowledge of many arts, I do not deny the charm of their speech, the keenness of their intellects, the richness of their diction; finally, if they make other claims, I do not deny them. But truth and honor in giving testimony that nation has never cherished. . . . Greeks never trouble to prove what they say, but only make a display of themselves by talking.

Still, somehow it was the idealism of Greek art that again and again captivated the Romans. Greek statues in great profusion stood in the Roman forums and in both public and private buildings; villas and baths were museums of Greek sculpture, filled with originals, copies, or adaptations suited to Roman taste. We read of 285 bronze and 30 marble statues brought from Corinth in 146 B.C., after the barbarous sack of that city, and of 500 bronzes brought from Delphi by Nero; when the stockpile of originals ran low, the demand for Greek sculpture was satisfied by copies of Greek works.

Portrait Sculpture

Even while under the spell of Hellenism, Roman portraitists produced works that have no parallel in Greek art. During the Hellenistic period, the quality of generalization that had distinguished earlier portraits already had given way to a style that was more particularizing and descriptive. The Roman's desire for literalness, together with the custom of keeping in the house, always before one's eyes, the *imagines* (death masks, usually of wax) of one's ancestors, influenced sculptors to accentuate individual traits still further. Etruscan influence, with its expressionistic realism, also persisted in Late Republican portraiture. The *Head of a Roman* (FIG. 6-14), for example, is striking by virtue of its "character"—at once alive and masklike. But the character may simply be accidental, the result of the artist's painstaking report of each rise and fall, each bulge and fold, of the facial surface, executed as if the sculptor were proceeding like a mapmaker, concerned not to miss the slightest detail of surface change. The artist apparently tries neither to idealize the subject—that is, to improve him in conformity with an ideal, as in Greek practice—nor to interpret his personality. The blunt and bald record of his features, the kind given by a life mask or a death mask, is quite enough. Thus, this *verism, a kind of superrealism,* is the artist's objective, and it is determined not so much by esthetic motives as by religious convention. The habit of mind that demands faithful records of this kind is similar to our curiosity about the fidelity of photographs of our forebears.

A quite different approach to the portrait subject can be seen in a head (probably from a statue) of *Pompey the Great* (FIG. 6-15). A sculptor confronting a powerful and famous man may be conscious of the need for a method different from mere recording; the goal may be to idealize, but also to personalize—to inter-

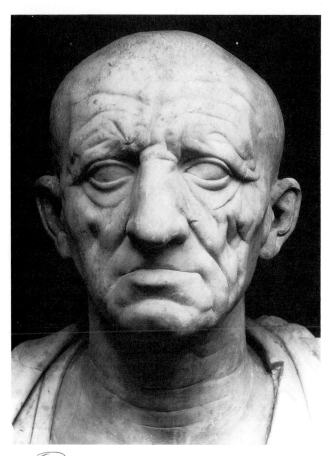

6-14 *Head of a Roman, c.* 80 B.C. Marble, life size. Palazzo Torlonia, Rome.

6-15 *Pompey the Great, c.* 55 B.C. Marble, life size. Frank E. Brown Collection, Rome.

pret the subject's personality. Viewing this head two thousand years after Pompey lived, we scan his face with far more knowledge of the man than we could ever bring to the contemplation of a portrait of an unknown Roman. Pompey was first the partner and then the rival of Julius Caesar in the devastating civil war that wrecked the Roman republic in the first century B.C. We know of him as a great general, successful in war and the near proprietor of all the Eastern world held by Rome. We know of him also as a political incompetent and as an ambitious man of the middle class who allowed himself to be made the dupe of the extremists of the Senatorial party. We know of him as hopelessly irresolute, a man who disappointed even his closest friends because he was unable to make up his mind. We know that he lost to Caesar in the bloody battle of Pharsalus, after which he was ignominiously assassinated by one of his own men. Yet he was a good man who refused to enrich himself by plunder of the provinces, a practice from which most of his contemporaries did not refrain. Cicero wrote of Pompey to a friend: "I knew him as a man honest, grave, and high-minded." ·

Thus, Pompey is a complex of traits played on by the accidents of history. Yet what kind of man of only slightly more than good talent could have bested Caesar? Knowing what we do about Pompey's main strengths and weaknesses, his triumphs and ultimate failure, we naturally approach his portrait as we might approach a bust of Washington or Lafayette—with curiosity about the individual man and his history. In the same way, it is likely that the artist of this work, although different from us in general cultural responses, would still have cared to make a likeness that would be more than a mere facial record. This desire is evident in this head, which has none of the rigidity of the death mask and possesses a subtly modeled surface, over which the light plays softly. The modeling is obviously contrived to suggest rather than to describe. The strong lines of the broad head and the somewhat flat surfaces of the face are softened by a curiously ambiguous expression. Would we be wrong to read in it self-doubt mingled with affectation or bluster under an official mask of power? At any rate, the very fact that we are tempted to such interpretation testifies to the sophisticated artist's power to make us thoughtful before this image of a great and unfortunate man.

Architecture

As striking as the manifestation of Roman originality is in naturalistic portraiture, it is even more pronounced in Roman architecture. During the Republican period, the Roman identity was first and most fully expressed in architecture and city planning. Unlike the religious architecture of the civilizations that preceded it (including that of the Greeks), the Roman temple was not particularly inventive or conspicuous. Although they built temples modeled on plans that blended Greek and Etruscan elements in unique fashion, Roman builders concentrated on imposing and utilitarian civic structures and plans. The Temple of "Fortuna Virilis" in Rome (FIG. **6-16**), dating from the late second century B.C., looks at first glance like an Ionic, peripteral temple. Now thought to have been dedicated to Portunus, god of the harbor, and standing appropriately on the banks of the Tiber River, this structure consists of a large cella located behind a deep porch. But the building stands on a high podium, which may be of Etruscan origin (see FIG. 6-1), and the cella occupies its entire width. This layout means that only the porch columns are freestanding and that the columns along the exterior walls of the cella are *engaged,* being purely decorative and having no supporting function. Seen from a distance, the engaged columns give the illusion of being freestanding; this type of construction is therefore designated *pseudoperipteral.* As a favorite with Roman builders, this temple type has survived in many examples, most of them larger than the one shown and most employing the Corinthian order.

6-16 Temple of "Fortuna Virilis," Rome, late second century B.C.

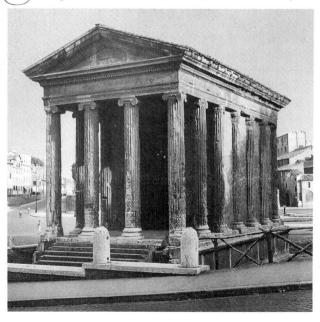

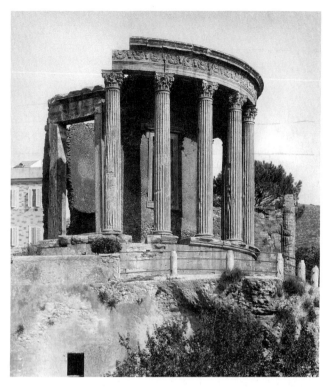

6-17 Temple of the "Sibyl" ("Vesta"?), Tivoli (ancient Tibur), Italy, early first century B.C.

The same superficial resemblance to Greek architecture appears in the Temple of the "Sibyl" (or "Vesta"?, FIG. **6-17**) at Tivoli (ancient Tibur). Built in the early first century B.C., the temple looks at first like a Corinthian tholos. However, like the "Fortuna Virilis," it stands on a podium and is accessible by means of a single flight of stairs that leads to the entrance of the cella. This arrangement introduces an axial alignment not found in Greek tholoi and serves to lessen the isolation of the building from its surroundings, diminishing somewhat the independent sculptural aspect so prized by the Greeks. A closer examination of the Temple of the "Sibyl" reveals other un-Greek features. The columns are *monolithic* (all of one piece) and not built up in the drum sections that were usual with the Greeks; the Romans preferred to use the monolithic column, often on a great scale, wherever possible. The frieze is embellished not with figure sculpture, as would be the case in Greece, but with a favorite Roman decorative motif—garlands held up by the heads of oxen—that repeats rhythmically around the whole frieze. (These are not the *bucrania,* or ox skulls, that became popular in later imperial architecture.) Finally, and also in contrast with Greek practice, the cella wall is built, not of cut stone, but of concrete, into which blocks of tufa have been set in an ornamental pattern.

6-18 Sanctuary of Fortuna Primigenia, Palestrina, Italy, 120–80 B.C. (?)

These significant departures from the Greek model are seen even more clearly in the sanctuary at Palestrina (FIGS. **6-18** and **6-19**), which was dedicated to Fortuna Primigenia. The sanctuary was built under Sulla, the first Roman dictator of the republic, around 80 B.C., at a site where oracular lots had long been cast. (The date is disputed; some scholars move it back forty to fifty years.) The great size of the sanctuary reflects the growing taste for colossal Hellenistic designs during the Late Republican period. Seven terraces rising against the hillside were placed with rigid, axial symmetry. The top terrace carried a semicircular, double colonnade that probably enclosed a small, round temple. We have full knowledge of the great temple only by an accident of war: Palestrina, modern successor of the medieval town that had been built over Praeneste, was bombed during World War II, and clearing of the resultant ruins disclosed the impressive remains of the Roman buildings. The Roman builders had converted an entire hillside here into a man-made design in a symbolic and ostentatious display of power and dominion. This assertive

6-19 Model of the reconstructed Sanctuary of Fortuna Primigenia. Museo Archeologico Nazionale, Palestrina.

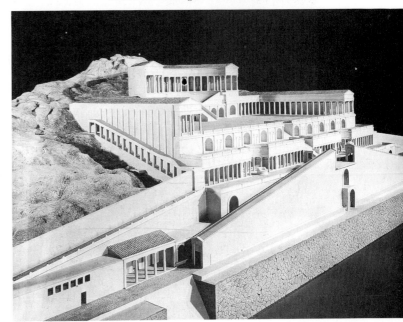

subjection of nature to man's will and rational order is the first full-blown manifestation of the Roman imperial spirit and contrasts with the more restrained Greek practice of crowning a chosen hill with sacred buildings rather than transforming the hill itself into architecture.

The substructures for the terraces (FIG. **6-20**) were built in concrete *(opus caementicium)*, a favorite Roman building material. Roman concrete was a mixture of lime mortar, water, and volcanic dust (found in limited areas, chiefly in central Italy). Developed in the second century B.C. and applied for centuries wherever the necessary ingredients were available, concrete (of generally inferior quality) had been used in the Near East, chiefly for the building of fortification walls, but its combination with the arch and the vault, as here at Praeneste, was revolutionary. As perfected during the Early Imperial period, concrete vaulting permitted Roman builders to cover spaces of unprecedented scale, without interior supports. Its use enabled the Roman architect to think of architecture in radically different terms from those of earlier builders—as an architecture of space rather than of sheer mass, as was the case with the Egyptian pyramid, or the Mesopotamian ziggurat, or even the lighter, but still space-encumbering, post-and-lintel system of the Greeks. (See the discussion of the Roman Pantheon, pages 226–28.) Roman concrete was poured over rubble that had been laid in courses between forms. Once solidified, this rubble concrete was cohesive and strong, although rough in appearance; it was Roman custom, however, to face the rough surfaces with marble slabs, plaster, or ornamental brickwork or stonework. In Praeneste, the concrete is faced with small, flat, irregularly shaped stones that produce a figuration called *opus incertum*.

In the eighteenth century, the imagination of Europe was excited by the discovery of the buried cities of Pompeii and Herculaneum, which had been overwhelmed by an eruption of Mount Vesuvius in A.D. 79. The discovery of these cities, prior to the first archeological expeditions to Egypt, fascinated Europe and provided the initial impetus for modern archeological curiosity. What made the discoveries of such poignant human interest, as well as so infinitely valuable for scientific history, was that they revealed to modern eyes, in almost perfect preservation and detail, the everyday communal life of these times and places past. Pompeii, a prosperous city of about twenty thousand inhabitants, had been preserved intact in volcanic ashes, invisible and forgotten for some sixteen hundred years. The remains of the city, which are still being excavated, permit us to reconstruct the Roman way of life during the Early Imperial period with a completeness far beyond that achieved at any other archeological site. The fullness of the archeological record, the city's appeal to our sense of the dramatic and terrible accidents of life, and its use-

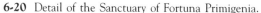

6-20 Detail of the Sanctuary of Fortuna Primigenia.

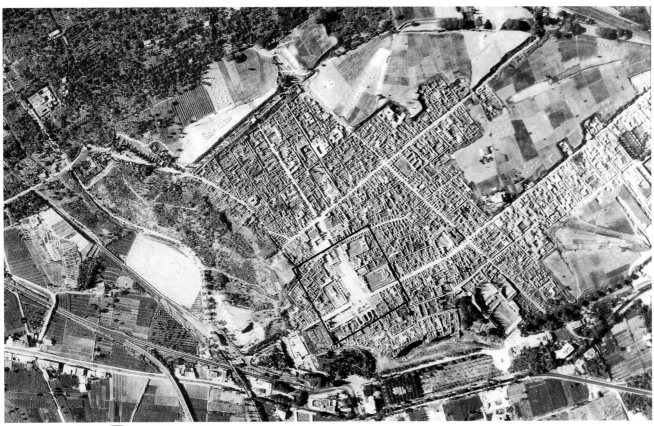

6-21 Aerial view of the excavated portion of Pompeii, Italy. Area enclosed by rectangle near center of photograph is shown in FIG. 6-22.

fulness for describing the architectural and artistic environment of quite ordinary people in an ancient city warrant considerable attention.

Although destroyed during the Early Imperial period, the city and many of its architectural monuments date from the Republican period. The plan of Pompeii, as seen in the parts excavated thus far (FIG. **6-21**), is not that of the ideal castrum type (see pages 218–19), but rather the irregular plan of a "grown" city that was subjected to revisions and regularizing at various periods. The Roman castrum type of city plan, based on the layout of a military camp, was used in the outlying, frontier, colonial regions and had its major development during the Early Imperial period (see FIG. 6-44), although an early form of it was used at Ostia in the fourth century B.C. Pompeii started as a small, unplanned settlement in the vicinity of the Greek colony of Naples (ancient Neapolis). The Oscans, early local rivals of the Romans, founded it in the sixth century B.C. It was seized in 425 B.C. by the Samnites, also rivals of the Romans, who fortified and replanned it under the influence of expanding Greek concepts of rational, urban planning. But the Greek grid system could not be applied rigidly without tearing down most of the city; as a result, the main organizing features—the north–south and east–west thoroughfares—do not intersect at right angles, and the blocks between them are irregular. The city was conquered by Sulla in the 80s and refounded as a Roman colony in 80 B.C. In A.D. 62, it was partially destroyed by an earthquake and had not yet been entirely rebuilt at the time of its final destruction seventeen years later. Pompeii has been especially valuable to the historian of Roman architecture; many building types that later were to become standard are found there, including the oldest amphitheater extant and the earliest known public baths.

Next to the Forum Romanum in Rome, from which it differs significantly in design, the forum of Pompeii (FIGS. **6-22** and **6-23**) is the most important example of an early Roman civic center. The Pompeian forum is a rectangular court in the proportion of $3\frac{1}{2}:1$, unified by continuous colonnades around three sides, which define its boundaries. The other type of plan, represented by the Forum Romanum, is bordered by more monumental, but individual and disconnected, structures. Like most Roman forums, the Pompeian forum was set apart from major traffic arteries and vehicles could not enter it. Its long, north–south axis is dominated by the Temple of Jupiter, a large temple set on a

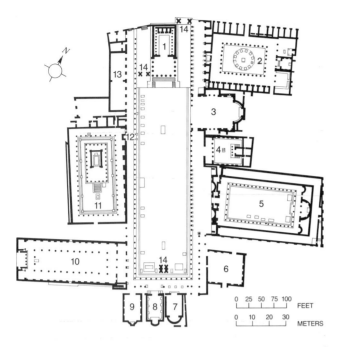

1. Temple of Jupiter
2. Macellum (provisions market)
3. Sanctuary of the City Lares
4. Temple of Vespasian
5. Building of Eumachia (fullers hall)
6. Comitium (voting hall)
7. Duovirs' (chief magistrates') office
8. Council chamber
9. Aediles' (junior magistrates') office
10. Basilica
11. Temple of Apollo
12. Control of weights and measures
13. Cereals market
14. Commemorative arches

6-22 Plan of the forum of Pompeii. Area diagrammed is indicated in FIG. 6-21 by rectangle inscribed near center of photograph.

high podium and dedicated to the three gods who protected Rome and her colonies. The Romans liked to place their temples in a dominant position at the end of an enclosure, in contrast to the Greek practice of building freestanding temples in sanctuaries where they could be seen and approached from all sides. Several smaller temples flank the long sides of the forum. At the south end stand the triple halls of the Curia (city council), representing civic authority, and the Basilica, the seat of law and business. This basilica, dating back to about 100 B.C., is an early example of one of the most important and influential classes of Roman buildings, the one from which the basic form of the Christian church building will derive. Thus, the forum combines the functions of a religious, commercial, and administrative civic center. In the same way, it is a kind of imperial center in miniature, and this combination of functions, as architecturally expressed in the Roman forum, would come to represent the central concerns and focus of the whole Roman Empire.

One would not expect the formality of a civic center also to be found in the streets that surround it. These, logically, would be less monumental and regular, their spaces less ample or perhaps even narrow and cramped. The streets had heavy flagstone pavements with flanking sidewalks. Stepping-stones for pedestrians crossing the street were spaced so that they could be straddled by the wheels of vehicles. Most

6-23 Forum of Pompeii

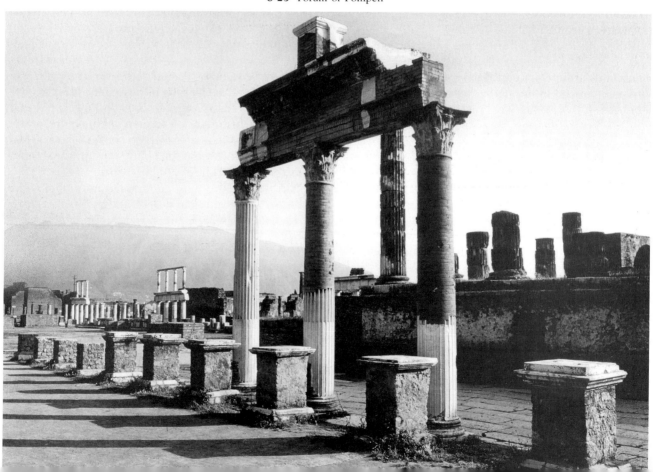

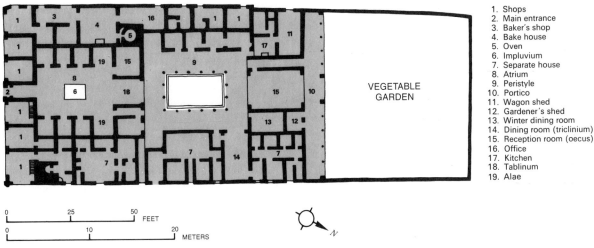

1. Shops
2. Main entrance
3. Baker's shop
4. Bake house
5. Oven
6. Impluvium
7. Separate house
8. Atrium
9. Peristyle
10. Portico
11. Wagon shed
12. Gardener's shed
13. Winter dining room
14. Dining room (triclinium)
15. Reception room (oecus)
16. Office
17. Kitchen
18. Tablinum
19. Alae

6-24 Plan of the House of Pansa, Pompeii, second century B.C.
(After Sir Banister Fletcher.)

intersections had continuously flowing public fountains. The problem of human convenience in an urban society, although not dealt with on the enormous scale that it is today, was worked out in Pompeii with an efficiency we can believe suited the needs of the people. The town had its commercial sections, like that of the Via dell' Abbondanza, where rows of small shops, offices, taverns, and bakeries flanked the streets. We still can see many painted advertisements on the walls in this section. Here and there, the rows of shops were interrupted by a gateway leading into a private residence, which spread out in the back of the shops and was entirely enclosed and isolated from them and from the noise and dust of the street.

The private house is probably the most precious and best-preserved record of urban life to come from Pompeii. The town houses of the well-to-do, like the House of Pansa (FIG. **6-24**), were frequently protected in Pompeii and Herculaneum by the volcanic ash and lava in which they were buried, and are extraordinarily well preserved, with their mural decorations still fresh and some equipment and household utensils intact. Such a house, known as an atrium type, stood flush with the sidewalk. Through a narrow door, one entered a vestibule that led into the *atrium*. The latter had an opening in the center of the roof (the *compluvium*) to admit light and air and a depression in the floor below it (the *impluvium*) to collect rainwater. Along the sides were small rooms; at the end, where the atrium extended the full width of the building, were two wings, or *alae*. Behind the atrium was the *tablinum, in which family* archives and statues were kept. The tablinum could be shut off or, in later Pompeian houses, could afford a passage to the *peristyle,* a

large colonnaded court of Hellenistic origin. This court contained fountains and a garden, around which the family's private apartments were arranged. At the back, a vegetable garden or an orchard was sometimes planted. Along the outer sides of the house and opening onto the street were the shops. The house faced inward, depending on its courts for light and air. Whenever space allowed it, units were symmetrically arranged on a long axis that reached back from the street. When opened through its entire length, this arrangement afforded a charming vista of open court, gardens, fountains, statues, colored marbles, mosaics, and brightly painted walls. Some of the largest of these atrium houses in Pompeii could truly be called palatial; the House of the Faun, in which *The Battle of Issus* mosaic (FIG. 6-37) served as a floor ornament, covered almost 30,000 square feet. A typical modern suburban house measures roughly 1,500 square feet. Of course, these houses, popular particularly in the region around Mount Vesuvius, were the homes of patricians and rich merchants; artisans, craftsmen, and shopkeepers lived in much more modest quarters, often in single rooms in back of or above their shops.

In their fullest development in the late Roman republic, the elaborate, skillfully planned houses of the great Romans combined an older Italic nucleus with features of the Hellenistic house and represented the highest achievements of domestic architecture in antiquity. The character of Roman domestic religion, which exhibited a traditional Italic feeling for the home, family, and hearth as sacred, helps to explain the careful elaboration of domestic architecture and the prominent role it played in Roman civilization throughout the empire.

Painting and Mosaic

The interiorizing design, with its open and independent arrangement of units, guaranteed complete privacy in Roman houses. Because of the small number of doors and windows, the design also offered considerable stretches of wall space suitable for decoration, as the atrium of the House of the Silver Wedding in Pompeii (FIG. 6-25) clearly shows. The decorations commonly used varied between types that emphasized the wall as a barrier and others that visually opened the wall and enhanced the space of the room. The colors were sometimes delicate greens and tans, sometimes striking reds and black (to throw the panels or figures into relief), and a rich creamy white used in the borders. The Romans obtained a certain brilliance of surface by careful preparation of the wall. The plaster, specially compounded with marble dust, was laid on in several layers and beaten with a smooth trowel until it became very dense. The surface then was polished to a marblelike finish.

The progression from flat to spatial wall decoration in Pompeii and Herculaneum has been divided, somewhat arbitrarily, into four successive, but overlapping and often coexisting styles. The first style (c. 200–60 B.C.), called *incrustation*, divides the wall into bright, polychrome panels of solid colors with occasional, schematically rendered textural contrasts (FIG. 6-26). This style is a continuation of Hellenistic practice, and examples of it have been found in houses at Priene and on the island of Delos.

A wall painting from the Villa Boscoreale, near Pompeii (FIG. 6-27), shows the second, or *architectural*,

6-26 First-style (*incrustation*) wall painting from a Samnite house, Herculaneum, second century B.C.

6-27 Second-style (*architectural*) wall painting from the Villa Boscoreale, near Pompeii, first century B.C. Metropolitan Museum of Art, New York (Rogers Fund, 1903).

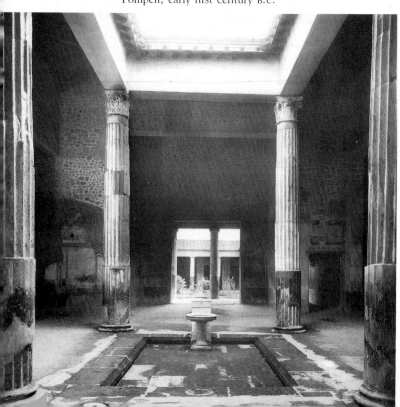

6-25 Atrium of the House of the Silver Wedding, Pompeii, early first century B.C.

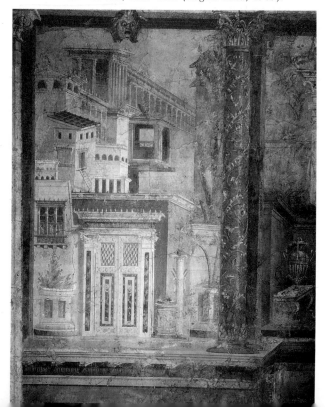

style (*c.* 60–20 B.C.), in which decoration is no longer restricted to a single visual plane. The space of the room is made to look as if it extends beyond the room itself by the representation of architectural forms in a visually convincing, but not really systematic, perspective. Columns, pilasters, and window frames painted on the wall serve to enframe distant views of cities and landscape. In the *herringbone perspective* used here, the *orthogonals*, or lines of perspective projection, do not converge on a single vanishing point on the horizon (as in Renaissance perspective); instead, several vanishing points (with associated orthogonals) tend to be distributed on an axis that runs vertically through the center of the panel. Although not consistently employed, this method does give a rather convincing illusion of objects receding in space. In halls over one story high, the architectural style is sometimes used to provide a firm, structural base for an upper register in a later style.

A second-style mural in the Villa of the Mysteries near Pompeii (*c.* 50 B.C.) displays painted figures that are among the finest to have come down to us from the ancient world (FIG. **6-28**). Although other rooms in the villa are decorated in a style very similar to the

pure architectural style of the Villa Boscoreale, the second-style illusionism here is confined to a painted ledge that looks like a shallow extension of the room proper and affords the figures a kind of narrow, supporting stage. The figures, set against a red-paneled background, in the style of a relief, are part of a large composition that circles the walls of the room, which may have doubled as a banqueting room and as a place for the celebration of the rites of some mystery cult, perhaps that of Dionysos. The meaning of these scenes is in dispute. We may, however, be fairly certain that this group represents the initiation of a young novice into the cult. Whipped by a winged genius or deity, the novice crouches for solace in the lap of a solicitous older woman, while a splendidly painted nude dances in Bacchic frenzy. The mystery cults, discussed later in connection with Christianity, made their way into the Roman Empire in increasing numbers from the Hellenized East. All cults included mysteries that were never to be divulged by the initiate, and that, when understood after painful introduction into the secret rites, would afford salvation through mystical union with a deity. The pictured ceremony from the Villa of the Mysteries is not only a

6-28 Second-style wall painting, details of a frieze from the Villa of the Mysteries, near Pompeii, c. 50 B.C. Figures approx. 60″ high.

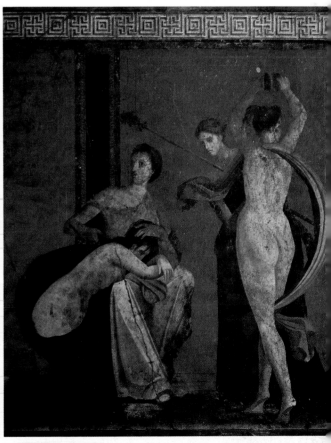

6-29 *Ulysses in the Land of the Lestrygonians* (scene from the *Odyssey Landscapes*), second-style wall painting from a house in Rome, late first century B.C. Approx. 60″ high. Vatican Library, Rome.

work of art of high order, but a most important record of one aspect of the gradual religious transformation of the Roman world by the westward migration of Oriental spiritualism. As always with Roman paintings of quality, we question whether this mural is an original Roman work or a derivative from a Hellenistic Greek original in some temple that is now lost. No decisive answer can be given.

The same question arises again, and more insistently, when we look at the second-style *Odyssey Landscapes* (FIG. **6-29**) from a house on the Esquiline Hill in Rome, which are now in the Vatican. In these landscapes, dating from the late first century B.C., painted piers divide the otherwise continuous stretch of landscape into eight compartments, in which scenes from the Homeric epic are represented. The shimmering landscapes extend the space of the room and their luminosity almost absorbs the subordinated, rapidly sketched figures. At the same time, the landscapes seem to be brought into the room almost magically—the flickering play of color and light, and especially the shaded edges of the solids, providing a stagelike presence, as of easily shifted props, that suggests distance and isolated action. The second

style, although "architectural," here exhibits its versatility, for the sole purpose of the rigid frames is to create the illusion of open and unconstrained landscape. If it could be established that the conception of an all-encompassing space in works like the *Odyssey Landscapes* is original with Rome, then a solid Roman contribution to the history of art could be acknowledged.

The architectural quality of the second style faded toward the end, and the triumph of the illusionism evident in the *Odyssey Landscapes* may be seen in the detail of a wall painting (FIG. **6-30**) from the House of Livia in Primaporta, near Rome, made toward the end of the first century B.C. The extension of the space of the room and its complementary effect, the bringing of the landscape into the room, creates an image of a garden just outside the limit of the wall. (This is a curious anticipation of the widely popular "picture window" of recent modern architecture, in which one enjoys the "view" by fixing it within a frame and at the same time thinking of the landscape as continuous with the room.) Here, deep perspectives and distant views are not desired, but rather the intimacy and freshness of natural beauty easily

6-30 *Garden Scene,* detail of a second-style wall painting from the House of Livia, Primaporta, late first century B.C. Portion shown approx. 9' wide. Museo Nazionale Romano, Rome.

6-31 Third-style (*ornate*) wall painting from a villa at Boscotrecase, near Pompeii, early first century A.D. Museo Nazionale, Naples.

within contact. In the second style, as it developed, the view comes ever closer, until one may think that it is one's own garden, free of any human intrusion, enclosed and isolated by the painted limits of the fence and by the backstopping of the foliage itself, which occupies a plane close to the viewer and shuts out distance.

In the third, or *ornate, style* (*c.* 20 B.C.–A.D. 60), during the time of the early Roman Empire, the wall ceased to serve as a framed view into nature and became a mere support for smaller, framed views. Simulated architecture disappeared, as the wall was subdivided into a number of panels by means of vertical and horizontal bands filled with vine scrolls or other decorative designs (FIG. **6-31**). The flat nature of the wall is here reaffirmed, and illusionism is confined to the pictures set into and emphasized by the decoratively patterned framework. At times whimsical and capricious, this style is characterized by delicate forms and colors, graceful elegance, and a deliberate rejection of the monumental constructions and broad illusionism of the second style. What might have become a view through an illusionistic window in the second style has been reduced here to a flat, white panel with a floating landscape motif on it.

The fourth Pompeian wall style, the *intricate,* dates from around A.D. 60 to A.D. 79 and may be seen to good advantage in the Ixion Room from the House of

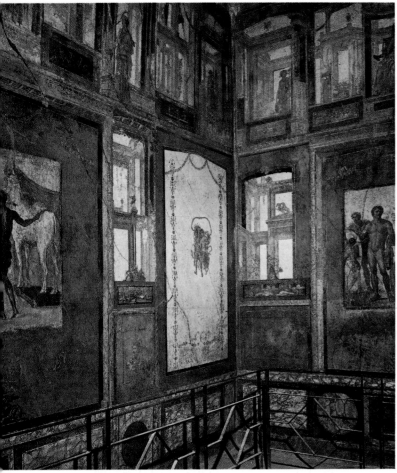

6-32 Fourth-style *(intricate)* wall painting from the Ixion Room, House of the Vetii, Pompeii, first century A.D.

the Vetii (FIG. 6-32). Here, under the influence of contemporary Roman theatrical design, the painters returned to the use of architectural frames and open vistas. However, an aerial perspective, rather than a linear one, is created by areas of color flooded with light and atmosphere, which unite the wall in a complex way, incorporating all the lessons of previous experiments in optical illusion. In fact, the fourth style is a kind of résumé of its predecessors. The incrustation style appears along the lower walls, and architectural panels are set into the ornate, third-style wall articulation, which is also reflected in the individual picture panels. Although the aerial perspective produces a certain unifying effect, the designs cannot be taken in or related to one another from any single point of view; obviously, the artists intended that we pass the pictures as we do in a gallery, stopping at each one, aware that it need have no relationship in subject or style to its neighbor.

A masterpiece of the fourth style (FIG. 6-33), from the Domus Aurea of the emperor Nero (A.D. 54–68) in Rome, is an earlier and more austere design preceding the compositional intricacies of the Ixion Room paintings. Here, the paintings exhibit the greatest elegance and delicacy in the placing and rendering of details and in the proportions and spacing of the panels. The artist makes a virtue of vacant space and slender enframements, avoiding all crowding and busyness. The effect is one of precise symmetry, but with subtle variations of balancing. The color scheme is a harmony of white, gold, and accents of

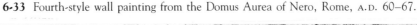

6-33 Fourth-style wall painting from the Domus Aurea of Nero, Rome, A.D. 60–67.

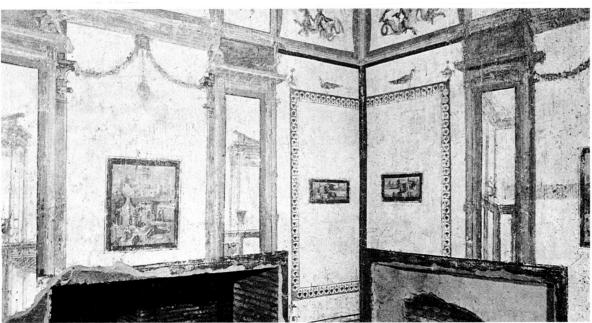

blue, deftly placed. The ornamental vocabulary is limited intentionally to a few motifs: in the transom panels, masks and sea-gods; below, birds, garlands, and architectural vistas. Centered in the main panels are framed landscapes, providing windowlike extensions of the space of the room. In the history of ancient painting and interior decoration, this work has scarcely an equal.

A still life with peaches and a carafe, a detail of a larger mural from Herculaneum (FIG. **6-34**), demonstrates that the Roman painter sought illusionistic effects in depicting small objects as much as in depicting architectural forms and landscape spaces. Here, the method used involves light and shade, with scrupulous attention to contour shadows and to highlights; undoubtedly, the artist worked directly from an arrangement made specifically for this painting. The fruit, the stem and leaves, and the translucent jar were set out on shelves to give the illusion of the casual, almost accidental, relationship of objects in a cupboard. But the picture is exact in neither drawing nor perspective, and the light and shade are approximate. Still, the illusion the painter contrives here marks the point of furthest advancement made by the ancients in the technique of representation. The artist seems to have an inkling that the look of things is a function of light. The goal is to paint light as one would strive to paint the touchable object that reflects and absorbs it. Painters like Paul Cézanne—often

6-34 *Still Life with Peaches,* from Herculaneum, *c.* A.D. 50. Detail of a wall painting transferred to wood, approx. 14″ × 13½″. Museo Nazionale, Naples.

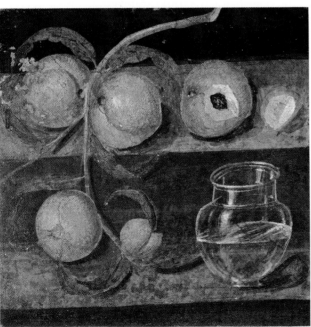

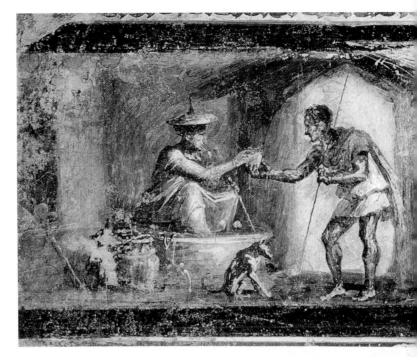

6-35 Genre scene (?) from the House of the Dioscuri, Pompeii, first century A.D. Detail of a wall painting transferred to wood, entire painting approx. 15″ × 17″. Museo Nazionale, Naples.

called the founder of modern art—in discarding the systematic, organizing devices of perspective and chiaroscuro (light and dark), produced distortions and irregularities in painted objects that resemble those of this ancient still life. It is unlikely, however, that Cézanne was familiar with Roman painting.

A painting from the House of the Dioscuri in Pompeii (FIG. **6-35**) offers evidence of the skillful illusionism achieved by the painters of the fourth style. The subject may be a scene from mythology or a genre scene. A woman seated before a stone building and a small hut receives a cup from a bowing man or perhaps extends the cup to him. It is difficult to decide. Whatever the interpretation, the brush technique is a deft impressionism, the strokes firm and practiced. The painter is entirely sure of the poses and the relationship of the figures in space. The problems of figural attitude, anatomy, movement, and proportion, which we have seen confronting the ancient artist for millennia, seem now to have their familiar solutions, so that the artist of this work proceeds easily and confidently, the paintbrush quickly expressing the painter's knowledge.

The style of the Dioscuri painting was contemporaneous with other, quite different styles. Several differences are apparent in a painting from Herculaneum that represents Herakles finding the infant Telephos being nursed by a doe in Arcadia (FIG. **6-36**).

The subject indicates that the picture was copied from one or more Hellenistic originals. One likely source of inspiration is the great Altar of Zeus and Athena at Pergamon (FIG. 5-77), where the inner frieze is devoted to the legend of Telephos and includes this theme. In the Herculaneum painting, the artist proceeds as if lifting figures from different sources and arranging them with little relationship to one another. Thus, the personification of Arcadia, the large seated figure, is not in proportion to Herakles, nor is their treatment the same. The statuesque Arcadia exhibits the pale, hard modeling we associate with sculpture, while the play of light and highlight on the supple surfaces of the Herakles figure is related to the effects we expect in pictorial illusionism, though the technique is by no means the free, "painterly" one we see in the Dioscuri work. All the figures are precisely modeled, with firm outlines. The artist is concerned chiefly with the solid volumes of the bodies, not with light or with the space the whole group occupies; each figure is contained, as it were, by its own particular space, the space it "fits." The depiction of space as an enveloping and unifying factor in

6-36 *Herakles and Telephos*, from Herculaneum, c. A.D. 70, after an original from the second century B.C. Wall painting, approx. 7' 2" × 6' 2". Museo Archeological Nazionale, Naples.

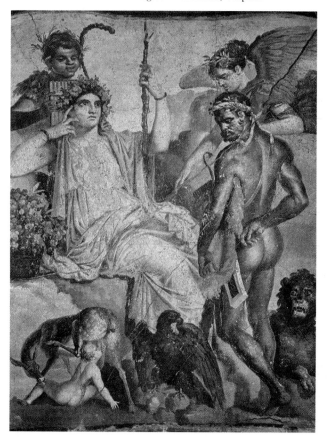

pictorial design may not be characteristic in Greek art, and this picture, as we have said, copies a Greek model. On the other hand, the special Roman contribution to painting may be precisely the representation of space as surrounding the whole group of objects and figures in any given composition, rather than merely coming between them.

It still seems to be a general tendency to deny any originality in Roman paintings and to insist that they are direct copies of, or closely inspired by, Hellenistic originals. Many Roman paintings do appear to be direct copies, among them the *Herakles and Telephos* just discussed and *The Battle of Issus* mosaic shown in FIG. 6-37. In fact, many paintings were probably done by transplanted Greek artists, and we might even grant that the Greek-derived style was the dominant one. But the Roman *landscape* seems to represent a radically different approach, particularly in its expression of a concept of space that simply is not evident in Greek art, and all attempts to derive Roman landscape painting from Hellenistic Greece lead us into extremely tenuous speculation based on unknown (or nonexistent) Greek prototypes. All extant Greek works show the Greek artist thinking in terms of solid volumes, like those of human figures (as in the *Herakles and Telephos* painting), and confining the role of space to a mere separating function, rather than an all-containing one. Thus, it might be much simpler to credit the Romans with the development of a new concept in painting: the projection of an enveloping, unifying volume of space on a flat surface. This refinement of abstraction, in which space, filled with air and light, is actually represented as being just as real as the objects it surrounds and contains, would complete the long development of representation that began with the silhouettes of early Egypt and Mesopotamia, or even earlier. At any rate, many now accept the view that the architectural illusionism of the second style was a Roman development and that this illusionism was a step in the transition to the spaces depicted in the smaller landscape panels (FIG. 6-31). For an artist thinking of the wall surface as a kind of extension of the space of the room (as in architectural illusionism), the next step would be to take a segment of the wall and convert it, windowlike, into a small block of framed space that extends "through" the wall and contains its own little universe of depicted objects.

In any case, the artist of the fourth style, chiefly interested in representing space, made the objects as small as possible and unified the whole composition, as we have seen, with light and atmosphere. Of course, recession in depth is suggested, not accurately projected. The Romans had no system of mathematical perspective. Instead, they employed (effec-

tively, if unsystematically) the diminution of figures and objects and, particularly, atmospheric perspective, with its hazed and sketchy outlines, the shift from local color toward blue, and the blurring of distant contours (compare FIG. 6-29).

The love of country life and the idealizing of nature—what we may call the Arcadian spirit—prevails in these landscapes. Characteristically, they contain shepherds, goats, fauns, little temples, garlanded columns, copses of trees, and other accessories, which from their part religious, part idyllic mood have been called *sacral-idyllic* scenes (FIG. 6-31). The Arcadian spirit of the time speaks in the formal, pastoral poetry of Vergil, and in one of his odes, Horace, proclaiming the satisfactions afforded the city man by his villa in the countryside, where life is beautiful, simple, and natural in contrast with the urban greed for gold and power, asks, ''Why should I change my Sabine dale for splendor full of trouble?''

The attitude that celebrates the virtues of rustic life must be associated very closely with an original Roman development in architecture. Many Arcadian landscapes have been found in *villas*—country residences developed by the Romans when congestion in the cities became severe, as it did in Pompeii during the first century B.C. The villas were located close to town (one might call them ''suburban''), so that their wealthy owners could enjoy the advantages of city life and the quiet of the countryside. The very spaciousness of the landscape around the villa came to be the subject matter of the wall paintings we have been examining. The modern desire to escape the tensions of the city and to return to nature is ancient in its architectural and pictorial expression, not to mention its appearance in literature. We will encounter this Arcadianism again and again in the history of the West, in the Renaissance and in the nineteenth and twentieth centuries, as urban pressures begin to strain human nerves.

The floors as well as the walls of Roman buildings were ornamented, usually in mosaics. *Mosaic* had its beginnings in the ancient Near East (see pages 184–85). It was used by the Greeks, often in geometric patterns, in place of carpets. The Romans continued the practice and, from the first century A.D. on, even applied mosaic to walls.* A striking aspect of Roman mosaics is the frequent attempt to copy not only the subject matter of painting but also the painter's technique in modeling, shading, and the like. Use of this technique was possible only if extremely small *tesserae* (the bits of glass or stone composing the mosaic) were used, as, for example, in the famous mosaic from the House of the Faun in Pompeii (FIG. 6-37), which, according to a widely accepted theory, is a copy of a

*The Romans used the words *tesselatum* (hence, *tesserae*) for floor mosaics and *musivum* (source of *mosaic*) for wall mosaics.

6-37 *The Battle of Issus*, from the House of the Faun, Pompeii, *c.* 80 B.C. Mosaic, approx. 8' 10" × 16' 9". Museo Nazionale, Naples.

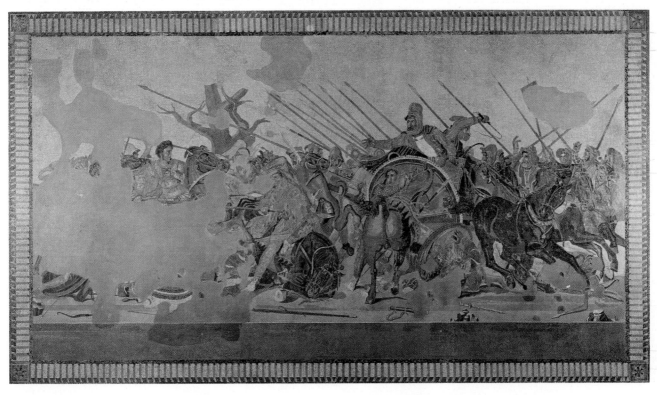

painting by the Hellenistic painter Philoxenos of Eretria. The mosaic, which represents the rout of Darius and his army by Alexander the Great at the battle of Issus, has those qualities of Greek style we have noted: the essentially sculpturesque emphasis on the solid forms, space defined by the forms themselves, and no attempt to show an enveloping space. Nevertheless, a remarkable taste for fidelity to appearance is shown in the details of action. The horses plunge into and out of the picture at the most daring angles, and the human figures are posed in such a variety of descriptive attitudes as to convince us that the artist was pursuing an ultimate realism. In keeping with this pursuit is the high degree of tonal smoothness achieved by the setting-in of tesserae so small that some fifty separate bits were used to model a single eye perhaps 1½ inches wide. The Romans appear to have developed a taste for this kind of minute workmanship, and the technical quality of mosaics must have been judged by the size of the tesserae used—the smaller, the better. Since, after all, the mosaics were seen at a distance of only five or six feet (one walked on them), such a criterion seems natural enough. The standard changed during the Early Christian period, when mosaics were placed high on church walls and apse vaults, making such minute differences scarcely noticeable and such painstaking technique meaningless.

The vast range of subjects represented in mosaics is comparable to that found in Roman painting. Themes from classical mythology vied in popularity with historical subjects or with topical ones, such as genre aspects of rural existence and scenes from the popular theater, gladiatorial battles, chariot races, and hunting.

Stylistically, the development was toward simplification of the extremely complex and detailed work exemplified in *The Battle of Issus* mosaic (FIG. 6-37). Tesserae tended to become larger, the designs, flatter and less illusionistic. From the middle of the first century A.D. on, human figures and animal forms appeared in black silhouette on white ground, prefacing the black and white mosaics that were to become the favorite floor decorations in Italy during the second and third centuries A.D. These floor mosaics were especially popular in bathing establishments, and a masterpiece of this type was found in the Baths of Neptune at Ostia (FIG. 6-38). Here, appropriately enough, marine divinities, accompanied by Nereids and Tritons, are carried across the waters by dolphins

6-38 Floor mosaic from the Baths of Neptune, Ostia, second century A.D.

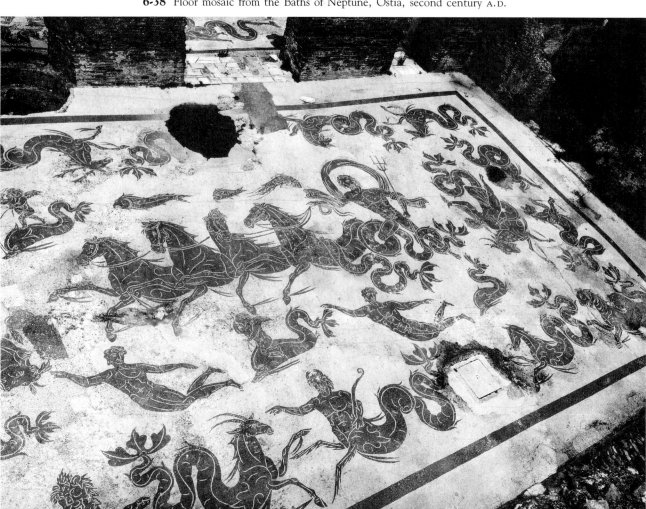

and horses with fish-tail bodies. The fluid, dynamic design is based on a repetition of curvilinear forms that evokes the movement of the sea.

During the second and third centuries A.D., polychrome mosaics also moved up from the floors—at first, to decorate grottoes and fountains, but eventually to cover walls. Less exposed to wear from sandaled feet, wall mosaics permitted the use of relatively fragile materials, such as glass paste (*smalto*) and enamel, and the achievement of stronger coloristic effects than were possible with colored stone or marble tesserae. The brilliant blue of the wall mosaic in the House of Neptune and Amphitrite in Herculaneum (FIG. **6-39**), achieved largely through the liberal use of smalto, also contributes to the rich tonality in the modeling of the figures, recalling the glassy surfaces in the Herakles figure from *Herakles and Telephos* (FIG. 6-36).

Painting, with all its advanced illusionistic devices, remains the standard for mosaic representation. What was achieved by way of subtle, pictorial effect can be seen equally in mural painting and, on a smaller scale, in the painted panel. We may judge the quality of panel painting by a portrait from Faiyum in Egypt, some sixty miles south of modern Cairo (FIG.

6-40). In Greek and Roman times, Faiyum was a busy, populous province, and its cemeteries have yielded some six hundred portraits painted on wood panels attached to the mummy cases of the deceased. The making of such portraits must have been a regional custom, as very few have been found elsewhere; they provide for us our largest gallery of ordinary people from the vast Roman imperial world when it was at the height of its power. Some Pompeian wall frescoes hint at what Greek murals may have looked like, but the Faiyum portraits give us the best idea we have of Hellenistic Greek painting techniques. Most of the portraits were done using the *encaustic* technique (pigments in hot wax; see pages 137–38), but *tempera* (pigments in egg yolk) also was used occasionally. Easel painting, on small, portable panels, had been highly esteemed in Greece, where the encaustic technique had a long tradition. Polygnotos had worked in encaustic in Classical times, and, as mentioned earlier, it had been used for the architectural decoration of buildings like the Parthenon. The example here (FIG. 6-40) shows the very highest level of craftsmanship: refined brushwork, soft and delicate modeling, and the subtlest possible reading of a sensitive subject. The Faiyum portraits

6-39 Wall mosaic from the House of Neptune and Amphitrite, Herculaneum, c. A.D. 70.

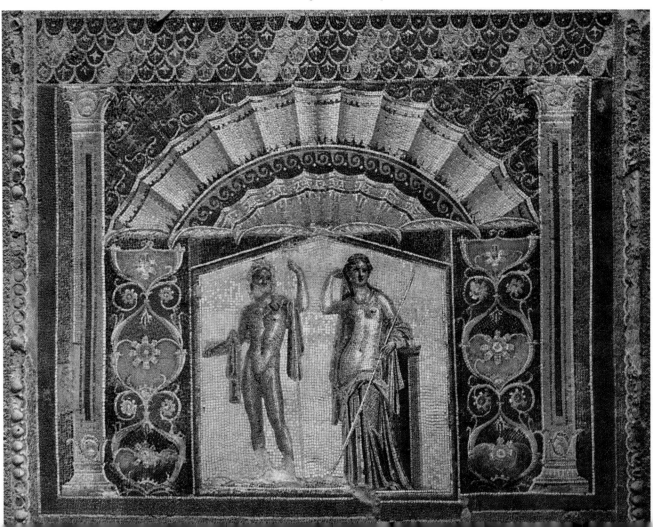

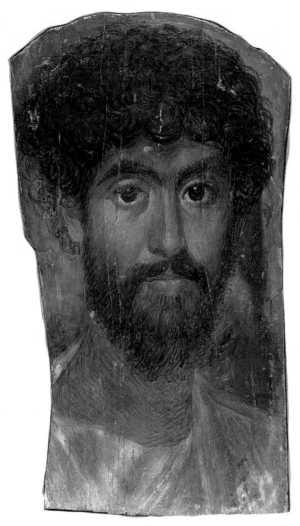

6-40 *Mummy Portrait of a Man*, from Faiyum, Egypt, c. A.D. 160–170. Encaustic painting on wooden mummy case, approx. 13¾″ × 8″. Albright-Knox Art Gallery, Buffalo (Charles Clifton Fund, 1938).

probably were painted from living persons, and, in this instance, we have the meeting of an unusually perceptive artist with a subject whose personality would require all of the artist's skill to render. The composure, the emphasized, thoughtful eyes, and the Hellenizing hairstyle are familiar in portraits made during the time of the Stoic emperor Marcus Aurelius (c. A.D. 160) and in the portraits of the emperor himself. The calm demeanor of the subject, the gaze that "sees the world steadily and sees it whole," evokes the philosophy of the emperor as set forth in his *Meditations*. As earlier we confronted the head of Pompey, familiar with his history, so may it aid us in meeting this image from the age of the Antonines to read the philosophic emperor as we read the painted features of our subject:

> Every moment think steadily as a Roman and a man to do what you have in hand with perfect and simple

dignity. . . . do every act of your life as if it were the last, laying aside all carelessness and passionate aversion from the commands of reason, and all hypocrisy, and self-love, and discontent with the destiny which has been given to you.

Our history has taken us beyond the period of the republic into that of the empire to show how Rome carried the ancient world's representation of landscape and of human individuality, which started in Mesopotamia and Egypt, to its fullest expression.

THE EARLY EMPIRE

When Octavian Caesar, the grand-nephew and heir of Julius Caesar, routed the forces of Antony and Cleopatra at Actium in 31 B.C., he brought to an end some ninety long years of destructive civil war that had shattered the Roman republic. Although Octavian proclaimed himself to be the restorer of the republic and the protector of its constitution and traditions, he became, in fact, the first emperor of Rome and, to all intents and purposes, ruled as emperor, taking the venerable name "Augustus," which was bestowed on him by a grateful Senate. The peace that began with Augustus has been called the "Pax Romana"; under the auspices of a long line of emperors, peace prevailed within the Roman world for 150 years, a record in world history.

Augustus (27 B.C.–A.D. 14), determined to establish his authority unshakably, kept command of the military and financial resources of the empire in his own hands and deliberately set out to build a new and magnificent Rome in order to give a splendid image to the imperial reality. As they carried the boundaries of the empire further in all directions, the Julio-Claudian emperors, Augustus's successors in the first century A.D., continued his policy of glorifying the visible aspect of empire (sometimes to an extravagant degree) in architecture, art, and a vast variety of public works. In the second century, under Trajan, Hadrian, and the Antonines, the empire reached its greatest geographical extent and the summit of its power (see map, page 197). Rome's might and influence were unchallenged in the Western world, although pressure was constantly being applied by the Germanic peoples in the north, the Berbers in the south, and the Parthians and resurgent Persians in the east. These pressures increased in the third century and, in combination with the decline of imperial authority within the empire, disintegration of the economic and administrative structure, and military anarchy, almost brought the empire to collapse. In A.D. 285, imperial authority was restored by one of the last pagan emperors, the capable Diocle-

tian, who became the overseer of the savage persecution of a sect called the Christians. Within a generation, the triumph of this sect would mark a major turning point in the history of the world.

Architecture and Public Works

The grandiose imperial designs of the early Roman Empire are reflected, perhaps most conspicuously, in its architecture. The relatively stable conditions produced by the Pax Romana facilitated the Romanization of the provinces, and *urbanism*—the planning and building of cities—played a principal role in this process. The rapid growth of population, especially city population, already has been cited as a reason for the escape to the suburban villa. The pressure of population in the city itself made the sprawling atrium house, which was wasteful of space, obsolete.

In Rome, a population of close to one million had to be housed in multistory apartment blocks *(insulae)*, built primarily of brick-faced concrete. Some forty-five thousand of these, constructed to the maximum legal height of five stories (60–70 feet), accommodated nearly 90 percent of Rome's population. Most of the almost fifty thousand inhabitants of Ostia, Rome's port city, also were housed in such apartments, some of which have been preserved to the level of the third story. The ground floors were occupied by shops; above were the apartments, which were accessible by individual staircases. Many of the apartments were substantially more spacious than are most of ours today, the suites sometimes containing as many as twelve rooms arranged on two levels. A reconstruction of an Ostian insula (FIG. **6-41**) shows the apartment blocks built around a central court; some of the larger courts may have been landscaped to contain a small shrine. Apparently, many apartments had balconies, still a standard feature of modern Italian apartment houses. Only deluxe apartments had private toilets; others were served by community latrines, usually on the ground floor. The insulae had no private baths, but public baths were located conveniently throughout various quarters of the city and were equipped with highly developed heating systems, which private houses and apartments lacked. The crowded conditions encouraged rent gouging and jerry-building. Deficiency in materials was often compounded by bad design, such as a foundation area too small in relationship to the height of a building—a means of maximal exploitation of the limited space available. The poet Juvenal wryly complained about the poorly constructed city buildings:

> We inhabit a city propped up for the most part by slats: for that is how the landlord patches up the crack in the old wall, bidding the inmates sleep at ease under the ruin that hangs above their heads.

The convenience of the ancient Roman of ordinary and less-than-ordinary means depended to a great

6-41 Reconstruction of an insula, Ostia, Italy.

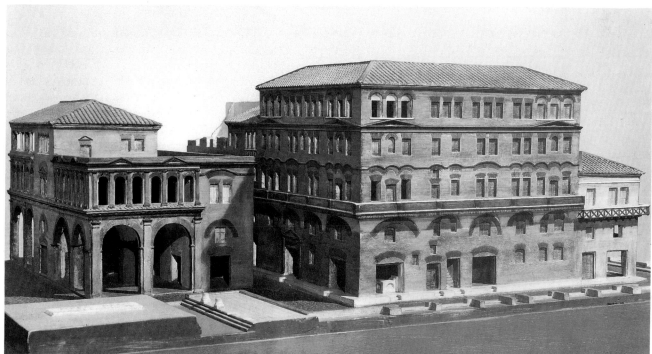

extent on facilities provided by imperial, provincial, or municipal authority. Millions of individuals depended on the government for food distribution, water supply and sanitation, recreation and entertainment, and roads and bridges, not to mention the protection afforded by police and firefighters. The administration of these services in the days of the empire was efficient even by our standards, given, of course, the limitations we would expect from a less highly developed technology and communications system. Second only to food distribution, an adequate water supply for the population of the overcrowded cities was the most imperative need. The Romans methodically developed water-supply systems as part of urban planning. The city of Rome began to build *aqueducts* for itself as early as the fourth century B.C., and Roman aqueducts or their ruins still stand in many former Roman cities, both in Italy and in the provinces. Water was carried from the source to the city by gravity flow, which required the building of channels with a continuous gradual decline over distances often exceeding fifty miles; we can appreciate, even in modern terms, what an important achievement of engineering this represents. The Pont du Gard (FIG. 6-42) near Nîmes (ancient Nemausus) in France is one of the most impressive specimens of Roman engineering skill. It carried the water channel across the valley of the river Gard. Each large arch spans some 82 feet and is constructed of uncemented blocks weighing up to two tons each. The quickening rhythm of the small top arches (which carry the chan-

nel), placed in groups of threes over the larger arches, manifests the Roman engineer's sense for the esthetic as well as the practical. The finished aqueduct carried water to Nîmes over a distance of some thirty miles and provided each inhabitant with about one hundred gallons of water a day. Services like this, and the awesome structures that provided them, could not help but impress on the diverse peoples who had come under the rule of Rome the advantages to be gained by complying with such practical power and the benefits that could accrue to them as the result of Romanization.

If the construction of aqueducts showed the value of homage to Rome, imagine how much more impressive the erection of a whole city would be. At Timgad (ancient Thamugadis) in North Africa (FIGS. 6-43 and 6-44), the Romans built a city, around A.D. 100, that lasted until the sixth century A.D. Built along a major military road one hundred miles from the sea, Timgad was probably planned to house a military garrison charged with keeping order locally. But this primary function was soon expanded, and no costs were spared in making this little provincial town into an attractive focal point for the local inhabitants. Here, the empire was a physical presence to the Africans; the city represented the authority of the emperor and the civilization of Rome. Like many other colonial settlements, Timgad served as a key to the process of Romanization. The town was planned with great precision, its design probably based on the layout of the Roman military encampment, the

6-42 Pont du Gard, near Nîmes (ancient Nemausus), France, first century B.C.

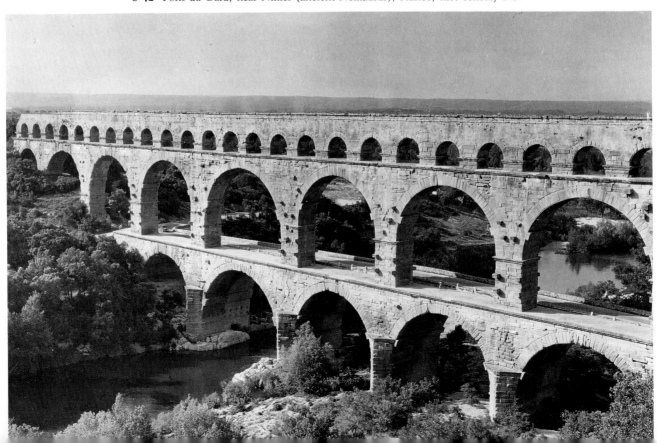

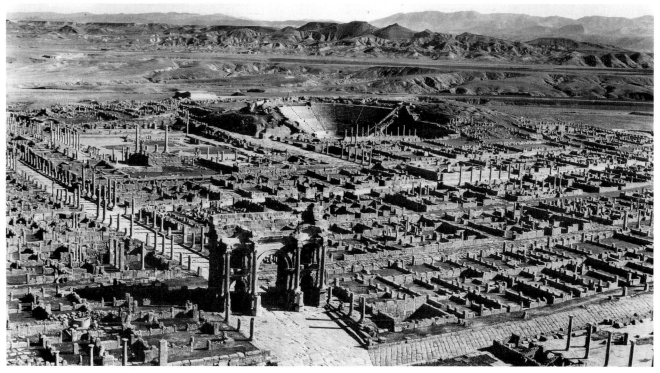

6-43 View of the ruins, Timgad (ancient Thamugadis), Algeria, founded *c.* A.D. 100.

6-44 Plan of Timgad, Algeria.

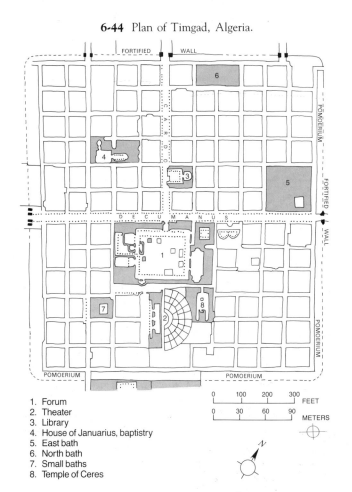

1. Forum
2. Theater
3. Library
4. House of Januarius, baptistry
5. East bath
6. North bath
7. Small baths
8. Temple of Ceres

castrum. (The question of precedence remains unresolved: the castrum may have been based on the layout of the Roman colonial city.) The typical provincial Roman city takes the form of a square that is divided into equal quarters by two main arteries—the *cardo* (the north–south axis) and the *decumanus* (the east–west axis)—that cross at right angles. The *forum* is located near this crossing. The quarters are subdivided into square blocks, and the forum and public buildings, like the theater, baths, and library, occupy areas that are multiples of these blocks. At Timgad, monumental gates led into the colonnaded streets of the city. The city itself covered some thirty acres, and its original population of two thousand soon grew to fifteen thousand. The whole plan was essentially a modification of the Hippodamian plan (see FIG. 5-88), but more rigidly ordered and systematized, with the forum set off from the main traffic pattern. The fact that most of these colonial settlements were laid out in the same manner, regardless of whether they were located in North Africa, the Near East, or England, expresses more concretely than any building type or other construction project the unity and centralized power characteristic of the Roman Empire at its height.

The architectural images of Rome set up in the outlying reaches of the empire had their even more monumental equivalents in the capital city itself. When all roads did indeed lead to Rome, they found

their symbolic terminus in the Forum Romanum and its imperial extensions. Even before the end of the Republican period, Rome's population had outgrown the old forum, and several new forums, beginning with that of Julius Caesar, were added to the original to provide space for larger crowds and for the growing ceremonial pomp of state functions. Beyond their practical purposes, these new imperial forums (FIG. 6-45) created a monumental architectural setting for the exaltation of their sponsors' achievements and the glorification of Roman imperial power. They stood witness to the "piety, might, good fortune, magnanimity, and happiness"—as their triumphal inscriptions proclaimed—of the successive emperors who built them. These new forums were not planned as a unit but were added one to another and their unity achieved by strict, axial alignment. They generally consisted of a large colonnaded court, designed to set off a temple dedicated to the god who was the special protector of the emperor under whose aegis the forum was constructed. The Forum Julium

(Forum of Caesar) set the style that was repeated, with modifications and on a larger scale, by the Forum Augustum. Both were dwarfed by the Forum of Trajan a century later.

OFFICIAL CONSERVATISM

The artistic taste of Augustus tended to be conservative (see Sculpture also). In architecture, he favored the trabeated style and a sumptuous display of the Greek orders, an attitude that seems to be reflected by VITRUVIUS, whose treatise, *The Ten Books of Architecture*, became the oracle of Renaissance architects. Vitruvius (*c.* 90–20 B.C.) was one of Caesar's military engineers during the latter's campaigns in Gaul and North Africa. After Caesar's death, Vitruvius entered the service of Octavian (Augustus), to whom the treatise is dedicated. Unquestionably, Vitruvius was a competent architect-engineer, and the description of the technology of his day shows him to be fully aware of all contemporary developments. On the other hand, his writings also reveal that he was conservative by nature; while he described brick and concrete construction, he emphasized more traditional approaches and quite obviously preferred trabeated Hellenistic buildings to the vaulted ones of Sulla's period. His admiration for Greek architecture paralleled Augustus's taste and must have made him a most compatible servant.

The Augustan style, however, was far from uniform. Classicizing tendencies occurred side by side with native Italic trends, and pseudoperipteral temples, like the Maison Carrée in Nîmes (FIG. 6-46) perpetuated a type that originated in the Republican period. Larger than the Temple of "Fortuna Virilis" in Rome (FIG. 6-16) and better preserved, the Maison

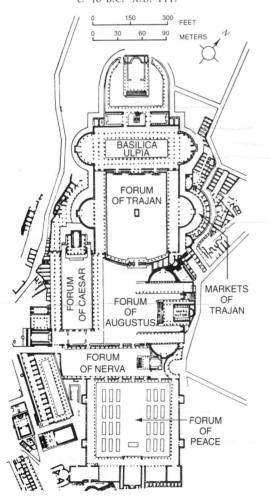

6-45 Plan of the imperial forums in Rome, *c.* 46 B.C.–A.D. 117.

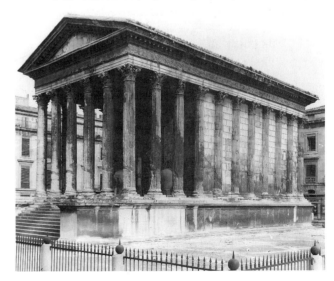

6-46 Maison Carrée, Nîmes, France, *c.* 20 B.C.

Carrée employs a Corinthian order that emphasizes height; its podium is higher and its monolithic columns are proportioned to look taller and more slender than those of its Classical Greek predecessors. Today, the structure serves as a museum.

A high podium and tall Corinthian columns also characterize the Temple of Mars Ultor (Mars the Avenger), the focal point of the Forum Augustum in Rome. Backed up against a high retaining wall, the temple faced forward into a large, colonnaded court and was the finial of a strictly symmetrical, axial composition. A significant innovation of the Forum Augustum was the widespread use of marble. By about the middle of the first century B.C., the newly opened quarries at Carrara began to produce marble, and this stone, formerly an exotic luxury imported from Greece and the Aegean, soon became commonplace. By the end of the century, marble had become the favored material for official buildings, and the claim of Augustus that he had converted Rome from a city of brick into one of marble became more than an idle boast.

THE COLOSSEUM

At the same time, of course, builders continued to use concrete, especially for utilitarian structures and in places where vaulting seemed to call for it. For instance, the Romans built theaters on level ground, unlike the Greeks, who backed them up against hillsides. The ascending seat rows of the auditorium demanded a massive substructure composed of a complex, multileveled system of vaults that could be constructed best in concrete. Concrete vaulting was used on a huge scale in the Colosseum (FIGS. **6-47** and **6-48**), which, for most people, still represents Rome as does no other building. So closely was it identified in the past with the city and the empire that an aphorism out of the early Middle Ages stated: "While the Colosseum stands, Rome stands; when the Colosseum falls, Rome falls; and when Rome, the world!"

The Flavian Amphitheater (popularly renamed the Colosseum after a now-lost colossal statue of Nero that stood nearby) was begun by Vespasian (A.D. 69–79), first in the Flavian line of emperors. The structure was dedicated in A.D. 80 by Vespasian's successor, Titus (A.D. 79–81), who employed prisoners from the Jewish Wars as builders. The building type is a Roman invention, designed by architects who expanded the *theater* into an *amphitheater*, which is essentially two facing theaters enclosing an oval space (the *arena*). The Roman Colosseum is the largest of its type, but most major cities in the empire had an amphitheater. Some, like the one at Verona, are still being used today for games or theatrical performances. The Colosseum was originally designed for

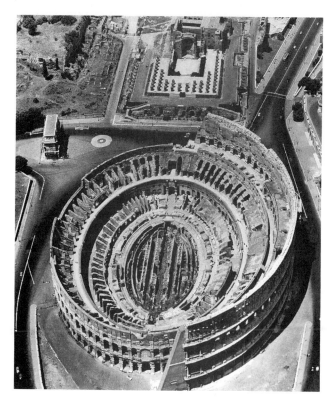

6-47 Aerial view of the Colosseum, Rome, A.D. 70–82.

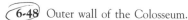

6-48 Outer wall of the Colosseum.

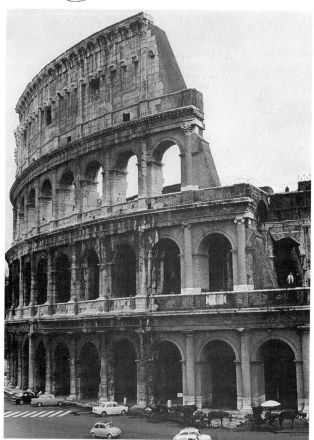

the staging of lavish spectacles—battles between animals and gladiators in various combinations. The mythical beast-men struggles represented in Mesopotamian art here came to bloody reality. The extravagantly inhuman shows cost thousands of lives, among them those of many Christians, and the Colosseum never quite has outlived its infamy. The emperors competed with each other to see who could produce the most elaborate spectacles. For the opening performance in A.D. 80, the arena was flooded and a complete naval battle, with over three thousand participants, was duplicated.

The oval arena of the Colosseum (FIG. 6-47) is surrounded by steeply rising rows of seats, which could hold over fifty thousand spectators. Its substructure consists of a complex system of radial and concentric corridors, covered by concrete vaults that rise to support the upper rows of seats. Originally, tall poles around the top of the structure supported ropes on which awnings could be spread to provide shade for the spectators. The basements below the arena proper contained animal cages, barracks for gladiators, and machinery for raising and lowering stage settings as well as the animal and human combatants. A great deal of technical ingenuity involving lifting tackle was employed to hurl hungry beasts suddenly from their dark dens into the violent light of the arena.

Roman ingenuity in the management of architectural space to fit a complex function may be observed even in the exterior of the Colosseum. The arcuated entrance-exit openings must have permitted rapid filling and emptying of the vast interior; no less than seventy-six numbered entrances led into the seating areas. The relationship of these openings to the tiers of seats within was very carefully thought out and, in essence, may be observed in the modern football stadium. The Colosseum exemplifies the Roman talent for coordinating public and private convenience within large-scale service structures.

The exterior of the building (FIG. 6-48), with its numerous functional openings, consists of *ashlar masonry*, in which dry-jointed blocks are held together by metal cramps and dowels, as in Greek architecture. Its present pockmarked appearance (as if it had been blasted by large shrapnel) is due to the fact that the metal fittings were pried from the joints during the Middle Ages, when metal was very hard to obtain. Indeed, for centuries the structure served as a convenient quarry for ready-made building materials, including marble and precut travertine blocks. The aerial view (FIG. 6-47) shows how much of the building has been dismantled, although what remains is impressive enough.

The exterior shell is 161 feet high, the height of a modern sixteen-story building. It is divided into four horizontal bands, with large, arched openings piercing the lower three. The arches are framed by ornamental Greek orders whose arrangement follows the standard Roman sequence for multistoried buildings: Doric-Ionic-Corinthian, from the ground up. This sequence is based on the inherent proportions of the orders, with the Doric, which appears to be the strongest, viewed as capable of supporting the heaviest load. The smooth wall of the top level is articulated with flat, Corinthian pilasters.

The arrangement in which an arch is framed by engaged columns that carry a lintel is a characteristic Roman combination that appears in triumphal arches and other Roman buildings. Revived in the Italian Renaissance, it has a long, illustrious history in Classical architecture. The framed arch has no structural purpose but fulfills the esthetic function of introducing variety into a monotonous surface, while unifying a multistoried façade by casting a net of verticals and horizontals over it that ties everything together.

THE FORUM AND MARKETS OF TRAJAN

The Forum of Trajan (FIG. 6-45) was the last and greatest of the imperial forums and, to the ancient visitor, must have been just as impressive as the Colosseum. The forum glorified Trajan's victories (he ruled from A.D. 98 to 117) in his two wars against the Dacians and was the work of his chief architect, APOLLODORUS of Damascus, who had served the emperor as military engineer during his Dacian campaigns. The plan incorporated many of the features of earlier forums, including that of Augustus, but deviated from them in one important respect: a huge basilica, not a temple, dominated the colonnaded open square. Visitors gained access to the forum through a monumental gate surmounted by a six-horse chariot; a colossal statue of Trajan stood in the center of the square, and in obvious symbolism, the attic story above the colonnades was decorated with now-lost atlantids representing Dacian prisoners.

The huge Basilica Ulpia (Trajan's family name was Ulpius), built in about A.D. 112, dominated the Forum of Trajan (FIG. 6-49). A larger version of the basilica in Pompeii, this structure was of a type that was perhaps the most characteristic of those developed by the Romans. The *basilica* was a public hall designed to accommodate large numbers of various kinds of business people. It was the locale of stock exchanges, law courts, business offices, and administrative bureaus and must have provided a center for civic services analogous to those of multiple-building municipal centers today. Years later, the Christians

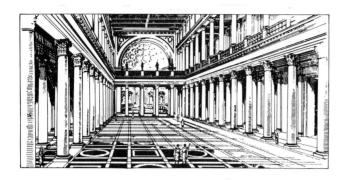

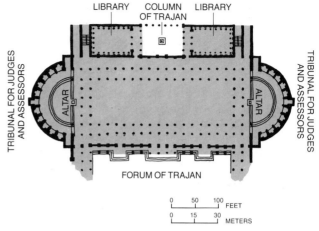

LIBRARY COLUMN LIBRARY
OF TRAJAN

TRIBUNAL FOR JUDGES AND ASSESSORS

ALTAR

ALTAR

TRIBUNAL FOR JUDGES AND ASSESSORS

FORUM OF TRAJAN

0 50 100 FEET
0 15 30 METERS

6-49 Reconstruction *(left)* and plan *(right)* of the Basilica Ulpia, Rome, c. A.D. 112. (After Sir Banister Fletcher.)

adapted the basilica (but more especially its subtype, the *palace audience hall*) to religious purposes, modifying it into the typical Christian church building. In plan, the basilica was rectangular, with two or more semicircular *apses*. In the Basilica Ulpia, one of the apses contained the Shrine of Liberty, where slaves were set free; the other may have served in ceremonies of the emperor's cult. The entrance was on one of the long sides of the basilica, an orientation that was changed by the Christians. The building was vast—400 feet long (without the apses) and 200 feet wide. Illumination for this great interior space was afforded by clerestory windows, provided by elevation of the timber-roofed nave above the colonnaded aisles. In the Basilica Ulpia, we once again encounter the Romans' instinctive feeling for broad, uninterrupted, architectural spaces, enclosed for the convenience of human transaction. Despite an imposing exterior, the interior space is what counts here, and although it is a colonnaded space, its effect is not like that of the externally perceived Greek temple, but rather like a dipteral Greek temple inverted: it is to be experienced from within, not from without.

Two simple rectangular, brick-faced concrete buildings that served as libraries were attached to the back of the basilica. Between the buildings, placed on the forum's central axis, stood Trajan's column (see page 234), the cubical base of which served as the emperor's mausoleum. What stood beyond it, on the north end of the forum complex, is unknown. Whatever it was, it was replaced a few years after Trajan's death by a temple that Hadrian built to honor his deified predecessor.

To provide a level space for the forum, the lower slopes of the Quirinal Hill had to be cut back a considerable distance and cut down to a depth of 125 feet. To replace the shops and businesses destroyed by

these excavations, Trajan ordered that a new commercial quarter be built to the east of his forum. The Markets of Trajan (FIGS. 6-45, and **6-50** to **6-52**), an urban development of considerable size, were built up in a series of terraces against the steep slope of the Quirinal Hill. The original extent of the development is unknown; what remains are some 170 rooms and a large, groin-vaulted market hall, arranged on six different levels and interconnected by a carefully

6-50 Interior of the "aula," Markets of Trajan, Rome. c. A.D. 100–112.

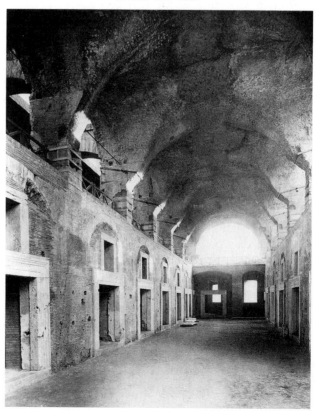

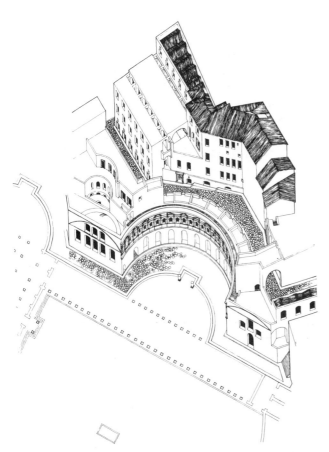

6-51 Markets of Trajan, Rome. (Axonometric view after A. Boethius and Ward-Perkins.)

6-52 Markets of Trajan, Rome.

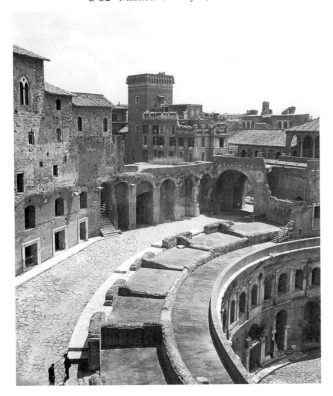

planned system of stairs, ramps, and corridors. The basic unit was the single shop (*taberna*), a barrel-vaulted room with a wide doorway facing a street, passageway, or the vaulted market hall. Some of the shops seem to have had a second interior level built on wooden supports, with a window above the doorway. In keeping with the utilitarian purpose of the buildings, their exteriors were left plain; only on the second level of the front facing the forum (the first level was masked by a curving precinct wall and not visible from the forum) were the arched openings framed with brick pilasters to provide some sort of visual transition from the Sunday magnificence of the imperial forum to the weekday simplicity of the markets. Otherwise, the brick-faced concrete walls of the market buildings were unadorned, except for the simple travertine framing of doorways and some windows. Without marble veneer, engaged orders, or screens of columns, the utilitarian structures could display their architectonic form without disguise. They revealed that their architect, Apollodorus, was a brilliant designer who, despite the orthodoxy he displayed in Trajan's Forum, was fully aware of contemporary structural and stylistic developments.

THE ARCHITECTURAL REVOLUTION

The official style of public buildings during Trajan's administration was conservative and Hellenizing, and, like the deliberately classicizing style during the time of Augustus, expressed prosperous stability. At the same time, however, the native Roman school continued to investigate and to exploit the properties of concrete, mainly in connection with private, commercial, and utilitarian structures. Apollodorus evidently could work with equal facility in the traditional, trabeated style and in the "modern" style of concrete vaulting; it is in this latter field that Rome made its great, original contribution to the history of architecture. The arch, the vault, and the dome were structural devices that the Romans adopted from earlier builders. By combining these forms with steadily refined concrete and an engineering knowledge of the properties of solids and the statics of inert masses, Roman builders acquired a flexibility unknown to their predecessors. Basically, the problem for the Roman builder was this: how does one enclose, roof over, and illuminate the largest possible space while keeping it open and free of interior roof supports?

The simplest vault used by the Romans was the *barrel or tunnel vault* (FIG. **6-53c**), a deep arch that forms a half-cylindrical roof over an oblong space; the edges of the half-cylinder rest directly on the side walls, which must be either thick enough to support the weight or reinforced by *buttresses*. Such a vault

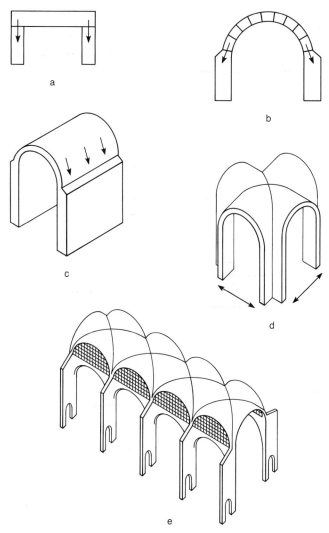

6-53 Roman vaulting systems: (**a**) post-and-lintel construction, (**b**) round arch, (**c**) barrel vault, (**d**) cross-barrel or groin vault, (**e**) fenestrated sequence of groin vaults. (Arrows indicate direction of thrust.)

can be made of brick or stone, as was done by earlier cultures, or of concrete, as preferred by the Romans. Both methods require the use of a temporary form (*centering*) that is the size and shape of the finished vault and that, in the case of concrete, holds the fluid mass until it hardens. If a barrel vault is intersected at right angles by another barrel vault of equal size, the result is a *groin vault*; the line of intersection is called the groin (FIG. **6-53d**). Besides being lighter in appearance than the barrel vault, the groin vault requires less buttressing. In the barrel vault, the thrust is concentrated along the entire length of the supporting wall and requires corresponding buttressing. In the groin vault, the thrust is concentrated along the groins, and buttressing is needed only at those points where the groins meet the vault's vertical supports (piers, walls, or columns). The system leaves the cov-

ered area open and free of load-carrying members. Moreover, more light can be admitted through clerestory windows set into the open ends of the cross vaults (FIG. **6-53e;** compare also FIGS. 6-52 and 6-61).

Some of the most significant experiments with concrete vaulting were made in the second half of the first century A.D., during the design and construction of the large, semiprivate, imperial palaces of Nero and Domitian. Augustus, who led an unobtrusively simple life, had been content to live in the house of a well-to-do citizen. His successors were neither as politically astute nor as frugal. Both Nero (A.D. 54–68) and Domitian (A.D. 81–96) built huge palaces for themselves. Nero's, never quite completed, was largely built over in later periods; Domitian's, which continued to be in use until the sixth century A.D., became the prototype for later imperial and vice-imperial residences throughout the Roman Empire.

The great fire of A.D. 64 destroyed large sections of Rome, including Nero's old palace, the Domus Transitoria. The city was rebuilt in accordance with a new code that required greater fireproofing, resulting in the increased use of concrete, which was both cheap and fire-resistant. This increased use gave rise to an entirely new attitude toward a still relatively new material—an attitude that found one of its first full expressions when Nero's architect, SEVERUS, was given the opportunity to use concrete inventively in the building of Nero's new palace, the Domus Aurea, or Golden House (FIGS. **6-54** and **6-55**).

As described by the Roman historians Tacitus and Suetonius, Nero's new palace was a huge and luxurious country villa in the heart of Rome, extending from the Palatine Hill to the Esquiline Hill. With a mile-long portico, it faced an artificial lake (later drained to become the site of the Colosseum) that was surrounded by a landscaped park in which tilled fields and vineyards alternated with pastures and woods filled with great numbers of wild and domestic animals. Probably, the palace was never completed. Vespasian, in a shrewd move to ingratiate himself with his subjects, turned most of the park over to the people in the 70s. Domitian preferred the Palatine Hill and had a new palace built there. What remained of the Domus Aurea was largely built over by later emperors, who, like Domitian, preferred to live on the Palatine.

The so-called Esquiline Wing of the Domus Aurea is the largest fragment of the Neronian palace known today; most of it was found imbedded in the basements of the Baths of Trajan. The excavated area measures about 660 feet long and 200 feet wide and contains a great number of rooms of uncertain purpose. Their walls and piers are of brick-faced concrete, most of them covered by vaults. The more important

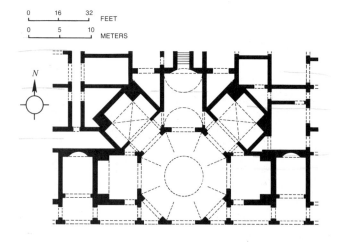

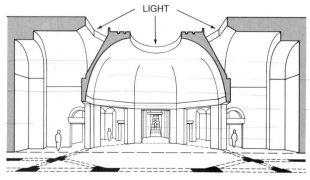

6-54 SEVERUS, plan (*above*) and section (*below*) of the Octagonal Hall, the Domus Aurea of Nero, Rome, A.D. 60–67.

6-55 Octagonal Hall, the Domus Aurea of Nero.

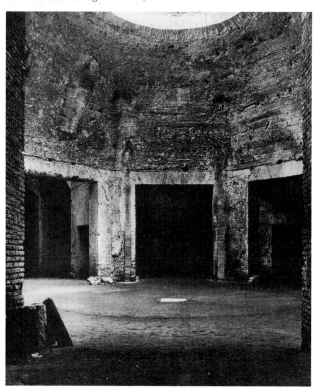

rooms of the wing seem to have been located on its southern side, where they faced the artificial lake. Traces of rich decorations, with marble paneling and painted and gilded stucco, have been found in them. The wing's general plan was fairly conventional, derived from the seaside villas, represented on Pompeian frescoes, that faced the ocean with porticoed façades. But, in what may have been the wing's central axis, a group of rooms expresses an entirely new approach to concrete architecture. An octagonal room is covered by a dome that modulates from an eight-sided to a hemispherical form as it rises toward a round central opening, the *oculus* (eye). Radiating outward from the pavilion's five inside sides (the other three, directly or indirectly, face the outside) are smaller, rectangular rooms, alternately covered by barrel and groin vaults (FIG. 6-54). These satellite rooms were enlivened by decorative recesses and, in the middle one, by a cascade. Their lighting was achieved in a most ingenious manner through what may be described as an inversion of a modified clerestory system. But most significant in the design of this group of rooms is the fact that here, for the first time, the architect appears to have been thinking of the architectural solids—the walls and vaults—not as space-limiting but as *space-molding* agents.

Today, deprived of its marble and stucco incrustation, the concrete shell stands without disguise and may appear crude to the casual observer (FIG. 6-55). Indeed, neither camera nor drawing board can capture the spatial complexity of this design, which only reveals itself fully to the visitor who actually walks through the rooms. Then the central, domed octagon is found to be defined not by walls, but by eight angled piers—the wide, square openings between them so large that the rooms beyond appear to be mere extensions of the central pavilion. The grouping of spatial units of different sizes and proportions under a variety of vaults constitutes a dynamic, three-dimensional composition that is both complex and unified. It reveals Severus as an original and inventive architect, whose design is not only unique, but also progressive in its recognition of the malleable nature of concrete, a material no longer bound by the rectilinear forms of traditional post-and-lintel construction.

THE PANTHEON

In the following century, the Pantheon (FIGS. **6-56** to **6-58**), one of the best preserved and most influential buildings in the history of architecture, revealed the full potential of concrete both as a building material and as a means for the shaping of architectural space. In this structure, the builder has created a single, unencumbered, interior space of overwhelming

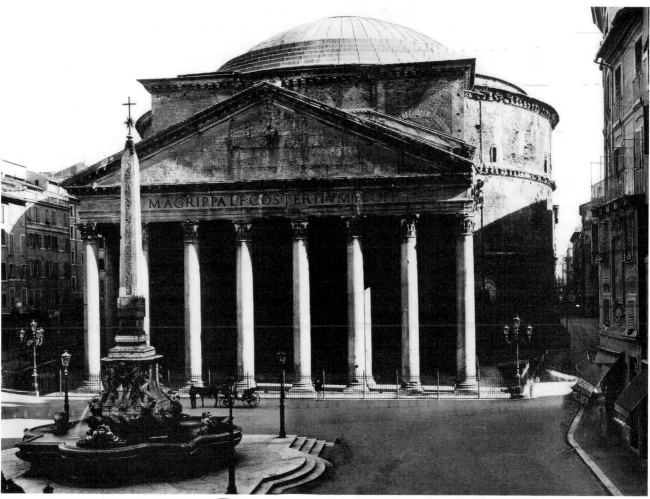

6-56 The Pantheon, Rome, A.D. 118–125.

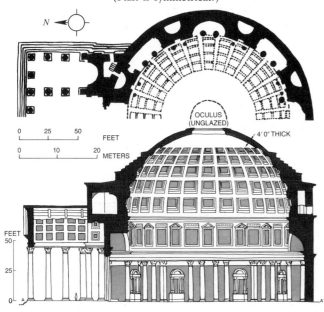

6-57 Half-plan (*above*) and section (*below*) of the Pantheon. (Plan is symmetrical.)

N

0 25 50
FEET
0 10 20
METERS

OCULUS
(UNGLAZED)

4' 0" THICK

FEET
50

25

0 A A'

scale, a monumental space scarcely suggested by the exterior. The Pantheon is a domed rotunda fronted with a rectangular portico. The original effect must have been different, for the building was only partly freestanding, its back and one of its sides hidden by older structures. Moreover, the portico stood at one end of a no-longer-extant colonnaded court, its siting similar to that of temples in the imperial forums and the Temple of Jupiter at Pompeii. Built during the rule of Hadrian (A.D. 117–138), the temple may have been conceived by that versatile emperor.

The Pantheon is of monumental simplicity and great scale. A hemispheric dome 144 feet in diameter covers the circular interior. The summit of the dome is the same distance from the floor. The design is thus based on the intersection of two circles (one horizontal, the other vertical), imaginable as sections of a globe of space inscribed within the building. The dome is a shell of concrete that gradually thickens toward the base to augment structural strength where it is most needed. The center of the dome is

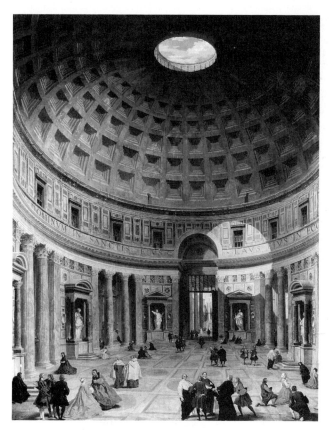

6-58 Giovanni Pannini, *Interior of the Pantheon, c.* 1740. National Gallery of Art, Washington, D.C. (Samuel H. Kress Collection).

pierced dramatically by the oculus, a round opening 30 feet in diameter, which, left unglazed and open to the sky, is the only source of light for the interior. Supporting the dome are piers of immense thickness, formed by alternating rectangular and rounded niches, each covered by a vault that channels pressures exerted by the weight of the dome into solid masonry. The dome is *coffered* (furnished with decorative, sunken panels called coffers) for the multiple purposes of making a handsome geometric foil of squares within the vast circle, reducing the weight and mass of the dome without weakening its structure, and symbolizing the starry heavens, each coffer having a gilded, bronze rosette at its center. The floor of the building is slightly convex, and drains are cut into the shallow depression in the center (directly under the oculus) to carry off any rain that falls through the opening far above.

Giovanni Pannini's painting of the interior of the Pantheon (FIG. 6-58) exhibits, better than any photograph, the unity and scale of the design, the simplicity of its relationships, and its breathtaking grandeur. Pannini's work almost records the experience one has on first entering this tremendous, shaped space—a feeling not of the weight of the enclosing masses, but of the palpable presence of space itself, for the archi-

tecture here displayed is first of all an *architecture of space*. In the architectures studied thus far, the form of the enclosed space is determined by the placement of the solids, which do not so much shape as interrupt the space. The solids are so prominent in Egyptian and Mesopotamian architecture that it is the solids we *see*; space is only "negative," simply happening between the solids. We think of this as an *architecture of mass*. Greek architecture, also primarily concerned with masses and their relationships and with the shaping of solid units, is designated as *skeletal* or *sculptural architecture*. It is the Roman architects who initially conceived of architecture in terms of units of space that could be shaped by enclosures. The interior of the Pantheon, in keeping with this interest, is a single, unified, self-sufficient whole, uninterrupted by supporting solids; it is a whole that encloses visitors without imprisoning them, a small cosmos that opens through the oculus to the drifting clouds, the blue sky, the sun, universal nature, and the gods. To escape from the noise and torrid heat of a Roman summer day into the sudden cool and calm immensity of the Pantheon is an experience almost impossible to describe and one that should not be missed. Above all, it is an *architectural* experience.

THE BATHS OF CARACALLA

The gigantic Baths of Caracalla (FIGS. **6-59** to **6-61**) date from about A.D. 215. The enclosure of great spaces by vaulting was common practice at this time. Although nothing of the covering is left, the baths reveal traces of the vaults that sprang up from the thick walls to heights of up to 140 feet; under them, spread out in unending variety, were spaces designed for the intellectual as well as physical recreation of thousands of leisured Romans, all at the expense of the state. The central buildings of the huge complex, in which the emperors hoped to keep an unruly and indigent populace preoccupied with pleasure, covered a large area (roughly 240 yards long and 120 yards wide); the baths, which were the center of interest, as well as the architectural center of the design, had a capacity of sixteen hundred bathers. The functions of various parts of the complex are still matters of controversy. The design was symmetrical along a central axis occupied by pools filled with water of different temperatures: the *frigidarium*, the cold-water pool; the *tepidarium*, the central room containing smaller, warm-water pools; and the *calidarium*, a circular, hot-water pool in a domed rotunda. The central buildings also contained steam baths, dressing rooms, lounges, lecture halls, and *palestrae* (exercise rooms). This whole core complex was surrounded by landscaped gardens bordered by secondary buildings that housed shops, restaurants, libraries, gymnasiums, and perhaps a stadium. The

6-59 Aerial view of the Baths (*thermae*) of Caracalla, Rome, *c.* A.D. 215.

6-60 Plan of the Baths of Caracalla, Rome.
(After Sir Banister Fletcher.)

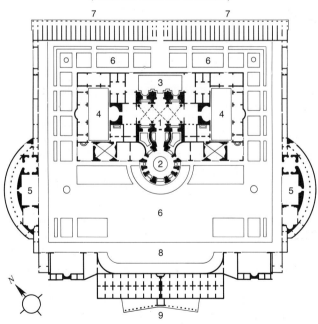

1. Central hall (tepidarium)
2. Calidarium
3. Natatio (frigidarium)
4. Palaestra
5. Lecture halls and libraries
6. Gardens
7. Shops
8. Stadium (?)
9. Aqueduct and reservoirs

```
0      160      320
                    FEET
0    50    100
                    METERS
```

long side of the entire complex measured almost one-quarter of a mile. Beneath it all was a subterranean world of corridors (some wide enough to accommodate vehicles), storerooms, and heating chambers populated by slaves and stokers. The halls and the water were heated by a system in which hot air was circulated through tubes and hollow bricks beneath the floors, in the walls, and sometimes in the vaults. The water was plentifully supplied by an individual aqueduct.

This enormous dedication of human ingenuity was directed toward the service of human ease. For a negligible admission fee, Romans could lounge for a whole day at the baths, in surroundings of the greatest magnificence. In fact, the baths were so lavish, ornate, and luxurious that moralists of the time complained of their wasteful ostentation. In his "Epistula Morales," the Roman philosopher-statesman Seneca, comparing his degenerate times with those of the heroic general Scipio, who bathed in austerely simple surroundings, complained:

But who in these days could bear to bathe in such a fashion? We think ourselves poor and mean if our walls are not resplendent with large and costly mirrors; if our marbles from Alexandria are not set off by mosaics of Numidian stone; if their borders are not faced over on all sides with difficult patterns, arranged in many colours like paintings; if our vaulted ceilings are not buried in glass; if our swimming

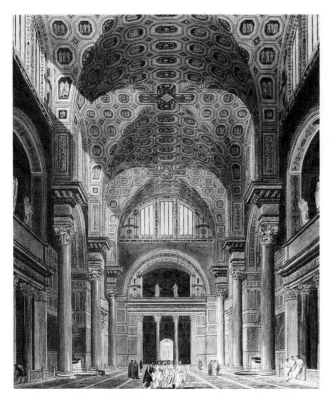

6-61 Central Hall (*tepidarium*) of the Baths of Caracalla, Rome. (Restoration drawing by G. Abel Blonet.)

pools are not lined with Thasian marble, once a rare and wonderful sight in any temple. . . . What a vast number of statues, of columns that support nothing, but are built for decoration, merely in order to spend money! And what masses of water that fall crashing from level to level! We have become so luxurious that we will have nothing but precious stones to walk upon.

The baths were, of course, social centers in which the whole day could be spent "sweetly doing nothing." And the baths were cultural centers as well, with their libraries and their profusion of magnificent statues. A large number of Roman copies after Greek originals were found in public baths, a few of the most important in the Baths of Caracalla. To the Romans, baths of this type were a natural and indispensable part of "civilization."

Sculpture and Monumental Relief

Sculpture in the Roman Empire began under the influence of Augustan Rome's admiration of Hellenic culture and of the emperor's apparent determination to base a cultural renewal of Rome on it. That the Hellenized glorification of the empire was politically motivated is undoubtedly true; we already have seen how Roman architecture was molded to the end of manifesting the imperial authority. But the imperial motivation produced the esthetic consequence that

work of the highest quality in all the arts bore the seal, as it were, of the Hellenic spirit. The *Augustus of Primaporta* (FIG. **6-62**), about 20 B.C., is an example of the sedate, idealizing manner we have come to recognize as "Augustan" (the same statement can be made concerning Vergil's *Aeneid*). The statue, which once stood in front of the imperial villa in Primaporta, about ten miles north of Rome, represents Augustus addressing his troops in the field. Though only a copy, the work is of the highest quality. At first glance, it might appear to be in the realistic mode of Republican statues, but on second glance, we find it strongly idealized, made according to Polykleitan proportions and even reminiscent of the *Doryphoros* (FIG. 5-58), especially in the walking pose. The reliefs on the emperor's breastplate are Roman in subject and refer to contemporaneous events, at least in the central theme: a Parthian returning a Roman standard to a Roman soldier. But these historical references are framed by mythological and allegorical figures representing the sky god, the earth goddess, and the pacified provinces of Spain and Gaul. Together, the figures symbolize the blessings of the new golden age that were expected to come with the Augustan peace. They also place, side by side, the idealizing and realistic tendencies in Roman art that would alternate and intermingle throughout imperial times.

6-62 *Augustus of Primaporta*, c. 20 B.C. Marble, 6' 8" high. Vatican Museums, Rome.

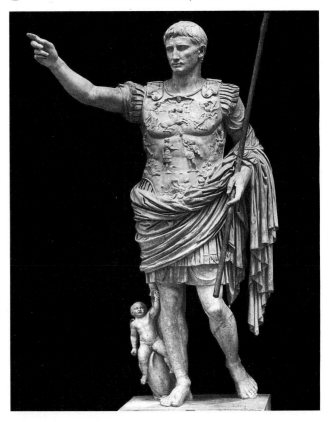

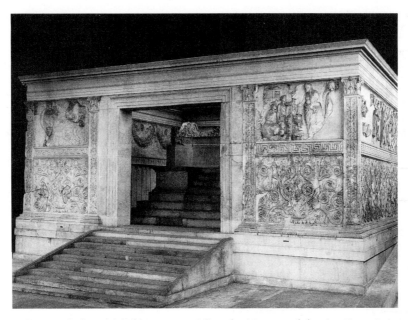

6-63 Ara Pacis Augustae, Rome, 13–9 B.C. Marble, approx. 35′ wide. Museum of the Ara Pacis Augustae. (Cornice restored.)

The idealistic and realistic mingle, yet remain distinguishable, in the sculptured figures of the Ara Pacis Augustae, or Altar of the Augustan Peace (FIG. **6-63**). Completed and dedicated in January, 9 B.C., to commemorate pacification of Spain and Gaul in 13 B.C., the altar can stand as a monument to the pacification of the whole Roman Empire in the Augustan years following the establishment of the new government in 27 B.C. Scholars disagree regarding the meaning of the altar's theme and figures. The actual altar is raised on an interior platform that is surrounded by a nearly square enclosure (35½ feet long and 39 feet wide). The exterior and interior surfaces of the enclosing walls are decorated with reliefs. Garlands are suspended from bucrania on the interior walls. On the exterior walls, a lower zone displays a delicately carved, decorative, acanthus-leaf pattern, arranged in spiral designs. An upper zone depicts a procession of men, women, and children and, on separate panels, allegorical subjects. The wall surfaces are framed by florid, Corinthian pilasters in a composition reminiscent of the second style of Pompeian wall painting.

The "*Tellus*" *Relief* panel from the Ara Pacis Augustae (FIG. **6-64**) may represent the ancient Roman earth mother, Tellus, flanked by personifications of the elements, their draperies blowing about them. The figures are seated in a fertile landscape against clouds simulated in low relief. Although we have come to think of the interest in the illusion of landscape as a Roman trait, the poses here, the style of the draperies, and the lateral placement of the figures in a single plane attest to the Greek influence. The whole tableau celebrates the Augustan peace as the source

of a new bounty of nature and the new richness and fertility of earth as the foundation of Roman wealth and power.

The *Procession* (FIG. **6-65**) carved on the Ara Pacis Augustae, led by the emperor himself, almost certainly was intended to represent the actual solemnities when the altar was dedicated. The historical particularity of the frieze is characteristic of the Roman feeling for the factual, especially as we have seen it expressed in the portrait bust, in a pragmatic architecture, and, to a degree, in landscape painting. This contrasts with the Greek practice of disguising historical events in the mythological, as in the great frieze of Pergamon (FIG. 5-78), on which a historical war between Greeks and Gauls becomes a struggle between gods and giants. In some respects, the Roman feeling for narrative bound to actual events resembles more the Assyrian than the Greek approach. Yet the style of the figures of the *Procession* is Hellenizing and

6-64 "*Tellus*" *Relief*, marble panel from the Ara Pacis Augustae, approx. 63″ high.

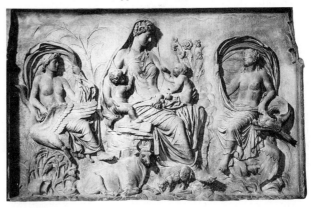

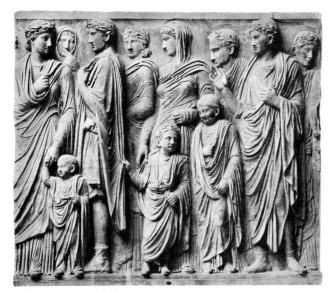

6-65 *Procession,* portion of the frieze of the Ara Pacis Augustae. Marble relief, approx. 63″ high.

may be directly inspired by the Panathenaic frieze of the Parthenon (FIG. 5-50). In the Ara Pacis Augustae, the *Procession* moves in several files. Differences in distance are signified by differences in degree of relief—the nearer the figure, the higher the relief. Individuals are differentiated carefully; the heads are moderately idealized portraits, and the artists added "human interest" touches—for example, clinging, restless children quieted by adults. The overall demeanor is solemn, as would have befitted the occasion, and the impression is of a quiet concourse of participants behaving in a manner they believe to be appropriate to a quasi-religious ceremony. The draperies, the quiet dignity, the ordered deployment within a shallow plane of space echo the older, Classical style, and the Ara Pacis Augustae, with its blend of the real and the ideal, signifies the Augustan style and the style of the empire in general.

The memorializing of actual events in monumental form finds striking expression in the imperial *triumphal arch,* one of the most popular types of commemorative monument. Essentially, the triumphal arch is an ornamental version of a city gate, often moved to the center of the city, but also located in other places, such as on bridges or on roads leading out of cities. The Arch of Titus (FIG. 6-66), dated A.D. 81, is located at a point at which the Via Sacra enters the Forum Romanum. These arches commemorated a wide variety of persons and events. As a building type, the triumphal arch exerted considerable influence on the architecture of the Renaissance. Closely related to the Colosseum-arch order, it consists of a single arch flanked by massive piers, to which the *Composite* order (a combination of Ionic and Corinthian) has been attached decoratively. Its typical superstructure, the

attic, bears the commemorative inscription. Occasionally, the flanking piers also are pierced by arches, producing a triple arch like the Arch of Constantine (FIG. 6-95). The walls of the passageway of the Arch of Titus are decorated with relief panels representing the triumphal return of Titus from the conquest of Jerusalem at the end of the Jewish Wars (A.D. 66–70). In later arches, the sculptural decor moved to the outside surfaces of the structure, as seen in the Arch of Constantine.

One of the archway reliefs shows soldiers of the Roman army carrying *Spoils from the Temple in Jerusalem,* including the seven-branched candelabrum from the Holy of Holies (FIG. 6-67). The panel is severely damaged. Beam holes in the upper part date from the Middle Ages, when the family of the Frangipani converted the arch into a private fortress and built a second story into the vault, only one of many examples of later indifference to the esthetic and historic value discovered in recent times in the ruins of Rome. But enough of the relief remains to show that spatial effects aimed at in the Ara Pacis Augustae reach full development here. The illusion of movement is complete and convincing. The marching files press forward from the left background into the center foreground and disappear through the obliquely placed arch in the right background. The energy and swing of the column of soldiers suggest a rapid marching cadence and the chant of triumph. The carving is extremely deep. The heads of the forward figures have been broken off, probably because they stood vulnerably free from the block, emphasizing their different placement in space from the heads in low relief, which are intact. The deep relief produces strong shadows and the light and shade quicken the move-

6-66 Arch of Titus, Rome, A.D. 81.

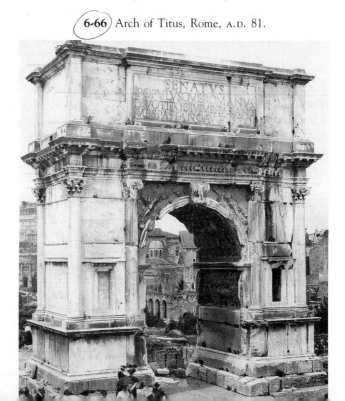

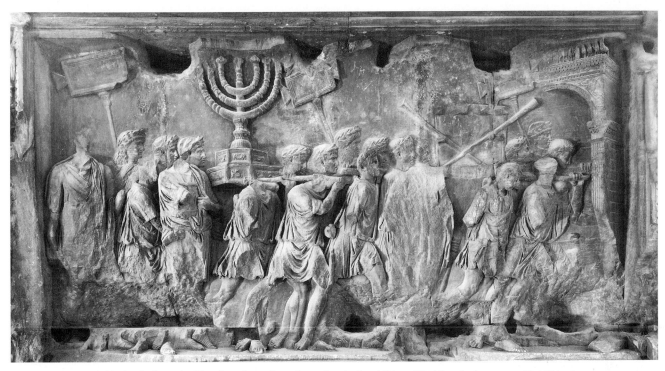

6-67 *Spoils from the Temple in Jerusalem*, from the Arch of Titus. Marble relief, approx. 7' 10" high.

ment and strikingly suggest the "momentary flash of a passing parade." The work brings to mind the experiments with light and space in imperial painting and architecture.

The *Triumph of Titus* (FIG. **6-68**), represented across the archway, is more slowly paced, without the thrusting movement of the marching soldiers carrying the spoils from the temple and without the spatial experiments found there. The numerous layers of figures do create an illusion of depth, and a bold attempt at representing the overlapping horses turning into the roadway, drawing the chariot of Titus, per-

suades us that the sculptor's intentions are alike in both panels. Close correspondence exists between the event as shown in the panels and as described by Josephus (contemporaneous Jewish soldier, statesman, and historian):

> Most of the spoils that were carried were heaped up indiscriminately, but more prominent than all the rest were those captured in the Temple of Jerusalem— a golden table weighing several hundredweight, and a lampstand similarly made of gold. . . . The central shaft was fixed to a base, and from it extended slender branches placed like the prongs of a trident, and

6-68 *Triumph of Titus*, from the Arch of Titus. Marble relief, approx. 7' 10" high.

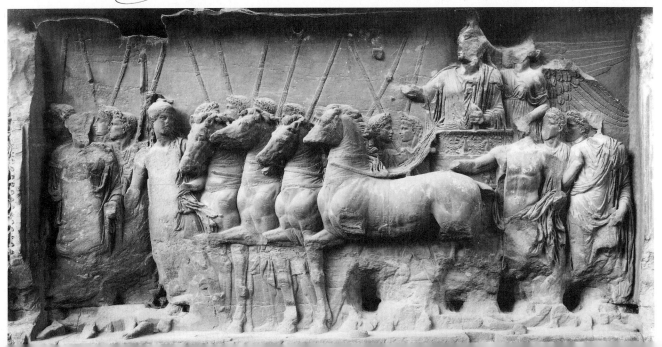

with the end of each one forged into a lamp: these numbered seven, signifying the honour paid to that number by the Jews. After these was carried the Jewish Law, the last of the spoils. Next came a large group carrying images of Victory, all fashioned of ivory and gold. Behind them drove Vespasian first with Titus behind him: Domitian rode alongside, magnificently adorned himself, and with his horse a splendid sight.

The Column of Trajan, another kind of commemorative monument, dating from A.D. 113, stood in his forum before the unexcavated temple of Trajan (FIGS. **6-69** and **6-70**). The column, perhaps the work of Trajan's favorite architect and military engineer, Apollodorus of Damascus, was often copied. As late as the nineteenth century, a column inspired by the Column of Trajan was erected in the Place Vendôme in Paris, in commemoration of the victories of Napoleon. The original column is 128 feet high. It was once crowned by a statue of Trajan, which was lost in the Middle Ages and replaced by a statue of St. Peter in the sixteenth century. The square base served as Trajan's mausoleum, and his ashes were deposited there in a golden urn in A.D. 117. The column records Trajan's two successful campaigns against the Dacians, which resulted in the extension of Roman dominion across the Danube into what is now Hungary and Rumania. Under Trajan, the limits of the Roman Empire reached their greatest extent. The marble reliefs, in a 625-foot band that winds the

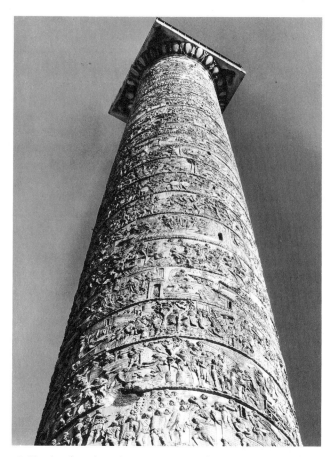

6-69 Attributed to Apollodorus, Column of Trajan, Rome, A.D. 113. Marble, 128′ high.

6-70 Detail of the two lowest bands of the Column of Trajan. Marble relief, each band approx. 36″ high.

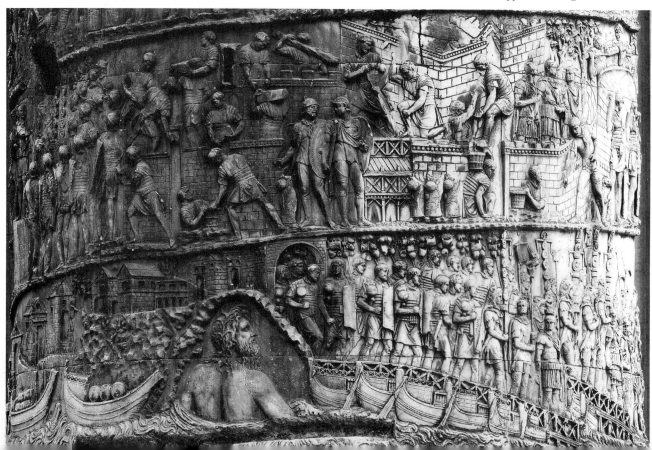

height of the column, represent a continuous record of the campaigns, told in 150 separate episodes with literally thousands of figures. The band increases in width as it winds to the top of the column (from approximately 36 inches to 50 inches) for better visibility from the ground. Recognition of the upper subjects must have been a problem, even though the column originally stood in a small courtyard surrounded by two-story buildings, from the upper story or roofs of which the topmost reliefs may have been recognizable.

The carving is executed in relatively low relief to reduce shadows to a minimum, as they would have tended to impair the legibility of the work. This low relief constitutes a significant reduction in illusionistic depth. The sculptured narrative places much emphasis on military architecture, fortifications, bridges, and the like, to demonstrate Roman technical superiority over the barbarian foe. At the bottom of the column a pontoon bridge is built across the Danube, while the river-god looks on in amazement at this achievement (FIG. 6-70); on the fourth circuit of the column, Trajan is shown speaking to his troops. The emperor's figure is seen many times throughout the narrative, appearing as a major motif. The story of the campaigns is told with objectivity; the enemy is not belittled, and the Roman victories are hard won. But only about a quarter of the reliefs show battle scenes. Much of the balance represents the Roman mission of bringing civilization to the benighted. Towns are built, crops harvested, rituals performed, and imperial speeches given. In short, the reliefs of the column are not only an exaltation of Trajan, but a hymn to *Romanitas*.

The Column of Trajan reliefs embody some features of great importance for the art of the Middle Ages. We already have indicated one of them—a *flattening of relief*—and the functional reason for it (better visibility). But the sacrifice of the strong illusionism seen in the Arch of Titus reliefs, or even in the Ara Pacis Augustae reliefs, may have another explanation: a desire for completeness of narrative description that required that a great number of actions be shown in a limited space. Thus, *narrative* fact, rather than *visual* fact, is required, and truth to appearance ("illusionism," "realism"), to a greater or lesser degree, can be sacrificed. A very singular and important sacrifice is made in the Column of Trajan compositions, and that is in the representation of space. In the Ara Pacis Augustae and the Arch of Titus reliefs, the figures are represented as standing and moving on the same ground line, at the eye level of a presumed observer who occupies an imagined place on the same line; thus, all the heads are approximately on the same level. But the figures of the Column of Trajan are superposed (placed in rows one above the other), a device altogether different from the approximate perspective of illusionism. From a perspective viewpoint, the figures and architecture of the Column of Trajan are entirely haphazard in their arrangement; from a narrative viewpoint, they occur where the story demands. Relative proportions often are sacrificed: soldiers are represented as large as the walls they attack, or (although not visible in our illustrations here) cavalrymen are as large as, or larger than, their horses. We can say that conventions of Medieval art already appear in the sculptures of the Column of Trajan.

The new conventions were not adopted immediately. They appear in the somewhat later Column of Marcus Aurelius, but in a relief of *Marcus Aurelius Sacrificing* (FIG. 6-71), the older illusionism persists, although not to the degree we find it in the Arch of Titus. In this relief, one of three panels surviving from a triumphal arch dedicated to the emperor and carved about A.D. 180, the procession was cut up into panels (each a part of a larger whole to be imagined by the viewer), because the narrative requirements were not so demanding. The poses of the figures and their draperies echo Hellenic Classicism. Hadrian, Antoninus Pius, and Marcus Aurelius were all Hellenophiles, and it is in their reigns that perhaps the last powerful influence of Classical Greece was felt in Roman art. The figures in the *Sacrificing* relief are cut to ideal proportions, but a considerable Roman realism appears in the details and in such illusionistic

6-71 *Marcus Aurelius Sacrificing*, panel from a triumphal arch dedicated to Marcus Aurelius, late second century A.D. Marble relief, approx. 10′ 6″ high. Palazzo dei Conservatori, Rome.

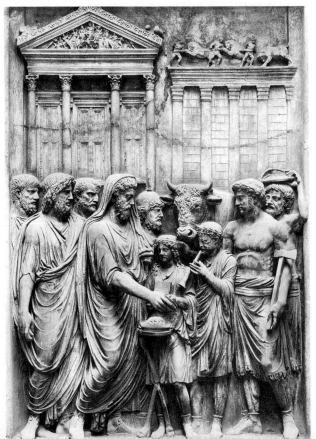

devices as the perspective of the background architecture and the varying depth of relief to show distance. The bland composure of the faces of the Ara Pacis Augustae does not appear; the times have changed and the end of the golden age has come. A kind of brooding solemnity prevails as the grave philosopher-emperor (the sculptor gives us a portrait likeness) prepares the sacrifice that may produce omens of a troubled future for the empire.

PORTRAIT SCULPTURE

Two portraits from Republican times (FIGS. 6-14 and 6-15) already have shown us the Roman aptitude for and skill in the art of portrait sculpture—an expression of the now-familiar Roman instinct for the factual. It is scarcely an accident that the historical reliefs just discussed contain portrait figures. Literally thousands of portrait busts have been found from the times of the republic and the empire, and the best are evidence of the important contributions the Romans made to portrait art. Two tendencies of style determine the production of portrait sculpture: the *verism* of the republic, and the Hellenizing *idealism* of the empire. In the later period, the tendencies alternate and sometimes converge. Significantly, members of the lower social classes generally are portrayed realistically in all periods, but official portraits of the ruling class tend to shift between realism and idealism, depending in part on the general style of the period, the preference of the sitters, or the artist's own interest in the psychological probing of personality.

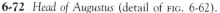

6-72 *Head of Augustus* (detail of FIG. 6-62).

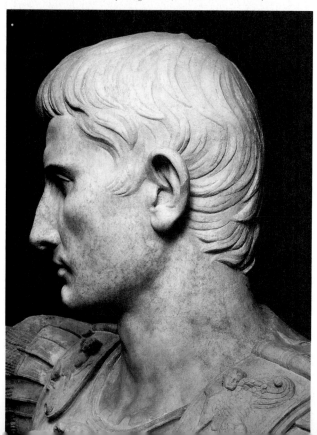

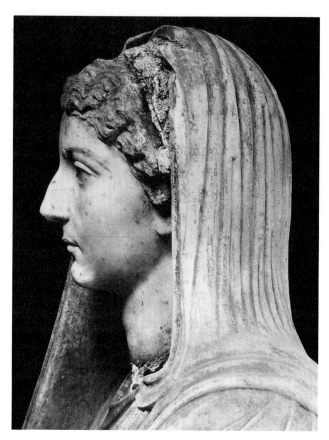

6-73 *Livia* (second wife of Augustus), *c.* A.D. 20. Marble, head approx. 15″ high. Antiquarium, Pompeii.

A portrait of the emperor Augustus (FIG. **6-72**), a detail of the Primaporta figure (FIG. 6-62), which can be profitably compared with earlier portraits from the republic, is very subtly idealized without any apparent loss of likeness. The hair, adhering closely to the skull, is reminiscent of the fifth-century B.C. Greek style and reflects Augustus's Classical taste prevailing over Hellenistic realism. We have met the Classicism of the Augustan Age in the Ara Pacis Augustae and have pointed out that Vergil's *Aeneid*, deliberately imitating Homer and commissioned by Augustus himself, reveals the same Classical spirit in its form. Livia, the second wife of Augustus and mother of the emperor Tiberius, is shown in a portrait bust as the tactful and elegant woman she is believed to have been (FIG. **6-73**). The same Augustan idealization and the same retention of the likeness are evident here. The lifelike quality is enhanced by effective use of color, much of which is preserved in the hair, eyes, and lips.

The emperor Vespasian, successor to Nero, reigned from A.D. 69 to 79. The portrait bust of this first emperor of the Flavian line (FIG. **6-74**) forcefully reveals the veteran general who had fought successfully in all parts of the empire. Vespasian was a man of simple origin and simple tastes, who desired to return to

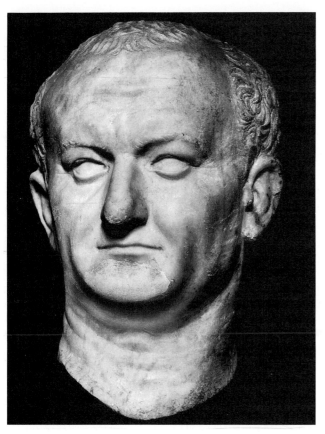

6-74 *Vespasian, c.* A.D. 75. Marble, life size. Museo Nazionale Romano, Rome.

Portraits of great persons who exhibit ambivalent qualities, such as that of Pompey (FIG. 6-15), are perhaps more interesting to us than portraits of persons of more uniform character. This quality of ambivalence was especially true of the emperor Hadrian (FIG. 6-76). We approach his portrait informed by the account of his personality given by an ancient biographer. Hadrian, beyond all other Roman emperors a lover of Greek art and culture and himself a skillful artist and architect, poet, scholar, and writer, is thus described:

He was grave and gay, affable and dignified, cruel and gentle, mean and generous, eager for fame yet not vain, impulsive and cautious, secretive and open. He hated eminent qualities in others, but gathered round him the most distinguished men of the state; at one time affectionate towards his friends, at another he mistrusted and put them to death. In fact he was only consistent in his inconsistency [*semper in omnibus varius*]. Although he endeavored to win the popular favor, he was more feared than loved. A man of unnatural passions and grossly superstitious, he was an ardent lover of nature. But, with all his faults, he devoted himself so indefatigably to the service of the state, that the period of his reign could be characterized as a "golden age."*

*Aelius Spartianus, in *Scriptores Historiae Augustae* (Cambridge, MA: Harvard University Press, Loeb Classical Library, rev. 1985).

Republican simplicity after Nero's extravagant misrule. He was a good administrator—honest, shrewd, and earthily humorous. These qualities speak from his portrait. The artist has attempted no flattery. Quite possibly, Vespasian himself discouraged the sculptor from idealizing too much; he preferred the blunt, rugged aspect of the soldier. From the portrait, we can understand the active man whose care was restoration of the empire and who is reported to have said on his deathbed, "An emperor should die standing." The portrait, although a little subtler in characterization, is almost Republican in its directness.

The *Portrait of a Lady* (FIG. 6-75) from the reign of Domitian (A.D. 81–96) is a departure from the usually rather stern portraits of Roman women. This portrait is a rare masterpiece in its inimitable union of sensitive beauty, noble elegance, and lucid intelligence. The elaborate coiffure, its corkscrew curls punched out by the adroit use of a drill, stands in striking textural contrast to the delicate, softly modeled features; the technique and effort needed to reproduce the luminosity and glow of actual flesh recall the art of Praxiteles. This truly regal work, exemplar of Roman portrait art at its height, can be instructively compared with the head of *Queen Nefertiti* (FIG. 3-39), done in the subtle Amarna style of Egypt.

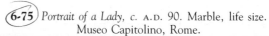

6-75 *Portrait of a Lady, c.* A.D. 90. Marble, life size. Museo Capitolino, Rome.

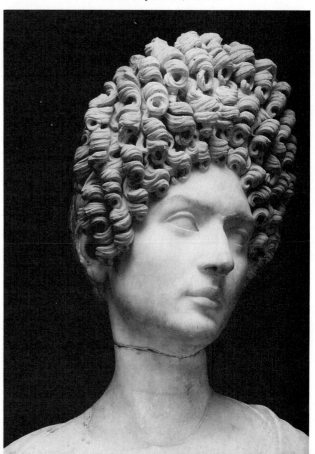

We might bring also to the contemplation of his portrait the poem, long famous, that Hadrian wrote at the end of his life:

> Charming, fleeting, little soul,
> My body's guest and comrade,
> Where now will you go
> Naked, pallid, unmoving
> Never again to play?

In this portrait (FIG. 6-76), *Hadrian* affects the Greek coiffure, in form much like the Early Classical ringlets of the *Apollo* from the Temple of Zeus at Olympia (FIG. 5-40). Perhaps inspired by portraits of Pericles, the artist also has adopted the Greek beard, abandoning the age-old tradition of the clean-shaven face. From this point on, most Roman emperors would be presented bearded. The head is idealized, but with restraint; the features are a little regularized and retouched, perhaps, but not so as to interfere with the likeness. A certain ambiguity and inscrutability shadows the face, but when we know a little about Hadrian, we are prepared for this.

6-76 *Hadrian, c.* A.D. 120. Marble, approx. 16" high. Museo Ostiense, Ostia.

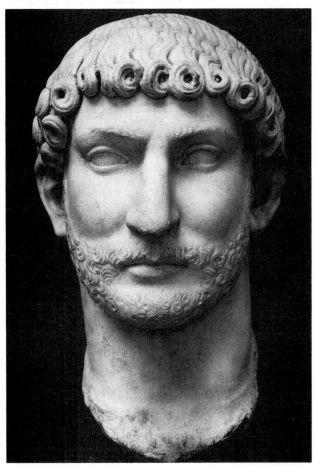

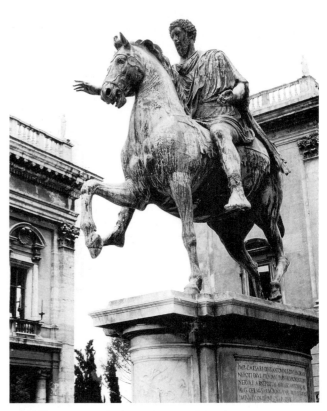

6-77 Equestrian statue of Marcus Aurelius, Capitoline Hill, Rome, *c.* A.D. 165. Bronze, over life size.

The last emperor of the great imperial line that included Trajan and Hadrian was the Stoic Marcus Aurelius. We have touched on his philosophy in looking at the Faiyum portrait (FIG. 6-40) of a man whose serenely gentle and reflective face manifests the emperor's philosophy. A great equestrian, bronze, portrait statue of Marcus Aurelius (FIG. **6-77**) has survived from the ancient world, unique in that it *did* survive, for there are no other examples of what must have been a statue type popular with the Roman emperors. (Medieval Christians probably melted the statues down for their bronze, because they were impious images from the pagan, demonic world of the Caesars. Some believe that the Christians mistook the statue of Marcus Aurelius for that of the first pro-Christian emperor, Constantine, and that is why it escaped destruction.) The emperor, whom we have seen earlier in his role as head priest, with his toga drawn over his head (FIG. 6-71), is portrayed in the equestrian statue exercising his office as commander of the legions, perhaps passing before the people. His gesture here is magisterial, benignly authoritative, and much like a later papal blessing. It conveys at once the awesome and universal significance of the Roman *imperium*, the almost godlike emperor presiding over the whole world. Yet, at closer view, we see

the same features as in the sacrifice panel—those of a man calmly aloof, meditative, and a little resigned. The magnificent, high-stepping charger, the war-horse mettlesome and impatient with the tameness of the parade, breathes hotly through dilated nostrils. This superb bronze was the inspiration, and some-times the despair, of Renaissance sculptors. Formerly placed on the Capitoline Hill (it has been removed for restoration), this authentic, ancient centerpiece of Michelangelo's great architectural design (see Chap-ter 17), represents, as does no other single object, the lost authority of the Roman Empire.

After the rule of Marcus Aurelius, the downward course of the empire became precipitous, although not at once; Septimius Severus held it level for a while. His son Caracalla (FIG. **6-78**), under whom the great baths named after him progressed toward com-pletion, was a brutal man, murderer of his own brother. He reigned briefly (A.D. 211–217), and his murder grieved no one. Edward Gibbon writes of him: "Caracalla was the common enemy of man-kind." To render his violent traits, the sculptor had to return to realism. We find a burly, suspicious, almost snarling man, more a cutthroat than an emperor, a man who could scarcely be more the opposite of Mar-cus Aurelius. Significantly for what was to follow—the military anarchy of the third century, when the "barracks emperors" were set up (and pulled down) by the army—Caracalla pursued the tyrant's rule that if one has the loyalty of the army, one need not con-sider the people. His soldiers, however, were not wary enough to protect him from the dagger of an assassin, and his death was the model death of the tyrant, a form repeated again and again throughout the terrible third century. "Such," writes Gibbon, "was the end of a monster who disgraced human na-ture." Yet Michelangelo was later to base his noble bust of Brutus on this bust of Caracalla.

Internal unrest, combined with attacks on frontiers by the new Sassanian line of Persian kings in the east and German tribes in the north, brought the empire to the verge of collapse. In the space of fifty years, some twenty barracks emperors were exalted and then assassinated by factions of the army. This cre-ated anguish and foreboding throughout the empire, which were curiously reflected in numerous por-traits, including that of a barracks emperor himself, *Philip the Arab* (FIG. **6-79**). Philip became emperor after having his predecessor, Gordianus, executed. In con-sidering his portrait, it is useful to know something about the close of his career. An adventurer himself, he knew that he was surrounded by adventurers (es-pecially in the army), who were ready to follow his example. Faced with a revolt, Philip appointed a brave and intelligent aristocrat, Decius, to put it

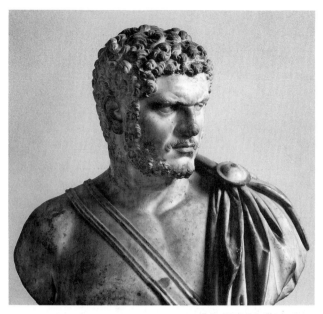

6-78 *Caracalla,* c. A.D. 215. Marble, life size. Vatican Museums, Rome.

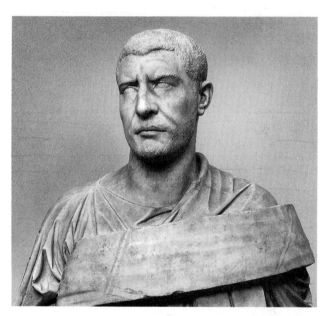

6-79 *Philip the Arab,* A.D. 244–249. Marble, life size, Vatican Museums, Rome.

down and to calm the army. The army accepted De-cius as its leader on condition that he agree to depose Philip or be put to death himself. Decius then led the best of the army against Philip, who was slain, and Decius became emperor. The portrait of Philip shows the face of a man who knows he is utterly without security. Fear, distrust, and suspicion work the face into a mask of guilt and anxiety. The brow is fur-rowed; the deep-set eyes shift sideways. The eye pupils are carved, an innovation that focuses on the

psychic state. The hair is cropped short; the beard is stubbly. The short, nervous chisel strokes adapt to the nervous mood. (In the works of later sculptors, these strokes would become increasingly abrupt and schematic, leading to the geometric patterning of the fourth century.) But it is the face, with its terrible tensions, that rarely had been seen before in the history of art. From the Archaic masks, we come at last, in the third century A.D., to a face so "modern" in what it reflects of trouble that we experience a shock of recognition. Both the ideal and the real in Roman sculpture have been replaced with something new, *expression*, wherein the sculptor is concerned first of all with expressing an emotional state—either the subject's or the artist's, or perhaps both.

THE LATE EMPIRE

The anarchy of the third century A.D., when at one time as many as eighteen claimants struggled for the throne and it seemed as if the empire would be divided into a number of small states, was brought to an end by a vigorous leader, Diocletian, in A.D. 285. Diocletian (A.D. 284–305) saw the impossibility of ruling a vast empire alone, given the continual German and Persian attacks in the north and east and countless revolts in the provinces. He restored political order by dividing authority among four officials, the *tetrarchs*, appointing himself as one of them. Diocletian appointed a coruler called, like himself, "augustus," and each of the two "augusti" then adopted an assistant of slightly lower rank, the "caesar." One augustus and one caesar ruled in the east; the other pair ruled in the west. Although political control was restored, a fatal precedent was set for the division of authority within the Roman Empire.

Constantine (A.D. 324–337) did away with Diocletian's system and ruled alone. He also instituted the practice of dividing the empire, like personal property, among the emperor's sons—a crippling, divisive custom that was to last into the Middle Ages. Even more divisive was Constantine's founding of a city he named after himself (Constantinople, now Istanbul, on the site of the ancient Greek city of Byzantium), which led inevitably to the decline of the city of Rome and the shift of imperial emphasis to the east. Byzantium gives its name to the later civilization of the eastern Roman Empire.

After the reign of Theodosius, at the end of the fourth century, the empire was irreparably divided, although the emperors of the east, at Constantinople, continued for centuries to claim the west. These claims were made in vain; in the fifth century, the barbarians took power in the west—the Ostrogoths in Italy, the Vandals in Africa, the Visigoths in Spain, the Franks and Burgundians in Gaul, and the Angles and Saxons in Britain. These Romano-Germanic petty kingdoms succeeded to the once centralized and almost universal power of Rome and became the predecessors of the nations of modern Europe. The eastern half of the empire lived on as the Byzantine Empire for a thousand years, until the conquest of Constantinople by the Turks in 1453.

Architecture

Developments in architecture powerfully express the ebbing authority of the Roman Empire. In the days of Augustus and Trajan, the "walls" of the empire had been the might of the legions on its remotest borders; behind the bulwark of the legions, a great empire could rest secure. But late in the third century, the emperor Aurelian was forced to girdle the city of Rome itself with walls, turning it into a fortress; Rome became what it had been at the start, a walled city, now dwindling into the ghost of an empire. Aurelian's insecurity was shared by Diocletian, who, unlike Tiberius in the first century A.D., could not afford to retire to the undefended paradise of Capri (ancient Capreae). Instead, about A.D. 300, he built, for his retirement, a well-fortified palace (FIGS. 6-80 and 6-81) on the Dalmatian coast at Split (ancient Spalatum) in Yugoslavia. The complex, which covers about ten acres, is laid out like a Roman colonial city. The plan is almost identical to the plan of Timgad (FIG. 6-44), although its military aspects, such as the fortified walls and tower-flanked gates, appear to be even more prominent in comparison with the relatively small scale of a palace. Such a fusion of military and imperial palace architecture strikingly reflects the changed life-style of the Late Imperial period, when increased centralization and standardization infused all levels of Roman society, private citizens and public officials alike, with militaristic thinking. In architecture, such standards of military behavior as obedience and subordination are reflected in symmetry, axiality, and unity of direction, all apparent in the plan of the Split palace.

The broad, columned street leading toward the palace constitutes a ceremonial axis that dominates the architectural layout. All other architectural features are arranged symmetrically around this wide avenue, which leads into a large columned (peristyle) court (FIG. 6-82) fronting the entrance of the palace proper. Designed as a three-bay Classical portico, the façade is marked by an unusual and quite un-Classical feature: over the central bay, the entablature arches

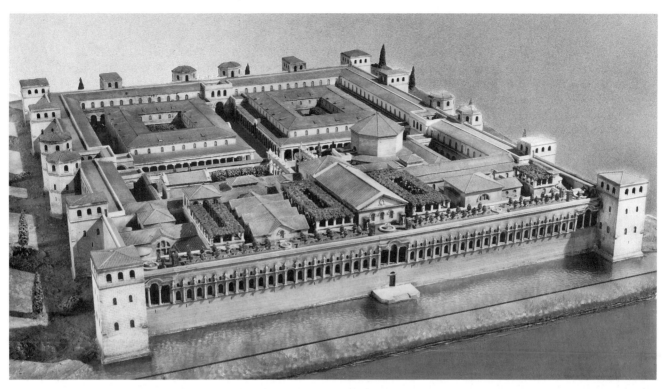

6-80 Palace of Diocletian, Split (ancient Spalatum), Yugoslavia, A.D. 300–305.
Museo della Civilta Romana, Rome. (Reconstruction by E. Hebrard.)

6-81 Plan of the palace of Diocletian, Split. Original Roman masonry is shown in solid black.

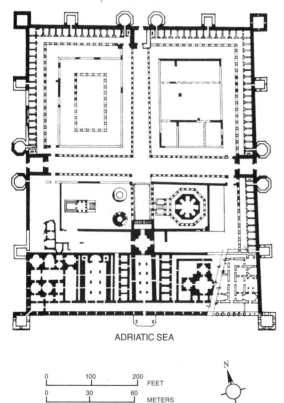

ADRIATIC SEA

0 100 200
 FEET
0 30 60
 METERS

N

upward into the triangular face of the pediment. Formally, the purpose of this "broken pediment" undoubtedly was to emphasize the central axis of the design. Symbolically, it became the "gable of glorification," under which the emperor appeared before those who gathered in the peristyle court.

The feature of the broken pediment had appeared earlier, mostly in the eastern provinces of the Roman Empire. It was found, for example, in the façade of the propylon to the Sanctuary of Jupiter and in the Temple of Venus at Baalbek (ancient Heliopolis) in Syria. It is, to repeat, an un-Classical device that represents a transitional stage between the Classical, column-supported, horizontal entablature and the springing of arches directly from column capitals, as is the case in the flanking colonnades of this same peristyle at Split. (Examples of this direct springing of the arch occur in Pompeian painting of the first century B.C., as well as in the architecture of Hadrian's villa at Tivoli [ancient Tibur].) The process of change from the *trabeated* (post-and-lintel) architecture of Greco-Roman antiquity (and earlier) to the *arcuated* (arch-column) architecture of the Middle Ages began in the first century A.D., and we see it here, in the arcade of the Split palace, in its perfected form and on a grand scale. It is interesting to observe the gradual emergence of arcuated architecture from the Roman

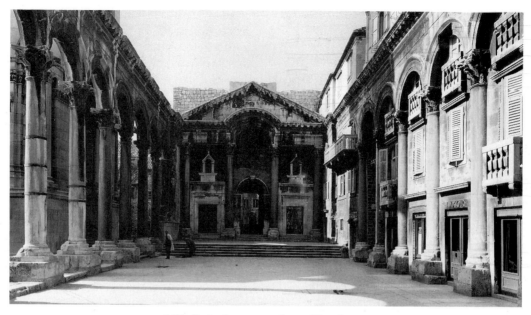

6-82 Peristyle court, palace of Diocletian.

arch order (FIG. **6-83**) and the Roman architect's reluctance to give up the conventional three-part division of the entablature, even once it had become only a blocklike fragment, as in the capital from the Baths of Caracalla (FIG. 6-61). Later, Byzantine architects would retain the entablature block but rid it of the old Classical features, geometrizing it into a flat-sided, trapezoidal, ''impost'' block (FIG. 7-35).

From early in imperial times, structural changes in Roman architecture continued to be based on Hellenistic developments but were accompanied by experiments in nonstructural design. Throughout the empire, purely ornamental combinations of the elements of Classical architecture could be found. These compositions were often so dramatically elaborate that they have been called ''baroque'' (see Chapter 19). A striking example is Al-Khazneh, the so-called Treasury, at Petra (FIG. **6-84**), in modern Jordan. This rock-cut structure of imposing scale (over 130 feet in height) has a decorative façade in two stories. The lower story contains a six-columned portico, the columns irregularly spaced, with niches for statuary between the outer pairs. The upper level splits the façade and the pediment to make way for a cylindrically shaped, tholos-like element, which contrasts sharply with the rectangles and triangles of the design. (Exactly this same feature appeared on a painted wall of the second style in one room of the House of the Labyrinth at Pompeii as early as 50 B.C.) The rhythmic alternation of deep projection and indentation creates dynamic patterns of light and shade, an effect of restless oppositions of form. The façade of the Treasury deliberately seems to contradict the ordered regularity we expect of Classical architecture. Its theatricality reflects, and perhaps was derived from, the scene buildings that backed the stages of Greek and Roman theaters, providing an elaborate backdrop for action and spectacle.

6-83 Development of arcuated architecture from trabeated architecture. (After Kimball and Edgell.)

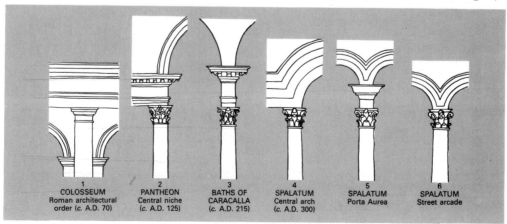

| 1 COLOSSEUM Roman architectural order (c. A.D. 70) | 2 PANTHEON Central niche (c. A.D. 125) | 3 BATHS OF CARACALLA (c. A.D. 215) | 4 SPALATUM Central arch (c. A.D. 300) | 5 SPALATUM Porta Aurea | 6 SPALATUM Street arcade |

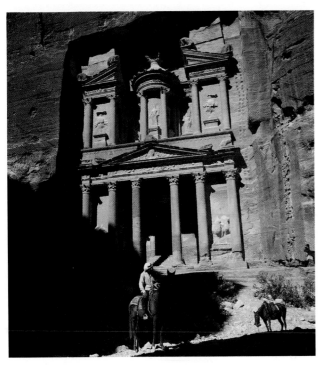

6-84 Al-Khazneh (the Treasury), rock-cut mausoleum, Petra, Jordan, second century A.D.

Symptomatic of the decline of Rome's central power and authority, major building efforts began to shift toward the provinces. After the division of the Roman Empire under Diocletian, who realized that the far-flung imperial holdings could no longer be ruled effectively from Rome, Constantius Chlorus, father of Constantine the Great, became caesar of the western empire and established his residence at Trier (ancient Augusta Trevirorum), West Germany, on the Moselle river. Trier became the largest city in the northwestern sector of the empire.

After being sacked by the Franks and Alemanni in A.D. 275–276, Trier was rebuilt and ringed with defensive walls. The Porta Nigra, or "Black Gate" (FIG. 6-85), which probably dates between this period and about A.D. 310, was never quite completed. Large enough to be converted into a Christian church later on, it is an outstanding example of a Roman city gate, built not only for defensive purposes, but also for the impression it would make on a visitor, manifesting the might of imperial Rome. The rough, blunt exterior gives it an unintended effect of *rustication*, partly due to the building's unfinished state. Its defensive function, moreover, scarcely would have permitted refined details, and the structure expresses Roman features like the Colosseum-arch order with a heavy, provincial accent.

The Porta Nigra is the north gate of a vast palace complex of some seven hundred acres. At the center of the palace complex stands the audience hall of the palace proper (FIG. 6-86), which dates from about A.D. 310. Its basic design is quite simple: a rectangular hall measuring about 190 feet long and 95 feet wide, covered by a flat, wooden, coffered ceiling some 95 feet above the floor. Added to the short,

6-85 The Porta Nigra (Black Gate), Trier (ancient Augusta Trevirorum), West Germany, c. A.D. 280–310.

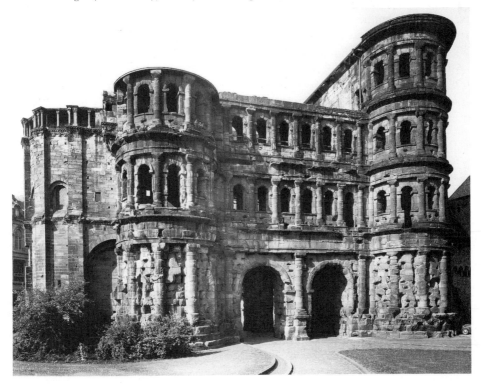

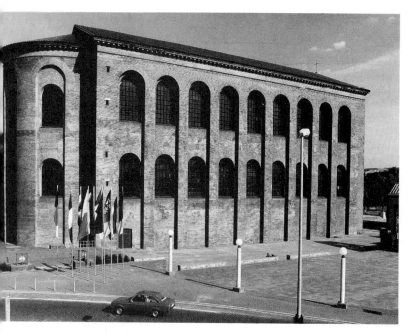

6-86 The Aula Palatina (audience hall of the palace), Trier, West Germany, c. A.D. 310.

north side is a semicircular apse, also with a flat ceiling, separated from the main hall by a triumphal arch. Arch and apse originally were decorated with marble incrustation and mosaics to provide a magnificent environment for the enthroned caesar. The interior was brightly lighted through double rows of large, arched windows.

The articulation of the building's exterior with boldly projecting vertical buttresses to create a pattern of alternating voids and solids is a significant feature and one that would become characteristic of much later Roman architecture. The verticality of the building originally was lessened by horizontal timber galleries, which permitted the servicing of the windows. The exterior was stuccoed in gray-white, with windows framed in color. The interior could be heated through a *hypocaust* system (hot air circulating through tubes built into the walls to a height of 24 feet). The growing taste for large windows was due to the development and increasing use of lead-framed panes of window glass, which offered late Roman builders the possibility of giving life and movement to blank exterior surfaces.

The villa at Piazza Armerina in Sicily (FIG. **6-87**) is a fascinating monument of the late Roman Empire and recalls, on a much smaller scale, the intricate planning of Nero's villa-palace, the Domus Aurea. The villa shows that patrons of great wealth still could live the opulent life of the caesars of the golden age. Excavated and studied in very recent times, the villa is still the subject of scholarly debate regarding its date of construction and its ownership; we place it in time between A.D. 310 and A.D. 350 and leave to further

study the question of whether its owner was Maxentius, the defeated rival of Constantine, or a multimillionaire with sufficient resources to live in imperial style. The rambling plan displays almost every spatial arrangement and building type in the Roman architectural repertory—porticoes, peristyles, tri-lobed and poly-lobed halls, thermae, a basilica, aqueducts—all arranged along a variety of axes. Although a contrapuntal play of square, round, and elliptical spaces is evident, the effect is quite casual. Many of the elements constitutive of the ecclesiastical architecture of early Christianity are present here in this pagan villa of the late Roman Empire.

Perhaps the most exciting feature of the villa is its 7,000 square feet of floor mosaic. The mosaics, which may be the work of craftsmen from North Africa, provide a compendium of late Roman themes: the hunt, the games, wild and domestic animals, river and forest life, genre scenes, scenes from mythology, allegorical subjects, and the like. A seated female figure, an *Allegory of Africa* (FIG. **6-88**), holds a horn of plenty as she embraces a sacred tree. She is flanked by animals symbolic of the tropical orient—an elephant, a tiger, and the mythical phoenix. Another frieze (FIG. **6-89**) shows briefly attired young women, who often are referred to as the "bikini girls," performing vigorous exercise and displaying trophies. The style of the Piazza Armerina mosaics is not distinguished; it represents a kind of commonplace vernacular familiar throughout the empire. But these mosaics do present an encyclopedia of pagan images drawn from real life or imagination. Many of them will survive, in some transformed state, through the Christian period.

6-87 Plan of the Roman villa at Piazza Armerina, Sicily, c. A.D. 310–350.

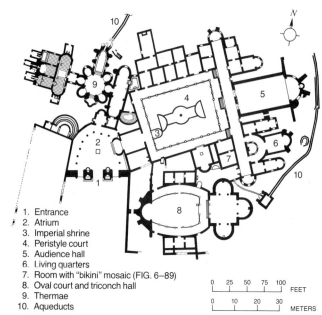

1. Entrance
2. Atrium
3. Imperial shrine
4. Peristyle court
5. Audience hall
6. Living quarters
7. Room with "bikini" mosaic (FIG. 6–89)
8. Oval court and triconch hall
9. Thermae
10. Aqueducts

6-88 *Allegory of Africa*, from the Roman villa at Piazza Armerina, Sicily, early fourth century A.D. Mosaic.

6-89 *Young Women Exercising*, from the Roman villa at Piazza Armerina, Sicily, early fourth century A.D. Mosaic.

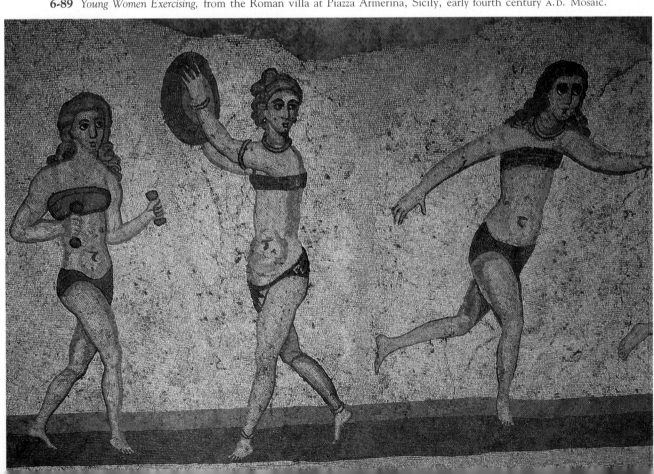

The style of the Piazza Armerina mosaics, in its reduction of modeling tonality to inner line and closed outline, is a denaturalization of Classical naturalism, foreshadowing the more abstract and schematized art of the earlier Middle Ages. But Classical art does not terminate in the fourth century; indeed, we can trace it through more or less authentic survivals and revivals for a thousand years until its commanding reappearance in the Italian Renaissance (Chapters 15–17). Classical themes and images, as well as Classical modes of representation, even though modified in the development of Medieval art by anti-Classical forms and tendencies, recognizably persist. Often, Classical and anti-Classical features, iconographic and stylistic, will exist side by side.

This opposition is strikingly evident as early as the fourth century, when we compare the de-classicizing style of the mosaics of Piazza Armerina with the mature, sophisticated Classicism of a work of art contemporary with them (FIG. **6-90**). A vast Roman floor mosaic recently discovered in Zippori, Israel (1988), and doubtless belonging to another luxurious, Late Imperial villa of the Piazza Armerina sort, yields a detail representing the head of a woman, as yet unidentified. The floor itself is decorated with theatrical masks and emblems of the rites of Dionysos, the ritual source of Classical drama. The fact that the site of the floor is adjacent to a theatrical building suggests that the lovely person represented may have been an actress, rather than a deity or allegorical figure. The beauty of the face is not stylized. It could be a deliberate likeness of a living subject (compare it with the head of the *Allegory of Africa*, FIG. 6-88). The lifelike, sensuous coloration, the slight, graceful tilt of the head, the individualized features, and the intimate glance aimed directly at the viewer, are what we might expect of a personal, quite private portrait made to record a beloved countenance. This portrait is not at all the conventionally idealized mask common in Roman pictorial and decorative design. All the resources of representational technique noted in the figurative art of the Greco-Roman world are brought into play here in the rendering of the head and facial features by subtle, illusionistic modeling. The gradations of light and shade (chiaroscuro) move so lightly across the woman's features as to create a vagueness of expression, an ambiguous and mysterious effect that has prompted the romantic, yet suggestive, comparison of this fascinating face with that of the *Mona Lisa* (FIG. 17-4). In any event, we have before us an unforgettable example of the vitality of Classical naturalism in the very period of its apparent decline, an apparition of its authentic spirit at a time when we would not expect it. Other works of this period yet may be unearthed that might cause us to alter our determination of the time limits that separate the Classical world from the Medieval.

We shall see presently that Classical forms, especially from the art of the Early Empire, will be appropriated by Constantine to give ideological weight and the endorsement of tradition to his own designs. He never lost sight of the political-historical significance of imperial Rome as expressed in the art of its golden age, borrowing and adapting it as he saw fit.

6-90 Head of woman (Aphrodite?), fourth century A.D. Detail of mosaic floor from Roman villa, Zippori (ancient Seppharis), Israel. Floor area 430 sq. ft.

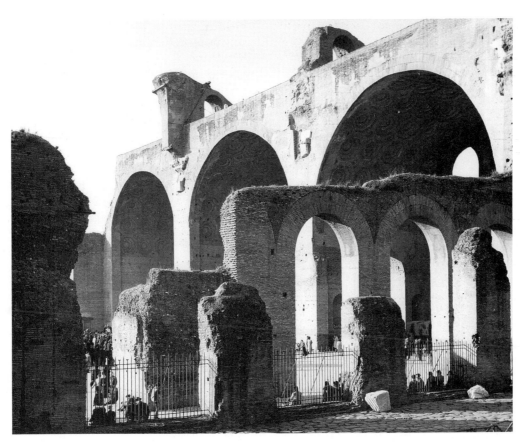

6-91 Basilica of Constantine, Rome, c. A.D. 310–320.

Although he moved the center of the Roman Empire to his new city on the site of ancient Byzantium, Constantine completed some important building projects prior to leaving Rome. One of these was the vast basilica begun between A.D. 306 and A.D. 310 by Maxentius, a rival of Constantine, and finished by Constantine after A.D. 313 (FIGS. **6-91** and **6-92**). All that remains of the building are three barrel-vaulted bays of the north aisle, with brick-faced concrete walls 20 feet thick supporting the coffered vaults. The interior, like that of the Baths of Caracalla (FIG. 6-61), was richly marbled and stuccoed. The ruins, most impressive by virtue of their size and mass, represent only a small part of the original structure, which measured 300 feet long and 215 feet wide and had a groin-vaulted central nave 114 feet high. The reconstruction (FIG. 6-92) shows groin vaults (over the central nave) that permitted lighting of the interior through the ends of the cross vaults, which were left open in a manner similar to clerestory construction. Buttresses reinforced the vault (where the groins join vertical supports) and channeled part of the pressures exerted by the weight of the vault across the aisles and into the outside walls. Remains of the springing of the central vault and of the buttresses can be seen in FIG. 6-91. This late, great building of the ancient world is a monument to the ingenuity of Roman ar-

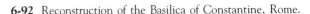

6-92 Reconstruction of the Basilica of Constantine, Rome.

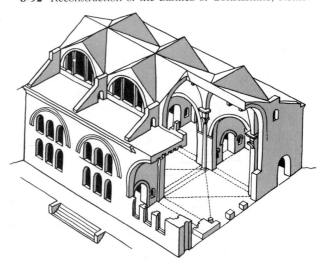

chitects. Exemplar of an architecture of space, it is designed on a grand, imperial scale—spacious, fully illuminated, uninterrupted by rows of vertical supports, and constructed of a highly malleable, versatile, fireproof material. In this respect, the Basilica of Constantine fulfills the requirements of architecture in periods of high civilization; not until Hagia Sophia would they be represented so artfully again.

Sculpture and Monumental Relief

The western apse of the Basilica of Constantine contained a colossal statue of the emperor, a seated figure some 30 feet high, the head of which has been preserved (FIG. **6-93**). The figure was composed of a brick core, a wooden torso covered with bronze, and head and limbs of marble. The head alone is 8½ feet high and weighs over eight tons. The characteristics of the earlier busts we have described, in which the real and the ideal alternate or blend, are no longer dominant here. Rather, we note the onset of traits familiar in the earlier, Archaic period: simplification of detail, with a regularizing and a flattening of the features that make the face a rigid mask, uncompromisingly frontal in aspect.* The eyes become enormously large in proportion to the rest of the features, although they still turn slightly to the side and upward in the Constantine head, as in certain third-century portraits like that of *Philip the Arab* (FIG. 6-79). Those unchanging qualities of the permanent form (first seen in Egypt and Mesopotamia, particularly in the representation of kings) once more make their appearance. The personality of the emperor is lost in the immense image of eternal authority. It is his authority, not his personality or his psychic state, that the sculptor exhibits. The colossal size, the Archaic rigidities, the eyes directed at no thing or person of this world—all combine to produce the formula of overwhelming power appropriate to the exalted position of Constantine as absolute despot, which he had certainly become by the early fourth century. It is not surprising that the first of the Christian emperors—in authority, the European equivalent of Ramses II—should be embodied in colossal form like the giant statues of the Egyptian king at Luxor and (formerly) Abu Simbel (FIG. 3-26).

The profound changes in style that occurred at an accelerated pace in the fourth century, introducing the epoch of Medieval art, can be seen in the group of two pairs of figures called *The Tetrarchs*, dating from about A.D. 305 (FIG. **6-94**). Although it is an earlier work than the portrait of Constantine, this piece is a much stronger reflection of the trend toward Archaism. Carved from porphyry (purple marble) in

*The living emperor himself, on formal occasions may have approximated a statue in appearance. H. P. L'Orange quotes the ancient writer Ammianus Marcellinus describing Constantius II, a successor to Constantine, on his entry into Rome: "He looked so stiffly ahead as if he had an iron band around his neck and he turned his face neither to the right nor the left; he was not as a living person, but as an image." L'Orange adds: "This hieratic emperor style, which as divine majesty (*divina maiestas*) in the same way leaves its mark upon palace, image and living reality, can furthermore be traced through Byzantium all the way down to the Holy Russian Empire." *Art Forms and Civic Life in the Late Roman Empire* (Princeton, NJ: Princeton University Press, 1965), pp. 124–25.

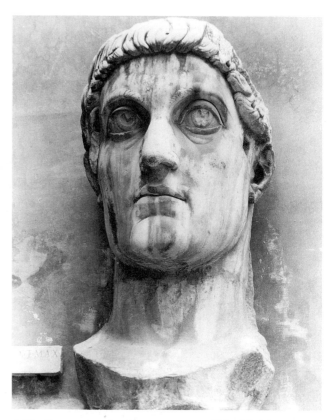

6-93 *Constantine the Great*, c. A.D. 330. Marble, approx. 8′ 6″ high. Palazzo dei Conservatori, Rome.

6-94 *The Tetrarchs*, c. A.D. 305. Porphyry, approx. 51″ high. Piazza San Marco, Venice.

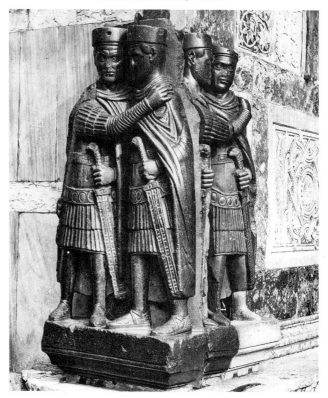

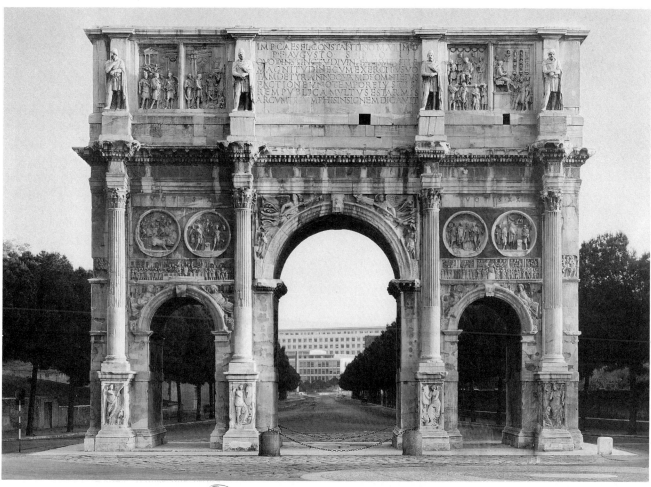

6-95 Arch of Constantine, Rome, A.D. 312–315.

one of the eastern provinces (perhaps Egypt), the group represents the four corulers of the empire: Diocletian and Maximian (the augusti) and Galerius and Constantius Chlorus (the caesars). They embrace each other to symbolize their hoped-for, but unrealized, serenity and concord. They seem, even as they embrace, to be huddled in fear and foreboding, facing some impending disaster, in an expression of the already noted prevalent anxiety of the age. Classical features have disappeared; the figures are not proportioned well, with large heads on squat bodies giving them a gnomelike appearance. The drapery is schematic and the bodies, shapeless. Here, some seven hundred years of Greek and Roman idealism and naturalism terminate. No portrait likenesses are attempted; the masklike faces are the same face in quadruplicate. Individuality and personality already belong to the past.

The waning creative power and technical skill of Rome in the west can be seen in the Arch of Constantine (A.D. 312–315) in the city of Rome (FIG. **6-95**). It is the last great triumphal arch preserved in the declin-

ing city. Dedicated to Constantine by a figurehead Senate, it commemorates the ruler's victory over his rival Maxentius, a victory that made Constantine the Great absolute monarch of the Roman Empire. But the occasion failed to stimulate the imagination of his builders. The design of the arch is similar to that of the Arch of Septimius Severus, of the early third century, and most of its decorative sculpture is taken from the monuments of rulers like Trajan, Hadrian, and Marcus Aurelius.

Beneath two Hadrianic medallions, which the emperor has refitted for his own narrative purpose, are reliefs belonging to Constantine's own period (FIGS. **6-96** and **6-97**), which give us an opportunity to estimate the degree of change from the style of the Early Imperial age to a new style that it is not inappropriate to call Medieval. Constantine, surrounded by his entourage, stands at the center of a rostrum, addressing the people. His central position corresponds to the frontality of his colossal statue and expresses a new, rigid formality of composition that increasingly would be based on the fixed positions of

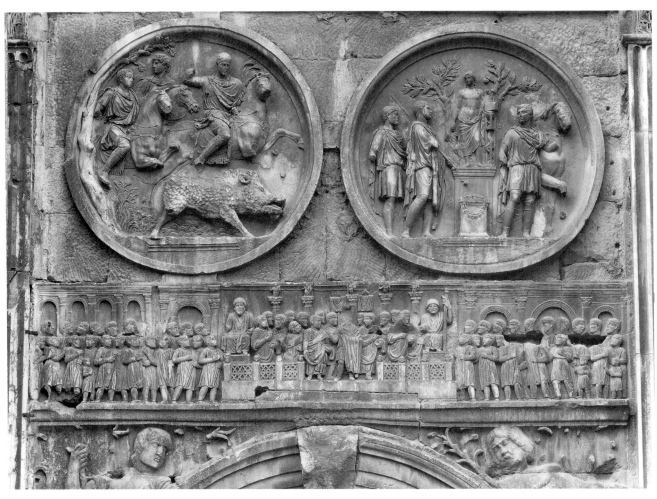

6-96 Reliefs from the Arch of Constantine: medallions, A.D. 117–138; frieze, early fourth century A.D. Marble, frieze approx. 40″ high.

6-97 Detail of the frieze shown in FIG. 6-96.

figures instead of on the representation of action. The figures are non-Classical in their lack of proportionality; in this respect, they are much like *The Tetrarchs*. Moreover, they do not move according to any principle of Classical-naturalistic movement, but rather with the mechanical and repeated stances and gestures of puppets. The relief is flattened back into the block; the forms are no longer fully modeled, and the details are incised. The lines of figures are superposed (a device used in the Column of Trajan, shown in FIG. 6-70); the spatial arrangement is, as noted, not casual, but a careful, head-counting lineup. The gestures are few and, like the uniform heads, are reproduced again and again. This presentation is not so much a historical narrative of action as the labeling of an event frozen into a tableau, so that the ordered groups can quickly be read and labeled as "crowd," "emperor," "servants of the emperor." The artist wished to include all the essential participants without the ambiguity that can accompany the description of particulars. These details have been reduced to an absolute minimum and replaced with formal placement and repetition of attitude and gesture.

We began the story of Roman art with two sculptured portraits that define, in different ways, the Roman bent for realism. We can end the story with two portraits stamped on Roman medallions (FIG. 6-98). These are the portraits of emperors whose reigns are separated by two centuries: Hadrian

(A.D. 117–138), and the emperor Maximin Daia (A.D. 308–314), tetrarch of the east, in the tetrarchy with Constantine, Licinius, and Galerius at the time of the first Edict of Toleration of the Christians. We have described the portrait and character of Hadrian and, in this bronze medallion, we have a sensitive, classicizing, naturalistic report of the emperor's features. This Classical naturalism contrasts markedly with the almost startling abstraction of the features portrayed on the gold medallion of Maximin Daia, which convey, through both sharp and blunt simplifications of form, the awesome strength of Late Imperial authority. Two centuries have transformed the image of the emperor as a particular man into an image of the emperor as the mask of power. Individual traits are suppressed in the force of the idea and the idea of force. The idea—not the thing—would henceforth dominate in art.

The archaizing of Greek and Roman figurative art in the Constantinian reliefs, *The Tetrarchs*, and the medallion portrait of Maximin Daia reflects a transformation in the way the peoples of the late Roman world interpreted the structure of appearance. Underlying this change in interpretation is a mighty spiritual change: the assimilation of Christianity into Greco-Roman civilization—a phenomenon so far-reaching in its influence as to separate the psychologies of two millennia, that of Greece-Rome and that of medieval Christianity.

6-98 *Left:* medallion of Hadrian (A.D. 117–138). Bronze, 1⅜″ diameter. *Right:* gold coin with portrait of Maximin Daia (A.D. 308–314). Gold, ⅘″ in diameter. Both Museo Nazionale, Rome.

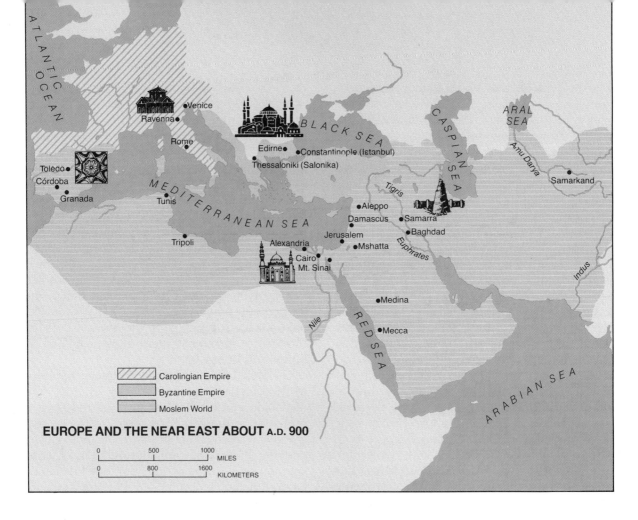

EUROPE AND THE NEAR EAST ABOUT A.D. 900

Carolingian Empire
Byzantine Empire
Moslem World

0	500	1000		MILES
0	800	1600		KILOMETERS

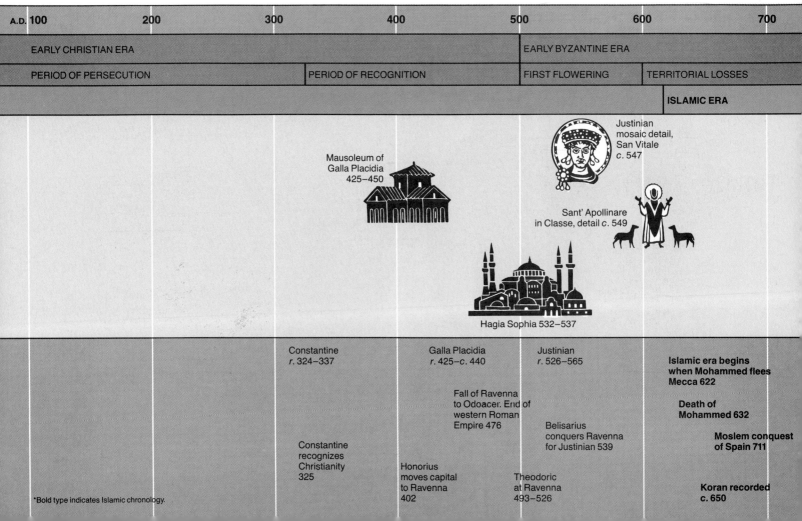

A.D. 100	200	300	400	500	600	700

| EARLY CHRISTIAN ERA | | | | EARLY BYZANTINE ERA | | |

| PERIOD OF PERSECUTION | | PERIOD OF RECOGNITION | | FIRST FLOWERING | TERRITORIAL LOSSES | |

ISLAMIC ERA

Mausoleum of
Galla Placidia
425–450

Justinian
mosaic detail,
San Vitale
c. 547

Sant' Apollinare
in Classe, detail c. 549

Hagia Sophia 532–537

Constantine
r. 324–337

Galla Placidia
r. 425–c. 440

Justinian
r. 526–565

**Islamic era begins
when Mohammed flees
Mecca 622**

Fall of Ravenna
to Odoacer. End of
western Roman
Empire 476

Belisarius
conquers Ravenna
for Justinian 539

**Death of
Mohammed 632**

**Moslem conquest
of Spain 711**

Constantine
recognizes
Christianity
325

Honorius
moves capital
to Ravenna
402

Theodoric
at Ravenna
493–526

**Koran recorded
c. 650**

*Bold type indicates Islamic chronology.

7
EARLY CHRISTIAN, BYZANTINE, AND ISLAMIC ART

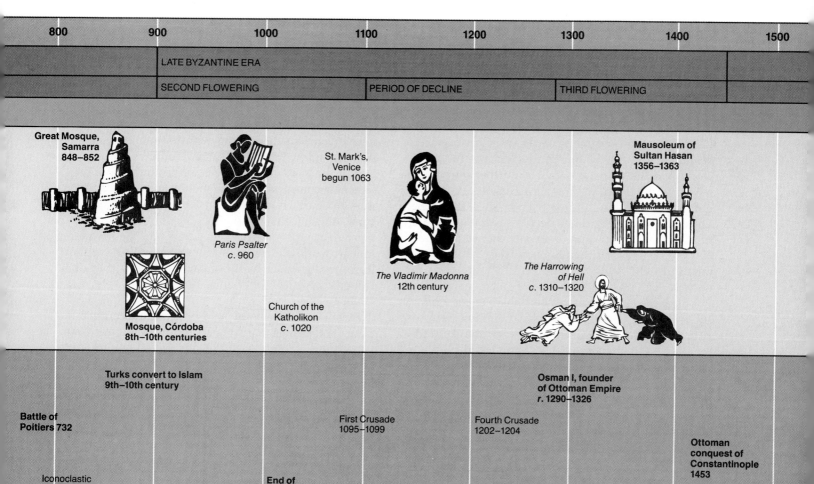

800	900	1000	1100	1200	1300	1400	1500

LATE BYZANTINE ERA

SECOND FLOWERING · PERIOD OF DECLINE · THIRD FLOWERING

Great Mosque,
Samarra
848–852

Paris Psalter
c. 960

St. Mark's,
Venice
begun 1063

The Vladimir Madonna
12th century

Mausoleum of
Sultan Hasan
1356–1363

The Harrowing
of Hell
c. 1310–1320

Mosque, Córdoba
8th–10th centuries

Church of the
Katholikon
c. 1020

Turks convert to Islam
9th–10th century

Osman I, founder
of Ottoman Empire
r. 1290–1326

Battle of
Poitiers 732

First Crusade
1095–1099

Fourth Crusade
1202–1204

Ottoman
conquest of
Constantinople
1453

Iconoclastic
Controversy
730–843

End of
Caliphate of
Córdoba 1031

CHRISTIANITY, like many Eastern cults, was a peculiarly persuasive religion of salvation. Its immense success in making converts among the teeming populations within the great imperial cities brought it to the attention of the Roman authorities. Because Christians refused to acknowledge the state religion, which was the cult of the emperor, and because they refused to participate in its rather perfunctory rites, they were regarded as politically subversive and were bitterly persecuted. Tacitus, reflecting the attitudes of his time, regarded the Christians as believers in a degenerate doctrine and practitioners of obscene and perverse rites that, he felt, were typical of Eastern cults; he referred to the Christians as "a class hated for its abominations." Pliny the Younger, reporting to the emperor Trajan on his investigation of Christian beliefs, wrote that he found merely a "depraved and extravagant superstition," although Christian ritual was innocent enough.

The pagan Romans believed in many gods; the Christians believed only in one. To the educated pagan, the Christian doctrines—the incarnation of a god in the body of a man, and the salvation or redemption of all mankind through the death and resurrection of the god-man Christ—must have seemed absurd to the point of insanity. The Christians exulted in this imputation of absurdity to their faith: Credo quia absurdum ("I believe because it is absurd") became their slogan. Pagan and Christian had opposed orientations: the pagan looked to this world; the Christian looked to the next. The religion of the empire, Romanitas, based its ritual and practice on imperial dominion, but Christ declared "My kingdom is not of this world" (John 18:36).

The differences between pagan and Christian were profound, as were the differences between the Judaic world and the Christian church. Further differences would divide the cultures of the Greek-speaking eastern Mediterranean and the Latin-speaking west. These divisions would cut deeply several ways. The fundamental opposition between the eastern and western spirit proclaimed in Zechariah, "when I have raised up thy sons, O Zion, against thy sons, O Greece . . ." (9:13), rings angrily once again in the words of the early Christian Tertullian: "Quid Athenae Hierosolymis!" ("What is there in common between Athens and Jerusalem? what between the Academy [of Plato] and the Church!"). Although the unmitigated hostility of Tertullian was by no means shared by all Christians, an antagonism between the ancient Semitic east and the Hellenic world that had, for a while, conquered it was inevitable and could not be suppressed.

Greek naturalism and rationalism had become integral to the western Roman world; yet, at the same time, they had been changed through contact with the old civilizations of the Middle East. Although the mystery cults, with their suspiciously secret rites, their redemptive messages and occult sciences, their solar and fertility myths and their savior gods, drew heavily on Egypt, Babylon, Persia, and even India, they also borrowed a good deal of the intellectual apparatus of Hellenic philosophy, mysticizing it and making of it a kind of magical formula and a gnosis—the privileged knowledge of only an initiated few.

Christianity, based as it was on Jewish teaching and tradition, differed radically from many of the crude cults with which Romans, like Tacitus, confused it. But Christianity also joined with those cults in the long, vast, historical reaction against the Hellenized West—against both its world view and that material manifestation of it, the increasingly oppressive Roman Empire. To Christians, the empire, with its exactions, cruelties, materialism, wars, and false gods, became regnum Caesaris, regnum Diaboli (the kingdom of Caesar, the kingdom of the Devil). Yet this same empire would be inherited by the Christians in 325,* when Constantine recognized Christianity; by the end of the century, Theodosius, his successor, had made it the official religion of the state.

In the eighteenth century, Edward Gibbon, in his monumental history, The Decline and Fall of the Roman Empire, accused Christianity of being the principal cause of that (in his time) calamity. We now do not believe that Christianity had that effect, but, as early as the fifth century, Augustine wrote his City of God to defend the Church against the pagan accusation that the sack of the city of Rome (in 410 by the Goths) was a punishment sent by the ancient gods because the city had become Christian. The disintegration of the Roman Empire, beginning with its nominal separation into the western and eastern empires toward the end of the third century, was a phenomenon of considerable complexity that cannot be laid at the door of the Christians, nor entirely at the door of the "barbarians," those Celtic, Germanic, Slavic, and other peoples who had been pressing slowly into the Mediterranean world for thousands of years. (We have met their predecessors in the great migrations that disturbed Egypt, Mesopotamia, Asia Minor, Crete, and Greece.)

At any rate, from the end of the third century, a slow, sometimes hardly perceptible, takeover was occurring—a takeover not of the unified empire, but of its already fragmented remains. The spiritual and ideological conquest made by the Christians in the politically consequential form of mass conversion paralleled the gradual infiltration and settlement by

*The epoch time designation A.D. will be dropped from now on.

the "barbarians," who, in actuality, had been present in the administrative and military structure as well as in recognized possession of imperial territories for a long time. The subsequent actions of these "barbarians," who were Christianized and in control of the western empire by the end of the fifth century, make up the history of the Middle Ages in the west. The eastern empire, which was actually but not officially severed from the western empire by the beginning of the fifth century, was to go its own continuous way as the Byzantine Empire, reverting to its Greek language and traditions, which, to be sure, had become much "Orientalized." The Byzantine world was a kind of protraction of the life of the late Roman Empire and the Early Christian culture that filled it. With a quite Oriental conservatism, which reminds us somewhat of the ancient Near Eastern civilizations, the Byzantine Empire remained Greek, orthodox, and unchanging for a thousand years, preserving the forms of its origin, oblivious to and isolated from the new.

In the seventh century, Islam, a new spiritual force, erupted from Arabia and swept across the Near East and the southern Mediterranean with astonishing speed. Islam created a new civilization that rivaled Christianity and that would have far-ranging influence in medieval Europe: Arabic translations of Aristotle and other Greek writers of antiquity were studied eagerly by Christian scholars of the twelfth and thirteenth centuries; Arabic love lyrics and poetic descriptions of nature inspired the early French troubadours; Arab scholars laid the foundations of arithmetic and algebra, as they are still taught in our schools, and their contributions to astronomy, medicine, and the natural sciences have made a lasting impression in the Western world. Although Islamic art may not fall within the scope of Western art in the more limited sense, it deserves attention at this point in our survey, particularly because its early monuments, like the Early Christian and Byzantine monuments, derive from earlier Near Eastern and Mediterranean artistic traditions. Most early monuments of Islamic art belong to the succession of Late Roman, Early Byzantine, and Iranian (Sassanian) art, although different social and religious needs soon would transform similar prototypes into quite different forms in the Islamic world than they would take in the Christian world.

EARLY CHRISTIAN ART

The style that we call Early Christian could as accurately be called Late Roman, or, in art-historical usage, Late Antique. Christian works are distinguished from pagan works only by subject, not by style. After all, the Christians of the time were as "Roman" as the pagans; they were trained in the same crafts, were brought up in the same environment, and spoke the same language. The Christian church itself, both in its organization and its philosophy, owed much to the Greco-Roman structure of life. Early Christian art shows the simple transformation of pagan into Christian themes and the freest kind of borrowing of pagan motifs and manners. Hybrid forms are produced throughout the Christianized late empire in the greatest profusion and with the greatest intermingling of regional styles, making it almost impossible to recognize any one style, or even half a dozen, that could definitely be called Early Christian or that could serve as an exclusive exemplar of what we mean by Early Christian.

In sculpture and painting, Greco-Roman naturalism underwent a kind of "denaturing," something that began as early as the Column of Trajan (FIG. 6-69) and was well advanced in the reliefs from the Arch of Constantine (FIG. 6-96), the sculpture group *The Tetrarchs* (FIG. 6-94), and the coin portrait of Maximin Daia (FIG. 6-98). Archaizing modes supervene on the old naturalism, and things come to look less and less like the Greco-Roman prototypes from which, ultimately, they derive. This "denaturing" process, variously influenced by barbarian styles, continues well into the western Medieval period. It should by no means be viewed as merely the negation of the Greco-Roman style, or as a clumsy botching of it by artists who had lost the sense of it and the necessary manual skill. Rather, it is the product of an entirely new world view—one that inevitably was to bring about the transformation of the naturalistic Classical tradition. Early Christian art shows that transformation in progress, already well under way in the late third century, while the Roman Empire was still intact.

The Early Christian era can be divided conveniently into the Period of Persecution (when the earliest communities were established in the first century) and the Period of Recognition (from 325, when Constantine recognized Christianity, along with other religions of the Roman Empire, until about 500, when the western provinces of the empire came under the sway of barbarian princes). Some authorities would extend the period of Early Christian art to the eighth century, when it was terminated in the east by the Iconoclastic Controversy. In the Period of Persecution, the Christians were, in the Roman view, a troublesome, even dangerous, sect that needed to be curbed. During this time, it is likely that the Christians, shrinking from the kind of attention public shrines might attract, worshiped in the private houses of their wealthier communicants, perhaps in

the elaborate atrium houses of the type seen in Pompeii (FIG. 6-25). It is quite possible that the atrium forecourt of the later public churches, the basilicas, derived from their liturgical relationship to the earlier atrium of the private house, as well as to the public forum.

THE CATACOMBS

The most significant monuments of the Period of Persecution are the least conspicuous in Rome; they are entirely underground. The catacombs are vast subterranean networks of galleries and chambers in Rome and other cities that were designed as cemeteries for the burial of the Christian dead, many of them sainted martyrs. From the second through the fourth centuries, the catacombs were in constant use; as many as four million bodies may have been accommodated in the Roman catacombs alone. In times of persecution, they also could have served as places of concealment for fugitives; evidence of this function survives in blocked and cut-off staircases, secret embrasures (openings) and passages, and concealed entrances and exits. Undoubtedly, the Christian mysteries must have been enacted here, although the principal function of the catacombs was mortuary.

In Rome, the catacombs were tunneled out of a stratum of granular tufa, the convenient properties of which had been exploited earlier by the Etruscan necropolis builders (FIG. 6-2). After a plot of ground had been selected for the cemetery (Christians were not prevented by Roman law from owning property), a gallery 3–4 feet wide was dug around its perimeter at a convenient level below the surface (FIG. 7-1). In the walls of these galleries, embrasures were opened parallel to the gallery axis to receive the bodies of the dead; these openings, called *loculi*, were placed one above another, like shelves (FIG. 7-2). Often, small rooms, called *cubicula*, were constructed in the walls to serve as mortuary chapels, and these were variously vaulted. Once the original perimeter galleries were full of *loculi* and *cubicula*, other galleries were cut at right angles to them; this process continued as long as lateral space permitted. Lower levels would then be dug and connected by staircases, some systems extending as deep as five levels. When adjacent burial areas belonged to members of the same Christian confraternity, or by gift or purchase fell into the same hands, communications were opened between the respective cemeteries, so that they spread laterally and gradually acquired a vast extent. After Christianity received official sanction, the catacombs fell into disuse, except as holy places—monuments to the great martyrs—which were visited by the pious.

Many *cubicula* were decorated with frescoes that were Late Antique (pagan) in manner and even in subject, as interpreted by the Christians to conform with their own beliefs. The geometric patterning of a ceiling in the catacomb of Saints Pietro and Marcellino in Rome (FIG. 7-3) becomes akin to the Dome of Heaven (the large circle), which has been inscribed with the basic symbol of the Christian faith, the cross. The arms of the cross terminate in four *lunettes* (semicircular fields) in which are represented the key episodes from the Old Testament story of Jonah, who is thrown from his ship on the left, emerges from the whale on the right, and, safe on land at the bottom, contemplates the miracle of his salvation and the mercy of God. (Jonah, an often-painted figure in

7-1 Plan (*top*) of the catacomb of Callixtus, Rome, second century, and section (*bottom*) through main gallery of oldest region.

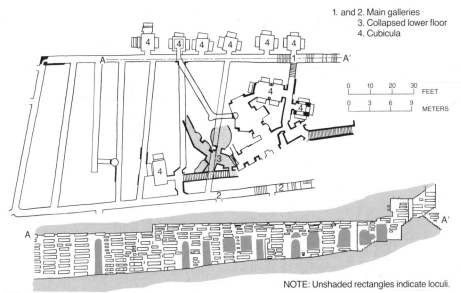

1. and 2. Main galleries
3. Collapsed lower floor
4. Cubicula

| 0 | 10 | 20 | 30 | FEET |

| 0 | 3 | 6 | 9 | METERS |

NOTE: Unshaded rectangles indicate loculi.

Early Christian art, was honored as a prefiguration of Christ, who rose from death as Jonah had been delivered from the belly of the whale.) The compartments between these lunettes are occupied by *orans* figures, their arms raised in the attitude of prayer; in the pagan world, from which they derive, they are symbols of piety.

The central medallion shows Christ as the Good Shepherd, whose powers of salvation are underscored by his juxtaposition with the story of Jonah. As a theme, the Good Shepherd can be traced back through Greek Archaic art to Egyptian art. In Classical art, the Good Shepherd signified the virtue of philanthropy, but here in the catacombs, it becomes the symbol for the loyal protector of the Christian flock, who said to his disciples, "Feed my lambs; feed my sheep." During the Period of Persecution, Christ almost invariably was represented in the catacombs either as the Good Shepherd or as a teacher. Only later, when Christianity became the official state religion of the Roman Empire, did Christ take on such imperial attributes as the halo, the purple robe, and the throne, which denoted rulership.

7-2 Gallery and loculi of the catacomb.

7-3 Painted ceiling from the catacomb of Saints Pietro and Marcellino, Rome, fourth century.

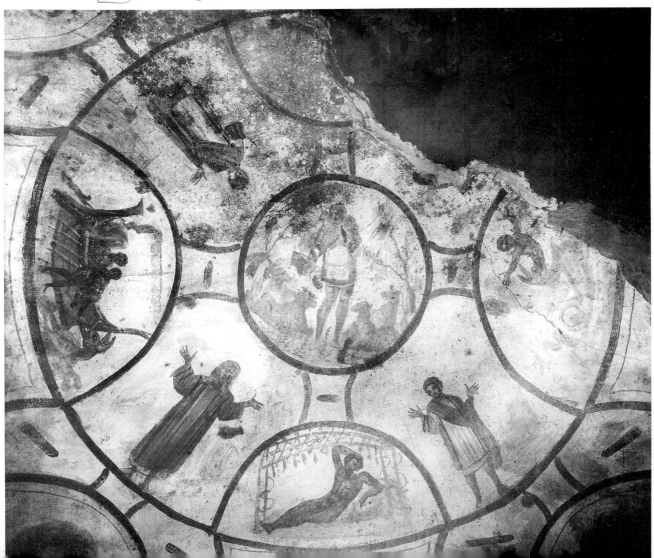

The style of the catacomb painters is most often the quick, sketchy impressionism we have seen in earlier Roman painting of the last Pompeian period, and the execution ranges from good to inferior—most often, the latter. We must take into account that the catacombs were very unpromising places for the art of the mural decorator. The air was spoiled by decomposing corpses, the humidity was excessive, and the lighting (provided largely by oil lamps) was entirely unfit for elaborate compositions or painstaking execution. For designs on ceilings, arches, and lunettes, the painter was required to assume awkward and tiring poses, and it is no wonder that the frescoes often were completed hastily and that the results frequently were of poor quality.

Architecture

Although some Christian ceremonies were held in the catacombs, regular services likely took place in private houses that were rearranged and partitioned off to make "community" houses, or in simple, columned halls. The latter were destroyed in the last great persecutions under Diocletian; the remains of one, a kind of rudimentary basilica, dating from 311, have been found beneath the cathedral of Aquileia. Dura-Europos preserves another. Once Christianity achieved imperial sanction under Constantine, an urgent need suddenly arose to set up buildings that would meet the requirements of the Christian liturgy and would aggrandize the Christian cult. Constantine was convinced that in 313 the God of the Christians had guided him to victory over Maxentius, his rival for the imperial throne. In lifelong gratitude, though he never actually became a Christian, Constantine protected and advanced the faith throughout the empire as well as in the obstinately pagan capital city of Rome. As emperor, he

was, of course, obliged to safeguard the ancient Roman religion, traditions, and monuments; as we have seen, he placed works of his own, like the vast basilica and the triumphal arch (FIGS. 6-91 and 6-95) at the very center of the city. But eager to provide buildings to house the rituals of the Christians, their venerated burial places, and especially the memorials of their founding saints, Constantine discreetly drew upon his own imperial patrimony to endow an extraordinary architectural enterprise, constructing elaborate basilicas, memorials, and mausoleums not only in Rome but at other sites sacred to Christianity, notably in Bethlehem and Jerusalem. His dual role as both Roman emperor and private champion of the Christian faith is reflected in the fact that he located the new churches of Rome not within its walls, but on the outskirts of the city, so as to avoid any confrontation of Christian and pagan ideologies as expressed in their distinctive temples. The city, dominated by its proud, senatorial families, remained conservatively pagan throughout the fourth century, and the stubborn resistance of the Roman populace to Constantine's pro-Christian policies may have prompted him to establish a new Christian city—Constantinople, built on the site of ancient Byzantium.

The design of Constantine's Christian buildings incorporated familiar architectural elements: the atrium house, the catacomb chapel, the Roman basilica, and the imperial audience hall. How these elements were combined into the masterful composition that was to become one of the first Christian church buildings of the new age—Old St. Peter's in Rome (FIGS. 7-4 and 7-6)—we do not know; discussion about the origins of the Christian basilica has not ended. Begun in 333, Old St. Peter's is probably the most important design in the history of church architecture. Its wide influence was augmented by the belief that it stood where Peter, the first Apostle, had

7-4 Reconstruction of Old St. Peter's, Rome, c. 333.

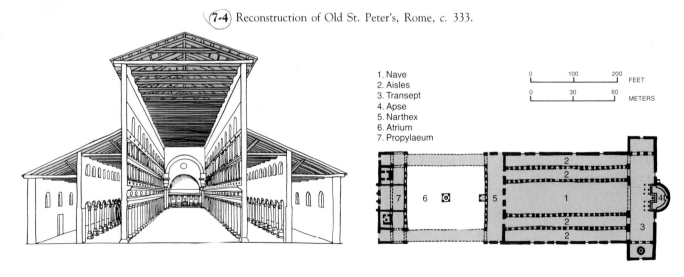

1. Nave
2. Aisles
3. Transept
4. Apse
5. Narthex
6. Atrium
7. Propylaeum

been buried. In the 1940s and 1950s, excavations some 22 feet beneath the high altar of the present basilica revealed the second-century *tropaion* (martyr's memorial) of St. Peter, set up over a grave site in a pagan Roman cemetery. Constantine and Pope Sylvester were both convinced that this was the veritable burial place of the Prince of the Apostles; thus, the great church was raised, at immense cost and labor, upon the irregular slope of the Vatican hill to enshrine beneath the crossing of transept and apse the most hallowed site in western Christendom.

The extraordinary dimensions of the Constantinian basilica are difficult to realize from the old drawings; the nave was as long, as high, and twice as wide as the nave of a great Gothic cathedral. Its interior was "one of the most spacious, most imposing, and most harmonious . . . ever built, imperially rich in its marbles and mosaics, grandiose yet forthright and large in the best Roman sense of the word."*

The plan of Old St. Peter's (FIG. 7-4) shows a rectangular building entered from the street through the *propylaeum*, a gateway building that leads into the *atrium*, an open, colonnaded court; the *narthex*, that part of the colonnade that is joined to the façade, functions as an entrance hall. The body of the church consists of the *nave*, low side *aisles*, the *apse*, and the transverse aisle, or *transept*, which is placed between the nave and the apse and projects slightly beyond the walls of the nave and aisles. This fundamental arrangement was used in subsequent Christian architecture, although it would be wrong to think that a rigid, standardized plan exists for basilican design; for instance, the transept, an occasional feature of churches in the city of Rome, is often lacking in other churches, especially in the smaller ones.

The cross section (FIG. 7-4) shows a great columned hall that obviously is related to such Roman secular basilicas as the Basilica Ulpia in the Forum of Trajan (FIG. 6-49). Unlike the slightly earlier Basilica of Constantine (FIGS. 6-91 and 6-92), Old St. Peter's was not vaulted, but timber-roofed, as were, traditionally, most Roman basilicas. (The vaulted Basilica of Constantine was an exception.) The pagan basilica's lateral entrance is moved to the short side of the Christian church. Only one of the multiple apses is retained, and that is placed opposite, and at a dramatic distance from, the entrance. Evenly spaced columns no longer surround the central nave, but flank it. All these modifications of the pagan basilica create a sweeping perspective that converges on the shrine as the focus of the whole design and the place of the principal mystery of the Christian faith.

*Kenneth Conant, *Early Medieval Church Architecture* (Baltimore: Johns Hopkins University Press, 1942), p.6.

From the time of its dedication in 354, Old St. Peter's was a focal point of reverend Christian attention. For centuries, it was the destination of multitudes of devout pilgrims from every corner of Christendom, a holy site second only to Jerusalem's Holy Sepulchre as a fountain of grace. The best-known church of the medieval West, and the fabled marvel of medieval Rome, Old St. Peter's is estimated to have accommodated over fourteen thousand worshipers at a time, congregated to witness the gorgeous ceremonies that celebrated the great festivals of the Church, especially those honoring St. Peter. For the throngs of pious visitors, standing on the marble pavement of the vast hall of the nave, or overflowing into the narthex and atrium, the basilica was monumental testimony to the legitimacy of the ordained successors of Peter, first bishop of Rome, and to the divine authority passed from Christ through Peter to all who would follow him in the episcopal chair. To the pilgrim worshipers, expecting as a result of their visit to the shrine to be absolved from their sins by the saint's God-given power to "bind or to loose," the church must have been overpowering evidence that Christ had indeed entrusted the keys of the kingdom to Peter and his successors. It must have been the palpable fulfillment of the words of the Lord: "Thou art Peter, and upon this rock (Greek: *petre*) I will build my church; and the gates of hell shall not prevail against it" (Matthew 16:18).

The old church of St. Peter no longer stands, and it is from an eighteenth-century print by Piranesi of its slightly later stylistic associate, St. Paul's (FIG. 7-5), that we can get some idea of its grandiose space, scale, and majesty. The "spiritualizing" of the secular

7-5 Interior of St. Paul's Outside the Walls, Rome, late fourth century. (Etching by GIOVANNI BATTISTA PIRANESI.)

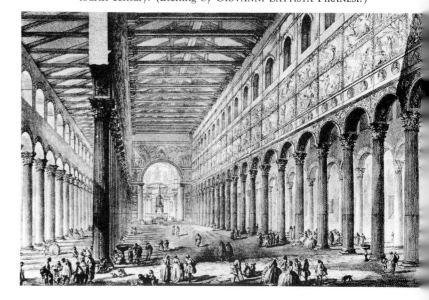

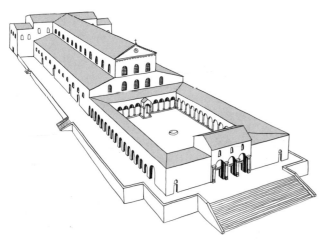

7-6 Conjectural reconstruction of Old St. Peter's, Rome. (After K. J. Conant.)

Roman design is evident not only in the realignment of the building's axis (to focus the viewer's whole experience on the ritual climax of the design), but also in its extreme simplicity of structure and the lightness of its bearing walls and columns. Roman mass—huge walls and ponderous weight, sculptured surfaces in relief and recess, and whole populations of statuary—has been lightened, rarefied, smoothed; we could say that it has been "dematerialized" to suit the new orientation toward a spiritual rather than a physical world.

The bird's-eye view of Old St. Peter's in reconstruction (FIG. 7-6), although partly conjectural, shows the stepped podium that we have seen before in Roman temples such as the Temple of "Fortuna Virilis" (FIG. 6-16) and the Maison Carrée (FIG. 6-46), which, in turn, had Etruscan predecessors; a propylaeum and a forum converted to an atrium are other elements with not only Roman but ancient antecedents. We believe that the exterior of Old St. Peter's was, like Christian basilicas in general, unadorned, reserving the whole decorative enterprise for the interior. It is as if the building imitated the ideal Christian, with a grave and plain exterior and a glowing and beautiful soul within.

The interior splendor of Old St. Peter's may have concealed from the unschooled worshiper the spiritual organization of its physical elements, the thorough-going symbolism of its design—in a word, its iconography. The architects, drawn by Constantine from the imperial building staff, were skilled practitioners, who had worked on the great municipal structures of Rome as well as on the church of St. John Lateran, which had preceded St. Peter's as the first of Constantine's Christian basilicas. In the design and construction of St. Peter's, a Christian building of unprecedented scale and magnificence, the architects undoubtedly were directed by learned ec-

clesiastics, who must have prescribed the thoroughly scriptural program of the design. Architectural historians have analyzed the basic scheme and proportions of the plan and elevation; the spacing of the parts, the enumeration of elements like windows, columns, and arches; and the placement of structural units and details. We can say with some certainty that the original model for the grouping of the compositional masses and spaces was drawn from the biblical description of Solomon's temple in Jerusalem (principally 1 Kings 6), as were the simple ratios of their dimensions. This venerable source of symbolic reference was augmented by numerological and metrological correspondences, pagan as well as Christian, that had long been thought to have hidden and sacred meaning. The great church was, thus, a fabric of interwoven symbolism mystically relating the shrine of the first of the apostles to those mysteries, revelations, prophesies, and miracles, both in the Old and the New Testaments, which shaped the dogma and ritual of Christianity and gave witness to its divine origin and authority. In this respect, Old St. Peter's, at the very beginning of the history of the architecture of the Middle Ages, was the ancestor of the great medieval churches, east and west, whose "sacred geometry" was intended, for those who could construe it, to exhibit the symbolic patterns and correspondences that composed the spiritualized Christian cosmos.

The rectangular, basilican church design was long the favorite of the western Christian world, but the Early Christian architects also adopted another Classical building type: the central plan—a round or polygonal domed structure that later was favored in the east. Byzantine architects developed this form to monumental proportions and amplified its theme in numerous, ingenious variations. In the west, the central-plan building was used generally for structures adjacent to the main basilicas, like mausoleums, baptistries, and private chapels.

A highly refined example of the central-plan design is Santa Costanza in Rome (FIGS. 7-7 to 7-9), built in the mid-fourth century as the mausoleum of Constantia, daughter of the emperor Constantine. Its antecedents can be traced to the beehive tombs of the Mycenaeans (FIG. 4-24), although its direct inspiration may have been the Pantheon (FIG. 6-56) or the pool-enclosing rotunda of some public baths, like those of Caracalla (FIG. 6-60). The Pantheon's mass, however, has been metamorphosed, as with the mutation of the pagan into the Early Christian basilica. In Santa Costanza, the circle of paired columns that carries the domed cylinder stands sufficiently free from the external walls to leave space for a barrel-vaulted corridor, or *ambulatory*. In fact, it is as if the basilican wall-arcade has been bent around a circle, the ambulatory

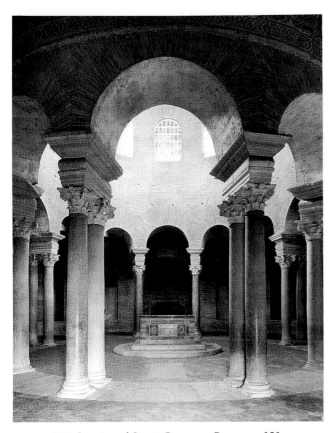

7-7 Interior of Santa Costanza, Rome, c. 350.

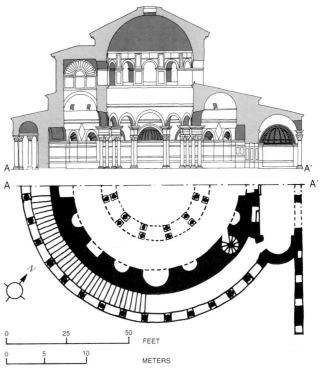

7-8 Section (*top*) and plan (*bottom*) of Santa Costanza.

corresponding to the basilican aisles and, like them, equipped with a high, ample clerestory. The exuberant naturalism of the luxurious mosaics in the vault of the ambulatory at Santa Costanza (FIG. 7-9) suggests a lingering influence of the pagan spirit.

All the important buildings of the fourth century, including Santa Costanza and the great, longitudinal basilicas, are associated closely with Constantine and his immediate relatives; it was through their patron-

age and supervision, as an expression of the new ideal of the Christian *imperium*, that these buildings were constructed. This close relationship between the Constantinians and Early Christian architecture may explain a certain consistency of design in the apparently diverse basilicas of the fourth and early fifth centuries. It also might explain partly how such apparently contradictory designs as the long church and the central church could be imagined as working together in meeting the requirements of Christian belief and ritual. Given centuries of tradition, it would have been perfectly natural for Constantine to memorialize

7-9 Detail of a mosaic in the vault of the ambulatory depicting a vintaging scene, Santa Costanza.

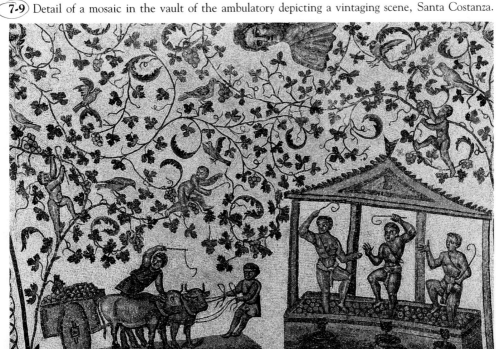

the place of Jesus' death and burial with a traditional monument, the domed rotunda, as he did in the Church of the Holy Sepulchre in Jerusalem. At the same time, the existing plan of the basilica might have been designed to offer the space needed for the congregations of pilgrims coming to the holiest place in Christendom. For several centuries then, the architectural problem, although never explicitly stated, was how to integrate the long plan and the central plan.

Mosaic and Painting

The church-building enterprise under Constantine and his successors was designed to meet the urgent ceremonial needs of Christianity, which suddenly had become official and public. As a result, wholesale programs of decoration for the churches also became necessary. To advertise the new faith in all its diverse aspects—its dogma, scriptural narrative, and symbolism—and to instruct and edify the believer, acres of walls in dozens of new churches had to be filled in the style and medium that would carry the message most effectively.

Brilliantly ornamental mosaics, with sparkling tesserae of reflective glass, rather than the opaque, marble tesserae preferred by the Romans, became the standard vehicle of expression almost at once. Mosaics were particularly suited to the flat, thin-walled surfaces of the new basilicas, becoming a durable, tangible part of the wall—a kind of architectural tapestry. The light flooding through the clerestories was caught in vibrant reflection by the mosaics, which produced abrupt effects and contrasts and sharp concentrations of color that could focus attention on the central, most relevant features of a composition. Mosaic, worked in the Early Christian manner, is not intended for the subtle changes of tone that a naturalistic painter's approach would require, although (as we have seen in the Roman mosaics) tonality is well within the mosaicist's reach. But in mosaic, color is *placed,* not *blended*; bright, hard, glittering texture, set within a rigorously simplified pattern, becomes the rule. For mosaics placed high on the wall, far above the observer's head, the painstaking use of tiny tesserae, seen in Roman floor mosaics, became meaningless. Early Christian mosaics, designed to be seen from a distance, employed larger stones; the surfaces were left uneven, so that the tesserae's projecting edges could catch and reflect the light, and the designs were kept simple, for optimum legibility. For several centuries, mosaic, in the service of Christian theology, was the medium of some of the supreme masterpieces of world art.

Content and style find their medium; the content of Christian doctrine took centuries to fashion, and, for a long time, even the proper manner of representing the founder of Christianity was in question. Once Christianity became the official religion of the Roman state, Jesus' status changed. In early works, he is shown as teacher and philosopher; in later works, he is imperialized as the ruler of Heaven and earth. In the fourth and fifth centuries, artists were hesitant about how to represent Jesus, and variant types of images were produced. After some crucial theological questions on Jesus' nature were resolved, a more or less standard formula for his depiction emerged.

In the minds of simple Christians who were only recently converted, Jesus easily could be identified with the familiar deities of the Mediterranean world, especially Helios (Apollo), the sun god, or his Romanized eastern aspect, Sol Invictus (the Unconquered Sun). The late third-century vault mosaic of a small Christian mausoleum in a pagan cemetery (FIG. 7-10), excavated underneath Old St. Peter's in Rome in the 1940s, shows Jesus as Apollo, driving the horses of the sun chariot through the heavens—a conception far more grandiose than that of the Good Shepherd.

7-10 Detail of a vault mosaic from the mausoleum of the Julii, Rome, 250–275.

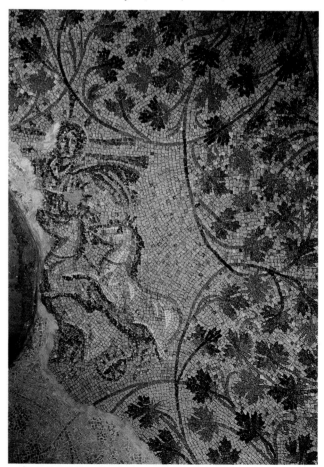

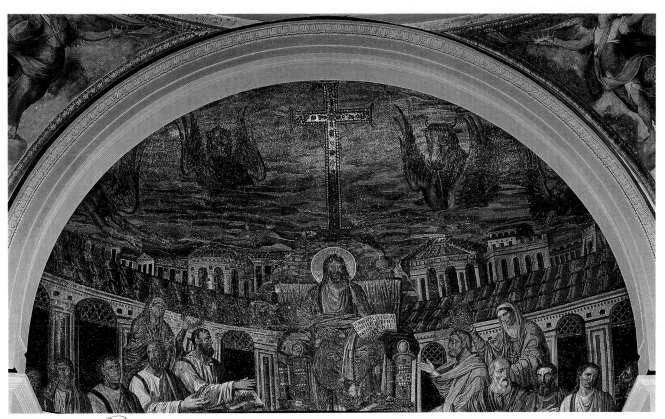

7-11 *Christ Enthroned in Majesty, with Saints,* apse mosaic, Santa Pudenziana, Rome, 402–417.

The style, or styles, of Christian art emerged as a transmutation of Greco-Roman art; for the mosaicists, the point of departure was Roman illusionism. We can see this readily in the apse mosaic of the church of Santa Pudenziana in Rome (FIG. **7-11**), dated about 410, which is the earliest surviving example in a succession of monumental apse mosaics that extend throughout the history of Christian art. Although the mosaic was drastically restored in the nineteenth century (almost the whole right half was damaged), enough remains to show the persistence of Roman forms and the assimilation of Roman imperial attributes to the image of Christ. On an emperor's throne, Christ, clad in imperial purple and gold, sits within the Heavenly Jerusalem and presides over the Church Triumphant. He is flanked on either side by ascending ranks of apostles, deployed like a Roman emperor's entourage of senators. Behind them, on either side of the throne, stand two women, the personifications of the Church of the Gentiles (New Testament) and the Church of the Synagogue (Old Testament). Above and behind the head of Christ is a representation of the jeweled cross that Constantine raised on the site of Christ's crucifixion. Within the gold-streaked, blue sky hover the four symbolic creatures of the visions of Ezekiel and the Book of Revelation, representing the Four Evangelists: the winged Man of St. Matthew (partly obscured here by the

arch), the Lion of St. Mark, the Ox of St. Luke, and (also partly obscured) the Eagle of St. John. (This is an early appearance of these symbols, which we will find commonly represented throughout Medieval art; see, for example, the top of FIG. 7-30.) The background recalls the kind of perspective illusionism and naturalistic depiction of architectural forms found in Pompeian wall paintings, and the buildings may reflect, to some degree, those actually in Jerusalem at the time the mosaic was installed.

We also can note the union of the old naturalism and the new symbolism in the great mosaic cycle in Santa Maria Maggiore in Rome, which dates from about 430. The panel representing *The Parting of Lot and Abraham* (FIG. **7-12**) tells its story (Genesis 13:5–13) succinctly. Agreeing to disagree, Lot leads his family and followers to the right, toward the city of Sodom, while Abraham moves toward a building (perhaps the Church?) on the left. Lot's is the evil choice, and the instrumentalities of the evil (his two daughters) are represented in front of him; the figure of the yet unborn Isaac, the instrument of good, stands before his father, Abraham. The cleavage of the two groups is emphatic, and each is represented by a shorthand device that could be called a "head cluster," which will have a long history in Christian art. The figures turn from each other in a kind of sharp dialogue of glance and gesture, and we recognize a moving away

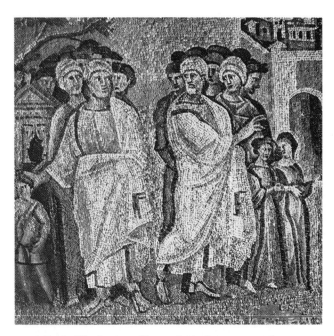

7-12 *The Parting of Lot and Abraham,* mosaic from Santa Maria Maggiore, Rome, *c.* 430.

from the flexibility of naturalism toward the significant gesture and that primary method of Medieval representation, *pantomime,* which simplifies all significance into body attitude and gesture. The wide eyes, turned in their sockets; the broad gestures of enlarged hands; the opposed movements of the groups all remind us of some silent, expressive chorus that comments only by gesture on the action of the drama. Thus, the complex action of Roman art stiffens into the art of simplified motion or dumb show, which has great power to communicate without ambiguity and which, in the whole course of Medieval art, will produce the richest kind of variety. The fact that the figures of the panel have been moved to the foreground and that the artist takes no great pains to describe either space or landscape setting also foreshadows the character of later Christian art; the background town and building are symbolic, rather than descriptive. But within this relatively abstract setting, the figures themselves loom with massive solidity. They cast shadows and are modeled in dark and light to give them the three-dimensional appearance that testifies to the artist's heritage of Roman pictorial illusionism. Another century and much modification under non-Hellenized Eastern influence will be required before artists will be able to think of figures entirely as flat images, rather than as plastic bodies.

The vivid narrative style of the Santa Maria Maggiore mosaic can be contrasted with the monumental stillness of the *orans* figures of martyrs in the great dome of the Church of St. George at Thessaloniki (Salonika) in northern Greece (FIG. **7-13**). These fig-

ures, with their architectural backgrounds and enframements, are the only survivors of a magnificent mosaic composition in concentric rings of golden tesserae, which climaxed at the summit of the dome in an apparition of Christ supported by flying angels. A middle zone may have contained figures in adoration before the Second Coming, to which the whole composition may have alluded. The formality of pose and the solemn, priestly demeanor of the figures—unvarying features of Byzantine art throughout its centuries of life—will coexist with the narrative approach that is brought into play when events of Scripture are illustrated. The formal style, intended to eternalize a vision of the transcendent mysteries of the faith, was confined principally to the upper levels of the church: the central dome, the apsidal dome, and the immediately lower levels that they command (FIG. 7-13). The elaborate architecture surrounding the St. George figures recalls the paintings on Pompeian walls and the actual "stage-set" architecture of buildings like the "Treasury" at Petra (FIG. 6-84). The Classical tradition persists even while the ethereal, golden splendor of the whole composition dissolves material form into spiritual phantasm. One could say that the dome mosaic of St. George completes the change from the images of the pagan floor mosaic, which are literally under the feet and of this world, to the floating images of a celestial world high above the Christian's wondering gaze. Yet the pagan substance is never entirely transformed.

7-13 *St. Onesiphorus and St. Porphyrius,* detail of dome mosaic, Church of St. George, Thessaloniki, Greece, late fifth century.

THE ILLUMINATED MANUSCRIPT

Santa Maria Maggiore is an early and outstanding example of the complementarity of the new basilican architecture and the detailed mosaics and paintings designed for it. But the earlier art of the catacombs could not have provided the resources for narratives as elaborate as those found at Santa Maria Maggiore; catacomb painting was much too narrow in scope of subject and much too rudimentary in style and technique. Rather, the church decorators must have drawn on a long tradition of pictures in manuscripts that began in pharaonic Egypt and was developed to a high degree by the Hellenistic Greeks of Alexandria. Thousands of texts must have been available to the Constantinian artists, richly illustrated with Hebrew, Greek, and Christian themes, or with combinations of all three.

Although both Jews and Christians were bound by the Second Commandment against images, the ban was somehow evaded and both sects made use of them. (Mural pictures found in the third-century Jewish synagogue at Dura-Europos in Mesopotamia illustrate themes from the Old Testament.) No Jewish illustrated manuscript has survived from ancient times; yet, it has been suggested that Jewish figural art, and certainly Jewish oral tradition, had considerable thematic influence on Christian art. We know that Constantine summoned numerous savants and literati from Alexandria, an intellectual center for both Jews and pagans since Hellenistic times and one of the great episcopal sees of the Christian church. He established a library where they gave instruction. We know also that he was a generous donor of manuscripts to the Church. Hence, it is no wonder that Constantinople became a center of traditional and Christian learning, which was transmitted by the copying and recopying of manuscripts through the centuries. The dissemination of manuscripts, as well as their preservation, was aided greatly by an important invention in the Early Imperial period. The long manuscript scroll (*rotulus*), used by Egyptians, Greeks, and Romans and made of the fragile papyrus, was superseded by the *codex*, which was made, much like the modern book, of separate pages enclosed within a cover and bound together at one side. Papyrus was replaced by the much more durable *vellum* (calfskin) and *parchment* (lambskin), which provided better surfaces for painting. These changes in the durability, reproduction, and format of texts greatly improved the possibility that the records of ancient civilizations could survive long centuries of neglect, even if not in great number.

The sacred texts were copied as faithfully as possible, as were the pictures in them. After the great fa-

7-14 Miniature from the *Vatican Vergil*, early fifth century. Approx. $12\frac{1}{2}'' \times 12''$. Vatican Library, Rome.

thers of the Eastern church recommended the didactic use of pictures in churches and books, the picture became only slightly less significant than the text from which it drew its authority. We can see the transition from the scroll to the codex (from continuous narrative to a series of individual pictures) in two manuscripts of different dates (the later manuscript still reflects the scroll procedure). The *Vatican Vergil* (FIG. 7-14) dates from the early fifth century and is the oldest painted manuscript known. Its content is pagan, representing a scene from Vergil's *Georgics*, in which a seated farmer (at the left) instructs two of his slaves in the art of husbandry, while Vergil (at the right) listens and records the instructions. (We are reminded of the Roman idealization of country life and nature.) The style is Late Antique and reminiscent of Pompeian landscapes. The quick, impressionistic touches that suggest space and atmosphere, the foreshortened villa in the background, and the small, active figures in their wide, spacious setting are all familiar features of Roman illusionistic painting. The heavy, black frame that isolates a single episode was also a feature of the late Pompeian styles.

The *Vatican Vergil* can be contrasted in form with the *Vienna Genesis* (FIG. 7-15), the earliest, well-preserved, painted manuscript we know of that contains biblical scenes. The *Vienna Genesis* employs the continuity of a frieze in a scroll. In a continuous narrative like this, two or more scenes of a story are represented within a single frame; this will become the common form of narrative in Medieval art. In this

7-15 *Rebecca and Eliezer at the Well*, from the *Vienna Genesis*, early sixth century. Book illumination painted on purple vellum, $9\frac{3}{4}'' \times 12\frac{1}{4}''$. Österreichische Nationalbibliothek, Vienna.

scene from the Book of Genesis (24:15–61), Rebecca leaves the city of Nahor to fetch water from the well in the first episode. In the second, she gives water to Eliezer and his camels. Her way is marked by a colonnaded avenue; her destination is indicated by a seminude, naïvely pert, little personification of the well— a lingering reminder of a pagan river-goddess, as well as a reminder of the persistence of Classical motifs and stylistic modes in Medieval art. The action is presented with all possible simplicity in an expressive pantomime that includes convincing touches; for example, Rebecca braces herself with her raised left foot on the rim of the well as she tips up her jug for Eliezer. The figures are silhouetted against a landscape that is blank except for the toylike city. Everything necessary to bare narrative is present, and nothing else. Although the figures have only narrative significance, the page itself is sumptuous: a rich, purple ground of vellum is lettered in silver. The luxuriousness of ornament that will become more and more typical of sacred books absorbs the human figure or confines it exclusively to iconic or narrative functions. The spiritual beauty of the text and the material beauty of the vehicle that serves and intensifies it will come to count above all else. The luster of holy objects becomes the intent and the effect of Byzantine art.

Closely related to the *Vienna Genesis* is another manuscript of about the same time, the early sixth century, and perhaps of the same provenance. *The Rossano Gospels* (known also as the *Codex Rossanensis*) is the earliest illuminated book we have that contains illustrations of the New Testament (FIG. **7-16**). We can infer from them that, by this time, a canon of New Testament iconography has been fairly well established. Like the *Vienna Genesis*, the text of *The Rossano Gospels* is inscribed in silver on purple vellum. The Rossano artist, however, has attempted, with considerable success, to harmonize the colors with the purple ground. The subject of our illustration, presented in vigorous pantomime, is the judgment of Jesus by Pilate or, more particularly, the people's choice of Barabbas over Jesus (Matthew 27:2–26). In the fashion of continuous narrative, several different episodes are included. The figures are arranged on two levels separated by a simple ground line. In the upper level, Pilate presides over the tribunal, at which the people demand the death of Jesus as Judas returns the thirty pieces of silver—an inaccuracy in the time and place of the episode as it occurs in the text. Jesus and the bound thief Barabbas appear in the lower level. Jesus, at the left, is now distinguished by the cross-inscribed *nimbus* (halo) that signifies his divinity; Barabbas, at the far right, is bending low in the

7-16 *Pilate Demanding That the People Choose Between Jesus and Barabbas*, from *The Rossano Gospels*, early sixth century. Book illumination on purple vellum, $11'' \times 10\frac{1}{4}''$. The Diocesan Museum, Archepiscopal Palace, Rossano, Italy.

direction of Judas, who hangs himself. The illuminator has assumed that the reader is perfectly familiar with the text being illustrated and has tried to make the composition as inclusive of all relevant episodes as possible, adding labels when they were needed. Here, the artist wants the picture to be as readable as the text; the story is all that counts.

By the sixth century, the canon of Christian sacred texts, as well as the cycles of illustration appropriate to them, had been agreed on. The denaturing of Classical form is well advanced, and a new art is originating. We are now a considerable distance in time from the painting of the Roman Imperial period, with its worldly themes, naturalism, perspective illusionism, modeling in light and shade, graded tonality, and proportionality. Very little regard will be given to the pagan ideals of beauty in the centuries to come.

Sculpture and Craft Art

The transformations that occurred in architecture in the period of early Christianity—the adaption of the multipurpose pagan basilica to the single purpose of Christian ritual and the "dematerialization" of the heavy materiality of Roman buildings into the screen-like thinness and lightness of Christian structure—are paralleled in the sculpture of the time. We have

seen anticipations of the change as early as the second century in the Column of Trajan (FIG. 6-70), and we have seen the change almost completed in early fourth-century reliefs on the Arch of Constantine (FIGS. 6-96 and 6-97).

A third-century relief on the so-called *Ludovisi Battle Sarcophagus* (FIG. **7-17**) should be interpolated between these two other works. This work, still quite pagan in theme and spirit, representing a struggle between Romans and barbarians, is most instructive as an illustration of the "flattened relief" and the "piled-up" perspective so characteristic of the denaturing of Greco-Roman naturalism and the emerging Medieval style. Although a strong descriptive realism persists in the details of physiognomy, dress, action, gesture, and accessories, *pattern* has taken over from figure composition. The writhing figures are all within the same plane; at the same time, the "foreground" figures (at the base of the pattern) are relatively small, while the "background" figures (at the top of the pattern) are the largest. This *reverse perspective* strengthens the surface into a dense mass with no illusion of space beyond (behind) it. Carving plays a lesser and lesser role, and quick effects of light and dark are achieved by gouging, punching, and drilling the surface. As yet, the formal placement of the figures that we find in the Arch of Constantine has not

7-17 *Battle Between Romans and Barbarians*, front panel of the so-called *Ludovisi Battle Sarcophagus*, third century. Marble, approx. 56″ high. Museo Nazionale, Rome.

appeared; of course, the subject does not call for that, and the sarcophagus composition is more a representation of the dissolution of the style of the Trajanic reliefs than of the advent of Constantinian formalism. But the patterning and constriction of surface, the sacrifice of realism of space and proportion, are all present and characteristic of Early Christian art.

Toward the end of the fourth century, we find the flattening and patterning process well advanced. *The Good Shepherd Sarcophagus* (FIG. **7-18**) has a thick, spaceless surface that is perforated rather than carved, producing a kind of hard lacing of flat darks and lights. This sarcophagus is interesting, too, for what it reveals of the Christian adaptation of pagan material. We have seen that the Good Shepherd theme appears in pre-Christian times and that the Christians chose it to signify Christ. Here, the motif appears three times, possibly in an allusion to the Trinity. Around the Good Shepherd twines a grapevine heavy with grapes, through which busy cupids climb, bringing in the harvest. Three cupids crush the grapes in a wine press; their wine, once sacred to Bacchus, now has become symbolic of the blood of Christ. The cupids themselves, once associated with love and erotic passion (Cupid is the son of Venus), are forerunners of the Christian cherubs. Thus, a purely pagan theme with orgiastic overtones is transmuted, by Christian intention, into a symbol of redemption through the blood of Christ. The figure style, with its stumpy proportions, frontalizing pose, and stereotyping of action, had its predecessor in the reliefs of the Arch of Constantine and is common (with many variations) to a great number of sarcophagi from the fourth, fifth, and sixth centuries.

Despite the great changes in sculpture during the second half of the third century, the Classical tradition was by no means extinguished, even though many artists almost deliberately seemed to be turning away from Greco-Roman art to something Archaic, abstract, and bluntly expressive, as seen in *The Tetrarchs*, the reliefs from the Arch of Constantine, and the medallion portrait of Maximin Daia. The Classical tradition lived on through the Middle Ages, if not with entirely discernible continuity, in intermittent revivals, renovations, and restorations, commingled with—or side by side and in contrast with—the opposing, nonclassicizing Medieval styles. The end of the medieval world will be signalized by the rise of Classical art to dominance in the Renaissance. One observer recently commented that the greatest accomplishment of Early Christian art from the third to the seventh century is that it "preserved, in the face of vast and cataclysmic changes, basic and essential elements of the Greco-Roman heritage."* As we follow the course of stylistic change throughout the history of Western art, especially in the Middle Ages, the strength of the Classical tradition in its dialogue with competing strains and tendencies of style should always be kept in mind.

Monumental sculpture began to decline in the fourth century and did not recover its place in the history of art until the twelfth century. The Christian tended to be suspicious of the freestanding statue, linking it with the false gods of the pagans. In his *Apologia*, Justin Martyr, a second-century ecclesiast

*Ernst Kitzinger, *Byzantine Art in the Making* (Cambridge, MA: Harvard University Press, 1977), p. 126.

7-18 *The Good Shepherd Sarcophagus*, from the catacomb of Praetextatus, late fourth century. Museo del Laterano, Rome.

mindful of the admonition of the Second Commandment to shun graven images, accused the pagans of worshiping statues as gods. But the Greco-Roman experience was still a living part of the Mediterranean mentality, and, at least in the west, the Semitic ban on images in sacred places was not likely to be adopted. The reasoning of the fathers of the early Church, that the use of pictures and statues could be justified on the grounds that they instructed the illiterate in the mysteries and stories of the faith, was later supplemented by the theological argument that since Jesus was "made flesh and dwelt among us," he had a human nature and human likeness that could be represented in art.

In any event, during the Early Christian and Byzantine periods, sculpture dwindled to craft art and small work: sarcophagus reliefs, commemorative ivory panels, metalwork, church furniture and accessories, book covers, and the like. Yet, in this great reduction of the scope of the medium, works of exquisite craftsmanship still were produced that reflected, even in Christian times, the persistence of pagan, Classical ideals of beauty. An ivory plaque (FIG. 7-19), probably produced in Rome toward the end of the fourth century, strikingly exhibits the endurance of Classical form. The ivory, one of a pair of leaves of a *diptych* (two carved, hinged panels), commemorates the marriage of members of two powerful Roman families of the senatorial class, the Nicomachi and the Symmachi, who remained pagan during this first triumphal period when the emperor Theodosius decreed Christianity to be the only legally recognized religion of the empire. Here, the families consciously seem to reaffirm their faith in the old pagan gods; certainly, they favor the esthetic ideals of the Classical past, much as we find these ideals realized in such works as the Parthenon frieze (FIG. 5-50) and the Ara Pacis Augustae (FIG. 6-64). The illustration represents a pagan priestess celebrating the rites of Bacchus and Jupiter; its companion piece shows a priestess honoring Ceres and Cybele. The priestess (FIG. 7-19) prepares a libation at an altar where the sacred fire burns. The precise yet fluent and graceful line, the easy, gliding pose, and the mood of spiritual serenity bespeak an artist practicing within a still vital Classical tradition, to which idealized human beauty is central. That tradition probably was sustained deliberately by the great senatorial magnates of Rome, who resisted the empirewide imposition of the Christian faith in the later fourth century.

A later work, carved in the eastern empire, perhaps in Constantinople, offers still further evidence of the persistence of Classical form, although subtle deviations from Classical rules are apparent here. The item

7-19 *Priestess Celebrating the Rites of Bacchus, c.* 380–400. Leaf of an ivory diptych of the Nicomachi and the Symmachi, 11¾″ × 5½″. Victoria and Albert Museum, London.

7-20 *St. Michael the Archangel*, early sixth century.
Leaf of an ivory diptych, approx. 17″ × 5½″.
British Museum, London.

is an ivory leaf from a diptych dating from the early sixth century, depicting *St. Michael the Archangel* (FIG. 7-20). The prototype of St. Michael must have been a pagan Victory; the flowing Classical yet naturalistic drapery, the delicately incised wings, and the facial type and coiffure are of the pre-Christian tradi-

tion. But even so, significant divergences—misinterpretations or misreadings of the rules of naturalistic representation—occur here. Subtle ambiguities in the relationship of the figure to its architectural setting appear in such details as the feet hovering above the stair without any real relationship to it and the placement of the scepter. These matters, of course, have little to do with the striking beauty of the form; they simply indicate the course of stylistic change, as the Greco-Roman world faded into history and the Medieval era began.

We find that change almost completed in the *Diptych of Anastasius* (FIG. 7-21), which represents the emperor Anastasius I, as consul, about to throw down the *mappa* (handkerchief), the signal for the games shown in the arena below him to start. Although the diptych, dated 517, is almost contemporary with the St. Michael ivory, the mutation of Classical naturalism is much further advanced (a reminder that the process does not proceed evenly along the same historical front or at the same tempo). The figure of the emperor in both panels is elevated above the lively scenes taking place in the arena. He is enthroned in rigid frontality, making a static, suspended gesture—entirely symbolic, the abstraction of his consular authority. His features are masklike,

7-21 *Diptych of Anastasius*, 517. Ivory, each leaf 14″ × 5″.
Bibliothèque Nationale, Paris.

7-22 Sarcophagus of Archbishop Theodore, seventh century. Marble. Sant' Apollinare in Classe, Ravenna, Italy.

and his quasi-divine status is announced by a halo. The halo, a shell form, originally would have been an architectural feature, part of the pediment of the niche; here, in an excellent example of a misreading of a prototype, it has migrated to its place behind the emperor's head. The details of the architecture are confused and have lost their original significance. The flattening and patterning of the surface is as we have seen it developing earlier. The work is entirely ornamental and symbolic; the living man is lost in the concept—in this case, the concept of supreme and suprahuman authority.

One hundred years after the *Diptych of Anastasius,* the sarcophagus of Archbishop Theodore (FIG. **7-22**) is not only ornamented with entirely symbolic forms, but the human figure is dismissed altogether. Peacocks, symbolic of eternity, flank a *chi-rho* monogram (chi [X] and rho [P] are the first two letters of "Christ" in Greek). The XP is supplemented in the monogram with the alpha (A) and the omega (Ω), the first and last letters of the Greek alphabet, representing the words of Christ, "I am the Beginning and the End." The fruiting vines behind the peacocks represent, as we have seen, the source of the redeeming blood of Christ. Set within wreaths on the lid of the tomb, the *chi-rho* monogram appears three times; it already had served as the *labarum* carried on the standards of the imperial Christian army. Thus, the hope of the deceased archbishop and the guarantee of his salvation are expressed entirely in symbol: eternity; redemption through the blood of Christ, who stands at the beginning and the end of time; and the triumph of Christianity. The accidents and irregularities of figural representation, and the busyness of narrative, are replaced by timeless signs of salvation and immortality.

BYZANTINE ART

The transition from Early Christian to Byzantine art is neither abrupt nor definite and, in fact, defies accurate definition. The almost contemporary diptychs of St. Michael (FIG. 7-20) and of Anastasius (FIG. 7-21) are both products of eastern carvers and might well be classified as Byzantine works. Yet *St. Michael the Archangel* is still firmly rooted in the Greco-Roman tradition, and the *Diptych of Anastasius* panels show the Medieval stress on the event rather than on its appearance. In the latter approach, which was essentially Near Eastern or Semitic, forms evolved into decorative symbols placed before a shallow, often neutral background that made little, if any, allusion to optical space.

One point of departure for the abstract, symbolic, Eastern Christian art may be a mural painting (FIG. 7-23) from Dura-Europos, a small garrison town on the west bank of the Euphrates in the heart of ancient Mesopotamia and on the very edge of the Roman Empire, already noted as the site of the Jewish synagogue with figural mural paintings (page 265). The mural dates from the second to third century, the time of the Roman occupation. The detail shown here may depict an attendant and priests of a forgotten

7-23 *Priests with Attendant,* detail of a mural from the Temple of the Palmyrene Gods, Dura-Europos, Syria, second to third century.

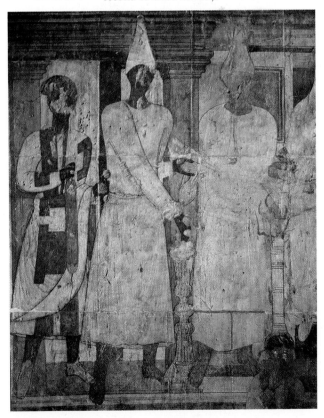

pagan cult of Parthia or Palmyra (biblical Tadmor). The figures stand with formal frontality in front of, or perhaps within, an architectural background. Their drapery is rendered by line, not tone, and their gestures are slow, ceremonial, and grave. Each figure is, in itself, a vertical design entity, isolated from its neighbor. The bodies hover weightlessly, their feet in ambiguous relationship to the ground and to the architectural setting, reminding us of the St. Michael ivory (FIG. 7-20) carved centuries later. Although the meaning of the enacted ceremony is lost to us, it must have been represented with utmost clarity to initiates, who could read the depicted symbols and gestures like a pictorial script—a script that moved laterally across the surface of the painted wall, unobstructed by perspective and other illusionistic devices.

As Christian dogma developed, this form of symbolic interpretation of reality became more favored, and a flat, decorative, abstract, "Byzantine" style, rooted in such Near Eastern works as the Dura-Europos murals, began to dominate Christian art. Although Western illusionism was tenacious and enjoyed repeated revivals, the transition was more or less complete by the middle of the sixth century.

Ravenna and Mount Sinai

Early in the fifth century, when the Visigoths, under their king, Alaric, threatened to overrun Italy, Emperor Honorius moved the capital of his crumbling empire to Ravenna, an ancient Roman city near Italy's Adriatic coast, some eighty miles south of Venice. There, in a city surrounded by swamps and thus easily defended, his imperial authority survived the

7-24 Mausoleum of Galla Placidia, Ravenna, Italy, 425–450.

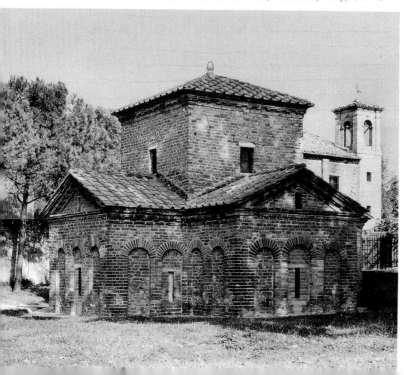

fall of Rome to Alaric in 410. Honorius died in 423, and the reins of government were taken over by his half sister, Galla Placidia, whose biography reads like an outrageously exaggerated adventure story. Galla Placidia died in 450, some twenty-five years before the last of her weak successors was deposed. In 476, Ravenna fell to Odoacer. Eventually, in 493, the city was chosen by Theodoric, the Goths' greatest king, to be the capital of his Ostrogothic kingdom, which encompassed much of the Balkans and all of Italy. During the short history of Theodoric's unfortunate successors, the importance of the city declined. But in 539, the Byzantine general Belisarius conquered Ravenna for his emperor, Justinian, and led the city into the third and most important stage of its history. Reunited with the eastern "empire," Ravenna remained the "sacred fortress" of Byzantium, a Byzantine foothold in Italy for two hundred years, until its conquest first by the Lombards and then by the Franks. Ravenna enjoyed its greatest cultural and economic prosperity during the reign of Justinian, at a time when the "eternal city" of Rome was threatened with complete extinction by repeated sieges, conquests, and sackings. As the seat of Byzantine dominion in Italy, ruled by Byzantine governors, or *exarchs*, Ravenna and its culture became an extension of Constantinople, and its art, more than that of the Byzantine capital (where relatively little outside of architecture has survived), clearly reveals the transition from the Early Christian to the Byzantine style.

The climactic points of Ravenna's history are linked closely with the personages of Galla Placidia, Theodoric, and Justinian. All left their stamp on the city in monuments that have survived to our day (one might say "miraculously," as the city was heavily bombed in World War II) and that make Ravenna one of the richest repositories of fifth- and sixth-century mosaics in Italy. The monuments of Ravenna, particularly the Justinianic ones, represent ideas that ultimately determined the forms of the culture, and certainly of the art, of the Middle Ages.

Galla Placidia's own mausoleum (the identity of which has recently been questioned) is a rather small, cruciform structure with a dome-covered crossing (FIGS. 7-24 and 7-25). Built shortly after 425, it was originally attached to the narthex of the now greatly altered basilican palace-church of Santa Croce. Although the mausoleum's plan is that of a Latin cross, the cross arms are very short and appear to be little more than apsidal extensions of a square. All emphasis is placed on the tall, dome-covered crossing, and the building becomes, in effect, a central-plan structure. On the other hand, this small, unassuming building also represents one of the earliest successful fusions of the two basic early church plans, the longi-

tudinal and the central, and it introduces us, on a small scale, to a building type that would have a long history in Christian architecture—the basilican plan with a domed crossing.

The mausoleum's plain, unadorned, brick shell encloses one of the richest mosaic ensembles in Early Christian art. Every square inch of the interior surfaces above the marble-faced walls is covered with mosaic decor: the barrel vaults of nave and cross arms, with garlands and decorative medallions reminiscent of snowflakes on a dark blue ground; the dome, with a large, golden cross set against a star-studded sky; other surfaces, with representations of saints and apostles; and the lunette above the entrance, with a representation of *Christ as the Good Shepherd* (FIG. **7-26**). We have seen earlier versions of the Good Shepherd, but none so regal as this. Jesus no longer carries a lamb on his shoulders but is seated among his flock in splendid isolation, haloed and robed in gold and purple. To his left and right, the sheep are distributed evenly in groups of three. But their arrangement is rather loose and informal (compare FIG. 7-28), and they have been placed in a carefully described landscape that extends from foreground to background and is covered by a blue sky. All forms are tonally rendered; they have three-dimensional bulk, cast shadows, and are disposed in

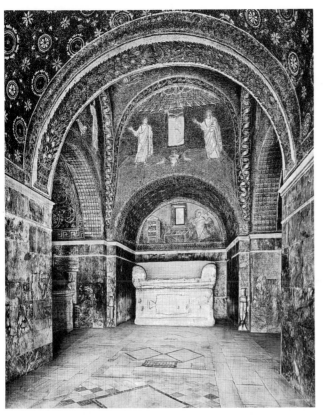

7-25 Interior of the mausoleum of Galla Placidia.

7-26 *Christ as the Good Shepherd,* mosaic from the entrance wall of the mausoleum of Galla Placidia, 425–450.

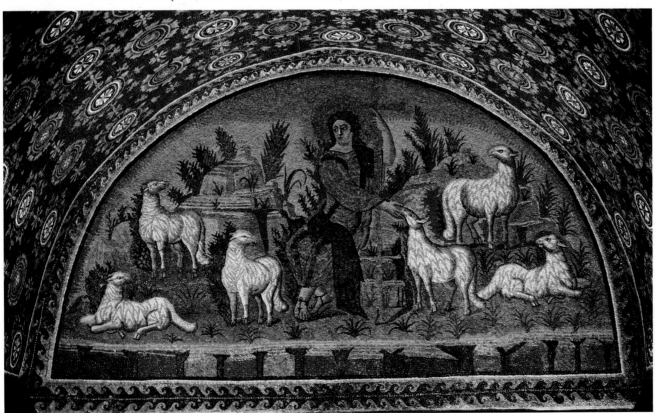

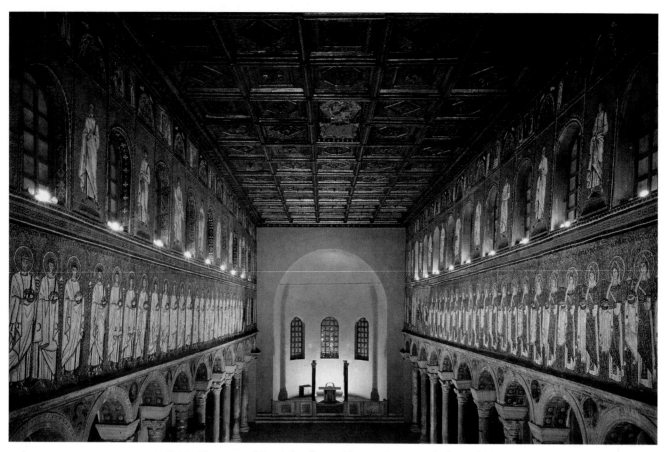

7-27 The nave of Sant' Apollinare Nuovo, Ravenna, Italy, *c.* 504.

depth. In short, the panel is replete with devices of Roman illusionism; its creator was still deeply rooted in the Hellenic tradition. Some fifty years later, this artist's successors would work in a much more abstract and formal manner.

Around 504, very soon after he settled in Ravenna, Theodoric ordered the construction of his own palace-church, a three-aisled basilica dedicated to the Savior. In the ninth century, the relics of Apollinaris were transferred to this church, which was rededicated and has been known since that time as Sant' Apollinare Nuovo. The rich mosaic decorations of the interior nave walls (FIG. 7-27) are arranged in three zones, of which the upper two date from the time of Theodoric. Old Testament patriarchs and prophets are represented between the clerestory windows; above them, scenes from the life of Christ alternate with decorative panels. The lowest zone originally bore subjects of either Arian or political character. Although Christians, Theodoric and his Goths were Arians (followers of the teachings of Bishop Arius), a sect declared heretical by the Orthodox church. After the Byzantine conquest of Ravenna, Bishop Agnellus ordered all mosaics that bore reference to Theodoric or to Arianism removed and replaced with the pres-

ent procession of orthodox saints (male on one side, female on the other). Agnellus had no quarrel with the subjects on the upper two levels, and they were left intact. Our example, *The Miracle of the Loaves and the Fishes* (FIG. **7-28**), must date from about 500. It illustrates well the stylistic change that has occurred since the decoration of Galla Placidia's mausoleum. Jesus, beardless and in the imperial dress of gold and purple, faces directly toward us as he directs his disciples to distribute the miraculously augmented supply of bread and fish to the great crowd to which he has preached. The artist has made no attempt to supply details to the event. The emphasis is instead on the sacramental character of it, the spiritual fact that Jesus, outstanding in the group, is performing a miracle by the power of God. The fact of the miracle takes it out of the world of time and of incident, for what is important in this scene is the presence of almighty power, which requires nothing but an unchanging presentation in terms of formal, unchanging aspect. The story is told with the bare minimum of figures necessary to make its meaning explicit; these figures have been aligned laterally, moved close to the foreground, and placed in a shallow picture box that is cut off by a golden screen close behind the

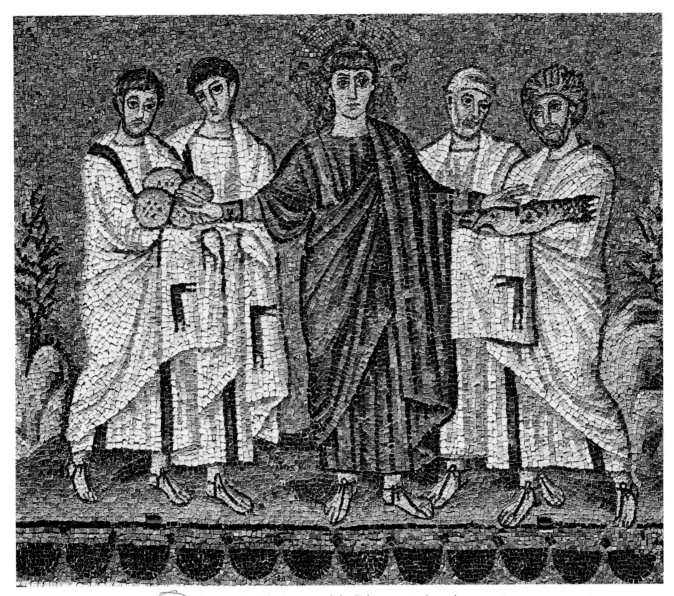

7-28 *The Miracle of the Loaves and the Fishes,* mosaic from the top register of the nave wall (above the clerestory windows) of Sant' Apollinare Nuovo, *c.* 504.

backs of the figures. The landscape setting, which was so explicitly described by the artist who worked for Galla Placidia, here merely is suggested by a few rocks and bushes that enclose the figure group like parentheses. That former reference to the physical world, the blue sky, is now replaced by a neutral gold, which would be the standard background color from now on. Remnants of Roman illusionism are found only in the handling of the individual figures, which still cast shadows and retain some of their former volume. But the shadows of the drapery folds have already narrowed into bars and will soon disappear completely.

The period of Justinianic Ravenna closes with the church of Sant' Apollinare in Classe, where, in the great apse mosaic, the Byzantine style reaches full maturity. Here, until the ninth century (when it was transferred to Ravenna), rested the body of St. Apollinaris, who suffered his martyrdom in Classe, Ravenna's port city. The building itself (FIG. **7-29**) is Early Christian in type, a three-aisled basilica with a plan quite similar to that of Theodoric's palace-church in Ravenna. The peculiar design of the apse, which combines a semicircular interior with a polygonal exterior, is typical of Ravenna churches and is probably of Byzantine origin. As usual for the period, the outside of the building is plain and unadorned. (The cylindrical bell tower, or *campanile,* is of a later date.)

The interior decoration in this case is confined to mosaics in the triumphal arch and the apse behind it.

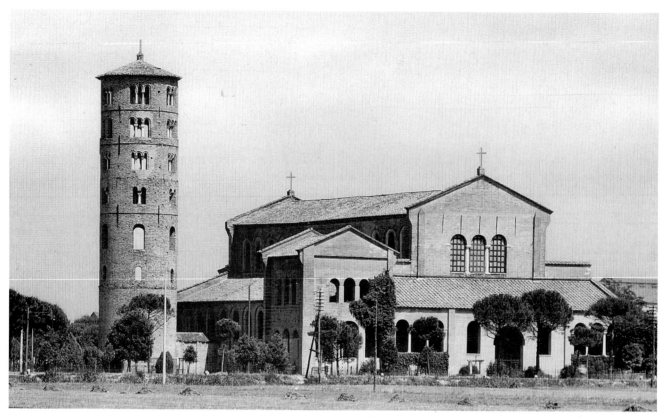

7-29 Sant' Apollinare in Classe, Ravenna, Italy, *c.* 533–549.

Of these, the mosaic decorating the semivault above the apse (FIG. **7-30**) was probably completed by 549, when the church was dedicated. It shows, against a gold ground, a large, blue medallion with a jeweled cross (symbol of the transfigured Jesus); this may be another representation of the cross Constantine had erected on the hill of Calvary to commemorate the martyrdom of Christ—the cross that we also saw represented at Santa Pudenziana in Rome (FIG. 7-11). Visible just above the cross is the hand of God. On either side of the medallion, in the clouds, appear the figures of Moses and Elijah, who appeared before Christ during his transfiguration. Below these two figures are three sheep, the three disciples who accompanied Christ to the foot of the Mount of the Transfiguration. Beneath, in the midst of green fields with trees, flowers, and birds, stands the patron saint of the church, Apollinaris. He is portrayed with uplifted arms, accompanied by twelve sheep, perhaps representing the Christian congregation under the protection of St. Apollinaris and forming, as they march in regular file across the apse, a wonderfully decorative base. On the face of the triumphal arch above, the image of Christ in a medallion and the Signs of the Evangelists are represented in the rainbow-streaked heavens. The twelve lambs, issuing from the cities of Bethlehem and Jerusalem, are the Twelve Apostles. The iconographical program is completed by the two palms of Paradise in the narrow spandrels of the arch and by the two archangels below them.

Comparison with the Galla Placidia mosaic (FIG. 7-26) shows how the style and the artist's approach to the subject have changed during the course of a century. In both cases, we are looking at a human figure and some sheep in a landscape. But in Classe, in the mid-sixth century, the artist no longer tries to recreate a segment of the physical world, but tells the story in terms of flat symbols, lined up side by side. All overlapping is carefully avoided in what must have been an intentional effort to omit all reference to the three-dimensional space of the material world and physical reality. Shapes have lost their volume and become flat silhouettes, into which details have been inscribed with lines. The effect is that of an extremely rich, flat, tapestry design that tells its story directly and explicitly without illusionistic devices. The Byzantine style has become the ideal vehicle for the conveyance of the extremely complex symbolism of the fully developed Christian dogma.

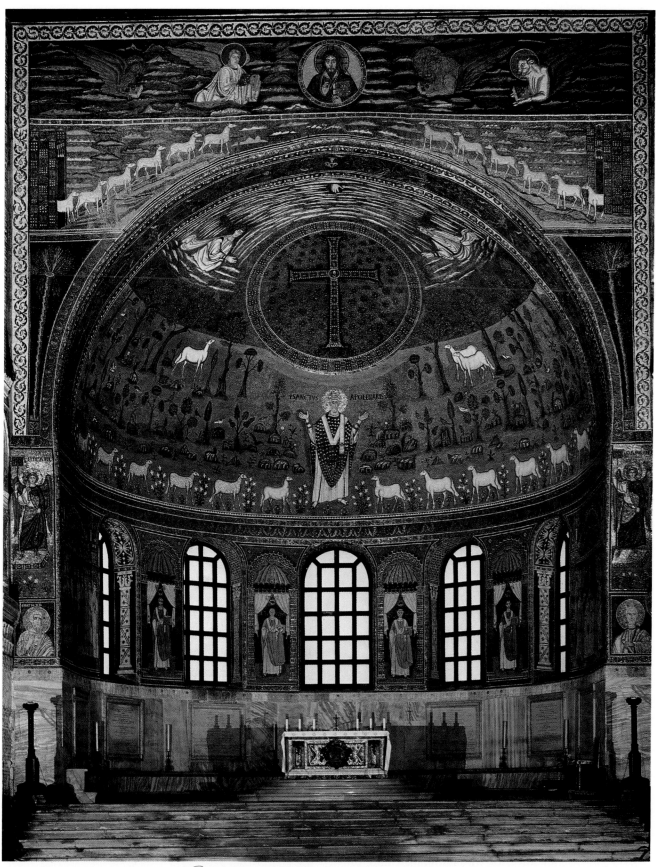

7-30 Apse mosaic from Sant' Apollinare in Classe, *c.* 549.

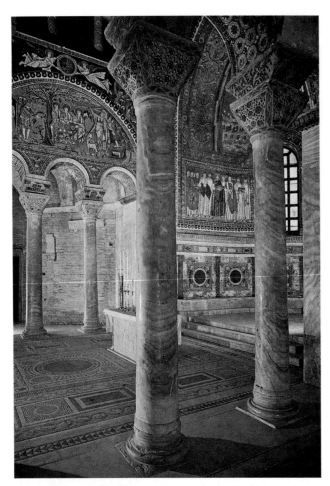

7-31 Sanctuary of San Vitale, Ravenna, Italy. Mosaics show in the forechoir (*left*): *Abraham and the Three Angels* and *The Sacrifice of Isaac*; and in the apse (*right*): *Justinian and Attendants.*

Our apse mosaic, for example, has much more meaning than first meets the eye. The transfiguration of Christ—here, into the image of the cross—symbolizes his own death, with its redeeming consequences, but also the death of his martyrs (in this case, St. Apollinaris). The lamb, also a symbol of martyrdom, is used appropriately to represent the martyred apostles. The whole scene expands above the altar, where the sacrament of the Eucharist—the miraculous recurrence of the supreme redemptive and transfigurative act—is celebrated. The very altars of Christian churches were, from early times, sanctified by the bones and relics of martyrs. Thus, the mystery and the martyrdom were joined in one concept: the death of the martyr, in imitation of Christ, is a triumph over death that leads to eternal life. The images above the altar present a kind of inspiring vision to the eyes of believers; the way of the martyr is open to them, and the reward of eternal life is within their reach. The organization of the symbolism and the images is hieratic, and the graphic message must

have been delivered to the faithful with overwhelming force. Looming above their eyes is the apparition of a great mystery, ordered in such a way as to make perfectly simple and clear the "whole duty of man" seeking salvation. That the anonymous artists, working under the direction of the priests, expended every device of their craft to render the idea explicit is plain enough; the devout could read it as easily as an inscription. The martyr's glorification beneath the cross, inscribed in the starry heavens, presented in one great tableau the eternal meaning of Christian life in terms of its deepest mystery.

The Byzantine style, born of the Orientalizing of Hellenistic naturalism, appears in monumental grandeur and ornamental splendor in the mosaics of San Vitale (FIG. **7-31**), which, in the high quality they share with the beautiful building itself, symbolize the achievements of the age of the emperor Justinian and are worthy representatives of the First Golden Age of Byzantine art. Begun shortly after Theodoric's death and dedicated by Bishop Maximianus in 547, San Vitale (FIG. **7-32**) shares, with the other Ravenna churches, its plain exterior (slightly marred by a Renaissance portal) and the polygonal apse. But beyond these features, it is an entirely different building (FIG. **7-33**). The structure is centrally planned and consists of two concentric octagons; the dome-covered inner octagon rises above the surrounding octagon to provide the interior with clerestory lighting. The central

7-32 San Vitale, 526–547 (view from the southeast).

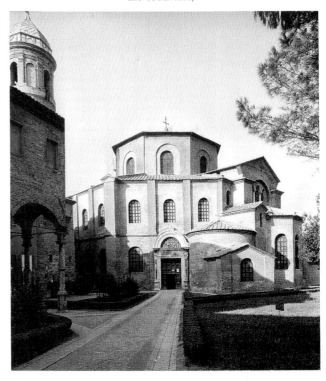

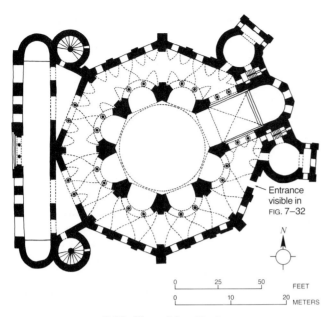

7-33 Plan of San Vitale.

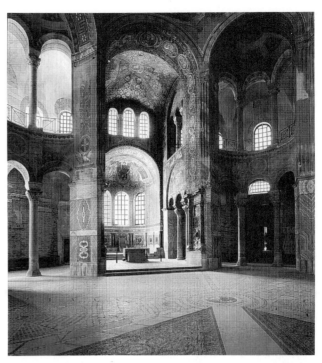

7-34 Interior of San Vitale (view facing forechoir and apse).

7-35 Capital with impost block from San Vitale.

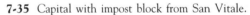

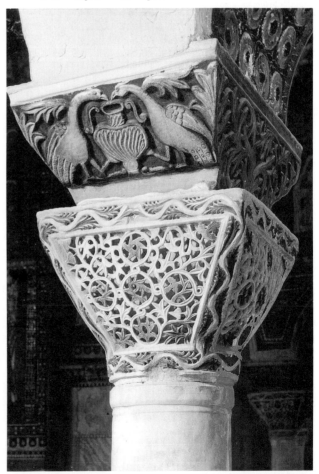

space is defined by eight large piers that alternate with curved, columned niches, pushing outward into the surrounding ambulatory and creating, on the plan, an intricate, octafoliate design. These niches effect a close integration between inner and outer spaces that, otherwise, would simply have existed side by side as independent units. A cross-vaulted sanctuary preceding the apse interrupts the ambulatory and provides the plan with some axial stability. This effect is weakened, however, by the unsymmetrical placement of the narthex, the odd angle of which never has been explained fully. (The atrium, which no longer exists, may have paralleled a street that ran in the same direction as the angle at which the narthex is placed; it also has been suggested that the angle of the narthex might have been intended to force visitors to reorient themselves as they entered the complex arrangement of the main space and, thereby, to experience the transition from the material world outside into the spiritual world of the church.) The ambulatory (FIG. **7-34**) has been provided with a second story, the gallery, which was reserved for women and is a typical feature of Byzantine churches. Probably also of Byzantine origin are the so-called *impost blocks*, which have been inserted between the simply profiled, but richly patterned, column capitals and the springing of the arches (FIG. **7-35**). Resembling an inverted, truncated pyramid, these impost blocks appear in nearly all Ravenna churches (compare FIG. 7-27) and may be highly abstracted reflections of the entablature segments inserted between column and arch by Late Roman architects (compare FIG. 6-83).

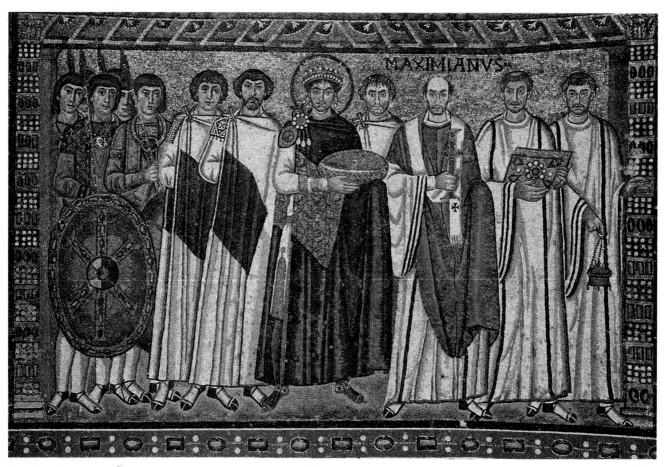

7-36 *Justinian and Attendants,* mosaic from the north wall of the apse, San Vitale, *c.* 547.

7-37 *Theodora and Attendants,* mosaic from the south wall of the apse, San Vitale.

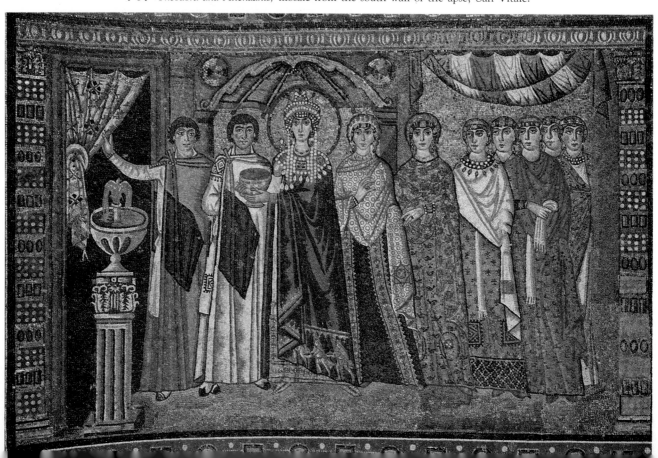

San Vitale's intricate plan and elevation combine to produce an effect of great complexity. Walking through the building, one is struck by the rich diversity of ever-changing perspectives. Arches looping over arches, curving and flattened spaces, and shapes of wall and vault seem to change constantly with the viewer's position. Light filtered through alabaster-paned windows plays over the glittering mosaics and glowing marbles that cover the building's complex surfaces, producing an effect of sumptuousness that is not Western but Oriental. And, indeed, the inspiration for this design is to be found in Byzantium, rather than Rome. In Constantinople, some ten years before the completion of San Vitale at Ravenna, a church dedicated to the saints Sergius and Bacchus appears to be a rough preparatory sketch for the later church, in which the suggestions of the earlier plan may be seen developed to their full potential.

Slightly earlier than those of Sant' Apollinare in Classe, but of higher quality, the mosaics that decorate the sanctuary of San Vitale, like the building itself, must be regarded as one of the climactic achievements of Byzantine art. Completed less than a decade after the surrender of Ravenna by the Goths, the decorations of apse and forechoir proclaim the triumph of Justinian and of the Orthodox faith. The multiple panels of the sanctuary form a unified composition, a theme of which is the holy ratification of the emperor's right to the whole western empire, of which Ravenna was now the principal city. The apse mosaics are portrait groups representing Justinian on one wall (FIG. **7-36**) and his empress, Theodora, on the other (FIG. **7-37**). The monarchs are accompanied by their retinues in a depiction of the offertory procession (the part of the liturgy when the bread and wine of the Eucharist are brought forward and presented). Justinian, represented as a priest-king, carries a vessel containing the bread, and Theodora carries the golden cup with the wine. Images and symbols covering the entire sanctuary express the single idea of man's redemption by Christ and the reenactment of it in the Eucharist. Moses, Melchizedek, Abraham, and Abel are represented as prefigurations of Christ and also as priestly leaders of the faithful, whose offerings to God were declared acceptable to heaven.

In the apse vault, the Second Coming is represented (FIG. **7-38**). Christ, seated on the orb of the world, with the four rivers of Paradise beneath him and rainbow-hued clouds above, extends a golden wreath of victory to Vitalis, the patron saint of the church, who is introduced by an angel. At Christ's left, another angel introduces Bishop Ecclesius, in whose time the foundations of the church were laid and who carries a model of it. The arrangement recalls Christ's prophecy of the last days of the world: "And then shall they see the Son of man coming in the clouds with great power and glory. And then shall he send his angels, and shall gather together his elect from the four winds, from the uttermost part of heaven" (Mark 13:26–27).

7-38 *Christ Between Angels and Saints* (*The Second Coming*), mosaic from the apse vault, San Vitale.

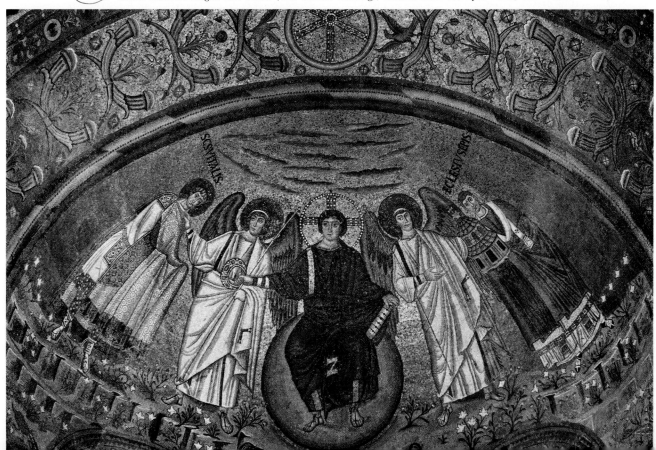

It appears that Justinian's offering is acceptable, for the wreath extended to St. Vitalis also is extended to him where he stands in a dependent mosaic on the wall below and to the right of the vault mosaic (FIGS. 7-31 and 7-36). Thus, his rule is confirmed and sanctified by these rites, in which (as is so typical of such expressions of the Byzantine imperial ideal) the political and the religious are one:

> In the atmosphere of Byzantium, the Christian emperor appeared as a Christ-like high priest and . . . the principles of his administration seemed to be symbolized in the liturgical rite. In the offertory procession, he appeared like the priest-king Melchizedek, "bringing forth bread and wine" on behalf of his people, to propitiate God.*

The laws of the Church and the laws of the state, united in the laws of God, are manifest in the person of the emperor and in his God-given right. The pagan emperors had been deified; it could not have been difficult, given that tradition, to accept the deification of the Christian emperor. Justinian is distinguished from his dignitaries not only by his wearing of the imperial purple but also by his halo, a device emanating from ancient Persia and originally signifying the descent of the honored one from the sun and, hence, his godlike origin and status.

The etiquette and protocol of the imperial court fuse here with the ritual of the liturgy of the Church (see FIG. 7-36). The positions of the figures are all-important; they express the formula of precedence and the orders of rank. Justinian is exactly at the center. At his left is Bishop Maximianus, the architect of his ecclesiastical-political policy and the man responsible for the completion of San Vitale and its consecration in 547. The bishop's importance is stressed by the label bearing his name, the only identifying inscription in the composition. Between Justinian and Maximianus is Julius Argentarius, the principal benefactor of the church. The figures are in three groups: the emperor and his staff (standing for the imperial administration); the clergy; and the army, who bear a shield with the *chi-rho* monogram seen on the sarcophagus of Archbishop Theodore (FIG. 7-22). Each group has a leader, one of whose feet precedes (by overlapping) the feet of those who follow. A curious ambiguity is observable in the positions of Justinian and Maximianus: although the emperor appears to be slightly behind the bishop, the sacred vessel he carries overlaps the bishop's arm. Thus, symbolized by place and gesture, the imperial and churchly powers are in balance. The paten (the plate holding the bread of the Eucharist) carried by Justinian, the cross carried by Maximianus, and the book and censer carried by his attendant clerics produce a movement that strikingly modifies the rigid formality of the scene. No background is indicated; the observer is expected to understand the procession as taking place in this very sanctuary, where the emperor will appear forever as a participant in the sacred rites and as the proprietor of this royal church, the very symbol of his rule of the western empire.

The portraits of the empress Theodora and her entourage (FIG. 7-37), on the other hand, are represented within a definite architecture, perhaps the narthex of San Vitale. The empress stands in state beneath an imperial canopy, waiting to follow the emperor's procession and to pass through the curtained doorway into which she is beckoned by an attendant. The fact that she is outside the sanctuary and only about to proceed attests that, in the ceremonial protocol, her rank is not quite equal to that of her consort, even though the representation of the Three Magi on the border of her robe recalls their offerings to the infant Christ and makes an allusive connection between Theodora and the Virgin Mary.

The figure style shows the maturing of conventions of representation that date back to Dura-Europos and earlier. Tall, spare, angular, and elegant, the figures have lost the rather squat proportions characteristic of much Early Christian work. The gorgeous draperies fall straight, stiff, and thin from the narrow shoulders; the organic body has dematerialized, and, except for the heads, we see a procession of solemn spirits, gliding noiselessly in the presence of the sacrament. Byzantine style will preserve this hieratic mood for centuries, no matter how many individual variations occur within its conventions.

We can hardly talk of Byzantine art without using the term "hieratic." Christianity, originating as a mystery cult, kept mystery as its center (one might say that the priest became a specialist in mystery). The priestly supernaturalism that disparages matter and material values prevails throughout the Christian Middle Ages, especially in Orthodox Byzantium. It is that hieratic supernaturalism that determines the look of Byzantine figurative art—an art without solid bodies or cast shadows, with blank, golden spaces, with the perspective of Paradise, which is nowhere and everywhere.

The portraits in San Vitale are individualized, despite the prevailing formality. However, this is true only of the principals; the lesser personages on the outskirts of the groups are treated more uniformly. In these portrait groups memorializing the dedicatory ceremony, the artists undoubtedly intended to create close likenesses of the central characters—the emperor and empress and the high officials of Church

*Otto von Simson, *Sacred Fortress: Byzantine Art and Statecraft in Ravenna* (Chicago: University of Chicago Press, 1948), p. 35.

and state. Since pagan times, the image of the deified emperor in public and sacred places has been tantamount to his actual presence, for the image and the reality were taken to be essentially one. The setting up of the image of the emperor was "an act which furnished the occasion for the declaration of submission on the part of the people";* those who gazed on the images must have known that they owed them absolute reverence: "In these awe-inspiring images, the sovereigns, though far away in Byzantium, had actually set foot on the soil of Italy."†

Thus, the symbol, the image, and what they represent are most often one and the same. Just as the image of Justinian or Theodora or a saint is venerated as if it were the person, so are a cross, relics, and mementos. Even vessels associated with holy rites came to be venerated as real presences of sacred powers that could cure not only spiritually but also physically. To the believer, this communion of reality between objects and what they represent is logical enough; if the body of Christ is reproducible through the ritual of the Eucharist, then representations of all holy things ought to be just as real as what they represent. Symbols, images, narratives, sacramental objects—the furniture and accessories of ritual—all can be venerable and spiritually potent in themselves;

*Otto von Simson, *Sacred Fortress: Byzantine Art and Statecraft in Ravenna* (Chicago: University of Chicago Press, 1948), p. 28.
†Ibid., p. 39.

this is like the magic of the Paleolithic caves, in which the hunter-artists believed they summoned and controlled their animal quarry by the miracle of representation.

In Ravenna, a powerful statecraft under the management of Justinian and Maximianus had been able to combine, in a group of monuments, the full force of Christian belief and political authority. In the process, a model of religious art, sacramental and magical in its power, was created that could work in the service of both the Church and the sanctified imperial state. This model, image, or ideal unity of the spiritual and temporal would influence the Middle Ages strongly in both the east and the west. The hieratic style of Byzantium, matured and exemplified in Ravenna, will remain both the standard and the point of departure for the content and form of the art of the Middle Ages.

Only slightly later than the Ravenna mosaics, the great apse mosaic in the church of the monastery of St. Catherine on Mt. Sinai (on the Sinai peninsula, now under Egyptian control) shows striking divergences from the Ravenna style, although both are likely to have emanated from Justinian's city, Constantinople. Justinian built the fortress monastery of St. Catherine between 548 and 565; it is unlikely that the apse mosaic could have been done much later than the year of the completion of the church building. In FIG. **7-39**, *The Transfiguration of Jesus* (Mark 9:2–8), Jesus appears in a deep blue mandorla, or

7-39 *The Transfiguration of Jesus*, apse mosaic from the church of the monastery of St. Catherine, Mount Sinai, Egypt, *c.* 560.

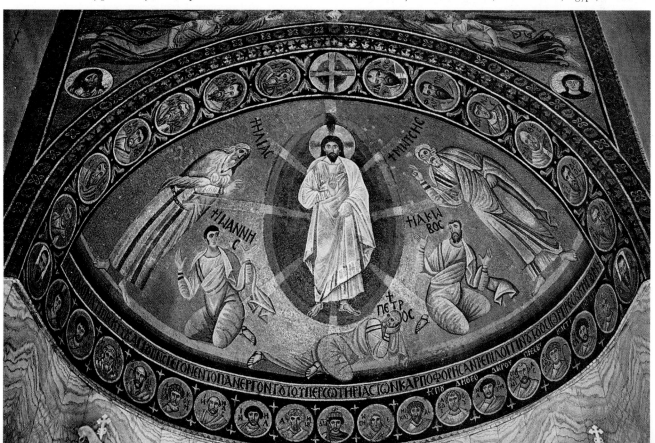

"glory," flanked by Elijah and Moses, with the disciples John, Peter, and James at his feet; the whole scene is framed by portraits of saints in medallions. The artist has stressed the intense whiteness of Jesus' transfigured, spiritualized form, from which rays stream down on the disciples. The stately figures of Elijah and Moses and the static frontality of Jesus set off the frantic terror and astonishment of the gesticulating disciples in a contrast of the eternal composure of heavenly beings with the distraught responses of the earthbound. All traces of landscape or architectural setting have been swept away and replaced by a depthless field of gold, on which the figures and their labels are fixed in isolation from one another. The gold field is bounded at its base by a rainbow band of colors graduating from yellow to blue, a ground line to which the figures are ambiguously related: sometimes they are placed behind it; sometimes they overlap it. The bodies cast no shadows, even though supernatural light streams over them. We are in the world of mystical vision, where all substance that might suggest the passage of time or motion through physical space is subtracted, so that the eternal and motionless world of religious truth can be contemplated by the devout.

The formal, hieratic style of Ravenna, appropriate to a court church, and the cultic, visionary style of Mt. Sinai, appropriate to a monastery church, although standing in obvious contrast, mark two main kinds of expression in Byzantine art and reflect their common source—Justinian's Constantinople.

Constantinople

Ravenna, the successor to Rome as imperial capital in Italy and then, as the so-called exarchate, the beachhead of Byzantium in the Germanized west, finally passed from Byzantine control. The images of Justinian and Theodora in San Vitale, proclaiming that the empire was still whole, were powerless to make it so. But the east remained firmly in the hands of successions of emperors for a thousand years; Constantinople became the magnificent citadel of Byzantine civilization, and its influence streamed to all points of the compass. At the time that the imperial presence in Ravenna was being symbolized in architecture and art, the vast church of Santa Sophia, or more properly Hagia Sophia, Church of the Holy Wisdom (FIGS. 7-40 to 7-42), was being built for Justinian in Constantinople by the architects ANTHEMIUS OF TRALLES and ISIDORUS OF MILETUS. Even today, this church, which was built between 532 and 537, remains one of the supreme achievements in the history of world architecture. Its dimensions alone are formidable for any structure not made of steel. In plan, it is about 270 feet long and 240 feet wide; the dome is 108 feet in diameter, and its crown rises some 180 feet above the pavement. In scale, Hagia Sophia rivals the great buildings we have seen in pagan and Christian Rome: the Pantheon, the Baths of Caracalla, or the Basilica of Constantine. In exterior view, the great dome dominates the structure, but the external aspects of the building are much changed from their original appearance. Huge buttresses were added to the original design, and four towering Turkish minarets were constructed after the Ottoman conquest of 1453, when Hagia Sophia became an Islamic mosque. The building has been secularized in the twentieth century and is now a museum.

The characteristic Byzantine plainness and unpretentiousness of exterior (which, in this case, also disguise the great scale) scarcely prepare us for the inte-

7-40 ANTHEMIUS OF TRALLES and ISIDORUS OF MILETUS, Hagia Sophia, Constantinople (Istanbul, Turkey), 532–537.

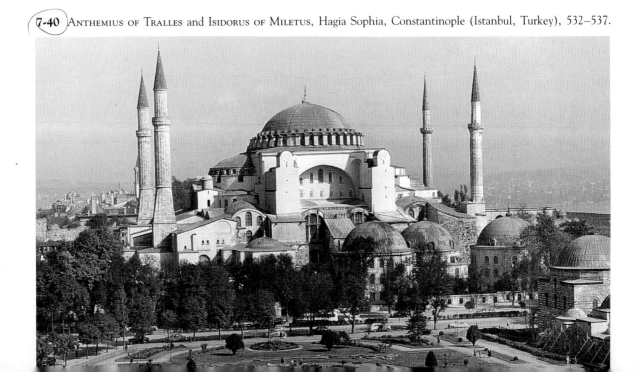

rior of the building (FIG. 7-41). The huge narthex, with its many entrances, leads into the center of the structure, over which the soaring, canopylike dome rides on a halo of light provided by windows in the dome's base. The impression made on the people of the time, an impression not lost on us, is carried in the words of the poet Paulus, an usher at the court of Justinian:

> About the center of the church, by the eastern and western half-circles, stand four mighty piers of stone, and from them spring great arches like the bow of Iris, four in all; and, as they rise slowly in the air, each separates from the other . . . and the spaces between them are filled with wondrous skill, for curved walls touch the arches on either side and spread over until they all unite above them. . . . The base of the dome is strongly fixed upon the great arches . . . while above, the dome covers the church like the radiant heavens. . . . Who shall describe the fields of marble gathered on the pavement and lofty walls of the church? Fresh green from Carystus, and many-colored Phrygian stone of rose and white, or deep red and silver; porphyry powdered with bright spots; emerald-green from Sparta, and Iassian marble with waving veins of blood-red and white; streaked red stone from Lydia, and crocus-colored marble from the hills of the Moors, and Celtic stone, like milk poured out on glittering black; the precious onyx like as if gold were shining through it, and the fresh green from the land of Atrax, in mingled contrast of shining surfaces.*

The dome rests on four *pendentives*. In pendentive construction (see FIG. 7-45), which apparently was developed after many years of experiment by builders in the Near East and constitutes *the* contribution of Byzantium to architectural engineering, a dome rests on what is, in effect, a second, larger dome. The top portion and four segments around the rim of the larger dome have been omitted and the four segments form four arches, the planes of which bound a square. By transferring the weight to piers, rather than to the wall itself, pendentive construction makes possible a lofty, unobstructed interior space, as is particularly evident in Hagia Sophia. In our view of the interior (FIG. 7-41), the arches that bound two of the great pendentives supporting the central dome can be seen converging on their massive piers. The domes of earlier, central-plan buildings, like the Pantheon, Santa Costanza, or even San Vitale, spring from the circular or polygonal bases of a continuous wall or arcade. The pendentive system is a dynamic solution to the problem of setting a round dome over a square or rectangular space, making a union of cen-

*In W. R. Lethaby, "Santa Sophia, Constantinople," *Architectural Review* (April 1905), p. 12.

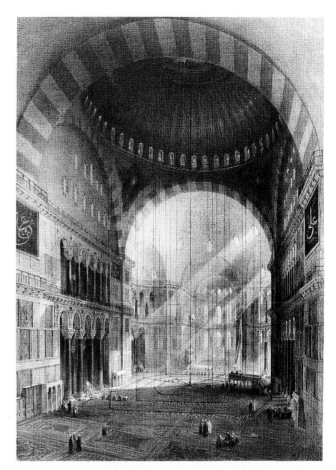

7-41 Interior of Hagia Sophia. (Engraving from *Aya Sophia* by CHEVALIER FOSSATI, London, 1852.)

tralized and longitudinal or basilican structures possible. Hagia Sophia, in its successful fusion of these two architectural types, becomes a domed basilica—a uniquely successful conclusion to several centuries of experiment in Christian church architecture. However, the thrusts of the pendentive construction at Hagia Sophia make other elements necessary: huge wall piers to the north and south, and, to the east and west, half-domes, whose thrusts descend, in turn, into still smaller domes (FIG. 7-42), covering columned niches that give a curving flow to the design, reminiscent of San Vitale (see FIG. 7-34). And, as in San Vitale, the wandering space, the diverse vistas, and the screenlike, ornamented surfaces all mask the lines of structure. The arcades of the nave and galleries have no real structural function; like the walls they pierce, they are only part of a fragile "fill" between the great piers. Structurally, although Hagia Sophia may seem Roman in its great scale and majesty, it does not have Roman organization of its masses. The very fact that what appears to be wall in Hagia Sophia is actually a concealed (and barely adequate) pier indicates that Roman monumentality was sought as an

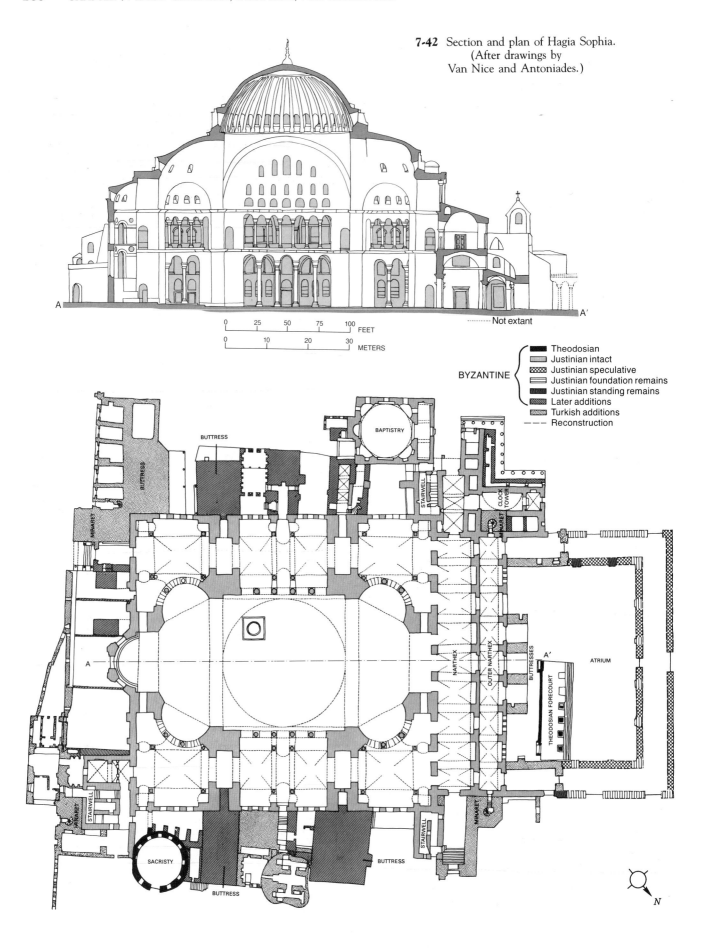

7-42 Section and plan of Hagia Sophia.
(After drawings by
Van Nice and Antoniades.)

0 25 50 75 100 FEET

0 10 20 30 METERS

-------- Not extant

Theodosian
Justinian intact
BYZANTINE { Justinian speculative
Justinian foundation remains
Justinian standing remains
Later additions
Turkish additions
--- Reconstruction

BUTTRESS

BAPTISTRY

BUTTRESS

STAIRWELL

CLOCK TOWER

MINARET

MINARET

STAIRWELL

NARTHEX

OUTER NARTHEX

BUTTRESSES

A'

ATRIUM

THEODOSIAN FORECOURT

A

STAIRWELL

MINARET

SACRISTY

BUTTRESS

BUTTRESS

N

effect and not derived directly from Roman building principles.

Visitors to Hagia Sophia have been struck by the quality of light within the church and the effect it has on the human spirit. The forty windows at the base of the dome create the peculiar illusion that the dome is resting on the light that floods through them; an observer of the time thought that it looked as if the dome were suspended by a "gold chain from Heaven." Procopius, the historian of the age of Justinian, wrote: "One would declare that the place were not illuminated from the outside by the sun, but that the radiance originated from within, such is the abundance of light which is shed about this shrine." Paulus observed: "The vaulting is covered over with many little squares of gold, from which the rays stream down and strike the eyes so that men can scarcely bear to look." Thus, we have a vastness of space shot through with light and a central dome that *appears* to be supported by the light it admits. Light is the mystic element—light that glitters in the mosaics, that shines forth from the marbles, and that pervades and defines spaces that, in themselves, seem to escape definition. Light becomes the agent that seems to dissolve material substance and transform it into an abstract, spiritual vision. At Hagia Sophia, the intricate logic of Greek theology, the ambitious scale of Rome, the vaulting tradition of the Near East, and the mysticism of Eastern Christianity combine to create a monument that is at once a summation of antiquity and a positive assertion of the triumph of Christian faith.

Hagia Sophia was a unique hybrid, uniting the Western basilican and the Eastern central plans into a design without successors. After it, the East forsook the long church for a thousand years or more to develop the central plan, while the basilican plan was consciously being revived in the West in Carolingian times.

LATER BYZANTINE ART

Between the tenth and the twelfth centuries, there occurred, under the auspices of the Macedonian dynasty, what has been called the Second Flowering or Second Byzantine Golden Age, during which Byzantine culture reencountered its Hellenistic sources and accommodated them to the styles inherited from the Age of Justinian, the time of the First Flowering.

Architecture

In architecture, a brilliant series of variations on the domed central theme began to appear. From the exterior, the typical later Byzantine church building is a

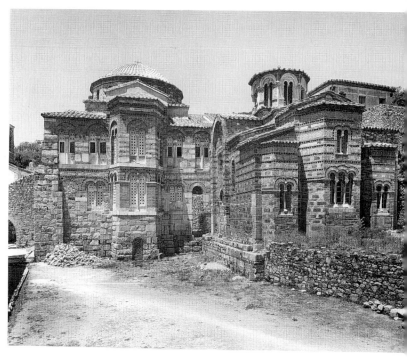

7-43 Monastery churches at Hosios Loukas, Phocis, Greece: Church of the Katholikon, *c.* 1020 *(left)*, and Church of the Theotokos, *c.* 1040 *(right)*. (View from the east.)

domed cube, with the dome rising above the square on a kind of cylinder or drum. (Less often, some other rectangular form, with something other than a square as its base, was used.) The churches are small, vertical, high-shouldered, and, unlike earlier Byzantine buildings, have exterior wall surfaces with ornament in relief. In the Church of the Theotokos (FIGS. 7-43 and 7-44), built about 1040 at Hosios Loukas in Greece, one can see the form of a domed cross with

7-44 Plans of the Church of the Katholikon *(bottom)* and the Church of the Theotokos *(top)*, Hosios Loukas.

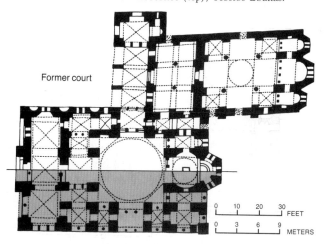

Former court

0 10 20 30 FEET
0 3 6 9 METERS

▓ Upper level
▒ Closed with masonry

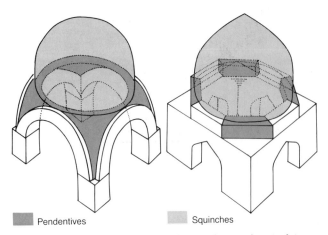

☐ Pendentives ☐ Squinches

7-45 Domes on pendentives *(left)* and squinches *(right)*.

four equal-length, vaulted cross arms (the Greek cross). Around this unit, and by the duplication of it, Byzantine architects developed bewilderingly involved spaces. In the adjacent, larger Church of the Katholikon (FIGS. 7-43 and 7-44), a dome is placed over an octagon inscribed within a square; the octagon is formed by *squinches*—arches, corbeling, or lintels that bridge the corners of the square (FIG. **7-45**). This arrangement represents a subtle extension of the older designs, such as Santa Costanza's circular plan (FIG. 7-8), San Vitale's octagonal plan (FIG. 7-33), and Hagia Sophia's dome on pendentives rising from a square (FIG. 7-42). The complex core of the Church of the Katholikon lies within two rectangles, the outermost forming the exterior walls. Thus, in plan, from the center out, a circle–octagon–square–oblong series exhibits an intricate interrelationship that is at once complex and unified.

The interior elevation of the Church of the Katholikon (FIG. 7-46) reflects its involved plan. Like earlier Byzantine buildings, the church creates a mystery out of space, surface, and light and dark. High and narrow, it forces our gaze to rise and revolve: "The overall spatial effect is overwhelmingly beautiful in its complex interplay of higher and lower elements, of core and ancillary spaces, of clear, dim, and dark zones of lighting."* Thus, the aim of Middle and Late Byzantine architecture seems to be the creation of complex interior spaces that issue into multiple domes in the upper levels; these, in exterior view, produce spectacular combinations of round forms that develop dramatically shifting perspectives.

The splendid Church of Holy Apostles, built in the time of Justinian, no longer exists. Fortunately, the great five-domed church of St. Mark's in Venice (FIGS. 7-47 to 7-49) reflects many of its key features. The original structure of St. Mark's, dating from the elev-

*Richard Krautheimer, *Early Christian and Byzantine Architecture* (Baltimore: Penguin, 1965), p. 244.

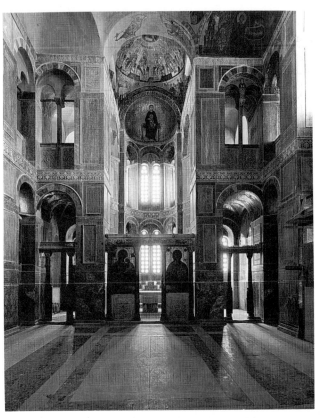

7-46 Interior of the Church of the Katholikon (view facing east).

7-47 Aerial view of St. Mark's, Venice, Italy, begun 1063.

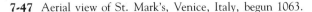

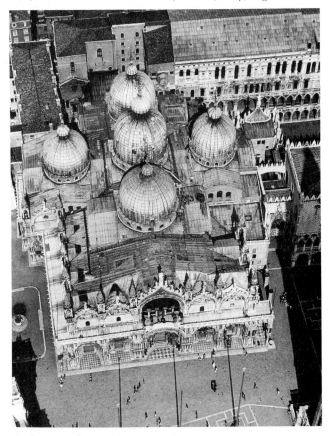

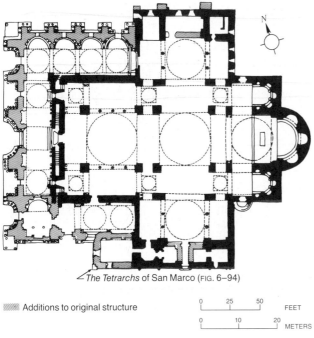

The Tetrarchs of San Marco (FIG. 6–94)

▨ Additions to original structure

0　25　50 FEET
0　10　20 METERS

7-48 Plan of St. Mark's. (After Sir Banister Fletcher.)

enth century, is disguised on its lower levels by Romanesque and Gothic additions. But in plan, or from an aerial view, the domes, grouped along a cross of equal arms (the Greek cross again), make the Byzantine origins of St. Mark's evident at once. The inner masonry shells are covered with swelling, wooden, helmetlike forms sheathed in gilded copper; these forms protect the inner domes and contribute to the exuberant composition. Venice, like Ravenna, some eighty miles to the south, was under strong Byzantine influence, despite the independence it had won early in the Middle Ages and preserved for centuries. The interior of St. Mark's is, like its plan, Byzantine in effect, although the great Justinianic scale and intricate syncopation of domed bays here are modified slightly by western Romanesque elements. The light effects and the rich cycles of mosaics, however, are entirely Byzantine.

Byzantine influence was wide-ranging not only in Italy, but also in the Slavic lands and in the regions of the east into which Islam had expanded. Byzantium brought its script, its religion, and much of its culture to Russia. The "holy" Russia prior to the

7-49 Interior of St. Mark's (view facing east).

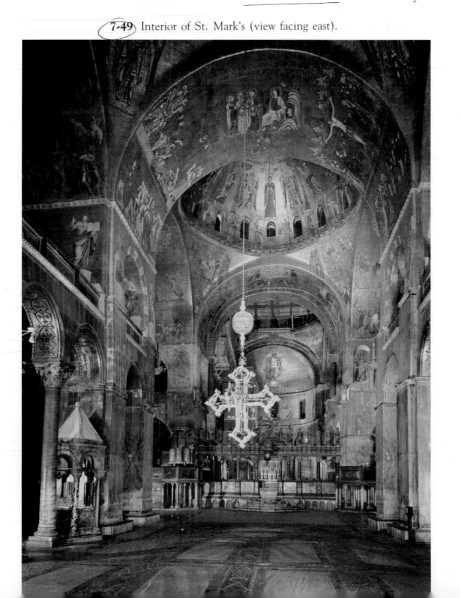

revolution of 1917 was largely Byzantine in its traditions and, one might even say, in its mood. Russian architecture, magnificently developed in the Middle Ages, is a brilliant, provincial variation on Byzantine themes.

The ecclesiastical architecture of medieval Russia was, at first, if not actually produced by Greeks, at least strongly under the influence of Constantinople. The church of St. Dmitri at Vladimir (FIG. **7-50**) is built on the typical plan of a square enclosing a Greek cross and crowned with a single dome on a high drum. The church is of stone, a rare building material in Russia, where brick, stucco, and wood are more usual. Exterior wall spaces, which have few openings, are decorated here with moldings. Some of these, rising unbroken from the ground to the roof, divide the wall into panels; others, much shorter, form blind arcadings. The surface within the arcadings is elaborately carved in low reliefs that are peculiarly well adapted to stone and are close, in subject matter and form, to Sassanian (Persian) and other western Asiatic carvings. St. Dmitri is a masterpiece of simplicity and compactness, with a classic, monumental dignity. Later structures will develop a colorful complexity of plan and elevation.

7-50 St. Dmitri at Vladimir, Soviet Union, 1194–1197.

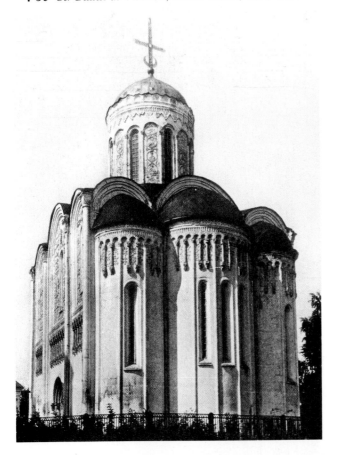

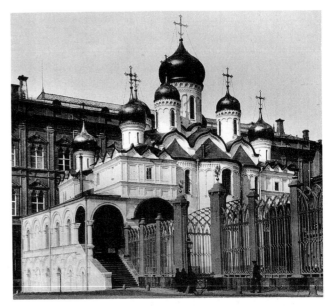

7-51 Cathedral of the Annunciation, the Kremlin, Moscow, 1482–1490.

In Moscow, within the walls of the Kremlin, stands the Cathedral of the Annunciation (FIG. **7-51**), which dates from the late fifteenth century. The domed-cross plan of Byzantium here receives a most spirited expansion. The cathedral is built on a square plan with eastern apses; its helmetlike domes, now greatly multiplied, rise in a kind of triumphant crescendo to the climax of the central unit, which is crowned with the typical Russian bulbous "onion" or "beet" dome. The bright metal caps, peaked with crosses like miniature masts, reflect the moody Russian skies and proclaim, as if in architectural polyphony, the glory of the Orthodox faith.

Painting and Sculpture

Although architecture enjoyed a fairly continuous development throughout the Byzantine period, the representational arts (painting and sculpture) suffered a severe setback during the eighth and ninth centuries, when they became the subject of a violent controversy. The Iconoclastic Controversy over the propriety of religious imagery, which raged for more than one hundred years (730–843), began with the temporary victory of the image-destroyers (*iconoclasts*), who interpreted the biblical ban against graven images literally. In 730, an imperial edict banned religious imagery throughout the Byzantine Empire, and artists either were forced to migrate to the west, where the edict could not be enforced, or, if they chose to remain in Byzantium, to turn their talents to secular subject matter, which was not affected by the ban.

Migrant Byzantine painters in Italy worked with religious subject matter in a classicizing style. Although little remains of their work, examples can be found in Rome, especially in Santa Maria Antiqua. There, in the eighth century, a succession of Greek popes provided an encouraging atmosphere for the forbidden culture and art of iconoclastic Byzantium. At Castelseprio in northern Italy, remarkable murals of uncertain date (FIG. **7-52**) are, without doubt, the work of a gifted Byzantine painter (probably from the late seventh or early eighth century) whose deft hand and fluent, sweeping style show the enduring illusionistic Classicism born in Hellenistic times and destined to recur often in the centuries after the First Golden Age of Byzantine art. This naturalistic manner could exist side by side with the austere and abstract style seen at Ravenna, or could merge with it. When the ban against religious images was lifted and religious painting was again encouraged in Byzantium, a style of painting emerged that was a subtle blend of the pictorial, classicizing Hellenistic and the later, more abstract and formalistic Byzantine style.

An eleventh-century crucifixion scene, a mosaic on the wall of the monastery church at Daphne in Greece (FIG. **7-53**) shows the simplicity, dignity, and grace of Classicism fully assimilated by the Byzantine artist into a perfect synthesis with Byzantine piety and pathos. Christ is represented on the cross, flanked by the Virgin and St. John. A skull at the foot of the cross indicates Golgotha, the "place of skulls." Nothing is needed to complete the tableau. In quiet sorrow and resignation, the Virgin and St. John point to Christ as if to indicate the meaning of the cross. Symmetry and closed space combine to produce an effect of the motionless and unchanging aspect of the deepest mystery of the Christian religion; the timeless presence is, as it were, beheld in unbroken silence. The picture is not a narrative of the historical event of the Crucifixion, but a devotional object, a thing sacramental in itself, to be viewed by the monks in silent contemplation of the mystery of the Sacrifice. Although elongated, these figures from the Second Golden Age of Byzantine art (the tenth and eleventh centuries) have regained their organic structure to a surprising degree, particularly compared to figures from the Justinian period (compare FIGS. 7-36 and 7-37). The style is a masterful adaptation of Classical, statuesque qualities to the linear Byzantine style.

Variations of Byzantine style appeared widely in the twelfth century throughout the Balkan world (Yugoslavia, Bulgaria, Romania) and in Venice, South Italy, and Sicily, where Mediterranean powers were eager to adopt Byzantine art and culture. At Nerezi in Yugoslavia (ancient Macedonia), paintings of amazing emotional power have been found that contrast

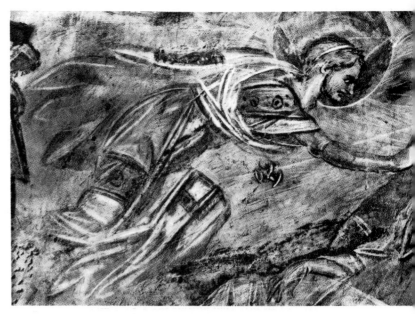

7-52 *The Angel Appearing to Joseph,* detail of wall painting, Santa Maria de Castelseprio, Castelseprio, Italy, early eighth century (?).

7-53 *The Crucifixion,* mosaic from the monastery church in Daphne, Greece, eleventh century.

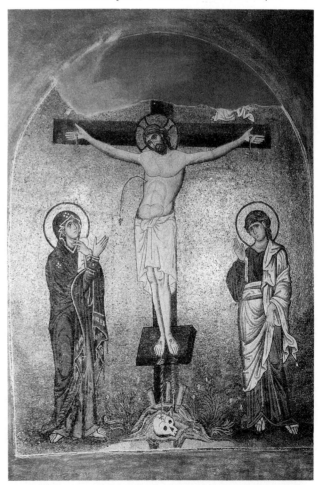

dramatically with the almost stern formalism and hieraticism of the Daphne mosaic. The *Lamentation over the Dead Christ* (FIG. 7-54), from the second half of the twelfth century, is a tableau of passionate grief. The friends of Christ are captured in attitudes, expressions, and gestures of quite human bereavement. The artist has striven above all to make this realization of the theme utterly convincing. The stirring staging of the subject points forward to the art of thirteenth-century (Gothic) Italy, when the reception of this mode of emotional realism would carry all before it into the Italian "proto-Renaissance" and the art of Giotto (compare FIG. 15-13).

In the art of the Second Byzantine Golden Age, particularly in its later phase, a kind of dialogue takes place between the formal, symbolic, hieratic style of the Daphne mosaic and the intense, emotional, active style of the Nerezi murals. The choice of one alternative over the other depended on the site and on ecclesiastical, political, and artistic intentions. An example of the hieratic style accommodated to a monumental site is found in the apse mosaic of the royal church of Monreale in Sicily (FIG. 7-55). This work was part of a total program of ecclesiastical-artistic aggrandizement conducted by Roger, the great Norman king of Sicily, who imported the splendor of Byzantium to glorify his reign, believing that his own sovereign power came directly from God. Christ, as Pantocrator, judge of the world, looms menacingly in the vault of the apse, a colossal image of kingly power and authority, whether spiritual or temporal. Below Christ in rank and dignity, the enthroned Virgin and saints are ranged symmetrically. Here, Byzantine formality manifests the very image of heavenly and earthly power; the former is presented explicitly, the latter, by association. From Sicily, from Venice, and from the Byzantine Balkans, the art of Byzantium found its way into the West, stimulating and influencing the art of the periods we call Romanesque and Gothic.

Recent cleaning and restoration on a grand scale have returned the mosaics of the church of St. Mark's in Venice (FIG. 7-49) to their original splendor. It is now possible to experience, in all its iconographic complexity, the awe-inspiring decorative program of a great Byzantine church and to appreciate to the fullest the radiance of mosaic (some 40,000 square feet of it!) as it covers, like a gold-brocaded and figured fabric, all architectural surfaces—walls, arches, vaults, and domes. This is the setting for the presentation of the divine personages who preside in this church as they preside in the spiritual universe; in Byzantine devotion, they are regarded not as mere representations, but as *icons* actually present and deserving of the reverence they would receive in Heaven. In the

7-54 *Lamentation over the Dead Christ*, wall painting, St. Pantaleimon, Nerezi, Yugoslavia, 1164.

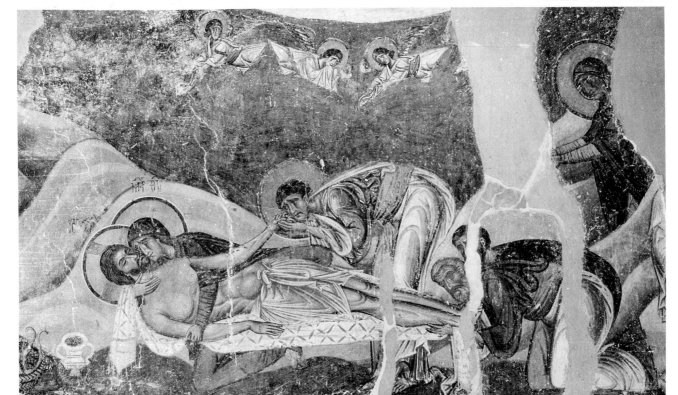

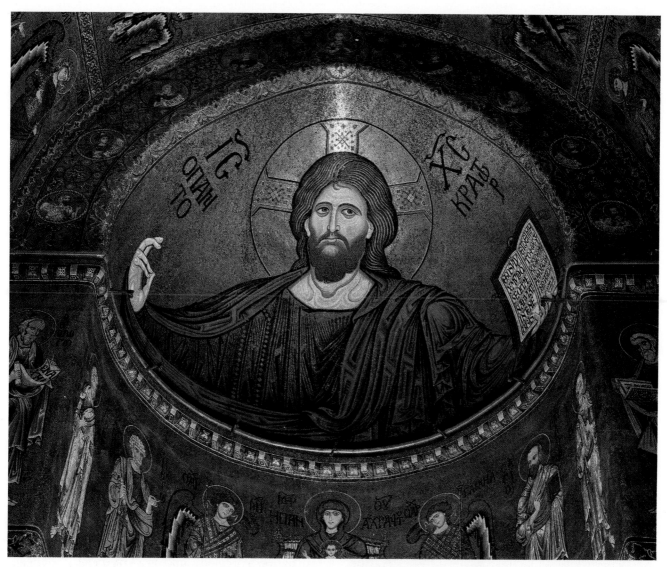

7-55 *The Pantocrator, with the Virgin, Angels, and Saints,* apse mosaic from the royal church of Monreale, Sicily, late twelfth century.

vast central dome, 80 feet above the floor and 42 feet in diameter, Christ reigns in the company of the Evangelists, the Virgin Mary, the Virtues, and the Beatitudes. The great arch, which partly interrupts our view of the dome, bears a narrative of the Crucifixion and Resurrection of Christ and of his liberation of the worthies of the Old Testament from death, the theme known as the Harrowing of Hell. On these golden surfaces, the figures ("sages standing in God's holy fire"), levitating and insubstantial, are drawn with a flowing, calligraphic line; they project from their flat field no more than the letters of the elegant Latin script that captions them. Nothing here reflects on the world of matter, of solids, of light and shade, of perspective space; the trees are ornamental standards, the furniture of Paradise. We have before us the open book of the heavenly order, its image as solemn and hieratic as the sacred text that reveals it in

words. Here, in hierarchical placement, the chief mysteries and narratives of the Christian Church are arrayed to present the supernatural and eternal world to which its dogma refers.

The New Testament is set forth within the church proper. Outside, in the shallow domes of the narthex, the Old Testament is recounted, particularly the Book of Genesis, which tells the story of the creation and fall of man. One of the domes (FIG. **7-56**) depicts the sojourn of Joseph in Egypt (Genesis 39, 40, 41, 42): the affair of Potiphar's wife, Joseph imprisoned, his interpretation of the dreams of Pharaoh and the baker. The episodes, with their captions, are arranged in a circle following the curve of the dome, their radial axes converging on an exquisite, starstudded medallion vaguely resembling the great rose windows of contemporaneous cathedrals in Gothic France (see page 397). The figures, like those of the

interior of the church, are rendered in sharp, precise line on a golden ground, with all the clarity and readability of the script that describes them. Again, we have the perfect harmony of architectural surface, figural image, and lettered inscription in a scintillating, rainbow-colored aureole. The mosaicists' masterly control of their medium, their consummate skill in design, their faultless geometric procedure, their subtle color harmonies, their deft, clear and economical draftsmanship make for a perfection almost without parallel in Byzantine art. The great mosaic cycles of St. Mark's would, in themselves, proclaim an artistic golden age. In them, we find the culmination and confluence of both the hieratic and narrative stylistic currents begun at Santa Maria Maggiore in Rome and at St. George in Thessaloniki (FIGS. 7-12 and 7-13) some eight centuries before.

From the last great period, the Third Golden Age of Byzantine art (thirteenth to late fourteenth century), we have a late example of vigorous, expressive action, related to the drama of the Nerezi painting but with a heightened naturalism that parallels developments in contemporaneous Italian art, and may even lead them in sophistication. A fresco completed about 1320 in the vault of a side chapel of the Mosque of the Ka'riye in Istanbul (originally the Church of the Blessed Savior of the Chora) represents, although inscribed *Anastasis* (Resurrection), *The Harrowing of Hell* (FIG. 7-57). Christ, after his death on the cross, descends into Hell, tramples Satan, and rescues

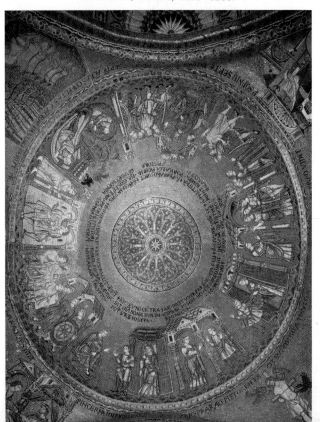

7-56 *Joseph in Egypt*, mosaic in the dome of the narthex, St. Mark's, Venice, 1255–1260.

Adam and Eve, while other worthies of the Old Testament stand by awaiting their liberation. The movement of the central figures is highly dramatic. The white-robed, aureole-surrounded figure of Christ is suffused with energy as he literally tears the parents of mankind from their tombs. The dynamic postures of the figures are reinforced by swirling draperies, agitated by the winds of a supramaterial force. But we also notice that, here and there, the carefully and precisely drawn drapery folds tend to take on a life of their own, as the Late Byzantine artist often showed delight in creating linear patterns for their own sake. These abstract, decorative, linear patterns tend to obscure the fact that, in its late stages, Byzantine art became increasingly realistic.

The characteristics of Byzantine painting were developed in large-scale mural decorations, but it was through miniatures in manuscripts and small panel paintings, more popularly known as *icons*, that the elements of the style were spread abroad. A fine example of the former is a page from a book of the Psalms of David, the so-called *Paris Psalter* (FIG. **7-58**), which reasserts the artistic values of the Classical past with astonishing authority. The *Psalter* is believed to date from the early tenth century—a time of enthusiastic and careful study of the language and literature of ancient Greece as well as a time when the classics were regarded with humanistic reverence. It was only natural that, in art, inspiration should be drawn once again from the Hellenistic naturalism of the pre-Christian Mediterranean world, especially Alexandria. David, the psalmist, is seated with his harp in a flowering, Arcadian landscape recalling those of Pompeian murals. He is accompanied by an allegorical figure of Melody and is surrounded by sheep, goats, and his faithful dog. Echo (or perhaps Spring) peers from behind a trophied column, and a reclining male figure points to an inscription that identifies him as representing the mountains of Bethlehem. These allegorical figures do not appear in the Bible; they are the stock population of Alexandrian and Pompeian landscape. Apparently, the artist had seen a work from Late Antiquity or perhaps earlier and partly translated it into a Byzantine pictorial idiom. In the figure of Melody, we find some incongruity between the earlier and later styles. Her pose, head, and torso are quite Hellenistic, as is the light, impressionistic touch of the brush, but the drapery enwrapping the legs is a pattern of hard line. Byzantine illuminations like this repeatedly will exert their influence on Western painting in the Romanesque and Early Gothic periods.

The icon, a devotional panel bearing the portrait of a saint, was a characteristic type of Byzantine painting. The icon's origins derive from the mosaic portrait

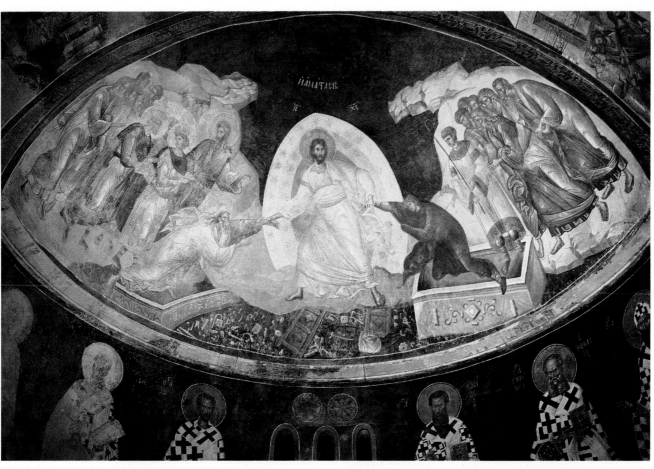

7-57 *The Harrowing of Hell,* fresco from the Mosque of the Ka'riye, Istanbul, Turkey, *c.* 1310–1320.

7-58 *David Composing the Psalms,* page from the so-called *Paris Psalter,*
c. 960. Approx. 15″ × 11″. Bibliothèque Nationale, Paris.

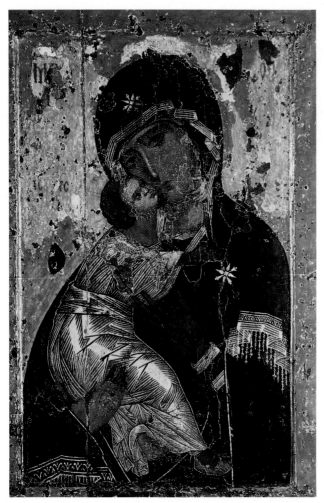

7-59 *The Vladimir Madonna,* twelfth century. Painted wood, original panel approx. 30½″ × 21″. State Historical Museum, Moscow.

In Russia, icon painting flourished for centuries, extending the life of the style well beyond the collapse of the Byzantine Empire in 1453. The development of the *iconostasis*—the large, icon-bearing screen that shuts off the sanctuary from the rest of the church—into an elaborate structure with more than five tiers had an important effect on icon painting. The purpose of these paintings was to enable the worshiper to read pictorially. Clear, pictorial legibility in wavering candlelight and through clouds of incense required strong pattern, firm lines, and intense color. Hence, the relatively sober hues of the Early Byzantine paintings gave way, more characteristically, to the intense, contrasting colors used in Russia. It was under a renewed Byzantine impulse, after the waning of the Mongol domination, and through the requirements of the iconostasis (just then reaching its highest development), that Russian painting reached a climax in the work of ANDREI RUBLËV (c. 1370–1430). *The Old Testament Trinity Prefiguring the Incarnation* (FIG. **7-60**) is a work of great spiritual

7-60 ANDREI RUBLËV, *The Old Testament Trinity Prefiguring the Incarnation, c.* 1410. Painted wood, 56″ × 45″. Tretyakov Gallery, Moscow.

medallions, like that of Christ in the triumphal arch of Sant' Apollinare in Classe (FIG. 7-30), conspicuous in Byzantine churches. A famous example of the icon is *The Vladimir Madonna* (FIG. **7-59**), which was probably painted by an artist in Byzantium in the twelfth century, exported to Vladimir, and then taken to Moscow in 1395 to protect that city from the Mongols. Because these icons were quickly blackened by incense and smoke from the devotional candles that burned before them, they frequently were repainted, often by inferior artists. In our panel, only the faces show the original surface, but the painting retains its Byzantine characteristics in the typical configuration of the Madonna's face, with its long, straight nose and tiny mouth, and in the decorative sweep of the unbroken contour that encloses the two figures and creates a flat silhouette against a golden background. The deep pathos of the Madonna's expression shows an interest in depicting emotion that would flow into the art of Russia and the West.

power, as well as an unsurpassed example of subtle line in union with intensely vivid color. The three angels who appeared to Abraham near the oaks of Mamre (Genesis 18:2–15) are seated about a table. (The angels are interpreted in Christian thought as a prefiguration of the Holy Trinity after the Incarnation of Christ.) The figures, each framed with a halo and sweeping wings, are suavely, languorously poised within an implicit circle, each, in its way, appearing rapt in meditation on the mystery of the Trinity. The tranquil demeanor of the figures is set off by the light, linear play of the draperies. Forms are defined by color, and areas frequently are intensified by the juxtaposition of a complementary hue. The intense blue and green folds of the cloak of the central figure, for example, stand out starkly against the deep red robe and the gilded orange of the wings. In the figure on the left, the highlights of the orange cloak are an opalescent blue-green. The color harmonies are Oriental in their unmodulated saturation, brilliance, and purity. In Russian painting, the Byzantine tradition was enlivened and enriched by a feeling and a touch that were not Byzantine or native but, rather, a fusion of the two; the same can be said of Russian architecture.

We should not forget, in considering the rich ecclesiastical art of Byzantium and Russia, the indispensable part played by other arts in the ensemble of a church interior: the carvings and rich metalwork of the iconostasis; the finely wrought, jeweled halos and other ornaments on the icons; the candlesticks and candelabra; the miters and ecclesiastical robes stiff with gold, embroidery, and jewels; the illuminated books bound in gold or ivory, inlaid with jewels and enamels; the crosses, croziers, sacred vessels, and processional banners. Each, with its great richness of texture and color, contributed to the total effect. In the life of Orthodox Byzantium, to produce this effect was to honor God and his vicar, the emperor.

Although carved ornament continued to appear in Byzantine churches, monumental stone sculpture was never encouraged to the degree that it was in western Europe. Life-size figures in the round apparently offended the Eastern Christians. Their uneasiness was underlined by the Iconoclastic Controversy; they made an early association between statues and pagan idols. Painted images, on the other hand, created forms that were less directly identified with natural figures (particularly given the stylistic conventions that were to develop). The Byzantine sculptor, however, was called on to carve small statues and reliefs, particularly in ivory, to be used primarily for devotional purposes, although secular themes also are evident. These objects were used to adorn books, caskets, portable plaques, and venerable images, in much the same manner as the painted icons.

A panel from a small work in ivory from the Second Byzantine Golden Age, the *Veroli Casket* (FIG. **7-61**), testifies to the persistence of Classical form and content in Byzantine art, and to their strong revival in the tenth century. This panel represents a scene at the end of Euripides' play, *Iphigenia in Aulis*, in which Iphigenia, at center, is about to be sacrificed. The characters are all identifiable, and the human types, poses, costumes, and accessories are all from classical antiquity, although the stunting of the proportions (perhaps partly a consequence of the diminutive space) and the bulbous modeling show the figures at a considerable distance in time and style from their prototypes in the Greco-Roman world.

7-61 *The Sacrifice of Iphigenia,* panel from the Veroli Casket, tenth or eleventh century. Ivory, whole casket 4½″ high, 16″ long. Victoria and Albert Museum, London.

From about the same time, the *Harbaville Triptych*, a portable shrine with hinged panels (FIG. **7-62**), manifests in its figures the hieratic formality and solemnity we have learned to associate with Byzantine art and have seen as standard in the mosaics of Ravenna. A softer, more fluent technique and the looser stance of the figures mitigate the hard austerity of the customary frontal pose. This softening may also result from the influential, classicizing spirit of the Second Byzantine Golden Age. Originating in a workshop associated with the imperial palace in Constantinople, the triptych marshals Christ and the saints in such a way as to align the powers of church and state, of God and emperor. Christ is enthroned between St. John and the Virgin in the upper central zone. Beneath them are five apostles. In the wings are soldier-saints like George and Theodore and bishop-saints like Demetrius and Procopius. Between the levels are portraits of other saints. Here, we have, in effect, a miniature, sculptured iconostasis, with the sacred personages placed in their celestial ranks of authority, like officials ranked in the imperial hierarchy.

Portable works like icons and ivories found their way to distant lands as royal gifts, as items of trade, or as plunder, so that the rich and potent religious art of Byzantium became known throughout Europe. Everywhere it had directing influence and, as we have seen, nowhere more than in Russia. For the Medieval West, the art of Byzantium was to inspire, through its steady influence, a return to the principles of Classical humanism and naturalism long implicit in it.

7-62 *Christ Enthroned with Saints*, the *Harbaville Triptych*, c. 950. Ivory, central panel 9½″ × 5½″. Louvre, Paris.

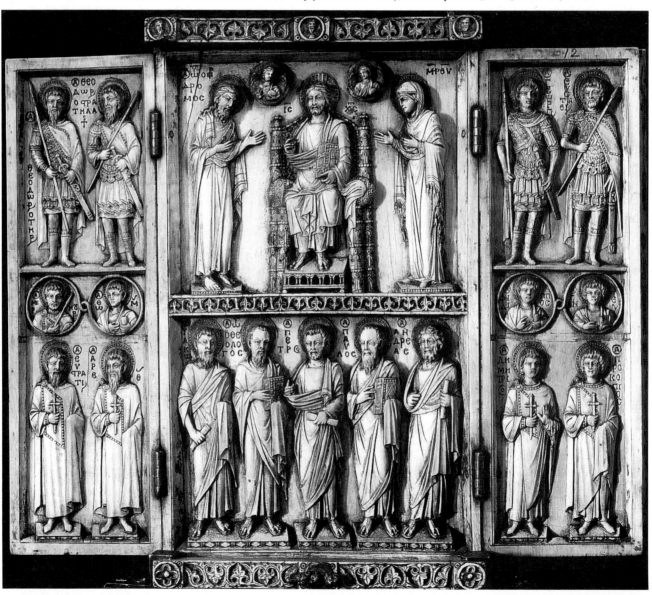

ISLAMIC ART

In 622, Mohammed fled from Mecca to Medinet-en-Nabi ("City of the Prophet," now Medina). From this flight, known as the "Hegira," Islam dates its beginnings.*

During the century that followed, the new faith spread with unprecedented speed from Arabia, where it first was espoused, through the Middle East to the Indus Valley and westward across North Africa to the Atlantic Ocean. By 640, Syria, Palestine, and Iraq had been conquered by Arab warriors in the name of Islam. In 642, the Byzantine army abandoned Alexandria, marking the Moslem conquest of Lower Egypt. In 651, Iran was conquered; by 710, all of North Africa had been overrun and a Moslem army crossed the straits of Gibraltar into Spain. A victory at Jerez de la Frontera in 711 seemed to open all of western Europe to the Mohammedans. By 732, they had advanced north to Poitiers in France, where an army of Franks under Charles Martel, the grandfather of Charlemagne, opposed them successfully. Although they continued to conduct raids in France, they were unable to extend their control beyond the Pyrenees. But in Spain, the great Caliphate of Córdoba flourished until 1031, and it was not until 1492, when Granada fell to Ferdinand and Isabella, that Islamic influence and power in the West came to a close. In the East, the Indus River had been reached by 751, and only in Anatolia was stubborn Byzantine resistance able to slow the Moslem advance. Relentless Moslem pressure against the shrinking Byzantine Empire eventually caused its collapse in 1453, when the Ottoman Turks conquered Constantinople.

The early lightning successes of Islam were due largely to the zeal and military prowess of Arab warriors who set out to conquer the earth for Allah and who burst on the Near Eastern and Mediterranean worlds when Persian and Byzantine military power were at a low ebb. But the fact that these initial conquests had effects that endured for centuries can be explained only by the nature of the Islamic faith and its appeal to millions of converts.

Many of the features of the Islamic faith are derived from the Judeo-Christian tradition. The sacred Islamic scripture is the Koran, the collection of Mohammed's revelations that was ordered gathered by the caliph Othman (644–656) and remains unchanged to the present day. The basic teachings and ethics of the Koran are similar to those of the Bible, and the Old Testament prophets, as well as Jesus, are counted among the predecessors of Mohammed. On the other hand, all Moslems believe that they have direct and equal access to God without need for complex ritual or an intervening priesthood. In addition, Mohammed established a new social order that was quite different from the Christian one; in it, he took charge of the temporal as well as the spiritual affairs of his community. This practice of uniting religious and political leadership in the hands of a single ruler was continued after Mohammed's death by his successors, the *caliphs*, who based their claims to authority on their descent from the families of the Prophet or those of his early followers.

Architecture and Architectural Ornament

During the early centuries of Islamic history, the political and cultural center of the Moslem world was the Fertile Crescent (Palestine, Syria, and Iraq)—that melting pot of East and West strewn with impressive ruins of earlier cultures that became one of the fountainheads of the development of Islamic art. The vast territories conquered by the Arabs were ruled by governors, originally sent out from Damascus or Baghdad, who eventually gained relative independence by setting up dynasties in various territories and provinces: the Umayyads in Syria (661–749) and in Spain (756–1031); the Abbasids in Iraq (749–1258; largely nominal after 945); the Fatimids in Tunisia and Egypt (909–1171); and so on. Despite the Koran's strictures against sumptuousness and license, the caliphs were not averse to surrounding themselves with luxuries commensurate with their enormous wealth and power. This duality is expressed by the two major architectural forms developed during the Early Islamic period: the *mosque* and the *palace*.

Moslem religious architecture is closely related to Moslem prayer, the performance of which is an obligation laid down in the Koran for all Moslems. Prayer as a private act requires neither liturgical ceremony nor a special locale; only the *qiblah*—the direction (facing Mecca) toward which the prayer is addressed—is important. But prayer also became a communal act for which a simple ritual was established by the first Moslem community. The community convened once a week, probably in the Prophet's house, the main feature of which was a large, square court with two *zullahs*, or shaded areas, along the north and south sides. These zullahs consisted of thatched roofs supported by rows of palm trunks; the southern zullah, wider and supported by a double row of trunks, indicated the qiblah. During these communal gatherings, the *imam*, or leader of collective worship, standing on

*Islam, "exclusive worship of the one God (Allah)," was Mohammed's name for his new religion. Mohammedan, Muhammadan, Muslim, and Moslem all refer to the same faith.

a pulpit known as a *minbar*, near the qiblah wall, pronounced the *khutbah*, which is both a sermon and an act of allegiance of the community to its leader. The minbar thus represents secular authority even as it serves its function in worship.

The requirements of this ritual were satisfied by the hypostyle mosque, the origin of which is still in dispute, although one prototype may well have been the Prophet's house in Medina. Once the Moslems had firmly established themselves in their conquered territories, they began to build on a large scale, impelled perhaps by a desire to create visible symbols of their power that would surpass those of their non-Islamic predecessors in size and splendor; the great size of some of the early mosques, however, may also be explained by the fact that they were intended to contain the entire Moslem population of a given city.

The Great Mosque of Samarra on the Tigris River (FIGS. **7-63** and **7-64**), built between 848 and 852 but now ruined, was the largest mosque of the Islamic world, measuring 800 feet by 520 feet. Over half its ten-acre area was covered by a wooden roof carried by 464 supports arranged in aisles around the open central court and leading toward the qiblah wall, the importance of which was emphasized by the greater number of aisles on its side. In the center of the qiblah wall is a niche, the *mihrab*, which became a standard feature in all later mosques. Its origin, purpose, and meaning are still matters of debate; some historians

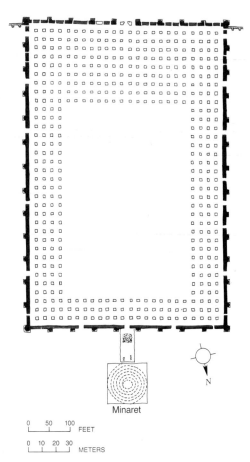

7-63 Plan of the Great Mosque, Samarra, Iraq, 848–852.

7-64 Aerial view of the Great Mosque.

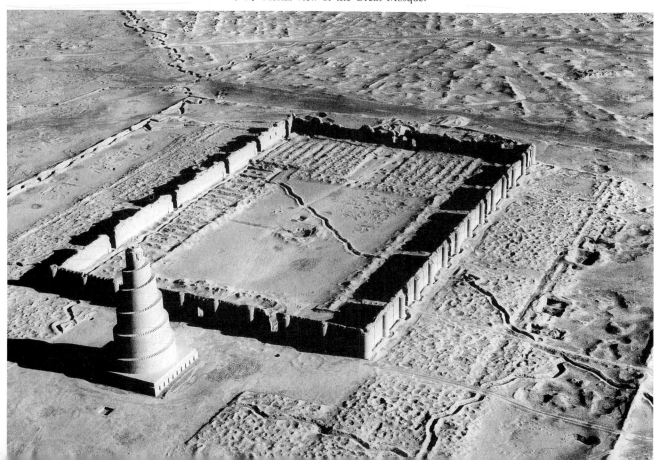

feel that the mihrab originally may have honored the place where the Prophet stood in his house at Medina when he led the communal prayers. If the mihrab has this symbolic function, it is unusual, because one of the characteristics of Early Islamic art is its concerted avoidance of symbols. In this respect, Early Islamic art offers a striking contrast to Medieval Christian art; the avoidance of religious symbolism, in fact, may reflect a conscious rejection of Christian customs and practices.

On the north side of the Great Mosque of Samarra stands a single, large minaret from which a *muezzin* called the faithful to prayer. Although its shape is reminiscent of the ancient ziggurats of Mesopotamia, it was probably inspired not by them but by a certain kind of spiral tower of unknown purpose found in Sassanian Iran. More numerous were minarets that were square in plan and derived from the towers of Early Christian churches in the Near East. Cylindrical minarets, from which the slender needles so characteristic of later mosques evolved, became popular only in the eleventh century.

The early Moslem hypostyle system, as illustrated by the Samarra mosque, was diffused and, except for the orientation of the building and the position of the qiblah wall, lacked architectural focus and direction. On the other hand, it was a flexible system that permitted enlargement and addition with minimum effort. Its main element was the single support, either a column or a pier, which could be multiplied at will and in any desired direction. A striking illustration of the flexibility of this system is the mosque of Córdoba (FIGS. **7-65** and **7-66**), which was begun in 784 and enlarged several times during the ninth and tenth centuries. The additions followed the original style

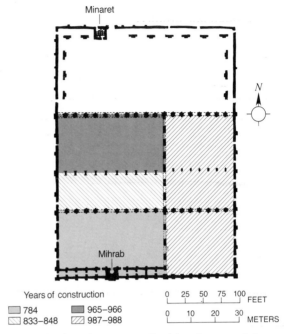

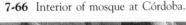

7-65 Plan of mosque at Córdoba, Spain, eighth to tenth centuries.

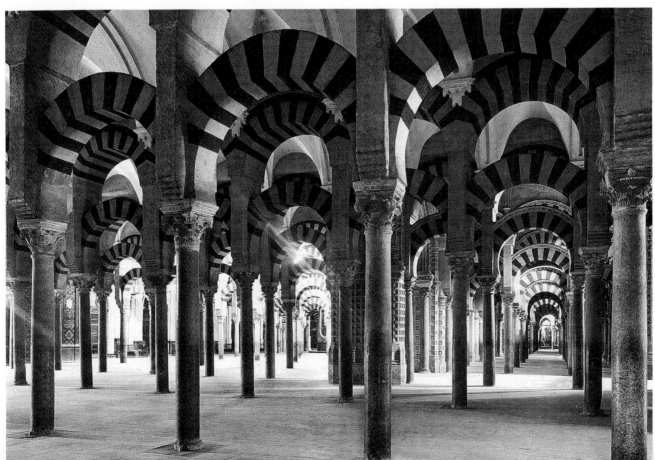

7-66 Interior of mosque at Córdoba.

and arrangement of columns and arches, and the builders were able to maintain a striking stylistic unity for the entire building. The thirty-six piers and 514 columns are topped by a unique system of double-tiered arches that carried a wooden roof, now replaced by vaults. The lower arches are horseshoe-shaped, a form perhaps adapted from earlier Near Eastern architecture or of Visigothic origin and now closely associated with Moslem architecture. Visually, these arches seem to billow out like sails blown by the wind, and they contribute greatly to the light and airy effect of the mosque's interior.

In areas the builders wished to emphasize, like that near the mihrab (FIG. 7-67), the arches become highly decorative, multilobed shapes. Other Early Islamic experiments with arch forms led to the pointed arch, which, however, was not used to cover variable spaces, as in Gothic buildings. Early Islamic buildings had wooden roofs, and the experiments with arch forms were motivated less by structural necessity than by a desire to create rich and varied visual effects. The same desire for decorative effect seems to have inspired the design of the dome that covers the area in front of the mihrab (FIG. 7-68), one of four domes built during the tenth century to stress the axis leading to the mihrab. Here, the large ribs that subdivide the hemispheric surface of the dome into a number of smaller sections are primarily ornamental. Only in the hands of Gothic builders, centuries later, were ribs, in combination with the pointed arch, to become fundamental structural ingredients of a new and revolutionary architectural vocabulary.

7-67 Mihrab of mosque at Córdoba.

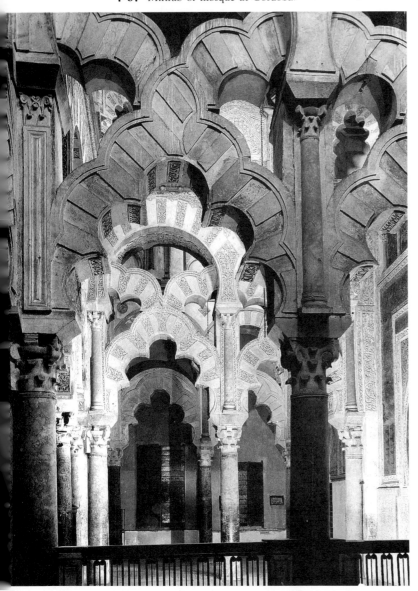

7-68 Dome before the mihrab of mosque at Córdoba.

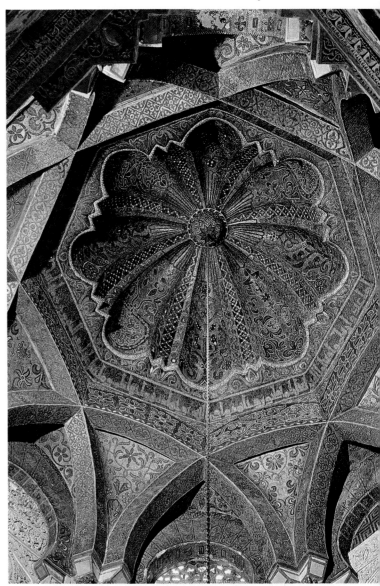

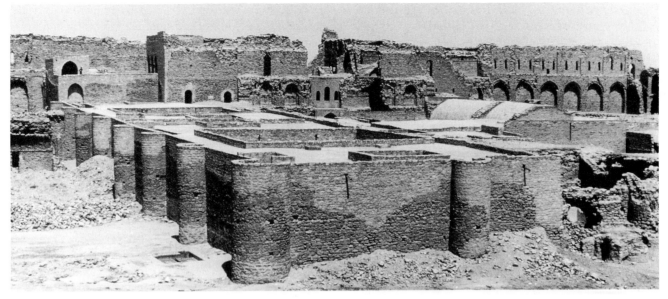

7-69 Palace at Ukhaydir, Iraq, late eighth century (view from the southeast).

Of the early palaces, only scattered remains have survived, and they are of limited historical importance, serving primarily to illustrate the way of life of Moslem aristocrats and to provide us with some notion of the decorative styles of Early Islamic art. Even the purpose of these early palaces is not quite certain. They were built both in cities and in the open country. The rural palaces, which have been better investigated, seem to have served a function similar to that of the Roman villas. That they reflect an Islamic taste for life in the desert seems too simple an explanation, although a desire to avoid plague-infested cities may well have been at least a partial motivation for their builders. But these rural palaces probably also served as nuclei for the agricultural development of conquered territories; in addition, they may have been symbols of authority over conquered and inherited lands, as well as expressions of the newly acquired wealth of their owners.

One of the better preserved of these early Moslem palaces is the palace at Ukhaydir in Iraq (FIGS. **7-69** and **7-70**), built in the second half of the eighth century. Somewhat larger than most, the palace is a separate entity within a fortified enclosure. From the outside, the high, tower-studded walls look much like those of the Great Mosque of Samarra (FIG. 7-64). This similarity illustrates a flexibility that is characteristic of Early Islamic monuments, as relatively minor changes could convert them from one purpose to another. Differences between a mosque, a palace, or a caravansary rarely were evident from the exterior; the structures tended to share a rather grim, fortified look that belied their military inefficiency. The high walls may have offered safety from marauding no-

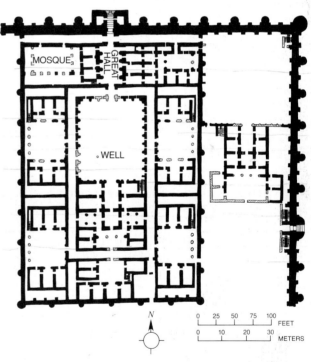

7-70 Plan of the palace at Ukhaydir.

madic tribes, but they also may have fulfilled abstract considerations more important to the builders, like the promise of seclusion for a mosque or, for a palace, privacy for the prince and the symbolic assertion of his power over newly conquered territories.

The plan of the palace at Ukhaydir (FIG. 7-70) expresses the structure's residential and official functions. An elaborate entrance complex, consisting of a monumentalized gate and a Great Hall between two

small, domed rooms, leads onto the large central court, beyond which is a reception hall surrounded by satellite rooms. Flanking this ceremonial axis are four smaller courts, all with three rooms on each of two sides. These grouped rooms appear to be self-contained and probably served as family living units or guest houses. To the right of the entrance hall is a mosque, a standard feature of these early palaces, which here is incorporated into the main building complex, although sometimes it stood by itself. Most palaces also were provided with fairly elaborate bathing facilities that displayed technical features, such as heating systems, adopted from the Roman tradition of baths. (The baths at Ukhaydir, only recently discovered near the mosque, are not shown on the plan.) Just as in classical antiquity, these baths probably served more than merely hygienic purposes. Large halls frequently attached to them seem to have been used as places of entertainment. Thus, a characteristic amenity of Classical urban culture that died out in the Christian world survived in medieval Islamic culture.

The decoration of the Ukhaydir palace seems to have been rather sparse and was confined to simply molded stucco and occasional decorative brickwork. In this respect, finds made in the western palaces in Syria and Palestine (modern Israel and Jordan) have been much richer. At Mshatta, an unfinished palace in the Jordanian desert, for instance, gate and façade are decorated by a wide, richly carved, stone frieze (FIGS. 7-71 and 7-72). Its design, arrangement, and relation to its carrier serve well to illustrate the major characteristics of Early Islamic decoration.

A long band, almost 15 feet high, is decorated with a series of triangles of the same size framed by an elaborately carved molding. Each triangle contains a large rosette that projects from a field densely cov-

ered with curvilinear, vegetal designs; no two triangles are treated the same way, and animal figures appear in some of them (FIG. 7-71). The sources of the various design elements are easily identified as Late Classical, Early Byzantine, and Sassanian Persian, but their combination and arrangement are typically Islamic.

7-71 Portion of stone frieze, palace at Mshatta, Jordan, *c.* 743. Staatliche Museen, Berlin.

7-72 Reconstruction of façade of the palace at Mshatta. (After Schulz.)

Most of the design elements of Islamic ornament are based on plant motifs, which are sometimes intermingled with symbolic geometric figures and with human and animal shapes. But the natural forms often become so stylized that they are lost in the purely decorative tracery of the tendrils, leaves, and stalks. These arabesques form a pattern that will cover an entire surface, be it that of a small utensil or the wall of a building. (This *horror vacui* is similar to tendencies in barbarian art, although other aspects of Islamic design distinguish it from the abstract, barbarian patterns.) The relationship of one form to another in Islamic art is more important than the totality of the design: the patterns have no function but to decorate. This system offers a potential for unlimited growth, as it permits extension of the designs in any desired direction. Most characteristic, perhaps, is the design's independence of its carrier; neither its size (within limits) nor its forms are dictated by anything but the design itself. This arbitrariness imparts a certain quality of impermanence to Islamic design, a quality that, it has been said, may reflect the Moslem taste for readily movable furnishings, such as rugs and hangings.

Stone carving was only one of several techniques used for architectural decoration. Floor mosaics and wall paintings continued a long Mediterranean tradition. In later periods, colored tile became increasingly important. A magnificent example of a floor mosaic was found in the bath of the palace at Khirbat al-Mafjar near Jericho in Jordan (FIG. **7-73**). Set into square and rectangular fields covered with a rich variety of floral and geometric patterns are medallions with extremely intricate abstract designs, some of them creating the illusion of a downward projection of the dome or half-dome under which they are placed.

The use of colored tile has a long history in the Middle East and Iran, reaching back into the Sumerian period. It enjoyed particular favor among the Babylonians (see FIG. 2-36). After periods of neglect, the art was revived by the Abbasids in the ninth century at Samarra, where tiles with a metallic sheen were developed. From there, the fashion spread throughout the Moslem world, reaching the height of its development during the sixteenth and seventeenth centuries in Turkey and Iran. Used as veneer over a brick core, tiles could sheathe entire buildings,

7-73 Floor mosaic, palace at Khirbat al-Mafjar, Jordan, mid-eighth century.

including their domes and minarets. Our example, the Dome of Madrasa-I-Shāh in Isfahan (FIG. 7-74), dates from the early seventeenth century and shows such tile work at its most brilliant. Beautifully adjusted to the shape of the dome, the design of the spiraling tendrils is at once rich and subtle, enveloping the dome without overpowering it. In contrast to the more general Islamic tendency to disguise structure, the design here enhances the dome's form without obscuring it. On parts of the dome and on the minarets, the tiles are curved to conform to the shape of the architecture.

Particularly popular were *stucco reliefs*, a method of decoration that was known, but not common, in pre-Islamic Iran and Iraq. Cheap, flexible, and effective, the basic material (wet plaster) was particularly adaptable to the execution of the freely flowing line that distinguishes Islamic ornament, and stucco decoration became a favorite technique. Some of the very richest examples are found in the Alhambra palace in Granada, Spain, the last Moslem stronghold in western Europe in the Middle Ages. In the Court of the Lions and the rooms around it (FIGS. 7-75 and 7-76), stucco decoration runs the gamut of the medium's possibilities and creates an exuberant atmosphere of elegant fantasy that seems to be the visible counterpart of the visions of the more ornate Moslem poets.

7-74 Dome of Madrasa-I-Shāh, Isfahan, Iran, 1612–1637.

7-75 Court of the Lions, the Alhambra, Granada, Spain, 1354–1391.

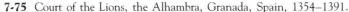

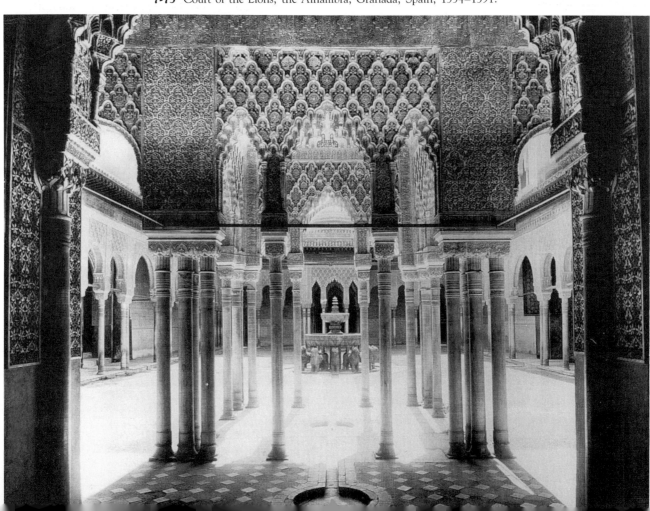

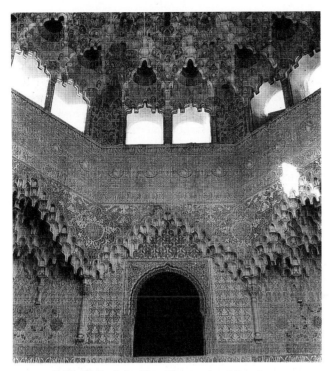

7-76 Hall of the Two Sisters, the Alhambra.

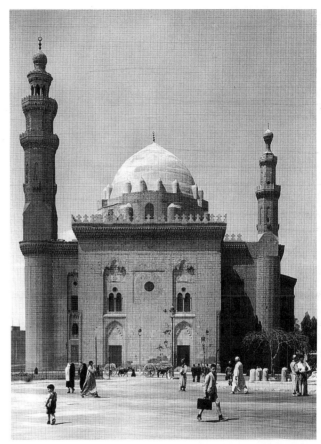

7-77 Madrasah and attached mausoleum of Sultan Hasan, Cairo, Egypt, 1356–1363 (view from the southeast).

7-78 Plan of the madrasah and mausoleum of Sultan Hasan.

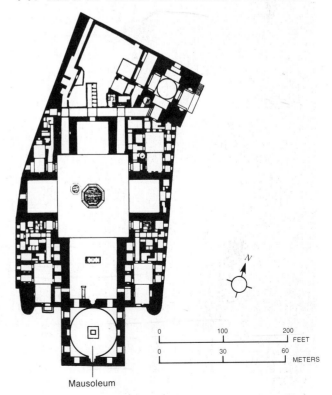

Mausoleum

The court itself (FIG. 7-75), proportioned according to the Golden Mean, is framed by rhythmically spaced single, double, and triple columns with slender, reedlike shafts that carry richly decorated block-capitals and stilted arches of complex shape. All surfaces above the columns are covered by colored stucco moldings that seem aimed at denying the solidity of the stone structure that supports them. The resulting buoyant, airy, almost floating appearance of the building is enhanced by the "stalactite" decorations that break up the structural appearance of the arches, transforming them into near-organic forms.

This same tendency to disguise architectural forms is shown even more vividly in the Hall of the Two Sisters (FIG. 7-76), which adjoins the Court of the Lions. Here, all surfaces are covered by a poly-chromed lacework of stucco and tile, in which an almost limitless variety of designs is held together by symmetry and rhythmic order. The overall effect of the incredibly rich decoration is that of tapestries suspended from walls and dome, the "stalactites" resembling pendant tassels. In this hall, the Moorish (North African and Spanish) style, heralded in the mosque at Córdoba (FIG. 7-66), has reached its ultimate refinement. Its influence on Spanish art remained strong throughout the Middle Ages and well into the Renaissance, and traces of it may be observed in the art of the Hispanic colonies of America.

A very different architectural concept is expressed in the madrasah and mausoleum of Sultan Hasan in Cairo (FIGS. 7-77 and 7-78). The *madrasah*, a combined

school and mosque, was a building type developed in Iran and brought westward by the advancing Seljuk Turks during the eleventh century. It shares with the hypostyle mosque the open central court but replaces the early Islamic forests of columns with austere masses of brick and stone. The court is now surrounded by four vaulted halls, the one on the qiblah side being larger than the other three. Crowded into the angles formed by these halls are the various apartments, offices, and schoolrooms of the Moslem educational institution. Decoration of the main building is confined to moldings around the wall openings and a frieze below the crenelated roofline, which serve to accentuate, rather than to disguise, the geometric clarity of the massive structure, presenting a striking contrast to the filigreed elegance of the contemporary Alhambra.

Attached to the qiblah side of the madrasah is the mausoleum, which is a simple cubical structure covered by a dome. Mausoleums (central-plan, domed structures) were adopted either from Iran or from the Antique vocabulary of the Mediterranean, as they had not been a part of the original inventory of Islamic architecture. They were built either as memorials to holy men or for the secular function of commemorating Islamic rulers. By the tenth century, the building type was well established in Iran, from which it spread both east and west; it became especially popular in Egypt, which, of course, had its own age-old tradition of large-scale funerary monuments.

The most famous of all Islamic mausoleums is the fabled Taj Mahal at Agra (FIG. **7-79**), which was built by one of the Moslem rulers in India, Shah Jahan, as a memorial to his wife, Mumtaz Mahal. The basic shape of the monument is that of the Cairo mausoleum, but modifications and refinements have converted the massive, cubical structure into an almost weightless vision of cream-colored marble that seems to float magically above the tree-lined reflecting pools. The interplay of shadowy voids with gleaming marble walls that seem paper-thin creates an impression of translucency, and elimination of the Cairo structure's heavy, projecting cornice (which separated the blocky base of the earlier building from its

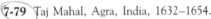

7-79 Taj Mahal, Agra, India, 1632–1654.

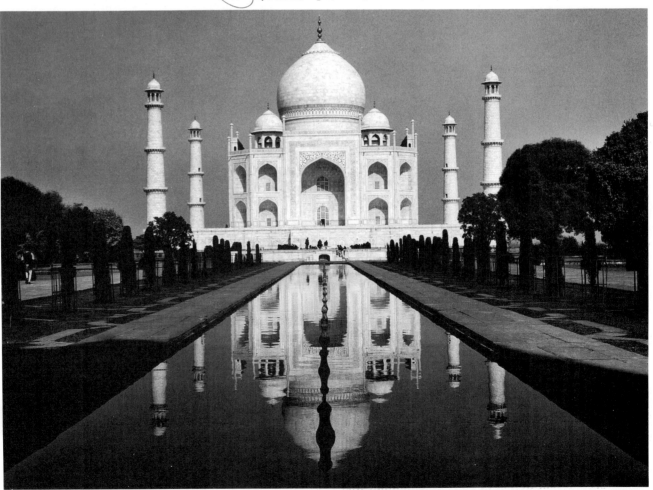

dome) ties all the elements together. The result is a sweeping, upward movement toward the climactic, balloon-shaped dome. Carefully related minarets and corner pavilions introduce, and at the same time stabilize, this soaring central theme. Although the entire monument recalls the fragile elegance of the Alhambra, it far surpasses the latter in subtle sophistication and represents one of the high-water marks of Moslem architecture.

OTTOMAN ARCHITECTURE

A related, yet different, Islamic architecture was developed by the Ottoman Turks. The Turkic people, of central Asian origin, had been converted to Islam during the ninth and tenth centuries. They moved into Iran and the Near East in the eleventh century, and, by 1055, the Seljuk Turks had built an imposing, although short-lived, empire that stretched from India to western Anatolia. It crumbled under the onslaught of the Mongols, led by Genghis Khan (about 1210–1220s). After its fall, a number of local dynasties established themselves in Anatolia, among them the Ottomans, founded by Osman I (1290–1326). Under his successors, the Ottoman state rapidly expanded over vast areas of Asia, Europe, and North Africa to become, by the middle of the fifteenth century, one of the great world powers.

Ottoman art, like Islamic art in general, expressed itself primarily in terms of architecture. But while other Moslem countries adopted the hypostyle mosque as their standard religious structure, Ottoman builders developed a new type of mosque with a square prayer hall covered by a dome as its core. In fact, the dome-covered square, which had been a dominant form in Sassanian Iran, became the nucleus of all Ottoman architecture. The combination, in addition to its appealing geometric clarity, was permeated with religious symbolism. To the Ottomans, a circle set into a square signified Heaven. (The circle, which has neither beginning nor end, symbolized eternity; the square symbolized the four corners of the universe.) At first used singly, the domed units came to be used in multiples, a turning point in Ottoman architecture, because it drew in its wake the desire to create unity of space and form out of conglomerate aggregates. The resultant Ottoman style is geometric and formalistic, rather than ornamental.

When the Ottoman Turks conquered Constantinople (which they renamed Istanbul) in 1453, their architectural code was firmly established. Although impressed by Hagia Sophia (FIG. 7-40), which, in some respects, conformed to their own ideals, Ottoman builders were not overwhelmed by it. Direct influence of Hagia Sophia was not felt until about 1500, when a second half-dome, opposite the mihrab, was used for the first time.* But the processional way of Hagia Sophia's interior never satisfied Ottoman builders, and Anatolian development moved instead toward the centralized quatrefoil mosque. The first examples of this cloverleaf plan, an ideal of Ottoman mosque design, were built in the 1520s, to be eclipsed only by the works of the most famous of Ottoman architects, SINAN THE GREAT (c. 1491–1588), called KOÇA ("the architect"). A contemporary of Michelangelo and with equal pretensions to immortality, Sinan carried Ottoman architecture to the height of its classical period. By his time, the use of the basic domed unit was universal. It could be enlarged or contracted as needed, and almost any number of units could be used together. Thus, the typical Ottoman building of Sinan's time was an assembly of parts, usually erected with an extravagant margin of structural safety. Measures and forms had been standardized, and design and engineering methods tended to be conservative, with little room given to experimentation. But despite such strictures, which might have been stifling to a lesser architect, Sinan constantly searched for solutions to the problems of unifying the additive elements and of creating a monumental, centralized space with ideal proportions.

In his early buildings, Sinan experimented with the cloverleaf plan, as well as with that of Hagia Sophia. In the mosque of Suleiman I in Istanbul, he flanked the central unit, in which the main dome is abutted by two half-domes, north and south, with dome-covered aisles. But where Hagia Sophia isolates the lateral aisles, Sinan, by reducing interior obstructions to a minimum, made every effort to combine them with the central area and to make central and flanking spaces flow into each other through wide and lofty arcades.

Sinan's efforts to overcome the limitations of a segmented interior found their ultimate expression in the Selimiye Cami (FIGS. 7-80 to 7-83) at Edirne (ancient Adrianople), where he created a structure that fully expresses "the earthly squareness of the gathering place of the faithful under the canopy of eternity" and where, at the same time, the mihrab is visible from almost any spot in the building. The Selimiye Cami reputedly was built for Selim II at Edirne (which had been the capital of the Ottoman Empire from 1367 to 1472) because the Sultan could find no adequate space for it in Istanbul. Its massive dome, effectively set off by four slender, pencil-shaped minarets (each more than 200 feet high), dominates the city's

*Ottoman builders had already adopted (from Byzantine architecture) the half-dome-covered apsidal projection for the mihrab, in addition to pendentive construction, although they preferred the Seljuk method of supporting domes with squinches or series of corbels (FIG. 7-45).

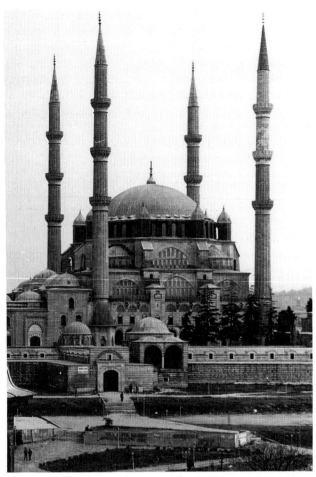

7-80 SINAN THE GREAT (KOÇA), the Selimiye Cami (Mosque of Selim II), Edirne (ancient Adrianople), Turkey, 1569–1575.

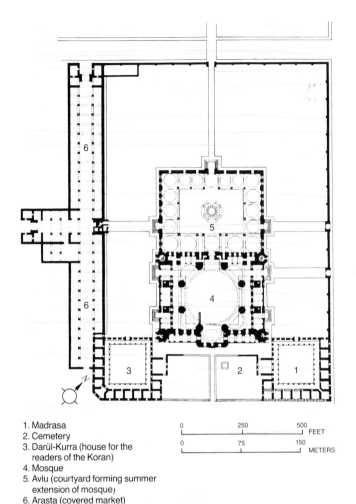

1. Madrasa
2. Cemetery
3. Darül-Kurra (house for the readers of the Koran)
4. Mosque
5. Avlu (courtyard forming summer extension of mosque)
6. Arasta (covered market)

7-81 Plan of the Selimiye Cami.

skyline. Various dependencies are placed around the mosque. (Most of the important mosques had numerous annexes, including libraries and schools, hospices, baths, soup kitchens for the poor, markets, and hospitals, as well as a cemetery containing the mausoleum of the sultan responsible for the building of the mosque. These utilitarian buildings were grouped around the mosque and axially aligned with it if possible; more generally, they were adjusted to their natural site and linked with the central building by plantings of shrubs and trees.)

The mosque is preceded by a rectangular court covering an area equal to that of the building. This *avlu* (a courtyard forming a summer extension of the mosque) is surrounded by porticoes formed by domed squares. Behind it, the building rises majestically to its climactic dome, which equals that of Hagia Sophia in width. But it is the organization of the interior space of this mosque that reveals the genius of its builder. The mihrab has been recessed into an apselike alcove deep enough to permit illumination from three sides, which makes the brilliantly colored tile

panels of its lower walls sparkle as if with their own glowing light. The plan of the main hall is an ingenious fusion of an octagon with the symbolic dome-covered square. The octagon, formed by the eight massive dome supports, is pierced by the four half-dome-covered corners of the square. The result is a fluid interpenetration of several geometric volumes that represents the culminating solution to Sinan's lifelong search for a monumental, unified, interior space. The square "singing gallery" (visible in FIGS. 7-82 and 7-83), a platform for the *muezzins* (criers) that at first may seem like a distracting piece of furniture, punctuates the central space. It restates the basic squareness of the prayer hall and provides an anchoring focus to a design that might seem diffuse without it. Placed under the center of the dome, it marks "the navel of the mosque."

Sinan's building elegantly resolves complicated laws of statics. The Islamic tendency to disguise the structural function of architectural elements (as, for instance, in the Alhambra, FIG. 7-76) is minimized and confined to a "honeycomb" treatment of the

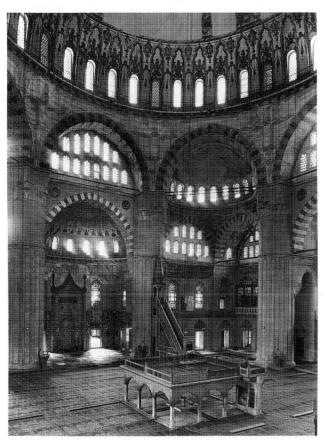

7-82 Interior of the Selimiye Cami.

7-83 Axonometric perspective of the Selimiye Cami.

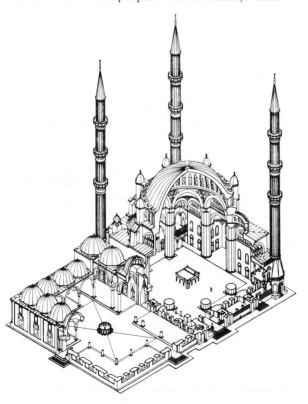

squinches and to "stalactite" capitals, a form of decoration that was popular from the twelfth century onward. Sinan's forms are clear and legible, like mathematical equations; height, width, and masses are related to each other in a simple but effective ratio of 1:2. The building is generally regarded as the climax of Ottoman architecture. Sinan himself proudly proclaimed it his masterpiece, and, indeed, it encloses one of the most impressive domed spaces ever built.

OBJECT ART AND TEXTILES

The furnishings of the palaces, as well as of the mosques, reflected a love of rich and sumptuous effects. Metal, wood, glass, and ivory were artfully worked into a great variety of objects for use in mosque or home. Basins (often huge), ewers, jewel cases, and writing boxes were made of bronze or brass, chased and inlaid with silver; enameled glass was used with striking effect in mosque lamps; richly decorated ceramics of high quality were produced in large numbers. Islamic potters, experimenting with different methods of polychrome painting, developed *luster painting*, a new and original technique that gives a metallic shine to a surface. Their designs were based on the motifs found in architectural decoration. This ready adaptability of motifs to various scales as well as to various techniques again illustrates both the flexibility of Islamic design and its relative independence from its carrier.

The most prestigious and highly valued objects of all were textiles, which, in the Islamic world, served more than purely utilitarian or decorative purposes. Produced by imperial factories, they were used not only in homes, palaces, and mosques, but also served as gifts, rewards, and signs of political favor.

The Moslem weavers adopted and developed the textile traditions of Sassanian Iran and the Mediterranean region (the latter were best known through Coptic textiles from Egypt). The art spread across the Islamic world, and by the tenth century, Moslem textiles were famous and widely exported. The art of carpet-making was developed to a particularly high degree in Iran, where the need for protection against the winter cold made carpets indispensable both in the shepherd's tent and in the prince's palace. In houses and palaces built of stone, brick, plaster, and glazed tile, carpets also provided a contrasting texture as floor and divan coverings and wall hangings.

The carpet woven for the tomb-mosque of Shah Tahmasp at Ardebil (FIG. **7-84**) is a large example of the medallion type and bears a design of effectively massed large elements surrounded and enhanced by a wealth of subordinated details. The field of rich blue is covered with leaves and flowers (chiefly peonies, a

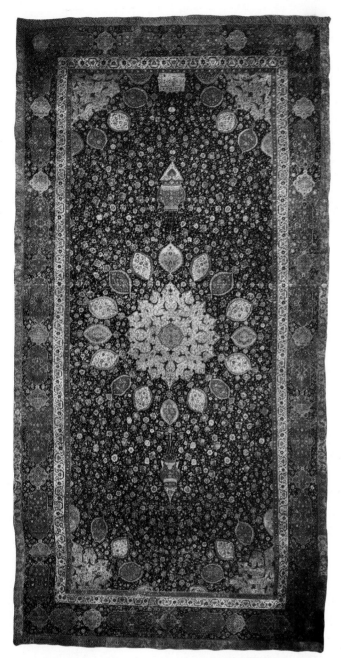

7-84 Carpet from the tomb-mosque of Shah Tahmasp at Ardebil, Iran, 1540. Approx. 34½' × 17½'. Victoria and Albert Museum, London.

Chinese influence) attached to a framework of delicate stems that weave a spiral design over the whole field. Great royal carpets like the one from Ardebil were products of the joint effort of a group of weavers, who probably were attached to the court. Pile weaving is a slow process at best, and because a carpet like the one from Ardebil often has more than three hundred knots to the square inch, a skilled weaver working alone would probably have needed more than twenty years to complete it.

Because the Ardebil carpet was made for a mosque, its decoration excludes human and animal figures, although other carpets from Ardebil show that the Koran's strictures against the representation of human and animal figures were not taken as seriously in secular art. The ban against the worship of idols, however, had practically eliminated the image of humans from Islamic religious art, and, even in early secular art, it appeared only occasionally in secluded parts of palaces as royal imagery. For this reason also, large sculpture in the round and mural or panel painting, as developed in Europe and in the Far East, was rather rare in Early Islamic art. Contributing to this lack of interest in monumental plastic art may have been the predilections of the people that made up the Moslem world; many of them—Arabs, Turks, Persians, Mongols—were nomads, who traditionally preferred small, movable objects (the so-called nomad's gear) to large-scale works of art. And so, perhaps, it should not be surprising that, when painting did develop in later times, it was mainly on the small scale of book illumination.

THE ART OF THE BOOK

The Arabs had no pictorial tradition of their own, and it seems possible that their interest in book illumination developed almost accidentally, as a by-product of their practice of translating and copying illustrated Greek scientific texts. In some of the earliest Islamic illuminated manuscripts (only a few dating earlier than about 1200), the illustrations seem to have been drawn by the scribes who copied the texts. Whatever its origins (often Christian and Mediterranean, but also local Iranian and Buddhist), an art of book illustration had developed, mostly in Iraq and Iran, by 1200.

The Persian rulers were lovers of fine books and maintained at their courts not only skilled calligraphers but also some of the most famous artists of their day. The secular books of the Timurids and the Safavids were illustrated by a whole galaxy of painters. Famous among them were BIHZAD (c. 1440–1536), AQA MIRAK, and SULTAN MUHAMMAD, court painters of Tahmasp (1524–1576), a great art patron. Although the rulers were Moslems, Orthodox Islamic restrictions regarding depiction of the human figure were interpreted rather liberally by them and did not affect their secular arts. Within the framework of illustrating specific stories, the gay scenes of their life of pleasure—the hunt, the feast, music, and romance—and battle scenes filled the pages of their books. In them, we feel the luxury, the splendor, and the fleeting happiness of Omar.

In *Laila and Majnun* (FIG. **7-85**), the painter Aqa Mirak has illustrated one of Nizami's romantic poems. The scene represents a school, apparently in a mosque, and deals less with the pleasures than with some of the more earnest aspects of life. Seated on a rug is a turbaned *mullah*, or teacher, rod in hand, listening to a youth reading; around him are other youths studying, all seated on their knees and heels or with one knee raised, the customary sitting postures of the East. Here and there are cross-legged bookrests. In the foreground, one boy is pulling his companion's ear, and at the left, near the large water jar, two boys are playing ball. In the middle distance are the lovers Laila and Majnun, each obviously aware of the other's presence. Although the figures are drawn expressively with delicate, flowing lines, they are flat, with no shading and with only a hint of perspective; the tiles in the court and the rugs on the floor appear to be hanging vertically. The painting is conceived from a point of view concerned not with natural appearance but with pattern and vivid color. To this end, the tones are kept bright and clear. The decorative quality of the miniature is emphasized by the broad margins of the page, which are tinted and flecked with gold.

In its general appearance, the miniature is much more closely related to the Ardebil carpet than to any European painting or, for that matter, to Chinese painting, by which it certainly was influenced. It falls within the general framework of the Islamic decorative style, which, despite early religious restrictions and the constraints that derive from a limited formal vocabulary, became one of the richest and most harmonious decorative styles in the world.

7-85 *Laila and Majnun at School,* miniature from a manuscript of the Khamsa of Nizami, 1524–1525. Ink, colors, and gold on paper. The Metropolitan Museum of Art, New York (gift of Alexander Smith Cochran, 1913).

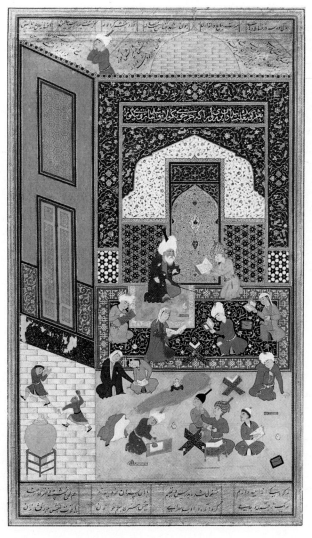

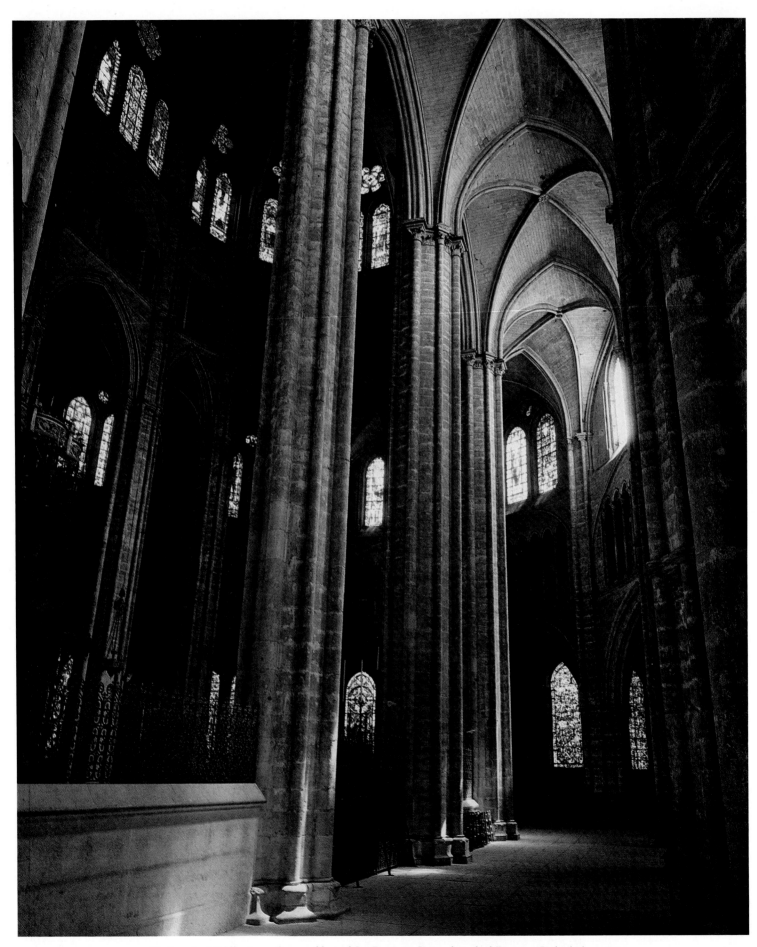

During the Middle Ages, Suger, abbot of St. Denis in Paris, described Bourges Cathedral, saying,
"The enchanting beauty of the House of God overwhelmed me."

II
THE MIDDLE AGES

The poets of the Augustan Age were singing the glories of "eternal Rome" while Jesus of Nazareth, obscure founder of the religion that was to transform the city of man into the city of God, was born and died. Within three centuries, Christianity had become the official cult of the dying empire and the faith of the new peoples, the barbarians, who were to inherit its remains. While Byzantium, eastern remnant of the Christianized Roman Empire, maintained a continuous sovereignty, the empire in the west disintegrated. What had been the imperial provinces broke up into contesting barbarian kingdoms—those of the Franks, Burgundians, Visigoths, Anglo-Saxons, Lombards, and others. Historians have called the ensuing epoch (the thousand years from about 400 to 1400) the "Middle Ages" or the "Dark Ages." For centuries, this interval between the passing of the Roman Empire and the rebirth of its civilization in the Renaissance was thought to be rough and uncivilized (in a word, barbarous). Between the ancient and the modern world, life was viewed as empty, cruel, and "dark," simply a blank between (in the "middle" of) two great civilizations. Even today, the word *medieval* is often used disparagingly.

But since the late eighteenth century, historians have been revising this view and, with it, the long-held belief that Medieval art was crude and primitive. The same romantic enthusiasm for past civilizations that motivated the archeological revolution of Heinrich Schliemann's time, and the consequent recovery of the ancient past, sent scholars in quest of the meaning of medieval culture—the meaning of monuments that existed in great number and that, in this case, were aboveground and visible. Although we now see these centuries with very different eyes, perceiving their innovation and their greatness, the terms *Middle Ages* and *medieval* continue to be used, simply for convenience.

Medieval civilization is characterized by an interrelationship of Christianity and the Greco-Roman tradition with the new, energetic spirit of the

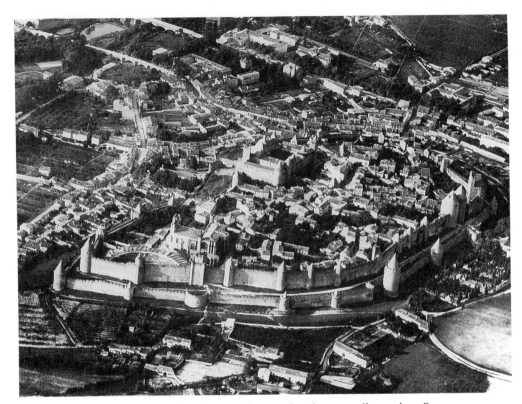

Carcassonne, in southern France, whose medieval inner walls stand on Roman foundations, illustrates the revival of an urban culture during the later Middle Ages after Latin urbanism had been temporarily eclipsed by the pastoral culture of the migrating Germanic tribes.

Celtic-Germanic peoples—the "barbarians," as the Greeks and the Romans had called them. Christianity, firmly established, constituted a unifying force, even in the midst of anarchy and chronic warfare. It mitigated the harsh passions of rough warriors. It kept alive learning and knowledge of the useful arts. Though itself often corrupted, it just as often was reformed. By the thirteenth century, when the Church was at the height of its power, western Europe had evolved into a great and original civilization, constantly stimulated by influences from the Greco-Roman past and from Byzantium and the world of Islam, but ever reworking those influences in novel ways. The Christian church, with its monopoly on education, also preserved and handed on aspects of the Roman culture not directly related to religion: the Latin language, Roman law, Roman administrative organization and practice, the idea and ideal of the Roman Empire—all elements used by the Church but, as the Renaissance would show, susceptible to entirely secular application.

Although the spirit of Christianity was oriented toward the world of the supernatural and although its learning was centered in theology, which regarded questions about the nature of the physical world as both irrelevant to salvation and irreverent in intention, by the thirteenth century, a new curiosity about the natural environment was stirring—even within the Church—that could not be stifled entirely by the prevailing religious disposition. In a thirteenth-century summation of medieval knowledge, the influential encyclopedia called the *Speculum Majus (Great Mirror)*, Vincent of Beauvais, a Dominican monk, included the "Mirror of Nature," a comprehensive compilation of lore about natural things. By no means an objective or scientific analysis of nature in the modern sense, this compilation

was rather a descriptive record of the appearances of things as the reflection of God's glory and beneficence. Within the medieval setting, notwithstanding its thoroughly religious view of nature, a different impulse was being felt—a secular and intellectual curiosity about the world that was to mature into modern science.

In addition, the period produced technological advances that pointed to consequences far beyond anything the ancient world had known. The invention and development of tools and mechanisms that extended humanity's powers over the environment and that facilitated manufacture were encouraged in part by the new dignity that the Church's disapproval of slavery conferred on manual labor and skills. Free craftsmen—not slaves, as in the ancient world—were the medieval agents of production; organized in guilds, they constituted the firm foundation of the medieval urban economy. Thriving towns, populated by free inhabitants, provided a stimulus for commerce and industry, and new towns were founded and flourished. Most of the prosperous European cities of today were established or underwent renovation around the twelfth century. Indeed, Florence, mother city of the modern world, had laid the foundations of its wealth early and, by the fifteenth century, had the spirit and the means to lead Europe into the bold, creative age of discovery we call the Renaissance.

NOTE: Maps at the beginning of the following (and preceding) chapters illustrate the simple fact that the boundaries of ancient civilizations do not correspond to modern political boundaries; the region where "Mesopotamian" art flourished now encompasses parts of the modern nations of Iran, Iraq, Syria, and Jordan. The same statement can be made in connection with the medieval monuments of Europe and those of the non-European civilizations that we will examine in later chapters. The medieval *artistic* regions do not correspond to the modern *political* boundaries of nations like France, Germany, or Italy. Obviously, this is because such political boundaries did not exist at the time the art was produced. Moreover, the fact that the monuments are situated or preserved within the present boundaries of the European nations does not mean that their stylistic origins or relatives were necessarily "French," "German," or "Italian." The old regional divisions that *did* exist during the Middle Ages, the boundaries within which Medieval art was produced—Northumbria, Normandy, Burgundy, Languedoc, Saxony, Tuscany—have long been absorbed within the boundaries of the nation-states we know. Thus, for example, to speak of "French," "German," or "Italian" Gothic is to refer only to the modern states where Gothic monuments are presently found and not to designate them as a uniquely national species of Gothic art produced by French, German, or Italian nationals. Actually, the boundaries of the modern states of Europe were not well in place until the seventeenth century. Germany and Italy, though long recognized as ethnic, cultural, and linguistic entities, did not become unified politically until as late as 1871. At present, the works of many of the art-producing cultures of the world, past and present, are identified by the same means—ethnic, cultural, and linguistic designations, and not political ones. Thus "Yoruba" denotes works created within the area of present-day Nigeria; "Kwakiutl," British Columbia; "Maya," Mexico, Guatemala, Belize, and Honduras; "Moche," Peru; and so forth.

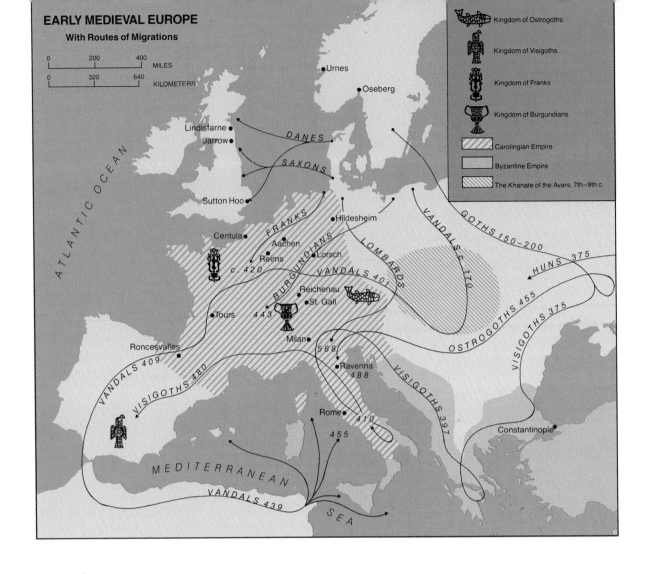

EARLY MEDIEVAL EUROPE
With Routes of Migrations

```
0        200      400
|---------|--------|    MILES
0        320      640
|---------|--------|    KILOMETERS
```

Kingdom of Ostrogoths
Kingdom of Visigoths
Kingdom of Franks
Kingdom of Burgundians
Carolingian Empire
Byzantine Empire
The Khanate of the Avars, 7th–9th c.

Urnes
Oseberg
ATLANTIC OCEAN
DANES
Lindisfarne
Jarrow
SAXONS
Sutton Hoo
FRANKS
Hildesheim
Centula
Aachen
Reims
Lorsch
c. 420
BURGUNDIANS
LOMBARDS
VANDALS 401
VANDALS c. 170
GOTHS 150–200
HUNS 375
Reichenau
St. Gall
Tours
443
Milan
568
Ravenna
488
Roncesvalles
OSTROGOTHS 455
VISIGOTHS 375
VANDALS 409
VISIGOTHS 480
VISIGOTHS 397
Rome
410
455
Constantinople
MEDITERRANEAN
VANDALS 439
SEA

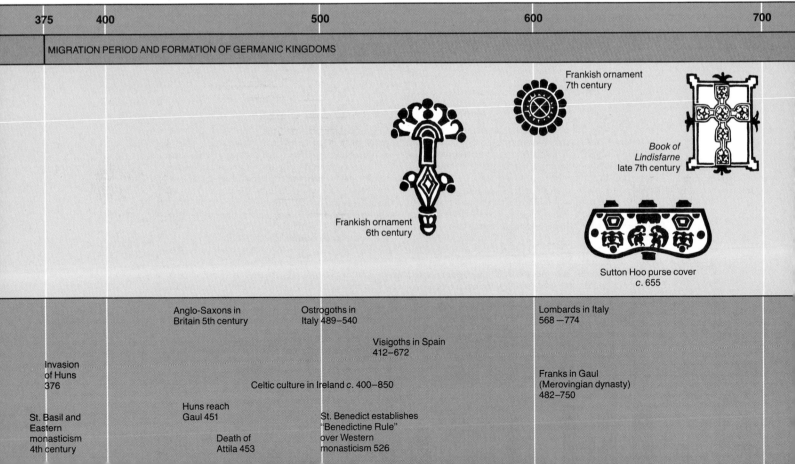

```
375        400                500                600                700
```

MIGRATION PERIOD AND FORMATION OF GERMANIC KINGDOMS

Frankish ornament
7th century

Book of
Lindisfarne
late 7th century

Frankish ornament
6th century

Sutton Hoo purse cover
c. 655

Anglo-Saxons in
Britain 5th century

Ostrogoths in
Italy 489–540

Lombards in Italy
568 –774

Visigoths in Spain
412–672

Invasion
of Huns
376

Celtic culture in Ireland c. 400–850

Franks in Gaul
(Merovingian dynasty)
482–750

Huns reach
Gaul 451

St. Benedict establishes
"Benedictine Rule"
over Western
monasticism 526

St. Basil and
Eastern
monasticism
4th century

Death of
Attila 453

8
EARLY MEDIEVAL ART

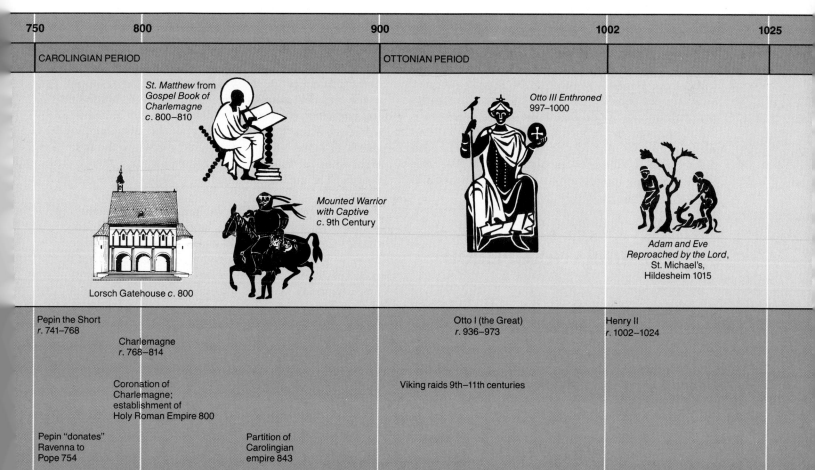

750	800	900	1002	1025
CAROLINGIAN PERIOD		OTTONIAN PERIOD		

St. Matthew from *Gospel Book of Charlemagne* c. 800–810

Otto III Enthroned 997–1000

Mounted Warrior with Captive c. 9th Century

Adam and Eve Reproached by the Lord, St. Michael's, Hildesheim 1015

Lorsch Gatehouse c. 800

Pepin the Short
r. 741–768

Charlemagne
r. 768–814

Otto I (the Great)
r. 936–973

Henry II
r. 1002–1024

Coronation of Charlemagne; establishment of Holy Roman Empire 800

Viking raids 9th–11th centuries

Pepin "donates" Ravenna to Pope 754

Partition of Carolingian empire 843

For thousands of years, waves of migrating people moved slowly across the great Eurasian steppes and down into the Mediterranean world; we have met them as the Achaeans and Dorians of Mycenaean times, and again as the Gauls, who invaded Asia Minor and were defeated by Attalus I of Pergamon in the third century B.C.

In the second century A.D., the Goths migrated southward from the Baltic region and settled on the north shore of the Black Sea, subjugating the Scythians and Sarmatians, who had inhabited the area for some eight centuries. On their march, the Goths had met and defeated the Vandals, pushing them toward central Europe and setting in motion one of the longest and most infamous migratory treks in history—one that was to end only in the fifth century with the establishment of a Vandal kingdom in North Africa. The Goths themselves split into two groups in the early fourth century: the Ostrogoths (eastern Goths), who remained in Sarmatia, and the Visigoths (western Goths), who moved on into the Danube River basin.

For centuries, these migratory movements had been checked by Roman military might along the Rhine and Danube rivers. Despite constant friction with them since the first century B.C., the Romans had been able to contain the barbarians along their northern frontiers. In the fourth century, however, the eruption of the Huns from the east pressed those tribes and nations against the Roman boundaries, which Rome found more and more difficult to defend. In 376, the Roman emperor Valens allowed the Visigoths, hard-pressed by the Huns, who had already conquered their Ostrogothic cousins, to settle west of the Danube. Maltreated by Roman officials, the Visigoths revolted two years later and, in a battle near Adrianople, killed the emperor and nearly two-thirds of his army. After this, Rome offered little resistance to the different barbarian nations, who crossed into western Europe almost at will. We refer to the following four centuries of ethnic upheavals in Europe as the Migration period.

THE MIGRATION PERIOD

As the name of the period implies, the invasions of Roman territory by barbarian tribes were, in reality, migrations of ethnic groups seeking not to overthrow the Roman Empire, for which they often had great admiration, but to find a place where they could settle peacefully. They seldom were allowed to remain in any one location, however, as other tribes and nations would press in behind them and force them to move on. The Visigoths, for example, who moved in and out of Italy and formed a kingdom in southern France, were forced southward into Spain under pressure from the Franks, who had crossed the lower Rhine and established themselves firmly in northern France. The Huns themselves, the force that triggered this chain reaction of ethnic dislocations, reached France and Italy in the mid-fifth century, and only the death of their great leader, Attila, in 453 prevented them from consolidating their vast conquests. As Hunnish power waned, the Ostrogoths shook off their yoke and moved first to Pannonia (at the junction of modern Hungary, Austria, and Yugoslavia) and then to Italy, where, under Theodoric, they established their kingdom, only to have it fall less than a century later to the Lombards.

During this time of upheaval, strife, fear, and uncertainty, the Church, benefiting from the prestige of such early leaders as Augustine and Gregory the Great, constituted the only central political and spiritual authority; the popes had, in effect, succeeded the Roman emperors. It was at this time that the foundations for the later authority of the Church were established firmly. In this connection, we should bear in mind that most of the barbarian tribes entering the Roman Empire were already Christian, although of the Arian creed, which had been condemned as heretical by the Orthodox church. In its contest with the Eastern Orthodox church for leadership in Christendom, papal Rome was strengthened when the Frankish king, Clovis, was converted to Catholicism. During his reign (481–511), the Franks gained control over the Burgundians (who had moved from the Baltic area into the region around Lake Geneva in the early fifth century), the Visigoths, and other groups in the area that is now France. With the recognition of the pope in Rome by this Frankish kingdom and with the success (in the sixth century) of the later Augustine's mission to England, where he became the first archbishop of Canterbury, Catholicism and the authority of Rome became firmly established in western Europe.

Accounts of the barbarian character vary. Tacitus, pointing up a moral for his Roman contemporaries, praises their courage, good looks, moral purity, fidelity, and good treatment of women, but finds them guilty of drunkenness and a lack of astuteness in matters of money. We get a better picture of the Germanic character from their epics, songs, and sagas, which show a somber pessimism built on a fundamental belief in fate or the inevitable. Their heroes, like Siegfried and Beowulf, struggle against a pagan world of dreadful monsters. Fierce joy in battle alternates with bragging and carousing; narratives of stoic

valor alternate with expressions of despair. Interpersonal loyalty, which became the basis of feudal ties and feudal law, is glorified in their poetry, as in this fragment of an Anglo-Saxon epic describing the last stand of a band of Saxons against the Danes:

> Remember the times when we spoke over our mead, when we raised up our boasts along the benches, heroes in the hall in anticipation of a hard fight! Now let us see who is brave. . . . Byrhtivold spoke up, an old retainer . . . he taught his warriors their duty: "Mind shall be the harder, heart the keener, courage the greater as our strength grows less."

The imagination of these wandering groups teemed with fantastic creatures of all sorts. Their belief that the deep, dark forests of the north virtually swarmed with zoomorphic and demonic populations was shared widely by the nomadic hunters of all tribes. Dragons, like Siegfried's Fafnir and Beowulf's Grendel, symbolize the mysterious and threatening universe of fierce forces that the later medieval world will picture as the devils and demons of Hell. Medieval peoples, long after they ceased their wanderings and despite Christianization, remained more than half pagan; their terrors were bound up with their tribal experiences and the memories of fiend-filled forests and pagan rites. Against this background, it is not surprising to find that the Germanic tribes readily adopted an art form that, although foreign, was ideally suited to their imagination—the Eastern animal style already encountered in Mesopotamian art.

The Animal Style: Scythian Antecedents

Animal style is a generic term for the characteristic ornamentation of artifacts worn and carried by nomadic peoples, who for almost two millennia (B.C. and A.D.), moved restlessly to and fro across the vast, open grasslands that stretch from China into western Europe. Originating in prehistoric times, the decorative animal form appears in ancient Egypt and Mesopotamia; we have seen a late example in the Luristan bronzes (FIG. 2-44). Transactions between the nomads and the settled civilizations of the Near East and the Mediterranean disseminated the style and produced numerous variants of its figures and patterns. The wide and steady propagation of the animal style was made possible by the fact that it was found on small, metal objects that were portable and easily exchanged. The great revolution in metallurgy that replaced the Bronze Age with the Iron Age after 1000 B.C. put the means of fashioning metallic artifacts in abundance into the hands of numerous skilled artisans, nomadic or sedentary, and guaranteed the

broadest distribution of these items through gift, exchange, plunder, or migration.

Perhaps the principal agents of the transmission of the animal style from east to west were the Scythians, an Iranian-speaking nomadic people who roamed the steppes north of the Black Sea. They were known to the ancient Assyrians, Iranians, and Greeks (Herodotus gives us a detailed account of them), with whom they were alternately in friendly and hostile contact. Though the period of Scythian predominance precedes the early medieval times we are describing, they (and their Sarmatian successors) are significant for passing on to the Germanic tribes, and to Medieval art in general, the repertory of animal ornament familiar in the art of the ancient world.

The remains of the settlements of the Scythian-Sarmatians, and especially the tombs of their kings, are scattered throughout southern Russia and the Crimea, the Caucasus, and Anatolia. From them modern archeology has recovered rich troves of metal treasure, the funeral ornaments and furnishings of elaborate royal burials. Whether of their own manufacture, or the work of Greek craftsmen, Scythian gold ornaments attest to what an ancient Roman author calls the "Scythian lust for gold." At the same time, these objects exhibit to perfection the motifs of the animal style that will be transmitted to the early medieval West.

A superb, crescent-shaped golden pectoral from about the fourth century B.C., a product of Greek craftsmanship, sums up the animal vocabulary favored by Scythian ornamental taste (FIG. 8-1). Some

8-1 Pectoral with scenes from Scythian life (Greek craft done for the Scythians), *c.* fourth century B.C. Gold, diameter 12", weight 2½ lbs. Historical Museum, Kiev.

forty-eight figures, mostly of animals cast singly and soldered to the frame, are distributed friezelike on three concentric bands separated by cable moldings. The innermost band represents Scythians in an encampment accompanied by their domestic animals. Men make a shirt out of an animal skin, close an amphora, and milk sheep. Calves and foals are suckling, and a horse casually scratches itself with a hind hoof. Birds, a kid, and a goat also are depicted. The central band is Classical Greek in its ornament of rhythmical vine scrolls, acanthus, and rosettes. The figures on the outer band contrast sharply with the pastoral mood of the other two; heraldically symmetrical griffins attack horses, lions and panthers tear at a deer and a boar, hounds pursue hares, and even grasshoppers challenge each other. The animals, actual and fantastic, are rendered with crisp realism. They later will be transformed into abstract zoomorphic motifs as they are adapted to the ornamental vocabularies of the migrant German peoples, the Goths and their successors.

Art of the Germanic Peoples

The original art of the Germanic peoples was abstract, decorative, and geometric and ignored the world of organic nature. It was confined to the decoration of small, portable objects—weapons or items of personal adornment such as bracelets, pendants, and belt buckles. Most characteristic, perhaps, and produced in quantity by almost all tribes, was the *fibula*, a decorative pin usually used to fasten garments. Fibulae (FIG. **8-2**) are made of bronze, silver, or gold and are decorated profusely, often with inlaid precious or semiprecious stones. The entire surface of these objects is covered with decorative patterns, reflecting the *horror vacui* so common in the art of primitive cultures. But we also note that the decorative patterns are adjusted carefully to the basic shape of the object they adorn and that they describe and amplify its form and structure, becoming an organic part of the object itself.

This highly disciplined, abstract, and functional type of decorative design was wedded to the animal style during the early centuries of the Medieval era. The Scythians passed the animal style on to their Gothic overlords in the third century A.D. From that time on, the Goths became the main transmitters of this style, which was readily adopted by many of the other Germanic tribes. But its application was controlled severely by the native Germanic sense of order and design. Abstracted to the point of absolute integration with dominantly geometric patterns, the zoomorphic elements frequently became almost unrecognizable, and one often must examine a fibula

a.

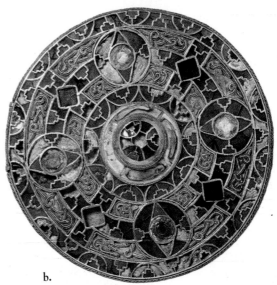

b.

8-2 Frankish ornaments, sixth and seventh centuries:
(a) looped fibula (4″ long), silver gilt worked in filigree, with inlays of garnets and other stones, Musée des Antiquités Nationales, Saint Germain-en-Laye; (b) round fibula (diameter 3¼″), gold, cloisonné technique, inlay of garnets and blue stones.
City of Liverpool Museums.

carefully to discover that it contains a zoomorphic form (in the case of FIG. 8-2a, a fish).

The art of the Germanic peoples was expressed primarily in metalcraft. One of their preferred methods of decoration was *cloisonné*, a technique that may be of Byzantine and, ultimately, of Near Eastern origin.

In this technique, used in the circular ornament shown in FIG. 8-2b, small metal strips (the *cloisons*), usually of gold, are soldered edge-up to a metal background. An enamel paste (subsequently to be fired) or semiprecious stones, such as garnets, or pieces of colored glass, are placed in the compartments thus formed. The edges of the cloisons remain visible on the surface and are an important part of the design. This cloisonné personal gear was prized highly and handed down from generation to generation. Dispersion of some of the princely hoards at an early date would account for the discoveries of identical techniques and designs in widely divergent areas. Certainly, cloisonné ware must have been given to vassals as gifts and tokens of gratitude; everywhere in barbarian poetry, the name for the prince and lord is "treasure-giver." Other collections or "treasures" must have been accumulated over time, which could explain the different forms present in the magnificent discovery made at Sutton Hoo in Suffolk, England.

Excavated in 1939, the Sutton Hoo site now is associated with the ship burial of the East Anglian king Anna, who died in 654. The purse lid shown in FIG. 8-3, which is by no means the best of the pieces found (fine as it is), is decorated with four symmetrically arranged groups of figures. The end groups consist of a man standing between two beasts; he faces front, they appear in profile. This heraldic type of grouping goes back to ancient Mesopotamia (FIG. 2-19), though

of course with variation. The two center groups represent eagles attacking ducks, again a familiar predatory motif seen in both Mesopotamian and Egyptian art. The animal figures are adjusted to each other with the cunning we associate with the whole animal style through centuries; for example, the convex beaks of the eagles fit against the concave beaks of the ducks. The two figures fit together so snugly that they seem at first to be a single, dense, abstract design; this is true also of the man-animals motif. Above these figures are three geometric designs. The outer ones are clear and linear in style. In the central design, an interlace pattern, the interlacements turn into writhing animal figures. Interlacement was known outside the barbarian world but was seldom used in combination with animal figures. The barbarian fondness for the interlace pattern may have come from the quite familiar experience of interlacing leather thongs. In any event, the interlace, with its possibilities for great complexity, had natural attraction for the adroit jeweler.

Metalcraft and its vocabulary of interlace patterns and other motifs, beautifully integrated with the animal form, is, without doubt, *the* art of the Early Middle Ages in the West. Interest in it was so great that the colorful effects of jewelry designs were imitated in the painted decorations of manuscripts, in stone sculpture, in the masonry of the early churches, and in sculpture in wood.

8-3 Purse cover from the Sutton Hoo ship burial, from Suffolk, England, *c.* 655. Gold and enamel, $7\frac{1}{2}''$ long. British Museum, London.

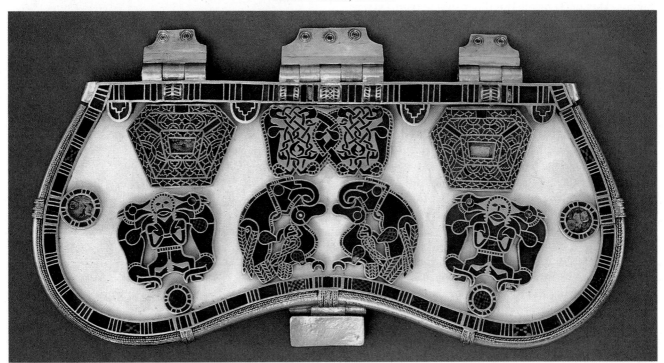

Viking Art

Wood is an especially important medium in Viking art. The Vikings (the word means "pirate" in the Norse language) were the pagan, seafaring plunderers from the Scandinavian north, who, from the ninth to the eleventh centuries, destructively raided the Celtic and Germanic settlements of Christian Europe. Once Christianized, the Vikings settled down to become the Normans (Northmen), giving their name to that part of France we call Normandy. Striking examples of Viking wood carving have been found in a royal ship buried near Oseberg, Norway. The Oseberg ship has yielded rich evidence of the quality of Early Viking art, which now has become established, along with Hiberno-Saxon art (with which it interacts), as an original and important artistic development of the Early Middle Ages. The ship has been reconstructed (FIG. 8-4), but we can judge, from such surviving parts as the ornament of the prow, the skill of craftsmen familiar with a tradition of interlace design that was widely dispersed along the routes of the great migrations. The carved bands that follow the gracefully curving lines of the prow are embroidered with tightly interwoven animals, which writhe gripping and snapping, in serpentine and lacertine (lizardlike) interlacement. The convulsive movement is strictly controlled within the continuous margins of the composition.

An animal head that caps a post (FIG. 8-5) expresses, like other animal forms in the ship, the fierce, untamed spirit and energy of the pagan sea rovers. This head brings together in one composition the image of a roaring beast—eyes protruding, nostrils flaring in predatory excitement—and the deftly carved, controlled, and contained interlace pattern. As in the carvings of the ship's prow, firm artistic limit is put to wild vigor. The Oseberg animal head is a powerfully expressive example of the union of two fundamental motifs of barbarian art: the animal form and the interlace pattern.

The interpatterning of these motifs culminated in the eleventh century with such elegant designs as that on the porch of the "stave" church at Urnes in Norway (FIG. 8-6). The church itself is constructed in wood (staves are wedge-shaped timbers placed vertically), which gives the wood-carver a special opportunity to show his craft in the embellishment of the architectural features of the building (in this case, the panels of the porch walls). Here, gracefully attenuated animal forms intertwine with flexible stalks and tendrils in spiraling rhythm; the effect of natural growth is astonishing. At the same time, the elaboration of the forms is so intricate and refined that the animal-interlace art of design seems to have reached

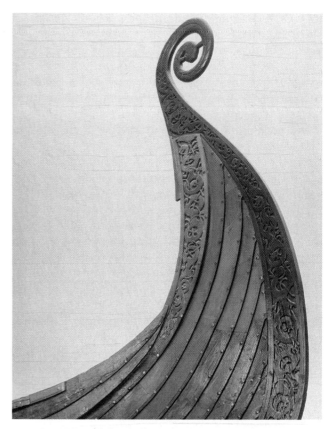

8-4 Prow of the Oseberg ship, early ninth century. Vikingskipshuset Museum, Oslo.

8-5 Animal-head post from the Oseberg ship burial, *c.* 825. Wood, approx. 5" high. Vikingskipshuset Museum, Oslo.

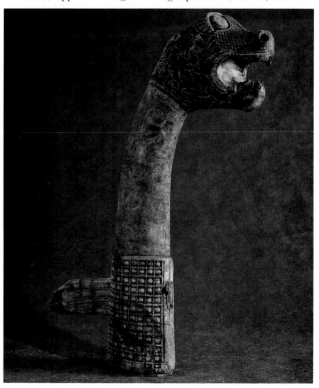

8-6 Wood-carved ornament (porch of stave church), Urnes, Norway, eleventh century.

its limit of inventiveness. The Urnes style is the culmination of three centuries of Viking art (from the eighth to the eleventh centuries), after which it merges with the Romanesque style. During the whole period that it flourished, the art of the Vikings interacted closely with Hiberno-Saxon art and the art of the continent.

Hiberno-Saxon Art

Two centuries of Viking incursions into Celtic Ireland and Anglo-Saxon England mingled artistic forms and motifs that, as we have seen, had long been elaborating into a recognizable regional style. The Christian culture of Celtic Ireland played a leading role in the civilizing of barbarian Europe. The Celts of Ireland, converted to Christianity in the fifth century, developed a form of monastic organization that preserved and cultivated literature, learning, philosophy, and the decorative and useful arts. Monasticism, a system by which communities of persons lived away from the world and dedicated themselves to the spiritual life, was instituted in the Eastern Christian world by St. Basil in the fourth century and in the West by St. Benedict in the sixth century. The

Irish adopted Eastern rather than Western forms of monasticism and were not firmly connected to the Roman church or the rule of the papacy. Their independence was strengthened by their historical good luck: they were not invaded by the Germanic migrants. From about 400 to 850, while western Europe sank gradually into conflict, confusion, and ignorance, Ireland experienced a golden age. Irish monks, filled with missionary zeal, founded monastic establishments in the British islands at Iona, off the west coast of Scotland, and at Lindisfarne, on the Northumbrian (northeastern) coast of Anglo-Saxon England. From these foundations, which became great centers of learning for both Scotland and England, Irish monks, moved by a "wonderful spirit of missionary enterprise," journeyed through Europe, establishing great monasteries in Italy, Switzerland, Germany, and France, and making the names of *Scot* (the old term for *Irish*) and *Ireland* familiar in all western Christendom as synonymous with education and learning. Until the eighth century, the influence of the Irish church rivaled that of Rome.

A style of decorative art we designate "Hiberno-Saxon," (or sometimes "Insular") to denote the Irish-English islands where it was produced, flourished

under the auspices of the Irish church and within its institutions. Hiberno-Saxon art brings to synthesizing focus those design elements of nomadic and Migration craft art that we have been describing. Traceable through centuries, from the Celtic Iron-Age art of western Europe, and across the Eurasian continent, they appear all together and in definitive patterns on the surfaces of the so-called *Tara Brooch,* an article of Irish costume jewelry from the eighth century (FIG. 8-7). The art of the Migration period is summed up, as it were, in this single, exquisite piece. In an age lacking artistic expression on a monumental scale, the human instinct for design concentrates powerfully, as here, in the small utensils of life: the clasps and fasteners of clothing, for example. The functional ring and pin of the brooch are embellished with panels of delicate filigree and are punctuated with studs of amber and amethyst-glass. The panels, chip-carved, engraved, and tooled, with inlays of copper, silver, and gold, enclose fields of ornamental motifs worked with threadlike refinement of detail. All the motifs of the decorative vocabulary of Migration art appear here: interlaced birds, animals and humanoids, strap

8-7 *Tara Brooch,* Ireland, *c.* 700. Bronze with overlay of gold filigree, glass and amber settings. Front *(top),* back *(bottom).* National Museum of Ireland, Dublin.

work, scrolled bands and ribbons, whorls, knots, and bosses. The patterns balance, repeat, and reflect one another in cunningly intricate play. Despite the astonishing profusion, intricacy, and density of the ornamental elements, the overall geometry of ring and pin is in strict control of their rich exuberance.

It would take pages of description and close work with a magnifying glass to do justice to the refinements of design and craftsmanship evident in the *Tara Brooch.* Though both elements are descended from long tradition and are not the consequence of unique invention, in the hands of an anonymous artisan of genius, they combine to make a world masterpiece of the jeweler's art.

MANUSCRIPT ILLUMINATION

Remarkable as such works of secular art as the *Tara Brooch* may be, they are complemented by the illuminated manuscripts sponsored by the Church. With the Christianization of the barbarian peoples, liturgical books became an important vehicle of miniature art and a principal medium for the exchange of stylistic ideas between the northern and the Mediterranean worlds. The exchange is the result not only of restless migrations and incursions of peoples, but also of the missionary activities of the Church, Celtic or Roman, as it sought to stabilize the wandering groups and establish its authority. The encounter between Irish and Roman Christianity during the missionary enterprise is reflected in the commingling of ornamental elements on the illuminated pages of gospel books produced in Ireland and Anglo-Saxon England between the seventh and the ninth centuries. These books were easy to transport, and we can follow the movements of some of them from place to place in sequences of influence.

The Hiberno-Saxon manuscripts combine Irish and Anglo-Saxon motifs, sharing essentially, but by no means in all details, the same style. An ornamental page (FIG. 8-8), only one of several from the *Book of Lindisfarne,* is an exquisite example of Hiberno-Saxon art at its best. Here, the craft of intricate ornamental patterning, developed through centuries and seen in Viking art, is manifested in a tightly compacted design. Serpentine interlacements of fantastic animals devour each other, curling over and returning on their writhing, elastic shapes. The rhythm of expanding and contracting forms produces a most vivid effect of motion and change—a palpable rippling, as on the surface of a rapid. The inscribed cross, a variation on the stone Celtic crosses familiar in Ireland, regularizes the rhythms of the serpentines and, perhaps by contrast with its heavy immobility, seems to heighten the effect of motion. The motifs are placed in detailed symmetries, with inversions, reversals,

8-8 Ornamental page from the *Book of Lindisfarne,* from Northumberland, England, late seventh century. Illumination, approx. 13″ × 10″. British Library, London.

and repetitions that must be studied closely to appreciate not so much their variety as their mazelike complexity. The zoomorphic forms are intermingled with clusters and knots of line, and the whole design pulses and vibrates like an electromagnetic energy field. The color is rich yet cool; the entire spectrum is embraced, but in hues of low intensity. Shape and color are so adroitly adjusted that a smooth and perfectly even surface is achieved, a balance between an overall, steady harmony of key (color) and maximum motion of figure and line. The discipline of touch is that of a master familiar with long-established conventions; yet neither the discipline nor the convention stiffens the supple lines that tirelessly and endlessly thread and convolute their way through the design.

This joy at working on small, infinitely complex and painstaking projects—this goldsmith's, jeweler's, and weaver's craft—will endure in northern art throughout the Middle Ages in architectural detail, ivory carving, illumination, stained-glass work, and, ultimately, in panel painting. The instinct and taste for intricacy and precision, propagated in the art of the wandering Celts and Germans, will broaden beyond art into technology and the making of machines.

The barbarian craft remained, but the Hiberno-Saxon ornamental style, with its gorgeous essays in interlacements, was fated to be replaced by the Mediterranean styles that descended from Early Christian and Late Antique art. Political realities hastened its demise. Irish Christianity lost its influence in Anglo-Saxon England and on the continent; the adherents to the rule of Benedict, the Benedictine order of monks, who wholeheartedly followed the papacy and the Roman version of Christianity, gained the upper hand in power and influence, and although the Irish church held out for some time, eventually it accepted the Roman form. Even while Hiberno-Saxon art prevailed in Ireland, Scotland, and Northumbria, other monastic foundations in England were copying Mediterranean prototypes. Naturally, the ascendancy of the Roman church would be expressed in manuscripts from the Mediterranean area, and wherever the Roman orthodoxy was accepted, an orthodox style of manuscript illumination had to follow. The contrast between the two very different styles is particularly striking in juxtaposition. *The Scribe Ezra Rewriting the Sacred Records* from the *Codex Amiatinus* (FIG. **8-9**) was copied from an Italian manuscript, the *Codex Grandior of Cassiodorus*, early in the eighth century by an illuminator with Italian training acquired in some Anglo-Saxon monastery, probably Jarrow. The same original must have been seen and "translated" a few years earlier by an artist trained in the

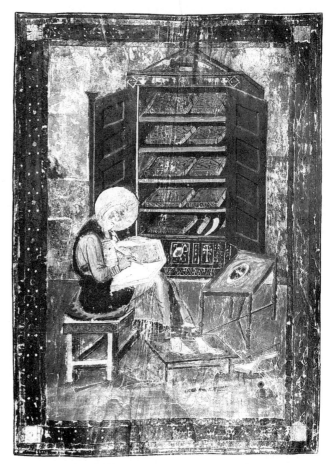

8-9 *The Scribe Ezra Rewriting the Sacred Records,* from the *Codex Amiatinus,* Jarrow, early eighth century. Approx. 14" × 10". Biblioteca Medicea-Laurenziana, Florence.

abstract Hiberno-Saxon manner; his version appears as the *St. Matthew* figure in the *Book of Lindisfarne* (FIG. **8-10**). The Ezra and the architectural environment of the *Codex Amiatinus* are closely linked with the pictorial illusionism of Late Antiquity. The style is essentially that of the brush; the color, although applied here and there in flat planes, is blended smoothly to model the figure and to provide gradual transitions from light to dark. This procedure must have been continued in the Mediterranean world throughout the Early Middle Ages, despite the formalizing into line that we have seen taking place in mosaics. But the Hiberno-Saxon artist of the *Lindisfarne Matthew,* trained in the use of hard, evenly stressed line, apparently knew nothing of the illusionistic, pictorial technique nor, for that matter, of the representation of the human figure. Although he carefully takes over the pose, he interprets the form in terms of line exclusively, "abstracting" the unfamiliar tonal scheme of his model into a patterned figure not unlike what we see in the king, queen, and jack of a deck of cards. The soft folds of drapery in the

Ezra become, in the *St. Matthew,* a series of sharp, regularly spaced, curving lines. No modeling is used; no variations occur in light and shade. The long training in the peculiar linear style of barbarian art made it necessary for the *Lindisfarne* artist to convert the strange Mediterranean forms into the linear idiom familiar to him; he finds before him a tonal *picture* and makes of it a linear *pattern.*

The Medieval artist did not go to nature for models but to a prototype—another image, a statue, or a picture in a book. Each copy might be one in a long line of copies, and, in some cases, we can trace these copies back to a lost original, inferring its former existence. The Medieval practice of copying pictures is closely related to the copying of books, especially sacred books like the Scriptures and the books used in the liturgy. The Medieval scribe or illuminator (before the thirteenth century, most often a monk) could have reasoned that just as the text of a holy book must be copied faithfully if the copy also is to be holy, so must the pictures be rendered faithfully. Of course, in the process of copying, mistakes are made, and while scholars seek to purge the book of these textual "corruptions," "mistakes" in the copying of pictures yield new pictorial styles, or represent the confluence of different styles, as in the relationship of the *Codex Amiatinus* and the *Book of Lindisfarne.* In any

8-10 *St. Matthew,* from the *Book of Lindisfarne,* from Northumberland, England, late seventh century. Approx. 11″ × 9″. British Library, London.

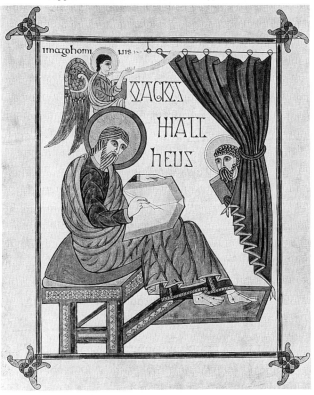

event, one should realize that the style of Medieval images, whether in sculpture or in painting, was the result of copying from sources thought to have sacred authority, not from natural models. Thus, one learned what was true from authorities who declared the truth—the Scriptures and the fathers of the Church—and one painted "true" pictures or sculpted "true" statues from authoritative images. To question authority on one's own, to investigate "nature" on one's own, would be to question God's truth as revealed and interpreted. Such actions would be blasphemy and heresy. It would be wrong, however, to leave the impression that dependence on authority in art is characteristic solely of the Middle Ages. In the Renaissance and since, and certainly today, new styles gain sudden authority and win widespread reverence and imitation, even for reasons that differ from those operative in the Middle Ages.

Sculpture

The high crosses of Ireland, erected between the eighth and the tenth centuries, are exceptional by their mass and scale within the art of the Early Middle Ages, which, as we have seen, is confined almost exclusively to works diminutive and portable. Indeed, the crosses are unique. These majestic monuments, some 17 feet in height or taller, preside over burial grounds adjoining the ruins of monasteries at sites widely distributed throughout the Irish countryside. Though several of these crosses have been found in England, they are regarded as characteristically Irish in form and origin. The Celtic cross has become the very symbol of Christian Ireland in both religious and secular iconography. Freestanding, unattached to any architectural fabric, the high crosses have the imposing unity, weight, and presence of both building and statue, architecture and sculpture combined. The *High Cross of Muiredach* at Monasterboice (FIG. **8-11**), though a late representative of the type (dated by inscription 923), can serve as standard for the form. The cross element crowns a four-sided shaft of stone, which rises from a base with sloping sides. The concave, looping arms of the cross are joined by four arcs, which form a circle. The arms expand into squared terminals (see the initial page of the *Lindisfarne* Gospels, FIG. 8-8). The circle-intersected cross is the characteristic figure that identifies the type as Celtic. The earlier high crosses bear abstract designs, especially the familiar interlace pattern. But the later ones, such as this, have figured panels, with scenes from the life of Christ, or, occasionally, events from the life of some Celtic saint, like Columcille. In addition, fantastic animals and grotesque human figures sometimes are portrayed. Here, at the center of

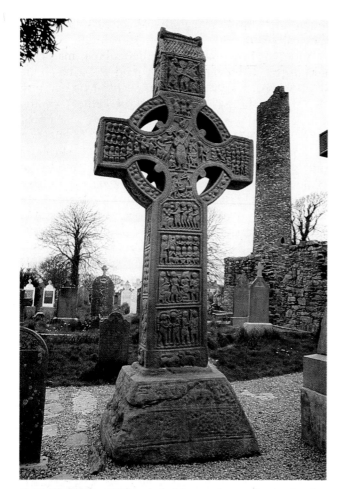

8-11 *High Cross of Muiredach*, Monasterboice, County Louth, Ireland, 923. Approx. 16' high.

the transom of the cross, stands the risen Christ as judge of the world, the hope of the neighboring dead. The iconographic and stylistic sources of the figural carvings are far-flung: Early Christian art, the art of Coptic (Christian) Egypt, the animal motifs of the Near East and the Migration period—all evidence of the cosmopolitanism of Irish culture in the period of its great flourishing. The high crosses are the monumental, consummate expression of the religious and esthetic values of Hiberno-Saxon creativity, which, by the twelfth century, was extinct.

THE CAROLINGIAN PERIOD

The remarkable historical phenomenon now called "Charlemagne's renovation"—an energetic, brilliant emulation of the art, culture, and political ideals of Christian Rome—occurred during the late eighth and early ninth century. Out of the confusions attendant on the migrations and settlement of the barbarians, Charlemagne's immediate forerunners built, by force

and political acumen, a Frankish empire that contained or controlled a large part of western Europe. Charlemagne, like Constantine, whom he often consciously imitated, wished to create a unified Christendom as a visible empire. He was crowned by the pope in Rome in 800 as head of the entity that became the Holy Roman Empire, which, waxing and waning over a thousand years and with many hiatuses, existed as a force in central Europe until its destruction by Napoleon in 1806.

Charlemagne was a sincere admirer of learning and the arts. To make his empire as splendid as that of Rome (he thought of himself as successor to the caesars), he invited to his court at Aachen the best minds and the finest craftsmen of western Europe and the Byzantine East. Although unlettered and scarcely able to write, he could speak Latin fluently and loved the discourses he frequently held with the learned men he gathered around him. Charlemagne also must have admired the splendid works created in the scriptorium of the school he established in his palace. One of his dearest projects had been the recovery of the true text of the Bible, which, through centuries of miscopying by ignorant scribes, had become almost hopelessly corrupt. Part of the great project, undertaken by the renowned scholar Alcuin of York at the new monastery at Tours, was the correction of the actual script used, which, in the hands of the scribes, had become almost unreadable. The Carolingian rehabilitation of the inherited Latin script produced a clear, precise system of letters; the letters on this page are descended from the alphabet renovated by the scribes of Tours.

Painting and Illumination

Charlemagne, his successors, and the scholars under their patronage imported whole libraries from Italy and Byzantium. The illustrations in these books must have astonished northern painters, some of whom had been trained in the Hiberno-Saxon manner of pattern making, while others were schooled in the weak and inept Frankish styles of the seventh and eighth centuries. Here, they were confronted suddenly with a sophisticated realism that somehow had survived from the Late Antique period amidst all the denaturing tendencies that followed.

The famous *Coronation Gospels* (the *Gospel Book of Charlemagne*, formerly in the Imperial Treasury in Vienna) may have been a favorite of Charlemagne himself; an old tradition records that it was found on the knees of the dead emperor when, in the year 1000, Otto III had the imperial tomb at Aachen opened. The picture of *St. Matthew* composing his gospel (FIG. **8-12**) descends from ancient depictions in sculpture

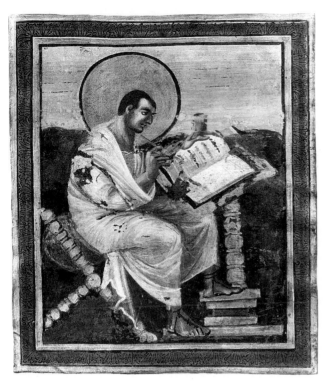

8-12 *St. Matthew*, from the *Coronation Gospels* (the *Gospel Book of Charlemagne*), *c.* 800–810. Approx. 9″ × 6¾″. Kunsthistorisches Museum, Vienna.

and painting of an inspired philosopher or poet seated and writing. Its technique is of the same antiquity—deft, illusionistic brushwork that easily and accurately defines the masses of the drapery as they wrap and enfold the body beneath. The acanthus of the frame of the ''picture window'' recalls the fourth Pompeian style (see FIG. 6-33); the landscape background is classicizing, and the whole composition seems utterly out of place in the north in the ninth century. How were the native artists to receive this new influence, so alien to what they had known and so strong as to make their own practice suddenly obsolete?

The style evident in the *Coronation Gospels* was by no means the only one that appeared suddenly in the Carolingian world. A wide variety of styles in all stages of change from Antique prototypes were distributed through the court schools and the monasteries—a bewildering array, one can believe, for the natives, who attempted to appropriate them by copying them as accurately as possible. Thus, Carolingian painting is extremely diverse and uneven, and classification becomes a difficult matter of ascertaining prototypes and the descendants of prototypes. If *St. Matthew* of the *Coronation Gospels* was painted by a Frank, rather than an Italian or a Byzantine, it is an amazing feat of approximation, since, except for the work of the Jarrow copyist, nothing is known that could have

prepared the way for it in the Hiberno-Saxon or Frankish West.

Another *St. Matthew*, in a gospel book made for Archbishop Ebbo of Reims (FIG. 8-13), may be an interpretation of a prototype very similar to the one used by the *Coronation Gospels* master, for it resembles it in pose and in brushwork technique. But there the resemblance stops. The Classical calm and solidity have been replaced by an energy that amounts to frenzy, and the frail saint almost leaps under its impulse. His hair stands on end, the folds of his drapery writhe and vibrate, the landscape behind him rears up alive. He appears in frantic haste to take down what his inspiration (the tiny angel in the upper-right-hand corner) dictates. All fidelity to bodily proportions or structure is forsaken in the artist's effort to concentrate on the act of writing; the head, hands, inkhorn, pen, and book are the focus of the composition. This presentation contrasts strongly with the settled pose of the *Matthew* of the *Coronation Gospels* with its even stress, so that no part of the composition starts out at us to seize our attention. The native power of expression is unmistakable and will become one of the important distinguishing traits of Late

8-13 *St. Matthew*, from the *Ebbo Gospels* (the *Gospel Book of Archbishop Ebbo of Reims*), Hautvilliers (near Reims), France, *c.* 816–835. Approx. 10″ × 8″. Bibliothèque Nationale, Paris.

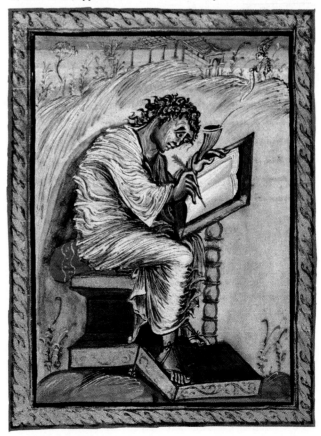

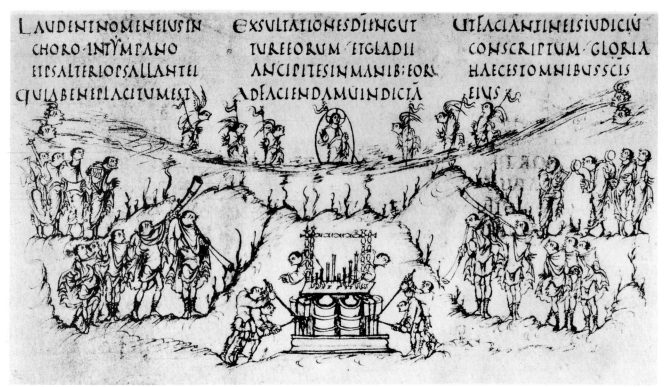

LAUDINTNOMINEIUSIN EXSULTATIONESDIINGUT UTFACIANTINEISIUDICIU
CHORO·INTYMPANO TURFEORUM·ETGLADII CONSCRIPTUM·GLORIA
ETPSALTERIOPSALLANTEI ANCIPITESINMANIB:EOR· HAECESTOMNIBUSSCIS
QUIABENEPLACITUMEST ADFACIENDAMUINDICIA EIUS·

8-14 *Psalm 150*, from the *Utrecht Psalter*, from Hautvilliers, France, c. 830. 4¾″ × 9½″. University Library, Utrecht, The Netherlands.

Medieval art. Just as the painter of the *Lindisfarne Matthew* (FIG. 8-10) transformed the *Ezra* portrait in the *Codex Amiatinus* (FIG. 8-9) into something original and strong, translating its classicizing manner into his own Hiberno-Saxon idiom, so the Ebbo artist translated his Classical prototype into a Carolingian vernacular that left little Classical substance. The four pictures should be studied carefully and compared.

Narrative illustration, so richly developed in Early Christian and Byzantine art, was revived by the Carolingians, and many fully illuminated books (some, large Bibles) were produced. One of the most extraordinary and enjoyable of all Medieval manuscripts is the famous *Utrecht Psalter*, written at Hautvilliers near Reims, France, about 830. The text, in three columns, reproduces the Psalms of David and is profusely illustrated by pen-and-ink drawings in the margins. The example shown in FIG. **8-14** depicts figures acting out Psalm 150, in which the psalmist exhorts us to praise the name of God in song and with timbrel, trumpet, and organ. The style shows a vivid animation of much the same kind as the *St. Matthew* of the *Ebbo Gospels* and may have been produced in the same school. The bodies are tense, shoulders hunched, heads thrust forward. The spontaneity of their actions and the rapid, sketchy technique with which they are rendered convey the same nervous vitality as the figure in the *Ebbo Gospels*. From details of the figures, their dress, and accessories, scholars

feel certain that the artist was following one or more manuscripts compiled some four hundred years earlier. His interest in simple human emotions and actions, the pantomimic skill in the variety and descriptiveness of gesture, however, are essentially Medieval characteristics, although they begin in Early Christian art. Note, for example, how the two musicians playing the pipe organ shout at their helpers to pump air more strenuously. This candid observation of human behavior, often in unguarded moments, was to lend both truth and charm to the art of the Late Middle Ages.

Craft Art

To our knowledge, little or no monumental sculpture was produced in the Carolingian period. The traditional taste for sumptuously wrought and portable metal objects, which created the barbarian works we have seen, persisted under Charlemagne and his successors and was responsible for the production of numerous precious and beautiful works, like the book cover of the *Codex Aureus of St. Emmeram* (FIG. **8-15**). Dating from the second half of the ninth century, this book cover probably originated at either the St. Denis or Reims court of Charles the Bald, a grandson of Charlemagne. Its golden surface is set with pearls and precious jewels. Within the inscribed, squared cross, Christ in Majesty appears in an atti-

tude not far removed from that in the apse mosaic of San Vitale (FIG. 7-38)—an example of the persistence of types and attitudes from Early Christian art into subsequent periods. The Four Evangelists are seated around Christ, outside the cross, and four scenes from Christ's life are portrayed above and below the saints. In general, manuscript illumination provides the generative prototypes for ivory and metalwork. Here, the style of the figures echoes that of the *Ebbo Gospels* and the *Utrecht Psalter*, although it is modified by influences from other Carolingian schools. No trace of the intricate interlace patterns of Hiberno-Saxon art remains, although the complex and delicate floral filigree clustering about the border jewels and enamels recalls them and provides a foil for the classicizing figure style. At the core of the Carolingian renovation, the translated, classicizing style of Italy prevails, in keeping with the tastes and aspirations of the great Frankish emperor who fixed his admiring gaze on the culture of the south.

Metalcraft was extended to produce works much larger than the book cover, while maintaining the same principles in terms of materials, methods of production, design, and figure style. An example is

8-15 *Christ in Majesty, Four Evangelists, and Scenes from the Life of Christ,* cover of the *Codex Aureus of St. Emmeram,* c. 870. Gold set with pearls and precious stones, 17″ × 13″. Bayerische Staatsbibliothek, Munich.

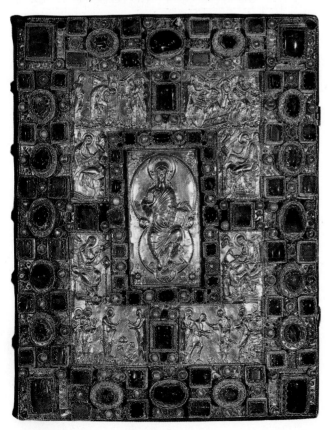

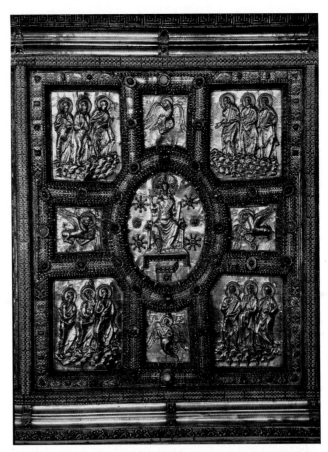

8-16 MASTER WOLVINIUS, detail of the *Paliotto* (golden altar), Sant' Ambrogio, Milan, early ninth century. Gold, silver, enamel, precious and semiprecious stones; entire altar 3′ high, 7′ long, 4′ deep.

the magnificent golden altar (the *Paliotto*) of the church of Sant' Ambrogio in Milan (FIG. **8-16**). Shaped like a kind of large tomb, the altar was designed to contain the bones of St. Ambrose, an early bishop of Milan and one of the fathers of the Latin church. Its four sides are ornamented with the jeweler's workmanship and lavish detail that we find in the *Codex Aureus* cover. Like that work, the *Paliotto* is divided into framed compartments of geometric simplicity and formality. Its gold, silver, and precious and semiprecious stones are set forth in exquisitely worked filigree to honor (in the central panels) the enthroned Christ, the Signs of the Evangelists, and the Twelve Apostles, all wrought in the classicizing figure style of the Carolingian renovation. Inscriptions on the back of the altar, where scenes from the life of Saint Ambrose are found, tell us that the donor was Archbishop Angilbert II, who governed the church in Milan between 824 and 859, which gives us a date for the monument. St. Ambrose places a crown on the bishop's head; he also places a crown on the head of the designer of the altar and its principal artist, a certain "Master Wolvinius," whose name suggests his

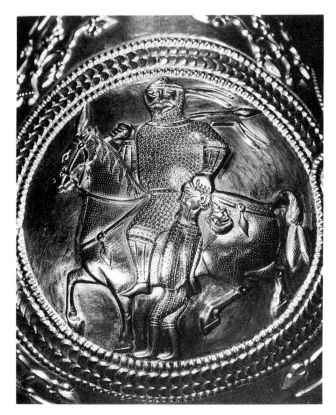

8-17 *Mounted Warrior with Captive* (detail of gold vessel; vessel 8¾" high), from the Nagy-szent-miklós treasure hoard found at Sinicolaul, Romania, probably ninth century. Kunsthistorisches Museum, Vienna.

east Frankish origins and that he may have been trained in the main centers of Carolingian art. Whatever the questions as to its sources, this work of WOLVINIUS and his fellow craftsmen remains perhaps the supreme masterpiece of the Age of Charlemagne.

Beyond the western regions under Carolingian control, migrations of warlike peoples from the east kept eastern and central Europe in turmoil throughout the ninth century. Mounted nomads rode the great grasslands as the Vikings rode the western seas. Charlemagne managed to repulse the Avars, who had long dominated the Hungarian plain. Like the migrating peoples in general, the Avars were skilled metal-craftsmen. A detail of a vase from a hoard of golden vessels left by them (a buried treasure never reclaimed) is illustrated here (FIG. **8-17**). Made of beaten gold, it bears a medallion with the image of a mounted, armored warrior. Posed both frontally and in profile, an Archaic convention we have seen in ancient art, the warrior carries a spear over his right shoulder, and seizes a disarmed man with his left hand; the thrown-back head of another figure which appears below the horseman's left wrist, may belong to a man he already has killed. The dominating bulk of the fierce victor is made larger by the puny stature

of his victims, another Archaic convention we have seen in the art of Mesopotamia (FIG. 2-24) and Egypt (FIG. 3-43). Here is the very image of the times, when armed, pagan horsemen swept all before them in endless war and depredation. Yet the art of the Avars was influenced by the art of the settled and more civilized nations they came in contact with; the bead and fish-scale molding of the medallion frame and the floral motifs of the shoulder and base of the vessel are derived from Byzantine and Sassanian (Late Persian) art. Whether inspired by the Christian God, or the god of war, the craft art of the Early Middle Ages achieves a rare distinction. The priest and the warrior are the patrons of the craftsman.

Architecture

In his eagerness to reestablish the imperial past, Charlemagne also encouraged the revival of Roman building techniques; in architecture, as in sculpture and painting, innovations made in the reinterpretation of earlier Roman-Christian sources became fundamental to Medieval designs. Perhaps *importation* is a more appropriate term here than *revival*, as the Mediterranean tradition of stonemasonry could never have been more than an admirable curiosity to northern builders. Although northern Europe was dotted with Roman colonial towns that contained many large and impressive stone structures, the Germanic tribes had always relied on the vast forests to supply them with building materials; northern architecture was a timber architecture and continued to be so well into the Middle Ages. The typical northern European dwelling was a timber-frame structure (FIG. **8-18**) that, in its essentials, has survived into our time. Its basic structural unit is the *bay*, which is constructed of four posts placed at the corners of a rectangle and interconnected and braced against each other with horizontal or oblique members. This type of unit is self-

8-18 Conjectural reconstruction of an Iron Age house on foundations excavated at Ezinge, Holland. (After W. Horn.)

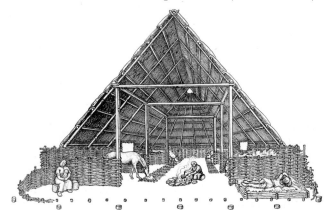

supporting; it can be roofed and, depending on the desired size of the building, multiplied at will. Thus, the interior of such a structure is characterized by a repetition of identical units that move in orderly progression down the length of the building. The plan of such a building is related to the size and proportions of one of its bays in that the bay is the *module,* or basic unit of measurement, and the structure is a multiple of that unit.

Charlemagne's adoption of southern building principles for the construction of his palaces and churches was epoch-making for the subsequent development of the architecture of northern Europe. For his models, he went to Rome and Ravenna—one, the former heart of the Roman Empire, which he wanted to revive, the other, the long-term western outpost of Byzantine might and splendor, which he wanted to emulate in his own capital at Aachen. Ravenna fell to the Lombards in 751 but was wrested from them only a few years later by the Frankish king, Pepin the Short, founder of the Carolingian dynasty and father of Charlemagne. Pepin donated the former Byzantine exarchate to the pope and thus founded the papacy's temporal power, which was to last until the late nineteenth century.

In 789, Charlemagne visited Ravenna, and historians have long thought that he chose one of its churches as the model for the Palatine Chapel of his own palace at Aachen. But although the plan of this structure (FIG. **8-19**) shows a resemblance to that of San Vitale (FIG. 7-33), recent study disproves a direct relationship between the two buildings. Nevertheless, a comparison of the two buildings is instructive. The Aachen plan is simpler; the apselike extensions reaching from the central octagon into the ambulatory have been omitted, so that the two main units stand in greater independence of one another. This solution may lack the subtle sophistication of the Byzantine building, but it gains geometric clarity. A view of the interior of the Palatine Chapel (FIG. **8-20**) shows that the ''floating'' quality of San Vitale has been converted into blunt massiveness and stiffened into solid geometric form. The conversion of a complex and subtle Byzantine prototype into a building that expresses robust strength and clear structural articulation foreshadows the architecture of the eleventh and twelfth centuries and the style we call Romanesque.

Charlemagne's dependence on Roman models is illustrated by a fascinating survival from his time, the Torhalle (gatehouse, FIG. **8-21**) of the Lorsch Monastery, which dates from about 800. Originally built as a freestanding structure in the atrium of the now-lost monastic church, this decorative little entrance gate is a distant relative of the Arch of Constantine (FIG. 6-95) by way of its reinterpretation in Christian terms

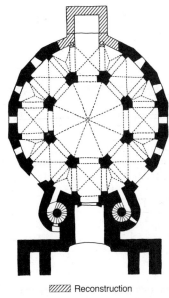

▨▨ Reconstruction

0	50	100	
			FEET
0	15	30	
			METERS

8-19 Restored plan of the Palatine Chapel of Charlemagne, Aachen, West Germany, 792–805.

8-20 Interior of the Palatine Chapel of Charlemagne.

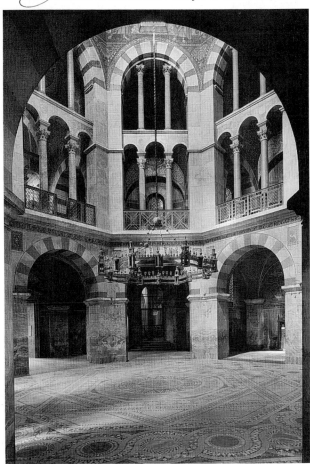

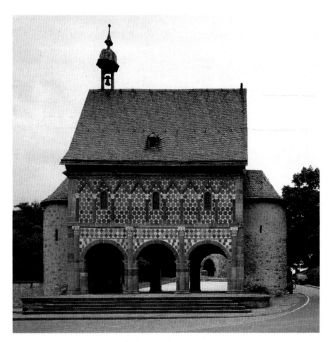

8-21 Torhalle (gatehouse), Lorsch, West Germany, *c.* 800.

of the entrance to the atrium of Old St. Peter's in Rome (if, in fact, the entrance to that structure resembled the reconstruction shown in FIG. 7-6). To Charlemagne, both the arch and the atrium entrance could have been symbols of Christian triumph over paganism. The triple-arched gateway on the lower level closely follows the design of Roman triumphal arches, with its column-arch combination, the fairly close copies of Late Roman capitals, and the decorative treatment of the flat wall surfaces with colored inlays of cream and pink stone in imitation of the Roman *opus reticulatum*. However, the columns support a decorative stringcourse instead of a full entablature, and what happens above it on the second level no longer has anything to do with triumphal arches. Instead of bearing the traditional dedicatory inscription, the second level is articulated with pseudo-Ionic pilasters that carry a zigzag of ornamental moldings, and the opus reticulatum has been converted into a decorative pattern of hexagons and triangles that form star shapes. Finally, the steeply pitched, timber roof that shelters a chapel dedicated to St. Michael unmistakably stamps this gatehouse as a northern building. Still, the source of inspiration is clear, and if the final product no longer closely resembles the original, it is due to the fact that it is not a copy but a free and fanciful interpretation of its model.

The models that carried the greatest authority for Charlemagne and his builders were those from the Christian phase of the late Roman Empire, and it was the adoption of the Early Christian basilica, rather than the domed, central plan of Byzantine churches, that was crucial to the subsequent development of

Western church architecture in general and to the Romanesque style in particular. Several churches of the basilican type were built in northern Europe during the reign of Charlemagne, but none has survived. Nevertheless, it is possible to reconstruct the appearance of some of them with fair accuracy. A number of these structures appear to have followed their Early Christian models quite closely; the abbey church of Fulda (begun in 802) derives directly from Old St. Peter's and other Roman basilicas with transepts. But in other instances, Carolingian builders subjected the basilica plan to some very significant modifications, converting it into a much more complex form.

The study of a fascinating Carolingian document, the ideal plan for a monastery preserved in the library of St. Gall, Switzerland (FIG. 8-22), may provide some insight into the motivations of the Carolingian planner. The monasteries were of central importance in the revival of learning. Monasticism held that the most perfect Christian life should be led in seclusion, removed from the temptations of ordinary life. In 526, Benedict had adapted the earlier regulations to the needs of western Europe. The Benedictine Rule, which won out over Irish monasticism and which demanded, among other things, vows of poverty, chastity, and obedience, provided the basic organization for most Western monasteries. Daily life was rigidly controlled, and each monastic community was self-sufficient. About 819, a schematic plan for one such community was copied from a lost original, probably designed by the abbot of Reichenau, and sent to the abbot of St. Gall for use as a guide in his planned rebuilding of that monastery.

Near the center, dominating everything, was the abbey church, with the cloister (not unlike the early colonnaded atrium) at one side. Around the cloister were grouped the most essential buildings: dormitory, refectory, kitchen, and storage rooms. Other buildings, including an infirmary, school, guest house, bakery, brewery, and workshops, were grouped around this central core of church and cloister. That the scheme may have been meant to be more than an ideal and actually to have been built is suggested by Walter Horn's recent discovery that the original plan must have been laid out on a modular base of $2\frac{1}{2}$ feet and by the fact that parts or multiples of this module have been used consistently throughout the plan. Therefore, the width of the nave, indicated on the plan as 40 feet, would be equal to 16 modules, the length of each monk's bed to $2\frac{1}{2}$ modules, and the width of paths in the vegetable garden to $1\frac{1}{4}$ modules.

Although the church is essentially a three-aisled basilica, it has features not found in any Early Christian churches. Perhaps most obvious is the addition of a second apse on the west end of the building. The

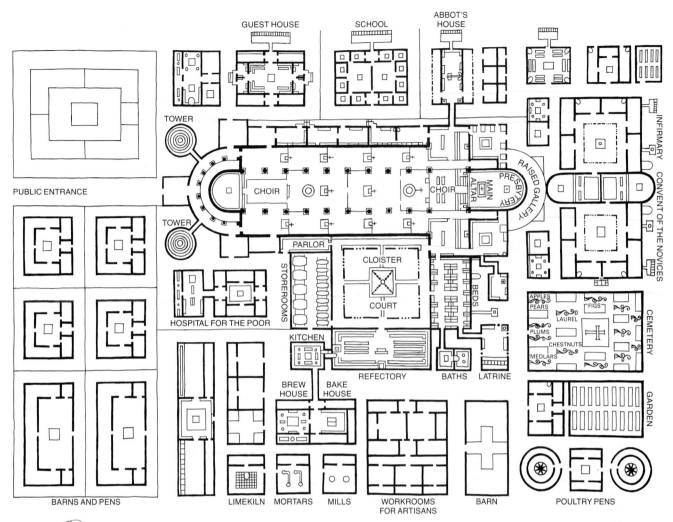

8-22 Schematic plan for a monastery at St. Gall, Switzerland, *c.* 819. (Redrawn after a ninth-century manuscript.)

origin and purpose of this feature have never been explained satisfactorily, but it remained a characteristic regional element of German churches to the eleventh century. Not quite as evident, but much more important to the subsequent development of church architecture in the north, is the fact that the transept is as wide as the nave. Early Christian builders had not been concerned with proportional relationships; they assembled the various portions of their buildings only in accordance with the dictates of liturgical needs. On the St. Gall plan, however, the various parts of the building have been related to each other by a geometric scheme that ties them together into a tight and cohesive unit. Equalizing the widths of nave and transept automatically makes the area in which they cross (the *crossing*) a square. This feature is shared by most Carolingian churches. But the St. Gall planner also took the subsequent steps that became fundamental to the development of Romanesque architecture: he used the crossing square as the unit of measurement for the remainder of the church

plan. The arms of the transept are equal to 1 crossing square, the distance between transept and apse is 1 crossing square, and the nave is $4\frac{1}{2}$ crossing squares long. The fact that the aisles are half as wide as the nave integrates all parts of the church in a plan that is clear, rational, lucid, and extremely orderly.

The St. Gall plan reflects a medieval way of thinking that is important for Romanesque art and architecture. As a guide for the builder of an abbey, it expresses the authority of the Benedictine Rule and serves as a kind of prototype. In the interest of clarity and orderliness, the rule is worked out with systematic care. All units are balanced as the site is divided and subdivided. (This parallels the medieval invention of that most convenient device, the division of books into chapters and subchapters.) The neat "squaring" that characterizes the St. Gall plan and the principle of the balance of clearly defined, simple units will dominate Romanesque architectural design. The eagerness of the medieval mind to explain the Christian faith in terms of an orderly, rationalistic

philosophy built on carefully distinguished propositions and well-planned arguments finds visual expression in the plan of St. Gall.

Although the rebuilding project for St. Gall was not consummated, the church of St. Riquier at Centula in northeastern France (FIG. 8-23) gives us some idea of what the St. Gall church would have looked like. A monastery church like that of St. Gall, the now-destroyed St. Riquier was built toward the very end of the eighth century and therefore predates the St. Gall plan by approximately twenty years. Our illustration, taken from a seventeenth-century copy of a much older drawing, shows a feature not indicated on the plan of St. Gall but most likely common to all Carolingian churches—multiple, integrated towers. The St. Gall plan shows only two towers on the west side of the church, but they stand apart from it in the manner of the Italian campaniles. If we assume a tower above the crossing, the silhouette of St. Gall

8-23 Monastery church of St. Riquier, Centula, France, c. 800. (Engraving made in 1612 after a now-destroyed, eleventh-century miniature.)

would have shown three towers rising above the nave. St. Riquier had six towers (not all are shown in the illustration) built directly onto or rising from the building proper. As large, vertical, cubic, and cylindrical masses, these towers rose above the horizontal roofline, balancing each other in two groups of three at each end of the basilican nave. Round stair towers on the west end provided access to the upper stories of the so-called *westwork* (entrance structure) and to the big, spired tower that balanced the spired tower above the eastern crossing. Such a grouping of three towers at the west, quite characteristic of churches built in the regions dominated by the Carolingians and their successors in German lands, probably foreshadows, in rudimentary form, the two-tower façades that were to become an almost universal standard in Late Romanesque and Gothic architecture. The St. Riquier design, particularly the silhouette with its multiple integrated towers, was highly influential, especially in Germany. On the second floor, the towered westwork contained a complete chapel flanked by aisles—a small upper church that could be used for parish services. The main floor of the building was reserved for the use of the clergy. (One must remember that this was a monastery church.) A gallery opened onto the main nave, and from it, on occasion, the emperor and his entourage could watch and participate in the service below.

THE OTTONIAN PERIOD

Charlemagne's empire survived him by less than thirty years. Under his three grandsons, Charles the Bald, Lothair, and Louis the German, the Carolingian Empire was partitioned (by 843) into western, central, and eastern areas, very roughly foreshadowing the later sections of France, Lorraine, and the Germanies. Intensified incursions by the Vikings in the west helped bring about the collapse of the Carolingians and the suspension of their great cultural effort. The breakup of the empire into weak kingdoms, ineffectual against the invasions, brought a time of darkness and confusion that was perhaps even deeper than the seventh and eighth centuries. The scourge of the Vikings in the west was complemented by the invasions of the Magyars in the east and by the plundering and piracy of the Saracen corsairs in the Mediterranean. Only in the mid-tenth century did the eastern part of the former empire consolidate under the rule of a new Saxon line of German emperors called, after the names of the three most illustrious members of the family, the "Ottonians." The three Ottos made headway against the invaders from the east, remained free

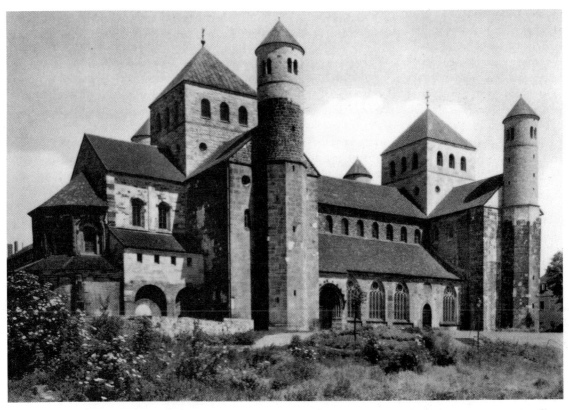

8-24 Abbey church of St. Michael, Hildesheim, West Germany, *c.* 1001–1031. (Restored.)

from Viking depredations, and were able to found an empire that, nominally at least, became the successor to Charlemagne's Holy Roman Empire. The culture and tradition of the Carolingian period not only were preserved but were advanced and enriched. The Church, which had become corrupt and disorganized, recovered in the tenth century under the influence of a great monastic reform encouraged and sanctioned by the Ottonians, who also cemented ties with Italy and the papacy. When the last of the Ottonian line, Henry II, died in the early eleventh century, the pagan marauders had become Christianized and settled, the monastic reforms had been highly successful, and several signs pointed to a cultural renewal that soon was destined to produce greater monuments than had been known since ancient Rome.

Architecture

Ottonian architects followed the direction of their Carolingian predecessors. St. Michael's, the abbey church at Hildesheim (FIG. **8-24**) built between 1001 and 1031 by Bishop Bernward, retains the tower groupings and the westwork of St. Riquier, as well as its massive, blank walls. But the addition of a second

transept and apse result in a better balancing of east and west units. The plan and section of St. Michael's (FIG. **8-25**) clearly show the east and west centers of

8-25 Section *(top)* and plan *(bottom)* of St. Michael's.

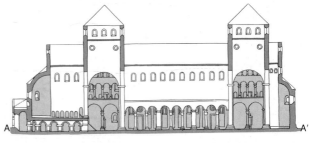

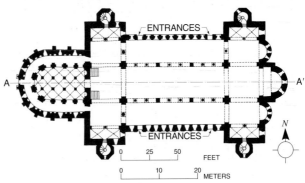

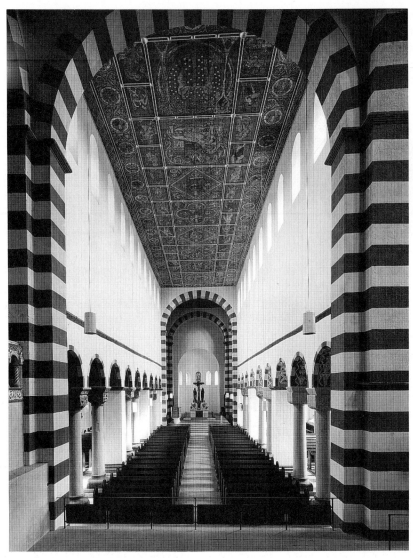

8-26 The nave of St. Michael's. (Restored.)

gravity, the nave being merely a hall that connects them. Lateral entrances leading into the aisles from the north and south are additional factors making for an almost complete loss of the traditional basilican orientation toward the east. The crossing squares have been used as a module for the dimensions of the nave, which is 3 crossing squares long and 1 square wide. This fact is emphasized visually by the placement of heavy piers at the corners of each square. These piers alternate with pairs of columns as wall supports, and the resultant "alternate-support system" will become a standard feature of many Romanesque churches in northern Europe. Contrary to one view, the alternate-support system is not related to the development of Romanesque systems of vaulting. It made its first appearance in timber-roofed structures of the tenth century (such as St. Cyriakus at Gernrode, begun in 961) and appears to be the logical outcome of the Carolingian suggestion that the length of a building could be a multiple of the crossing square. Thus, the suitability of the alternate-support system to some Romanesque vaulting systems is only incidental; it seems to have been adopted not as a structural but as an esthetic device that furnishes visual proof of the geometric organization of the building's plan. It has been suggested that the alternate-support system is an importation from the eastern empire, perhaps from Salonika (ancient Thessaloniki). If so, it seems to have been adopted enthusiastically by northern architects, who, it has been proposed lately, may have seen it as an ideal means of converting unbroken basilican interiors into the modular units to which they were accustomed in their native timber architecture (FIG. 8-18).

A view of the interior of St. Michael's (FIG. **8-26**) shows the rhythm of the alternating light and heavy

wall supports. It shows as well that this rhythm is not reflected yet in the upper nave walls—that in fact it has not yet been carried further than the actual supports. Although its proportions have changed (it has become much taller in relation to its width than a Roman basilica), the nave retains the continuous and unbroken appearance of its Early Christian predecessors. We will see a fully developed Romanesque interior only when the geometric organization of the church plan is fully reflected in the elevation of the nave walls and the interior space takes on the appearance of being composed of several vertical segments.

Sculpture

St. Michael's is an important and highly refined transitional monument that fills a gap between the Carolingian and Romanesque styles. Its patron, Bishop Bernward, who made Hildesheim a center of learning, was skilled not only in affairs of state, but also was an eager scholar, a lover of the arts, and, according to his biographer, an expert craftsman and bronze caster. In 1001 he visited Rome as a guest of the emperor, Otto III, whom he had tutored and who was his friend. This stay must have acquainted him with monuments like the Column of Trajan (FIG. 6-69), which may have influenced the great, column-like, paschal candlestick he set up in St. Michael's. The wooden doors of an Early Christian church,

Santa Sabina, may have inspired the remarkable bronze doors the bishop had cast for his splendid church. The doors were cast in a single piece, the first of their kind since ancient Rome. Carolingian sculpture, like most sculpture since antiquity, consisted primarily of small art executed in ivory and metal; the St. Michael's doors anticipated the coming reinstatement of large-scale sculpture in the Romanesque period. The style of the figures on the doors (FIG. **8-27**) derives from Carolingian manuscript illumination but has an expressive strength of its own—once again, a case of the form derived from a prototype becoming something new and firmly itself. God is accusing Adam and Eve after their fall from grace. As he lays on them the curse of mortality, the primal condemnation, he jabs his finger at them with the force of his whole body. The force is concentrated in the gesture, which becomes the psychic focus of the whole composition. The frightened pair crouch, not only to hide their shame but to escape the lightning bolt of the divine wrath. Each passes the blame—Adam pointing backward to Eve, Eve pointing downward to the deceitful serpent. The starkly flat setting throws the gestures and attitudes of rage, accusation, guilt, and fear into relief; once again, the story is presented with all the simplicity and impact of skilled pantomime.

We have seen how the instinct for pantomimic pose and gesture guides the representations and narratives of Medieval art from the very beginning. Such

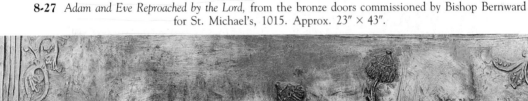

8-27 *Adam and Eve Reproached by the Lord,* from the bronze doors commissioned by Bishop Bernward for St. Michael's, 1015. Approx. 23" × 43".

8-28 *Doubting Thomas*, c. 1000. Ivory, approx. 9″ × 4″. Staatliche Museen, Berlin.

pantomime, emphasized by telling exaggeration, appears in an ivory carving (FIG. **8-28**) that surely is among the masterpieces of the art of the Middle Ages. This small panel, only 9 inches high and 4 inches wide, carries a composition of two intertwined figures, beautifully adjusted to the space. The theme is the persuasion of Doubting Thomas. After the Resurrection, when Christ appears for the second time to his sorrowing disciples (John 20:24), all believe that he is truly Christ and truly risen except the skeptical Thomas, who demands to feel the bodily wounds of the master he has seen crucified. In the panel, Thomas explores the wound in Christ's side in a kind of climbing, aggressive curiosity. Christ, his right arm raised to reveal his side, bends over Thomas in an attitude that wonderfully combines gentleness, benign affection, protectiveness, and sorrow. The figures are represented entirely within the context of emotion; the concentration on the single act of Christ's revelation to the doubter, the emotional vibrations that accompany the doubt, and the ensuing conversion of Thomas determine every line of the rendering. We are not aware here of the influence of a prototype; we seem to have before us an original work of great power.

Painting and Illumination

We must assume that, by Ottonian times, artists had become familiar enough with the Carolingian figurative modes to work with considerable independence, developing a functional, vernacular style of their own. A supreme example of this is an illumination in the *Lectionary of Henry II* (FIG. **8-29**), in which an angel announces the birth of Christ to the shepherds. The angel has just alighted on a hill, his wings still beating, and the wind of his landing agitates his draperies. He looms immense above the startled and terrified shepherds, filling the sky, and bends on them a fierce and menacing glance as he extends his hand in the gesture of authority and instruction. Emphasized more than the message itself are the power and majesty of God's authority. The electric force of God's violent pointing in the Hildesheim doors is felt again here with the same pantomimic impact. Although the figure style may stem ultimately from the Carolingian school at Tours, the painters of the scriptorium of Reichenau (an island in Lake Constance on the German-Swiss border) who produced the *Lectionary of Henry II* have made of their received ideas something fresh and powerful; a new sureness in the touch is epitomized by the way in which the draperies are rendered in a hard, firm line

8-29 *The Annunciation to the Shepherds,* from the *Lectionary of Henry II,* 1002–1014.
Approx. 17″ × 13″. Bayerische Staatsbibliothek, Munich.

8-30 *Otto III Enthroned Receiving the Homage of Four Parts of the Empire* (with nobility and clergy), from the *Gospel Book of Otto III*, 997–1000. Approx. 14″ × 10″. Bayerische Staatsbibliothek, Munich.

and the planes are partitioned in sharp, often heavily modeled shapes. We saw these features in Middle and Late Byzantine art, and indeed a close connection existed between the Ottonian and Byzantine spheres. Yet, for the most part, the Ottonian artists went their own way; Ottonian painting was produced for the court and for the great monasteries—for learned princes, abbots, and bishops—and thus appealed to an aristocratic audience that could appreciate independent and sophisticated variations on inherited themes. Although an illumination like *The Annunciation to the Shepherds* could by no means be called Classical, it does display a certain sculpturesque clarity—a strong, relieflike projection and silhouette that suggests not a hesitating approximation of misunderstood prototypes from antiquity but a confident, if unconscious, capturing of the Antique spirit.

At the same time, the powerful means of expression of *The Annunciation to the Shepherds* miniature imply an intensification of Christian spirituality that is perhaps related to the broad monastic reforms of the tenth and eleventh centuries. With that force of expression goes a significantly new manner of fashioning the human figure in art, one that is not slavishly dependent on prototypes even when prototypes are exchanged and studied. Ottonian figurative art reveals a translation of prototypal material into a kind of ready idiom of forms and a native way of drawing. Although exceptions are known, for the most part, Ottonian figures have lost the old realism of the *Coronation Gospels* (FIG. 8-12), inherited from the Antique style, and move with an abrupt, hinged, jerky movement that is not "according to nature" but nevertheless possesses a sharp and descriptive expressiveness. This new manner would be passed on to the figurative artists of the Romanesque period. As the western European spoken and written languages emerged from the polyglot Latin-Germanic of the early centuries into the vernacular tongues we recognize today, so figurative art gradually developed out of the same kind of mixture of Latin, Germanic, and Celtic elements into a new, strong, and self-sufficient vernacular of representation.

A picture from the *Gospel Book of Otto III*, representing the emperor himself (FIG. **8-30**), sums up much of what went before and points to what is coming. The emperor is represented enthroned, holding the scepter and cross-inscribed orb that represent his universal authority. He is flanked by the clergy and the barons (the church and the state), both aligned in his support. Stylistically remote, the picture still has a clear political resemblance to the Justinianic mosaic in San Vitale (FIG. 7-36). It was the vestigial, imperial ideal—awakened in the Frankish Charlemagne and preserved for a while by his Ottonian successors in Germany—that gave partial unity to western Europe while the barbarians were settling down. This imperial ideal, salvaged from ancient Rome and bolstered by the experience of Byzantium, would survive long enough to give an example of order and law to the barbarians; to this extent, ancient Rome lived on to the millennium. But native princes in England, France, Spain, Italy, and eastern Europe would aspire to a sovereignty outside the imperial Carolingian and Ottonian hegemony; staking their claims, they make the history of the medieval power contests that led to the formation of the states of Europe as we know them. In the illumination (FIG. 8-30), Otto, sitting between the rivalrous representatives of church and state, typifies the very model of the medieval predicament that will divide Europe for centuries. The controversy of the Holy Roman Emperors with the popes will bring the German successors of the Ottonians to bitter defeat in the thirteenth century, and with that defeat, the authority of ancient Rome will come to an end. The Romanesque period that is to follow will, in fact, deny the imperial spirit that had prevailed for centuries. A new age is about to begin, one in which Rome—an august memory—will cease to be the deciding influence.

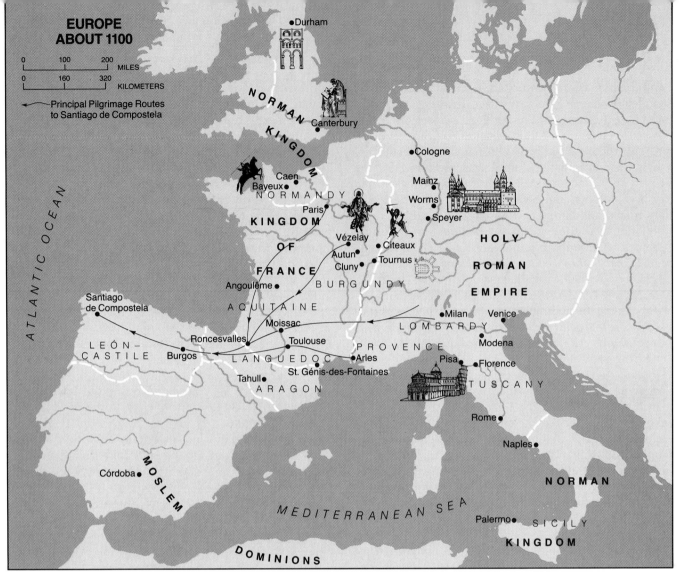

EUROPE
ABOUT 1100

0	100	200
MILES

0	160	320
KILOMETERS

→ Principal Pilgrimage Routes
to Santiago de Compostela

Durham

NORMAN
KINGDOM

Canterbury

Cologne

Caen
Bayeux
NORMANDY

Mainz
Worms
Speyer

Paris

KINGDOM

Vézelay
Autun
Cluny

Citeaux
Tournus

HOLY

ROMAN

OF

EMPIRE

FRANCE

BURGUNDY

Angoulême

ATLANTIC OCEAN

Santiago
de Compostela

AQUITAINE

Moissac

Milan
Venice

LOMBARDY

Modena

Roncesvalles

Toulouse

PROVENCE

LEÓN–
CASTILE

Burgos

LANGUEDOC

Arles
St. Génis-des-Fontaines

Pisa
Florence

TUSCANY

Tahull

ARAGON

Rome

MOSLEM

Córdoba

Naples

NORMAN

MEDITERRANEAN SEA

Palermo
SICILY

KINGDOM

DOMINIONS

900	950	1000
FIRST ROMANESQUE		ROMANESQUE PERIOD

Crypt of St. Philibert,
Tournus c. 950–1020

Speyer Cathedral begun 1030

Germany under
Ottonian Emperors
936–1024

Germany under
Salian and Franconian
Emperors
1024–1138

Viking raids 9th–11th centuries

Cluniac Order
founded 910

9
ROMANESQUE ART

1050	1100	1150

Pisa Cathedral
1053–1272

Bayeux Tapestry
1070–1080

Durham Cathedral
begun c. 1093

Moralia in Job
early 12th century

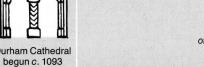

The Mission
of the Apostles,
Vézelay
1120–1132

The Scribe
Eadwine
c. 1150

First Crusade
1095

Second Crusade
1146

Germany under
Hohenstaufen Emperors
1138–(1268)

Norman conquest
of England (Battle
of Hastings)
1066

Norman conquest
of Southern Italy
and Sicily
1060–1101

Cistercian Order
founded 1098

THE MID-ELEVENTH CENTURY marked a turning point in European history; Europe *as* Europe began to emerge. The past was a boiling confusion of barbarian movements, coalescing into settlements and then aggregating into empires, like the Carolingian and Ottonian, which had their spiritual and political roots in the memory of the Roman *imperium.* After about 1050, although a Latin culture and tradition persisted and still were accepted with reverence, medieval people were not as retrospective; they had new experiences and took new directions.

After the disintegration of the Carolingian state, when the successors to the imperializing Ottonians had begun to limit their concerns to Italy and the German duchies, numerous feudal political entities—petty and great, within and without the outlines of the old Frankish and Saxon "empires"—pursued their own interests and developed in their own ways. Two institutions gave them a certain coherence: the Christian church and feudalism. If the descendants of the barbarians had anything in common, it was, above all else, their Christianity. Feudalism, which had its origins both in barbarian custom and in late Roman institutions, preserved a stability, but it was a stability of a local kind and was naturally antagonistic to broad, centralized government.

Essentially, feudalism was an economic system based on land tenure that involved a complicated series of interpersonal relationships, obligations, and services. A feudal lord held a piece of land, a *fief,* and paid for it, not in money, but in service (often military service). Feudal obligation led downward from a lord to his vassal to the lower orders of society and ultimately to the serf, who was bound to the land and to the unquestioning service of the lord. The lords or nobles held fiefs in various ways from each other or from an overlord, such as a king. Inevitably, many of them became large landowners and were so powerful that they ignored their obligations and defied their king. Their time was spent in petty wars for the purpose of protecting or increasing the extent of their holdings. The *château fort,* or castle, surrounded by walls and moats, was the symbol and seat of feudal authority. The moldering ruins of these castles, found throughout the European countryside, recall the modern visitor to an age when government was always visible, singular, personal, and absolute.

The Romanesque baron or knight, still in the heroic tradition of the Germanic hero, was loyal, defiant, and proud. However, being a Christian, he was without the deep barbarian fatalism of the earlier Saxons and Norsemen and hoped not only for immortal honor in battle (won as much by the power of religious faith as by his own strength and courage) but also for life eternal in Heaven. These beliefs established the mood—the psychological set—of the aristocratic, warring magnates who led the Crusades and maintained the feudal system.

Monasticism, which reached its peak at the same time as feudalism, provided seclusion from the world, an assurance of salvation, and almost the only means of receiving an education. The history of monasticism, which, as we have seen, began in the early Middle Ages, is essentially a series of reform movements. Because gifts and bequests to them were potent means of assuring salvation, monasteries grew wealthy. With wealth came luxury and laxness and recurrent reforms to combat them. The reforms led to the formation of new monastic orders. The two great Romanesque orders were the Cluniac and the Cistercian. The former, which especially fostered the arts, was founded early in the tenth century and had its main abbey at Cluny near Mâcon in France. Encouraged by the Ottonian emperors, the Cluniac order owed allegiance only to the pope in Rome and formed, with the vast number of its priories scattered all over Europe, a centrally organized administration that contrasted sharply with the decentralizing tendencies of feudalism. The Cluniac reform, based on a liberal interpretation of St. Benedict's original rule, stressed intellectual pursuits, the study of music, and the cultivation of the other arts. The wealth and vast resources of the Cluniac order soon provoked still another reform—one that emphasized self-denial and the virtues of manual labor and gave rise to the Cistercian order, which also grew rapidly.

With feudalism and monasticism triumphant, the barons and the monastery clergy (the latter often themselves feudal lords) played a peculiarly cooperative role, and the feudal stratification of society into strictly separated classes was given religious sanction. Notwithstanding this cooperation, however, the chief conflict of the time was between the popes and the feudal principals—not over the justice or injustice of the feudal system but over the question of who should assume the position of the supreme feudal lord, that is, over the question of who is king.

The endless pilgrimages to innumerable shrines and the first two Crusades, which saw thousands of people trek from western Europe to the Holy Land during this period, involved great movements of population. The pilgrimage was a principal feature of medieval Christian life. Travel to the distant shrine of a saint, whose spiritually powerful relics there could be venerated, commonly was enjoined as a penitential act on which the salvation of the pilgrim depended. Outside of Rome itself, the most famous shrine in the West was that of St. James (Santiago) at Compostela in Spain. Travel, extremely dangerous in

those turbulent times, became the duty and the hope of thousands. The Crusades were a militant expansion of the pilgrimages. Crusader and pilgrim were bound by similar vows and hoped not only to expiate sin and win salvation but to glorify God and extend the power of the Church. Most important of the immediate results of the Crusades were the establishment of the Church as a leader of the people and the reopening of commerce with the great trading centers in the Near East.

Pisan ships carried the crusading barons to the Holy Land and brought back their bones. The Pisans prospered, as did the burghers of the towns that the barons left behind them and to whom they had given charters of liberty in return for financing for their campaigns. Thus, the Crusades created subcurrents of independence; the towns obtained their charters, and a middle class of merchants and craftsmen grew up to countervail the power of feudal barons and the great monasteries. A growing city culture was quick to receive new impulses from abroad. The lines of commerce, often the arteries of ideas, conveyed new learning to Europe. The Crusades, destructive as they were, effected a new insight into Greek science and philosophy through contact with Islam, which had assimilated Greek culture much earlier and, within a century, vastly expanded the rather limited store of knowledge possessed by the Carolingians and Ottonians.

Not the least of the effects of the Crusades on the West was a new and stimulating impulse from the civilization and art of Byzantium. The disruption of the Byzantine world wrought by Crusader aggression and traffic opened to the relatively backward West new markets for ideas, new avenues of learning, and new models for art. Western European sculpture and painting came under the dominating and fertile influence of Byzantine prototypes, so much so that, despite their own integrity and quality, many western European works almost can be classified among the peripheral provinces of Byzantine art. (A style that appears at some distance from its origin, in an artistic "province" rather than at an artistic "capital," is termed *provincial*.) Classical naturalism, always latent in the figural art of Byzantium, will, in Western art, break out of Byzantine formal conventions and assume a new naturalistic form during the course of the thirteenth century.

ARCHITECTURE

As a term, *Romanesque* first was used in the nineteenth century to designate buildings with round arches and blunt, heavy walls that were supposed to bear some resemblance to ancient Roman architecture, just as the developing "Romance" languages were related to Latin. Although the Romanesque style varies widely and embraces numerous provincial differences within its almost two-century span, architectural historians now regard it as complete within itself and not as the imperfect antecedent of the Gothic style. Thus, despite its variety, Romanesque architecture readily is recognizable as such. An aerial view of the church of St. Sernin at Toulouse in the south of France (FIG. 9-3) shows certain features that appear in Romanesque buildings no matter how their arrangement differs. An overall blocky appearance is characteristic. A grouping consists of large, simple, easily definable, geometric masses—rectangles, cubes, cylinders, and half-cylinders. The main masses are subdivided by enframing buttresses or colonnettes. Exterior wall surfaces, which had been plain and unadorned through the Ottonian period, now reflect the interior organization of the structure. This enlivening of formerly blank wall surfaces foreshadows the structural translucency that would typify Gothic architecture.

The new demands of a people with religious as well as commercial reasons to travel shaped the new architecture. The building impulse, which became almost a medieval obsession, was noted by an eleventh-century monk, Raoul Glaber, who wrote:

> There occurred, throughout the world, especially in Italy and Gaul, a rebuilding of church basilicas. Notwithstanding, the greater number were already well established and not in the least in need, nevertheless each Christian people strove against the others to erect nobler ones. It was as if the whole earth, having cast off the old . . . were clothing itself everywhere in the white robe of the church.*

Glaber does not mention that a contributing cause of this eleventh-century building "obsession" may have been the widely felt relief and thanksgiving that the millennium (1000) did not bring an end to the world, as had been feared.

Great building efforts were provoked not only by the pilgrimages and the Crusades and the needs of growing cities, but also by the fact that hundreds of churches (notably in Italy and France) had been destroyed during the depredations of the Norsemen and the Magyars. Architects of the time seemed to see their fundamental problem in terms of providing a building that would have space for the circulation of its congregations and visitors and that would be solid, fireproof, well lighted, and acoustically suitable. These requirements, of course, are the necessities

*In E. G. Holt, ed., *Literary Sources of Art History* (Princeton, NJ: Princeton University Press, 1947), p. 3.

of any great civic or religious architecture, as we saw in ancient Rome, but in this case, fireproofing must have been foremost in the builders' minds, for the wooden roofs of the pre-Romanesque churches of Italy, France, and elsewhere had burned fiercely and totally when set aflame by the marauders from north, east, and south in the ninth and tenth centuries. The memory was fresh in the victims' minds; the new churches would have to be covered with cut stone, and the structural problems that arose from this need for a solid masonry were to help determine the "look" of Romanesque architecture.

Languedoc-Burgundy

A fascinating building of the so-called First Romanesque period, in which a variety of experimental solutions to the vaulting problem are illustrated, is the church of St. Philibert at Tournus on the Saône river in Burgundy (FIGS. **9-1** and **9-2**). The long and complex building history of this church explains, in part, the curious assembly of various vaulting systems found in it. Of the original building, which was begun around 950, only the crypt survived a disastrous fire in 1008. The rebuilt church was consecrated in 1019, although the nave was not vaulted until 1066 and the crossing and choir were not completed until 1120. The new choir was built according to the plan of the crypt below it, but the original westwork was replaced with a two-story narthex.

The unusual variety of vaults resulted when each successive generation of builders addressed the problem of vaulting anew and produced fresh and ingenious solutions. In the crypt, the builders used small groin vaults over square areas defined by slender, supporting columns; the corridor surrounding the central area was covered by a curving barrel vault. The vaulting of the narthex, which probably was completed by 1019, is more complex. The groin-vaulted square bays of the ground floor's central passage are flanked by aisles slightly less than half as wide as the nave; they had to be covered with shallow barrel vaults, as true groin vaults can be erected only over square areas. Above this entrance hall, on the second level, stands a three-aisled chapel dedicated to St. Michael. Here, the central nave is covered by a longitudinal barrel vault that is buttressed by *quadrant vaults* (half-barrel vaults) over the flanking aisles. Most remarkable is the main church, where groin-vaulted aisles flank a nave that rises to a series of five parallel, transverse barrel vaults that buttress each other and obviate the massive side walls that a single, longitudinal vault would have required. This solution also allowed the builders to cut generous clerestory windows into the end walls of the barrels,

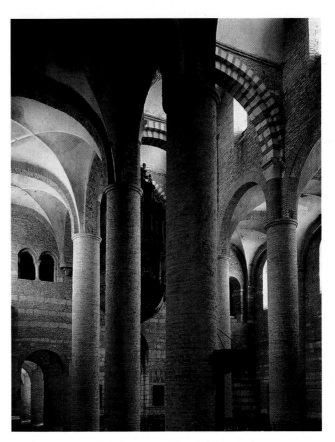

9-1 Interior of St. Philibert, Tournus, France, c. 950–1020 and later.

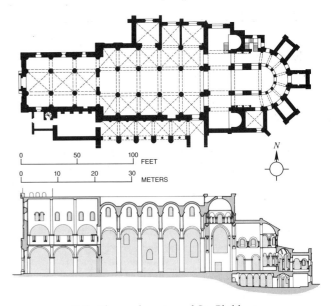

9-2 Plan and section of St. Philibert.

which serve no major supporting function. As a result, the interior is adequately illuminated and light can play with marvelous effect over the simple, curved surfaces of the ceiling and the sturdy, cylindrical columns.

Just about all known vaulting methods, except the dome, were explored in this single building—a ready-to-choose-from collection of solutions for later builders. (As we will soon see, Burgundian masons opted for the longitudinal barrel vault.) But possibly an even more important and influential feature of this unique building is revealed by the plan of the choir (FIG. 9-2), which, if it does not repeat that of the one destroyed by the fire of 1008, does duplicate that of the crypt of 950. The monks' choir is surrounded by an ambulatory from which a series of chapels (and a stairwell) radiate outward. The ambulatory afforded easy circulation for the pilgrims who came to venerate the relics of St. Philibert, without interrupting the monks' obligations. This arrangement, in which subordinate chapels and ambulatories are ingeniously integrated, was to become, with due modifications, a standard feature of later pilgrimage churches.

St. Sernin at Toulouse (FIG. **9-3**) was one of the churches constructed in the Cluniac-Burgundian style that may have profited from the experiments made at Tournus; it met the requirement of a stone ceiling by using a semicircular barrel vault below a timber-roofed loft. Such churches dominated much of southern France and were related closely to those built along the pilgrimage road to Santiago de Compostela in northwest Spain. The plan of St. Sernin (FIG. **9-4**) is one of extreme regularity and geometric precision. The crossing square, flanked by massive piers and marked off by heavy arches, has been used as the module for the entire body of the church. In this *square schematism*, each nave bay measures exactly one-half and each square in the aisles exactly one-quarter of a crossing square, and so on throughout the building. The first suggestion of such a planning scheme was seen almost three centuries earlier in the St. Gall plan (FIG. 8-22). Although St. Sernin is neither the earliest nor the only (perhaps not even the ideal) solution, it does represent a crisply rational and highly refined realization of the germ of an idea first seen in Carolingian designs.

A view of the interior (FIG. **9-5**) shows that this geometric floor plan is fully reflected in the nave walls, which are articulated by half-columns that rise from the corners of each bay to the springing of the vault and are continued across the nave as transverse arches. Ever since Early Christian times, basilican interiors had been framed by long, flat walls between arcades and clerestories that enclosed a single, horizontal, unbroken volume of space. Now the aspect of the nave is changed radically, so that it seems to be composed of numerous, identical, vertical volumes of space that have been placed one behind the other, marching down the length of the building in orderly procession. This segmentation of St. Sernin's interior

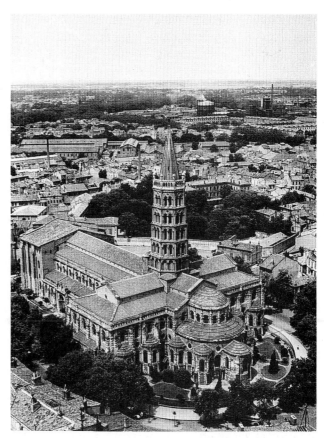

9-3 Aerial view of St. Sernin, Toulouse, France, c. 1080–1120 (view from the southeast).

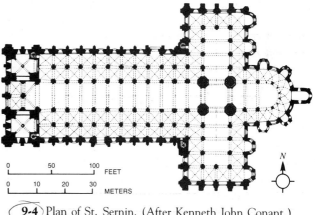

9-4 Plan of St. Sernin. (After Kenneth John Conant.)

space corresponds with and renders visual the geometric organization of the building's plan and also is reflected in the articulation of the building's exterior walls. The result is a structure in which all parts have been integrated to a degree unknown in earlier Christian architecture.

The grand scale of St. Sernin at Toulouse is frequent in Romanesque churches. The popularity of pilgrimages and of the cult of relics brought great

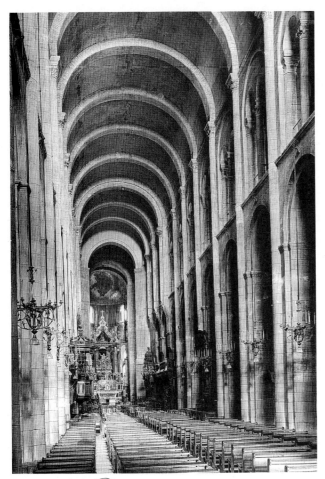

9-5 The nave of St. Sernin.

crowds even to relatively isolated places, and large congregations were common at the shrines along the great pilgrimage routes and in the reawakening cities. Additional space was provided by increasing the length of the nave; by doubling the side aisles; and by building, over the inner aisle, upper galleries, or *tribunes*, to accommodate overflow crowds on special occasions. Circulation was complicated, though, as the monks' choir often occupied a good portion of the nave. As seen in St. Philibert at Tournus, an extension of the aisles around the eastern end to make an ambulatory facilitated circulation, and the opening of the ambulatory (and often of the transepts) into separate chapels (as at St. Sernin) provided more space for worshipers and for liturgical processions. Not all Romanesque churches were as large as St. Sernin, however, nor did every one have an ambulatory with radiating chapels, but such chapels are typical Romanesque features, especially when treated as separate units projecting from the mass of the building.

The continuous, cut-stone barrel (or tunnel) vaults at St. Sernin (FIG. 9-5) put constant pressure along the entire length of the supporting masonry. If, as in most instances, including St. Sernin, the nave was flanked by side aisles, then the main vaults rested on arcades and the main thrust was transferred to the thick outer walls by the vaults over the aisles. In larger churches, the tribune galleries and their vaults (in cross section, often a quadrant, embracing a ninety-degree arc) were an integral part of the structure, buttressing the high vaults over the nave. The wall-vault system at St. Sernin is successful in its supporting function; its great scale provides ample space, and its squaring-off into cleanly marked bays, as well as the relief of wall and pier, are thoroughly Romanesque. But the system fails in one critical requirement—that of lighting. Due to the great thrust exerted by the barrel vault, a clerestory was difficult to construct, and windows cut into the haunch of the vault would make it unstable. A more complex and efficient type of vaulting was needed. One might say that, structurally, the central problem of Romanesque architecture was the development of a masonry vault system that admitted light.

In working toward this end, Romanesque architectural ingenuity produced numerous experimental consequences that appear as a rich variety of substyles. We already have mentioned that one of the apparently confusing features of Romanesque architecture is the great variety of regional and local building styles—a variety that still makes classification, coordination, and interpretation very difficult for scholars. Ten or more types may be identified in France alone, each with its distinctive system of vaulting and its varying solutions to the problems of lighting the interior.

Among the numerous experimental solutions, the groin vault turned out to be the most efficient and flexible. The groin vault had been used widely by Roman builders, who saw that its concentration of thrusts at four supporting points would allow clerestory fenestration (see FIG. 6-53). The great Roman vaults were made possible by an intricate system of brick-and-tile relieving arches, as well as by the use of concrete, which could be poured into forms, where it solidified into a homogeneous mass. The technique of mixing concrete did not survive into the Middle Ages, however, and the technical problems of building groin vaults of cut stone and heavy rubble, which had very little cohesive quality, limited their use to the covering of small areas. But during the eleventh century, Romanesque masons, using cut stone joined by mortar, developed a groin vault of monumental dimensions. Although it still employed heavy buttressing walls, this vault eventually evolved into a self-sufficient, skeletal support system.

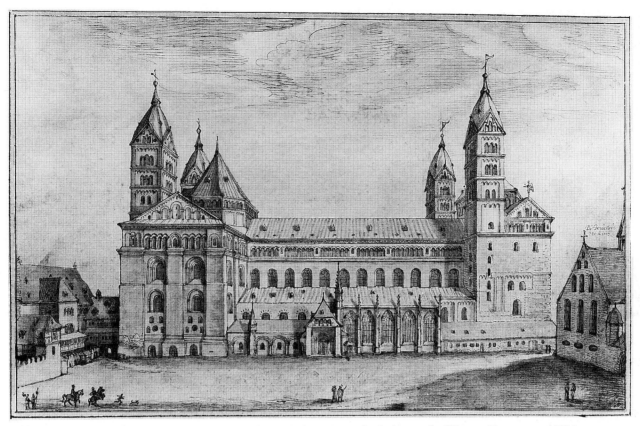

9-6 Speyer Cathedral, West Germany, begun 1030. (Pen-and-ink drawing by WENZEL HOLLAR, *c.* 1620.)
Graphische Sammlung Albertina, Vienna.

Germany-Lombardy

The progress of vaulting craft can be seen best in two regions: Germany-Lombardy and Normandy-England. Speyer Cathedral in the German Rhineland (FIGS. **9-6** to **9-9**) was begun in 1030 as a timber-roofed structure. When it was rebuilt by the emperor Henry IV, between 1082 and 1106, it was covered with groin vaults. Thus, it may be one of the earliest, fully vaulted Romanesque churches in Europe. Its exterior preserves the Ottonian tradition of balanced groups of towers east and west but adds to it a rich articulation of wall surfaces. A great many of the decorative features, such as the arcades under the eaves, the stepped arcade gallery under the gable, and the moldings marking the stages of the towers, may be of Lombard origin. The inspiration for the groin vaults covering the aisles also may be Lombardic; groin-vaulting on a small scale had been used by Lombard builders throughout the early Middle Ages. The large groin vaults covering the nave (FIG. **9-8**), however—probably the achievement of German masons—represent one of the most daring and successful vaulting enterprises of the time. (The nave is 45 feet wide, and the crowns of the vaults are 107 feet high.)

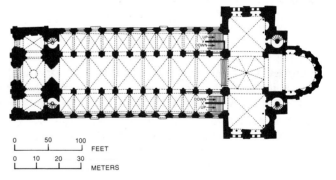

9-7 Plan of Speyer Cathedral.

The plan of the cathedral (FIG. **9-7**) shows that the west apse and the lateral Ottonian entrances have been eliminated and that the entrance has been moved back to the west end, reestablishing the processional axis leading to the sanctuary. The marked-off crossing, covered by an octagonal dome, has been used as the module for the arrangement of the building's east end. Because the nave bays are not square, the use of the crossing as a unit of measurement is not as obvious. In fact, the length of the nave is almost four times the crossing square, and every third wall support marks off an area in the nave the size of

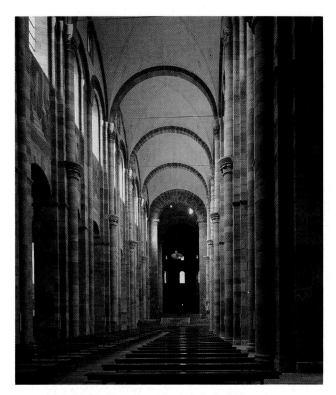

9-8 Interior of Speyer Cathedral.

the crossing; the aisles are half the width of the nave. Although the plan has some irregularities and has not been worked out as neatly and precisely as the plan of St. Sernin, the builders' intention to apply the square schematism is quite clear. Curiously, the alternate-support system, which now is carried all the way up into the vaults (FIG. 9-8), does not seem to reflect the square schematism of the building's plan. This discrepancy may be explained by the fact that the original building of 1030 was a timber-roofed structure and that the walls were articulated by a series of identical shafts that rose to enframe the clerestory windows (FIG. 9-9). The alternate-support system was introduced in the 1080s (when the building was vaulted), perhaps partially to strengthen the piers at the corners of the large vaults and to provide bases for the springing of the transverse arches across the nave. The builders may have chosen to use every other support to anchor a nave vault simply because the walls were not as stable as the massive piers that carry the crossing dome, so that it would be safer to reduce each area to be vaulted by one-third. The resultant bay arrangement, in which a large unit in the nave is flanked by two small units in each aisle, becomes almost standard in northern Romanesque architecture. Speyer's interior shows the same striving for height and the same compartmentalized effect shown in St. Sernin. By virtue of the use of the alternate-support system, the rhythm of the Speyer nave

is a little more complex—a little richer, perhaps—and because each compartment is individually vaulted, the effect of a sequence of vertical blocks of space is even more convincing.

From Carolingian times, Rhineland Germany and Lombardy had been in close political and cultural contact, and it generally is agreed that the two areas cross-fertilized each other artistically. But no such agreement exists as to which source of artistic influence was dominant: the northern or the southern. The question, no doubt, will remain the subject of controversy until the construction date of the church of Sant' Ambrogio in Milan, the central monument of Lombard architecture, can be established unequivocally. Dates ranging from the tenth to the early twelfth century have been advanced for the present building, which was preceded by an earlier church that dated back to the fourth century; the late eleventh and early twelfth centuries apparently are most popular with architectural historians today.

9-9 Reconstruction of the original nave of Speyer Cathedral, c. 1030–1060.

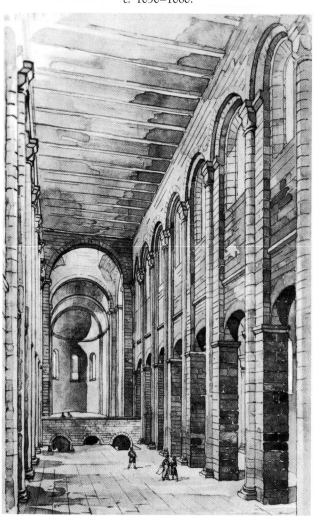

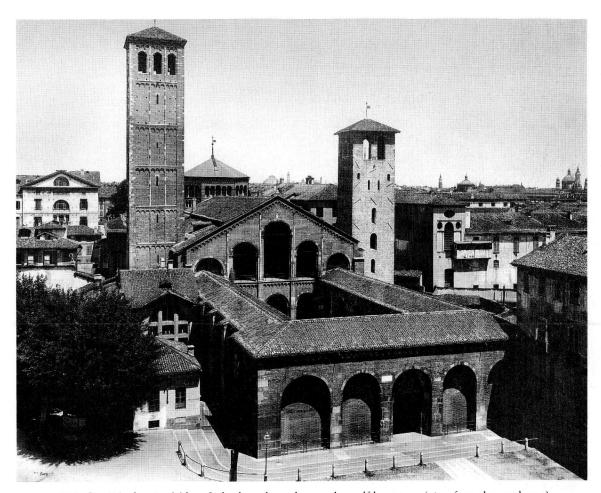

9-10 Sant' Ambrogio, Milan, Italy, late eleventh to early twelfth century (view from the northwest).

Whether or not it is a prototype, Sant' Ambrogio remains a remarkable building. As shown in FIG. **9-10,** it has an atrium (one of the last to be built), a two-story narthex pierced by arches on both levels, two towers joined to the building, and, over the east end of the nave, an octagonal tower that recalls the crossing towers of German churches. Of the façade towers, the shorter one dates back to the tenth century, while the taller north tower was built during the twelfth century. The latter is a sophisticated and typical example of Lombard tower design; it is articulated by pilasters and shafting and divided, by means of corbel tables (horizontal projections resting on corbels), into a number of levels, of which only the topmost (the bell chamber) has been opened by arches.

In plan (FIG. **9-11**), Sant' Ambrogio is three-aisled and without a transept. The square schematism has been applied with greater consistency and precision than at Speyer, each bay consisting of a full square in the nave flanked by two small squares in each aisle, all covered with groin vaults. The main vaults are slightly domical, rising higher than the transverse arches, and the last bay is covered by an octagonal

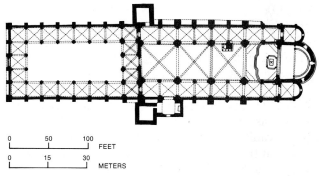

9-11 Plan of Sant' Ambrogio.

dome that provides the major light source (the building lacks a clerestory) for the otherwise rather dark interior (FIG. **9-12**). The geometric regularity of the plan is reflected perfectly in the emphatic alternate-support system, in which the light supports are interrupted at the gallery level and the heavy ones rise to support the main vaults. These ponderous vaults, which have supporting arches along their groins, are occasionally claimed to be the first examples of

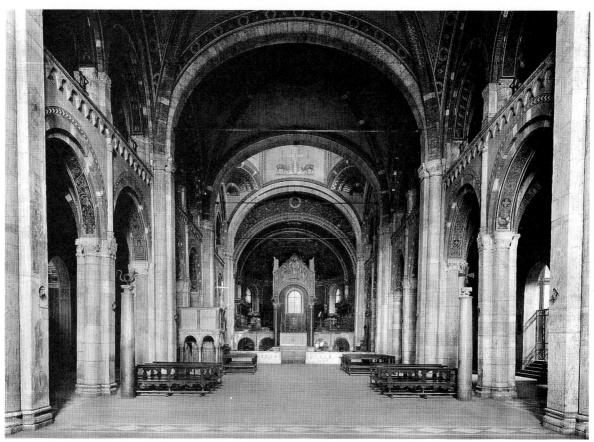

9-12 Interior of Sant' Ambrogio.

rib-vaulting; however, in fact, these vaults are solidly constructed groin vaults that have been strengthened by diagonal ribs.

The dating of the Sant' Ambrogio vaults remains controversial. Most scholars seem to feel that they were not built until after 1117, when a severe earthquake damaged the existing building. If 1117 is the correct date, the Speyer vaults would be earlier than the vaults of Sant' Ambrogio, and the inspiration and technical knowledge for the construction of groin vaults of this size would seem to have come from the north. But such possible influence did not affect the proportioning of the Milanese building, which does not aspire to the soaring height of the northern churches. Sant' Ambrogio's proportions are low and squat and remain close to those of Early Christian basilicas. As we will see, Italian architects never accepted the verticality found in northern architecture, not even during the height of the Gothic period.

The fame of German architecture rests on its achievements in the eleventh and early twelfth centuries. After the mid-twelfth century, the Germans made no major contribution to architectural design. The architectural statements at Speyer were repeated at Worms and Mainz and in other, later churches.

German builders were content with refining their successful formula; beyond that, they tended to follow the lead of the more adventurous and progressive Franks and Normans.

Normandy-England

The predatory, pagan Vikings settled in northwestern France after their conversion to Christianity in the tenth century and, almost at once, proved themselves skilled administrators and builders. With astounding rapidity, they absorbed the lessons to be learned from Ottonian architecture and went on to develop the most progressive of the many Romanesque styles and the one that was to become the major source in the evolution of Gothic architecture. The church of St. Étienne at Caen in Normandy is generally considered to be the master model of Norman Romanesque architecture. It was begun by William of Normandy (William the Conqueror) in 1067 and must have advanced rapidly, as he was buried there in 1087. The west façade (FIG. **9-13**) is a striking design that looks forward to the two-tower façades of later Gothic churches. Four large buttresses divide it into three bays that correspond to the nave and aisles in the

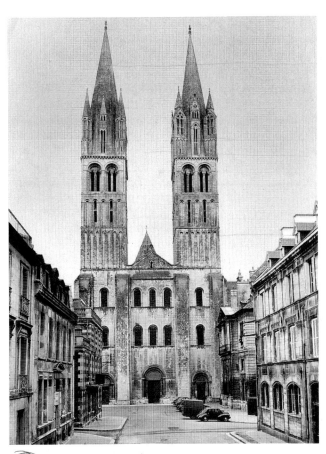

9-13 West façade of St. Étienne, Caen, France, begun 1067.

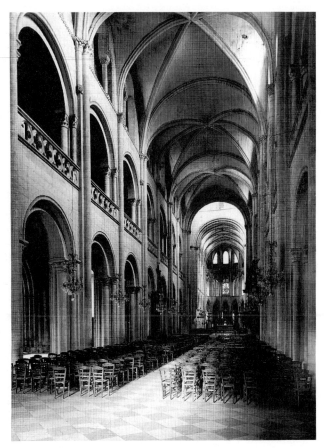

9-14 Interior of St. Étienne, vaulted *c.* 1115–1120.

interior. Above their buttresses, the towers also display a triple division and a progressively greater piercing of their walls from lower to upper stages. The spires are a later (Gothic) feature. The tripartite division is employed throughout the façade, both vertically and horizontally, organizing it into a close-knit, well-integrated design that reflects the careful and methodical planning of the entire structure. Like Speyer Cathedral, St. Étienne originally was planned to have a wooden roof, but, from the beginning, the walls were articulated in an alternating rhythm (simple half-columns alternating with shafts attached to pilasters) that mirrors the precise square schematism of the building's plan (FIGS. **9-14** and **9-15**). This alternate-support system was utilized effectively some time after 1110 (significantly later than it was used at Speyer), when it was decided to cover the nave with vaults. Its original installation, however, must have been motivated by esthetic rather than structural concerns. In any event, the alternating compound piers soar all the way to the springing of the vaults, and their branching ribs divide the large, square-vault compartments into six sections, making a sexpartite vault. These vaults, their crowns slightly depressed to avoid the "domed-up" effect of those at Sant'

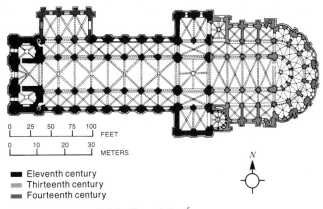

9-15 Plan of St. Étienne.

Ambrogio, rise high enough to make an efficient clerestory; they also are viewed as some of the earliest true *rib vaults*, in which the diagonal and transverse ribs compose a structural skeleton that partially supports the still fairly massive paneling between them. Rib-vaulting was to become universal practice during the Gothic period, and its development by Norman builders must be rated as one of the major structural innovations of the Middle Ages. Other elements in St. Étienne also point to the future. The complex

piers, their nuclei almost concealed by attached pilasters and engaged columns, forecast the Gothic "cluster pier," and the reduction in interior wall surfaces that resulted from use of very large, arched openings anticipates the bright curtain walls of Gothic architecture. In short, St. Étienne at Caen is not only a very carefully designed structure but also a highly progressive one in which the Romanesque style begins to merge into the Early Gothic.

The conquest of Anglo-Saxon England in 1066 by William of Normandy began a new epoch in English history; in English architecture, it signaled the importation of Norman building and design methods. Durham Cathedral in northern England, begun around 1093, apparently was designed for vaulting at the outset. Like most Romanesque churches in England, it was subjected to many later alterations that, in this case, fortunately were confined largely to the exterior; the interior (FIG. 9-16) has its original severe Romanesque appearance. Ambitious in scale—comparable to both St. Sernin at Toulouse and St. Étienne at Caen—its 400-foot length compares favorably with that of the great imperial cathedral of Speyer. With the latter, it also shares a reliance on mass for stability. But unlike Speyer, this building was conceived from the very beginning as a completely integrated skeleton in which the vaults stand in intimate and continuous relation to the vertical elements of the compound piers that support them. At Durham, the alternate-support system is interpreted with blunt power and more emphasis, perhaps, than in any other Romanesque church. Large, simple pillars ornamented with abstract designs (diamond, chevron, and cable patterns descended from the metalcraft ornamentation of the migrations) alternate with compound piers that carry the transverse arches of the vaults. The pier–vault relationship scarcely could be more visible or the structural rationale of the building better expressed. The plan (FIG. 9-17), typically English with its long, slender proportions and strongly projecting transept, does not develop the square schematism with the same care and logic we see at Caen. But the rib vaults of the choir are the earliest in Europe (1104), and, when they were combined with slightly pointed arches in the western parts of the nave (before 1130), the two key elements that would determine the structural evolution of Gothic architecture were brought together for the first time. Only the rather massive construction and the irregular division into seven panels prevent these vaults from qualifying as Early Gothic structures.

Among the numerous regional Romanesque styles of architecture, it was the northern—more specifically, the Norman—style that indirectly would influence the development of Gothic architecture; no other style had as great a potential for evolution.

9-16 The nave of Durham Cathedral, England, begun *c.* 1093 (view facing east).

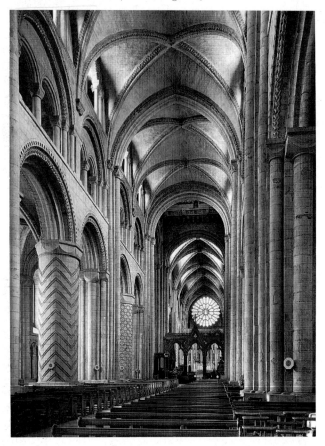

9-17 Plan of Durham Cathedral. (After Kenneth John Conant.)

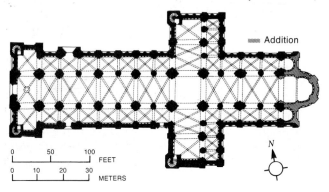

Addition

0 50 100 FEET
0 10 20 30 METERS

N

Tuscany

South of the Lombard region, Italy retained its ancient traditions and, for the most part, produced Romanesque architecture that was structurally less experimental than that of Lombardy. The buildings of Tuscany seem to adhere more closely than those of any other region to the traditions of the Early Christian basilica. The cathedral group of Pisa (FIG. 9-18)

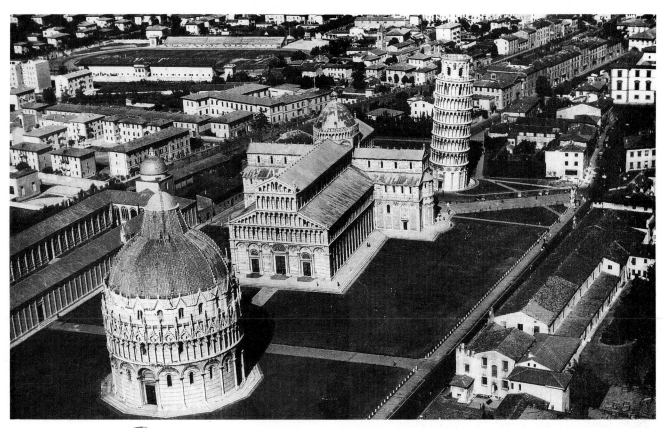

9-18 Aerial view of the cathedral group (baptistry, cathedral, and campanile) of Pisa, Italy, 1053–1272 (view from the southwest).

manifests, in addition to these conservative qualities, those of the great Classical "renaissance" of the late eleventh and twelfth centuries, when architects, craftsmen, poets, and philosophers again confronted Classical-Christian prototypes and interpreted them in an original yet familiar way. The cathedral is large, five-aisled, and one of the most impressive and majestic of all Romanesque churches. At first glance, it resembles an Early Christian basilica, but the broadly projecting transept, the crossing dome, the rich marble incrustation, and the multiple arcade galleries of the façade soon distinguish it as Romanesque.

The interior (FIG. 9-19) also at first suggests the basilica, with its timber roof rather than vault (originally the rafters were exposed, as in Early Christian basilicas), nave arcades, and Classical (imported) columns flanking the nave in unbroken procession. Above these columns is a continuous, horizontal molding, on which rest the gallery arcades. The gallery, of course, is not a basilican feature but is of Byzantine origin. Other divergences from the basilica form include the relatively great verticality of the interior and, at the crossing, the markedly un-Classical pointed arch, which probably was inspired by Islamic architecture. The striped incrustation, produced by alternating dark green and cream-colored marble,

9-19 The nave of the cathedral of Pisa (view facing east).

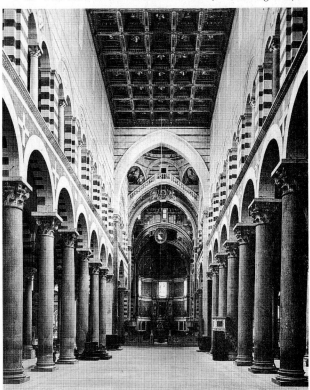

provides a luxurious polychromy that will become a hallmark of Tuscan Romanesque and Gothic buildings. The leaning campanile, the result of a settling foundation, tilted from the vertical even while it was being built and now inclines some 21 perilous feet out of plumb at the top. Round, like the Ravenna campaniles, it is much more elaborate; its stages are marked by graceful, arcaded galleries that repeat the motif of the cathedral's façade and effectively relate the tower to its mother building. Although the baptistry, with its partly remodeled Gothic exterior, may strike a slightly discordant note, the whole composition of the three buildings, with the adjacent Campo Santo (cemetery), makes one of the handsomest ensembles in the history of architecture. This grouping dramatically expresses the new building age that the prosperity enjoyed by the busy maritime cities of the Mediterranean made possible.

Another Tuscan church, San Miniato al Monte (FIG. 9-20) in Florence, completed in 1062, recalls Early Christian architecture, although the wall arcading

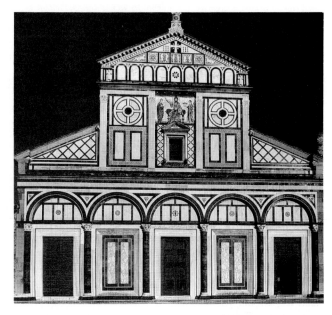

9-20 West façade of San Miniato al Monte, Florence, Italy, completed 1062.

9-21 Interior of San Miniato al Monte (view facing east).

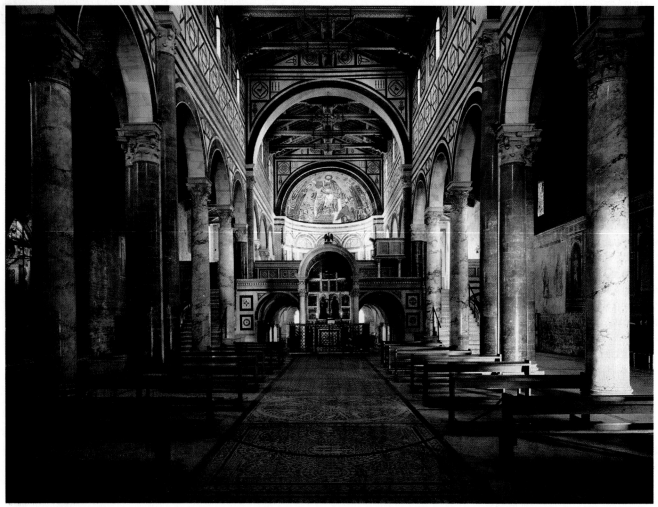

and its elaborate, geometric incrustation in colored marbles make for a rich ornamental effect foreign to the austere exteriors of the earlier buildings. Retrospective as San Miniato may appear externally, the interior (FIG. **9-21**) is another matter. Although the church is timber-roofed, as are most Tuscan Romanesque churches, the nave is divided into three equal compartments by *diaphragm arches* that rise from compound piers. The piers alternate with pairs of simple columns in a rhythm that recalls St. Michael's in Hildesheim (FIG. 8-26). The diaphragm arches, which appear here for the first time (before 1060), have multiple functional and esthetic purposes. They brace the rather high, thin walls, provide firebreaks within the wooden roof structure, and compartmentalize the basilican interior in the manner so popular with most Romanesque builders. Antique, or neo-Antique, motifs appear in the capitals as well as in the incrustation, expressing again the persistence of the Classical tradition in Tuscany.

Aquitaine

Influences crisscrossed in Romanesque architecture, creating diversity and exotic hybrids. In the region of Aquitaine in southwestern France, for instance, it became customary to roof the churches with domes, reflecting the influence of Byzantium, Armenia, and Cyprus—the Crusaders' bridge between East and West. Curiously, most of these Aquitanian churches mate the dome with a longitudinal plan to which, at first glance, it seems ill-suited. St. Pierre in Angoulême (FIGS. **9-22** and **9-23**) exhibits several characteristic features of the typical Aquitanian church. A longitudinal, aisleless nave is covered by a sequence of domes (see FIG. 7-45), which, in turn, usually are covered by pitched wooden roofs. The resulting design turns out to be highly practical, as the pendentive-supported domes require much less buttressing than, for instance, continuous barrel vaults. Also, the system automatically produces the cherished compartmentalized effect of Romanesque architecture. Although they never aimed at the soaring height of northern Romanesque structures, these Aquitanian domed churches not only represent an almost perfect fusion of geometric plan with elevation, but also are visually most effective, clearly exhibiting the functions of all their structural parts.

From about 1050 on, the old dependence of the pre-Romanesque (Carolingian and Ottonian) on Late Antique and Early Christian design concepts fades gradually, although never completely. Romanesque architecture develops a number of clear characteristics: the square schematism, the alternate-support system, and the increased relief and depth of walls

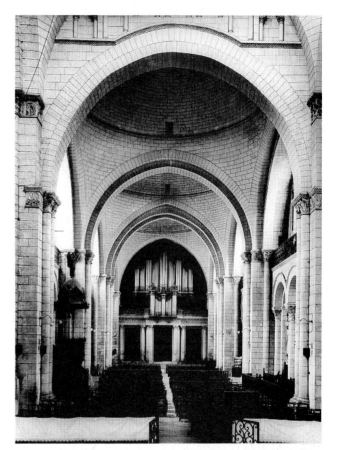

9-22 Interior of St. Pierre, Angoulême, France, twelfth century (view facing west).

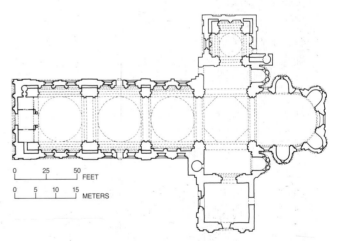

9-23 Plan of St. Pierre.

and piers as they connect with the vaults above. The Romanesque architect conceives a building in terms of the geometric relation of its parts, a view basically different from that of the Early Christian architect, who never thought of large units as related geometrically and who thought of the wall not as essentially a structural element, but as a surface to receive applied decoration.

SCULPTURE

For Medieval art, the first definite relation of architecture and sculpture appears in the Romanesque style. Figurative sculpture, confined for centuries to small art, flowers again in the new Romanesque churches of the mid-eleventh century. The rich profusion of sculpture and something of its nature may be guessed from Bernard of Clairvaux's famous tirade against it, written in 1127:

> I say naught of the vast height of your churches, their immoderate length, their superfluous breadth, the costly polishings, the curious carvings and paintings. . . . [Men's] eyes are feasted with relics cased in gold, and their purse-strings are loosed. They are shown a most comely image of some saint, whom they think all the more saintly that he is the more gaudily painted. Men run to kiss him, and are invited to give; there is more admiration for his comeliness than veneration for his sanctity. Hence the church is adorned with gemmed crowns of light. . . . candelabra standing like trees of massive bronze, fashioned with marvellous subtlety of art, and glistening no less brightly with gems than with the lights they carry. . . . O vanity of vanities, yet no more vain than insane! The church is resplendent in her walls, beggarly in her poor; she clothes her stones in gold and leaves her sons naked. . . . in the cloister, under the eyes of the Brethren who read there, what profit is there in those ridiculous monsters, in that marvellous and deformed comeliness, that comely deformity? To what purpose are those unclean apes, those fierce lions, those monstrous centaurs, those half-men, those striped tigers, those fighting knights, those hunters winding their horns? Many bodies are there seen under one head, or again, many heads to a single body. . . . For God's sake, if men are not ashamed of these follies, why at least do they not shrink from the expense?*

Stone sculpture had almost disappeared from the art of western Europe during the eighth and ninth centuries. The revival of the technique is one of the most important Romanesque achievements. As stone buildings began to rise again, so did the impulse to decorate parts of the structure with relief carving in stone. One might expect that the artists should turn for inspiration to surviving Roman sculpture and to sculptural forms such as ivory carving or metalwork; it is obvious that they also relied on painted figures in manuscripts. But these Romanesque artists developed their own attitude toward ornamental design and its relation to architecture. At first, this concept was somewhat random and haphazard; the artists put the sculpture wherever there seemed to be a con-

*In E. G. Holt, ed., *Literary Sources of Art History* (Princeton, NJ: Princeton University Press, 1947), pp. 17–18.

venient place. A little later, the portals of the church seemed the appropriate setting, both for religious reasons and for the practical matter of display. As Romanesque sculpture turns into Gothic, the portal statuary becomes integrated with the design of the whole façade, following the lines of the architecture.

An example of the earlier, looser arrangement, in which sculpture is not yet an intrinsic part of the architecture, is the figure of *Christ in Majesty*, the center piece of a group of seven marble slabs affixed to the wall of the ambulatory of the church of St. Sernin at Toulouse (FIG. **9-24**). The sculptured figures represent angels introducing saints to Christ. An inscription on a marble altar, part of the group, indicates that these figures were all part of an ensemble, a shrine dedicated to St. Saturninus (St. Sernin), and that the artist was a certain BERNARDUS GELDUINUS. These works of Gelduinus from the year 1096 are the first indisputably datable specimens of monumental Romanesque sculpture in France. The sources of Gelduinus's style are debated; certainly, a principal one must be a Carolingian or Ottonian work in metal or ivory, perhaps a book cover. The polished marble has the gloss of both materials. Christ is seated in a mandorla, his

9-24 *Christ in Majesty,* from the ambulatory of St. Sernin, Toulouse, France, 1096.

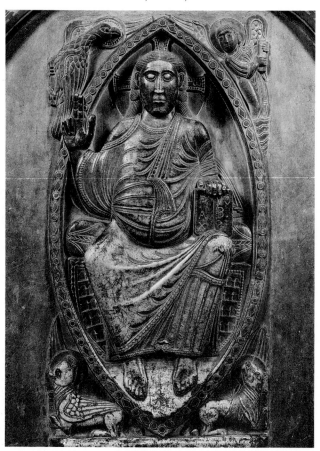

right hand raised in blessing, his left hand resting on an open book inscribed *"Pax vobis."* The Signs of the Evangelists occupy the corners of the slab: above, the Eagle of St. John and the Angel of St. Matthew, below, the Ox of St. Luke and the Lion of St. Mark. Though at this time sculpture is not structurally integrated with the architectural elements, the discrete slabs are arranged so as to make an iconographically readable group. We shall see presently that in the later mode of sculptural composition the architectural limits of the parts of a portal, or the shapes of a pier or capital, were respected as an integrating framework for sculpture. Typically, the Romanesque portal reveals this integration of sculpture in architecture. At Vézelay (FIG. 9-33) and at St. Trophime, Arles (FIG. 9-35), the standard elements are revealed: jambs, lintel, semicircular tympanum (beneath the arches [or archivolts]), the pier *(trumeau)* in the middle of the doorway (FIG. **9-25**).

Before the elements of the Romanesque portal were assembled in a unified design, they were placed in isolation inside or outside the church building, without any apparent scheme of organization. The St. Sernin figure, as we have seen, is set into the ambulatory wall. At St. Génis-des-Fontaines in the extreme south of France, sculpture appears in the lintel over a doorway (FIG. **9-26**). Dated 1020 by inscription, the quite primitive style is more or less characteristic of what we call "First Romanesque." It is representative

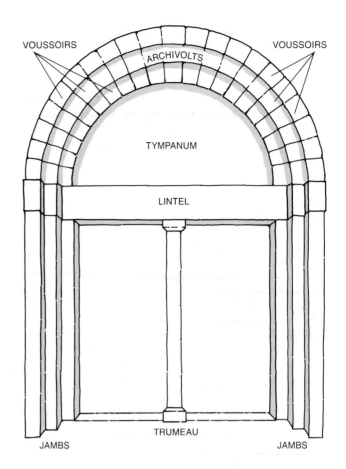

9-25 Diagram of a Romanesque portal.

9-26 *Christ in Majesty with Apostles,* lintel over doorway, St. Génis-des-Fontaines, France, *c.* 1019–1020. Marble, 24" high.

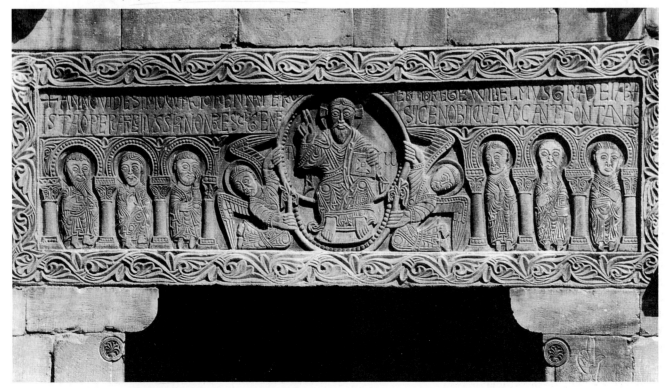

of developments in sculptural art common to northeastern Spain, southern France, and northern Italy, an artistically integrated region that can be considered as originative of Romanesque art. On the lintel at St. Génis-des-Fontaines, Christ is enthroned in a lobed mandorla supported by angels and is flanked by apostles in an arcade. The latter motif goes back centuries to Late Antiquity. Some Late Antique or Early Christian sarcophagus, or perhaps some later Carolingian or Ottonian derivative therefrom, may have been the sculptor's prototype. Whatever his source, he has translated its images into his own rudimentary idiom and similarly has adapted the original's ornament in the foliate motifs of the frame.

Almost a century later, the full Romanesque style emerges in the sculptured frieze of the façade of the Modena Cathedral in northern Italy (FIG. **9-27**). The sculpture, which extends on two levels across three bays of the façade, represents scenes from Genesis. The segment shown illustrates the *Creation and Temptation of Adam and Eve* (Genesis 2, 3:1–8) and, at the far left, Christ in a mandorla held by angels—the theme of the central section of the lintel at St. Génis-des-Fontaines. But here the style and execution are far more mature in representational sophistication. The frieze is the work of a master craftsman, whose name (Wiligelmus) is given in an inscription on another relief on the façade. The name is German, and the sculptor is believed to have been a German gold-smith. If so, the close relationship of Germany and Lombardy is indicated here in architecture as well as in sculpture. The figures have broken through the constriction of the arcade to make for a more continuous narrative. They are no longer in flat pattern but are cut in deep relief, some parts almost entirely in the round. The origins of the authoritative style of Wiligelmus are obscure. His prototypes may have been fragments of Late Antique sarcophagi, Carolingian ivories, or the panels of doors like those at Hildesheim (FIG. 8-27). The rectilinear shape and the arrangement of the frieze suggest that it may have been inspired by sculptured altar frontals; as yet, the shape and arrangement are not logically related to the architecture of the façade, as the sculpture of the great Romanesque portals will be. Yet the Modena sculpture of Wiligelmus, whose work the inscription rightfully honors, is an outstanding and abrupt introduction to a new artistic style—"High Romanesque."

The stirring of the peoples in Romanesque Europe, the Crusades, the pilgrimages, and the commercial journeyings brought a slow realization that Europeans were of the same religion, even if of different ethnic stock. The reception of hitherto unknown documents of Greek thought and learning strongly influenced theology, bringing to it, along with new and deep challenges, a kind of order and concentration. Theologians undoubtedly dictated the subjects of the Romanesque portals; church authorities felt it

9-27 WILIGELMUS, *Creation and Temptation of Adam and Eve*, frieze on the west façade, Cathedral of Modena, Italy, c. 1110. Approx. 36" high.

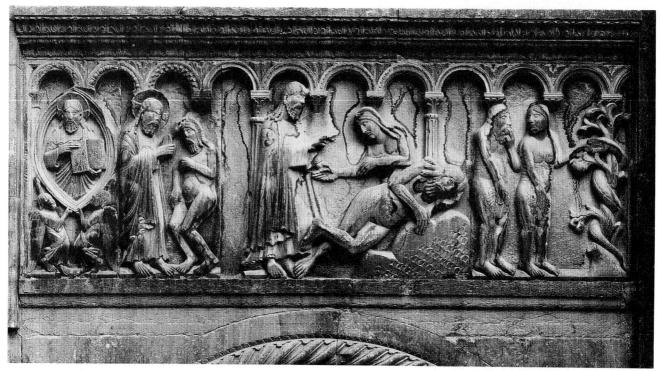

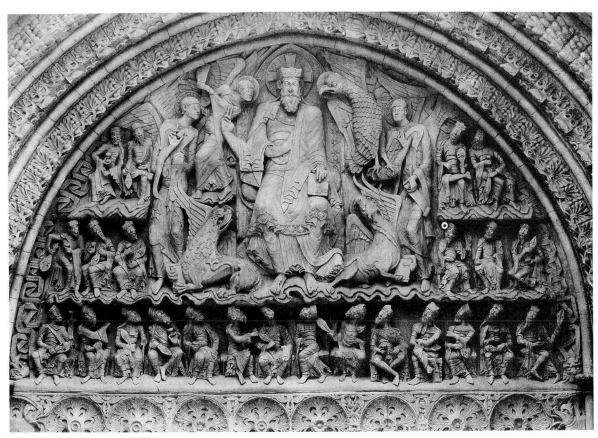

9-28 Tympanum of the south portal of St. Pierre, Moissac, France, c. 1115–1135. Diameter 16' 6".

was just as important to have the right subjects carved in the right places as to have the right arguments rightly arranged in a theological treatise. The apocalyptic vision of the Last Judgment, appalling to the imagination of twelfth-century believers, was represented conspicuously at the western entrance portal as an inescapable reminder to all who entered.

At Modena, the great frieze recounted the beginning of the human race; in a portal at Moissac, some twenty-five years later, its end was announced. With new architectural and iconographic organization giving coherence to sculptural design on a grand scale, the vast tympanum that crowns the portal of St. Pierre at Moissac depicts the Second Coming of Christ as King and Judge of the world in its last days (FIG. 9-28). As befits his majesty, Christ is centrally enthroned, reflecting a rule of composition that we have seen followed since Early Christian times. The Signs of the Evangelists flank him: on his right side, the Angel of St. Matthew and the Lion of St. Mark, and on his left, the Eagle of St. John and the Ox of St. Luke. To one side of each pair of signs is an attendant angel holding scrolls on which to record the deeds of mankind for judgment. The figures of crowned musicians, which complete the design, are the twenty-four music-making elders who accompany Christ as

the kings of all this world and make music in his praise. Each turns to face him, much as would the courtiers of a Romanesque monarch in attendance on their lord. The central group, reminiscent of the heraldic groupings of ancient Mesopotamian art, is set among the elders, who are separated into three tiers by two courses of wavy lines that symbolize the clouds of Heaven.

As many variations exist within the general style of Romanesque sculpture as within Romanesque architecture, and the figures of the Moissac tympanum constitute no exception. Yet elements familiar in painting and sculpture throughout western Europe in the eleventh and twelfth centuries also are found here. The extremely elongated figures of the recording angels, the curious, cross-legged, dancing pose of the Angel of St. Matthew, and the jerky, hinged movement are characteristic in general of the emerging vernacular style of representing the human figure. Earlier Carolingian, Ottonian, and Anglo-Saxon manners diffused and interfused to produce the now sure and unhesitating style-languages of the Romanesque. The zigzag and dovetail lines of the draperies (the linear modes of manuscript painting are everywhere apparent), the bandlike folds of the torsos, the bending back of the hands against the body, and the

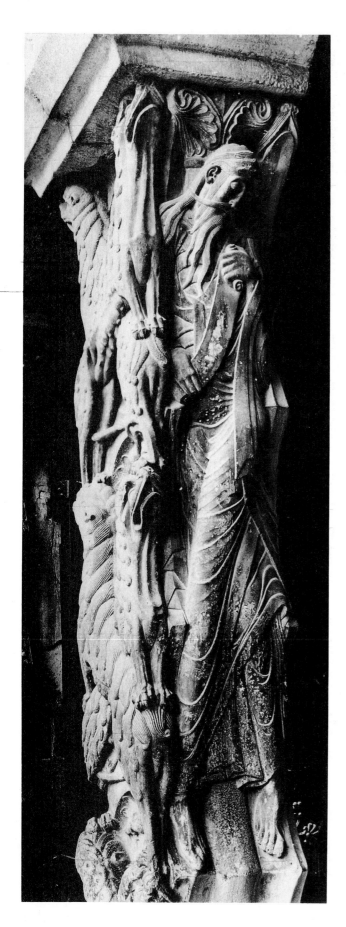

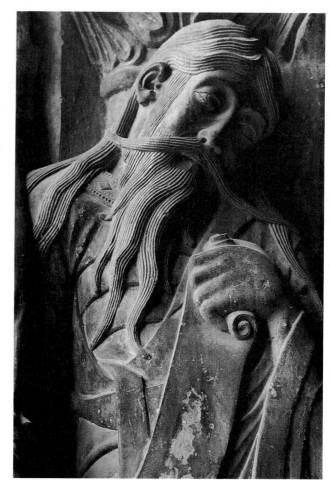

9-29 *Left: The Prophet Jeremiah (Isaiah?)* from the trumeau of the south portal of St. Pierre. Life size. *Above:* detail.

wide cheekbones are also common features of this new, cosmopolitan style.

A triumph of the style is the splendid figure of *The Prophet Jeremiah* (identified by some as Isaiah) carved in the trumeau of the Moissac portal (FIG. 9-29). His position below the apparition of Christ as the apocalyptic judge is explained by his prophecy (recalled here by his scroll) of the end of the world, when "ruin spreads from nation to nation." He is compressed in the mass of the trumeau behind roaring, interlaced lions of the kind familiar not only in barbarian art but also in the art of ancient Mesopotamia and Persia and in Islamic Spain. The totemistic animal was never far from the instinct and imagination of the Medieval artist and was certainly not far from the medieval mind in general. Kings and barons often were named by association with animals thought to be the most fiercely courageous—for example, Richard the Lionheart, Henry the Lion, and Richard III of England, whose heraldic animal was the wild boar. It is not unthinkable that the Medieval artist, with millennia of animal lore and ornament to draw on, associated

animal strength with architecture—the animal body
being thought of as providing support and symboliz-
ing the forces locked in the architectural fabric. The
sphinxes and winged monsters at the palace gates in
the ancient world—at Boghazköy, Khorsabad, Per-
sepolis, and Mycenae (FIGS. 2-27, 2-30, 2-38, 4-23)—
are the ancestors of the interlaced lions at Moissac.

The figure of the prophet is very tall and thin, in
the manner of the angels of the tympanum, and, like
the Angel of St. Matthew, he executes a cross-legged
step that repeats the crisscrossing of the lions, al-
though no representation of movement is yet appar-
ent in terms of the actual structure of the body or its
natural proportions. At this beginning of a new
epoch in the history of sculpture, movement is a kind
of grotesque, mechanical dance. The placing of the
parts of the body depends on the architectural set-
ting, on the sculptor's interpretation of whatever
carved or painted model is being used, or on the vo-
cabulary of the prevailing vernacular styles; the art-
ist's originality also might play a large part, as in this
case. The folds of the drapery are incised in flowing,
calligraphic lines that ultimately derive from manu-
script illumination and here play gracefully around
the elegant figure.

A detail of the head and shoulders (FIG. 9-29) re-
veals the artist's striking characterization of the sub-
ject. The long, serpentine locks of hair and beard
(familiar in the vocabulary of French Romanesque
details) frame an arresting image of the dreaming
mystic. The prophet seems entranced by his vision of
what is to come, the light of ordinary day unseen by
his wide eyes. His expression is slightly melancholy—
at once pensive and wistful. For the Middle Ages,
two alternative callings were available: one calling
was to the active life (*vita activa*); the other was to the
religious life of contemplation (*vita contemplativa*), the
pursuit of the beatific vision of God. The sculptor of
the Moissac prophet has given us the very image of
the vita contemplativa. It has been said of Greek sculp-
ture that the body becomes "alive" before the head
(as in the *Fallen Warrior* from Aegina, FIG. 5-32); in the
epoch that begins in the eleventh century, the head
becomes humanly expressive well before the body is
rendered as truly corporeal. The Moissac prophet is a
remarkable instance of this.

Romanesque sculpture at Moissac is not confined
to the portals; it also appears in delightful variety in
the carved capitals within the church and in the clois-
ter walk. It was sculpture such as this that Bernard of
Clairvaux complained distracted the monks from
their devotions. We are distracted, too—by the work's
ingenuity and decorative beauty. The capitals of the
Moissac cloister (FIG. **9-30**)—some of which are
historiated, some purely decorative—are excellent

9-30 Capitals from the cloister of St. Pierre.

examples. The capital in the foreground of the view at the top has an intricate leaf-and-vine pattern with volutes, an echo of the Corinthian capital. The abacus carries rosettes, and its upper edge exhibits the fish-scale motif. The capital in the background has figures seated at a table, probably a representation of the Marriage Feast at Cana. The two other capitals shown reveal the richness and color of the Romanesque sculptor's imagination. Monsters of all sorts—basilisks, griffins, lizards, gargoyles—cluster and interlace and pass grinning before us. We have the medieval bestiary in stone.

Yet for all its distinctive stylistic characteristics and exotic appearance, Romanesque art reveals its debt to ancient Roman, Early Christian, and Byzantine art, and to their Classical heritage. For example, the beautifully carved rosettes on the lintel beneath the tympanum at Moissac (FIG. 9-28) derive from ancient Roman types. Some very late, still classicizing work, perhaps of the seventh century, probably served as model for the rosettes. Other rosettes closely resembling those of the Moissac lintel survive. At the same time, Islamic influence is unmistakable in other decorative motifs of the portal.

The relatives of the monsters of the Moissac capitals appear as the demons of Hell in the awesome tympanum of the church of St. Lazare at Autun in Burgundy (FIGS. 9-31 and 9-32). At Moissac, we saw the apparition of the Divine Judge before he has summoned man; at Autun, the Judgment is in progress. The detail (FIG. 9-32) shows the weighing of souls (the reader may remember this theme from the Egyptian scroll in FIG. 3-45), while below, in the lintel, the dead are rising, one being plucked from the earth by giant hands. Humanity's pitiful weakness and littleness are distilled in these terror-stricken, weeping dolls, whom an angel with a trumpet summons to Judgment. Angels and devils contest at the scales where souls are being weighed, each trying to manipulate the beam for or against a soul. Hideous demons guffaw and roar. Their gaunt, lined bodies, with legs ending in sharp claws, writhe and bend like long, loathesome insects. A devil, leaning from the dragon-mouth of Hell, drags souls in, while, above him, a howling demon crams souls headfirst into a furnace. The resources of the Romanesque imagination, heated by a fearful faith, provide an appalling scene. We can appreciate the terror that the Autun tympa-

9-31 GISLEBERTUS, west tympanum of St. Lazare, Autun, France, c. 1130. 11′ 4″ high, 21′ wide at base.

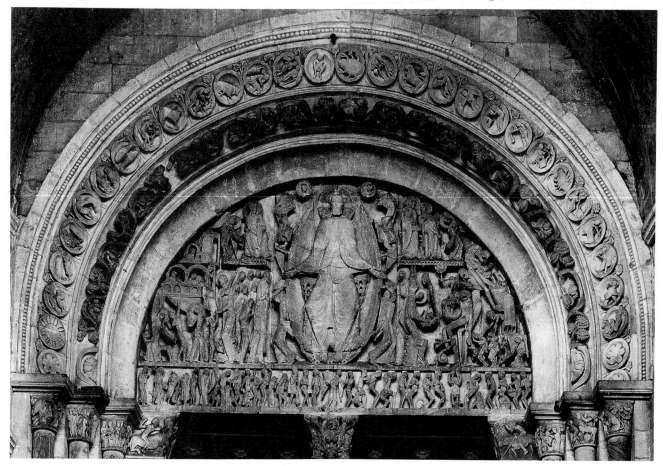

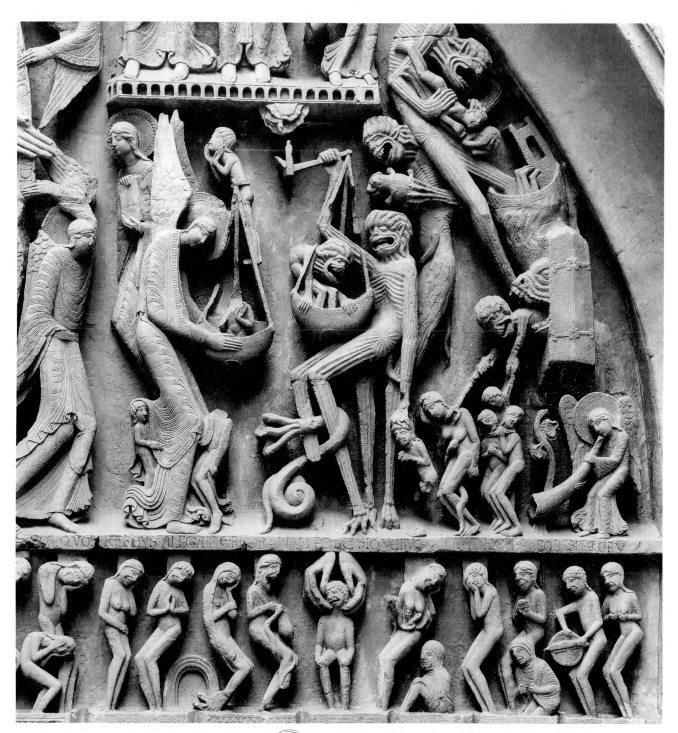

9-32 Detail of FIG. 9-31.

num must have inspired in the believers who passed beneath it as they entered the cathedral.

An inscription on the tympanum names MASTER GISLEBERTUS as the artist. This master stone-carver, whose work appears elsewhere at St. Lazare as well as on its portal, is like Wolvinius, who made the *Paliotto* in Sant' Ambrogio, Milan (FIG. 8-16), Gelduinus, who carved the St. Sernin sculptures (FIG.

9-24), and Wiligelmus, sculptor of the Modena frieze (FIG. 9-27). He wants to make sure his work is remembered in association with his name. In the twelfth century, more and more craftsmen-artists, illuminators as well as sculptors, would begin to identify themselves (we have yet to encounter MASTER HUGO [FIG. 9-40] and EADWINE THE SCRIBE [FIG. 9-41]). Although many Medieval artists remain anonymous,

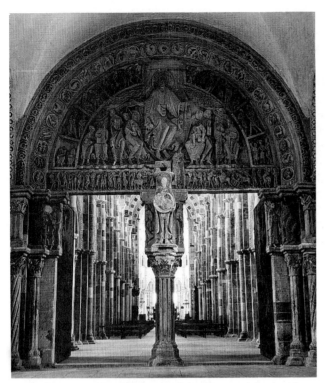

9-33 *The Ascension of Christ and the Mission of the Apostles,* center portal of the narthex of La Madeleine, Vézelay, France, 1120–1132.

the trend is now set that will culminate in the self-concerned, "fine" artist of the Renaissance, who is attentive to reputation and fame.

Another great tympanum, this one at the church of La Madeleine at Vézelay, not far from Autun, varies the theme of the apocalyptic Last Judgment, representing *The Ascension of Christ and the Mission of the Apostles* (FIGS. **9-33** and **9-34**). As related in scripture (Acts 1:4–9), Christ foretold that the apostles would receive the power of the Holy Ghost and become the witnesses of the truth of the Gospels throughout the world. The rays of light emanating from Christ's hands represent the promise of the coming of the Holy Ghost. The apostles, holding the Gospel books, receive their spiritual assignment. Christ assigns three specific tasks to the apostles and gives them the power to perform them: to save or to condemn; to preach the Gospel to all nations; to heal the sick and drive out devils. The task of saving or condemning is indicated in the central scene and in the lower four compartments adjacent to it. The task of preaching the Gospel to all nations (some at the very edge of the world) is represented on the lintel. The task of healing the sick and driving out devils is indicated in the upper four compartments. The outer archivolt has a repeated ornamental device; the inner archivolt has

9-34 Detail of FIG. 9-33.

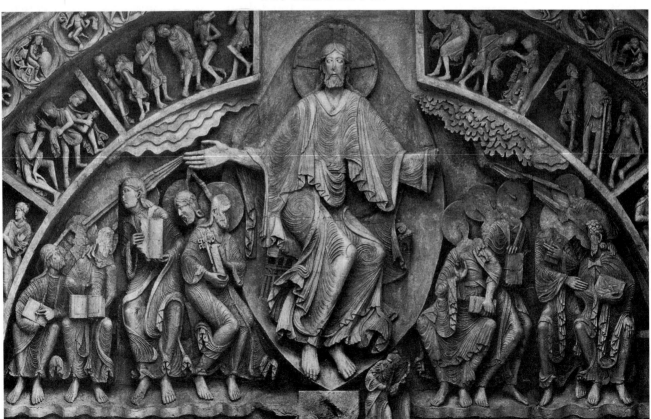

medallions with the signs of the zodiac, the seasons, and the labors characteristic of each month of a calendar year.

The Vézelay tympanum reflects, like a vast mirror, religious and secular writings and the influence of antiquity and the Byzantine East. It is a complete and encyclopedic work, in which the mission of the apostles and their power to perform it are merged in a single subject. The theme has its sources in the Acts and in the Gospels, in the prophecies of Isaiah, and in writings of antiquity and of the Middle Ages. The crowding, agitated figures reveal wild deformities. We find people with the heads of dogs, enormous ears, fiery hair, snoutlike noses; the lexicon of human defects and ailments includes hunchbacks, mutes, blind men, and lame men. Humanity, still suffering, awaits the salvation to come. The whole world is electrified by the promise of the ascended Christ, whose great figure, seeming to whirl in a vortex of spiritual energy, looms above human misery and deformity. Again, as in the Autun tympanum, we are made emphatically aware of the greatness of God and the littleness of human beings.

Vézelay is more closely associated with the Crusades than any other church in Europe. Pope Urban II had intended to preach the First Crusade at Vézelay in 1095, about thirty years before the tympanum was carved. In 1146, some fifteen years after the tympanum was in place, Bernard preached the Second Crusade, and King Louis VII of France took up the cross. In 1190, it was from Vézelay that King Richard the Lion-heart of England and King Philip Augustus of France set out on the Third Crusade. The spirit of the Crusades undoubtedly determined the iconography of the Vézelay tympanum, for it was believed that the Crusades were a kind of "second mission of the apostles" to convert the infidel.

Stylistically, the figures of the Vézelay tympanum display characteristics similar to those of the Moissac and Autun tympanums: abrupt and jerky movement (strongly exaggerated at Vézelay), rapid play of line, wind-blown drapery hems, elongation, angularity, and agitated poses, gestures, and silhouettes. The figure of the Vézelay Christ (FIG. 9-34) is a splendid essay in calligraphic theme and variation and is almost a summary of the Romanesque skill with decorative line. The lines of the drapery shoot out in rays, break into quick, zigzag rhythms, and spin into whorls, wonderfully conveying the spiritual light and energy that flow from Christ over and into the animated apostles. The technical experience of centuries of working with small art—with manuscripts, ivories, and metalcraft—is easily read from this monumental translation of such work into stone (compare the spiral whorls in FIG. 9-42 with those here).

In Provence, rich in the remains of Roman art and architecture, the vivid linear style of Languedoc (Moissac) and Burgundy (Autun and Vézelay) is considerably modified later in the twelfth century by the influence of the art of antiquity. The quieting influence of this art is seen at once in the figures on the façade of St. Trophime at Arles and in the design of the portal (FIG. **9-35**), which reflects the artist's interpretation of a Roman triumphal arch. The tympanum shows Christ surrounded by the Signs of the Evangelists. On the lintel, directly below him, the Twelve Apostles appear at the center of a continuous frieze that depicts the Last Judgment; the outermost parts of the frieze depict the saved (on Christ's right) and the damned in the flames of Hell (on his left). Below this, in the jambs and the front bays of the portals, stand grave figures of saints draped in Classical garb, their quiet stance contrasting with the spinning, twisting, dancing figures seen at Autun and Vézelay. The stiff regularity of the figures in the frieze also contrasts with the animation of the great Burgundian tympanums and reminds us of the "lining-up" seen in Early Christian sarcophagus sculpture. The draperies of these frieze figures at Arles, like those of the large statues below, are also less agitated and show

9-35 Portal on the west façade of St. Trophime, Arles, France, late twelfth century.

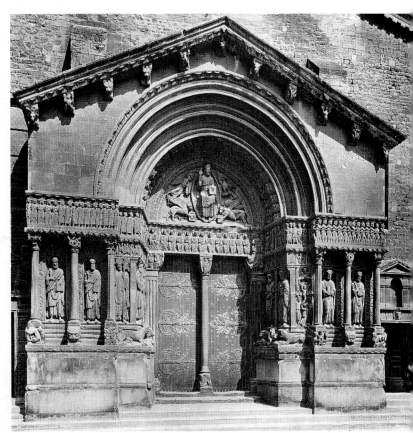

nothing of the dexterous linear play familiar at Moissac, Autun, and Vézelay. Here, the rigid lines of the architecture of the façade as a whole (rather than just an enframing element, such as a tympanum) now are determining the placement and look of the sculpture, and the freedom of execution appropriate to small art has been sacrificed to a simpler and more monumental adjustment to the architecture. In the north of France, near Paris, a new system of portal sculpture developed some thirty years earlier than that at St. Trophime. In the Royal Portals of the cathedral of Chartres (FIG. 10-14), we shall see the expansion of the whole portal design into a magnificent frontispiece, in which the architectural and sculptural elements are balanced, the sculptural style being firmly determined by the lines of the building.

PAINTING AND ILLUMINATION

We can begin an account of Romanesque painting with a work that is *not* a painting. Nor is the famous and unique *Bayeux Tapestry* (FIG. 9-36) a woven tapestry. It is rather an embroidered (needle-worked) fabric made of wool sewn on linen. Some 20 inches high and about 230 feet long, this work is a continuous, friezelike, pictorial narrative of a crucial moment in the history of England and of the events that led up to it. The Norman defeat of the Anglo-Saxons at Hast-

ings in 1066 brought Saxon England under the control of the Normans, uniting all of England and much of France under one rule; the dukes of Normandy (descendants of the Viking Norsemen) became the kings of England. Commissioned by Bishop Odo, the half brother of the conquering Duke William (under whose reign in Normandy St. Étienne at Caen had been begun), the "tapestry" may have been sewn by ladies at the Norman court, although some believe it was the work of English needlewomen in Kent, where Odo had been given lands and influence by Duke William.

The *Bayeux Tapestry* is unique in Romanesque art in that it depicts a contemporary event in full detail at a time shortly after it took place—a kind of distant anticipation of modern pictorial reportage. Inscriptions accompanying the pictures comment on the action. A section of the embroidered frieze shows a charge of Norman cavalry; the upper and lower margins show various fanciful beasts and birds in heraldic arrangement. Despite the schematic simplification of form, the Archaic flatness without cast shadows, and an entirely neutral background, the tapestry conveys a surprisingly exact description of arms and armor, as well as a convincing representation of action, pose, and gesture. The work is of great importance, not only as art, but also as a valuable historical document. The stylistic unity and consistency found throughout the whole length of the tapestry suggest that it is the

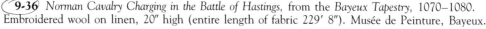

9-36 *Norman Cavalry Charging in the Battle of Hastings,* from the *Bayeux Tapestry,* 1070–1080. Embroidered wool on linen, 20″ high (entire length of fabric 229′ 8″). Musée de Peinture, Bayeux.

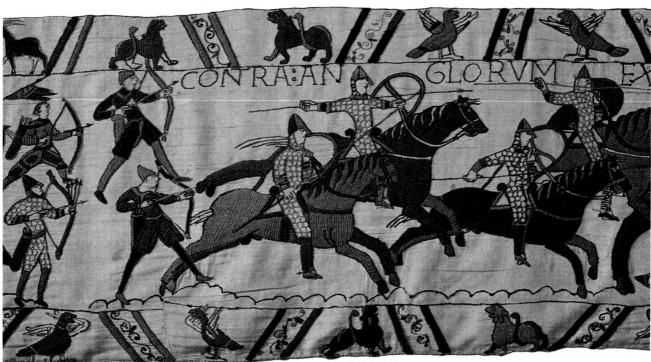

product of a single designer or a small "school" of needleworkers thoroughly trained in a distinctive idiom of representation.

Like monumental sculpture, monumental mural painting comes into its own once again in the eleventh century. Although we have several examples of it from Carolingian and Ottonian times and although an unbroken tradition of such painting existed in Italy, it blossoms in the Romanesque period. As with architecture and sculpture, mural painting exhibits many regional styles and many degrees of sophistication. Sometimes a provincial style can reveal more clearly than its sophisticated source the elements common to both. Such a case is the mural painting in the apse of the little church of Santa Maria at Tahull in Catalonia, in the extreme northeastern corner of Spain. This painting (FIG. **9-37**) could be called provincial Byzantine, as, for that matter, could much Romanesque painting. If we compare it with a Byzantine mosaic like the one at Daphne (FIG. 7-53) or the apse mosaic at Monreale (FIG. 7-55), we find that its distance from the Byzantine source—much greater than the distance from Venice or Sicily to Byzantium—results in a loss of subtlety and refinement and some misunderstanding of motifs in the original style. On the other hand, the Tahull painting has a simple and strong directness, even bluntness, that gives it a peculiarly expressive force. One emphatic feature is the partitioning of the draped figures into separate, decoratively modeled segments that almost break the figure itself into independent parts. (Note the similarity to the modulation and articulation of Romanesque architecture.) This feature is seen especially well in the pattern made by the pipelike legs and the ladderlike folds between them. The decorative banding of the surface here serves to keep the figures flat and contributes to the effect of stiff formality. The drapery, also with decorative partitioning, is scarcely distinguished from the body. Even the hands of the Madonna are subdivided, as are the heads and necks of other figures. This technique, which had begun to appear in Ottonian painting (FIG. 8-29), is almost universal in Romanesque painting; it may be seen beneath the whirling linear draperies of the sculptures at Autun and Vézelay (FIGS. 9-30 and 9-32) and in the angels of the Moissac tympanum (FIGS. 9-28 and 9-29). At Tahull, the sharp patterning of the figures is assisted by bold coloring, and the whole effect is one of rude strength, not a little of which derives from the architectural planes to which the patterned figures masterfully are adjusted.

The vernacular Romanesque style can be seen almost in exaggeration in a manuscript illumination from northern France illustrating the life of St. Audomarus (Omer) (FIG. **9-38**). Here, the figures are

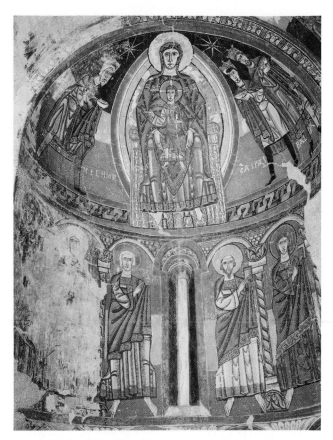

9-37 *Adoration of the Magi*, apse fresco from Santa Maria, Tahull, Spain, eleventh century.

9-38 *The Life and Miracles of St. Audomarus (Omer)*, eleventh century. Illuminated manuscript. Bibliothèque Municipale, Saint-Omer.

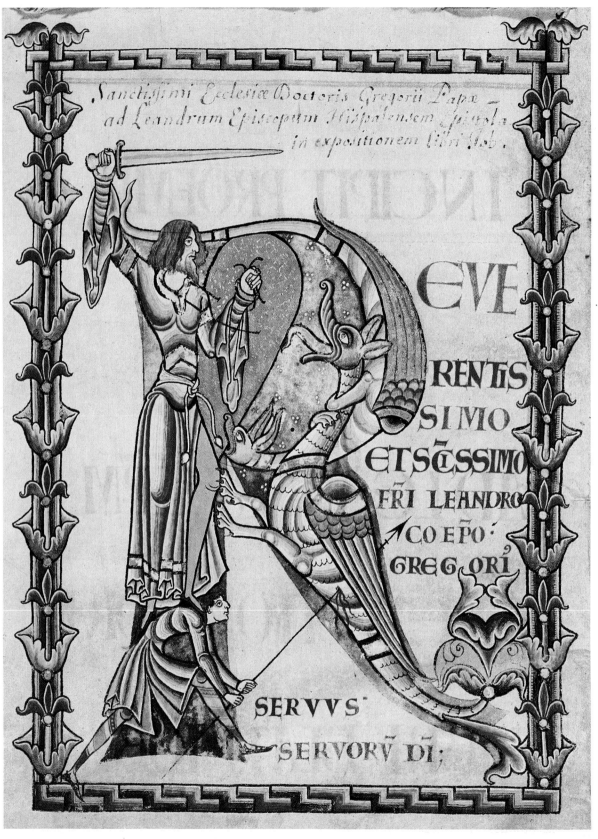

9-39 Initial R with *St. George and the Dragon*, from the *Moralia in Job*, Cîteaux, France, early twelfth century. Illuminated manuscript, 13¾″ × 9¼″. Bibliothèque Municipale, Dijon.

cut into patterns by hard lines, and the action is remote from even an approximation of organic motion. St. Audomarus (bound and pulled by the beard) and his captors seem to be performing some bouncing ritual ballet. The frame creates no sense of containment, as it did in Anglo-Saxon and Carolingian manuscripts, and bodies and feet move arbitrarily in, out of, and across it. Although locally different from the Tahull mural, the St. Audomarus illumination shares its fundamental vocabulary.

That same vocabulary, richly applied and gracefully modulated, appears in what surely must be one of the masterpieces of Medieval art—a manuscript illuminated in Bernard's great abbey of Citeaux, the motherhouse of the Cistercian order. Citeaux, and its sister abbey, Clairvaux, where Bernard was abbot, produced magnificent illuminated manuscripts throughout the twelfth century. One of the most remarkable was Gregory's *Moralia in Job*, painted before 1111. A splendid example of Cistercian illumination, the historiated initial from this manuscript (FIG. **9-39**) represents St. George, his squire, and the roaring dragons intricately composed to make the letter *R*. St. George, a slender, regal figure, raises his shield and sword against the dragons— distinguished representations of the age-old animal style so often encountered—while the squire, crouching beneath St. George, runs a lance through one of the monsters. (An image of status, the greater and the lesser dragons correspond to the lord and his man.) The ornamented initial goes back to the Hiberno-Saxon eighth century; the inclusion of a narrative within the initial is a practice that would have an important future in Gothic illumination. The banding of the torso, the fold partitions (especially evident in the skirts of the servant), and the dovetail folds—all part of the Romanesque manner—are done here with the skill of a master who deftly avoids the stiffness and angularity that result from less skillful management of the vocabulary. Instead, this artist makes a virtue of stylistic necessity; the partitioning accentuates the verticality and elegance of the figure of St. George and the thrusting action of his servant. The flowing sleeves add a spirited flourish to St. George's gesture. The knight, handsomely garbed, cavalierly wears no armor and aims a single stroke with proud disdain. This miniature may be a reliable picture of the costume of a medieval baron and of the air of nonchalant gallantry he cultivated.

An illumination of exceedingly refined execution, exemplifying the sumptuous illustration common to the large Bibles produced in the wealthy Romanesque abbeys, is the frontispiece to the Book of Deuteronomy from the Bury Bible (FIG. **9-40**). Produced at the

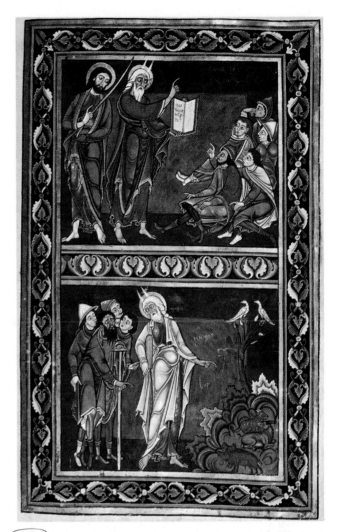

9-40 MASTER HUGO, *Moses Expounding the Law*, from the Book of Deuteronomy, Bury Bible, the abbey of Bury St. Edmunds, England, early twelfth century. Illuminated manuscript, approx. 20″ × 14″. Reproduced by permission of the Master and Fellows of Corpus Christi College, Cambridge, England.

abbey of Bury St. Edmunds in England in the early twelfth century, this work shows two scenes from Deuteronomy enframed by symmetrical leaf motifs in softly glowing, harmonized colors. The upper register shows Moses and Aaron proclaiming the law to the Israelites; the lower portrays Moses pointing out the clean and unclean beasts. The gestures are slow and gentle and have quiet dignity. The figures of Moses and Aaron seem to glide. This presentation is quite different from the abrupt emphasis and spastic movement seen in earlier Romanesque painting; here, as the patterning softens, the movements of the figure become more integrated and smooth. Yet the patterning does remain in the multiple divisions of the draped limbs, the lightly shaded volumes being connected with sinuous lines and ladderlike folds;

9-41 *The Revelation to St. John: Enthroned Christ with Signs of the Evangelists and the Twenty-four Elders,*
from the *Apocalypse of St. Sever,* painted in the abbey of St. Sever, France, *c.* 1050.
Bibliothèque Nationale, Paris.

the drapery and body are still thought of as somehow the same. The frame now has a quite definite limiting function, and the figures are carefully fitted within it.

The apocalyptic vision of the Second Coming of Christ, recorded in the Book of Revelation and carved on the great tympanum at Moissac (FIG. 9-27), is represented in the illuminations of the *Apocalypse of St. Sever* (FIG. **9-41**), a book of commentaries on the Apocalypse written by Beatus of Liébana, an eighth-century theologian. The theme of the Second Coming was of such interest that numerous manuscripts of Beatus's commentary were copied and illustrated; with the exception of this book, all were produced in Spain. The *Apocalypse of St. Sever,* made in the French monastery of that name, is significant not only as a masterpiece of the illuminator's art but also as a pictorial relative of the Moissac tympanum, for which it, or another book like it, may have served as a prototype. The characters in the drama are essentially the same; only the composition is different. In both cases, the artist has strictly followed the biblical account of the vision of St. John (Revelation 4:6–8, 5:8–9). Christ, enthroned in a sapphire aura, is sur-

rounded by the Signs of the Evangelists, whose bodies are full of eyes and who are borne aloft by numerous wings. The twenty-four crowned and music-making elders offer their golden cups of incense and their stringed rebecks (viols). Flights of angels frame the great circle of the apparition. Color, intense and vivid, is harmonized with great sophistication. The agile figures are fluently drawn. The seated elders are shown in a kind of bird's-eye perspective, in which their figures overlap, and some of them are seen from behind. Within a context of visionary abstraction, these deft touches of realism still are contained by the characteristic patternings of Romanesque figural art.

The transition from the Romanesque vernacular style to something new seems to reach a midpoint in a work of great expressive power, the portrait of *The Scribe Eadwine* in the *Canterbury Psalter* (FIG. **9-42**). This portrait was made in Canterbury about the same time as the Bury Bible. Particularly noteworthy is the fact that the portrait represents a living man, a priestly scribe—not some sacred person or King David, who usually dominated the Psalter. Although it is true that Carolingian and Ottonian manuscripts included

portraits of living men, those portraits were of reigning emperors, whose right to appear in sacred books was God-given, like the right of Justinian and Theodora and their court to be depicted in the sanctuary of San Vitale (FIGS. 7-36 and 7-37). Here, the inclusion of his own portrait sanctified the scribe's work, marking a change in attitude that points to the future emergence of the artist as a person and a name. Eadwine greatly has aggrandized his importance by likening his image to that of an Evangelist writing his gospel (FIGS. 8-9, 8-10, 8-12, 8-13) and by including an inscription within the inner frame that identifies him and proclaims that he is a prince among writers. He declares that, due to the excellence of his work, his fame will endure forever and that he can offer his book as an acceptable gift to God. The Medieval artist, concerned as he might be for his fame, is not yet aware of the concepts of fine art and fine artist; these will emerge in the Renaissance. As yet, his work exists not for its own sake, but for God's.

The style of the Eadwine portrait is related to that of the Bury Bible, but, although the patterning is still firm (notably in the cowl and the thigh), the drapery has begun to fall softly, to wrap about the frame, to overlap parts of it, and to follow the movements beneath. Here, the arbitrariness of the Romanesque vernacular style yields slightly, but clearly, to the requirements of a more naturalistic representation. The artist's instinct for decorative elaboration of the surface remains, as is apparent in the whorls and spirals of the gown, but significantly, these are painted in very lightly and do not conflict with the functional lines that contain them.

With the distinction of body and drapery finally achieved in the Gothic art of the thirteenth century, an epoch of increasing naturalism will begin. As did Exekias's billowing sail (FIG. 5-7), the Eadwine figure marks a turning point—in this case, in the history of Medieval representation. The Late Romanesque and Early Gothic "feel" of body and drapery as surfaces that interact forcefully implies not only a sense of their materiality but also a sense of depth. That sense will sharpen and deepen into the representational art of the Renaissance.

9-42 EADWINE THE SCRIBE (?), *The Scribe Eadwine* from the *Canterbury Psalter, c.* 1150, Trinity College, Cambridge, England.

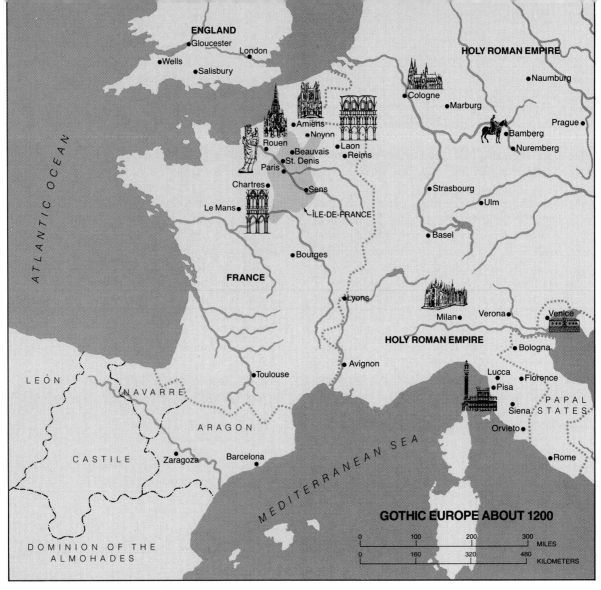

GOTHIC EUROPE ABOUT 1200

ENGLAND
- Gloucester
- London
- Wells
- Salisbury

HOLY ROMAN EMPIRE
- Naumburg
- Cologne
- Marburg
- Prague
- Bamberg
- Nuremberg
- Amiens
- Noyon
- Rouen
- Beauvais
- St. Denis
- Laon
- Reims
- Paris
- Strasbourg
- Ulm
- Chartres
- Sens
- ÎLE-DE-FRANCE
- Le Mans
- Basel

FRANCE
- Bourges
- Lyons
- Milan
- Verona
- Venice
- Bologna
- HOLY ROMAN EMPIRE
- Avignon
- Lucca
- Florence
- Pisa
- PAPAL STATES
- Toulouse
- Siena
- Orvieto
- Rome

ATLANTIC OCEAN

LEÓN
NAVARRE
ARAGON
CASTILE
- Zaragoza
- Barcelona

MEDITERRANEAN SEA

DOMINION OF THE ALMOHADES

```
0        100       200       300
                                    MILES
0        160       320       480
                                    KILOMETERS
```

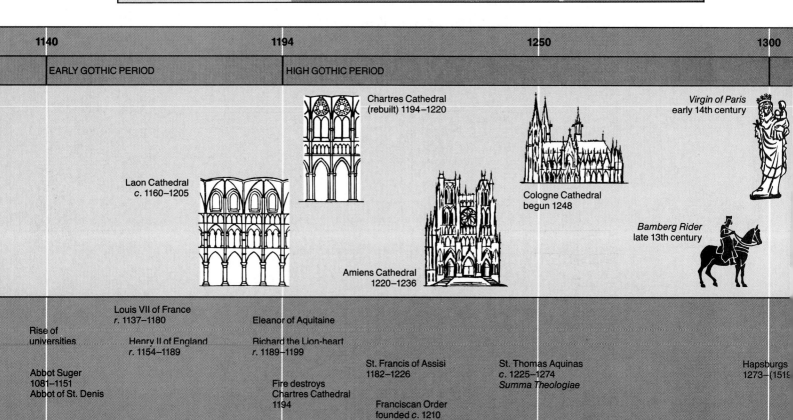

1140	1194	1250	1300
EARLY GOTHIC PERIOD	HIGH GOTHIC PERIOD		

Chartres Cathedral (rebuilt) 1194–1220

Virgin of Paris early 14th century

Laon Cathedral c. 1160–1205

Cologne Cathedral begun 1248

Bamberg Rider late 13th century

Amiens Cathedral 1220–1236

Rise of universities

Louis VII of France r. 1137–1180

Eleanor of Aquitaine

Henry II of England r. 1154–1189

Richard the Lion-heart r. 1189–1199

Abbot Suger 1081–1151 Abbot of St. Denis

St. Francis of Assisi 1182–1226

St. Thomas Aquinas c. 1225–1274 *Summa Theologiae*

Hapsburgs 1273–(1519

Fire destroys Chartres Cathedral 1194

Franciscan Order founded c. 1210

Bernard of Clairvaux c. 1090–1153 Abbot of Cistercian Order

Third Crusade 1189–1192

Fourth Crusade 1204

Marco Polo in China 1271–1292

10

GOTHIC ART

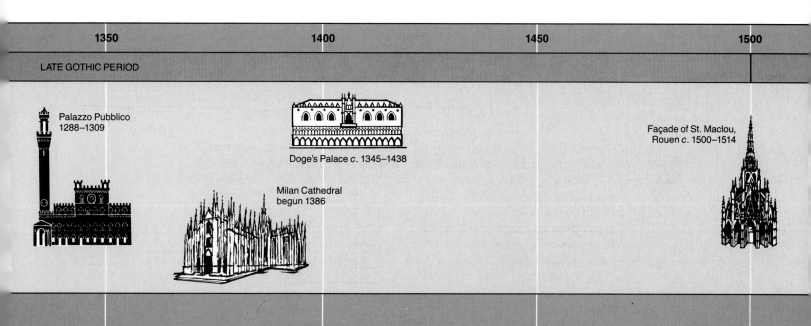

| 1350 | 1400 | 1450 | 1500 |

LATE GOTHIC PERIOD

Palazzo Pubblico
1288–1309

Doge's Palace c. 1345–1438

Milan Cathedral
begun 1386

Façade of St. Maclou,
Rouen c. 1500–1514

Babylonian captivity
of papacy at Avignon
1309–1378

The Great Schism 1378–1417

Papacy returns
to Rome
1377

Council of Constance
1415–1417; end of the
Great Schism

The Black Death c. 1340–1400

Pope Martin V
1417–1431

OTHIC FIRST WAS used as a term of derision by Renaissance critics, who condemned the lack of conformity of Gothic art to the standards of Classical Greece and Rome. "May he who invented it be cursed," wrote one of them. The style, the critics mistakenly thought, had originated with the Goths, who thus were responsible for the destruction of the good and true Classical style. People of the thirteenth and fourteenth centuries, however, referred to the Gothic cathedrals as *opus modernum* (modern work) or *opus francigenum* (Frankish work). They recognized in these structures that towered over their towns a style of building and of decoration that was original. It was with confidence in their own faith that they regarded their cathedrals as the real image of the City of God, the Heavenly Jerusalem, which they were privileged to build on earth.

The Gothic and the Romanesque environments and points of view contrast sharply. Romanesque society was dominated by the uncertainties inherent in the anarchic tendencies of feudalism. The great barons of the countryside and the great abbeys enjoyed almost total independence, and the conflict of their claims to privilege led to constant warfare. Gothic society was also feudal, but it was a comparatively ordered feudalism. Here and there, powerful barons had been able to make themselves kings, and monarchy, especially in England and France, asserted itself strongly to limit the independence of lesser lords and the Church. Centralized government was established, and law and order instilled confidence in people of all walks of life. The cities, entirely new or built on the foundations of old Roman ones, began to thrive and to become strong; allied for common defense, they very often were powerful enough to defy kings and emperors. Within their walls, those who had escaped from the land could find freedom. "The air of the city is the breath of freedom," one slogan had it. City life took on a complex but ordered form. Craft guilds, resembling strong unions, were formed to give protection and profit to artisans of the same specialties. A middle class, made up of craftsmen, merchants, and professionals (lawyers, doctors, teachers, and many others) came to constitute a new and powerful force to check and balance the feudal aristocracy. The fear and insecurity that pervaded the Romanesque world were mitigated by the new alignment of economic and social forces, and the Gothic world emerged.

Romanesque society had been dominated by men. In Gothic society, women assumed a more important role. Wandering minstrels sang less of the great deeds of heroes in war and more of love, beauty, and springtime. Eleanor of Aquitaine, wife of Louis VII of France and of Henry II Plantagenet of England and mother of King Richard the Lion-heart and John, was one of the first to rule over a "court of love," in which respect for the lady was prerequisite. The code of chivalry that so decided social relationships in the later Middle Ages was to emanate from courts such as this. The monastic prejudice against women no longer determined their representation in art. In the twelfth century, *luxuria, sensual pleasure*, is represented at Moissac as a woman with serpents at her breasts; in the thirteenth century luxuria is a pretty girl looking into a mirror. The Gothic upper classes turn almost with relief from the *chansons de geste* to the new amorous songs and romances, in which the lover adores his lady and in which such immortal lovers as Tristan and Isolde are celebrated. Marie de France, herself a noblewoman, introduced this tale, along with many other new Arthurian legends, to northern French feudal society. The poetry of the times nicely illustrates the contrast between Romanesque and Gothic taste and mood: in the Romanesque *Song of Roland*, the dying hero waxes rhapsodic over his sword, but the German minnesinger of the Gothic period, dreaming in a swooning ecstasy of his lady, is "woven round with delight."

The love of woman, celebrated in art and formalized in life, received spiritual sanction in the cult of the Virgin Mary, who, as the Mother of Heaven and of Christ and in the form of Mother Church, loved all her children. It was Mary who stood compassionately between the Judgment seat and the horrors of Hell, interceding for all her faithful. Worshipers in the later twelfth and thirteenth centuries sang hymns to her, put her image everywhere, and dedicated great cathedrals to her. Her image was carried into battle on banners, and her name sounded in the battle cry of the king of France: "Sainte Marie . . . Saint Denis . . . Mont-joie!" Mary became the spiritual lady of chivalry, and the Christian knight dedicated his life to her. The severity of Romanesque themes stressing the Last Judgment yields to the gentleness of the Gothic, in which Mary is represented crowned by Christ in Heaven.

It was not only the new position of women, the lyrical and spiritual exaltation of love, or the cult of the Virgin that softened barbarous manners. In concert with the new mood was the influence of one remarkable man, St. Francis of Assisi, who saw Christ not as the remote and terrible judge but as the loving Savior who had walked among men and himself had been one of the "rejected of men." The series of reform movements that make up the history of medieval monasticism culminates in St. Francis's founding of the religious order that bears his name—the Franciscans. St. Francis felt that the members of his order should shun the cloistered life and walk the streets of the busy cities as mendicants, preaching the

original message of Christ—the love of oneself and one's neighbor. Shortly after Francis's death and against his wish that his followers never settle in monasteries, the Franciscans commenced the great basilica in his name at Assisi. The historical importance of the Franciscan movement lies in its strengthening of religious faith, its stimulating of the religious emotion among people in cities, and its weakening of the power and influence of the old, Romanesque, country abbeys. St. Francis could be said to have brought a kind of democracy to religion in Europe at the expense of its feudal establishment.

Courtly love, the development of chivalry, the cult of the Virgin Mary, and the teaching and example of St. Francis could not, of course, nullify (although they could mitigate) the cruel realities of medieval life. While St. Francis was still living, the Fourth Crusade sacked Christian Constantinople, visiting atrocities on it that would outdo those of the later conquest by the Ottoman Turks. The papacy and the king of France collaborated in the annihilation of the peoples of Languedoc and Provence in the south of France, the so-called Albigensians, who were accused of heresy but who also stood in the way of the territorial ambitions of royal France. It was this region that had fostered the new poetry of the troubadours and produced the Romanesque sculpture examined earlier. The Albigensian "crusade" also produced the Inquisition or "Holy Office," that grim and fateful instrument of heretic hunting, instituted by St. Dominic. The Dominicans, called in fearful derision *Domini Canes* (dogs of the Lord), were in many ways rivals of the Franciscans and saw themselves as rooting out unbelievers and heretics and guarding the purity of orthodox dogma. The Dominicans' concern for theology led them to be teachers, and they produced one of the great Christian theologians and philosophers, St. Thomas Aquinas, who, at mid-thirteenth century, was the leading light of the University of Paris.

The institution of the university begins to appear in the Early Gothic period in its natural setting: the city. The monastic and cathedral schools of the earlier Middle Ages had sought to keep the learning of the fathers of the Church alive and to reassess these teachings in the light of newly developing Christian thought. From these schools, the universities, communities of scholars and their pupils, evolved in the twelfth and thirteenth centuries at Bologna and Padua, Oxford and Paris. The most important study at the university was theology, but several other subjects were taught, among them mathematics, astronomy, music, grammar, logic, law, and medicine. Ancient Greek philosophy, principally that of Aristotle, was recovered from Arabic translations and had an enormously stimulating effect on theology. Here appeared a reasoned, systematic method of argument

and a treasury of lore and observation of natural things. The philosophers set to work to find some way to adjust this new authoritative knowledge to Christian belief; they sought, in short, to rationalize religion. Their method was to arrive at proofs for the central dogmas of the faith by argument, or disputation. This method, taught in the schools and universities, came to be called "scholasticism," and its proponents "schoolmen." The greatest exponent of this systematic procedure was St. Thomas Aquinas. Typical of the method is his treatise, the *Summa Theologiae*, which was laid out into books, the books into questions, the questions into articles, each article into objections with contradictions and responses, and, finally, answers to the objections.

Within this framework, the shrewdest and subtlest arguments of the Middle Ages were advanced. The habit of mind it created lasted for centuries, an obstacle to the rise of empirical thought and science; yet much value still is found in it today. The Scholastic habit of disputation quite possibly is reflected in the thought processes of Gothic architects, as Erwin Panofsky suggested (see pages 396–97).

St. Thomas wrote his summary of Christian theology at a time when the great cathedrals were manifesting a kind of architectural "summation" of the Christian universe. The papacy ruled supreme in Europe, not only spiritually but temporally. At the beginning of the thirteenth century, Pope Innocent III, who, for a while took England away from King John, could claim: "Single rulers have single provinces, and single kings single kingdoms; but Peter . . . is pre-eminent over all, since he is the Vicar of Him whose is the earth and the fulness thereof, the whole wide world and all that dwell therein."

The thirteenth century represents the summit of achievement for unified Christendom: the triumph of the papacy; a successful and inspiring synthesis of religion, philosophy, and art; and the first firm formation of the states that will make modern history. The scene of this great but brief equilibrium of forces favoring religion is the Gothic city; within the city, the soaring cathedral, "flinging its passion against the sky," asserts the nature of the Gothic spirit.

EARLY GOTHIC
Architecture

On June 11, 1144, Louis VII of France, Eleanor of Aquitaine (his queen), members of the royal court, and a host of distinguished prelates, including five archbishops, as well as a vast crowd, converged on the royal abbey of St. Denis, just a few miles north of Paris, for the dedication of the new choir. This choir, with its crown of chapels radiant with stained-glass

windows, set a precedent that the builders in the region surrounding Paris, the Île-de-France, were to follow for the next half century.

Two eminent persons were particularly influential in the formation of the Gothic style: Bernard of Clairvaux and Suger, abbot of St. Denis. Bernard held the belief that faith was mystical and intuitive rather than rational. In his battles with Abelard, a contemporary Scholastic philosopher whose views were a basis for the dialectical method of Aquinas, he upheld this position with all the persuasiveness of his powerful personality and eloquence and by the example of his own holiness. The Cistercian churches that were being built under Bernard's influence reflected his theology, stressing purity of outline, simplicity, and a form and lighting peculiarly conducive to meditation.

Although Bernard denounced lavish decoration and elaborate architecture, the Gothic style was initiated by a fellow abbot who, accepting Bernard's admonitions to reform his monastery, built his new church in a style that surpassed the Romanesque in splendor. The fellow churchman was the Abbot

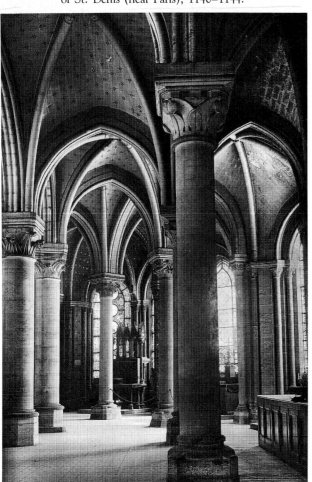

10-1 Ambulatory and radiating chapels of the abbey church of St. Denis (near Paris), 1140–1144.

Suger, who had risen from humble parentage to become the right-hand man of both Louis VI and Louis VII, and, during the latter's absence in the Second Crusade, served as regent of France. From his youth, Suger wrote, he had dreamed of the possibility of embellishing the church that had nurtured him, the royal Church of France, within the precincts of which its kings had been buried since the ninth century. It was in fact his intention to confer authority on the claims of the kings of royal France to the territory we recognize as France today, for, in Suger's time, the power of the French king, except for scattered holdings, was confined to an area not much larger than the Île-de-France. Thus, Suger's political role and his building role were one; he sought to construct a kingdom and an architectural expression of it. In 1122, he was elected abbot of St. Denis and, within fifteen years, was at work rebuilding the old monastery, which had been in use for almost three centuries. As he made his plans for the new building, he must have recalled many of the churches seen during his travels, and the workmen and artists who labored to raise the church were summoned from many regions. St. Denis, one of the last great abbey churches to be built, became the monastic inspiration for the city cathedrals and is known as the cradle of Gothic art.

Suger described his new choir at St. Denis (FIG. **10-1**) as follows:

> Moreover, it was cunningly provided that—through the upper columns and central arches which were to be placed upon the lower ones built in the crypt—the central nave of the new addition should be made the same width, by means of geometrical and arithmetical instruments, as the central nave of the old [Carolingian] church; and, likewise, that the dimensions of the new side-aisles should be the same as the dimensions of the old side-aisles, except for that elegant and praiseworthy extension . . . a circular string of chapels, by virtue of which the whole [church] would shine with the wonderful and uninterrupted light of most luminous windows, pervading the interior beauty.*

The abbot's description is a key to the understanding of Early Gothic architecture. As he says, the major dimensions of the structure were dictated by an older church, but it was the "elegant and praiseworthy extension"—the "string of chapels" with "luminous windows"—that proclaimed the new style.

Although the crypt at St. Denis served as a foundation for the choir above it, a comparison of their respective plans and structures (FIG. **10-2**) reveals the major differences between Romanesque and Gothic

*Erwin Panofsky, trans., *Abbot Suger on the Abbey Church of St. Denis and Its Art Treasures* (Princeton, NJ: Princeton University Press, 1951), p. 101.

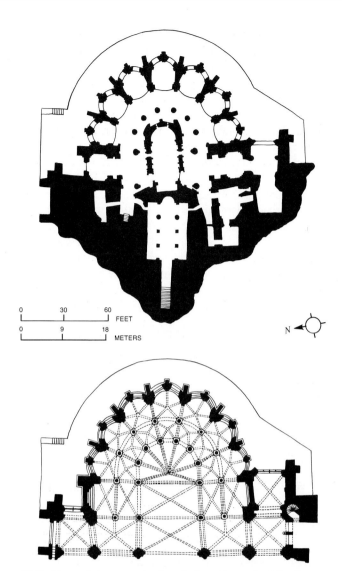

10-2 Plans of the crypt *(top)* and choir *(bottom)* of St. Denis. (After Sumner Crosby.)

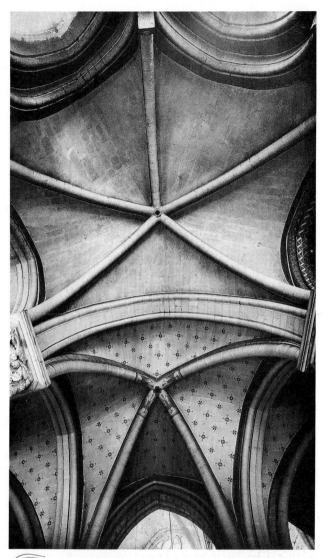

10-3 Vaults of the ambulatory and radiating chapels of the choir of St. Denis.

building. The thick walls of the crypt create a series of separate volumes (a careful Romanesque "partitioning" into units), whereas the absence of walls in the choir above produces a unified space. The crypt is essentially a wall construction, and it is covered with groin vaults; the choir, on the other hand, is a skeletal construction, and its vaults are Gothic rib vaults (FIG. **10-3**).

The ancestors of the Gothic rib vault were found at Caen and Durham. A rib vault is identified easily by the presence of crossed, or diagonal, arches under the groins of a vault. These arches form the armature, which serves as the framework for Gothic skeletal construction. The Gothic vault may be distinguished from other rib or arched vaults by its use of the pointed, or broken, arch as an integral part of the skeletal armature, by the presence of thinly vaulted

webs, or severies, between the arches, and by the fact that usually, regardless of the space to be vaulted, the crowns of all the arches are at approximately the same level—something the Romanesque architects could not achieve with their semicircular arches (FIG. **10-4**). Thus, a major advantage of the Gothic vault is its flexibility, which permits the vaulting of compartments of varying shapes, as may be seen readily in the plan of the choir of St. Denis and in many other Gothic choir plans. Moreover, although it does not support the webs entirely, the Gothic armature allows the builder to predetermine the alignment and concentration of thrusts to be buttressed.

Despite the fact that the medieval mason unquestionably derived great satisfaction from his mastery of these technical problems and at times must have been preoccupied with them, he did not permit them to be

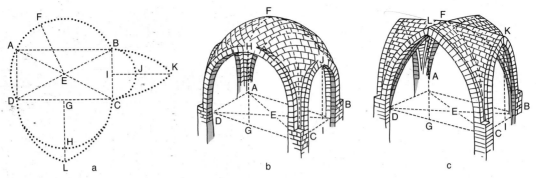

10-4 The Gothic rib vault and the domical vault differ in ways that derive from the fact that they are based on the pointed arch and the semicircular arch, respectively. Diagram **a** illustrates this: *ABCD* is an oblong bay to be vaulted; *AC* and *BD* are the diagonal ribs; *AB* and *DC*, the transverse arches; and *AD* and *BC*, the wall arches. If semicircular arches (the dotted arcs) are used, their radii, and therefore their heights (*EF, GH,* and *IJ*), will be different. The result will be a domical vault (diagram **b**), irregular in shape and difficult to light. If pointed arches are used, the points (and hence the ribs) can have the same heights (*IK* and *GL*). The result will be a Gothic rib vault (diagram **c**), a lighter, more flexible system than the domical vault, affording ample space for large clerestory windows.

an end in themselves. The ambulatories and chapels at St. Denis are proof that the rib vault was exploited, as Suger wrote, so that the whole church "would shine with . . . wonderful and uninterrupted light." This concept was, in medieval terms, the *scientia, or the theory,* that motivated the creation of the Gothic style, and it was *ars, or technical knowledge and practical skill, that made it possible.* The difference between the two was akin to the difference between modern physics and engineering; when a medieval architect spoke of the "art of geometry," he meant not the abstract nature of geometric forms, but the practical uses to which mathematical formulations might be put in designing a piece of sculpture or in erecting a building. An understanding of Gothic architecture will not be reached, however, by trying to decide whether Gothic architects predominantly were concerned with ars or with scientia, but rather by realizing that the cathedrals were the result of both. And it is in the stones themselves—in the extraordinary sensitivity of the Gothic mason for stone as a building material—that the spirit of Gothic architecture is to be discovered. The fact is that procedure was often hit or miss and rule of thumb; buildings often collapsed and were rebuilt with very large margins of safety. No one sure way was accepted and Gothic builders certainly had not reached a fundamental agreement about method. The certainties of modern engineering—themselves sometimes not so certain—were centuries beyond the Gothic reach. Even so, what still stands of Gothic architecture is a monument to the supreme skill, persistence, and vision of the Gothic architects.

It was the scientia of light that led Suger to the invention of the Gothic building. The slender, skeletal structure permitted the flooding of the interior with light. This "theory" came from the writings of a fifth-century mystic called "pseudo-Dionysius the Areo-

pagite" because of his claim to be the true Dionysius, a first-century Athenian follower of St. Paul. This pseudo-Dionysius had become confused with the patron saint of royal France, St. Denis, making it natural for Suger to take the former's mystical identification of light with the divine as a kind of prescription for any building dedicated to St. Denis. When Suger, steeped in the theology of the Areopagite, envisioned the new St. Denis, he saw it as a mystic radiance. This example demonstrates once again the significance of religious authority in the Middle Ages. Scripture and the works of the fathers of the Church were the keys to reality, and things had to be interpreted in terms of the authority that churchmen exercised.

The evolution of Gothic architecture is a continuing adjustment of scale, proportion, buttressing, vault arrangement, and wall and façade design that, in Erwin Panofsky's image, is like the steps of a complex Scholastic argument. Only the choir and narthex of St. Denis were completed in the twelfth century; for a fairly complete view of the Early Gothic style of the second half of the century, one must turn to Laon Cathedral (FIGS. **10-5** to **10-8**). Begun about 1160 and

10-5 Plan of Laon Cathedral, France, *c.* 1160–1205. Choir extended after 1210. (After E. Gall.)

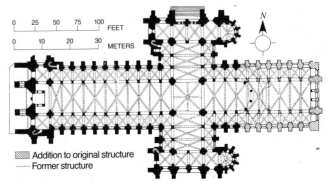

Addition to original structure
Former structure

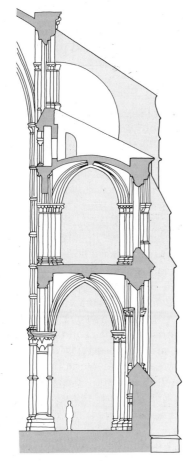

10-6 Section through the aisle, gallery, triforium, and clerestory of Laon Cathedral. (After E. Gall.)

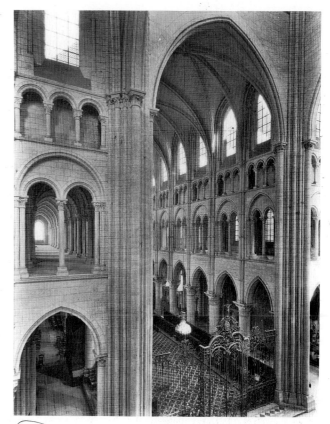

10-7 Laon Cathedral (view into the choir from the gallery of the north transept).

completed shortly after 1200, this building retains many Romanesque features but combines them with the new Gothic structural devices of the rib vault and the pointed arch. Shortly after the building's completion, the choir was enlarged, and the present plan, relatively long and narrow with a square east end, has a decidedly English flavor.

Among the plan's easily discernible Romanesque features are the strongly marked-off crossing square and the bay system, composed of a large unit in the nave flanked by two small squares in each aisle (FIG. 10-5). The nave bays are defined by sexpartite rib vaults and an alternate-support system that, in combination, continue the Romanesque tradition of subdividing the interior into a number of separate compartments. Both features, as well as the gallery above the aisles, have been derived from Norman Romanesque architecture, which enjoyed great prestige in northern France throughout the twelfth century (FIGS. 9-14 and 9-15). A new feature of the interior, however, is the *triforium*, the band of arcades below the clerestory that occupies the space corresponding to the exterior strip of wall covered by the sloping timber roof above the galleries. The triforium ex-

presses a growing desire to break up and eliminate all continuous wall surfaces. Its insertion produces the characteristic Early Gothic nave-wall elevation of four parts: nave arcade, gallery, triforium, and clerestory (FIGS. 10-6 and 10-7).

At Laon, the alternate-support system is treated less emphatically than in other Early Gothic churches (Sens or Noyon, for example). It is not reflected in the nave arcade (although colonnettes were added to a few of the columns as an afterthought), as alternating bundles of three and five shafts have their origin above the level of the main wall supports (FIG. 10-7). It appears that the Laon architect no longer is completely happy with the compartmentalized effect of Romanesque interiors, which tends to make visitors pause as they advance from unit to unit. Gothic builders aim, as yet rather timidly at Laon, to create an integrated, unified interior space that sweeps uninterruptedly from west to east. The alternate-support system, hugging the ground in Ottonian times and rising to dominate nave walls in northern Romanesque, has lost its footing at Laon and, like the solid masonry of Romanesque walls, is about to evaporate.

Important changes in the design of the church exterior were also part of the Early Gothic experience. At Laon, the doorways (under protective porches) and

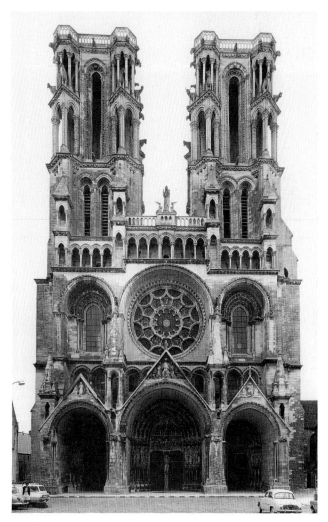

10-8 West façade of Laon Cathedral, begun *c.* 1190.

the towers have been treated as integral parts of the mass of the building (FIG. 10-8). The interior stories are reflected in the levels into which the façade is divided. (A noticeable discontinuity between the central and flanking portions of the façade was to be regulated in later designs.) Typically Gothic are the deep embrasures of the doorways and windows and the open structure of the towers. A comparison of the façades of Laon and St. Étienne at Caen (FIG. 9-13) reveals how deep the penetration of the mass of the wall has become. Here, as in Gothic architecture generally, the operating principle is one of the reduction of sheer mass by its replacement with intricately framed voids.

Laon has a pair of towers flanking each arm of the transept (only two were actually completed) and a lantern tower over the crossing, which, with the two western towers, gives a total of seven, the perfect mystic number. (Composed of three and four, it represents the Trinity and the Evangelists or the Gos-

pels.) This complement of towers was the Early Gothic ideal and continued the German Romanesque tradition of multiple integrated towers. Rarely, however, did building funds suffice for the completion of all towers. Even the façade towers of French cathedrals seldom were finished; most, including those of Laon, lacked the crowning spires planned for them. Eventually, the massed towers of the east end were omitted from building plans, and the Norman two-tower façade became the French High Gothic standard.

Transept towers were not part of the plan for the cathedral of Paris, the renowned Notre Dame (FIG. 10-9). Thus, this essentially Early Gothic building has a High Gothic silhouette in which only the slender crossing spire interrupts the long horizontal roof line that extends eastward behind the massive façade towers (FIG. 10-10). Notre Dame of Paris, begun in 1163, only a few years after Laon, embodies a fascinating mixture of conservative and progressive ideas. Choir and transept were completed by 1182; the nave, by 1225; and the façade, by 1250. The plan (FIG. 10-11) shows an ambitiously scaled, five-aisled structure in which a Romanesque bay system is combined with Early Gothic six-part (sexpartite) nave vaulting.

10-9 West façade of Notre Dame, Paris, begun *c.* 1215.

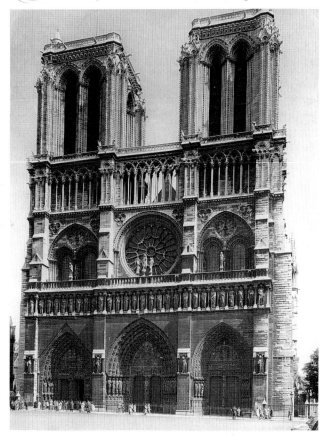

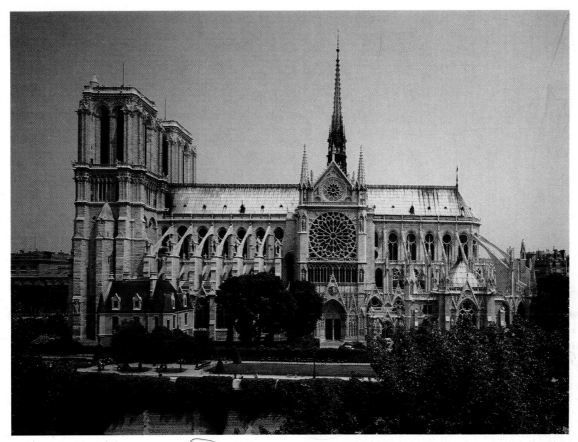

10-10 South flank of Notre Dame, Paris.

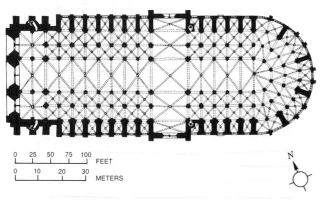

10-11 Plan of Notre Dame, Paris. (After Frankl.)

The original transept was short and did not project beyond the outer aisles. The original nave wall elevation had four parts, in the Early Gothic manner, with a triforium in the form of a series of rosettes.

The building was extensively modified shortly after it was completed. Between 1225 and 1250, chapels were built into the spaces between buttresses, and in 1250 the transept arms were lengthened. At the same time—perhaps as the result of a fire (according to Viollet-le-Duc, the cathedral's nineteenth-century restorer), but probably to admit more light into the nave—changes were made in the nave wall (the bays adjacent to the crossing were redone by Viollet-le-Duc), as shown in FIG. **10-12**. By this time, the nave of Chartres Cathedral (FIG. 10-18) had been completed and had rendered Early Gothic galleries and four-level wall elevations obsolete. As the galleries of Notre Dame already had been built, the "modernization" of the nave there had to be a compromise. The clerestory windows were lowered to the top of the gallery by suppressing the rosettes of the triforium. This alteration, in turn, required that the gallery roof be lowered and redesigned. The solution was a pitched roof with one slope inclined toward the nave wall, which created a difficult drainage problem that was solved only in the nineteenth century, when Viollet-le-Duc designed a single-slope roof to throw the water outward.

Like the interior, the façade of Notre Dame (FIG. 10-9) seems to waver between the old and the new. Begun after the Laon façade had been completed, it appears to be much more conservative and, in the preservation of its "mural presence," more closely related to Romanesque than to High Gothic façades. From the modern observer's point of view, this may be one of its great assets. Less perforated and more

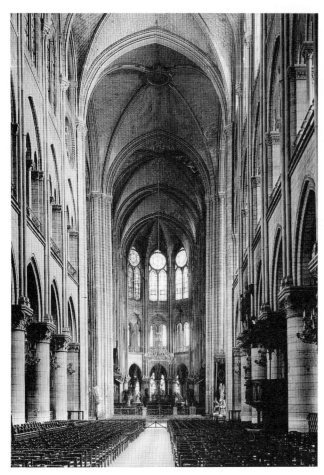

10-12 East end and part of the nave of Notre Dame, Paris, begun 1163; modified 1225–1250.

orderly than that of Laon, Notre Dame's façade exudes a sense of strength and permanence that is lacking in many contemporary and later designs. Careful balancing of vertical against horizontal elements has achieved a quality of restful stability that makes this façade one of the most satisfying and memorable in Gothic architecture.

While the new Gothic style was developing in northern France, the regional Romanesque style prevailed in the south of France and in most of Europe. We have seen the Romanesque church of St. Trophime at Arles (FIG. 9-35), which, like its neighbor St. Gilles-du-Gard, reflects ancient Roman architectural motifs, such as the gabled portico and triumphal arch. This region of the lower Rhône valley is crowded with remnants of Roman monuments, some of which, such as the Pont du Gard near Nîmes (FIG. 6-42), the Maison Carrée at Nîmes (FIG. 6-46), and the triumphal arch at Orange (not discussed in this text) are very well preserved. The classicizing Romanesque style in Italy (FIG. 9-20) almost can be regarded as an anticipation of the classicizing Renaissance style to come.

Sculpture

Gothic sculpture makes its first appearance in the Île-de-France and its environs with the same dramatic suddenness as Gothic architecture and, it is likely, in the very same place—the abbey church of St. Denis. Almost nothing of the sculpture of the west façade of St. Denis survived the French Revolution, but it was there that sculpture emerged completely from the interior of the church to dominate the western entrances, which were regarded as the "gateways to Heavenly Jerusalem" and as the "Royal Portals." These Royal Portals, so named because of the statues of kings and queens on the embrasures flanking the doorways, are typified by the west portals of Chartres Cathedral (FIGS. **10-13** to **10-15**), carved between 1145 and 1170. The lower parts of the massive west towers at Chartres and the portals between them are all that survived of an Early Gothic cathedral that was destroyed in a disastrous fire in 1194 before it had been completed. The cathedral was reconstructed immedi-

10-13 West façade of Chartres Cathedral, France, c. 1145–1170.

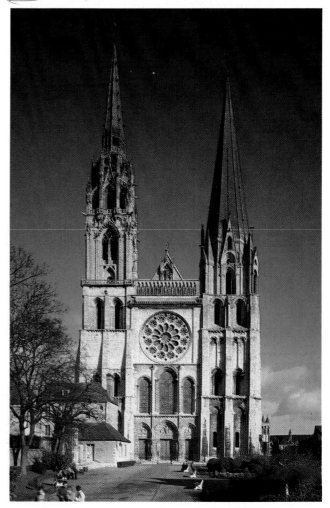

ately, but in the High Gothic style. The portals, however, constitute the most complete and impressive corpus of Early Gothic sculpture.

The three west portals of Chartres, treated as a unit, proclaim the majesty and omnipotence of Christ. His Birth, the Presentation at the Temple, and Christ in Majesty with the Virgin Mother are shown on the right portal; Christ's Ascension into Heaven is shown on the left portal. Scenes from his life and from the Passion are carved vividly on the capitals, which continue as a frieze from one portal to the next. The Second Coming is depicted on the central portal. Christ is surrounded by the Signs of the Four Evangelists, and the Twelve Apostles are shown below, seated as representing the corporate body of the Christian church. The Second Coming—in essence, the Last Judgment theme—remains centrally important, as in the Romanesque works we have seen, which are only twenty years older than the west portals of Chartres. Here, however, this theme has become a symbol of salvation rather than damnation. It is, moreover, combined with other scenes and symbolic figures as part of a larger theme rather than a symbol of the dogma itself. In the archivolts of the right portal the seven liberal arts are shown. These represent the core of medieval learning and therefore are symbolic of man's knowledge, which will lead him to the true faith. The signs of the zodiac and scenes representing the various labors of the months of the year are carved into the left-portal archivolts as symbols of the cosmic and terrestrial worlds. Around

the central tympanum are the twenty-four elders of the Apocalypse, accompanying the Second Coming. Decorating the multiple jambs flanking each doorway are the most striking figures: the great statues of the kings and queens of the Old Testament, the royal ancestors of Christ. The medieval observer undoubtedly also regarded them as the figures of the kings and queens of France, symbols of secular as well as of biblical authority. The unity of the triple portal in its message and composition complements the unity of the cathedral itself, which, in its fluent, uninterrupted, vast, and soaring space, compounds earth and Heaven in a symbol of the spiritually perfected universe to come.

The jamb statues are among the few original forms of architectural sculpture to have appeared in any age. At first glance, in their disregard of normal proportions and their rigid adherence to an architectural frame, they seem to follow many of the precepts of Romanesque architectural sculpture. Yet the differences are striking and important. The statues stand out from the plane of the wall; they are not cut back into it. They are conceived and treated as three-dimensional volumes. They move into the space of the observer and participate in it with him. Most significant of all is the first trace of a new naturalism: drapery folds are no longer calligraphic exercises translated into stone; they now either fall vertically or radiate naturally from their points of suspension. Although carefully arranged in regular patterns, these folds suggest that the artist is no longer copying

10-14 Royal (west) Portals of Chartres Cathedral.

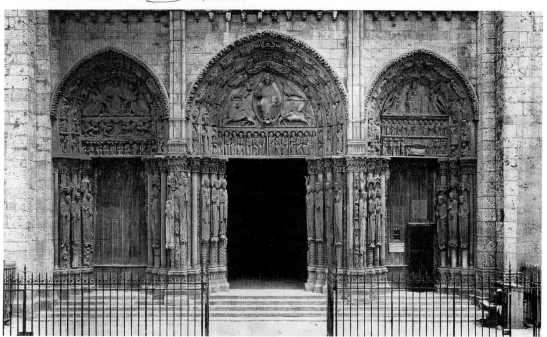

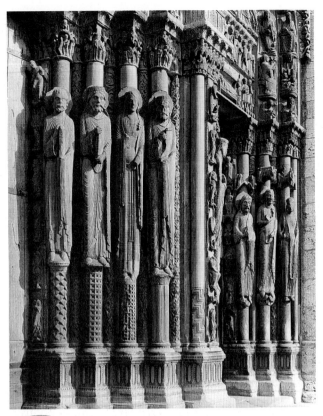

10-15 Jamb statues, Royal Portals, Chartres Cathedral.

painted images but that actual models have been used here.

This observation is true particularly of the figures flanking the central doorway (some appear in the left foreground of FIG. 10-15), which are the work of the anonymous HEADMASTER, the artist in charge of the overall design and decoration of the portals. The advanced nature of his style becomes noticeable especially when his figures are compared with those on the outside jamb of the lateral portal (right background in FIG. 10-15), which evidently were carved by a different, perhaps older, and certainly more conservative artist. The latter's approach still is rooted deeply in the Romanesque tradition. His figures seem more agitated; their silhouettes are curvilinear and broken. The drapery folds are treated decoratively and, here and there, continue to rotate in abstract swirls. Only the windblown lower garment edges, characteristic of much Romanesque sculpture, have come to rest—reluctantly, it seems, and perhaps at the Headmaster's insistence. Even so, the figures fail to adjust themselves as neatly to their architectural setting as do the Headmaster's statues, which—although they have stepped out of the wall and have become corporeal—are severely disciplined and have been rigorously subordinated to their architectural background. Seen from a distance, they appear to be little more than vertical, decorative accents within the larger designs of portals and façade (FIG. 10-14). And yet, within and despite this architectural straitjacket, the incipient naturalism has softened the appearance of the figures. This softening is noticeable particularly in their faces, in which the masklike features of the Romanesque can be seen being converted into human likenesses. A personalizing naturalism has begun that will become transformed first into idealized portraits of the perfect Christian and finally into the portraiture of specific individuals.

During the early twelfth century, great changes were taking place in Western humanity's view of itself, especially with respect to the relation of body and soul. Previously, the old Augustinian view had prevailed. The essence of the soul was completely unlike that of the body: the soul was spiritual and immortal; the body was material and subject to corruption. With the rediscovery of the main works of Aristotle, people gradually came to believe that the soul and the body were closely interrelated, that the soul was the *form* of the body, and that, therefore, the body no longer was to be despised as merely the corruptible prison of the soul from which it is released only when the body dies. One Scholastic philosopher saw the soul and the body as meeting and that union as responsible for the personality of the individual. Another saw the soul as ruling the body but also cherishing its prison. These views, in which the body is seen as coming into its own, reflected a universally changing outlook. John of Salisbury (*c.* 1110–1180), the great English Scholastic, took the perhaps radical view that the soul is stimulated and acted on by sensations from the world, rather than inspired and moved by entirely spiritual principles. He even declared that some of the principal problems of Scholastic philosophy could be solved by psychological examination of the way we think. The West was now speaking with a new voice: souls must be manifested through bodies—the individual bodies of men and women. Thus, the new, individualized heads of Chartres herald an era of artistic concern with the realization of personality and individuality that may only now, in our times, be terminating. The figures of the Royal Portals of Chartres hold a place analogous to the works of Greek artists in the late sixth century B.C.; they turn the corner into a historical avenue of tremendous possibility.

HIGH GOTHIC

Architecture

The new cathedral of Chartres, as rebuilt after the fire of 1194 and largely completed by 1220, is usually considered to be the first of the High Gothic build-

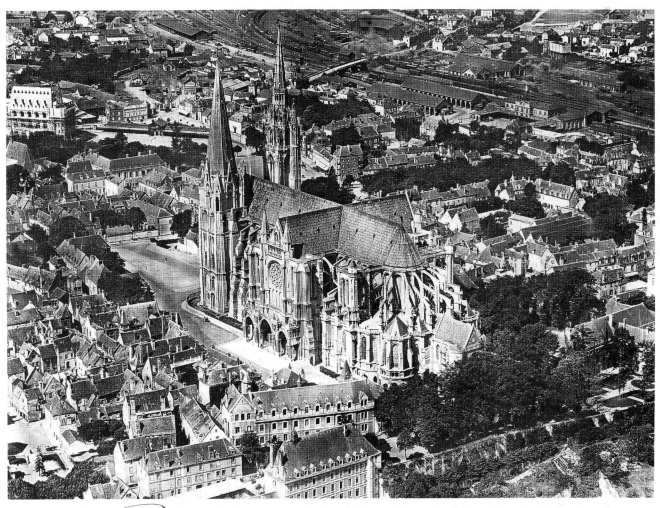

10-16 Chartres Cathedral, as rebuilt after 1194 (aerial view from the southeast).

ings—the first to have been planned from the beginning for the use of flying buttresses.

The flying buttress, that exceedingly useful and characteristic Gothic structural device, seems to have been employed by about 1180 for the bracing of the nave of Notre Dame in Paris and, shortly thereafter, at Laon. A section through Laon Cathedral (FIG. 10-6) shows how the flying buttress (lightly shaded at top right) reaches across the lower vaults of aisle and gallery and abuts the nave walls at the points at which the vaults exert their major thrusts. Similar methods for strengthening the walls of vaulted naves already had been used in Romanesque architecture, but there the buttresses were concealed under the aisle roofing. Now, they are left exposed in a manner that has been both condemned as "architectural crudity" and praised as "structural honesty."

An aerial view of Chartres Cathedral (FIG. **10-16**) shows that a series of these highly dramatic devices has been placed around the *chevet* (the east end of the church), thus supporting the vaults with permanent arms, like scaffolding left in place. With the mastery of this structural form, the technical vocabulary of

Gothic architecture became complete. The buttress eliminates the need for Romanesque walls and permits the construction of a self-consistent and self-supporting skeletal structure. The Chartres architect was the first to arrive at this conclusion and to design his building accordingly.

At Chartres, after the great fire, the overall dimensions of the new structure were determined by the façade left standing to the west and by the masonry of the crypt to the east. For reasons of piety and economy, the crypt—the repository of the most precious relic of Chartres, the mantle of the Virgin—was used as the foundation for the new structure. The earlier forms did not limit the plan (FIG. **10-17**), however; it shows an unusual equilibrium between chevet, transept, and nave, which are almost equal in dimension. More important, perhaps, the plan reveals a new kind of organization. The last remnants of square schematism, still present in Early Gothic churches, have been replaced by a "rectangular-bay system" that will become the High Gothic norm. Now a rectangular unit in the nave, defined by its own vault, is flanked by a single square in each aisle. This new bay

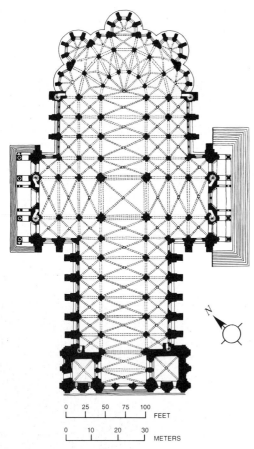

10-17 Plan of Chartres Cathedral. (After Frankl.)

10-18 Nave of Chartres Cathedral (view facing east).

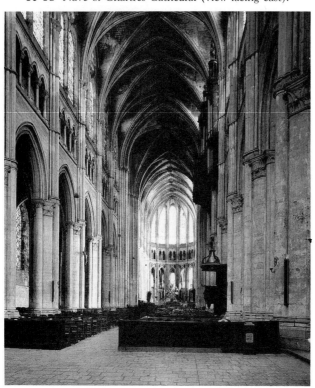

arrangement was accompanied by a change in vault design. The new High Gothic vault, which covers a relatively smaller area and therefore is braced more easily than its Early Gothic predecessor, has only four panels. The visual effect of these changes is to decompartmentalize the interior (FIG. **10-18**); identical units have been aligned so that they are seen in too rapid a sequence to be discriminated as individual volumes of space. The alternate-support system, of course, is gone, and the nave, although richly articulated, has become a vast, continuous hall.

The organic, "flowing" quality of the High Gothic interior was enhanced by a new nave-wall elevation, which admits more light to the nave through greatly enlarged clerestory windows. The use of flying buttresses made it possible to eliminate the tribune gallery above the aisle, which had partially braced Romanesque and Early Gothic naves. The new, High Gothic, tripartite nave elevation, consisting of arcade, triforium, and clerestory, emphasizes the large clerestory windows; those at Chartres are almost as high as the main arcade. A comparison of the elevations of Laon and Chartres (FIG. **10-19**) illustrates the radical changes that could be achieved by logical application of the flying buttress, which had been used only tentatively at Laon.

Despite the vastly increased size of the clerestory windows, some High Gothic interiors remain relatively dark, largely due to the light-muffling effects of

10-19 Elevations of the nave walls of the cathedrals of Laon (*left*) and Chartres (*right*), which is drawn to a smaller scale than the Laon elevation. (Umschau-Verlag, Frankfurt/Main.)

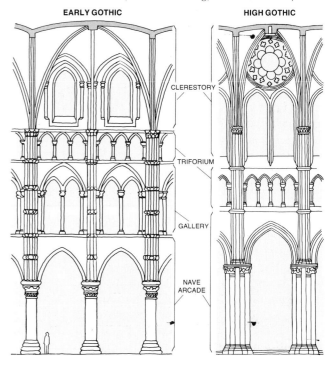

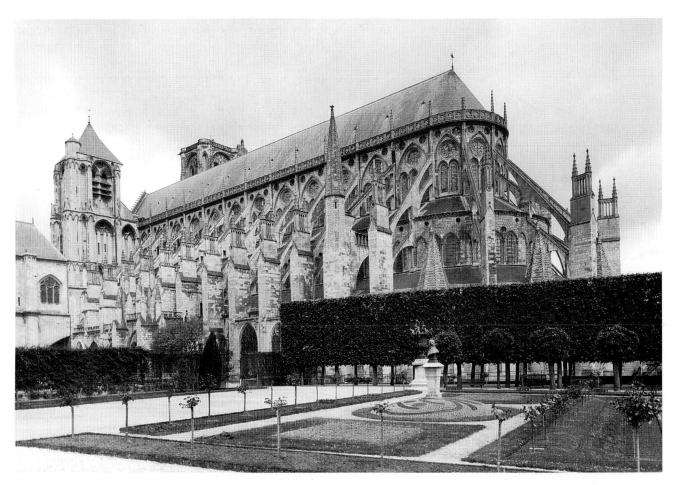

10-20 Bourges Cathedral, France, 1195–1255 (view from the southeast).

their colored glass. Chartres has retained almost the full complement of its original stained glass, which, although it dims the interior, sheds a color-shot light of great beauty that has helped to make Chartres the favorite church of lovers of Gothic architecture.

Whatever the glory of Chartres, it had a contemporary rival in Bourges Cathedral (FIG. **10-20**), which, although it may lack the esthetic power of Chartres, may have been, to a degree, its superior in structural ingenuity, stability, and economy of means. The two buildings, begun at about the same time, were completely different yet satisfactory solutions to the problems of Gothic architectural design. As such, they offered architects two alternative models. The design of Chartres later was perfected at Amiens and Reims, and at Beauvais, the first master architect conceived a kind of synthesis of Chartres and Bourges.

The plan of Bourges Cathedral (FIG. **10-21**) is strikingly different from that of Chartres Cathedral, resembling more the plan of Notre Dame in Paris (FIG. 10-11). At Chartres, the chevet, transept, and nave are of almost equal dimension. At Bourges, the plan is continuous, eliminating the transept entirely, so

that the double side aisles continue without interruption from the western façade around the choir to the east. The unity and sweeping continuity of the plan is furthered by the unusual elevation (FIG. **10-22**). Instead of one aisle on each side of the nave, Bourges has two; the inner one is higher and boasts its own clerestory, triforium, and arcade, all of which are visible through the nave arcade. The stepping upward of the heights of the side aisles to a climax in the nave vaults and the restatement in the inner aisle (albeit on a smaller scale) of the three-part nave-wall elevation provide a rhythmic, vertical repetition of the distinctive High Gothic arrangement. At the same time, windows at three levels enhance the fluent opening of the space of the nave into the aisles by saturating the interior with a form-dissolving permeation of light—the goal of Gothic architecture.

The retention of older, Romanesque features at Bourges, like the sexpartite vaults, the alternate-support system (seen in the slight differentiation in the membering of alternate piers), and the small clerestory, does not reflect structural uncertainty. Modern engineering analyses of wind and dead-load

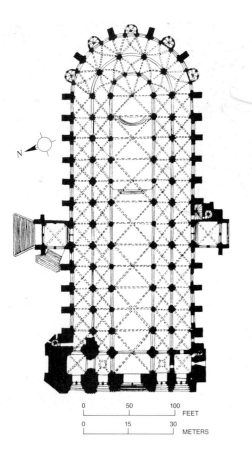

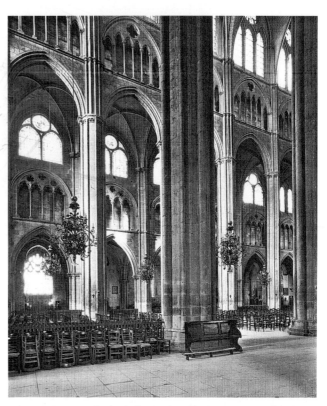

10-22 Bourges Cathedral, 1225–1250 (view across the nave from the south side).

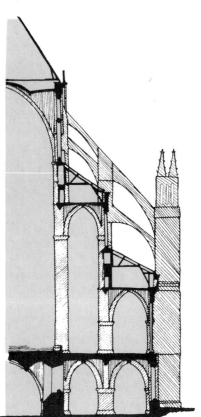

10-21 Plan (*top*) and section (*bottom*) of Bourges Cathedral.

stresses (necessary for the high-rise structures of today) show that the lighter and more open buttresses of Bourges transfer structural forces to the foundations more efficiently than the massive ones at Chartres; a pier buttress at Chartres is estimated to weigh one thousand tons, versus four hundred tons at Bourges, yet the stress levels for high winds have been shown to be equivalent. Nevertheless, the Chartres design, with its balanced, additive, and logical arrangements of plan and elevation, became the more influential of the two. At Bourges, the relationships of the parts were perhaps too elusive and individual to be grasped readily and applied widely as a standard.

The Cathedral of Amiens (FIGS. **10-23** to **10-26**) continued the Chartrian manner and gracefully refined it. Amiens was begun in 1220, according to the designs of ROBERT DE LUZARCHES. The nave was finished in 1236 and the radiating chapels were completed by 1247, but work on the choir continued until almost 1270. The façade (FIG. 10-23), slightly marred by uneven towers (the shorter dates from the fourteenth century, the taller from the fifteenth century), was begun at the same time as the nave (1220). Its lower parts seem to reflect the influence of the Laon façade in the spacing of its funnellike and gable-covered portals. However, unlike Laon's, the Amiens

portals do not project from the façade but are re-cessed behind the building's buttress-defined frontal plane. The upper parts of the façade, on the other hand, seem to be related to Notre Dame in Paris, the rose window (with fifteenth-century tracery) being placed above the "king's gallery" and between double-arched openings in the towers. But the Amiens façade goes well beyond its apparent models in the richness and intricacy of its surface decoration. The deep piercing of walls and towers seems to have left few continuous surfaces to be decorated, but the ones that remain have been covered with a network of articulating colonnettes, arches, pinnacles, rosettes, and other decorative stonework that visually screens and nearly dissolves the structure's solid core. Despite its decorative intricacy, the façade retains its monumental grandeur and is one of the first to achieve full integration with the building behind it. The cavernous portals correspond in width and placement to the nave and aisles, and (although in slightly different proportions) the façade's three-part elevation reflects that of the nave, the rose window corresponding to the clerestory.

The plan of Amiens (FIG. 10-24), like the façade, is exemplary of the grand High Gothic style. Derived from Chartres and perhaps even more elegant in its proportions, it reflects the builder's unhesitating and confident use of the complete Gothic structural vocabulary: the rectangular-bay system, the four-paneled rib vault, and a buttressing system that permits almost complete dissolution of the heavy masses and thick weight-bearing walls of the Romanesque style. The concept of a self-sustaining, skeletal architecture has reached full maturity; what remains of the walls has been stretched like a skin between the piers and seems to serve no purpose other than to provide a weather screen for the interior (FIG. 10-25). From a height of 144 feet, the tense, strong lines of the vault ribs converge to the colonnettes and speed down the shell-like walls to the compound piers; almost every part of the superstructure has its corresponding element below, the only exception being the wall rib (the rib at the junction of the vault and the wall). The overall effect is one of an effortless strength, of a buoyant lightness one would never associate with the obdurate materiality of stone. Viewed directly from below, the vaults of the choir (FIG. 10-26) seem like a canopy, tentlike and suspended from bundled masts. The light flooding in from the clerestory imparts even more "lift" and, at the same time, blurs structural outlines. The effect is visionary, and we are reminded of another great building, one utterly different from Amiens, in which light plays an analogous role—Hagia Sophia in Constantinople (FIG. 7-41). Not only is the physical mass of the building reduced by struc-

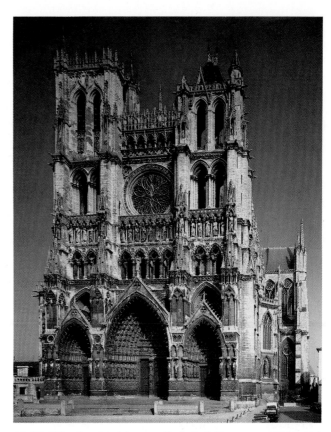

10-23 West façade of Amiens Cathedral, France, c. 1220–1236 (area above the rose window, early sixteenth century).

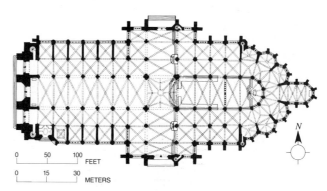

10-24 ROBERT DE LUZARCHES, plan of Amiens Cathedral. (After Frankl.)

tural ingenuity and daring, but what remains visually is dematerialized further by light. As with Scholastic philosophy, the logic of the structure here is in the service of mystery. Although philosophy might prove the existence of God with reason, the experience of the beatific vision gave the believer a mystical proof, like Dante's experience in Paradise as he gazed, rapt, into the "heart of Light, the heart of Silence."

In examining the interior of Amiens, it may be useful to reconsider Erwin Panofsky's suggestion of a

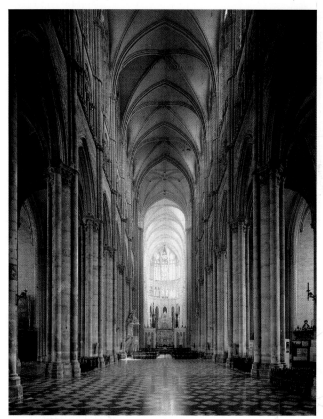

10-25 Nave of Amiens Cathedral (view facing east).

10-26 Choir vault of Amiens Cathedral.

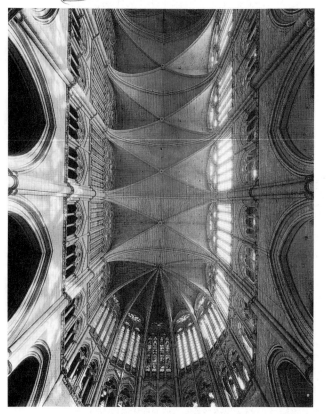

connection between Gothic architecture and Scholastic philosophy and the description of the method as typified in Aquinas's *Summa Theologiae*. Most striking in the propositions of Aquinas and in the structure of Amiens is an insistence on an order and unity made up of clearly distinguished and clearly related parts—the philosopher aiming at logical consistency, the architect striving for structural coherence. In neither is the order intended to be less than total. Aquinas's *Summa* was designed to treat *all* possible questions in which faith and reason touch; in Amiens, all individual elements are subordinated to the whole, unlike the sharply subdivided, often opposed units of Romanesque design. This principle of *manifestatio* (manifestation, transparency) determines the look of the philosophic system, as it does the look of the cathedral. As Panofsky wrote:

> A man imbued with the Scholastic habit [of thought] . . . would look upon the mode of architectural presentation, just as he looked upon the mode of literary presentation, from the point of view of *manifestatio*. He would have taken it for granted that the primary purpose of the many elements that compose a cathedral was to ensure stability, just as he took it for granted that the primary purpose of the many elements that constitute a *Summa* was to ensure validity.
>
> But he would not have been satisfied had not the membrification of the edifice permitted him to re-experience the very processes of architectural composition, just as the membrification of the *Summa* permitted him to re-experience the very processes of cogitation. To him, the panoply of shafts, ribs, buttresses, tracery, pinnacles, and crockets was a self-analysis and self-explication of . . . architecture, much as the customary apparatus of parts, distinctions, questions, and articles was, to him, a self-analysis and self-explication of reason. . . . The Scholastic mind demanded a maximum of explicitness. It accepted and insisted upon a gratuitous clarification of function through form, just as it accepted and insisted upon a gratuitous clarification of thought through language.*

The other principle Panofsky saw at work in philosophy and architecture is that of *concordantia* (harmony), whereby contradictory possibilities are accepted and ultimately reconciled. This reconciliation is achieved by careful debate, the *disputatio,* in which a possibility is stated, one authoritative view is cited, another authoritative view is cited in objection, the solution (a reconciliation of positions) is given, and finally a reply is given to each of the original arguments now rejected. Panofsky saw this process in the resolution of three "questions" in Gothic architec-

*Erwin Panofsky, *Gothic Architecture and Scholasticism* (Latrobe, PA: Archabbey Press, 1951), pp. 58–60.

ture: the placement and design of the rose window in the west façade, the design of the interior wall beneath the clerestory, and the conformation of the pier. (Very likely the development of the Gothic plan also could be seen as an evolved "solution" to a "question.") Evidence that the habit of mind reflected in the disputatio was not exclusive with the Scholastics in the universities, but was more broadly shared, is found on a page from the "album" of drawings by the thirteenth-century architect Villard de Honnecourt (Introduction, FIG. 13 and FIG. 10-37). According to the inscription, Villard and another architect, Pierre de Corbie, arrived at an ideal plan for a chevet after a disputatio.

THE RAYONNANT STYLE

From the grand style of the first half of the thirteenth century came a period of great refinement, the so-called *rayonnant (radiant) style*, which dominated the second half of the century and was associated with the royal Paris court of Louis IX (St. Louis), famed throughout Europe for his justice, chivalry, and piety, and the medieval ideal of the "saint-king."

Royal France, growing increasingly wealthy, powerful, and prestigious, radiated its art and culture throughout Europe. The king was lavish in embellishing the realm, especially with religious architecture.

Preeminent examples of rayonnant design are the two great rose windows in the north and south transept façades of Notre Dame in Paris (FIGS. 10-10 and 10-27). The tremendous north rose window, the work of the master builder JEAN DE CHELLES, is a masterpiece of architectural ingenuity. Almost the entire mass of wall opens up into stained glass, which is held in place by an intricate armature of stone tracery that practically has the tensile strength of steel. Here, the Gothic passion for light leads to a most daring and successful attempt to subtract all superfluous material bulk just short of destabilizing the structure and to transform hard substance into insubstantial, luminous color. The fact that this vast, complex fabric of stone-set glass has maintained its structural integrity and equilibrium against the disintegrative forces of nature and time for seven hundred years attests to the master builder's engineering genius.

10-27 JEAN DE CHELLES, rose window of the north transept, Notre Dame, Paris, 1240–1250. Stained glass, iron and lead stone-bar tracery, diameter 43'.

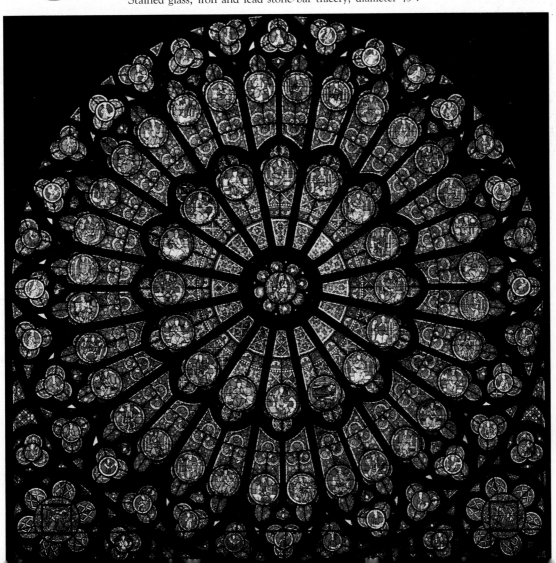

The "multifoliate rose" of light, ever-changing in hue and intensity with the hours of the day, seems to turn solid architecture into a floating vision of the celestial heavens—a constellation of radiant, jewellike stars. Expressive of the Gothic adoration of the Virgin Mary, the concentric circles exalt her as Mother of Christ; she appears at the very center of the design. Around her are figures of the prophets who foretold the Incarnation; in the second circle, are thirty-two Old Testament kings, the ancestors of Christ; in the outermost circle, are thirty-two high priests and patriarchs, who also testify to the royal lineage and divinity of Christ. The light of the north rose window is predominantly blue, the color of the northern sky, of the heavens, and of the mantle of the Virgin, which she throws protectively around all those devoted to her as the queen of Heaven.

10-28 Sainte Chapelle, Paris, 1243–1248 (view toward the tribune). The rose window was installed after 1485.

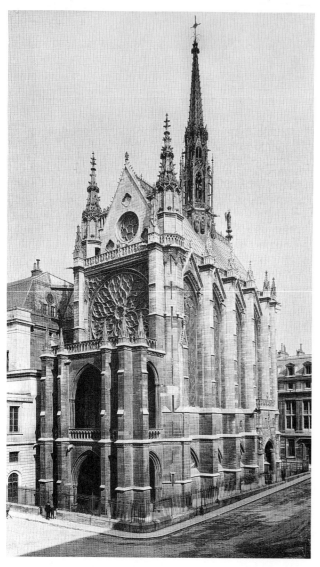

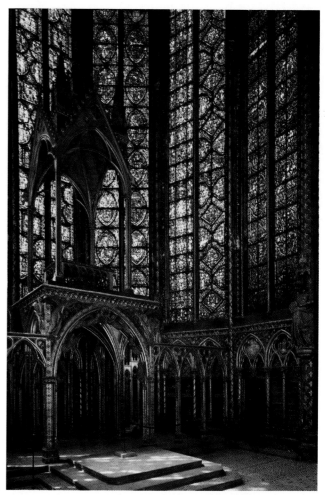

10-29 Interior of Sainte Chapelle.

The Gothic architect uses light as a medium, as does the Byzantine, but they use it in opposite ways. In Gothic architecture, light is *transmitted through* a kind of diffracting screen of stone-set glass; in Byzantine architecture, light is *reflected from* myriad glass tesserae set into the hard bed of the wall (FIGS. 7-28 and 7-38). With light, both stained glass and mosaic create an opalescent splendor that transforms solid substance into insubstantial vision—the material world into the spiritual.

If the rose windows of the transepts of Notre Dame demonstrate the wall-dissolving architecture of rayonnant design, the Sainte Chapelle in Paris shows the principle of the style applied to a whole building (FIGS. **10-28** and **10-29**). The building, joined to the royal palace, was intended to be a repository for relics of the Passion of Christ brought back by Louis IX after the ill-fated Sixth Crusade, so that its resemblance to an intricately carved reliquary is intentional. Here, the dissolution of the wall and the reduction of the bulk of the supports has been carried to the point that more than three-quarters of the structure is com-

posed of stained glass. The supporting elements have been so reduced that they are hardly more than large *mullions* separating the enormous windows, which are approximately 49 feet high and 15 feet wide and are the largest designed up to their time. Although the chapel was heavily restored during the nineteenth century (after being damaged in the French Revolution), it has retained most of its original thirteenth-century glass, which filters the light and fills the interior with an unearthly rose-violet atmosphere. Amid richly colored stone surfaces and shimmering strips of decorative mosaic stand statues of the apostles. Multicolored also, they stand on *soffits* almost independent of the architecture, and their related poses, with multiple axes, foreshadow the graceful rhythms of later thirteenth- and fourteenth-century sculpture. The technical and esthetic refinements here would have upset the solemn harmonies and monumentality of the art of the earlier part of the century. The emphasis on the extreme slenderness of the architectural forms and on linearity in general, with exquisite color and precise carving of details, does recall the richly ornamented reliquaries of the time.

Beauvais Cathedral (FIGS. **10-30** and **10-31**) was begun in 1247, after plans that had been drawn in the 1230s. As was customary, the builders began construction at the east end, so that apse and choir would be finished and ready for use while the remainder of the building was being completed. In contrast to monastic churches, which usually were assured of funding before construction began and which were completed in fairly short order, the building histories of urban cathedrals often extended over decades, and sometimes over centuries. Their financing depended largely on collections and public contributions (not always voluntary), and building programs were often interrupted by a lack of funds. Unforeseen events, such as wars, famines, or plagues, could stop construction, which might not be resumed for years, or even decades. The rebuilding of Chartres Cathedral took a relatively short twenty-seven years; the building history of Cologne Cathedral (see FIG. **10-57**) extended over six centuries, and Beauvais Cathedral never was completed.

The wisdom of starting at the east end and working westward was proven at Beauvais, where construction stopped around 1500 after a ''flamboyant'' Late Gothic transept had been added to the choir. Although the building is unfinished, the completed and serviceable part stands to this day as one of the most impressive examples of the Gothic ''rush into the skies.'' That skyward impulse, seen first in the height of the nave of Notre Dame at Paris, became an obsession with French Gothic builders. With their new

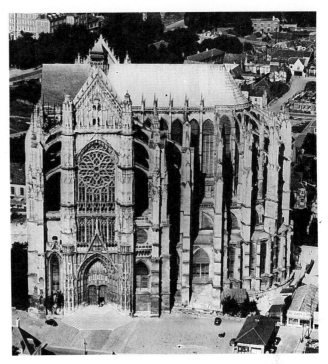

10-30 Beauvais Cathedral, France, begun 1247 (aerial view from the south).

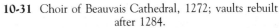

10-31 Choir of Beauvais Cathedral, 1272; vaults rebuilt after 1284.

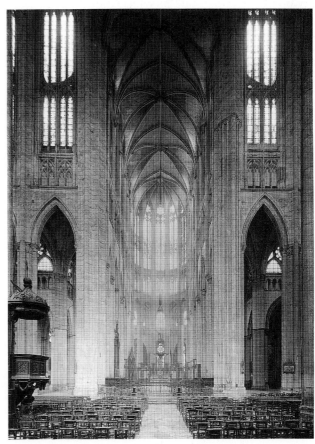

skeletal frames of stone, they attempted goals almost beyond limit, pushing with ever-slenderer supports to new heights, aiming always at effects of insubstantial visions floating far beyond human reach. The nave vaults at Laon had risen to a height of about 80 feet; at Paris, to 107 feet; at Chartres, to 118 feet; and at Amiens, to 144 feet. In 1272, the builders of the choir of Beauvais planned a height of 157 feet.

In 1284, the vaults collapsed; the cause of the failure is still a matter of scholarly debate. The original design of the first master architect had been brilliant, audacious, and stable; the parts of the choir hemicycle completed by him remained standing. Modern engineering analysis, of the kind we have mentioned in the discussion of Chartres and Bourges, indicates that succeeding builders seem to have miscalculated wind and dead-load stresses, particularly those on the external intermediate piers. The choir, rebuilt with a broad margin of safety, has additional piers and old-fashioned, sexpartite vaults, not unlike those at Bourges. Unfortunately, the rebuilt vaults and piers disfigure the original design, for it was exactly those former features of wide-spread piers and slender buttresses that the rayonnant architects had sought in their effort to make an architecture seemingly out of nothing but line and light. Henceforth, the great structural innovations of the High Gothic style and the vast scale in which they were worked out would be things of the past. Late Gothic architecture, born of the linear rayonnant design, would be confined to buildings of quite modest size, conservative in structure and ornamented with restless designs of intricately meshed, pointed motifs.

Sculpture

Sculpture, as it had been since the Romanesque period, was subservient to architecture during the High Gothic period, but rapid changes were taking place. The unity of idea that controls the design of the Royal Portals of Chartres (FIG. 10-14) expanded to embrace the whole cathedral (see the façade of Amiens Cathedral, FIG. 10-23). The sculptural program came to include not only the huge portals but the upper levels of the building as well. The summit of Gothic art—the cathedral-building and cathedral-adorning age—lasted from about 1210 to 1260. The range of the iconography of the sculpture is as vast and complex as the buildings themselves. Most of the carved figures are symbolic, but many, particularly the grotesque gargoyles (used as rainspouts) and other details of the upper portions, are purely decorative and show the vivacity and charm of the medieval spirit at this moment, when it was confident in its faith. The iconographic program, no longer confined

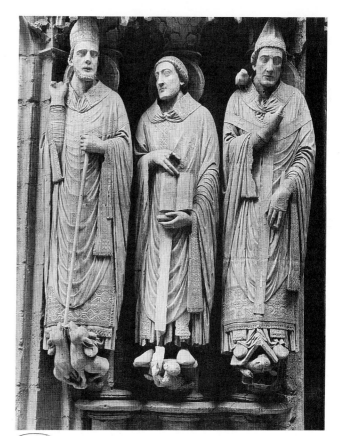

10-32 *St. Martin, St. Jerome, and St. Gregory,* c. 1220–1230, from the Porch of the Confessors, Chartres Cathedral, France.

almost entirely to the letter of the dogma (as in Romanesque art), is extensive enough to embrace all the categories of medieval thought. Indeed Émile Mâle showed that many iconographic schemes were based on the *Speculum Majus* (Great Mirror) of Vincent of Beauvais, a comprehensive summary of medieval knowledge in which accounts of natural phenomena, scriptural themes, and moral philosophy serve a didactic religious purpose.

Nature begins to come forward as important, and in art the human figure comes forward with it. Three figures from the Porch of the Confessors in the south transept of Chartres Cathedral illustrate how much the incipient realism of the Royal Portals has advanced. The figures, representing St. Martin, St. Jerome, and St. Gregory (FIG. **10-32**), date from 1220–1230. Although attached to the architectural matrix, their poses are not determined by it as much as they would have been earlier. The setting now allows the figures to communicate quietly with one another, like waiting dignitaries; they turn slightly toward and away from each other, breaking the rigid vertical lines that, on the Royal Portals, fix the figures immovably. Their draperies no longer are described by the stiff and reedy lines of the figures of the Royal Portals;

the fabric falls and laps over the bodies in soft, if still regular, folds.

The faces are most remarkable. They show, for the first time since the ancient world, the features of specifically Western men, with no admixture whatever of the denatured mask passed down over a thousand years. Moreover, they seem to have been taken from particular persons, and we have no difficulty characterizing them. St. Martin is tall and ascetic, an intense priest with gaunt features (compare the spiritually moved but not particularized face of the Moissac Jeremiah or Isaiah in FIG. 9-29). The subject may have been a saintly canon of Chartres who reluctantly became a bishop; in any event, in another realistic touch, his vestments are the liturgical costume of the time. One of his companions, St. Jerome, who appears as a humorous, kindly, practical administrator-scholar, holds his Vulgate translation of the Scriptures. Standing beside St. Jerome, the introspective St. Gregory seems lost in thought as he listens to the dove of the Holy Ghost on his shoulder. Thus, the three men are not simply contrasted in terms of their poses, gestures, and attributes but, most particularly and emphatically, as *persons,* so that personality, revealed in human faces, makes the real difference—a rarity even in Classical art. In another century or so, the identifiable portrait will emerge.

The fully ripened Gothic style can be seen in the west portals of Reims Cathedral (FIG. **10-33**), built in the mid-thirteenth century. At first glance, the jamb statues appear to be completely detached from their architectural background. The columns to which they are attached have shrunk into insignificance and in no way impede the free and easy movement of the full-bodied figures. (On the Royal Portals of Chartres, the background columns occupy a volume equal to that of the figures; see FIG. 10-15.) However, two architectural devices limit the statues' spheres of activity and tie them to the larger design of the portal and the architectural matrix—the pedestals on which they stand and the canopies above their heads. Less submissive than their predecessors from the Royal Portals of Chartres, these Reims figures create an electric tension within the portal design; they were designed for this portal, however, and would look incongruous in any other setting. Gothic portal statues placed in museums to protect them from weathering look, without exception, forlorn and out of place.

On the right jamb of the central portal, the two figures on the left in our illustration (FIG. **10-34**) represent *The Annunciation* while those on the right portray *The Visitation*. Their different styles reflect the hands of several anonymous masters. The master of the *Visitation* group, quite original in his manner, manifests a classicizing bent startlingly unlike anything seen

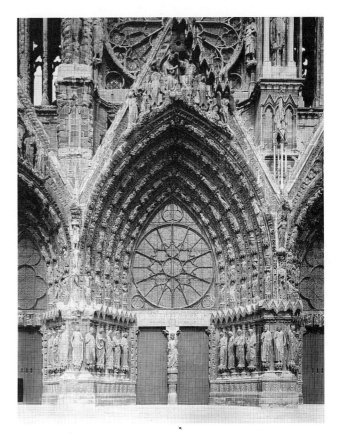

10-33 Central portal of the west façade of Reims Cathedral, France, c. 1225–1290.

10-34 *The Annunciation (left)* and *The Visitation* (detail of FIG. 10-33). Jamb statues over life size.

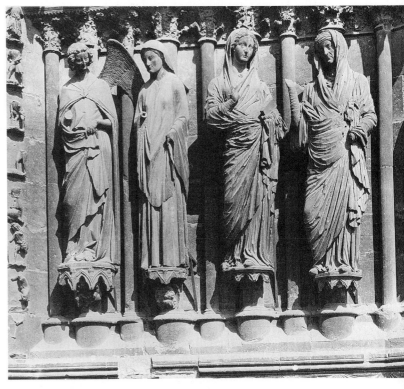

since Roman times. The group illustrates the impact on its master carver of either actual Classical statuary he had seen or of manuscripts or ivories from Late Antiquity or Byzantium. Whatever the artist's source, the facial types, costumes, and drapery treatment are astonishing approximations of the naturalistic style traits of ancient figure sculpture. The sculptor even has tried to represent the Classical contrapposto stance, although the only partially successful result betrays his ignorance of human anatomy.

The two figures of the *Annunciation* group evidently were carved by different masters. The Virgin is by a sculptor who may have worked at Amiens before he came to Reims and whose style is characterized by a weighty, massive quality. Drapery resembling a thick, flannellike material falls heavily from the figure's shoulders to her feet and, by stressing mass and verticality, imparts an aspect of grave solemnity. The angel of the *Annunciation* group differs strikingly from the Virgin. This almost dainty figure is tall and slender, animated by a kind of swaying curve, the head quite small, the face bright with a winsome smile. The angel figure, contrasting with the still and somber Virgin, represents the new, courtly style—corresponding to the rayonnant style in architecture—that was ushered in with the reign of Louis IX and the cultural dominance of the Île-de-France after mid-century.

The influence of these great cathedral statues must have been felt widely by those who contemplated them. John of Garland, writing in the thirteenth century on how university students should conduct themselves, advised, " . . . regard as models of deportment the graven images of the churches, which you should carry in your mind as living and indelible pictures." Certainly, the statues' influence on artists must have been great, as in the case of the painter of the *Psalter of St. Louis* (see FIG. 10-38). Although the degree and the progress of that influence had not yet been worked out in complete detail, it is certain that, by the fourteenth century, Gothic sculpture was widely naturalized in Italy and elsewhere outside of France. In Italy, by the beginning of the fifteenth century, the native Gothic sense for realism had fused with a new classicizing impulse—generated partly from Byzantine art and partly from the discovery of the art of ancient Rome—to form the first distinctive styles of the Renaissance.

Stained Glass and Illumination

Gothic accomplishments in architecture and sculpture are matched by the magnificent stained glass of the time, which we already have seen at Notre Dame and Sainte Chapelle in Paris. This medium almost is synonymous with the Gothic style; no other age has managed it with such craft and beauty. The mysticism of light that induced Abbot Suger to design an architecture that would allow for great windows is widespread in Gothic theology. "Stained-glass windows," wrote Hugh of St. Victor, "are the Holy Scriptures . . . and since their brilliance lets the splendor of the True Light pass into the church, they enlighten those inside." St. Bernard compared the manner in which light is tinted by a stained-glass window to the process of the Incarnation and virgin Birth of Jesus. The Gothic mood seems to take its inspiration from the Gospel of John (1:4–5): "In him was life; and the life was the light of men. And the light shineth in darkness."

The difference between these words and the sonorous verses of Revelation, which provide the program of the Romanesque "Last Judgments," reflects the

10-35 *Crucifixion*, detail of a window from St. Remi, Reims, France, c. 1190. Stained glass, approx. 12' high.

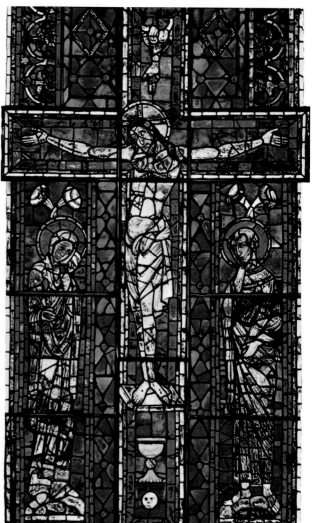

difference between the shining walls of colored light, which change with every passing hour or cloud, and the painted walls of Romanesque churches or the shimmering Byzantine mosaics.

Colored glass was used as early as the fourth century to decorate the windows of churches. Perfection of the technique must have been gradual, with the greatest advancements made during the tenth and eleventh centuries. The first accurately dated windows, those of the choir of St. Denis (1144), show a high degree of skill; according to Suger, they were "painted by the exquisite hands of many masters from different regions," proving that the art was known widely at that time. Yet the stained-glass window may be said to be the hallmark of the Gothic style, particularly in northern Europe, where the almost total dissolution of walls left few surfaces that were suitable for decoration with frescoes.

Imperfections or unexpected results in making colored glass were frequent; yet this was not an art left entirely to chance. The different properties of colors were well understood and carefully controlled. The glass was blown and either "spun" into a "crown" plate of varying thickness or shaped into a cylindrical "muff," which was cut and rolled out into square

pieces. These pieces were broken or cut into smaller fragments and assembled on a flat table on which a design had been marked with chalk dust. Many of the pieces actually were "painted" with a dark pigment, so that details, such as those of a face or clothing, could be rendered. The fragments then were "leaded," or joined by strips of lead that were used to separate colors or to heighten the effect of the design as a whole (FIGS. **10-35** and **10-36**). The completed window was strengthened with an armature of iron bands, which, in the twelfth century, took the form of a grid over the whole design (FIG. 10-35); in the thirteenth century, these bands were shaped to follow the outlines of the medallions and of the surrounding areas (FIG. 10-36).

The technical difficulties of assembling a large stained-glass window and fixing it firmly within its frame were matched by compositional problems. Illuminated manuscripts, the painter's chief vehicle during the earlier Middle Ages, had little instructional value for artists who not only had to work on an unprecedented scale but who also had to adjust their designs to the larger whole of the church building and its architecture. Sculptors, of course, already had solved these problems, and it is not surprising

10-36 Detail of the *Good Samaritan* window, Chartres Cathedral, France, early thirteenth century. Stained glass.

to learn that painters turned to them for instruction. Certainly, the saints flanking the cross in the St. Remi window (FIG. 10-35) seem vaguely familiar. Their erect poses, the straight, almost unbroken silhouettes, and the rather precarious manner in which they perch on their hilltop pedestals stamp them as not too distant relatives of the jamb statues from the Royal Portals at Chartres. Here, the Romanesque process has been reversed, and the sculptors—the former students who found their inspiration in paintings—now have become the teachers.

Like the architects and sculptors with whom they worked in close collaboration, the stained-glass artists relied heavily on the *ars de geometria* for their designs, layouts, and assemblies. The sketchbook compiled by VILLARD DE HONNECOURT, the mid-thirteenth-century architect, was intended as a text for his students, but in it he does not confine his instruction to architecture alone. In addition to details of buildings, plans of choirs with radiating chapels, and church

10-37 VILLARD DE HONNECOURT, page from a notebook, c. 1240. Bibliothèque Nationale, Paris.

towers, he also presents information on lifting devices, a saw mill, and stained-glass windows. Sprinkled liberally throughout the pages are drawings of figures, religious and worldly, and animals—some surprisingly realistic, others purely fantastic. In our illustration (FIG. 10-37), Villard evidently is informing his students of the usefulness of the ars de geometria in designing human heads and animals. In some instances, he claimed to have drawn his animals from nature, but even these appear to have been composed around a skeleton not of bones but of abstract geometric figures. The designers of stained-glass windows probably proceeded in a similar manner. No matter how their designs and layouts were arrived at, the effect of these glowing, translucent paintings, which often seem to be suspended in space, is as spellbinding today as it must have been to the medieval churchgoer (FIG. 10-27). For the first time in centuries, the art of painting was accessible to the common man—painting in a form so compelling that the desire to have more and more of it, from pavement to vault, well may have influenced the development of Gothic architecture. By about the mid-thirteenth century, architectural techniques had advanced to the point that the space of cathedrals seems to be defined by the burning intensity of the stained-glass windows, rather than by the stone structure.

The radiance of stained glass must have inspired the glowing color of illuminated manuscripts; in some cases, glass and book must have been produced by masters in the same shop, or perhaps by one master who was expert in both arts. The *Psalter of St. Louis* (FIG. **10-38**) is believed to have been one of a number of books produced in Paris in the late thirteenth century for King Louis IX of France (St. Louis) by craftsmen associated with those who made the stained glass for Sainte Chapelle (FIGS. 10-28 and 10-29). Certainly, the figures in the illuminated *Psalter* express the same aristocratic elegance as the "court" style of architecture (the rayonnant) favored by royal Paris. The painted architectural setting in the *Psalter* reflects the pierced, screenlike lightness and transparency of royal buildings like Sainte Chapelle and the new work at St. Denis. The intense colors, especially the blues, emulate glass; the borders resemble glass partitioned by leading; and the gables, pierced by rose windows, are almost portraits of rayonnant architectural features.

The subject of the page from the *Psalter of St. Louis* shown here (FIG. 10-38) is *Abraham and the Three Angels.* (See Andrei Rublëv's version of essentially the same theme in FIG. 7-60.) Two episodes are included, separated by the Tree of Mamre. In one, Abraham greets the three angels; in the other, he entertains

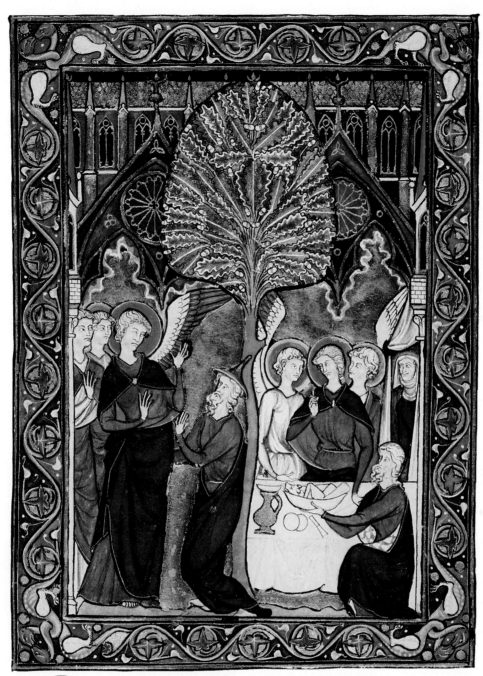

10-38 *Abraham and the Three Angels*, illuminated page from the *Psalter of St. Louis*,
1253–1270. Bibliothèque Nationale, Paris.

them while Sarah peers at them from the tent. Compared with the figures in Romanesque illumination (FIG. 9-38), these are quieter in pose and attitude and have a firmness of stance and a sense of weight suggestive of sculpture. Moreover, here the busyness of the drapery lines is subdued, making us less mindful of the flat areas that encourage decorative line-play and more aware of the modeling tones that suggest plastic form and contour.

Although these figures owe much of their color to stained-glass works, the influence of sculpture also is evident. The lead angel in the group at the left closely resembles the angel of the *Annunciation* group at Reims (FIG. 10-34), and if we look at the general arrangement of the portal (FIG. 10-33) in which the Reims group appears, we see that the *Psalter* illuminator thinks of the sacred personages in the *Abraham* episodes as framed, canopied, and backed by the

architecture and their placement as determined by it—like the actual sculptures of the portal.

The artist's response to the monumental, over-life-size sculptures of the cathedral portals may have led to a new sense of the possibilities of representation—the function of light and shade, for example, and of volume, contour, and silhouette. These imposing figures could have had a new, awesome authority that was not conveyed by the traditional prototypes (ivory carvings, say, or painted pages). The impulse toward naturalism and pictorial illusionism, endemic in the Greco-Roman world, and by no means lost in Early Christian and Byzantine art, could be receiving here a new and powerful impulse from monumental sculpture. The illusionistic effect of sculpture may have caught and held the Gothic artist's attention.

Byzantine artists will go in a different direction—working within received conventions, disdaining sculpture and the pictorial form built on it, respecting the flat surface, and showing little regard for the more or less systematic pursuit of three-dimensional illusionism widely favored in the West from this time till the twentieth century. We read of a Byzantine priest in the sixteenth century rejecting some paintings by Titian, the great Venetian master of the Renaissance (FIGS. 17-60 and 17-61), because "the figures stand quite out from the canvas" and therefore look "as bad as a group of statues."* The Byzantine artist did not find monumental sculpture like that of the Gothic portals in his environment. Would Byzantine painting and mosaic have been different if he had? The Gothic painter could not help but be struck by these majestic figures of great scale. The attention paid them is clearly evident in the figures of the *Psalter of St. Louis*.

LATE GOTHIC

The collapse of the vaults of Beauvais Cathedral would seem to have brought the great thirteenth-century architectural debate to an unarguable conclusion. Analogously, the followers of Aquinas came to believe that his accommodation of faith and reason was impossible and that both must go their separate ways. This conviction was the beginning of the dissolution of the medieval synthesis, which would lead to the eventual destruction of the unity of Christendom. The resolution of opposites could not be achieved; the conflict that would reshape western Europe was about to begin.

*Edward Gibbon, *The Decline and Fall of the Roman Empire*. Quoted with citation in Ernst Kitzinger, *Byzantine Art in the Making* (Cambridge, MA: Harvard University Press, 1977), p. 107.

Villard de Honnecourt left us a record of these years in which so much was expected of art because art already had achieved so much. The search for an ideal solution for a building and the codification of artistic, as well as philosophical, procedures were essentially academic in spirit—conscious evaluations of a style that already had reached and passed its complete definition. For a long time, artistic practice and Scholastic method would retrace ground already covered, dealing with elaborations of surface forms but no longer attempting grandiose innovations in structure.

By the early fourteenth century, the monumental and solemn sculpture of the High Gothic portals had been replaced by the "court" style developed from the angel in the *Annunciation* group at Reims (FIG. 10-34), a quite rarefied example of which may be seen in the statue of *The Virgin of Paris* within Notre Dame (FIG. 10-39). The curving sway of the figure, emphasized by the bladelike sweeps of drapery

10-39 *The Virgin of Paris*, Notre Dame, Paris, early fourteenth century.

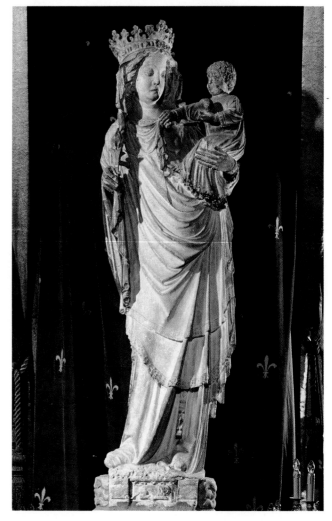

that converge to the child, has a mannered elegance that will mark Late Gothic sculpture in general. This famed Late Gothic S-curve will be encountered again and again during the fourteenth and fifteenth centuries. Superficially, it somewhat resembles the shallow S-curve adopted by Praxiteles in the fourth century B.C. (FIG. 5-62), but unlike its Classical predecessor, the Late Gothic S is not organic (deriving from within the figure), nor is it the result of a rational, if pleasing, organization of the figure's anatomical parts. Rather, it is an artificial form imposed on the figure—a decorative device that may produce the desired effect of elegance but that has nothing to do with the figure's structure. In fact, in our example, the body is quite lost behind the heavy drapery, which, deeply cut and hollowed, would almost deny the figure a solid existence. The ornamental line created by the flexible fabric is analogous to the complex, restless tracery of the "flamboyant" style in architecture, which dominated northern Europe in the fourteenth and fifteenth centuries. The emphasis on ornament for its own sake is in harmony with the artificial prettiness the artist has contrived in the Virgin's doll-like face, with its large eyes and tiny mouth under a heavy, gem-encrusted crown.

The change from rayonnant architecture to the Late Gothic or *flamboyant* style (named for the flamelike appearance of its pointed tracery) took place in the fourteenth century. The style reached its florid maturity nearly a century later. This period was a difficult one for royal France. Long wars against England and Burgundy sapped its economic and cultural strength, and building projects in the royal domain either were halted or not begun. The new style found its most enthusiastic acceptance in regions outside the Île-de-France. Normandy is particularly rich in flamboyant architecture, and its close ties with England suggest that the Anglo-Norman school of "decorated" architecture may have had much to do with the development of the flamboyant style.

The church of St. Maclou (FIG. **10-40**), in Rouen, the capital of Normandy, presents a façade that differs widely from the thirteenth-century style. St. Maclou, some 75 feet high and 180 feet long, is almost diminutive compared with the great cathedrals. The five portals, two of them blind, bend outward in an arc and are crowned by five gables, pierced through and filled with sinuous, wiry, flamboyant tracery. Spidery arcades climb steeply to the center bay, marching along behind the transparent gables. The overlapping of all features, pierced as they are, confuses the structural lines and produces a bewildering complexity of views. It is almost as if the Celtic-Germanic instinct for intricate line, expressed in works like the *Book of Lindisfarne* (FIG. 8-8), is manifesting itself once again

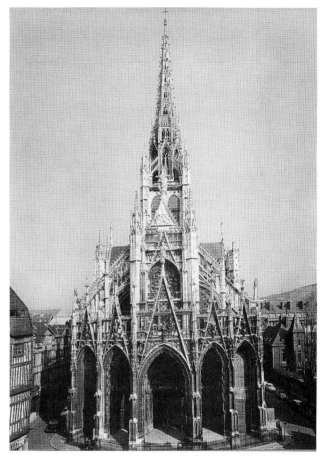

10-40 West façade of St. Maclou, Rouen, France, c. 1500–1514.

against the form and logic newly abstracted from the traditions of the Mediterranean. Yet the Renaissance is not far off, and, within a generation or two, France will adopt a new Classical style from Italy.

NON-FRENCH GOTHIC

Around 1269, the prior of a German monastery "hired a skilled architect who had just come from the city of Paris" to rebuild his monastery church. The architect reconstructed the church *opere francigeno* (in the Frankish manner)—that is, in the Gothic style of the Île-de-France. In 1268, Pope Clement IV, stipulating the conditions for the building of a new cathedral at Narbonne, wrote that the building was "to imitate the noble and magnificently worked churches . . . , which are built in the kingdom of France." The diffusion of the French Gothic style had begun even earlier, but it was in the second half of the thirteenth century that the new style became dominant and European architecture turned Gothic in many different ways. Because the old Romanesque traditions lingered on in many places, each area, marrying its local

Romanesque design to the new style, developed its own brand of Gothic architecture.

England

French Gothic came early to England—in the last quarter of the twelfth century. As was so often the case with the great cathedrals, the new style was inaugurated by a devastating fire in 1174 that swept away an older Romanesque structure in the ancient see of Canterbury, creating a new architectural opportunity. (We know of the fire and what followed from a contemporary chronicler, Gervase of Canterbury, who describes the events in dramatic and informative detail.) WILLIAM OF SENS, a master builder who was commissioned to construct the new cathedral, brought to it the Early Gothic manner of the cathedral in Sens (his home in France), which was related closely to the design of Laon Cathedral. The choir and choir chapel of Canterbury Cathedral, completed by WILLIAM THE ENGLISHMAN (FIG. 10-41), resemble those of Sens and Laon (FIG. 10-7) and are essentially French—much more so than most of the mature English Gothic churches to follow, which will retain older Norman features in balance with importations from France. In the end, these later churches will be distinctively English.

The characteristics of English Gothic architecture are embodied admirably in Salisbury Cathedral (FIGS. 10-42 to 10-45), built, for the most part, between 1220

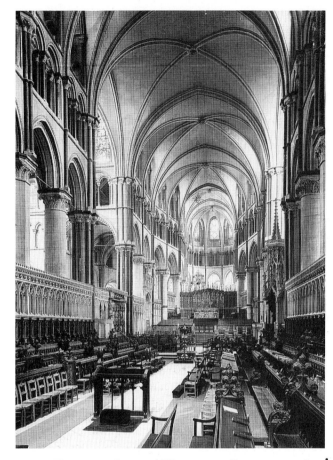

10-41 WILLIAM OF SENS and WILLIAM THE ENGLISHMAN, choir and Trinity Chapel, Canterbury Cathedral, England, 1179–1184.

10-42 Salisbury Cathedral, England, begun *c.* 1220 (view from the northwest).

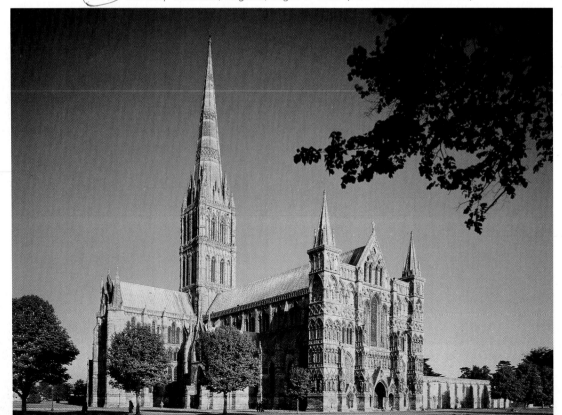

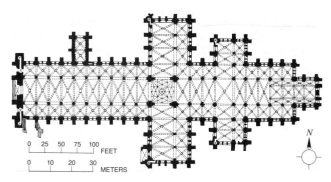

10-43 Plan of Salisbury Cathedral.

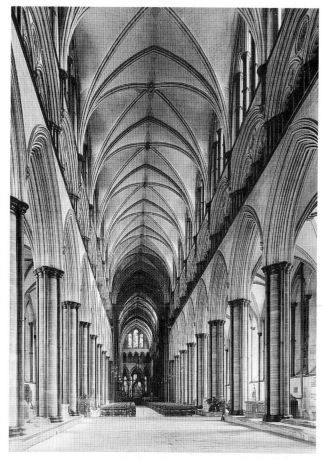

10-44 Nave of Salisbury Cathedral (view facing east).

10-45 Lady Chapel of Salisbury Cathedral, *c.* 1225
(view facing southeast).

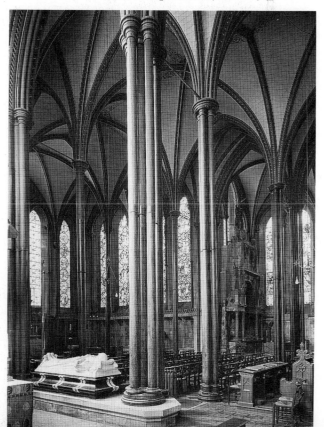

and 1260 (the tower and flying buttresses were erected in the fourteenth century). Its location in a park (or *close*), surrounded by lawns and stately trees, contrasts markedly with that of continental churches, around which city dwellings nestle closely. The screenlike façade (FIG. 10-42) reaches beyond and does not correspond to the interior. With its dwarf towers, horizontal tiers of niches, and small entrance portals, the Salisbury façade differs emphatically from the façades of either Notre Dame of Paris (FIG. 10-9) or Amiens Cathedral (FIG. 10-23). Also different is the emphasis on the great crossing tower (*c.* 1320), which dominates the silhouette. The height of Salisbury is modest compared with that of the almost contemporary cathedral of Amiens; as height in the English building is not a decisive factor, the flying buttress is used sparingly and as a rigid prop rather than as an integral part of the armature of arches. The exterior of the building at Salisbury, were it not for its pointed features, would look more like an "additive" Romanesque than a Gothic building.

Equally distinctive is the long rectilinear plan (FIG. 10-43), with its double transept and flat eastern end. The latter feature was characteristic of Cistercian churches and had been favored in England since Romanesque times. The interior (FIG. 10-44), although Gothic in its three-story elevation, pointed arches, rib vaults, and compound piers (actually a combination of columnar piers with detached monolithic shafts or colonnettes), shows conspicuous differences from the French Gothic style. The pier colonnettes do not ride up the wall to connect with the vault ribs; instead, the vault ribs rise from corbels in the triforium, producing a strong horizontal emphasis. The rich detail in the moldings of the arches and the tracery of the triforium, enhanced by the contrast of colored stone, gives a peculiarly crisp and vivid sparkle to the interior. The structural craft of the English stonemason is at its best in the Lady Chapel (dedicated to the Virgin Mary) of Salisbury Cathedral (FIG.

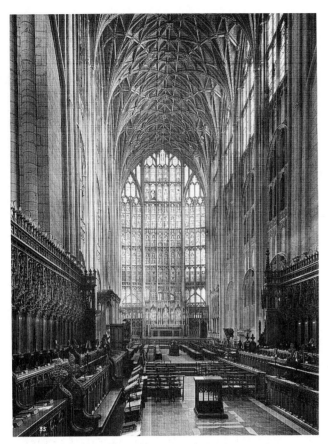

10-46 Choir of Gloucester Cathedral, England, 1332–1357 (view facing east).

10-47 Detail of the vault of the Chapel of Henry VII, 1503–1519, Westminster Abbey, London.

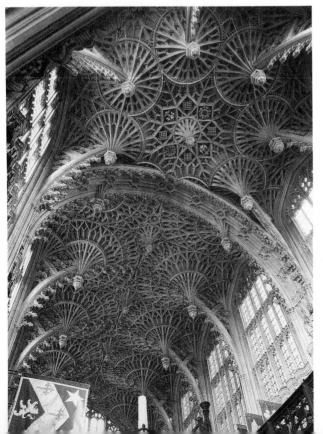

10-45). There, incredibly slender piers composed of unattached shafts of Purbeck marble seem to tether the billowing vaults to the ground rather than to support them. The linearity and slender forms of this daring construction are analogous to the rayonnant style found on the continent.

Early on, English architecture finds its native language in the elaboration of architectural pattern for its own sake; structural logic, expressed in the building fabric, is secondary. The pier, wall, and vault elements became increasingly complex and decorative in the fourteenth century, and English Gothic architecture of that period has been described as "decorated." The choir of Gloucester Cathedral (FIG. **10-46**), built about a century after Salisbury, illustrates the transition from the decorated to the last English Gothic style, the *perpendicular* or "Tudor," which was named after the line of English kings that began with Henry VII in 1485.

The characteristically flat east end of Gloucester Cathedral opens into a single, enormous window divided into horizontal tiers of "transom" windows of like shape and proportion, reminiscent of the screen façade of Salisbury. In the nave wall, however, the strong, horizontal accents of Salisbury have been erased, as the vertical wall elements (the *responds*) lift directly from the floor to the vaulting, pulling the whole elevation into a fluent unity. The vault ribs, which had begun to multiply soon after Salisbury, now have become a dense thicket of entirely ornamental strands that serve no structural purpose. This vault, in fact, is no longer a rib vault, but a continuous barrel vault with applied decorations.

We can see the culmination of the English perpendicular style and the flowering of the Tudor style (one of the late phases of the perpendicular) in the vault of the Chapel of Henry VII (FIG. **10-47**), which adjoins Westminster Abbey and was built in the first two decades of the sixteenth century. Here, the linear play of ribs has become a kind of architectural embroidery, pulled into "fan vault" shapes with pendent keystones resembling stalactites. The vault looks like something organic that has been petrified in the process of melting. The chapel represents the dissolution of structural Gothic into decorative fancy; its original lines, released from function, multiply, variegate, and flower into uninhibited architectural virtuosity and theatrics. The perpendicular style in this Tudor structure expresses peculiarly well the precious, affected, even dainty style of life codified in the dying etiquette of chivalry at the end of the Middle Ages. Life was, of course, as violent as ever—indeed, we are at the threshold of the boisterous English Renaissance—but the description and expression of it in art comes in forms that are delicate rather than robust.

Germany

The architecture of Germany remained conservatively Romanesque well into the thirteenth century. The plan and massing of German churches included the familiar Rhenish double-apse system, with towers flanking both apses. In many of these, the only Gothic feature is the rib vault, which is buttressed solely by the heavy masonry of the walls. By midcentury, though, French influence had increased, and the great 150-foot-high choir of Cologne Cathedral (FIG. **10-48**) is a skillful and energetic interpretation of Amiens (FIG. 10-26). Cologne Cathedral (page 415) has one of the longest building histories on record. Begun in 1248, it stood without a nave and with only its chevet, transept, and lower parts of the façade towers completed for some five centuries. Only in the early nineteenth century, when the original designs for the building were found, was the decision made that the structure should be completed.

The choir of Cologne Cathedral (FIG. 10-48) expresses the Gothic "rush into the skies" even more emphatically than the taller (but wider) choir of Beauvais Cathedral (FIG. 10-31). The nave walls (FIG. **10-49**) of Cologne are among the most weightless and translucent designed during the Gothic period. (Remember that the nave, although actually built in the nineteenth century, was constructed strictly in accordance with the original thirteenth-century plan, and its walls can be accepted as some of the most refined examples of High Gothic curtain-wall design.) Stretched tautly, like skins, between slender vertical supports, the walls have reached a degree of transparency unmatched in earlier architecture. Their luminous quality is enhanced by the fact that the triforium also has been fenestrated—a feature made possible by the replacement of the traditional, single-sloped shed roofs over the aisles with double-sloped tent roofs. This change created difficult drainage problems that appear to have been solved during the second half of the thirteenth century. Now, clerestory and triforium could act together to form an enormous glass wall, held together by a seemingly insubstantial framework of slender piers supported on the outside by an intricate system of vertical and flying buttresses. The impression of weightlessness—of the dematerialization of the building's very substance—is complete here. And yet the design is not weak or uncertain; all of the lines are crisp and sharply defined, describing forms that seem to have the resiliency of living organic growth.

Despite the cathedral's seeming lack of substance, the structure's stability was proven effectively during World War II, when the city of Cologne was subjected to extremely heavy aerial bombardments. The church

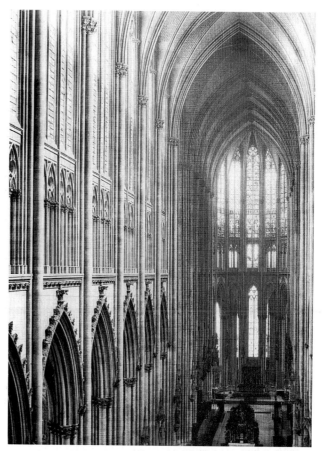

10-48 Choir of Cologne Cathedral, West Germany, thirteenth and fourteenth centuries.

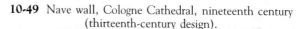

10-49 Nave wall, Cologne Cathedral, nineteenth century (thirteenth-century design).

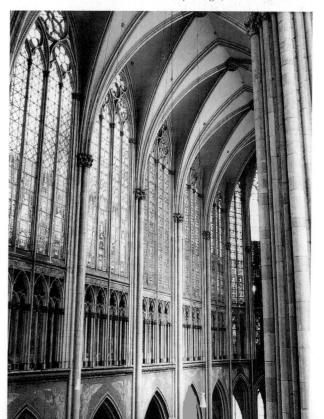

survived the war by virtue of its Gothic, skeletal design. Once the first few bomb blasts had blown out all of its windows, the structure offered no further resistance to the effects of subsequent blasts, and the skeleton remained intact and structurally sound.

A different type of design, probably of French origin, that met with great favor and was developed broadly in Germany is that of the *hallenkirche,* or hall church. The term applies to those buildings in which the aisles rise to the same height as the nave section. An early and successful example of this type is the church of St. Elizabeth at Marburg (FIGS. **10-50** to **10-52**), built between 1233 and 1283. Because the aisles provide much of the bracing for the central vault, the exterior of St. Elizabeth is without the dramatic parade of flying buttresses that circles French Gothic chevets and appears rather prosaic. But the interior, lighted by double rows of tall windows, is

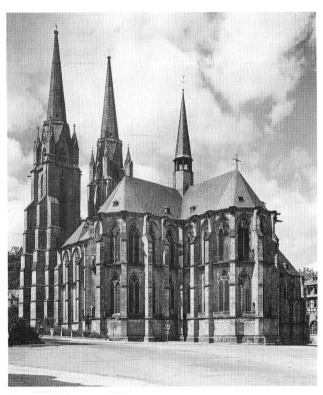

10-51 St. Elizabeth, 1233–1283 (view from the southeast).

10-52 Interior of St. Elizabeth (view facing west).

10-50 Plan and section of St. Elizabeth, Marburg, West Germany.

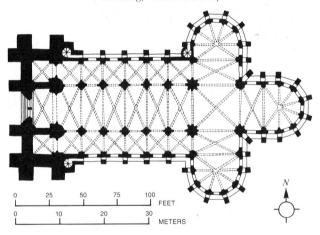

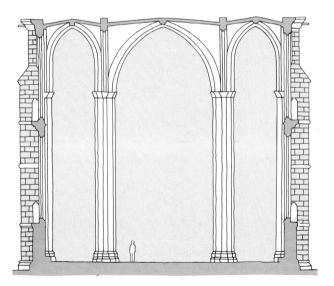

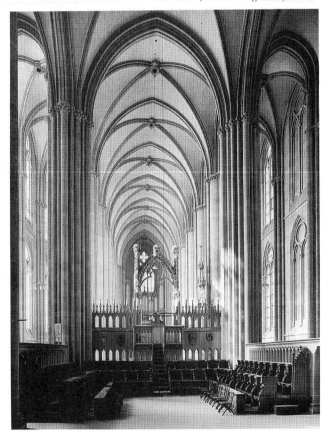

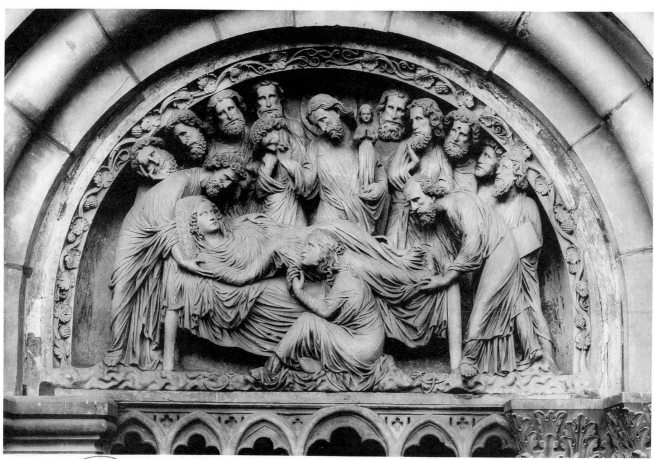

10-53 *Death of the Virgin*, tympanum, south transept portal, Strasbourg Cathedral, France, *c.* 1230.

more unified and free flowing, less narrow and divided, than the interiors of other Gothic churches. A form widely used by later Gothic architects, the hall church heralds the age of the Protestant Reformation in Germany, when the old ritual, which focuses on the altar, will be modified by a new emphasis on preaching, which will center attention on the pulpit.

Like French Gothic architecture, French sculpture also had its effect abroad. In Germany, the commingled influences of the statuary of the transept portals at Chartres (FIGS. 10-32 and 16-7) and the west façade at Reims (FIG. 10-34) directed the sculptors of the south transept portal at Strasbourg Cathedral (FIG. 10-53). The sculptured tympanum represents the death of the Virgin Mary. She is surrounded by the Twelve Apostles; at their center, Christ receives her soul (the doll-like figure near his left shoulder). Mary Magdalene, wringing her hands in grief, crouches beside the deathbed. The sorrowing figures express emotion in varying degrees of intensity, from serene resignation to gesturing agitation. The group is organized not only by dramatic unification and by pose and gesture but also by the rippling flow of deeply incised drapery that passes among them like a rhythmic, electric pulse. The sculptor's objective is not to produce a timeless tableau presenting some mystery of the faith, but to depict a human event in a particular space and time—an event designed to stir an emotional response in the observer as if he or she were present. In the Gothic world, art is increasingly being humanized and made natural; in the art of the German lands, we will find an increasing and characteristic emphasis on passionate drama.

The Strasbourg style, with its feverish emotionalism, is balanced and complemented by two stately and reposeful statues from the west choir of Naumburg Cathedral (FIG. 10-54) that depict the quiet, regal deportment of the French statuary of the High Gothic portals, but with a stronger tincture of realism. *Ekkehard and Uta* represent persons of the nobility who, in former times, had been patrons of the church; the particularity of costume and visage almost makes these figures portrait statues, although the subjects lived well before the sculptor's time. Ekkehard, blunt and Teutonic, contrasts with the charming Uta, who, with a wonderfully graceful gesture, draws the collar

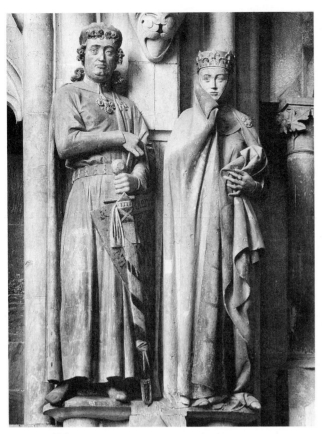

10-54 *Ekkehard and Uta,* c. 1250–1260, west choir, Naumburg Cathedral, West Germany.

10-55 *Bamberg Rider,* late thirteenth century, Bamberg Cathedral, West Germany. Sandstone, 90½″ high.

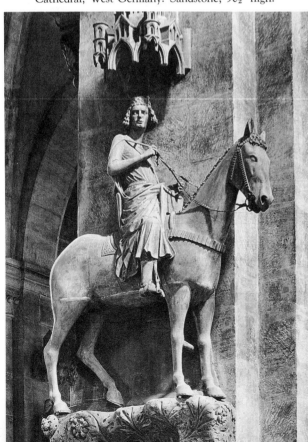

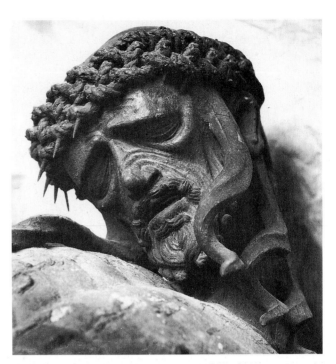

10-56 Head of a crucifix, 1301. Wood. St. Maria im Kapitol, Cologne, West Germany.

of her gown partly across her face while she gathers up a soft fold of drapery with a jeweled, delicate hand. The drapery and the body it enfolds now are understood as distinct entities. The shape of the arm that draws the collar is subtly and accurately revealed beneath the drapery, as is the full curve of the bosom. The drapery folds are rendered with an accuracy that indicates the artist's use of a model. We have before us an arresting image of medieval people—a feudal baron and his handsome wife—as they may well have appeared in life. By mid-thirteenth century, images not only of sacred but also of secular personages had found their way into the cathedral.

The equestrian figure of a Gothic nobleman mounted against a pier in the cathedral of Bamberg (FIG. **10-55**) is familiarly known as the *Bamberg Rider.* Like *Ekkehard and Uta,* this statue has the quality of portraiture; some believe it represents the German emperor Conrad III. The artist has carefully described the costume of the rider, the high saddle, and the trappings of the horse. The proportions of horse and rider are real, although the anatomy of the animal is not quite comprehended and its shape is rather stiffly schematic. An ever-present pedestal and canopy firmly establish dependence on the architectural setting and manage to hold the horse in strict profile. The rider, however, turns easily toward the observer, as if presiding at a review of troops, and is beginning to break away from the pull of the wall. The stirring and turning of this figure seem to reflect the same

impatience with subordination to architecture that is found in the portal statues at Reims (FIG. 10-34).

The gradual growth of naturalism during the thirteenth century was modified during the fourteenth century by an impulse toward charmingly ornamental effects and courtly convention, as seen in *The Virgin of Paris* (FIG. 10-39). A new intensity of expression, anticipated in the *Death of the Virgin* at Strasbourg (FIG. 10-53), also was developing at this time. The Crucifixion, the Man of Sorrows, and the Sorrows of the Virgin Mary became common themes. The head of a crucifix in St. Maria im Kapitol in Cologne (FIG. 10-56), the features wrenched with pain and sorrow, shows the new preference for interpretations of sacred story in terms of human feeling rather than of dogma and mystery. The humanizing that began in the twelfth century is accelerated. The anguish of the suffering Christ is represented with such force that it could not fail to stir the emotions powerfully and to arouse deep empathy in the observer. As motion was introduced into portal sculpture, so motion—read as emotion—here activates the human face. Increasingly, images reach out, not only into physical space but into the emotions of the observer. The artist presents more than the simple theological tenet in terms of some impersonal symbol; the mystery is brought back to earth once more, incarnate in the image of physical and psychic suffering.

Italy

Few Italian architects accepted the northern Gothic style, and the question has been raised as to whether it is proper to speak of buildings like Florence Cathedral (FIGS. **10-58** to **10-60**) as Gothic structures. Begun in 1296 by ARNOLFO DI CAMBIO and so large that it seemed to the fifteenth-century architect Leon Battista Alberti to cover "all of Tuscany with its shade," the cathedral scarcely looks Gothic. Most of the familiar Gothic features are missing; the building has neither flying buttresses nor stately clerestory windows, and its walls are pierced only by a few, relatively small openings. Like the façades of San Miniato al Monte (FIG. 9-20), the building's surfaces are ornamented, in the old Tuscan fashion, with marble-incrusted geometric designs to match it to the eleventh-century Romanesque baptistry nearby. Beyond an occasional ogival window and the fact that the nave is covered by rib vaults, very little identifies this building as Gothic. The vast gulf that separates this Italian church from its northern European cousins is strikingly evident when the former is compared with a full-blown German representative of the High Gothic style, such as the cathedral of Cologne (FIG. **10-57**).

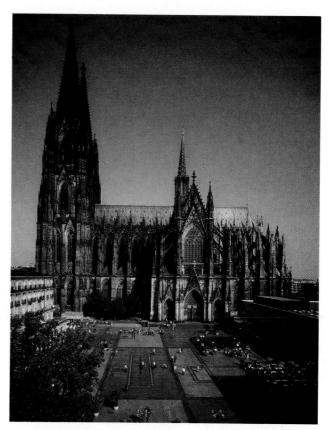

10-57 Cologne Cathedral, West Germany, 1248; nave, façade, and towers, nineteenth century (view from the south).

10-58 Florence Cathedral, Italy, 1296–1436 (view from the south).

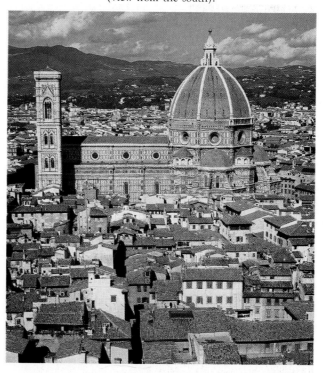

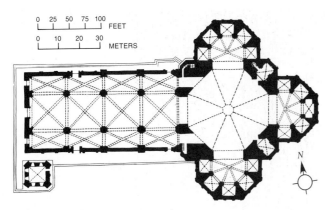

10-59 Plan of Florence Cathedral. (After Sir Banister Fletcher.)

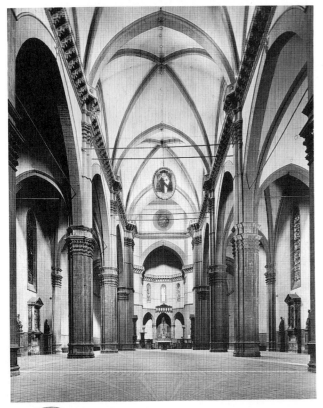

(10-60) Nave of Florence Cathedral (view facing east).

In Cologne Cathedral, an emphatic stress on the vertical produces an awe-inspiring upward rush of almost unmatched vigor and intensity. The building has the character of an organic growth shooting heavenward, its toothed upper portions engaging the sky. The pierced, translucent stone tracery of the spires merges with the atmosphere. Florence Cathedral clings to the ground and has no aspirations to flight. All emphasis is on the horizontal elements of the design, and the building rests firmly and massively on the ground. Simple, geometric volumes are defined clearly and show no tendency to merge either into each other or into the sky. The dome, though it may

seem to be rising because of its ogival section, has a crisp, closed silhouette that sets it off emphatically against the sky behind it. But because this dome is the monument with which architectural historians usually introduce the Renaissance (it was built by Filippo Brunelleschi between 1420 and 1436), a comparison of the campanile with the Cologne towers may be somewhat more appropriate. Designed by the painter Giotto di Bondone in 1334 (and completed with some minor modifications after his death), the Florence campanile (FIG. 10-58) stands apart from the cathedral in the Italian tradition. In fact, it could stand anywhere else in Florence without looking out of place; it is essentially self-sufficient. The same can hardly be said of the Cologne towers (FIG. 10-57); they are essential elements of the building behind them, and it would be unthinkable to detach one of them and place it somewhere else. Heinrich Wölfflin compared buildings of this kind to a flame from which no single tongue can be separated.* This comparison holds true for every part of the Cologne structure, down to its smallest details. No individual element seems to be capable of an independent existence; one form merges into the next, in an unending series of rising movements that pull the eye upward and never permit it to rest until it reaches the sky. This structure's beauty is amorphous rather than formal; it is a beauty that speaks to the heart rather than to the intellect.

The Italian tower is entirely different. Neatly subdivided into cubic stages, Giotto's tower is the sum of its clearly distinguished parts. Not only could this tower be removed from the building without adverse effects, but each of the component parts—cleanly separated from one another by continuous, unbroken moldings—seems capable of existing independently as an object of considerable esthetic appeal. This compartmentalization is reminiscent of Romanesque, but it also forecasts the ideals of Renaissance architecture: to express structure in the clear, logical relationships of its component parts and to produce self-sufficient works that could exist in complete independence. Compared to the north towers of Cologne, Giotto's campanile has a cool and rational quality that appeals more to the intellect than to the emotions.

In the plan of Florence Cathedral (FIG. 10-59), the nave almost appears to have been added to the crossing complex as an afterthought; in fact, the nave was built first, pretty much according to Arnolfo's original plans (except for the vaulting), and the crossing was redesigned midway through the fourteenth century to increase the cathedral's interior space. In its present form, the area beneath the dome is the focal point

*Heinrich Wölfflin, *Classic Art*, 2nd ed. (London: Phaidon, 1953).

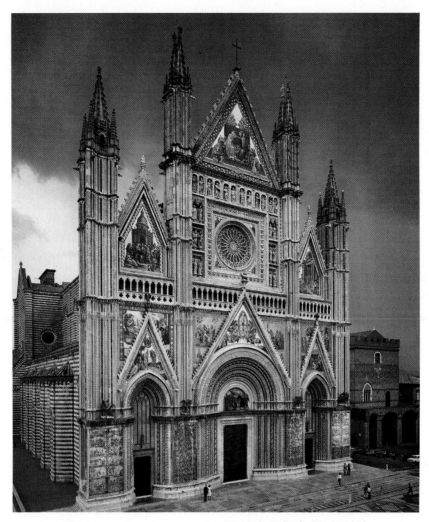

10-61 West façade of Orvieto Cathedral, Italy, begun c. 1310.

of the design, and the nave leads to it, as Paul Frankl says, "like an introduction of slow chords, to a goal of self-contained finality." To the visitor from the north, the nave seems as strange as the plan; neither has a northern European counterpart. The Florence nave bays (FIG. 10-60) are twice as deep as those of Amiens (FIG. 10-25), and the wide arcades permit the shallow aisles to become part of the central nave. The result is an interior that has an unmatched spaciousness. The accent here, as in the exterior, is on the horizontal elements. The substantial capitals of the piers prevent them from soaring into the vaults and emphasize their function as supports. This interior lacks the mystery of northern naves, and Nikolaus Pevsner has observed that its serene calm and clarity tell the visitor that the Tuscan architects never entirely rejected or forgot their Classical heritage and that it is indeed only here, in central Italy, that the Renaissance could have been born.

The façade of Florence Cathedral was not completed until the nineteenth century, and then in a form much altered from its beginnings. In fact, Italian builders exhibited little concern for the façades of their churches, and dozens remain unfinished to this day. One reason for this may be that the façades were not conceived as integral parts of the structures, but rather as screens that could be added to the fabric at any time. The façade of Orvieto Cathedral (FIG. **10-61**) is a typical and handsome example. Begun in the early fourteenth century, it pays the graceful compliment of imitation to some parts of the French Gothic repertory of ornament, especially in the four large pinnacles that divide the façade into three bays. But these pinnacles—the outer ones serving as miniature substitutes for the big, northern, west-front towers— grow up, as it were, from an old Tuscan façade (FIG. 9-20) and, ultimately, from the Early Christian. The rectilinearity and triangularity of the old Tuscan marble incrustation (here enframing and pointing to the precisely wrought rose window) are seen clearly behind the transparent Gothic overlay. The whole effect of the Orvieto façade is that of a great altar screen, its

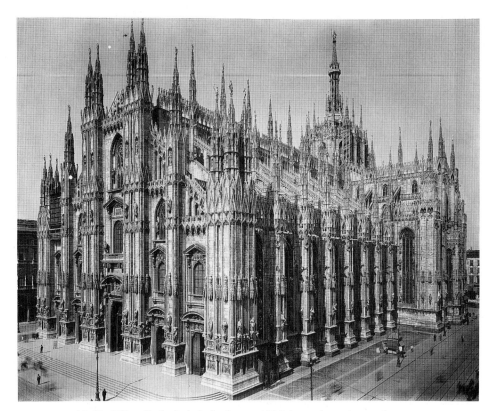

10-62 Milan Cathedral, Italy, begun 1386 (view from the southwest).

single plane covered with carefully placed carved and painted ornament. In principle, Orvieto belongs with San Miniato al Monte or the cathedral of Pisa, rather than with Amiens or Notre Dame of Paris.

Since Romanesque times, northern European influences had been felt more strongly in Lombardy than in central Italy. When the citizens of Milan decided to build their own cathedral (FIG. **10-62**) in 1386, they invited and consulted experts not only from Italy but also from France, Germany, and England. These experts must have carried on a rough disputatio about the strength of the foundations and the composition and adequacy of the piers and the vaults—the application of the true geometric scientia in working out plan and elevation. The result was a compromise; the proportions of the building, particularly those of the nave, became Italian (that is, wide in relation to height), and the surface decorations and details remained Gothic. But even before the cathedral was half finished, the new Classical style of the Renaissance had been well launched and the Milan design had become anachronistic. The elaborate façade represents a confused mixture of Late Gothic and Classical elements and stands as a symbol of the waning of the Gothic style.

The city churches of the Gothic world were just as much monuments of civic pride as they were temples or symbols of the spiritual and natural world. To un-

dertake the construction of a great cathedral, a city had to be rich with thriving commerce. The profusion of large churches during the period attests to the affluence of those who built and maintained them, as well as to the general revival of the economy of Europe in the thirteenth century.

The secular center of the community, the town hall, was almost as much the object of civic pride as the cathedral. A building like the Palazzo Pubblico of Siena (FIG. **10-63**), the proud commercial and political rival of Florence, must have earned the admiration of Siena's citizens as well as of visiting strangers, inspiring in them respect for the city's power and success. More symmetrical in its design than most buildings of its type and period, it is flanked by a lofty tower, which (along with Giotto's campanile in Florence) is one of the finest in Italy. This tall structure served as lookout over the city and the countryside around it and as a bell tower from which signals of all sorts could be rung to the populace. The medieval city, a self-contained political unit, had to defend itself against neighboring cities and often against kings and emperors; in addition, it had to be secure against internal upheavals, which were common in the history of the Italian city-republics. Feuds between rich and powerful families, class struggle, even uprisings of the whole populace against the city fathers were constant threats to a city's internal security. The heavy

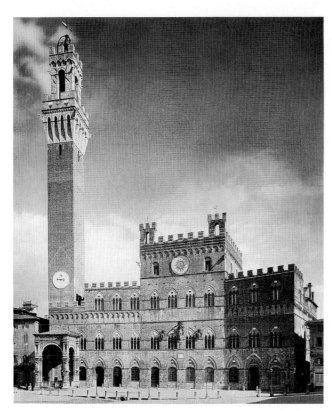

10-63 Palazzo Pubblico, Siena, Italy, 1288–1309.

walls and battlements of the Italian town hall eloquently express the frequent need of city governors to defend themselves against their own citizens. The high tower, out of reach of most missiles, is further protected by *machicolated* galleries, built out on corbels around the top of the structure to provide openings for a vertical (downward) defense of the tower's base.

The secular architecture of the Italian mainland tends to have this fortified look. But Venice, some miles out in the Venetian lagoon, was secure from land attack and could rely on a powerful navy for protection against attacks from the sea. Internally, Venice was a tight corporation of ruling families that, for centuries, provided an unshakable and efficient establishment, free from disruptive tumults within. Such a stable internal structure made possible the development of an unfortified, "open" architecture, exemplified in the Doge's Palace (FIG. **10-64**), the seat of government of the Venetian republic. This, the most splendid public building of medieval Italy, seems to invite passersby to enter rather than to ward them off. In a stately march, the short and heavy columns of the first level support low-pointed arches and look strong enough to carry the weight of the upper structure. Their rhythm is doubled in the upper arcades, where more slender columns carry ogival arches, which terminate in flamelike tips between medallions pierced with quatrefoils. Each story is taller than the one beneath it, the topmost being as high as the two lower arcades combined. Yet the building does not look top-heavy—a fact due in part to the complete absence of articulation in the top story and in part to the delicate patterning of the walls, in cream and rose-colored marbles, which somehow makes them appear paper-thin. The Doge's Palace is the monumental representative of a delightful and charming variant of Late Gothic architecture. Its slightly exotic style reminds us of Venice's strategic position at the crossroads of the West and the Orient, where it could synthesize artistic stimuli received from either direction. Colorful, decorative, light and airy in appearance, and never overloaded, the Venetian Gothic is ideally suited to the lagoon city of Venice, which floats between water and air.

10-64 The Doge's Palace, Venice, Italy, c. 1345–1438.

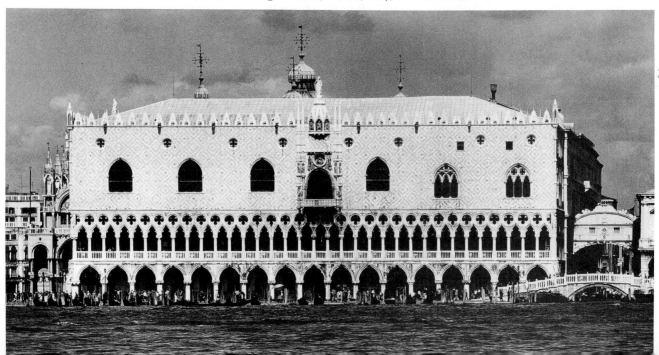

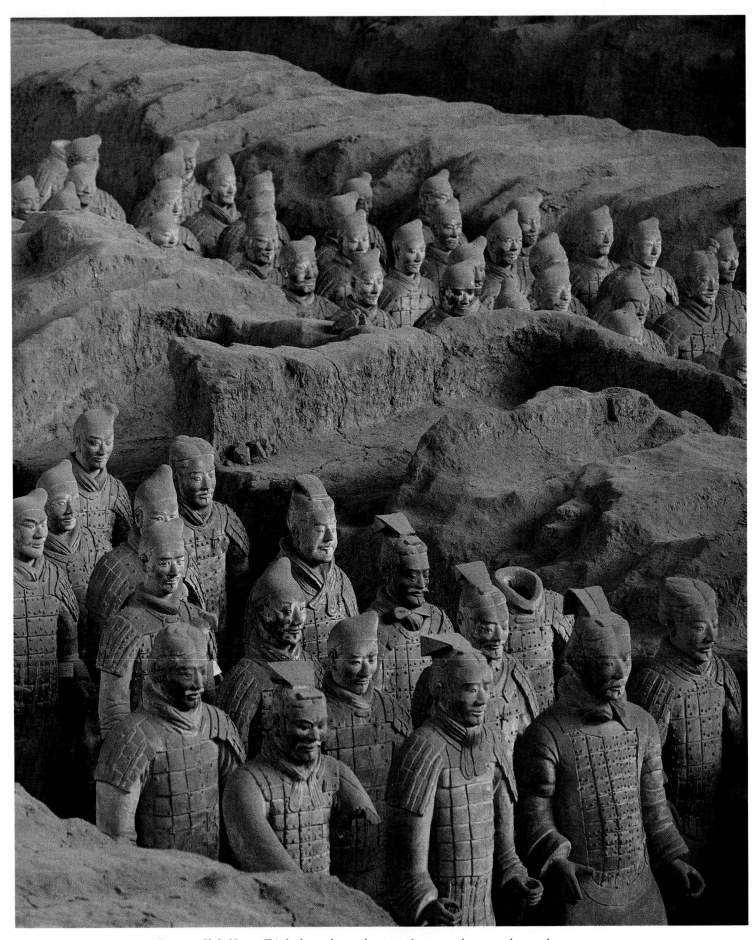

Emperor Shih Huang Ti's bodyguards march again after more than two thousand years as the result of excavations at Xi'an, Shensi, China.

III

THE NON-EUROPEAN WORLD

The art of non-European civilizations is introduced at this point in our survey because much of it is more closely related to the art of the prehistoric period and of the earlier Middle Ages than to the art of the Renaissance and of subsequent times until the twentieth century. In these latter periods, the Western artist moves from a dominantly religious and conceptual approach toward an increasingly secular and perceptual one. This drive toward optical realism and the persistent search for a rational, if not scientific, basis for the objectivization of natural appearances were not shared by the numerous cultures outside the mainstream of European history. Thus, non-European art is more akin to Byzantine and other art of the Middle Ages, although its forms, which are based on non-Western cultural and spiritual precepts, are, of course, very different.

Sporadic contacts between Africa and the Far East and the West have occurred since antiquity. The Phoenicians are said to have circumnavigated Africa as early as 600 B.C., and Alexander the Great, bent on exploration as much as conquest, took his armies beyond the Indus River into India. Nomadic peoples from central Asia made repeated incursions into the Near East and Europe; the Huns, under Attila, reached France in the fifth century. In the later Middle Ages, the search for trade routes to the East inspired the exploratory journeys of such enterprising merchants as the Polo brothers, Nicolo and Maffeo, and Nicolo's famous son, Marco, who reached Peking in the late thirteenth century.

Yet all of these contacts were transient and, even when given permanence through the establishment of sea routes during the Renaissance and Baroque periods, served commercial rather than cultural interests. Imported objects were admired as exotic curiosities, and even the eighteenth-century fascination with things Chinese was little more than a superficial and passing fashion. Only toward the end of the nineteenth century, when Western art had exhausted itself in its persistent drive toward realism and was beginning to

search for alternative approaches, did non-Western art begin to have a more serious impact on the West.

Even though conquests, colonization, and missionary activity after the Middle Ages carried Christianity well beyond the boundaries of western Europe, we may identify the non-European world as the non-Christian world. This vast region, which dwarfs the area of Europe, produced a great variety of artistic styles and ideas. Of these, the art of Islam already has been surveyed (Chapter 7). The enormous remainder can be subdivided roughly into Oriental art and Third World art. The former embraces the art of Southeast Asia, China, Korea, and Japan; the latter includes the essentially tribal arts of the North and South American Indian, of Africa, and of the South Pacific.

The earliest art works from the great Eastern civilizations in India, China, Korea, and Japan date from Paleolithic and Neolithic times. Buddhism was the common denominator of the later arts of these different countries, although each developed a distinctive style—or, rather, a series of styles. Indian sculpture, from its beginnings, has been characterized by a pulsating vigor in reproducing the living body. Early Chinese bronzes display amazing technical virtuosity in the use of highly symbolic, though abstract, decorative motifs. In later dynasties, in sculpture and particularly in painting, carefully observed details are rendered lyrically and produce a haunting image of nature. Japanese art, in spite of being subject to recurring waves of foreign

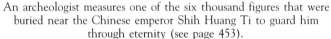

An archeologist measures one of the six thousand figures that were buried near the Chinese emperor Shih Huang Ti to guard him through eternity (see page 453).

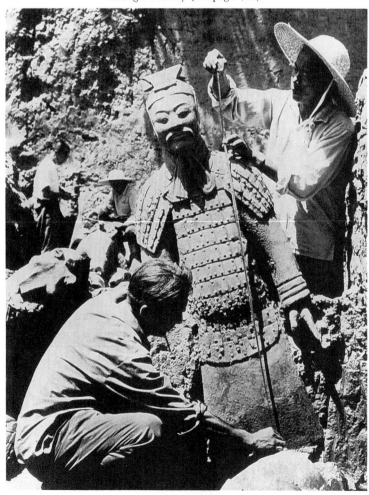

influence (especially from China), insistently returns to native traditions. Painting and, above all, architecture show a sensitivity to the relationship between decorative designs and natural forms.

In pre-Columbian Mexico, Central America, and the Andean region of South America, highly cultured peoples, using Stone Age technology, erected great temple complexes elaborately decorated with reliefs and practiced the crafts of weaving and pottery with great skill. About A.D. 500, the native North Americans began to settle in agricultural communities. Some groups, such as the Pueblo of the southwestern United States, reached a highly developed state in the eleventh, twelfth, and thirteenth centuries. Their stylized arts reflect an extraordinary understanding of the decorative qualities of abstract design.

The peoples native to Africa and the South Sea Islands produced a distinguished and individual art until contact with Europeans either modified it or brought it to a halt. This art, far from being technically or esthetically crude, is sophisticated in its presentation of conceptual rather than naturalistic images and has asserted itself in the West with ever-stronger effect and ever more respectful recognition and appreciation. As we shall see in subsequent chapters, its rhythmical, abstract forms have become a valuable resource and inspiration for many modern artists of great distinction and originality.

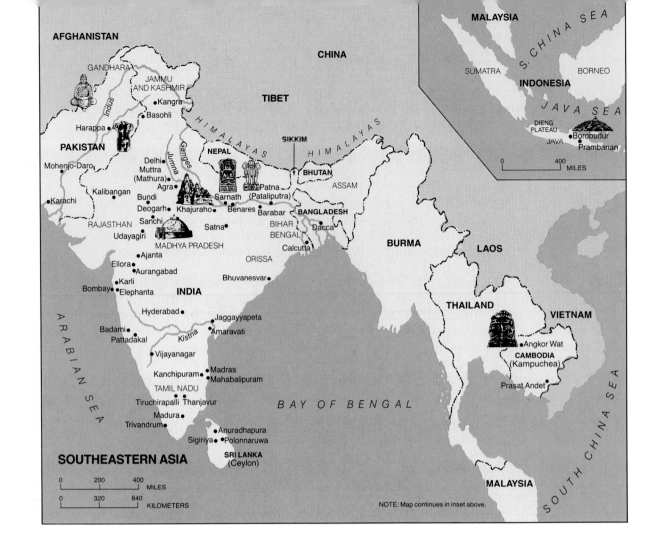

SOUTHEASTERN ASIA

3000 B.C.	c. 1800	1700	1500	500	322	184	70 B.C.	A.D. 30
INDUS VALLEY CIVILIZATION	ARYAN INVASIONS				MAURYA (ASOKA) PERIOD	SUNGA PERIOD	ANDHRA PERIOD	
								KUSHAN PERIOD

Harappa torso
c. 3000–2000 B.C.

Capital,
Palace of Asoka
272–232 B.C.

Great Stupa,
Sanchi, completed
1st century

Seated Buddha,
Gandhara
late 3rd century

Vedic religion
introduced by Aryans
c. 1800 B.C.

Birth of
Sakyamuni
c. 563 B.C.

Upanishads
evolve
800–600 B.C.

Gandhara conquered
by Alexander
the Great
327 B.C.

Fall of Mauryan dynasty,
political fragmentation
of India c. 184 B.C.

Bhagavad-Gita
c. 1st–2nd century B.C.

11
THE ART OF INDIA

320		c. 600	c. 750	846	1000	1173	1336	1736
GUPTA PERIOD (North India)			LATER HINDU DYNASTIES		MOSLEM DYNASTIES			
CHALUKYA PERIOD (Central India)								
PALLAVA PERIOD (South India)				CHOLA KINGDOM			VIJAYANAGAR/NAYAK (HINDU) DYNASTIES	

Seated Buddha, Sarnath 5th century

Stupa, Borobudur, Java c. 800

Visvanatha Temple, Khajuraho c. 1000

Bayon, Angkor Thom 12th–13th century

Siva as Nataraja c. 1000

Indian emigrations to Burma, Cambodia, Java, Thailand, Sumatra 5th century

Moslem invasions begin 1000

THE SUBCONTINENT OF INDIA, contiguous with the Asian mainland on its northern boundaries, has three distinct geographical areas: the northeast, where the massive Himalayas, the traditional home of the gods, rise as a barrier; the fertile, densely populated area to the northwest and to the south of the Himalayas, where the valleys of the Indus and the Ganges rivers lie; and peninsular India, composed of tropical tablelands separated from the northern rivers by mountains and forests. These areas exhibit great extremes of climate that range from tropical heat to perpetual snow and glaciers, from desert conditions to some of the heaviest rainfall in the world.

The ethnic characteristics and religions of the people vary as much as the geography. The most common language of north central India is Hindi, a Sanskrit derivative. Urdu, closely related, is spoken by most of the Moslem population. Several Dravidian languages, unrelated to Sanskrit, are spoken in the south. Hinduism is the main religion of India, as Islam is of Pakistan, but Jainism and Christianity have many adherents, and Buddhism and Judaism also have a few.

BEGINNINGS

The first major culture of India centered around the upper reaches of the Indus River valley during the late third and early second millennia B.C. Mohenjo-Daro and Harappa in Pakistan were the chief sites. Recently, other important centers of this culture have been found farther south at Kalibangan in Rajasthan, India, and near Karachi, Pakistan.

The architectural remains of Mohenjo-Daro suggest a modern commercial center, with major avenues along a north–south orientation, streets as wide as 40 feet, multistoried houses of fired brick and wood, and elaborate drainage systems.

Some sculptures from this Indus civilization reflect Mesopotamian influences; others indicate the presence of a thoroughly developed Indian tradition. The latter is exemplified by a miniature torso from Harappa (FIG. **11-1**), which, at first glance, appears to be carved according to the precepts of Greek naturalism. (Some historians question the dating of this piece.) The emphasis given (by polishing) to the surface of the stone and to the swelling curves of the abdomen, however, reveals an interest, not in the logical anatomical structure of Greek sculpture, but in the fluid movement of a living body. This sense of pulsating vigor and the emphasis on sensuous surfaces were chief characteristics of Indian sculpture for four thousand years.

11-1 *Male Nude*, Harappa, Pakistan, late third to early second millennium B.C. Red sandstone, $3\frac{1}{2}''$ high. National Museum, New Delhi.

Great numbers of intaglio steatite seals found at Mohenjo-Daro exhibit a blend of Indian and Near Eastern elements (FIG. **11-2**). Indeed, it was the finding of a Mohenjo-Daro seal at a datable Mesopotamian site that enabled scholars to assign dates to the Indus valley cultures. The script on the seals has not been deciphered. Varied devices worked into the stone, such as trees (sometimes associated with animals and humanoid figures), are represented as objects of worship. The beasts most common on the seals are various kinds of bulls (including the humped variety), the water buffalo, the rhinoceros, and the elephant. Fantastic animals and anthropomorphic deities also are represented.

On one seal, a seated, three-headed figure appears in what is later known as a "yoga position." The heads carry a trident-shaped device that two thousand years later was used to symbolize the Buddhist community and the Hindu deity Siva. Around the deity are various animals, including the bull and the tiger, which also became symbols of Siva. Given its date, this seal probably represented a prototype of that god. Such continuity of iconography indicates the deep roots of religious tradition in India.

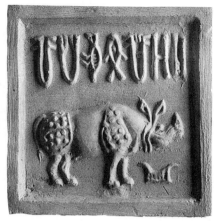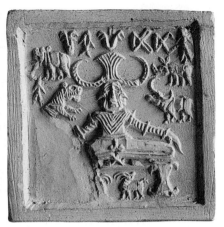

11-2 Seals, from Mohenjo-Daro, Pakistan, third millennium B.C. Steatite. National Museum, New Delhi.

Style, too, shows a continuous tradition. The animals on the Indus valley seals have the flowing contours and sensuous surfaces (also seen in the Harappa figure) that characterize sculpture throughout most of Indian history. This artistic continuity is remarkable, not only because of the time spanned, but also because of the fact that virtually no remains of the visual arts have been found for the period between the disappearance of the Indus civilization (about 1700 B.C.) and the rise of the Maurya Empire (third century B.C.). The Aryan invasions, which began about 1800 B.C., may account for the break in the sequence of Indian art. The persistence of so many indigenous traits is even more amazing in view of the Aryans' profound effect on Indian culture. Destruction by the invaders, as well as the perishability of the materials used, undoubtedly accounted for the disappearance of many of the objects by which Indian traditions were passed on during the two thousand years following the collapse of the Indus civilization.

The Aryans brought the Vedic religion with them to India. The term derives from the hymns (Vedas), which have survived to this day. These hymns are addressed to the gods, who are personified aspects of nature. The warrior god Indra is thunder; Surya, the sun; and Varuna, the sky. These are but three of many. All were worshiped by means of hymns and sacrificial offerings in conformance with strict laws of ritual. Fire altars, built according to prescribed formulas, served as the focus of devotion. So important was the act of ritual that, in time, Agni (the sacrificial fire) and Soma (the sacrificial brew) became personified as gods in their own right.

The rather simple form of religion and propitiation so beautifully expressed in the Vedic hymns was elaborated greatly in the Upanishads (800–600 B.C.), a series of treatises on the nature of man and the universe that introduced a number of concepts alien to the simple nature worship of the northern invaders. Chief among the new ideas were those of *samsara* and *karma*. Samsara meant the transformation of the soul into some other form of life on the death of the body. The type of existence into which the reborn soul entered depended on karma, the consequence of actions in all previous lifetimes. A bad karma meant a dark future—rebirth in a hell or in this world as a lower animal (a reptile, for example, or an insect). A good karma meant that the soul might go into the body of a king, a priest, or even a god, for gods also were subject to eventual death and to the endless cycle of rebirth. The goal of religion therefore became the submersion of individual life in a world soul, which was attainable only after an individual's karma had been perfected through countless rebirths. Penance, meditation, and asceticism were believed to speed the process.

During the sixth century B.C., two major religions developed in India. One, Buddhism, exerted a profound influence on the culture and art of India as a whole from the third century B.C. to the sixth or seventh century A.D. (In some parts, like Bengal and Bihar, it was influential to the eleventh century and, in the south, to an even later date.) Although Jainism, the other major religion, never achieved Buddhism's dominance, it continues to the present day as a small but distinct religion in India, while Buddhism is practically extinct there.

The arts of many Asian countries derive from Indian Buddhism, which began with the birth of the Buddha Sakyamuni about 563 B.C. The son of a king who ruled a small area on the border of Nepal and India, the child, according to legend, was miraculously conceived and sprang from his mother's side. Named Siddhartha, and also known as Gautama, the child displayed prodigious abilities. A sage predicted

that he would become a Buddha, an "enlightened" holy man destined to achieve "nirvana." After a series of confrontations with old age, sickness, religious asceticism, and death, called the Four Encounters, Siddhartha renounced courtly luxury and the secular life. While meditating under a pipal tree in the city of Bodh Gaya, he obtained illumination—the complete understanding of the universe that is Buddhahood. His teachings may be summed up as follows: all existence implies sorrow; the cause of sorrow is attachment to work and the self; this attachment can be dissolved through the elimination of desires, which also bind the self to a countless succession of rebirths; the cessation of rebirth can be accomplished by following the Eightfold Path, which prescribes simple practices of right thought, right speech, and right action. This initial formulation of Buddhism, in which salvation was achieved by individual efforts, was later known as Hinayana Buddhism. The religion of Buddhism, so conceived, was not opposed to basic Hindu thought, but was rather a minor heresy deriving from certain speculations in the Upanishads. What Buddhism did was to offer a specific method for solving the ancient Indian problem of how to break the chain of existence so that the individual could find ultimate peace.

BUDDHIST DOMINANCE

Early Architecture and Sculpture

The earliest known examples of art in the service of Buddhism (from the middle of the third century B.C.) are both monumental and sophisticated. Emperor Asoka (272–232 B.C.), the grandson of Chandragupta, founder of the Maurya dynasty (c. 322–184 B.C.), was converted to Buddhism after witnessing the horrors of the brutal military campaigns by which he himself forcibly had unified most of northern India. His palace at Patna in Bihar (ancient Pataliputra) was designed after the Achaemenid palace at Persepolis (FIG. 2-38).

Megasthenes, a Greek ambassador at the court of Asoka, has left a glowing report of Pataliputra. Only parts of columns, the foundations of buildings, and remnants of a wooden palisade now remain, but we may draw some idea of the architectural details from a series of commemorative and sacred columns that Asoka raised throughout much of northern India. These monolithic pillars were of polished sandstone, some as high as 60 or 70 feet. The capital of one (FIG. **11-3**), now in the Sarnath Museum near Benares, typifies the style of the period. It consists of a *lotiform* capital (a capital in the form of a lotus petal), on which rests a horizontal disk sculptured with a frieze

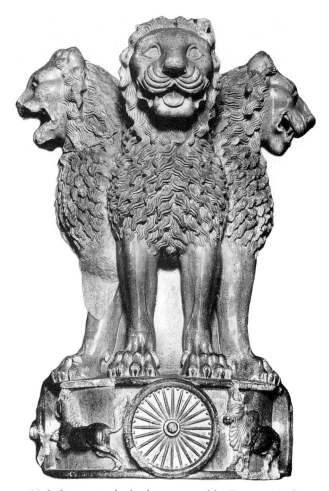

11-3 Lion capital of column erected by Emperor Asoka (272–232 B.C.), from Patna (ancient Pataliputra), India. Polished sandstone, 7' high. Archeological Museum, Sarnath.

of four animals alternating with four wheels. Seated on the disk are four *addorsed* (back-to-back) lions that originally were surmounted by another huge wheel. All of the forms are symbolic. The lotus, traditional symbol of divinity, also connoted humanity's salvation in Buddhism. The wheel represented the cycle of life, death, and rebirth. This "wheel of life" often had other levels of meaning. In this instance, it was the teaching of Buddha—the "turning of the wheel of the law." The wheel itself (probably developed from ancient sun symbols) and the four animals (the four quarters of the compass) with which it is associated here imply a cosmological meaning in which the pillar as a whole symbolizes the world axis. The lions also had manifold meanings, but here they were specifically equated with Sakyamuni Buddha, who was known as the lion of the Sakya clan.

The pillars are noteworthy not only for their symbolism, but also because they exemplify continuity of style. Although the stiff, heraldic lions are typical of Persepolis, the low-relief animals around the disk are treated in the much earlier, fluid style of Mohenjo-

Daro. So, too, are the colossal figures of *yakshas* and *yakshis*, sculptured during Asoka's time or somewhat later. These male and female divinities, originally worshiped as local nature spirits, gods of trees and rocks, now were incorporated into the Buddhist and Hindu pantheons.

THE CAVE TEMPLE

The Mauryan period also witnessed the beginnings of a unique architectural form—sanctuaries cut into the living rock of cliffs. Parts of the exteriors (and later the interiors) of these caves were carved to imitate in accurate detail the wooden constructions of the time. The Lomas Rishi cave, hollowed out during Asoka's reign, exhibits an entrance type (FIG. **11-4**) that will be perpetuated for a thousand years. This faithful replica of a wooden façade has a doorway with a curving eave that mimics a flexible wooden roof bent over rectangular beams. A decorative frieze of elephants over the doorway carries on the indigenous sculptural traditions.

THE STUPA

The fall of the Mauryan dynasty, around the beginning of the second century B.C., led to the political fragmentation of India. Under the Sungas and the Andhras, who were the chief successors of the Mauryas, numerous *chaitya* (Buddhist assembly halls) and *viharas* (monasteries) were cut into the hills that run across central India from east to west. At the same time, the *stupa*, which originally was a small burial or reliquary mound of earth, evolved as an

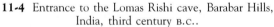

11-4 Entrance to the Lomas Rishi cave, Barabar Hills, India, third century B.C..

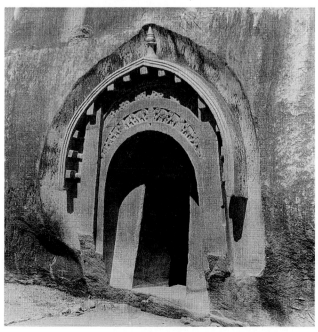

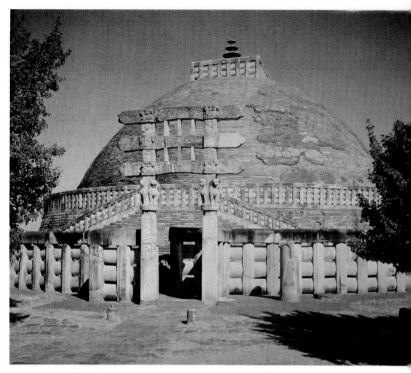

11-5 The Great Stupa, Sanchi, India, completed first century.

important architectural program. Asoka is supposed to have built thousands of stupas throughout India. By the end of the second century B.C., huge stupas were being constructed. Sculptured fragments from early stupas have been found at Muttra (ancient Mathura), near Satna (ancient Bharhut), and elsewhere in India, but the grandeur of this type of structure can be seen best at Sanchi in the state of Madhya Pradesh. There, on a hill overlooking a wide plain, several stupas containing sacred relics were built over a period of centuries. Of these, the Great Stupa (FIG. **11-5**), the tallest and finest, was originally dedicated by Asoka. Enlarged and finally completed about the middle of the first century,* it now stands as the culminating monument of an era.

A double stairway at the south side leads from the base to a drum about 20 feet high and permits access to a narrow, railed walk around the solid dome, which rises 50 feet above the ground. Surmounting the dome is the *harmika,* a square enclosure from the center of which arises the *yasti,* or mast. The yasti is itself adorned with a series of *chatras* (umbrellas). Around the whole structure is a circular stone railing with ornamented *toranas* (gateways; FIG. **11-6**) on the north, east, south, and west sides.

The stupa, like most Indian structures, has more than just one function. As a receptacle for relics, it is an object of adoration, a symbol of the death of the

*As a reminder, all dates not designated by the epoch time designation B.C. refer to the period A.D. Unless required for clarification, especially in Chapters 11–14, where large ranges of time from B.C. to A.D. are being covered, A.D. will no longer be used throughout the text.

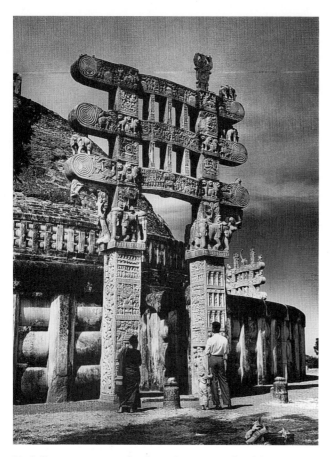

11-6 Eastern gateway, the Great Stupa, completed first century.

Buddha, or a token of Buddhism in general. Devotion is given the stupa by the believer, who circumambulates its dome. But, in another sense, the stupa is a cosmic diagram, the world mountain with the cardinal points emphasized by the toranas. The harmika

symbolizes the heaven of the thirty-three gods; the yasti, as the axis of the universe, rises from the mountain-dome and through the harmika, thus uniting this world with the paradises above.

The railings and domes of some stupas were decorated with relief sculpture. The toranas at Sanchi are covered with Buddhist symbols, deities, and narrative scenes, but the figure of the Buddha never appears. Instead, he is symbolized by such devices as an empty throne, the tree under which he meditated, the wheel of the law, or his footprints.

The awe expressed in this iconographic restraint, echoed by the quiet mass of the dome itself, is contradicted strikingly and paradoxically by the sculptural luxuriance that crowds the toranas. Lush foliage mingles with the flowing forms of human bodies, and warm vitality pervades both animal and human forms. Sensuous yakshis hang like ripe fruit from tree brackets. This almost hedonistic expression is alien to the Buddhist renunciation of life. It is an assertion, rather, of a basic Indian attitude that at all times unites and dominates almost all of Buddhist, Hindu, and Jain art.

Sanchi is the greatest constructed monument of early Buddhism, much as the chaitya at Karli is the finest of the sculptured cave temples. During the second and first centuries B.C., the cave sanctuaries had developed complexities far beyond their simple beginnings in the Lomas Rishi cave. Splendid façades reproducing wooden architecture in exact detail were given permanence in stone. Around the year 100, at Karli, in the Western Ghats near Bombay, a cliff was hollowed out and carved into an apsidal temple nearly 45 feet high and 125 feet long. The nave of the hall leads to a monolithic stupa in the apse (FIG. **11-7**),

11-7 Interior of the chaitya hall at Karli, India, c. 100.

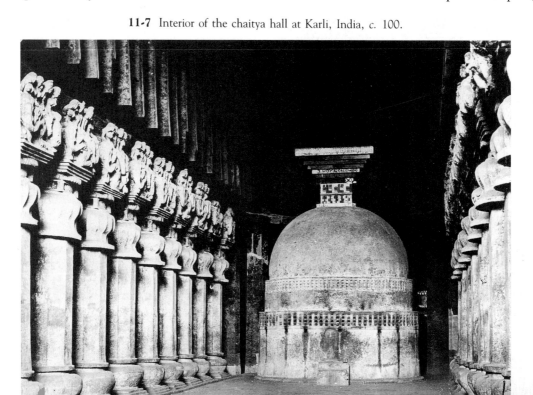

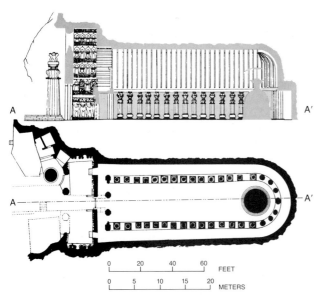

11-8 Section (*top*) and plan (*bottom*) of the chaitya hall at Karli.

and on either side of the nave is an aisle formed by a series of massive columns crowned with male and female riders on elephants. These great columns follow the curve of the apse, thus providing an ambulatory behind the stupa (FIG. **11-8**). The inner wall of the narthex, despite some later additions, is almost intact, and today it functions as a magnificent façade. On each side of the entrance, massive elephants, like

11-9 *Amorous Couple,* from the entrance of the chaitya hall at Karli.

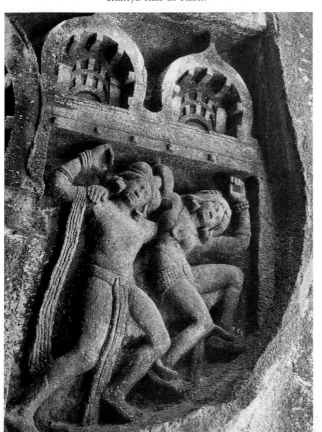

atlantids, support a multistoried building, while male and female pairs (related to yakshas and yakshis) flank the central doorway, enhancing the rich surfaces with heroic and voluptuous forms. These undulant figures (FIG. **11-9**) contrast with the immobile severity of the stupa within and, like the yakshis of Sanchi, speak of life, not death.

THE BUDDHA IMAGE

For some four hundred years before the second century, the Buddha was represented only in symbols. At the end of the first century, in both Gandhara and Mathura, he suddenly was depicted in anthropomorphic form. The explanation for his sudden depiction is to be found partly in the development of the Buddhist movement, which, during the first century, was divided by two conflicting philosophies. The more traditional believers regarded the Buddha as a great teacher who had taught a method by which man ultimately might attain nirvana. The newer thought, called *Mahayana* (the Great Vehicle) as opposed to the older *Hinayana* (the Lesser Vehicle), deified the Buddha and provided him with a host of divinities (*Bodhisattvas*) to aid him in saving humanity. According to the older belief, Sakyamuni was the last of seven Buddhas to exist on earth. The Mahayanists peopled the universe with thousands of Buddhas, of whom Amitabha, Lord of the Western Paradise, and Maitreya, a messiah who was to appear on this earth, soon rivaled Sakyamuni in popular favor. Symbols of the Buddha were too cold and abstract to appeal to great masses of people and were not suited to the pageantry of the new faith. In addition, Buddhism had borrowed from a reviving Hinduism the practice of *bhakti* (the adoration of a personalized deity as a means of achieving unity with it), which demanded the human figure as its focus. Thus Buddhism, out of emulation of its rival, produced its most distinct symbol, the Buddha image.

Gandhara, where one of the two versions of the anthropomorphic Buddha first appeared, may be taken loosely to include much of Afghanistan and the westernmost section of northern India, now part of modern Pakistan. In 327 B.C., Gandhara was conquered by the armies of Alexander the Great. Although the Greek occupation lasted only a short time, it led to continued contact with the Classical West. It is not surprising, then, that the Buddha image that developed at Gandhara (FIG. **11-10**) had Hellenistic and especially Roman sculpture as its model. Indeed, the features of the Master often suggest those of a marble Apollo, and many details, such as drapery patterns and coiffures, recall successive styles in contemporaneous Roman carving. Although the iconography was Indian, even the distinguishing marks of the Buddha (*lakshanas*) sometimes were translated into a

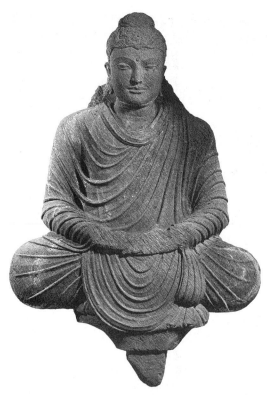

11-10 *Seated Buddha,* from Gandhara, Pakistan, late third century. Stone, 28¾" high. Yale University Art Gallery.

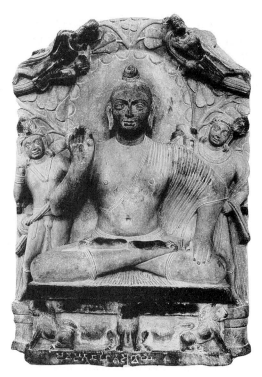

11-11 *Seated Buddha,* from Mathura, India, second to third centuries. Red sandstone, 27¼" high. Archeological Museum, Muttra.

Western idiom. Thus, the *ushnisha,* a knot of hair on the head, took on the appearance of a Classical chignon. At times, even the robe of the Indian monk was replaced by the Roman toga, and minor divinities were transformed into Western water gods, nymphs, or atlantids.

While this intrusion of Western style was dominating the northwest, the purely Indian version of the anthropomorphic Buddha was evolving one hundred miles south of Delhi in the holy city of Mathura. This image (FIG. **11-11**) is carved in stele form, which is common to most seated Buddha images in India. Sitting on a throne, with heraldic lions at its base, and flanked by two turbaned men, the Buddha is surrounded by the leaves and branches of the Tree of Enlightenment. The image derives directly from the yaksha of popular art and, like the yaksha, is draped in a mantle so thin and clinging that, at first glance, the figure seems to be nude. The Mathura Buddha also has broad shoulders, a narrow waist, and a supple grace. Only such iconographic details as the ushnisha, the *urna* (a whorl of hair between the brows, represented as a dot), the long-lobed ears, and the *mudra* (a symbolic hand gesture) distinguish the Buddha from the earlier yaksha.

By the third century, the two anthropomorphic Buddha types began to coalesce into a form that served as a model for the earliest Chinese versions. But it is the Buddha at Sarnath (FIG. **11-12**), from the

11-12 *Seated Buddha Preaching the First Sermon,* from Sarnath, India, fifth century. Stele, sandstone, 63" high. Archeological Museum, Sarnath.

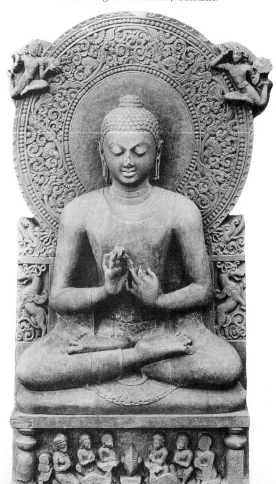

end of the fifth century, that conveys both the abstract idealism of the religion and the sensuousness of Indian art. The first element is evident in the simplified planes of the face; the second is found in the clinging drapery, which reveals the human form.

HINDU RESURGENCE

While Buddhism was at its height, Hinduism slowly was gathering the momentum that eventually was to crush its heretical offspring. Buddhism owed its original victory to the clearness of its formula for achieving salvation. About the first or second century B.C., Hinduism's answer appeared in the Bhagavad Gita, a poetic gospel that has been fundamental to Hindu doctrine ever since. According to the Gita, meditation and reason can lead to ultimate absorption in the godhead; so, too, can the selfless fulfillment of everyday duties. Because the Gita also stressed bhakti, which answered a fundamental emotional need, the Gita swept Hinduism to final supremacy in the sixth and seventh centuries A.D.

Architecture and Sculpture

Sporadic examples of Hindu art dating from the last centuries B.C. have been found, but we know of no great monuments before the fourth century A.D. At that time, the Hindus began to emulate Buddhist cave temples, first by carving out monumental icons in shallow niches. One such temple is the *Boar Avatar of Vishnu* (FIG. **11-13**)* at Udayagiri near Sanchi. Here, a 12-foot figure of Varaha, a manlike creature with a boar's head, is shown raising the earth goddess from the ocean—an act symbolic of the rescuing of the earth from destruction. The powerful form of Varaha, first formulated by the Kushans, served as a model for innumerable later sculptures of this popular theme. Within a few decades, more developed caves at the same site acquired sculptural doorways, interior columns, and central icons.

During the sixth century, in the rock hillsides at Badami to the south, the Chalukyans carved out rectangular temples that had pillars, walls, and ceilings ornamented with figures of their favorite deities. Porches and interiors were defined by the embellished columns, which were so ordered as to focus attention on the shrine in the center of the rear wall. In a temple dedicated to Siva (with Vishnu, one of the two chief divinities of the Hindu pantheon), the god is shown in his cosmic dance, with numerous arms spread fanlike around his body (FIG. **11-14**). Some of

*An *avatar* is a manifestation of a deity in which the deity performs a necessary function on earth; the number of avatars varies, with Vishnu usually having ten, or sometimes twenty-nine.

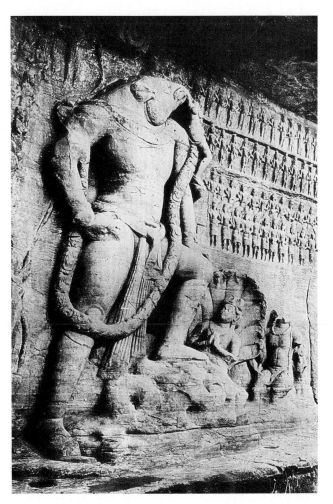

11-13 *Boar Avatar of Vishnu,* Cave V at Udayagiri, India, c. 400. Vishnu is 12′ 8″ high.

11-14 *Dancing Siva,* relief from cave temple, Badami, India, sixth century.

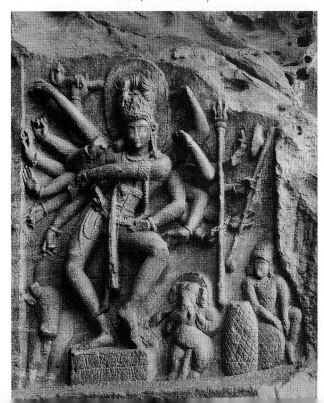

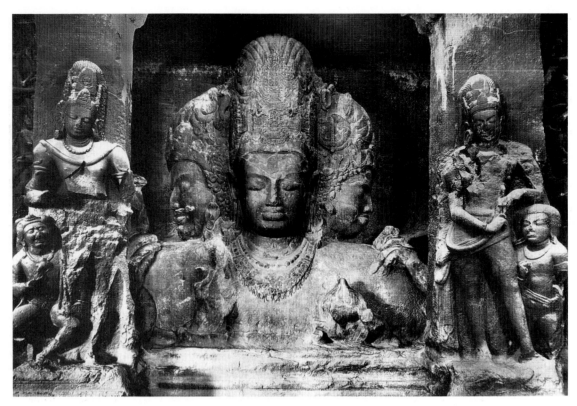

11-15 *Siva as Mahadeva* in rock-cut temple, Elephanta, India, sixth century. Siva is 17' high.

the god's hands hold objects; others are represented in prescribed gestures (mudra). Each object and each mudra signifies a specific power of the deity. The arrangement of the limbs is so skillful and logical that it is hard to realize that the sculptor conceived of the figure as a symbol and not as an image of a many-armed being.

Perhaps the supreme achievement of Hindu art is at Elephanta, where, in the sixth century, craftsmen excavated a hilltop and carved out a pillared hall almost 100 feet square. On entering this sanctuary, the visitor peers through rows of heavy columns. As one's eyes adjust to the dark, the gigantic forms of three heads (FIG. **11-15**) begin to emerge from the end wall. The heads represent Siva as Mahadeva, Lord of Lords and incarnation of the forces of creation, preservation, and destruction. The concept of power is immediately transmitted by the sheer size of the heads, which rise nearly 17 feet from the floor, dwarfing the onlooker.

The trinity of colossal faces is placed so as to receive light from all of the different entrances of the cave, creating the awe-inspiring illusion that the forms rise mysteriously out of the shapeless darkness of the background. Each of the three faces expresses a different aspect of the eternal. The center one, neither harsh nor compassionate, looks beyond humanity in the supreme indifference of eternal meditation. The other two faces—one soft and gentle, one angry and fearsome—speak of the sequence of birth and destruction that can be ended only by union with the godhead. The assurance of the period is manifest in the guardians of the shrine, who stand tall and relaxed. On the surrounding walls, deeply cut panels illustrating the legends of Siva carry on the robust and sensuous traditions of Harappa (FIG. 11-1) and Karli (FIG. 11-9).

During the fourth, fifth, and sixth centuries, Buddhism, in turn, borrowed heavily from Hindu doctrine. Elaborate rituals and incantations, inspired by similar Hindu practices, replaced the simple activities the Buddha had prescribed. Esoteric sects sprouted, and the popular Hindu worship of Sakti, the female power of the deity, was adapted for Buddhist usage. A sixth-century relief in a Buddhist cave temple at Aurangabad (FIG. 11-16) depicts worship of the Buddha through music and dance in a scene that might have been taken from a Hindu temple; the volatile and rapturous figures of the musicians and the dancer represent an Indian, rather than Buddhist, way of life. With little to distinguish it from Hinduism, Buddhism and its art gradually withered and, within a few centuries, virtually disappeared.

In the same burst of creativity that produced cave temples, other innovative Hindu architects were building the first structural temples with stone. One

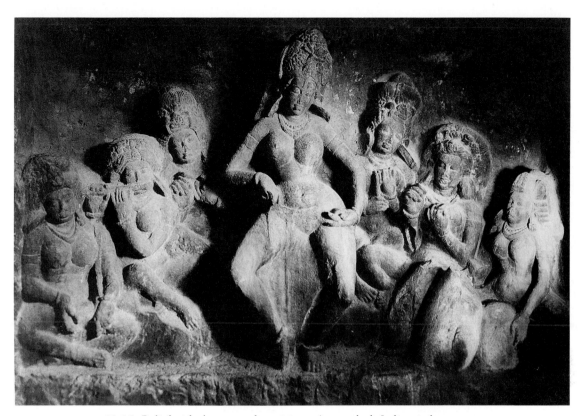

11-16 Relief with dancers and musicians, Aurangabad, India, sixth century.

of the earliest that remains is the Vishnu temple built in the early sixth century during the Gupta period (320–*c.* 600) at Deogarh in north central India (FIG. **11-17**). All later developments of the Hindu temple were in many ways elaborations on the principles embodied in Deogarh.

The Hindu temple is not a hall for congregational worship; it is the residence of the god. The basic requirement is a cubic cella for the cult image or symbol. This most holy of places, called the *garbha griha,* or womb chamber, has thick walls and a heavy ceiling to protect the deity. A doorway through which the devotee may enter is the only other architectural necessity. Like the stupa, the temple has other meanings, for it is also the symbol of the *purusha,* or primordial human being. In addition, in its plan, it is a *mandala,* or magic diagram of the cosmos, and its proportions are based on modules that have magical reference. Thus, the temple itself is a symbol to be observed from the exterior. Contemporary Western theories of architecture, defining it as the art or science that deals with the space-enclosing forms within which people carry on their activities, do not apply to the Hindu temple, which is to be appreciated as sculpture rather than as architecture.

In early temples, such as Deogarh, decoration is limited and restrained, and the form is a simple cube that originally was surmounted by a tower *(sikhara).*

11-17 Vishnu Temple (side view), Deogarh, India, early sixth century.

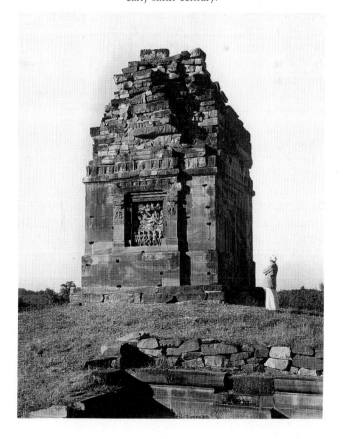

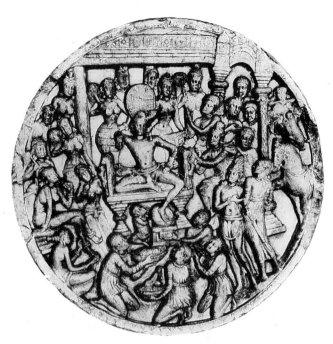

11-18 Relief from stupa, from Amaravati, India, second century. Musée Guimet, Paris.

the Bay of Bengal. The major sites, in chronological order (dating roughly from the second century B.C. to the third century A.D.), are Jaggayyapeta, Amaravati, and Nagarjunakonda. Little remains from the first, but many reliefs from the other two sites are extant. These are ornamented elaborately and filled with hosts of figures that, particularly in the later Amaravati scenes (FIG. 11-18), are slender and graceful, rendered almost as if by brush.

The record of Indian art farther to the south begins with a cave temple at Mandagadippattu (early seventh century) that was commissioned by the first great ruler of the Pallavas, Mahendravarman I, and dedicated to the Hindu trinity. Mahendravarman soon was surpassed by his immediate successors at Mahabalipuram, on the coast not far from the city of Madras. Here, near a miscellany of monuments that includes cave shrines, carved cliff sides, and a masonry temple, a unique group of five, small, free-standing temples, known as *rathas* (FIG. 11-19), were sculptured, perhaps as architectural models, from some of the huge boulders that litter the area. One of the temples is apsidal; another has a long, vaulted shape with a barrel roof, the ends of which reproduce the bentwood curves of the ancient chaitya halls. The smallest is a square shrine with a pyramidal roof that mimics in stone the thatch of primitive shrines as they appear in reliefs on the rails of early stupas. The Dharmaraja, largest of the rathas, has a simple cubic cella, as at Deogarh, but the *vimana* (composed of the garbha griha and the sikhara) ascends, in typical southern style, in pronounced tiers of cornices deco-

All of the walls except the entrance wall are solid but include sculptured panels, some like false doorways, framed in the walls. On these panels, in scenes from Hindu mythology, relaxed and supple figures carry on the Indian tradition of ease and poise.

In striking contrast to the robust plasticity of northern sculpture are the carvings on the Buddhist monuments situated at the mouth of the Kistna River on

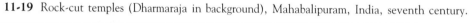

11-19 Rock-cut temples (Dharmaraja in background), Mahabalipuram, India, seventh century.

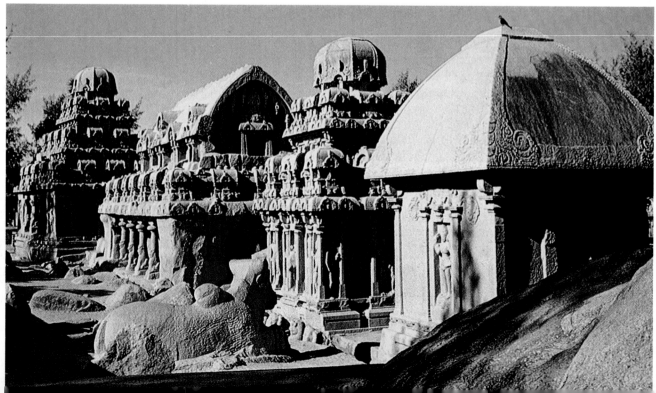

rated with miniature shrines (foreground, FIG. 11-19). Niches spaced along the walls contain figures of the major deities; these niches will become a regular feature of the southern temple.

The southern Indian temple was developed further at the beginning of the eighth century in nearby Kanchipuram and by the artists of the Chalukya dynasty in the Virupaksha Temple (*c*. 740) at Pattadakal near Badami. The vimana here is related to the Dharmaraja ratha, but porches and an assembly hall (*mandapa*) have been added in front of the garbha griha. The interior of this shrine consists of a dimly lighted ambulatory surrounding the cella, which is entered through a large, columned assembly hall, and two subsidiary shrines. Light that enters the mandapa through narrow windows and two projecting porches plays over elaborate relief carvings on the columns and walls. The devotee, who entered through an open porch, walked from the blazing light through a cool, softly lighted, and spacious area before reaching, in darkness, the enigma of the garbha griha itself. There, in the austere chamber, the worshiper came face to face with the barely visible symbol of the deity. The sense of mystery offered the worshiper was as satisfying to the Hindu as the soaring exultation of the Gothic cathedral was to the Christian.

In the following few centuries, a different architectural order evolved in northern India, characterized by a smoother integration of halls and porches with the main shrine and tower and by an increased vertical emphasis in all parts. The problem of creating a unified exterior was solved in separate stages. The first step, adding height to the mandapa to mitigate the disparity between the vertical vimana and the horizontal mandapa, is illustrated in the immense Kailasa Temple (*c*. 750), an extraordinary rock-cut monument at Ellora. A second step is exemplified by the lovely Muktesvar Temple at Bhuvanesvar, Orissa (FIG. **11-20**), where a high, pyramidal superstructure over the mandapa brought disproportionately horizontal elements into complete harmony with the tall sikhara. This evolution culminated during the tenth and eleventh centuries at Khajuraho (FIG. **11-21**) in north central India. There, the temples, numbering over twenty, became larger, more elaborate, and, by virtue of their high plinths, even more prominent. Two and sometimes three mandapa were put before the cella. The greatest esthetic advance was made in the roofs of the mandapa and their pyramidal eaves, which unite with the sikhara to create a rapid and torrential sequence of cascading forms. The lower sections of the building, bound by a series of horizontal registers, are laden with sculptured deities, legends, and erotic scenes. Elongated figures often are set in complex, twisting poses that emphasize the

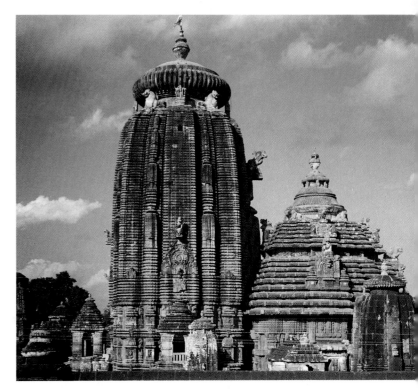

11-20 Muktesvar Temple, Bhuvanesvar, India, *c.* 950.

11-21 Visvanatha Temple, Khajuraho, India, *c.* 1000.

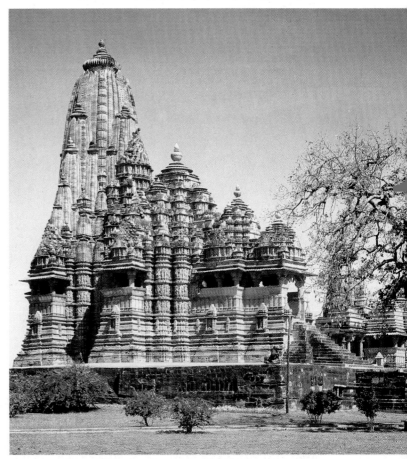

sinuously curved lines of the body. Although the rendering of living forms has become less natural and at times even disturbingly contorted, the sculptures function superbly in leading the eye around the shifting planes of the sides of the temple.

In the year 1000, the first of a series of Moslem invasions sounded the knell of Hindu architecture in northern India. But in the south—first under the Chola kingdom (846–1173) and later under the Hoysala (1022–1342), the Vijayanagar (1336–1565), and the Nayak (1420–1736) dynasties—sculpture and architecture continued to flourish.

Of particular beauty are the small, early Chola temples scattered throughout Tamil Nadu. Many are incomparable in their architectonic order, sensitive detail, and sculpture. A trend toward larger buildings, reflecting the imperial grandeur of the Chola kingdom, led to the great Brihadesvara Temple (c. 1000) of Thanjavur, which is 160 feet high and replete with architectural elements and figures. Many deities are represented on its walls, although fewer than at Khajuraho, and most appear in niches spaced with restraint at ordered intervals.

Bronze images were made to grace the shrines and to be carried in processions during important ceremo-

11-22 *Siva as Nataraja* (Lord of the Dance), Naltunai Isvaram Temple, Punjai, India, c. 1000. Bronze.

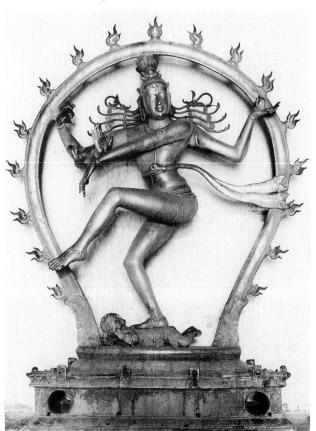

nies. Some of the world's superb bronzes were produced in the Chola kingdom, where the figures of Siva as Nataraja, Lord of the Dance, reached a high point of quality in the tenth century. The Nataraja (c. 1000) at the Naltunai Isvaram Temple at Punjai, Tamil Nadu (FIG. **11-22**), shows the god, represented in an ideal human form, dancing vigorously within a flaming nimbus, one foot on the Demon of Ignorance. His flying locks terminate in rearing cobra heads and, on one side, support a tiny figure of the river goddess, Ganga. One of Siva's four hands sounds a drum, while, from another, a flame flashes. Dancing thus, the god periodically destroys the universe so that it may be reborn again. Exquisitely balanced, yet full of movement, this bronze is a triumph of three-dimensional sculpture and the art of bronze casting.

Enormous temple compounds were built around the nucleus of earlier temples. The Minakshi Temple at Madura and the Srirangam Temple at Tiruchirapalli eventually covered acres of ground. "Thousand-pillared" halls, built almost one beside the other, have the aspect of a continuous structure, interrupted only by courtyards and sacred water tanks for ritual bathing. Elaborate monolithic columns, carved with high- and low-relief figures, evoke a solemn mood, the stone sculpture having the effect of iron castings. The original walled enclosure came to be surrounded by other walls as the temple expanded, and the gateways (*gopuram*) at each of the four cardinal points grew progressively higher with each additional wall. The fully developed gopuram is multistoried and crowded with sculpture. Many gopurams are over 150 feet high, and for this reason they dominate the landscape of southern India.

The spread of Moslem domination gradually weakened the Indian tradition, even in the south. By the seventeenth century, the harmonious proportions of earlier figures had been lost, and even the metal castings had become inferior.

Painting

In India, the art of painting was probably as great as the art of sculpture but, unfortunately, less of it survives. The earliest traces are a few fragments in Cave X at Ajanta that date from approximately the first century B.C. Like the ornamentation on the toranas at Sanchi (FIG. 11-6), to which they are related in style, these fragments illustrate scenes from the past lives of the Buddha.

In Caves I and XVII at Ajanta, we find the next and most magnificent examples of Indian painting. These murals, dating from the fifth, sixth, and seventh centuries, embody all the clarity, dignity, and serenity of

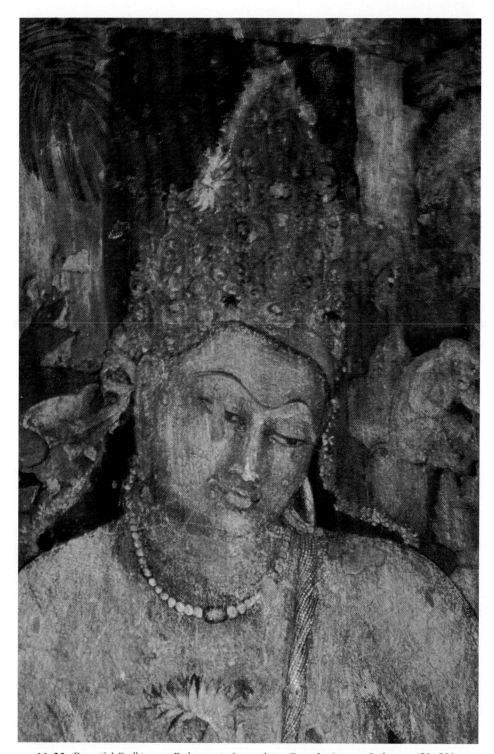

11-23 *Beautiful Bodhisattva Padmapani,* fresco from Cave I, Ajanta, India, *c.* 450–500.

Gupta art and must be ranked among the great paintings of the world. The *Beautiful Bodhisattva Padmapani* in Cave I (FIG. **11-23**) moves with the subtle grace of the Deogarh sculptures, while the glow of color imparts an even more spiritual presence. The Ajanta paintings, however, are more than the manifestations of Buddhist devotion. Their genrelike scenes and worldly figures, although illustrating Buddhist texts, reflect a sophisticated and courtly art.

The Ajanta painting tradition, in all its colorful vitality, was continued under the Chola rule, as witnessed by the paintings in the Brihadesvara Temple at Thanjavur. The dancing figures in these paintings, although drawn in the vivacious postures familiar in

11-24 *Krishna and Radha in a Pavilion,* from Punjab, c. 1760. Opaque watercolor on paper, $11\frac{1}{8}'' \times 7\frac{3}{4}''$. National Museum, New Delhi.

the Chola bronzes, retain some of the modeling and the soft tonality of the Gupta style.

The Moslem conquests inhibited the evolution of Hindu sculpture and architecture in northern India after the thirteenth century but revitalized the art of painting. In the sixteenth century, especially under the reign of Akbar, who was sympathetic to Hindu-

ism and Christianity as well as Islam, traditional Indian painters were exposed to the delicate and conventionalized miniatures of the great Persian artists. During the seventeenth and eighteenth centuries, painting responded vigorously to the interplay between foreign modes at the imperial capital and autochthonous idioms at isolated feudal courts.

Many delightful hybrids and innovations resulted—some delicate and lyrical, as at Bundi and Kishangarh (Rajasthan); some stark and bold, as at Basohli in the Himalayan foothills. Among others, the hill schools in Guler and Kangra developed their own idioms, emphasizing such subjects as elegant figures in serene landscapes, portraits of rulers, interpretations of musical modes *(ragamalas)*, and religious themes. The joyous exuberance of these new styles was particularly well suited to newer Hindu cults, which were dedicated to the worship of Krishna, an avatar of Vishnu, whose praises were sung in the erotic poetry of the *Gita-Govinda.* The love of the lush and the sensuous, which the earliest Indian sculptures had expressed, thus found an entirely new medium in exquisitely colored, often tender paintings like the miniature *Krishna and Radha in a Pavilion* (FIG. **11-24**). Krishna, the "Blue God," gently caresses his favorite shepherdess, Radha. They are seated within a golden pavilion hung with a rich scarlet textile and wreathed with flowering vines and succulent mangoes. Above the pavilion a lightning bolt crackles in the dark heavens, symbolizing the physical and spiritual energy that unites the pair. The firm yet gentle delineation describes a myriad of colored shapes with perfect fidelity and evenness, integrating the luxuriant variety of all elements of the design into coherent unity. Yet, such is the cunning of the designer that the figures of the narrative are adroitly centered and not absorbed into the pattern (compare FIG. 11-24 with FIG. 7-85). In this masterful depiction, the erotic theme is rarified into a suprasensual ideal of the mutual and enduring affection between man and woman. At the same time, the gorgeously colored accessories and the sinuously curved and supple bodies of the young lovers pay homage to the substances and rhythms of material nature as the source of love and pleasure. The last native masterpieces of Indian art, flourishing in the courts of the art-loving magnates of the Punjab, are among the world's supreme exemplars of amorous vision, rendered with delicacy and subtlety, sweetness and grace.

THE SPREAD OF INDIAN ART

The vigorous culture that generated the great achievements of art in India overflowed its borders. The great tide of Buddhism in the early centuries of the Christian era carried Mahayana beliefs and Gandhara-Mathura art through Afghanistan, across the desert trade routes of Turkestan into China, and eventually into Japan.

The path of Hinayana Buddhism (see page 431), which was opened in the third century B.C. by the son of the emperor Asoka, led in another direction—south from Amaravati across the straits to Sri Lanka (formerly Ceylon). From that time on, Sri Lanka became a "little India"; its arts were influenced first by Amaravati and then, successively, by the Guptas, the Pallavas, and the Cholas. The largest concentrations of art were at two royal centers: Anuradhapura (virtually an extension of Amaravati), where most of what remains is from the second and third centuries, and Polonnaruwa, best known for the colossal 46-foot-long sculpture of the expiring Buddha found there (FIG. **11-25**), which dates from the eleventh and twelfth centuries. Sri Lanka also is the site of many

11-25 *Buddha,* from Gal Vihara, near Polonnaruwa, Sri Lanka, eleventh and twelfth centuries. Stone, whole figure 46' long.

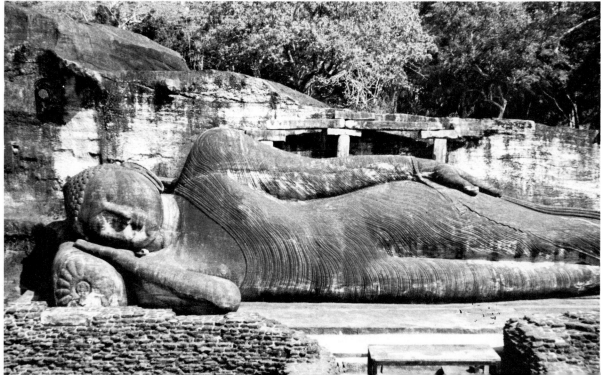

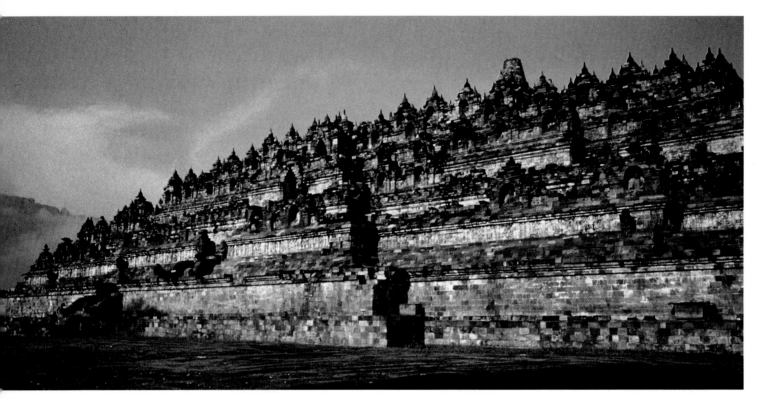

11-26 Stupa, Borobudur, Java, Indonesia, c. 800.

famous stupas that basically adhere to the Amaravati tradition but are simpler. Innovative carvings of guardian figures on stelae are placed at stupa entrances. Although some paintings have been discovered at Polonnaruwa, the earliest (fifth century) and most exquisite are the heavenly maidens on the escarpment of the fortress at Sigiriya.

By the fifth century, a series of emigrations from India began to bring the impact of Indian culture to Burma, Thailand, Cambodia, Sumatra, and Java. There, Buddhism and Hinduism continued their struggle for supremacy, with each introducing and fostering its arts. While Buddhism was under siege in India, one of its greatest monuments was rising at Borobudur in Java. There, around 800, a huge stupa (FIG. **11-26**), basically square and measuring over 400 feet across the base, was built of stone in nine terraced levels, with a central stairway in each of the four sides. The base and the first four tiers are rectilinear and signify the terrestrial world of sensation; the upper four tiers are circular and symbolize the heavens.

On the base, mostly covered by earth, 160 reliefs depict people trapped in the karmic cycle of life, death, and rebirth. Abundantly decorating the walls along the corridors of the next four tiers are over one thousand cautionary scenes from the *jatakas* and different *sutras* (scriptural accounts of the Buddha). But above, on the circular terraces, no narratives intrude. Here, ringing the pathways in solitary dignity, are latticed stupas, in each of which, barely visible, is a seated Buddha of gentle beauty (originally, seventy-two of these small stupas were constructed to crown the upper tiers). A larger stupa, rising at the pinnacle, may have enclosed a single Buddha, symbol of the Ultimate.

This architectural orchestration of sculptures is a mandala, a cosmic diagram perhaps representing the three spheres of Buddhist cosmology: the Human Sphere of Desire (didactic narratives crowded with figures and foliage); the Bodhisattva Sphere of Form; and the Buddha Sphere of Formlessness, where the simplicity and isolation of the individual stupas effect a serene release. The entire stupa has 505 Buddha figures. It is an eloquent statement of the Esoteric Buddhism that developed from Mahayana in Java.

The Buddhists in Java also erected *chandis* (temples). Two near the stupa of Borobudur that date to the same time period are Chandi Mendut and Chandi Pawon. Their dark sanctuaries, containing colossal Buddhist images, have the same awesome impact on the visitor as the shrines of the Buddhist cave temples in northwest India. Indeed, those caves, as well as other sacred sites throughout India, were well known to Indonesian pilgrims, whose exposure to Indian monuments and texts influenced their island culture.

The Hindus also were active in Java. On the Dieng Plateau, they erected single-celled Siva temples based on southern Indian Pallava models. At Prambanan in central Java, where structures and motifs were rap-

11-27 *Ramayana* scene, Siva temple, Lara Jonggrang, Java, Indonesia, ninth and tenth centuries.

idly Javanized, the tall and narrow Siva temple of Lara Jonggrang (ninth and tenth centuries), is characteristically a studied aggregate of piled-up stones, terraced peaks, and sanctuaries—a symbol of Mahameru, axis of the universe and mountain home of the gods. Reliefs on the temple balustrade illustrate the great Hindu epic *Ramayana*. Naturalistic yet decorative, these dramatic narratives (FIG. **11-27**) are a harmony of Indian forms and Javanese physical types.

The Indochinese mainland, in contact with India by the third century, also reacted to the stimuli of Indian culture. In Thailand, the softly modeled figures of bronze and stucco that were produced during the Dvaravati period (sixth to tenth centuries) were inspired by the Gupta style. During the pre-Angkor or Early Khmer period (fifth to ninth centuries), the Cambodians, too, borrowed the flowing planes and sensitive surfaces of Gupta. Around the seventh century, they also worked in the manner of the southern Indian Pallavas, as we can see in the figure of *Harihara* (a combined form of Siva and Vishnu) from Prasat Andet (FIG. **11-28**). The elegance of the Pallava prototypes at Mahabalipuram has been modified only slightly in this stone representation by the addition of a taut, almost springlike tension. Tall, broad shouldered, full-bodied, and slender legged, this is an idealized figure, more godly than human. We shall see later how the classical configuration of the pre-Angkor gods gradually was transformed into a distinctly more Cambodian type, with a broad face composed of full lips (doubly outlined), continuous eyebrows, and flat nose (FIG. 11-33).

11-28 *Harihara*, from Prasat Andet, Cambodia, seventh century. Stone, 6′ 3″ high. Musée Albert Sarraut, Phnom Penh.

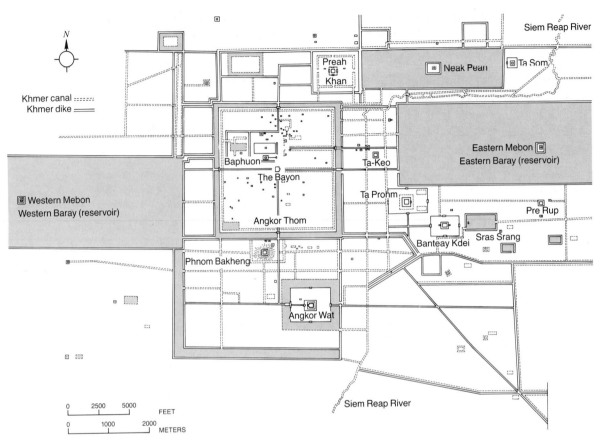

Khmer canal ╌╌╌╌
Khmer dike ═══

11-29 Overall plan of Angkor site, Cambodia, during the twelfth and thirteenth centuries.

11-30 View of Angkor Wat, Cambodia.

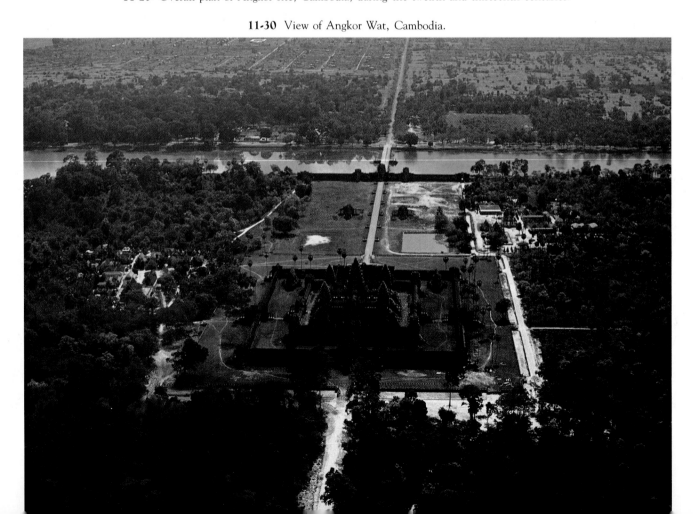

The temple in Cambodia was directly related to the Angkorian concept of kingship. Whereas in India the ideal king was the Universal Lord *(chakravartin)* who ruled through goodness, in Cambodia he was the god-king *(devaraja)* in life and after death. The temple the king built was dedicated to himself as the god. As the kings grew more powerful and ambitious, their temples were enlarged and the architectural and decorative elements multiplied.

At Angkor (meaning "the city" or "the capital" in the Khmer language), in the midst of a fertile plain, a dozen Khmer kings built their successive capitals between the ninth and the thirteenth centuries. Eventually, this agglomeration of capital cities spread across some seventy-five square miles and comprised many major brick and stone monuments amid a vast and intricate irrigation system (FIG. **11-29**). Only the temples were of stone or brick (materials reserved for the gods); other buildings, including the royal palaces, were constructed of wood and perished long ago. Laid out orthogonally, the network of canals, supported from large reservoirs *(barays),* served as a means of transportation as well as of irrigation for the fertile rice fields that fed an estimated population of one million. The canals also interconnected and fed the moats around many of the major temples, including the two largest, Angkor Wat and Angkor Thom.

Angkor Wat (a *wat* is a Buddhist monastery; FIG. **11-30**) was originally a Hindu temple built between 1113 and 1150. Dedicated to Vishnu by its builder, King Suryavarman II, it is a physical representation of Hindu cosmology. The five central towers represent the peaks of Mount Meru, the Olympus of the Hindu gods and the center of the universe. The outer wall symbolizes the mountains at the edge of the world; the moat represents the oceans beyond. Recent study suggests that the layout also had astronomical significance and that the sections of the design were aligned to form a kind of solar calendar by which the summer and winter solstices and the spring and fall equinoxes could be fixed. Sight lines from vantage points within the temple complex can be constructed to show that the varying positions of the sun and moon throughout the year could be observed, predicted, and marked systematically. The dimensions of the complex are enormous. The moat is $2\frac{1}{2}$ miles long, and the circumference of the outer gallery measures half a mile and contains reliefs with literally thousands of figures representing the myths of Vishnu, Krishna, and Rama. The temples comprising this great complex are set at the corners of two concentric walls that gird the central shrine. Each of the temple towers repeats the form of the main spire, which rises in the center from a raised platform like the apex of a pyramid. The towers themselves resemble, in outline, the sikhara of northern Indian temples.

The relief carvings (FIG. **11-31**) express the Cambodian predilection for rhythmic design, the juxtaposition of two, three, or more identical figures, and the repetition of undulating contours. These graceful but stylized forms, thus locked together, move in a harmonious rhythm like their counterparts in Cambodian dance.

The Bayon at Angkor Thom (FIG. **11-32**), dating from the twelfth and thirteenth centuries, is, in many ways, the culmination of the Indian temple, particularly in its complete integration of sculpture and architecture. It also illustrates the syncretic relationship of Hinduism and Buddhism. The long, impressive approach to the Bayon, a Buddhist temple, is lined in

11-31 Dance relief, from Angkor Wat, twelfth century. Musée Guimet, Paris.

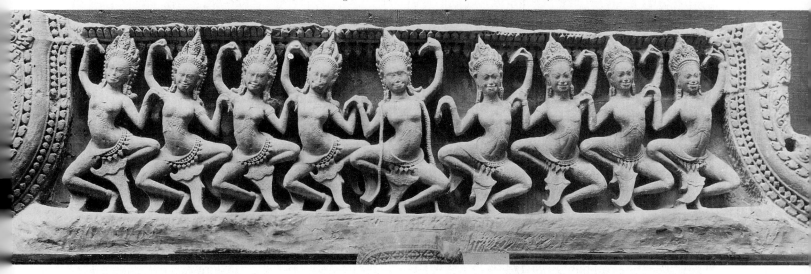

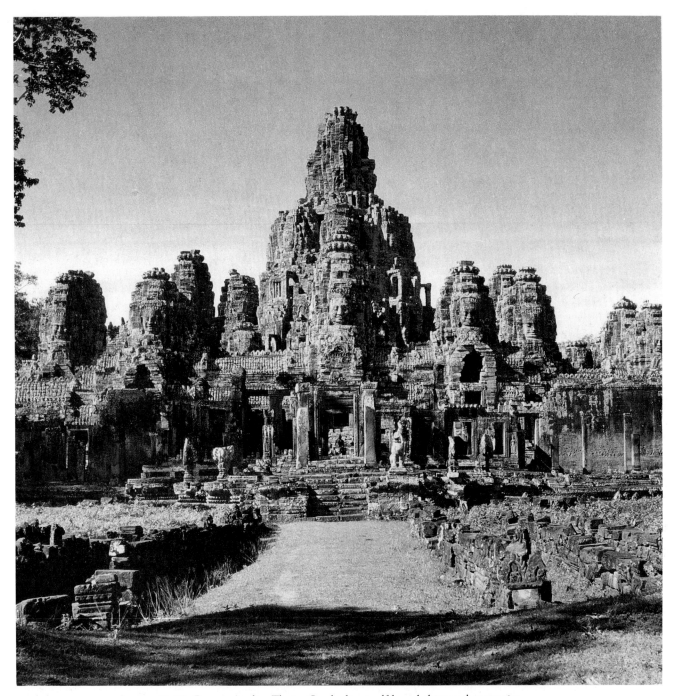

11-32 Bayon, Angkor Thom, Cambodia, twelfth and thirteenth centuries.

places with giant gods and demons holding onto the body of the serpent Vasuki in an enactment of a Hindu legend, the Churning of the Sea of Milk. But the uniqueness of the Bayon lies in the size and disposition of the colossal heads, one on each side of the square towers (FIG. **11-33**). These faces, their Cambodian features now fully stylized, smile enigmatically from a lofty height. They are the faces of the Bodhisattva Lokesvara, a god form of the reigning king and symbol of the inexhaustible powers of the Devaraja-Bodhisattva, which extend to all points of the compass. The Bayon was conceived as the world mountain. On it and around it, a luxuriance of decorative and narrative carvings intensifies its magic. The creative force that had been India left its last great record abroad in these compassionate faces of Lokesvara, surveying from eternity the legendary history carved on the walls below.

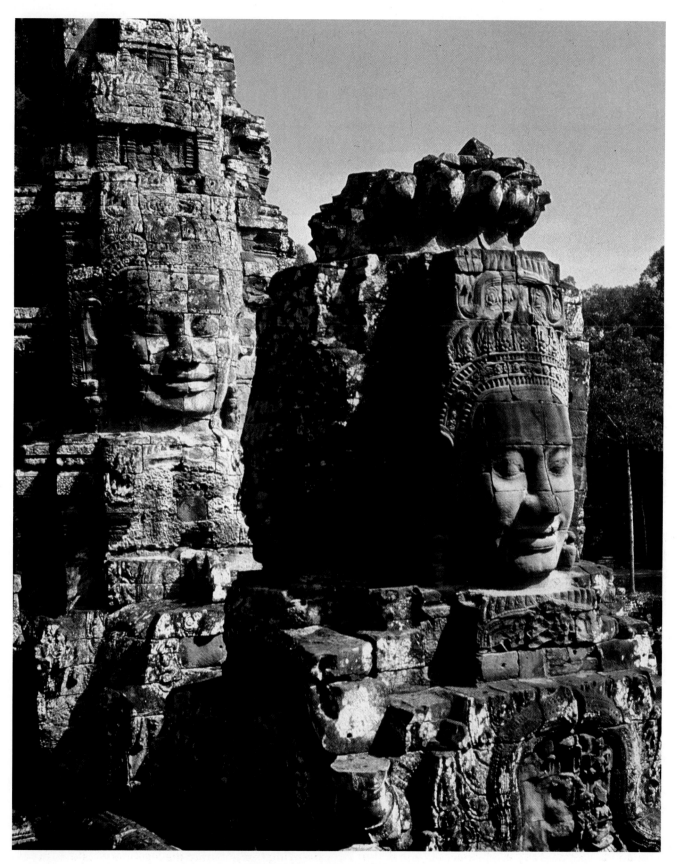

11-33 Tower of Bayon, Angkor Thom.

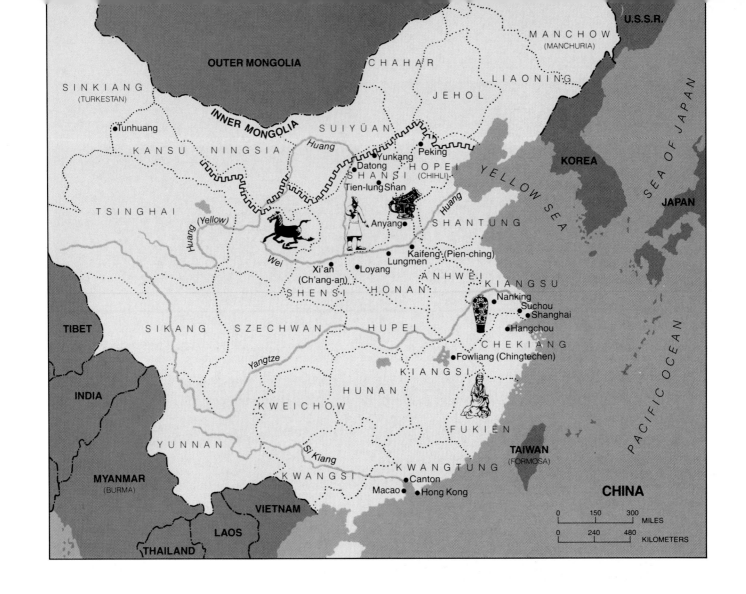

China map

OUTER MONGOLIA
U.S.S.R.
SINKIANG (TURKESTAN)
CHAHAR
MANCHOW (MANCHURIA)
INNER MONGOLIA
LIAONING
JEHOL
SUIYÜAN
Tunhuang
KANSU NINGSIA
Huang
Yunkang · Peking
Datong
SHANSI HOPEI (CHIHLI)
Tien-lung Shan
KOREA
YELLOW SEA
SEA OF JAPAN
JAPAN
TSINGHAI
(Yellow)
Huang
Wei
Anyang
Huang
SHANTUNG
Xi'an (Ch'ang-an)
Kaifeng (Pien-ching)
Loyang Lungmen
SHENSI HONAN
ANHWEI KIANGSU
Nanking
Suchou
Shanghai
Hangchou
TIBET
SIKANG SZECHWAN
HUPEI
Yangtze
CHEKIANG
Fowliang (Chingtechen)
KIANGSI
INDIA
HUNAN
KWEICHOW
MYANMAR (BURMA)
YUNNAN
FUKIEN
Si Kiang
KWANGSI
KWANGTUNG
Canton
Macao · Hong Kong
TAIWAN (FORMOSA)
PACIFIC OCEAN
CHINA
VIETNAM
LAOS
THAILAND

0 150 300 MILES
0 240 480 KILOMETERS

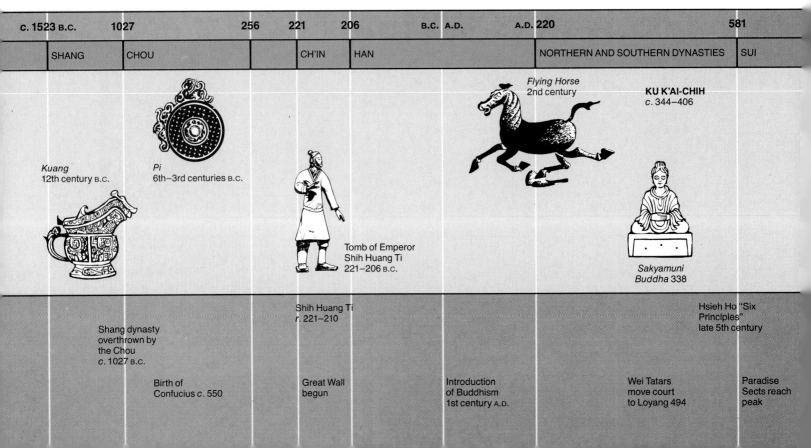

c. 1523 B.C.	1027		256	221	206	B.C. A.D.	A.D. 220		581
SHANG	CHOU			CH'IN	HAN		NORTHERN AND SOUTHERN DYNASTIES		SUI

Flying Horse
2nd century

KU K'AI-CHIH
c. 344–406

Kuang
12th century B.C.

Pi
6th–3rd centuries B.C.

Tomb of Emperor
Shih Huang Ti
221–206 B.C.

*Sakyamuni
Buddha* 338

Shang dynasty
overthrown by
the Chou
c. 1027 B.C.

Shih Huang Ti
r. 221–210

Hsieh Ho "Six
Principles"
late 5th century

Birth of
Confucius c. 550

Great Wall
begun

Introduction
of Buddhism
1st century A.D.

Wei Tatars
move court
to Loyang 494

Paradise
Sects reach
peak

12

THE ART OF CHINA

618	c. 906	960	1127	1279	1368	1644	1912	1949
T'ANG	FIVE DYNASTIES	N. SUNG	S. SUNG	YÜAN	MING	CH'ING	REPUBLIC	PEOPLE'S REPUBLIC

WANG WEI
699–759

Bodhisattva
c. 700

FAN K'UAN
Travelers among Mountains and Streams
11th century

HUANG KUNG-WANG
1269–1354

WU CHEN
1280–1354

Mei-p'ing vase

Kuan-yin
17th and 18th centuries

Suchou school

TUNG CH'I-CH'ANG **TAO-CHI**
1555–1636 1641–c. 1717

The Rent Collection Courtyard 1965

Hsüan Tsang
introduces
doctrines of
Esoteric Sects
7th century

Confucian
persecutions
845

Hui Tsung
r. 1101–1125

Capital of
China moved
south 1127

S. Sung dynasty
falls to
Kublai Khan
1279

Mongols
driven from
power 1368

Manchus
overrun
China 1644

Mao Tse-tung
establishes
People's Republic
1949

OF THE GREAT non-Western civilizations, that of China was the first to be known and appreciated in Europe. But only in the past half-century or so have the achievements of Chinese art and culture progressively been revealed and systematically been studied. Still, many in the West who now realize the extent and continuity of Chinese civilization and who recognize the striking beauty of its art are not fully aware of the complexity of either. Our task here is to identify the spirit of Chinese art and to trace, at least in outline, its major developments and styles.

China is a vast and topographically varied country about the size of the United States. Its political and cultural boundaries have spread, at times, to double that area, encompassing Tibet, Chinese Turkestan (Sinkiang), Mongolia, Manchuria, and parts of Korea. The country includes great stretches of sandy plains, mighty rivers, towering mountains, and fertile farmlands. North China, centered around Peking,* has a dry and moderate-to-cold climate, whereas south China is moist and tropical.

Although the spoken language of China varies so much as to be unrecognizable in different areas, the written language has remained uniform and intelligible in all parts of the country, permitting literary, philosophic, and religious traditions to be shared by people thousands of miles apart. Distinct regional styles of art did appear, especially in the early eras and during times of political fragmentation, but a broad cultural unity also permitted an easy flow of artistic ideas and influences throughout China.

The primarily expressive function of Chinese painting during the last millennium gradually has been made more comprehensible to the Western mind, partly by developments in the modern art of the West. Many of the fundamental differences between Chinese secular art and the traditional, premodern art of the West are based on differences between the philosophies of nature and of human nature held by the two cultures. For the Chinese, human beings are not dominant in nature; they are a part of it, responding, like all living creatures, to its rhythms. To be happy is to live in accord with nature; to be a painter is to be the instrument through which nature reveals itself. The painter's work is an expression of personal immersion in the flow of life and of attunement to all that changes and grows; in so being, the work is also the expression of a personal character refined by the contemplation of nature. Because nature is not mea-

*In the romanization system called *pinyin,* Peking presently is known as Beijing. This text, however, will use the place-name spellings more commonly recognized prior to the official 1979 adoption of the pinyin spellings for use in all texts in the Roman alphabet.

sured and classified according to space and time, Chinese painters do not frame it off in perspective boxes with colors scaled in light and shade. They do not attempt to duplicate and fix natural appearances by such means. The asymmetry of growing things, the ceaseless and random movements of nature, the infinity of cosmic events—these forbid all enframements, rigid regularities, beginnings and ends. Appearance is transformed by the artist's passage through it. Each artist becomes part of the total expression of the art being produced, just as the art is the total expression of one's experience of nature.

This philosophical attitude of the Chinese toward secular painting can be seen even in the artists' almost ritualistic preparation of their medium, their materials. The best ink, for instance, was derived from soot or lampblack mixed with animal glue and pulverized clay, oyster shells or powdered jade, and various fragrances. From these ingredients, each of which had symbolic as well as physical properties, an ink stick (often carved) was formed that was treasured by the artist.

SHANG DYNASTY

A series of Neolithic cultures characterized by a variety of painted wares date back to the fourth millennium B.C. According to traditional Chinese history, the fourth millennium would have been the period of the Hsia. Although the Hsia state is still a matter of legend, the remains of a considerable kingdom, discovered within the last sixty years, have confirmed the existence of the Shang dynasty. As late as 1928, many scholars doubted the existence of the Shang dynasty, but excavations at Anyang in northern China in that year brought to light not only one of the last capitals of the Shang but also evidence of the dynasty's earlier development. Large numbers of inscribed bones, once used for divination, were among the astounding discoveries. The inscriptions tell us much about the Shang people. Their script was basically pictographic but sufficiently developed to express abstract ideas. These fragmentary records, together with other finds from the excavations, reveal an advanced, if barbaric, civilization. They indicate that the king was a feudal ruler and that some of his wives were also his vassals, living in different cities. Warfare with neighboring states was frequent, and all cities were protected by surrounding walls of pounded earth. Royal tombs were extensive, and the beheaded bodies of servants or captives accompanied deceased rulers to their graves. Chariots, trappings of horses buried alive, weapons, and ritual objects

found in these graves help us to describe the art of this period.

Although sculpture in marble and small carvings in bone and jade exist, the great art of the Shang dynasty consisted of ritual bronze vessels. These bronzes were made in piece molds. They show a casting technique as advanced as any ever used in the East or West, indicating that this art must have been practiced for some centuries before the period of Anyang. The bronze vessels were intended to hold wine, water, grain, and meat for use in sacrificial rites. The major elements of decoration are zoomorphic, but usually the background and sometimes the animals themselves are covered with round or squared spirals. Conventions, which obviously evolved over a long period, rigidly governed the stylistic representation of animals, so that images or symbols often are involved and difficult to decipher. A major zoomorphic motif is that of an animal divided in half lengthwise, with the two halves spread out on the vessel body in a bilaterally symmetrical design. The two head parts, meeting in the center, often also can be read as a complete frontal animal mask with vestigial bodies at both sides. Such ambiguity of design occurs frequently on Shang vessels, with fragmentary parts of bodies taking on a life of their own.

The covered libation vessel, or *kuang*, shown here (FIG. 12-1) is decorated with just such an animal. In

12-1 *Kuang*, Shang dynasty, twelfth century B.C. Bronze, 6½″ high. Smithsonian Institution, Freer Gallery of Art, Washington, D.C.

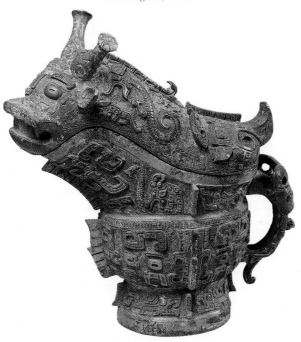

this complex design, the representation (on the vessel's side) may be of the eyes of a tiger and the horns of a ram. (On other such Shang vessels, the eyes may be those of a sheep and the horns those of a bull, water buffalo, or deer.) The front of the lid is formed of a horned animal; the rear depicts a horned head with a bird's beak in its mouth. Another horned head is on the handle. Fish, birds, elephants, rabbits, and more abstract, composite creatures swarm over the surface against a background of spirals. Specific combinations of such animal motifs may have defined certain concepts; for example, an animal or bird in the mouth of another animal may signify generation. The multiple designs and their enigmatic fields of spirals are integrated so closely with the form of the vessel that they are not merely an external embellishment but an integral part of the sculptural whole. The tense outline of the bronze compactly encloses the forces symbolized on its surface. These vessels were not only ritual containers but also, in their very form and decoration, a kind of sculptural icon or visualization of the early Chinese attitude toward the powers of nature.

CHOU DYNASTY

About 1027 B.C., the Shang dynasty was overthrown by the Chou, whose dynasty endured until 256 B.C. Although the Chou were a more primitive people from the west, their culture apparently resembled that of the Shang.

The very earliest Chou bronzes are indistinguishable from those of the Shang. Indeed, they probably were made by the same craftsmen. But within a generation, the new and bolder spirit of the conquerors was imprinted unmistakably on the ritual vessels. Where the Shang silhouette had been suave and compact, the Chou (FIG. 12-2) was explosive and dynamic. Gradually, this vitality diminished, and, in a hundred years, the shapes became more utilitarian and the zoomorphic designs more ornamental. The animal forms were distorted and twisted into interlaces until, by the beginning of the Late Chou period (600–256 B.C.), almost all evidence of the awesome original motifs was lost in an exuberance of playful rhythms over the surface of the bronzes. What once had expressed the power of magic and religion was transformed into a secular display of technical skill and fantasy.

During the sixth century B.C., the Chou Empire began to dissolve into a number of warring feudal states. As old values were forgotten, Confucius and other philosophers strove to analyze the troubles of

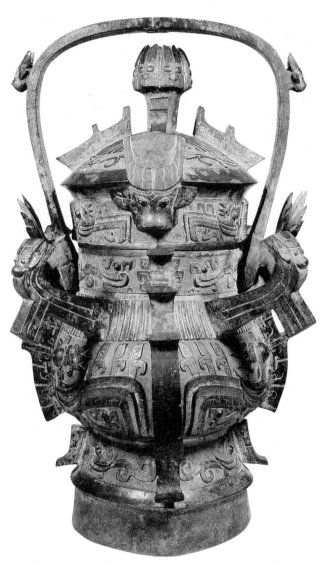

12-2 *Yu,* Early Chou dynasty, *c.* tenth century B.C. Bronze, 20⅙" high. Smithsonian Institution, Freer Gallery of Art, Washington, D.C.

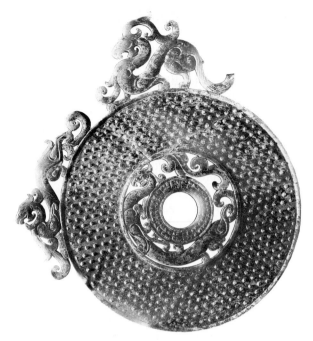

12-3 *Pi* (disc), Late Chou dynasty, sixth to third centuries B.C. Jade, 6½" in diameter. Nelson Gallery-Atkins Museum, Kansas City, Missouri (Nelson Fund).

their day. While Confucius urged intelligent and moral action on his followers, his famous contemporary, Lao-tzu, favored meditation, inaction, and withdrawal from society. Neither philosophy, however, was to affect Chinese art for several centuries.

The art of the Late Chou, whether in bronze, jade (FIG. 12-3), or lacquer, was produced to satisfy the elaborate demands of ostentatious feudal courts that vied with each other in lavish display. Bronzes inlaid with gold and silver were popular at this time as were mirrors highly polished on one side and decorated with current motifs on the other. About the fourth century B.C., ritual bronzes were embellished with an entirely new system of narrative designs. Scenes of hunting, religious rites, and magic practices, although small, nevertheless reveal subjects and com-

positions that probably are reflective of paintings lost but mentioned in the literature of the period.

In the Late Chou period, carvings of jade, a stone regarded with special reverence by the Chinese and often found in Neolithic tombs, reached a peak of technical perfection in the jewelry and ritual objects entombed with the dead (FIG. 12-3). At this time, Confucius extolled the virtues of jade, in which, he said, superior men in ancient times "found the likeness of all excellent qualities." It was soft, smooth, and glossy (when polished), like benevolence; fine, compact, and strong, like intelligence; angular, but not sharp and cutting, like righteousness; and (when struck), like music. Like loyalty, its flaws did not conceal its beauty nor its beauty its flaws, and, like virtue, it was conspicuous in the symbols of rank.*

The culture that had produced the great bronzes and jades of the Shang and Chou periods was being transformed. The political turbulence of the Late Chou period, at times called the "period of the Warring States," was accompanied by an intellectual and artistic upheaval that coincided with the rise of conflicting schools of philosophy, and, in art, a new iconography and style combined with vestigial elements from the Shang and Early Chou periods. During the next four hundred years, a radically different art was to develop.

*From the *Li Chi* attributed to Confucius, translated by James Legge, *The Sacred Books of the East* (New York: Clarendon Press, 1966), Vol. 28, p. 464.

CH'IN AND HAN DYNASTIES

The political chaos of the last few hundred years of the Chou dynasty was halted temporarily by Shih Huang Ti, ruler of the state of Ch'in (hence, the name "China"), whose powerful armies conquered all rival states. Shih Huang Ti became the First Emperor of China, establishing totalitarian control over most of the country between 221 and 210 B.C. His reign was signalized by the building of the Great Wall and by his attempt to eradicate old traditions by destroying all historical books and burying alive thousands of Confucian scholars.

In 1974, the immense tomb mound of Shih Huang Ti was discovered in Shensi, and excavations in its vicinity, which are still proceeding, have revealed an astonishing collection of monuments, making this tomb mound one of the great archeological discoveries of modern times. More than six thousand life-size clay figures of soldiers and horses—and, more recently, bronze horses and chariots—have been found. Replicating the invincible hosts of the emperor, they serve as the immortal imperial bodyguard (FIGS. **12-4** and **12-5**), deployed outside a vast, underground funerary palace designed to match the fabu-

12-4 Soldiers of the Imperial Bodyguard, tomb of emperor Shih Huang Ti, Shensi, 221–206 B.C. Painted ceramic, life size.

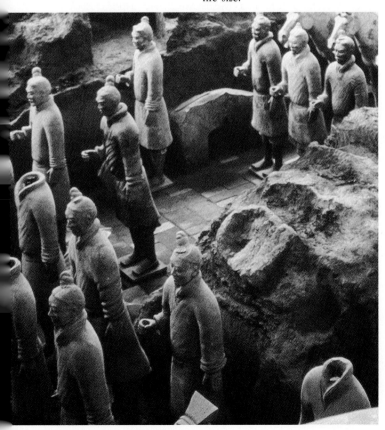

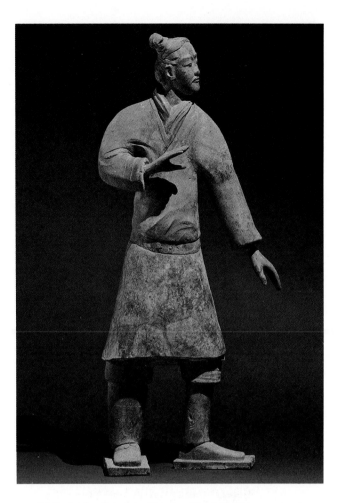

12-5 Soldier Poised for Hand-to-Hand Combat, tomb of emperor Shih Huang Ti. Painted ceramic, life size.

lous palace occupied by the emperor in life. Both palaces were described by the ancient historian Sima Quian (136–85 B.C.), whose account was not taken seriously until these recent discoveries validated it. The statues, originally in vivid color, were arranged in long ranks and files, as if lined up for battle: infantry, cavalry, horses and chariots, archers, lancers, and hand-to-hand fighters. The style of the Ch'in warriors blends archaic formalism—simplicity of volume and contour, rigidity, and frontality—with sharp realism of detail. Set poses are repeated with little or no variation, as if from a single mold, but subtle differences in details of facial features, coiffures, and equipment are delineated. An unarmed warrior (FIG. 12-5) assumes the watchful stance of a fighter skilled in hand-to-hand combat, presumably similar to karate. He stands in line with scores of other figures exactly matching his pose and gesture.

On the death of Shih Huang Ti, the people of Ch'in revolted, and a new dynasty, the Han, was founded in 206 B.C. A powerful, centralized government extended the southern and western boundaries of

China. Chinese armies penetrated far into Turkestan, and indirect trade was maintained with distant Rome. Confucianists struggled with Taoists (followers of the mystic philosophy of Lao-tzu) for control of governmental power. The Confucianists eventually won, although the formalized Confucianism that triumphed was far removed from the teachings of the master. The Confucian legends of filial piety and the folklore of Taoism together provided most of the subject matter of Han art.

The Han pictorial style is known from a few extant paintings and many stone reliefs as well as stamped pottery tiles. In some paintings, the outlines of figures are rendered in the characteristic Chinese line, with calligraphic elasticity that conveys not only outline but depth and mass as well. Overlapping of arms and drapery further emphasizes the third dimension, while flat colors, applied within contours, accent the rhythmic relationship between figures. Background and environment are not represented.

Numerous stone reliefs from the Wu family shrines in Shantung (c. A.D. 150) also reflect modes of Han pictorial representation. On the slabs, scenes from history and folklore depict mythological beings associated with Taoism as well as exemplars of Confucian piety. The story on each relief unfolds in images of flat polished stone against an equally flat, though roughly striated, ground (FIG. 12-6). The rounded figures are related by the linear rhythms of their contours. In addition, buildings and trees now indicate a

milieu. Space, however, is conceptual, as in Egyptian painting, and distance is suggested by the superposition of figures, although, curiously enough, chariot wheels overlap. Individuals of importance are shown hierarchically, in larger size than their subordinates. Most interesting are the trees, which are highly stylized as masses of intertwined branches bearing isolated, overlarge leaves. Yet within this schematic form, some accidental variation in a twisted branch or broken bough shows how the designer's generalization derived from the observation of specific trees and how a detail of the particular can individualize the general. It is this subtle relationship between the specific and the abstract that will become one of the most important esthetic attributes of later Chinese painting.

A group of reliefs from Szechwan, although similar to those of the Wu tombs and probably of the same date, are more advanced. Rhythms are more rapid, and space and the environment are stated more fully. Some subjects concern everyday life, in contrast to the earlier preoccupation with mythological or historical themes. A figure of the Buddha also appears— probably the earliest in China and therefore the first reference to the religion that was to dominate Chinese thought for the next one thousand years.

A superb example of Han bronze craft, in the tradition of the Chinese mastery of that metal prevalent since Shang times, is a figure of a horse (FIG. 12-7) from a tomb in Kansu discovered in 1969. Although

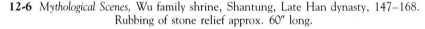

12-6 *Mythological Scenes*, Wu family shrine, Shantung, Late Han dynasty, 147–168.
Rubbing of stone relief approx. 60″ long.

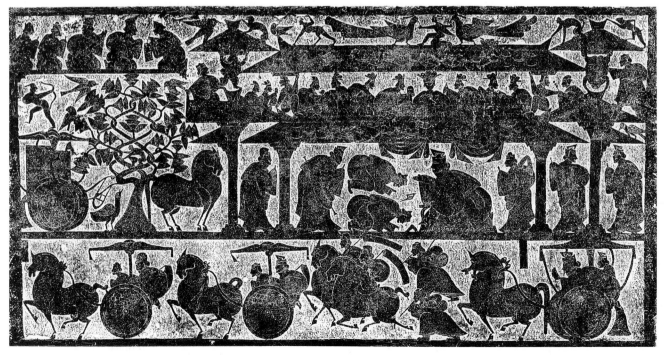

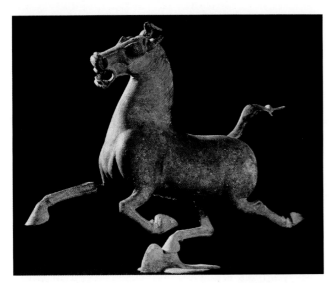

12-7 *Flying Horse Poised on One Leg on a Swallow*, from a tomb at Wuwei, Kansu, Late Han dynasty, second century. Bronze, 13½″ high, 17¾″ long. The exhibition of archeological finds of the People's Republic of China.

its action is certainly that of a quick trot, the animal seems to be flying, one hoof lightly poised on a swallow, its single point of attachment to its pedestal. The horse, because it was revered for its power and majesty, has a prominence in Chinese art tantamount to that of the lion or bull in the art of the Near East.

THREE KINGDOMS AND SUI DYNASTY

Buddhism (pages 427–28), whose spirit differed profoundly from the ancient and native philosophies of China, was introduced by the first century of the Christian era. During the last century of Han rule and the succeeding Three Kingdoms period, China, splintered by strife, grasped eagerly at a new ideal by which to live. The Confucian system of ethics had proved itself incapable of adapting to the anarchy of the times, and Taoism, having degenerated into magic and superstition, no longer appealed to the philosophic mind. Buddhism offered the Chinese masses the promise of hope beyond the troubles of this world. In addition, the fully developed Buddhist system of logic, refined to the point of surpassing any previous Chinese system of thought, attracted the intellectuals. Buddhist missionaries from India, working at first with the ruling families, spread their gospel so successfully that their teachings ran like wildfire through China.

The arts flourished in the service of the imported religion. Following the brief Three Kingdoms period in the third century, China entered an era of political confusion known as the period of the Northern and Southern dynasties, which fostered many short-lived states. Native Chinese dynasties, centered at Nanking, ruled in the south. Most of the Buddhist art that survives from this period, however, originated in the northern states, which were ruled by barbarian peoples who rapidly adopted Chinese ways and culture. A new esthetic developed in imitation of Indian or central Asian models that harmonized with the prescribed formalism of Buddhist doctrine. The earliest important Buddhist image, a gilt-bronze statuette of *Sakyamuni Buddha* (FIG. **12-8**), dated, by inscription, to the year 338, is related clearly, in both style and iconography, to the prototype conceived and developed at Gandhara (FIG. 11-10).* The heavy concentric folds

*So new were the icon and its meaning that the Chinese craftsman, although endeavoring to make an image faithful to prescription, nevertheless erred in representing the canonical *mudra* of meditation: the Buddha's hands are clasped across his stomach; they should be turned palms upward, with thumbs barely touching (FIG. 11-12).

12-8 *Sakyamuni Buddha*, Northern and Southern dynasties, 338. Gilt bronze, 15½″ high, 9⅝″ wide. Asian Art Museum of San Francisco, The Avery Brundage Collection.

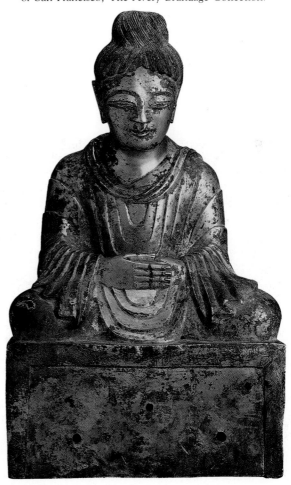

of the robe, the ushnisha on the head, and the cross-legged position all derived ultimately from the Indian prototype, examples of which were brought to China by pilgrims and priests who had made the hazardous trip along the desert trade routes of central Asia.

The Chinese artist transformed the basic Indian pattern during the following century or so. These changes are evident in a series of great cave temples that were carved into the hillsides after the fashion of the early Buddhists in India. At Tunhuang, western-most gateway to China, over three hundred sanctuaries were cut into the loess cliffs, the walls decorated with paintings, and the chambers adorned with images of painted, unfired clay and stucco. This site was dedicated in 366, but the earliest extant caves date from the late fifth century. About the same time, in 460, sculptors at Yunkang, near Tatung in northern China, were carving temples in cliffs of sandstone. Although the materials are different, both sites have an archaic style similar to the sculpture of the sixth century B.C. in Greece and of the early twelfth century in France. Like their Western counterparts, the faces of the cave figures are carved in sharp planes and their drapery is conventionalized into angular patterns (FIG. **12-9**). Considered as a whole, they too express the intense and noble dignity of a deeply felt religion. The Buddhist concept of divinity may be seen in the caves of Yunkang, where the image of the Buddha—a blend of conventional restraint and religious fervor—became human enough for popular

12-9 Colossal Buddha, from Cave XX, Yunkang, Shansi, Northern and Southern dynasties, *c.* 460. Sandstone, 45′ high.

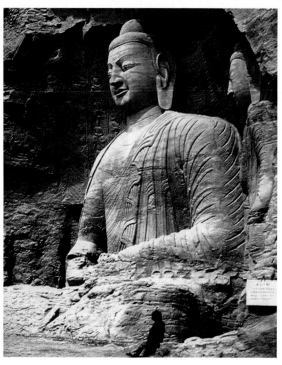

recognition but remained idealized enough to carry the worshiper beyond the image to the abstraction it symbolized.

In 494, the Wei Tatars, staunch Buddhists who had supported the colossal program at Yunkang, moved their court southward to Loyang in Honan. Near there, in the limestone cliffs of Lungmen, another series of caves was started. The first phase of work here continued until the early part of the sixth century. The new carvings reveal elongated body and facial types and a fluid elegance in the rendering of drapery folds that reflect the influence of native Chinese styles, including those of painting. An air of courtly sophistication begins to appear, especially in some of the secular figures of imperial donors. The new linearity and elongation, combined with pure body volumes and balanced poses, result in many images that harmonize religious sincerity with extraordinary grace of design.

While the Lungmen caves were being worked on, the popular imagination was captured by a new form of Buddhism (promoted by various Paradise Sects) that promised rebirth in a Buddhist paradise rich in the material pleasures denied to most in this world. As an idyllic existence in this paradise could be gained merely by faith in the word of the Buddha, many who might have failed to appreciate the goal of nirvana and the ultimate extinction of personality were won over to Buddhism by the more tangible and attractive goal offered by the Paradise Sects. Glories beyond those even of the imperial court thus were offered to every person who placed trust in the Buddha. The pleasant aspirations of these Buddhists were reflected in the greater naturalism of their arts, particularly the humanization of the deity. It is no wonder, therefore, that by the time the Paradise Sects reached their peak in the Sui dynasty (581–618), the Buddha gradually had been transformed from an archaic image of divine perfection into a gentle and human savior. The transition is manifest in a gilt-bronze shrine (FIG. **12-10**), which also reflects the attenuated Lungmen style. Prabhutaratna (Buddha of the remote past) listens to the sermon by Sakyamuni, the most recent Buddha. Seated within flamelike aureoles, the graceful, slender figures are almost absorbed into the rhythmic fall and flow of linear drapery that is beginning to acquire the character of cloth. The humanization is manifest in the gentle, suave beauty of attitude and gesture, although the faces retain the characteristics of archaic formulas.

A comparable development of Buddhist images can be observed in the richly painted walls of the Tunhuang sanctuaries, which were calculated to inspire in the worshiper the splendor of Buddhism and (like Medieval paintings) to instruct the illiterate. Hieratic

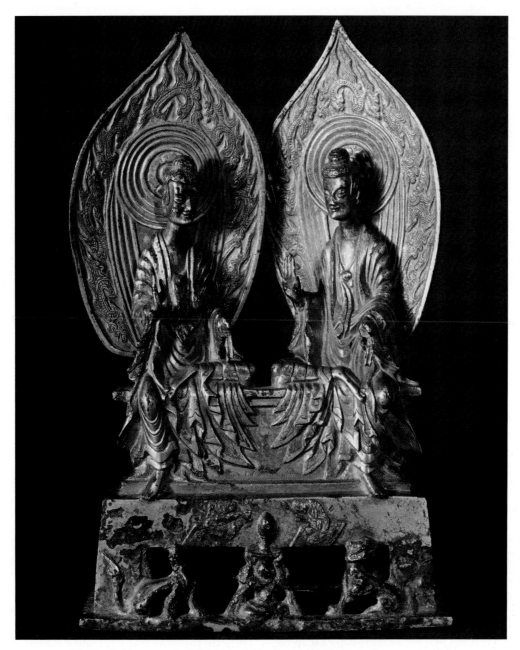

12-10 *Prabhutaratna and Sakyamuni,* Northern and Southern dynasties, *c.* 518.
Gilt bronze, 10½" high. Musée Guimet, Paris.

figures of the Buddha are surrounded by illustrations of stories about past lives (*jataka*). The formalized patterns of the individual Buddhas are like those of the sculptured images at Yunkang and Lungmen, but the narrative scenes carry on the traditions of Han painting, especially in the cell-like composition, the leaping rhythms, and the disproportionate relationship of figures to diminutive, conventionalized settings.

By 539, most traces of central Asian influence had disappeared. Like the sculpture of the time, Buddhist painting responded to the happy credo of the Paradise Sects with increasing naturalism and grace. Although the Buddha groups retained the strict frontality and rigid balance of ritualistic art, the jataka tales expanded haphazardly over the temple walls. Their figures—now slim, elegant, and emancipated from their compartmental designs—moved freely over the plane surface. By the end of the century, the abstract environment of the painted figures began to be three-dimensional. Overlapping was used to create depth, and a sense of reality was heightened further by surrounding the celestial groups with such earthly phenomena as trees, pavilions, lotus ponds, and bridges.

12-11 Attributed to Ku K'ai-chih, *Lady Feng and the Bear*, section of the *Admonitions of the Instructress to the Court Ladies*. Horizontal scroll, ink and colors on silk, 7⅝" high. British Museum, London.

Painting flourished at the courts of the Southern dynasties during this period. Taoist nature cults and a new appreciation of landscape themes in poetry provided the stimulus for the early development of landscape painting. No scrolls from the hands of individual masters have survived from this early era, but descriptive texts indicate that the almost magical potential of landscape painting to re-create and organize the experience of nature or to transport the viewer to an imaginary realm already was well appreciated. When the painter Tsung Ping (373–443), for example, became too old to continue his mountain wanderings, he re-created favorite landscapes on the walls of his studio so that he could take imaginary journeys. Of the representational power of painting, Tsung wrote:

> Nowadays, when I spread out my silk to catch the distant scene, even the form of the K'un-lun [Mountain] may be captured within a square inch of space; a vertical stroke of three inches equals a height of several thousand feet. . . . By such means as this, the beauty of the Sung and Hua Mountains and the very soul of the *Hsuan-p'in* [Dark Spirit of the Universe] may all be embraced within a single picture.*

Another fifth-century painter, Wang Wei, elaborated on the re-creative potential of landscape painting:

> I unroll a picture and examine it, and reveal mountains and seas unfamiliar to me. The wind scatters in the verdant forests, the torrent overflows in bubbling foam. Ah, how could this be achieved merely by the skillful use of hands and fingers? The spirit must also

exercise control over it. For this is the essence of painting.[†]

The painter and essayist Ku K'ai-chih (c. 344–406) is one of the few individual artists from this period to whom extant paintings seriously have been attributed. In an essay on landscape painting couched in Taoist terms, he describes "crags, fanglike and tapering," and "rocks, split with fissures as though torn by lightning." But for Ku K'ai-chih and others of his time, the crucial aspect of painting was not mere imitation of appearance but transmission of "spiritual quality." Indeed, in the late fifth century, the critic Hsieh Ho named, as the first of the "Six Principles" of painting, "spirit-consonance engendering movement"—a sense of animation through transmission of the vital spirit that pervades both artist and object—which was to remain the cardinal principle for artists and critics in China until modern times.

Something of this vital spirit appears in a horizontal scroll attributed to Ku K'ai-chih called *Admonitions of the Instructress to the Court Ladies*, perhaps an early copy of a painting of Ku's era. Scrolls in this format were meant to be viewed slowly and in sections; in this case, scenes are illustrated between passages of explanatory text. One of the sections (FIG. **12-11**) depicts a well-known act of heroism in which the Lady Feng saved the life of her emperor by placing herself between him and an attacking bear. Although no background is shown and only a minimal setting for the scene is provided, fluid poses and fluttering ribbons of drapery, in concert with individualized facial expressions, convey the quality of animation called for in texts of the period.

*For this and other excerpts from essays on painting quoted subsequently, see Michael Sullivan, *The Birth of Landscape Painting in China* (Berkeley: University of California Press, 1962).

[†]Ibid.

T'ANG DYNASTY

The short-lived Sui dynasty was followed by the T'ang dynasty (618–906), under which China entered a period of unequaled magnificence. Chinese armies marched across central Asia, opening a path for the flow of wealth, ideas, and foreign peoples. Arab traders, Nestorian Christians, and other travelers journeyed to the cosmopolitan capital of the T'ang, and the Chinese, in turn, ventured westward. During the middle of the seventh century, Hsüan Tsang, a Chinese monk, visited India, as had some earlier devotees. He returned from the mother country of Buddhism with revolutionizing doctrines of the recently developed Esoteric Sects. These years were a critical time for Buddhism in China; Buddhist religious beliefs were being brought into disrepute by a lax court and a corrupt clergy. Under the notorious Empress Wu, who had usurped the throne, religion was used as an instrument for political power and as a cloak for personal excess. The material rewards promised in Heaven by the Paradise Sects offered no effective antidote to the troubles of the time. But the elaborate and mysterious rituals of the new Esoteric Sects attracted worshipers by giving them in their daily life many of the sensory pleasures that the Paradise Sects had promised in Heaven. As the new cult spread, Chinese craftsmen again looked to India, where they found appropriate models in Gupta sculpture.

The fluid style of art developed during the Gupta period in India (FIGS. 11-13 and 11-14) already had affected Chinese sculpture during the late sixth century, and, by the end of the seventh, Buddhist sculpture in China had lost much of its own character due to its borrowing from the sensuous carvings of India. Fleshiness increased even more, and drapery was made to cling, as if wet, against the body. The new wave of influence from India brought not only stylistic changes but also the iconography of the Esoteric Sects, which we see in figures with multiple arms and heads, symbolizing various aspects of the deities as described in the new gospels.

The Early T'ang style, heavily influenced by Indian prototypes, is exemplified admirably by the *Bodhisattva* (FIG. **12-12**). The sinuous beauty of this figure has been accented by the hip-shot pose and revealing drapery, as in Gupta sculpture. Executed at almost the same time as the *Bodhisattva* (around 700) were carvings in the caves of Ti'en-lung Shan, which anticipated the later T'ang style. These cave figures might seem gross were it not for the graceful postures and the soft drapery that falls in rhythmic patterns over the plump bodies.

Esoteric Buddhism, with its emphasis on detailed and complicated ritual, placed the deity in a formal

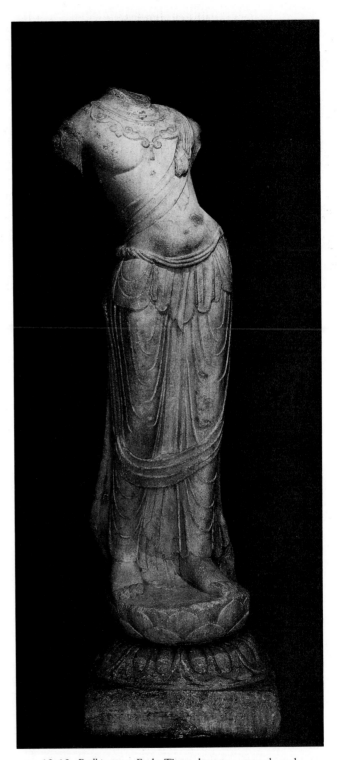

12-12 *Bodhisattva,* Early T'ang dynasty, seventh and eighth centuries. Marble. Private collection of Charles Uht, New York.

relationship to the worshiper. The followers of Amitabha Buddha—one of the most important Buddhas of the Paradise Sects—in stressing salvation by faith, visualized a warm and human deity, but, by the ninth century, the arduous discipline of the Esoteric

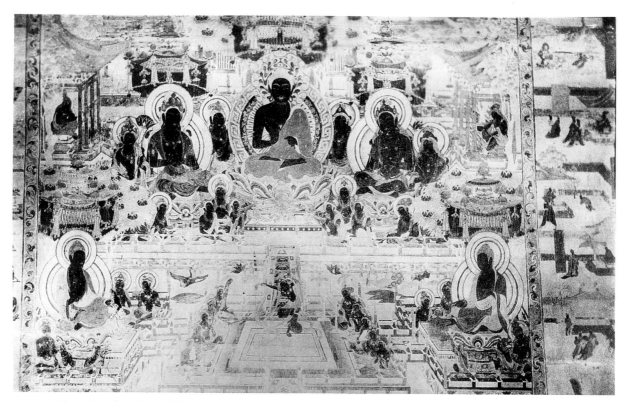

12-13 *Paradise of Amitabha,* Cave 139A, Tunhuang, Kansu, T'ang dynasty, ninth century. Wall painting.

Sects had inspired an austere, heavyset, almost repellent icon. At times, fleshiness was exaggerated almost to the point of obesity, and yet sufficient restraint lent the figures a somber dignity.*

The westward expansion of the T'ang Empire increased the importance of Tunhuang. Here, the desert routes converged and the cave temples profited from the growing prosperity of the people. By the eighth century, wealthy donors to Buddha were demanding larger and more elaborately decorated caves. The comparatively simple Buddha group in paintings of the previous century was enlarged to include crowds of attendant figures, lavish architectural settings, and minor deities who worshiped the resplendent Buddha with music and dance. The opulence of the T'ang style is reflected in the detailed richness of the brilliantly colored *Paradise Paintings* (shown is *Paradise of Amitabha,* FIG. **12-13**). Vignettes flanking the Buddha group illustrate incidents from specific *sutras.* These little scenes, like the jataka tales in earlier caves, usually are set in landscapes painted in an altogether different style from that of the hieratic groups. Mountains, for example, are stacked one

behind the other and painted in graded washes to give the impression of distance. (Although each mountain is related to the adjacent peak through this device of atmospheric perspective, no continuous perspective yet gives a sense of recession into the distance.)

The Confucian persecutions of 845 did not affect Tunhuang, which was then under Tibetan rule. Numerous paintings (murals and scrolls) were produced in this region, but because the area was isolated from the mainstream of Chinese culture, the paintings remained stylistically static from the middle of the ninth century to the beginning of the eleventh century. Meanwhile, during the seventh and eighth centuries at the T'ang court in Ch'ang-an (modern Xi'an)—perhaps the greatest city in the world during this period—a brilliant tradition of figure painting developed that, in its variety and balance, reflected the worldliness and self-assurance of the T'ang Empire. Indeed, Chinese historians regard the Early T'ang dynasty as their golden age of figure painting. Glowing accounts by poets and critics and a few remaining examples of the paintings themselves permit us to understand this enthusiasm.

Wall paintings from the tomb of the T'ang princess Yung-t'ai (built in 706 near Ch'ang-an) allow us to view court painting styles unobscured by problems of authenticity and reconstruction. The figures of *Palace Ladies* (FIG. **12-14**) are arranged as if on a shallow

*Few sculptures survived the terrible persecutions of Buddhism during a revival of Confucianism in 845. Many wooden temples were destroyed by fire, and their bronze images were melted down. Fortunately, we are able to reconstruct the style of the period from Buddhist art in Japan, which was then under direct Chinese influence (see FIGS. 13-3 to 13-5).

stage; although no indications of background or setting are given, intervals between the two rows and the grouping of the figures in an oval suggest a consistent ground plane. The women are shown full-face and in three-quarter views from the front and the back. The device of paired figures facing into and out of the space of the picture in a near mirror image—an effective means of creating depth—appears often in paintings attributed to this period. Thick, even contour lines describe full-volumed faces and suggest solid forms beneath the drapery, all with the utmost economy. This simplicity of form and drawing, along with the measured cadence of the poses, results in an air of monumental dignity, as befits a daughter of the ruling house of the T'ang.

In perfect accord with descriptions of the robust T'ang style are the unrestored portions of *Portraits of the Emperors*, masterfully drawn in line and in colored washes by YEN LI-PEN (d. 673), a celebrated painter and statesman of the seventh century. Each emperor is represented as standing in undefined space, his eminence clearly indicated by his great size relative to that of his attendants. Yen Li-pen also made designs for a series of monumental and spirited stone horses that once flanked the approach to the tomb of the T'ang emperor T'ai Tsung.

The horse in Chinese art reflected the importance the emperors placed on the quality of their stables. Even Han emperors had sent missions westward to Bactria for blooded stock. Paintings of the finest among his forty thousand steeds were commissioned by the emperor Ming Huang (713–756), and one of these may be the picture of a tethered horse that is attributed to HAN KAN (active 742–756), Ming Huang's favorite painter of horses. The fiery stallion (FIG. **12-15**) evokes the dynamic "inner vitality" so stressed by Chinese critics.

Two of the most famous artists of the T'ang period were WANG WEI (699–759; not to be confused with Wang Wei of the fifth century) and WU TAO-TZŬ (active *c.* 725–750), both of whom have become almost legendary figures, although none of their paintings has survived. Wang was not only a painter, but like many other Chinese artists, he was also a poet. His poems are mellow and lyrical, as his paintings are said to have been. Numerous imitations of his painting style have the peaceful lyricism of his poems. Many of these copies are of snow scenes, a favorite subject of Chinese artists, probably due to its adaptability to monochrome painting, an art of infinite variation and contrast in black and white. Wu's work, according to reports of his time, was very different. He painted with such speed and "ferocious energy" and over such large surfaces that people are said to have watched with awe as astonishingly real images rapidly appeared. His bold brushwork and expansive

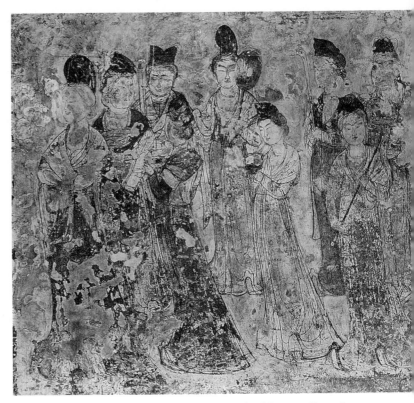

12-14 *Palace Ladies*, from the tomb of Princess Yung-t'ai, near Ch'ang-an (Xi'an), Shensi, T'ang dynasty, 706. Wall painting.

12-15 HAN KAN, *Horse*, T'ang dynasty, eighth century. Album leaf, ink on paper, 11$\frac{13}{16}$" high. Metropolitan Museum of Art, New York.

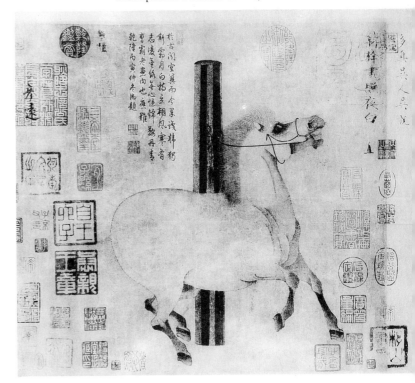

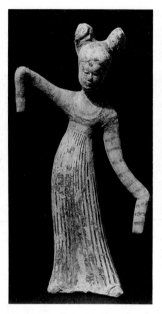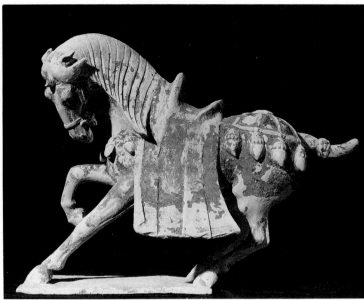

12-16 T'ang tomb figurines, seventh to ninth centuries: (*left*) Peddler, 24½″ high, Portland Art Museum, Portland, Oregon; (*middle*) Dancer, 10¾″ high, Nelson Gallery-Atkins Museum, Kansas City, Missouri; (*right*) Horse, 14½″ high, Fogg Art Museum, Harvard University, Cambridge, Massachusetts.

forms frequently were copied, and rubbings were made from engraved replicas. Later artists looked to Wu's virtuoso brushwork and to Wang's subtle harmonies for their models.

The T'ang rulers embellished their empire with extravagant wooden structures, all of which have disappeared. Judging from records, however, they were colorfully painted and of colossal size. Bronze mirrors with decorations in strong relief added to T'ang luxury and to the furnishings of a court already enriched by elaborate gold and silver ornaments.

The potter met the demand for display by covering his wares with colorful lead glazes and by inventing robust shapes with clearly articulated parts—base, body, and neck. Earlier potters had imitated bronze models, but T'ang craftsmen derived their forms directly from the character of the clay. Ceramic figures of people, domesticated animals, and fantastic creatures also were made by the thousands for burial in tombs (FIG. **12-16**). The extraordinarily delicate grace and flowing rhythms of these figures have a charm and vivacity seldom equaled in ceramic design. Their subject matter, which included such diverse figures as Greek acrobats and Semitic traders, is proof of the cosmopolitanism of T'ang China.

FIVE DYNASTIES AND NORTHERN SUNG DYNASTY

The last century of T'ang rule witnessed the gradual disintegration of the empire. When the dynasty

finally fell in 906, China once more was left to the ravages of civil war. Conflicting claims between rival states were not resolved until the country was consolidated under the Sung, whose court was at Pienching (modern Kaifeng in Honan). During the interim of internal strife known as the Five Dynasties (906–960), a marked development took place in the styles and techniques of landscape painting. An analogy with events of the period of the Northern and Southern dynasties may be justified here; that earlier period of political and social turmoil also witnessed a turning away from portrayals of society toward an involvement with nature and an accompanying development of landscape art.

CHING HAO (*c.* 900–967) left an essay in which he listed his criteria for judging paintings. Under the classification of "divine," he grouped the greatest paintings. In these, he wrote, "there appears no trace of human effort; hands spontaneously reproduce natural forms." In the lowest category, he placed the "skillful" artist who "cuts out and pieces together fragments of beauty and welds them into the pretense of a masterpiece. . . ." "This," he added, "is owing to the poverty of inner reality and to the excess of outward form." Although these ideas were not original with Ching Hao, his restatement of them showed the continuity of thought underlying Chinese painting regardless of changing styles. The artist who painted the truth beneath surface appearances had to be imbued with *ch'i,* the "divine spirit" of the universe. Any artist who achieved this did so only through years of self-cultivation. Ching Hao and his

equally famous contemporary LI CH'ENG (active *c.* 940–967), through the inherent power of their personalities, departed from T'ang landscape formulas, breathing life into every twig and rock they painted. Succeeding generations went to their works for inspiration—great artists, to catch the spirit; lesser painters, to copy tricks for drawing trees and hills.

We know enough about the art of this period to distinguish the styles of some individual masters, such as TUNG YUAN and CHU-JAN, of the mid-tenth century, and FAN K'UAN and KUO HSI, active early and late in the eleventh century, respectively. Paintings by the latter two artists, which exemplify the maturity of landscape painting styles in the Northern Sung period (960–1127), express very different personalities and yet exhibit a common feeling for monumentality. A characteristic painting in this style presents a vertical landscape of massive mountains rising from the distance (FIG. **12-17**). Human figures, reduced to minute proportions, are dwarfed by overwhelming forms in nature. Paths and bridges in the middle region vanish, only to reappear in such a way as to lead the spectator on a journey through the landscape—a journey facilitated by shifting perspective points. No single vanishing point organizes the entire perspective, as in many Western paintings; as a result, the observer's eye moves with freedom. But to appreciate these paintings fully, one must focus on intricate details and on the character of each line.

The full development of the horizontal handscroll occurred during this period. The scroll, which might measure as long as 50 feet or more, had to be unrolled from right to left; only a small section could be seen at a time and then, properly, by only two or three persons. The organization of these paintings has been compared to the composition of a symphony because of the way in which motifs are repeated and moods are varied in the different sections. The temporal sequence of the scroll involved memory as well as vision; it was an art of contemplation and leisure.

Among the versatile figures clustered around the court at Pien-ching was SU TUNG-P'O (1036–1101), one of China's greatest poets, a celebrated painter and statesman. Another, LI KUNG-LIN (1040–1106), was famous for his original Buddhist compositions and for his outline drawings of horses. These, along with the antiquarian and landscape artist MI FU (1052–1109), were the leading figures in a group of scholar-gentlemen painters who created an alternative to the emphasis on the skillful representation of nature then prevalent among professional and academy artists. These amateurs of the "literary" school, by contrast, saw painting as primarily expressive of the moods and personality of the artist. Representational accuracy was deemphasized, or even derided, in favor of learned allusions to antique styles, sometimes

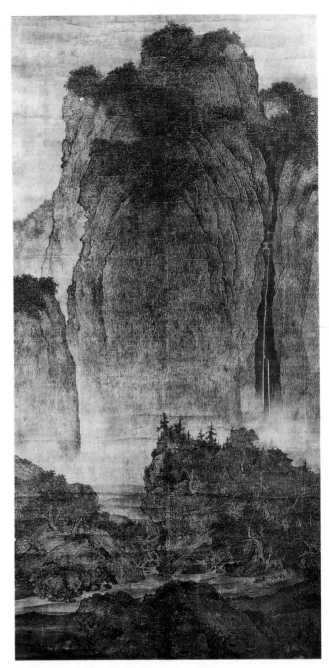

12-17 FAN K'UAN, *Travelers Among Mountains and Streams,* Northern Sung dynasty, early eleventh century. Hanging scroll, ink and colors on silk, 6' 9" × 2' 5". Collection of the National Palace Museum, Taipei, Taiwan.

couched in deliberately awkward or naïve forms. Many paintings in this style concentrate on qualities inherent in the medium of brush and ink. In this, they are close to the expressiveness of calligraphy, which depends, for its effects, on the controlled vitality of individual brush strokes and on the dynamic relationships of strokes within a character and among the characters themselves. Training in calligraphy was a fundamental part of the education and self-cultivation of Chinese scholars and officials; with

Su Tung-p'o and Mi Fu ranked among the greatest of Northern Sung calligraphers, calligraphic qualities and effects became part of the repertory of many painters as well.

The emperor HUI TSUNG (ruled 1101–1125), an avid collector and patron of art, was himself an important painter. He is known particularly for his meticulous pictures of birds, in which almost every feather is carefully drawn in sharp lines. Lesser artists attached to the imperial court functioned as a sort of academy and, in general, followed the detailed and colorful style of the emperor. Illustrating some lines of poetry in painting often served as an examination for court office. Fans painted by master artists were treasured in albums. But while the court spent its energy on esthetic refinements, less cultured neighbors were assaulting the frontiers of China.

SOUTHERN SUNG DYNASTY

In 1127, as a result of increasing pressure from the Tatars and Mongols in the west and north, the capital of China was moved to the south. From then until 1279, the Southern Sung court lived out its days amid the tranquil beauty of Hangchou. Neo-Confucianism, a blend of traditional Chinese thought and some Buddhist concepts, became the leading philosophy. Accordingly, orthodox Buddhism declined. Buddhist art continued to develop in the north, where a Tatar tribe had established itself as the Chin dynasty (1115–1234), but it stagnated in the south. Buddhist sculpture in the Southern Sung period merely added grace and elegance to the T'ang style. Secular paintings and those associated with Ch'an (a meditative school of Buddhism), however, reflected a new and more intimate relationship between the human being and nature.

A typical Southern Sung landscape basically is asymmetrical. It is composed on a diagonal and consists of three parts: foreground, middle distance, and far distance. These parts are separated from each other by a field of mist. The first part is marked by a rock, which, by its position, emphasizes the distance of the other parts. The middle distance may be marked by a flat cliff or given over entirely to mist or water. In the far distance, mountain peaks, which are usually tinted in pale blue, suggest the infinity of space. The whole composition illustrates the manner in which the Sung artists used great voids to hold solid masses in equilibrium. The technique is one of China's unique contributions to the art of painting. To this basic composition, of which many variations were employed, the artist frequently added the figure of a scholar meditating under a gnarled pine tree, ac-

companied by an attendant. Such paintings were expressions of the artist's ideal of peace and pantheistic unity.

The chief painters in the Southern Sung style were MA YUAN (c. 1190–1224) and HSIA KUEI (c. 1180–1230). Ma was a master of suggestion, as demonstrated by a small, fan-shaped album leaf (FIG. 12-18), a picture of tranquility stated in a few sensitively balanced and half-seen shapes. Hsia Kuei's misty landscapes were often so like those of Ma Yuan—though sometimes more delicate and sometimes bolder—that the Chinese refer to these artists and their followers as the Ma-Hsia school. But the Ma-Hsia tradition, despite its gentle beauty, could not be maintained. It perpetuated an ephemeral, classic moment, but the serenity of its beliefs soon was threatened by political realities.

As orthodox Buddhism lost ground under the Sung, the new school of Buddhism (called Ch'an in China, but better known by its Japanese name, Zen) gradually gained importance, until it was second only to Neo-Confucianism. The Zen sect traced its semilegendary origins to Bodhidharma, an Indian missionary of the sixth century. By the time of the Sixth Ch'an Patriarch, who lived during the Early T'ang period, the pattern of the school already was established, and Zen remains an important religion in Japan today.

12-18 MA YUAN, *Bare Willows and Distant Mountains*, Southern Sung dynasty, thirteenth century. Album leaf, ink and colors on silk, $9\frac{1}{2}'' \times 9\frac{1}{2}''$. Museum of Fine Arts, Boston.

required years of training. Their impact can be a shock, much like the shock of Zen understanding.

Southern Sung artists also produced superb ceramics with monochrome glazes. The most famous of the single-glaze wares are known as *celadon* (a mat gray-green), *ying-ch'ing* (a subtle pale blue), and *ting* (a fine, white protoporcelain). One type of the heavier *chun* ware employed a blue glaze, splashed with red and purple flowing over a stoneware body. A quite different kind of pottery, loosely classed as *tz'u-chou*, is a northern Chinese ceramic type. The subtle techniques of underglaze painting and incision of the design through a colored slip were developed for this pottery during the Sung period. The intricate black-white design of the *mei-p'ing* vase shown here (FIG. **12-20**) was produced by cutting through a black slip to a white slip. The tightly twining vine and petal motifs closely embrace the high-shouldered vessel in

12-19 LIANG K'AI, *The Sixth Ch'an Patriarch Chopping Bamboo*, Southern Sung dynasty, thirteenth century. Hanging scroll, ink on paper, 29¼″ high. Tokyo National Museum.

The followers of Zen repudiate texts, ritual, and charms as instruments of enlightenment. They believe, instead, that the means of salvation lie within the individual, that meditation is useful, and that direct personal experience with some ultimate reality is the necessary step to enlightenment. Zen enlightenment is conceived of as a sudden, almost spontaneous act. These beliefs shaped a new art.

LIANG K'AI, a Zen painter of the thirteenth century, has left us two portraits of Hui Neng, the Sixth Ch'an Patriarch. In one (FIG. **12-19**), the patriarch is a crouching figure chopping bamboo; in the other, he is tearing up a Buddhist sutra. Both are informal sketches that look as though they were caricatures of the revered figure. The brush strokes are staccato and splintery, like the spontaneous process of Zen enlightenment. Each sketch probably was painted in a few minutes, but, like enlightenment, their execution

12-20 *Mei-p'ing* vase, Sung dynasty. *Tz'u-chou* stoneware, carved black slip over white slip, 19½″ high, 7¾″ wide. Asian Art Museum of San Francisco, The Avery Brundage Collection.

a perfect accommodation of surface design to vase shape—a common characteristic of Chinese pottery in its great periods. These shapes were generally more suave than those of the T'ang period; some, however, reflecting the prevailing interest in archeology, imitated the powerful forms of the Shang and Chou bronzes. Other crafts, particularly jade carving, also were subjected to the influence of archeological or antiquarian interests.

YÜAN DYNASTY

The artistic vitality of Southern Sung was not a reflection of the political conditions of the times. In 1279, the Sung dynasty crumbled beneath the continued onslaughts of Kublai Khan. Yüan, the dynasty of the Mongol invaders, dominated China only until 1368, yet it profoundly affected the culture of the country and particularly the art of painting. Many scholar-painters chose exile in the provinces to avoid service under the barbarian usurpers in Peking. Forced by their exile to reappraise their place in the world, these artists no longer looked at a landscape as an idyllic retreat; it had become part of a formidable environment. This new austerity is evident in a painting (FIG. 12-21) by one of the great masters of Yüan, HUANG KUNG-WANG (1269–1354). Here, the misty atmosphere of the Southern Sung landscapes has been replaced by massive, textureful forms. The

inner structure and momentum of the landscape is rendered by a rhythmic play of brush and ink.

Another leader of the Yüan scholar-artist movement was CHAO MENG-FU (1254–1322), whose paintings contain knowing allusions to old styles. The landscapes of his grandson, WANG MENG (d. 1385), reached a high level of dynamic, expressive intensity. Most of these painters rejected the mellow harmonies of Southern Sung as no longer valid; for their sources, they went back to the more monumental works of the tenth century. The degree to which styles could become personalized in this period is shown in the spare, almost brittle landscapes and bamboo-and-rock paintings of NI TSAN (1301–1374), which reveal an aloof and fastidious personality. These works contrast markedly with the paintings of WU CHEN (1280–1354), which are done in a softer and more relaxed manner. Paintings of bamboo (FIG. 12-22), for which Wu Chen is famous, were particularly favored at this time, for that plant is a symbol of the ideal Chinese gentleman, who, in adversity, bends but does not break. Moreover, the pattern of leaves, like that of calligraphic script, provided an excellent opportunity for the display of brushwork.

The Mongol regime apparently did little to disturb the Chinese potters' increasing mastery of porcelain. A Late Yüan or Early Ming vase of white porcelain (FIG. 12-23), discovered in 1961, exhibits brilliance in the use of the underglaze decoration that was so successful in the Sung period.

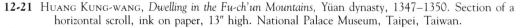

12-21 HUANG KUNG-WANG, *Dwelling in the Fu-ch'un Mountains,* Yüan dynasty, 1347–1350. Section of a horizontal scroll, ink on paper, 13″ high. National Palace Museum, Taipei, Taiwan.

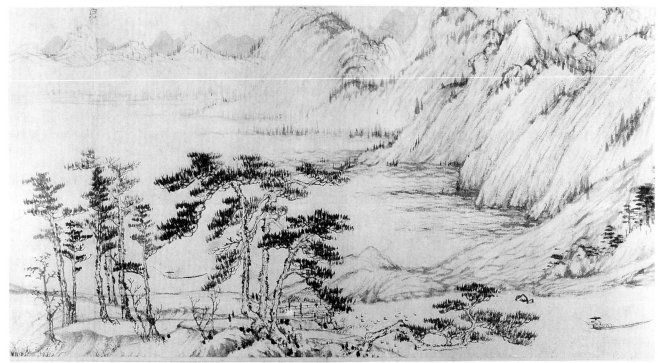

12-22 Wu Chen, *Bamboo*, Yüan dynasty, 1350. Album leaf, ink on paper, 16″ × 21″.
Collection of the National Palace Museum, Taipei, Taiwan.

12-23 Covered vase (excavated at Peking), Late Yüan or Early Ming dynasty, late fourteenth century. White porcelain with underglaze decoration, 26½″ high. The exhibition of archeological finds of the People's Republic of China.

MING, CH'ING, AND LATER DYNASTIES

In 1368, a popular uprising drove out the hated Mongol overlords, and, from that time until 1644, China was ruled by the native Ming dynasty. Many of the fifteenth-century Ming masters, such as TAI CHIN (1388–1452), reverted to Sung models. The court, where Tai Chin worked, was one center of patronage and activity; local schools of painting, such as those centered in Nanking and in Suchou, also became important. The Suchou school, under the leadership of SHEN CHOU (1427–1509) and WEN CHENG-MING (1470–1559), included many highly educated amateur painters who concentrated on refined recreations of the styles of the masters of the preceding Yüan dynasty. Professional artists, active in Suchou and elsewhere, executed works that displayed great skill and spontaneity.

The distinction between scholar-amateur and academic-professional traditions was codified, rather artificially, in the writings of the influential critic, statesman, and artist TUNG CH'I-CH'ANG (1555–1636),

12-24 TUNG CH'I-CH'ANG, *Autumn Mountains*, Ming dynasty, early seventeenth century. Horizontal scroll, ink on paper, 15⅛″ × 53⅞″. Cleveland Museum of Art (purchase from the J. H. Wade Fund).

at the end of the Ming period. Tung's glorification of the amateur or literary school reflected his own voracious study and collecting of old paintings. His theories promoted the creation of an orthodoxy in later art that could be stifling, but his own works were true to his ideal of the transformation of old styles, rather than the sterile imitation of them. In Tung's landscapes, his attempts to reveal the inner structure and momentum of nature often result in a radical reorganization of forms (FIG. **12-24**). Ground planes are allowed to tilt or shift; this—and the bold arrangement of rocks and trees to emphasize repeated abstract shapes and textures, without regard for natural scale and surface qualities—may seem arbitrarily distorted, or even crude. What is lost in harmony of surface or representational accuracy, however, is more than made up in qualities of monumentality and power. Paintings by Tung and other masters during the period of social and intellectual readjustment at the end of the Ming dynasty created an atmosphere of artistic freedom. The artists who lived into the next dynasty were its beneficiaries.

The internal decay of Ming bureaucracy permitted another group of invaders, the Manchus, to overrun the country in the seventeenth century. Established as the Ch'ing dynasty (1644–1912), these northerners quickly adapted themselves to Chinese life. The early Ch'ing emperors cultivated a knowledge of China's arts, but their influence merely seems to have encouraged academic work. While the Yüan style continued to be fashionable among the conservatives, other painters experimented with extreme effects of massed ink or individualized patterns of brushwork. Bold and freely manipulated compositions that had a new, expressive force began to appear.

Two artists with intensely personal styles stand out against a mass of lesser painters during this period. The sketchy brush and wet-ink technique of CHU TA (1625–c. 1705) derived from sixteenth-century precursors, but his subjects—whimsical animals or petulant birds that are tensely balanced on an album page—demonstrated his discontent with conventional themes. The theoretical writings of Chu Ta's great contemporary TAO-CHI (1641–c. 1717) called for a return to wellsprings of creativity through use of the "single brush stroke" or "primordial line" that was the root of all phenomena and representation. The figure in a hut in one of Tao-chi's album leaves (FIG. **12-25**) is surrounded by the surging energy of free-floating colored dots and multiple, sinuous, contour lines that suggest the vital arteries of an organism. What is depicted is not so much the appearance of the landscape as the animating, molding forces that run through it—the prime focus of Chinese landscape art from the earliest times.

Some twentieth-century artists, such as CH'I PAI-SHIH, have found the free brush expressive and have maintained the calligraphic tradition with vitality. HSU PEI-HUNG (1895–1953), known for his boldly brushed pictures of horses, has imbued his work with social content, in keeping with China's political developments. The coming decades will reveal whether a popular art can assimilate the traditions of aristocratic painting that have dominated Chinese art for over a thousand years.

In ceramics, the technical ingenuity of the Ming and Ch'ing potters exceeded the skill of even the Sung potters. In general, porcelain was favored over stoneware and earthenware, with the exception of Ming stonewares, which were decorated broadly in

12-25 TAO-CHI, *Landscape*, Ch'ing dynasty, late seventeenth century. Album leaf, ink and colors on paper, 9½″ × 11″. C. C. Wang Collection, New York.

"three-color" enamels. More delicate designs were painted on "five-color" wares, fine clay forms decorated with enamels and underglaze painting. The celebrated blue-and-white porcelains (FIG. **12-26**) owe their quality as much to the distinction of their painted decoration as to the purity of their imported cobalt pigments. Craftsmen also devised a "secret," barely visible decoration that was carved into paper-thin porcelain.

When the Manchus came to power in 1644, they continued to support the great kilns at Fowliang (ancient Chingtechen), where enormous quantities of excellent porcelains were made until the destruction of the kilns during warfare in the mid-nineteenth century. During the K'ang-hsi period (1662–1722), delicate glazes known as *clair de lune* (a silvery blue) and *peachbloom* (pink dappled with green) vied with the polychrome wares. Experiments with glazes led to the invention of the superb imperial yellow and oxblood monochromes. A brief revival of Sung simplicity occurred during the reign of Yung Chêng (1723–1735), but under Ch'ien Lung (1736–1795), a reaction against Sung simplicity led to a style that was sometimes more elaborate than artistic.

Fine embroidered and woven textiles, created for lavish court ceremonies, followed the general style of

12-26 Vase, Ming dynasty, fifteenth century. Porcelain with blue underglaze decoration. Musée Guimet, Paris.

the age, becoming more intricate and, at the same time, more delicate.

During this long period, from the mid-seventeenth to the late eighteenth century, sculpture consisted primarily of charming but inconsequential porcelain bibelots and jade and ivory carvings of an almost unbelievable technical perfection. An example of this work is the white porcelain *Kuan-yin* (FIG. **12-27**), goddess of compassion, from the Early Ch'ing dynasty, which completes that long process of the humanization of the sacred Buddhist images that began even before the T'ang period (see FIG. 12-10). This lovely statuette, reflecting the culmination of the technical achievement of Chinese ceramists, embodies the Bodhisattva's quality of mercy in its softness of form. An easy play of line betrays the influence of painting on ceramics. This "white china ware" (*blanc-de-Chine*) was exported widely to Europe in the eighteenth century, and, in the West to this day, fine ceramic wares, especially porcelain, are called "china."

As the eighteenth century waned, huge workshops, much like our own production-line factories, continued to provide masses of materials for imperial use. Specialists, instead of designer-craftsmen, worked on each stage of manufacture. By the middle of the nineteenth century, this system had drained all vitality from the crafts.

The establishment of the People's Republic of China in 1949 produced a social realism in art that is familiar to the world of the twentieth century (see pages 1015–27) and that breaks drastically with traditional Chinese art. Some Chinese artists carry on cre-

12-27 *Kuan-yin*, Early Ch'ing dynasty, seventeenth and eighteenth centuries. Fukien ware, white porcelain, 8⅞" high, 6¼" wide. Trustees of the Barlow Collection, University of Sussex, England.

12-28 Anonymous team of sculptors, *The Rent Collection Courtyard* (detail of a larger tableau), Ta-yi, Szechwan, 1965. Clay-plaster, life size.

ative work based on the old traditions, but for most, the purpose of art now is, as the People's Republic would claim, to serve the people in the struggle to liberate and elevate the masses. In the work shown (FIG. **12-28**), a life-size tableau, the old times are depicted grimly in a scene common enough before the revolution. Peasants, worn and bent by toil, are bringing their taxes (in the form of produce) to the courtyard of their merciless, plundering landlord. The message is clear: this kind of thing must not happen again. Significantly, the artists who depict the event are an anonymous team. The "name" artist belongs to the past; only collective action, say its theoreticians, can bring about the transformations the People's Republic is seeking. Ironically, "collective action" by students protesting in Tiananmen Square in early June, 1989, produced not an image of an oppressed peasant or a militant worker, but an allegorical statue of "Liberty" based on the colossal one in New York Harbor. This was not at all the kind of art the leaders of the People's Republic wanted to see.

ARCHITECTURE

We have said little about Chinese architecture, partly because few early buildings exist and partly because Chinese architecture has not displayed distinctive changes in style over the centuries. The modern Chinese building closely resembles its prototype of a thousand years ago. Indeed, the dominant silhouette of the roof, which gives Chinese architecture much of its specific character, may go back to Chou or Shang times. Even the simple buildings depicted on Han stone carvings reveal a style and a method of construction still basic to China. The essentials consist of a rectangular hall, dominated by a pitched roof with projecting eaves supported by a bracketing system and wooden columns. The walls serve no bearing function but act only as screening elements.

Within this limited formula, the Chinese architect has focused his attention on the superstructure. As early as the Han dynasty, combinations of brackets, impost blocks, and columns were devised to support the weight of massive, tiled roofs (FIG. **12-29**). The architects gave animation to the exterior by varying the shapes of the brackets. From these simple beginnings, later architects developed very intricate systems of support. Some brackets were placed parallel to the walls; others reached outward to support a beam or other brackets, until the multiplication of units created a rich pattern of light and shade. The effect was intensified by decorations in red and gold lacquer (FIG. **12-30**). Function often was subordinated

12-29 Structural diagram of typical Chinese construction. (After Watson.)

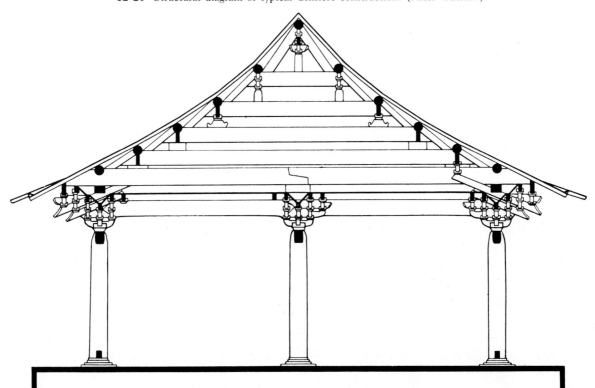

12-30 Console bracket cluster supporting eaves of a bell tower, Xi'an, Shensi.

to ornament; where only minimal support was required, complicated bracket systems sometimes were introduced for decoration.

On the exterior, the coloristic interplay of the supports formed a pleasing contrast to the uninterrupted sweep of the pitched roof. The overhanging eaves became even wider during the T'ang period, and builders began to turn up the corners. These slightly curving eaves were exaggerated in later buildings, especially in south China, where they produced a riotous fantasy of upswept lines. But in most areas, the gentle curves of the roofs give an air of grace to the otherwise severe rectangular form and rigid symmetry that were imposed by the plans of the buildings. The style was imported by Japan along with Buddhism, and the Phoenix Hall of the Byodo-in Temple at Uji, Japan (FIG. 13-11), may serve as a good example of the Chinese style. In China proper, the best-known building is the T'ai-ho Tien (Hall of Supreme Harmony, FIG. **12-31**) in the Forbidden City of Peking. Built in 1627, rebuilt in 1697, and restored in 1765, it is one of the less florid examples of Chinese architecture that impresses more through size (it is over 200 feet long) than gracefulness. Raised high on a terraced marble podium, the wooden structure is the largest of several similar buildings that are aligned along a central north–south axis that runs through the rectangu-

12-31 T'ai-ho Tien, Imperial Palace, Forbidden City, Peking, seventeenth century and later.

lar, moat-surrounded former imperial compound. Although here its exterior is somewhat blunt and massive in appearance, the building's proportions are pleasing enough and the upswept corners of the roof soften what otherwise might have been a rather heavy and forbiddingly stern appearance. For centuries, the orientation of buildings, even of whole cities, had been ordered on a strict north–south axis. Houses, palaces, temples, and official buildings all fell within one formal pattern. Even the seeming randomness of the varied bridges and pavilions in the informal gardens was carefully devised.

Buddhist architecture contributed a specific form—the *pagoda* (FIG. **12-32**)—which, to many, has become a symbol of China. These pagoda towers, which dot the countryside and seem so native to the land, were derived from the Indian stupa (FIG. 11-5). Most of the wooden pagodas, with their multiplicity of winged eaves, bear little resemblance to the solid domes of Sanchi or Amaravati, but their origin, like that of the Chinese Buddha, is to be found in Gandhara, where terraced and towering variants of the stupa once had impressed Chinese pilgrims with their grandeur. So quickly was the stupa structure assimilated by the Chinese that even the earliest pagodas (sixth to eighth centuries) show only a few traces of their Indian origin. In the Chinese wooden idiom, all that remained of the Indian stupa were the yasti and parasols, which crowned that structure. Instead of a circular plan, the Chinese preferred a four-, six-, or eight-sided one, and story was piled on story in order to form towers as high as 300 feet. Each story was marked by its own projecting eaves, the curved lines of which soared into the sky. Like other Chinese architectural forms, the pagoda was imported by Japan, where, stylistically modified, it marks the sites of many Buddhist temples.

12-32 Pagoda of the Temple of the Six Banyan Trees, Canton, Kwangtung, 537 (rebuilt 1098). 180′ high.

It is curious that the architecture of China, the oldest continuing civilization in the world, should be represented by few surviving buildings older than the ninth century. This phenomenon is due largely to a flexible construction that is easily dismantled, moved to other sites, or simply replaced. The joinery, like cabinet-making in its exquisite fitting together of the component parts, almost invites taking apart. At the same time, this structural flexibility has permitted easy replication and the perpetuation of a style recognizable through the ages as indigenously and characteristically Chinese.

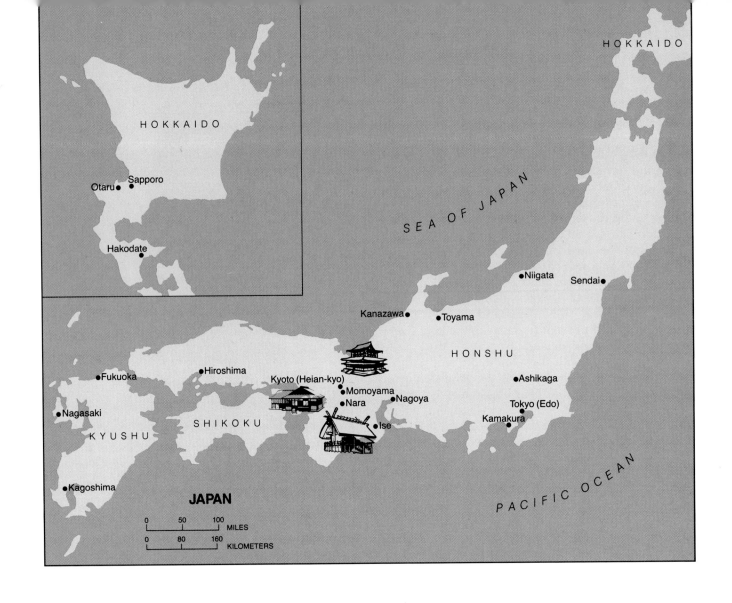

HOKKAIDO

HOKKAIDO

• Otaru • Sapporo

• Hakodate

SEA OF JAPAN

• Niigata Sendai •

• Kanazawa • Toyama

HONSHU

• Fukuoka • Hiroshima

Kyoto (Heian-kyo) • Ashikaga

• Momoyama

• Nara • Nagoya

Tokyo (Edo) •

• Nagasaki Kamakura •

KYUSHU SHIKOKU • Ise

• Kagoshima

JAPAN

PACIFIC OCEAN

```
0      50     100
|——|——|——|  MILES
0      80     160
|——|——|——|  KILOMETERS
```

3000 B.C.		B.C. A.D.		552	710	794	1185
JOMON CULTURE		ARCHAIC PERIOD		ASUKA AND HAKUHO PERIODS	NARA PERIOD	EARLY AND LATE HEIAN (FUJIWARA) PERIODS	KAMAKURA PERIOD

Haniwa figure
5th–6th century

TAKAYOSHI (?)
The Tale of Genji
12th century

*The Sage Kuya
Invoking the
Amida Buddha*
13th century

Ise Shrine 3rd-century type

Kondo 7th century

Kimmei, Emperor
of Japan 552

Zen Buddhism
begins rise

Civil wars
lead to end of
Fujiwara rulers

Introduction
of Buddhism
to Japan

New capital
established
at Kamakura
1185

13
THE ART OF JAPAN

c. 1392	1573	1868
ASHIKAGA PERIOD	MOMOYAMA AND EDO (TOKUGAWA) PERIODS	MODERN JAPAN

SHUBUN
15th century

Uji Bridge 16th–17th century

KIYOTADA
*Dancing Kabuki
Actor c.* 1725

TANGE
1913–

ISOZAKI
1931–

SESSHU
1420–1506

SOTATSU
1576–1643

BUSON
1716–1783

HARUNOBU
1725–1770

Katsura Palace
and gardens
1615–1663

HOKUSAI *The Great Wave
c.* 1823–1829

Origin of the
tea ceremony

Kamakura
rule ceases
1333

Tokugawa Ieyasu
consolidates his power
as Shogun of Edo
(modern Tokyo) 1615

Civil wars
1333–1392

THE ARTS OF JAPAN have neither the progressive, stylistic continuity of the arts of India nor the wide variety of those of China. A series of foreign influences sporadically affected the course of Japan's artistic evolution. Yet, no matter how overwhelming the impact of new forms and styles, the indigenous tradition invariably reasserted itself. Hence, the artistic pattern evolved in a rhythmic sequence of marked periods of borrowing, absorption, and return to native patterns.

Because Japan and its nearby islands are of volcanic origin, little stone suitable for carving or building is available. In architecture, this scarcity led to the development of wooden construction carefully devised to withstand the frequent earthquakes and tempests. In sculpture, figures were modeled in clay, which was often left unfired, cast in bronze by the *cire perdue* process familiar to many other cultures, or constructed of lacquer. Although the lacquer technique originated in China, Japanese artists excelled in creating large, hollow, lacquer figures by placing hemp cloth soaked in the juice of the lacquer tree over wooden armatures. The surfaces gradually were added to and finished, but the technique remained one of modeling rather than of carving. Such figures were not only light but very durable, being hard and resistant to destructive forces. Hollow lacquer figures eventually were superseded by sculptures carved in wood, with unusual sensitivity for grain and texture.

ARCHAIC PERIOD

The first artifacts known in Japan are pottery vessels and figurines from a culture designated Jomon, which apparently flourished as early as the fourth millennium B.C. These objects are associated with Neolithic tools, although they persisted in northern Japan as late as the fourth or fifth century A.D., even while a metal culture was being developed fully in the south.

Japanese objects dating from about the beginning of the Christian era are of three kinds: those imported from the Asian mainland, those copied from imported articles, and those of Japanese invention. Examples, for instance, would include bronze mirrors from Han China, as well as replicas of these mirrors made in Japan. Some of the replicas are adorned with a Japanese innovation—spherical rattles attached to the perimeter. A gray pottery known as *sue* came from Korea, another source of continental influence. Sue soon was copied, and small, comma-shaped stones (*magatama*) were used in necklaces. A third area, Indochina, was the source of motifs used on

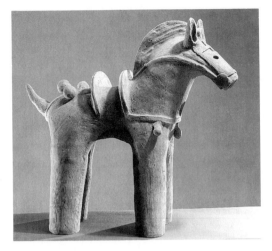

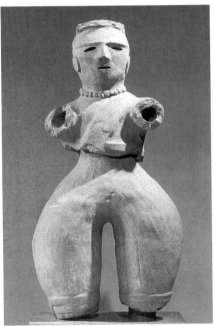

13-1 *Haniwa* figures, horse and peasant, fifth to sixth centuries. Clay. Horse, Cleveland Museum of Art (gift of The Norweb Collection); peasant, Cleveland Museum of Art (James Parmelee Fund purchase).

bell-shaped bronzes, known as *dotaku*. The houses and boats depicted on these bronzes are similar to those on contemporaneous drums from Annam (modern Vietnam), in Indochina.

Within this heterogeneous culture, a specifically Japanese creativity asserted itself in the production of *haniwa*—tubular sculpture made of fired clay—that was placed fencelike around burial mounds, possibly to control erosion or to protect the dead. The upper parts of the haniwa are usually modeled in human form, but these sculptures also sometimes take the shape of a horse (FIG. **13-1**), a bird, or even a house. Simple pottery cylinders were used similarly in Indo-

china, but the sculptural modeling of haniwa is uniquely Japanese. The arms and legs, as well as the mass of the torso, in most instances, recapitulate the cylindrical base of the haniwa. The tubelike character of some later monumental sculpture—and even of a particular wooden doll common in Japan today— may derive from these remote ancestors.

Aside from colossal tomb mounds, reminiscent of those found in China, the earliest Japanese architecture was limited to pit dwellings and simple constructions of thatched roofs on bamboo or wooden stilts. From these primitive origins evolved what may be called the native Japanese style of architecture, as distinguished from the imported Chinese style. This native building style has survived into our time in some of the shrines of Shinto, the indigenous faith of the Japanese people.* The custom at the Ise Shrine in

*Shinto, or ''the Way of the Gods,'' was based on love of nature, of the family, and, above all, of the ruling family, as direct descendents of the gods. Nationalistic in character, Shinto was embodied in symbolic forms and shunned pictorial representation.

Mie Prefecture (FIG. **13-2**) has been to disassemble the buildings every twenty years and to replace them with exact copies. This process has been repeated since the third century, and we may assume that the structures there today reproduce the original ones with considerable accuracy.

The typical Shinto shrine, like the Buddhist temple, consists of several buildings within a rectangular, fenced enclosure. The buildings are disposed symmetrically along a central axis that leads from the outside, through one or more ceremonial gates (*torii*), into and through the compound. This axis is interrupted only by the off-center outermost gate and by the transversely placed main building. The main sanctuary was regarded as the dwelling place of the deity and was not accessible to worshipers, who said their prayers outside the innermost gate. The sanctuary was to be seen only from the outside (much like a Greek temple), and all of the builders' efforts were directed toward the refinement of the building's proportions and details.

13-2 Ise Shrine, Japan. Rebuilt in 1973, reproducing third-century type.

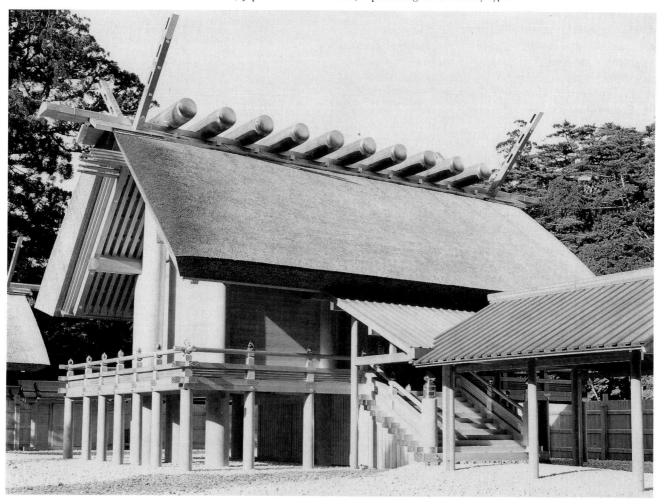

The Ise Shrine (FIG. 13-2), the greatest of all Shinto shrines, was rebuilt for the sixtieth time in 1973. It covers an area 55 by 127 yards and is enclosed by four concentric fences. Aside from their thatched roofs, the buildings are constructed entirely of wood fitted together in a mortise-and-tenon system (without nails), the wall boards being slipped into slots in the pillars. Two massive, freestanding posts (once great trunks of cypress trees), one at each end of the building, support most of the weight of the ridgepole. Golden-hued columns and planks of the same wood are burnished to mellow surfaces, their color and texture contrasting with the white gravel that covers the ground of the sacred precinct. In the characteristic manner of the Japanese artist, the thatched roof was transformed from a simple functional element into one that established the esthetic of the entire structure. Browned by a smoking process, the thatch was sewn into bundles and then carefully laid in layers that gradually decreased in number from the eaves to the ridgepole. The entire surface was then sheared smooth, and a gently changing contour resulted. The roofline was enhanced further by decorative elements that once had been structural—the *chigi* or crosspiece at the gables, and cylindrical, wooden weights placed at right angles across the ridgepole. The repeats and echoes of the various parts of the main building and the related structures are a quiet study in rhythmic form. The shrine, in its setting, is an expression of purity and dignity, effectively emphasized by the extreme simplicity of the precisely planned proportions, textures, and architectural forms employed.

ASUKA PERIOD

The development of native traditions was interrupted in 552 by an event of paramount importance to Japan. In that year, the ruler of Kudara (Korean: Paekche), a kingdom in Korea, sent a gilt bronze figure of the Buddha to Kimmei, emperor of Japan. With the image came the gospels. For half a century, the new religion met with opposition, but at the end of that time, Buddhism and its attendant arts were established firmly in Japan.

Among the earliest examples of Japanese art serving the cause of Buddhism is *The Shaka Triad* (FIG. 13-3), a bronze sculpture of Shaka (Sanskrit: Sakyamuni) and attendant Bodhisattvas, made in 623 by Tori Busshi, a third-generation Korean living in Japan. Tori's style is that of the mid-sixth century in China. His work proved how tenaciously the formula for a "correct" representation of the icon had been maintained since the introduction of Buddhism almost a century earlier. Yet, at the same time, a new

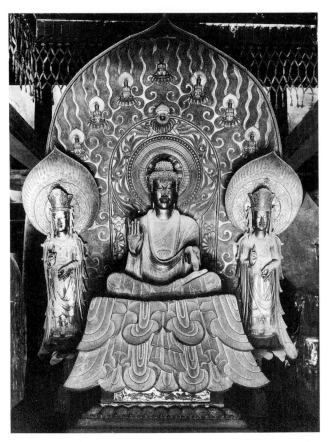

13-3 Tori Busshi, *The Shaka Triad,* Asuka period, 623. Bronze, 69½" high. Hōryū-ji, Nara, Japan.

influence was coming from Sui China, which may be seen in the cylindrical form and flowing draperies of the wood sculpture known as the *Kudara Kannon* (Chinese: *Kuan-yin*). The two styles were blended, and, in the middle of the seventh century, they coalesced in one of Japan's finest sculptures, the *Miroku* (Sanskrit: *Maitreya*) of the Chugu-ji (the suffix *-ji* means "temple") nunnery near Nara (FIG. **13-4**). In this figure, the Japanese artist combines a gentle sweetness with formal restraint in a manner unknown in Chinese sculpture.

Within a little more than half a century, however, all the archaisms of the fused style (loosely called Suiko, after the empress who reigned from 593 to 628, or Asuka, after the site of the capital) were swept aside by a new influence from T'ang China. The T'ang style, which found its way to Japan at the end of the Hakuho period (645–710), dominated Japanese art during the following periods of late Nara (710–794) and Early Heian (794–897). Chinese models were followed not only in sculpture and painting but also in architecture, literature, and even etiquette.

The mature T'ang style appeared suddenly in Japan in the bronze *Shrine of Lady Tachibana* (FIG. **13-5**). The shrine consists of three full-round figures: the

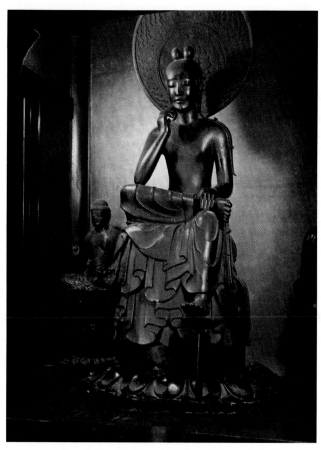

13-4 *Miroku*, Asuka period, mid-seventh century. Wood, 62″ high. Chugu-ji nunnery, Hōryū-ji, Nara.

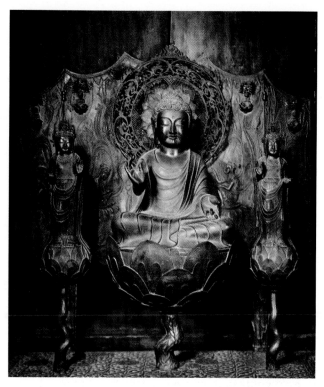

13-5 *The Amida Triad*, from the *Shrine of Lady Tachibana*, Nara period, early eighth century. Gilded bronze; Amida, 11″ high, attendants, 10″ high. Hōryū-ji, Nara.

13-6 *Tamamushi Shrine*, Hōryū-ji, Nara, Asuka period, seventh century. Lacquer on wood, 7′ 8″ high. Hōryū-ji Museum.

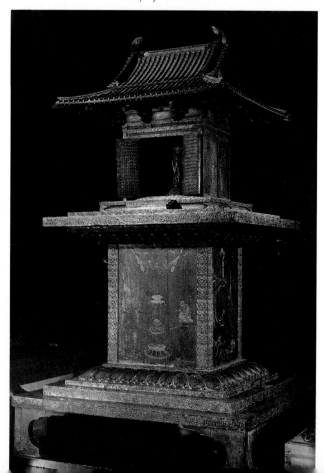

Buddha Amida (Sanskrit: Amitabha) seated on a lotus between the smaller figures of Kannon and Dai Seishi (Bodhisattva attendants), each standing on a lotus. All three are rising from a platform that represents the stylized waters of the Sukhavati lake in the paradise of the Buddha. Behind them is a threefold screen on which are modeled, in relief, the graceful forms of *apsaras* (heavenly nymphs) seated on lotuses and the tiny figures of souls newly borne into heaven. The upswept scarves of the apsaras and the petals, tendrils, and pads of the lotuses create an exquisite background for the three divinities, while a detached, openwork halo of delicate design frames the head of the Buddha. The ensemble gives us some idea of the glorious T'ang bronzes that were melted down in China during the Buddhist persecutions of 845. It also clearly demonstrates the remarkable adaptability of the Japanese artist in seizing a new art form and making it his own.

The development of painting in Japan paralleled that of Buddhist sculpture. Some of the earliest surviving examples are found on the *Tamamushi* (beetle-wing) *Shrine* (FIG. 13-6), which dates from the first half of the seventh century. The shrine is in the form of a miniature temple on a high wooden base, which

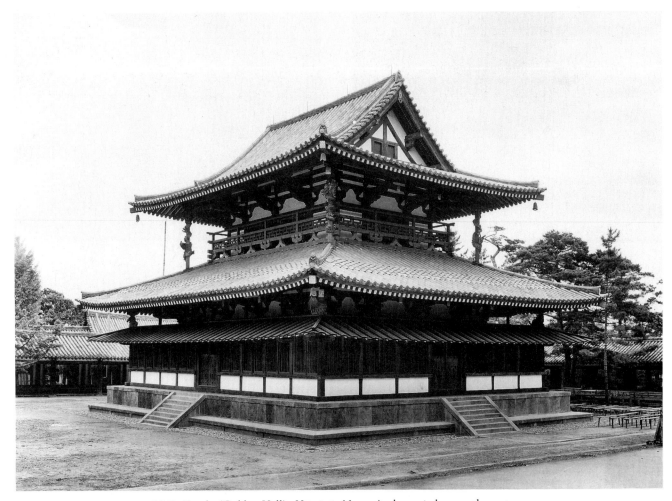

13-7 Kondo (Golden Hall), Hōryū-ji, Nara. Asuka period, seventh century.

was decorated with the iridescent wings of beetles. The four side panels of the base are painted with scenes from the *Jataka* in the style of the Chinese Tun-huang caves of a century earlier, as may be seen in the cell-like composition, the crystalline rock formations, the attenuated figures, and the free linear movement. The shrine paintings also manifest the same delight in surface pattern to the point of disregard of naturalism in scale and spatial relationships.

The Japanese dependence on China during the seventh and eighth centuries is not confined to sculpture and painting. Buddhist architecture adhered so closely to Chinese models that the lost T'ang style can be reconstructed from such temple complexes as the Hōryū-ji or the Todai-ji, which still stand in Japan. The Kondo (Golden Hall) of the Hōryū-ji (FIG. 13-7), which dates from shortly after 670, is one of the oldest wooden buildings in the world. Although periodically repaired and somewhat altered (the covered porch was added in the eighth century; the upper railing, in the seventeenth), the structure retains the light and buoyant quality characteristic of the style of

the Northern and Southern dynasties in China. A rather unusual feature of this building is the entasis of its wooden columns. The appearance of this feature here is said to be due to Greek influence, as third-hand knowledge of it may have reached Japan, along with Buddhism, from India by way of China. Although seemingly more appropriate to elastic wood than to brittle stone, entasis was a short-lived feature that soon disappeared again from Japanese architecture.

EARLY HEIAN AND LATE HEIAN (FUJIWARA) PERIODS

A new style of representation arrived in Japan at the beginning of the ninth century. Under the influence of Esoteric Buddhism (pages 459–60), a heavier image with multiple arms and heads was introduced—a type that, in China, was then replacing the earlier, classic grace of the T'ang style. The bloated forms of the new style, though they may be repellent, have

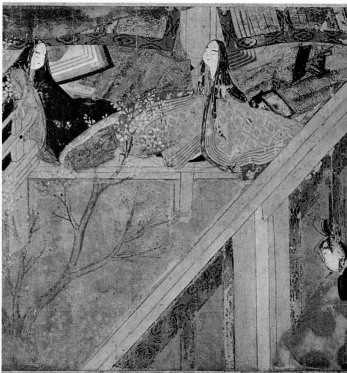

13-8 TAKAYOSHI(?), detail illustrating *The Tale of Genji*, Late Heian (Fujiwara) period, twelfth century. Scroll, color on paper, $8\frac{1}{2}'' \times 15\frac{3}{4}''$. Tokugawa Museum, Nagoya, Japan.

the merit of somber dignity. In paintings, these bulky figures, often cut off at the sides, give the effect of a mighty force expanding beyond the pictorial format.

From the middle of the ninth century, relations between Japan and China deteriorated so rapidly that, by the end of that century, almost all intercourse had ceased. No longer able to reflect the fashions of China, the artists of Japan began to create their own forms during the Late Heian, or Fujiwara, period (897–1185). At this time, court practices at Heian-kyo (modern Kyoto) were refined to the point of preciosity. A vivid and detailed picture of the period appears in Lady Murasaki's eleventh-century novel, *The Tale of Genji*, a work of superb subtlety. The picture that emerges is one of a court in which etiquette overwhelmed morality, a society in which poor taste—in such matters as the color of a robe, the paper used in the endless writing of love letters, or the script itself—was considered a cardinal sin.

The essence of this court is reflected in a set of scrolls (illustrating *The Tale of Genji*) formerly attributed to the twelfth-century court artist TAKAYOSHI, but now considered to be an anonymous group effort. Painted in the horizontal-scroll (*makimono*) format, small pictures like the one shown here (FIG. **13-8**) alternate with sections of text. The artists, using a distinctly Japanese technique for representing space, view the scenes from an elevation, remove the ceil-

ings to expose the interiors, and tilt the ground plane sharply toward a high horizon, or one that often is excluded altogether. Thus, the area of representation is expanded in terms of content and abruptly contracted by the resulting diminution of a sense of depth. Flat fields of unshaded color emphasize the painting's two-dimensional character, as do strong diagonal lines, which direct the eye more along the surface than into the picture space. Human figures have the appearance of being constructed of stiff layers of contrasting fabrics, and although they represent specific characters, their features are scarcely differentiated. A formula for such aristocratic faces, which produced a depersonalizing effect, called for a brush stroke for each eye and eyebrow, one for the nose, and a final stroke (sometimes omitted) for the mouth. Paintings in this purely Japanese style, known as *Yamato-e*,* reflect the sophisticated taste of the Fujiwara nobility for whom these works were created.

A different facet of Yamato-e is represented by *The Shigisan Engi* (the *Legends of Mount Shigi*), painted at the end of the Fujiwara period. One of the first Japanese scrolls designed as a continuous composition, *The Shigisan Engi* illustrates the story of a Buddhist

*Yamato is the area around Kyoto and Nara regarded as the cradle of Japanese culture. The suffix *-e* means "picture."

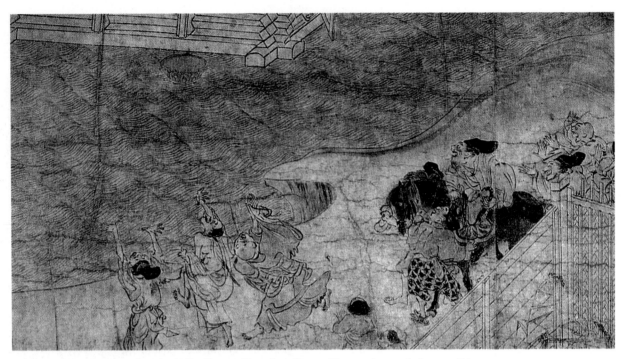

13-9 Detail of *The Shigisan Engi*, Late Heian (Fujiwara) period, late twelfth century. Horizontal scroll, ink and color on paper, 12½" high. Chogosonshi-ji, Nara.

monk and his miraculous golden bowl. Our episode, called *The Flying Storehouse* (FIG. **13-9**), depicts the bowl lifting the rice-filled storehouse of a greedy landowner and carrying it off to the monk's hut in the mountains of Wakayama. The gaping landowner, his attendants, and several onlookers are shown in various poses—some grimacing, others gesticulating wildly and scurrying about in frantic astonishment. The Fujiwara aristocracy felt that only the crude and ill-bred would display such feelings and that they were therefore appropriate subjects for humorous

caricature. The faces—so unlike the generalized masks in the *Genji* scrolls—are drawn with each feature exaggerated, conforming to a convention of the period to distinguish the lower classes from the nobility. Cartooning of this kind became an important element in Japanese pictorial art.

From the same general period (but of disputed date) are four horizontal scrolls of animal caricatures, which are more typical of Chinese Zen painting than of the refined style of Yamato-e. Painted in ink monochrome with a free calligraphic brush, one of these

13-10 Formerly attributed to TOBA SOJO, animal caricatures, Late Heian (Fujiwara) period, c. late twelfth century. Detail of a horizontal scroll, ink on paper, approx. 12" high. Kozan-ji, near Kyoto, Japan.

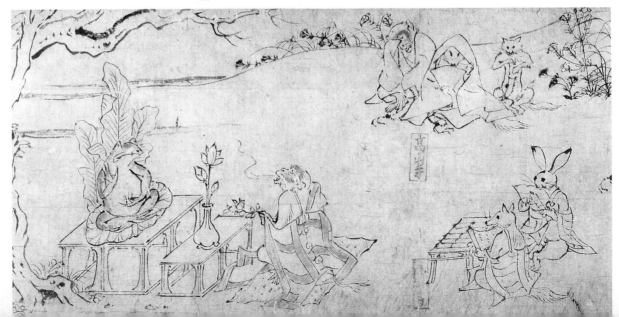

scrolls, previously attributed to the Buddhist Abbot Toba (TOBA SOJO), depicts a medley of frogs, monkeys, and hares in a hilarious burlesque of Buddhist practices. In one section (FIG. **13-10**), a monkey dressed as a priest pays homage to a Buddha in the shape of a frog seated pompously on a lotus throne with a nimbus of luxuriant banana leaves. In another, more animated passage, the animals tumble and frolic while washing each other in a river. Throughout this whimsical satire, the Japanese predilection for decoration asserts itself in charming clumps of foliage that play a delicate counterpoint to the vigorous movement of the animals.

A more conservative style of Buddhist art continued through the Late Heian period, but a new subject was added. This subject, known as *raigo*, portrayed the Buddha Amida descending through clouds amid a host of Bodhisattvas, welcoming deceased believers to his paradise. Such paintings, products of the Paradise Sects (page 456), eased the rigors of religion for the luxurious courtiers in Kyoto. A remarkable sculptural rendering of the raigo theme is housed at the Hoodo (Phoenix Hall) of the Byodo-in Temple at Uji, near Kyoto (FIG. **13-11**). The gilded wooden figure of *Amida* (FIG. 13-11) by the sculptor JOCHO (d. 1057) embodies a serene grace through the expanding curves of face and torso, stabilized into a triangular composition by the elongated legs below. The smaller

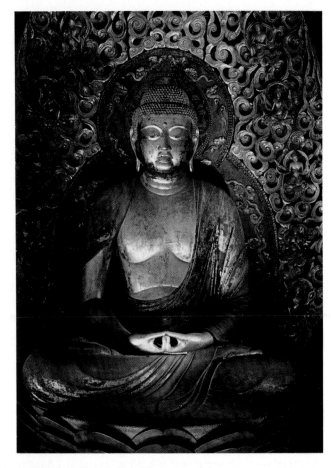

13-11 *Below:* Hoodo (Phoenix Hall), Byodo-in Temple at Uji, Japan, Heian period, eleventh century. *Above:* JOCHO, *Amida* (from the interior of the Hoodo), 1053; gilded wood, 9′ 4″ high.

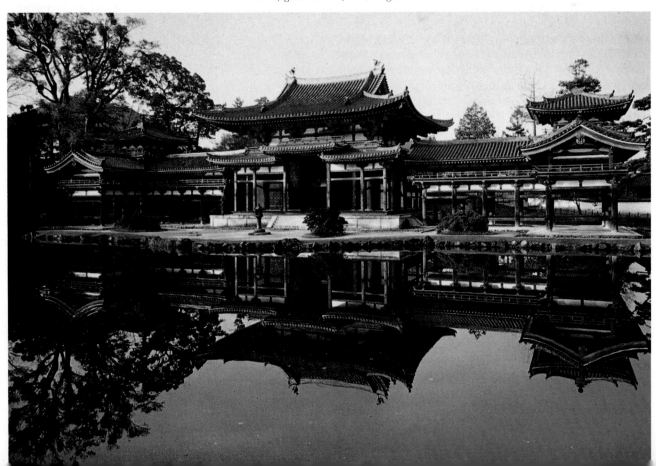

figures of angels and celestial musicians, floating on clouds as they accompany Amida Buddha on his descent, complete the impression of courtly elegance.

The building that shelters the *Amida* originally was a country villa inherited by Fujiwara Yorimichi (992–1074). In ancient Japan, villas could serve as temporary retreats from the pressures and turbulence of city life, but they often also were converted to temples by their owners and became their places of permanent interment. As explained by J. E. Kidder, Jr., "The transition from the city to the country, from a villa to a temple, from a recreation spot to a grave, from this world to the next, was seen hardly as a break in the pattern of human existence and only one more rite of passage." Yorimichi converted his villa into a monastery in 1053 and settled there in 1068, when he retired from politics.

The Phoenix Hall was inspired by aristocratic Chinese palace pavilions but was Japanized through greater integration with its natural surroundings. It is named after the two bronze phoenixes that decorate the ridgepole ends. The phoenix, rising to new life from its own ashes, is a symbol of immortality and thus appropriate for a tomb. Here, this symbolism is not confined to the two rooftop sculptures but seems to permeate the design of the entire building. The plan resembles a great bird in flight, and the swinging, multiple rooflines, with their widely overhanging eaves, suggest its beating wings. Carried by the slenderest of supports, the roofs convey a feeling of floating weightlessness that belies their mass and weight. This impression is enhanced when the building is viewed across the rippling surface of the reflection pond, where its image is put into perpetual motion. We cannot be sure whether this symbolism was intended or not; with or without it, the Phoenix Hall is the most delightful and elegant creation of Chinese-inspired architecture to be found in Japan.

KAMAKURA PERIOD

A series of civil wars led to the downfall of the decadent Fujiwara rulers, and their successful rivals established a new capital at Kamakura, the city that gave its name to the period from 1185 to about 1392. The new rulers, reacting against what they considered to be the effeteness of the Fujiwaras, supported art that emphasized strength and realism. The style of the Nara period (710–794) was revived by UNKEI (d. 1223), perhaps the greatest sculptor of Japan. Unkei and his followers went even further than the earlier realists, carefully reproducing their observations of every accidental variation in the folds of drapery and using crystal for the eyes of their sculp-

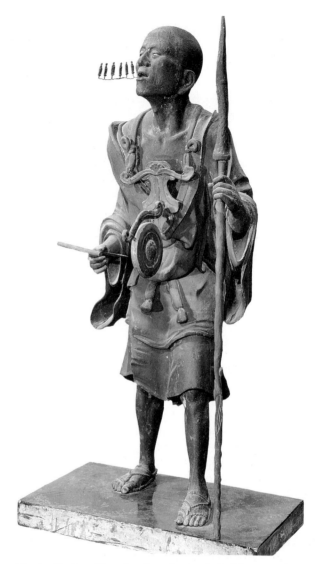

13-12 *The Sage Kuya Invoking the Amida Buddha,* Kamakura period, thirteenth century. Painted wood, approx. 46". Rokuharamitsu-ji, Kyoto.

tures. That they were able, nonetheless, to keep a sensitive balance between the spiritual and the realistic is evident in the superb representation of Kuya (FIG. **13-12**), a priest who is shown as he walked about invoking the name of Amida Buddha. Not only is every detail meticulously rendered, but six small Buddha images issue from the sage's mouth, representing the syllables of a prayer in which Amida's name is evoked. Realism here is carried to the point at which the sculptor is attempting to invest his figures with speech.

Painting during the Kamakura period is most interesting for the advances made in the Yamato-e style, although all types of Fujiwara art also were continued. Perhaps the greatest Yamato-e of this time is *The Burning of the Sanjo Palace* (FIG. **13-13**), one of a series of horizontal scrolls illustrating tales of the Heiji In-

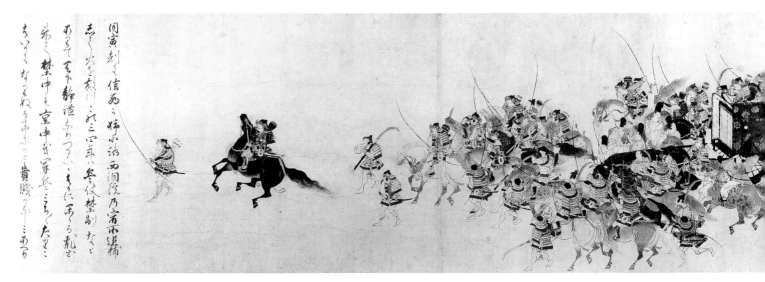

13-13 *The Burning of the Sanjo Palace,* Kamakura period, thirteenth century. Detail of a horizontal scroll, ink and color on paper, 1′ 4¼″ × 22′ 10″. Fenollosa-Weld Collection, Museum of Fine Arts, Boston.

surrection (*Heiji Monogatari*). Here, the artist, perfecting the symphonic composition of the Chinese landscape scroll, has added drama with swift and violent staccato brushwork and vivid flashes of color. At the beginning of the scroll (read from right to left), the eye is caught by a mass of figures rushing toward a blazing building—the crescendo of the painting—and is then led at a decelerated pace through swarms of soldiers, horses, and bullock carts. Finally, the viewer's gaze is arrested by a warrior on a rearing horse (FIG. 13-13), but the horse and rider are positioned to serve as a deceptive cadence (false ending). They are merely a prelude to the single figure of an archer, who picks up and completes the mass movement of the soldiers and so draws the turbulent narrative to a quiet close.

ASHIKAGA PERIOD

The power of the Kamakura rulers ceased in 1333, after which internal warfare persisted until 1392, when the Ashikaga shoguns (military dictators) imposed a brief peace. Civil war soon broke out again, although the shoguns managed to maintain control amid almost continuous insurrections, and lasted until 1573. A central government was formed, and, after centuries of suspension of diplomatic contact, official relations with China were once again established. The arts, under increased Chinese influence, flourished. New painting styles imported from China coexisted with conventional Buddhist pictures and with paintings in the Yamato-e style carried on by artists of the Tosa family. The monochrome landscape style of the thirteenth-century Sung masters

Ma Yuan and Hsia Kuei was adopted by the painter-monk SHUBUN at the beginning of the fifteenth century. Shubun created evocative, idealized landscapes, sometimes with subjects and associated poems based on Chinese themes, which reflect the deep involvement of Japanese monasteries with Chinese culture during this period. MINCHO (1352–1431), also known as CHO DENSU, and other painters went directly to Yüan dynasty models. But the most powerful current to come from China was the one that accompanied Zen Buddhism and that accounts largely for the flowering of art despite the troubled times of the Ashikaga period. The new philosophy appealed to the *samurai,* a caste of professional warriors composed of men who held a relatively high position in society and who were supporters of the feudal nobility. They lived by rigid standards that placed high values on such virtues as loyalty, courage, and self-control. The self-reliance required of its adherents made Zen the ideal religion for the samurai.

Because the samurai found Zen attractive, the arts that had been associated with it in China swept Japan. Sculpture, as in China under the influence of Ch'an Buddhism, declined in importance, and painting imitated the bold brush of the Sung masters of the Ch'an school. Early in the Ashikaga period, the artist KAO (d. 1345) worked in the style of the thirteenth-century Chinese artist Liang K'ai, while his contemporary, MOKUAN (active *c.* 1323–1345), painted almost indistinguishably from a Chinese predecessor, Mu-ch'i. Of all the Zen artists in Japan at this time, SESSHU (1420–1506) is the most celebrated. He had several different styles but is best known for paintings in the Ma-Hsia manner (page 464). Sesshu greatly admired Sung painting, and, although he

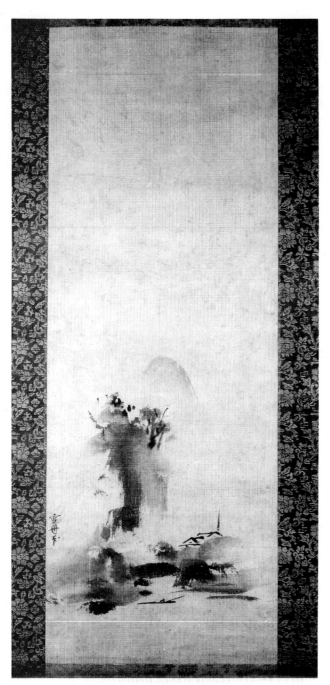

13-14 SESSHU, *Landscape*, Ashikaga period, 1495. Detail of a hanging scroll, ink on paper, approx. 55″ high. Tokyo National Museum.

studied in China, he decried the work of contemporary Ming painters. Nevertheless, he was affected by the Ming style; one of his masterpieces, an ink-splash landscape in the National Museum in Tokyo (FIG. 13-14), contains elements basic to the Ming as well as to the Sung style. Although the landscape recalls the wet style characteristic of Ch'an painters of the Sung, the brushwork is more abstract and the tonal contrasts are more startling, after the Ming manner.

The Tea Ceremony

The influence of Zen went considerably beyond painting. It gave rise, during the Ashikaga period, to the *tea ceremony*, a unique custom that, among other things, provided a new outlet for the products of the Japanese artist-craftsman. This ceremony soon became a major social institution of the aristocracy in Japan. Its function and purpose are described by Father João Rodrigues (1562–1633), a Portuguese Jesuit who spent more than thirty years in Japan and who was a keen observer of Japanese customs and culture. Everything used in the tea ceremony, he reports, "is as rustic, rough, completely unrefined, and simple as nature made it, after the style of a solitary and rustic hermitage." The purpose of the ceremony was "to produce courtesy, politeness, modesty, moderation, calmness, peace of body and soul, without pride or arrogance, fleeing from all ostentation, pomp, external grandeur and magnificence."

The setting for the tea ceremony was appropriately unpretentious. Special, small teahouses, designed to give the appearance of refined simplicity, were placed into carefully planned and subtly arranged garden settings. The Shokintei (Pavilion of the Pine Lute, named after the sound of the wind in the surrounding trees, FIGS. **13-15** to **13-17**) in the gardens of the Katsura Palace, dating from the early Tokugawa period, is a charming example. Its exterior was planned carefully to blend with the calculated casualness of the gardens (FIG. 13-15). A flagstone path leads past moss-covered stone lanterns to an entrance where the guests washed their hands at a "natural" spring. In a rectangular room, scaled to create a feeling of intimacy and adorned only with a shallow alcove (*tokonoma*) in which a single painting and perhaps, a stylized flower arrangement might be displayed, the host would entertain his guests. The ritual of tea drinking in this setting imposed a set of mannered gestures and even certain topics of conversation on all participants. Every effort was made to prevent any jarring note that might disturb the perfectly planned occasion.

Although often emulated in modern times, originally no two teahouses were alike. According to an old teamaster, "beauty is lost through imitation," and originality was as important an aspect of the design as the perfection of its execution. Visual surprises were appreciated highly; for instance, the bold pattern of blue and white rectangles with which the tokonoma in our example (FIG. 13-16) is papered is an unusual and rather daring departure from the usually neutral and, at best, lightly textured treatment of these alcoves. Important also were the subtlety and finesse with which the building components were

13-15 The Shokintei, Katsura Palace gardens, near Kyoto, early 1660s.

13-16 The first room of the Shokintei, Katsura Palace.

13-17 Pond and garden as seen from the second room of the Shokintei, Katsura Palace.

treated. Supporting posts were fashioned to keep their natural appearance, and they often remained rounded and knotty like tree trunks. All surfaces were painstakingly rubbed and burnished to bring out the natural beauty of their grains and textures. Common to all teahouses, and expressive of the Japanese love of nature, was the close integration of the building with its natural setting; when their translucent, paper-covered, sliding screens (*shoji*) are opened, the rooms become no more than roofed-over extensions of the garden (FIG. 13-17).

Although inspired and developed by Zen monks and subsequently adopted by the high and low aristocracy, the ritual of the tea ceremony, with its refined standards of taste, had a lasting influence on the style of living of the people at large. The studied simplicity, austerity, and understatement of the fifteenth-century teahouse were monumentalized in the Katsura Palace (see pages 490–91) and, from there, filtered down into domestic architecture to become what is now regarded as the traditional Japanese dwelling.

13-18 Tea-ceremony water jar, named *kogan* (ancient stream bank), Momoyama period, late sixteenth century. *Shino* ware with underglaze design, 7″ high. Hatakeyama Memorial Museum, Tokyo.

The esthetics of the tea ceremony were found in the beauty of the commonplace, and each object employed in the ceremony was selected with the utmost discrimination. The connoisseur preferred a tea bowl, a flower container, or other ritual utensil that appeared to have been made without artifice. Potteries used in the ceremony (FIG. **13-18**) were covered with heavy glazes, seemingly applied in a casual manner, belying the skill that had controlled the colors and textures. The irregular, sometimes battered or flawed shapes of many Japanese tea wares provide an extreme contrast to the technical perfection common in Chinese ceramics (FIG. 12-26). Many Japanese wares of this type were given individual names based on literary or historical associations of their decor or on the visual and tactile qualities of the entire piece. Conferring such attention on an individual object and attaching such importance to it at this stage foreshadows the advent of major ceramic artists, who would sign, paint, and even inscribe poems on their wares as part of the development of this craft into a self-conscious and sophisticated art.

The Tosa and Kano Schools

The artistic understatement of the tea ceremony was counterbalanced by the continuing Yamato-e style of decorative painting. TOSA MITSUNOBU (1434–

1525), the foremost exponent of Yamato-e during the Ashikaga period, retained the coloristic patterns of his native style but also emphasized ink outline after the fashion of Chinese painting. The new manner of painting that resulted from this combination is most apparent in pictures of the Kano school. KANO MOTONOBU (1476–1559), who was most likely the grandson of the founder of the Kano school, worked so closely in the Sung tradition that some of his paintings have been mistaken for those of Hsia Kuei (page 464). Motonobu had, however, a more personal style, in which we find a new emphasis on brushed outlines and strong tonal contrasts—features that became distinctive of the Kano school. In addition, Motonobu often used Tosa coloring and, at times, even painted in a purely Tosa manner. As a result, the Tosa and Kano schools became less distinguishable after the sixteenth century.

MOMOYAMA AND EDO (TOKUGAWA) PERIODS

In the Momoyama period (1573–1615), which followed the stormy Ashikaga, a succession of three dictators finally imposed peace on the Japanese people. Huge palaces were erected—partly as symbols of power, partly as fortresses. The grand scale of the period is typified by the Nagoya Castle, built about 1610. This castle also exemplifies how well the new style of decorative painting suited the tastes of the Momoyama nobility. The sliding doors and large screens within the mammoth structure were covered with gold leaf, on which were painted a wide range of romantic and historical subjects, even exotic portrayals of Dutch and Portuguese traders. Traditional Chinese themes were frequent, as were commonplace subjects of everyday experience. But all were transformed by an emphasis on two-dimensional design and striking color patterns (FIG. **13-19**). The anecdotal or philosophical content almost was lost in a grandiose decorative display.

Not every Momoyama artist worked exclusively in the colorful style exemplified by the Nagoya paintings. HASEGAWA TOHAKU (1539–1610), for instance, carried on the Zen manner of Mu-ch'i with brilliant success. His versatility, which was shared by most artists of the time, is evident in a brilliant, monochromatic screen painting, *Pine Trees* (FIG. **13-20**), whose strong verticals and diagonals are distinctively Japanese. In Japan, the decoration of screens was very highly developed and often exemplifies the highest quality of painting.

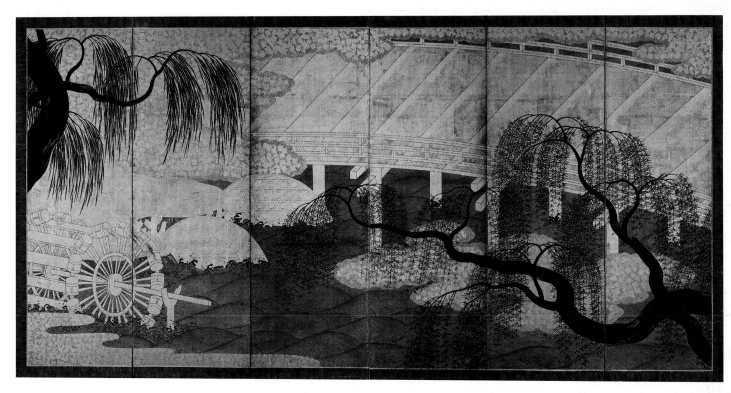

13-19 *Uji Bridge*, Momoyama period, sixteenth to seventeenth centuries.
Six-fold screen, color on paper, 62″ high.
Tokyo National Museum.

13-20 HASEGAWA TOHAKU, *Pine Trees*, Momoyama period, sixteenth to
seventeenth centuries. Six-fold screen, ink on paper,
61″ high. Tokyo National Museum.

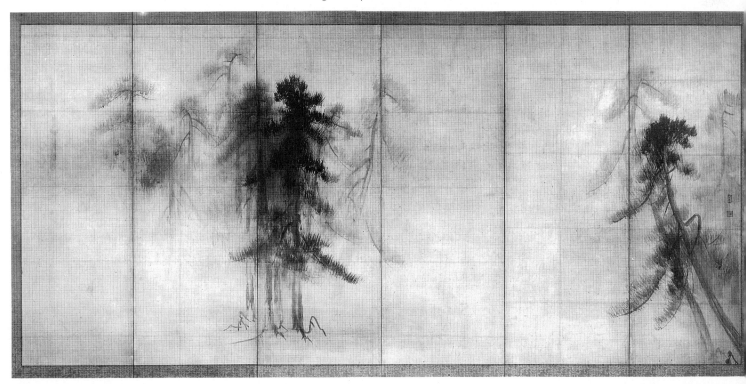

The Katsura Palace

In 1615, Tokugawa Ieyasu, the last of the Momo-yama rulers, consolidated his power as shogun of Edo (modern Tokyo) and established the Tokugawa, or Edo, shogunate, which lasted until 1868. By this time, the emperors had lost their political power and independence and, under a succession of military dictators, had become little more than ceremonial figureheads. Still, in the hope of legitimizing their authority, the shoguns supported the traditional imperial institutions, and Ieyasu, in a magnanimous gesture, donated some land at Katsura (which was at that time a suburb of Kyoto) to members of the imperial family. There, over a period of some fifty years, successive generations of the Hachijo family developed a modest country retreat (*besso*) into a country palace that became the admired, but rarely equaled, standard for domestic Japanese architecture down to modern times.

The Katsura Palace (*c.* 1615–1663; FIGS. **13-21** to **13-23**) was built at a time when the tea ceremony was enjoying its greatest popularity, and many of the palace's design features and tasteful subtleties can be traced back to the earlier teahouses (see FIGS. 13-15 to 13-17). The straight rooflines of traditional Japanese architecture go back all the way to the Ise Shrine (FIG. 13-2) and stand in striking contrast to the swinging, curving ridgepoles and eaves of the Buddhist archi-tecture imported from China, which originally served structural functions but by this time were overloaded and had become ostentatious decoration (compare FIGS. 13-7 and 13-11). At Katsura, the architectural forms express their function simply and without disguise, and the subtle adjustment of their pleasing proportions to each other and to the whole has produced a building of astonishing beauty. The main entrance to the palace, the so-called Palanquin Entry (FIG. 13-22), is a marvelously rich and subtle composition of juxtaposed solids and voids, of rectangular shapes of varying sizes and proportions, arranged along vertical, horizontal, and sloping planes. Lines, planes, and volumes are enriched by a variety of textures (stone, wood, tile, plaster) and by subdued colors and tonal values that build up toward and enframe the composition's focal point—the sliding panels of the doorway.

In the interior (FIG. 13-23), lacquered posts and wooden trim surround painted panels and screens to create settings more sumptuous than those of the teahouse, but just as refined and delicate. Everything is done with the utmost restraint. The rooms are not large by Western standards, but the screens between them can be slid apart, or removed completely, to create sweeping areas of rectangular spaces that also can be opened to the outside to achieve that harmonious integration of building and garden that we have seen, on a smaller scale, in the teahouse (FIG. 13-17).

13-21 Eastern façade of the Katsura Palace, c. 1615–1663.

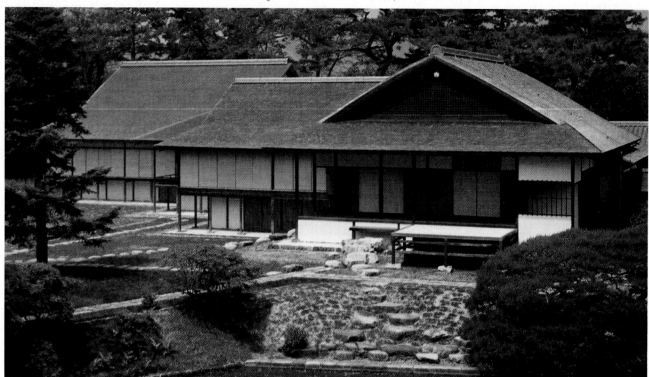

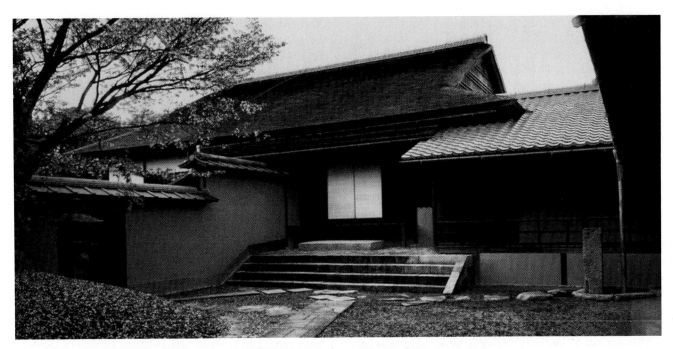

13-22 Palanquin Entry, Katsura Palace.

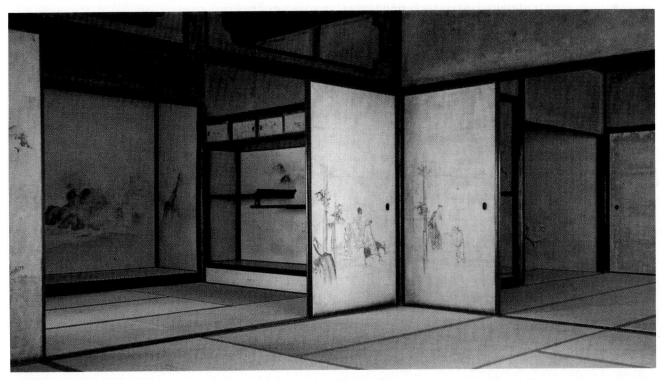

13-23 Interior, Katsura Palace.

Gardens

In Japanese garden design, as in architecture, man-made and natural elements are combined to create a sense of balance, proportion, and harmony. Japanese gardens are intended to be retreats in which one can enjoy peaceful seclusion and meditation. They create ''landscape pictures'' in which waterfalls, streams, lakes, bridges, and teahouses are artfully combined with stones, trees, and shrubs to simulate, in a restricted area, vistas of much larger landscapes. The Katsura gardens skillfully exploit the element of surprise. Long walkways suddenly are blocked by a wall

of shrubbery that forces the visitor to turn in the direction of a designed view, such as a single shaped tree dramatically silhouetted against the glittering surface of a pond. Guests are led along carefully designed paths that present charming views of garden and landscape elements at planned intervals. The stepping stones along these paths are small and irregularly spaced, so that visitors must keep their eyes down in order not to stumble. Here and there, larger stones invite a rest and allow guests to lift their heads safely to view their surroundings and appreciate the designed prospect offered to their eyes.

The Katsura gardens cover several acres and are meant to be walked through. The Zen rock gardens, which originated in the thirteenth century, are much smaller and were intended to be viewed from a fixed position. The rock gardens consist of stone groupings in dry landscapes that are symbolic and suggestive of large landscape features. Level ground covered with raked sand or pebbles represents rivers, lakes, or oceans. Scattered over this surface and framing it are rocks, carefully placed singly or in groups: the vertical ones represent islands, cliffs, and mountain ranges; the horizontal ones denote embankments, bridges, and ships. Peninsulas and islands, carved out by the ocean, or a coastline with mountain ranges may be symbolized. The ensemble is intended to induce and facilitate intense meditation, to encourage the spirit to take off in free flight and transform the limited sphere of a tiny plot of soil into a cosmic universe without man-made boundaries.

Decorative Painting

Screen painting during the Tokugawa period was continued in all of its Momoyama magnificence by such artists as KANO SANRAKU (1561–1635), HON-AMI KOETSU (1558–1637), and TAWARAYA SOTATSU (1576–1643), whose lives spanned both periods. Koetsu and Sotatsu also composed numerous scrolls on which pictorial forms of flowers or animals were interlaced with strokes of a free-flowing calligraphy. One such collaborative effort is a deer scroll (FIG. **13-24**), in which the shapes of the animals, painted in decorative gold and silver, are repeated with subtle variations in pose and interval to create an almost musical effect.

OGATA KORIN (1658–1716) and his brother OGATA KENZAN (1663–1743) carried the decorative tradition that characterized the Momoyama on into the eighteenth century. Korin was primarily a decorative painter, who also worked as a lacquer designer; Kenzan was a master potter, whose line of "natural" wares is still produced today by the ninth artist to take his name. Korin is famous largely for his dramatic renderings of rocks, tree branches, and waves, which he combined in elegant and flowing compositions (FIG. **13-25**). Both artists harmonized the decorative styles of Momoyama and Early Edo with the studied simplicity required of art in the service of the tea ceremony.

Nanga and Realism

Although the decorative style of the Sotatsu-Korin schools continued to flourish until the nineteenth century, it had to share its popularity with several other trends in later Japanese painting. One, Nanga, "southern school painting," was inspired by the Chinese "literary" school painting of Su Shih and Mi Fu (pages 463–64). The Nanga painters transformed the techniques of their Chinese models into a style that combined virtuoso brushwork with decorative pattern and a strong sense of humor. Two outstanding

13-24 TAWARAYA SOTATSU and HON-AMI KOETSU, *Deer and Calligraphy*, Tokugawa period, early seventeenth century. Section of a horizontal scroll, ink and gold and silver on paper, 12½" high. Seattle Art Museum (gift of Mrs. Donald E. Frederick).

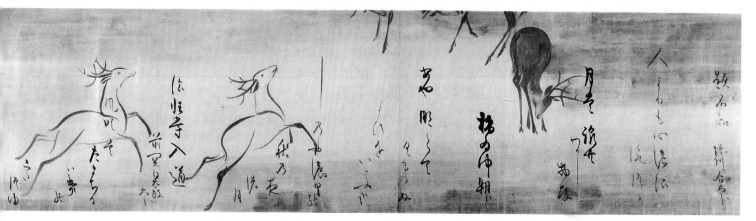

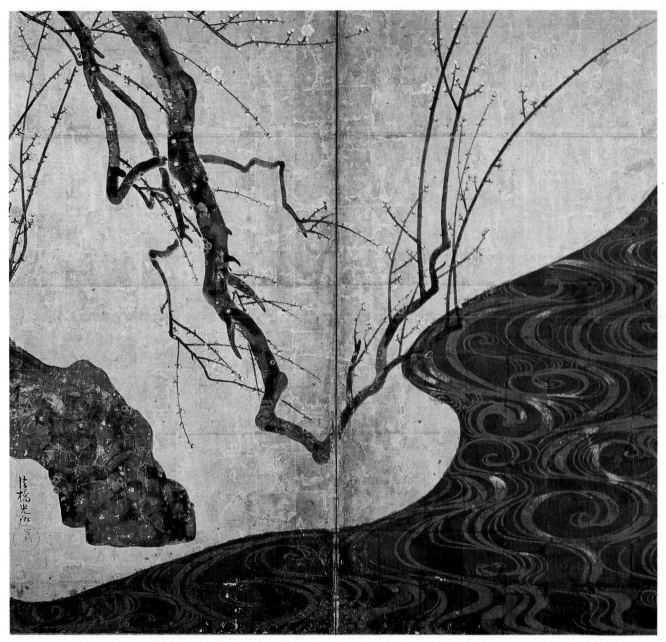

13-25 OGATA KORIN, *White Plum Blossoms in the Spring*, Tokugawa period, late seventeenth to early eighteenth centuries. Screen, color on gold paper, 62″ high. Tokyo National Museum.

early representatives of this style are IKENO TAIGA (1723–1776) and YOSA BUSON (1716–1783), who jointly illustrated an album entitled *The Ten Conveniences and the Ten Enjoyments of Country Life*. On one of the pages illustrated by Buson (FIG. **13-26**), a bulbous-nosed figure peering from a hut at richly textured summer foliage is shown with wistful humor by this master of the brush.

Another major style of later Japanese painting, which has been called realistic or naturalistic, is represented by MARUYAMA OKYO (1733–1795). His stud-

ies of animals, insects, and plants (FIG. **13-27**) combine an almost Western objectivity with an unusual handling of the brush to produce a style that follows the observed forms rather than established conventions. This kind of realism may well be due, in part, to Western influence. From the mid-sixteenth century on, Portuguese and Spanish missionaries and Dutch traders visited Japan, bringing with them paintings and illustrated books that, despite the efforts of the Tokugawa shoguns to bar foreign influences, had some effect on Japanese art.

13-26 Yosa Buson, *Enjoyment of Summer Scenery,* from *The Ten Conveniences and the Ten Enjoyments of Country Life,* Tokugawa period, 1771. Album leaves, ink and color on paper, 7″ high. Yasunari Kawabata Collection, Kanagawa, Japan.

13-27 Maruyama Okyo, detail of *Nature Studies,* Tokugawa period, eighteenth century. Horizontal scroll, ink and color on paper, 12½″ high. Nishimura Collection, Kyoto.

Ukiyo-e and Printmaking

The Tokugawa shoguns maintained a static and stratified society, and, as a result, each class developed its own distinctive culture. The center of the plebeian culture was the Yoshiwara entertainment area of Edo, where the popular idols were the talented courtesans of the teahouses and the actors of the Kabuki theater. Kabuki itself was a popular and lusty form of drama that developed in response to a demand for a more intelligible and more easily enjoyed theater than that of the highly stylized Nō plays, which were patronized exclusively by the nobility and a small number of the nouveau riche. Kabuki eventually provided endless subjects for a new art form—a style of genre painting (see FIG. 21-74) instituted in about 1600—that was to have considerable influence on Western art in the nineteenth century. This new art, known as *ukiyo-e*, or "pictures of the floating (or passing) world," was centered largely in Kyoto. Toward the end of the seventeenth century, the center of production shifted to Edo and the predominant medium soon became the woodblock print, which reflected the tastes and pleasures of a bourgeoisie emerging in a feudal society.

The woodblock as a device for printing had been invented in China during the T'ang dynasty. The technique was introduced in Japan during the eighth century, when it was employed chiefly to reproduce inexpensive religious souvenirs or charms. In the seventeenth century, Chinese woodblock book illustrations inspired the production of low-cost illustrated guidebooks of the Yoshiwara district.

The art of block printing, as it ultimately developed in the eighteenth century, was a triumph of collaboration. The artist, having been selected and commissioned by a publisher, prepared his design in ink, merely adding color notations. A specialist in woodcutting then transferred the lines to the blocks, and a third man did the printing. The quality of the finished picture depended as much on the often anonymous cutter and printer as on the painter of the original design.

HISHIKAWA MORONOBU (c. 1625–1694) was probably the first Japanese artist to employ the woodblock print to illustrate everyday subjects in books and to make and produce individual prints, which he started to do in about 1673. The woodblock quickly evolved as a medium for cheap reproduction and wide distribution. Moronobu's woodblock prints were executed simply in black outline against a plain white paper, as were the prints produced for the next fifty years, but often they were hand-colored by their purchasers. Moronobu's designs of large and simple forms had the exuberance of a young art. The same

13-28 TORII KIYOTADA, an actor of the Ichikawa clan, *c.* 1710–1740. Hand-colored woodcut, 11¼″ × 6″. Metropolitan Museum of Art, New York (Harris Brisbane Dick Fund, 1949).

vitality was expressed in prints of the Torii school by such artists as KIYONOBU I (1664–1729), KIYOMASU I (active 1694–1716), and TORII KIYOTADA (active in the early eighteenth century; FIG. **13-28**). These artists specialized in portraying Kabuki actors. (Kiyonobu I was an actor's son.) They worked with a broad rhythmic outline, and, for emphatic pattern, used the bold textile designs of the actors' robes.

At about the same time, members of the Kaigetsudo family were painting pictures and making designs for woodblock prints of elegant courtesans. The Kaigetsudo figures had more grace but somewhat less power than those of the Torii painters. In general, the print style gradually acquired more delicacy during the eighteenth century. The invention of a process of printing in color directly from blocks brought the "primitive" period of ukiyo-e printmaking to an end by about 1741.

OKUMURA MASANOBU (1686–1764) experimented with what is called lacquer technique in an effort to

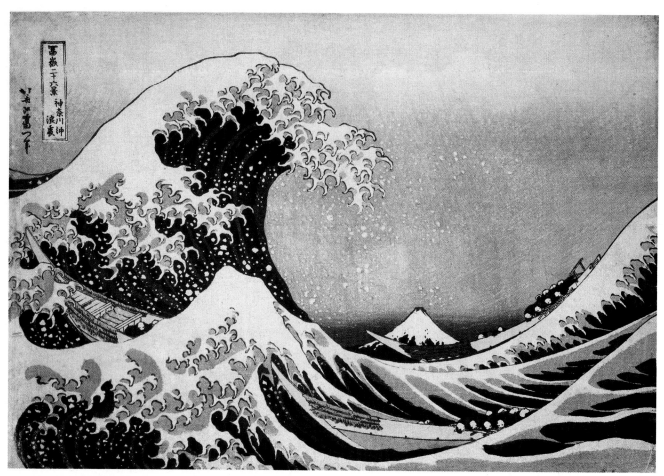

13-29 KATSUSHIKA HOKUSAI, *The Great Wave*, from *Thirty-Six Views of Mt. Fuji*, Tokugawa period, c. 1823–1829. Woodblock print, 14¾" wide. Museum of Fine Arts (Spaulding Collection), Boston.

increase the luster of the ink in his black-and-white prints. Later, he used a new, two-color method for printing in pink and green (*benizuri-e*), in which the dominant pink contrasts with patches of pale green and still smaller areas of black to produce a strong color vibration despite the very limited palette. Coincident with the use of color printing, the artists began to work in smaller, more delicate scale. In 1765, a device was introduced that permitted more accurate register and the successful use of even smaller color areas. This led to the development of the *nishiki-e* or "brocade picture," which was a true polychrome print. The new technique encouraged greater refinement and delicacy, evident in prints by the two leading print masters of the time—the incomparable SUZUKI HARUNOBU (1725–1770) and ISODA KORYUSAI (active 1764–1788). In their work (see FIG. 21-74), a new loveliness replaces the monumentality of earlier compositions. The figures are of slighter proportions, the colors are more muted, and the line is lyric rather than dramatic.

After Harunobu died, prints changed rapidly in style, shape, subject, and color. TORII KIYONAGA

(1752–1815) and KITAGAWA UTAMARO (1753–1806) revived the taste for tall, willowy figures. Utamaro, who later concentrated on half-length figures, was fortunate to have the services of craftsmen who were skilled enough in woodcutting to allow him to create extraordinary nuances in color, texture, and line. BUNCHO (active 1766–1790), working in another vein, made many striking portraits of well-known figures. Even more dramatic are the prints of TOSHUSAI SHARAKU, who, active for a brief ten months during 1794 and 1795, was a unique and enigmatic figure among print artists. About 160 of his prints survive—all of them piercing, rather acid, psychological studies of actors, wrestlers, or managers. UTAGAWA TOYOKUNI I (1769–1825) followed in a similar, less biting manner, but the strength of this style was dissipated in the hands of later artists.

Dozens of other artists contributed to the popular art of printmaking, but, during the nineteenth century, KATSUSHIKA HOKUSAI (1760–1849) and ANDO HIROSHIGE (1797–1858) were outstanding. Increasing political and moral censorship, which was to contribute to the decline of this art, led Hokusai to select

landscapes as his ukiyo-e subjects. His brilliant and ingenious compositions, such as his *Thirty-Six Views of Mt. Fuji* (FIG. **13-29**), make use of striking juxtapositions and bold, linear designs. Nature was his primary subject, but, in its setting, he also included genre and anecdote as minor themes. Hiroshige, too, specialized in landscape and, like Hokusai, painted birds, flowers, and legendary scenes. In general, however, Hiroshige's prints did not evoke the sense of grandeur implicit in Hokusai's work.

These prints, although sometimes influenced by European art, show the Japanese attitude toward nature—the regard for natural forms in their utmost simplicity as a point of departure for an interpretation of reality—which, in turn, will lead to abstract pictorial design.

DOMESTIC ARCHITECTURE

Until recently, the Japanese home—modest or pretentious—has been designed according to basically the same structural and esthetic principles that apply to the teahouse or the Katsura Palace. The traditional Japanese dwelling almost invariably is related intimately to the land around it, and, wherever possible, it is set in a garden closed off by a bamboo fence (a thing of beauty in itself), providing a sense of privacy and intimacy in even the most crowded environment.

The structure is essentially a series of posts supporting a roof. The walls, which are screens rather than supports, slide open from one room into the next or onto the outside. Space is treated as continuous yet harmoniously divisible—a concept that revolutionized architectural theory in the West. Uniformity and harmony of proportions are achieved by the use of the conventional straw mat (*tatami*) as a module. Its dimensions (3 feet by 6 feet) determine most measurements of both the plan and the elevation of the house, so that many of its structural elements can be prefabricated—another feature highly appreciated by Western architects.

In the traditional Japanese house, no furniture is used, except for some low tables and cushions (bedding is rolled up and kept in closets during the day). The various rooms of the house have no specific functions and can be used for any and all purposes. The main room, in which guests are received (FIG. **13-30**), is identified by the tokonoma, where works of art from the owner's collection are displayed one at a time. Quite unlike Western collectors, who tend to convert their homes into museums by displaying all of their objets d'art together, their Japanese counterparts rotate the works in their collections, showing a single work in the tokonoma to suit season or mood—

13-30 Main room of a traditional Japanese house.

an attitude that conforms with the simplicity and architectural understatement of the traditional Japanese dwelling.

Despite its sophistication and refinement, the traditional Japanese house suffers from the inconvenience that it cannot be heated adequately. Unlike their Korean neighbors, the Japanese never developed an efficient heating system for their homes. The Japanese love of nature has been cited as a partial explanation for this, to us, evident deficiency. Rather than shutting themselves off from nature's manifestations by retreating into hermetically sealed enclosures, the Japanese preferred to experience climatic changes and simply protected themselves against the winter cold with additional layers of clothing. No wonder, perhaps, that the modern Japanese, newly aware of and acquainted with Western standards of living, long to live in a Western-style house.

With the advent of the Meiji period in 1868, Japan has become increasingly exposed to Western influences. The process of adjusting not only its economy, but also its life-style, to Western standards accelerated after the turn of the century, to reach a crescendo after the end of World War II. The pace of Japan's recent development is awesome, not only in its industrial production, which is well known to us, but also in the arts. The Japanese excelled particularly in the fields of architecture and design in recent years and such men as KENZO TANGE and ARATA ISOZAKI now must be ranked among the foremost contemporary architects.

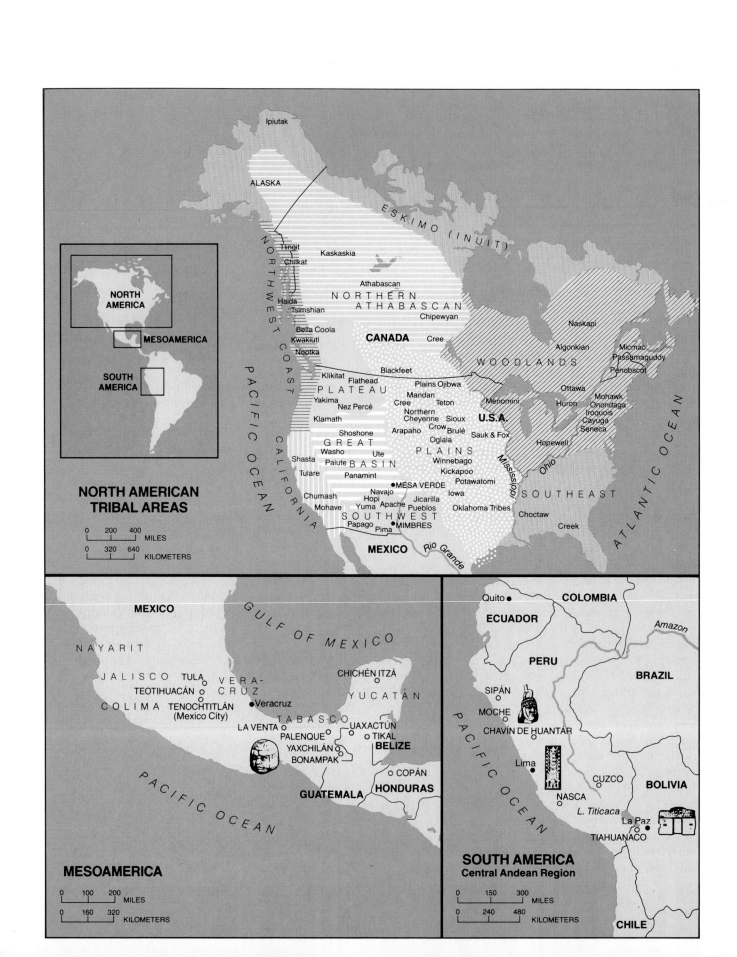

NORTH AMERICAN TRIBAL AREAS

Ipiutak

ALASKA

ESKIMO (INUIT)

NORTHWEST COAST

Tlingit
Chilkat
Kaskaskia
Athabascan

NORTHERN ATHABASCAN

Haida
Tsimshian
Chipewyan

Bella Coola
CANADA
Cree

Kwakiutl
Nootka

Klikitat
Blackfeet
Naskapi
Algonkian
Micmac
Passamaguddy
Penobscot

Flathead
Plains Ojibwa
WOODLANDS

PLATEAU
Yakima
Nez Percé
Mandan
Cree
Teton
Ottawa
Huron
Mohawk
Onondaga
Iroquois
Cayuga
Seneca
Menomini

Klamath
Northern
Cheyenne
Sioux
U.S.A.

Shoshone
Arapaho
Crow
Brulé
Sauk & Fox

GREAT
Oglala
Hopewell

Washo
Ute
PLAINS

Shasta
Paiute
BASIN
Winnebago
Ohio
SOUTHEAST

Tulare
Panamint
Kickapoo

CALIFORNIA
MESA VERDE
Potawatomi

Chumash
Navajo
Iowa

Hopi
Jicarilla

Mohave
Yuma
Apache
Pueblos
Oklahoma Tribes
Choctaw

SOUTHWEST
Papago
Pima
MIMBRES

Creek

MEXICO
Rio Grande

PACIFIC OCEAN
ATLANTIC OCEAN
Mississippi

NORTH AMERICA
MESOAMERICA
SOUTH AMERICA

0 200 400 MILES
0 320 640 KILOMETERS

MESOAMERICA

MEXICO
GULF OF MEXICO

NAYARIT

JALISCO TULA VERA-
TEOTIHUACÁN CRUZ
CHICHÉN ITZÁ
YUCATÁN

COLIMA TENOCHTITLÁN
(Mexico City)
Veracruz
TABASCO

LA VENTA
PALENQUE
YAXCHILÁN
BONAMPAK
UAXACTÚN
TIKAL
BELIZE

COPÁN

GUATEMALA
HONDURAS

PACIFIC OCEAN

0 100 200 MILES
0 160 320 KILOMETERS

SOUTH AMERICA
Central Andean Region

Quito
COLOMBIA

ECUADOR
Amazon

PERU
BRAZIL

SIPÁN
MOCHE
CHAVÍN DE HUANTÁR

Lima
CUZCO
BOLIVIA

NASCA
L. Titicaca
La Paz
TIAHUANACO

PACIFIC OCEAN

CHILE

0 150 300 MILES
0 240 480 KILOMETERS

14

THE NATIVE ARTS
OF THE AMERICAS, AFRICA,
AND THE SOUTH PACIFIC

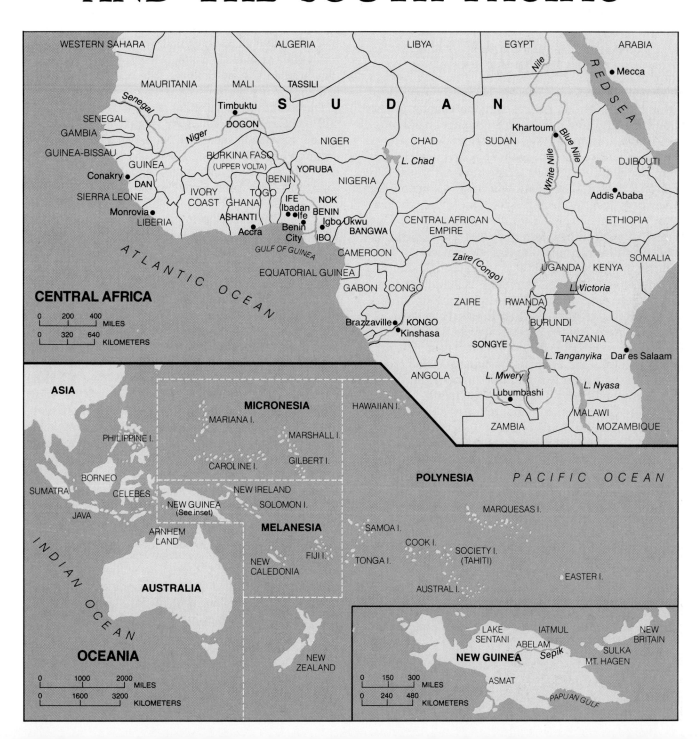

BY "NATIVE ARTS," WE understand those products of skilled craft that originate within an indigenous community, that are intended for its own use, and that are expressive of its own mentality and values. Opposed to native arts are those that are foreign, alien; they originate outside the community and are incomprehensible to it. In this chapter, we describe the arts of native peoples who were conquered and colonized by Europeans between the sixteenth and the twentieth centuries. It will be obvious to readers of this book how different—in principle, antagonistic—the art forms produced by the foreign conquerors and the conquered natives are in function, style, and meaning.

SIGNIFICANCE OF THE NATIVE ARTS

Europeans looked down on the native inhabitants of the New World, Africa, and the islands of the South Pacific; they thought them savage, barbarous, wild, and animallike. At best, they viewed them as childlike and backward, without religion or civilization. In every way, they were supposed inferior to white, Christian Europeans, who seriously believed it their duty to bring true religion and higher civilization to the benighted and unlettered heathen. This sense of mission to inferior peoples lasted well into the twentieth century. It was sloganized as "the white man's burden"; racial as well as religious superiority served as the fundamental assumptions justifying the entire colonial enterprise. In the early nineteenth century, the American historian, William H. Prescott, narrating the exploits of the first Europeans in "New Spain" in his *History of the Conquest of Mexico*, makes Cortés, the Spanish *conquistador*, the hero of the story and the instrument of Divine Providence: "It was beneficially ordered by Providence that the land [of Aztec Mexico] should be delivered over to another race who would rescue it from brutish superstition. . . . The debasing institutions of the Aztec furnish the best apology for their conquest." Two centuries earlier, Prescott's Puritan forebears had briefly and bluntly proclaimed the same religious and racial right, not only to the land they were disputing with the stubborn native tribes, but to the whole world. At a town meeting in Milford, Connecticut, in 1640, the Puritan fathers approved the following resolution: "Voted, that the earth is the Lord's and the fulness thereof; voted, that the earth is given to the saints; voted, that we are the saints."* This conviction

*In R. C. Padden, *The Hummingbird and the Hawk: Conquest and Sovereignty in the Valley of Mexico, 1503–1541* (New York: Harper & Row, 1970), p. 137, n. 4.

doubtless was shared by generations of European colonizers as they suppressed native populations throughout the world.

It is not our aim to summarize the story of Europe's colonial imperialism here in these pages. For our purpose, the important assumption made by the European colonizers was that the natives and all their deeds and works were abjectly *inferior* to their colonial proprietors'. The native arts were thought to be ugly, outlandish toys, baubles, trinkets, fetishes, and idols fit only for travelers' souvenirs; native artworks were viewed as bizarre and grotesque curiosities of interest only to eccentric collectors. If such objects had any value at all, it was due to the precious stones or metals that composed them.

In the twentieth century, particularly in its later half, the status of native arts, if not of native peoples, has been upgraded dramatically. Three historical developments—one political, one scientific, and one esthetic—have promoted this new assessment.

The political development is obvious enough; it is still going on. The erstwhile colonial native peoples largely have won their independence as the colonial empires have dissolved. They have claimed a place and value in world civilization equal to that of their former European masters. The old labels ("savage," "barbarous," "wild") no longer have reference to them, and the label "primitive," which appeared to take the place of these earlier descriptions, is now an unpardonable slur. Yet "primitive" has been the heading under which the native arts have been classified in libraries and museums and grouped in exhibitions to this very day. This designation is in part the result of the second historical development—the scientific one.

In the colonial age, many Europeans did not share the contemptuous hostility toward native peoples typical of the rapacious colonizers. A neutral, even sympathetic, view of the inhabitants of the New World appeared in the work and writings of missionaries such as the Franciscan friars who accompanied the expeditions of Cortés. Missionary tolerance later was to be augmented by scientific curiosity. From the eighteenth century on, interest in the mysteries of human nature, its physical and social constitution, the origin, diffusion and interrelation of the races, and the seemingly infinite variety of religions, customs, and languages, ripened from the speculations of philosophers and the guesswork of explorers into the science of anthropology. The native populations of the colonial world gave anthropologists an ideal opportunity to observe and record scientifically the peculiarities of strange new societies in the undisturbed wholeness of their natural habitats. Early observers thought it possible to generalize the basic

traits of human nature from their elementary forms as seen in the pristine native condition, unobscured by the distorting influences of civilization.

In the process, anthropologists came up with a key concept—*culture*—by which they could classify and organize the observed data. "Culture" was a name for the sum of characteristics by which a given human community could be identified—race, physique, social organization, language, religion, technology, artifacts. The comparison of cultures led to the conclusion that cultures *as* cultures are equivalent in value, that they are not better or worse, but merely different. Scientific objectivity left no room for value judgments, certainly not the "superior" or "inferior" distinctions by which the colonizers had ruled the subjugated native populations.

Yet one distinction remained, not to be challenged until recently. Some cultures are more "advanced" than others—more successful in adapting to the environment, more flexible in responding to outside challenge, more in control of the conditions of life, more adept technologically or linguistically. Being more advanced meant being farther ahead and "later" in a progressive evolution of society; being less advanced meant being at an "earlier" stage. Consciously or unconsciously using European civilization as both the standard and the goal of human achievement, anthropologists classed native cultures as "early," that is to say, "primitive." And "primitive" could not escape a sense of "inferior."

Thus, the work of native hands came to be seen as *artifact*, not yet *art*. The great collections of artifacts made by anthropologists were not exhibited in museums of art, but in museums of "natural history." They were placed among relics of prehuman and prehistoric ages—markers on the path of progress to higher and later forms of existence. And when artifacts finally were acknowledged to be art, the label "primitive art," by which they were classified, still suggested backwardness. The prevailing theory of art as progressive could not fail to associate "backward" with "inferior."

The change in status from artifact to art was the consequence of the third historical development, the esthetic one. This was a profound change of taste, beginning in the late nineteenth century, by which artists, critics, and connoisseurs, along with a small public audience, came to perceive the intrinsic beauty and power of native arts. The story of that revelation and its effect on the rise of modern art is told in the last chapters of this book. In brief, this change of taste led to a full appreciation of the esthetic value of the arts of native peoples and to the acknowledgment of their right to a place in museums of art and in the history of the art of those museums. The arts of native peoples came to be viewed not as artifacts, nor as the primitive stage in the development of museum art, but rather as the coeval, equal, and rival of that art—perhaps its alternative, or perhaps, as some would suggest, its successor.

Stylistic Community of the Native Arts

Like the styles that make up other great areas of the history of art, those of the native arts have certain characteristics in common that allow us to recognize and group them as a stylistic community. These styles bear little resemblance to the art of the other areas, except for certain features that we shall note presently. It was their stylistic uniqueness and community in world art that drew the attention and the admiration of the moderns, leading to the adoption of radically new principles of design that contrasted sharply with Western tradition.

Small-scale works of native art, easily transportable and readily accessible in exhibitions, were the first to suggest a new design. With the exception of the pre-Columbian peoples of North and South America, native cultures rarely produced monumental architecture, sculpture, or painting. The native genius for design generally appeared in relatively small sculpture in stone, wood, metal, bone, and perishable materials of many kinds. Painting was done on a variety of framed and unframed surfaces and in a variety of media, and its ornamental systems were applied in ceramics, weaving, embroidery, basketry, jewelry, costume, and utensils. In this chapter, we are concerned primarily with works of this kind.

A remarkable consistency is maintained throughout the many variations among styles and substyles of native art. Native artists work almost by instinct in what we call *abstract* forms—nonobjective, nonrepresentational, stylized. We also have seen such forms in early Egyptian and Mesopotamian art, in the "idols" of Crete, in Islamic art, in the art of the European migrations, in the Early Romanesque, and in the haniwa art of Japan; we shall see them presently as an enormous influence on modern art. But the art of native peoples, with a few startling exceptions, remains consistently and conservatively abstract. In abstraction, the complex systems of color, light and shade, shape, and contour and surface that are given to the eye in optical perception are drastically simplified into basic, geometrical forms: in sculpture, *volumes*—spheroid, cuboid, conoid, pyramidal; in painting, *planes*—curvilinear, rectilinear, angular. In sculpture, shadow-casting projections are often much reduced, largely eliminating detail, except as it may be incised linearly upon surfaces. In painting, color-tone is laid

on, without value gradations (chiaroscuro), within line-bound shapes, to make flat, hard-edged silhouettes. Colorful patterns on painted surfaces, textiles, pottery, and basketry are composed of motifs ingeniously repeated and expanded. Indeed, the formality of abstract shape and pattern dominates *all* the native arts; it is not, as in other world styles, confined primarily to ornament.

The consistency of style in native art finds its counterpart in the consistency of its modes of signification. Insofar as it signifies by images, native art can be said to be representational, but only to a degree strictly limited by convention (convention which, as we have noticed, largely eliminates detailed report of the optical world). Geometrical simplicity of form is best suited to the rendering of signs, symbols, and images that have unchanging attributes and general meaning, like "divinity," "royalty," and "kinship." In its simplicity of form, native art approaches the abstraction of pictographic and written figuration, although it incorporates much more information from the optical world. This information, altered to fit the meanings the artist wishes to signify, appears in characteristic distortions of the forms of nature. In the representation of the human figure, natural proportions are disregarded: the head may be larger than the torso, the features of the face may be exaggerated, abbreviated, misplaced, or partly eliminated. The face most often has the character of a mask; the body and limbs take on the aspect of a hinged mannikin, the motions of which have been arbitrarily twisted and fixed. In this connection, we must note the importance of the mask and the ceremonial dance in native cultures; both are crucial in the rituals of native religion. The powerfully exaggerated features of the mask are consistent with the patterned, abruptly repeated rhythms of the dance performed by the masked participants.

The consistency of style and signification in native art is reinforced by their conventionality and conservatism; the three characteristics are mutually reinforcing. Native art is overwhelmingly religious, and in religious art, as in religious rite, conventional forms, established from time immemorial, are conservatively retained, with only slight change. Thus, we find little of the *historical* development of style in native art that we have traced in the art of other periods. (The art of ancient Egypt, conservative as it was, moved from an earlier style resembling native art [see FIG. 3-2] to the standard style by which we easily identify it.) In native art, continuity does exist, but almost no traceable change could be called developmental. Great diversity is apparent in the working out of stylistic possibilities, but invention and experimentation remain within the limits imposed by the rules of convention.

The astonishing realism of the African bronzes of Ife and Benin (FIGS. 14-44 and 14-45) seem inexplicable as part of any line of development. The power of convention that restrains innovation and conserves stylistic types is a brake on any developmental motion leading to new languages of form and signification. Within world art, the art of native peoples, in its consistency, conservatism, and conventionality, has preserved a timeless community resistant to the destructive influences of imported change.

THE PRE-COLUMBIAN ART OF THE AMERICAS

Among the native cultures of the world, those that flourished in the Americas before the coming of Columbus are exceptional in several important respects. We have remarked in passing that these New World cultures are distinguished by monumental architecture, sculpture, and painting, as well as the craft arts. In addition, some of these groups, like the Maya, had a highly developed writing system and knowledge of mathematical calculation that made possible the keeping of precise records and the creation of a sophisticated calendar and a highly accurate astronomy. Although they used Stone Age technology, did not use the wheel (except for toys), and had no pack animals but the llama, pre-Columbian peoples excelled in the engineering arts associated with the planning and construction of cities, civic and domestic buildings, roads and bridges, and irrigation and drainage systems. They mastered complex agricultural techniques using only rudimentary tools of cultivation. Their works, left in ruins by the Spanish invasions or abandoned to the forces of nature, are being reclaimed from erosion and the encroachment of tropical forests. Today, ever more important discoveries are being made, and now the ruined cities can be visited and marveled at as among the most prodigious creations of human hands.

The origins of these peoples are still a matter of some dispute, centering primarily about the chronology of their arrival in America from Asia. They crossed the now submerged land bridge, "Beringia," which connected the shores of the Bering Strait, sometime between 30,000 B.C. and 10,000 B.C. These Stone Age Asian nomads were hunters; their only tools were made of bone, pressure-flaked stone, and wood. They had no knowledge of agriculture but possibly some of basketry. They could control fire and probably built rude shelters. Over many centuries, they spread out until they occupied the two American continents. They were few in number: the total population of the hemisphere in 1492 may not

have exceeded fifteen million. By about 3000 B.C., a number of the migrants had learned to cultivate wild grasses, setting the stage for the maize (corn) culture that was basic to the early peoples of the Americas. As agriculturists, the nomads became a settled people and learned to make pottery utensils and lively figurines of clay. Metals were used for ornament, not for tools; these cultures never developed a metal technology. With these skills as a base, many cultures arose over long periods of time. Several reached a high level of accomplishment by the early centuries of the Christian era.

MESOAMERICA

The term *Mesoamerica* (Middle America) names the region comprised of Mexico, Guatemala, Belize, and Honduras, triply referring to its geography, ethnology, and archeology. The Mexican highlands are a volcanic and seismic region. In highland Mexico, great reaches of arid plateau land, fertile for maize and wheat wherever water is available, lie between heavily forested mountain slopes, which at some places rise to perpetual snow. The moist tropical jungles of the coastal plains yield rich crops, when the land can be cleared. In Yucatán, a subsoil of limestone furnishes abundant material both for building and carving. The limestone tableland, covered with jungle, continues into the Petén region of Guatemala, which separates Mexico from Honduras. Some of the most spectacular of Maya ruins are located in the region of Yucatán and the Petén, where dense jungle is interspersed with broad stretches of savanna. The great mountain chains of Mexico and Guatemala extend into Honduras (which is 75 percent mountainous) and slope sharply down to tropical coasts. Highlands and mountain valleys, jungle and coastlines,

with their chill, temperate, and humid climates, alternate dramatically.

The variegated landscape of Mesoamerica may have much to do with the diversity of languages spoken by its native populations; a very large number of different languages are distributed among no less than fourteen linguistic families. Many of the languages spoken in the pre-conquest periods survive to this day: the Maya tongue still can be heard in Guatemala; the Náhuatl of the Aztecs is spoken in the Mexican highlands; the Zapotec and Mixtec languages linger in Oaxaca and its environs. Diverse as the languages of these peoples were, their cultures otherwise had much in common (in this respect, the peoples of pre-Columbian Mesoamerica resemble the peoples of Europe): maize cultivation, religious rites, myths, traditions and folklore, social structures, customs and arts. Yet, some (like the Maya) were distinguished as rich in total achievement; the Toltecs were renowned as great builders and organizers; the Aztecs were reputedly implacable warriors; and the Mixtecs were known as master craftsmen in gold and turquoise. As their history becomes better known, the cultures of Mesoamerica, taken in sum, are revealed as rivaling more familiar great cultures of the world.

Archeological investigation, with ever increasing refinement of technique, has been uncovering, describing, and classifying Mesoamerican monuments for more than a century. Since 1960, when important steps were taken in the decipherment of the hieroglyphic script of the Maya and in the systematic interpretation of their pictorial imagery, evidence for a detailed account of Mesoamerican history and art has fallen into place. Like the pharaohs of ancient Egypt, many Maya rulers now can be listed by name and the dates of their reigns fixed with precision. This accomplishment reinforced the general Mesoamerican

MESOAMERICAN CHRONOLOGY

2000 B.C.	1000	B.C. A.D.	1000	1519
PRECLASSIC (FORMATIVE) PERIOD		CLASSIC PERIOD*	POSTCLASSIC PERIOD	
Olmec (Gulf Coast region) *La Venta, San Lorenzo, Tres Zapotes* Colima Maya (El Petén) *Nakbe*		Teotihuacán Maya (Yucatán, El Petén) *Uaxactún, Tikal, Copán, Yaxchilán, Jaina, Bonampak* Zapotec (Oaxaca) *Monte Albán* Totonac *El Tajín*	Totonac *El Tajín* Mixtec *Monte Albán* Maya/Toltec (northern Yucatán) *Chichén Itzá* Toltec (central Mexico) *Tula* Aztec (Valley of Mexico) *Tenochtitlán*	

*Many of the cultures listed in the Classic period actually originated during the later Preclassic. The Classic period was the period in which they achieved their unprecedented magnificence.

chronology, which is now well established and widely accepted. The standard chronology is divided into three epochs, with some overlapping of subperiods: the Preclassic (Formative) extends from 2000 B.C. to A.D. 300; the Classic period runs from A.D. 200 to 900; and the Postclassic begins in A.D. 900 and ends during the first several decades of the sixteenth century. The principal regions of pre-Columbian Mesoamerica are the Gulf Coast region (Olmec culture); Yucatán and the Petén (Maya culture); southwestern Mexico and the region of Oaxaca (Zapotec and Mixtec cultures); and the Valley of Mexico (Teotihuacán, Toltec, and Aztec cultures). The expansion and wide influence of the principal cultures, however, has made for a fairly even distribution of important archeological sites throughout Mesoamerica.

Preclassic: 2000 B.C.—A.D. 300

OLMEC

Olmec culture is known as the "mother culture" of Mesoamerica; the religious, social, and artistic traditions largely reach back to it. Though we know little of its origins and history, its influence is traced readily through the wide diffusion of its institutional forms, its monuments, arts, and artifacts.

Settling in the tropical lowlands of the Gulf of Mexico (the present-day states of Veracruz and Tabasco), the Olmec peoples cultivated a terrain of rain forest and alluvial lowland washed by numerous rivers that flowed into the Gulf. It was here that social organization assumed the form adapted and developed by later Mesoamerican cultures. The mass of the population—food-producing farmers scattered in hinterland villages—provided the sustenance and labor that maintained a hereditary caste of rulers, hierarchies of priests, functionaries, retainers, and artisans. These were located by rank within enclosed precincts that served ceremonial, administrative, and residential functions, and perhaps the economic purpose of marketplace as well. At regular intervals, the whole community convened for ritual observances at religious-civic centers such as San Lorenzo and La Venta, which now can be regarded as the formative architectural expressions of the structure and ideals of Olmec society.

At La Venta, earthen platforms and stone enclosures mark out two great courtyards; at one end of the larger was a volcano-shaped clay "pyramid" or mound almost 100 feet high. The La Venta layout is an early form of the temple-pyramid, plaza-courtyard complex that will be characteristic of Mesoamerican "urban" design.

Facing out from the plaza are four colossal heads of basalt that weigh about ten tons each and stand be-

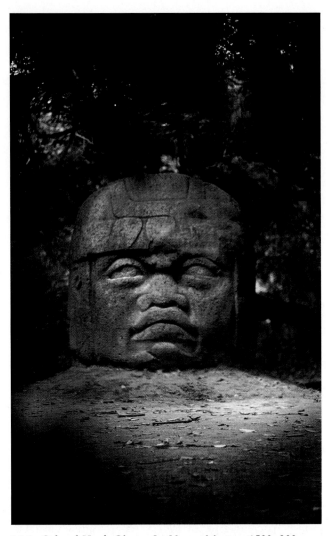

14-1 *Colossal Head*, Olmec, La Venta, Mexico, 1500–300 B.C. Basalt, 8' high, 21' in circumference.

tween 6 and 8 feet high (FIG. **14-1**). Almost as much of an achievement as the carving of these huge stones was their transportation across the sixty miles of swampland from the nearest known source of basalt. The heads are hallmarks of Olmec art; a number of others like them have been found at Tres Zapotes and the earlier site of San Lorenzo. Archeologists have not been able to determine whether they are images of gods or rulers. Both San Lorenzo and La Venta were violently overthrown, and the great heads were deliberately defaced, perhaps for ritual reasons or as the result of the vandalism of particularly hostile invaders.

Though the Olmec worked primarily in basalt, they also created beautifully wrought statuettes in jade representing humanoid creatures with jaguarlike muzzles, doubtless reflecting the cult of a jaguar-god (FIG. **14-2**). The Mesoamerican motif of the animal-man deity here makes an early appearance.

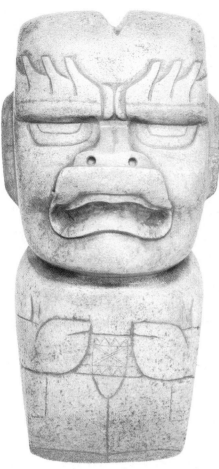

14-2 Ceremonial ax, Olmec, from La Venta, Mexico, 1500–300 B.C. Jadeite, 11½″ high. British Museum, London.

WEST MEXICO: COLIMA

In the area of Mexico far to the west of the tropical heartland of the Olmec, Preclassic sites along the country's Pacific coast have yielded small art of a distinctive kind. The pre-Columbian peoples of West Mexico produced neither massive architecture nor large-scale stone sculpture and, in general, did not share in the cultural achievements of the central and southern zones of Mesoamerica. In fact, the West Mexico states of Jalisco, Nayarit, and Colima frequently have been referred to as cultural "backwaters" relative to the "high" cultures for which Mesoamerica is most famous.

Yet West Mexico had a long and rich artistic tradition, principally in the medium of clay sculpture. Effigy figures of humans, animals, and mythological creatures have been encountered in distinctive tombs consisting of shafts (as deep as 50 feet) with chambers at their bottom end. Unfortunately, this area was long neglected by archeologists, and our limited knowledge of tomb contents derives primarily from the operations of grave robbers.

The large, hollow, ceramic figures found in these tombs exhibit a distinct sense of volume, particularly in the swollen torsos and limbs. The Colima figures are consistently a highly burnished red-orange, in contrast with the distinctive variegated surfaces of the majority of other West Coast ceramics. The area also is noted for small-scale clay scenes that include modeled houses or temples and numerous solid figurines, the latter shown in a variety of lively activities, some of which have been interpreted as festivals and battles.

The sculpture from this area frequently is described as exhibiting a secular quality seldom encountered in the arts elsewhere in Mesoamerica. To some degree this viewpoint may have been a result of our inability to discriminate religious from nonreligious objects. Many figures have been identified, for example, as "warriors" or as "shamans." The latter seems to be the correct identification for the seated figure shown here (FIG. **14-3**), especially since it is becoming increasingly clear that the arts of this area, with few exceptions, were largely connected with religion and mortuary ritual.

14-3 *Seated Figure with Raised Arms,* from Colima, Mexico, 1000–300 B.C. Terra-cotta, 13½″ high. Stendahl Collection, Los Angeles.

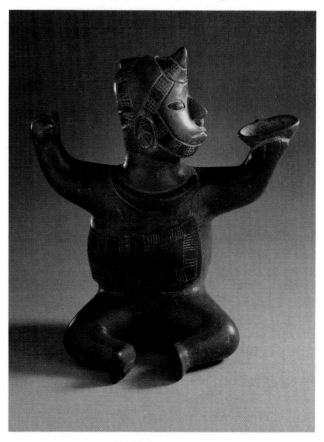

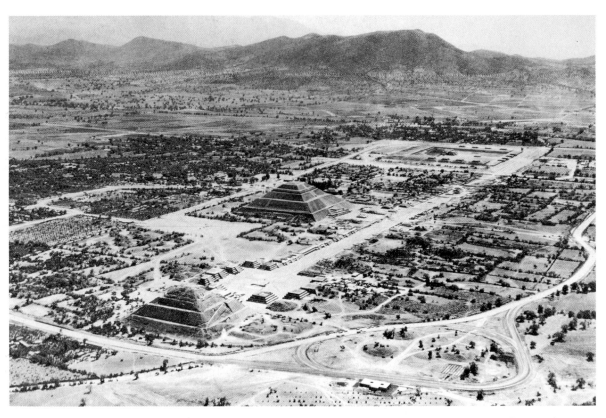

14-4 Teotihuacán, Valley of Mexico. Aerial view from the northwest. Pyramid of the Moon (*foreground*),
Pyramid of the Sun (*center*), the Citadel (*right background*); all connected by the Avenue of the Dead;
main structures *c.* A.D. 50–200, site *c.* 100 B.C.–A.D. 600.

Classic: A.D. 200–900

VALLEY OF MEXICO: TEOTIHUACÁN

The time period designated as the Classic period
in Mesoamerica witnesses the rise and flourishing of
great civilizations that are on a par with those of the
ancient Near East, which in many respects they re-
semble. Though these advanced civilizations origi-
nate in the later Preclassic, it is in the Classic period
that they achieve their unprecedented magnificence.
We have seen at Olmec La Venta an embryonic form
of the temple-pyramid-plaza layout. At the awe-
inspiring site of Teotihuacán, northeast of modern
Mexico City, we can observe the monumental expan-
sion of the Olmec scheme into a genuine city. The
carefully planned area covers nine square miles and
is laid out in a grid pattern, the axes of which were
oriented consistently by sophisticated surveying (FIG.
14-4). At its peak, around A.D. 600, Teotihuacán may
have had as many as two hundred thousand resi-
dents; it would have been at that time the sixth larg-
est city in the world. Divided into numerous wardlike
sectors, this metropolis must have had a uniquely
cosmopolitan character, with Zapotec peoples located
in the western wards of the city and Maya in the east-
ern. The city's urbanization did nothing to subtract

from it as a religious center; its importance as such
was vastly augmented. Teotihuacán was known
throughout Mesoamerica as "the place of the gods";
it was visited regularly and reverently by later Aztec
kings long after it had been abandoned.

The grid plan is quartered by a north–south and an
east–west axis, each four miles in length (we are re-
minded of Hellenistic and Roman urban planning
[FIGS. 5-88 and 6-44]). The main north–south axis, the
Avenue of the Dead, is a thoroughfare 130 feet wide.
It connects the Pyramid of the Moon complex with
the Citadel, which houses the well-preserved Temple
of Quetzalcóatl. The Pyramid of the Sun, the center-
piece of the city and its largest structure, is oriented
to the west and rises on the east side of the Avenue of
the Dead to a height of over 200 feet. The imposing
mass and scale of the monuments at Teotihuacán are
early indicators of the great feats of the Classic
period.

Although the pyramids here do not yet have the
regularity of shape characteristic of other Classic pe-
riod pyramids, they do exhibit the basic elements of
form: solid stone construction; superposed, squared
platforms, diminishing in perimeter; and ramped
stairways ascending to a crowning temple (the tem-
ple is missing at Teotihuacán). The pyramids at this

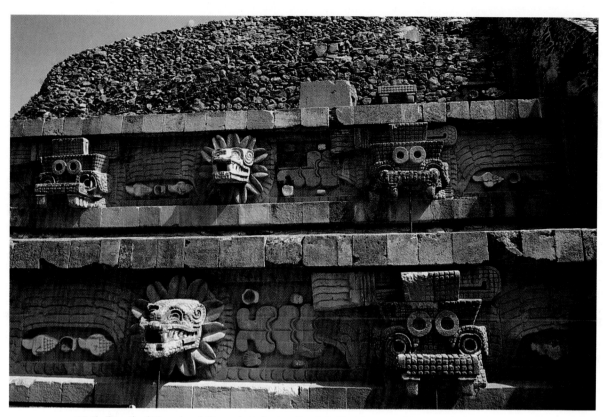

14-5 Detail of Temple of Quetzalcóatl, the Citadel, Teotihuacán, Mexico, third century (?).

site at once recall the ziggurat of Mesopotamia and the stepped pyramid of Egypt (FIGS. 2-13 and 3-6). Since these New World structures were built more than two millennia later than their Near Eastern counterparts, we have no good reason to suppose that they were influenced by the earlier works erected halfway around the world. Yet, it is interesting that intensely religious civilizations in two different hemispheres seem to agree in their selection of the pyramid form for the worship of their gods.

At the south end of the Avenue of the Dead is the great quadrangle of the Citadel. It encloses a smaller shrine, the Temple of Quetzalcóatl (a major god in the Mesoamerican pantheon). Its sculptured panels, protected by subsequent building, are well preserved (FIG. **14-5**). The six terraces of the temple are each decorated with massive, projecting stone heads of the feathered serpent, the mask-symbol of Quetzalcóatl, which alternate with heads of the goggle-eyed rain god, Tlaloc. Linking these alternating heads are low-relief carvings of feathered-serpent bodies and seashells, the latter reflecting Teotihuacán contact with the peoples of the Mexican coasts. The stone temple and its carved décor manifest that mutually reinforcing union of monumental sculpture and architecture that reminds us of the powerful ensembles distinguishing the art of the ancient Near East, Hellenic civilization, and the Gothic world.

The influence of Teotihuacán was all-pervasive in Mesoamerica. Colonies like Cholula, on the Mexican plateau, were established widely. Others adjoined the southern borders of Maya civilization, in the highlands of Guatemala, some eight hundred miles from Teotihuacán. Political and economic interaction between Teotihuacán and the Maya in southern Mexico and Guatemala linked the two outstanding cultures of the Early Classic.

GUATEMALA-HONDURAS-YUCATÁN: MAYA

A considerable number of strong cultural influences stemming from the Olmec tradition and from Teotihuacán were active in the development of Classic Maya culture, which has been called "the most advanced, sophisticated, and subtle civilization of the New World"; certainly, Maya culture is exemplary of the whole of Mesoamerican achievement. As with Teotihuacán, Maya civilization's foundations were laid in the Preclassic period, as early as 200 to 50 B.C.* At that time, the Maya, who occupied the moist lowland areas of Guatemala and Honduras, abruptly

*Archeologists working in the jungles of Guatemala at the site of Nakbe currently are excavating the ruins of an early Maya urban center dated about 800–600 B.C. This discovery pushes back dramatically the time at which Maya civilization is supposed to have begun and will alter significantly our historical picture of that society.

abandoned their early, more or less egalitarian pattern of village life and adopted a hierarchical, autocratic society. This system evolved into the typical Maya theocratic city-state, governed by hereditary rulers and ranked nobility. How and why this happened is still in doubt. The change was signalized by stupendous building projects. Stone structures rivaling those of Teotihuacán in scale rose dramatically, covering square miles of territory with vast, enclosed complexes of terraced temple-pyramids, tombs, palaces, plazas, ball courts, and residences of the governing elite. The new architecture, and the art that embellished it, advertised the power and interrelationship of rulers and gods and their absolute control of human as well as cosmic life. The unified institutions of religion and kingship were established so firmly, their hold on life and custom was so tenacious, and their meaning was so fixed in the symbolism and imagery of art, that the rigidly conservative system of the Classic Maya lasted almost a thousand years. Maya civilization collapsed in about the year 900, vanishing more abruptly and unaccountably than it had appeared.

Though the causes of the beginning and end of Classic Maya civilization are obscure, the events of its history, beliefs, ceremonies, conventions, and patterns of daily life presently are being revealed in minute detail. The Maya now enter upon the stage of world history as believably as the peoples of the other great civilizations we have been studying. The distorting lenses of myth and legend, which made this group almost akin to the fantastic characters of science fiction, have been removed. This more accurate picture is the consequence of the documentary bequest of the Maya on the one hand and the work of modern archeology on the other.

As we have seen, the Maya possessed an elaborate writing system and highly developed knowledge of arithmetical calculation. These accomplishments enabled them to keep exact records of important events, times, places, and people. They were able to establish the all-important genealogical lines of rulers, which certified their claim to rule, and could construct astronomical charts and tables. They contrived an intricate but astonishingly accurate calendar. Their calendric structuring of time, though radically different in form from ours, was just as sophisticated and efficient. The sixteenth-century Franciscan chronicler of the Maya of Yucatán, Bishop Diego de Landa, declared that time reckoning was "the science in which they believed most and which they valued most highly" of all their achievements. In addition, the Maya mirrored themselves in carved and painted imagery. Though strictly conventional in style, their images, with their hieroglyphic "captions," have great descriptive value.

With these ample documentary materials, modern archeologists have deciphered numerous additional elements of Maya writing in the last three decades. They have made a precise historical record from the calendar and have clarified the iconography of symbol and image. All of these advances have enabled them to bring into ever sharper focus a true picture of the civilization of the Maya.

Time reckoning, like all the arts and institutions of this civilization, was religious in purpose. It aimed to bring human life into the closest possible correspondence with the rhythmic pulse of the living cosmos—the movements of the stars, the diurnal career of the sun, the changes of the seasons, the fluctuations of the climate, and the growth of crops. Within the vital universe of the Maya, all things—animate and inanimate—were interlinked by occult affinities; arts like astrology and divination were practiced to recognize these affinities and determine their influence on human action, while rituals were performed to control them.

Whole populations of greater and lesser gods filled the Maya pantheon and were represented in their art: gods of the Overworld, the Middleworld, the Underworld; gods of the points of the compass; gods of wind and stone, of water lilies, trees, maize, jaguars, jade, serpents, hummingbirds; even a god of the number zero. The business of religion was to gain access to the gods, to propitiate them with sacrifice and manipulate them with magic. By rituals of sacrifice a god could be summoned up. The celebrants of the rituals, through a vision induced by hallucinogenic drugs or by massive letting of their own blood (usually both), could then unite their essence with that of the god, though only for the duration of the rite. In this mingling of human and divine, the distinction between natural and supernatural disappeared.

This commingling of human and divine also applied to Maya statecraft, for statecraft and religion were one. The ruler was not merely godlike; he (or at times, she) *was* a god. Kingship and deity shared the rule of the cosmos as well as the rule of the state. In art, the Maya ruler was shown holding the sky in his arms, controlling the motions of the sun and Venus (the morning and evening star), those most ancient and august twin gods of the Maya pantheon. Rulers and gods reciprocally existed, the rulers requiring the gods for the preservation of the state, the gods depending on the ruler for their honor and sustenance. One could not exist without the other. It was in the ritual ceremonies of bloodletting and human sacrifice that the natures of god and king, of divinity and humanity, were commingled.

In the mythology of the Maya, the gods created human beings by self-sacrifice. Fashioning them from

maize and water, they brought them to life with their own blood. The reciprocal relationship between humans and gods required that human beings strengthen and nourish the gods. The blood of the gods had to be replaced by human blood; blood had to be perpetually supplied in order for the gods to survive. The most sacred and necessary function of Maya religion was, therefore, the procurement of human blood for the nourishment of the gods. The life of the gods, the state, and the cosmos demanded blood sacrifice.

On all occasions of state, public bloodletting was an integral part of Maya ritual. The ruler, his consort, and certain members of the nobility drew blood from their own bodies and sought union with deity in ecstatic vision (the vision quest). This ceremony was regularly accompanied by the wholesale slaughter of captives taken in war. Wars between the Maya city-states and foreigners were fought principally to provide victims for sacrifice. After prolonged participation in bloodletting rites, these individuals were stretched out on specially designed altars or bound to scaffolds placed on high temple platforms. Their hearts eventually were cut out, and their bodies hurled down the steep stairways. Many captives were forced to play the fatal ballgame in courts laid out adjacent to the temples. The losers of the game were decapitated or otherwise killed. The torture, mutilation, and execution of the victims of the blood ceremonies presented the public with spectacles of profoundly religious import. It has been said that blood was the very mortar of the structure of the Maya system.

Architecture The relationship of the Maya politico-religious system to Maya architecture is obvious. The enclosed, centrally located precincts, where the most sacred and majestic buildings of the Maya city were raised, were intended as settings for those religious-civic transactions that guaranteed the order of state and cosmos. The drama of the blood ritual took place within a sculptured and painted environment, where huge symbols and images proclaimed the nature and necessity of that order. The spacious plazas were designed for vast audiences, who, stimulated by drugs, drums, and dancing, were exposed to an overwhelming propaganda. The programmers of that propaganda, the ruling families and troops of priests, nobles, and retainers, carried its symbolism through in their costumes. They were clad in extravagant profusions of vividly colorful textiles and feathers, each ornamental article having meanings that linked it to supernatural persons and powers. On the different levels of the painted and polished temple platforms, before sanctuaries glittering in the sun, the ruling classes performed the offices of their rites in clouds of incense to the music of maracas, flutes, and drums.* The architectural complex at the center of the city was transformed into a theater of religion and statecraft.

The stagelike layout of a characteristic Maya city complex can be seen in a reconstruction of the site of Uaxactún (FIG. **14-6**). It is the setting for public art and activity. The plazas conspicuously occupy the major operational spaces; the buildings themselves are

*Though our knowledge of the music of the Maya is slight, elite tombs at the site of Pachitun in Belize have yielded a cache of musical instruments from the Late Classic period, some of which still can be played. Among them are a drum, flute-maracas, flutes, and "figurine ocarinas." The painted walls of Bonampak show processions of musicians beating drums, rattling maracas, and blowing wooden trumpets.

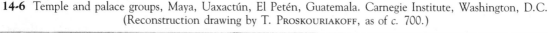

14-6 Temple and palace groups, Maya, Uaxactún, El Petén, Guatemala. Carnegie Institute, Washington, D.C. (Reconstruction drawing by T. Proskouriakoff, as of c. 700.)

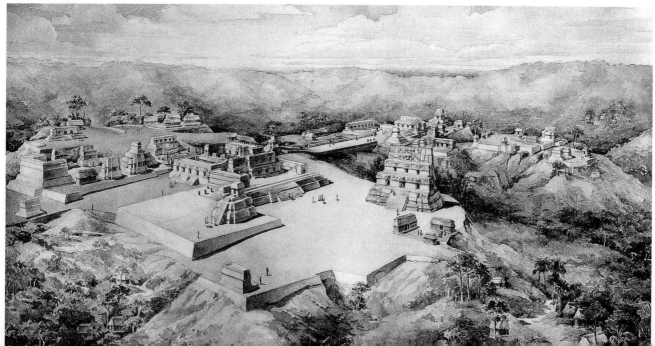

more like stage properties. Tall slabs of sculptured stone, anywhere from 5 feet to 25 feet in height, further define the space of the plazas. Permanent fixtures, these stelae describe in images and glyphs the history and meaning of the site and are characteristic features of Classic Maya urban composition. The temple group at Uaxactún was part of a larger assembly of temples and buildings on hilltops, all connected by roadways and covering many square miles. The base of the group was composed of receding terraces with stairways ascending to the temple court. The massive temple roofs were surmounted by ornate and towering roof combs painted in a variety of colors. The whole complex, contemporaneous with Teotihuacán, dates from the Late Preclassic period, 200 B.C. to A.D. 50.

The public character of Maya architecture is evident in its stress upon the exterior aspect of its principal buildings. The interiors were limited spatially by corbel vaulting, the structural form we have seen at Tiryns in Mycenean Greece (FIG. 4-22). Such chambers were rarely more than 15 feet in width, but might be of any length; temples constructed in this manner were aggregates of one or more long narrow compartments.

About twenty air miles from Uaxactún, Tikal, one of the oldest and largest of the Maya cities, rises above the thick tropical forest that once had invaded it completely. The city and its suburbs originally covered some seventy-five square miles and served as the ceremonial center of a population of perhaps seventy-five thousand. Central Tikal was not laid out on a grid plan like its contemporary, Teotihuacán; instead, irregular groupings were connected by causeways. Modern surveys have uncovered the remains of as many as three thousand separate constructions in an area of about six square miles. The site's nucleus, the Great Plaza, which is studded with sculptured stelae, contains numerous structures, the most prominent of which are two soaring pyramids facing each other across an open square. The larger construction (FIG. 14-7), Temple I (also called the Temple of the Giant Jaguar after a motif on one of its lintels) reaches a height of 144 feet. It is the temple-mausoleum of a ruler of Tikal, whose tomb is encased in a vaulted chamber excavated at the level of the plaza. The structure is made up of nine sharply inclining platforms, culminating at the summit in a superstructure composed of a supplementary platform and stairway. These elements serve as a base for a three-chambered

14-7 Temple I (Temple of the Giant Jaguar), Maya, Tikal, El Petén, Guatemala, Classic, *c.* 700.

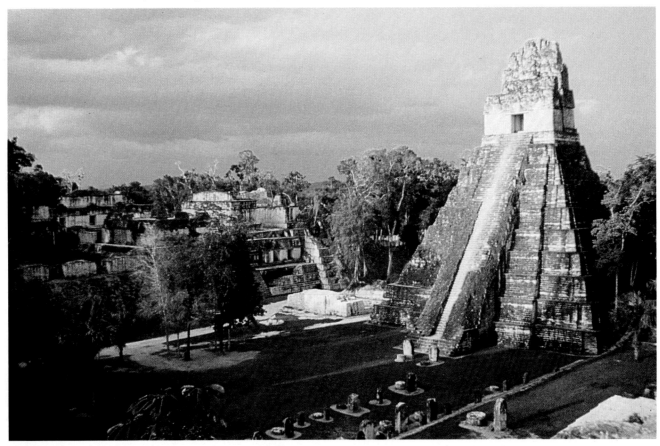

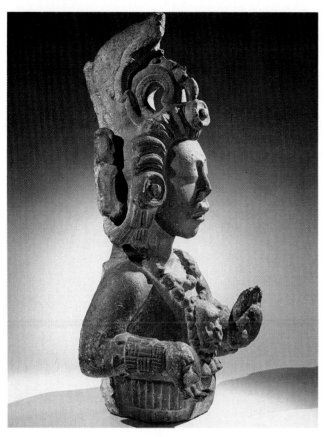

14-8 *Maize God,* from Temple 22, Maya, Copán, Honduras, c. 775. Limestone, 35⅓″ × 21⅓″. British Museum, London.

temple surmounted by an elaborately carved roof comb. The swift upward drive of the great staircase, forbiddingly steep (and perilous in descent!), forces these elements into the towerlike verticality of the pyramid, elevating the temple unit far above the public concourse. This structure exhibits most concisely the Mesoamerican formula for the stepped temple-pyramid and, freed from its dense jungle cover, the compelling esthetic and psychological power of Maya architecture.

Sculpture and Painting Architecture, the dominant Maya art, also provided the matrix of Maya sculpture and painting. Rarely do we have sculpture independent of architecture, whether in high relief, in the round, or freestanding. The sculptured stele resembles the detached panel of a wall, and freestanding sculpture, such as it is, is found on the scale of the ceramic figurine. Painting is bound to architecture; murals are the most common form. But considerable painting also has survived on the surfaces of ceramic receptacles, cups, bowls, and pots, which provide detailed information concerning Maya life and culture.

A striking sculptured head representing the maize god (FIG. **14-8**) was found in the ruins of a palace at

the site of Copán. With others like it, it originally was tenoned into the architectural fabric, jutting out from the flat frieze of a cornice. We have noted the significance of maize as the basic foodstuff of Mesoamerica. The personification of natural elements and forces in Maya religion found embodiment in the figurative arts. Here, in the features of head and headdress, the sculptor alludes metaphorically to ripening corn: the face is the cob, the necklace the kernels, the hair the cornsilk, and the headdress the clustering foliage. The graceful motion of the hands suggests the waving of the stalks in the wind. The closed, heavy-lidded eyes turn inward to the young plant's interior life. In the youthful beauty and sensitivity of the face, we find expression of the very idea of spiritual composure. The work is executed with that deft simplification of appearances into plane and volume that we have seen to be characteristic of native arts. But here the simplifying process stops well short of total abstraction of form. The peculiar traits of Maya physiognomy are smoothed into a symmetry and regularity that subordinate the real to the ideal.

Farther along toward abstraction, but replete with descriptive detail, are the figures of a carved lintel from Yaxchilán (FIG. **14-9**). The calendrical glyphs surrounding the figures date the commemorated event

14-9 *Bird-Jaguar Taking a Prisoner,* Maya, Yaxchilán, from Chiapas, Mexico, Late Classic, 755–770. Limestone, 31″ × 30″ × 2¾″. British Museum, London.

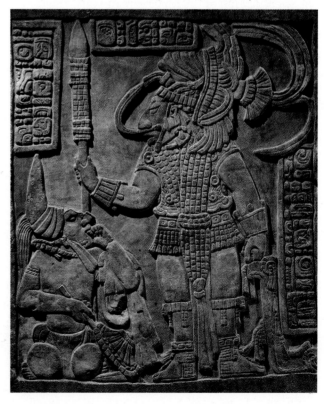

precisely at February 1, A.D. 752 (around the beginning of the Carolingian Empire in Europe). On that day, the Yaxchilán ruler Bird Jaguar (named for the form of his name glyph) took captive a rebellious local lord, who is seen crouching apprehensively at his feet. The capture of a nobleman, later to be sacrificed, was probably a feat prerequisite to the rite of Bird Jaguar's accession to the throne. The humbled captive, his face bloody, his parasol broken, makes the gesture of eating dirt. The king, with spear and feathered crown, looms threateningly above him. His facial features are accommodated to those of the jaguar mask, symbol of fierce authority. (The Maya inherited the jaguar cult from the Olmec and believed that the legitimacy of their titles descended from the same ancient source.)

The hard-edged, slablike carving recalls to a degree the low relief of ancient Assyria (FIG. 2-32), the slight projection being flat rather than round in cross section. This feature is characteristic of much Mesoamerican sculpture. Though Bird Jaguar's image is confined within the formal rigidity of pose befitting the representation of a ruler, considerable visual information is given in the figure of the captive. The sculptor has sharply observed the foreshortening of the legs, for example, and has been able to pose the figure in a convincing posture of shrinking abjection.

The almost unlimited variety of figural attitude and gesture permitted in the modeling of clay explains the profusion of informal ceramic figurines that illustrate the everyday life of the Maya. Small-scale, freestanding figures in the round, they are remarkably lifelike, carefully descriptive, shrewdly psychological, and often comic. A pair that might be called "an amorous couple" (FIG. **14-10**) shows a lecherous old man fondling a courtesan, who replies in kind; he lifts her skirt, she advances her knee. Though apparently no more than an amusing piece of sexual genre, the pair may have religious overtones. The female figure could be the inconstant goddess of the moon, the old man, the God N, a supporter of the arc of heaven. Figurines representing a great variety of subjects regularly are found in tombs among the funeral accessories. This pair comes from Jaina, the Maya necropolis, an island of the dead off the coast of Yucatán. Their mortuary function must be kept in mind as we appreciate their piquant liveliness.

The vivacity of the figurines and their variety of pose are not destructive of the formality of Maya art. Simplification of plane, volume, and contour still is to be seen in the overall form as well as in its details. This same unity of action with formality of design appears at Bonampak (Mayan for "painted walls"). Three chambers in one structure at this site contain mural paintings that are vivid vignettes of Maya court

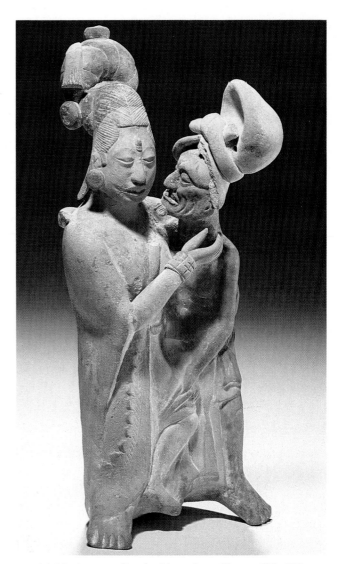

14-10 *Amorous Couple*, Maya, Late Classic, 700–900. Polychromed ceramic, 9¾". Detroit Institute of the Arts, Detroit.

life (FIG. **14-11**). As in most Egyptian painting (FIGS. 3-36 and 3-45), the figures are rendered in line and flat tone without shading or perspective. They are arranged friezelike in superposed horizontal registers without background settings. Maya painting, like Maya sculpture, is mural; architecture is its matrix. But, again, the architectural limits do not in any way restrict the scope and circumstantial detail of the narrative; presented with great economy of means, the information given is comprehensive, explicit, and presented with the fidelity of an eye-witness report. At Bonampak, not only can we identify the royal personages who pass in review, but inscriptions give us the precise dates for the events recorded, the days and the months in the years A.D. 790 and 791. Like the inscribed dates on the Bird Jaguar lintel, these impress us with the almost obsessive Maya concern for accurate time reckoning.

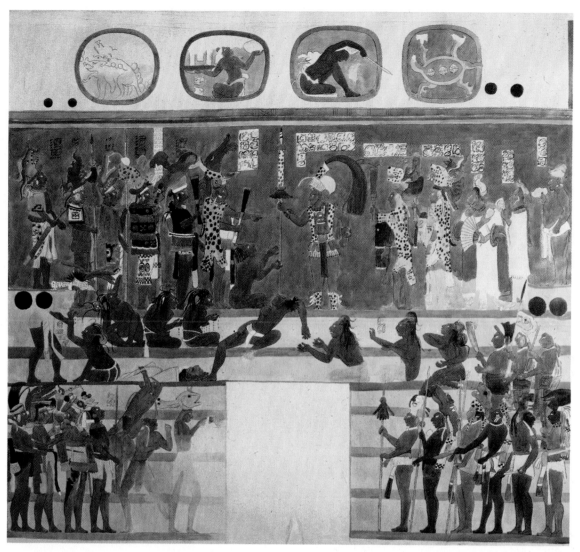

14-11 Temple mural of warriors surrounding captives on a terraced platform, Maya, from Bonampak, Mexico, *c.* sixth century. Peabody Museum, Harvard University, Cambridge, Massachusetts. (Watercolor copy by ANTONIO TEJEDA.)

The scenes recorded at Bonampak relate the ceremonies that welcome a new heir to the throne; they include presentations, preparations for a royal fête, dancing, battle, and the taking and sacrificing of prisoners. In the scene representing the arraignment of the prisoners (FIG. 14-11), the uppermost register depicts a file of gorgeously appareled nobility wearing animal headgear. Conspicuous among them on the right are retainers clad in jaguar pelts and jaguar heads. The ruler himself, in jaguar jerkin and buskins, is posed at the center and closely resembles Bird Jaguar in the Yaxchilán lintel (FIG. 14-9). Like the latter figure, he is accompanied by a crouching victim who appears to beg his mercy. The middle level is crowded with naked captives anticipating death. One of them, already dead, sprawls at the feet of the ruler; others dumbly contemplate the blood dripping from their mutilated hands. The lower zone, divided by a doorway, shows clusters of attendants who are doubtless of inferior rank to the lords of the upper zone. The stiff formality of the grandees and the attendants contrasts graphically with the supple, imploring attitudes and gestures of the hapless victims. In this single composition, we have a narrative of those appalling rituals of blood so central in the life of the Maya and throughout pre-Columbian civilizations in Mesoamerica.

The Postclassic: A.D. 900–1521

Throughout Mesoamerica, the Classic period culminated in the disintegration of the great civilizations. Teotihuacán's political and cultural empire was disrupted around 600, and its influence waned. In 700 the great city was destroyed by fire, presumably at the hands of invaders from the north. Around

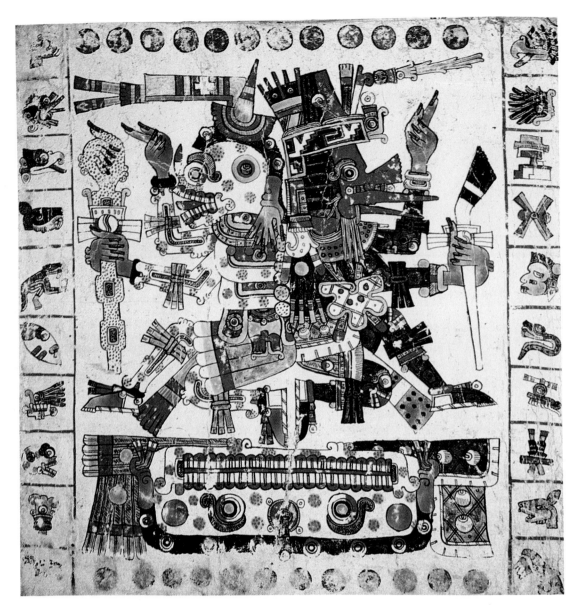

14-12 *Life God (Quetzalcóatl)* and *Death God (Mictlantecuhtli)*, from the *Borgia Codex,*
Mixtec, Late Postclassic, *c.* 1400. Deerskin, 10⅔″ × 4″. Vatican Library, Rome.

A.D. 900, many of the great Maya sites were abandoned to the jungle. Though a later Maya culture continued in northern Yucatán during the Postclassic period, it was strongly subordinated by Toltec influences from central Mexico. The Classic culture of the Zapotecs, centered at Monte Albán in the state of Oaxaca, came to an end around A.D. 700, and the neighboring Mixtec peoples assumed supremacy in this area during the Postclassic. Classic El Tajín (Totonac culture), later heir to the Olmec in the Veracruz plain, survived the general crisis that afflicted the others but was burned out sometime in the twelfth century, again, by northern invaders.

The war and confusion that followed the collapse of the Classic civilizations broke the great states up into small, local political entities isolated in fortified sites. The collapse encouraged warlike regimes, chronic aggression, and expansion of the bloodletting rite. In Mexico, the Toltec and the Aztec peoples, ruthless migrants from the north, forged empires by force of arms and glorified militarism.

The Mixtecs, who succeeded to Zapotec Monte Albán, were exceptional in that they extended their political sway in Oaxaca by dynastic intermarriage rather than by war. The magnificent treasures found in the tombs at Monte Albán bear witness to Mixtec wealth, and the quality of these works demonstrates the high level of Mixtec artistic achievement. These people were accomplished in sculpture and ceramics. Metallurgy was introduced into Mexico in Late Clas-

sic times, and the Mixtec became the skilled goldsmiths of Mesoamerica. They were renowned for their turquoise mosaic, and, perhaps most important, they were producers of painted manuscripts.

The Classic Maya were preeminent in the art of writing and had libraries of painted books. The painted and inscribed book, somewhat inaccurately called a *codex* (plural *codices*), was the precious vehicle that recorded religious occurrences, historical events, genealogical charts, astronomical tables, calendric calculations, maps, and trade and tribute accounts. Codices were painted on long sheets of fig-bark paper or deerskin, which were coated with fine white lime plaster and folded into accordionlike pleats. These manuscripts were protected by wooden covers. Their hieroglyphs were designed to be read in zigzag fashion from left to right and top to bottom. Only four Maya codices survive. Bishop Diego de Landa, whom we have met as the Spanish chronicler of the Maya of Yucatán, explains why: "We found a great number of these books in Indian characters and because they contained nothing but superstition and the Devil's falsehoods we burned them all; and this they felt most bitterly and it caused them great grief."

Eight Mixtec codices survive. A "page" from one of them, the beautifully illuminated *Borgia Codex* (FIG. **14-12**), shows the god of life, Quetzalcóatl, seated back-to-back with the lord of death, Mictlantecuhtli. Below them is an inverted skull with a double keyboard of teeth. Both figures hold scepters in one hand and gesticulate with the other. Strings of flesh hang from the death god's red, triple jaws. The margins are paneled with symbols of the days of the year ruled by each of the two deities.

The fantastic image is an explosion of shapes. The design approaches complete abstraction of visual materials. Were the shapes in less confusion, they would resemble in their taut line and flat, sharp color the face cards of a playing deck. The artist's imagination conjures up and personifies the wild powers of the gods, producing a terrifying figment of the sort that might be experienced in the delirium of the vision quest. Reality vanishes in nightmare.

CHICHÉN ITZÁ: LATER MAYA

The flat, scrub-vegetation covered, low limestone peninsula of Yucatán lies north of the rolling and densely forested region of central Yucatán and the Petén. During the Classic period, this northern region was inhabited sparsely by Mayan-speaking peoples who settled around such centers as Uxmal. For unknown reasons, when the Classic sites were abandoned after A.D. 900, many new temples still were built in this area. A new art style, which can be seen in these late temples at Chichén Itzá, is contempora-

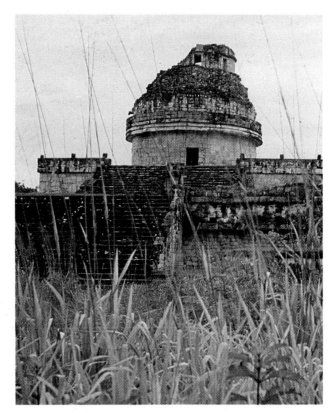

14-13 The Caracol (observatory), Chichén Itzá, Toltec-Maya, Yucatán, Mexico, Postclassic, c. 1050.

neous with the political ascendancy in the Yucatán of the Toltecs from Tula (a site northwest of Mexico City). The Toltecs ruled at Chichén Itzá during the twelfth and thirteenth centuries.

The northern Maya (under heavy influence from the Toltecs) experimented with building construction and materials to a much greater extent than the Maya farther south; piers and columns were placed in doorways, encrusted decoration of stone mosaic enlivened outer facades. The northern groups invented a new type of concrete construction: a solid core of coarse rubble faced inside and out with a veneer of square limestone plates. The region provided plenty of solid material to work with; Bishop Landa wrote of Yucatán: "The whole land is made of limestone!"

The design of the structure known as the Caracol at Chichén Itzá (FIG. **14-13**) suggests that the northern Maya were as inventive of architectural form as they were experimental with construction and materials. A cylindrical tower rests on a broad terrace, which is supported, in turn, by a larger platform measuring 169 by 232 feet. The tower is composed of two concentric walls enclosing a circular staircase that leads to a small chamber near the top of the structure. Windows along the staircase and an opening at the summit were doubtless used for astronomical observation, which has given the building another name—

"The Observatory." Observation of the stars and of their movements made possible the essential astrological calculations that charted their influence.

TULA: TOLTEC

The circular Caracol is but one of a number of impressive buildings constructed at the site of Chichén Itzá. Among the others, the colonnaded Temple of the Warriors resembles buildings excavated at Tula, the Toltec capital north of Mexico City. Detailed resemblances between the sculptures of the two sites support the inference that the builders of Tula worked for the same Toltec masters as those who ruled the Maya at Chichén Itzá.

The name Toltec, which signifies "makers of things," generally is applied to a powerful tribe of barbarian invaders from the north, whose arrival in south-central Mexico coincided with the great disturbances that, as we have seen, must have brought down the Classic civilizations. The Toltec capital at Tula flourished from about A.D. 900 to 1200. The Toltecs were great political organizers and military strategists and came to dominate large parts of north and central Mexico, Yucatán, and the highlands of Guatemala. They were respected as the masters of all that came to hand, and later peoples looked back on them admiringly, proud to claim descent from them.

Legend and history recount that in the city of Tula civil strife between the forces of peace and those of

14-14 *Colossal Atlantids*, Pyramid B, Toltec, Tula, Hidalgo, Mexico, Early Postclassic, *c.* 1050. Stone, 16' high.

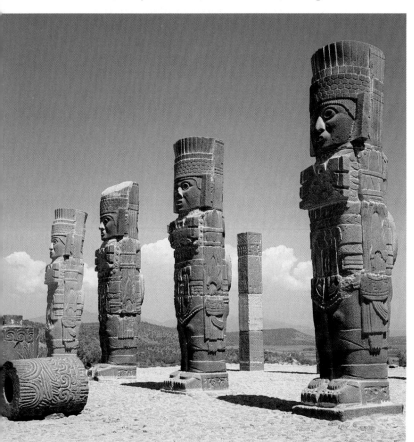

war and bloodletting resulted in the victory of the militarists. The grim, warlike regime that followed is personified in four colossal atlantids that portray armed warriors (FIG. **14-14**). Built up of four stone drums each, these sculptures loom above Pyramid B at Tula. They originally were designed to support a now missing temple roof and wear stylized feathered headdresses and, as breastplates, stylized butterflies, heraldic symbols of the Toltecs. In one hand they clutch a bundle of darts, in the other, an *atlatl* (throwstick). The architectural function of these support figures requires rigidity of pose, compactness, and strict simplicity of contour; where possible, all projecting details are suppressed. The unity and regularity of architectural mass and silhouette here combine perfectly with abstraction of form. The effect is that of overwhelming presence. These images of brutal and implacable authority, with "gaze blank and pitiless as the sun," stand eternally at attention, warning off all hostile threats to sovereign power, good or evil.

By 1180, the last Toltec ruler abandoned Tula and was followed by most of his people. Some years later, the city was catastrophically destroyed, its ceremonial buildings burnt to their foundations, its walls thrown down, and the straggling remainder of its population scattered throughout Mexico.

TENOCHTITLÁN: AZTEC

The destruction of Tula and the disintegration of the Toltec empire in central Mexico made for a century of anarchy in the Valley of Mexico. Barbaric northern invaders, who again must have wrought the destruction, gradually organized into small, warring city-states. Nevertheless, they civilized themselves on the cultural remains and traditions of the Toltecs. When the last wave of northern invaders appeared, they were regarded as detestable savages.

These "savages" were the Aztecs, the "people whose face nobody knows." With astonishing rapidity, they were transformed within a few generations from outcasts and serfs to mercenaries of the Tepanec imperialists, and then masters in their own right of the petty kingdoms of the Valley of Mexico. In the process, they acquired, like their neighbors, the culture of the Toltecs. They had begun to call themselves *Mexica*, and, following a legendary prophecy that they would build a city where they saw an eagle perched on a cactus with a serpent in its mouth, they settled in the marshes on the west shore of the great "Lake of the Moon," Lake Texcoco. Their settlement grew into the magnificent city of Tenochtitlán, which in 1519 so astonished the Spanish conqueror Cortés and his men.

The Aztecs were known by those they subdued as fierce in war and cruel in peace. Indeed, they gloried in warfare and in military prowess. They radically

changed the social and political situation in Mexico. The cults of bloodletting and human sacrifice, though still practiced, had been waning in central Mexico since Toltec times. The Aztecs revived the rituals with a vengeance—and a difference. In the older civilizations, like the Classic Maya, the purposes of religion and statecraft were in balance. With the Aztec, the purpose of religion was to serve the policy of the state. The Aztecs believed that they had a divine mission to propagate the cult of their tribal god, Huitzilopochtli,* the hummingbird god of war. This goal meant forcing conformity on all peoples conquered by them. Subservient groups had not only to submit to Aztec military power but also were forced to accept the cult of Huitzilopochtli and to provide victims for sacrifices to him. Thus, Aztec statecraft used the god to achieve and maintain its ruthless political dominion. Human sacrifice was vastly increased in a reign of terror designed to keep the Aztec empire under control. To this end, tribute of sacrificial victims was regularly levied on unwilling subjects. It is no wonder that Cortés, in his conquest of the Aztec state, found ready allies among the peoples the Aztecs had subjugated.

The ruins of the Aztec capital, Tenochtitlán, lie directly beneath the center of Mexico City. The exact location of many of the most important structures within the Aztec "sacred precinct" was discovered in the late 1970s, and extensive excavations near the cathedral in Mexico City are ongoing. The principal building is the Great Temple (Templo Mayor), a double temple-pyramid honoring the gods Huitzilopochtli and Tlaloc, the rain god, whose image we have seen in the company of Quetzalcóatl on his pyramid at Teotihuacán. Two great staircases sweep upward from the plaza level to the double sanctuaries at the summit. The Great Temple is a remarkable example of superimposition, a common trait in Mesoamerica. The excavated structure is composed of five shells, the earlier walls nested within the later. The sacred precinct also contained palaces, the temples of other deities (the Aztec pantheon was as crowded as that of the Maya), a ball court, and a skull rack for the exhibition of thousands of the heads of victims killed in sacrificial rites.

Tenochtitlán was a city laid out on a grid plan in quarters and wards. Its location on an island in Lake Texcoco caused communication and transport to be conducted by canals and waterways; many of the Spaniards thought of Venice when they saw the city rising from the waters like a radiant vision. It was crowded with buildings, plazas, and courtyards, and was equipped with a vast and ever busy marketplace. The city proper had a population of more than one

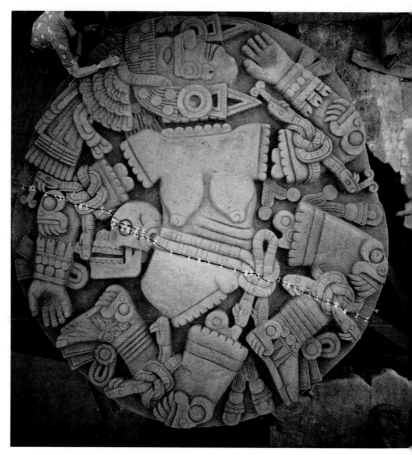

14-15 *Coyolxauhqui,* from the Great Temple of Tenochtitlán, Aztec, Mexico City, Late Postclassic, *c.* 1400–1500. Stone, diameter approx. 11′.

hundred thousand people; the total population of the area of Mexico dominated by the Aztecs at the time of the conquest has been estimated at eleven million.

The Temple of Huitzilopochtli commemorates his victory over his brothers and sister; since he was a sun god, the nature myth reflects the sun's conquest of the stars and the moon. Revenging the death of his mother, Coatlicue,† at the hands of his siblings, he kills them and dismembers the body of his evil sister, Coyolxauhqui.‡ The macabre event is depicted in a work of sculpture, whose discovery in 1978 set off the ongoing archeological investigations near the main plaza in Mexico City. The huge stone disk (FIG. **14-15**), about 11 feet in diameter, was placed at the foot of the staircase leading up to the shrine of Huitzilopochtli. Carved on it is an image of the segmented body of Coyolxauhqui. The horror of the theme should not distract us from its artistic merit; the disk has a kind of dreadful, yet formal, beauty. At the same time, it is an unforgettable expression of Aztec temperament and taste, and the cruelty inculcated by

*weet-zeel-O-POCH-tle

†kwah-TLEE-kway

‡ko-yol-SHOW-kee

ceremonies of blood. The image proclaimed the power of the god over his enemies and the inevitable fate that must befall them. As such, it was an awful reminder to sacrificial victims, as they were ritually halted beside it preparatory to mounting the stairs that led to the temples above and death.

The sculpture is marvelously composed. Within the circular space, the carefully enumerated, richly detailed components of the design are so adroitly placed that they seem to have a slow, turning rhythm, like some revolving constellation. (This presentation would be appropriate for a goddess of the sky, no matter her decrepitude!) The carving is confined to a single level, a smoothly even, flat surface raised from a flat ground. We have seen this kind of relief in the Bird Jaguar lintel from Yaxchilán (FIG. 14-9). It is the sculptural equivalent of the line and flat tone, figure and neutral ground, characteristic of Mesoamerican painting.

In addition to relief carving, the Aztecs, unlike the Maya, produced sculpture unbound to architecture, freestanding and in the round. The colossal monster statue of Coatlicue (Lady of the Skirt of Serpents), ancient earth mother of the gods Huitzilopochtli and Coyolxauhqui, is a massive apparition of dread congealed into stone (FIG. **14-16**). Sufficiently expressive of the Aztec taste for the terrible, the beheaded goddess is composed of an inventory of macabre and repulsive objects. Up from her headless neck writhe two serpents whose heads meet to form a tusked mask. The goddess wears a necklace of severed human hands and excised human hearts. The pendant of the necklace is a skull. Her skirt is formed of entwined snakes. Her hands and feet have great claws, with which she tears the human flesh she consumes. All of her loathsome attributes symbolize sacrificial death. Yet, in Aztec thought, this mother of the gods combines savagery and tenderness, for out of destruction arises new life. In this expression of the concept, the tenderness is missing.

The main forms are carved in high relief, the details are executed either in low relief or by incising. The overall aspect is of an enormous, blocky mass, the ponderous weight of which is in itself a threat to the awed viewer. In its original setting, where it may have functioned in the visual drama of sacrificial rites, it must have had a terrifying effect on victims.

It was impossible for the Spanish conquerors to reconcile the beauty of the great city of Tenochtitlán with its hideous cults. They wonderingly admired its splendid buildings, ablaze with color; its luxuriant and spacious gardens, sparkling waterways, teeming markets, and vivacious populace; its grandees resplendent in the feathers of exotic birds. But when Moctezuma, king of the Aztecs, brought Cortés and his entourage into the shrine of Huitzilopochtli's tem-

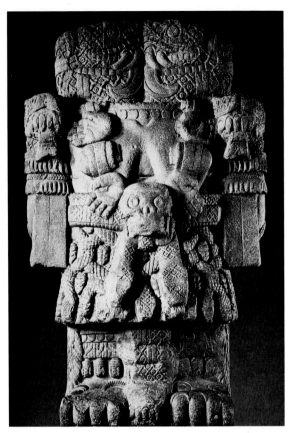

14-16 *Coatlicue (Lady of the Skirt of Serpents)*, Aztec, fifteenth century. Andesite, approx. 8′ 6″ high. Museo Nacional de Antropología, Mexico City.

ple, the newcomers started back in horror and disgust from the huge statues clotted with dried blood. One of Cortés's party, Bernal Diaz del Castillo recorded: ''There was on the walls such a crust of blood, and the whole floor bathed in it, that even in the slaughter houses of Castile there is not such a stench.'' Cortés was furious. Denouncing Huitzilopochtli as a devil, he proposed to put a high cross above the pyramid and a statue of the Virgin in the sanctuary to exorcise its evil.

This proposal would come to symbolize the avowed purpose and the historic result of the Spanish conquest of Mesoamerica. The cross and the Virgin, triumphant, would be venerated in new shrines raised upon the ruins of the plundered temples of the Indian gods, and the banner of the Most Catholic Kings of Spain would wave over new atrocities of a European kind.

SOUTH AMERICA: CENTRAL ANDES

The story of the great cultures of Andean South America was much the same as that of the pre-Columbian peoples of Mesoamerica: native civiliza-

tions jarring against and stimulating one another; production of distinctive architecture and art; extermination in violent confrontations with the Spanish *conquistadores*—Cortés in Mesoamerica and Pizarro in the Andes.

The central Andean region of South America lies between Ecuador and northern Chile. It consists of three well-defined geographic zones, running north and south, roughly parallel to one another: (1) a narrow western coastal plain, where a hot desert is crossed by rivers, creating habitable, fertile valleys; (2) the great Cordillera of the Andes, whose high peaks hem in plateaus of a temperate climate; and (3) the eastern slopes of the Andes, a hot, humid jungle. Highly developed civilizations flourished both on the coast and in the highlands, but their origins are still obscure. These civilizations and their arts succeeded one another with rough correspondence to the Mesoamerican chronology.

CHAVÍN

Evidence indicates that, in the first millennium B.C., a cult began to grow that, at its height, prevailed over great portions of the coast and highland areas.* The cult is called Chavín, after the ceremonial center of Chavín de Huantar, which is located in the northern highlands and consists of a number of stone-faced, pyramidal platforms penetrated by narrow passageways and small chambers, surrounding a sunken court.

Chavín de Huantar is famed, too, for its stone carvings. Associated with the architecture and consisting of much sunken relief on panels, lintels, and columns and some rarer instances of sculpture in the round, Chavín sculpture is essentially linear, hardly more than incision. Freestanding sculpture is represented by an immense cult image in the center of the oldest structure, as well as by heads of mythological creatures tenoned into the exterior walls. Although, at first glance, the subject matter of Chavín stone carving appears to exhibit considerable variety, the emphasis is most consistently on composite creatures that combine feline, avian, reptilian, and human features. The *Raimondi Stone* (FIG. **14-17**), which was

*On the basis of recent discoveries, archeologists are now concluding that Chavín culture was the culmination of developments that began some two thousand years earlier in other Andean regions. Complex ancient communities documented by radiocarbon dating as having been built from one thousand to twenty-five hundred years before Chavín are changing researchers' assessments of early New World cultures. Work at such sites as Aspero, Sechín Alto, and Pampa de las Llamas-Moxeke indicates that planned communities boasting monumental architecture, organized labor systems, and bright, multicolored adobe friezes dotted the narrow river valleys that drop from the Andes to the Pacific Ocean centuries earlier than previously thought.

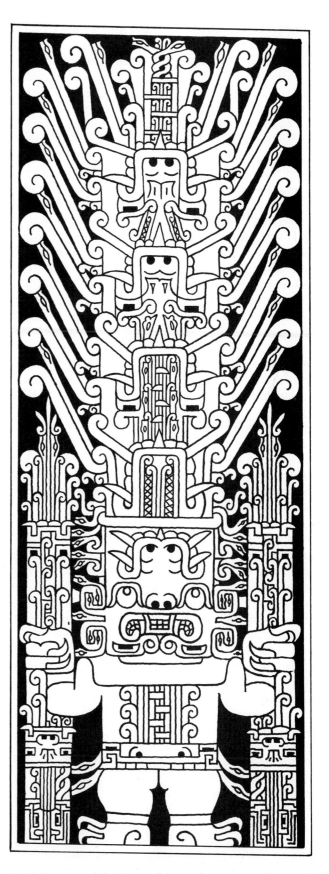

14-17 Drawing of the *Raimondi Stone*, from principal pyramid, Chavín de Huantar, Peru, first millennium B.C. Incised green diorite, 6' high. Instituto Nacional de Cultura, Lima, Peru.

named after its discoverer, is representative of the late variant of Chavín stone carving. On the lower third of the stone is a figure called the "staff god," versions of whom have been encountered from Colombia to northern Bolivia, but seldom with the degree of elaboration found at Chavín. In this instance, the squat, scowling deity, who is always depicted holding staffs, is shown with his gaze directed upward. An elaborate headdress dominates the upper two-thirds of the slab. Inverting the image reveals that the headdress is composed of a series of fanged, jawless faces, each emerging from the mouth of the one above it. Snakes abound; they extend from the deity's belt, forming part of the staffs; serve as whiskers and hair for the deity and the headdress creatures; and, finally, form a guilloche at the apex of the composition.

The ceramic vessels of the northern Chavín area are identified easily by their massiveness of chamber, spout, and surface relief. The motifs are much like those found on Chavín stone carvings. The stirrup spout became popular at this time and continued to be a commonly used North Coast form until the advent of the Spaniards.

MOCHE (MOCHICA)

The great variations within Peruvian art styles are exemplified by two coastal traditions that developed during the period between about 200 B.C. and A.D. 600 in the cultures of the Moche in the north and the Nasca in the south.

The Moche concern with ritual is reflected clearly in their ceremonial architecture and ceramic vessels. The former consisted of immense, pyramidal, supporting structures for temples that, due to the scarcity of stone, were constructed of sun-dried mud brick or adobe. Their scale may be surmised from the remains of the Temple of the Sun in the lower Trujillo Valley, which utilized millions of adobes. The temple atop it already had disappeared by the advent of the Spaniards. As a result of persistent treasure hunting by early colonial residents, only a remnant of the original pyramid remains.

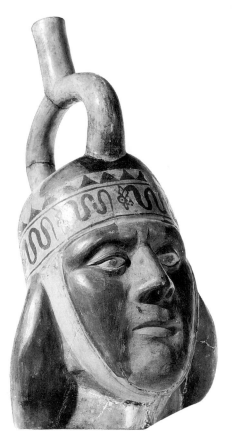

14-18 Portrait bottle, Moche, Peru, fifth to sixth century. Ceramic, 11½" high. American Museum of Natural History, New York.

Probably the most famous art objects produced by the ancient Peruvians are the ceramic vessels of the Moche, which were predominantly flat-bottomed, stirrup-spout jars, molded without the aid of a potter's wheel and generally decorated with a bichrome slip. (Their abundance can be credited to the ancient Peruvian practice of seeing that the dead were accompanied in the grave by many offerings.) Moche potters continued to employ the stirrup spout, making it an elegant tube much more slender than the Chavín prototype. This refinement may be seen in one of the famous Moche portrait bottles (FIG. 14-18), believed to be either a warrior or a priest. In early bottles of this

SOUTH AMERICAN CHRONOLOGY: CENTRAL ANDES

	2000 B.C.		1000		B.C. A.D.		1000		1534
PRECERAMIC PERIODS	INITIAL PERIOD		EARLY HORIZON		EARLY INTERMEDIATE PERIOD	MIDDLE HORIZON	LATE INTERMEDIATE PERIOD	LATE HORIZON	
			Chavin *Chavín de Huántar*		Moche (Mochica) *Sipán* *Moche* Nasca	Tiahuanaco	Inca *Machu Picchu*		

type, the sculptured form was dominant; in time, however, linear surface decoration came to be employed equally.

Warrior and priest are one and the same for the incumbent of a rich tomb recently (1988) excavated near the little village of Sipán on the arid northwest coast of Peru. The unlooted tomb and a pottery cache nearby have yielded a treasure of golden artifacts and more than a thousand ceramic vessels. The tomb's discovery has made a great stir in the world of archeology, contributing immensely to our knowledge of Moche culture, and elevating the Moche above the Inca in importance. Located beneath a large adobe platform adjacent to two high but greatly eroded pyramids, the tomb had escaped the attention of village grave robbers. The splendor of the funeral trappings that adorned the body of the "warrior-priest" (as he has been called), the quantity and quality of the sumptuous accessories, and the bodies of the retainers buried with him in this tomb indicate that he was a personage of the highest rank. Indeed, he may have

been one of the warrior-priests so often pictured on Moche ceramic wares (and in this tomb, on a golden, pyramid-shaped rattle), assaulting his enemies and participating in sacrificial ceremonies, wherein victims' throats were slit and their blood drunk from ornamental cups.

An ear ornament of turquoise and gold found in the tomb shows a warrior-priest clad much like the dead man (FIG. **14-19**). Represented frontally, he carries a war club and shield and wears a necklace of owls' heads. The figure's bladelike, crescent-shaped helmet is a replica of the large golden one buried with the warrior-priest. The ear ornament of the image is a simplified version of the piece on which it is portrayed. The nose guard, which is removable, and the golden chin guard, also are like those worn by the deceased. Two retainers, with similar helmets and ear ornaments, are shown in profile.

Though the Andean cultures did not develop a system of writing, they had an advanced knowledge of metallurgy long before the Mesoamericans, who

14-19 Ear ornament, from a tomb chamber, Moche, from Sipán, northwestern Peru, c. 300–700. Gold and turquoise, approx. 4⅘". Bruning Archeological Museum, Lambayeque, Peru.

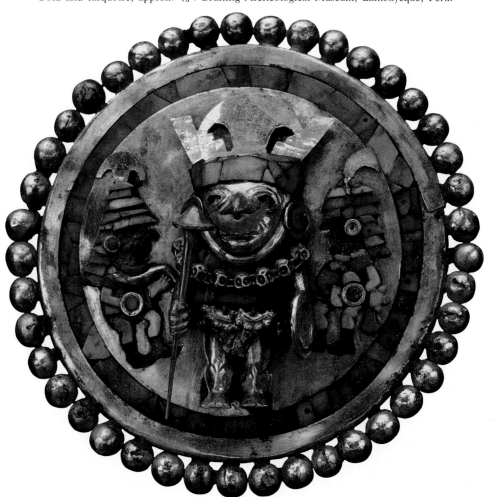

must have received it from them as late as the tenth century. Treasure of silver and gold, of course, lured the Spanish invaders to the Americas, and the wild-cat plundering of pre-Columbian tombs by grave robbers, both foreign and domestic, continues to scatter precious artifacts worldwide. Needless to say, this hampers the work of archeology. The value of the Sipán find is incalculable for what it reveals about the Moche culture. Moche craftsmanship in gold and other metals and their sophisticated ceramic production place them among the most ingenious cultures of North and South America.

NASCA

Although the Nasca rarely produced ceremonial architecture on a large scale, they did create a comparable art form in their ceramic vessels, which, unlike their counterparts on the north coast, had round bottoms, double spouts connected with bridges, and smoothly burnished, polychrome surfaces. The subject matter is of great variety, with particular emphasis on plants, animals, and mythological creatures. The initially elegant simplicity of their depiction evolved into a style exhibiting a marked complexity and bold stylization (FIG. **14-20**).

Nasca is not known only for its polychrome pottery. Some 1,300 kilometers of lines, drawn in complex networks on the dry surface of the Nasca Valley in southwestern Peru, have long attracted world attention as the most mysterious and gigantic works of human art. The earliest of these works trace out biomorphic figures: birds, fish, plants, and, in our example, a hummingbird (FIG. **14-21**)—a motif that, incidentally, is almost identical to hummingbirds on

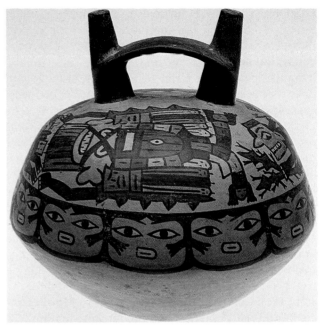

14-20 Bridge-spout vessel, Nasca, Peru, c. fifth and sixth centuries. Ceramic with slip, 5½" high. Museum of Cultural History, University of California, Los Angeles.

contemporaneous Nasca pottery. The wingspan of the hummingbird is over 200 feet. To produce figures of this scale and accuracy of proportion required some rudimentary geometry and an elementary method of measurement. Geometric forms with miles-long straight lines were drawn later, perhaps as late as Inca times. Uniformly, the Nasca Lines appear light on a dark ground, an effect produced by scraping aside the sun-darkened desert pebbles to reveal the lighter layer of whitish clay and calcite beneath.

14-21 Aerial view of a drawing of a hummingbird on Nasca Plain, Nasca, southwestern Peru, 200–600. Dark layer of pebbles scraped aside to reveal lighter clay and calcite beneath, 27" wide, 200' wingspan, and 450' total length.

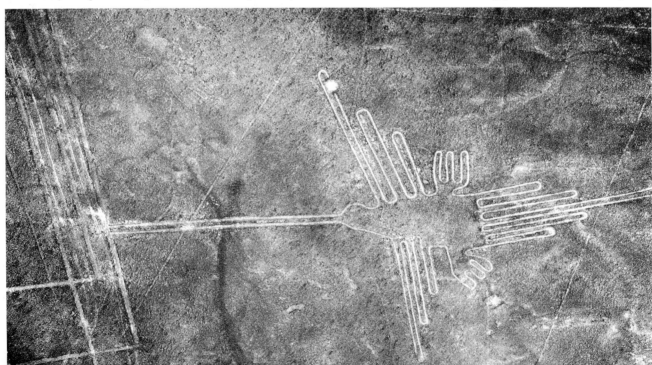

Speculation continues as to the source, construction, and meaning of the Nasca Lines. Some of the explanations are fantastic: the lines were the work of superhuman beings from outer space who arrived by spaceship or of designers of a colossal athletic field. The construction of such ingenious shapes and of such regular geometry seems nearly beyond mere human agency, especially since, given their immense length and bewildering intricacy, the lines were supposed visible only from the air. But, in fact, the lines are visible from the Andean foothills and the great coastal dunes. Moreover, they are constructed quite easily from available materials; simple stone-and-string methods can be used to lay out paths. Lines left uncompleted have guided the modern reproduction of them.

Indeed, the lines seem to be some sort of paths. They lead in traceable directions across the deserts of the Nasca drainage; they are punctuated by many shrinelike nodes, like the knots on a cord; and they converge at central places usually situated close to sources of water. They seem to be associated with water supply and irrigation, and may have become pilgrimage routes for those who journeyed to shrines by foot. They probably had astronomical and calendric functions, forecasting the onset of the planting seasons. Altogether, the vast arrangement of the Nasca Lines is a system—not a meaningless maze, but a traversable map that plotted out the whole terrain of the material and spiritual concerns of the Nasca.

TIAHUANACO

The bleak highland country surrounding Lake Titicaca in southeastern Peru contrasts markedly with the warm valleys of the coast. Isolated in these mountains, at a height of 12,500 feet, another culture developed semi-independently of the coastal cultures until 1000. The art style of this culture, named for Tiahuanaco, the principal archeological site on the southern shores of the lake, then spread to the adjacent coastal area as well as to other highland areas, extending from southern Peru to northern Chile.

Tiahuanaco was an important ceremonial center. The buildings of its Calasasaya sector were constructed of the fine stone of the region: sandstone, andesite, and diorite. Among these impressive structures is the imposing Gateway of the Sun, a huge, monolithic block of andesite, pierced by a single doorway and crowned with a sculptured lintel (FIG. **14-22**). Shrunken beneath an enormous head, the central figure, rigidly frontal, stands on a terraced step holding a staff in each hand. From the blocklike head project rays that terminate in circles and puma heads. The form recalls that of the *Raimondi Stone* (FIG. 14-17) in its frontality and in the symmetrical

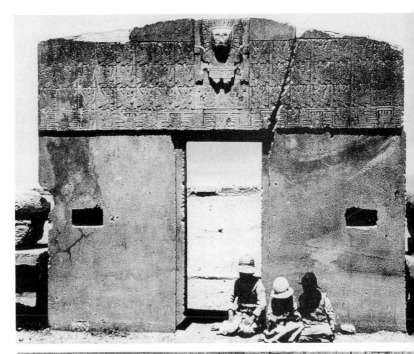

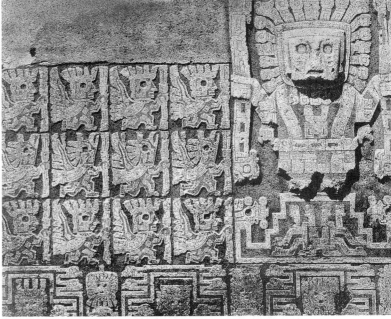

14-22 Monolithic gateway (*top*), detail (*bottom*), Tiahuanaco, Bolivia, ninth century (?).

staffs, as well as in the geometrical conventions used for human and animal representation. The "staff-god" appears in art throughout the Tiahuanaco period, associated, as here, with smaller-scale attendant figures. On this lintel the god is carved in high relief and stands out prominently against the low-relief border of rows of condors and winged men with weapons who run toward the center. Each of the running figures fills a square panel, giving an effect of movement, which quickens slightly the otherwise static formality of the composition. A border of frets

interspersed with masklike heads forms a kind of supporting lower step.

The carving method should be compared with those of the Maya (FIG. 14-9) and the Aztecs (FIG. 14-15). Here, again, flat relief is carved on a flat ground, although as mentioned, the central panel on the Sun Gate projects an extra level beyond, casting a sharp shadow. But the Tiahuanaco figures are radically abstract, the sculptured equivalent of the linear painting in the *Borgia Codex* (FIG. 14-12). By abstractive distortion of bodily proportion and suppression of descriptive detail, the figures are reduced almost to pictographs; they are more symbols than images.

INCA

The Inca were a small highland tribe who established their rule in the valley of Cuzco, with the city of Cuzco as their capital. Between the thirteenth and the fifteenth centuries, they gradually extended their power until their empire stretched from Quito in Ecuador to central Chile, a distance of more than three thousand miles.

The dimensions of this vast empire required skillful organizational and administrative control, and the Inca had rare talent for both; in this respect, they resemble the imperial Romans. Without writing, but with ingenious maps and models, they divided the empire into sections and subsections, provinces and communities, the boundaries of which all converged on, or radiated from, Cuzco. Their organizational tal-

ent was matched by their constructional prowess; they were skillful engineers, who knitted together the fabric of empire with networks of roads and bridges. They established a highly efficient, swift communication system of runners who used their excellent road system to carry messages the length of the empire in relays. The Inca mastered the difficult problems of Andean agriculture with expert terracing and irrigation. They were metallurgists and mined extensively, accumulating the fabled troves of gold and silver that motivated Pizarro to conquer them.

Although the Inca aimed at imposition of their art style throughout their realm, objects of pure Inca style were confined to areas that came under the power of Cuzco. The Inca were concerned not so much with annihilating local traditions as with subjugating them to those of the empire. Local styles, although they sometimes came to employ a few Inca features, continued to be produced in areas marginal to the centers of Inca power.

Like the Romans, the imperial Inca were great architects. They valued the building art highly and drew their professionals from the nobility. Unlike the Romans, who built in concrete, the Inca were supreme masters of shaping and fitting stone. In addition, they had an almost instinctive grasp of the proper relation of architecture to site. As a militant, conquering people they selected sites fortified by nature and further strengthened them by building various defensive structures.

14-23 Aerial view of Machu Picchu, Inca, Peru, c. 1500.

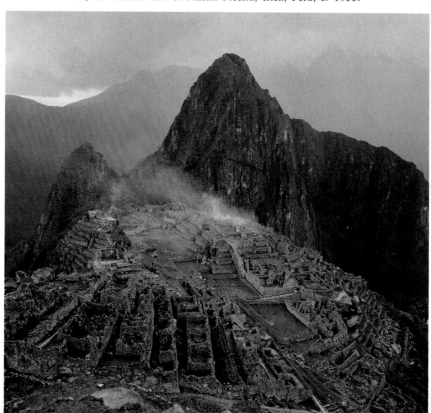

Machu Picchu (FIG. **14-23**) was an Inca city built to protect the highlanders from attacks by lowland tribes living in the Amazonian jungles to the east. One of the world's most awe-inspiring sights, the city perches on a ridge between two jagged peaks, 9,000 feet above sea level. Hiram Bingham, the American discoverer of Machu Picchu (1911), described one aspect of its wildly dramatic situation: "On both sides tremendous precipices fall away to the white rapids of the Urubamba River," some 1,600 feet below. In the very heart of the Andes, the site is about fifty miles north of Cuzco, and like other cities of the region, may have been part of a defensive pale around the capital. Though relatively small and insignificant among its neighbors (with a resident population of little more than a thousand), Machu Picchu is of great archeological importance as a site left undisturbed since Inca times. The accommodation of its architecture to the landscape is so complete that it seems a natural part of a geologically terraced mountain range.

We have noted the Inca as masters of stone masonry. Their technique of dry-joining ashlar construction is famous; blocks of stone were fitted together entirely without mortar. The joints of the ashlar could be beveled to show their tightness, or laid in courses with perfectly joined faces so that the lines of separation were hardly visible. The close joints of Inca masonry were produced by abrasion alone; each stone was swung in slings against its neighbor until the surfaces were ground to a perfect fit. Stones in the walls of more important buildings, like temples or administrative palaces, were usually laid in regular, horizontal courses; for lesser structures, they were laid in polygonal (mostly trapezoidal) patterns. (The trapezoid was a favorite architectural figure, commonly appearing as the shape of niches, doorways, and windows.) With Inca stonecraft, walls could be fashioned with curved surfaces, their planes as level

and continuous as if they were a single form poured in concrete. It is interesting that building techniques similar to the Inca method of walling in stone were known across the Pacific (in Cambodian temples like Ankor Thom [FIG. 11-33], monumental stone sculpture is actually built up like shaped wall).

A prime example of the single-form effect is a surviving wall from the great Temple of the Sun in Cuzco (FIG. **14-24**). The most magnificent of all Inca shrines, this structure originally was known as Coricancha (Court of Gold) and was dedicated to the worship of the Supreme Being of the Inca, Viracocha. Viracocha ruled over all the gods of nature, the sun, moon, stars, and the elements. Sixteenth-century Spanish chroniclers wrote in awe of the gold and silver splendor of Coricancha: the interior was veneered with sheets of gold, silver, and "emeralds" (turquoise). "It was," wrote one, "one of the richest temples there was in the world." During the Inca revolt against the Spaniards in the 1530s, the temple was destroyed. Later, the church of Santo Domingo, in the Spanish colonial style, was erected on what remained of it, the curved section of wall serving as the foundation of the apse.

The hewn stones, precisely fitted and polished, form a curving, semiparabola (a sickle-shape) and are set in such a way as to be flexible in earthquakes, allowing for a temporary dislocation of the courses, which return to their original position. A violent earthquake in 1950 seriously damaged the church; the wall was left standing, and much of the original substructure of the temple came into view, with its chambers, courtyards, and trapezoidal niches and doorways. Santo Domingo has been rebuilt, and now the two contrasting architectural styles stand one atop the other (FIG. 14-24).

The Coricancha is of more than architectural and archeological interest. It is a symbol of the Spanish conquest of the Americas and serves as a composite

14-24 Temple of the Sun (now church of Santo Domingo, *left*), detail of wall showing Coricancha masonry (*right*), Inca, Cuzco, Peru, fifteenth century.

monument to it—one civilization built on the ruins of another. We perceive at once the enduring tension between the native and the foreign arts, the theme we stated at the beginning of this chapter.

NORTH AMERICA

The styles and objects of the cultures native to North America are well known, beginning with the period of prolonged contact with Europeans. We also have considerable knowledge of many earlier forms and styles, although our information is not nearly as extensive as our knowledge of earlier periods in South America and Mesoamerica. In many parts of the United States and Canada, "prehistoric" cultures have been discovered that reach back as far as twelve thousand years; most of the finer art objects, however, come from the last two thousand years. "Historic" cultures, beginning with the earliest date of prolonged contact with Europeans, which varies from the sixteenth to the nineteenth century, have been widely and systematically recorded by anthropologists. The material objects from these cultures usually reflect profound changes wrought by the impact of alien tools, materials, and values on the native peoples.

Scholars divide the vast and varied territory involved into a number of areas on the basis of relative homogeneity of language and culture patterns. We will briefly discuss both prehistoric and historic art forms from most of these culture areas in this section.

Prehistoric Era

Eskimo (Inuit) sculpture, often severely economical in the handling of form, is at the same time refined—even elegant—in the placement and precision of both geometric and representational incised designs. A carved ivory burial mask (FIG. **14-25**) from the Ipiutak culture (*c.* 300) is composed of nine carefully shaped

14-25 Set of burial carvings, Ipiutak, *c.* 300. Ivory, greatest width 9½″. American Museum of Natural History, New York.

parts that are interrelated to produce several faces, both human and animal, in the manner of a visual pun. The mask is a confident, subtle composition in shallow relief, a tribute to the artist's imaginative control over his materials. Over the centuries, Eskimos also have carved hundreds of small human and animal figures (usually in ivory) and highly imaginative "mobile" (with moving parts) masks used by shamans (FIG. **14-26**) that, due to their fanciful forms and odd juxtapositions of images and materials, were much appreciated by Surrealists in the 1920s.

Early Native American artists also excelled in working stone into a variety of utilitarian and ceremonial objects. The quite realistic handling of the so-called

NORTH AMERICAN CHRONOLOGY

1000 B.C.		B.C. A.D.	1000	1500	1990	
PREHISTORIC ERA*					HISTORIC ERA	
Adena-Hopewell		Ipiutak	Kuaua Pueblo		Navajo	
			Mississippian		Hopi	
					Chilkat, Haida, Kwakiutl, Tlingit	
					Iroquois	
			Mesa Verde		Crow	
					Mandan	
			Mimbres			

*Culture placements in the Prehistoric era reflect not just a period designation but actual chronological positioning.

14-26 Eskimo mask representing a moon goddess, before 1900. The Robert H. Lowie Museum of Anthropology, Berkeley, California.

14-27 Adena pipe, Adena, *c.* 1000–300 B.C. Stone, 8″ high. Ohio Historical Society, Columbus.

14-28 Incised shell gorget, Mississippian culture, from Sumner County, Tennessee, *c.* 1200–1500. 4″ wide. Museum of the American Indian, New York.

Adena pipe (FIG. **14-27**), a figural pipe bowl dated between 1000 and 300 B.C., provides an interesting contrast to the two-dimensional, more animated composition on a shell gorget (FIG. **14-28**) found at a Mississippian culture site in Tennessee and dating from the Temple Mound II period (*c.* A.D. 1200–1500). The standing pipe figure, although simplified, has naturalistic joint articulations and musculature, a lively, flexed-leg pose, and an alert facial expression—all of which combine to suggest movement. The incised shell gorget depicts a kneeling personage with an elaborate headdress, who carries a mace in his left hand and a severed human head in his right. Most Adena and Mississippian objects come from burial and temple mounds and are thought to have been gifts to the dead to ensure their safe, prosperous arrival in the land of the spirits. Other art objects found in such contexts include fine mica and embossed copper cut-outs of hands, bodies, snakes, birds, and other presumably symbolic forms.

Serpent Mound (FIG. **14-29**) in Adams County, Ohio, one of the larger Native American creations, is an artistic transformation of the natural environment. Undoubtedly made for spiritual purposes, this monument is a spectacular prehistoric example of the universal practice of creating visually impressive settings for ceremonial activities. The serpent, which has been restored, is about a quarter of a mile long. Other effigy mounds are known, and complex platformed

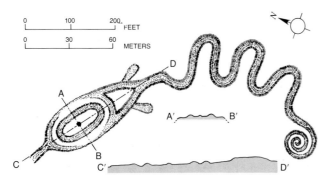

14-29 Serpent Mound, Adams County, Ohio. Approx. 1,400′ long.

temple mounds have been discovered. The latter, along with small, incised, shell reliefs, such as the Mississippian shell discussed earlier (FIG. 14-28), show strong influence from pre-Columbian Meso-america.

Engravings and paintings on rock are distributed widely across North America. Many of these are sacred sites and probably were used for communal rituals or the recording of personal spiritual experiences, which were very important in traditional Native American religions. Rock arts vary from lively naturalistic or schematic renderings of humans and animals to complex, convoluted compositions of as yet undeciphered symbols. The processions of linear, geometric, human (or spirit) figures picked into rock

surfaces near Dinwoody, Wyoming (FIG. 14-30), have overlays suggesting successive visits, probably for ritual purposes. Precise dating of rock art often is impossible, and, although the example shown probably was made prior to European contact, others depict horses and guns and have more naturalistic renderings, indicating a later date of execution.

Most Native American art forms (rock painting, pottery, architecture) span great periods of time. Detailed chronological sequences of pottery styles are, in fact, the historian's major tool in dating and reconstructing the cultures of the distant past, especially in the Southwest, where written records were unknown. Many fine specimens of ceramics from the Southwest date from before the Christian era until the present day, but pottery became especially fine, and its decoration most impressive, after about 1000.

A thirteenth-century bowl (FIG. 14-31) from the Mimbres culture has an animated, graphic rendering of a warrior with a shield in a composition that creates a dynamic tension between the black figuring and the white ground. Thousands of different compositions are known from Mimbres in the Southwest. They range from lively and often complex geometric patterns to fanciful, often whimsical pictures of humans and animals; almost all are imaginative creations of artists who seem to have been bent on not repeating themselves. Designs are created by linear rhythms balanced and controlled within a clearly de-

14-30 Human figures engraved on a sandstone cliff, prehistoric Shoshone (?), Dinwoody, Wyoming. Panel, 8′ 2″ × 18′.

14-31 Bowl, Mimbres, thirteenth century. Ceramic, diameter 9″. Peabody Museum, Harvard University, Cambridge, Massachusetts.

In the later centuries of the prehistoric era, Native Americans of the Southwest constructed many architectural complexes that reflect masterful building skills and impressive talents of spatial organization. Of the many ruins of such complexes, Cliff Palace at Mesa Verde, Colorado, and Pueblo Bonito at Chaco Canyon in New Mexico are among the best known. Cliff Palace (FIG. **14-32**) occupies a sheltered ledge above a valley floor and has about two hundred rectangular rooms (mostly communal dwellings) in several stories of carefully laid stone or adobe and timber; twenty larger circular underground structures, called *kivas*, were the spiritual and ceremonial centers of Pueblo life. Pueblo Bonito contains similar rooms but contrasts with Mesa Verde in its open site and, especially, in its superbly unified plan. The whole complex is enclosed by a wall in the shape of a giant D. The careful planning suggests that it was designed by a single architect or master builder and constructed by hundreds of workers under a firm, directing hand. Modern terraced pueblos, like Taos in New Mexico, although impressive, reflect neither such unified design nor such a massive, well-organized building effort.

fined border. Because the potter's wheel was unknown in the Southwest, countless sophisticated shapes of varied size were built by the coiling method. These ceramics are always characterized by technical excellence.

Between 1200 and 1400, long before Europeans arrived in the New World, ancestors of the present-day Hopi and Zuñi decorated their kivas with elaborate mural paintings representing deities associated with agricultural fertility. The detail of the Kuaua Pueblo

14-32 Cliff Palace, Mesa Verde National Park, Colorado, c. 1100.

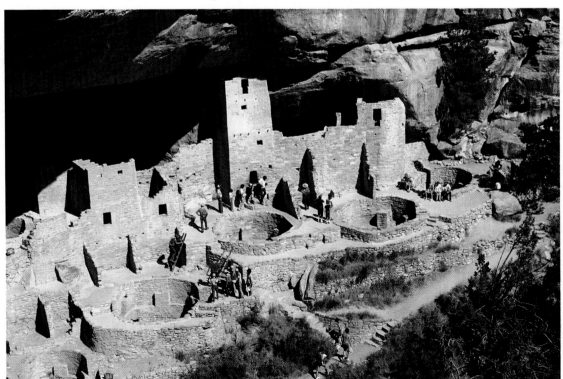

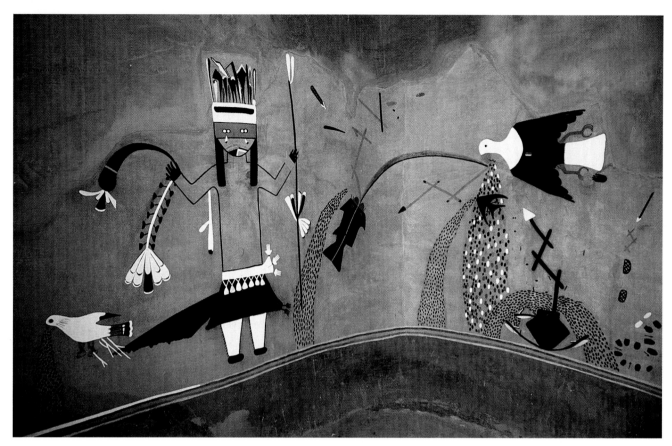

14-33 Detail of a kiva painting from Kuaua Pueblo (Coronado State Monument), New Mexico, c. 1300–1500. Museum of New Mexico, Santa Fe.

mural shown (FIG. **14-33**) depicts a "lightning man" on the left side. Fish and eagle images (associated with rain) appear on the right side. Seeds, a lightning bolt, and a rainbow stream from the eagle's mouth. All of these figures are associated with the fertility of the earth and the life-giving properties of the seasonal rains.

Historic Era

SOUTHWEST

Obviously, the motivations, functions, and means of art forms from the historic period are better known than those of the art forms from earlier eras; while the complex prehistoric religious murals from the Southwest are hard to interpret, Navajo sand painting, an art that still survives, is susceptible of detailed elucidation. The highly transient sand paintings, constructed by artist-priests to the accompaniment of prayers and chants, are an essential part of ceremonies for curing disease. (In the healing ceremony, the patient sits in the center of the painting to absorb the healing, life-giving powers of the gods and their representations.) Similar rites are performed to assure success in hunting and to promote fertility in human

beings and nature alike. The natural materials used (corn pollen, charcoal, and varicolored, powdered stones) play a symbolic role that reflects the Native Americans' preoccupation with the spirits and the forces of nature. The paintings, which depict the gods and mythological heroes whose help is sought, are destroyed in the process of the ritual, so that no models exist; still, the traditional prototypes, passed on from artist to artist, must be adhered to as closely as possible. Mistakes can render the ceremony ineffective. Navajo dry-painting style is rigid—composed of simple curves, straight lines, and serial repetition—despite the potential freedom of freehand drawing (FIG. **14-34**). Navajo weaving and silver jewelry making are later developments that, until very recently, have met high technical and artistic standards.

Another art form from the Southwest, the Kachina spirit mask, contrasts markedly with the Northwest Coast and Eastern Woodlands masks. The Hopi spirit mask of a rain-bringing deity (FIG. **14-35**) is painted in geometric patterns based on rainbow, cloud, and flower forms. The more expressionistic handling of human physiognomy is quite obvious in the Northwest Coast and Eastern Woodlands masks (FIGS. 14-36 and 14-42).

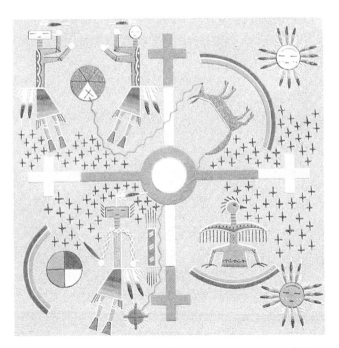

14-34 Ceremonial dry painting, Navajo, Arizona, modern.

14-35 Kachina spirit mask, Hopi, late 1890s. 22″ high. Museum of the American Indian, New York.

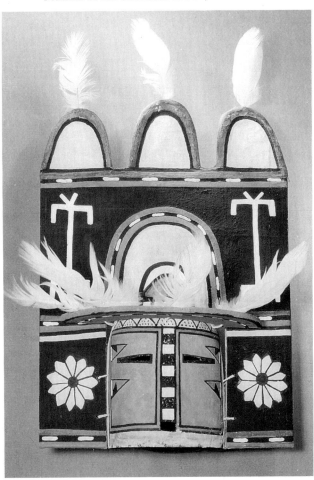

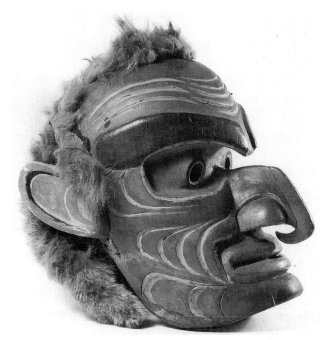

14-36 Mask, Kwakiutl, *c.* 1890. Approx. 13¼″ high. Denver Art Museum.

NORTHWEST COAST

Working in a highly formalized, subtle style, the Native Americans of the Northwest Coast have produced a wide variety of art objects: totem poles, masks, rattles, chests, bowls, clothing, charms, and decorated houses and canoes. Masks were carved for use by shamans in their healing rites and by others in public reenactments of "spirit quests." The animals and mythological creatures encountered on such quests were, in turn, represented in masks and a host of other carvings. The mask from the Kwakiutl people (FIG. **14-36**) owes its dramatic character to the exaggeration of facial parts and to the deeply undercut curvilinear depressions, which result in strong shadows. It is a refined, yet forceful carving typical of the more expressionistic styles of the area. Others are more subdued, and some, like a wooden Tlingit helmet (FIG. **14-37**), are exceedingly naturalistic, probably actual portraits, almost as if the artist were proving that no restrictions could be set on artistic representation. Inherited motifs and styles usually were preferred, however, above radical new departures. Although Northwest Coast arts have a spiritual dimension, they are more important as expressions of social status, in that the art form one uses and, indeed, the things one may depict, are functions of that status. Haida mortuary poles and house frontal poles (FIG. **14-38**), used where totemic crest emblems of clan groups are displayed before the clan chief's house, are striking expressions of this interest in social status.

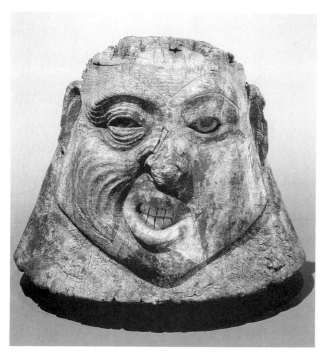

14-37 Helmet, Tlingit. Wood, 12″ high. American Museum of Natural History, New York.

14-38 Haida mortuary poles and house frontal poles at Skedans Village, British Columbia, 1878. National Archives, Canada. (After a photograph by GEORGE M. DAWSON.)

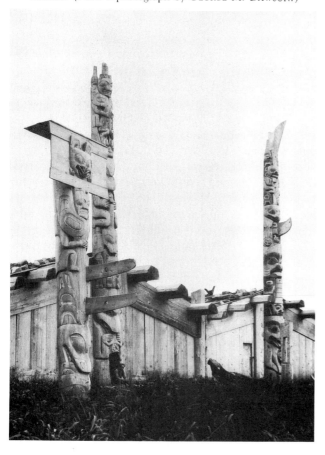

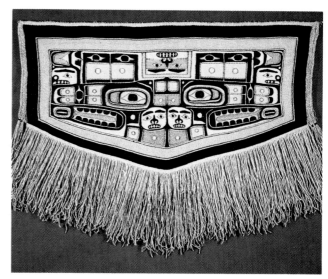

14-39 Chilkat blanket with stylized animal motifs, Tlingit, early twentieth century. Wild goat's wool and cedar bark in bright colors, 72″ × 35″. Southwest Museum, Los Angeles.

Another characteristic Northwest Coast art form is the Chilkat blanket (FIG. **14-39**). Male artists provided the designs for these blankets in the form of pattern boards from which female weavers worked. The blankets, which became widespread prestige items of ceremonial dress during the nineteenth century, display several recurrent characteristics of the Northwest Coast style: symmetry and rhythmic repetition, schematic abstraction of animal motifs (in the blanket illustrated, a bear), eye designs, a regularly swelling and thinning line, and a tendency to round off corners.

Elegant, precise, and highly accomplished technically, the art of the Northwest Coast is held by many to be one of the sophisticated high points of Native American artistic accomplishment.

GREAT PLAINS

Artists of the Great Plains worked in materials and styles quite different from those of the Northwest Coast. Much artistic energy went into the decoration of leather garments, first with compactly sewn quill designs and later with beadwork patterns. Tepees, tepee linings, and buffalo-skin robes were painted with geometric and stiff figural designs prior to about 1830; after that, naturalistic scenes, often of war exploits, in styles adapted from those of visiting European artists, were gradually introduced. After the Europeans introduced the horse to North America and the establishment of colonial governments disrupted settled indigenous communities on the east coast, a new, mobile Native American culture flourished for a short period of time on the Great Plains. The tepee lining illustrated (FIG. **14-40**) is of that later

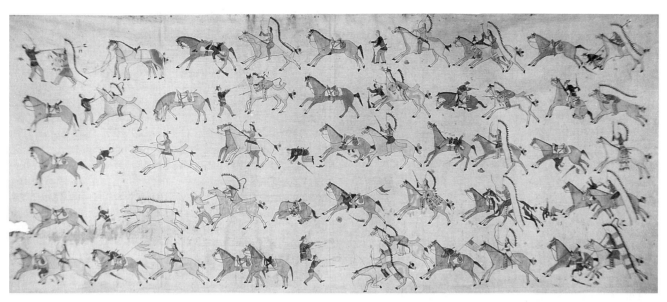

14-40 Tepee lining with pictograph of war scenes, Crow, late nineteenth century. Painted muslin, 2′ 11″ × 7′ 1″. Smithsonian Institution, Washington, D.C.

style, when realistic action and proportions, careful detailing, and a variety of colors were employed.

Because, at least in later periods, most Plains peoples were nomadic, their esthetic attention was focused largely on their clothing and bodies and on other portable objects, such as shields, clubs, pipes, tomahawks, and various containers. Transient but important Plains art forms sometimes can be found in the paintings and drawings of visiting white artists. The Swiss KARL BODMER, for example, accurately portrayed the personal decoration of Chief Four Bears (Mato-Tope, FIG. **14-41**), a Mandan warrior and chief. The chief's body paintings and feather decorations, all symbolic of his affiliations and military accomplishments, may be said to be his biography—a composite artistic statement in several media—which could be "read" easily by other Native Americans. Plains peoples also made shields and shield covers that were both artworks and "power images." Shield paintings often derive from religious visions; their symbolism, the pigments themselves, and added materials, such as feathers, provided their owners with magical protection and supernatural power.

EASTERN WOODLANDS

Artists of the Eastern Woodlands made quilled and beaded objects and items of clothing, often decorated with curvilinear, floral motifs. The Iroquois also carved compelling, expressionistic masks (FIG. **14-42**) for use in the False Face Society ceremonies, which healed physical and psychological sickness and cleansed whole communities of destructive impurities. The spirit "faces" portray legendary supernaturals whose exploits are recounted in mythology. Bold

14-41 KARL BODMER, *Mandan Chief Mato-Tope*, 1840. Lithograph, 14″ × 10″. The Thomas Gilcrease Institute of American History and Art, Tulsa, Oklahoma.

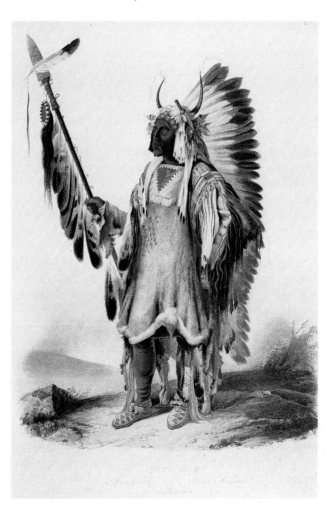

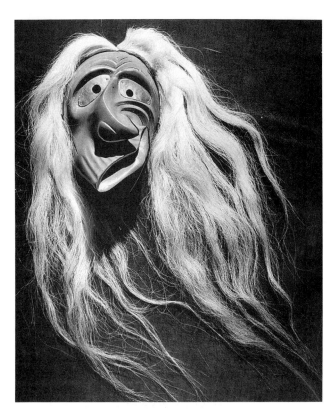

14-42 ELON WEBSTER, False Face mask, Iroquois, 1937. Wood. (The artist was an Onondaga of the Tonawanda Reservation.) Courtesy of Cranbrook Institute of Science, Bloomfield Hills, Michigan.

in conception, these masks rely on a dramatizing distortion and exaggeration of facial features for their strong effects. Like others used in Africa and Oceania, these masks must be hidden when not in use, lest their power inadvertently cause injury.

Whether secular and merely decorative or spiritual and highly symbolic, the diverse styles and forms of Native American art testify to the ancient and continuing artistic sensibility of the peoples of North America. Their creative use of local materials and pigments constitutes an artistic reshaping of nature that, in many cases, reflects the Native Americans' reliance on and reverence toward the environment that they considered it their privilege to inhabit.

AFRICA

The population of the huge continent of Africa is subdivided into several racial and linguistic groups. Although nearly all African peoples have produced artists (dancers, musicians, storytellers, rock painters, architects, and masters at personal decoration), only those groups dwelling in the vast areas drained by the Niger and Congo rivers—essentially, tropical Africa—have produced the extraordinary sculptures,

mostly in wood, that deservedly have become famous as "African art." It is largely this art that we will survey here.

Africa is as widely varied artistically as it is sociopolitically, geographically, ecologically, linguistically, and racially. Divine rulers headed great kingdoms, and groups of elders governed small tribes; forest regions along the coast give way inland to grassy savannas and highlands and, in turn, to the semiarid lands south of the Sahara desert.

Like North America, Africa has hundreds of Neolithic rock painting sites, especially in the Tassili region of the Algerian Sahara, which contain the earliest examples of its art. These paintings and engravings, which are considerably more recent than the Paleolithic works found in Spain and southern France, are equally accomplished renderings of humans, animals, and a host of nonrepresentational patterns thought to be symbolic.

NIGERIA

From a number of archeological sites collectively labeled Nok, we have precise radiocarbon dates of between 500 B.C. and A.D. 200. The earliest African evidence of sculpture in the round was found at these sites. Because they are so confidently handled, Nok terra-cotta heads (FIG. **14-43**) and figures of humans

14-43 *Jemaa Head*, from Nok, fifth century B.C. Terra-cotta, $9\frac{13}{16}$" high. National Museum, Lagos, Nigeria.

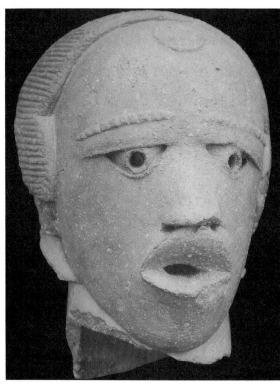

and animals suggest wooden or other clay proto-
types, now lost. No "formative" prototypes are yet
known. Volumes are full and surfaces are modeled
smoothly in these terra-cotta sculptures, which some
authorities believe to be direct ancestors of terra cot-
tas and bronzes found at Ife (150 miles southwest of
the Nok area) that date from 1000 to 1200.

By about the ninth century, at Igbo Ukwu in tropi-
cal Africa, sophisticated cire perdue (lost-wax) casting
techniques had evolved, and, by the twelfth century,
the most naturalistic style known for any tropical Af-
rican era had appeared. Wood carvings certainly were
made in the twelfth century, too, but no examples
have survived. The bronze figure illustrated here
(FIG. **14-44**) undoubtedly is an ancient, divine king of
Ife, the city in western Nigeria that is still the spiritual
capital of the numerous Yoruba peoples. The king fig-
ure, unlike most African wood sculpture, shows
fleshlike modeling that attempts a realistic rendering
of the human form. The idealized naturalism of the

14-44 Ife king figure, Yoruba, tenth to twelfth century.
Bronze, 18½″ high. Ife Museum, Nigeria.

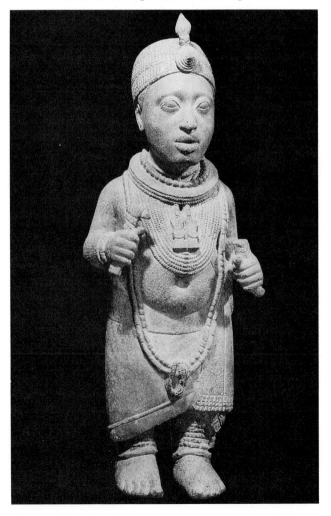

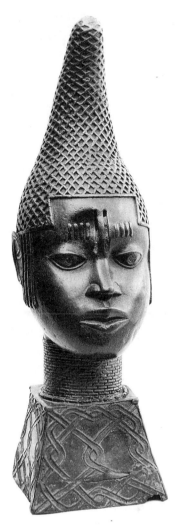

14-45 *Queen Mother Head*, from Benin, early sixteenth
century. Bronze, 20″ high. National Museum, Lagos, Nigeria.

flesh and head in this figure approaches portraiture,
although its proportions, which exaggerate the head,
are not lifelike. The casting is fine, though somewhat
weathered, and accurately records precise details of
the costume and jewelry worn by ancient Ife kings.

Numerous historical and ritual ties are known to
have existed between the divine kings of Ife and
those who presided over the kingdom of Benin,
which was ascendant from the fifteenth to the eigh-
teenth centuries. Many complex, finely cast bronzes,
as well as ivory, wood, terra-cotta, and wrought-iron
sculptures, were produced in Benin, where bronze
casting and ivory carving were royal prerogatives car-
ried out by guilds of highly trained professionals.

An exquisite bronze portrait of a royal lady (FIG.
14-45) shows the Ife-Benin style at its classic height.
Cast in the cire perdue process, the head seems to be
designed on principles of form familiar in Greek ide-
alizing art; the naturalistic traits of the subject are
simplified into near-geometric volumes. In any event,

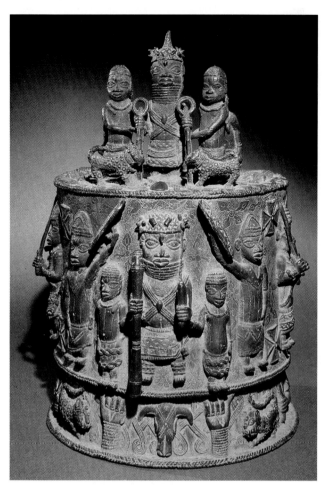

14-46 *Altar of the Hand,* 1550–1680, Benin, from Nigeria. Bronze, 17½″ high. British Museum, London.

the Benin queen and related portraits in clay and bronze contrast noticeably in their realism of proportion and likeness with much of the African sculpture we are surveying in this chapter. The queenly beauty wears a high, conoid, basket-weave headdress, plaited side curls, and a wide, tight choker; ornamental scars adorn her forehead. The serene and proud composure of her expression is reinforced by the formal control of the elegant surfaces and contours. The perfect unity of form and expression achieved here places this portrait sculpture among the masterpieces of world art.

Much Benin art, like the gilded objects of the Ashanti further west, glorifies the office and trappings of the divine king. The divine king is the central figure in the casting shown in FIG. **14-46** and in many other works. As in the Ife king figure (FIG. 14-44), the head here is greatly exaggerated, reflecting the view that it is the center of being and the source of power and intelligence. Taken together with the hieratic arrangement of the group, this distortion clearly affirms the importance of symbolism to the artist.

The Ijo Iphri sculpture (FIG. **14-47**) manifests the symbolism of power in a less centralized culture than that of Benin. The "owner of the power" is seen sitting atop a monstrous animal (symbolic of his own aggressiveness), holding a fan and libation vessel. This Ijo piece seems more expressionistic in form and freer in invention than the more court-regulated style at Benin (FIG. 14-46).

In understanding the range and quality of African art, customary definitions must be broadened to include more than monuments, more than objects that can be displayed in museums. This observation is especially true of the art of masquerade, which depends on music, dance, and costuming for its real vitality. Although many of the wooden masks used in

14-47 Iphri figure, Ijo, from Nigeria, nineteenth to twentieth century. Wood, 25½″ high. Metropolitan Museum of Art, New York (Michael C. Rockefeller Memorial Collection of Primitive Art, gift of the Matthew T. Mellon Foundation).

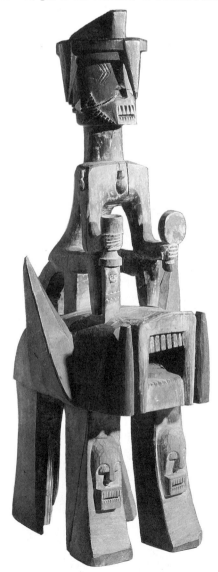

such performances are dramatic carvings in their own right, they should be seen as single, important elements in a complex of interacting artistic media that occupy time as well as space. (We noted earlier on page 502 the importance of dance and mask in the community of the native arts.)

The Yoruba Gelede masquerader from Nigeria (FIG. **14-48**), photographed in full costume and caught in motion, is a case in point. Gelede is a cult devoted to the propitiation and entertainment of powerful senior women in Yoruba communities and deities associated with witchcraft. The masqueraders perform in pairs, their rich, appliqué-panel costumes activated by vigorous dance movements. Theater and ritual combine in the dance, and the masked characters present a

14-48 Dancer of the Gelede Society of Meko, Yoruba, Nigeria, 1969.

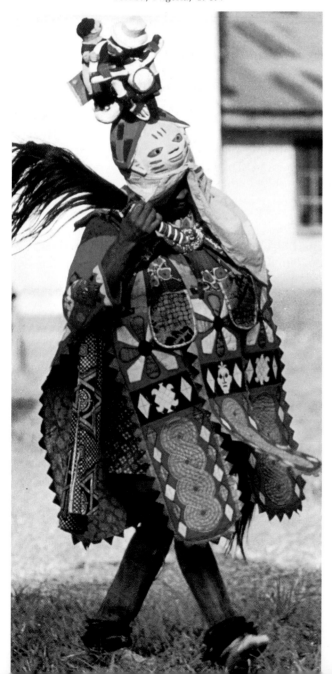

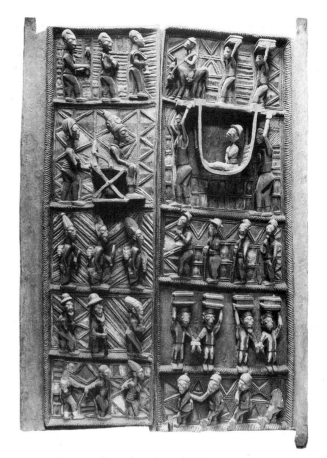

14-49 OLOWE of Ise, door from the king's palace at Ikerre, Yoruba, Nigeria, *c.* 1910. Wood, approx. 6' high. Trustees of the British Museum, London.

bewildering array of traditional and modern types: a motorcyclist, cloth seller, hunter, leopard, king, white man, prostitute, policeman. Performances involve considerable social criticism of the community at large, which is expressed in song, gesture, dance, and in the masks themselves.

The Yoruba, Africa's most prolific artists, have created an abundance of art forms other than masks: cult figures in wood, bronze, terra cotta, and iron; beaded objects and garments; as well as palace houseposts and doors designed to enhance the dignity and prestige of leaders. One such door (FIG. **14-49**), which stood at the king's palace at Ikerre, was carved by the master sculptor OLOWE of Ise (d. 1938), around 1910. It tells of the visit of a British colonial official, Captain Ambrose, to the king. In the panels on the right leaf of the door, the captain, carried in a litter, is accompanied by his guards and luggage bearers; on the left leaf, the king, his wives, and retainers await the visitor. Genre scenes and anecdotes of Yoruba life are represented in other panels. Olowe, a virtuoso woodcarver, sets his figures in such high relief that they stand almost free of the panel surface. Though recognizably of the Yoruba family, the style is distinctively

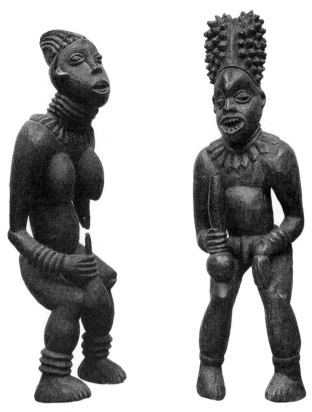

14-50 *Dancing Royal Couple*, Bangwa, from Cameroon, nineteenth century. Wood, female 33½" high, male 35½" high. Private collection.

Olowe's. The strong, elegant abstraction of the forms and the precise, facetlike carving yield the kind of expressive force that would fascinate European artists in the early decades of the twentieth century and generate a radically new, ''expressionistic'' style. Like many African artists, Olowe had a clearly recognizable personal style, although individuality and personal, idiosyncratic style are of less concern here than, for example, in the modern West.

As the prevalence of the multimedia art of masquerade suggests, dance may be the artistic medium most important and expressive to native Africans. Many sculptures are used in dance contexts, and many others depict people dancing. The vital, energetic figures from the Bangwa kingdom of the Cameroon grasslands (FIG. **14-50**) express the vigor of dance in several complementary ways: by active, asymmetrical posing; a head thrust back with open mouth; constrictions at the joints, which rhythmically energize the figures; and the use of rough textures (surfaces faceted with tool marks). The female figure is believed to portray a priestess and finder of witches. Both of these figures stood among dozens of royal carvings depicting ancestors, chiefs, and priests—those, whether living or dead, who were responsible for the continuity of life itself. Such figures, intended among the Bangwa to display the wealth, power, and taste of the ruler who presided over them, were gathered for rituals and given food and drink. The importance of artistic display to Cameroon leaders made them major patrons, as well as critics, of the arts.

Ibo *mbari* houses, like the Yoruba door (FIG. 14-49), are complex works of art. These elaborate, unified complexes consist of groupings of clay sculptures (often with more than a hundred pieces in one mbari) and paintings placed in a specially designed architectural setting. The houses are built to honor principal community deities, often the goddess of the earth. In the house shown (FIG. **14-51**), the goddess is seated with dignity in the center of the front side, her children close by; her servants, in high relief, stand guard behind her. The sculptor has enlarged and extended her torso, neck, and head to express her aloofness and power. She is the apex of a formalized, hieratic composition that is balanced on either side by seated couples.

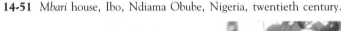

14-51 *Mbari* house, Ibo, Ndiama Obube, Nigeria, twentieth century.

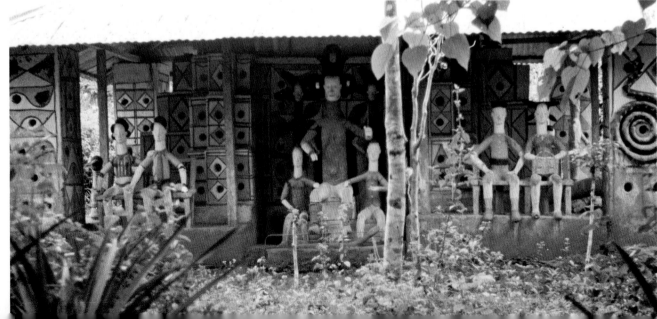

More informally posed figures and groups are found on the other sides of the house—beautiful, amusing, or frightening figures of animals, humans, and gods taken from history, mythology, and everyday life. The complex, secret mbari construction rituals, as well as the sculptural program, suggest that each house is in fact a cosmic symbol and that the building process itself is a stylized, world-renewal ritual. Ceremonies of opening the house to public view indicate that the god has accepted the offering (of the house) and, for a time at least, will be benevolent. The mbari is never repaired; instead, it is allowed to disintegrate and return to the earth from which it is made and to which it often is dedicated. These houses, then, are a relatively transient art form, as are the arts of masquerade, personal ornamentation, and festivals. (The last three are best seen on film, which preserves the movement inherent in their design.)

OTHER REGIONS

Ancestral or power images from Zaire (formerly the Belgian Congo) are more conventional sculptural forms, often carefully preserved by their owners for generations. The commemorative, ancestral mother-and-child carving from the Kongo peoples (FIG. **14-52**) has a smooth, refined delicacy, whereas the composite power figure from the Songye people several hundred miles to the east (FIG. **14-53**) deals with the human form more abstractly, in abrupt and forceful carving. The functions of the two works are comparable, both being visible manifestations of ancestral power, which can affect people's lives so materially. The Kongo piece, probably a symbolic repository of the soul of a deceased noblewoman, received prayers invoking her continuing care and beneficence; the Songye figure directed (for the benefit of the community) specific ancestral powers activated by (and to some extent contained in) various "medicines" positioned inside and on the figure. Such power figures most commonly were used to protect warriors in battle, to promote human and crop fertility, to cure disease, and to end drought.

The dramatic stylistic contrast between the Songye image and the Kongo mother and child suggests the wide range and variety of carving conventions present in Africa. Indeed, tendencies toward realism or

14-52 Ancestral figure, Kongo, from Zaire, nineteenth to twentieth century. Wood and brass, 16″ high. Musée Royal de l'Afrique Centrale, Tervuren, Belgium.

14-53 Power figure, Songye, from Zaire, nineteenth to twentieth century. Wood, iron, copper, horn, fibers, cowrie shells, feathers, and glass beads, 35″ high. Musée Royal de l'Afrique Centrale, Tervuren, Belgium.

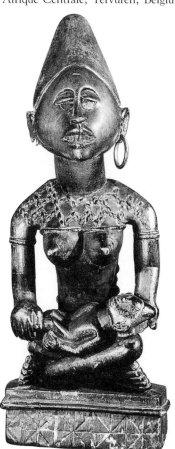

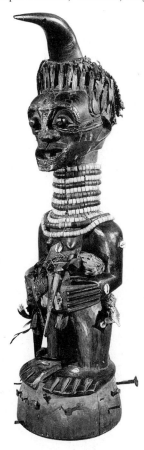

toward abstraction are not easily charted on the African map; deviations sometimes occur between neighboring tribes, within a tribe, and, occasionally, in the work of a single artist, as is the case among the Dan and related peoples of Liberia, Sierra Leone, and the Ivory Coast. Like many African peoples, the Dan evolved a great variety of masks representing judges, policemen, priests, and a host of other people, both harmful and helpful. In many cases, the role conferred by the mask was functionally real. A person wearing a judge or an executioner mask, for example, actually judged cases or executed criminals. Members of the men's masking society, armed with the power of the bush spirits and clothed in anonymous masking costumes, regulated the behavior of the community. The society also held masked entertainments, impersonating secular personages, whose behavior was held up for public scrutiny, or performing spectacular acrobatic and stilt dances.

Dan woodcarvers, required to make representations of varied spiritual and secular types, became skilled in several contrasting styles. The same artist could carve a refined, polished mask depicting a beautiful woman (FIG. **14-54**) and a rougher, highly abstracted mask called *kagle* (FIG. **14-55**). In fashioning the female mask, the carver has simplified facial planes and brought their smooth surfaces to a high polish, while retaining naturalistic shapes and the placement of features. The carver of kagle, on the

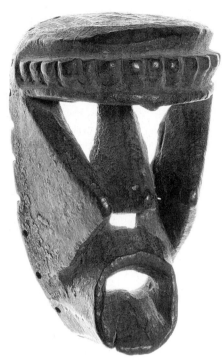

14-55 *Kagle* (mask), Dan, from Sierra Leone, c. 1775–1825. Wood, 9″ high. Yale University Art Gallery, New Haven, Connecticut (gift of Mr. and Mrs. James M. Osborn for the Linton Collection of African Art).

other hand, simplifies and abstracts, creating a series of forceful thrusting and receding positive and negative shapes with great dramatic impact.

The royal Kuba sculptors of central Zaire created an entirely different type of mask to represent a primordial ancestor who helps to oversee the ritual passage of boys into adulthood. (Many other African peoples use masks in analogous ceremonies.) The creator of the *mboom* mask illustrated here (FIG. **14-56**) employs a rich combination of beads, feathers, copper, fur, and raffia to embellish a carved, wooden helmet. A strong basic head shape with a bulging forehead is overlaid with visually complex textural effects that are Kuba symbols of royalty.

The seated male and female sculpture shown in FIG. **14-57** is an example of another well-known African style, that of the Dogon people of Mali. Depicting mythical ancestors of the human race, this group is a masterfully integrated composition of vertical forms enclosed by tubular shapes, with geometric incised decorations on the surfaces of both. Rejecting naturalistic rendering in this instance (though capable of it), the Dogon sculptor here seems to have dismantled the human body, straightening, simplifying, and distorting its parts before reassembling them. Body parts are present but often sharpened, attenuated, or reduced to suggestions. Perhaps it was this primordial couple's remoteness from life that prompted the

14-54 Mask, Dan, from Liberia, nineteenth to twentieth century. Wood, 8½″ high. Metropolitan Museum of Art, New York.

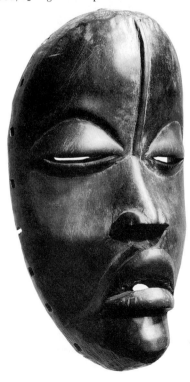

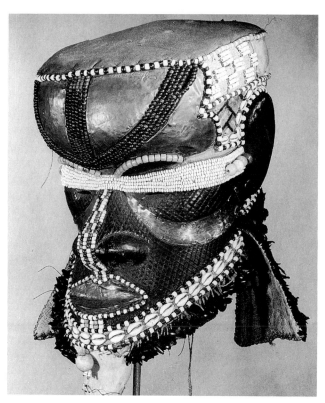

14-56 *Mboom* helmet mask, Kuba, from Zaire, nineteenth to twentieth century. Wood, brass, cowrie shells, beads, seeds, 13″ high. Musée Royal de l'Afrique Centrale, Tervuren, Belgium.

14-57 *Couple,* Dogon, Mali. Wood, 30″ high. Photograph copyright © 1975 by the Barnes Foundation.

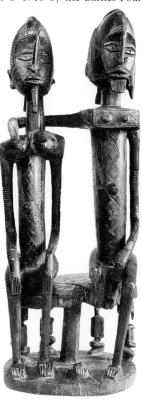

artist to work in such a schematic style. In any case, the group remains one of the great monuments of African creative genius, a strong and complex statement about human values—indeed, about the very origins of the human race itself.

Recent research among the Baule people of the Ivory Coast has led to new information regarding the male and female figures so popular in European and American private and public collections. Figures that represent spirit "marriage partners" (*blolo bla,* the male, and *blolo bia,* the female) differ neither formally nor conceptually from figures that represent wild bush spirits (*asie usu*). The main distinction is found in the surface. The asie usu (FIG. **14-58**) have a "sacrificial patina"—a surface thickly encrusted with matter accumulated when they are "fed" during sacrificial ritual; the spirit "marriage partners," on the other

14-58 *Wild Bush Spirit,* Baule, from the Ivory Coast, nineteenth to twentieth century. Wood, male figure approx. 22″ high. Metropolitan Museum of Art, New York (Michael C. Rockefeller Memorial Collection of Primitive Art, gift of Nelson A. Rockefeller, 1969).

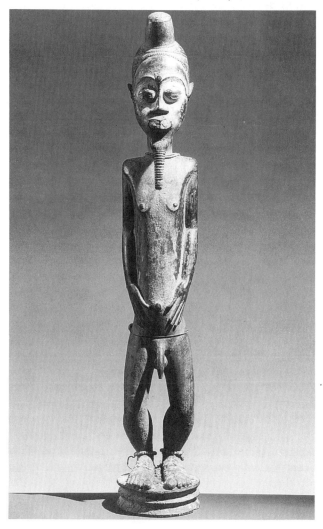

hand, are rubbed and polished, so that, in time, they acquire a smooth and shiny surface.

African arts also include beautifully decorated, utilitarian objects such as stools, chairs, pipes, and spoons; a host of sculptural as well as decorated buildings; body painting and scarification; miniature objects, such as the well-known Ashanti gold weights; finely crafted textiles and leatherwork; and countless forms of pottery and basketry. Subdivision of the arts into "fine," "decorative," and "craft" is a barrier to the understanding of African artistic sensibilities, for African arts often play a role in everyday affairs, as well as in the life-crisis rituals (initiations, funerals, and the countless other events) that punctuate human existence.

OCEANIA

Relative to the abundant records associated with Western art, only a vague chronology can be established for the arts of Oceania in the absence of documentary evidence, even though archeologists, linguists, and others have gone far in sorting out migration routes, language and racial distributions, and early aspects of Stone Age technology and social organization.

The thousands of islands that make up Oceania conventionally are divided into three cultural areas: Polynesia, Melanesia, and Micronesia. Polynesia was the last area in the world to be settled. Its inhabitants seem to have brought complex sociopolitical and religious institutions with them, and a general homogeneity of style (lacking in Melanesia) characterizes much Polynesian art, despite the relative isolation of various island groups during the several centuries prior to European exploration. Polynesian societies typically are aristocratic, with ritual specialists and elaborate political organizations headed by chiefs. Polynesian art forms often serve as a means of upholding spiritual power (mana), which is vested in the nobility and channeled by ancestral and state cults.

Melanesia certainly was settled early, and its art forms seem to suggest a variety of overlays of style and symbolism brought with a series of migrations. Art styles are numerous and extremely varied. Typical Melanesian societies are more democratic than Polynesian societies and relatively unstratified. Their cults and art forms address a host of legendary ancestral and nature spirits. Masks, absent in Polynesia, are central in many Melanesian spirit cults, and elaborate festivals, in which masks and other art forms are displayed, occur with some frequency.

Micronesia, in contrast to the other two areas, has little visual material and will not be discussed. The rich arts of Australia, though quite distinct from those of other areas, often are included in discussions of Oceanic art and will be mentioned briefly here.

Polynesia

Polynesian artists excelled in carving figural sculptures in wood, stone, and ivory in sizes that range from the gigantic fabled stone images of Easter Island to tiny ivory Marquesan ear plugs an inch long. These sculptures were generally full-volumed, monochromatic human figures, often dynamic in pose. Polynesians also were adept at making decorative bark cloth, called *tapa,* and the art of tattooing was highly developed (the word *tattoo* is of Polynesian origin).

Polynesian carving at its most dramatic is represented by the Hawaiian figure of the war god, *Kukailimoku* (FIG. **14-59**). Huge wooden images of this deity were erected on stone temple platforms that, in varied forms, were part of the apparatus of all Polynesian state religions. Although relatively small, the figure illustrated here is majestic in scale and forcefully carved to convey vigorous tensions; in short, the form possesses much of the ferocity attributed to the

14-59 *Kukailimoku,* from Hawaii. Wood, 30" high. British Museum, London.

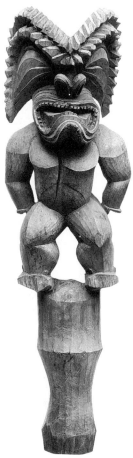

deity. Flexed limbs and faceted, conventionalized muscles combine with the aggressive, flaring mouth and serrated headdress to achieve a tense dynamism seldom rivaled in any art. This carving is the work of a master sculptor supremely confident with respect to materials and technique—a work that speaks forcefully across cultural barriers.

Even though Polynesians were skillful navigators, various island groups remained sufficiently isolated from one another to allow distinct regional styles to develop within a recognizable, general Polynesian style. Thus, the arts of central Polynesia, represented here by the contrasting art forms of a wooden *District God* (FIG. **14-60**) and a skeletalized, double-headed male figure from Easter Island (FIG. **14-61**), are quite different from the Hawaiian figures. The highly polished *District God* from the Cook Islands (FIG. 14-60) has a blade-shaped head and schematized features.

14-60 *Below left: District God,* from the Cook Islands, nineteenth century. Wood, approx. 25″ high. Peabody Museum, Harvard University, Cambridge, Massachusetts.

14-61 *Below right:* double-headed male figure (*moai kava-kava*), from Easter Island, before 1860. Wood, approx. 16″ high. Museum of Natural History, La Rochelle, France.

Instead of a body, numerous tiny, abstracted figures—the god's progeny—are carved in the same geometric, angular style as the head above. Such carvings probably represented clan ancestors, revered for their protective and procreative powers. Analogous images from Mangaia in the Cook Islands and Rurutu in the Austral Islands also have multiple figures attached to their bodies. All such images refer ultimately to creator deities, who are revered for their central role in human fertility. The double-headed male figure (FIG. 14-61) may represent a mythological ancestor or deity of the early inhabitants of Easter Island. Its bent posture and the emphasis on skeletal structure reflect an esthetic quite different from that of the massively aggressive sculpture of the Hawaiian war god (FIG. 14-59).

Polynesians developed the painful but prestigious art of tattoo more fully than other Oceanic peoples. Nobles and warriors, especially, were concerned with increasing their status, mana, and personal beauty by accumulating various tattoo patterns over the years. An early nineteenth-century engraving (FIG. **14-62**) shows Marquesan tattoo patterns, with divided and subdivided geometric motifs covering most of the

14-62 Tattooed Marquesan warrior, nineteenth century. Engraving.

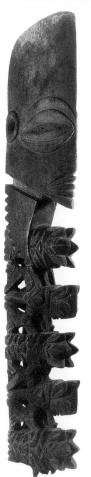
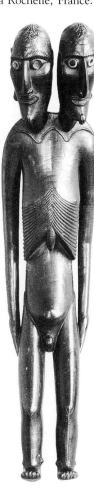
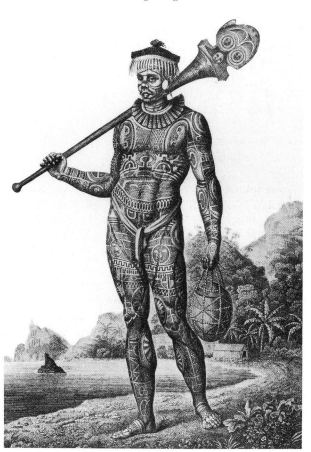

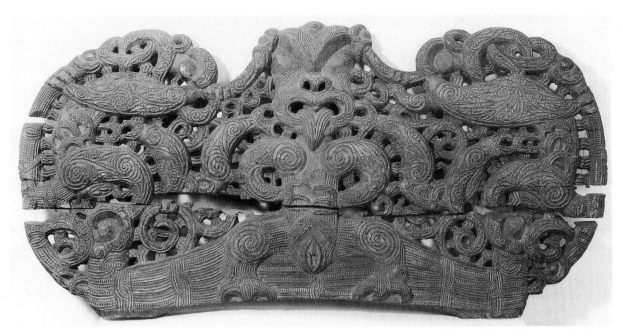

14-63 Door lintel, Maori, from New Zealand, late nineteenth century. Wood, 19″ × 45″.
Peabody Museum of Salem, Massachusetts.

body. Such a multiplication of small, repetitive, abstract forms (a feature also seen in the "children" on the Cook Islands figure [FIG. 14-60]) is one major tendency in much Polynesian art. The other main tendency—that toward bold, full-volume, large-scale figural sculptures—is manifest in the Hawaiian war god (FIG. 14-59).

The highly distinctive arts of the Maori peoples of New Zealand merge these two stylistic currents in images that are at once dynamic and intricate; major forms are bold but surfaces are covered and interconnected by minute curvilinear detailing. The door lintel shown (FIG. **14-63**) comes from a council house generously decorated, inside and out, with technically refined, complex imagery. The subjects are real and mythological ancestors, whose advice and protection were sought for the political, war-making, and ritual deliberations that took place within the council structure. Countless prestige items and weapons used by the Maori nobility displayed this unique style, as did the tattooing on their faces and bodies (Introduction, FIG. 15).

Melanesia

Despite the aggressive poses of the figural art of Hawaii and the lively surface convolutions found in the art of New Zealand, Polynesian art generally is characterized by compactness, solidity, and restraint, as exemplified in the Cook Islands *District God* (FIG. 14-60). Melanesian art, on the other hand, has an insubstantial, colorful, flamboyant aspect, epitomized in wood carvings from New Ireland (FIG. **14-64**). The bewildering intricacy of the New Ireland wood carvings called *malanggan*, which are used in display ceremonies of the same name, stems from generous use of openwork and sliverlike projections and from over-painting in minute geometric patterns that further subdivide the image. The result is a "splintered" or fragmented and airy effect. This style is even more remarkable in view of the fact that most of these forms are carved from a single block of wood (a characteristic of all of the woodcarving considered in this chapter). In the dramatic scene shown, several malanggan showpieces are set up in a special house that was opened to the public; the associated rituals served both to commemorate ancestors and to initiate youths into adulthood. Dancers wearing a variety of intricate masks also performed during these rites.

The Melanesian penchant for color and drama in art is reflected too in the Abelam cult sculptures and paintings found on (and inside) the monumental Men's Houses in New Guinea (FIG. **14-65**). Rows of mythological creatures, intricately painted in contrasting bright colors, are portrayed in the gable paintings on these buildings. This kind of repetition and almost compulsive space-filling are common to the native arts.

In other Melanesian art forms from the Papuan Gulf and Asmat areas of New Guinea's south coast, the artists distort human forms according to local preferences, which here, as elsewhere, are not at all attuned to realistic proportions or modeling. The fact that remote spirits (Papuan Gulf, FIG. **14-66**) and

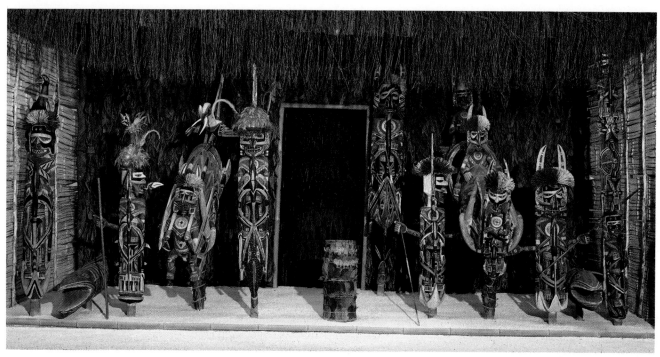

14-64 Malanggan tableau, from New Ireland, nineteenth to twentieth century. Bamboo, palm and croton leaves, painted wood, approx. 8' high, 16' 6" wide, 10' deep. Museum für Völkerkunde, Basel, Switzerland.

14-65 Ceremonial Men's House, Abelam, New Guinea.

14-66 Spirit figure, from the Papuan Gulf, New Guinea. Wood, fibers, bark, red and white paint, 51" long. Tropenmuseum, Amsterdam, Netherlands.

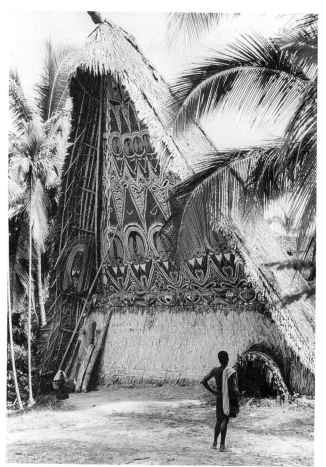

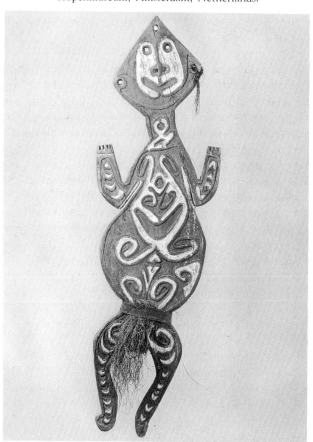

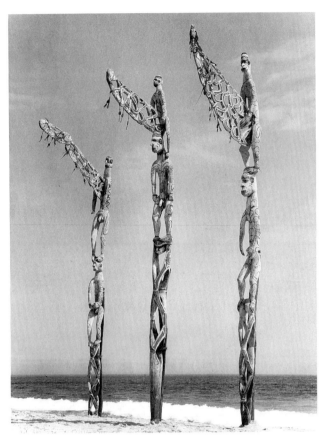

14-67 Ancestral poles, Asmat, from New Guinea, 1960. Wood, paint, sago palm leaves, approx. 18' high. Metropolitan Museum of Art, New York.

ancestors (Asmat, FIG. **14-67**) are portrayed partially accounts for the lack of naturalism, as do the long traditions of repeating and renewing such spiritual images—a repetition that seems to give rise to highly conventionalized styles in conservative societies. The Papuan Gulf figure is a Melanesian version of the power image, whose in-dwelling spirit is invoked to protect and otherwise benefit the figure's owner. The Asmat pole is erected in ceremonies that prepare the participants to avenge the death of a community member in war. The openwork "flags" are penises, exaggerated in a reflection of the Asmat male's aggressive roles in sex and head-hunting.

The Asmat and many other Oceanic peoples were headhunters until early in the twentieth century, and many of their art forms were created for rituals concerned with head-hunting and attendant beliefs about the loss and gain of the life-force. In several cultures, including the Iatmul of the Sepik River, artists cleaned actual human skulls and reworked them into art objects (FIG. **14-68**) by modeling over the skull with a claylike paste and painting the resultant form with the kinds of flowing facial decoration worn in life, particularly on ritual occasions. These graphic

images (a fascinating parallel to the "reconstructed" prehistoric skulls found at Jericho, FIG. 2-2) were believed to contain the life-force or power that men sought to increase by head-hunting; the heads were displayed in ceremonies preparing for war or celebrating its success, as well as at funerals.

Face and body decoration are still important art forms in several parts of New Guinea. Although of course extremely transient, such embellishments can be highly complex, colorful, multimedia assemblages of pigments, feathers, fur, leaves, shells, and other materials, which gain both symbolic significance and artistic impact from their combination. Men and women decorate themselves in this fashion to display their idealized beauty and to compete with rivals similarly embellished.

Varied types and styles of masks were worn in Iatmul ceremonies, as well as in ceremonies conducted by the peoples of New Britain, New Ireland, Abelam, the Papuan Gulf, Asmat, and other areas. These masks were used in ceremonies to materialize spirits whom the people felt the need to entertain and propitiate (uses similar to those for which masks were employed in Africa and the Americas). Elaborate festivals sometimes included over a hundred such "spirit impersonators," who danced to amuse the human community and, at the same time, to remind it of its obligations to supernatural ancestors and culture-bringers. Many of the same masked spirits played an important role in initiating and educating youths to be fully socialized, productive members of the group. Melanesian artists seem to have given free rein to their creativity and imagination, especially in

14-68 Skull, Iatmul, from New Guinea, nineteenth to twentieth century. Human skull, clay, paint, human hair, cuscus fur, 10″ high. Metropolitan Museum of Art, New York (gift of Mr. and Mrs. John J. Klijman).

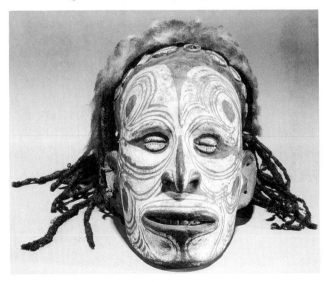

the design of the heads and bodies of spirits. A bi-zarre, flamboyant Sulka mask (FIG. 14-69) is but one example of a type of mask made by stretching and sewing vegetable fibers over a light framework. These and other Melanesian masks were quite per-ishable; indeed, in some areas, the masks were de-stroyed ritually at the end of a ceremony, an act that banished the spirits until their next "invitation" to intervene in human affairs.

Some Melanesian styles, like that of the Solomon Islands, are more restrained than those just dis-cussed. In the canoe-prow carving shown here (FIG. 14-70), which served both practical and spiritual pur-poses of protection, the emphasis is on strong model-ing, the enlargement of facial features, and very pre-cise inlay patterns of seashell fragments that contrast with the solid dark color of the head itself. In several Melanesian areas, styles combine high-contrast, intri-cate surface patterns with bold sculpture. In some other areas, masks are not used, suggesting that these may be transitional cultures between those in which the wilder, less restrained Melanesian style prevails and those in which the more restrained Poly-nesian style, with its more solid, full-volumed sculp-ture, is dominant.

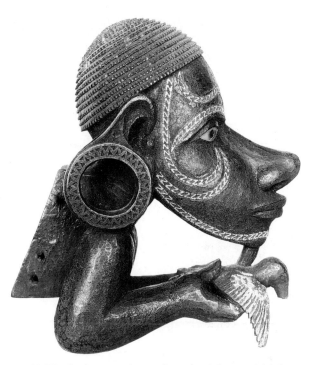

14-70 Canoe-prow figure, from the Solomon Islands, Melanesia, nineteenth to twentieth century. Wood with mother-of-pearl, 6½″ high. Museum für Völkerkunde und Schweizerisches Museum für Völkskunde, Basel, Switzerland.

14-69 Mask, Sulka, from Melanesia, 1900–1910. Fiber struc-ture covered with pith, feathers, and pieces of wood, 27″ high (without leaf skirt). Übersee-Museum, Bremen, West Germany.

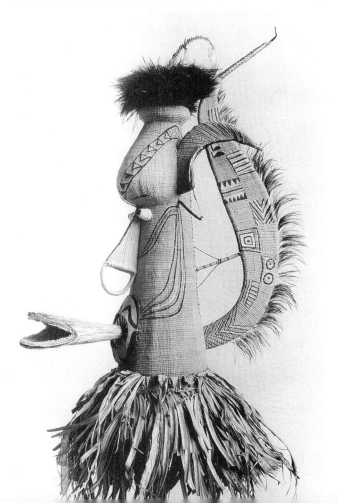

Australia

In Australia, a number of styles and object types bear little relationship to the arts of neighboring New Guinea. Most objects are ceremonial aids used to project the Australian people into the legendary past (Dream Time), when their world, its creatures, and its institutions were created. For the native Austra-lian, the fertility of nature and humanity and the con-tinuity of life itself depended on reenactments of the primordial events of the Dream Time. Cosmogonic myths were recited in concert with songs and dances, and many art forms (body painting, carved figures, decorated stones, rock and bark paintings) were es-sential props in these dramatic re-creations. A bark painting by MUNGARAWAI, entitled *The Djanggawul Sisters* (FIG. 14-71), describes, in schematic form, the birth of the human race, along with other mythical episodes from the Dream Time. The Djanggawul sis-ters and brothers were the mythological progenitors of the Yirrkala people of Arnhem Land, a region on the north coast of Australia in the Northern Territory. Symbolic motifs include trees and pole emblems, the rising and setting sun, a Djanggawul brother, and (top right) the artist himself. The intricate style is rep-resentative of the main features of Yirrkala art: rhyth-mic repetition, subdivision into crowded panels, fine detailing, and lack of a ground line, perspective, or modeling.

14-71 MUNGARAWAI, *The Djanggawul Sisters*, Yirrkala, from Arnhem Land, Australia. Bark and paint. Art Gallery of New South Wales, Australia.

14-72 *Hunter and Kangaroo*, Oenpelli, from Arnhem Land, Australia, *c.* 1913. Paint on bark, 51″ × 32″. National Museum of Victoria, Melbourne, Australia.

Australian art is well known, too, for its ''X-ray'' style, which simultaneously depicts both the insides (backbone, heart, and other organs) as well as the outsides of human beings and animals (FIG. **14-72**). This style of painting is common to the area of Arnhem Land called Oenpelli. Our example shows a hunter and his quarry, a black kangaroo, at the moment a spear is about to strike the startled animal. In contrast to the rather static order of the Yirrkala composition, the Oenpelli painting has a fluid and dynamic quality. The figures are large in relation to the surface on which they have been placed and, unlike the distant, ''bird's-eye'' view of the Yirrkala painting, the immediacy of the depicted action tends to draw the viewer into its orbit.

AFTERWORD: THE PRESENT

At the beginning of this chapter, we noted the community of the native arts; that such a community does exist is apparent from the works we have surveyed. Despite the differences in regional styles, the native arts exhibit general agreement on the funda-

mentals of form and content. The almost exclusive motive and theme of art is religion, with all its symbols and ceremonials. The native arts have kinship with the religious art of many other cultural communities—India, Islam, East Asia, medieval Europe—in reinforcing this emphasis.

Of course, important differences do exist. Aside from the Mesoamerican and central Andean cultures, planned urban complexes, monumental architecture and sculpture in durable materials, mural painting, and other media are not, with some exceptions, conspicuous in the program of the native arts, nor primarily characteristic of them. These omissions by no means diminish the esthetic value of the native arts, their power of expression, nor the fascination with which we now can regard them.

Many of the traditional arts of the Native Americans and the Eskimo, of Africa, Oceania, and Australia are not now being practiced, for they no longer have critical roles in cultural continuity and survival. Ironically, only now, at a time when most of them no longer may be accessible to be appreciated and preserved, are we coming to acknowledge the variety and richness of the native traditions.

Yet an echo of these traditions persists in "folk art," the art that is made by unsophisticated, untaught, or self-taught persons as a kind of abstract version of the once dominant art of their societies. The native arts, on the other hand, predominate in their cultures. They are the products of trained, highly skilled professionals, who work in traditional styles and techniques that fully express the beliefs, ideals, and customs of their peoples. The patrons of the native artists are the powers that rule the society: kings and priests, nobility and merchants. Folk artists have no such official, privileged status, just as they have none of the specialized competence of the native artists whose forms they approximate. Folk art, existing as a substyle, can come into view when great traditions have been broken down or are exhausted. When this happens, we find that folk art does share some fundamental principles of design and representation with the native art of all times and places.

A contemporary example, a figured textile produced in Pakistan and offered for sale in an Islamabad bazaar, presents the recent Soviet war in Afghanistan with only a few representative objects (FIG. 14-73). Their elegantly simplified shapes are linear, flat, and vividly colored. Silhouetted against monochrome ground and placed on superposed levels, the figures are painted in the mode of representation that we find in ancient Egyptian painting (FIG. 3-36), the Bayeux Tapestry (FIG. 9-35), the murals of Bonampak (FIG. 14-11), and the Crow tepee lining (FIG. 14-40). They distantly echo the style of Islamic book illumination (FIG.7-85). And the ironic contrast of old and new warfare, the Afghan horsemen and the Soviet helicopter, could hardly be a more poignant comment on the fatal impact of alien force upon native peoples.

In the faint replication of it in folk art, native art continues to live. Its vitality lies in the undying human instinct and capacity for making art that dramatizes and intensifies life itself. For native peoples, life without art was unknown.

14-73 *Horsemen and Helicopters,* from Islamabad, Pakistan, 1987. Fringed textile. (Courtesy of Mr. Todd Disotell.)

PRONUNCIATION GUIDE*

Artist's Name	Phonetic Pronunciation	Artist's Name	Phonetic Pronunciation
Aalto, Alvar	AHL-toe, AHL-vore	Bosch, Hieronymus	Bosh, He-air-ON-ee-moose
Abakanowicz, Magdalena	Ah-bah-KAHN-oh-veetz, Mahg-dah-LAY-nah	Botticelli, Sandro	Bo-tee-CHAY-lee, SAHN-droh
Agesander	Ag-uh-SAN-dur	Boucher, François	Booh-SHAY, Frahn-swah
Alberti, Leon Battista	All-BEAR-tee, Lay-OWN Bah-TEE-stah	Bouguereau, Adolphe William	Boo-gher-OH, Ah-DOHLF VEAL-yam
Albinus, Bernard Siegfried	ALL-bee-noose, BAYRN-hart SEEG-freed	Bourgeois, Louise	Bor-JWAH
Altdorfer, Albrecht	AHLT-dore-fur, AHL-bresht	Bouts, Dirk	Boats, Durk
Andokides Painter	Ahn-DOH-kee-days	Bramante	Brah-MAHN-tay
Andrea del Castagno	Ahn-DRAY-ah dayl Cah-STAN-yo	Brancusi, Constantin	Braun-COOSH, Cone-stahn-TEEN
Andrea del Sarto	Ahn-DRAY-ah dayl SAAR-toe	Braque, Georges	Brahk, Joerj
Angelico, Fra	On-JAY-lee-coe, Frah	Broederlam, Melchior	Broo-dare-lam, Male-key-ORE
Anguissola, Sofonisba	On-ghee-SO-lah, So-fone-EE-spah	Bronzino	Brone-ZEE-noh
Anthemius of Tralles	Ahn-THAY-mee-us of TRAH-layss	Bruegel, Pieter, the Elder	BROI-gull, PEE-ter
Antonello da Messina	Ahn-TOHN-ay-lo dah May-SEE-nah	Brunelleschi, Filippo	Broo-nay-LAY-skay, Fee-LEE-poh
Antonio da Sangallo the Younger	See Sangallo, Antonio da, the Younger	Brygos Painter	BRIG-ohs
Apollodorus	Ah-poe-low-DOE-russ	Buffalmacco, Buonamico	Boo-fall-MA-coe, Bone-ah-MEE-coe
Apollonius	Ah-poe-LOW-nee-oose	Buñuel, Luis	Boon-WHALE, Lou-EESS
Aqa Mirak	Ah-KAH MEE-rahk	Buson, Yosa	Boo-SONE, YO-sah
Archuleta, Felipe	Arc-chu-LAY-tah, Fay-LEE-pay	Callot, Jacques	Kah-LOW, Jock
Arnolfo di Cambio	Are-NAWL-foe dee KAHM-bee-oh	Cambio, Arnolfo di	See Arnolfo di Cambio
Arp, Jean	Arp, Jaw(n)	Campin, Robert	Kah(n)-PEH(n), Roe-BEAR
Asam, Cosmas Damian	Ah-SAHM, KOZ-mahs DAY-mee-en	Canaletto, Antonio	Kahn-ah-LAY-toe, On-TONE-ee-oh
Asam, Egid Quirin	Ah-SAHM, A-gheed KEER-in	Canova, Antonio	Kah-NO-vah, On-TOE-nee-oh
Atget, Jean Eugène Auguste	Aht-JAY, Jaw(n) uh-JEN oh-GOOST	Caradosso, Christoforo Foppa	Car-ah-DOE-so, Kree-STOW-fore-oh FO-pah
Athenodoros	Ahth-an-ah-DOHR-us	Caravaggio	Kah-rah-VAH-gee-oh
Barlach, Ernst	BAR-lock, Airnst	Carpeaux, Jean Baptiste	Car-POH, Jaw(n) Bahp-TEESTE
Bartolommeo, Michelozzo di	See Michelozzo di Bartolommeo	Carracci, Agostino	Car-RAH-chee, Ah-gust-EENO
Barye, Antoine Louis	Bah-REE(yuh), On-TWAHN Loo-EE	Carracci, Annibale	Car-RAH-chee, on-NEE-ball-ay
Beckmann, Max	BAYK-mahn, Mox	Carracci, Lodovico	Car-RAH-chee, Loo-doe-VEE-ko
Behnisch, Günter	BAYHN-ish, GOON-tare	Carriera, Rosalba	Car-ree-AY-rah, Roe-SAHL-bah
Bellini, Giovanni	Bay-LEE-nee, Gee-oh-VAH-nee	Cartier-Bresson, Henri	Car-tee-AY-Bress-OH(n), On-REE
Berlinghieri, Bonaventura	Bare-leen-ghee-AY-ree, Bone-ah-vane-TOO-rah	Cassatt, Mary	Kah-SAHT
Bernini, Gianlorenzo	Bare-NEE-nee, Jon-loe-REN-zoh	Castagno, Andrea del	See Andrea del Castagno
Bertoldo di Giovanni	Bear-TOLL-doh dee Gee-oh-VAH-nee	Cavallini, Pietro	Kah-vah-LEAN-ee, Pee-AY-troh
Beuys, Joseph	Boyss, YO-zef	Cellini, Benvenuto	Chay-LEE-nee, Ben-ven-OO-to
Bihzad	Bee-ZAHD	Cézanne, Paul	Say-ZAH(n), Pole
Boccioni, Umberto	Bo-chee-OH-nee, Oom-BEAR-toe	Chagall, Marc	Shah-GALL, Mark
Bochner, Mel	BOKE-ner	Chardin, Jean Baptiste Siméon	Shahr-DAH(n), Jaw(n) Bahp-TEEST See-may-OH(n)
Bodmer, Karl	BODE-mare	Chelles, Jean de	SHELL, Jaw(n) duh
Boethos	Bo-AY-toss	Ch'i Pai-shih	Chee By-shur
Boffrand, Germain	Bohff-RAH(n), Jayr-MEH(n)	Chirico, Giorgio de	Key-REE-coe, JOR-gee-oh day
Bologna, Giovanni da	See Giovanni da Bologna	Christo	KREE-stoh
Bonheur, Rosa	Bone-UR, ROE-zah	Christus, Petrus	KREES-tuhs, PAY-tross
Borromini, Francesco	Bore-oh-MEE-nee, Frahn-CHAY-skoe	Cimabue, Giovanni	Cheem-ah-BOO-ay, Gee-oh-VAHN-ee
		Clodion	Kloh-dee-OH(n)
		Clouet, Jean	Cloo-AY, Jaw(n)
		Corot, Jean Baptiste Camille	Kore-OH, Jaw(n) Bahp-TEEST Kah-MEAL
		Correggio	Core-AY-gee-oh
		Courbet, Gustave	KOOR-bay, Goo-STAHV
		Cranach, Lucas, the Elder	KRAH-nahk, LOO-cus
		Cuvilliés, François de	Koo-vee-YAY(s), Frahn-swah duh

*Compiled by Cara-lin Getty, University of South Carolina at Sumter, and Mikle Ledgerwood, Rhodes College.

Artist's Name	Phonetic Pronunciation	Artist's Name	Phonetic Pronunciation
Daguerre, Louis Jacques Mandé	Dah-GHAIR, Loo-EE Jock Mahn-DAY	Gérôme, Jean-Léon	Jay-ROME, Jaw(n) Lay-OH(n)
		Ghiberti, Lorenzo	Ghee-BEAR-tee, Lo-REN-tsoh
Dali, Salvador	Dah-LEE, Sahl-vah-DORE	Ghirlandaio, Domenico	Gear-lon-DIE-oh, Doh-MANE-ee-coe
Daumier, Honoré	DOH-mee-ay, Oh-nor-AY		
David, Jacques Louis	Dah-VEED, Jock Loo-EE	Giacometti, Alberto	Jah-coe-MAY-tee, All-BEAR-toe
De Chelles, Jean	See Chelles, Jean de	Giacomo da Vignola	See Vignola, Giacomo da
De Chirico, Giorgio	See Chirico, Giorgio de	Giacomo della Porta	See Porta, Giacomo della
Degas, Edgar	Day-GAH, Aid-GAR	Giorgione	Gee-ore-gee-OH-nay
De Kooning, Willem	Deh KOON-eeng, VIL-em	Giotto	Gee-OH-toh
Delacroix, Eugène	Duh-lah-KRAWH, Uh-JEN	Giovanni, Bertoldo di	See Bertoldo di Giovanni
De La Tour, Georges	See La Tour, Georges de	Giovanni da Bologna	Gee-oh-VAH-nee dah Bo-LOAN-ya
Della Francesca, Piero	See Piero della Francesca		
Della Porta, Giacomo	See Giacomo della Porta	Girardon, François	Gee-rahr-DOH(n), Frahn-SWAH
Della Quercia, Jacopo	See Jacopo della Quercia	Girodet-Trioson, Anne Louis	Jee-roh-DAY-Tre-oh-SOH(n), On Loo-EE
Della Robbia, Luca	See Robbia, Luca della		
Derain, André	Dare-EH(n), On-DRAY	Gislebertus	Geez-lay-BARE-tuss
De Sica, Vittorio	Day SEE-kah, Vee-TORE-ee-oh	Giuliano da Sangallo	See Sangallo, Giuliano da
Desiderio da Settignano	Day-see-DAY-ree-oh dah Say-teen-YAWN-oh	Godard, Jean-Luc	Go-DAHR, Jaw(n)-LUKE
		Goes, Hugo van der	Guhs, HYOU-go fahn dare
De Stael, Nicolas	See Stael, Nicolas de	Gogh, Vincent van	Vahn Go (Dutch Fahn-hohk)
Diebenkorn, Richard	DEEB-in-corn	Golub, Leon	Go-LUBE, Lee-on
Disdéri, André-Adolphe-Eugène	Deez-DAY-ree, On-DRAY Ah-DOLF Uh-JEN	Gonzalez, Julio	Goan-ZAH-lay(z), HOO-Lee-oh
		Gossaert, Jan	GO-sayrt, Yawn
Domenichino	Do-mane-ee-KEY-no	Goujon, Jean	Goo-JOE(n), Jaw(n)
Domenico Veneziano	Doh-MEH-nee-coh Vay-nee-zee-AH-no	Goya, Francisco	GOE-yah, Frahn-SEESE-coe
		Greenough, Horatio	GREEN-oh, Hore-AY-shee-oh
Donatello	Done-ah-TAY-loh	Greuze, Jean Baptiste	Gruhz, Jaw(n) Bahp-TEEST
Duccio	DOOCH-ee-oh	Gropius, Walter	GROW-pee-oohss, VAHL-ter
Duchamp, Marcel	Dyu-SHAH(n), Mahr-SELL	Gros, Antoine Jean	Groh, On-TWAHN Jaw(n)
Dürer, Albrecht	DYURE-ur, ALL-brekt	Grünewald, Matthias	GROO-nuh-vahld, Mah-TEE-ahss
Durieu, Eugène	DURE-ree-UH, Uh-JEN		
Eakins, Thomas	AY-kinz	Guarini, Guarino	Gwah-REE-nee, Gwah-REE-noh
Eiffel, Alexandre Gustave	Eh-FELL, AHL-ex-ahn-druh Goo-STAVH	Hals, Frans	Halls, Frahnz
		Han Kan	Hahn Gahn
Eisenstein, Sergei	EYE-zen-stine, SAYR-gay	Hardouin-Mansart, Jules	Are-DWEH(n)-Mahn-SAHR, Jool
El Greco	Ale GRAY-koe		
Ergotimos	Ehr-GOH-tee-mohs	Harunobu, Suzuki	Har-roon-NO-boo, Su-zoo-kee
Ernst, Max	Airnst, Mox	Hasegawa Tohaku	Hah-saw-GAH-wah Toe-HAH-coo
Euphronios	U-FROHN-ee-ohs		
Euthymides	U-THEEM-ee-days	Hawes, Josiah Johnson	Hawz, Joe-SIGH-uh
Exekias	Ek-ZEE-kee-ahs	Herrera, Juan de	Hay-RAH-rah, Hwahn day
Eyck, Hubert van	IKE, HUE-beart fahn	Hippodamos	Ee-POH-deh-muss
Eyck, Jan van	IKE, Yawn fahn	Höch, Hannah	Hoke, HAHN-ah
Fabriano, Gentile da	See Gentile da Fabriano	Holbein, Hans, the Younger	HOLE-bine, Hahnz
Falconet, Étienne-Maurice	FAHL-cone-AY, Ay-tee-EN-Moe-REESE	Hon-Ami Koetsu	Hone-AH-mee Coe-ET-sue
		Honnecourt, Villard de	UN-uh-coor, Vee-YA(r) duh
Fan K'uan	Fahn Kwahn	Honthorst, Gerard van	HAUNT-horst, HAY-ralt fahn
Fiorentino, Rosso	See Rosso Fiorentino	Horta, Victor	Ore-TAH, Veek-TORE
Fossati, Chevalier	Foh-SAH-tee, Shev-AH-lee-ay	Houdon, Jean Antoine	Oo-DOH(n), Jaw(n) On-TWAHN
Fouquet, Jean	Foo-KAY, Jaw(n)		
Fra Filippo Lippi	Frah Fay-LEE-poh LEE-pee	Hsu Pei-hung	Shoo Bay-hong
Fragonard, Jean Honoré	Frah-goh-NAHR, Jaw(n) Oh-no-RAY	Huang Kung-wang	Hwahn Gong-wang
		Hugo van der Goes	See Goes, Hugo van der
Frankenthaler, Helen	FRANK-in-tall-ur	Iktinos	Eek-TEE-nohs
Friedrich, Caspar David	FREED-reek, KOSS-par DAH-vid	Il Guercino	Eel Gwair-CHEE-no
Fuseli, Henry	Foo-SAY-lee	Imhotep	Im-HOH-tep
Gabo, Naum	GAH-boh, Nowm	Ingres, Jean Auguste Dominique	AING(ruh), Jaw(n) Oh-GOOST Doh-mee-NEEK
Gaddi, Taddeo	Gah-DEE, Tah-DAY-oh		
Gainsborough, Thomas	GAINZ-burr-oh	Isidorus of Miletus	Ee-see-DOE-russ of My-LEE-tuss
Garnier, J. L. Charles	Gahr-nee-AY, Shahrl	Jacopo da Pontormo	See Pontormo, Jacopo da
Gaudí, Antoni	Gow-DEE, On-TONE-ee	Jacopo della Quercia	JAH-coe-poe DAY-lah KWAIR-chee-ah
Gauguin, Paul	Go-GEH(n), Pole		
Gentile da Fabriano	Jayn-TEE-lay dah Fah-bree-AH-no	Jones, Inigo	IN-ago
		Jouvin, Hippolyte	Jew-VAN, Ee-poh-LEET
Gentileschi, Artemisia	Jane-teel-ESS-key, Are-tay-MEESE-ee-ah	Juvara, Filippo	Jew-VAH-rah, Fee-LEE-poh
		Kahlo, Frida	KAH-low, FREE-duh
Gentileschi, Orazio	Jane-teel-ESS-key, oh-RAH-tsee-oh	Kalf, Willem	Kahlf, VIL-em
		Kallikrates	Kal-EE-krah-tees
Géricault, Théodore	Jay-ree-KOE, Tay-oh-DORE	Kandinsky, Wassily	Kahn-DEEN-skee, VAH-see-lee

Artist's Name	Phonetic Pronunciation	Artist's Name	Phonetic Pronunciation
Kaprow, Allan	CAP-roe	Millais, John	Mee-lay
Käsebier, Gertrude	KAY-zuh-beer, Gayr-TRUE-duh	Millet, Jean François	Mee-LAY, Jaw(n) Frahn-swah
Katsushika Hokusai	Kaht-su-SHEE-kah Hok-oo-SIGH	Mirak, Aqa	*See* Aqa Mirak
Kauffmann, Angelica	KOWF-mahn, Anne-JAY-lee-kah	Miró, Joan	Mee-ROE, Joe-ON
Kiefer, Anselm	KEY-fer, On-selm	Mnesikles	Mee-NES-see-klayz
Kienholz, Edward	KEEN-holtz	Moholy-Nagy, László	Moe-HOE-lee-NAH-ghee, LAHZ-low
Kirchner, Ernst	KEERCH-nair, Airnst		
Kiyotada	Key-oh-TAH-dah	Mondrian, Piet	Moan-dree-ON, Pate
Klee, Paul	Clay, Pole	Monet, Claude	Moan-AY, Klohd
Kleitias	KLAY-tee-ahs	Moreau, Gustave	More-OH, Goo-STAHV
Klimt, Gustav	Kleemt, GOO-stahv	Munch, Edvard	Moonk, ED-vahrd
Kline, Franz	Kline, Frahnz	Mungarawai	Mung-ar-AH-wah
Koca	COE-suh	Muybridge, Eadweard	MY-bridge, Ed-WARD
Kollwitz, Käthe	COLE-vits, KATE-eh	Nadar	Nah-DAHR
Ku K'ai-chih	Goo Kai-jur(n)	Nanni di Banco	Nah-nee dee BANH-coe
Labrouste, Henri	La-BROOSTE, On-REE	Neri, Manuel	NAY-ree, Mahn-WHALE
La Tour, Georges de	Lah Tour, Jorg duh	Nervi, Pier Luigi	NAIR-vee, PEE-ayr Loo-EE-gee
Le Brun, Charles	Luh Bruh(n), Sharl	Neumann, Balthasar	NOY-mahn, Ball-tar-ZAHR
Le Corbusier	Luh Core-BOO-see-AY	Nièpce, Joseph Nicéphore	KNEE-eps, KNEE-say-for
Le Gray, Gustave	Luh Gray, Goo-STAHV	Niobid Painter	Nee-OH-bid
Lehmbruck, Wilhelm	LAME-broook, VEEL-helm	Novius Plautius	NOH-vee-oohss PLOW-tee-oohss
Leibl, Wilhelm	LIE-bul, VEEL-helm	Ogata Korin	Oh-GAH-tah Coe-REEN
Le Nain, Louis	Luh Neh(n), Loo-EE	Okyo, Maruyama	OAK-yo, Mah-roo-YAH-mah
Le Nôtre, André	Luh NOH(treh), On-DRAY	Oldenburg, Claes	OLD-in-burg, Klayss
Lescaze, William	Lez-KAHZ	Olowe of Ise	O-lah-WAY of EE-see
Lescot, Pierre	Luh-SKOH, Pee-AIR	Orozco, José Clemente	Oh-ROZ-coe, Hoe-ZAY Clay-MEN-tay
Le Vau, Louis	Luh Voh, Loo-EE		
Liang K'ai	Lee-ong Kai	Otto, Frei	OH-toe, FRAY-ee
Limbourg, Hennequin	Lem(h)-BOOR, En-nee-KIN	Pacher, Michael	Pock-er, MOEK-aisle
Limbourg, Herman	Lem(h)-BOOR, Air-MAHN	Paik, Nam June	Pike, NAHM Joon
Limbourg, Pol	Lem(h)-BOOR, Pole	Palladio, Andrea	Pa-LA-dee-oh, Ahn-DRAY-ah
Lin, Maya Ying	Leen, MY-yah Yeen	Pannini, Giovanni	Pah-NEE-nee, Gee-oh-VAH-nee
Lipchitz, Jacques	Leep-SHITZ, Jock	Paolozzi, Eduardo	Pow-LOH-zee, Aid-WAHR-do
Lippi, Fra Filippo	*See* Fra Filippo Lippi	Parmigianino	Par-mee-gee-ah-NEE-noh
Lochner, Stephan	LOHK-ner, STAY-fahn	Patinir, Joachim	PAHT(ee)-neer, Yo-AH-keem
Longhena, Baldassare	Loan-GAY-nah, Ball-dah-SARE-ay	Pei, Ieoh Ming	Pay, Yueh Ming
		Perrault, Claude	Pay-RO, Clohd
Lorenzetti, Ambrogio	Low-ren-ZET-ee, Ahm-BROH-gee-oh	Perugino	Pay-roo-GEE-no
		Pfaff, Judy	P(uh)faff
Lorenzetti, Pietro	Low-ren-ZET-ee, Pee-AY-troh	Phiale Painter	Fee-AH-lay
Lorrain, Claude	Loh-REHN, Clodh	Phidias	FHEE-dee-ahs
Luca Signorelli	*See* Signorelli, Luca	Piano, Renzo	Pee-AH-no, REN-tzoh
Luzarches, Robert de	Lose-AHRSH, ROH-bear duh	Picasso, Pablo	Pee-KaH-so, PA-bloh
Lysippos	Lee-SEE-poess	Piero della Francesca	Pee-AY-roh DAY-lah Frahn-CHEE-skah
Ma Yuan	Ma You-an		
Mabuse	Mah-BYOUZ	Pilon, Germain	Pee-LOH(n), Jer-MEH(n)
Machuca, Pedro	Ma-CHEW-kah, PAY-droh	Piranesi, Giovanni Battista	Pee-rah-NAY-see, Gee-oh-VAH-nee Bah-TEE-stah
Maderno, Carlo	Mah-DARE-no, CAR-low		
Maillol, Aristide	MY-yole, Are-ee-STEED		
Malevich, Kasimir	MAH-lay-veech, Kah-zee-MEER	Pisano, Andrea	Pee-SAHN-no, Ahn-DRAY-ah
Manet, Édouard	Mah-NAY, Aid-ooh-AHR	Pisano, Giovanni	Pee-SAHN-no, Gee-oh-VAHN-ee
Mansart, François	Mahn-SAR, Frahn-swah		
Mantegna, Andrea	Mahn-TANE-yah, Ahn-DRAY-ah	Pisano, Nicola	Pee-SAHN-oh, NEE-koh-la
		Pissarro, Camille	Pee-ZAHR-oh, Kah-MEAL
Manzù, Giacomo	Mahn-ZOO, Gee-AH-kah-moe	Pollaiuolo, Antonio	Poh-lie-oo-OH-loh, Ahn-TOE-nee-oh
Martens, Friedrich von	MAHR-tenz, FREED-rick fahn		
Martini, Simone	Mar-TEE-nee, See-MOAN-ay	Pollock, Jackson	PAUL-ock
Masaccio	Ma-SAH-chee-oh	Polydoros	Poh-lee-DOH-rahs
Masolino da Panicale	Mah-so-LEE-no dah Pah-nee-KAH-lee	Polygnotos	Pol-og NO-tus
		Polykleitos	Poh-lee-KLY-tohss
Matisse, Henri	Ma-TEES, On-REE	Pontormo, Jacopo da	Pone-TORE-mo, JAH-coe-poe dah
Méliès, Georges	May-lee-AYSS, Jee-orge		
Memling, Hans	Maym-LEENG, Hahnz	Porta, Giacomo della	PORE-tah, JAH-coe-moe DAY-lah
Messina, Antonello da	*See* Antonello da Messina		
Metsys, Quentin	Met-seese, KWEN-tin	Poussin, Nicolas	Poo-SEH(n), NEE-koe-lah
Michelangelo	Mee-kell-AHN-jay-low	Pozzo, Fra Andrea	POE-tzo, Frah On-DRAY-ah
Michelozzo di Bartolommeo	Mee-kell-OH-tsoe dee Bar-toe-low-MAY-oh	Praxiteles	Prax-EE-tell-ees
		Primaticcio, Francesco	Pree-mah-TEE-chee-oh, Frahn-CHAY-skoh
Mies van der Rohe, Ludwig	Meese fahn dare ROE(huh), LOOD-vig		
		Pucelle, Jean	Pyou-CELL, Jaw(n)

Artist's Name	Phonetic Pronunciation	Artist's Name	Phonetic Pronunciation
Puget, Pierre	Pyou-JAY, Pee-AIR	Soufflot, Jacques-Germain	Soo-FLOH, Jock-Jayr-MEH(n)
Pugin, A. W. N.	PYU-gin	Southworth, Albert Sands	SUHTH-uhrth
Puvis de Chavannes, Pierre	Pyou-VEE duh Shah-VAHN, Pee-AIR	Spranger, Bartholomeus	SPRAHN-gurr, Bar-toe-low-MAY-us
Quarton, Enguerrand	Kvar-TON(n), In-gher-OH(n)	Stael, Nicolas de	STAH-ell, Neck-oh-LAH duh
Raphael	RAH-fah-el	Stieglitz, Alfred	STEEG-litz, ALL-fred
Rauschenberg, Robert	ROWSH-en-burg ("ow" as in "now")	Stoss, Veit	Shtohss, Fite
		Takayoshi	Tah-kah-YO-shee
Redon, Odilon	Ruh-DOH(n), Oh-dee-LOH(n)	Tao-chi	Dao-jee
Reimann, Walter	RYE-mahn, VAHL-tare	Tatlin, Vladimir	Taht-LEEN, Vlah-DEE-meer
Rembrandt van Rijn	Rem-BRAN(DT) fahn RINE	Tawaraya Sotatsu	Tah-WAH-rah-yah So-TAHT-sue
Reni, Guido	RAY-nee, GWEE-doe	Theotokopoulos, Domenikos	Tay-oh-toe-KOE-poe-lohss, Doe-MANE-ee-kos
Renoir, Auguste	Ruh-NWAHR, Oh-GOOSTE		
Repin, Ilya	RYE-pin, EEL-yah	Tiepolo, Giambattista	Tee-EH-poh-loe, Jahm-bah-TEESE-tah
Ribera, José de	Ree-BAY-rah, Ho-SAY day		
Richter, Hans	RICK-tur, HAHNZ	Tinguely, Jean	Tehng-LEE, Jaw(n)
Riefenstahl, Leni	REE-fen-stall, LAY-nee	Tintoretto	Teen-toe-RAY-toe
Riemenschneider, Tilman	REE-MEN-schnigh-dare, TEEL-mahn	Titian	TEE-shun
		Toba Sojo	TOE-bah SO-jue
Rietveldt, Gerrit	REET-felld, GARE-it	Toledo, Juan Bautista de	Toe-LAY-doe, Wahn Bough-TEE-stah day
Rigaud, Hyacinthe	Ree-GOH, Ee-ah-SEH(n)t		
Robbia, Luca della	ROBE-ee-ah, LOO-kah DAY-lah	Tori Busshi	TOE-ree BOO-shee
Rodin, Auguste	Roe-DEH(n), Oh-GOOSTE	Toulouse-Lautrec, Henri de	TOO-looze-Low-TREK, On-REE duh
Rogier van der Weyden	See Weyden, Rogier van der		
Röhrig, Walter	ROAR-igg, VAHL-tare	Tournachon, Gaspard Félix	Toor-nah-SHOH(n), Gah-SPAHR Fay-LEEKS
Romano, Giulio	Ro-MA-no, JEW-lee-oh		
Rosa, Salvator	ROE-sah, Sal-vah-TORE	Traini, Francesco	Trah-EE-nee, Frahn-CHEE-skoh
Rossellino, Antonio	Ro-say-LEE-no, Ahn-TOE-nee-oh	Tung Ch'i-ch'ang	Dung Chee-chang
Rossellino, Bernardo	Ro-say-LEE-no, Bear-NAHR-do	Uccello, Paolo	Oo-CHAY-loh, Pah-OH-loh
Rosso Fiorentino	ROH-so Fee-ore-in-TEE-no	Vanbrugh, John	Van-BROO
Rosso, Medardo	Roh-soe, May-DAHR-do	Van der Rohe	See Mies van der Rohe, Ludwig
Rouault, Georges	Roo-OH, JEE-orge	Van Der Zee, James	VAHN Dayr Zee
Rousseau, Henri	Roo-SO, On-REE	Van Dyck, Anthony	Fahn Dike
Rublëv, Andrei	Roob-LEY-ayv, Ahn-DRAY-ee	Van Honthorst, Gerard	See Honthorst, Gerard van
Rude, François	Rood, Frahn-swah	Vasarely, Victor	Vah-SAR-uh-lee, VEEK-tore
Ruisdael, Jacob van	ROIS-dahl, YA-kobe fahn	Vecelli, Tiziano	Vay-CHAY-lee, Tee-tsee-AH-no
Runge, Philipp Otto	ROON-guh, Fee-LEEP O-toe	Velázquez, Diego	Vay-LAHSS-kayss, Dee-AY-go
Ruscha, Edward	ROO-shah	Veneziano, Domenico	See Domenico Veneziano
Saar, Bettye	Sahr, Bet-ee	Venturi, Robert	Ven-TOO-ree
Saint-Gaudens, Augustus	Saint-GAW-dens	Vermeer, Jan	Fare-MEER, Yawn
Sangallo, Antonio da, the Younger	Sahn-GALL-oh, Ahn-TONE-ee-oh dah	Veronese	Vay-roe-NAY-say
		Verrocchio, Andrea del	Vay-RO-kee-oh, Ahn-DRAY-ah dayl
Sangallo, Giuliano da	Sahn-GALL-oh, Jew-lee-AH-no dah		
		Vigée-Lebrun, Élisabeth Louise	Vee-JAY-Luh-BROH(n), Ay-leez-ah-BET Loo-EEZ
Sansovino, Andrea	Sahn-so-VEE-no, On-DRAY-ah		
Sansovino, Jacopo	Sahn-so-VEE-no, YAH-coe-poe	Vignola, Giacomo da	Veen-YO-lah, JAH-koe-moe dah
Sarto, Andrea del	See Andrea del Sarto	Vignon, Pierre	Veen-YOHN, Pee-AYR
Schöffer, Nicolas	SHOFF-er, Neck-oh-LAH	Vitruvius	Vee-TROO-vee-oose
Schongauer, Martin	SHONE-gow-er, MAR-teen ("ow" as in "now")	Warhol, Andy	WAR-hall
		Warm, Hermann	Vahrm, HAIR-mahn
Schwitters, Kurt	SHVIT-ers, Koort	Watteau, Antoine	Wah-TOH, On-TWAHN
Scopas	SKOH-pahs	Welliver, Neil	WELL-ih-vur
Senmut	Sen-MOO(ut)	Wen Cheng-ming	Wone Jung-ming
Sesshu	SESS-you	Weyden, Rogier van der	VAY-den, ROE-jeer fahn dare
Settignano, Desiderio da	See Desiderio da Settignano	Wiligelmus	Vee-lee-GHELL-moose
Seurat, Georges	Suh-RAH, JEE-orge	Witz, Conrad	Vits
Severus	Sev-AIR-oose	Wodiczko, Krzysztof	Voh-DYAY-skoh, KREE-stofe
Shen Chou	Sun Joe	Wu Chen	Woo Jun
Signorelli, Luca	Seen-yore-ALE-ee, LOO-kah	Zavattini, Cesare	ZAH-vah-tee-nee, Chay-sah-ruh
Sinan the Great	SEE-nahn	Zurbarán, Francisco de	Thoor-bah-RAHN, Frahn-SEE-skoy day
Sluter, Claus	SLOO-ter, Klows		

GLOSSARY

Italicized terms in definitions are defined elsewhere in the Glossary.

abacus (AB-a-kus) The uppermost portion of the *capital* of a *column*, usually a thin slab.

abstract In painting and sculpture, emphasizing a derived, essential character that has only a stylized or symbolic visual reference to objects in nature.

academy A place of study, derived from the name of the grove where Plato held his philosophical seminars. Giorgio Vasari founded the first academy of fine arts, properly speaking, with his *Accademia di Disegno* in Florence in 1563.

acroterium or **acroterion** (ak-roh-TEE-ri-um) In Classical buildings, a figure or ornament usually at the apex of the *pediment*.

acrylic A painting medium that uses *pigment* in a synthetic base (made with acrylic thermal-plastic resins).

addorsed Set back-to-back, especially as in heraldic design.

adobe (a-DOE-bee) The clay used to make a kind of sun-dried brick of the same name; a building made of such brick.

aerial perspective See *perspective*.

agora (AG-o-ra) An open square or space used for public meetings or business in ancient Greek cities.

aisle The portion of a church flanking the *nave* and separated from it by a row of *columns* or *piers*.

alabaster A variety of gypsum or calcite of dense, fine texture, usually white, but also red, yellow, grey, and sometimes banded.

alla prima (A-la PREE-ma) A painting technique in which pigments are laid on in one application, with little or no drawing or underpainting.

altarpiece A panel, painted or sculptured, situated above and behind an altar. See also *retable*.

ambulatory A covered walkway, outdoors (as in a *cloister*) or indoors; especially the passageway around the *apse* and the *choir* of a church.

amphora (AM-fo-ra) A two-handled, egg-shaped jar used for general storage purposes.

anamorphic image An image that must be viewed by some special means (such as a mirror) to be recognized.

apadana (ap-a-DAN-a) The great audience hall in ancient Persian palaces.

apse A recess, usually singular and semicircular, in the wall of a Roman *basilica* or at the east end of a Christian church.

arabesque Literally, "Arabian-like." A flowing, intricate pattern derived from stylized organic motifs, usually floral, often arranged in symmetrical *palmette* designs; generally, an Islamic decorative motif.

arcade A series of *arches* supported by *piers* or *columns*.

arcading An uninterrupted series of *arches*.

arch A curved structural member that spans an opening and is generally composed of wedge-shaped blocks (*voussoirs*) that transmit the downward pressure laterally. A **diaphragm arch** is a transverse, wall-bearing arch that divides a *vault* or a ceiling into compartments, providing a kind of firebreak. See also *thrust*.

architectonic Having structural or architectural qualities, usually as elements of a nonarchitectural object.

architrave (ARK-i-trayv) The *lintel* or lowest division of the *entablature*; sometimes called the *epistyle*.

archivolt (ARK-i-volt) One of a series of concentric *moldings* on a Romanesque or a Gothic arch.

arcuated (AR-kew-ate-id) Of *arch–column* construction.

armature In sculpture, a skeleton-like framework to support material being modeled.

aspara In India, a nymph of the sky or air; in Chinese Buddhism, a heavenly maiden.

assemblage A three-dimensional composition made of various materials such as *found objects*, paper, wood, and cloth. See also *collage*.

atlantid A male figure that functions as a supporting *column*. See also *caryatid*.

atmospheric perspective See *perspective*.

atrium (AY-tree-um) The court of a Roman house that is near the entrance and partly open to the sky. Also, the open, colonnaded court in front of and attached to a Christian *basilica*.

automatism Process of yielding oneself to instinctive actions after establishing a set of conditions (such as size of paper or medium) within which a work is to be carried out.

avant-garde (a-vahn-GARD) Artists whose work is in the most advanced stylistic expression.

avatar (AH-vah-tar) In Hinduism, an incarnation of a god.

axial plan See *plan*.

axis An imaginary line or lines about which a work, a group of works, or a part of a work is visually or structurally organized, often symmetrically.

baldacchino (bal-da-KEE-no) A canopy on columns, frequently built over an altar.

barrel vault See *vault*.

bas (bah) **relief** See *relief*.

basilica (ba-SIL-i-kah) In Roman architecture, a public building for assemblies (especially tribunals), that is rectangular in plan with an entrance on a long side. In Christian architecture, an early church somewhat resembling the Roman basilica, usually entered from one end and with an *apse* at the other, creating an *axial plan*.

batter To slope inward, often almost imperceptibly, or such an inward slope of a wall.

bay A subdivision of the interior space of a building. In Romanesque and Gothic churches, the transverse *arches* and *piers* of the *arcade* divide the building into bays.

beehive tomb A beehive-shaped type of subterranean tomb constructed as a *corbeled vault* and found at pre-Archaic Greek sites.

belvedere (bell-vuh-DARE-eh) An open, roofed story built to provide a scenic view.

ben-ben A pyramidal stone; a *fetish* of the Egyptian god Re.

benizuri-e (BEN-i-ZUR-i-ee) A two-color method of Japanese printing in pink and green that produces strong color vibration.

bevel See *chamfer*.

bhakti (buh-HOCK-tee) In Hinduism, the devout, selfless direction of all tasks and activities of life to the service of one god; the adoration of a personalized deity.

black-figure technique In early Greek pottery, the silhouetting of dark figures against a light background of natural, reddish clay.

blind arcade (wall arcade) An *arcade* having no actual openings, applied as decoration to a wall surface.

Bodhisattva (bo-dee-SOT-va) In Buddhism, a being who is a potential Buddha.

bottega (but-TAY-ga) A shop; the studio-shop of an Italian artist.

bouleuterion (boo-loo-TEE-ri-on) In ancient Greece, an assembly hall or council chamber.

broken pediment A *pediment* in which the *cornice* is discontinuous at the apex or the base.

bucrania (pl.) In classical architecture, an ornament, usually in the friezes, having the shape of an ox skull.

Buddha The supreme enlightened being of Buddhism; an embodiment of divine wisdom and virtue. **Buddhist** (*adj.*)

burin (BYOOR-in) A pointed steel tool for *engraving* or *incising*.

buttress An exterior masonry structure that opposes the lateral thrust of an *arch* or a *vault*. A **pier buttress** is a solid mass of masonry; a **flying buttress** consists typically of an inclined member carried on an arch or a series of arches and a solid buttress to which it transmits lateral *thrust*.

calidarium The hot-bath section of a Roman bathing establishment.

calligraphy Handwriting or penmanship, especially elegant or "beautiful" writing as a decorative art.

calotype Photographic process in which a positive image is made by shining light throught a negative image onto a sheet of sensitized paper.

camera lucida A device in which a small lens projects the image of an object downward onto a sheet of paper. Literally, "lighted room."

camera obscura An ancestor of the modern camera in which a tiny pinhole, acting as a lens, projects an image on a screen, the wall of a room, or the ground-glass wall of a box; used by artists in the seventeenth, eighteenth, and early nineteenth centuries as an aid in drawing from nature. Literally, "dark room."

campanile (kam-pa-NEEL-eh) A bell tower, usually freestanding.

capital The upper member of a *column*, serving as a transition from the *shaft* to the *lintel*.

Caravaggisti (kara-va-GEE-stee) Artists influenced by Caravaggio's dramatically contrasting dark–light effects; painters of "night pictures" in the "dark manner" (*tenebroso*).

cardo The north–south road in Etruscan and Roman towns, intersecting the *decumanus* at right angles.

carte de visite (KART duh VEE-zeet) Separate photographs made on a single negative and mounted on a card the size of the standard calling card; in the nineteenth century, an inexpensive means of creating mass-produced prints.

cartoon In painting, a full-size drawing from which a painting is made. Before the modern era, cartoons were customarily worked out in complete detail; the design was then transferred to the working surface by coating the back with chalk and going over the lines with a *stylus*, or by pricking the lines and "pouncing" charcoal dust through the resulting holes.

cartouche (kar-TOOSH) A scroll-like design or medallion, purely decorative or containing an inscription or heraldic device. In ancient Egypt, an oval device containing such elements as *hieroglyphic* names of Egyptian kings.

caryatid (KAR-ee-AT-id) A female figure that functions as a supporting *column*. See also *atlantid*.

casting In sculpture, process of duplicating a modeled or fabricated original in which a mold is used to make a cast in plaster, metal, polyester, or other hard-setting material.

castrum A Roman military encampment.

cella (SEL-a) An enclosed chamber (Greek, *naos*); the essential feature of a Classical temple, in which the cult statue usually stood.

centering A wooden framework to support an *arch* or a *vault* during its construction.

central plan See *plan*.

ceramics The art of making objects such as pottery out of clay; also, the objects themselves.

chaitya (CHIGHT-yuh) An Indian shrine, especially a Buddhist assembly hall having a votive *stupa* at one end.

chalice A cup or goblet, especially that used in the sacraments of the Christian Church.

chamfer The surface formed by cutting off a corner of a board or post; a *bevel*.

chandi A Javanese temple.

chatra See *parasol*.

chevet (sheh-VAY) The eastern end of a Gothic church, including *choir*, *ambulatory*, and radiating chapels.

chevron A zigzag or V-shaped motif of decoration.

chiaroscuro (kee-AR-o-SKOOR-o) In drawing or painting, the treatment and use of light and dark, especially the gradations of light that produce the effect of *modeling*.

chiton (KITE-on) A Greek tunic, the essential (and often only) garment of both men and women, the other being the *himation* or *mantle*; a kind of cape.

choir The space reserved for the clergy in the church, usually east of the *transept* but, in some instances, extending into the *nave*.

ciborium (sih-BOR-ee-um) A canopy, often freestanding and supported by four columns, erected over an altar; also, a covered cup used in the sacraments of the Christian Church. See *baldacchino*.

cinematic montage Motion-picture effects produced by superimposing separate, unrelated images or showing them in rapid sequence.

cinquecento (cheenk-way-CHAIN-toh) The sixteenth century in Italian art. Literally, the "1500s."

cire perdue (seer pair-DEW) The **lost-wax process.** A bronze-casting method in which a figure is modeled in wax and covered with clay; the whole is fired, melting away the wax and hardening the clay, which then becomes a mold for molten metal.

clerestory (KLEER-sto-ry) The *fenestrated* part of a building that rises above the roofs of the other parts.

cloison (klwa-ZOHN) Literally, a partition. A cell made of metal wire or a narrow metal strip that is soldered edge-up to a metal base to hold enamel or other decorative materials.

cloisonné (klwa-zoh-NAY) A process of enameling employing *cloisons*.

cloister A court, usually with covered walks or *ambulatories* along its sides.

closed form A *form*, especially in painting, with a contour that is not broken or blurred.

cluster pier See *compound pier*.

codex Separate pages of *vellum* or *parchment* bound together at one side and having a cover; the predecessor of the modern book. In Mesoamerica, a painted and inscribed book on long sheets of fig-bark paper or deerskin coated with plaster and folded into accordionlike pleats.

coffer A sunken panel in a *soffit*, a *vault*, or a *ceiling*; often ornamental.

collage (kul-LAHZH) A composition made by combining on a flat surface various materials such as newspaper, wallpaper, printed text and illustrations, photographs, and cloth. See also *photomontage*.

colonnade A series or row of *columns*, usually spanned by *lintels*.

colonnette A small *column*.

color See *hue*, *saturation*, and *value*.

column A vertical, weight-carrying architectural member, circular in cross section and consisting of a base (sometimes omitted), a *shaft*, and a *capital*.

complementary after-image The image (in a *complementary color*) that is retained briefly by the eye after the stimulus is removed.

complementary colors Those pairs of colors, such as red and green, that together embrace the entire spectrum. The complement of one of the three *primary colors* is a mixture of the other two. In pigments, they produce a neutral grey when mixed in the right proportions.

compluvium An opening in the center of the roof of a Roman *atrium* to admit light.

compound or **cluster pier** A *pier* composed of a group or cluster of members, especially characteristic of Gothic architecture.

computer graphics Medium developed during the 1960s and 1970s that uses computer programs and electronic light to make designs and images on the surface of a computer or television screen.

concretion In the work of Jean Arp, Surrealistic sculptural form characterized by twisting and growing effects.

connoisseur (kon-nuh-SER) An expert on works of art and the individual styles of artists.

contour A visible border of a *mass* in space; a *line* that creates the illusion of *mass* and *volume* in space.

contrapposto (kon-tra-POH-stoh) The disposition of the human figure in which one part is turned in opposition to another part (usually hips and legs one way, shoulders and chest another), creating a counter-positioning of the body about its central *axis*. Sometimes called **weight shift** because the weight of the body tends to be thrown to one foot, creating tension on one side and relaxation on the other.

cool color Blue, green, or blue-violet. Psychologically, cool colors are calming, unemphatic, depressive; optically, they generally appear to recede. See also *warm color*.

corbel (KOR-bel) A projecting wall member used as a support for some element in the superstructure. Also, courses of stone or brick in which each course projects beyond the one beneath it. Two such structures, meeting at the topmost course, create an *arch*.

cornice The projecting, crowning member of the *entablature*; also, any crowning projection.

cramp (or **clamp**) A device, usually metal, to hold together blocks of stone of the same course. See also *dowel*.

crenelated (KREN-el-ate-id) Notched or

indented, usually with respect to tops of walls, as in battlements.

crocket A projecting, foliate ornament of a *capital, pinnacle, gable, buttress,* or spire.

Cro-Magnon (kro-MAG-non) Of or pertaining to the *homo sapiens* whose remains, dating from the Aurignacian period, were found in the Cro-Magnon caves in Dordogne, France.

cromlech (KROM-lek) A circle of *monoliths.*

crossing The space in a cruciform church formed by the intersection of the *nave* and the *transept.*

crossing square The area in a church that is formed by the intersection (crossing) of a *nave* and a *transept* of equal width.

crown The topmost part of an *arch,* including the *keystone;* also, an open *finial* of a tower.

cruciform (KROO-suh-form) Cross-shaped.

crypt A *vaulted* space under part of a building, wholly or partly underground; in Medieval churches, normally the portion under an *apse* or a *chevet.*

cubiculum A small room constructed in the wall of an Early Christian catacomb to serve as a mortuary chapel.

cuneiform (kyoo-NEE-ih-form) Literally, "wedge-shaped." A system of writing used in ancient Mesopotamia, the characters of which were wedge-shaped.

Cyclopean (sike-lo-PEE-an) Gigantic; vast and rough; massive. **Cyclopean architecture** is a method of stone construction using large, irregular blocks without mortar.

daguerreotype (dah-GAIR-oh-type) A photograph made by an early method on a plate of chemically treated metal; developed by Louis J. M. Daguerre.

decumanus (dek-yoo-MAN-us) The east–west road in an Etruscan or Roman town, intersecting the *cardo* at right angles.

differential focus Photographic technique in which everything in the foreground shows clearly while everything else is less distinct.

diffraction gratings Sheets of glass, plastic, or metal inscribed with grids whose lines or dots diffract any light directed at the gridded surface and break this light up into its color spectra so that the rays may be measured accurately.

diptych (DIP-tik) A two-paneled painting or *altarpiece;* also, an ancient Roman and Early Christian two-hinged writing tablet, or two ivory memorial panels.

di sotto in sù (dee SUH-toe in soo) A technique of representing perspective in ceiling painting. Literally, "from below upwards."

divisionism System of painting in small color dots that stand in relation to each other based on certain color theories. See *pointillism.*

dolmen (DOHL-men) Several large stones (*megaliths*) capped with a covering slab, erected in prehistoric times.

dome A hemispheric *vault;* theoretically, an *arch* rotated on its vertical *axis.*

double-exposure techniques Photographic techniques that combine images made at different moments in time. See *straight photography.*

dowel In ancient architecture, a wooden or metal pin placed between stones of different courses to prevent shifting. See also *cramp.*

dromos The passage to a *beehive tomb.*

drum The circular wall that supports a *dome;* also, one of the cylindrical stones of which a non-monolithic *shaft* of a *column* is made.

dry point An engraving in which the design, instead of being cut into the plate with a *burin,* is scratched into the surface with a hard steel "pencil." The process is quicker and more spontaneous than standard engraving and lends itself to the creation of painterly effects. Its disadvantage is the fact that the plate wears out very quickly. See also *engraving, etching, intaglio.*

duecento (doo-ay-CHAIN-toh) The thirteenth century in Italian art. Literally, the "1200s."

earth colors Pigments, such as yellow ochre and umber, that are obtained by mining; usually compounds of metals.

echinus (eh-KY-nus) In architecture, the convex element of a *capital* directly below the *abacus.*

eclecticism (eh-KLEK-ti-sism) The practice of selecting from various sources, sometimes to form a new system or style.

écorché (ay-kor-SHAY) A figure painted or sculptured to show the muscles of the body without skin.

elevation In drawing and architecture, a geometric projection of a building on a plane perpendicular to the horizon; a vertical projection.

embrasure A *splayed* opening in a wall that enframes a doorway or a window.

emulsion Chemical coatings used to transfer photographic images directly onto metal plates (for the daguerreotype), paper, fabric, or other surfaces.

enamel A vitreous, colored paste that solidifies when fired. See also *champlevé, cloisonné.*

encaustic A method of painting with colored, molten wax in which the wax is fused with the surface by the application of heat.

engaged column A columnlike, nonfunctional form projecting from a wall and articulating it visually. See also *pilaster.*

engobe (en-GOHB) A slip of finely sifted clay used by Greek potters; applied to a pot, it would form a black *glaze* in firing.

engraving The process of *incising* a design in hard material, often a metal plate (usually copper); also, the print or impression made from such a plate. See also *dry point, etching, intaglio.*

entablature The part of a building above the *capitals* of *columns* and below the roof or the upper story.

entasis (EN-tah-sis) An almost imperceptible convex tapering (an apparent swelling) in the *shaft* of a *column.*

epistyle See *architrave.*

esthetic The distinctive vocabulary and theory of a given *style.*

esthetics Theories about the nature of art and artistic expression.

etching A kind of *engraving* in which the design is *incised* in a layer of wax or varnish on a metal plate. The parts of the plate left exposed are then **etched** (slightly eaten away) by the acid in which the plate is immersed after incising. See also *dry point, engraving, intaglio.*

extrados (eks-TRAH-dohs) The upper or outer surface of an *arch.* See *intrados.*

façade Usually, the front of a building; also, the other sides when they are emphasized architecturally.

faïence (feye-AHNCE) Earthenware or pottery, especially with highly colored design (from Faenza, Italy, a site of manufacture for such ware).

fan vault See *vault.*

fenestration The arrangement of the windows of a building.

ferroconcrete See *reinforced concrete.*

fête galante (fet ga-LAHNT) An elegant and graceful celebration; often represented in the works of Antoine Watteau and other Rococo painters.

fetish An object believed to possess magical powers, especially one capable of bringing to fruition its owner's plans; sometimes regarded as the abode of a supernatural power or spirit.

fibula A decorative pin, usually used to fasten garments.

figure-ground In two-dimensional works of art, the visual unity, yet separability, of a form and its background.

filigree A delicate, lacelike, intertwined, ornamental work or design.

fin de siècle (fan duh SEE-akl) Characteristic of the progressive ideas and customs of the last years of the nineteenth century.

finial A knoblike ornament (usually with a foliate design) in which a vertical member, such as a *pinnacle,* terminates.

flamboyant Flamelike, flaming; applied to aspects of Late Gothic style, especially architectural tracery.

flute or **fluting** Vertical channeling, roughly semicircular in cross section and used principally on *columns* and *pilasters.*

flying buttress See *buttress.*

foreshortening The use of *perspective* to represent in art the apparent visual contraction of an object that extends back in space at an angle to the perpendicular plane of sight.

form In its widest sense, total structure; a synthesis of all the visible elements of that structure and of the manner in which they are united to create its distinctive character. The *form* of a work is what enables us to apprehend it. See also *closed form* and *open form.*

formalism Strict adherence to, or depend-

ence on, stylized shapes and methods of composition.

forum The public square or marketplace of an ancient Roman city.

found images (or **materials** or **objects**) Images, materials, or objects as found in the everyday environment that are appropriated into works of art.

fresco Painting on plaster, either dry (**dry fresco** or **fresco secco**) or wet (**wet** or **true fresco**). In the latter method, the pigments are mixed with water and become chemically bound to the plaster. Also, a painting executed in either method.

fret or **meander** An ornament, usually in bands but also covering broad surfaces, consisting of interlocking geometric motifs.

frieze (freez) The part of the *entablature* between the *architrave* and the *cornice*; also, any sculptured or ornamented band in a building, on furniture, etc.

frigidarium The cold-bath section of a Roman bathing establishment.

frottage A process that combines patterns achieved by rubbing a crayon or other medium across a sheet of paper placed over a surface with a strong and evocative texture pattern.

full round Sculpture in full and completely rounded form (not in *relief*).

gable See *pediment*.

gallery The second story of an *ambulatory* or *aisle*.

garbha griha The *cella* or inner sanctum of the Hindu temple.

gargoyle In architecture, a waterspout (usually carved), often in the form of a *grotesque*.

genre (ZHAHN-reh) A style or category of art; also, a kind of painting realistically depicting scenes from everyday life.

gesso (JESS-oh) Plaster mixed with a binding material and used for *reliefs* and as a *ground* for painting.

glaze A vitreous coating applied to pottery to seal the surface and as decoration; it may be colored, transparent, or opaque, and glossy or *matte*. In oil painting, a thin, transparent, or semitransparent layer put over a color to alter it slightly.

glory See *nimbus*.

Golden Mean or **Golden Section** A proportional relation obtained by dividing a line so that the shorter part is to the longer part as the longer part is to the whole. The *esthetic* appeal of these proportions has led artists of varying periods and cultures to employ them in determining basic dimensions.

gopuram (GO-poor-am) The massive, ornamented entrance structure of South Indian temples.

graphic arts Visual arts that are linear in character, such as drawing and *engraving*; also, generally, visual arts that involve impression (printing and printmaking).

graver A cutting tool used by engravers and sculptors.

Greek cross A cross in which all the arms are the same length.

grisaille (greez-EYE) A monochrome painting done mainly in neutral greys to simulate painting.

groin The edge formed by the intersection of two *vaults*.

groin vault See *vault*.

grotesque In art, a kind of ornament used in antiquity—and sometimes called (imprecisely) *arabesque*—consisting of representations of medallions, sphinxes, foliage, and imaginary creatures.

ground A coating applied to a canvas or some other surface to prepare that surface for painting; also, background.

guilloche (gee-USH) An ornament consisting of interlaced, curving bands.

hallenkirche (HOLL-en-keer-sheh) A hall church. In this variety of Gothic church, especially popular in Germany, the *aisles* are as high as the *nave*.

haniwa Sculptured pottery tubes, modeled in human, animal, or other forms, and placed around early (archaic) Japanese burial mounds.

Happenings Loosely structured performances initiated in the 1960s, whose creators were trying to suggest the dynamic and confusing qualities of everyday life; most shared qualities of unexpectedness, variety, and wonder.

harmika A square enclosure on top of the *dome* of a *stupa* from which the *yasti* arises.

hatching A technique used in drawing, engraving, etc., in which fine lines are cut or drawn close together to achieve an effect of shading.

haunch The part of an *arch* (roughly midway between the *springing* and the *crown*) at which the lateral *thrust* is strongest.

herringbone perspective See *perspective*.

hieratic (higher-AT-tic) The priestly supernaturalism disparaging matter and material values that prevailed throughout the Christian Middle Ages, especially in Orthodox Byzantium.

hieroglyphic (high-roh-GLIF-ic) A system of writing using symbols or pictures; also, one of the symbols.

himation (him-MAT-ee-on) A Greek *mantle* worn by men and women over the tunic and draped in various ways.

historiated Ornamented with representations, such as plants, animals, or human figures, that have a narrative—as distinct from a purely decorative—function. Historiated initial letters were a popular form of manuscript decoration in the Middle Ages.

holography Medium that reconstructs in light alone the surface appearance of the subject, providing a real, three-dimensional image; recorded with the light of a laser.

horror vacui (VACK-ui) Literally, "fear of empty space"; crowded design.

hue The name of a color. *Pigment* colors combine differently than colors of light. The *primary colors* (in pigment: blue, red, and yellow; in light: blue, red, and green)

together with the *secondary colors* (in pigment: green, orange, and violet; in light: cyan, magenta, and yellow) form the chief colors of the spectrum. See also *complementary colors, cool color, saturation, value, warm color*.

hydria (HIGH-dree-a) An ancient Greek three-handled water jar.

hypostyle hall A hall with a roof supported by columns; applied to the colonnaded hall of the Egyptian *pylon* temple.

icon (EYE-con) A portrait or image; especially in the Greek church, a panel with a painting of sacred personages that are objects of veneration. In the visual arts, a painting, a piece of sculpture, or even a building regarded as an object of veneration.

iconography (eye-con-OG-ra-fee) The analytic study of the symbolic, often religious, meaning of objects, persons, or events depicted in works of art.

iconostasis (eye-con-OS-ta-sis) In eastern Christian churches, a screen or a partition, with doors and many *tiers* of *icons*, that separates the sanctuary from the main body of the church.

idealization The representation of things according to a preconception of ideal *form* or type; a kind of *esthetic* distortion to produce idealized forms. See also *realism*.

ideogram A simple, picturelike sign filled with implicit meaning.

illumination Decoration with drawings (usually in gold, silver, and bright colors), especially of the initial letters of a manuscript.

imagines (i-MAJ-i-nees; *sing.* **imago**) In ancient Rome, wax portraits of ancestors.

imam (eye-MAHM) One who leads worshipers in prayer in Moslem services.

impasto (im-PAH-stoh) A style of painting in which the pigment is applied thickly or in heavy lumps, as in many of Rembrandt's paintings.

impluvium A depression in the floor of a Roman *atrium* to collect rainwater.

impost block A stone with the shape of a truncated, inverted pyramid, placed between a *capital* and the *arch* that springs from it.

incising Cutting into a surface with a sharp instrument; also, a method of decoration, especially on metal and pottery.

incrustation A style of wall decoration in Pompeii and Herculaneum in which the wall was divided into bright, polychrome panels of solid colors with occasional, schematically rendered textural contrasts.

in situ (SI-too) In place; in original position.

insula A multistoried Roman apartment block.

intaglio (in-TAL-yoh) A category of graphic technique in which the design is *incised*, so that the impression made is in *relief*. Used especially on gems, seals, and dies for coins, but also in the kinds of printing or printmaking in which the ink-bearing surface is depressed. Also, an object so decorated. See also *dry point, engraving, etching*.

intarsia (in-TAHR-sya) Inlay work, primarily in wood and sometimes in mother-of-pearl, marble, etc.

intercolumniation The space or the system of spacing between *columns* in a *colonnade*.

intrados (in-TRAH-dohs) The underside of an *arch* or a *vault*. See *extrados*.

isocephaly (eye-soh-SEF-ah-lee) The arrangement of figures so that the heads are at the same height.

jataka (JAH-tah-kah) Tales of the lives of the Buddha.

jump cuts Cinema technique used to disrupt narrative flow by arbitrarily omitting chunks from the middle of long continuous shots to dislocate any sense of progressive action.

ka (kah) In ancient Egypt, immortal human substance; the concept approximates the Western idea of the soul.

kagle A rough, highly abstracted African (Dan) mask.

kakemono (KAH-keh-moh-noh) A Japanese hanging or scroll.

karma (KAR-muh) In Buddhist and Hindu belief, the ethical consequences of a person's life, which determine his or her fate.

keystone The central, uppermost *voussoir* in an *arch*.

khutbah (KOOT-bah) In Moslem worship, a sermon and a declaration of allegiance to a community leader.

kiln A large stove or oven in which pottery is fired.

kinesiologist Scholar of motion who often uses photographs to study the discrete phases of a particular movement.

kore (KOR-ay) Greek for "girl."

kouros (COOR-aus) Greek for "young man."

krater/crater (KRAY-ter) An ancient Greek wide-mouthed bowl for mixing wine and water.

kuang (gwahng) A Chinese covered libation vessel.

kylix/cylix (KYE-liks) An ancient Greek drinking cup, shallow and having two handles and a stem.

lacquer A resinous spirit varnish, such as shellac; often colored.

lantern In architecture, a small, often decorative structure with openings for lighting that crowns a *dome*, *turret*, or roof.

lapis lazuli (LA-pis LA-zyoo-lye) A rich, ultramarine, semiprecious stone used for carving and as a source of *pigment*.

Latin cross A cross in which the vertical member is longer than the horizontal member.

lectionary A list, often illustrated, of *lections*, selections from the Scriptures that are read in church services.

lierne (lee-ERN) A short *rib* that runs from one main rib of a *vault* to another.

line The mark made by a moving point, which has psychological impact according to its direction and weight. In art, a line

defines space and may create a silhouette or define a *contour*, creating the illusion of *mass* and *volume*.

linear perspective See *perspective*.

lintel A beam of any material used to span an opening.

lithography In graphic arts, a printmaking process in which the printing surface is a polished stone or a special metal or plastic plate on which the design is drawn with a greasy material. Greasy ink, applied to the moistened surface, is repelled by all surfaces except the lines of the drawing. The process permits linear and tonal *values* of great range and subtlety.

local color In painting, the actual *color* of an object.

loggia (LUH-jee-uh) A gallery that has an open *arcade* or a *colonnade* on one or both sides.

lost-wax process See *cire perdue*.

lotiform In the form of a lotus petal.

lunette A semicircular opening (with the flat side down) in a wall over a door, a niche, or a window.

luster A thin *glaze* (usually metallic) sometimes used on pottery to produce a rich, often iridescent color. Used particularly in Persian pottery and in *majolica*.

machicolation (mah-CHIK-oh-lay-shun) An opening in the floor of an overhanging gallery through which the defenders of a castle dropped stones and boiling liquids on attackers.

madrasah (muh-DRAH-suh) A combined Moslem school and *mosque*.

magazine A room or building designed for storage.

majolica (ma-JO-lik-ah) A kind of Italian Renaissance pottery coated with a whitish tin-compound enamel, brilliantly painted and often *lustered*.

makimono (MAH-kee-MOH-noh) A Japanese horizontal scroll.

malanggan (mah-LOHNG-gahn) Intricately carved Melanesian ceremonial masks.

mandala (MAN-duh-luh) In Hinduism and Buddhism, a magical, geometric symbol of the cosmos.

mandapa (man-DOP-ah) A Hindu assembly hall, part of a temple.

mandorla An almond-shaped *nimbus*, or *glory*, surrounding the figure of Christ.

maniera greca (man-YERA GRE-ka) A formal Byzantine style that dominated Italian painting in the twelfth and thirteenth centuries; characterized by shallow space and linear flatness.

mantle A sleeveless, protective outer garment or cloak. See *himation*.

mass The effect and degree of bulk, density, and weight of matter in space. As opposed to plane and area, mass is three-dimensional.

mastaba (MAH-sta-bah) A bench-shaped ancient Egyptian tomb.

matte (mat) In painting, pottery, and photography, a dull finish.

mbari Ceremonial houses filled with clay sculptures and paintings, honoring community deities of the Ibo tribe in Africa.

meander See *fret*.

medium The substance or agency in which an artist works; also, in painting, the vehicle (usually liquid) that carries the *pigment*.

megalith Literally, "great stone"; a large, roughly hewn stone used in the construction of monumental, prehistoric structures. **megalithic** (*adj.*) See also *cromlech*, *dolmen*, *menhir*.

megaron (MEH-ga-ron) A rectangular hall, fronted by an open, two-columned porch, traditional in Greece since Mycenaean times.

menhir (MEN-heer) A prehistoric *monolith*, uncut or roughly cut, standing singly or with others in rows or circles.

metamatic In the work of Jean Tinguely, machines programmed electronically to act with antimechanical unpredictability.

métier (MAY-tee-yay) One's area of expertise.

metope (MET-a-pee) The space between *triglyphs* in a Doric *frieze*.

mihrab (MEE-rahb) In the wall of a *mosque*, the niche that indicates the direction of Mecca.

minbar (MEEN-bar) The pulpit found near the *qiblah* wall in a *mosque*.

miniature A small picture illustrating a manuscript; also, any small portrait, often on ivory or *porcelain*.

modeling The shaping or fashioning of three-dimensional forms in a soft material, such as clay; also, the gradations of light and shade reflected from the surfaces of matter in space, or the illusion of such gradations produced by alterations of *value* in a drawing, painting, or print.

module (MOD-yool) A basic unit of which the dimensions of the major parts of a work are multiples. The principle is used in sculpture and other art forms, but it is most often employed in architecture, where the module may be the dimensions of an important part of a building, such as a *column*, or simply some commonly accepted unit of measurement (the centimeter or the inch, or, as with Le Corbusier, the average dimensions of the human figure).

molding In architecture, a continuous, narrow surface (projecting or recessed, plain or ornamented) designed to break up a surface, to accent, or to decorate.

monochrome A painting, drawing, or print in one color; also, the technique of making such an artwork.

monolith A column that is all in one piece (not built up); a large, single block or piece of stone used in *megalithic* structures.

monumental In art criticism, any work of art of grandeur and simplicity, regardless of its size.

mortice See *tenon*.

mosaic Patterns or pictures made by embedding small pieces of stone or glass (*tesserae*) in cement on surfaces such as walls and floors; also, the technique of making such works.

mosque A Moslem place of worship.

mudra (muh-DRAH) A stylized gesture of mystical significance, usually in representations of Hindu deities.

mullion A vertical member that divides a window or that separates one window from another.

mural A wall painting; a *fresco* is a type of mural medium and technique.

naos See *cella*.

narthex A porch or vestibule of a church, generally colonnaded or arcaded and preceding the *nave*.

Naturalism The doctrine that art should adhere as closely as possible to the appearance of the natural world. Naturalism, with varying degrees of fidelity to appearance, recurs in the history of Western art.

nave The part of a church between the chief entrance and the *choir*, demarcated from *aisles* by *piers* or *columns*.

necking A groove at the bottom of the Greek Doric *capital* between the *echinus* and the *flutes* that masks the junction of *capital* and *shaft*.

necropolis (neh-KROP-o-lis) A large burial area; literally, a city of the dead.

New Wave cinema (La Nouvelle Vague) Cinema style developed in the 1950s and 1960s that characteristically attempted to subvert viewer expectations by using ambiguity, surprize, fuzzy camera work, and abrupt changes in space, time, and mood.

niello (nee-EL-o) Inlay in a metal of an alloy of sulfur and such metals as gold or silver. Also, a work made by this process, or the alloy itself.

nimbus A halo, aureole, or **glory** appearing around the head of a holy figure to signify divinity.

nirvana (neer-VAH-nah) In Buddhism and Hinduism, a blissful state brought about by absorption of the individual soul or consciousness into the supreme spirit.

nonobjective Having no discernible reference to the external appearance of the physical world.

objet d'art (objay-DAR) A relatively small object (such as a figurine or vase) of artistic value.

obverse On coins or medals, the side that bears the principal type or inscription. See also *reverse*.

oculus A round, central opening or "eye" in a *dome*.

odalisque (OH-dah-lisk) A female slave or concubine; a favorite subject of such artists as Ingres and Matisse.

oenochoe (eh-NUK-oh-ee) An ancient Greek wine pitcher.

oeuvre (UH-vreh) The whole of an artist's output; literally, the artist's "work."

ogee (OH-jee) A *molding* having in profile a double or S-shaped curve. Also, an *arch*, each side of which has this *form*.

ogive The diagonal *rib* of a Gothic *vault*; a pointed, or Gothic, *arch*. **ogival** (*adj.*)

oil color/paint *Pigment* ground with oil.

open form A *mass* penetrated or treated in such a way that space acts as its environment rather than as its limit. See also *closed form*.

order In Classical architecture, a style represented by a characteristic design of the *column* and its *entablature*. See also *superimposed order*.

orthogonal A line imagined to be behind and perpendicular to the *picture plane*; the *orthogonals* in a painting appear to recede toward a *vanishing point* on the horizon.

pagoda A Buddhist tower with a multiplicity of winged eaves; derived from the Indian *stupa*.

palestra A Roman exercise room.

palette (PAL-it) A thin board with a thumb hole at one end on which an artist lays and mixes colors; any surface so used. Also, the colors or kinds of colors characteristically used by an artist.

palmette (pal-MET) A conventional, decorative ornament of ancient origin composed of radiating petals springing from a cuplike base.

panorama Originally, a specially designed building that housed colossal, circular murals. Also, any broad, spectacular vista.

Pantheon (PAN-thee-on) All the gods of a people, or a temple dedicated to all such gods; especially, the Pantheon in Rome (although it is not certain that this was its function).

papier collé (PAH-pee-yay CAHL-lay) Variety of collage in which paper shapes are combined into one work of art; literally, "stuck paper."

papyrus (pah-PIE-rus) A plant native to Egypt and adjacent lands used to make a paperlike writing material; also, the material or any writing on it.

parasol An umbrella atop a Chinese *pagoda*; a vestige of the **chatra** on an Indian *stupa*.

parchment Lambskin prepared as a surface for writing or painting.

passage grave A burial chamber entered through a long, tunnel-like passage.

pastel Finely ground *pigments* compressed into chalklike sticks. Also, work done in this *medium*, or exhibiting its characteristic paleness.

pastiche (pas-TEESH) An artistic hodgepodge that imitates or ridicules another artist's style.

patina (pa-TEEN-a) The colored, oxidized layer, often green, that forms on bronze and copper; also, the creation of a colored surface on metal sculpture by the application of an acid solution.

pediment (PED-i-ment) In Classical architecture, the triangular space (**gable**) at the end of a building, formed by the ends of the sloping roof and the *cornice*; also, an ornamental feature having this shape.

pendentive (pen-DEN-tiv) A concave, triangular piece of masonry (a triangular section of a hemisphere), four of which provide the transition from a square area to the circular base of a covering *dome*. Although they appear to be hanging (**pendent**) from the dome, they in fact support it.

peripteral (per-IP-ter-al) A style of building in which the main structure is surrounded by a *colonnade*.

peristyle (PAIR-i-stile) A *colonnade* surrounding a building or a court.

persistence of vision Retention in the brain for a fraction of a second of whatever the eye has seen; causes a rapid succession of images to merge one into the next, producing the illusion of continuous change and motion in media such as cinema.

perspective A formula for projecting an illusion of the three-dimensional world onto a two-dimensional surface. In **linear perspective**, the most common type, all parallel lines or lines of projection seem to converge on one, two, or three points located with reference to the eye level of the viewer (the horizon line of the picture), known as *vanishing points*, and associated objects are rendered smaller the further from the viewer they are intended to seem. **Atmospheric** or **aerial perspective** creates the illusion of distance by the greater diminution of *color* intensity, the shift in color toward an almost neutral blue, and the blurring of *contours* as the intended distance between eye and object increases. In **herringbone perspective**, the lines of projection converge not on a vanishing point, but on a vertical *axis* at the center of the picture, as in Roman paintings.

photogram An assemblage of objects on photosensitive paper exposed to light to yield an image of ghostly silhouettes floating in a void of darkened space.

photomontage (MOHN-tahzh) A composition made by fitting together pictures or parts of pictures, especially photographs. See also *collage*.

photoscreen Technique employing photo processes to create stencil screens from graphic images, which then become part of complex printing or painting processes.

pi (bee) The Chinese symbol of Heaven; a jade disk.

piano nobile (PEEA-no NO-bee-lay) The principal story, usually the second, in Renaissance buildings.

pictograph A picture, usually stylized, that represents an idea; also, writing using such means. See also *hieroglyphic*.

picture plane The surface of a picture.

pier A vertical, unattached masonry support.

Pietà (pee-ay-TA) A work of art depicting the Virgin mourning over the body of Christ.

pigment Finely powdered coloring matter mixed or ground with various vehicles to form paint, crayon, etc.

pilaster (pil-LAS-ter) A flat, rectangular, vertical member projecting from a wall of which it forms a part. It usually has a base and a *capital* and is often *fluted*.

pillar Usually a weight-carrying member, such as a *pier* or a *column*; sometimes an isolated, freestanding structure used for commemorative purposes.

pilotis (pee-LOW-teez; *sing.* **piloti**) Thin steel or reinforced concrete posts used by architects in the early twentieth century to

support concrete roof and floor slabs, avoiding the need for load-bearing walls.

pinnacle A tower, primarily ornamental, that also functions in Gothic architecture to give additional weight to a *buttress* or a *pier*. See also *finial*.

pithos (PITH-oss; *pl.* **pithoi**) A large, clay storage vessel frequently set into the earth and therefore possessing no flat base.

plan The horizontal arrangement of the parts of a building, or a drawing or a diagram showing such an arrangement as a horizontal *section*. In **axial plan,** the parts of a building are organized longitudinally, or along a given *axis;* in a **central plan,** the parts radiate from a central point.

plasticity In art, the three-dimensionality of an object. **plastic** (*adj.*)

plinth The lowest member of a base; also, a block serving as a base for a statue.

pointillism The method of painting of some French Post-Impressionists in which a white ground is covered with tiny dots of color, which, when viewed at a distance, blend together to produce a luminous effect. See *divisionism*.

polychrome Done in several colors.

polyptych (POL-ip-tik) An *altarpiece* made up of more than three sections.

porcelain Translucent, impervious, resonant *pottery* made in a base of **kaolin,** a fine white clay; sometimes any pottery that is translucent, whether or not it is made of kaolin.

porphyry (POUR-feary) An Egyptian rock containing large crystals of feldspar in a purplish groundmass; used in ancient architecture and sculpture.

portico A porch with a roof supported by *columns;* an entrance porch.

post-and-lintel system A *trabeated* system of construction in which two posts support a *lintel*.

potsherds Broken pottery, discarded by earlier civilizations, that settles into firmly stratified mounds over time and provides archeological chronologies.

pottery Objects (usually vessels) made of clay and hardened by firing.

Poussinistes (Poo-sehn-EESTS) Adherents to the doctrine that form, rather than color, was the most important element in painting. See *Rubénistes*.

predella The narrow ledge on which an *altarpiece* rests on an altar.

primary colors In *pigment,* the *hues* red, yellow, and blue. From these three colors, with the addition of white or black, it is theoretically possible to mix the full range of colors in the spectrum. In light, the hues red, blue, and green, which can be combined in varying amounts to produce the full range of colors in the spectrum. Combining the three primary colors of light in equal proportions produces pure white light. The primary colors of either pigment or light cannot be produced by mixing other colors together.

program The architect's formulation of a design problem with respect to considerations of site, function, materials, and aims of the client; also, in painting and sculpture, the conceptual basis of a work.

pronaos (pro-NAY-os) The space in front of the *cella* or *naos* of a Greek temple.

propylaeum (prah-pi-LAY-um; *pl.* **propylaea**) A gateway building leading to an open court preceding a Greek or Roman temple.

proscenium (pro-SEEN-i-um) The stage of an ancient Greek or Roman theater.

prostyle A style of Greek temple in which the *columns* stand in front of the *naos* and extend its full width.

provenance Origin; source.

psalter A book containing the Psalms of the Bible.

putto (*pl.* **putti**) A young child, a favorite subject in Italian painting and sculpture.

pylon (PIE-lon) The *monumental* entrance of an Egyptian temple.

qiblah (KEEB-lah) The direction (toward Mecca) in which Moslems face in prayer. (Often *kibla.*)

quadro riportato (kwahd-roh ree-por-TAH-toh) The simulation of a wall painting for a ceiling design in which painted scenes are arranged in panels resembling frames on the surface of a shallow, curved *vault*.

quatrefoil (KAT-re-foyl) An architectural ornament having four lobes or **foils.** See also *trefoil*.

quattrocento (KWAT-tro-CHAIN-toh) The fifteenth century in Italian art. Literally, the "1400s."

quoin (koin) A large, sometimes *rusticated,* usually slightly projecting stone (or stones) that often form the corners of the exterior walls of masonry buildings.

raking cornice The *cornice* on the sloping sides of a *pediment*.

Ramayana A Sanskrit epic telling of Rama, an incarnation of the Hindu god Vishnu.

rathas Small, freestanding Hindu temples, perhaps sculptured as architectural models.

rayograph In the work of Man Ray, a *photogram*.

rayonnant The "radiant" style in thirteenth-century architecture that is associated with the royal Paris court of Louis IX.

readymades Manufactured objects, sometimes altered or joined with other objects and displayed as works of art to stimulate thought.

realism The representation of things according to their appearance in visible nature (without *idealization*). In the nineteenth century, an approach that supported the representation of the subject matter of everyday life in a realistic mode. Iconographically, nineteenth-century Realism is the subject matter of everyday life as seen by the artist.

red-figure technique In later Greek pottery, the silhouetting of red figures against a black background; the reverse of the *black-figure technique*.

reinforced concrete (ferroconcrete) Concrete with increased tensile strength produced by iron or steel mesh or bars embedded in it.

relief In sculpture, figures projecting from a background of which they are part. The degree of relief is designated high, low (**bas**), sunken (hollow), or *intaglio*. In the last, the backgrounds are not cut back and the points in highest relief are level with the original surface of the material being carved. See also *repoussé; stiacciata*.

reliquary A small receptacle for a sacred relic, usually of a richly decorated, precious material.

repoussé (ruh-poo-SAY) Formed in *relief* by beating a metal plate from the back, leaving the impression on the face. The metal is hammered into a hollow mold of wood or some other pliable material and finished with a *graver*. See also *relief*.

reserve column In Egyptian rock-cut and Etruscan domed tombs, a *column* that is hewn from the living rock and serves no supporting function.

respond An engaged *column, pilaster,* or similar structure that either projects from a *compound pier* or some other supporting device or is bonded to a wall and carries one end of an *arch,* often at the end of an *arcade*. A **nave arcade,** for example, may have nine *pillars* and two responds.

retable (ruh-TAY-bl) An architectural screen or wall above and behind an altar, usually containing painting, sculpture, carving, or other decorations. See also *altarpiece*.

reverse On coins or medals, the side opposite the *obverse*.

rhyton (RIGHT-on) An ancient Greek ceremonial drinking vessel with a base usually in the form of the head of an animal, a woman, or a mythological creature.

rib A relatively slender, molded masonry *arch* that projects from a surface. In Gothic architecture, the *ribs* form the framework of the *vaulting*.

ribbed vault See *vault*.

ridgepole The horizontal beam at the ridge of a roof, to which the upper ends of the rafters attach.

rinceau (ran-SO) An ornamental design composed of undulating foliate vine motifs.

rocaille (row-cah-EEE) Literally, "pebble." Refers to small stone and shell motifs in some eighteenth-century ornamentation.

Romanitas (Roh-MAN-ee-tahs) The religion of the Holy Roman Empire; its ritual and practice was based on imperial dominion.

rose or **wheel window** The large, circular window with *tracery* and stained glass frequently used in the *façades* of Gothic churches.

rotulus A long manuscript scroll used by the Egyptians, Greeks, and Romans; predecessor of the *codex*.

Rubénistes (Rue-bay-NEESTS) Adherents to a doctrine proclaiming the supremacy of color, rather than form, as the proper guide for the artist. See *Poussinistes*.

rusticate To give a rustic appearance by roughening the surfaces and *beveling* the edges of stone blocks to emphasize the joints between them. A technique popular

during the Renaissance, especially for stone courses at the ground-floor level.

sacra conversazione (SAH-krah cone-ver-sotz-ee-OHN-ee) In Italian, literally "holy conversation"; a grouping of the Madonna, Child, and saints in the same spatial setting, so that they appear to be conversing with one another.

sacral-idyllic scene A landscape depicting country life and idealized nature.

Salon (sah-LON) The government-sponsored exhibition of works by living artists held in Paris, first biennially and (since the mid-eighteenth century) annually.

salon In the eighteenth and early nineteenth centuries, a social assembly, in a private dwelling, of leaders in art and public affairs.

samsara (som-SAH-rah) In Hindu belief, the rebirth of the soul into a succession of lives.

santos (SAHN-toes) Simple, painted, wooden folk sculptures of holy figures found throughout Latin America and the Southwest.

sarcophagus (sar-KOF-a-gus) A stone coffin.

saturation The purity of a *hue*; the higher the *saturation*, the purer the hue. *Value* and saturation are not constantly related. For example, high-saturation yellow tends to have a high value, but high-saturation violet tends to have a low value.

satyr (SAT-er) In Greek mythology, a kind of demi-god or deity; a follower of Dionysos; wanton and lascivious and often represented with goatlike ears and legs and a short tail.

scale The dimensions of the parts or the totality of a building or an object in relation to its use or function. In architectural *plans*, the relation of the actual size of a structure to its representative size.

scriptorium A Medieval writing room in which scrolls were also housed.

sculpture in the round Freestanding figures, carved or modeled in three dimensions.

secondary colors The colors (in pigment: green, orange, and purple; in light: cyan, magenta, and yellow) that result from mixture of pairs of *primary colors*.

section In architecture, a diagram or representation of a part of a structure or building along an imaginary plane that passes through it vertically.

seicento (say-CHAIN-toh) The seventeenth century in Italian art. Literally, the "1600s."

serdab A small, concealed chamber in an Egyptian tomb for the statue of the deceased.

severe style An early, pre-Classical, transitional style of mid-fifth-century Greek statuary that is formal but not rigid in pose and emphasizes the principle of weight distribution; a liberation from the Archaic limitations of frontal rigidity found in Egyptian portrait statues.

sfumato (sfoo-MA-toh) A smokelike haziness that subtly softens outlines in painting; term is particularly applied to the painting of Leonardo and Correggio.

sgraffito (zgra-FEE-toh) Decoration produced by scratching through a surface layer of plaster, *glazing*, etc., to reveal a different colored *ground*; also, pottery or other ware so decorated.

shaft The part of a *column* between the *capital* and the base.

shaft grave A grave in the form of a deep pit, the actual burial spot being at the base of the shaft or in a niche at the base.

shaman (SHAH-mon) A priest or medicine man who can influence good and evil spirits; *shamanism* is the religion of some American Indians and Eskimos.

shinto Indigenous faith of the Japanese people.

shoji (SHOW-jee) A translucent rice-paper-covered sliding screen that serves as a room divider in traditional Japanese houses.

sikhara (SHIH-ka-rah) In Hindu temples of Vishnu, the tower above the shrine.

silver point A drawing technique involving the use of a silver-tipped "pencil" on a paper with a white *matte* coating; also, the delicate drawings so made.

sinopia or **sinopie** Reddish-brown earth color; also, the *cartoon* or underpainting for a *fresco*.

sistrum An instrument of metal rods loosely held in a metal frame, which jingle when shaken. Peculiarly Egyptian, it was used especially in the worship of Isis and is still used in Nubia.

sizing Traditional protective coat of glue applied to canvas.

slip Potter's clay dispersed in a liquid and used for *casting*, decoration, and to attach parts of clay vessels, such as handles.

smalto The colored glass or enamel used in *mosaics*.

socle (SOH-kel) A molded projection at the bottom of a wall or a *pier*, or beneath a pedestal or a *column* base.

soffit The underside of an architectural member such as an *arch*, *lintel*, *cornice*, or stairway. See also *intrados*.

soft focus A term used especially in photography to refer to an image made when the lens is thrown slightly out of sharp focus so that the contours of any object appear moderately soft and blurred.

space-time A concise way of referring to the understanding of the universe as an entity composed of inextricably interwoven space and time; a conception based especially on the theories of Albert Einstein. In this view of the universe, anything that happens to alter the condition of space also affects the condition of time, and vice versa.

spandrel The roughly triangular space enclosed by the curves of adjacent *arches* and a horizontal member connecting their vertexes; also, the space enclosed by the curve of an *arch* and an enclosing right angle.

splay A large *bevel* or *chamfer*.

splayed opening An opening (as in a wall) that is cut away diagonally so that the outer edges are farther apart than the inner edges. See also *embrasure*.

springing The lowest stone of an *arch*, resting on the *impost block*.

square schematism A church *plan* in which the *crossing square* is used as the *module* for all parts of the design.

squinch An architectural device used to make a transition from a square to a polygonal or circular base for a *dome*. It may be composed of *lintels*, *corbels*, or *arches*.

stave A wedge-shaped timber; vertically placed staves embellish the architectural features of a building.

stele (STEE-lee) A carved stone slab or *pillar* used especially by the ancient Greeks as grave or site markers and for similar purposes. Also found in Maya area of Mesoamerica to commemorate historical events.

stiacciata or **sciacciata** (stee-ah-CHAH-tah) A kind of very low relief, originated by Donatello, that incorporates much of the illusionism of painting into carving, which in places is hardly more than a scratching of the surface.

still life A painting representing inanimate objects, such as flowers, fruit, or household articles.

stoa (STOH-a) In ancient Greek architecture, an open building with a roof supported by a row of *columns* parallel to the back wall.

straight photography Photography that represents direct, "real-time" seeing as opposed to the combination of images made at different moments in time. See *double-exposure techniques* and *photomontage*.

stringcourse A horizontal *molding* or band in masonry, ornamental but usually reflecting interior structure.

stucco Fine plaster or cement used as a coating for walls or for decoration.

stupa (STOO-puh) A large, mound-shaped Buddhist shrine.

style A manner of treatment or execution of works of art that is characteristic of a civilization, a people, or an individual; also, a special and superior quality in a work of art.

stylobate (STY-loh-bate) The upper step of the base of a Greek temple, which forms a platform for the *columns*.

stylus A needlelike tool used in *engraving* and *incising*.

superimposed orders *Orders* of architecture that are placed one above another in an *arcaded* or *colonnaded* building, usually in the following sequence: **Doric** (the first story), **Ionic**, and **Corinthian**. Superimposed orders are found in Greek *stoas* and were used widely by Roman and Renaissance builders.

sutra (SOO-truh) In Buddhism, an account of a sermon by or a dialogue involving the *Buddha*.

swag A kind of decoration for walls, furniture, etc., done in *relief* and resembling garlands and gathered drapery, that was particularly popular in the eighteenth century.

symmetry *Esthetic* balance that is usually achieved by disposing *forms* about a real or an imaginary *axis* so that those on one side

more-or-less correspond with those on the other. The correspondence may be in terms of shape, *color*, texture, etc.

tablinum A room behind the *atrium* in a Roman house in which family archives and statues were kept.

tectiforms Shapes resembling man-made structures found painted on the walls of Paleolithic caves.

tell In Near Eastern archeology, a hill or a mound, usually an ancient site of habitation.

tempera A technique of painting using *pigment* mixed with egg yolk, glue, or casein; also, the *medium* itself.

Tenebrists (TEN-i-brists) A group of seventeenth-century European painters who used violent contrasts of light and dark.

tenebroso Painting in the "dark manner"; a technique of the *Caravaggisti*.

tenon A projection on the end of a piece of wood that is inserted into a corresponding hole (**mortice**) in another piece of wood to form a joint.

tepidarium The warm-bath section of a Roman bathing establishment.

terra cotta Hard-baked clay, used for sculpture and as a building material, that may be *glazed* or painted.

tesserae (TESS-er-ee) Small, shaped pieces of glass or stone used in making *mosaics*.

tholos (THOH-los) A circular structure, generally in Classical Greek style; also an ancient, circular tomb.

thrust The outward force exerted by an *arch* or a *vault* that must be counterbalanced by *buttresses*.

tier A series of architectural rows, layers, or ranks arranged above or behind one another.

tondo A circular painting or *relief* sculpture.

torano (TOR-uh-nuh) Gateway in the stone fence around a *stupa*, located at the cardinal points of the compass.

torus A convex *molding* or part of a molding, usually the lowest in the base of a *column*.

totem An animal or object and its representation or image, considered to be a symbol of a given family or clan.

trabeated (TRAY-bee-ate-id) Of *post-and-lintel* construction. Literally, "beamed" construction.

tracery Branching, ornamental stonework, generally in a window, where it supports the glass; particularly characteristic of Gothic architecture.

transept The part of a *cruciform* church with an *axis* that crosses the main axis at right angles.

trecento (tray-CHAIN-toh) The fourteenth century in Italian art. Literally, the "1300s."

trefoil An architectural ornament having three lobes or *foils*. See also *quatrefoil*.

triforium In a Gothic cathedral, the blind, *arcaded* gallery below the *clerestory*.

triglyph A projecting, grooved member of a Doric *frieze* that alternates with *metopes*.

trilithon A pair of *monoliths* topped with a *lintel*; found in *megalithic* structures.

triptych (TRIP-tik) A three-paneled painting or *altarpiece*.

trompe l'oeil (trohmp-LOY) A form of illusionistic painting that attempts to represent an object as if it exists in three dimensions at the surface of the painting; literally, "eye-fooling."

trumeau (troo-MOH) A *pillar* in the center of a Romanesque or Gothic portal.

turret A small, often ornamental tower projecting from a building, usually at a corner.

tympanum The space enclosed by a *lintel* and an *arch* over a doorway; also, the recessed face of a *pediment*.

ukiyo-e (OO-kee-oh-ee) A style of Japanese *genre* painting ("pictures of the floating world") that influenced nineteenth-century Western art.

urna The whorl of hair, represented as a dot, between the brows of a Hindu diety.

ushnisha (ush-NISH-uh) Stylized protuberance of the *Buddha*'s forehead, emblematic of his superhuman consciousness.

value The amount of light reflected by a *hue*; the greater the amount of light, the higher the value. See also *saturation*.

vanishing point In *linear perspective*, that point on the horizon toward which parallel lines appear to converge and at which they seem to vanish.

vanitas (VAHN-ee-tahs) Painting subject, often a still life, in sixteenth and seventeenth centuries, meant to encourage the viewer to meditate on death as the inevitable end of all human life.

vault A masonry roof or ceiling constructed on the *arch* principle. A **barrel** or **tunnel vault**, semicylindrical in cross section, is in effect a deep arch or an uninterrupted series of arches, one behind the other, over an oblong space. In a **cross-barrel vault**, the main barrel (tunnel) vault is intersected at right angles with other barrel (tunnel) vaults at regular intervals. A **quadrant vault** is a half-barrel (tunnel) vault. A **sexpartite vault** is a rib vault with six panels. A **fan vault** is a development of *lierne* vaulting characteristic of English Perpendicular Gothic, in which radiating *ribs* form a fan-like pattern. A **groin** or **cross vault** is formed at the point at which two *barrel (tunnel) vaults* intersect at right angles. In a **ribbed vault,** there is a framework of ribs or arches under the intersections of the vaulting sections.

veduta (veh-DUE-tah) Type of naturalistic landscape and cityscape painting popular in eighteenth-century Venice. Literally, "view" painting.

vellum Calfskin prepared as a surface for writing or painting.

vernacular architecture Nonprofessional, popular architecture.

video synthesizer Special instrument that allows video artists to manipulate and change electronic video information, causing images to stretch, shrink, change color or break up, and to layer, inset, or merge with other images.

vignette Originally, a decorative element of vine leaves and tendrils in the page margins of Gothic manuscripts; later, a decorative design with no distinct borders to separate it from the text of a book page.

vihara (vee-HAH-rah) A Buddhist monastery, often cut into a rock.

vimana (vih-MAH-nuh) In Hindu and Buddhist temples, the pyramidal tower above the shrine (composed of the *garbha griha* and the *sikhara*).

volume See *mass*.

volute A spiral, scroll-like form characteristic of the Greek Ionic *capital*.

voussoir (voo-SWAHR) A wedge-shaped block used in the construction of a true *arch*. The central voussoir, which sets the arch, is the *keystone*.

warm color Red, orange, or yellow. Psychologically, warm colors tend to be exciting, emphatic, and affirmative; optically, they generally seem to advance or to project. See also *cool color*.

wash In *watercolor* painting especially, a thin, transparent film of color.

watercolor A painting technique using *pigment* (usually prepared with gum) mixed with water and applied to an absorbent surface; also, the *medium* itself. The painting is transparent, with the white of the paper furnishing the lights.

weight shift See *contrapposto*.

westwork A multistoried *mass*, including the *façade* and usually surmounted by towers, at the western end of a Medieval church, principally in Germany.

woodcut A wooden block on the surface of which those parts not intended to print are cut away to a slight depth, leaving the design raised; also, the printed impression made with such a block.

yaksha (YAK-shah) A divinity in the Hindu and Buddhist pantheon. (*f.* **yakshi**)

Yamato-e (yah-MAH-toh-ee) A purely Japanese style of sophisticated and depersonalized painting created for the Fujiwara nobility.

yasti (YAHS-tee) The mast surmounting the *dome* of a *stupa*.

yu A covered Chinese libation vessel.

Zen A Buddhist sect and its doctrine, emphasizing enlightenment through intuition and introspection rather than the study of scripture. In Chinese, *Ch'an*.

ziggurat (ZIG-oor-at) A roughly pyramidal structure, built in ancient Mesopotamia, consisting of stages; each succeeding stage is stepped back from the one beneath.

zoomorphism The representation of gods in the form or with the attributes of animals; the use of animal forms in art or symbolism.

zoopraxiscope (zoe-oh-PRAX-is-cope) Device invented by Eadweard Muybridge, which he developed to project sequences of images (mounted on special glass plates) onto a screen in rapid succession, creating the illusion of motion pictures. See *perspective of vision*.

BIBLIOGRAPHY

This supplementary list of books is intended to be comprehensive enough to satisfy the reading interests of the unspecialized student and general reader, as well as those of more advanced readers who wish to become acquainted with fields other than their own. The books listed range from works that are valuable primarily for their reproductions to scholarly surveys of schools and periods. No entries for periodical articles appear, but a few of the periodicals that publish art-historical scholarship in English are noted.

SELECT PERIODICALS

Archaeology
The Art Bulletin
Art History
The Art Journal
The Burlington Magazine
Journal of the Society of Architectural Historians
Journal of the Warburg and Courtauld Institutes

REFERENCE BOOKS

Arntzen, Etta, and Rainwater, Robert. *Guide to the Literature of Art History.* Chicago: American Library Association/Art Book Company, 1980. (Later edition available.)

Bator, Paul M. *The International Trade in Art.* Chicago: University of Chicago Press, 1983. (Later edition available.)

Bindman, David, ed. *The Thames & Hudson Encyclopedia of British Art.* London: Thames & Hudson, 1985. (Later editions available.)

Broude, Norma, and Garrard, Mary D., eds. *Feminism and Art History: Questioning the Litany.* New York: Harper & Row, 1982.

Chilvers, Ian, and Osborne, Harold, eds. *The Oxford Dictionary of Art.* New York: Oxford University Press, 1988.

Christe, Yves, et al. *Art of the Christian World, 200–1500: A Handbook of Styles and Forms.* New York: Rizzoli, 1982.

Encyclopedia of World Art. 15 vols. New York: Publisher's Guild, 1959–1968. Supplementary vols. 16, 1983; 17, 1987.

Feilden, Bernard B. *The Conservation of Historic Buildings.* London: Butterworth Scientific Books, 1982.

Fielding, Mantle. *Dictionary of American Painters, Sculptors, and Engravers.* 2nd rev. and enl. ed. Poughkeepsie, NY: Apollo, 1986.

Fleming, John; Honour, Hugh; and Pevsner, Nikolaus. *Penguin Dictionary of Architecture.* Baltimore: Penguin, 1980.

Fletcher, Sir Banister. *A History of Architecture.* 18th rev. ed. New York: Scribner, 1975.

Giedion, Siegfried. *The Beginnings of Architecture: The Eternal Present, a Contribution on Constancy and Change.* Princeton: Princeton University Press, 1981.

————. *Space, Time and Architecture: The Growth of a New Tradition.* 5th ed., rev. and enl. Cambridge: Harvard University Press, 1982.

Gombrich, Ernst Hans Josef. *Art and Illusion.* 5th ed. London: Phaidon, 1977.

Haggar, Reginald G. *A Dictionary of Art Terms: Architecture, Sculpture, Painting, and the Graphic Arts.* Poole, England: New Orchard Editions, 1984.

Hall, James. *Dictionary of Subjects and Symbols in Art.* 2nd rev. ed. London: J. Murray, 1977. (Later edition available.)

Harris, A. S., and Nochlin, L. *Women Artists: 1550–1950.* Los Angeles: County Museum of Art; New York: Knopf, 1976. (Later edition available.)

Hauser, Arnold. *The Sociology of Art.* Chicago: University of Chicago Press, 1982.

Hind, Arthur M. *A History of Engraving and Etching from the Fifteenth Century to the Year 1914.* 3rd rev. ed. New York: Dover, 1963.

Holt, Elizabeth G., ed. *A Documentary History of Art.* 2nd ed. 2 vols. Princeton: Princeton University Press, 1981.

Huyghe, René, ed. *Larousse Encyclopedia of Byzantine and Medieval Art.* New York: Prometheus Press, 1963; Excalibur Books, 1981.

————. *Larousse Encyclopedia of Renaissance and Baroque Art.* New York: Prometheus Press, 1964; Hamlyn/American (paperbound), 1976.

James, John, et al. *The Traveler's Key to Medieval France: A Guide to the Sacred Architecture of Medieval France.* New York: Knopf, 1986.

Janson, H. W., ed. *Sources and Documents in the History of Art Series.* Englewood Cliffs, NJ: Prentice-Hall, 1966.

Kostof, Spiro. *A History of Architecture: Settings and Rituals.* Oxford: Oxford University Press, 1985.

Kronenberger, Louis. *Atlantic Brief Lives: A Biographical Companion to the Arts.* Boston: Little, Brown, 1971.

Lucie-Smith, Edward. *The Thames & Hudson Dictionary of Art Terms.* London: Thames & Hudson, 1984.

Murray, Peter, and Murray, Linda. *A Dictionary of Art and Artists.* New York: Penguin, 1976; (paperbound) 1984.

Myers, Bernard Samuel, ed. *Encyclopedia of Painting: Painters and Painting of the World from Prehistoric Times to the Present Day.* 4th rev. ed. New York: Crown, 1979.

————. *Encyclopedia of World Art,* Suppl. vol. 16. Palatine, IL: McGraw-Hill/The Publishers Guild, 1983. (Later edition available.)

Myers, Bernard S., and Myers, Shirley D., eds. *Dictionary of 20th-Century Art.* New York: McGraw-Hill, 1974.

Osborne, Harold, ed. *The Oxford Companion to 20th Century Art.* New York: Oxford University Press, 1981.

Pevsner, Nikolaus. *A History of Building Types.* 1979. Reprint. London: Thames & Hudson (paperbound), 1987.

————. *An Outline of European Architecture.* 8th rev. ed. Baltimore: Penguin, 1974.

Pierson, William H., Jr., and Davidson, Martha, eds. *Arts of the United States, A Pictorial Survey.* 1960. Reprint. Athens: University of Georgia Press, 1975.

Placzek, A. K., ed. *Macmillan Encyclopedia of Architects.* 4 vols. New York: Macmillan/Free Press, 1982.

Podro, Michael. *The Critical Historians of Art.* New Haven: Yale University Press, 1982.

Quick, John. *Artists' and Illustrators' Encyclopedia.* 2nd ed. New York: McGraw-Hill, 1977.

Read, Herbert, and Stangos, Nikos, eds. *The Thames & Hudson Dictionary of Art and Artists.* Rev. ed. London: Thames & Hudson, 1988.

Redig de Campos, D., ed. *Art Treasures of the Vatican.* New York: Park Lane, 1974.

Rubenstein, Charlotte Streifer. *American Women Artists from Early Indian Times to the Present.* Boston: G. K. Hall/Avon Books, 1982.

Schiller, Gertrud. *Iconography of Christian Art.* 2 vols. Greenwich, CT: New York Graphic Society, 1971.

Smith, G. E. Kidder. *The Architecture of the United States: An Illustrated Guide to Buildings Open to the Public.* 3 vols. Garden City, NY: Doubleday/Anchor, 1981.

Stierlin, Henri. *Encyclopedia of World Architecture 1978.* 1978. Reprint. New York: Van Nostrand, Reinhold, 1983.

Stratton, Arthur. *The Orders of Architecture: Greek, Roman and Renaissance.* London: Studio, 1986.

Trachtenberg, Marvin, and Hyman, Isabelle. *Architecture, from Prehistory to Post-Modernism.* New York: Abrams, 1986.

Tufts, Eleanor. *American Women Artists, Past and Present, A Selected Bibliographic Guide.* New York: Garland Publishers, 1984.

————. *Our Hidden Heritage, Five Centuries of Women Artists.* New York: Paddington Press, 1974.

Waterhouse, Ellis. *The Dictionary of British 18th Century Painters in Oils and Crayons.* Woodbridge, England: Antique Collectors' Club, 1981.

Wittkower, Rudolf. *Sculpture Processes and Principles.* New York: Harper & Row, 1977.

Wölfflin, Heinrich. *The Sense of Form in Art.* New York: Chelsea, 1958.

Young, William, ed. *A Dictionary of American Artists, Sculptors, and Engravers.* Cambridge, MA: W. Young, 1968.

CHAPTER 1 THE BIRTH OF ART

Bandi, Hans-Georg; Breuil, Henri; et al. *The Art of the Stone Age: Forty Thousand Years of Rock Art.* 2nd ed. London: Methuen, 1970.

Bataille, Georges. *Lascaux: Prehistoric Painting or the Birth of Art.* Lausanne: Skira, 1980.

Breuil, Henri. *Four Hundred Centuries of Cave Art.* New York: Hacker, 1979. Reprint.

Graziosi, Paolo. *Paleolithic Art.* New York: McGraw-Hill, 1960.

Hawkes, Jacquetta. *The Atlas of Early Man.* New York: St. Martin's Press, 1976.

Kubba, Shamil A. A. *Mesopotamian Architecture and Town-planning: From the Mesolithic to the End of the Proto-historic Period.* Oxford: B. A. R., 1987.

Leroi-Gourhan, Andre. *The Dawn of European Art: An Introduction to Paleolithic Cave Painting.* Cambridge: Cambridge University Press, 1982.

————. *Treasures of Prehistoric Art.* New York: Abrams, 1967.

Lewin, Roger. *In the Age of Mankind: A Smithsonian Book of Human Evolution.* Washington DC: Smithsonian Institution Books, 1988.

Megaw, J. V. S. *The Art of the European Iron Age.* New York: Harper & Row, 1970.

Pfeiffer, John E. *The Creative Explosion: An Inquiry into the Origins of Art and Religion.* New York: Harper & Row, 1982.

Powell, T. G. E. *Prehistoric Art.* New York: Praeger, 1966.

Renfrew, Colin, ed. *British Prehistory: A New Outline.* London: Noyes Press, 1975.

Sandars, Nancy K. *Prehistoric Art in Europe.* 2nd ed. New York: Penguin, 1985.

Sieveking, Ann. *The Cave Artists.* London: Thames & Hudson, 1979.

Trump, David H. *The Prehistory of the Mediterranean.* New Haven: Yale University Press, 1980. (Later edition available.)

Wainwright, Geoffrey. *The Henge Monuments: Ceremony and Society in Prehistoric Britain.* London: Thames & Hudson, 1990.

Windels, Fernand. *The Lascaux Cave Paintings.* New York: Viking, 1950.

CHAPTER 2 THE ANCIENT NEAR EAST

Amiet, Pierre. *Art of the Ancient Near East.* New York: Abrams, 1980.

Amiet, Pierre, et al. *Art in the Ancient World: A Handbook of Styles and Forms.* New York: Rizzoli, 1981.

Culican, William. *The Medes and Persians.* London: Thames & Hudson, 1965; New York: Praeger, 1965.

Frankfort, Henri. *The Art and Architecture of the Ancient Orient.* Baltimore: Penguin, 1971. (Later edition available.)

Ghirshman, Roman. *Iran from Earliest Times to the Islamic Conquest.* New York: Penguin, 1978.

Groenewegen-Frankfort, H. A. *Arrest and Movement: An Essay on Space and Time in Representational Art of the Ancient Near East.* Cambridge, MA: Belknap Press, 1987.

Hinz, Walther. *The Lost World of Elam.* New York: New York University Press, 1973.

Kenyon, Kathleen M. *Digging Up Jericho.* New York: Praeger, 1974.

Kramer, Samuel N. *The Sumerians: Their History, Culture, and Character.* Chicago: University of Chicago Press, 1963. (Later edition available.)

Leick, Gwendolyn. *A Dictionary of Ancient Near Eastern Architecture.* New York: Routledge, 1988.

Lloyd, Seton. *The Archaeology of Mesopotamia: From the Old Stone Age to the Persian Conquest.* London: Thames & Hudson, 1978. (Later edition available.)

————. *The Art of the Ancient Near East.* New York: Praeger, 1969.

Lloyd, Seton, and Muller, Hans Wolfgang. *Ancient Architecture: Mesopotamia, Egypt, Crete.* New York: Electa/Rizzoli, 1986.

Mellaart, James. *Çatal Hüyük: A Neolithic Town in Anatolia.* New York: McGraw-Hill, 1967.

————. *The Earliest Civilizations of the Near East.* New York: McGraw-Hill, 1965.

————. *The Neolithic of the Near East*. New York: Scribner, 1975.
Oppenheim, A. Leo. *Ancient Mesopotamia*. Rev. ed. Chicago: University of Chicago Press, 1977.
Paris, Pierre. *Manual of Ancient Sculpture*. Rev. and enl. ed. New Rochelle, NY: Caratzas, 1984.
Parrot, André. *The Arts of Assyria*. New York: Golden Press, 1961.
————. *Sumer: The Dawn of Art*. New York: Golden Press, 1961.
Porada, Edith, and Dyson, R. H. *The Art of Ancient Iran: Pre-Islamic Cultures*. Rev. ed. New York: Greystone Press, 1969.
Wolf, Walther. *The Origins of Western Art: Egypt, Mesopotamia, the Aegean*. New York: Universe Books, 1989.
Woolley, Charles L. *The Art of the Middle East, Including Persia, Mesopotamia and Palestine*. New York: Crown, 1961.
————. *The Development of Sumerian Art*. Westport, CT: Greenwood Press, 1981.

CHAPTER 3 THE ART OF EGYPT

Aldred, Cyril. *The Development of Ancient Egyptian Art from 3200 to 1315 B.C.* 3 vols. London: Academy Edition, 1973.
Badawy, Alexander. *A History of Egyptian Architecture*. 3 vols. Berkeley: University of California Press, 1973.
Baines, John, and Malek, Jaromir. *Atlas of Ancient Egypt*. New York: Facts on File, 1980.
Emery, Walter B. *Archaic Egypt*. Baltimore: Penguin, 1972. (Later edition available.)
Gardiner, Sir Alan Henderson. *Egypt of the Pharaohs*. London: Oxford University Press, 1978.
Lange, Kurt, with Hirmer, Max. *Egypt: Architecture, Sculpture and Painting in Three Thousand Years*. 4th ed. London: Phaidon, 1968.
Lurker, Manfred. *The Gods and Symbols of Ancient Egypt: An Illustrated Dictionary*. New York: Thames & Hudson, 1980. (Later edition available.)
Mahdy, Christine, ed. *The World of the Pharaohs: A Complete Guide to Ancient Egypt*. London: Thames & Hudson, 1990.
Mekhitarian, Arpag. *Egyptian Painting*. New York: Skira, 1978.
Mendelsohn, Kurt. *The Riddle of the Pyramids*. New York: Thames & Hudson, 1986.
Robins, Gay. *Egyptian Painting and Relief*. Aylesbury, England: Shire Publications, 1986.
Romer, John. *Valley of the Kings*. New York: William Morrow, 1981.
Schafer, Heinrich. *Principles of Egyptian Art*. Rev. reprint. Oxford: Aris and Phillips, 1986.
Smith, E. Baldwin. *Egyptian Architecture as Cultural Expression*. Watkins Glen, NY: American Life Foundation, 1968.
Smith, William Stevenson, and Simpson, W. *The Art and Architecture of Ancient Egypt*. Rev. ed. New York: Viking, 1981.
Woldering, Irmgard. *Gods, Men and Pharaohs: The Glory of Egyptian Art*. New York: Abrams, 1967.

CHAPTER 4 THE AEGEAN: CYCLADIC, MINOAN, AND MYCENAEAN ART

Chadwick, John. *The Mycenaean World*. New York: Cambridge University Press, 1976.
Cottrell, Arthur. *The Minoan World*. New York: Scribner, 1980.
Demargne, Pierre. *Aegean Art: The Origins of Greek Art*. London: Thames & Hudson, 1964.
Doumas, Christos. *Thera, Pompeii of the Ancient Aegean: Excavations at Akrotiri, 1967–1979*. New York: Thames & Hudson, 1983.
Evans, Sir Arthur John. *The Palace of Minos*. 4 vols. 1921–1935. Reprint. New York: Biblo & Tannen, 1964.
Graham, James W. *The Palaces of Crete*. Princeton: Princeton University Press, 1969. (Later edition available.)
Higgins, Reynold Alleyne. *Minoan and Mycenaean Art*. Rev. ed. New York: Oxford University Press, 1981.
Marinatos, Spyridon, with Hirmer, Max. *Crete and Mycenae*. London: Thames & Hudson, 1960.
Matz, Friedrich. *The Art of Crete and Early Greece*. New York: Crown, 1965.
Palmer, Leonard R. *Mycenaeans and Minoans*. 2nd rev. ed. 1963. Reprint. Westport, CT: Greenwood Press, 1980.

Pendlebury, John. *The Archeology of Crete*. London: Methuen, 1967.
Schliemann, Heinrich. *Ilios: The City and the Country of the Trojans*. 1881. Reprint. New York: B. Blom, 1968. (Other reprints available.)
————. *Mycenae*. 1880. Reprint. New York: Arno Press, 1976.
————. *Tiryns*. 1885. Reprint. New York: Arno Press, 1976.
Vermeule, Emily. *Greece in the Bronze Age*. Chicago: University of Chicago Press, 1972.
Wace, Alan. *Mycenae, an Archeological History and Guide*. New York: Biblo & Tannen, 1964.
Warren, Peter. *The Aegean Civilizations*. London: Elsevier-Phaidon, 1975.
Willetts, R. F. *The Civilization of Ancient Crete*. Berkeley: University of California Press, 1978.

CHAPTER 5 THE ART OF GREECE

Arias, Paolo. *A History of One Thousand Years of Greek Vase Painting*. New York: Abrams, 1962. (Later edition available.)
Ashmole, Bernard. *Architect and Sculptor in Classical Greece*. New York: New York University Press, 1972.
Beazley, John D. *Attic Red-Figure Vase-Painters*. 3 vols. 1963. Reprint. New York: Hacker, 1984.
————. *The Development of the Attic Black-Figure*. Rev. ed. Berkeley: University of California Press, 1986.
Beazley, John D., and Ashmole, Bernard. *Greek Sculpture and Painting to the End of the Hellenistic Period*. Cambridge: Cambridge University Press, 1966.
Berve, Helmut. *Greek Temples, Theatres, and Shrines*. New York: Abrams, 1963.
Bieber, Margarete. *Sculpture of the Hellenistic Age*. 1961. Reprint. New York: Hacker, 1980.
Blumel, Carl. *Greek Sculptors at Work*. London: Phaidon, 1969.
Boardman, John. *Greek Art*. Rev. ed. New York: Thames & Hudson, 1987.
————. *Greek Sculpture: The Classical Period: A Handbook*. London: Thames & Hudson, 1987.
Branigan, Keith, and Vickers, Michael. *Hellas, the Civilizations of Ancient Greece*. New York: McGraw-Hill, 1980.
Brilliant, Richard. *Arts of the Ancient Greeks*. New York: McGraw-Hill, 1973.
Buschor, Ernst. *Greek Vase Painting*. New York: Hacker, 1978.
————. *On the Meaning of Greek Statues*. Amherst: University of Massachusetts Press, 1980.
Carpenter, Rhys. *Greek Sculpture: A Critical Review*. Chicago: University of Chicago Press, 1960.
Charbonneaux, Jean. *Archaic Greek Art*. New York: Braziller, 1971.
Charbonneaux, Jean; Martin, Roland; and Villard, François. *Hellenistic Art*. New York: Braziller, 1973.
Chitham, Robert. *Classical Orders of Architecture*. New York: Rizzoli, 1985.
Cook, Robert M. *Greek Art: Its Development, Character and Influence*. Harmondsworth, England: Penguin, 1976.
Coulton, J. J. *Ancient Greek Architects at Work*. Ithaca, NY: Cornell University Press, 1977. (Later edition available.)
Dinsmoor, W. B. *The Architecture of Ancient Greece*. 3rd ed. New York: Norton, 1975.
Hampe, Roland, and Simon, Erika. *The Birth of Greek Art*. New York: Oxford University Press, 1981.
Havelock, Christine Mitchell. *Hellenistic Art: The Art of the Classical World*. 2nd rev. ed. New York: Norton, 1981.
Lawrence, Arnold W. *Greek Architecture*. 2nd ed. Baltimore: Penguin, 1967. (Later edition available.)
Lullies, Reinhard, and Hirmer, Max. *Greek Sculpture*. Rev. ed. New York: Abrams, 1960.
Martin, Roland. *Greek Architecture: Architecture of Crete, Greece, and the Greek World*. New York: Electa/Rizzoli, 1988.
Onians, John. *Art and Thought in the Hellenistic Age: The Greek World View, 350–50 B.C.* London: Thames & Hudson, 1979.
Papaioannou, Kostas. *The Art of Greece*. New York: Abrams, 1989.
Pfuhl, Ernst. *Masterpieces of Greek Drawing and Painting*. 2nd ed. Chicago: Argonaut, 1967.

Pollitt, Jerome J. *The Ancient View of Greek Art*. New Haven: Yale University Press, 1974.
————. *Art and Experience in Classical Greece*. Cambridge: Cambridge University Press, 1972.
————. *Art in the Hellenistic Age*. Cambridge: Cambridge University Press, 1986.
————. *The Art of Greece 1400–31 B.C.* Englewood Cliffs, NJ: Prentice-Hall, 1965.
Richter, Gisela M. *Attic Red-Figure Vases: A Survey*. New Haven: Yale University Press, 1958.
————. *A Handbook of Greek Art*. 9th ed. Oxford: Phaidon, 1987.
————. *The Portraits of the Greeks*. Rev. ed. Ithaca, NY: Cornell University Press, 1984.
————. *The Sculpture and Sculptors of the Greeks*. 4th ed. New Haven: Yale University Press, 1970.
Ridgway, Brunilde Sismondo. *Fifth Century Styles in Greek Sculpture*. Princeton: Princeton University Press, 1981.
————. *The Severe Style in Greek Sculpture*. Princeton: Princeton University Press, 1970.
Robertson, Donald S. *Greek and Roman Architecture*. 2nd ed. Cambridge: Cambridge University Press, 1969.
Robertson, Martin. *Greek Painting*. New York: Rizzoli, 1979.
————. *A History of Greek Art*. 2 vols. Cambridge: Cambridge University Press, 1976.
————. *A Shorter History of Greek Art*. Cambridge: Cambridge University Press, 1981.
Scranton, Robert L. *Greek Architecture*. New York: Braziller, 1962.
Scully, Vincent. *The Earth, the Temple, and the Gods: Greek Sacred Architecture*. Rev. ed. New Haven: Yale University Press, 1979.
Stewart, Andrew. *Greek Sculpture*. 2 vols. New Haven: Yale University Press, 1990.
Swindler, Mary H. *Ancient Painting from the Earliest Times to the Period of Christian Art*. 1929. Reprint. New Haven: Yale University Press, 1929.
Travlos, John. *Pictorial Dictionary of Ancient Athens*. 1971. Reprint. New York: Hacker, 1980.
Vermeule, Cornelius C. *The Art of the Greek World, Prehistoric through Pericles*. Boston, MA: Department of Classical Art, Museum of Fine Arts, 1982.
————. *Greek and Roman Sculpture in America: Masterpieces in Public Collections*. Berkeley: University of California Press, 1981.
————. *Greek Art, Socrates to Sulla*. Boston, MA: Department of Classical Art, Museum of Fine Arts, 1980.

CHAPTER 6 ETRUSCAN AND ROMAN ART

Andreae, Bernard. *The Art of Rome*. New York: Abrams, 1977.
Bianchi Bandinelli, Ranuccio. *Rome, the Late Empire*. New York: Braziller, 1971.
Boethius, Axel. *The Golden House of Nero*. Ann Arbor: University of Michigan Press, 1960.
Brilliant, Richard. *Roman Art, from the Republic to Constantine*. New York: Praeger, 1974.
————. *Visual Narratives: Storytelling in Etruscan and Roman Art*. Ithaca, NY: Cornell University Press, 1984.
Brown, Frank Edward. *Roman Architecture*. New York: Braziller, 1961.
Buchthal, Hugo. *Art of the Mediterranean World, A.D. 100 to 1400*. Art History Series 5. Washington, DC: Decatur House Press, 1983.
Goldscheider, Ludwig. *Roman Portraits*. London: Phaidon, 1940.
Hanfmann, George. *Roman Art*. Greenwich, CT: New York Graphic Society, 1964.
Kraus, Theodor. *Pompeii and Herculaneum: The Living Cities of the Dead*. New York: Abrams, 1975.
Leach, Eleanor Winsor. *The Rhetoric of Space: Literary and Artistic Representations of Landscape in Republican and Augustan Rome*. Princeton: Princeton University Press, 1988.
L'Orange, Hans Peter. *The Roman Empire: Art Forms and Civic Life*. New York: Rizzoli, 1985.
MacDonald, William L. *The Architecture of the Roman Empire*. Rev. ed. New Haven: Yale University Press, 1982.
McKay, Alexander G. *Houses, Villas, and Palaces in the Roman World*. Ithaca, NY: Cornell University Press, 1975.
Maiuri, Amedeo. *Pompeii*. 14th ed. Rome: Istituto Poligrafico dello Stato, 1970.
————. *Roman Painting*. Geneva: Skira, 1953.

Mansuelli, Guido. *The Art of Etruria and Early Rome.* New York: Crown, 1965.

Nash, Ernest. *Pictorial Dictionary of Ancient Rome.* 2 vols. New York: Hacker, 1981.

Pollitt, Jerome J. *The Art of Rome, 753 B.C.–A.D. 337.* Englewood Cliffs, NJ: Prentice-Hall, 1966.

Richardson, Emeline. *The Etruscans: Their Art and Civilization.* Chicago: University of Chicago Press, 1976.

Rivoira, Giovanni. *Roman Architecture and Its Principles of Construction Under the Empire.* New York: Hacker, 1972.

Robertson, Donald S. *Greek and Roman Architecture.* 2nd ed. Cambridge: Cambridge University Press, 1969.

Sprenger, Maja, and Bartoloni, Gilda. *The Etruscans: Their History, Art, and Architecture.* New York: Abrams, 1983.

Strong, Donald, and Ling, Roger. *Roman Art.* 2nd rev. ed. New York: Penguin, 1988.

Vermeule, Cornelius C. *Roman Art: Early Republic to Late Empire.* Boston: Museum of Fine Arts, Department of Classical Art, 1979.

Vickers, Michael. *The Roman World.* Oxford: Elsevier-Phaidon, 1977.

Ward-Perkins, John B. *Roman Architecture.* New York: Electa/Rizzoli, 1988.

———. *Roman Imperial Architecture.* 2nd integrated. New York: Penguin, 1981.

Ward-Perkins, John, and Boethius, Axel. *Etruscan and Roman Architecture.* Harmondsworth, England: Penguin, 1970.

Zanker, Paul. *The Power of Images in the Age of Augustus.* Ann Arbor: University of Michigan Press, 1988.

CHAPTER 7 EARLY CHRISTIAN, BYZANTINE, AND ISLAMIC ART

Arnold, Thomas W. *Painting in Islam.* New York: Dover, 1965.

Aslanapa, Oktay. *Turkish Art and Architecture.* London: Faber & Faber, 1971.

Atil, Esin. *Renaissance of Islam: Art of the Mamluks.* Washington, DC: Smithsonian Institution Press, 1981.

Beach, Milo Cleveland. *Early Mughal Painting.* Cambridge: Harvard University Press, 1987.

Beckwith, John. *The Art of Constantinople: An Introduction to Byzantine Art (330–1453).* New York: Phaidon, 1968.

———. *Early Christian and Byzantine Art.* New York: Penguin, 1979. (Later edition available.)

Chatzidakis, Manolis. *Byzantine and Early Medieval Painting.* New York: Viking, 1965.

Crespi, Gabriele. *The Arabs in Europe.* New York: Rizzoli, 1986.

Creswell, K. A. C. *A Short Account of Early Muslim Architecture.* Rev. and enl. ed. Aldershot, England: Scolar, 1989.

Dalton, Ormonde M. *Byzantine Art and Archaeology.* New York: Dover, 1961.

Demus, Otto. *Byzantine Art and the West.* New York: New York University Press, 1970.

———. *The Mosaic Decoration of San Marco, Venice.* Chicago: University of Chicago Press, 1988.

Du Bourguet, Pierre. *Early Christian Art.* New York: William Morrow, 1971.

Ettinghausen, Richard. *Arab Painting.* Geneva: Skira, 1977.

———. *From Byzantium to Sasanian Iran and the Islamic World.* Leiden: Brill, 1972.

Ettinghausen, Richard, and Grabar, Oleg. *The Art and Architecture of Islam, 650–1250.* New York: Viking Penguin, 1987. (Later edition available.)

Golombek, Lisa, and Wilber, Donald. *The Timurid Architecture of Iran and Turan.* 2 vols. Princeton: Princeton University Press, 1988.

Goodwin, Godfrey. *A History of Ottoman Architecture.* New York: Thames & Hudson, 1987.

Gough, Michael. *The Origins of Christian Art.* New York: Praeger, 1973.

Grabar, André. *The Beginnings of Christian Art, 200–395.* London: Thames & Hudson, 1967.

———. *Byzantine Painting.* Geneva: Skira, 1953.

———. *Christian Iconography.* Princeton: Princeton University Press, 1980.

———. *The Golden Age of Justinian: From the Death of Theodosius to the Rise of Islam.* New York: Odyssey Press, 1967.

Grabar, André, and Chatzidakis, Manolis. *Greek Mosaics of the Byzantine Period.* New York: New American Library, 1964.

Grabar, Oleg. *The Formation of Islamic Art.* Rev. and enl. ed. New Haven: Yale University Press, 1987.

Grover, Satish. *The Architecture of India: Islamic (727–1707).* New Delhi: Vikas, 1981.

Grunebaum, Gustave von. *Classical Islam: A History, 600–1258.* Chicago: Aldine, 1970.

Hamilton, George H. *The Art and Architecture of Russia.* 2nd ed. New York: Viking, 1975. (Later edition available.)

Hamilton, John A. *Byzantine Architecture and Decoration.* 1933. Freeport, NY: Books for Libraries/Arno Press, 1972.

Hoag, John D. *Islamic Architecture.* New York: Abrams, 1977; Rizzoli (paperbound), 1987.

Hutter, Irmgard. *Early Christian and Byzantine Art.* London: Herbert Press, 1988.

Huyghe, René, ed. *Larousse Encyclopedia of Byzantine and Medieval Art.* See **Reference Books**.

Kitzinger, Ernst. *Byzantine Art in the Making.* Cambridge: Harvard University Press, 1977.

———. *Early Medieval Art with Illustrations from the British Museum Collection.* Rev. ed. Bloomington: Indiana University Press, 1983.

Krautheimer, Richard, and Curcic, Slobodan. *Early Christian and Byzantine Architecture.* 4th rev. ed. New York: Penguin, 1986.

Kühnel, Ernst. *Islamic Art and Architecture.* London: Bell, 1966.

Lane, Arthur. *Early Islamic Pottery, Mesopotamia, Egypt and Persia.* New York: Faber & Faber, 1965.

Levey, Michael. *The World of Ottoman Art.* New York: Scribner, 1975.

Lewis, Bernard, ed. *Islam and the Arab World.* New York: Knopf, 1976.

Lowrie, Walter S. *Art in the Early Church.* New York: Norton, 1969.

MacDonald, William L. *Early Christian and Byzantine Architecture.* New York: Braziller, 1962. (Later edition available.)

Maguire, Henry. *Art and Eloquence in Byzantium.* Princeton: Princeton University Press, 1981.

Mango, Cyril. *Byzantine Architecture.* New York: Electa/Rizzoli, 1985.

———. *Byzantium and Its Image: History and Culture of the Byzantine Empire and Its Heritage.* London: Variorum Reprints, 1984.

Meyer, Peter. *Byzantine Mosaics: Torcello, Venice, Monreale, Palermo.* London: Batsford, 1952.

Milburn, Robert L. P. *Early Christian Art and Architecture.* Berkeley: University of California Press, 1988.

Perkins, Ann Louise. *The Art of Dura-Europos.* Oxford: Clarendon Press, 1973.

Pope, Arthur, and Ackerman, Phyllis. *A Survey of Persian Art from Prehistoric Times to the Present.* London: Oxford University Press, 1977.

Rice, David T. *The Appreciation of Byzantine Art.* London: Oxford University Press, 1972.

———. *The Art of Byzantium.* New York: Abrams, 1959.

———. *Byzantine Art.* London: Variorum Reprints, 1973.

———. *Islamic Art.* London: Thames & Hudson, 1975.

Schiller, Gertrud. *Iconography of Christian Art.* See **Reference Books.**

Schimmel, Annemarie. *Islam in India and Pakistan.* Leiden: Brill, 1982.

Smith, Earl Baldwin. *Architectural Symbolism of Imperial Rome and the Middle Ages.* Princeton: Princeton University Press, 1956.

———. *The Dome, a Study in the History of Ideas.* Princeton: Princeton University Press, 1971.

Snyder, James. *Medieval Art: Painting, Sculpture, and Architecture, 4th–14th Century.* New York: Abrams, 1989.

Swift, Emerson H. *Hagia Sophia.* New York: Columbia University Press, 1980.

Volbach, Wolfgang. *Early Christian Mosaics, from the Fourth to the Seventh Centuries.* New York: Oxford University Press, 1946.

Volbach, Wolfgang, and Hirmer, Max. *Early Christian Art.* New York: Abrams, 1962.

Von Simson, Otto G. *Sacred Fortress: Byzantine Art and Statecraft in Ravenna.* Chicago: University of Chicago Press, 1976. (Later edition available.)

Walter, Christopher. *Art and Ritual of the Byzantine Church.* London: Variorum, 1982.

Weitzmann, Kurt. *Ancient Book Illumination.* Cambridge: Harvard University Press, 1959.

———. *Art in the Medieval West and Its Contacts with Byzantium.* London: Variorum, 1982.

———. *Illustrations in Roll and Codex.* Princeton: Princeton University Press, 1970.

Weitzmann, Kurt, et al. *The Icon.* New York: Knopf, 1982.

CHAPTER 8 EARLY MEDIEVAL ART

Arnold, Bruce. *Irish Art: A Concise History.* Rev. ed. London: Thames & Hudson, 1989.

Beckwith, John. *Early Medieval Art: Carolingian, Ottonian, Romanesque.* New York: Oxford University Press, 1974.

Calkins, Robert G. *Illuminated Books of the Middle Ages.* Ithaca, NY: Cornell University Press, 1983.

Conant, Kenneth. *Carolingian and Romanesque Architecture 800–1200.* 2nd integrated rev. ed. Harmondsworth, England: Penguin, 1978. (Later edition available.)

Dodwell, C. R. *Anglo-Saxon Art: A New Perspective.* Ithaca, NY: Cornell University Press, 1982. (Later edition available.)

Finlay, Ian. *Celtic Art: An Introduction.* London: Faber & Faber, 1973.

Goldschmidt, Adolf. *German Illumination.* New York: Hacker, 1970.

Grabar, André, and Nordenfalk, Carl. *Early Medieval Painting from the Fourth to the Eleventh Century.* New York: Skira, 1967.

Harbison, Peter, et al. *Irish Art and Architecture from Prehistory to the Present.* London: Thames & Hudson, 1978.

Henderson, George. *Early Medieval Art.* Pelican Style and Civilization Series. New York: Penguin, 1972.

Henry, Françoise. *Irish Art During the Viking Invasions, 900–1020.* Ithaca, NY: Cornell University Press, 1970.

———. *Irish Art in the Early Christian Period, to 800.* Rev. ed. London: Methuen, 1965.

Hinks, Roger P. *Carolingian Art.* Ann Arbor: University of Michigan Press, 1974.

Klindt-Jensen, Ole, and Wilson, David M. *Viking Art.* 2nd ed. Minneapolis: University of Minnesota Press, 1980.

Laszlo, Gyula. *The Art of the Migration Period.* London: Allen Lane, 1974.

Leeds, Edward T. *Early Anglo-Saxon Art and Archaeology.* Westport, CT: Greenwood Press, 1970. (Later reprint available.)

Lucas, A. T. *Treasures of Ireland: Irish Pagan and Early Christian Art.* New York: Viking, 1973.

Megaw, Ruth, and Megaw, John V. *Celtic Art: From Its Beginning to the Book of Kells.* London: Thames & Hudson, 1989.

Mütherich, Florentine, and Gaehde, J. E. *Carolingian Painting.* New York: Braziller, 1976. (Later edition available.)

Nordenfalk, Carl. *Celtic and Anglo-Saxon Painting: Book Illumination in the British Isles 600–800.* New York: Braziller, 1977.

Porter, Arthur K. *The Crosses and Culture of Ireland.* New York: Benjamin Blom, 1971.

Simons, Gerald. *Barbarian Europe.* New York: Time-Life Books, 1979.

Stokstad, Marilyn. *Medieval Art.* New York: Harper & Row, 1986.

Taylor, Harold M., and Taylor, Joan. *Anglo-Saxon Architecture.* 2 vols. Cambridge: Cambridge University Press, 1980. (Later volume available.)

Wilson, David M., ed. *The Northern World: The History and Heritage of Northern Europe A.D. 400–1100.* New York: Abrams, 1980.

Zarnecki, George. *Art of the Medieval World.* New York: Abrams, 1975. (Later edition available.)

CHAPTER 9 ROMANESQUE ART

Clapham, Alfred W. *English Romanesque Architecture After the Conquest.* Oxford: Clarendon Press, 1964.

———. *Romanesque Architecture in Western Europe.* Oxford: Clarendon Press, 1959.

Conant, Kenneth John. *Carolingian and Romanesque Architecture, 800–1200.* 2nd integrated rev. ed. New York: Penguin, 1979.

Crichton, George H. *Romanesque Sculpture in Italy.* London: Routledge & Paul, 1954.

Decker, Heinrich. *Romanesque Art in Italy.* New York: Abrams, 1959.

Demus, Otto. *Romanesque Mural Painting.* New York: Abrams, 1970.

Deschamps, Paul. *French Sculpture of the Romanesque Period—Eleventh and Twelfth Centuries.* 1930. Reprint. New York: Hacker, 1972.

Dodwell, C. R. *Painting in Europe 800–1200.* Harmondsworth, England: Penguin, 1971.

Duby, Georges. *History of Medieval Art, 980–1440.* New York: Skira/Rizzoli, 1986.

Evans, Joan. *Art in Medieval France 987–1498.* Oxford: Clarendon Press, 1969.

Focillon, Henri. *The Art of the West in the Middle Ages.* Vol. 1. 2nd ed. London: Phaidon, 1969; Ithaca, NY: Cornell University Press (paperbound), 1980. (Later volume available.)

Gantner, Joseph; Pobé, Marcel; and Roubier, Jean. *Romanesque Art in France.* London: Thames & Hudson, 1956.

Gibbs-Smith, Charles H. *The Bayeux Tapestry.* London: Phaidon, 1973.

Grabar, André, and Nordenfalk, Carl. *Romanesque Painting.* New York: Skira, 1958.

Hearn, Millard F. *Romanesque Sculpture in the Eleventh and Twelfth Centuries.* Ithaca, NY: Cornell University Press/Phaidon, 1981.

Holt, Elizabeth Gilmore, ed. *A Documentary History of Art, I: The Middle Ages.* Princeton: Princeton University Press, 1981.

Kubach, Hans E. *Romanesque Architecture.* New York: Abrams, 1975. (Later edition available.)

Kuenstler, Gustav, ed. *Romanesque Art in Europe.* New York: Norton, 1973.

Leisinger, Hermann. *Romanesque Bronzes: Church Portals in Mediaeval Europe.* New York: Praeger, 1957.

Male, Émile. *Art and Artists of the Middle Ages.* Redding Ridge, CT: Black Swan Books, 1986.

Michel, Paul H. *Romanesque Wall Paintings in France.* Paris: Éditions Chêne, 1949.

Morey, Charles R. *Medieval Art.* New York: Norton, 1970.

Porter, Arthur K. *Medieval Architecture.* 2 vols. 1909. Reprint. New York: Hacker, 1969.

————. *Romanesque Sculpture of the Pilgrimage Roads.* 1923. Reprint. New York: Hacker, 1969.

Rickert, Margaret. *Painting in Britain: The Middle Ages.* 2nd ed. Harmondsworth, England: Penguin, 1965.

Rivoira, Giovanni. *Lombardic Architecture: Its Origin, Development, and Derivatives.* 1933. Reprint. New York: Hacker, 1975.

Saalman, Howard. *Medieval Architecture: European Architecture 600–1200.* New York: Braziller, 1962.

Schapiro, Meyer. *Romanesque Art: Selected Papers.* London: Chatto & Windus, 1977; New York: Braziller, 1976.

Stoddard, Whitney. *Art and Architecture in Medieval France.* New York: Harper & Row, 1972.

Stone, Lawrence. *Sculpture in Britain in the Middle Ages.* Baltimore: Penguin, 1972.

Swarzenski, Hanns. *Monuments of Romanesque Art.* Chicago: University of Chicago Press, 1974.

Webb, Geoffrey F. *Architecture in Britain: The Middle Ages.* Harmondsworth, England: Penguin, 1965.

Zarnecki, George. *Romanesque Art.* New York: Universe Books, 1971.

————. *Studies in Romanesque Sculpture.* London: Dorian Press, 1979.

CHAPTER 10 GOTHIC ART

Adams, Henry B. *Mont-Saint-Michel and Chartres.* New York: Doubleday/Anchor, 1959. (Later reprint available.)

Arnold, Hugh. *Stained Glass of the Middle Ages in England and France.* London: A. & C. Black, 1956.

Arslan, Edoardo. *Gothic Architecture in Venice.* London: Phaidon, 1971.

Aubert, Marcel. *The Art of the High Gothic Era.* New York: Crown, 1965.

————. *Gothic Cathedrals of France and Their Treasures.* London: N. Kay, 1959.

Bony, Jean. *The English Decorated Style.* Ithaca, NY: Cornell University Press, 1979.

————. *French Gothic Architecture of the XII and XIII Centuries.* Berkeley: University of California Press, 1983.

Branner, Robert. *Chartres Cathedral.* New York: Norton, 1969.

————. *Gothic Architecture.* New York: Braziller, 1961.

Duby, George. *The Age of the Cathedrals.* Chicago: University of Chicago Press, 1981.

Dupont, Jacques, and Gnudi, Cesare. *Gothic Painting.* New York: Rizzoli, 1979.

Evans, Joan. *Art in Medieval France 987–1498.* Oxford: Clarendon Press, 1969.

————. *The Flowering of the Middle Ages.* London: Thames & Hudson, 1985.

Fitchen, John. *The Construction of Gothic Cathedrals: A Study of Medieval Vault Erection.* Chicago: University of Chicago Press, 1977; Phoenix Books, 1981.

Focillon, Henri. *The Art of the West in the Middle Ages.* Vol. 2. Ithaca, NY: Cornell University Press, 1980.

Foster, Richard. *Discovering English Churches.* New York: Oxford University Press, 1982.

Frankl, Paul. *Gothic Architecture.* Baltimore: Penguin, 1963.

————. *The Gothic Literary Sources and Interpretations.* Princeton: Princeton University Press, 1960.

Grodecki, Louis. *Gothic Architecture.* New York: Electa/Rizzoli, 1985.

Harvey, John H. *The Gothic World.* New York: Harper & Row, 1969.

Huizinga, Johan. *The Waning of the Middle Ages.* 1924. Reprint. New York: St. Martin's Press, 1988.

Jantzen, Hans. *High Gothic: The Classic Cathedrals of Chartres, Reims, and Amiens.* Princeton: Princeton University Press, 1984.

Johnson, James. *The Radiance of Chartres.* New York: Random House, 1965.

Johnson, Paul. *British Cathedrals.* New York: William Morrow, 1980.

Katzenellenbogen, Adolf. *The Sculptural Programs of Chartres Cathedral.* Baltimore: Johns Hopkins Press, 1959.

Male, Émile. *The Gothic Image: Religious Art in the Twelfth Century.* Rev. ed. Princeton: Princeton University Press, 1978.

————. *Religious Art in France: The 13th Century—A Study of Medieval Iconography and Its Sources.* Princeton: Princeton University Press, 1984.

————. *Religious Art in France: The Late Middle Ages—A Study of Medieval Iconography and Its Sources.* Princeton: Princeton University Press, 1986. (Later editions available.)

Mark, Robert. *Experiments in Gothic Structure.* Cambridge: MIT Press, 1982.

Martindale, Andrew. *Gothic Art.* London: Thames & Hudson, 1967. (Later edition available.)

————. *The Rise of the Artist in the Middle Ages and Early Renaissance.* New York: McGraw-Hill, 1972.

Panofsky, Erwin. *Abbot Suger on the Abbey Church of St. Denis and Its Art Treasures.* 2nd ed. Princeton: Princeton University Press, 1979.

————. *Gothic Architecture and Scholasticism.* New York: Meridian Books, 1963.

Pevsner, Nikolaus. *The Buildings of England.* 46 vols. Harmondsworth, England: Penguin, 1951–1974.

Robb, David M. *The Art of the Illuminated Manuscript.* Cranbury, NJ: A. S. Barnes, 1973. (Later edition available.)

Sauerlander, Willibald, and Hirmer, Max. *Gothic Sculpture in France 1140–1270.* New York: Abrams, 1973.

Sheridan, Ronald, and Ross, Anne. *Gargoyles and Grotesques: Paganism in the Medieval Church.* Boston: New York Graphic Society, 1975.

Stoddard, Whitney. *Monastery and Cathedral in Medieval France.* Middletown, CT: Wesleyan University Press, 1966. (Later editions available.)

Swaan, Wim. *The Late Middle Ages: Art and Architecture from 1350 to the Advent of the Renaissance.* Ithaca, NY: Cornell University Press, 1977.

Thompson, Daniel. *The Materials and Techniques of Medieval Painting.* New York: Dover, 1956.

Von Simson, Otto Georg. *The Gothic Cathedral: Origins of Gothic Architecture and the Medieval Concept of Order.* 3rd enl. ed. Princeton: Princeton University Press, 1988.

Zarnecki, George. *Art of the Medieval World.* New York: Abrams, 1975.

CHAPTER 11 THE ART OF INDIA

Acharya, Prasanna Kumar. *An Encyclopedia of Hindu Architecture.* 2nd ed. New Delhi: Oriental Books Reprint Corporation, 1979.

Archer, William G. *Indian Miniatures.* Greenwich, CT: New York Graphic Society, 1960.

————. *Indian Paintings from the Punjab Hills.* 2 vols. London: Sotheby Parke Bernet, 1973.

Asher, Frederick M. *The Art of Eastern India, 300–800.* Minneapolis: University of Minnesota Press, 1980.

Bachhofer, Ludwig. *Early Indian Sculpture.* 1929. Reprint. New York: Hacker, 1972. (Later edition available.)

Balasubrahmanyam, S. R. *Early Chola Art—Part I.* New York: Asia Publishing House, 1966.

————. *Early Chola Temples: Parantakat to Rajaraja I, A.D. 907–985.* Bombay: Orient Longman, 1971.

Barrett, Douglas E. *Early Chola Bronzes.* Bombay: Bhulabhai Memorial Institute, 1965.

Barrett, Douglas E., and Gray, Basil. *Painting of India.* Geneva: Skira, 1963.

Basham, Arthur L. *The Wonder That Was India.* 3rd rev. ed. Paris: Arthaud, 1976.

Bhattacharji, Sukumari. *The Indian Theogony, a Comparative Study of Indian Mythology.* London: Cambridge University Press, 1970. (Later edition available.)

Coomaraswamy, Ananda K. *History of Indian and Indonesian Art.* New Delhi: Munshiram Manaharlal, 1972. (Later edition available.)

————. *Yaksas.* New Delhi: Munshiram Manaharlal, 1971.

Craven, Roy C. *Indian Art: A Concise History.* London: Thames & Hudson, 1985.

Dehejia, Vidya. *Early Buddhist Rock Temples.* Ithaca, NY: Cornell University Press, 1972.

Ghosh, Amalananda. *Ajanta Murals.* New Delhi: Archaeological Survey of India, 1967.

Ghosh, Sankar Prosad. *Hindu Religious Art and Architecture.* Delhi: D. K. Publications, 1982.

Gopinatha Rao, T. A. *Elements of Hindu Iconography.* 2nd ed. 4 vols. New York: Paragon, 1968.

Gray, Basil, ed. *The Arts of India.* Ithaca, NY: Cornell University Press/Phaidon, 1981.

Groslier, Bernard P., and Arthaud, Jacques. *The Arts and Civilization of Angkor.* New York: Praeger, 1957.

Grover, Satish. *The Architecture of India: Buddhist and Hindu.* Sahibabad, Distt. Ghaziabad: Vikas, 1980.

Harle, James C. *The Art and Architecture of the Indian Subcontinent.* New York: Penguin, 1986. (Later edition available.)

————. *Gupta Sculpture: Indian Sculpture of the Fourth to the Sixth Centuries.* Oxford: Clarendon Press, 1974.

Head, Raymond. *The Indian Style.* Boston: Allen and Unwin, 1986.

Huntington, Susan L, and Huntington, John C. *The Art of Ancient India: Buddhist, Hindu, Jain.* New York: Weatherhill, 1985.

Khosa, Sunil. *Art History of Kashmir and Ladakh, Medieval Period.* New Delhi: Sagar, 1984.

Kramrisch, Stella. *The Art of India through the Ages.* 3rd ed. London: Phaidon, 1965. (Later editions available.)

————. *The Hindu Temple.* 2 vols. Delhi: Motilal Banarsidass, 1976. (Later reprint available.)

————. *Indian Sculpture.* The Heritage of India Series. London: Oxford University Press, 1933.

Krishna, Deva. *Temples of North India.* New Delhi: National Book Trust, 1969.

Krishna Murthy, C. *Saiva Art and Architecture in South India.* New Delhi: Sundeep Prakashan, 1985.

Lee, Sherman E. *Ancient Cambodian Sculpture.* New York: Intercultural Arts Press, 1970.

Manwani, S. N. *Evolution of Art and Architecture in Central India: With Special Reference to the Kalachuris of Ratanpur.* Delhi: Agam Kala Prakashan, 1988.

Meister, Michael W. *Encyclopedia of Indian Temple Architecture.* Philadelphia: University of Pennsylvania Press, 1983.

Munsterberg, Hugo. *Art of India and Southeast Asia.* New York: Abrams, 1970.

Rawson, Philip. *The Art of Southeast Asia.* New York: Praeger, 1967.

Rosenfield, John. *Dynastic Arts of the Kushan.* Berkeley: University of California Press, 1967.

Rowland, Benjamin. *The Art and Architecture of India: Buddhist, Hindu, Jain.* Harmondsworth, England: Penguin, 1977.

Sivaramamurti, C. *South Indian Bronzes.* New Delhi: Lalit Kala Akademi, 1963.

————. *South Indian Paintings.* New Delhi: National Museum, 1968.

Srinivasan, K. R. *Temples of South India.* New Delhi: National Book Trust, 1972.

Stutley, Margaret. *An Illustrated Dictionary of*

Hindu Iconography. Boston: Routledge and Keegan Paul, 1985.

Welch, Stuart Cary. *India: Art and Culture, 1300–1900.* New York: Metropolitan Museum of Art/Holt, Rinehart & Winston, 1985.

Williams, Joanna Gottfried. *The Art of Gupta India: Empire and Province.* Princeton: Princeton University Press, 1982.

Zimmer, Heinrich, and Campbell, Joseph, eds. *The Art of Indian Asia; Its Mythology and Transformations.* Bollingen Series 39. 2 vols. Princeton: Princeton University Press, 1983.

CHAPTER 12 THE ART OF CHINA

Bush, Susan, and Murck, Christian, eds. *Theories of the Arts in China.* Princeton: Princeton University Press, 1983.

Cahill, James. *Chinese Painting.* New ed. Geneva: Skira, 1977; New York: Rizzoli, 1977.

Davidson, J. Leroy. *The Lotus Sutra in Chinese Art: A Study in Buddhist Art to the Year 1880.* New Haven: Yale University Press, 1954.

Gray, Basil, and Vincent, John B. *Buddhist Cave Paintings at Tun-Huang.* Chicago: University of Chicago Press, 1959.

Honey, William B. *The Ceramic Art of China and Other Countries of the Far East.* New York: Beechhurst Press, 1954.

Hutt, Julia. *Understanding Far Eastern Art: A Complete Guide to the Arts of China, Japan, and Korea.* New York: Dutton, 1987.

Lee, Sherman E. *Chinese Landscape Painting.* 2nd ed. Cleveland: Cleveland Museum of Art, 1962. (Later edition available.)

———. *Past, Present, East and West.* New York: Braziller, 1983.

Loehr, Max. *The Great Painters of China.* New York: Harper & Row, 1980.

———. *Ritual Vessels of Bronze Age China.* New York: Asia Society, 1968.

Mizuno, Seiichi. *Bronzes and Jades of Ancient China.* Tokyo: Nihon Keizai, 1959.

Mizuno, Seiichi, and Nagahiro, Toshio. *A Study of the Buddhist Cave Temples at Lung-Men, Honan.* Tokyo: Zanho Press, 1941.

Munsterberg, Hugo. *Dictionary of Chinese and Japanese Art.* New York: Hacker, 1981.

———. *Symbolism in Ancient Chinese Art.* New York: Hacker, 1986.

Rudolph, Richard. *Han Tomb Art of West China.* Berkeley: University of California Press, 1951.

Sickman, Lawrence C., and Soper, Alexander. *The Art and Architecture of China.* Baltimore: Penguin, 1956. (Later edition available.)

Siren, Oswald. *Chinese Painting: Leading Masters and Principles.* New York: Hacker, 1973.

———. *Chinese Sculpture from the Fifth to the Fourteenth Centuries.* 4 vols. 1925. Reprint. New York: Hacker, 1970.

———. *A History of Later Chinese Painting.* 1938. Reprint. London: Medici Society, 1978.

Sullivan, Michael. *The Arts of China.* 3rd ed. Berkeley: University of California Press, 1984.

———. *The Birth of Landscape Painting in China.* Berkeley: University of California Press, 1962.

———. *A Short History of Chinese Art.* Berkeley: University of California Press, 1970.

Sullivan, Michael, and Darbois, Dominique. *The Cave Temples of Maichishan.* London: Faber & Faber, 1969.

Thorp, Robert L. *Son of Heaven: Imperial Arts of China.* Seattle: Son of Heaven Press, 1988.

Van Oort, H. A. *The Iconography of Chinese Buddhism in Traditional China.* Leiden: Brill, 1986.

Watson, William. *The Art of Dynastic China.* New York: Abrams, 1981. (Later edition available.)

Weber, Charles D. *Chinese Pictorial Bronze Vessels of the Late Chou Period.* Ascona, Switz: Artibus Asiae, 1968.

Willetts, William. *Foundations of Chinese Art.* New York: McGraw-Hill, 1965.

CHAPTER 13 THE ART OF JAPAN

Akiyama, Terukazu. *Japanese Painting.* Geneva: Skira; New York: Rizzoli, 1977.

Cahill, James F. *Scholar Painters of Japan: The Nanga School.* New York: Arno Press, 1976. (Later edition available.)

Drexler, Arthur. *The Architecture of Japan.* New York: Arno Press, 1966.

Eliseef, Danielle, and Eliseef, Vadime. *The Art of Japan.* New York: Abrams, 1985.

Fontein, Jan, and Hickman, M. C., eds. *Zen Painting and Calligraphy.* Greenwich, CT: New York Graphic Society, 1970.

Kanda, Christine Guth. *Shinzo: Hachiman Imagery and Its Development.* Cambridge: Harvard University Press, 1985.

Kidder, J. Edward. *Early Japanese Art.* London: Thames & Hudson, 1969.

———. *Japanese Temples: Sculpture, Painting, and Architecture.* Tokyo: Bijutsu Shuppansha, 1964.

Lee, Sherman E. *A History of Far Eastern Art.* London: Thames & Hudson, 1975. (Later edition available.)

———. *Japanese Decorative Style.* New York: Harper & Row, 1972.

Paine, Robert Treat, and Soper, Alexander. *The Art and Architecture of Japan.* 3rd rev. ed. Harmondsworth, England: Penguin, 1981.

Rosenfield, John M. *Japanese Art of the Heian Period, 749–1185.* New York: Asia Society, 1967.

Rosenfield, John M., and Shimada, Shujiro. *Traditions of Japanese Art.* Cambridge: Fogg Art Museum, Harvard University, 1970.

Soper, Alexander. *The Evolution of Buddhist Architecture in Japan.* 1942. Reprint. New York: Hacker, 1978.

Stanley-Smith, Joan. *Japanese Art.* New York: Thames & Hudson, 1984.

Stern, Harold P. *Master Prints of Japan: Ukiyo-e Hanga.* New York: Abrams, 1969.

Sugiyama, Jiro. *Classic Buddhist Sculpture: The Tempyo Period.* New York: Kodansha/Harper & Row, 1982.

CHAPTER 14 THE NATIVE ARTS OF THE AMERICAS, AFRICA, AND THE SOUTH PACIFIC

Pre-Columbian Art of the Americas

Anderson, Richard L. *Art in Small-Scale Societies.* 2nd ed. Englewood Cliffs, NJ: Prentice-Hall, 1989.

Anton, Ferdinand, et al. *Primitive Art: Pre-Columbian, North American Indian, African, Oceanic.* New York: Abrams, 1979.

Bennett, Wendell C. *Ancient Arts of the Andes.* New York: Museum of Modern Art/Arno Press, 1966.

Bernal, Ignacio. *The Olmec World.* Berkeley: University of California Press, 1977.

Coe, Michael D. *The Maya.* London: Thames & Hudson, 1980. (Later edition available.)

———. *Mexico.* 3rd ed. New York: Thames & Hudson, 1984. (Later edition available.)

Coe, Michael D., and Diehl, R. A. *In the Land of the Olmec.* 2 vols. Austin: University of Texas Press, 1980.

Coe, William R. *Tikal: A Handbook of the Ancient Maya Ruins.* 3rd ed. Philadelphia: University Museum, University of Pennsylvania, 1970. (Later edition available.)

Emmerich, André. *Sweat of the Sun and Tears of the Moon: Gold and Silver in Pre-Columbian Art.* New York: Hacker, 1977.

Franch, José Alcina. *Pre-Columbian Art.* New York: Abrams, 1983.

Grider, Terence. *Origins of Pre-Columbian Art.* Austin: University of Texas Press, 1982.

Heyden, Doris, and Gendrop, Paul. *Pre-Columbian Architecture of Mesoamerica.* New York: Abrams, 1975.

Kubler, George. *The Art and Architecture of Ancient America: The Mexican, Maya, and Andean Peoples.* 2nd ed. Harmondsworth, England: Penguin, 1975. (Later edition available.)

Lapiner, Alan C. *Pre-Columbian Art of South America.* New York: Abrams, 1976.

Lehmann, Walter, with Doering, Heinrich. *The Art of Old Peru.* New York: Hacker, 1975.

Los Angeles County Museum of Art. *Sculpture of Ancient West Mexico: Nayarit.* Los Angeles: Los Angeles County Museum of Art, 1970.

Mason, John Alden. *The Ancient Civilizations of Peru.* Rev. ed. Harmondsworth, England: Penguin, 1975. (Later edition available.)

Miller, Mary Ellen. *The Art of Mesoamerica: From Olmec to Aztec.* New York: Thames & Hudson, 1986.

Morley, Sylvanus G. *The Ancient Maya.* 3rd rev. ed. Stanford: Stanford University Press, 1973. (Later edition available.)

Paddock, John, ed. *Ancient Oaxaca: Discoveries in Mexican Archeology and History.* Stanford: Stanford University Press, 1970.

Pasztory, Esther. *Aztec Art.* New York: Abrams, 1983.

Peterson, Frederick. *Ancient Mexico.* New York: Capricorn Books, 1962.

Pettersen, Carmen L. *The Maya of Guatemala: Their Life and Dress.* Guatemala City: University of Washington Press, 1976. (Later edition available.)

Proskouriakoff, Tatiana Avenirovna. *A Study of Classic Maya Sculpture.* Washington, DC: Carnegie Institute of Washington, 1950.

Robertson, Donald. *Pre-Columbian Architecture.* New York: Braziller, 1963.

Robertson, Merle G.; Rands, Robert L.; and Graham, John A. *Maya Sculpture from the Southern Lowlands.* Berkeley: Lederer, Street & Zeus, 1972.

Rowe, John H. *Chavín Art: An Inquiry into Its Form and Meaning.* New York: Museum of Primitive Art, 1962.

Sabloff, Jeremy A. *The Cities of Ancient Mexico.* New York: Thames & Hudson, 1989.

Schele, Linda, and Miller, Mary Ellen. *The Blood of Kings: Dynasty and Ritual in Maya Art.* New York: Braziller, 1986.

Steward, Julian H. *Handbook of the South American Indians.* 7 vols. New York: Cooper Square Publishers, 1963.

Stierlin, Henri. *Art of the Aztecs and Its Origins.* New York: Rizzoli, 1982.

———. *Art of the Incas and Its Origins.* New York: Rizzoli, 1984.

Thompson, J. E. S. *Maya History and Religion.* Norman: University of Oklahoma Press, 1972. (Later edition available.)

Wauchope, Robert, ed. *Handbook of Middle American Indians.* 16 vols. Austin: University of Texas Press, 1964–1976.

Weaver, Muriel Porter. *The Aztecs, Maya, and their Predecessors: The Archaeology of Mesoamerica.* 2nd ed. New York: Academic Press, 1981.

North America

Boas, Franz. *Primitive Art.* 1927. Reprint. Magnolia, MA: Peter Smith, 1962.

Broder, Patricia Janis. *American Indian Painting and Sculpture.* New York: Abbeville Press, 1981.

Collins, Henry, et al. *The Far North: Two Thousand Years of American Eskimo and Indian Art.* Bloomington: Indiana University Press in association with the National Gallery of Art, Washington, DC, 1977.

Corbin, George A. *Native Arts of North America, Africa, and the South Pacific: An Introduction.* New York: Harper & Row, 1988.

Curtis, Edward S. *The North American Indian.* 30 vols. Cambridge: Cambridge University Press, 1907–1930. (Later reprint available.)

Dockstader, Frederick. *Indian Art in America: The Arts and Crafts of the North American Indian.* Greenwich, CT: New York Graphic Society, 1961.

———. *Indian Art of the Americas.* New York: Museum of the American Indian, Heye Foundation, 1973.

Ewers, John C. *Plains Indian Painting.* Stanford: Stanford University Press, 1939. (Later reprint available.)

Feder, Norman. *Two Hundred Years of North American Art.* New York: Praeger, 1972.

Feest, Christian F. *Native Arts of North America.* New York: Oxford University Press, 1980. (Later edition available.)

Grant, Campbell. *Rock Art of the American Indian.* 1967. Reprint. New York: Promontory Press, 1974. (Later edition available.)

Gunther, Erna. *Art in the Life of the Northwest Coast Indians.* Portland, OR: Portland Art Museum, 1966.

Kopper, Philip. *The Smithsonian Book of North American Indians.* Washington, DC: Smithsonian Institution Books, 1986.

Murdock, George P., and O'Leary, Timothy. *Ethnographic Bibliography of North America.* 4th ed. New Haven: Human Relations Area Files Press, 1972.

Ray, Dorothy J. *Artists of the Tundra and the Sea.* Seattle: University of Washington Press, 1961. (Later edition available.)

Ritchie, Carson I. A. *The Eskimo and His Art.* New York: St. Martin's Press, 1976.
Snow, Dean. *The Archaeology of North America/American Indians.* New York: Thames & Hudson, 1980. (Later edition available.)
Whiteford, Andrew H. *North American Indian Arts.* New York: Golden Press, 1973.

Africa

Allison, Philip. *African Stone Sculpture.* New York: Praeger, 1968.
Bascom, William R. *African Art in Cultural Perspective: An Introduction.* New York: Norton, 1973.
Ben-Amos, Paula. *The Art of Benin.* New York: Thames & Hudson, 1980.
Brentjes, Burchard. *African Rock Art.* London: Dent, 1967.
Cornet, Joseph. *Art of Africa: Treasures from the Congo.* London: Phaidon, 1971.
D'Azevedo, Warren L., ed. *The Traditional Artist in African Societies.* Bloomington: Indiana University Press, 1973. (Later edition available.)
Delange, Jacqueline. *Art and Peoples of Black Africa.* New York: Dutton, 1974.
Elisofon, Eliot, and Fagg, William. *The Sculpture of Africa.* New York: Hacker, 1978.
Eyo, Ekpo, and Willett, Frank. *Treasures of Ancient Nigeria.* New York: Knopf, 1980.
Fagg, William B. *Nigerian Images: The Splendor of African Sculpture.* New York: Praeger, 1963.
Forman, Werner. *Benin Art.* London: Hamlyn, 1960.
Fraser, Douglas F., and Cole, H. M., eds. *African Art and Leadership.* Madison: University of Wisconsin Press, 1972.
Gaskin, L. J. P. *A Bibliography of African Art.* London: International African Institute, 1965.
Gillon, Werner. *A Short History of African Art.* New York: Facts on File, 1984. (Later edition available.)
Laude, Jean. *The Arts of Black Africa.* Berkeley: University of California Press, 1973.
Lieris, Michel, and Delange, Jacqueline. *African Art.* New York: Golden Press, 1968.
Thompson, Robert F. *Black Gods and Kings: Yoruba Art at U.C.L.A.* Bloomington: Indiana University Press, 1976.
————. *Flash of the Spirit: African and Afro-American Art and Philosophy.* New York: Random House, 1983.
Trowell, Kathleen M. *Classical African Sculpture.* London: Faber & Faber, 1970.
Walker Art Center. *Art of the Congo.* Minneapolis: Walker Art Center, 1967.
Wassing, René S. *African Art: Its Background and Traditions.* New York: Abrams, 1968. (Later edition available.)
Willett, Frank. *African Art: An Introduction.* New York: Thames & Hudson, 1985.
————. *Life in the History of West African Sculpture.* New York: McGraw-Hill, 1967.

Oceania

Barrow, Terence. *An Illustrated Guide to Maori Art.* Honolulu: University of Hawaii Press, 1984.
Barrow, Tui T. *Art and Life in Polynesia.* Rutland, VT: Charles E. Tuttle, 1973.
————. *Maori Wood Sculpture of New Zealand.* Rutland, VT: Charles E. Tuttle, 1970.
Batterberry, Michael, and Ruskin, Ariane. *Primitive Art.* New York: McGraw-Hill, 1973.
Bernot, Ronald M. *Australian Aboriginal Art.* New York: Macmillan, 1964.
Buck, Peter H. *Arts and Crafts of Hawaii.* Honolulu: Bishop Museum Press, 1964.
Dodd, Edward H. *Polynesian Art.* New York: Dodd, Mead, 1967.
Firth, Raymond. *Art and Life in New Guinea.* 1936. Reprint. New York: AMS Press, 1977.
Fraser, Douglas. *Primitive Art.* London: Thames & Hudson, 1962.
Guiart, Jean. *Arts of the South Pacific.* New York: Golden Press, 1963.
Kooijman, S. *The Art of Lake Sentani.* New York: Museum of Primitive Art, 1959.
Linton, Ralph, and Wingert, Paul. *Arts of the South Seas.* 1946. Reprint. New York: Arno Press, 1972.
Newton, Douglas. *Art Styles of the Papuan Gulf.* New York: Museum of Primitive Art, 1961.
Rockefeller, Michael C. *The Asmat of New Guinea: The Journal of Michael Clark Rockefeller.* Greenwich, CT: New York Graphic Society, 1967.

Schmitz, Carl A. *Oceanic Art; Myth, Man and Image in the South Seas.* New York: Abrams, 1971.
Stubbs, Dacre. *Prehistoric Art of Australia.* New York: Scribner, 1975.
Taylor, Clyde R. H. *A Pacific Bibliography: Printed Matter Relating to the Native People of Polynesia, Melanesia, and Micronesia.* 2nd ed. Oxford: Clarendon Press, 1965.
Wingert, Paul. *Primitive Art: Its Traditions and Styles.* Cleveland: World Publishing, 1970.

CHAPTER 15 THE "PROTO-RENAISSANCE" IN ITALY

Andrés, Glenn, et al. *The Art of Florence.* 2 vols. New York: Abbeville Press, 1988.
Antal, Frederick. *Florentine Painting and Its Social Background.* London: Keegan Paul, 1948.
Cole, Bruce. *Sienese Painting: From Its Origins to the Fifteenth Century.* Bloomington: Indiana University Press, 1985. (Later edition available.)
Fremantle, Richard. *Florentine Gothic Painters from Giotto to Masaccio: A Guide to Painting in and near Florence.* London: Secker & Warburg, 1975.
Hills, Paul. *The Light of Early Italian Painting.* New Haven: Yale University Press, 1987.
Meiss, Millard. *Painting in Florence and Siena after the Black Death.* New York: Harper & Row, 1973. (Later edition available.)
Panofsky, Erwin. *Renaissance and Renascences in Western Art.* New York: Harper & Row, 1969. (Later edition available.)
Pope-Hennessy, John. *Introduction to Italian Sculpture.* 3rd ed. 3 vols. New York: Phaidon, 1986.
————. *Italian Gothic Sculpture.* 3rd ed. Oxford: Phaidon, 1986.
Schevill, Ferdinand. *The Medici.* New York: Harper & Row, 1960.
Smart, Alastair. *The Dawn of Italian Painting.* Ithaca, NY: Cornell University Press, 1978.
Stubblebine, James, ed. *Giotto: The Arena Chapel Frescoes.* New York: Norton, 1969.
————. *Assisi and the Rise of Vernacular Art.* New York: Harper & Row, 1985.
Van Marle, Raimond. *The Development of the Italian Schools of Painting.* 19 vols. 1923–1938. Reprint. New York: Hacker, 1970.
Venturi, Lionello, and Skira-Venturi, Rosabianca. *Italian Painting; The Creators of the Renaissance.* 3 vols. Geneva: Skira, 1950–1952.
White, John. *Art and Architecture in Italy 1250–1400.* 2nd integrated ed. New York: Viking Penguin, 1987. (Later edition available.)

CHAPTER 16 FIFTEENTH-CENTURY ITALIAN ART

Baxandall, Michael. *Painting and Experience in Fifteenth Century Italy. A Primer in the Social History of Pictorial Style.* 2nd ed. New York: Oxford University Press, 1988.
Berenson, Bernard. *The Italian Painters of the Renaissance.* Ithaca, NY: Phaidon/Cornell University Press, 1980.
————. *Italian Pictures of the Renaissance.* Ithaca, NY: Phaidon/Cornell University Press, 1980.
Bober, Phyllis Pray, and Rubinstein, Ruth. *Renaissance Artists and Antique Sculpture: A Handbook of Sources.* Oxford: Oxford University Press, 1986.
Borsook, Eve. *The Mural Painters of Tuscany.* New York: Oxford University Press, 1981.
Burckhardt, Jacob. *The Architecture of the Italian Renaissance.* Rev. ed. London: Secker & Warburg, 1985. (Later edition available.)
————. *The Civilization of the Renaissance in Italy.* 4th ed. 1867. Reprint. London: Phaidon, 1960.
Chastel, André. *The Age of Humanism.* New York: McGraw-Hill, 1964.
————. *A Chronicle of Italian Renaissance Painting.* Ithaca, NY: Cornell University Press, 1984.
————. *Studios and Styles of the Italian Renaissance.* New York: Braziller, 1971.
Cole, Bruce. *Masaccio and the Art of Early Renaissance Florence.* Bloomington: Indiana University Press, 1980.
Decker, Heinrich. *The Renaissance in Italy: Architecture, Sculpture, Frescoes.* New York: Viking, 1969.
De Wald, Ernest T. *Italian Painting, 1200–1600.* New York: Holt, Rinehart & Winston, 1961.
Earls, Irene. *Renaissance Art: A Topical Dictionary.* New York: Greenwood Press, 1987.
Edgerton, Samuel Y., Jr. *The Renaissance Rediscovery of Linear Perspective.* New York: Harper & Row, 1976.

Ferguson, Wallace K., et al. *The Renaissance.* New York: Henry Holt, 1940.
Gadol, Joan. *Leon Battista Alberti: Universal Man of the Early Renaissance.* Chicago: University of Chicago Press, 1969.
Gilbert, Creighton. *History of Renaissance Art throughout Europe.* New York: Abrams, 1973.
————. *Italian Art 1400–1500: Sources and Documents.* Englewood Cliffs, NJ: Prentice-Hall, 1970.
Godfrey, F. M. *Early Venetian Painters, 1415–1495.* London: Tiranti, 1954.
Gombrich, E. H. *Norm and Form: Studies in the Art of the Renaissance.* 4th ed. Oxford: Phaidon, 1985.
Hale, John R. *Italian Renaissance Painting from Masaccio to Titian.* New York: Dutton, 1977.
Hartt, Frederick. *History of Italian Renaissance Art: Painting, Sculpture, Architecture.* 3rd ed. Englewood Cliffs, NJ: Prentice-Hall, 1987.
Helton, Tinsley, ed. *The Renaissance: A Reconsideration of the Theories and Interpretations of the Age.* Madison: University of Wisconsin Press, 1964.
Heydenreich, Ludwig H., and Lotz, Wolfgang. *Architecture in Italy 1400–1600.* Harmondsworth, England: Penguin, 1974.
Holt, Elizabeth B. *A Documentary History of Art.* 2nd ed. Vol. 1. Garden City, NY: Doubleday, 1957.
Huyghe, René. *Larousse Encyclopedia of Renaissance and Baroque Art.* See **Reference Books.**
Janson, Horst W. *The Sculpture of Donatello.* 2 vols. Princeton: Princeton University Press, 1957. (Later edition available.)
Krautheimer, Richard, and Krautheimer-Hess, Trude. *Lorenzo Ghiberti.* Princeton: Princeton University Press, 1956. (Later edition available.)
Lieberman, Ralph. *Renaissance Architecture in Venice.* New York: Abbeville Press, 1982.
Lowry, Bates. *Renaissance Architecture.* New York: Braziller, 1962.
McAndrew, John. *Venetian Architecture of the Early Renaissance.* Cambridge: MIT Press, 1980.
Meiss, Millard. *The Painter's Choice, Problems in the Interpretation of Renaissance Art.* New York: Harper & Row, 1976. (Later edition available.)
Murray, Peter. *The Architecture of the Italian Renaissance.* Rev. ed. New York: Schocken, 1986.
————. *Renaissance Architecture.* New York: Electa/Rizzoli (paperbound), 1985.
Murray, Peter, and Murray, Linda. *The Art of the Renaissance.* London: Thames & Hudson, 1981. (Later edition available.)
Panofsky, Erwin. *Renaissance and Renascences in Western Art.* New York: Harper & Row, 1969. (Later edition available.)
Pater, Walter. *The Renaissance: Studies in Art and Poetry.* Edited by D. L. Hill. Berkeley: University of California Press, 1980.
Pope-Hennessy, John. *An Introduction to Italian Sculpture.* 3rd ed. 3 vols. New York: Phaidon, 1986.
————. *Sienese Quattrocento Painting.* New York: Oxford University Press, 1947.
Schevill, Ferdinand. *The Medici.* New York: Harper & Row, 1960.
Seymour, Charles. *Sculpture in Italy, 1400–1500.* Baltimore: Penguin, 1966.
Symonds, John Addington. *The Renaissance in Italy.* 7 vols. 1875–1886. Reprint. New York: Modern Library, 1935. (Other reprints available.)
Van Marle, Raimond. *The Development of the Italian Schools of Painting.* 19 vols. 1923–1938. Reprint. New York: Hacker, 1970.
Vasari, Giorgio. *The Lives of the Most Eminent Painters, Sculptors, and Architects, 1550–1568.* 3 vols. New York: Abrams, 1979.
Werkmeister, William H., ed.; Ferguson, Wallace, et al. *Facets of the Renaissance.* New York: Harper & Row, 1963.
White, John. *The Birth and Rebirth of Pictorial Space.* 3rd ed. Boston: Faber & Faber, 1987.
Wilde, Johannes. *Venetian Art from Bellini to Titian.* Oxford: Clarendon Press, 1981.
Wittkower, Rudolf. *Architectural Principles in the Age of Humanism.* 4th ed. London: Academy, 1988.

CHAPTER 17 SIXTEENTH-CENTURY ITALIAN ART

Ackerman, James S. *The Architecture of Michelangelo.* Rev. ed. Chicago: University of Chicago Press, 1986.
————. *Palladio.* New York: Penguin, 1978.

Bialostocki, Jan. *The Art of the Renaissance in Eastern Europe*. Ithaca, NY: Cornell University Press, 1976.

Blunt, Anthony. *Artistic Theory in Italy, 1450–1600*. London: Oxford University Press, 1975.

Briganti, Giuliano. *Italian Mannerism*. London: Thames & Hudson, 1962.

Castiglione, Baldassare. *Book of the Courtier*. 1528. Reprint. New York: National Alumni, 1907. (Other reprints available.)

Cellini, Benvenuto. *Autobiography*. Reprint. New York: Grolier, 1969. (Other reprints available.)

Freedberg, Sydney J. *Painting in Italy, 1500–1600*. 2nd ed. New York: Penguin, 1983.

———. *Painting of the High Renaissance in Rome and Florence*. Rev. ed. New York: Hacker, 1985.

Friedlaender, Walter. *Mannerism and Anti-Mannerism in Italian Painting*. New York: Schocken, 1965.

Holt, Elizabeth Gilmore, ed. *A Documentary History of Art*. Vol. 2, *Michelangelo and the Mannerists*. Rev. ed. Princeton: Princeton University Press, 1982.

Levey, Michael. *High Renaissance*. Harmondsworth, England: Penguin, 1975. (Later edition available.)

Murray, Linda. *The High Renaissance and Mannerism*. New York: Oxford University Press, 1977.

Partner, Peter. *Renaissance Rome, 1500–1559: A Portrait of a Society*. Berkeley: University of California Press, 1977.

Pietrangeli, Carlo, et al. *The Sistine Chapel: The Art, the History, and the Restoration*. New York: Harmony Books, 1986.

Pope-Hennessy, John. *Cellini*. London: MacMillan, 1985.

———. *Italian High Renaissance and Baroque Sculpture*. 3rd ed. 3 vols. Oxford: Phaidon, 1986.

Shearman, John K. G. *Mannerism*. Baltimore: Penguin, 1978.

Venturi, Lionello. *The Sixteenth Century: From Leonardo to El Greco*. New York: Skira, 1956.

Von Einem, Herbert. *Michelangelo*. London: Methuen, 1976.

Wölfflin, Heinrich. *The Art of the Italian Renaissance*. New York: Schocken, 1963.

———. *Classic Art: An Introduction to the Italian Renaissance*. 4th ed. Oxford: Phaidon, 1980.

Würtenberger, Franzsepp. *Mannerism: The European Style of the Sixteenth Century*. New York: Holt, Rinehart & Winston, 1963.

CHAPTER 18 THE RENAISSANCE OUTSIDE OF ITALY

Benesch, Otto. *Art of the Renaissance in Northern Europe*. Rev. ed. London: Phaidon, 1965.

———. *German Painting from Dürer to Holbein*. Geneva: Skira, 1966.

Blunt, Anthony. *Art and Architecture in France 1500–1700*. 4th ed. Baltimore: Penguin, 1982.

Chatelet, Albert. *Early Dutch Painting*. New York: Rizzoli, 1981. (Later edition available.)

Cuttler, Charles P. *Northern Painting from Pucelle to Bruegel*. New York: Holt, Rinehart & Winston, 1968.

Evans, Joan. *Monastic Architecture in France from the Renaissance to the Revolution*. New York: Hacker, 1980.

Friedlander, Max J. *Early Netherlandish Painting*. 14 vols. New York: Praeger/Phaidon, 1967–1976.

———. *From Van Eyck to Bruegel*. 3rd ed. Ithaca, NY: Cornell University Press, 1980.

Fuchs, Rudolph H. *Dutch Painting*. London: Thames & Hudson, 1978.

Hind, Arthur M. *History of Engraving and Etching from the Fifteenth Century to the Year 1914*. 3rd rev. ed. New York: Dover, 1963.

———. *An Introduction to a History of Woodcut*. New York: Dover, 1963.

Hitchcock, Henry-Russell. *German Renaissance Architecture*. Princeton: Princeton University Press, 1981.

Huizinga, Johan. *The Waning of the Middle Ages*. 1924. Reprint. New York: St. Martin's Press, 1988.

Kaufmann, Thomas DaCosta. *The School of Prague*. Chicago: University of Chicago Press, 1988.

Meiss, Millard. *French Painting in the Time of Jean de Berry*. New York: Braziller, 1974.

Panofsky, Erwin. *Early Netherlandish Painting*. Cambridge: Harvard University Press, 1953.

———. *The Life and Art of Albrecht Dürer*. 4th ed. Princeton: Princeton University Press, 1971.

Prevenier, Walter, and Blockmans, Wim. *The Burgundian Netherlands*. Cambridge: Cambridge University Press, 1986.

Snyder, James. *Northern Renaissance Art*. New York: Abrams, 1985.

Waterhouse, Ellis. *The Dictionary of 16th and 17th Century British Painters*. Woodbridge, England. Antique Collectors' Club, 1988.

Wolfthal, Diane. *The Beginnings of Netherlandish Canvas Painting, 1400–1530*. New York: Cambridge University Press, 1989.

CHAPTER 19 BAROQUE ART

Alpers, Svetlana. *The Art of Describing: Dutch Art in the Seventeenth Century*. Chicago: University of Chicago Press, 1983. (Later edition available.)

Bazin, Germain. *Baroque and Rococo Art*. New York: Praeger, 1974.

Blunt, Anthony, ed. *Baroque and Rococo: Architecture and Decoration*. Cambridge: Harper & Row, 1982.

Brown, Jonathon. *Velázquez: Painter and Courtier*. New Haven: Yale University Press, 1986.

Fokker, Timon H. *Roman Baroque Art: The History of a Style*. London: Oxford University Press, 1938.

Freedberg, Sydney J. *Circa 1600: A Revolution of Style in Italian Painting*. Cambridge: Harvard University Press, 1983. (Later edition available.)

Gerson, Horst, and ter Kuile, E. H. *Art and Architecture in Belgium 1600–1800*. Baltimore: Penguin, 1960. (Later edition available.)

Haak, Bob. *The Golden Age: Dutch Painters of the Seventeenth Century*. London: Thames & Hudson, 1984.

Held, Julius, and Posner, Donald. *17th and 18th Century Art*. New York: Abrams, 1974.

Hempel, Eberhard. *Baroque Art and Architecture in Central Europe*. Baltimore: Penguin, 1965. (Later edition available.)

Hibbard, Howard. *Bernini*. Harmondsworth, England: Penguin, 1976.

———. *Caravaggio*. New York: Thames & Hudson, 1983.

———. *Carlo Maderno and Roman Architecture, 1580–1630*. London: Zwemmer, 1971.

Hinks, Roger P. *Michelangelo Merisi da Caravaggio*. London: Faber & Faber, 1953.

Howard, Deborah. *The Architectural History of Venice*. London: B. T. Batsford, 1981.

Huyghe, René, ed. *Larousse Encyclopedia of Renaissance and Baroque Art*. See **Reference Books.**

Kahr, Madlyn Millner. *Dutch Painting in the Seventeenth Century*. New York: Harper & Row, 1978.

———. *Velázquez: The Art of Painting*. New York: Harper & Row, 1976.

Kitson, Michael. *The Age of Baroque*. London: Hamlyn, 1976.

Lees-Milne, James. *Baroque in Italy*. New York: Macmillan, 1960.

Martin, John R. *Baroque*. New York: Harper & Row, 1977.

Millon, Henry A. *Baroque and Rococo Architecture*. New York: Braziller, 1965.

Nicolson, Benedict. *The International Caravaggesque Movement*. Oxford: Phaidon, 1979.

Norberg-Schulz, Christian. *Baroque Architecture*. New York: Rizzoli, 1985. (Later edition available.)

———. *Late Baroque and Rococo Architecture*. New York: Electa/Rizzoli, 1985.

Pope-Hennessy, Sir John. *The Study and Criticism of Italian Sculpture*. New York: Metropolitan Museum, 1981.

Portoghesi, Paolo. *The Rome of Borromini*. London: Phaidon, 1972.

Powell, Nicolas. *From Baroque to Rococo: An Introduction to Austrian and German Architecture from 1580 to 1790*. London: Faber & Faber, 1959.

Rosenberg, Jakob; Slive, Seymour; and ter Kuile, E. H. *Dutch Art and Architecture, 1600–1800*. Baltimore: Penguin, 1979.

Spear, Richard E. *Caravaggio and His Followers*. New York: Harper & Row, 1975.

Stechow, Wolfgang. *Dutch Landscape Painting of the 17th Century*. Oxford: Phaidon, 1981.

Summerson, Sir John. *Architecture in Britain: 1530–1830*. 7th rev. and enl. ed. Baltimore: Penguin, 1983.

Tapie, Victor-Lucien. *The Age of Grandeur: Baroque Art and Architecture*. New York: Praeger, 1966.

Varriano, John. *Italian Baroque and Rococo Architecture*. New York: Oxford University Press, 1986.

Waterhouse, Ellis Kirkham. *Baroque Painting in Rome*. London: Phaidon, 1976.

———. *Italian Baroque Painting*. 2nd ed. London: Phaidon, 1969.

———. *Painting in Britain, 1530–1790*. 4th ed. New York: Penguin, 1978. (Later edition available.)

White, Christopher. *Peter Paul Rubens: Man and Artist*. New Haven: Yale University Press, 1987.

Wittkower, Rudolf. *Gian Lorenzo Bernini: The Sculptor of the Roman Baroque*. 3rd rev. ed. Oxford: Phaidon, 1981.

Wölfflin, Heinrich. *Principles of Art History: The Problem of the Development of Style in Later Art*. 7th ed. New York: Dover, 1950.

———. *Renaissance and Baroque*. London: Collins, 1984.

Wright, Christopher. *The French Painters of the 17th Century*. New York: New York Graphic Society, 1986.

CHAPTER 20 THE EIGHTEENTH CENTURY: ROCOCO AND THE BIRTH OF THE MODERN WORLD

Arnason, H. H. *The Sculptures of Houdon*. New York: Oxford University Press, 1975.

Bacou, Roseline. *Piranesi: Etchings and Drawings*. Boston: New York Graphic Society, 1975.

Blunt, Anthony. *Art and Architecture in France, 1500–1700*. 2nd ed. Harmondsworth, England: Penguin, 1970.

Braham, Allan. *The Architecture of the French Enlightenment*. Berkeley: University of California Press, 1980.

Burchard, John, and Bush-Brown, Albert. *The Architecture of America: A Social and Cultural History*. Boston: Little, Brown/The American Institute of Architects, 1965.

Chatelet, Albert, and Thuillier, Jacques. *French Painting from Le Nain to Fragonard*. Geneva: Skira, 1964.

Cobban, Alfred, ed. *The Eighteenth Century: Europe in the Age of the Enlightenment*. New York: McGraw-Hill, 1969.

Conisbee, Philip. *Painting in Eighteenth-Century France*. Ithaca, NY: Phaidon/Cornell University Press, 1981.

Crow, Thomas E. *Painters and Public Life in Eighteenth-Century Paris*. New Haven: Yale University Press, 1985.

Hayes, John T. *Gainsborough: Paintings and Drawings*. London: Phaidon, 1975.

Herrmann, Luke. *British Landscape Painting of the Eighteenth Century*. New York: Oxford University Press, 1974.

Hitchcock, Henry Russell. *Rococo Architecture in Southern Germany*. London: Phaidon, 1968.

Holt, Elizabeth Gilmore, ed. *From the Classicists to the Impressionists: A Documentary History of Art and Architecture in the Nineteenth Century*. Garden City, NY: Anchor Books/Doubleday, 1966.

Irwin, David. *English Neoclassical Art*. London: Faber & Faber, 1966.

Kalnein, Wend Graf, and Levey, Michael. *Art and Architecture of the Eighteenth Century in France*. New York: Viking/Pelican, 1973.

Kimball, Sidney F. *The Creation of the Rococo*. New York: W. W. Norton, 1964.

Levey, Michael. *Painting in Eighteenth-Century Venice*. Ithaca, NY: Phaidon/Cornell University Press, 1978.

———. *Rococo to Revolution: Major Trends in Eighteenth-Century Painting*. London: Thames & Hudson, 1966.

Millon, Henry A. *Baroque and Rococo Architecture*. New York: George Braziller, 1961, 1965.

Norberg-Schulz, Christian. *Late Baroque and Rococo Architecture*. New York: Harry N. Abrams, 1974.

Pierson, William. *American Buildings and Their Architects: Vol. 1, The Colonial and Neo-Classical Style*. Garden City, NY: Doubleday, 1970.

Pignatti, Terisio. *The Age of Rococo*. New York: Hamlyn, 1969.

Pevsner, Nikolaus. *An Outline of European Architecture*. 6th ed. Baltimore, MD: Penguin Books, 1960.

Powell, Nicolas. *From Baroque to Rococo: An Introduction to Austrian and German Architecture from 1580 to 1790*. London: Faber & Faber, 1959.

Raine, Kathleen. *William Blake*. New York: Oxford University Press, 1970.

Rosenblum, Robert. *Transformations in Late Eighteenth Century Art.* Princeton, NJ: Princeton University Press, 1970.

Waterhouse, Ellis K. *Painting in Britain, 1530–1790.* 4th ed. New York: Penguin, 1978.

Whinney. Margaret Dickens. *English Art, 1625–1714.* Oxford, England: Clarendon Press, 1957.

———. *Sculpture in Britain, 1530–1830.* Baltimore, MD: Penguin, 1964.

Whinney, Margaret D., and Millar, Oliver. *English Sculpture, 1720–1830.* London: H. M. Stationery Office, 1971.

Wittkower, Rudolf. *Art and Architecture in Italy, 1600–1750.* New York: Penguin, 1980.

CHAPTER 21 THE NINETEENTH CENTURY: PLURALISM OF STYLE

Aslin, Elizabeth. *The Aesthetic Movement: Prelude to Art Nouveau.* New York: Frederick A. Praeger, 1969.

Baudelaire, Charles; Mayne, Jonathan, tr. *The Mirror of Art, Critical Studies.* Garden City, NY: Doubleday & Co., 1956.

Barr, Margaret Scolari. *Medardo Rosso.* New York: The Museum of Modern Art, 1963.

Bisanz, R. M. *German Romanticism and Philipp Otto Runge.* De Kalb: Northern Illinois University Press, 1971.

Boime, Albert. *The Academy and French Painting in the 19th Century.* London: Phaidon, 1971.

Bonnat, Jean. *Degas: His Life and Work.* New York: Tudor Publishing Company, 1965.

Borsch-Supan, H. *Caspar David Friedrich.* New York: George Braziller, 1974.

Brion, Marcel. *Art of the Romantic Era: Romanticism, Classicism, Realism.* New York: Frederick A. Praeger, 1966.

Broun, Elizabeth. *Albert Pinkham Ryder.* Washington, DC: National Museum of American Art/Smithsonian Institutions, 1989.

Clark, Kenneth. *The Gothic Revival: An Essay in the History of Taste.* New York: Humanities Press, 1970.

Clay, Jean. *Romanticism.* New York: Phaidon, 1981.

Courthion, Pierre. *Romanticism.* Geneva: Skira, 1961.

Delacroix, Eugène; Pach, Walter, tr. *The Journal of Eugène Delacroix.* New York: Grove Press, 1937, 1948.

Dixon, Roger, and Muthesius, Stefan. *Victorian Architecture.* London: Thames & Hudson, 1978.

Dorra, Henri. *The American Muse.* London: Thames & Hudson, 1961.

Eitner, Lorenz. *Neo-Classicism and Romanticism 1750–1850: Sources and Documents on the History of Art.* 2 vols. Englewood Cliffs, NJ: Prentice-Hall, 1970.

Elsen, Albert. *Rodin.* New York: Museum of Modern Art, 1963.

Friedlaender, Walter. *From David to Delacroix.* New York: Schocken Books, 1968.

Fusco, Peter, and Janson, H. W. *The Romantics to Rodin: French 19th-Century Sculpture from American Collections.* Los Angeles: Los Angeles County Art Museum/New York: George Braziller, 1980.

Hamilton, George Heard. *Manet and His Critics.* New Haven, CT: Yale University Press, 1954.

Hanson, Anne Coffin. *Manet and the Modern Tradition.* New Haven, CT: Yale University Press, 1977.

Harker, Margaret F. *Henry Peach Robinson: Master of Photographic Art, 1830–1901.* Oxford, England: Basil Blackwell, 1988.

Hawley, Henry. *Neo-Classicism: Style and Motif.* Cleveland: Cleveland Museum of Art, 1964.

Hilton, Timothy. *The Pre-Raphaelites.* New York: Oxford University Press, 1970.

Holt, Elizabeth B. *From the Classicists to the Impressionists: Art and Architecture in the Nineteenth Century.* Garden City, NY: Doubleday/Anchor, 1966.

Honour, Hugh. *Neo-Classicism.* New York: Harper & Row, 1979.

———. *Romanticism.* New York: Harper & Row, 1979.

Janson, Horst W. *19th-Century Sculpture.* New York: Harry N. Abrams, 1985.

Leymarie, Jean. *French Painting in the Nineteenth Century.* Geneva: Skira, 1962.

Macaulay, James. *The Gothic Revival, 1745–1845.* Glasgow, Scotland: Blackie, 1975.

Middleton, Robin, ed. *The Beaux-Arts and Nineteenth-Century French Architecture.* Cambridge, MA: MIT Press, 1982.

Miller, Lillian B. *Patrons and Patriotism: The Encouragement of the Fine Arts in the United States, 1790–1860.* Chicago: The University of Chicago Press, 1966.

Newhall, Nancy. *P. H. Emerson.* New York: An Aperture Monograph, 1975.

Newton, Eric. *The Romantic Rebellion.* New York: Schocken Books, 1964.

Nochlin, Linda. *Gustave Courbet: A Study of Style and Society.* New York: Garland, 1976.

———. *Impressionism and Post-Impressionism, 1874–1904: Sources and Documents.* Englewood Cliffs, NJ: Prentice-Hall, 1966.

———. *Realism and Tradition in Art: Sources and Documents.* Englewood Cliffs, NJ: Prentice-Hall, 1966.

Novak, Barbara. *American Painting of the Nineteenth Century.* New York: Frederick A. Praeger, 1969.

Novotny, Fritz. *Painting and Sculpture in Europe: 1780–1880.* 2nd ed. Harmondsworth, England: Penguin, 1978.

Pelles, Geraldine. *Art, Artists and Society: Origins of a Modern Dilemma: Painting in England and France, 1750–1850.* Englewood Cliffs, NJ: Prentice-Hall, 1963.

Pevsner, Nikolaus. *Pioneers of Modern Design.* Harmondsworth, England: Penguin, 1964.

Poole, Phoebe. *Impressionism.* London: Thames & Hudson, 1967.

Rewald, John. *The History of Impressionism.* New York: Museum of Modern Art, 1973.

———. *Post-Impressionism: From Van Gogh to Gauguin.* New York: Museum of Modern Art, 1956.

Rewald, John; Ashton, Dore; and Joachim, Harold. *Odilon Redon, Gustave Moreau, Rodolphe Bresdin.* New York: Museum of Modern Art, 1962.

Roberts, Keith. *The Impressionists and Post-Impressionists.* New York: E. P. Dutton, 1977.

Rosen, Charles, and Zerner, Henri. *Romanticism and Realism: The Mythology of Nineteenth-Century Art.* London: Faber and Faber, 1984.

Rosenblum, Robert, and Janson, Horst W. *19th Century Art.* New York: Harry N. Abrams, 1984.

Russell, John. *Seurat.* New York: Frederick A. Praeger, 1965.

Sambrook, James, ed. *Pre-Raphaelitism: A Collection of Critical Essays.* Chicago: University of Chicago Press, 1974.

Sloane, Joseph C. *French Painting Between the Past and the Present: Artists, Critics, and Traditions from 1848 to 1870.* Princeton, NJ: Princeton University Press, 1973.

Sullivan, Louis. *The Autobiography of an Idea.* New York: Dover Publications, 1956.

Van Gogh: A Self Portrait: Letters Revealing His Life as a Painter. Selected by W. H. Auden. New York: E. P. Dutton, 1963.

Vaughan, William. *German Romantic Painting.* New Haven, CT: Yale University Press, 1980.

Weisberg, Gabriel P. *The Realist Tradition: French Painting and Drawing, 1830–1900.* Cleveland: Cleveland Museum/Indiana University Press, 1980.

Wood, Christopher. *The Pre-Raphaelites.* New York: Viking Press, 1981.

CHAPTER 22 THE EARLY TWENTIETH CENTURY

Ades, Dawn. *Dali and Surrealism.* New York: Harper & Row, 1982.

Adams, Ansel with Alinder, Mary Street. *Ansel Adams: An Autobiography.* Boston: Little, Brown & Co., 1985.

Anderson, Troels. *Malevich.* Amsterdam, Holland: Stedelijk Museum, 1970.

Apollinaire, Guillaume. *The Cubist Painters: Aesthetic Meditations, 1913.* New York: Wittenborn, 1970.

Barr, Alfred H., Jr. *Cubism and Abstract Art.* New York: Museum of Modern Art, 1936.

———. *Picasso: Fifty Years of His Art.* New York: Museum of Modern Art, 1946.

Barsacq, Léon. *Caligari's Cabinet and Other Grand Illusions: A History of Film Design.* New York: New American Library, 1978.

Bayer, Herbert; Gropius, Walter; Gropius, Ise, eds. *Bauhaus 1919–1928.* Boston: Charles T. Branford Co., 1959.

Benevolo, Leonardo. *History of Modern Architecture.* 2 vols. Cambridge, MA: MIT Press, 1977.

Blake, Peter. *Frank Lloyd Wright.* Harmondsworth, Middlesex: Penguin Books, 1960.

———. *The Master Builder.* New York: W. W. Norton, 1976.

Boesinger, Willy, ed. *Le Corbusier.* New York: Frederick A. Praeger, 1972.

Breton, André. *Surrealism and Painting.* New York: Harper & Row, 1972.

Campbell, Mary Schmidt; Driskell, David C.; Levering, David Lewis; and Ryan, Deborah Willis. *Harlem Renaissance: Art of Black America.* New York: The Studio Museum, Harlem/Harry N. Abrams, 1987.

Carls, Carl Dietrich. *Ernst Barlach.* London: Pall Mall Press, 1969.

Carrá, Massimo; Rathke, Ewald; Tisdall, Caroline; and Waldberg, Patrick. *Metaphysical Art.* New York: Frederick A. Praeger, 1971.

Carter, Peter. *Mies van der Rohe at Work.* London: Pall Mall Press, 1974.

Cassou, Jean. *Chagall.* New York: Frederick A. Praeger, 1965.

Cassou, Jean, and Pevsner, Nikolaus. *Gateway to the Twentieth Century.* New York: McGraw-Hill, 1962.

Dupin, Jacques. *Alberto Giacometti.* Paris: Maeght Éditeur, 1963.

Duthuit, Georges. *The Fauvist Painters.* New York: Wittenborn, Schultz, 1950.

Edwards, Ehrlig. *Painted Walls of Mexico.* Austin, TX: University of Texas Press, 1966.

Eisner, Lotte. *The Haunted Screen.* Berkeley: The University of California Press, 1965.

Elderfield, John. *Kurt Schwitters.* New York: Museum of Modern Art/Thames & Hudson, 1985.

———. *The "Wild Beasts": Fauvism and Its Affinities.* New York: The Museum of Modern Art/Oxford University Press, 1976.

Elsen, Albert. *Origins of Modern Sculpture.* New York: George Braziller, 1974.

Frampton, Kenneth. *A Critical History of Modern Architecture.* London: Thames & Hudson, 1985.

Friedman, Mildred, ed. *De Stijl: 1917–1931, Visions of Utopia.* Minneapolis: Walker Art Center/New York: Abbeville Press, 1982.

Fry, Edward, ed. *Cubism.* London: Thames & Hudson, 1966.

Fuller, R. Buckminster, and Marks, Robert. *The Dymaxion World of Buckminster Fuller.* Garden City, NY: Anchor Press/Doubleday, 1960.

Geist, Sidney. *Constantin Brancusi, 1876–1957: A Retrospective Exhibition.* New York: Solomon R. Guggenheim Museum/Philadelphia: Philadelphia Museum of Art/Chicago: Chicago Art Institute, 1969.

George, Waldemar, and Vierny, Dina. *Maillol.* London: Cory, Adams, and Mackay, 1965.

Giannetti, Louis D. *Understanding Movies.* 2nd ed. Englewood Cliffs, NJ: Prentice-Hall, 1976.

Giedion-Welcker, Carola. *Constantin Brancusi.* New York: George Braziller, 1959.

Gilot, François, and Lake, Carlton. *Life with Picasso.* New York: McGraw-Hill, 1964.

Golding, John. *Cubism: A History and an Analysis, 1907–1914.* rev. ed. Boston: Boston Book & Art Shop, 1968.

Gowing, Lawrence. *Matisse.* New York: Oxford University Press, 1979.

Gray, Camilla. *The Russian Experiment in Art: 1863–1922.* New York: Harry N. Abrams, 1970.

Gray, Christopher. *Cubist Aesthetic Theories.* Baltimore: Johns Hopkins University Press 1953.

Grohmann, Will. *Kandinsky: Life and Work.* New York: Harry N. Abrams, 1958.

Gropius, Walter. *Scope of Total Architecture.* New York: Collier Books, 1962.

Herrera, Hayden. *Frida: A Biography of Frida Kahlo.* New York: Harper & Row, 1983.

Hepworth, Barbara. *A Pictorial Autobiography.* London: The Tate Gallery, 1978.

Hof, August. *Wilhelm Lehmbruck.* London: Pall Mall Press, 1969.

Jaffé, Hans L. *De Stijl.* New York: Harry N. Abrams, 1971.

James, Philip. *Henry Moore on Sculpture.* New York: Viking Press, 1971.

Janis, Sidney. *Abstract and Surrealist Art in America.* 1944. reprint. New York: Arno Press, 1969.

Jean, Marcel; Taylor, Simon Watson, tr. *The History of Surrealist Painting*. New York: Grove Press, 1960.

Kahnweiler, Daniel H. *The Rise of Cubism*. New York: Wittenborn, Schultz, 1949.

Kandinsky, Wassily; Sadler, M. T. H., tr. *Concerning the Spiritual in Art*. New York: Dover Publications, 1977.

Kyrou, Ado. *Le Surréalisme au cinéma*. Paris: Le Terrain Vague, 1963.

Langaard, Johan H., and Revold, Reidar. *Edvard Munch: Masterpieces from the Artist's Collection in the Munch Museum in Oslo*. New York: McGraw-Hill, 1964.

Le Corbusier. *The City of Tomorrow*, Cambridge, MA: MIT Press, 1971.

Levin, Gail. *Edward Hopper: The Art and the Artist*. New York: Whitney Museum of American Art/ Norton, 1980.

Leyda, Jay. *Kino, A History of the Russian and Soviet Film: A Study of the Development of Russian Cinema from 1896 to the Present*. New York: Collier Books, 1973.

Lodder, Christina. *Russian Constructivism*. New Haven, CT: Yale University Press, 1983.

Maddow, Ben. *Edward Weston*. Boston: Aperture, New York Graphic Society, 1963.

Martin, Marianne W. *Futurist Art and Theory*. Oxford, England: Clarendon Press, 1968.

Martinell, César. *Gaudí: His Life, His Theories, His Work*. Cambridge, MA: MIT Press, 1975.

Mashek, Joseph, ed. *Marcel Duchamp in Perspective*. Englewood Cliffs, NJ: Prentice-Hall, 1975.

Mast, Gerald, and Cohen, Marshall, eds. *Film Theory and Criticism: Introductory Readings*. 2nd ed. New York: Oxford University Press, 1979.

Matthews, J. H. *Surrealism and Film*. Ann Arbor: The University of Michigan Press, 1971.

Meltzer, Milton. *Dorothea Lange: A Photographer's Life*. New York: Farrar, Strauss, Giroux, 1978.

Miller, Margaret, ed. *Paul Klee*. New York: Museum of Modern Art, 1946.

Moholy-Nagy, László. *Vision in Motion*. Chicago: Paul Theobald and Company, 1969, first published in 1946.

Mondrian, Pieter Cornelius. *Plastic Art and Pure Plastic Art*. 3rd ed. New York: Wittenborn, Schultz, 1952.

Morse, John D., ed. *Ben Shahn*. London: Secker & Warburg, 1972.

Motherwell, Robert, ed. *The Dada Painters and Poets*. New York: Wittenborn, Schultz, 1951.

Myers, Bernard S. *The German Expressionists: A Generation in Revolt*. New York: Frederick A. Praeger, 1956.

Norman, Dorothy. *Alfred Stieglitz: An American Seer*. Middleton, NY: Aperture, 1973.

O'Keeffe, Georgia. *Georgia O'Keeffe*. New York: Penguin, 1977.

Overy, Paul. *De Stijl*. London: Studio Vista, 1969.

Passuth, Krisztina. *Moholy-Nagy*. New York: Thames & Hudson, 1985.

Raymond, Marcel. *From Baudelaire to Surrealism*. London: Methuen, 1970.

Read, Herbert. *The Art of Jean Arp*. New York: Harry N. Abrams, 1968.

———, ed. *Surrealism*. New York: Frederick A. Praeger, 1971.

Richter, Hans. *Dada: Art and Anti-Art*. London: Thames & Hudson, 1961.

Rosenblum, Robert. *Cubism and Twentieth-Century Art*. New York: Harry N. Abrams, 1976.

Rubin, William S. *Dada and Surrealist Art*. New York: Harry N. Abrams, 1968.

———. *Dada, Surrealism and Their Heritage*. New York: Museum of Modern Art, 1968.

———. *Miró in the Collection of The Museum of Modern Art*. New York: Museum of Modern Art, 1973.

Rubin, William S., ed. *Pablo Picasso: A Retrospective*. New York: Museum of Modern Art/Boston: New York Graphic Society, 1980.

———. *"Primitivism" in 20th-Century Art: Affinity of the Tribal and the Modern*. 2 vols. New York: Museum of Modern Art, 1984.

Russell, John. *Max Ernst: Life and Work*. New York: Harry N. Abrams, 1967.

Schiff, Gert, ed. *Picasso in Perspective*. Englewood Cliffs, NJ: Prentice-Hall, 1976.

Schneede, Uwe M. *Surrealism*. New York: Harry N. Abrams, 1974.

Schwarz, Arturo. *The Complete Works of Marcel Duchamp*. London: Thames & Hudson, 1965.

———. *Man Ray: The Rigors of Imagination*. New York: Rizzoli, 1977.

Selz, Peter. *German Expressionist Painting*. 1957. reprint. Berkeley: University of California Press, 1974.

Selz, Peter, and Dubuffet, Jean. *The Work of Jean Dubuffet*. New York: Museum of Modern Art, 1962.

Seuphor, Michel. *Piet Mondrian: Life and Work*. New York: Harry N. Abrams, 1956.

Shattuck, Roger; Béhar, Henri; Hoog, Mitchell; Lauchner, Carolyn; and Rubin, William. *Henri Rousseau*. New York: Museum of Modern Art, 1985.

Snyder, Robert. *Buckminster Fuller: An Autobiographical Monologue Scenario*. New York: St. Martin's Press, 1980.

Soby, James Thrall. *Georges Rouault: Paintings and Prints*. New York: Museum of Modern Art/ Simon and Schuster, 1947.

Sotriffer, Kristian. *Expressionism and Fauvism*. New York: McGraw-Hill, 1972.

Speyer, James A. with Koeper, Frederick. *Mies van der Rohe*. Chicago: Art Institute of Chicago, 1968.

Stephenson, Robert C., tr. *Orozco: An Autobiography*. Austin, TX: University of Texas Press, 1962.

Stott, William. *Documentary Expression and Thirties America*. New York: Oxford University Press, 1973.

Taylor, Joshua C. *Futurism*. New York: Museum of Modern Art, 1961.

Troyen, Carol, and Hirshler, Erica E. *Charles Sheeler: Paintings and Drawings*. Boston: Museum of Fine Arts, 1987.

Tucker, William. *Early Modern Sculpture*. New York: Oxford University Press, 1974.

Vogt, Paul. *Expressionism: German Painting, 1905–1920*. New York: Harry N. Abrams, 1980.

Von Hartz, John. *August Sander*. Millerton, NY: Aperture, 1977.

Waldman, Diane. *Joseph Cornell*. New York: George Braziller, 1977.

Wright, Frank Lloyd; Kaufmann, Edgar, ed. *American Architecture*. New York: Horizon, 1955.

Wheat, Ellen Harkins. *Jacob Lawrence: American Painter*. Seattle: University of Washington Press, 1986.

CHAPTER 23 THE CONTEMPORARY WORLD

Albright, Thomas. *Art in the San Francisco Bay Area: 1945–1980*. Berkeley: University of California Press, 1985.

Alloway, Lawrence. *American Pop Art*. New York: Whitney Museum of American Art/Macmillan Publishing Co., 1974.

———. *Robert Rauschenberg*. Washington, DC: National Collection of Fine Arts/ Smithsonian Institutions, 1976.

———. *Topics in American Art Since 1945*. New York: W. W. Norton, 1975.

Amaya, Mario. *Pop Art and After*. New York: Viking Press, 1972.

Armes, Roy. *Patterns of Realism: A Study of Italian Neo-Realist Cinema*. New York: A. S. Barnes and Company, 1971.

Battcock, Gregory, ed. *Minimal Art: A Critical Anthology*. New York: Studio Vista, 1969.

———. *The New Art: A Critical Anthology*. New York: E. P. Dutton, 1973.

———. *New Artists Video: A Critical Anthology*. New York: E. P. Dutton, 1978.

———. *Super Realism: A Critical Anthology*. New York: E. P. Dutton, 1975.

Battcock, Gregory, and Nickas, Robert, eds. *The Art of Performance: A Critical Anthology*. New York: E. P. Dutton, 1984.

Beardsley, Richard. *Earthworks and Beyond: Contemporary Art in the Landscape*. New York: Abbeville Press, 1984.

Beardsley, John, and Livingston, Jane. *Hispanic Art in the United States: Thirty Contemporary Painters and Sculptors*. Houston: Museum of Fine Arts/New York: Abbeville Press, 1987.

Benthall, Jeremy. *Science and Technology in Art Today*. New York: Frederick A. Praeger, 1972.

Bourdon, David. *Christo*. New York: Harry N. Abrams, 1972.

Brion, Marcel; Hunter, Sam; et al. *Art Since 1945*. New York: Harry N. Abrams, 1958.

Buck, Robert T., Jr.; Cathcart, Linda L.; Nordland, Gerald; and Tuchman, Maurice. *Richard Diebenkorn: Paintings and Drawings, 1943–1980*. Buffalo, NY: Albright-Knox Art Gallery, 1980.

Carmean, E. A., Jr.; Rathbone, Elizabeth; and Hess, Thomas B. *American Art at Mid-Century: The Subjects of the Artists*. Washington, DC: The National Gallery of Art, 1978.

Cassou, Jean; Hultèn-Pontus, K. G.; and Hunter, Sam, with statement by Schöffer, Nicolas. *Two Kinetic Sculptors: Nicolas Schöffer and Jean Tinguely*. New York: Jewish Museum/October House, 1965.

Chicago, Judy. *The Dinner Party: A Symbol of Our Heritage*. Garden City, NY: Anchor Press/ Doubleday, 1979.

Cockcroft, Eva; Weber, John; and Cockcroft, James. *Toward a People's Art*. New York: E. P. Dutton, 1977.

Crichton, Michael. *Jasper Johns*. New York: Whitney Museum of American Art/Harry N. Abrams, 1977.

Cummings, Paul. *Dictionary of Contemporary American Artists*. 3rd ed. New York: St. Martin's Press, 1977.

Davies, Hugh, and Yard, Sally. *Francis Bacon*. New York: Abbeville Press, 1986.

Deken, Joseph. *Computer Images: State of the Art*. New York: Stewart, Tabori, and Chang Publishers, 1983.

Diamondstein, Barbaralee. *American Architecture Now*. New York: Rizzoli, 1980.

Diehl, Gaston, and Hennessey, Eileen B. *Vasarely*. New York: Crown Publishers, 1972.

Gilbert and George, and Ratcliff, Carter. *Gilbert and George: The Complete Pictures, 1971–1985*. London: Thames & Hudson, 1986.

Glaeser, Ludwig. *The Work of Frei Otto*. New York: Museum of Modern Art, 1972.

Goodman, Cynthia. *Digital Visions: Computers and Art*. New York: Harry N. Abrams, 1987.

Goodyear, Frank H., Jr. *Contemporary American Realism Since 1960*. Boston: New York Graphic Society, 1981.

Gordon, John. *Louise Nevelson*. New York: Whitney Museum of American Art, 1967.

Gough, Harry F. *The Vital Gesture: Franz Kline*. Cincinnati: Cincinnati Art Museum/New York: Abbeville Press, 1985.

Graham, Peter. *The New Wave*. Garden City, NY: Doubleday, 1968.

Gray, Cleve, ed. *David Smith on David Smith: Sculpture and Writings*. London: Thames & Hudson, 1968.

Hamilton, Richard. *Collected Words 1953–1982*. London: Thames & Hudson, 1982.

Hertz, Richard, ed. *Theories of Contemporary Art*. Englewood Cliffs, NJ: Prentice-Hall, 1985.

Hess, Thomas B. *Barnett Newman*. New York: Walker and Company, 1969.

———. *Willem de Kooning*. New York: Museum of Modern Art, 1968.

Jacob, Mary Jane. *Magdalena Abakanowicz*. New York: Abbeville Press, 1982.

Jacobus, John. *Twentieth-Century Architecture: The Middle Years, 1940–1964*. New York: Frederick A. Praeger, 1966.

Jencks, Charles. *Architecture 2000: Prediction and Methods*. New York: Frederick A. Praeger, 1971.

Joyce, Paul. *Hockney on Photography: Conversations with Paul Joyce*. New York: Harmony Books, 1988.

Kaprow, Allan. *Assemblage, Environments, and Happenings*. New York: Harry N. Abrams, 1966.

Kepes, Georgy. *Arts of the Environment*. New York: George Braziller, 1970.

Kirby, Michael. *Happenings*. New York: E. P. Dutton, 1966.

Kostelanetz, Richard, ed. *Esthetics Contemporary*. Buffalo, NY: Prometheus Books, 1978.

Lippard, Lucy R. *Eva Hesse*. New York: New York University Press, 1976.

———, ed. *Pop Art*. New York: Frederick A. Praeger, 1966.

———, ed. *Six Years: The Dematerialization of the Art Object from 1966 to 1972*. New York: Frederick A. Praeger, 1973.

Livingstone, Marco. *David Hockney*. London: Thames & Hudson, 1981.

Lovejoy, Margot. *Postmodern Currents: Art and Artists in the Age of the Electronic Media*. Ann Arbor, MI: UMI Research Press, 1989.

Lucie-Smith, Edward. *Movements Since 1945*. new rev. ed. New York: Thames & Hudson, 1984.

McShine, Kynaston. *Andy Warhol: A Retrospective*. New York: Museum of Modern Art, 1989.

————. *An International Survey of Recent Painting and Sculpture*. New York: Museum of Modern Art, 1984.

Meyer, Ursula. *Conceptual Art*. New York: E. P. Dutton, 1972.

Monaco, James. *The New Wave: Truffaut, Godard, Chabrol, Rohmer, Rivette*. New York: Oxford University Press, 1976.

Nervi, Pier Luigi. *Aesthetics and Technology in Building*. Cambridge, MA: Harvard University Press, 1965.

Norris, Christopher, and Benjamin, Andres. *What Is Deconstruction?* New York: St. Martin's Press, 1988.

O'Connor, Francis V. *Jackson Pollock*. New York: Museum of Modern Art, 1967.

O'Hara, Frank. *Robert Motherwell*. New York: Museum of Modern Art, 1965.

Price, Jonathan. *Video Visions: A Medium Discovers Itself*. New York: New American Library, 1977.

Reichardt, Jasia, ed. *Cybernetics, Art & Ideas*. Greenwich, CT: New York Graphics Society, 1971.

Risatti, Howard, ed. *Postmodern Perspectives*. Englewood Cliffs, NJ: Prentice-Hall, 1990.

Robbins, Corinne. *The Pluralist Era: American Art, 1968–1981*. New York: Harper & Row, 1984.

Robbins, David, ed. *The Independent Group: Postwar Britain and the Aesthetics of Plenty*. Cambridge, MA: MIT Press, 1990.

Rose, Barbara. *Claes Oldenburg*. New York: Museum of Modern Art, 1970.

————. *Frankenthaler*. New York: Harry N. Abrams, 1975.

Rosenberg, Harold. *The Tradition of the New*. New York: Horizon Press, 1959.

Russell, John. *Francis Bacon*. London: Thames & Hudson, 1971.

Russell, John, and Gablik, Suzi. *Pop Art Redefined*. New York: Frederick A. Praeger, 1969.

Sandler, Irving. *The Triumph of American Painting: A History of Abstract Expressionism*. New York: Frederick A. Praeger, 1970.

Schneider, Ira, and Korot, Beryl. *Video Art: An Anthology*. New York: Harcourt Brace Jovanovich, 1976.

Schwarz, Paul Waldo. *The Hand and Eye of the Sculptor*. New York: Frederick A. Praeger, 1969.

Sitney, P. Adams. *Visionary Film: The American Avant-Garde*. New York: Oxford University Press, 1974.

Smagula, Howard. *Currents: Contemporary Directions in the Visual Arts*. 2nd ed. Englewood Cliffs, NJ: Prentice-Hall, 1989.

Smith, Patrick S. *Andy Warhol's Art and Films*. Ann Arbor, MI: UMI Research Press, 1986.

Smithson, Robert; Holt, Nancy, ed. *The Writings of Robert Smithson*. New York: New York University Press, 1975.

Solomon, Alan. *Jasper Johns*. New York: The Jewish Museum, 1964.

Sonfist, Alan, ed. *Art in the Landscape: A Critical Anthology of Environmental Art*. New York: E. P. Dutton, 1983.

Stangos, Nikos. *Concepts of Modern Art*. 2nd ed. New York: Harper & Row, 1985.

Tisdall, Carolyn. *Joseph Beuys*. New York: Solomon R. Guggenheim Museum, 1979.

Tomkins, Calvin. *The Scene Reports on Post-Modern Art*. New York: Viking Press, 1976.

Tuchman, Maurice. *American Sculpture of the Sixties*. Los Angeles: Los Angeles County Museum of Art, 1967.

Venturi, Robert; Scott-Brown, Denise; and Isehour, Steven. *Learning from Las Vegas*. Cambridge, MA: MIT Press, 1972.

Waldman, Diane. *Mark Rothko, 1903–1970: A Retrospective*. New York: Solomon R. Guggenheim Museum, 1978.

Wallis, Brian, ed. *Art After Modernism: Rethinking Representation*. New York: New Museum of Contemporary Art in association with David R. Godine, 1984.

Wheeler, Dennis, ed. *Form and Structure in Recent Film*. Vancouver, BC: Vancouver Art Gallery, 1972.

Wye, Deborah. *Louise Bourgeois*. New York: Museum of Modern Art, 1982.

Youngblood, Gene. *Expanded Cinema*. New York: E. P. Dutton, 1970.

Books Spanning the Eighteenth, Nineteenth, and Twentieth Centuries

Ades, Dawn. *Art in Latin America: The Modern Era, 1820–1980*. London: The Hayward Gallery, 1989.

Antreasian, Garo, and Adams, Clinton. *The Tamarind Book of Lithography: Art and Techniques*. Los Angeles: Tamarind Workshop and New York: Harry N. Abrams, 1971.

Armstrong, John; Craven, Wayne; and Feder, Norma, et al. *200 Years of American Sculpture*. New York: Whitney Museum of American Art/Boston: David R. Godine, 1976.

Battcock, Gregory. *Minimal Art: A Critical Anthology*. New York: Studio Vista, 1969.

Brown, Milton; Hunter, Sam; and Jacobus, John. *American Art: Painting, Sculpture, Architecture, Decorative Arts, Photography*. New York: Harry N. Abrams, 1979.

Canaday, John. *Mainstreams of Modern Art*. New York: Holt, Rinehart & Winston, 1959.

Chipp, Herschel. *Theories of Modern Art*. Berkeley: University of California Press, 1968.

Coke, Van Deren. *The Painter and the Photograph From Delacroix to Warhol*. rev. and enl. ed. Albuquerque: University of New Mexico Press, 1972.

Collins, Peter. *Changing Ideals in Modern Architecture, 1750–1950*. London: Faber & Faber, 1971.

Condit, Carl W. *The Rise of the Skyscraper: Portrait of the Times and Career of Influential Architects*. Chicago: University of Chicago Press, 1952.

Driskell, David C. *Two Centuries of Black American Art*. Los Angeles: Los Angeles County Museum of Art/New York: Alfred A. Knopf, 1976.

Elsen, Albert. *Origins of Modern Sculpture*. New York: George Braziller, 1974.

Fine, Sylvia Honig. *Women and Art: A History of Women Painters and Sculptors from the Renaissance to the 20th Century*. Montclair, NJ: Alanheld and Schram, 1978.

Flexner, James Thomas. *America's Old Masters*. New York: McGraw-Hill, 1982.

Freund, Gisele. *Photography and Society*. Boston: David R. Godine, 1980.

Gernsheim, Helmut. *Creative Photography*. New York: Bonanza Books, 1962.

Giedion, Siegfried. *Mechanization Takes Command: A Contribution to Anonymous History*. New York: Norton, 1948.

————. *Space, Time and Architecture: The Growth of a New Tradition*. 4th ed. Cambridge, MA: Harvard University Press, 1965.

Giedion-Welcker, Carola. *Contemporary Sculpture: An Evolution in Volume and Space*. London: Faber & Faber, 1960.

Goldberg, Vicki. *Photography in Print*. New York: A Touchstone Book, Simon and Schuster, 1981.

Goldwater, Robert, and Treves, Marco, eds. *Artists on Art*. 3rd ed. New York: Pantheon, 1958.

Greenough, Sarah; Snyder, Joel; Travis, David; and Westerbeck, Colin. *On the Art of Fixing a Shadow: One Hundred and Fifty Years of Photography*. Washington, DC: The National Gallery of Art/Chicago: The Art Institute of Chicago, 1989.

Hamilton, George Heard. *Nineteenth- and Twentieth-Century Art*. Englewood Cliffs, NJ: Prentice-Hall, 1972.

Hammacher, A. M. *The Evolution of Modern Sculpture: Tradition and Innovation*. New York: Harry N. Abrams, 1969.

Hitchcock, Henry-Russell. *Architecture: Nineteenth and Twentieth Centuries*. 4th ed. Baltimore: Penguin, 1977.

Hopkins, H. J. *A Span of Bridges*. Newton Abbot, Devon, England: David & Charles, 1970.

Hunter, Sam. *Modern French Painting, 1855–1956*. New York: Dell, 1966.

Irving, Donald J. *Sculpture: Material and Process*. New York: Van Nostrand Reinhold Company, 1970.

Kaufmann, Edgar, Jr., ed. *The Rise of an American Architecture*. New York: Metropolitan Museum of Art/Frederick A. Praeger Publishers, 1970.

Klingender, Francis Donald and Elton, Arthur ed. and rev. *Art and the Industrial Revolution*. London: Evelyn, Adams and MacKay, 1968.

Licht, Fred. *Sculpture, Nineteenth and Twentieth Centuries*. Greenwich, CT: New York Graphic Society, 1967.

Loyer, Francois. *Architecture of the Industrial Age*. New York: Rizzoli, 1983.

Lyons, Nathan, ed. *Photographers on Photography*. Englewood Cliffs, NJ: Prentice-Hall, 1966.

McCoubrey, John W. *American Art, 1700–1960: Sources and Documents*. Englewood Cliffs, NJ: Prentice-Hall, 1965.

Mason, Jerry, ed. *International Center of Photography Encyclopedia of Photography*. New York: Crown Publishers, 1984.

Newhall, Beaumont. *The History of Photography*. New York: The Museum of Modern Art, 1982.

Pehnt, Wolfgang. *Encyclopedia of Modern Architecture*. New York: Harry N. Abrams, 1964.

Peterdi, Gabor. *Printmaking: Methods Old and New*. New York: Macmillan Company, 1961.

Pevsner, Nikolaus. *An Outline of European Architecture*. 6th ed. Baltimore: Penguin, 1960.

Phillipe, Robert. *Political Graphics: Art as a Weapon*. New York: Abbeville Press, 1980.

Pierson, William. *American Buildings and Their Architects: Technology and the Picturesque*. vol. 2. Garden City, NY: Doubleday, 1978.

Risebero, Bill. *Modern Architecture and Design: An Alternative History*. Cambridge: MIT Press, 1983.

Rosenblum, Naomi. *A World History of Photography*. New York: Abbeville Press, 1984.

Rosenblum, Robert. *Modern Painting and the Northern Romantic Tradition: Friedrich to Rothko*. New York: Harper & Row, 1975.

Ross, John, and Romano, Clare. *The Complete Printmaker*. New York: The Free Press, 1972.

Ross, Stephen David, ed. *Art and Its Significance: An Anthology of Aesthetic Theory*. Albany, NY: SUNY Press, 1987.

Sachs, Paul, Jr. *Modern Prints and Drawings: A Guide to a Better Understanding of Modern Draughtsmanship*. New York: Alfred A. Knopf, 1954.

Schapiro, Meyer. *Modern Art: 19th and 20th Centuries*. New York: George Braziller, 1980.

Scharf, Aaron. *Art and Photography*. Baltimore, MD: Penguin Books, 1974.

Scully, Vincent. *American Architecture and Urbanism*. New York: Frederick A. Praeger, 1969.

Selz, Peter; Michelson, Annette, tr. *Modern Sculpture: Origins and Evolution*. London: Heinemann, 1963.

Seuphor, Michel. *The Sculpture of this Century*. New York: George Braziller, 1960.

Shikes, Ralph E. *The Indignant Eye: The Artist as Social Critic, from the Renaissance to Picasso*. Boston: Banion Press, 1969.

Slatkin, Wendy. *Women Artists in History: From Antiquity to the 20th Century*. 2nd ed. Englewood Cliffs, NJ: Prentice-Hall, 1985.

Spencer, Harold. *American Art: Readings from the Colonial Era to the Present*. New York: Charles Scribner's Sons, 1980.

Summerson, Sir John. *Architecture in Britain: 1530–1830*. 7th rev. and enl. ed. Baltimore: Penguin, 1983.

Sypher, Wylie. *Rococo to Cubism in Art and Literature*. New York: Random House, 1960.

Szarkowski, John. *Photography Until Now*. New York: Museum of Modern Art, 1989.

Weaver, Mike. *The Art of Photography: 1839–1989*. New Haven, CT: Yale University Press, 1989.

Whiffen, Marcus, and Koeper, Frederick. *American Architecture, 1607–1976*. Cambridge: MIT Press, 1983.

Wilmerding, John. *American Art*. Harmondsworth, England: Penguin, 1976.

————. *The Genius of American Painting*. London: Weidenfeld & Nicolson, 1973.

Wilson, Simon. *Holbein to Hockney: A History of British Art*. London: The Tate Gallery & The Bodley Head, 1979.

Books Spanning the Whole of the Twentieth Century

Ades, Dawn. *Photomontage*. Rev. and enl. ed. London: Thames & Hudson, 1976.

Andersen, Wayne. *American Sculpture in Process: 1930–1970*. Boston: New York Graphic Society, 1975.

Andrew, J. Dudley. *The Major Film Theories: An Introduction*. New York: Oxford University Press, 1976.

Arnason, H. H. *History of Modern Art: Painting, Sculpture, Architecture*. 3rd rev. and enl. ed. Englewood Cliffs, NJ: Prentice-Hall 1988.

Ashton, Dore. *Twentieth-Century Artists on Art*. New York: Pantheon Books, 1985.

Banham, Reyner. *Guide to Modern Architecture*. Princeton, NJ: D. Van Nostrand, 1962.

Barsam, Richard Meran. *Nonfiction Film: A Critical History*. New York: E. P. Dutton, 1973.

Burnham, Jack. *Beyond Modern Sculpture. The Effects of Science and Technology on the Sculpture of This Century.* New York: George Braziller, 1968.

Castelman, Riva. *Prints of the 20th Century: A History.* New York: Oxford University Press, 1985.

Compton, Susan, ed. *British Art in the 20th Century.* London: Royal Academy of Arts/Berlin: Prestel Verlag, 1986.

Cook, David A. *A History of Narrative Film.* New York: Norton, 1981.

Curtis, David. *Experimental Cinema: A Fifty-Year Evolution.* New York: Dell, 1971.

Davis, Douglas. *Art and the Future: A History/ Prophecy of the Collaboration Between Scientists, Technology and the Arts.* New York: Frederick A. Praeger, 1973.

Diehl, Gaston. *The Moderns: A Treasury of Painting Throughout the World.* Milan: Uffizi, 1961.

Frascina, Francis, and Harrison, Charles, eds. *Modern Art and Modernism: A Critical Anthology.* New York: Harper & Row, 1982.

Goldberg, Rosalee. *Performance: Live Art, 1909 to the Present.* New York: Harry N. Abrams, 1979.

Haftmann, Werner. *Painting in the Twentieth Century.* New York: Frederick A. Praeger, 1960.

Hamlin, Talbot F., ed. *Forms and Functions of Twentieth-Century Architecture.* 4 vols. New York: Columbia University Press, 1952.

Hatje, Gerd, ed. *Encyclopedia of Modern Architecture.* London: Thames & Hudson, 1963.

Herbert, Robert L., ed. *Modern Artists on Art.* Englewood Cliffs, NJ: Prentice-Hall, 1964.

Hertz, Richard, and Klein, Norman M., eds. *Twentieth-Century Art Theory: Urbanism, Politics, and Mass Culture.* Englewood Cliffs, NJ: Prentice-Hall, 1990.

Hunter, Sam, and Jacobus, John. *Modern Art: Painting, Sculpture, and Architecture.* New York: Harry N. Abrams, 1985.

Hunter, Sam. *Modern American Painting and Sculpture.* New York: Dell, 1959.

Jencks, Charles. *Modern Movements in Architecture.* Garden City, NY: Anchor Press/ Doubleday, 1973.

Joachimides, Christos. M.; Rosenthal, Norma; and Schmied, Wieland, eds. *German Art in the 20th Century: Painting and Sculpture, 1905–1985.* Munich: Prestel-Verlag, 1985.

Kraus, Rosalind E. *Passages in Modern Sculpture.* Cambridge, MA: MIT Press, 1981.

Lynton, Norbert. *The Story of Modern Art.* 2nd ed. Englewood Cliffs, NJ: Prentice-Hall, 1989.

MacGowan, Kenneth. *Behind the Screen.* New York: A Dell Book, Delta Publishing Co., 1965.

Monaco, James. *How to Read a Film: The Art, Technology, Language, History, and Theory of Film and Media.* New York: Oxford University Press, 1977.

Phaidon Dictionary of Twentieth-Century Art. Oxford: Phaidon Press, 1973.

Phillips, Gene D. *The Movie Makers: Artists in an Industry.* Chicago: Nelson-Hall Company, 1973.

Pontus-Hultén, K. G. *The Machine as Seen at the End of the Mechanical Age.* New York: Museum of Modern Art, 1968.

Popper, Frank, et. al. *Electra: Electricity and Electronics in the Art of the 20th Century.* Paris: Musée d'art moderne de Paris, 1983.

————.; Benn, Stephen, tr. *Origins and Development of Kinetic Art.* Greenwich, CT: New York Graphic Society, 1968.

Raynal, Maurice. *History of Modern Painting.* 3 vols. Geneva: Skira, 1949–1950.

Read, Herbert. *Concise History of Modern Painting.* 3rd ed. New York: Frederick A. Praeger, 1975.

————. *A Concise History of Modern Sculpture.* rev. and enl. ed. New York: Frederick A. Praeger, 1964.

Rickey, George. *Constructivism: Origins and Evolution.* New York: George Braziller, 1967.

Ritchie, Andrew Carnduff, ed. *German Art of the Twentieth Century.* New York: Museum of Modern Art, 1957.

————. *Sculpture of the Twentieth Century.* New York: The Museum of Modern Art, n.d.

Rose, Barbara. *American Art Since 1900.* rev. ed. New York: Frederick A. Praeger, 1975.

Russell, John. *The Meanings of Modern Art.* New York: Museum of Modern Art/Thames & Hudson, 1981.

Scully, Vincent. *American Architecture and Urbanism.* New York: Frederick A. Praeger, 1969.

————. *Modern Architecture.* rev. ed. New York: George Braziller, 1974.

Sloane, J. C. *French Painting Between the Past and the Present.* Princeton, NJ: Princeton University Press, 1951.

Spalding, Francis. *British Art Since 1900.* London: Thames & Hudson, 1986.

Tomkins, Calvin. *The Bride and the Bachelors, Five Masters of the Avant-Garde.* New York: Viking Press, 1968.

Tuchman, Maurice, and Freeman, Judi, eds. *The Spiritual in Art: Abstract Painting, 1890–1985.* Los Angeles: Los Angeles County Art Museum/New York: Abbeville Press, 1986.

Wescher, Herta; Wolf, Robert E., tr. *Collage.* New York: Harry N. Abrams, 1968.

Whittick, Arnold. *European Architecture in the Twentieth Century.* Aylesbury, England: Leonard Hill Books, 1974.

PICTURE CREDITS

The authors and publisher are grateful to the proprietors and custodians of various works of art for photographs of these works and permission to reproduce them in this book. Sources not included in the captions are listed below.

Introduction Opening illustration: Nathan Benn; AL/AR: 4, 9, 10; Hir: 12; Photo courtesy Soichi Sunami/The Museum of Modern Art.

Part I Opening illustration: Adam Woolfitt/Susan Griggs Agency; page 24: Metropolitan Museum of Art (Egyptian Expedition).

Chapter 1 Courtesy Department of Library Services/AMNH: 9, 10, 13; Arch. Phot. Paris/S.P.A.D.E.M.: 7, 8, 11; Hinz: 1, 4; Hunting Aerofilms, Ltd.: 15; Photo Láborie, Bergerac, France: 5; MAS: 14; Edwin Smith: 16; Jean Vertut: 6, 12 (Coll. Begouen).

Chapter 2 AL/AR: 43; British School of Archaeology in Jerusalem: 1, 2; C.M.N.: 25, 37, 40; Hir: 13, 15, 27, 30, 34; Mansell: 31, 32; Arlette Mellaart: 6, 7, 8; James Mellaart: 5; OI: 16, 17, 21, 38, 41, 42; The University Museum/University of Pennsylvania: 19, 20; R.M.N.: 24, 26; Scala/AR: Staatliche Museen zu Berlin: 10.

Chapter 3 Photo by Bruno Balestrini by courtesy of Elemond, Milano: 9; Bettmann Archive: 26; Bildarchiv Preussischer Kulturbesitz, Berlin: 39; © Lee Boltin: 41; C.M.N.: 44; Egyptian Antiquities Organization: 24, 46; Egyptian Museum, Cairo: 1; Harding: 13, 30, 42, 43; Hir: 2, 3, 14, 15, 16, 17, 18, 19, 25, 33, 38; Mar/AR: 27; Metropolitan Museum of Art (Egyptian Expedition): 22, 36; OI: 23; George Gerster/PRI: 10; Geoffrey Clifford/Wheeler Pictures: 6, 20, 29.

Chapter 4 AR: 13; © "Cahiers d'Art": 1, 2, 3; Conway Library/Courtauld Institute of Art, London: 25; Alison Frantz: 23; Gir/AR: 20; Hir: 4, 5, 7, 8, 9, 12, 15, 16, 17, 18, 19, 22, 26, 27, 28, 29; Scala/AR: 14; TAP Service: 10, 11.

Chapter 5 AL/AR: 14, 26, 58, 62, 64, 66, 76, 86; Anderson/AR: 63; AR: 6; C.M.N.: 9, 60; Deutsches Archäologisches Institut, Rome: 12; Alison Frantz: 39, 40, 41, 51, 52; Gir/AR: 2; Harding: 55; Walter Hege: 45; Hinz: 10; Hir: 8, 11, 17, 18, 19, 22, 29, 32, 33, 37, 38, 44, 46, 47, 48, 49, 50, 53, 56, 57, 65, 75, 82, 87; Herschell Levit: 24; Barbara Malter/Instituto Centrali per il Catalogo e la Documentazione: 84; Mar/AR: 69, 70; Caecilia H. Moessner, Munich: 5, 7; J. Powell, Rome: 59; Frederick Ayer III/PRI: 71; Scala/AR: 34, 35, 36, 61, 79; Dr. Franz Stoedtner: 28; TAP Service: 4, 16, 68, 74, 95.

Chapter 6 AL/AR: 6, 10, 11, 17, 25, 35, 41, 64, 66, 67, 68, 70, 71, 80, 94, 96, 97; Anderson/AR: 38, 56, 65, 74; Photo by Bruno Balestrini by courtesy of Electa Editrice, Milano: 55; C.M.N.: 46; Deutsches Archäologisches Institut, Rome: 14, 73, 75, 93, 95; Walter Drayer: 2, 9, 12; Fototeca: 15 (Frank E. Brown), 16, 18, 19, 20, 21, 43, 50, 52, 59, 61, 63; Gab: 3, 76; Madeline Grimoldi Archive: 39, 98; HBJ Collection: 33, 36, 42; Hir: 4, 8; The Israel Museum, Jerusalem: 90; G. E. Kidder-Smith: 91; Photo KLM: 48; Amedeo Maiuri, Roman Painting, Editions d'Art Albert Skira: 26; Mar/AR: 82; Monumenti Musei e Gallerie Pontificia: 31; Rapho/PRI: 77; Leonard von Matt/PRI: 69; Rheinisches Landesmuseum, Trier: 85, 86; Charles Rotkin/PRI: 47; Scala/AR: 23, 28, 29, 30, 32, 34, 37, 88, 89; Gunter Heil/ZEFA: 84.

Chapter 7 AL/AR: 35, 62; Anderson/AR: 17, 22, 25, 66; Benedettine di Priscilla, Rome: 2; Byzantine Visual Resources, © 1989 and 1990, Dumbarton Oaks, Washington, D.C.: 41, 56; Enrico Ferorelli © 1989: 55; Sostegni/Fotocielo: 47; Alison Frantz: 43, 46; Gir/AR: 23; HBJ Collection: 5, 13, 50, 51, 69; Photo André Held: 10, 19, 57; Hir: 7, 16, 18, 20, 21, 24, 29, 32, 34, 40; Hunting Aerofilms, Ltd.: 64; State of Israel/Department of Antiquities and Museums, Jerusalem: 73; A. F. Kersting: 82; G. E. Kidder-Smith: 77; Angelo Longo Editore, Ravenna: 26, 27, 36, 37; MAS: 67, 68, 76; NYPL: 52; Novosti from Sovfoto: 60; Pontifica Commissione Centrale per l'Arte Sacra in Italia: 3; J. Powell, Rome: 53, 54, 74; Scala/AR: 9, 11, 12, 28, 30, 31, 38, 49; TASS/Sovfoto: 59; Staatliche Museen zu Berlin: 71; Russell A. Thompson/Taurus Photos: 79; Tourism Counselor's Office/Turkish Embassy, Washington, D.C.: 80; Weitzman/Princeton University: 39; Linares/Yale University Photo Collection: 75.

Part II Opening illustration: Scala/AR; page 316: Hunting Aerofilms, Ltd.

Chapter 8 ©Lee Boltin: 1; Bridgeman Art Library/AR: 2-b; Dr. Harold Busch: 20; HBJ Collection: 16, 24,

26, 27; Hir: 21; Mar/AR: 28; Copyright University Museum of National Antiquities, Oslo, Norway/ Photo by Erik Irgens Johnsen: 5; NYPL: 10, 14; R.M.N.: 2-a; © Mick Sharp, Photographer: 11; Photo Zodiaque: 6.

Chapter 9 AL/AR: 10, 11, 12, 19, 27; © Arch. Phot. Paris/S.P.A.D.E.M.: 1, 29, 30; Bulloz: 28, 32, 34; Jean Dieuzaide: 3, 24; Sergio Sostegni/Fotocielo: 18; Gir/AR: 35, 38, 39; HBJ Collection: 9, 33; Hir: 8; Evelyn Hofer: 20; A. F. Kersting: 16; Jean Roubier: 5, 13, 22, 26, 31; Scala/AR: 21; SEF/AR: 37; W. S. Stoddard: 14; Tapisserie de Bayeux, avec autorisation speciale de la Ville de Bayeux: 36; The Master and Fellows of Trinity College, Cambridge: 42.

Chapter 10 AL/AR: 62, 63; Anderson/AR: 60; Dr. Harold Busch/AR: 49, 52; F. Damm/Stadt Köln: 57; D.P.I., Inc.: 58; Electa Editrice: 18; Gir/AR: 32, 34, 36, 39; HBJ Collection: 1, 3, 35; Hir: 8, 10, 12, 13, 23, 25; Hunting Aerofilms, Ltd.: 16, 30; Mar/AR: 31, 33, 51, 53, 55; National Monuments Record, London: 41, 44, 45, 46; George Holton/PRI: 64; Rapho/PRI: 40; Rheinisches Bildarchiv, Cologne: 56; Jean Roubier: 9, 15; H. Rogier-Viollet: 14, 28; Scala/AR: 27, 29, 61; Helga Schmidt-Glassner: 54; Edwin Smith: 47; W. S. Stoddard: 20; Superstock International: 42; Clarence Ward, Photographic Archives, National Gallery of Art, Washington, D.C.: 7, 22, 26, 48.

Part III Opening illustration, National Film Board of Canada: page 422.

Chapter 11 Archaeological Survey of India, Government of India: 1, 2, 3, 4, 8, 9, 12, 14, 15, 17; Borromeo/AR: 5, 21; Asian Art Photographic Distribution, Department of the History of Art, University of Michigan: 16; Barnaby's Picture Library: 19, 20; Photograph by Ananda Coomaraswamy, Courtesy Fine Arts Library, Harvard University: 7; Photograph by Edgar Oscar Parker, courtesy of the Visual Collections, Fine Arts Library, Harvard University: 13; J. Leroy Davidson: 27; Eliot Elisofon, LIFE Magazine © Time Inc.: 28; Courtesy of the Fogg Art Museum, Harvard University, Cambridge, Mass.: 13; HBJ Collection: 22, 25; Marie J. Mattson: 32; R. Rowan/PRI: 30; © Allan Eaton/Sheridan Photo Library: 26; Superstock International: 33; I. Job Thomas: 23.

Chapter 12 Harry N. Abrams, Inc.: 4; Chavannes: 6; Courtesy of the Cultural Relics Bureau, Beijing and the Metropolitan Museum of Art, New York: 5; Editions d'Art, Paris: 30; HBJ Collection: 9, 13; Harding: 7, 23; © Joan Lebold Cohen: 32; © Marc Riboud/Magnum: 31; NYPL: 14; R.M.N.: 10, 26; Audrey R. Topping: 28.

Chapter 13 From A History of Far Eastern Art by Sherman E. Lee, Harry N. Abrams, Inc.: 7, 9, 26, 27; Photograph courtesy of the International Society for Educational Information, Inc.: 19, 25; Japan National Tourist Organization: 30; National Commission for Protection of Cultural Properties, Tokyo: 3, 10, 12; Sakamoto Photo Research Lab: 4, 8; Shashinka Photo: 15, 16, 17, 21, 22, 23; © 1981, Shogakukan Publishing Co. Ltd., Tokyo: 2, 5, 6, 11.

Chapter 14 © Albert Moldvay/AR: 1; Archive of Hispanic Culture, Library of Congress: 22-b; Tom Bahti: 34; © Lee Boltin: 5, 13; by Bill Ballenberg © 1988 National Geographic Society: 19; Chicago Natural History Museum: 22-a; From H. S. and C. B. Cosgrove, The Swarts Ruin: A Typical Mimbres Site in Southwestern New Mexico, Peabody Museum Papers, Vol. 15 No. 1. Reprinted with permission.: 31; Herbert M. Cole: 51; Todd Disotel: 73; David Gebhard, The Art Galleries, University of California, Santa Barbara: 30; Abraham Guillen: 24-b; E. Hadingham: 21; Dr. Norman Hammond, Boston University: 7; David Hiser/Photographers Aspen: 15; © Susan Holtz: 32; Peter Horner: 64; Dr. George Kennedy, University of California, Los Angeles: 65; © Justin Kerr: 8, 9, 10; Rene Millon, 1973: 4; Courtesy of the Native Land Foundation, Hampton, CT: 24; National Commission for Museums and Monuments, Lagos: 43, 44, 45; Peabody Museum, Harvard University, Cambridge: 11; John Running: 33; Photo Jerry Thompson: 58; From Karl von Steiner, Die Marquesaner und ihre Kunst I: 62; Frank Willett: 48; ZEFA: 14; © Neville Presho/ZEFA: 23.

Part IV Opening illustration: Scala/AR; page 555: AR.

Chapter 15 AL/AR: 2, 3, 4, 5, 8, 14, 15, 17; Anderson/AR: 22; Dmitri Kessel/LIFE Magazine © Time Inc.: 12; Scala/AR: 1, 6, 7, 9, 10, 11, 13, 18, 19, 20, 21.

Chapter 16 AL/AR: 4, 5, 6, 9, 13, 14, 17, 20, 22, 42, 45, 47, 48, 49, 52, 54, 57, 63; Anderson/AR: 12, 18, 25, 38, 41, 53; Brogi/AR: 3, 24; AR/AR: 7; HBJ Collection: 1, 2, 39, 44; Hinz: 58; Mar/AR: 11, 15, 46; Nimatallah/AR: 36; Scala/AR: 8, 10, 26, 28, 30, 31, 32, 33, 34, 35, 37, 51, 60, 61, 62, 64, 65; Copyright 1990 Antonio Quattrone: 27; Gerhard Reinhold, Leipzig-Mölkau: 67.

Chapter 17 Harry N. Abrams, Inc.: 50; Alinari/AR: 3, 9, 11, 27, 28, 45, 46, 47; Anderson/AR: 31, 37; AR: 49, 55; Artothek: 64; British Architectural Library, RIBA, London: 10; Fototeca: 30, 33; HBJ Collection: 13, 20; Phyllis Dearborn Massar: 51, 53, 54; NYPL: 34; Nimatallah/AR: 14; © Nippon Television Corporation: 26; R.M.N.: 4, 18, 21, 22, 59, 63; Rotkin/P.F.I.: 29; Scala/AR: 1, 15, 16, 17, 19, 23, 24, 25, 35, 36, 39, 40, 41, 56, 57, 60, 61, 62, 65, 66, 67, 68; Edwin Smith: 48; Vanni/AR: 6.

Chapter 18 ACL: 6, 7, 18, 19; Alinari/AR: 53; Anderson/AR: 45; ©Arch. Phot. S.P.A.D.E.M.: 1, 24, 49; Artothek: 31, 40; Bildarchiv Preussischer Kulturbesitz: Bulloz: 52; Giraudon/AR: 4, 34, 51; Hinz: 22; HBJ Collection: 27, 28, 50; Kavaler/AR: 43; MAS: 12, 20, 21, 54, 55, 56, 57, 58, 59; R.M.N.: 1, 24,

48, 49; Photo Verlag Gundermam, Würzburg: 28; Rheinisches Bildarchiv: 29; Scala/AR: 16, 17, 33, 34.

Chapter 19 ACL: 39; Alinari/AR: 10, 13, 14, 25, 26, 49, 72; Anderson/AR: 5, 16, 36; © Arch. Phot. Paris/ S.P.A.D.E.M.: 48, 71, 73; Artothek: 40, 41; Avery Architectural and Fine Arts Library, Columbia University, New York: 14; British Stationery Office: 74; © 1966, Henri Dauman. All rights reserved.: 68; Gab: 21; HBJ Collection: 19, 22, 67, 69; Hunter Aerofilms, London: 65; A. F. Kersting: 4, 64; G. E. Kidder-Smith: 18, 20; NYPL: 66; Novosti/Sovfoto: 50; MAS: 34, 38; R.M.N.: 28, 42, 44, 48, 57, 58, 60, 61, 71, 73; H. Roger-Viollet: 70; Rotkin/P.F.I.: 3; Scala/AR: 7, 8, 9, 12, 24, 27, 29, 31, 33, 45; Helga Schmidt-Glassner: 63.

Chapter 20 ACL: 41; Alinari/AR: 14, 24; AR: 5; © Arch. Photo. Paris/S.P.A.D.E.M.: 3, 29; Photo British Museum: 31; British Stationery Office: 2; HBJ Collection: 12, 15, 25; Hir: 18; Hunting Aerofilms: 38; A. F. Kersting: 16, 33, 36; Reproduced from the Collections of the Library of Congress: 43; NYPL: 11; Printing Services Collection (#NPS-2645), Special Collections Department, University Archives, University of Virginia Library: 44; R.M.N.: 4, 6, 29, 40; Rapho/PRI: 1; Royal Commission on the Historical Monuments of England: 26; Scala/AR: 13; Tate Gallery/AR: 46; Virginia State Library: 42.

Part V Opening illustration: Courtesy Jeremy Stone Gallery, San Francisco.

Chapter 21 Alinari/AR: 2, 7; Wayne Andrews: 98; © Arch. Phot. Paris: 1, 8 (Moreau); Photograph © 1990 The Art Institute of Chicago. All rights reserved: 76, 80, 87, 92; Copyright 1990 ARS N.Y./ A.D.A.G.P.: 91; Copyright © 1955 by Paris/ S.P.A.D.E.M.: 54, 55, 56; Bulloz: 6, 15; Richard Cheek/The Preservation Society of Newport County: 9; Chicago Architectural Photography Co.: 97; French Government Tourist Office: 96; Gernsheim Collection, Harry Ransom Humanities Research Center, The University of Texas at Austin: 50, 53; Gir/AR: 12, 39; Hedrich-Blessing, Chicago: 99; HBJ Collection: 75, 95; A. F. Kersting: 5; Library of Congress: 64; MAS: 25, 26, 27; Mar/AR: 94; Massachusetts General Hospital, News and Public Affairs, Boston: 34; Novosti/Sovfoto: 45; Brownlie/ PRI: 4; R.M.N.: 10, 11, 13, 14, 16, 18, 19, 37, 72, 88; The Royal Photographic Society, Bath, England: 35; Scala/AR: 65; Staatliche Museen zu Berlin: 22; Tate Gallery/AR: 57, 58, 78.

Chapter 22 Jörg P. Anders, Berlin: 28; George Roos/ AR: 5; Copyright 1990 ARS N.Y./A.D.A.G.P.: 4, 7, 10, 16, 17, 25, 26, 30, 37, 45, 47; Copyright 1990 ARS N.Y./Cosmopress: 38, 42, 43; Copyright 1990 ARS N.Y./S.P.A.D.E.M.: 6, 9, 11, 56, 57, 83; Copyright 1990 ARS N.Y./S.P.A.D.E.M./A.D.A.G.P.: 34; Henri Cartier-Bresson/Magnum Photos, Inc.: 74; Courtesy of the Center for Creative Photography, University of Arizona: 67; Chicago Architectural Photography Co.: 53; Photo by Geoffrey Clements, New York: 12; Courtesy of the Trustees of Dartmouth College, Hanover, N.H.: 82; Copyright 1990 DEMART PRO ARTE/ARS N.Y.: 36; For more information concerning Buckminster Fuller, please contact the Buckminster Fuller Institute, 1743 South La Cienega Blvd, Los Angeles, CA 90035.: 63; © Hans Hammarskiold: 70; HBJ Collection: 22, 58; Photo by David Heald: 47; Lucien Hervé: 56, 57; Hinz: 7, 41, 50; William Lescaze and Associates: 62; Library of Congress: 18; The Museum of Modern Art, New York: 1, 59, 61; The Museum of Modern Art/Film Stills Archive: 20, 33, 35, 77, 78, 79; MAS: 3, 83; R.M.N.: 9; Photo by Sandak, Inc.: 80; Ezra Stoller © Esto: 55; Copyright 1990 SUCCESSION H. MATISSE/ARS N.Y.: 5; Tate Gallery/AR: 51; Courtesy Donna Van Der Zee: 71.

Chapter 23 Courtesy of Brooke Alexander, New York: 55; Photograph © 1990 The Art Institute of Chicago. All rights reserved: 25; Copyright 1990 ARS N.Y./A.D.A.G.P.: 5, 27; Copyright 1990 ARS N.Y./ S.P.A.D.E.M.: 9, 10, 22; Photo © Margaret Benyon: 47; Mel Bochner: 54; Rudolph Burckhardt: 24, 39; © Christo 1983/photo by Wolfgang Volz: 77; Photo by Geoffrey Clements: 64; Paula Court: 65; Electronic Arts Intermix: 48, 49; Esto Photography: 21; Lee Fatherree: 1; Through the Flower Corporation: 71; David Gahr: 42; © Gianfranco Gorgoni, New York: 76; Solomon R. Guggenheim Museum, New York: 69/Photo by Robert E. Mates: 7, 8; HBJ Collection: 2; Douglas Hollis: 79; Institut für Leichte Flachentragwerke, Stuttgart: 19; G. E. Kidder-Smith: 10; Photo courtesy Barbara Kruger: 73; Photo courtesy Richard Long: 78; Robert McElroy: 51; Middendorf Gallery, New York: 16; The Museum of Modern Art/ Film Stills Archive: 52, 66; Courtesy National Gallery of Canada/Experimental Film Office and Michael Snow: 53; © 1990 Dolores Neuman: 80; Copyright 1990 Pollock-Krasner Foundation/ARS N.Y.: 1; Michel Proulx, Architectural Record: 61; George Holton/PRI: 9; Rapho/PRI: 43; Rheinisches Bildarchiv, Cologne: 26; Copyright 1990 Kate Rothko-Prize and Christopher Rothko/ARS N.Y.: 24; Oscar Savio: 87; Photo by Steven Sloman: 14; Courtesy Holly Solomon Gallery, New York: 59; Courtesy Sonnabend Gallery, New York: 59; Artur Starewicz, Warsaw: 30; Bernice Steinbaum Gallery, New York: 72; Ezra Stoller © Esto: 17; James A. Sugar, © National Geographic Society: 20; Tate Gallery/AR: 40; Venturi and Rauch: 60; Virginia Museum of Fine Arts: 41; © William Walker, 1970/ Photo courtesy J. P. Weber: 69; Copyright 1990 The Estate and Foundation of Andy Warhol/ARS N.Y.: 40; Courtesy Westin Hotels: 62.

Illustration Credits

FIGS. 1-2, 1-3 From "The Archeology of Lascaux Cave," by Arlette Leroi-Gourhan. Copyright © 1982 by Scientific American. All rights reserved.
FIGS. 2-3, 2-4 From Arlette Mellaart.
FIG. 2-11 From E. S. Piggott, Ed., The Dawn of Civilization, London: Thames and Hudson, 1961, p. 70.
FIG. 2-12 From H. Frankfort, The Art and Architecture of the Ancient Orient, Harmondsworth and Baltimore: Penguin, 1970, p. 69.
FIG. 2-28 From © 1975 The Royal Institute of British Architects and the University of London, by permission of the Athlone Press.
FIG. 2-29 From Sir Bannister Fletcher's A History of Architecture, 19th ed. Ed. John Musgrove, 1987. Plan H, p. 76. The Royal Institute of British Architects and the University of London.
FIG. 3-4 Adapted from the "Later Canon" of Egyptian Art, figure 1 in Erwin Panofsky, Meaning in the Visual Arts. Copyright © 1955 by Erwin Panofsky. Used by permission of Doubleday and Company, Inc.
FIG. 3-7 From K. Lange and M. Hirmer, Ägypten, Architectur, Plastik, und Malerei in drei Jahrtausenden, Munich, 1957. Used by permission of Phaidon Press and Hirmer Fotoarchiv.
FIG. 3-8 From J. P. Lauer, La Pyramide à degrés: L'Architecture, 3 vols., Cairo, 1936–1939.
FIGS. 3-21, 3-31, 5-27, 6-24, 6-49, 6-57a, 6-60, 7-48, 10-59 From Sir Bannister Fletcher, A History of Architecture on the Comparative Method, 17th ed., rev. by R. A. Cordingly, 1961. Used by permission of the Athlone Press of the University of London and the British Architectural Library, Royal Institute of British Architects, London.
FIGS. 4-6, 7-1, 7-8 From Hirmer Fotoarchiv.
FIGS. 5-23, 16-40 From Marvin Trachtenberg and Isabelle Hyman, Architecture From Prehistory to Post-Modernism/The Western Tradition, Englewood Cliffs, NJ: Prentice Hall, 1986, p. 86, p. 293. Used by permission.
FIG. 5-54 From Sir Bannister Fletcher's A History of Architecture, 19th ed. Ed. John Musgrove, 1987. B&C elevations, p. 117. The Royal Institute of British Architects and the University of London.
FIGS. 5-89, 5-90, 5-92 From Richard Brilliant, Arts of the Ancient Greeks, 1973. Adapted by permission of McGraw-Hill Book Co.
FIG. 5-93 From J. Charbonneaux, et al., Hellenistic Art 330–50 B.C., 1973. Adapted by permission of George Braziller, Inc.
FIG. 6-51 From The Architecture of the Roman Empire, I, Introductory Study, rev. ed. William L. MacDonald, New Haven and London: Yale University Press, 1982, Fig. 75.
FIG. 6-53 From A Concise History of Western Architecture by Robert Furneaux Jordan. © 1969 by Harcourt Brace Jovanovich, Inc. Reproduced by permission of the publisher.
FIG. 6-54 From J. B. Ward-Perkins, Roman Architecture. Adapted by permission of Electa Editrice, Milan.
FIG. 6-81 From Deutsches Archäologisches Institut, Rome.
FIG. 6-83 From Fiske Kimball, M. Arch, and G. H. Edgell, A History of Architecture, 1918. Used by permission of Harper & Row, Inc., publishers.
FIG. 6-87 After George M. A. Hanfamann, Roman Art: A Survey of the Art of Imperial Rome. A New York Graphic Society Book. By permission of Little, Brown and Co.
FIGS. 7-6, 9-4, 9-17 From Kenneth J. Conant, Early Medieval Church Architecture. Used by permission of The John Hopkins Press.
FIGS. 7-63, 7-70 From K. A. C. Creswell, Early Muslim Architecture. Adapted by permission of Clarendon Press/Oxford University Press.
FIG. 7-65 From G. Marçais, L'Architecture Musulmane d'Occident. By permission of Arts et Metiers Graphiques, Paris.
FIG. 7-72 Staatliche Museen zu Berlin.
FIG. 7-81 Plan drawn by Christopher Woodward.
FIG. 7-83 From "Sinan" by D. Kuban from Macmillan Encyclopedia of Architects, Adolf K. Placzek, Editor-in-Chief, Vol. 4 p. 68, © 1982 by The Free Press, a division of Macmillan, Inc.
FIGS. 9-2, 16-16 From H. Stierlin, Die Architektur der Welt, Vol 1, p. 147, p. 188, © 1977 Hirmer Verlag, Munich.
FIGS. 10-4, 10-5, 10-6 From Ernst Gall, Gotische Kathedralen, 1925. Used by permission of Klinkhardt & Biermann, publishers.
FIG. 10-19 Used by permission of Umschau Verlag, Frankfort.
FIG. 11-8 From Benjamin Rowland, The Art and Architecture of India, 1953, Penguin Books.
FIG. 11-29 From Madeleine Giteau, The Civilization of Angkor. Adapted by permission of Rizzoli International Publications.
FIG. 12-29 From William Watson, Art of Dynastic China, 1981. Used by permission of Harry N. Abrams, Inc.
FIG. 14-22 From "The Serpent Mound of Adams County, Ohio" by Charles C. Willoughby from Art and Archaeology, IV, 6, © 1916. Reproduced by permission of the Archaeological Institute of America.
FIG. 16-43 From Nikolaus Pevsner, An Outline of European Architecture, 6th ed., 1960, Penguin Books, Ltd., © Nikolaus Pevsner, 1943, 1960, 1963.
FIG. 19-23 Christian Norberg-Schulz, Baroque Architecture, 1971. Used by permission of Harry N. Abrams, Inc.

INDEX

Page numbers in italics indicate illustrations.